Christ among the Medieval Dominicans

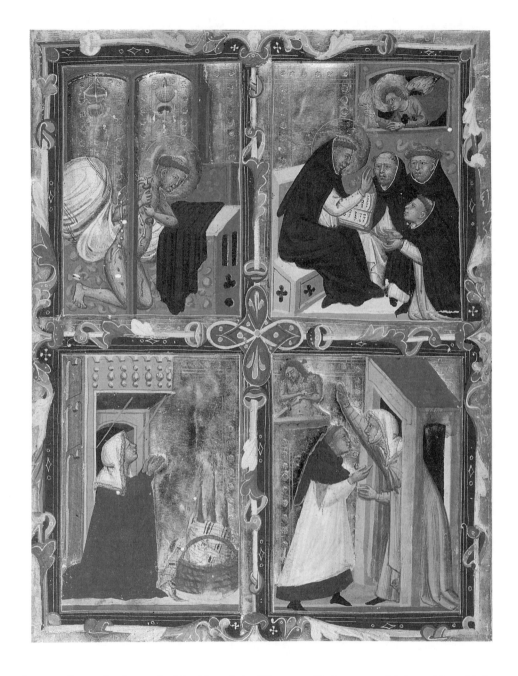

Scenes from the legend of St. Dominic, Hungary/Bolognese, 14th c., New York,
The Pierpont Morgan Library, M. 360, fol. 26.

CHRIST
AMONG THE
MEDIEVAL DOMINICANS
Representations of Christ in
the Texts and Images of
the Order of Preachers

Edited by
Kent Emery, Jr.
and
Joseph Wawrykow

NOTRE DAME CONFERENCES IN MEDIEVAL STUDIES
NUMBER VII

Institute of Medieval Studies
University of Notre Dame
John Van Engen, Director

University of Notre Dame Press

Notre Dame, Indiana

Library of Congress Cataloging-in-Publication Data

Christ among the medieval Dominicans : representations of Christ in
the texts and images of the Order of Preachers / edited by Kent
Emery, Jr. and Joseph Wawrykow.
 p. cm. — (Notre Dame conferences in medieval studies : no. 7)
ISBN 0–268–00831–0 (cloth: alk. paper)
ISBN 0–268–00836–1 (pbk.: alk. paper)
1. Dominicans—History Congresses. 2. Monasticism and religious
orders—History—Middle Ages, 600–1500—Congresses. 3. Jesus
Christ—Person and offices—History of doctrines—Middle Ages,
600–1500—Congresses. I. Emery, Kent, 1944– . II. Wawrykow,
Joseph Peter. III. Series. IV. Series: Notre Dame conferences in
medieval studies ; 7.
BX3506.2.C47 1998
271′.2—dc21 98–34870

Contents

Contributors

David L. d'Avray, Department of History, University College London

Denise Bouthillier, Commissio Leonina: *Codices manuscripti operum Thomae de Aquino*, Montréal

Stephen F. Brown, Director, Institute of Medieval Philosophy and Theology, Boston College

Joanna Cannon, Courtauld Institute of Art, University of London

Kent Emery, Jr., Program of Liberal Studies and Medieval Institute, University of Notre Dame

Joseph Goering, Department of History, University of Toronto

Jeffrey F. Hamburger, Graduate Department of the History of Art, University of Toronto

Maarten J. F. M. Hoenen, Faculteit der Wijsbegeerte, Katholieke Universiteit Nijmegen

Ulrich Horst, O.P., Director, Grabmann-Institut der Universität zu München

Louis E. Jordan, Curator, Special Collections, University of Notre Dame

James Long, Department of Philosophy, Fairfield University

Edward P. Mahoney, Department of Philosophy, Duke University

Alain Nadeau, Institut d'Études médiévales, Université de Fribourg (Suisse)

Richard Newhauser, Department of English, Trinity University, San Antonio

Monique Paulmier-Foucart, Atélier Vincent de Beauvais, Université de Nancy II

Riccardo Quinto, Istituto di Storia della Filosofia dell'Università di Padova

Miri Rubin, Pembroke College, Oxford

Richard Schenk, O.P., Director, Forschungsinstitut für Philosophie Hannover

Margot Schmidt, Theologische Fakultät, Katholische Universität Eichstätt

Alfred Thomas, Department of Slavic Languages and Literatures, Harvard University

Jean-Pierre Torrell, O.P., Albertinum, Université de Fribourg (Suisse) and Commissio Leonina

Simon Tugwell, O.P., Istituto Storico Domenicano, Roma

John Van Engen, Department of History (formerly Director, Medieval Institute), University of Notre Dame

Joseph P. Wawrykow, Department of Theology and Medieval Institute, University of Notre Dame

Edouard-Henri Wéber, O.P., Couvent Saint-Jacques and Centre Nationale de Recherche Scientifique, Paris

Siegfried Wenzel, Emeritus, Department of English, University of Pennsylvania

Robert Wielockx, (formerly Katholieke Universiteit Leuven), Commissio Leonina, Roma-Grottaferrata

Walter Senner, O.P., Regent of Studies, Dominikanerkloster Hl. Kreuz, Köln, and Commissio Leonina

Abbreviations

Bibliographical abbreviations

AA.SS
: *Acta sanctorum quoquot toto orbe coluntur, vel a catholicis scriptoribus celebrantur . . . collegit, digessit, notis illustravit Joannes Bollandus.* Editio novissima curante J. Carnandet et al. 68 vols. Paris: Apud Victorem Palme, 1863–.

AFH
: *Archivum Franciscanum Historicum.* Quaracchi: Collegium S. Bonaventurae, 1908–.

AFP
: *Archivum Fratrum Praedicatorum.* Rome: Istituto Storico Domenicano, 1931–.

AHDLMA
: *Archives d'histoire doctrinale et littéraire du moyen âge.* Paris: J. Vrin, 1926–.

Albert the Great, Cologne Edition
: Albertus Magnus. *Opera omnia ad fidem codicum manuscriptorum edenda, apparatu critico, notis, prolegomenis, indicibus instruenda curavit Institutum Alberti Magni Coloniense, Bernhardo Geyer praeside.* In progress. Münster i.W.: Aschendorff, 1951–. First reference to a volume gives volume editor and year of publication.

ANTS
: Anglo-Norman Text Society. Oxford: B. Blackwell, and London: Birbeck College, 1939–.

BGPTMA
: Beiträge der Philosophie und Theologie des Mittelalters. Münster i.W.,1895–; 43 volumes. Neue Folge: 1970–.

Bonaventure, Quaracchi Edition
: *Doctoris seraphici S. Bonaventurae s.r.e. episcopi cardinalis Opera omnia.* Edited by Fathers of the College of St. Bonaventure. 10 volumes. Quaracchi: Collegium S. Bonaventurae, 1882–1902.

Borgnet
: *B. Alberti Magni Ratisbonensis episcopi, Ordinis praedicatorum, Opera omnia, ex editione lugdunensi religiose castigata, et pro auctoritatibus ad fidem vulgate versionis accuratiorumque patrologiae textuum revocatur.* Edited by Auguste Borgnet. 38 volumes. Paris: Vives, 1890–99.

BRHE
: Bibliothèque de la Revue d'histoire ecclésiastique. Louvain: Bureaux de la Revue, Bibliothèque de l'Université, 1927–.

BTAM
: *Bulletin de Théologie ancienne et médiévale.* Louvain: Abbaye du Mont César, 1929–96.

Busa
: *Index Thomisticus.* Sancti Thomae Aquinatis operum omnium indices et concordantiae in quibus verborum omnium et singulorum formae et lemmata cum suis frequentiis et contextibus variis modis referuntur. Project directed by

	R. Busa. Multi-volumes in 3 sections. Stuttgart-Bad Canstatt: Frommann-Holzboog, 1974–.
CCCM	Corpus Christianorum Continuatio Mediaeualis. Turnhout: Brepols, 1971–.
CIMAGL	*Cahiers de l'Institut du moyen-âge grec et latin.* University of Copenhagen, 1969–.
CPTMA	Corpus philosophorum Teutonicorum medii aevi. Published under the direction of Kurt Flasch and Loris Sturlese. Hamburg: F. Meiner, 1983–.
CCSL	Corpus Christianorum Series Latina. Turnhout: Brepols, 1954–.
Copinger	Copinger, Walter Arthur. *Supplement to Hain's Repertorium bibliographicum.* 2 volumes in 3. London: H. Sotheran and co., 1895–1902.
CUP	*Chartularium Universitatis Parisiensis.* Edited by H. Denifle, A. Chatelain and others. 4 volumes. Paris: Delalain, 1889–97.
DS	*Dictionnaire de spiritualité, ascétique et mystique.* Edited by M. Viller, F. Cavallera and J. de Guibert. 16 volumes and index-volume. Paris: G. Beauchesne, 1932–95.
Duns Scotus, Opera omnia (1639)	*R.P.F. Ioannis Duns Scoti, Doctoris Subtilis, Ordinis Minorum, Opera omnia.* (Edidit L. Wadding), collecta, recognita, Notis, Scholis et Commentaria illustrata a PP. Hibernis, Collegii Romani S. Isidori Professoribus. Lyon: L. Durand. Reprinted with a Foreword by Tullio Gregory in volume 1. 12 volumes in 16. Hildesheim: G. Olms, 1968–69.
Eckhart, DW	Eckhart, Meister. *Die deutschen Werke.* Edited by Josef Quint. 4 volumes to date. Stuttgart: W. Kohlhammer, 1958–.
Eckhart, LW	Eckhart, Meister. *Die lateinischen Werke.* Various editors. 5 volumes. Stuttgart: W. Kohlhammer, 1956–64.
EETS	Early English Text Society. London-Oxford: Oxford University Press, 1864–.
FZPhTh	*Freiburger Zeitschrift für Philosophie und Theologie.* Freiburg, Switzerland: Paulusverlag, 1954–.
Glorieux, *Répertoire*	P. Glorieux. *Répertoire des Maîtres en théologie de Paris au XIIIe siècle* (Études de philosophie médiévale 17). Paris: J. Vrin, 1933.
GW	*Gesamtkatalog der Wiegendrucke.* Edited by the Commission for the Gesamtkatalog. 9 volumes and two parts of volume 10 to date. Stuttgart: A. Hiersemann, 1921–; New York: H. P. Kraus, 1968–. References cite entry numbers.
Hain	Hain, Ludwig. *Repertorium bibliographicum: in quo libri omnes ab arte typographica inventa usque ad annum MD. typis expressi, ordine alphabetico vel simpliciter enumerantur vel adcuratius recensentur.* 2 volumes in 4. Berlin: J. Altmann, 1925.

JEGP	*Journal of English and Germanic Philology*. Urbana, Illinois: University of Illinois, 1903–.
Kaeppeli, *Scriptores*, Kaeppeli and Panella, *Scriptores* 4	Kaeppeli, Thomas, O.P. *Scriptores ordinis praedicatorum medii aevi*. 4 volumes, with *Addenda et corrigenda* by Emilio Panella, O.P., in vol. 4: 13–282. Rome: Sta. Sabina, 1970–93. References cite entry numbers (Panella is cited by volume and page numbers).
M&H	*Medievalia et humanistica*. Boulder, Colorado: Summit Press, N.S. 1970–.
MGH	Monumenta Germaniae Historica. Published in various series, e.g., Auctores antiquissimi (abbreviated MGH.AA), Schriften (MGH Schriften), Scriptores rerum germanicarum (MGH.SS). Berlin, 1877–1919 (AA); Stuttgart, 1938– (Schriften); Hannover, 1826–1934 (SS).
MOPH	Monumenta Ordinis Fratrum Praedicatorum Historica. Rome: Institutum Historicum Fratrum Praedictorum, 1896–.
MP	*Modern Philology*. Chicago: University of Chicago Press, 1903–.
MThZ	*Münchener Theologische Zeitschrift*. Aschaffenburg: Pattloch, 1950–.
MyGGI/	*Mystik in Geschichte und Gegenwart: Texte und Untersuchungen. Abt. 1: Christiche Mystik*. Edited by Margot Schmidt and Helmut Rielinger. Stuttgart-Bad Canstatt: Frommann-Holzboog, 1985–. The volume number in Abt. I is indicated after the slash.
N.F.	Neue Folge
N.S.	New Series
PG	Patrologiae cursus completus: Series Graeca. Edited by J.-P. Migne. 161 vols. Paris, 1857–66.
PL	Patrologiae cursus completus: Series Latina. Edited by J.-P. Migne. 221 vols. Paris, 1844–64.
Peter Lombard, *Sent.* (Quaracchi Edition)	*Magistri Petri Lombardi Parisiensis episcopi Sententiae in IV libris distinctae* (Spicilegium Bonaventurianum 4–5). Edited by Fathers of the College of St. Bonaventure (Quaracchi). 2 volumes, volume 1 in 2 parts. 3rd ed. Grottaferrata: Editiones Collegii S. Bonaventurae ad Claras Aquas, 1971–.
Polain	Polain, M.-Louis. *Catalogue des livres imprimés au quinzième siècle des bibliothèques de Belgique*. 4 volumes. Brussels: Société des bibliophiles et iconophiles de Belgique: Foundation universitaire de Belgique, 1932.
QF	Quellen und Forschungen zur Geschichte des Dominikanerordens in Deutschland. Leipzig: 1907–52. Neue Folge: Berlin, 1992–.
RLT	*Rassegna di letteratura tomistica*. Naples: Edizioni Domenicane Italiane, 1966–.

RTAM	*Recherches de Théologie ancienne et médiévale.* Louvain: Abbaye du Mont César, 1929–96 (continued as *Recherches de Théologie et Philosophie médiévales*, Cologne-Leuven: Peeters, 1997–).
SC	Sources Chrétiennes. Paris: Les Éditions du Cerf.
SCG	Thomas Aquinas, *Summa contra gentiles;* see the abbreviation, Thomas Aquinas, *Liber CG.*
Schneyer, *Repertorium*	J. B. Schneyer. *Repertorium der lateinischen Sermones des Mittelalters* (Beiträge der Philosophie und Theologie des Mittelalters 43). 11 volumes. Münster i.W.: Aschendorff, 1969–1990.
ST	Thomas Aquinas, *Summa theologiae*
Stegmüller, RB	F. Stegmüller. *Repertorium Biblicum Medii Aevi.* 9 volumes. Madrid: Consejo Superior de Investigaciones Cientificas, 1950–1977.
Stegmüller, RCS	F. Stegmüller. *Repertorium Commentariorum in Sententias Petri Lombardi.* 2 volumes. Würzburg, 1947.
Summa Halensis, Quaracchi Edition	*Summa theologica* [vol. 4 adds:] *seu sic ab origine dicta 'Summa fratris Alexandri'.* Edited by the Fathers of the College of St. Bonaventure. 4 volumes. Quaracchi: Collegium S. Bonaventurae, 1924–48.
Thomas Aquinas, *Catena*	*S. Thomae Aquinatis Doctoris Angelici Catena aurea in quatuor evangelia.* Edited by A. Guarienti. 2 volumes. Turin-Rome: Marietti, 1953.
Thomas Aquinas, Leonine Edition (Édition Léonine)	*Sancti Thomae Aquinatis doctoris angelici Opera omnia iussu impensaque/Leonis XIII P.M. edita.* (Some volumes have the general title: *Opera omnia iussu edita Leonis XIII P.M.*) Edited by the members of the Leonine Commission. Rome: Sta. Sabina, 1882–.
Thomas Aquinas, *Liber CG*	*S. Thomae Aquinatis Doctoris Angelici Liber de veritate Catholicae fidei contra errores infidelium, qui dicitur Summa contra gentiles.* Edited by P. Marc with the help of C. Pera and P. Caramello. 3 volumes. Turin: Marietti, 1961.
Thomas Aquinas, Parma Edition	*Sancti Thomae Aquinatis Doctoris Angelici ordinis praedicatorum Opera omnia: secundum impressionem Petri Fiaccadori Parmae 1852–1873 photolithographice reimpressa.* New York: Musurgia Publishers, 1948–50.
Thomas Aquinas, *Scriptum*	*Scriptum super libros sententiarium magistri Petri Lombardi Episcopi Parisiensis.* 4 volumes. Vols. 1–2 edited by P. Mandonnet, vols. 3–4 edited by M. F. Moos. Paris: P. Lethielleux, 1929–47.
Thomas Aquinas, *Super epp.*	*S. Thomae Aquinatis Doctoris Angelici Super Epistolas S. Pauli lectura.* Edited by Raphael Cai, O.P. 2 volumes. Turin-Rome: 1953.

Thomas Aquinas, *Super Ioan.*	*S. Thomae Aquinatis Doctoris Angelici Super evangelium S. Ioannis lectura.* Edited by Raphael Cai, O.P. Turin-Rome: Marietti, 1952.
Thomas Aquinas, *Super Matth.*	*S. Thomae Aquinatis Doctoris Angelici evangelium S. Matthaei lectura.* Edited by Raphael Cai, O.P. Turin-Rome: Marietti, 1951.
TOB	*Traduction oecuménique de la Bible: Nouveau Testament.* Edition intégrale. Paris: Les Éditions du Cerf, 1983.
Variorum CS	Variorum Collected Studies Series. London-Aldershot: Ashgate Pub., 1970–.
VL	*Die Deutsche Literatur des Mittelalters. Verfasserlexikon.* Edited by W. Stammler and Karl Langosch. 5 volumes. Berlin-Leipzig: 1933–55.
VL²	*Die Deutsche Literatur des Mittelalters. Verfasserlexikon.* Second edition, edited by Kurt Ruh, et al. XX volumes to date. Berlin: de Gruyter, 1977–.
YLS	*The Yearbook of Langland Studies.* East Lansing, Michigan: Colleagues Press, 1987–.

Editorial abbreviations

Book (*liber*) numbers will be cited in the first place by number only.

a., aa.	articulus, articuli
ad (cum numero)	responsio ad obiectionem (argumentum)
arg.	argumentum
c., cc.	capitulum, capituli
Cod. (cod.)	Codex. Used for particular shelf-marks, according to the custom of the library.
corp.	corpus articuli (quaestionis, etc.)
d., dd.	distinctio, distinctiones
fol., fols.	folio, folios
h.l.	hoc loco
Hs., Hss.	Handschrift, Handschriften. Used for particular shelf-marks, according to the custom of the library.
lect.	lectio
lin.	linea, lineae
Ms., Mss. (ms., mss.)	Manuscript, Manuscripts (Manuscrit, Manuscrits, etc.). Used for particular shelf-marks, according to the custom of the library. MS, MSS are used for generic references (e.g., MS A)
n., nn.	note, notes (nota, notae)
n°, n^os	numero, numeros
ob.	obiectio
q., qq.	quaestio, quaestiones
qc.	quaestiuncula

resp.	responsio
sed c.	sed contra
sol.	solutio
tit.	titulus
tr.	tractatus
v., vv.	versus, versus
§	paragraphus

Abbreviations in Manuscript Apparatus

add.	addidit
corr.	correxit
del.	delivit
dub.	dubium
exp.	expunxit
in marg.	in margine
interl.	interlinearis
inv.	invertit
iter.	itera(-vit,-tum)
lac.	lacuna
om.	omittit
om.(hom.)	omittit per homoioteleuton
ras.	rasura
scr.	scripsit
suppl.	supplevimus

Introduction

T HE ESSAYS in this volume examine depictions of Christ in the writings and art of the medieval Dominicans.

The theme of this collection may on the face of it seem obvious, even redundant. The Order of Preachers was an evangelical order, whose task it was to preach the Gospel of Jesus; the founder of the Order, Saint Dominic, reportedly carried with him at all times a copy of the Gospel of Matthew, because of his devotion to the humanity of Christ; Dominican men and women wrote texts that express the common late-medieval piety towards the divine and human Jesus Christ. Nonetheless, when we first told colleagues at Notre Dame and elsewhere about our idea, they seemed struck by its "novelty," an impression echoed by many who attended the conference at which these papers were originally presented. It seems to us that this perceived novelty is due in large part to modern conventions of religious historiography. Clearly enough, the philosophical interests of neo-Scholastic thinkers curtailed attention to the role of the figure of Christ in the thought of Albert the Great, Thomas Aquinas and other Dominican thinkers. As significantly, we think, religious historians and historians of spirituality have developed and exploited the broad categories of "Christocentric and Theocentric spirituality" in order to differentiate the religious spirit of the Franciscans and the Dominicans. Despite these defining categories, which have become commonplace in the general surveys, the idea behind the conference and this volume clearly struck a chord, as is evident not only from the enthusiasm with which many of the leading international experts on the medieval Dominicans enlisted in the project but also from the high quality of many of the contributions.[1]

While inevitably calling such commonplaces into question (see, for example, the essay by Siegfried Wenzel, which with fine irony "deconstructs" lines of interpretation of medieval English religious literature that are based on the use of these categories), there is no intention here to replace one set of overgeneralizations with another, to reduce, as it were, medieval Dominicans to medieval Franciscans. In initiating this project, we made it clear to our contributors that we had no interest in establishing some broad thesis about Christ among the Dominicans. These essays do not seek to show that the Dominicans were just as "Christocentric" as the Franciscans, or that their fascination with Christ mirrored exactly that of their contemporaries. It is simply true that the human and divine Jesus Christ is in a special and remarkable way the central focus of Franciscan thought and activity. It is also true, as several essays in this volume point out, that Saint Dominic was never perceived by his followers as an *alter Christus* in the same way as Saint Francis was perceived by his followers. Rather, as far as we are concerned, the issue of Christ among the medieval Dominicans is an inter-

pretative problem to be investigated and explored heuristically. Our contributors were encouraged to address the topic of Christ among the Dominicans as they saw fit and to present their findings. The result is a volume that shows the complexity and range of Dominican approaches to Christ; by encouraging a "novel" treatment of Dominican writings and art, the volume at the same time offers fresh perspectives on the medieval Dominicans in every aspect of their common life and activities.

By necessity, a volume such as this must be selective: it is simply impossible to examine the role of Christ in every significant medieval thinker and artist associated with the Dominican Order. In preparing this volume, however, it was essential that the entire spectrum of cultural and religious activities engaged in by Dominicans in the Middle Ages find representation. The primary mandate of the Order of Preachers was to preach, hear confessions and direct pastoral life. Not surprisingly, therefore, the writing of members of the Order comprised mainly moral and pastoral works, sermons and resource works supplying materials for preaching and pastoral care. Works of this kind by countless Dominican authors and compilers survive in thousands of manuscripts in libraries throughout the world. In recent decades, social historians, codicologists and literary critics have made good use of these extensive materials, as a mirror reflecting the actual mores, perceptions and sentiments of the medieval people to whom the friars preached, as an illustration of later medieval ways of organizing and making ready for use huge amounts of textual material, and as a treasure-trove of popular psychology and interpretation that demonstrably influenced not only the contents but also the form of medieval literary works. Building on this research, many of the essays in this volume ask about the figure of Christ in such pastorally-oriented material. Thus, Van Engen, Tugwell, Paulmier-Foucart and Nadeau, and Thomas consider the role of Christ in Dominican hagiographies and histories; Goering, Newhauser, d'Avray and Rubin look at sermons, collections of moral or political *exempla* and pastoral works.

This collection acknowledges the central place of Thomas Aquinas in the spiritual and intellectual physiognomy of the Dominican Order and the rich tradition of scholarship devoted to his thought and writings. The remarkable modern interest in Thomas's thought has played no small part in drawing scholarly attention to the medieval religious Order to which he belonged. Centers founded to study medieval Scholastic thought in general and Thomas Aquinas in particular established extraordinary traditions of scholarship, which have greatly shaped the course of medieval studies. To name only some, the Dominicans at Le Saulchoir, the Grabmann-Institut in Munich, The Albertus-Magnus-Institut in Bonn, the Thomas-Institut in Cologne, the De Wulf-Mansion Centre at Louvain, The Pontifical Institute of Mediaeval Studies at Toronto, and the Medieval Institute at Notre Dame have set high standards of medieval scholarship not only for historians of philosophy and theology, but for all of those who study the primary documents and sources concerning medieval life. Essays in this volume treat various dimensions of Thomas's teaching—exegetical, devotional, pastoral and speculative (in part Goering, Bouthillier, Wielockx, Wawrykow, Torrell, Horst)—and the immediate influence of Thomas's Christological teaching on Scholastic theologians within and outside of his Order (Brown).

Properly enough, the authors treat Thomas as a theologian, reflecting not only the topic of the volume but their own understandings and the growing consensus of recent historical scholarship. It scarcely seems controversial to suggest that the modern interest in medieval Scholasticism was originally motivated by a particular intellectual and social agenda, which has its own intrinsic merit and has yielded much good fruit. "Neo-Scholastics" and "neo-Thomists," as they are often called, emphasized those metaphysical and strictly philosophical elements in the thought of Thomas Aquinas and other medieval Scholastics that seemed most relevant to modern intellectual and social problems. In response to this general tendency of interpretation, such leading scholars as Etienne Gilson and M.-D. Chenu repeatedly reminded students that Thomas Aquinas was first of all a theologian, and that his works must therefore be read in that light. Their view was influential but not wholly dominant. Somewhat ironically, the great reform of the Roman Catholic Church, which diminished the nearly exclusive intellectual authority of Thomas Aquinas, has had a salutary effect, to our minds, on the study of Thomas's thought and writings. It has opened the way to a more historically "distinterested" assessment; generally, this new assessment understands more emphatically the theological intention and finality of all of Thomas's writings. Moreover, an enormous contribution to our deeper understanding of Thomas's thought has been made by exemplary Leonine editions of his works. These critical editions, against which all others should be measured, confirm in general and in minute detail the theological intent, form and execution of Thomas's writings.

On this point, however, the essays presented here suggest an important qualification. Understanding that Thomas was first of all a theologian must not be a pretext for drowning his stringent metaphysical speculation in a sea of religious psychology or an elastically defined "spirituality." Father Torrell, for example, explicitly and rightly qualifies the sense in which the term "spirituality" may be applied to Thomas. As René-Antoine Gauthier emphasizes, especially Albert the Great and Thomas introduced philosophical speculation as an integral part of reflection on Christian wisdom; one must not underestimate the significance of their choice, the opposition it aroused, nor the courage required to make it:

> Au-delà de l'environment social, et même si elle est conditionée par lui, il y a donc une option personelle, qui fait l'originalité d'un penseur. Cette option, avant d'être celle de saint Thomas, a été celle de saint Albert. Ce serait simplifier à l'extrême les choses que de dire que cette option a été une option pour Aristote. . . . Sans Albert, sans Thomas, Aristote aurait continué sa marche triomphante, mais la culture profane se serait trouvée coupée de culture religieuse. L'option d'Albert, ce fut d'introduire Aristote en théologie, de maintenir par là le lien entre la faculté des arts et la faculté de théologie, d'assurer enfin l'unité de la culture médiévale. Option qui n'alla pas sans peine. . . . Dans son cours sur Denys, donné à Cologne vers 1250 devant frère Thomas, Albert s'en plaignait en termes d'une rare violence: "Il y des gens qui, parce que ce sont des ignorants, veulent à toute force combattre l'usage de la philosophie dans l'exposition de la foi, et ces gen-là, c'est surtout chez les frères prêcheurs qu'on les trouve—et chez ces frères, il n'y a personne pour leur tenir tête—; comme des bêtes brutes, ils

blasphèment ce qu'ils ignorent." . . . La colère même d'Albert montre que son choix n'a pas été sans courage.[2]

In this text, Gauthier indicates the decisive importance of Albert the Great and alludes to the fact that not all Dominican theologians chose to follow his and Thomas's lead. Many have tended to study other Dominican Scholastic teachers as a "back-drop" against which to measure the progress and perfection of Thomas Aquinas's thought or as figures in a sorry tale of miscomprehension or even betrayal, in what Marshall McLuhan used to call a "dromedary" version of intellectual history. In recent decades, however, scholars have come to study other Dominican Scholastic thinkers in their own right and to appreciate them in all of their variety.

This is notably the case with Albert the Great. A long tradition of hagiography and doxography, originating in polemics of the fifteenth century, characterized Albert primarily as "the teacher of Thomas Aquinas," that is, as one who paved the way, by much labor and great erudition, for the subsequent perfect synthesis of his student. Increasingly, this paradigm of interpretation fails. As with Thomas Aquinas, a deeper understanding of Albert's enterprise has been advanced by the critical edition of his writings by members of the Albertus-Magnus-Institut. Moreover, recent interpretative studies forcefully argue the distinctive integrity of Albert's thought, its intrinsic difference from that of Thomas Aquinas, and its own history of reception and influence.[3] In the latter regard, the critical editions of other German Dominican philosophers and theologians published in the *Corpus philosophorum Teutonicorum medii aevi* have given us texts of innovative and hitherto relatively unknown thinkers.[4] Contemporary interpretations of Albert and his "followers" stress their developments in philosophy "strictly speaking." These strong interpretations must now be tested and the role of theological doctrine in the speculations of Albert and other German friars be more fully examined. Several essays in this volume (Mahoney, Senner, Wéber, Hoenen) conduct such examinations.

Likewise, new critical editions have drawn attention to, and advanced knowledge of, the English Dominicans Richard Fishacre and Robert Kilwardby, who follow traditions of medieval thought distinctive from those shared by Albert and Thomas. Two of those scholars most responsible for our knowledge of Fishacre and Kilwardby offer essays here (Long, Schenk). We hope that recent editions of philosophical texts by another English Dominican, Robert Holcot, herald further study of his wide-ranging and independent thought, theological and moral as well as philosophic.[5] As far as Scholastic literature is concerned, this volume also includes an essay that illustrates, among other things, the revival of Albert the Great's and Thomas Aquinas's philosophic and theological authority in the fifteenth century, during the "autumn of the Middle Ages" (Hoenen).

It is a platitude of medieval intellectual history that medieval thinkers considered theology to be "the queen of the sciences" and that theology meant sacred Scripture ("theologia, id est, sacra Scriptura"). Despite significant methodological differences, this remained as much true for later as well as earlier medieval and patristic theologians. But whereas patristic exegesis, the patristic compilation in the *Glossa ordinaria,* and twelfth-century developments in the study "of the letter" have received much

scholarly attention, later medieval and Scholastic scriptural commentary remains a relative *terra incognita*. How many of the commentaries recorded in Stegmüller's *Repertorium biblicum* have been edited or studied in any detail?[6] As in other fields, Dominicans made major contributions to later medieval biblical scholarship and interpretation. We are pleased that two essays in this volume (Quinto, Bouthillier) present "micro-studies" of scriptural commentaries and reference works; many more studies of this kind must be made before any general survey of the full course of medieval exegesis can be written. Moreover, several other essays presented here make extensive use of the scriptural commentaries of Dominican theologians (e.g., Torrell, Mahoney).

Dominican theological writing in the Middle Ages is not restricted to Scholastic theology and scriptural commentary; many Dominicans also wrote more personal, "mystical" works on the spiritual life. A number of essays reflect on the spiritualities promoted by medieval Dominicans: Margot Schmidt discusses writings emanating from the early years of the Order, including the correspondance of Jordan of Saxony and Diana of Andalo; Father Wéber shows how the figure of Christ is inseparable from Meister Eckhart's mystical understanding, which is often presented as the prime example of the Dominicans' "theocentric" spirituality; and, Jeffrey Hamburger sheds new light on the spirituality of Suso through the consideration of artistic images in the manuscripts of Suso's writings.

We are especially gratified by the contributions of two art historians (Cannon, Hamburger). Their studies of visual elements of medieval Dominican life provide very special evidence, too often neglected by intellectual and textual historians. It seems to us that the most instructive studies in art history, like theirs, situate images and artifacts in their full institutional, social and literary contexts; reciprocally, textual, manuscript and literary scholars, as well as institutional and social historians, do well to assimilate visual evidence into their own interpretations. Accordingly, the catalogue of manuscripts and old books that concludes this volume (Emery and Jordan) makes generous use of visual materials to establish newly-discovered facts about the historical transmission of Dominican texts.[7]

As at the conference, the essays are here presented not according to scholarly specialization but in rough chronological order. Hence, essays on pastoralia and art are interspersed among essays on Scholastic and spiritual theology. At the conference, this ordering stimulated discussion across disciplines. As a reminder that even the most refined Scholastic meditation should be seen in conjunction with other intellectual and artistic work and, ultimately, in the context of the religious aspirations of the Order, it has seemed prudent to retain this order in the volume.

The organization of the conference and the publication of this volume could not have been accomplished without generous patronage and support from colleagues at the University of Notre Dame. We wish to thank Professor Harold W. Attridge, formerly Dean of the College of Arts and Letters; Professor Lawrence S. Cunningham, formerly Chair of the Department of Theology; Professor Thomas F. O'Meara, O.P., William K. Warren Chair in Theology at Notre Dame; Harriet Baldwin of the Center for Continuing Education; Dianne Phillips; and especially Professor John Van Engen,

formerly Director of the Medieval Institute, for his "magnificence," an ancient virtue so estimable that at least some medieval Dominicans were constrained to find a place for it within their Christian pedagogy.

Kent Emery, Jr.
Joseph Wawrykow

NOTES

1. For an appreciative appraisal of the conference by one of the participants, see Jean-Pierre Torrell, O.P., "*Le Christ chez les Dominicains au Moyen Âge,* colloque international de Notre Dame (Indiana, États-Unis), 6–9 Septembre 1995," *Mémoire Dominicaine* 8 (1996): 212–14.

2. René-Antoine Gauthier, O.P., *Saint Thomas d'Aquin, Somme contre les gentils: Introduction* (Collection Philosophie Européenne, Paris, 1993), 178–79.

3. See notably Alain de Libera, *Albert le Grand et la philosophie* (Paris, 1990) and the extensive monographic literature he cites. Unfortunately, Professor de Libera was unable to accept our invitation to participate.

4. See CPTMA in the table of abbreviations.

5. *Die "Conferentiae" des Robert Holcot O.P. und die akademischen Auseinandersetzungen an der Universität Oxford 1330–1332,* ed. Fritz Hoffmann (BGTPMA N.F. 36, Münster, 1993); *Seeing the Future Clearly: Questions on Future Contingents by Robert Holcot,* ed. Paul A. Streveler, Katherine H. Tachau with Hester Goodenough Gelber and William J. Courtenay (Studies and Texts 119, Toronto, 1995).

6. See Stegmüller, RB in the table of abbreviations.

7. This catalogue of manuscripts and early-printed books now in the Library of the University of Notre Dame reveals the continuity of medieval Dominican literary traditions well after the invention of printing and the Council of Trent, which supposedly changed all.

Dominic and the Brothers:
Vitae as Life-forming *exempla* in the Order of Preachers

John Van Engen

MEDIEVAL RELIGIOUS COMMUNITIES were founded upon a rule (*regula*) and formed by a life (*vita*). Members vowed allegiance to a common *regula* and drew inspiration from exemplary *vitae*. The rule structured their communal life: impressed upon novices, reviewed daily or weekly in chapter, it was to be internalized as a second nature. Yet structure was not the end; religious were to strive for personal perfection, a human perfection realized in a divine holiness. To achieve this end, professed religious drew inspiration from several sources. Not least, they had impressed upon their ears and hearts the stories of those who had gone before, exemplary legends, tales, and sayings read out at meals, in the night office, on feast days. Such stories imaged in human form the desired perfection; they might image patterns of perfection realizable within a specific religious order. Without the animating vision provided by these exemplary lives, organized religion threatened to settle into a lifeless social regimen.

Vitae that embodied—or, substituted for—a *regula*: this pattern went back to the Desert Fathers. Their lives had informed early monastic rules, breathed human life into them. Telling and re-telling their stories in succeeding ages had endowed monastic life with a proverbial wisdom both human and divine. In western medieval history, Benedictines eventually created a paradigmatic link between a binding *regula* and an animating *vita*. Monks were to order their lives by Benedict's rule and to live in the spirit of his life, as told by Pope Gregory in his *Dialogues*. In the next five centuries, absent any notion of a congregation, individual monastic houses overlaid Benedict's rule with a customary and his life with the *vita* of their holy founder; hence, for instance, the life of John of Gorze in the tenth century and the customs that issued from his house. Cluniacs, with a dawning sense of congregation, self-consciously promoted their customary and the exemplary lives of their abbots. Distant houses, committed to the Benedictine Rule, could adopt the custom of Cluny and have their monks look up to the lives of its abbots.

Reform movements after 1050 only sharpened the need for a rule and a life. Now there was choice. Cistercians insisted upon a literal adherance to Benedict's rule, then devised a novel constitution to implement it. They also commissioned a *vita* of Bernard during his lifetime, in fact six years before he died, a text they re-worked and supplemented until they obtained his canonization in 1174. Canons regular, after choosing the rule of Augustine, faced the daunting task of finding means to implement it and a *vita* to exemplify their ideal. Augustine, a confessor-saint, radiated the holiness of an antique bishop, not a twelfth-century canon. The canons of Prémontré, emu-

lating White Monks, proved the most successful: They worked out an ever more re-
fined customary, while they wrote and then re-wrote the life of Norbert, emphasizing
in the second version not the flamboyant preacher and imperial bishop but the man of
prayer, faithful in choir and spiritual direction. Reforming preachers, canons, and her-
mits in the twelfth century, however novel their original vision, never wholly trans-
formed religious institutions to match the way of life they had imagined as apostolic.
So powerful still was the age-old monastic imprint that pressures went mostly the
other way, toward a cloistered regimen.[1]

In the early thirteenth century Francis challenged this long-standing pattern di-
rectly. He offered his *regula* as a *vita,* indeed one that recapitulated the Gospel itself.[2]
His followers struggled to turn this "rule and life" into a religious institution: They
soon divided bitterly over approved and non-approved forms of the rule, as they wrote
and re-wrote lives of Francis himself to highlight their *exemplum*'s Christ-like char-
acter. Thomas of Celano's first *vita* of 1232 culminated (II.9) in the "Lesser Brothers"
gazing awe-struck at the mystery of the stigmata. The major legend, completed in
1260/63 by Bonaventure as Master General and mandated in 1266 to replace all others,
declared in its prologue that the "sign of similitude" to Christ was impressed upon the
very body of Francis, making this messenger of God "imitable for us and admirable for
the world" (*imitabilem nobis et admirabilem mundo*).[3] The life of Francis, an essential
source for his rule, endlessly fascinated, and produced ever more tales (despite the pro-
hibition), some of constitutional importance. Shaping his *vita* became crucial to sanc-
tioning his rule, and the two together—even more than in previous instances—were to
form the inner life of the community.

Medieval Dominicans appear to mark the real exception to this pattern. They
adopted the existing Augustinian Rule and, initially, the customary of Prémontré and
the liturgy of Citeaux. They were called "Dominicans" only from the fifteenth cen-
tury onwards, two hundred years after Dominic's death. Here was an order not overtly
shaped by a distinctive rule or *vita.* The saint's own influence upon the group he had
founded, his exemplary presence within the Order of Preachers, seemed slight, as most
historians have judged it, incomparably less than Francis's within the Order of Lesser
Brothers. Nearly all the energy that might have been directed toward imitating Domi-
nic's person was channeled instead into fidelity to the order and its rule, leaving his
personal image "very vague."[4] The primary impression produced by early Dominican
documents, given their mostly impersonal character, is that of a highly effective corps
of clerics. Yet these "companion-preachers" grew overnight into an international reli-
gious order. Within a generation or so, they became, arguably, the most significant
teaching and pastoral arm of the medieval church, its most active and enterprising
missionary arm, and through the inquisition its most powerful enforcement arm.
Mendicants so fully invaded the new cities that historians, reversing the logic, have
argued that urban spaces should be counted as cities if Preachers and Lesser Brothers
chose to set up shop there. They could tell a real city better than we. Within these cities
Preachers attracted significantly fewer to their ranks than did "Lesser Brothers" (per-
haps 1:4 or even less), a social reality that would seem to bolster the forbidding images
of impersonality.

Dominic himself, a canon regular compelled by the pope to accept one of the sanc-

tioned rules, kept Augustine's and lent it structure by way of the strictest and most sophisticated customary he knew, that of Prémontré. Dominic's followers—some say Dominic himself—poured creative energy into revising that customary and designing a constitution more suitable to the group's purposes. Dominican preachers, confessors, teachers, missionaries, and inquisitors would hone, simplify, and render supple much of the communal detail inherited from Prémontré, without ever giving up entirely the conventual and choir life of canons. The legislative structure they invented, a highly influential model for later orders, anchored communal life in each conventual chapter and in an elected prior, with matching institutions at the provincial level and an annual general chapter headed by an elected master general.[5] Representatives to the general chapter meeting debated and amended regulations declared collectively binding, each new ruling requiring approval in three consecutive years to gain legislative force.

Such a structural overview of the Dominican approach to a *regula* fails to capture the energy that animated this innovative scheme of governance. Early Dominicans acted in much the same spirit that drove townsmen to form guilds at the same time and in the same urban spaces. Groups formed voluntarily to pursue under rules, with authoritative elected heads and yet with a relative freedom of association, their particular ends as merchants or masters. What guildsmen attempted to achieve as laymen operating within a new commercial environment, the followers of Dominic sought to realize as clerics operating within a new religious environment. Both presupposed the social consequences of urbanization, and both sought to distance themselves from the inherited routines of the rural village (farm or church) and to claim a relative freedom over against inherited authorities (prince or bishop). Revealing details—to push this social analogy further would require a separate essay—point up the analogues. Brothers greeted their elected prior, like a guild master, with due respect but without the bows and elaborate obeisances expected by a lord abbot. More importantly, in 1236, within the first generation, the general chapter ruled that the order's constitutions bound brothers under pain of penalty but not of sin.[6] This contradicted notions of the obligations a brother incurred by swearing allegiance to a *regula* then current within other orders. It recalled instead the penalties assessed against guildsmen for infractions of their statutes.

Guilds were organized to protect and facilitate the pursuit of particular ends, such as baking or banking or teaching. Dominic organized his band of clerics for preaching. This was to be their craft (the medieval Latin word "*ars*"). In 1215 the bishop of Toulouse issued a document, perhaps the first to reveal Dominic's intentions, "instituting Dominic and his companions as preachers in our diocese to root out heresy, drive out vices, teach the rule of faith, and imbue people with right morals."[7] According to Jordan of Saxony, in October 1215 Dominic, accompanied by the bishop of Toulouse, sought from Pope Innocent III confirmation for an "order of preachers."[8] A papal document from 1217 makes legible just how novel this request sounded in the 1210s. The privilege, addressed initially to those "preaching in Toulouse" (*predicantibus in Tolosa*), was visibly altered to read "preachers in Toulouse" (*predicatoribus in Tolosa*)[9]—that is, from a verbal to a nominative form, from a task to a type. "Preaching" signified an age-old church function of growing importance, one more and more enthusiasts were taking into their own hands, a right restricted in principle still to bishops. "Preachers"

separated out and banded together in a guild-like profession as a religious order—this was unheard of, virtually a contradiction in terms, yielding a title nearly as provocative in its claim as Francis's "lesser brothers." The privilege of 1217 had to be hand-corrected to identify its recipients not as clerics licensed to preach but as a new type called simply "preachers."

If Dominic and his followers organized a guild of Preachers, Francis and his followers initially gathered a band of lay penitents. While a corps of clerics found it comparatively easy to take on the forms of an order, a band of lay penitents found it famously difficult, and looked steadily to their singular exemplar for the paradigm of a Christ-like penitential life. Hence the built-in structural importance of Francis's life. Dominic's *vitae*, all agree, paled beside those of Francis, and played a far smaller role in the life of the order.[10] Yet the writing of their *vitae* proceeded in parallel, the noteworthy differences between them set off by fascinating correspondences.

Francis was canonized in July 1228, two years after his death and virtually by acclamation. Pope Gregory IX asked afterwards that a suitable *vita* be written to serve as the official legend, a work completed by Thomas of Celano in 1229. Ten years after the death of Dominic (1221), Master Jordan of Saxony (1222–37) wrote, at his brothers' request, a "little book" on the origins of the guild of Preachers. The account highlighted Dominic's role but interwove his story with others. Drafted *mostly before* Dominic's translation in 1233 and canonization in 1234, Jordan's narrative, upon adding the translation and its accompanying wonders, conceded that the founder's cult had been neglected the first decade after his death.[11] Finally, sometime before 1239, a legend was prepared suitable for reading at table and on Dominic's feastday. A Spanish brother named Peter of Ferrand excerpted its contents mainly from Jordan's book on origins. Constantine of Orvieto re-worked this legend in 1246–47, building upon Jordan's base but adding more stories, especially more miracle stories. Among the Lesser Brothers, meanwhile, Thomas wrote a second *vita* of Francis in 1246–47, likewise to take account of more stories and especially more miracles. Both of these *vitae* were re-worked a third time by the master generals of each order: Dominic's by Humbert of Romans (1254–63) sometime before 1260 when it was declared the official version, and Francis's by Bonaventure (1257–74) in 1260–63 and mandated in 1266 to serve as the official version. Neither mandate put a stop to the writing of new *vitae*; both disclosed increasing anxiety about managing the image of their founding saint.

Such historical parallels were not entirely accidental. Early Franciscans borrowed from the Dominican constitutions,[12] and early Dominicans soon perceived the utility of a cult devoted to their founder-saint. Between the writing of the first and the third version of the legend, the general chapter and masters general also promoted increased allegiance to Dominic as founder and patron of Preachers. Daily and annual liturgical observances were to aid the Preachers' remembrance of Dominic. In 1239 the general chapter ruled that a conventual mass should be said at least once a week in his honor; on feastdays with nine readings, antiphons in honor of Dominic should be added at vespers, lauds, and second vespers; and on ordinary weekdays antiphons for Dominic said at vespers and matins.[13] Humbert made a concerted effort after 1245, even before he was elected master general, to regularize the Preachers' liturgical life, adjusting many of the usages originally taken over from Cistercians. Dominicans streamlined

the elaborate observances of choir monks; but where they might remove suffrages, they added prayers to Dominic. The oldest customary, borrowing from Prémontré's canons, had Brothers bow whenever they named the Virgin in prayer; in 1249–51 the general chapter decided that they should also bow at every mention of Dominic's name in prayer.[14] In those same years (1250) the chapter called upon priors and brothers to look out for opportunities to dedicate churches to Dominic.[15] The chapter at which Humbert was elected master general, in 1254, issued a whole series of key provisions: that Dominic's name be added to the vow of profession, thus a promise of obedience henceforth to God, Mary, Dominic, and the master general; that the names of Dominic and Peter Martyr be added to all calendars and litanies, with their persons depicted in churches (*picture fiant in ecclesiis*) and their feasts celebrated; and that a procession be allowed on Dominic's feastday.[16]

As liturgical commemoration multiplied during the twenty-five years after Dominic's canonization, the Preachers also reconfigured his *vita* three times (1239, 1246–47, 1260), as noted above. Each version built on the other, and all derived finally from Jordan's *Libellus*. Jordan of Saxony, while still a bachelor of theology, had watched Dominic preach at Paris, took his advice to be ordained a deacon, then joined the order about 1219 and made his confession to Dominic personally. A good ten years later, so Jordan claimed, new Preachers sought information on the "quality and number" of the first brothers and on the origin of an order, as Jordan presented it, "provided by divine dispensation [to meet] the dangers of these last times."[17] The first master general (1222–36) composed his "little book" in narrative layers, with an account of Dominic's translation and miracles added after 1233–34. In a prefatory letter, addressed to all brothers and manifestly drafted after his narratives had been completed, Jordan explicitly looked back upon his account of origins, of Dominic, and of other brothers as written to remind younger sons of their origins.[18] The Dominican tradition, in short, was not grounded in a life written to capture the holy radiance of an acclaimed saint but in life-stories written to delineate the origins of a guild of Preachers.

Jordan's narrative, written before the cult and canonization, projected a companionate vision of these Preachers, closer in spirit to the university guilds Jordan had known at Paris. While his later prefatory letter named Dominic a "venerable servant of Christ" and the "first founder, master, and brother of this religion" (c.2), his text had orginally begun with Dominic's bishop (*Incipit narratio de Didaco Oxomensi episcopo*), depicted as a model of religious integrity and the organizer of a community of canons regular (c.4). Interweaving other stories with Dominic's characterized Jordan's entire approach. His *narratio* subsequently gave Bishop Diego due credit for shaping young Dominic, indeed showed this bishop (not Dominic!) advising Cistercian abbots to adopt real poverty in the face of heretics, founding the first house for women, and in the end joining the Cistercian order. But Jordan knew and echoed the *vita* tradition. His account of Dominic himself (c. 5) began with a vision ascribed to Dominic's mother prior to his birth, a story taken verbatim from Bernard of Clairvaux's *vita*.[19] Jordan then described expansively Dominic's early disputes with heretics, his first brothers, efforts to organize preachers into an order, and his dispersing of brothers in troubled times to Bologna, Orleans and Paris (cc.49–55). Next Jordan turned to the conversion of Reginald (cc.56–65), a master of canon law, the first famous and learned

recruit; then composed a long and moving tribute to his own closest friend, Henry (cc.66–85), also a student of theology and after his conversion prior of the Preachers' house in Cologne. There follow accounts of the first chapter meetings in Bologna (cc.86–88) and of Dominic's death (cc. 96–99), a section concluded by two miracle stories (cc.100–101). Among the early companions, Jordan saw and memorialized several in a single book.

However guild-like his sense of the community, Jordan nonetheless projected Dominic as the paradigmatic exemplar. Prior to the translation and cult, the little book had closed with an account of Dominic's exemplary *mores* (cc.103–08) and—in what must have originally formed the concluding paragraph (c. 109)[20]—offered a rhetorically charged send-off, a *laus viri Dei beati Dominici.* Jordan exhorted the brothers to imitate the foosteps of the father (*Immitemur, fratres, ut possumus, paterna vestigia*) and to give thanks to the Redeemer for making manifest such a leader (*dux*) in these idle times, when such a figure evoked wonder (*Mirari possumus et ipsius exemplo pensare nostri temporis inertiam*). The imitation Jordan urged was not of an acclaimed saint— that had not yet happened—but of a holy and exemplary leader of their band.

By 1239, five years after Dominic's canonization, Brother Peter of Ferrand reduced Jordan's material to a saint's life suitable for cultic use. In the main he kept Jordan's language and narrative, sometimes abbreviating, sometimes ornamenting. The book enjoyed an initial diffusion; in some priories it must have remained the main account of the Preachers' founder-patron for a decade or two at least. To the *laus Dominici* Peter added, notably, a last "testament," possibly to echo Francis's famous testament. In Peter's account, Dominic leaves his sons with a pithy saying: "Have charity, keep humility, possess voluntary poverty." He also warns them not to taint their profession of poverty with temporal wealth[21]—a new problem in 1239 for which Dominic's authority is invoked, or rivalry with the Franciscans.

Eight years later (1246–47) Constantine of Orvieto was urged by his provincial prior to add miracle stories. In a letter to the Master General, Constantine claimed only to have inserted a few tales into Peter's *vita* and thinned irrelevancies.[22] Most historians have taken him more or less at his word, since his language remained deeply indebted to Jordan. But his work yielded more than a sharper focus on the saint and his powers. Dominic's story was made to serve the Order's purposes explicitly, evident in two examples. Dominic, left behind to preach in Toulouse, had two companions and no order, according to Peter; Constantine, with an appropriate chapter title, has him turn his mind to founding an order.[23] Second, Jordan and to a lesser degree Peter describe the dispersing of the brothers from Toulouse as a virtual necessity in the face of difficulty. Constantine prefaced the dispersal narrative with a vision granted Dominic at St. Peter's in Rome. In it the founder received from Peter and Paul a book and a staff and an injunction to preach; only after it did he send out his companions two by two.[24] Along with stories about the choosing of a rule and vows and Dominic's wondrous powers to convert people, the legend designed by Constantine, plainly, aimed to link the founder-saint far more explicitly to the forming of an order. Constantine also adjusted the concluding *laus Dominici* to take account of Dominic's saintly rank. Equal weight was given to miracles wondrous in their patron (*quod admiramur aspicimus*)

and deeds suitable for imitation (*nobis ad imitandum proponitur invenimus*).[25] He concluded the *vita* with a series of miracles nearly as long as the life (cc. 71–122).

By the mid-1240s, in sum, twenty-five years after his death, Dominic's image was intentionally adjusted to fit that of a heavenly intercessor and holy founder—even as liturgical commemoration increased. The representatives who gathered in general chapters took an active interest in their founder's image. Already in 1242, the chapter voted to remove a passage from the *vita* where it said that though he remained a virgin Dominic was not above the imperfection of sensing female charms.[26] In 1245 a call went out for additional miracle stories concerning Dominic, also Master Jordan (*idem dicimus de magistro Iordane*).[27] A few years after Constantine's *legenda*, in 1255, Master Humbert issued a new call for miracle stories (also for Peter Martyr).[28] In 1259, more notably, the general chapter decided to alter the *vita:* where it reported that Bishop Diego had founded the first house of Sisters at Prouille—as it read in Jordan's and Peter's *vitae*—the *legenda* should hereafter state that Dominic had done so, as it reads in Humbert's account.[29]

The definitive legend was issued about 1260, just as a more concerted focus on Dominic came to its apogee within the order. Humbert wove together paragraphs from Peter and Constantine, but moved mostly in Constantine's direction, that is, toward an account focused sharply on Dominic as saint and founder. As the chapter had mandated, he ascribed to him acts formerly reported of Diego. Humbert ended the *vita* with a version of the *laus*, a long recital of Dominic's virtues. Notably, he re-inserted at the end Jordan and Peter's language exhorting the brothers to imitate their father's footsteps.[30] Dominic's testament, as given by Peter, was set by Humbert for reading on the octave of their founder's feastday. In 1263/66 the general chapter declared that this rewritten legend, inserted in the lectionary, be used exclusively, and no others thereafter be written.[31] All these *vitae*—except Jordan's *Libellus de principio ordinis*, plainly meant for instruction and edification, perhaps especially of novices—were written for the cult, and all except Humbert's major legend subsequently disappeared, extant now in only a handful of manuscripts.

Dominic's cult touched people beyond the convent. Between 1250 and 1265 a woman from Magdeburg named Mechthild put down in writing a series of revelations and teachings called *The Flowing Light of Divinity*. A Preacher, Heinrich of Halle, acted as her spiritual father, and issued this mélange of prose and poetic texts as a single book. Mechthild named Dominic the saint she loved most, and on his feastday prayed for the entire order of Preachers. On one occasion she was graced with a vision. Christ brought Dominic to her, and praised four virtues: his never troubling brothers with willful demands, supplying their needs in food, providing an example of wise moderation, and never imposing a penance not required by the order.[32] The Lord further named several items he specially loved in all Preachers, beginning with their holiness of life and usefulness to the church and ending with their forming a holy band of faith.[33] Finally, Mechthild asserted that she was vouchsafed this vision of Dominic and his Preachers because she had herself been abandoned for the love of God and steadily treated with contempt by the friends of God.[34] Her meaning must be inferred. While others (beguines?) had turned on her for her extraordinary spiritual experiences,

Preachers offered solace and encouragement, and she came to love their founder best of all the saints.

Whatever the cult of Dominic in the 1260s, it might be objected, will this disclose whether Dominic's *vita* came to serve as a life-forming *exemplum* for Preachers? In his pioneering book on the early Dominicans, Tugwell devoted forty pages to the life of Dominic and another forty to Dominican nuns. He did not treat these *vitae*, however, as the dominant spiritual force, indeed found no predominant spiritual voice in the first generation. Tugwell proposed instead that Master Humbert of Romans' book on the "mental formation" (*eruditione*) of preachers, by instilling the craft or skill for which this guild of clerics was chiefly founded, centrally guided the Preachers' ideal.[35] However reasonable a point, Humbert's treatise, especially its essential Part I, gained hardly any distribution at all; four manuscripts survive from the fifteenth and sixteenth centuries.

A work known as the *Vitae fratrum*, by contrast, completed between 1256 and 1259 by Gerard of Frachet, exists still in well over fifty manuscripts, and once probably graced most Dominican houses.[36] Though never prescribed for liturgical reading like Dominic's *vita*, the book was sent out by the master general with a prefatory letter expressing his hope that it would confirm brother-Preachers in their love of the order. In recommending Gerard's *vitae*, Master Humbert explicitly recalled the tradition of exemplary *vitae* used to shape the inner consciousness of religious, and referred to a series of texts extending from Eusebius, the Desert Fathers, and Gregory's *Dialogues* to—his most recent example—Peter the Venerable's *Liber de miraculis* concerning Cluny.[37] The first task enjoined upon a Dominican novice master—a precept taken over from Prémontré—was to teach aspirants about the order (*eos de ordine doceat*).[38] Master Jordan's book on origins essentially disappeared after being excerpted for Dominic's legend. Gerard's *Vitae fratrum* instead effectively provided the main instrument for inducting people into the life and spirit of Preachers. Gerard's text, nonetheless, has enjoyed limited visibility because historians have tended to dismiss it as a rump protest against the order's ever more learned tone.[39] Gerard, it is supposed, proposed an antidote: miracles in place of erudition, storied lives in place of tedious study. Whatever tensions may have arisen among Preachers in the 1250s, this reading risks a fundamental misunderstanding. It injects an antithesis between miracle and study, story and learning, that is exaggerated at best, resonant more of nineteenth-century concerns than of thirteenth-century realities.

To grasp the appeal and utility of Gerard's *Vitae fratrum*, compiled in the same years that Humbert prepared the definitive version of Dominic's legend, the circumstances of its composition must be recalled. This has little to do with the author himself, who entered the Order in Paris in 1225 and made profession to Jordan in 1226, served as provincial prior for eight years in Provence (1251–59) and as prior in Montpellier (1259–63), and died in 1271. Gerard served the ends of the order. In 1255, at the first general chapter under Humbert's direction, a call went out for "any miracle, vision, or edifying occurance worthy of memory that had happened in the order since its inception," so the master general could "put them down in writing for the use of future brothers." The next year Humbert specified that priors should write such stories down and send them on to the master general.[40] In these very years, after a generation of

phenomenal growth, the order faced its most severe challenge: attempts to shut it out of the university in Paris, loud complaints about its invasion of dioceses, even in 1255–56 a momentarily hostile papacy. Gerard's work was essential to bolster confidence within, and yet, given its contents, so open to misunderstanding or reproach without. Master Humbert accordingly ordered that it not be publicized (i.e., distributed) outside the order without his permission.[41] At this critical juncture and in such an atmosphere of distrust, he feared to open their stories to the critique or mockery of those outside.

Master Humbert had passed along to Gerard dozens of stories about Preachers received from across Europe. Gerard shaped them into five books, and imposed a structure that bore a powerful message. He promised to treat beginnings, Dominic, Jordan, the advance of the brothers, and their departure from this world. These stories, he said, were to edify and admonish present and future brothers, and to persuade them of the dignity of an order that acted in succession to the apostles.[42] Book I compiled in fact every possible vision, miracle, or scriptural prophecy that pointed toward the coming of an order of Preachers. It confirmed their divine calling by highlighting the Virgin Mary's role as protector—the same patron claimed earlier by Cistercians and Premonstratensians. Preachers went beyond them and claimed her special presence because they, uniquely, sang the *Salve regina* at compline. These stories of her miracles and appearances, as told by Gerard, made a point every Preacher could assimilate. One, for instance, told only a year or two after the event itself, recalled how Pope Innocent IV had already decided upon and written up a bull to deny brothers many of their privileges. One brother, described only as being of great authority (perhaps Humbert), skipped his meal in desperation and pleaded with the Virgin before her image. Almost at once (*et ecce subito*), rumors reached the brothers of their possible liberation from danger.[43] Gerard delicately said no more to explain this liberation. In a chronicle of the order, also ascribed to him, he wrote plainly that within a few days of composing this bull the pope had died.[44] The Virgin had protected the Order from the pope.

The issue went beyond protection. These stories assured Preachers of her sanction for their unusual order. A monk saw the Virgin dictating a sermon to a successful Preacher as he spoke, and thereafter went around saying that all good clerics and Cistercians should join the Preachers to pursue the salvation of souls.[45] A Carthusian, the most prestigious of the contemplative orders, was sent by the Virgin to the Preachers to learn from them how better to show devotion to her.[46] When Preachers came under attack from Parisian masters, it was agreed throughout the order to say psalms and litanies in each house to the Virgin and to Dominic. A brother in Rome, asleep during the litany, so another story went, saw the Virgin and Son seated over the altar. She held her Son's hand with one of hers and extended the other in protection over the praying brothers, saying to her Son, "Listen to them." Soon the turn came, not a papal death this time but a change of mind on the part of his successor, Alexander IV. The Virgin and Son had swayed the Pope in behalf of Preachers.[47] New recruits or long-term members could be reassured, despite the dangers through which they had just come, that the order enjoyed the highest possible sanction, that of Christ's virgin mother.

Gerard turned next, in Book II, to the Preachers' founder. He claimed to add to Dominic's legend only a few testimonies of sanctity. In practice, he made him more of a holy exemplar than had the legends, ascribing to him (rather than to Bishop Diego)

the initial confrontation with Cistercian abbots about how best to deal with heretics. Gerard also made him more Christ-like, for instance, weeping over sinful cities as he approached them to preach.[48] Dominic also once—a story supposedly revealed only after his death—prayed for a miracle of tongues so he could "preach the Lord Jesus" to German-speaking pilgrims.[49]

Gerard's *Vitae fratrum* devotes more space by half to Jordan than he had to Dominic. Book III, an innovative tribute to the man who had brought him into the order, highlighted the master general whose work shaped the order in its first fifteen years. Jordan was, for Gerard, the "mirror of all religion and an exemplar of the virtues."[50] Most stories turned on his effective interactions with others. If Dominic was the holy founder, Jordan was the model preacher. Jordan summarized the rule of Preachers as to "live honestly, to learn, and to teach." His highest study, like the apostle Paul's, was to be all things to all people, to conform himself to the soldier, to the religious or cleric, even to the tempted.[51] Preachers more likely drew their images of an effective preacher from these stories about Jordan than from manuals that supplied techniques and materials.

In Book IV Gerard promised to talk about the "progress of the brothers," that is, not the expansion of the Order but the religious character of the Brothers. In effect, he proposed to teach the virtues of a Preacher not only by way of Dominic and Jordan but through the collective stories of all the Brothers. The structuring of his chapters reveals that he had novices in mind. After presenting the fervor, vigor, and virtue of early brothers, he devoted much of the book to reasons brothers had given for joining this order, the various temptations they then faced and overcame, and the special revelations, consolations, and miracles they later received. Novices—and also more mature brothers—could hear the stories of people who faced hardships like their own: the spareness of clothing and bed, a silence that could make you dizzy and almost explode, even doubt and sheer disbelief in the face of religious overload.[52] A companion of Humbert, distinguished by his ability to console novices, appears, nearly more than Dominic or Jordan, as the saintly ideal, a light to all; though learned, he was more devoted to reading *vitae* than theology.[53]

Gerard's fifth book drew together the stories of brothers who had made good ends, their presence in heaven assured by some dream or vision, their time in purgatory relieved by the brothers' prayers. This was the promise held out to those who joined the order and were formed in the Preachers' way of life: the Virgin's protection at the beginning and the sureness of heaven at the end, with the models of Dominic, Jordan, and all the other brothers to sustain them along the way. The most remarkable feature of Gerard's book, however, was not its overarching argument but its multiplicity of stories. Brother-Preachers were not formed in the model of one life but of many. Just as the Preachers had adopted certain features of a guild structure, allowing for the interaction and decision-making of companion-priests, so their formative *vitae* were not singular but collective.

Gerard built an argument into his arrangement of these stories, *vitae* disposed to sustain brothers in their love of the order and its way of life. Gerard's stories also reinforced other messages for those Brothers attuned to hear them. Nearly all the stories in Book IV concerned student-clerics, identified as such, recruited into the order. Preach-

ers drew their recruits from the floating bands of clerics that congregated around the new universities. As Peter Classen once noted, the Preachers were essentially a "student movement."[54] When secular masters, bishops, and the pope threatened to bar them from the university, it struck at the heart of their *modus operandi*. In such a threatening climate Gerard's stories took for granted, and reinforced, the normalcy of university clerics within the new order. Jordan, Gerard noted, sought out university towns as his best recruiting grounds. He made habits up in advance, and one year in February stole away—so the schools perceived it—twenty-one scholars. The Parisian convent, like a beehive, recruited numerous clerics and sent them on to other provinces.[55] Gerard presents Dominic as visiting familiarly with students in Bologna, and reminding these high-spirited young men of death and their final reckoning.[56] When he recruited a student of civil law, his frustrated family threatened violence. Dominic warned that more than 200 angels hovered over the house to protect the Preachers.[57] Notably, Dominic established that general chapter meetings would alternate between the university cities of Bologna and Paris, as they did for nearly a generation (1220–44), until the Order became truly international and met at Cologne, the greatest city of the German Empire.

To grasp the Preachers' appeal to student-clerics, a remark attributed to Jordan may hit the mark. Asked why so many artists (beginning arts students) had joined but so few theologians and canonists, Jordan observed that those who spent the week drinking the water of Aristotle and other philosophers became instantly inebriated on Sundays or feastdays when they drank the wine of Christ and the words of his followers.[58] All these students, semi-clerical or semi-lay, functioned within a Christian culture but pursued learning in a social context that linked it mostly to preferment or ambition. Preachers offered a way to turn their high-spirited learning, their inner drive for *scientia* and understanding, to supernatural rather than strictly social ends, to the salvation of one's self and one's neighbors, the winning of human souls. This, they were persuaded, was the highest calling for the human intellect. Yet Preachers retained the organizational feel of their former life as clerics attached to an office or students and masters in a university guild.

Despite this concerted outreach to student-clerics, Gerard—like Jordan earlier and Humbert later—emphasized, as a counterweight, that effective Preachers were marked by "simplicity," for the pride of philosophy and learning could betray a Preacher's calling. Thus Gerard tells how an English brother planning to polish his sermon with a bit of philosophy had a dream—the Lord Jesus handed him a Bible outwardly besmirched with filth—and he woke to realize his mistake.[59] In the Roman province, a brother begged the Lord to open to him the way to higher learning; in a dream, a book was offered to him scribbled full with questions about the faith. Then a voice explained: The Master says nothing in all this but that you be permitted to serve Christ in simplicity.[60] One brother, recalling the origin of his vocation, admitted that he was first drawn to the Waldensians, for he had perceived these heretics as more humble, more radiant with signs of virtue. The Preachers seemed to him by contrast high-spirited and arrogant (*iocundos et nimis pomposos*)[61]—the traits of student-clerics become Dominicans. Many such stories, together with explicit warnings from Humbert and others elsewhere about the lures of *scientia* and ambition, must be read in context. Gerard

never intended to disparage his fellow Preachers' learning but to warn a community made up of former students and masters. A life of advancement and pride in learning, not subservient to the ends of preaching, represented potentially their chief temptation.

If Gerard presumed in his collective stories, and yet sought to shape, the learning appropriate to Preachers, he likewise addressed their formation and self-understanding as preachers. He frequently described individuals as "gracious" or successful preachers. Gerard told one story about how the Devil lured Jordan with a promise never again to tempt his brothers if only he would give up preaching, his snatching of souls away from the Devil; Jordan, of course, did not yield.[62] Gerard's stories again presumed rather than rehearsed what went into the making of preachers, the oral models they heard and reproduced, the manuals they prepared or studied as aids. Gerard told his stories not to celebrate or instruct preachers but to drive home especially one crucial point. Jordan, he noted of his own master, was not only eloquent and full of apt examples, the rhetorical or learned marks of a preacher; he was able to address each person according to their status (*conditio*). He showed compassion to the tempted. He drew brothers to correction more by mercy than by harsh discipline.[63] Gerard's *vitae fratrum*, carefully read, tells many stories of preaching as care of souls. Preachers, these stories taught, were to develop a sense not only for the right philosophical word with the learned or the right theological word with the heretic or the right rhetorical word with the crowd but the right "consoling" word—this the most common term—to touch the soul of each troubled person. Two stories may illustrate. One student-brother grew so intent upon investigating the deity that he "fell into a cloudiness of heart," as the text says, and came to doubt God's existence; his brothers could not move him by argument, scriptural authority, or prayer. Jordan instructed the man's prior to say to him: Believe as I (Jordan) do. The cloud lifted, and the brother believed, freed henceforth from this blasphemous temptation.[64] Obscure as Jordan's pithy remark is, it apparently communicated empathy and encouragement from a former Parisian student and master: I understand, it seems to say, and I still believe. The story, as retold by Gerard, imparts a preacher's soul-seeking sympathy even for the student (brother) who has pushed to the blasphemous outer edges of *scientia*. A second story must suffice for this essay. A young woman, impregnated twice by her guardian uncle and persuaded to abort the children, became pregnant again. Not daring to resist her uncle, she verged on suicidal despair, and took a knife to her swelling stomach. Between life and death, she was instructed by the Virgin in a vision to entrust herself wholly to the counsel of Jordan, who won her back from despair. She eventually joined a Cistercian convent.[65]

Gerard's *Vitae fratrum*, in sum, was intended to form and bolster the entire community of Preachers. Their order, they learned from these stories, enjoyed the sanctions of Scripture and the Virgin, and promised a blessed end. The holy men after which they were to pattern themselves went beyond Dominic to include Jordan and the whole community. The members of their guild, drawn mostly from student-clerics and intent upon preaching, were to make the crafts of learning and preaching serve their true ends. They were to think of their preaching as addressing not only the learned or the crowd but each individual soul. This essay could stop here, and the point would be made. For Dominicans too, *vitae* played an essential role, alongside the rule, the con-

stitutions, and the chapter meetings, in shaping the life and spirit of Preachers. But their exemplary *vitae* were collective and various, not focused upon a single Christ-like founder, thus true to the nature and spirit of their "guild."

This leaves one issue unresolved, the role of Dominic. Did the life of their canon-ized founder enjoy any special place? Brothers made their profession to him, prayed to him on innumerable occasions, heard his life read at table, celebrated his feastday. About 1250 Mechthild believed she could characterize Dominic and his Preachers alike, the one standing in for his followers. So too at the end of the thirteenth century a Preacher from the house at Erfurt named Dietrich of Apolda, author of a *vita* of Dominic in 1297, believed he could characterize Franciscans and Dominicans almost entirely by way of their founders. The Lord sent his servant Francis, he said, to mirror perfectly all the virtues over against arrogant clergymen and proud lay people. He sent Dominic, by contrast, to crush (*conterendum*) the hardness of unbelievers and the per-fidy of heretics, additionally to serve as a light to the peoples both wise and foolish, to provide them with the "science of salvation" in the form of words to sustain the weary, to console the afflicted, and to proffer medicine to sinners.[66] A woman outside the order and a man within it, that is to say, believed they could characterize the tasks and vir-tues of Preachers largely in terms of the likeness to Dominic. This returns us to the question with which this paper opened, the role of *vitae* as life-forming *exempla* within religious orders.

Even if Preachers had a more collective sense of their community, evident in their constitutions and in Gerard's *Vitae fratrum,* might the presence of Dominic's person in prayer, vows, and legend have contributed certain distinctive features to what Preachers aimed to be? Three items would be unmistakeable in Dominic's life for any medieval brother who heard his story regularly and made profession to him.

First, Preachers, as instruments of the Word, were to uphold true teaching in the face of heresy, dissent, indifference, even persecution. On his very first night in Tou-louse, Dominic is represented as arguing and teaching so successfully as to convert his host from heresy. Later, his bishop counseled the assembled Cistercian abbots to dis-mount from their horses, put away their finery, and go among the heretics teaching as the truly poor of Christ—an episode later ascribed by the order to Dominic himself. The young Dominic was first called "frater," the legend claims, when he did so him-self. Likewise, his first miracle came in a kind of trial by ordeal staged against heretics: the little book he wrote against them resisted the flames while theirs burned up. Dominic, the legend goes on, discovered his mission when he remained alone among the heretics for ten years to preach and teach. All these stories and images, given here more or less as they appear in Humbert's authorized legend,[67] had a powerful joint impact. Dominic was depicted as besieged by hostile heretics—as Brothers generally were when they came into a new region as orthodox preachers and inquisitors. In the 1250s Gerard regarded this theme as self-evident and summarized it in the opening words of his fifth and last book: "Since the order of preachers was specially founded at Toulouse by the blessed Dominic against heresies and errors, and for almost forty years the brothers did battle in those parts in hunger and thirst, cold and inadequately clothed, amidst numerous tribulations" and so on. The pope, it continues, instituted the inquisition, which only brought more hatred and persecution down upon them.[68]

Brothers must have absorbed early this image of their holy founder and by extension of themselves: that they acted as Preachers of the Word in a highly dangerous situation, battling against the odds for God's truth—a mentality, that is, of siege and special calling only reinforced when the secular clergy and university masters turned against them as well. This sense of siege, of facing hostility on all sides for attempting a mission of preaching and teaching, came through dramatically in the *Acta* for the year 1252[69] and in Master Humbert's general encyclical to all the brothers in 1255.[70] While by the end of the thirteenth century Dominicans had emerged as respected teachers and feared enforcers, the image fostered within by the telling of Dominic's life communicated the reverse in their own spiritual formation: a calling to preach and teach the truth in a precarious, often hostile environment.

The second cluster of images in the *vita* depicted brothers as people sent out to serve a mission. This must be contextualized to capture its resonance. Merchants or traders traveled far from home to do their jobs, as did crusaders and sometimes warriors. Students had now begun to do so, but rarely clergymen. Secular clerics were tied to the patronage networks and worldly obligations of their home communities, monks and canons regular to the liturgical rounds of their choir. Preachers, however, were sent out, to regional towns, to universities, to distant lands. The *vitae* make this point firmly: Often the earliest brothers were not the best and brightest by human standards, but Dominic confidently sent them out, and they achieved their missions. He knew their calling was divine. Though the *vitae* also made much of recruiting a great master, the heart of the matter was not to boast of talents but to act in the quality of being sent out. This came hard, even if it was instilled in young Preachers reading Dominic's life. The first time Dominic was specifically invoked in an extant encyclical from a master-general, by Humbert in 1255, his point was precisely to get preachers sent to foreign lands. Humbert had encountered resistance among brothers on two counts: ignorance of languages and reluctance to leave native soil. Think of Dominic, he exclaimed, and rehearsed the quality of being sent out as at the heart of belonging to this band of preachers.[71]

Third, the *vita*'s presentation of the founding exemplar depicted his personal virtues after tracing out his mission to heretics, the faithful, and the infidel. This pattern had a rhetorical logic in Jordan's *Libellus*, an account of the order's origins, but it persisted in all forms of the legend and came to serve a signal purpose. Unlike traditional monks or holy people, Preachers could regard their individual virtues as in some sense subsidiary to their mission. This was revolutionary. In the entire monastic tradition since the Desert Fathers—and in Francis too—the mission was personal holiness. Outwardly-directed missions, as functionalist arguments have presented them, only sprang from holy powers accrued by, or perceived as already present in, people of God. Dominic and his bishop from the beginning made virtue instrumental to the mission, thus adopting poverty to refute (or compete with) heretics. Dominic's band gave up immoveable property and became mendicants to be free for preaching, as the *vita* makes very clear.[72] The Dominican general chapter shortened the office taken over from Cistercians to free Preachers for their work, especially teachers and students for their studies.[73] Within a generation worries surfaced within the order that this emphasis upon mission could shift too far. An encyclical of Master Humbert in 1260 admon-

ished his Preacher-Brothers: What you teach others you must display yourself if you expect to be heard.[74]

By comparison with Francis, it might finally be argued, these three themes in Dominic's *vitae* appear to intersect only tangentially with the Gospel's life of Christ. Even if Dominic served as a formative exemplar, he was not overtly an embodiment of the Gospel. After canonization Preachers assigned as the Gospel reading for Dominic's feastday a passage from the Sermon on the Mount where Christ instructed his disciples to be the salt and the light. He had come not to destroy but to fulfill the Law; any who did so would be great in the kingdom of heaven (Matthew 5:13–19). Few texts could have captured so well the Preacher's image of their calling to heretics and the faithful alike, a salt still full of savour, a light not hidden under a basket, a perfect fulfilling of the law of Christ. In a key chapter of the legend, Dominic is made to cite exactly this text (Let your light so shine . . . that people glorify your Father in heaven) as his chief instruction about how Preachers were to conduct themselves before the laity/worldly (*saeculares*) in order to win back souls.[75]

The *vitae* of Dominic employ relatively few Gospel texts or images. Yet two, to conclude, importantly illumine the animating spirit of the Preachers, surely imparted to any novice who listened. The lives of both Dominic and Jordan, more than once, tell stories echoing Christ's miracle of the multiplication of the loaves and fishes. In the *Legend*, as first reported by Constantine, the brothers at Saint Sixtus in Rome had spent the day begging and turned up little. Dominic was present, and the procurator expressed his worries. Without hesitation Dominic blessed the bread they had; it miraculously sufficed, and more, for all the brothers.[76] Heard in context this story communicated more than its echo of the Gospel. To live in poverty by begging, not to count on landed endowments as monks and canons had for hundreds of years, was to take an enormous risk. These stories offered assurance: like the followers of Christ in the gospels, brother-Preachers would receive sufficient bread and to spare, miraculous though it might often seem in chancy settings and early days. This was to read the Gospel image of poverty—and the corresponding *vita*—very differently from Franciscans, but no less newly. In the face of skepticism from Cistercians, the most venerable order of the previous three generations, Jordan asserted that Preachers, though living hand-to-mouth as beggars, would survive longer. For when the persecution came, Preachers had no fear to be dispersed two by two to beg, whereas monks would surely perish once their goods were taken away.[77]

The second Gospel image characterizes the preaching undertaken by Preachers. Their sermons were said to warm, even to penetrate like fire. This went back at least to Jordan, possibly Dominic himself. Master Reginald, the master of law whose conversion perhaps kept the early preachers from collapsing, returned to Bologna to preach, now not as a secular master but as a new Preacher. His sermon conveyed an "eloquence set powerfully alight" (*ignitum erat eloquium eius vehementer*), quoting Psalm 119:140.[78] The word "*ignitum*" appears frequently thereafter as the quality of sermons that hit their mark, set people alight, illumined hearts, turned them to penance. Humbert devoted an entire encyclical to it in 1259.[79] For people who had known little preaching until then, and that mostly indifferent, the words of the Preachers had a glowing quality, a power to warm. They could even move factious Italians to make

peace with enemies in the Alleluia revivals of 1233, the year of Dominic's transla-
tion.[80] Gerard chose as his first words to describe Jordan's extraordinary power as a
preacher, *"ignitis superhabundaret eloquiis."*[81] In his *Libellus* Jordan made clear that
the image was understood as evangelical. Of his dearest friend, Henry, Jordan noted
that his preaching in Cologne won for Christ innumerable souls, something of which
all Cologne was still speaking. About this preaching Jordan reported two items: that
he had taught the people a special reverence and devotion to the name "Jesus," and had
set alight the hearts of many, a fire he carefully tended. Jordan explicitly likened this
to Christ's saying: I have come to set fire on the earth (Luke 12:49).[82]

This Gospel image seems the right place to end, for it gets at an interior quality of
this life which is conveyed in the *vitae,* but not in the innovative constitutions or the
Acta of general chapters. Here was a guild of preachers, drawn mostly from high-spir-
ited bands of clerics at universities, encouraged to pursue a risky new form of poverty
by stories of multiplying loaves, formed to think of preaching as the care of individual
souls, hardened to meet resistance and indifference. They enjoyed the sanction of the
Virgin and the promise of a blessed life. All this they could learn from the lives of
Dominic, Jordan, and the brothers presented by Gerard. The purpose of their guild was
to preach, to craft words—but to the special end signalled by the *vitae.* Preached words
provided the tools for a learning and an eloquence that would act as a purging fire for
all those who had fallen into error; but for all the indifferent faithful, the instruments
to fan a warming, enkindling fire.

NOTES

1. C. H. Lawrence, *The Friars: The Impact of the Early Mendicant Movement on Western Society*
(London, 1994), 17, recently noted, perhaps a little too categorically: "It was this perception of the
apostolic life that had moved individual ascetics like Robert of Abrissel and St. Norbert of Xanten to
adopt the role of an itinerant preacher while depending upon begging for their food and shelter. But
neither of them succeeded in translating their personal vision of the apostolic life into the institutions
they founded. Both the Order of Fontevrault and the Premonstratensian canons conformed to the ac-
cepted norms of monastic organisation."

2. *Regula non bullata,* Prologus, c.1, ed. K. Esser, SC 285 (Paris 1981), 122: "Haec est vita evan-
gelii Jesu Christi, quam frater Franciscus petiit a domino papa concedi et confirmari sibi. Et ille con-
cessit et confirmavit sibi et suis fratribus habitis et futuris. . . . Regula et vita istorum fratrum haec est,
scilicet vivere in obedientia, in castitate, et sine proprio, et domini nostri Jesu Christi doctrinam et
vestigia sequi. . . . " The *Regula bullata* begins (180): "Regula et vita Minorum Fratrum haec est, scili-
cet, domini nostri Jesu Christi sanctum evangelium observare vivendo in obedientia, sine proprio et in
castitate."

3. Bonaventure, *Legenda maior,* Prologus 2, Analecta Franciscana 10 (Quaracchi 1926–41), 558.

4. Thus André Vauchez, *La sainteté en occident aux derniers siècles du moyen age* (Rome 1981),
390. Vauchez summarized well what has become a common judgement: compare Berthold Altaner,
"Zur Beurteilung der Persönlichkeit und der Entwicklung der Ordensidee des hl. Dominikus," *Zeit-
schrift für Kirchengeschichte* 46 (1927): 396–407; then, more nuanced, Kaspar Elm, "Franziskus und
Dominikus: Wirkungen und Antriebskräfte zweier Ordensstifter," *Saeculum* 23 (1972): 127–47; more
resistive was C. N. L. Brooke, "St. Dominic and his First Biographer," *Transactions of the Royal His-
torical Society,* Fifth Series, 17 (1967): 23–40.

5. A good introduction remains G. R. Galbraith, *The Constitution of the Dominican Order, 1216–1360* (Manchester 1925). For the constitution, see (with literature) A. H. Thomas, *De oudste constituties van de Dominicanen*, BRHE 42 (Louvain 1965).

6. *Acta capitulorum generalium ordinis Praedicatorum*, ed. B. M. Reichert, MOPH 3 (Rome 1898), 8. (hereafter cited as *Acta*): " . . . volumus et declaramus ut constituciones nostre non obligent nos ad culpam, set ad penam, nisi propter contemptum vel preceptum."

7. *Monumenta Diplomatica S. Dominici*, ed. Vladmimír J. Koudelka with Raymundo J. Loenertz, MOPH 25 (Rome 1966), no. 63, June-July 1215 (57): "Notum sit omnibus presentibus et futuris quos nos F(ulco), Dei gratia Tolosane sedis minister humilis, ad extirpandam hereticam pravitatem et vitia expellenda et fidei regulam edocendam et homines sanis moribus imbuendos, instituimus predicatores in episcopatu nostro fratrem Dominicum et socios eius, qui in paupertate evangelica pedites religiose proposuerunt incedere et veritatis evangelice verbum predicare." Dominic may have had a hand in composing this; it reflects well the purposes of the later Order.

8. Jordan, *Libellus de principiis ordinis Praedicatorum* 40, ed. H. C. Scheeben, MOPH 16, (Rome 1935), 45.

9. *Monumenta Diplomatica S. Dominici* no. 79 (ed. Koudelka, 78), with the note to line 19.

10. Dominic's have certainly received far less scholarly attention. The basic study remains Berthold Altaner, *Der heilige Dominikus: Untersuchungen und Texte* (Breslau 1922). The basic editions of different versions of the *Legenda* are found in the *Monumenta Historica sancti Patris nostri*, MOPH 16 (Rome 1935): *Legenda Petri Ferrandi*, ed. M.-H. Laurent (197–260); *Legenda Constantini Urbevetani*, ed. H. C. Scheeben (263–352); *Legenda Humberti de Romanis*, ed. A. Walz (355–433). To this must be added the lifelong work of M. H. Vicaire, *Saint Dominic and His Times*, trans. K. Pond (New York 1964), which built upon work done with P. Mandonnet, *S. Dominique: L'idée, l'homme et l'oeuvre*, 2 vols (Paris 1938). Their studies, though historical in form, partook still of the spirit in which the *vitae* were written, as living guides to the religious life.

11. Jordan, *Libellus* 121–25 (ed. Scheeben, 81–85).

12. Rosalind B. Brooke, *Early Franciscan Government: Elias to Bonaventure* (Cambridge 1959), 225–31, 293–96.

13. *Acta* a. 1239 (ed. Reichert, 11).

14. *Acta* a. 1249 (ed. Reichert, 43). See R. Creytens, "Les constitutions des Frères Prêcheurs dans la rédaction de s. Raymond de Peñafort (1241)," AFP 18 (1948): 5–68, here 32.

15. *Acta* a. 1250 (ed. Reichert, 53).

16. *Acta* a. 1254 (ed. Reichert, 70–71). See Creytens, "Les constitutions," 41, and Simon Tugwell, "Dominican Profession in the Thirteenth Century," AFP 53 (1983): 5–52.

17. Jordan, *Libellus* 2 (ed. Scheeben, 25).

18. Ibid., 3 (ed. Scheeben, 26): "Visum est, inquam, mihi ea que vidi personaliter et audivi et primitivorum fratrum relatione cognovi de principiis ordinis, de vita et miraculis beati viri patris nostri Dominici, de aliis quoque quibusdam fratribus, prout se memorie mee talium ingessit occasio, sub scripto redigere, ne filii qui nascentur et exsurgent ordinis huius ignorent primordia. . . . "

19. See Jordan, *Libellus* 5 (ed. Scheeben, 27–28).

20. It still ends with an "Amen."

21. Peter Ferrand, *Legenda* 50 (ed. Laurent, 248–49): " 'Hec sunt, inquit, fratres carissimi, que nobis tanquam filiis hereditario iure possidenda relinquo. Caritatem habete, humilitatem servate, paupertatem voluntariam possidete.' . . . Illud autem pater egregius districte prohibuit ne quisquam in hoc ordine possessiones induceret temporales, maledictionem Dei et suam horribiliter imprecans ei qui hunc ordinem, quem precipue paupertatis dotavit professio, terrenarum diviciarum pulvere presumeret obfuscare." This testament and its interpretation appear first in Peter's *Legend*, with no indications of its possible source.

22. Constantine, *Legenda* 2–3 (ed. Scheeben, 286–87).

23. To the brief notice in Jordan's *Libellus* 29 (ed. Scheeben, 39–40), and the more elaborate account in Peter, *Legenda* 18, 25 (ed. Laurent, 219–20, 228–29) (Nondum ordo Predicatorum erat tunc temporis institutus, nec ulla edita constitutio ex iis que nunc in ordine observantur, sed tamen de institutione ordinis tractabatur), compare Constantine, *Legenda* 20 (ed. Scheeben, 300), with his programmatic chapter title: Qualiter cepit disponere de ordinis institutione, qui Predicatorum diceretur et esset.

24. Constantine, *Legenda* 25 (ed. Scheeben, 304).

25. Ibid., 62 (ed. Scheeben, 331).

26. *Acta* a. 1242 (ed. Reichert, 24).

27. *Acta* a. 1245 (ed. Reichert, 33).

28. *Acta* a. 1255 (ed. Reichert, 76–77).

29. To Jordan, *Libellus* 27 (ed. Scheeben, 39) and the *Legenda Petri* 16 (ed. Laurent, 221); compare the *Legenda Humberti* 18 (ed. Walz, 382), which is *not* "wörtlich" taken from Ferrand, as 382 n. 2 claims.

30. Humbert, *Legenda* 60 (ed. Walz, 417–18).

31. *Acta* a. 1260 (ed. Reichert, 105).

32. Mechthild von Magdeburg, *Das fliessende Licht der Gottheit* 4.20–21, ed. Hans Neumann (Münchner Texte und Untersuchungen zur deutschen Literatur des Mittelalters 100, Munich-Zurich 1990), 136–37.

33. Ibid., 4.21 (ed. Neumann, 137).

34. Ibid., 4.22 (ed. Neumann, 138–39).

35. *Early Dominicans: Selected Writings*, ed. and trans. Simon Tugwell (New York 1982).

36. See Kaepelli, Scriptores 2: 35–37 [n° 1282.]

37. Gerard, *Vitae fratrum ordinis Praedicatorum*, ed. Benedictus Maria Riechert, MOPH 1, (Louvain 1896), Prologus, 3–4. Reichert's edition of Gerard's *Cronica ordinis* is also found in this volume (321–38).

38. Creytens, "Les constitutions," 40. Compare Thomas, *Die oudste constituties van de Dominicanen*, 322.

39. See, in general, Isnard Wilhelm Frank, "Die Spannung zwischen Ordensleben und wissenschaftlicher Arbeit im frühen Dominikanerorder," *Archiv für Kulturgeschichte* 49 (1967): 164–207.

40. *Acta* a. 1255, 1256 (ed. Reichert, 77, 83).

41. *Vitae fratrum*, Prologus (ed. Reichert, 4–5): "Cum autem multis discretis fratribus opus illud legentibus placuisset et dignum approbacione iudicarent, nos tandem de approbacione multorum discretorum ac bonorum fratrum illud inter fratres duximus publicandum. Nolumus tamen quod extra ordinem tradatur sine licentia nostra."

42. Ibid., Prologus (ed. Reichert, 2).

43. Ibid., 1.6.22a (ed. Reichert, 57).

44. *Cronica Ordinis* (ed. Reichert, 338).

45. *Vitae fratrum*, 1.6.14 (ed. Reichert, 50).

46. Ibid., 1.6.5 (ed. Reichert, 41–42).

47. Ibid., 1.7.8 (ed. Reichert, 44–45).

48. Ibid., 2.23 (ed. Reichert, 81–82).

49. Ibid., 2.10 (ed. Reichert, 74–75).

50. Ibid., 3.1 (ed. Reichert, 101).

51. Ibid., 3.42.5, 21 (ed. Reichert, 138, 145).

52. Ibid., 4.17.1,2,6 (ed. Reichert, 199–203).

53. Ibid., 4.3 (ed. Reichert, 154–56).

54. Peter Classen, *Studium und Gesellschaft im Mittelalter*, ed. Johannes Fried, MGH Schriften 29 (Stuttgart 1983), ix.

55. *Vitae fratrum* 3.12 (ed. Reichert, 108–09).

56. Ibid., 2.28 (ed. Reichert, 83).

57. Ibid., 2.21 (ed. Reichert, 81).

58. Ibid., 3.42.9 (ed. Reichert, 141).

59. Ibid., 4.20.1 (ed. Reichert, 208).

60. Ibid., 4.20.5 (ed. Reichert, 209).

61. Ibid., 3.13.5 (ed. Reichert, 183–84).

62. Ibid., 3.30 (ed. Reichert, 124).

63. Ibid., 3.5 (ed. Reichert, 103).

64. Ibid., 3.15 (ed. Reichert, 112).

65. Ibid., 3.27 (ed. Reichert, 121–22).

66. Dietrich of Apolda, *Vita Dominici* 32, AA.SS 35: 623E.

67. Humbert, *Legenda* 11–24 (ed. Walz, 377–85).

68. *Vitae fratrum* 5.1 (ed. Reichert, 231).

69. *Acta* a. 1252 (ed. Reichert, 63).

70. *Litterae Encyclicae magistrorum generalium*, ed. Benedictus Maria Reichert, MOPH 5, (Rome, 1900), 21–24.

71. *Litterae encyclicae* V (ed. Reichert, 19).

72. Humbert, *Legenda* c. 14, 16 (ed. Walz, 379, 380).

73. This begins already in 1240 for students at Paris. *Acta* a. 1240 (ed. Reichert, 16).

74. *Litterae encyclicae* XII (ed. Reichert, 52–55).

75. Peter Ferrand, *Legenda* 23 (ed. Laurent, 227–28), Humbert, *Legenda* 26 (ed. Walz, 387–88).

76. Humbert, *Legenda* 43 (ed. Walz, 402–03); see Constantine, *Legenda* 37–39 (ed. Scheeben, 312–14).

77. *Vitae fratrum* 3.42.6 (ed. Reichert, 140).

78. Jordan, *Libellus* 58 (ed. Scheeben, 53).

79. *Litterae encyclicae* XI (ed. Reichert, 49).

80. Augustine Thompson, *Revival Preachers and Politics in Thirteenth-century Italy: The Great Devotion of 1233* (Oxford 1992).

81. *Vitae fratrum* 3.11 (ed. Reichert, 108).

82. Jordan, *Libellus* 79 (ed Scheeben, 63).

Dominic *alter Christus?* Representations of the Founder in and after the *Arca di San Domenico*

Joanna Cannon

THE CONCEPT OF St. Francis as *alter Christus*—a second Christ—is nowadays a familiar one to students of the art of late-medieval Italy. The approach of St. Francis to *conformitas* with the sufferings of Christ, expressed in writings emanating from the Order,[1] has been shown to have informed visual representations of St. Francis. We may consider, for example, the image of St. Francis, arms extended to display his *stigmata*, and framed by seraphim, which was completed by the Sienese artist Taddeo di Bartolo in 1403, and which formed the central panel of the rear face of the high altarpiece of San Francesco al Prato in Perugia (fig. 1). It has been argued by van Os that this double-sided altarpiece crystallises the visual type of St. Francis *alter Christus* which is, moreover, placed below the image of Christ showing his wounds, and back to back with the infant Christ represented on the front of the altarpiece.[2]

For art historians, the San Francesco al Prato image is only one expression of this theme among many in Franciscan art.[3] Forerunners are seen in, for example, the decoration of the basilica of San Francesco at Assisi. The nave of the Lower Church at Assisi was decorated, in the 1260s, with a series of murals which presented parallels between the life of St. Francis and the Passion of Christ. Despite the very damaged state of these paintings it is still possible to see that the nave cycle began with a comparison between a scene, on the left nave wall, in which the naked St. Francis, as a prelude to the religious life, rejects his father and his possessions (fig. 2); and a scene facing it, on the right nave wall, in which, as a prelude to the Crucifixion, Christ is stripped of his garments and prepares to mount the ladder to the cross (fig. 3).

The earliest, and probably also the best-known visual reference to this *conformitas* between Francis and Christ is to be found in the remarkable iconography of the Stigmatisation of St. Francis. One example among many of this type is to be found on the inner face of the right wing of a pair of painted wooden shutters, now in the Pinacoteca in Siena (figs. 4, 6). The shutters originally served as protection for the burial niche of Beato Andrea Gallerani, a Sienese layman who died in 1251, and whose remains were preserved in San Domenico, Siena. The painting is attributed to an anonymous Sienese artist of the later thirteenth century, and may have been installed in about 1274.[4] Gallerani was noted for his foundation of a hospital of the *Misericordia* in Siena, for his charity, and for his devotion to prayer. These facets of his life are illustrated on the outer faces of the two shutters (the centre of fig. 4) and in the two scenes on the lower inner faces (the outer images in fig 4). Gallerani was not formally affiliated to either of

the two main mendicant orders,[5] but it was evidently considered suitable to refer to both of them on his reliquary shutters.

The choice of Franciscan imagery in this case was relatively straightforward: the Stigmatisation of St. Francis, painted on the upper part of the right shutter, provided a clear spiritual predecessor for the image of Andrea Gallerani, shown, on the lower left wing, kneeling in prayer, with his *paternoster* cord, before the Crucifix. But what of Dominic? What scene from Dominican sources should be chosen to set beside the image of St. Francis Stigmatised? It seems safe to assume that the artist of the Gallerani shutters was in a good place to seek advice since the shrine was set in the nave of a Dominican church. Yet the choice may, at first sight, seem surprising. The scene selected was the Vision of Blessed Reginald of Orleans (fig. 5). Reginald is shown in the upper part of the picture field. A distinguished canon lawyer, Reginald was on the point of joining the Dominican Order when he fell ill. The Virgin appeared to him in a vision, accompanied by two female companions, and anointed him with healing ointment. She then showed him the habit of the Dominican Order which he was to join. The scene of St. Francis's Stigmatisation (fig. 6) shows a direct and miraculous contact between Francis and the crucified seraph/Christ. The action is clear, the message is direct. But in the Dominican scene, Dominic is divided from the main event. It is Reginald who is the beneficiary of the miracle, and the protagonist with whom the heavenly being communicates directly.

It is frequently acknowledged that the spirituality of St. Francis stood at the heart of Franciscanism. His spiritual life provided the template which each Franciscan should emulate—a template which was to create so many difficulties for the Order. The Stigmatisation painted on the right shutter thus presents an image central to Franciscanism—St. Francis's approach to *conformitas* with Christ, which was to be summed up, as we have seen, in the epithet *Franciscus alter Christus*. But what might the Dominican scene painted on the left shutter express about the role of St. Dominic within the Order which *he* founded?

I should like to draw attention to three elements in the choice and disposition of this scene. First: the description of the vision of Blessed Reginald which we find in the accounts of Dominic's life provided by Peter Ferrand, Constantine of Orvieto, and Humbert of Romans,[6] all stress the strength and efficacy of St. Dominic's prayers for Reginald's recovery.[7] Dominic himself does not perform or participate in the miracle. Our painting shows him in a separate setting, at prayer, acting as an agent between a prospective member of the Order and divine power. The theme of Dominic as an agent—or intermediary—between his Order and the Divine is one to which we will shortly return.

A second point about this choice of scene is the opportunity which it gave the artist to draw attention to the habit of the Order. Divine approbation for the habit is clearly demonstrated and thus the scene celebrates not only St. Dominic and Blessed Reginald but also all those who choose to wear the black cappa and white scapular. This celebration of St. Dominic *together* with his Order is another point to which we shall return.

The third point to which I wish to draw attention is Dominic's choice of divine

champion. This image, and the text of Constantine of Orvieto, make it clear that Dominic has prayed to the Virgin—not to Christ—for the healing of Reginald. Constantine's text emphasises that Dominic considered that the Virgin, *Regina Misericordia*, had special care for the whole Order.[8] How is the art historian to square this with the theme of this book? *Is* there visual evidence of the Order's awareness of Christ among them, or is this presence always mediated by the representation of the Virgin? If the concept of "Francis *alter Christus*" is central to an art historian's approach to Franciscan art, should we be looking for "Dominic *alter Christus*" to illuminate our understanding of art made for members of the Dominican Order?[9]

There are, it seems to me, at least two ways in which to tackle this issue in relation to the art of late-medieval Italy. One method is to gather together the representations of Christ either accompanied by members of the Order or, at least, made for a Dominican context, and to consider what, if anything, might be said to characterise these representations. The material for such an investigation in central Italy, during the first century of the Order, is not abundant, but it certainly exists, and I shall simply provide a very brief outline of it here.

We can, for a start, find images which link a timeless representation of the living Christ with members of the Dominican Order, as in, for example, a detached leaf from a set of Choir Books made for an unidentified house of Dominican nuns in the later thirteenth century (Sotheby's Sale, 5 December 1994, Lot 40, now Private Collection, Geneva) (fig. 7).[10] The image (set at the introit for the feast of the Purification) is a relatively straightforward one, in which the friars and nuns who presumably represent the house in question raise their hands in prayer towards the image of the Blessing Christ.

A more subtle expression of the relation between Christ and the Dominicans is to be found in a late-thirteenth-century Antiphonary from San Domenico, Perugia, now in the Biblioteca Comunale Augusta in Perugia, Ms.2797 (I) (fig. 8).[11] Here, illustrating the feast of Mary Magdalen (fol. 220v.), a striking visual parallel is drawn. In the upper part of the initial the Magdalen anoints Christ's feet, while directly below a friar, carrying a napkin over his shoulder as he begs for bread, receives a loaf from a townswoman. Thus the penitence and free gift of this thirteenth-century woman is blessed as the Magdalen's actions are blessed. By giving to a Dominican it is as though she also gives to Christ.

These two examples concern the presentation of a visual connection between the living Christ—either biblical or timeless—and members of the Dominican Order. But it was probably the image of the dead Christ, hanging upon the cross, which would have predominated in the cells and churches of the early Italian Dominicans. It seems that images of the Crucified Christ (and also of the Virgin) were permitted—even encouraged—in the cells of the friars from the early days of the Order.[12] A rare surviving example of a small-scale Crucifixion scene with a Dominican devotee is an early fourteenth-century panel in a private collection in Paris, Sienese in style, which must once have formed the central panel of a small triptych (fig. 9).[13] Dominican devotees also appear on a monumental, thirteenth-century crucifix, presumably intended for more public display (figs. 10, 12). This painting came from the church of San Sisto Vecchio in Rome and includes, at the foot of the cross, the figures of four supplicants—two nuns

and two friars—who probably represent the members of the San Sisto house.[14] The inclusion of Dominicans as supplicants on a large-scale early-Italian crucifix is unusual. The paintings which survive suggest that unlike a substantial number of their contemporaries the Dominicans were not generally eager to be represented in close proximity to the crucified Christ.[15] Nor did they favour representations of their founder at the foot of the cross, or embracing the cross like the Magdalen or, in numerous examples, St. Francis.[16]

This is not to say that members of the Order ignored the new developments in monumental painted crucifixes encouraged, in particular, through Franciscan patronage. Some of the finest, and art-historically most significant crucifixes, still belong in Dominican churches.[17] Most notable among these are the highly refined crucifix signed by Giunta Pisano from San Domenico, Bologna (fig. 11), the powerful crucifix attributed to Cimabue in San Domenico, Arezzo (fig. 13), and the magnificent crucifix attributed to Giotto from the Florentine church of Santa Maria Novella (fig. 14). In different ways all three of these works concentrate, as directly as possible, on the suffering of the crucified Christ. But they do not include an image of St. Dominic. We have to supply the Dominican context ourselves. And it could be argued that these powerful images were generally directed more towards the laity than to the Dominicans seated within the choir.[18]

One other type of image of the suffering Christ can be explicitly visualised within a Dominican context. I am referring here to the image known as the Man of Sorrows, a Byzantine type which became popular in the West from the later thirteenth century onwards. The example illustrated here is found on a triptych, probably painted either by a Byzantine and/or a Venetian artist, on loan from a private collection to the Mr. Simon van Gijn Museum, Dordrecht (fig. 15).[19] The central figure of Christ as the Man of Sorrows—the *Imago pietatis*—is flanked by the Virgin and John the Evangelist. When the left wing of the triptych, with the image of the Virgin, was folded over the central image (fig.16) the rear of that panel showed a painting of two Dominicans, one of whom was presumably the owner of the triptych and the other either St. Dominic or—more likely, since the figure has no halo—an important member of the Dominican hierarchy (fig. 17).[20]

The Dordrecht triptych suggests an interest among the Dominicans, on a personal level, in this type of representation of Christ. Such an interest is also to be found in a more institutional context. The polyptych from the Dominican Church of Santa Caterina in Pisa, completed by Simone Martini in 1320, provides the first surviving example of the inclusion of the Man of Sorrows in the predella of a Sienese polyptych (fig. 18). This splendid painting, which was, in a sense, a corporate commission of the whole convent at Pisa, can be shown to express a number of major concerns of the Dominican Order.[21] It has been argued on various occasions that eucharistic connotations attach to this particular type of representation of the body of Christ—or *Corpus Christi*.[22] It is interesting, in that context, to note the inclusion, to the right of the Man of Sorrows and St. Mark, of St. Thomas Aquinas, who was, of course, credited with the composition of the Office of *Corpus Christi*.

An object which connects a kneeling Dominican directly with the Man of Sorrows has more recently come to light. This is an enamelled plaque, thought to have been

produced in central Italy in the mid-fourteenth century, which was acquired by the Metropolitan Museum in New York in 1982 (fig. 19).[23] The inscription on its base, "SOTIETATIS. Ŝ.DOMINICI" together with the kneeling figure of a flagellant to the right of the Man of Sorrows, indicate that this work was connected with a flagellant confraternity dedicated to St. Dominic.[24] Here we may trace the diffusion of interests from within the Order to art used by the laity under Dominican guidance.

The interpretation of these images of Christ—both biblical and timeless, triumphant and suffering—of which we have just made such a rapid review has certainly yielded interesting insights, which various writers, notably Hans Belting, and Henk van Os (and including the present writer) have touched on,[25] and about which there is no doubt more to be said. But this is not the material on which I have chosen to focus in the space available in this paper. As my title indicates, I have chosen to approach the theme of Christ among the Dominicans from a somewhat oblique but, I hope, fruitful angle. Rather than looking at representations of Christ, we shall be looking at representations of Dominic, in search of visual reflections of the imagery of Christ.

The starting-point for any such art-historical enquiry must be Dominic's third tomb, the *Arca di San Domenico* in the Church of San Domenico in Bologna.[26] No contract for the work survives, but its high quality has led to a generally-accepted attribution to the Pisan sculptor Nicola Pisano, together with Arnolfo di Cambio and other members of Nicola's workshop.[27] Something can also be deduced about the circumstances of patronage: the enterprise was clearly an official undertaking. In 1265 an appeal was made to every member of the Order, via the General Chapter, for funds to complete the tomb.[28] Since the *Arca* was complete by 1267 the Order may have contributed, thus possibly making the tomb one of the few examples of corporate Dominican patronage.[29] Moreover one of Nicola Pisano's probable assistants on the tomb, Fra Guglielmo, was himself a Dominican.[30]

The monument has undergone several changes since the thirteenth century, but we can be confident that the carved tomb-chest itself is substantially unchanged. The tomb chest is not, as far as I am aware, the heir to any established cycle of scenes. St. Dominic's first and second tombs had no figural decoration, and no other surviving scenes appear to predate the *Arca*. The scenes chosen for representation appear to adhere closely to the available texts. All these events can be found in the version of Dominic's *Legenda* compiled by Humbert of Romans, which was approved for inclusion in the new Dominican lectionary in 1256,[31] and all of these events had also appeared in one or more of the various earlier versions of Dominic's life compiled by members of the Order. Since these texts evidently provided more material than could fit on a single monument, a considerable element of choice could be exercised in the selection of scenes. Those responsible for planning the *Arca* do not always appear to have made the choices one might have expected—for example, the birth and death of the saint, both treated with potentially appealing visual details in the *Legenda*—or a concentration on miraculous cures, whether performed *in vita* or posthumously.

One explanation for the lack of emphasis on miraculous healing—which might, after all, have been expected at the shrine of an important saint—may well be the active discouragement of St. Dominic's cult, at its inception, on the part of the Bologna friars. We read in Jordan of Saxony's *Libellus* that many people suspended wax ex-votos,

representing eyes, hands, feet and so on, over Dominic's tomb in gratitude for cures. But these were soon removed, and moves were made to smother the nascent cult.[32] Another reason for the lack of emphasis on miracles, or on the birth or death of Dominic, is, I would argue, a lack of biographical intent or chronological sequence in the design of the *Arca*.[33] As Christopher Brooke elegantly demonstrated in his assessment of the portrait of Dominic given in Jordan of Saxony's *Libellus* (the earliest version of St. Dominic's life, composed between 1232 and 1233) Dominic's role within the Order is given as much emphasis as his individuality. The *Libellus* is the story of all the early friars, not Dominic alone.[34]

So too, in the *Arca*, as we shall see, the story presented is not simply that of the founder but also that of his Order. We will begin our consideration of the *Arca* reliefs with the story of St. Dominic's vision of Sts. Peter and Paul, granted to him in St. Peter's as he prayed for the preservation and growth of the Order (fig. 21). The event is first found in Constantine of Orvieto's *Legenda*, which was approved by the General Chapter in 1248.[35] Constantine's account—repeated verbatim by Humbert and in other later versions—says that after Dominic had been given a staff and book by Peter and Paul, he received a vision of his friars going through the world, two by two, preaching the word of God. The scene on the *Arca* is even more explicit in showing Dominic as an agent of transmission within the foundation of the Order. We see him twice: once kneeling before Sts. Peter and Paul, and once standing, handing on the book which he has received to one of his friars, while four other Dominicans also listen to his instructions.

The Vision of Sts. Peter and Paul is shown on the left, short, side of the *Arca*. The rear of the *Arca*[36] also tells the story of the foundation of the Order, showing Innocent III's Confirmation of the Order, his dream of Dominic supporting the Lateran, and Honorius III's full confirmation of the Order and of its choice of the Augustinian Rule (fig. 22). These two crucial steps in official papal approval for the Order are already recounted in Jordan of Saxony's *Libellus*,[37] and are always repeated in the later versions of Dominic's *vita*. Innocent III's Dream first occurs in Constantine of Orvieto's *Legenda* but, as I have discussed elsewhere, appears to borrow not only textually but also, on the *Arca*, visually, from Franciscan sources.[38]

The rear of the *Arca* also includes the story of Blessed Reginald of Orleans (fig. 20), which we encountered at the start of this paper (fig. 5). Here the scene is divided into three, rather than two sections, creating a visual balance for the three scenes of the Approval of the Rule which we have just considered. This gives the sculptor the opportunity to show Reginald's meeting with Dominic, under the aegis of Innocent III, at which he decided to enter the Order. The central scene focuses on the swooning body of Reginald, with the prayerful Dominic fitted into the top of the composition. On the right the Virgin, accompanied by two beautiful women, anoints Reginald with healing ointment, while the habit of the Order is prominently displayed by her. These events are already presented in Jordan's *Libellus*,[39] with the emphasis on the importance of Dominic's prayers added, as we noted earlier, by Peter Ferrand, whose *Legenda* was probably composed between 1235 and 1239.[40]

The choice of scenes considered so far all concern the establishment of the Order, its mission, its habit, its recruitment of important figures,[41] and Dominic's role in

assisting these developments. Twice he mediates between heavenly beings and the members of his Order, but he is not shown as a Christ-like figure—so far we have not succeeded in finding any visual trace of "Dominic *alter Christus*."

We might expect to find some parallel between St. Dominic and the Life of Christ on the front of the *Arca* which, in contrast to the busy programme of the rear face, is devoted to only two events, both of them miracles mediated by St. Dominic.[42] The Miracle of the Book (fig. 24) concerns the disputation with Cathars in Southern France—either in Fanjeaux or Montréal—which is described in some form in all the Lives of St. Dominic, from Jordan's *Libellus* onwards.[43] Books play an important role elsewhere in the *Arca*. We have already seen the codex (presumably a Bible) passed from St. Peter, via Dominic, to his Order (fig. 21); and papal approval for the book of the Dominican's chosen rule (fig. 22). Here the open book, containing Dominic's own arguments in support of the catholic faith, triumphs miraculously over the false doctrines of the Cathars as it leaps unharmed not once, not twice, but thrice from the flames.[44] This triumph of catholicism, specifically as expounded by Dominic and his companions, explains both the origins of the Order and the legitimacy of its task and of its teachings. The scene may also contain a further reference to the establishment of the Order. Max Seidel has suggested that the standing female figure at the extreme left of the composition—a figure based on the carving of a barbarian woman on a battle sarcophagus in Pisa—is intended to represent one of the noble women of the area whom Dominic gathered together to form a house of nuns at Prouille.[45]

The composition used for the visualisation of the Miracle of the Book seems slightly familiar. At first sight it perhaps recalls the well-known scenes of the Trial by Fire of St. Francis before the Sultan, as seen, most famously, in the Upper Church at Assisi and in the Bardi Chapel of Sta. Croce in Florence. But these compositions postdate the *Arca*.[46] The scene also has echoes of a much longer-established iconography, that of the youthful Christ Teaching in the Temple. But the sculptor of this scene may have had an even earlier type in mind, a composition which stands behind that of Christ teaching in the Temple, when designing this scene. The Roman philosopher sarcophagus type was taken into the vocabulary of the Early-Christian sarcophagus for the figure of the seated, teaching Christ, holding a roll or codex, and flanked by two or more of his apostles.[47] The seated Christ is shown as a youthful, beardless figure on the well-known sarcophagus of Junius Bassus (A.D.359),[48] and on the front face of the late-fourth-century "Stilicho" sarcophagus in Sant'Ambrogio in Milan (fig. 25).[49]

If we now look again at the *Arca* scene of the Miracle of the Book (fig. 24) we can, I believe, appreciate that an Early-Christian sarcophagus such as that in Milan, with a representation of the beardless philosopher-Christ, seated and elevated, holding a book, flanked by Sts. Peter and Paul, had some part to play in the sculptor's conception of the central part of this *Arca* relief.[50] If this was, indeed, the case, then this compositional echo is of interest in the context of our search for "Dominic *alter Christus*" for the composition provides a parallel between the young philosopher-Christ and the figure of the young judge presiding at the centre of the *Arca* scene, *not* between Christ and Dominic. It may, of course, have been the artist rather than the patron who knew this Early-Christian composition, and chose to use elements from that existing schema for new purposes.[51] Nevertheless, any instructions which he had received do not seem to

have encouraged him to look exclusively—or even primarily—for compositions in which St. Dominic might be seen to parallel Christ.[52]

The other miracle shown on this side of the *Arca* is the Raising of Napoleone Orsini (fig. 23). It is the only relief which presents the type of healing miracle which, as we have already noted, might be expected on the shrine of a saint. This was one of only two miracles of raising from the dead—important elements in a canonisation process—which Dominic is said to have accomplished during his lifetime. The incident is found in the written sources from Jordan's *Libellus* onwards.[53] Even this scene may constitute a reference to the story of the establishment of the Order. Although the various versions of Dominic's *Legenda* do not specify when the miracle occurred, there is one text which is more informative. This is the *Miracula beati Dominici* which includes an eyewitness account of the event, dictated by the Dominican nun Cecilia to one of her fellow nuns, Suora Angelica, in the Bologna monastery of Sant'Agnese.[54] According to Suora Cecilia the miracle took place on the very day when Dominic, together with several important prelates, succeeded in persuading the nuns of Rome to gather together, under a Dominican rule, in a newly-founded monastery attached to the church of San Sisto.[55] Thus the event commemorates, in a sense, the foundation of the Dominican second order within Italy.[56] It is thought that Suora Cecilia's stories of St. Dominic were written down by Suora Angelica at some time between ca.1272 and 1288, in other words some time after the completion of the *Arca*, but it seems quite possible that Cecilia's memories were well known to the Dominicans of Bologna—she had, after all, been made prioress of the Bolognese monastery of Sant'Agnese in ca.1237.[57] Indeed, the choice of this scene might even be, in a way, an acknowledgment of her direct link with St. Dominic.[58] Here again there is no clear visual parallel offered with the Christ figure of a healing miracle. Rather, it is Dominic's prayer for divine healing which is given visual emphasis.[59]

Walking around the *Arca* from the front to the right side, we come to the only scene which we have not yet considered. And here, at last, we are, I believe, offered a parallel between Dominic and Christ. The scene concerns the miraculous appearance of bread in the refectory (fig. 26), and the parallel which I have in mind is, of course, the representation of the Last Supper and of Christ's institution of the Eucharist.

The relation between this scene and the written sources is particularly interesting—and not entirely straightforward. The provision of bread is first mentioned in depositions taken in Bologna for the canonisation process of St. Dominic, in August 1233.[60] The written record of the canonisation process takes the form of sworn statements from eye-witnesses and its nature and content differs substantially from that of Jordan's *Libellus* or, even more noticeably, from the later versions of Dominic's life. In the testimony of Fra Buonviso of Piacenza we read that while he was serving as procurator of the convent at Bologna and Dominic was present there, there was, one fast day, no bread to give to the friars in the refectory. On hearing this Dominic raised his hands and praised the Lord. At the same moment two men entered, carrying baskets—one full of bread, the other of dried figs, so that the friars could eat abundantly.[61] Less specifically, Fra Rodolfo of Faenza, who also served as procurator during one of Dominic's residences in the Bologna house, related that if he went to Dominic to report a lack of bread or wine Dominic would reply that he should go and pray, and the Lord would

provide: the necessary food was then always available. Sometimes, if there was insufficient bread, Dominic ordered Fra Rodolfo to place it on the refectory table and the Lord supplied that which was lacking—here we may perhaps be reminded of the miracle of the loaves and fishes.[62] These eyewitness accounts provide us with the seeds of a tradition which came to be represented on the *Arca*, if not with every detail.

A further visual trace of a miraculous Bolognese meal is provided by a panel painting preserved in the church of SS. Maria e Domenico della Mascarella (also known as Santa Maria della Purificazione) in Bologna (fig. 27). The Mascarella was the Dominican's first convent in Bologna, which they occupied from early in 1218 until their move to San Nicolò delle Vigne in the Spring of 1219.[63] Pious tradition has located a miracle of the loaves at the Mascarella, and the panel painting which commemorates it is said to have been painted on the very refectory table at which the miracle occurred.[64] By the fifteenth century the painted table was displayed on a beam in the church of the Mascarella, and in later years the table was kept as a relic, hidden behind shutters for most of the time.

There seems little doubt that the object in question did indeed serve as a long (originally at least 5.75 metres) and narrow (now a maximum of 39 cms. wide) refectory table, so narrow that the friars could presumably only eat seated along one side of the table. In the late nineteenth century it was cut into three main sections, and is now displayed with these sections placed one above another attached to the front of a side-altar in the church of the Mascarella.[65] Recent cleaning has confirmed that the painting, thought to be the work of an anonymous thirteenth-century Bolognese artist, is executed in a somewhat crude but pleasingly bold style.[66] The whole composition shows St. Dominic (seen at the centre of fig. 27 which illustrates the central section of the painting) flanked by thirty-four friars standing behind the table (before the panel was cut there would have been a greater number of friars). This composition does not explicitly refer to a specific miracle, and the inscription which it once bore is sadly illegible,[67] but it certainly came to be regarded as a relic associated with the life of St. Dominic—one of the few which exist, and certainly the largest—and, more specifically, with a miracle of the loaves.

At some time, perhaps before the end of the fifteenth century, the reverse of the panel was also painted.[68] This second image, which also covered the full length of the panel, is now in such poor condition that it is extremely hard to date it on stylistic grounds. Cavazza's late-nineteenth-century illustration of this side of the table, copied in a mediocre reproduction by Fornasini,[69] may be hard to interpret, but the painting itself (now detached from the main panel and displayed on the wall of the same chapel) is even more illegible in its present condition. Nevertheless, there can be no doubt concerning the basic subject matter of the central portion of the painting from the reverse of the panel: Dominic is seated at table, flanked by twelve friars. The traces of two winged figures—presumably bringing the miraculous bread—can be seen on the near side of the table.

The miracle, like the loaves themselves, seems to have multiplied. No mention of it is made in Jordan's *Libellus* or Peter Ferrand's *Legenda*, but Constantine of Orvieto's version of Dominic's life reports a miracle told to him by Jacopo da Melle of Rome, former procurator of San Sisto, the first Dominican house in Rome, which the friars

occupied before their move to Santa Sabina in the Spring of 1221:[70] When very little bread had been found by begging, Dominic, nevertheless, said grace, and blessed and broke the bread—presumably the moment shown on the *Arca* (fig. 26). Two young men then appeared with napkins round their necks which were filled with bread (these napkins probably resembled the cloth bags which the friars carried when begging for alms) (see e.g., fig. 8). The young men left the bread and then immediately disappeared. Constantine tells us that this miracle was confirmed by many surviving witnesses, and he also records that Fra Jacopo told him about another similar miracle which occurred in the same place.[71] Humbert of Romans is content to repeat this Roman version of the miracle,[72] but Gerard of Frachet, whose *Vitae fratrum* was approved in 1260,[73] reports instead a rather different version of the *Bologna* miracle, which resembles the testimony of Fra Rodolfo of Faenza in the canonisation process. Gerard's informant is a certain Fra Reginald, papal penitentiary, who says that once in Bologna there were only two loaves to feed the convent, but miraculously these were sufficient to feed everyone.[74]

The impression which these various sources give is that a miraculous donation or multiplication of loaves, associated with St. Dominic as he prayed—or more specifically recited a blessing over the bread, surrounded by the friars of the convent seated at table—was widely disseminated in the Order's memory. Moreover it is interesting to note that this event—whether situated in Bologna or Rome—was also often associated with Dominic's presence in the earliest Dominican foundation in that city, and thus with the Order's early days as an established body in central Italy. The miracle is the only event represented on the *Arca* which is described by witnesses to the canonisation process, and the quality of an eye-witness report is retained in almost every version of the story. The significant variations in these accounts suggest that, at least in this particular case, an oral tradition existed which had grown up independently of written sources.

At least one contemporary witness residing in Bologna still had her story to tell. This was Suora Cecilia, received into the Order by Dominic himself, whom we have already encountered in connection with the Raising of Napoleone Orsini. Cecilia was sent from Rome to Bologna in 1223, to help establish the monastery of Sant'Agnese, becoming prioress in about 1237.[75] As we have seen, she told her stories of the Miracles of St. Dominic to Suora Angelica at some time between ca.1272 and 1288.[76]

Cecilia's version, written down so long after the event, seems to have been considerably embroidered during the course of numerous retellings over the years.[77] The forty friars of S. Sisto in Constantine of Orvieto's version have here grown to one hundred. We follow the footsteps of Giovanni da Calabria and Alberto Romano, sent out—unsuccessfully—to beg, who give the one loaf which they received to a poor woman. The central part of the story remains the same. Dominic calls the friars to eat, despite the lack of food; he joins his hands in prayer and two young men appear, each carrying a white cloth full of bread. A new detail is the information that those at the bottom of the table are served first with the miraculous bread. Wine is also miraculously provided. Cecilia gives a list of witnesses who relayed news of the miracle to the nuns then living at Santa Maria in Tempulo. Some remains of the miraculous bread and wine were given to the nuns who kept them, for a time, as relics.

One of the new details introduced in Cecilia's version suggests that here again she could have made a contribution to the appearance of the *Arca*. If we look carefully (fig. 26) we can see that the two young friars seated in the foreground clearly hold bread in their hands while all their companions, with the exception of St. Dominic himself, have not yet been provided with the miraculous loaves. It is also possible to see that these two young friars, unlike their companions, have not yet received the full tonsure—in other words they are novices, seated at the foot of the table. As in Cecilia's story—and as in Dominican custom[78]—they have been served first.

The relief on the *Arca* distils for us the appeal which these various related stories may have held for thirteenth-century Dominicans. Crucially, these events are vindications of the initially daring and controversial choice of the mendicant life—miraculous interventions which indicate divine confirmation for Dominic's contention that the Lord will provide.[79] At the same time we see how the daily routine of the communal meal in the refectory is transformed into a miraculous event, in which Dominic offers a parallel for Christ, praying at the start of the communality of the Last Supper, and his friars—halved in number here for artistic convenience—assume the role of the apostles. In the *Arca* the rolls which they receive resemble the *rosette* familiar to visitors to present-day Rome. But the crosses imprinted on each circular roll are surely also a reflection of a cross-stamped host[80] (and the white cloths in which they are borne may perhaps recall a corporal). Thus both the Last Supper and its continuing re-enactment within a Dominican context are commemorated here.

How receptive were the friars and nuns to this reflected image of Christ among the Dominicans? In order to pursue this question it will be helpful to consider a number of choir books made for various houses of the Order in central Italy in the later thirteenth and early fourteenth centuries. These, we can be sure, were made for a specifically Dominican audience, and their use was an integral part of the daily life of the convent or monastery. The fortunate survival of choir books associated with houses of Dominican nuns provides us with a certain amount of information concerning them as well as their better-studied brethren. The Getty Gradual,[81] in particular, gives us not only a means of considering a number of images seen by Dominican nuns, but also a visual representation (fol. 48v., fig. 28) of a choir of nuns using their gradual as a friar celebrates Mass and their sister nuns follow the service with their own books.

We have surviving volumes from some dozen sets of choir books made for Dominican houses in Italy in the thirteenth and early fourteenth centuries.[82] Five of these sets include scenes—as distinct from isolated images—of St. Dominic. Of these five sets, three have a group of scenes—as many as seven—large enough to be described as a cycle (figs. 29, 30, 31). Altogether some dozen different scenes were chosen for representation. All the indications are that in most cases the work was undertaken by professional lay illuminators, following their commissioners' instructions as best they could. The relation between these cycles and the programme set out by the *Arca* is intriguing. Of the eight scenes shown on the *Arca* all but two—those showing Innocent III and Honorius III approving the Order and its choice of Rule—were used at least once. But there is no example in which we can be certain that the illuminator followed the composition found on the *Arca*. None of the choir books restrict themselves to choos-

ing exclusively from scenes included on the *Arca*. In other words there is no evidence that the *Arca* constituted a canonical cycle which was promulgated by—or less officially diffused from—Bologna.[83]

No two books made exactly the same selection of scenes. If we are correct in assuming that the commissioners of these choir books had a relatively free hand in their choice of scenes, then it is notable that some scenes proved more popular than others. Only three scenes occur more than twice: Fra Guala's vision of Dominic ascending a ladder to heaven at the hour of his death—this was especially suitable for the initial I of *In medio ecclesie* (see, e.g., fig. 30); Dominic receiving the Staff and Book from Sts. Peter and Paul (which occurs four times, see, e.g. figs. 30, 31); and the Miracle of the Loaves.

The three versions of the Miracle of the Loaves, which we find in the choirbooks of the *"Muriolus"* group (to which the Getty Gradual belongs),[84] Spoleto,[85] and Gubbio,[86] seem to confirm that the *Arca* was not viewed as a canonical source for the iconography of St. Dominic. Each focuses on different elements in the related stories. The Getty version (fig. 33) which is, most regrettably, cut at the base of the leaf, shows Dominic with his hands joined in prayer—as specified in Suora Cecilia's description of the event.[87] The version in the Spoleto set of choir books (fig. 34), which consisted of a drawing which was never painted, is even more severely damaged. All that is left is the drawing, at the foot of the page, of the partial figures of two young men, approaching the blessing figure of a friar (Dominic? or, since he has no halo, a procurator?) carrying loaves in napkins slung over their shoulders. The Gubbio version (fig. 35), which is by far the best preserved, shows the bread being brought not by young men but by angels.

Just as the verbal versions of the miracle vary, so too do the visual ones. In other words, the interest in such a miracle was sufficiently strong and sufficiently diffused to occur afresh, it seems, to at least three advisers planning the decoration of choir books and wishing to present a selection of scenes featuring St. Dominic.

The visual evidence can be pressed a little further in helping us to gauge the interest felt in the Miracle of the Loaves within the Order. The art historian who seeks to compare representations of St. Dominic with those of St. Francis is rapidly made aware of the dearth of evidence concerning St. Dominic.[88] This lack is noticeable in art both within and outside the Order. As early as 1247, the legislation of the provincial chapter of the *Provincia Romana* shows an awareness that the display of the image of a saint has a role to play in the promotion of his cult.[89] This idea was taken up in 1254 and 1256 by the General Chapter which urged the Dominicans to display an image of St. Dominic in their churches.[90] The magnificent reliefs of the *Arca* di San Domenico could have set the tone for the presentation of St. Dominic to the faithful. But there seems to have been scant interest, before the beginning of the fourteenth century, in presenting the founder and his story. In the *Provincia Romana*—the area with whose art I am most familiar—what interest there is tends to be directed to the friars' own use, rather than to the laity. The greatest concentration of images and scenes of St. Dominic is—as we have briefly seen—in choir books made for the Order. Of the 26 convents which were fully established within the *Provincia Romana* (an area roughly equivalent to present-day Tuscany, Umbria and Lazio) by the first decades of the four-

teenth century, only two churches still contain any evidence of frescoes narrating Dominic's story.

In the nave of San Domenico, Arezzo, we find the remains of the scene of St. Peter and St. Paul handing the Book and Staff to Dominic. It appears that other scenes, no longer in existence, once accompanied this painting. In the *Cappella Maggiore* of the Dominican church of SS. Domenico e Giacomo in the Umbrian town of Bevagna we have the unique survival of two scenes on the north wall (fig. 32).[91] The lower register shows the Miracle of the Book, and above this we find, once again, the Miracle of the Loaves (fig. 36). Yet again, a different moment in the stories is chosen: the loaves are brought by angels—as at Gubbio—and Dominic is shown taking one, while distributing another to a friar who seems amazed by the event. Here, as in the choir books, the scene—painted in the *Cappella Maggiore* of the church—is directed not to the laity, but to the members of the Order themselves. The evidence is, admittedly, fragmentary and scattered, but this makes it all the more striking that when evidence *does* survive as to what happens when members of the Order have the opportunity to choose how they wish to see their founder visualised, their choice includes, more often than not, the founder seated at a table, surrounded by friars, and praying for—or touching—miraculous bread.

I would emphasize that this is a choice made for their own viewing—in choir books or on choir walls. An instructive contrast may be provided by Francesco Traini's altarpiece of 1344–45, for the Dominican church of Santa Caterina in Pisa. This painting was paid for from the testamentary donation of a layman, commissioned by a lay executor, and originally stood in a part of the church accessible to the laity.[92] Its programme includes miracles associated with Dominic's birth and death—material *not* chosen in the *Arca*, but among the staple iconographic fare for the representation of other saints; it does not include the Miracle of the Loaves.[93]

To conclude: the scene of the Miracle of the Loaves in which Dominic is represented among the Dominicans was, it seems, chiefly cherished among the Dominicans—both by friars and, in at least one case—nuns (fig. 28).[94] Its appeal lay in several elements. It brought the daily routine of the friars closer to a re-enactment of the past: the past of the early days of the Order (in Rome and/or Bologna) when the friars who gathered around the founder followed Dominic's encouragement to live by alms and were rewarded with miraculous provision—and, that more distant, apostolic past which the early friars sought to imitate: the past of living by alms and of the breaking of bread at the Last Supper, as Christ sat among his apostles.

So, have we found here a glimpse of "Dominic *alter Christus*"? Did the friar, or nun, who looked at these images see a *conformitas* between Dominic and Christ? This would, I think, be an oversimplified interpretation. But it does not seem unreasonable to suppose that this image offered to the friar a parallel between his life and that of the apostles, with a leader—Dominic—as agent for Christ, among the Dominicans.

And what of the eucharistic significance of the image? Is it legitimate to see Dominic offering his Order here the host of a Dominican mass? One last image from a Dominican choir book suggests that this is an interpretation which can be entertained. In an image which is—as far as I am aware—unique, accompanying the first Nocturn

for the Feast of St. Dominic in an early-fourteenth-century Antiphonary from San Domenico, Perugia,[95] Christ is seated alone, at the head of the table of the Last Supper (fig. 37). A group of twelve men approach with caution, amazement, hesitancy, and perplexity. The empty bench in the foreground still awaits them. These twelve, a mixed group of laymen and clerics, are invited to join the Dominican Order and to emulate the apostles. Those in the foreground can be seen to unbutton their cloaks as they prepare to enter the room and, in due course, to assume the Dominican habit. And behind the table, between Christ and this fourteenth-century group, stands St. Dominic, beside the open door, gesturing to them to approach and participate in Christ's Last Supper—and in the Eucharist within the Dominican Order.[96]

Yet again, Dominic appears in Dominican art as the agent of Christ, not his imitator.[97] As this paper has sought to demonstrate, the visual sources from central Italy in the century following the Order's foundation tell us that Christ's position among the medieval Dominicans was, indeed, unique. But the visual sources also suggest that the founder of the Order might approach a Christ-like role—not through suffering and *compassio*, but by gathering his friars around him to live the apostolic life, and by offering to them the eucharistic meal.[98]

NOTES

1. See S. da Campagnola O.F.M., *L'angelo del sesto sigillo e l'"alter Christus." Genesi e sviluppo di due temi francescani nei secoli XIII–XIV* (Rome, 1971).

I am delighted to have the opportunity to express here my gratitude to Kent Emery, Jr., to Joseph Wawrykow, and especially to Dianne Phillips, for a number of reasons: for having organised such an excellent conference and ensured its publication; for having elected to include in this collection of studies the historical evidence of images; and for having prompted me to return to and to reconsider material from my doctoral thesis. Encouraged by them, and by others at the conference, I plan to prepare a more extensive, book-length publication of material from my thesis in the near future. I should also like to record here my debt to the Conway Library and the Garrison Collection, Courtauld Institute of Art, for help in consulting and obtaining illustrations, and to the library of the Warburg Institute, without which this paper could not have been completed.

2. H. W. van Os, "St. Francis of Assisi as a second Christ in early Italian painting," *Simiolus* 7 (1974): 115–32. For a subsequent reconstruction of the altarpiece see G. Solberg, "A reconstruction of Taddeo di Bartolo's altar-piece for S. Francesco a Prato, Perugia," *Burlington Magazine* 134 (1992): 646–56. I am grateful to Dr. Solberg for permission to reproduce the photomontage of her reconstruction.

3. Among other discussions of this theme in thirteenth and fourteenth-century Italian art see esp. G. Ruf, O.F.M.Conv, *Franziskus und Bonaventura. Die heilsgeschichtliche Deutung der Fresken im Langhaus der Oberkirche von S. Francesco in Assisi aus der Theologie des Heiligen Bonaventura* (Assisi, 1974); Idem., *Das Grab des hl. Franziskus. Die Fresken der Unterkirche in Assisi* (Freiburg im Breisgau, 1981); J. Gardner, "The Louvre Stigmatisation and the problem of the narrative Altarpiece," *Zeitschrift für Kunstgeschichte* 45 (1982): 217–47; D. Blume, *Wandmalerei als Ordenspropaganda. Bildprogramme im Chorbereich franziskanischer Konvente Italiens bis zur Mitte des 14. Jahrhunderts* (Worms, 1983) with further bibliography; K. Krüger, *Der frühe Bildkult des Franziskus in Italien* (Berlin, 1992) with further bibliography.

4. See J. H. Stubblebine, *Guido da Siena* (Princeton, 1964), 69–71.

5. Stubblebine, 70, mistakenly describes Gallerani as a member of the Dominican Third Order, an error which I repeated in Cannon, "Dominican Patronage" (cited below, note 12). For Gallerani's

cult see A. Vauchez, "La commune de Sienne, les Ordres Mendiants et le culte des saints. Histoire et enseignements d'une crise (novembre 1328–avril 1329)," Les Ordres Mendiants et la ville en Italie centrale (v.1220–v.1350), *Mélanges de l'Ecole française de Rome. Moyen Age—Temps Modernes* 89 (1977): 757–67; esp.757–8.

6. See the editions of all three *legenda* texts in MOPH 16 (Rome, 1935): *Legenda Petri Ferrandi*, ed. M.-H. Laurent, O.P. (197–260); *Legenda Constantini Urbevetani*, ed. H.-C. Scheeben (263–352); *Legenda Humberti de Romanis*, ed. A. Walz, O.P. (355–433). New editions of these texts, and the related texts by Jean de Mailly, Dietrich of Apolda and Jordan of Saxony, are planned for publication in MOPH by Father Simon Tugwell, O.P.

7. Peter Ferrand, *Legenda*, 33–36 (ed. Laurent, 233–37); Constantine, *Legenda* 30–32 (ed. Scheeben, 307–10); Humbert, *Legenda* 35 (ed. Walz, 394–6).

8. Constantine, *Legenda* 31 (ed. Scheeben, 308).

9. The relation of representations of St. Dominic to the concept of Francis *alter Christus* has been briefly raised, with differing conclusions, in some recent literature. A. F. Moskowitz, *Nicola Pisano's Arca di San Domenico and its Legacy* (University Park, Pennsylvania, 1994), esp. 11, 12, 24, regards some of the reliefs as proof of a "competitive hagiography with St. Francis *alter Christus*" and considers that the *Arca* took up a similar theme with regard to St. Dominic. In contrast Krüger, *Der frühe Bildkult des Franziskus in Italien*, 141–47, stresses the differences between the *bildkult* of the two mendicant saints. Although Krüger sees the *Arca* as a direct reaction to the St. Francis cycle in the Lower Church at Assisi, he considers that the *Arca* expresses the Dominican mission and beliefs through the actions of its founder rather than representing him as Christ-like in his individual personality. Krüger points to the distinction between the two saints in the Gallerani reliquary shutters but considers that some St. Francis iconography had a certain influence on the development of St. Dominic scenes during the course of the 14th century. W. Hood, *Fra Angelico at San Marco* (New Haven and London, 1993), esp. 58–60, also considers earlier art connected with the Order. In discussing the format and design of the St. Dominic altarpiece by Francesco Traini and the Triumph of St. Thomas Aquinas panel, both from S. Caterina, Pisa, he identifies an influence of St. Francis *"alter Christus"* on Dominican iconography as a secondary development of the second quarter of the fourteenth century but, like Krüger, and unlike Moskowitz, he sees this as an infrequent theme in Dominican art "For one thing the Dominicans never portrayed by word or image any of their saints as the "other Christ" whom the Franciscans promoted in the figure of their founder."

10. For reference to the set of choir books to which this leaf belongs see below, note 84.

11. For an attribution to an anonymous Perugian artist in the last decade of the thirteenth century see the entry by E. Lunghi in the exhibition catalogue *Francesco d'Assisi: documenti e archivi, codici e biblioteche, miniature* (Milan, 1982), 212–14.

12. According to Gerard of Frachet, *Vitae fratrum* 4.1, ed. B. M. Reichert, O.P., MOPH 1 (Louvain, 1896) 149, looking back to the early days of the Order from the mid-thirteenth century, "In cellis eciam habebant beate Virginis ymaginem et filii sui crucifixi ante oculos suos, ut legentes et orantes et dormientes ipsas respicerent, et ab ipsis respicerentur oculo pietatis." Reichert, introduction, xvi, shows that the original text of the *Vitae fratrum* was approved in 1260. See the brief but interesting remarks about this passage in H. Belting, *Das Bild und sein Publikum im Mittelalter* (Berlin, 1981), 94–6, 284–6.

It has been claimed several times in the recent literature that the type of images described anecdotally by Gerard of Frachet had also been laid down, in Dominican legislation, as acceptable, desirable, or even mandatory as furnishings for the cell of a Dominican friar from the mid-thirteenth century onwards. This misunderstanding probably stems from a reference by S. Orlandi, O.P., *Beato Angelico* (Florence, 1964), 78, to a passage in the Constitutions, "Fratres non habeant nisi unicam cellam pauperam, sine ornamentis aut imaginibus profanis, sed cum imaginibus Crucifixi, Beatae Virginis et patris nostri Dominici. . . . " Orlandi did not explain that the version of the Constitutions from which he quoted was that published in 1932 and that the paragraph concerning images in cells was first included in the Constitutions at that date. Citing Orlandi, C. Gilbert, "Tuscan Observants and Painters in Venice c.1400," *Interpretazioni Veneziane. Studi di storia dell'arte in onore di Michelangelo Muraro*, ed. D. Rosand (Venice, 1984) 109–20; see 109, stated that *"The rule (of 1260, never repealed)* forbade images in cells, except those of "Crucifixi, Beate Virginis et Patris nostri Dominici" (my italics), but there is no trace of such a statute in the General Chapter Acts for 1260, or in any of the thirteenth-century versions of the Constitutions. O. von Simson, "Über die Bedeutung von Masaccios Trinitätsfresko in S. Maria Novella," *Jahrbuch der Berliner Museen* N.F. 8 (1966): 119–59; 144–5, implied, without reference but probably also using Orlandi as a source, that Gerard of Frachet's description refers to instructions already laid down in the Constitutions by his time. Hood, *Fra Angelico*, 196, may

have been conflating Orlandi's reference and Frachet's description when he said that " . . . images of Christ Crucified, the Virgin Mary, or Saint Dominic were to be kept in each cell as an aid to meditation." (I am grateful to Father Simon Tugwell for helping me to identify the edition of the Constitutions which Orlandi was using and for supplying me with the following passage from Father Tugwell's provisonal edition of Dietrich of Apolda's *Libellus* on St. Dominic, composed between 1288 and ca.1295, which corroborates Gerard of Frachet's information concerning Dominican practice—but *not* Dominican legislation—during the thirteenth century: "Habebant itaque in cellulis habitaculisque suis expressas ymagines uirginis cum filio et crucifixi pendentis in ligno, quarum aspectus memoriam dormitantem excitaret exterioremque sensum ad uana lubricum spiritali robore solidaret.")

For detailed discussion of Dominican legislation relating to art and architecture in the Order's first century see J. Cannon, "Dominican Patronage of the Arts in Central Italy: the *Provincia Romana*, c.1220–c.1320," Ph.D diss. (University of London, 1980), 74–108.

13. The panel (32.5 × 22.7 cms) which belongs to the G. Sarti Gallery, Paris was lot 162, Christie's Sale, 8 May 1987. In correspondence with the gallery Filippo Todini has proposed an attribution to Ugolino di Nerio. The panel shows the Crucified Christ with, standing below, St. John the Baptist, the Virgin, St. John the Evangelist, and St. Dominic. The Magdalen, kneeling and embracing the foot of the cross, looks towards the diminutive figure of a donor, hands raised in prayer, who wears a Dominican habit. (Unfortunate damage to the Magdalen's face makes it appear, at first sight, as though she were looking out of the painting rather than towards the supplicant.) Todini proposed that in view of his attribution to Ugolino di Nerio, who painted a polyptych for the high altar of S. Maria Novella at some time before 1323, the Dominican supplicant may have been a member of that Florentine convent. One might even press this further and consider the name of Fra Baro Sassetti, the friar who arranged for that polyptych to be made, as a possible identification (for Sassetti see Cannon, "Simone Martini," cited below, note 21, 87–91). However, Ugolino may also have worked for the Dominican house in Siena, and the question must remain open. The panel is, in any case, a rare example of a small Crucifixion scene demonstrably made for the private use of an individual Dominican—perhaps in his own cell. (I am grateful to Giovanni Sarti for permission to examine the panel, for providing a photograph of it, and for making available Filippo Todini's correspondence.)

For a panel painting of the Crucifixion with a Dominican devotee (presumably a friar rather than St. Dominic, since he lacks a halo) attributed to a Florentine artist (circle of Andrea di Bonaiuti) working in the 1370s, see Hood, *Fra Angelico*, 196–7, who makes the intriguing proposal that the small panel, now in the Pinacoteca Vaticana, could have come from one of the cells in S. Maria Novella.

14. E. B. Garrison, *Italian Romanesque Panel Painting. An Illustrated Index* (Florence, 1949), no. 488. See also L. Mortari, "L'antica Croce dipinta della chiesa romana dei SS. Domenico e Sisto," *Studi in onore di Guilio Carlo Argan* (Rome, 1984), 1: 11–28.

15. For the handful of possible occurences of Dominican supplicants on crucifixes in the area of the *Provincia Romana* (roughly equivalent to present-day Tuscany, Umbria, and Lazio) within—or slightly beyond—the first century of the Order, see Cannon, "Dominican Patronage," 230, note 27. For illustration and discussion of a Crucifixion panel (as distinct from a Crucifix) of ca. 1333, now in the Galleria Nazionale dell'Umbria, Perugia, which includes a small-scale Dominican devotee combined with Mary Magdalen embracing the foot of the cross, see D. Gordon, "The so-called Paciano Master and the Franciscans of Perugia," *Apollo* 143 (March 1996): 33–39; 38–39.

Later in the century in German-speaking areas, and in the following century in Italy, different attitudes to representations of the crucified Christ began to prevail among Dominican patrons, as is clearly shown in the paper in this volume by Jeffrey Hamburger and the paper on Fra Angelico delivered by William Hood at the Notre Dame conference. These intriguing developments and contrasts require further investigation.

16. Within the *Provincia Romana* there is one clear exception: a Crucifix in San Domenico, Spoleto, painted by an Umbrian artist, ca.1330, in which the head of a haloed Dominican, presumably Dominic, kissing Christ's feet, is all that survives of a damaged figure at the foot of the cross. See D. Gordon, "Art in Umbria, c.1250–c.1350," Ph.D diss. (University of London, 1979) 260 and, for illustration, F. Todini, *La Pittura umbra dal Duecento al primo Cinquecento* (Milan, 1989) II, 133, fig.278. This painting presumably reflects the strength of influence of local Umbrian spirituality on visual imagery.

It is interesting to note that in the Sarti panel (fig. 9) St. Dominic stands at some distance from the cross, simply gesturing towards it, while the Magdalen, adopting a relatively restrained pose, acts as an intermediary between the isolated figure of the crucified Christ and the fourteenth-century Dominican supplicant.

For a convenient grouping of Crucifixes including St. Francis, with generous illustration, see Krü-ger, *Die frühe Bildkult,* chapter 5 and figs. 296–313. See also D. Russo, "Saint François, les Franciscains et les représentations du Christ sur la croix en Ombrie au XIIIe siècle. Recherches sur la formation d'une image et sur une sensibilité esthétique au Moyen Age," *Mélanges de l'Ecole française de Rome. Moyen Age—Temps Modernes* 96 (1984): 647–717.

17. For discussion of the Dominican contribution to the development of painted Crucifixes and further references for the works illustrated here, see Cannon, "Dominican Patronage," chapter 6.

18. For near-contemporary illustration of the positioning of monumental painted crucifixes on a rood beam or screen to the west of the choir, facing the nave, see the often-cited examples in the St. Francis cycle in the Upper Church of S. Francesco at Assisi, the *Miracle of the Crib at Greccio* and the *Funeral and Testing of the Stigmata of St. Francis,* illustrated and discussed in H. Hager, *Die Anfänge des italienischen Altarbildes* (Munich, 1962) 69–70, figs.86,87.

19. See H. W. van Os, "The Discovery of an Early Man of Sorrows on a Dominican Triptych," *Journal of the Warburg and Courtauld Institutes* 41 (1978): 65–75; Belting, *Das Bild und sein Publikum im Mittelalter,* 61–2, 272–4.

20. Belting, 274, note 155, states that the inner and outer faces of the triptych are contemporary but the stylistic and technical differences between the two Dominican figures and those inside the triptych are so striking that it does not seem possible to explain them simply as different manners of painting suited to the representation of, on the one hand, biblical and, on the other hand, near-contemporary figures. Examination of the triptych with the naked eye (but without the evidence provided by seeing the work under a microscope) suggests that the figures of the two Dominicans, the heraldic bird and Christ in Majesty in a Mandorla could easily have been added to the reverse of one of the panels of an existing painting. The absence of any underlying linen beneath the gesso ground of this face of the panel might indicate that the reverse of the panel with the Virgin was not originally intended to receive figurative painting. The rear of the other two panels, which form the two outer covers when the triptych is closed (fig. 16), are decorated with mock-marbling (red on the reverse of Christ, green on the reverse of St. John the Evangelist) with illusionistically shaded fictive frames (visible to the left of fig. 17). The possibility that the triptych was painted in two phases reopens the question of its artistic and icono-graphic origins: while the Dominicans fit comfortably in a Venetian context similar to, although cer-tainly not identical with, Paolo Veneziano, as noted by van Os, "The Discovery of an Early Man of Sorrows," 65–6, the interior of the triptych could be the work of an Eastern artist, working either in Venice or further East, adapted at some time (not necessarily immediately) after purchase, at the re-quest of its Dominican owner.

21. For a detailed discussion of the programme of this painting and further illustrations see J. Cannon, "Simone Martini, the Dominicans and the Early Sienese Polyptych," *Journal of the Warburg and Courtauld Institutes* 45 (1982): 69–93, esp.69–75. Van Os, "Man of Sorrows," 71–2, and Belting, *Das Bild und Sein Publikum,* 61, considered that the Pisa Polyptych Man of Sorrows formed the central part of a triptych composition, with St. Mark taking the place of St. John the Evangelist, but fig. 18 makes clear that the Man of Sorrows and the Virgin form a diptych framed by, to the right, St. Mark and, communicating with the Virgin on the left, St. Luke.

22. See, e.g., Belting, chapter 4, with further references.

23. Inventory no.1982.480. (10.3 × 7.8 cm) Translucent and opaque enamel on copper gilt. See C. Gomez-Moreno in *Notable Acquisitions 1982–1983: The Metropolitan Museum of Art* (New York, 1983), 22.

24. Confraternities attached to the Dominican houses in Perugia, Pistoia, Prato, and Siena all had the appropriate dedication and were in existence by the first half of the fourteenth century. See Cannon, "Dominican Patronage," 394, 407, 410, 439 with further references. If Gomez-Moreno is correct in attributing the piece to Umbria, the Perugia confraternity (founded by 1318) may be the most likely candidate for provenance.

25. See the works by Belting, van Os, and Cannon cited above. See also the recent remarks in E. Simi Varanelli, "Cristologia tomista e rinnovo dell'iconografia del *patiens* nel tardo Duecento," *Arte e Spiritualità negli Ordini Mendicanti: Gli Agostiniani e il Cappellone di San Nicola a Tolentino* (Rome, 1992), 93–7, who looks to the Christology of Aquinas as a context for the major change in representation of the Crucified Christ found in the S. Maria Novella Crucifix (fig. 14).

26. The following analysis of reliefs on the *Arca di San Domenico* is developed from chapter 4 of Cannon, "Dominican Patronage" (which gives a fuller discussion of Dominic's first three tombs.) A more recent study is Moskowitz, cited above, note 9. See also the forthcoming paper by Serena Romano, in the proceedings of the Congrès International d'Histoire de l'Art, 1996, to be held in Amsterdam,

particularly for its interesting proposal of possible links between witnesses to the first translation of St. Dominic's body (1233) and the commissioning and conception of the second *Arca,* and for several stimulating proposals concerning possible sources for the design of the *Arca.* I should like to thank Dr. Romano for sending me a copy of her paper in advance of the conference.

27. The classic study of attribution on the *Arca* is C. Gnudi, *Nicola, Arnolfo, Lapo* (Florence, 1948). See also the subsequent important contributions of M. Seidel, notably "Studien zur Antikenrezeption Nicola Pisanos," *Mitteilungen des Kunsthistorischen Institutes in Florenz* 19 (1975): 307–92, esp.345–53.

28. *Acta capitulorum generalium ordinis Praedicatorum,* ed. B. M. Reichert, MOPH 3 (Rome, 1898), 130.

29. The translation took place on 5 June 1267 at the time of the General Chapter. See the eye-witness account by Bartolomeo of Breganze in M. Piò, O.P., *Delle Vite degli Huomini Illustri di S. Domenico,* revised ed. (Bologna, 1620) cols.116–25. Serena Romano draws attention to Taegio's early 16th-century report of an individual donation, that of Andrea Fieschi (d. 1270), of 80 gold coins towards the cost of completing the *Arca.*

30. First stated in the late-fourteenth-century obituary list of Santa Caterina, Pisa, "Cronaca del Convento di Santa Caterina," ed. F. Bonaini, *Archivio storico italiano* 6, 2 (1848): 463–7. Discussed by Gnudi, *Nicola, Arnolfo, Lapo,* 11–12,17–19; S. Bottari, "L'Arca di S. Domenico in Bologna," *Scritti di Storia dell'Arte in Onore di Mario Salmi,* (Rome, 1961) 1: 391–415; see 391–4.

31. Humbert, *Legenda* (ed. Walz, 369–433); for composition and dating see Walz's introduction, 355–60. Moskowitz, *Nicola Pisano's Arca di San Domenico and its Legacy,* 12, incorrectly states that the Raising of Napoleone Orsini is not included in Humbert's version of the Legenda.

32. Jordan of Saxony, *Libellus de principiis ordinis Praedicatorum,* ed. H.-C. Scheeben, MOPH 16, 122 and 123 (83–4).

33. Compare, for example, the order of scenes on the *Arca,* reading clockwise from the Miracle of the Books, with the paragraph numbers in Humbert's version of the *Legenda:* Miracle of the Books = H 17/18; Raising of Napoleone Orsini = H 41; Dominic's Vision of Sts. Peter and Paul = H 34; The Dream of Innocent III and the Approval of the Order and Choice of Rule = H 30/33; The Healing of Reginald of Orleans = H 35; The Miracle of the Loaves = H 43/44. Moskowitz's contention (*Nicola Pisano's Arca,* 9,12) that the sequence of scenes on the *Arca* closely follows Humbert's account, is certainly not borne out by the paragraph numbering in Walz's edition, cited here, or the identical order of readings in the lectionary on which that numbering is based, e.g., in the thirteenth-century compendium of Dominican service books British Library Add. Ms. 23935.

34. C. N. L. Brooke, "St. Dominic and his First Biographer," *Transactions of the Royal Historical Society,* series 5, 17 (1967): 23–40.

35. Constantine, *Legenda* 25 (ed. Scheeben, 304). For date of approval of this *Legenda* see Scheeben's introduction, 281–84.

36. This assumes that the scenes of the Raising of Napoleone Orsini and the Miracle of the Book always constituted the front face of the *Arca,* as they do now. See below, notes 42 and 56.

37. Jordan, *Libellus* 40, 41, 45 (ed. Scheeben, 45–7).

38. Constantine, *Legenda* 21 (ed. Scheeben, 301–2). For discussion of the relationship between the *Arca* scene and that concerning St. Francis in the Lower Church at Assisi see J. Cannon, "Dating the Frescoes by the Maestro di San Francesco at Assisi," *Burlington Magazine* 124 (1982): 65–9. For a more recent consideration of the relationship between Constantine's text and the parallel event, concerning St. Francis, in Thomas of Celano's *Vita secunda,* which supports the view that the Dominican version borrowed a motif originally applied to St. Francis, see S. Tugwell, O.P., "Notes on the life of St. Dominic," AFP 65 (1995): 10–11.

39. Jordan, *Libellus,* 56–58 (ed. Scheeben, 51–3).

40. Peter Ferrand, 33–36 (ed. Laurent, 233–7); for date of composition see 203–4.

41. Jordan, in his *Libellus,* 58, 60 (ed. Scheeben, 52–3), describes Reginald's crucial role in attracting a large number of people into the Order in Bologna.

42. It is thought that the *Arca* was originally situated in the nave immediately to the west of the choir screen, on the south side of the church, near the altar of the laity (see the fundamental study by J. J. Berthier, O.P., *Le Tombeau de Saint Dominique* (Paris, 1895), 8, 23, note 1, 24). It is generally assumed that the face of the *Arca* which now faces into the *Cappella di San Domenico* was always the "front" face, which would have been readily visible to the approaching laity (Berthier, 23, note 1). This assumption is supported by the contrast in composition and choice of subjects between the two long sides of the tomb chest: the two scenes on the "front" have simple compositions with long rows of

figures on the same level, easily read at a distance, which relate two notable miracles performed through Dominic's agency. The more numerous scenes on the "back" consist of more complicated, interlocking compositions, based on diagonal lines, and relate events concerning the establishment of the Order whose significance would have been particularly appreciated by the friars, whose choir was situated to the east of the rear of the *Arca*.

43. Jordan, *Libellus*, 24, 25 (ed. Scheeben, 38). There are, however, significant variations between different versions of this story. The scene on the *Arca* is closer to the versions in Jordan, Peter Ferrand, and Constantine than to that in Humbert or the *Legenda Aurea*.

44. The open book once bore an inscription, picked out in gold leaf, which is now virtually illegible (the opening word may be *liber*).

45. Seidel, "Studien zur Antikenrezeption Nicola Pisanos," 348–51.

46. A point which I failed to note in Cannon, "Dominican Patronage," 180, note 37.

47. A. Grabar, *Christian Iconography. A Study of its Origins* (London, 1969), 12, 32–3, figs. 21, 22.

48. Now displayed in the Vatican Grottoes. Grabar, 33–4, figs. 29(c), 69, 70.

49. W. F. Volbach, *Frühchristliche Kunst* (Munich, 1958), 54, figs. 46, 47. The sarcophagus, which stands under the medieval pulpit in S. Ambrogio, may have been made for that church from the outset and may therefore have been visible throughout the middle ages. See *Storia di Milano* 1 (Milan, 1953), 660–62. Another example of the type, which was certainly visible by the mid-thirteenth century, is found on the sarcophagus used for the burial of Beato Egidio (d.1261 or 1262) in S. Francesco al Prato, Perugia. See D. Gordon, "A Perugian Provenance for the Franciscan double-sided altar-piece by the Maestro di S. Francesco," *Burlington Magazine* 124 (1982): 75, fig.10.

50. The S. Ambrogio Christ is raised above two supplicant figures of the deceased who recall, in purely compositional terms, the stooping figure wielding the bellows in the centre foreground of the *Arca* relief.

51. For Nicola Pisano's varied use of motifs from classical sarcophagi see esp. Seidel's lucid study, "Studien zur Antikenrezeption Nicola Pisanos."

52. If there *is* a parallel to be made with Dominic it is a different one, concerning his resemblance to the St. Peter-like figure who stands behind him in the *Arca* relief, flanking the seated, presiding figure as St. Peter does in sarcophagus compositions (see e.g. fig. 25). Once again, the connotation is that of Dominic as Christ's lieutenant and agent, not of Dominic as a Christ-like figure himself.

53. Jordan, *Libellus*, 100 (ed. Scheeben, 72–3).

54. See A. Walz O.P., "Die *Miracula beati Dominici* der Schwester Cäcilia," AFP 37 (1967): 5–45; c.2, 23–5.

55. See V. J. Koudelka, O.P., "Le *Monasterium Templi* et la fondation dominicaine de San Sisto," AFP 31 (1961): 5–81; see 54–9.

56. It is interesting to note that the two scenes which appear to refer to the foundation of Dominican houses for women—Prouille and San Sisto—are placed together on what was presumably always (as discussed in note 42) the front face of the *Arca*. The *Arca* was originally situated in the south nave aisle—the area of a church traditionally accessible to women (see Berthier, *Le Tombeau de Saint Dominique*, 8, 23, note 1, 24). This raises the question of whether these two allusions to the role of women within the Order, from its early days, may have been consciously included on the side of the *Arca* most visible to women.

57. Walz, "*Miracula beati Dominici*," 7–12.

58. Moskowitz, *Nicola Pisano's Arca di San Domenico and its Legacy*, 10–12, following Alfonsi, proposes that Cecilia may have been consulted about the details of Dominic's life. Her suggestion that the aged and dishevelled woman at the top left of this scene, who turns her semi-naked back to the viewer, is intended to represent Suora Cecilia narrating the miracle seems, on grounds of decorum, improbable.

59. Moskowitz, 11–12, sees an intention to draw a strong parallel with Christ, and specifically with the Raising of Lazarus, in the choice of this scene, but the composition on the Arca does not appear to draw on, or to offer deliberate parallels with representations of the standing, and generally isolated, figure of Christ in the Raising of Lazarus or in other miracles of resuscitation. Krüger, *Der frühe Bildkult des Franziskus in Italien*, 146–7, stresses that this scene does not show a miracle accomplished directly by Dominic, but a heavenly intervention brought about by Dominic's prayer. The kneeling figure of the saint is certainly a key element in the composition, but Krüger may have failed to notice the second figure of Dominic, standing immediately behind and to the left of the praying figure, who supports the resuscitated child and presents him to his mother. Thus the distinc-

tion which Krüger draws between the *Arca* version of the miracle and that shown on the panel by Francesco Traini from S. Caterina, Pisa, (1344–45) which Krüger believes presents a contrast by showing Dominic to be directly responsible for the resuscitation miracle, is incorrect. Traini's St. Dominic, presenting the resuscitated child, has a pose very similar to the standing St. Dominic in the *Arca* scene.

60. *Acta Canonizationis S. Dominici,* ed. A. Walz, O.P., MOPH 16, 91–194. For a discussion of the problems surrounding the textual history of the *Acta* see S. Tugwell, O.P., *Early Dominicans: Selected Writings* (New York, 1982), 474–5.

61. *Acta Canonizationis,* 22 (ed. Walz, 141).

62. Ibid., 31 (ed. Walz, 149).

63. See V. Alce, O.P., "Documenti sul convento di San Domenico in Bologna dal 1221 al 1251," AFP 42 (1972): 5–7.

64. See A. Cavazza, *Cenni storici sulla tavola detta di S. Domenico che conservasi nella chiesa priorale e parrocchiale di Sta Maria della Purificazione in Via Mascarella* (Bologna, 1883). G. Fornasini, *La chiesa priorale e parrocchiale di S. Maria e S. Domenico detta della Mascarella in Bologna* (Bologna, 1943), 17–23, gives an account of the panel which is generally closely based on Cavazza, but which—confusingly—differs from him in reversing the relative chronology of the painting of the two sides of the table (see below, note 68).

65. Second chapel on north nave wall. One or two small sections of the panel were separated, at some time, from the three main sections, and appear to have been kept in San Domenico, Bologna (see A. d'Amato, O.P., *I Domenicani a Bologna* (Bologna, 1988), 1, 60). In 1961 a section of the table, measuring approx. 20 × 30 cm and representing two friars, was presented to the Master General of the Order by the Bologna convent and is now displayed in the conventual museum of Santa Sabina in Rome.

66. For the attribution and date see Garrison, *Italian Romanesque Panel Painting,* no.606. I am grateful to the Soprintendenza per i beni artistici e storici di Bologna for making available to me color slides and black and white photographs of the panel taken after its restoration in 1993.

67. For a transcription of what remains see Cavazza, *Cenni storici,* 15, repeated by Fornasini, *La chiesa priorale e parrocchiale,* 22, neither of whom can suggest any meaning for the jumble of surviving letters.

68. This painting was executed on canvas attached to the wooden panels. Cavazza dated this painting to the first half of the fifteenth century and assumed that it was substantially later than the painting on the other side (fig. 27) which he dated to the thirteenth or early fourteenth century. Fornasini, on the other hand, assumed that the painting on what I have termed the reverse of the panel was executed in the thirteenth century ("contemporanea al miracolo stesso") and placed the painting of St. Dominic with thirty-four companions (fig. 27) later in the same century. The present ruined condition of the painting from the reverse of the table makes any stylistic judgement very difficult, but Cavazza's chronology seems much more convincing than Fornasini's. Garrison judged the painting on the reverse to be "probably 15th century imitating 13th century style."

69. A fold-out plate at the end of Cavazza, and reproduced in Fornasini, 20, fig. 6.

70. Constantine, *Legenda,* 37 (ed. Scheeben, 312–3). For the move from San Sisto to Santa Sabina see Koudelka, "Le *Monasterium Templi*," 54.

71. Constantine reports that there were, at the time, forty friars in San Sisto—probably the number of friars originally represented on the Mascarella painted table.

72. Humbert, *Legenda,* 43, 44 (ed. Walz, 402–4).

73. Reichert, "introduction," Gerard of Frachet, *Vitae fratrum,* xvi.

74. *Vitae fratrum* 2.20 (ed. Reichert, 80).

75. Walz, "Miracula beati Dominici," 8.

76. Ibid., 10–12 (following Altaner's dating arguments).

77. Cecilia, *Miracula,* c.3 (ed. Walz, 25–7).

78. See the Constitutions, Dist.I, cap.7, in A. H. Thomas, O.P., *De Oudste Constituties van de Dominicanen,* BRHE 42 (Louvain, 1965), 318.

79. For further discussion of the significance of the miraculous provision or multiplication of loaves in relation to the Order's choice of mendicancy, especially in the Order's early decades, see the essays by Van Engen and Tugwell in this volume.

80. For imprinting of the host with a cross in the Western Church see J. Jungmann, *The Mass of the Roman Rite* (New York, 1955), 2, 36–7. For a detailed survey of the Eastern Church see G. Galavaris, *Bread and the Liturgy. The Symbolism of Early Christian and Byzantine Bread Stamps* (Madison, 1970). The bread in the *Arca* scene may have been based directly on the model of the *panis quadratus* shown on Early Christian sarcophagi (see Galavaris, 169 and 170, fig. 87).

81. J. Paul Getty Museum, Malibu, California, MS.83.MH.84 (MS Ludwig VI 1). See below, note 84, for references for the group to which this book belongs.

82. For a list of these illuminated choir books and introductory bibliography see Cannon, "Dominican Patronage," appendix 4, 480–91. (Note that Perugia, Biblioteca Augusta, MSS 2790, 2792, 2795 came originally from S. Salvatore, the Dominican house in Spoleto, and only later came into the possession of S. Domenico, Perugia, the provenance given in appendix 4.) To this list should now be added Orvieto, Archivio dell'Opera del duomo, Corali 189, 190, ex S. Domenico, Orvieto; Pesaro, Biblioteca Oliveriana MSS.B 21-12-3, B 24-12-1, B 24-12-4, B 34-12-5, ex. S. Domenico, Urbino; Sotheby's Sale, 7 December 1982, Lot 70; Chicago, Art Institute, seven leaves from a Gradual, inv. nos. 42.547–42.553; and various leaves and cuttings from Dominican choir books discussed in entries by R. Gibbs and F. Lollini in the exhibition catalogue *Neri da Rimini. Il Trecento riminese tra pittura e scrittura* (Milan, 1995), 80–81, 94–7, 126–7 (see also the entry by B. Montuschi Simboli, 192–6, on the S. Domenico, Urbino choir books). The patronage and decoration of Dominican choir books is also discussed in Cannon, chapter 3(c), 139–45; for representations of St. Dominic in these books see chapter 5, 193–202.

83. Compare the situation which Blume, *Wandmalerei als Ordenspropaganda,* hypothesises for the St. Francis cycle in the Upper Church at Assisi, within the Franciscan Order. Krüger, *Der frühe Bildkult des Franziskus in Italien,* 146, considered that the *Arca* reliefs remained the essential kernel for subsequent St. Dominic cycles (remarks based on the panel now in the Museo di Capodimonte, Naples; the panel by Francesco Traini for S. Caterina, Pisa; and the Gubbio choir books).

84. Introit for the feast of St. Dominic, J. Paul Getty Museum, Malibu, California, MS.83.MH.84, fol.38r. This codex is signed by the professional scribe and illuminator Jacobellus de Salerno, known, he tells us, as *Muriolus* (little mouse) and dated, on stylistic grounds, c.1270. See A. von Euw and J. M. Plotzek, *Die Handschriften der Sammlung Ludwig,* (Cologne, 1979), 1, 262–65.

The Getty Gradual has been shown to be one of a set from which other volumes or leaves exist in several public and private collections, including the Antiphoner now Nationalmuseum, Stockholm, B 1578, and the single leaves Philadelphia Museum of Art, acc. no. 62-146-2, the Breslauer Collection, and the leaf in a private collection in Geneva (fig. 7). (For further details and other leaves see the catalogue entry by C. de Hamel for Lots 39–40, Sotheby's Sale, London, 5 December 1994.) C. Nordenfalk, "Miniatyrsamlingen Nyuppställning och Nyförvärv 1948–50," *Nationalmusei Årsbok 1949–50* (Uppsala, 1952), 72–4, figs. 18–19, Id., *Bokmålningar från medeltid och renässans i Nationalmusei samlingar* (Stockholm, 1979) 78–80, figs. 104–7, 220, 222, color plate 9, noted that the second volume of the Stockholm Antiphoner was a codex in the Art Institute, Chicago, acc. no.11.142.B, and this information has been repeated by de Hamel and by the present author. A recent visit to the Art Institute reveals, however, that no such manuscript is currently in the collection.

This set of Choir Books was evidently made for a house of Dominican nuns, although which of the thirty monasteries in existence in northern and central Italy by 1303 this was, has not yet been determined. (S. Guglielmo, Bologna, proposed by von Euw and Plotzek and accepted by de Hamel, is unlikely to be the original provenance, since it appears to be a post-medieval foundation).

85. Introit for the feast of St. Dominic, Perugia, Biblioteca Comunale Augusta, MS.2795(A), fol. 46v, from S. Domenico (Salvatore) Spoleto. Dated on stylistic grounds to the last quarter of the thirteenth century. See under the catalogue entry for Biblioteca Augusta MS.2792(D) by F. Todini in the exhibition catalogue *Francesco d'Assisi* (cited above, note 11) 193–4.

86. Introit for the feast of St. Dominic, Gubbio, Archivio Comunale, Corale C, fol.76v. from S. Domenico, Gubbio. G. Théry O.P., "A propos des livres choraux des Dominicains de Gubbio," AFP 2 (1932): 252–83, dated the Gubbio choir books to the first quarter of the fourteenth century, on liturgical grounds. See also G. Castelfranco, "I corali miniati di S. Domenico di Gubbio," *Bolletino d'arte* 8 (1929): 529–55; id., "Contributi alla Storia della Miniatura Bolognese del '200," *Bologna* 7 (1935): 11–22, esp. n. 29, 18–22. In the earlier article Castelfranco illustrates the choir books extensively and attributes them, on stylistic grounds, to one Bolognese master with a few closely imitative assistants, working at the end of the thirteenth century. In the later article he rejects Théry's later dating, producing convincing arguments, on liturgical and stylistic grounds, for a dating in the last decade of the thirteenth century.

87. Cecilia, *Miracula,* c.3 (ed. Walz, 25–7).

88. For a broader discussion of representations of St. Dominic in central Italy in the first century of the Order, and some comparison with the evidence for St. Francis, see Cannon, "Dominican Patronage," Chapter 4 (169–182), Chapter 5 (183–218), Conclusion (321–334). Krüger, in his recent *Der frühe*

Bildkult des Franziskus in Italien, makes some thoughtful comments on the contrast presented by early representations of St. Dominic (pp. 74–7, 141–7, and see above, note 9).

89. *Acta capitulorum prov.* 1247, ed. T. Kaeppeli O.P. and A. Dondaine O.P., MOPH 20, (Rome, 1941), 7: "Item quilibet prior studeat habere imaginem b. Dominici in domo sua, et dies festi eius in kalendariis secularium faciant annotari."

90. *Acta capitulorum generalium ordinis Praedicatorum* a. 1254 (ed. B. M. Reichert, 70–71): "Priores et alii fratres curam habeant diligentem quod nomen beati Dominici et beati Petri martiris in kalendariis et in litaniis scribantur et picture fiant in ecclesiis et quod fiant festa eorum."

Ibid., a. 1256 (ed. Reichert, 81): "Apponatur diligencia quod festum beati Dominici et beati Petri ubique celebretur et quod ymagines eorum in locis congruentibus depingantur et nomina eorum in kalendariis et litaniis et martirologiis annotentur."

91. Attributed to an anonymous Umbrian artist active in Perugia in the first half of the fourteenth century. See Todini, *Pittura umbra*, 1, 179.

92. For splendid color illustrations see Hood, *Fra Angelico*, 44, fig. 28, 58, fig. 46. Krüger and Hood both note a change of emphasis in the treatment of Dominic on the Traini panel, and Hood emphasizes that the painting was not intended to stand on the altar of a Dominican choir, but neither mentions the circumstances of patronage which may have contributed to the difference. (See above, notes 9 and 59). The relevant documents and inscription are published in full, with further details about the laymen in question, in F. Bonaini, *Memorie inedite intorno alla vita e ai dipinti di Francesco Traini* (Pisa, 1846), esp. 9–12, 109–25. The inscription and extracts from the documents are also given in M. Meiss, "The Problem of Francesco Traini," *Art Bulletin*, 15 (1933): 97–173, esp. 98, notes 6 and 7, 172–3. It is not clear from Albizzo delle Stadere's will (Bonaini, 115–6) where the newly-built altar or chapel for which the painting was intended was to be located within the church. Vasari probably saw the painting in the Cappella di San Domenico, (Giorgio Vasari, *Le Vite de'più eccellenti Pittori, Scultori e Architettori*, ed. R. Bettarini and P. Barocchi (Florence, 1966–87) 2, 226). Meiss, 98, assumed that the painting had always been in that location, and that the chapel was in the north transept of S. Caterina. The chapel was in fact located on the south side of the church, opening off an aisle, added to the eastern part of the south side of the church in the 1340s. Although this area of the church was to the east of the *tramezzo* it appears to have been linked with the cemetery to the south of the church and to have been accessible to, perhaps even primarily intended for, the laity. See G. Corallini, *La Chiesa di S. Caterina in Pisa* (Pisa, 1969), 7–8, 12, 15.

93. The St. Dominic scenes in the Hungarian Angevin Legendary (Biblioteca Apostolica Vaticana, Vat. Lat. 8541, fol. 90v. and New York, Pierpont Morgan Library, M.360, leaf xxvi), attributed to a Bolognese workshop of the 1330s, include Dominic's Birth and some posthumous miracles, but not the Miracle of the Loaves. Since this luxury picture-book was made for royal use it would seem, at first sight, to support this observation. However, since the sequence now lacks four scenes, it is impossible to be certain about which particular episodes were omitted. See F. Levárdy, *Magyar Anjou Legendárium* (Budapest, 1973), ills. 144, 145; id., "Il Leggendario ungherese degli Angiò conservato nella Biblioteca Vaticana, nel Morgan Library e nell'Ermitage," *Acta Historiae Artium Academiae Scientarum Hungaricae* 9 (1963): 75–138.

The panel of St. Dominic now in the Museo di Capodimonte in Naples (Garrison, *Italian Romanesque Panel Painting*, no.169), to which twelve scenes were added in the course of the fourteenth century, does include a version of the Miracle of the Loaves. The main panel includes two kneeling Dominican supplicants who receive from Dominic, probably as prior and subprior on behalf of the members of their convent, a bible open at Mark 16:15, "euntes in mundum universum praedicate. . . . " This is surely an indication of the initial audience for the panel; however it is not known where this panel was originally displayed, nor to whom the added side scenes were primarily addressed.

94. In addition to the Getty Gradual it is interesting to note, beyond the period in question, the mid-fifteenth-century fresco in the refectory of the Dominican Monastery of S. Niccolò in Prato. The Miracle of the Loaves shows Dominic (both hands extended and holding a loaf) surrounded by twelve friars. The loaves are brought by two angels while two lay brothers carrying empty baskets look on in amazement, and a kneeling Dominican nun, presumably the donor, accompanied by a kneeling boy, is placed in the foreground of the composition. (This version has elements in common with, but is not identical to, Cecilia's version of the miracle, discussed above.) See D. Rigaux' stimulating study *A la table du Seigneur. L'Eucharistie chez les Primitifs italiens 1250–1497* (Paris, 1989), 248–9, fig. 104; for good color reproductions and further information about the Monastery see S. Bardazzi and E. Castellani, *S. Niccolò a Prato* (Prato, 1984), 269–71, 288–96, figs. 252–63. Rigaux draws attention to the par-

allel with the Last Supper offered by this composition, and links the origins of this type in the Dominican Order with a growth in Dominican encouragement of eucharistic devotion in the 1320s.

95. Perugia, Biblioteca Comunale Augusta, MS 2785(H), fol.44v, miniature attributed by Todini to his "Secondo Miniatore Perugino" active in Perugia at the start of the 14th century (catalogue entry in *Francesco d'Assisi*, 226–7).

96. This image is an appropriate development of the text which it accompanies ("Mundum vocans ad agni nuptias hora cene paterfamilias servum mittit promittens varias vite delitias. Ad hoc convivium tam permagnificum elegit nuntium sanctum Dominicum"), which is itself based on the opening verses of the Parable of the Wedding Feast, Matthew 22:3,4 and Luke 14:16,17.

97. A vivid word-picture of this attitude within the *Provincia Romana* at about the same time is found in the text of a miracle recorded by a friar of S. Domenico in Arezzo in 1326, concerning one of his confrères, recently published in E. Panella, O.P., "San Domenico d'Arezzo 1326. Racconto e legenda," AFP 64 (1994): 75–100; see 85–8. An ailing friar on the point of death received a vision, on the vigil of the feast of St. Dominic, in which the founder handed him a host, following the actions of a Dominican mass, and told the friar that Christ would then heal him: " . . . ipse beatus Dominicus suo proprio sinu extraxit unam patenam calicis de auro refulgentem et postea extraxit pissidem et de pisside hostiam, et tenens hostiam manu dextera et patenam sinistra dixit 'Fili, accipe sacram istam comunionem et Christus sanabit te.' "

98. When this article was in proof I had the opportunity to consult Klaus Krüger's forthcoming paper "Selbstdarstellung im Konflikt. Zur Repräsentation der Bettelorden im Medium der Kunst," *Die Repräsentation der Gruppen*, ed. O. G. Oexle and A. von Huelsen-Esch, Veröffentlichungen des Max-Planck-Instituts für Geschichte [Göttingen, 1998]. This includes a brief consideration of the choice of scenes on the *Arca di San Domenico*, and a stimulating discussion of the relation between the design of the *Arca* and the re-use of classical sarcophagi. Krüger explores the interest of the patrons in such models. Late antique and early christian works were recalled in the design of the *Arca*, he argues, in order to express a religious renewal of the apostolic past and, at the same time, to represent a new type of sanctity. I am grateful to Dr. Krüger for sending me a copy of his paper in advance of publication.

The Influence of Stephen Langton on the Idea of the Preacher in the *De eruditione predicatorum* of Humbert of Romans and the *Postille* on the Scriptures of Hugh of Saint-Cher

Riccardo Quinto

BREUES DIES HOMINIS *sunt et numerus mensium eius infra primos limites cohortatur.* This verse from Job (14: 5) not only provides the first line to a pseudo-Langtonian *Summa*,[1] and to one of Hugh of Saint-Cher's sermons.[2] It also expresses the initial trepidation of a scholar faced with the daunting task of going through the writings of authors as prolific as Stephen Langton and Hugh of Saint-Cher, as well as those of the Dominican Master General Humbert of Romans. The works of Stephen and Hugh represent the most evident and extensive achievement of the theological program proposed by Peter the Chanter (†1197) near the end of the twelfth century in his *Verbum abbreviatum*, a program organized according to the three exercises of *lectio, disputatio* and *praedicatio.* I prefer to quote the famous formula of this program not in the redaction of Peter himself but in that of Thomas of Chobham, who states it at the beginning of his *Summa de arte predicandi,* compiled not later than 1227–28:

> Theologie autem officium, quantum ad scolasticam exercitationem, in tribus consistit: in legendo, in disputando, in predicando. Quantum uero ad forensem administrationem, latitudinem sui terminat officii in iudicando, in penitentiam dando, in predicando.

> Cum igitur officium predicandi doctoribus et pastoribus sit commune, merito predicationis scientiam optinet priuilegium, cuius nec doctores nec prelati sustinere debent defectum.[3]

In this formulation we find two sets of three: first, reading, disputing and preaching; second, judging, giving penitence and, again, preaching. One might think that Thomas has added to Peter's original set the second set of three, but that would be incorrect. Although the Corpus Christianorum editor of the *Summa* omits to note it in his *adparatus fontium,* both parts of the definition originate in the *Verbum abbreviatum:* the first set in chapter 1, the second in chapter 66, *de officio praelati tripartito,* which reads:

> Tripartitum officium praelati, scilicet iudicare, poenitentiam dare, praedicare.[4]

I place this piece of pedantry before the reader to underscore the following point: most of the ideas which we shall observe as expressed by Stephen Langton and then

preserved in the 13th century under the pen of Hugh and Humbert in fact originate in the 12th century in the teaching of a master such as Peter the Chanter.

My second goal in recalling the three scholastic exercises is to indicate a basis of comparing in manageable form Stephen's and Hugh's vast literary production. The following schema is based on Kaeppeli's repertorium of Dominican writers:[5]

Hugh of Saint-Cher OP, Card. tit. S. Sabinae († 1263)	Stephen Langton, Arch. of Canterbury, Card. tit. S. Chrisogoni (†1228)

Lectio

Commentary on Lombard's *Sentences* (uned.)	Commentary on Lombard's *Sentences* (ed. Landgraf)[6]
Commentary on Comestor's *Historia scholastica* (in progress—M. J. Clark)	Commentary on Comestor's *Historia scholastica* (in progress—M. J. Clark)[7]
Postilla in uniuersum uetus et nouum testamentum (edited: 8 vols. in-folio[8])	Commentary on most of the books of the Bible. No sure attribution for the Psalms and the Gospels For Paul's epistles, commentary through Lombard's *Magna Glossatura*[9] Edited: Ruth (Lacombe)[10] Chronicles (*I-II Paralipomena*) (Saltman)[11]
Correctorium bibliae[12]	Reordination of biblical books and their subdivision in chapters—Collection of variant readings are attested in commentaries and in the *Quaestiones*
Verbal concordances of the scriptures[13]	*Interpretatio nominum hebraicorum*[14] Pastoral concordances of biblical texts and glosses: *summa De diuersis*[15] *Distinctiones*[16] "*De uitando consortio, consilio, colloquio et exemplo malorum*"[17]

Disputatio

Quaestiones uariae Chiefly ms. Douai 434	*Summa quaestionum theologiae* Among other, partly in ms. Douai 434
Partly ed. (Stegmüller,[18] Torrell)[19]	Partly edited (Ebbesen-Mortensen, Quinto)[20]

Tractatus super missam (enor-
mously diffused—old and modern
editions)[21]

Praedicatio

Sermons[22] Sermons (part. ed. Roberts)[23]

Works issued in connection with ecclesiastical duties

Epistles Epistles (ed. Major)[24]
Declarationes[25] *Constitutiones Oxonienses*[26]

aliaque plura . . .

Thus, the short commentary on the Lombard by Stephen Langton, which Landgraf calls "the first sentence commentary of early scholasticism,"[27] is edited, while the long commentary by Hugh remains unedited.

The commentaries of both authors on Comestor's *Historia scholastica* have found their editor in Mark J. Clark; when his work is published we will be sure to have good grounds for comparison.

I will linger on the biblical commentaries later in the essay. For the moment I will only stress that all of the scholars who have compared the comments on the different books, such as Monsignor Landgraf for the Pauline epistles[28] and Avrom Saltman for Chronicles, attest that Hugh's commentaries are not much more than updated abridgments of those by Stephen, so that it is possible to conclude that "Hugh compiled his commentary on Chronicles with a manuscript of Langton at his side."

Such strict parallelism is absent, on the contrary, from a different section of the work of these authors: the *disputatio* represented by the *Quaestiones theologiae*. Even where the same arguments are treated (as in the questions on prophecy, studied by Father Torrell), ideological coincidence cannot always be regarded as proof of textual dependence, since Langton's influence is very often mediated by William of Auxerre's *Summa aurea*, a work perhaps less original but much more systematic and ready-to-hand for consultation. While Hugh's *Quaestiones* are about thirty in number, Langton's include about two hundred and cover more or less the whole of theological matter, according to the Lombard's plan, from divine names down to last things.[29]

At the place which corresponds in my schema to Hugh's verbal concordance of the scriptures, I have listed a series of different Langtonian works about which I will speak in detail. Although these different works are quite difficult to put into a well-defined category, I am now inclined to consider them as a kind of pastoral concordance of the Bible, not very different from those which are published nowadays for the use of modern preachers. To distinguish them from those by Hugh, which are "verbal concordances," we can describe these works as "pastoral" in their goal, and "real" in the way they are conceived.[30] Or, at least, these works can be regarded as collections of material for building up such pastoral (real) concordances. In these works, as we will later see,

in the spirit of Peter the Chanter, preaching as the first duty of the clergy is one of the prominent themes.

My starting point will be the comparison of Langton's commentaries and Hugh's *Postilla*.

<div align="center">I</div>

By virtue of the brevity of human life, my comparisons will be restricted to the parts of biblical commentaries by our authors which are already edited. Hence I will examine here their commentaries on Ruth and Chronicles.

First, Chronicles. Avrom Saltman's edition of Langton's commentary on these two books was published in 1978. The text is divided into two parts, the first a literal commentary, the second a moral commentary. The latter is much shorter than the former, and unlike the literal commentary it does not explain all of the lemmas of the text, stopping instead only in certain chapters and verses. In the words of Saltman, Langton "was content to assemble sermon-material which could be attached to appropriate texts in the Chronicles."[31] In the words of Langton: "a principio libri quedam loca moralia quasi quosdam flosculos decerpamus."[32] Langton's technique can be described as follows:

1.1. The text at 4: 21 is: *Cognationes domus operantium byssum in domo iuramenti.* Hence, there is a house of oath, which recalls the pit of oath (Gen. 21: 32), causing Langton to write: "Hec est descripcio theologorum."[33] In fact, the pit is deep, which is true as well of Holy Scripture. This is also a house "propter quietem."[34] The people of this house wrought "fine linen," an image for the purity of flesh. So theologians must be pure through chastity, to be worthy to enter the house of Holy Scripture.

At 6: 10, Azaria becomes a priest; he is the only priest recalled in this genealogy. The reason is that Azaria resisted Ozia when the king tried to usurp the priesthood. This provides the commentator occasion to disapprove of those modern priests who do not cry out against princes and powerful sinners. We meet here a typical Langtonian theme: the idea that the prelates must resist the pride and violence of secular princes. If they do not, they are unworthy of their calling and their mission, even if there is some arguably good reason for omitting this duty. If they fear for their safety, their sin is called *timor humanus*; if they fear for their money, it is called *timor mundanus*. A variant reading to the *quaestio de timore seruili* in Ms. 434 of Douai has: "timor mundanus, quo quis timet pelli sue: talis est in prelato catholico bene litterato qui non audet insurgere contra hereticos ne ab illis interficiatur . . . mundanus, quo quis timet dampnum rerum suarum: talis est in prelato qui desistit ab increpatione potentium ne incurrat iacturam temporalium."[35] We will meet the same idea in the same context again in the treatise *De eruditione praedicatorum* by Humbert of Romans. In addition, these cowardly prelates are the *canes muti* (dumb dogs), unable to bark, mentioned in Isaiah 56: 10, a verse in which Peter the Chanter had already seen prelates unable or unwilling to defend their flock in face of the danger of powerful and faithless secular princes: "Officium praelatorum maxime roborat . . . latratus eorum, quo arceantur

lupi a grege, ne sint *canes muti, non valentes latrare, non opponentes se murum pro domo Israel.*"[36] We will see the extent to which Stephen will develop this idea.

In contrast, at 6: 31, Stephen finds Asaph, Emam, Ethan, the chiefs of the davidic chanters, who are models for good prelates. Using the interpretation of their Hebrew names, Stephen recalls the characteristics of good prelates. Good prelates must gather their people through preaching, be high and strong in good life, and be brothers to the sheep committed to them. Good prelates feed the sheep with the nourishment of word, example, and material help.[37]

At 1 Chronicles 16: 4, the staves of the Levites must always remain in the rings of the ark (Exodus 25: 14), that is, prelates must always be in the Holy Scripture.[38]

The final example to be discussed here is taken from 2 Chronicles, where the question of bronze occurs twice. There is in the tabernacle an *altare eneum* (2 Chronicles 1: 5). Further, the Egyptian Sisach steals the golden shields made by Salomon, which Roboamus replaces with bronze ones (2 Chronicles 12: 9–10). It is characteristic of bronze to sound when struck. Langton's exegesis: Salomon, who is Christ, or a good prelate, puts into the Church golden—so good and strong—men, who have wisdom, i. e., holy knowledge together with saintly life. But the devil (Sisach), substitutes for them bronze ones, i. e., clerics having science but no saintly life, and so resounding uselessly like bronze.[39] The origin of this interpretation is Gregory the Great commenting in the book of Job on the description of Behemoth (the hippopotamus), whose bones are like bronze bars (Job 40: 18): these are the bones of the devil, resounding without any sense, that is, prelates able to teach well other people but lacking an exemplarly life.[40] Let me note that this interpretation is taken over in its integrity in Langton's *Summa de diuersis*.[41]

This essay might now be expected to proceed to show which of these interpretations dealing with the idea of the preacher remains in the parallel commentary by Hugh of Saint-Cher, for as Saltman has noted[42] the commentary of Hugh copies to a large extent that by Langton. But, Saltman fails to note that Hugh copies only the literal part of Langton's commentary. In fact, the manuscript tradition of Langton's commentary on Chronicles reveals the following: in some manuscripts only the literal commentary is found, in some only the moral, in a couple the full commentary, but in abridged and variant form.[43] Now, Hugh must have had at hand a copy of Langton's literal commentary. In distinction from his other commentaries, Hugh's *Postilla* on Chronicles does not present any rubric *Mystice* or *Allegorice* to introduce the moral interpretations.

1.2. The situation is different for the book of Ruth: the commentary by Hugh has for each chapter first the literal explanation, and then the allegorical interpretation. Here, it is necessary to recall briefly the story of Ruth: In the time of the Judges in Israel, in a period of famine, a man called Elimelech emigrated from Bethlehem to the land of Moab with his wife Naomi. The two sons of Elimelech and Naomi married moabite girls, Ruth and Orpha. Both Orpha and Ruth remain widows of the sons of Naomi, widowed in her turn. When Naomi decides to go back to her country, Ruth accompanies her, and they arrive during the season when people are going to harvest barley.

Ruth goes to glean in the fields of a man called Booz, who is a relative of her father-in-law, Elimelech. At the end, according to the levirate law, Booz takes Ruth as his wife, in order to provide Elimelech a descendant. The son of Ruth is called Obed, and he will be the father of Jesse, father of King David. This introduction puts into focus the main elements upon which Langton's allegorical exegesis will be built: first the famine, then the scene of the corn-harvest in Palestine. For both Stephen and Hugh (and later for Humbert) famine and hunger mean the dearth of the word of God. Famine is the lack of preaching the good news. The members of Elimelech's family are *Effrataei*, coming from Bethlehem in Juda: from the interpretation of these three Hebrew names, Stephen more clearly, but Hugh too, can derive the characteristics of good preachers. They must thanks to their science be able to carry good fruits (effrataei—*frugiferi*), they must be domestic with the bread of good doctrine (Bethlehem—*domus panis*), and they must confess through their life what they preach (Iuda—*confessio*).[44]

On this basis, Hugh has an interesting development, echoing ecclesiastical polemic. Naomi says to her daughters-in-law: "Go, return each to her mother's house . . . are there yet any more sons in my womb, that they may be your husbands? . . . if I should have an husband also to night, and should also bear sons; would ye tarry for them till they were grown?"[45] Hugh transposes this speech as follows. Widows are those churches that lack good clergy in their service, so that the speech of Naomi could be that of a bishop saying: I do not see in the chapter any worthy man, well-suited for pastoral care. Naomi says that even if she could bear other children, they would be too young to marry her daughters-in-law. This—still according to Hugh—is the speech of some bishops who say to the churches depending on them: remain a widow, without man, until my nephews, who fill my household, are old enough to take over these ecclesiastical offices and their prebends. Or, even worse, such bishops appoint to the churches their nephews when they are still children. Though lacking in Stephen, the reference nevertheless goes back to Peter the Chanter, who has in his *Verbum abbreviatum* a long chapter (chapter 61—PL 205: 185–189) *Contra prelatos pueros, uel nouitios*. Naomi jokes to her daughters-in-law, imagining she will conceive *that very night* new children. For Hugh this is the attitude of certain bishops who, wanting to appoint their relatives and blood relations, do so in the night, i. e., secretly: "Ecce consanguinei . . . ecce fratres: tales hodie praeficiunt Episcopi, et paucos alios. Sed quando? Certe in nocte positi, peccant enim hoc faciendo."[46] In Stephen, we do not find anything similar; and if we like to make light of such things, we might recall that Langton the Archbishop of Canterbury was accused of managing to have appointed his brother Simon as archbishop of York,[47] finally calling him to Canterbury as Archdeacon. But, since the election of Simon at York was repealed by Innocent III, I am more inclined to refer here to the anti-nepotism of the Pope, who used Langton's brother to punish him for his firm position in the *Magna Charta*-affair.[48]

The commentaries go on with evident points of contact. Both see in Booz the typus of Christ. Both recognize in the three measures of barley[49] collected by Ruth in the field of Booz the image of the Trinity (but Stephen adds—or Hugh omits—that to find those measures is to find the Trinity *in the Holy Scripture*).[50] Both discover in the parts of the "ear of wheat" the characteristics of studying of the Word of God: in the prickly *arista* the hard study, in the bran the humble *littera*, in the nourishing corn the sweet mystical sense. Both give a christological interpretation of the cover under which Ruth sleeps

with Booz (3: 7–14), although Stephen's is the more elaborate. The cover is the veiling literal sense of the Old Testament, and can be understood only by entering from the foot-side, as Naomi advises Ruth, i. e., beginning with the Incarnation and Passion of Christ: after the Passion and resurrection, it is possible to understand the New Testament hidden in the Old.[51]

Concluding this first part, we can say that although Hugh's commentary clearly depends on that of Stephen, he never copies it in an uncritical way. Through the information that he finds in the older commentators, and chiefly in Langton, he builds up his own personal work. His own interests are not exactly the same as Langton's: the latter seems completely fascinated by the Word of God itself, and by his own committment as theologian. From this perspective, the long-lasting study of the bible—the daily bread of the theologian—naturally flourishes in preaching. After the literal explanation, the moral exegesis is chiefly the collection, from the forest of biblical text and its patristic interpretation, of themes for possible sermons. Sometimes in commenting on Ruth, as earlier in Chronicles, he notes it explicitly: *Sermo in passione,*[52] i. e., on this text it is possible to construct a sermon. We will shortly see that he actually collected all of these themes and ordered them in repertories. What is more, the whole work of the theologian is for him not much more than the "collecting" of sentences. Holy Scripture is a large field. First come the reapers, i. e., the fathers, then follow the gleaners, the *moderni doctores,* who collect what has escaped the former. His favorite text comes from Sirach 33 (16–18): "Ego novissimus omnium evigilavi, et [factus sum] sicut qui colligit racemos post vindimiatores."[53] Langton repeats this refrain on many occasions, and his best known pupil, Geoffrey of Poitiers, used it to open the prologue of his own *Summa.*[54] Even outside the strict Langtonian school, this self-comprehension of theology seems to have found adherents through the 1230s. The same idea—this time using the text of Ruth—is proposed in the prologue of Philip the Chancellor's *Summa de bono:*

> Vadam in agrum et colligam spicas que fugerunt manus metentium, ubicumque clementis in me patris familias reperero gratiam . . . Utinam essem Ruth et dicere possem: "Vadam in agrum," id est sacram scripturam," et colligam spicas que fugerunt manus metentium." Metentes sunt antiqui patres et doctores qui agrum sacre scripture falce ingenii latius messuerunt et forsitan spicas, id est aliqua discutienda, posteris reliquerunt.[55]

When Ruth leaves Booz after her night visit to him, he advises her to extend her cloak with both hands (*Expande pallium*), and pours her six measures of barley. For Stephen, *expandere pallium* means to amplify devotion through good deeds, and this moral accomplishment of faith is the condition for obtaining a deeper revelation from God:

> Ruth non collegit per se nisi tres modios et sex dat ei Booz. Sic per nos in sacra pagina vix colligimus tres modios, quia deus plura revelat de sacra scriptura claustralibus bone conversationis, pallio extenso, quam scolaribus et <iis qui> subtilibus sepe locuntur de deo.[56]

For his part, while he does note this "theological" interpretation, Hugh prefers a different one. The field is the church, the reapers are the preachers, the ears are the

souls which they collect and reassemble in sheaves. Ruth and the other gleaners are the minor preachers, who cannot speak in subtle ways, but sometime can, through their coarse arguments, convert more souls than the former: Shamgar, fighting with an ox goad, could kill six hundred men,[57] while Ehud, with his dagger, killed only king Eglon.[58] Compared with Langton, this concern of Hugh's to match preaching with different kinds of audience is something new. For him, what is important in the preacher is his accomplished, affectionate knowledge of the Holy Scripture, linked to his moral dignity; technical requirement are, for him, less interesting.

II

We turn now to comparing Stephen's views with those of Humbert of Romans. Attempting such a comparison would not have occurred to me if I had not spoken last summer in Dublin,[59] in the presence of the Corpus Christianorum editor of Humbert's *De eruditione praedicatorum*, about some tools for preachers which I proposed to link to the name of Stephen Langton. After my paper, Father Tugwell kindly suggested to me that that kind of text could contain some clues to the sources of Humbert's treatise. The suggestion has guided some subsequent research, and I now think I have additional evidence for the proposed authorship of the different texts.

2.1. The first work to be examined here is a *Summa de diuersis*,[60] which had a quite extensive diffusion: I have found 15 manuscripts containing the text[61] in longer or shorter form. The attribution is also easier than for the other works, for we have some external evidence. Four manuscripts preserved on the Continent bear an attribution to Langton. Moreover, a work with the same *incipit* is attributed to him by bibliographers such as John Bale and is also indicated as existing in British monastic libraries in the *Registrum Angliae de libris doctorum et auctorum ueterum*.[62] Finally, it has been possible to compare the contents of this *summa* with authentic works of Langton, in the process discerning strict correspondences which confirm the attribution to him.[63] After having read more carefully some parts of Langton's biblical commentaries, I am now even more convinced of the authenticity of this work. Langton's predilection for certain themes favored in the commentaries is evident in this work too: the opening chapters are devoted to the saving memory of our sins compared with Christ's benefits, and we find the same ideas, equally expressed, in the Chronicles commentary;[64] the image of the hippopotamus-bones is exploited in the same way in both works,[65] and so on.

In the *Summa de diuersis* it is possible to distinguish 258 chapters in the Amiens manuscript, while in the Milan manuscipt there are 249,[66] in Venice 229, in Douai 194 (plus some additions), and in other incomplete manuscripts far fewer. Worthy of note is that there does not seem to be any kind of order in the sequence of chapters of this work.

2.2. The second work I wish to take into account is a collection of *Distinctiones*, which survives in two different manuscripts, both of them containing also several other au-

thentic works by Stephen Langton: Paris, BN, Ms. lat. 393 (fols. 22r–31v) and Ms. lat. 14526 (fols. 161r–174r). Ms. lat. 14526 bears an attribution to our author and seems to give the work the title of *De uitiis et uirtutibus* (the rubric was partly cut out during the binding). I have tried to check Langton's authorship through comparisons with genuine works, such as the *Quaestiones theologiae*.[67]

Each *Distinctio* consists of a title and of some quotations from the Bible. Sometimes these quotations are organized according to a certain theological plan: for instance, according to the different senses of a single word used in the Bible, like 'bed'[68] or 'rage';[69] or according to the different properties of a thing named by a word (e. g., the different actions of the 'fire').[70] Or, a chapter can list similar actions of God in different circumstances, like the different circumstances in which God has called men to his service.[71] Finally, one or more subsequent chapters can deal with moral or theological concepts, such as the conditions for a good confession of sins.[72]

Both of these manuscripts contain 86 *Distinctiones*, and in Ms. 14526 it is possible to read a chapter numeration from 1 to 90 (chapters 85 to 88 are missing). There is no alphabetical or systematic order among the chapters, except for the fact that chapters 1 to 33 begin with a verse of the Psalms in regular sequence from Ps. 74: 1 to Ps. 94: 2.

2.3. We can relate these *Distinctiones* to one other work, very similar to the previous, which seems at least to have a more systematic plan. This work can be found at folia 335r–354va of Paris, Bibliothèque Nationale, Ms. Nouv. acq. lat. 999, which chiefly contains sermons. In this part of the manuscript there is a collection of *Distinctiones*, rather similar to those about which I have just written. The *Distinctiones* of Ms. Nouv. Acq. lat. 999 are more numerous: there are exactly 208, but the most interesting thing is that, unlike the first two mentioned works, the collection seems to be organized according to a systematic plan. The order of the *Distinctiones* is not alphabetical or biblical, but thematic.

After a week of research in Douai, I can be more precise in my description. The text found in Ms. Nouv. Acq. lat. 999 is also to be found in Douai, Bibliothèque Municipale, Ms. 434, vol. 3, fols. 67r to 74v, with the same number of chapters, though numbered 1–230.[73] In the manuscript, it immediately follows the *Summa de diuersis* by Langton. We can also provide for this text the name of an author, Nicholas of Tournai, more exactly Nicholas called Buchiau. This man, who taught theology at Paris before the scholastic strike of 1229/31, was then dean in Tournai between 1230/31 and 1241; nothing is known of him after 1242/44. In addition to the *Distinctiones*, to be called more precisely *Compilatio*, he also wrote moralities on Genesis, a commentary on Luke and some sermons. But his explanations on Exodus, Proverbs and Judith must probably be attributed to Stephen Langton or Hugh of Saint-Cher.[74]

One characteristic of Nicholas's *Compilatio* is that most of the over 200 chapters clearly depend on the first two works discussed so far: Langton's *Summa de diuersis* and *Distinctiones*. Nicholas copied the Langtonian chapters, abridging and condensing them in such a way that allows us to rule out an hypothesis that I previously held, i. e., that this work could be the source, and not the satellite, of the others (in particular of

the *Distinctiones*).[75] Second, as regards the *Distinctiones*, the *Compilatio* does not follow any biblical order for the chapters, but tries to organize them systematically.

The series is opened by some remarks about the Law of God, which is Holy Scripture, and some related themes, such as the contraposition between biblical wisdom and secular science (chs. 1–10).

Then there is a passage devoted to faith and its opposite (heresy) (11–14).

At this point a long set of chapters begins, dealing with prelates (15–54). In this long section the prelates are sometimes actually referred to as prelates (*prelati*) and sometime as preachers (*predicatores*); there are a good number of chapters about preaching itself (*predicatio*).

After this, as an introduction to the section about sin, there are some chapters about the devil (56–62), then a chapter which does not consist of biblical quotations, but is a systematic treatise about the seven capital sins (61).[76] At this point begin the chapters about individual sins, considered in the order: capital sins, related sins, opposite virtues, sometime with related virtues and ascetic developments.

After the whole treatment of sins and virtues (62–130), there is a long treatment of the sacrament of confession (134–59). Related to penitence we find a development about the deeds of mercy (alms and visiting poor people; 160–62). Then there are a couple of chapters about the theological virtues, faith and hope, a consideration of some mysteries of the faith (Incarnation and Passion of Christ with their effects), and a single chapter about the sacrament of Eucharist, from the point of view of those who celebrate or receive it in an illicit way. After this there is a consideration of some mysteries of Christ's life, with the treatise concluding with a reflection about the last things, in particular judgment and punishment. The last section of these *Distinctiones* consists of some ascetic advice for a good Christian life and some chapters devoted to biblical themes, such as the bed, the 'sign' of Christ, the banquet, the kiss, the ark of God, the spiritual building.

2.4. Let us now turn to the last work. In the chapter devoted to Stephen Langton in his *Catalogus* of British writers, the English bibliographer John Bale mentions a work with the title "Concordia ueteris et novi [utriusque] testamenti," beginning with the words: "De uitando consortio, consilio, colloquio et exemplo malorum."[77] In his *Index Britanniae Scriptorum* the same Bale specifies that he saw this work at Lincoln College, Oxford.[78]

By luck, I think I have discovered this work in the Oxford, Bodleian Library, Ms. Bodley 631, fols. 1–183r and more recently in two further copies (see Appendix II, 2.1.2.). It lacks any attribution, to Stephen Langton or to anybody else. I will not speculate about the authorship of this text, but I do want to point out that it represents another possible reorganization of the material found in the *Summa de diuersis* and in the *Distinctiones*. Textual coincidences are striking.

The work has a rather elaborate structure. It is divided into 19 "Tituli." Most of them are then divided into a variable number of parts:

The *Titulus primus* is on "de uitando consortio consilio colloquio et exemplo malorum"; the *Titulus secundus*, on "de celeri conuersione a seculo uel a peccato."

The *Titulus tertius* is divided into 34 parts, devoted to the topic of prelates, preachers and preaching. This part is very similar to chapters 15–54 of the *Compilatio* of Nicolas of Tournai.

The *Titulus quartus* is the longest of the work. It consists of 61 chapters. After the consideration of the active and the contemplative life (parts 1–16) begins a part devoted to the seven mortal sins, which follow basically the same order as in Ms. Nouv. Acq. lat. 999 (from *superbia* to *luxuria*), with the sole difference that the consideration of the opposite virtues does not follow the related vices. As in the *Distinctiones*, after the enumeration of sins (17 to 32) there follows a study of the sacrament of confession, whose characteristics are enumerated here just in the same way as in the *Distinctiones* of Paris Mss. 393–14526 and Paris Nouv. acq. 999. Then comes fear before God's judgment, faith and hope, and then the enumeration of the virtues, whose first seven are *fides, spes, caritas, prudentia, temperantia, iusticia, fortitudo.* These are followed by *mansuetudo, humilitas, timor dei, obedientia, patientia, fidelitas, maturitas, compassio, simplicitas* and then some other chapters about God's gift and contemplation.

Titulus quintus has no subdivisions.

Titulus sextus is divided into two parts.

Titulus septimus consists of only one chapter, devoted to alms.

Titulus octavus is divided into 33 parts, dealing with the tongue (*lingua*), and treats its possible positive and negative uses: for instance to speak badly about one's neighbour, or to explain Holy Scripture.

Tituli 9 and 10 are simple. *Titulus* 11 consists of 5 parts dealing with last things (resurrections, judgment, fear before it, and the Anti-Christ).

Titulus 12, divided into 7 parts, treats of some Christian mysteries, beginning with the Lord's incarnation and ending with the sending of the Holy Spirit.

Titulus 13 (5 parts) treats of the troubles of the *iusti,* and the consolation they can get from the reading of the Scripture.

Titulus 14 treats again of the troubles the good can expect from bad people.

Titulus 15 (3 parts) deals with divine justice and mercy and the next title (4 parts) speaks again about the condition of damned and saved souls.

Titulus 17 consists of 14 parts, which present ascetic themes, and seems to be addressed to monks. It takes into consideration some arguments already found in the *Distinctiones.*

Tituli 18 and 19, respectively of 3 and 8 parts, close the work with some final considerations about sins and confession.

The whole manuscript is written in clear handwriting, and the text consists almost exclusively of biblical quotations, ordered in very schematic form: on the left there is the Book of the Bible, then, in a second column, the chapter and an indication of the verse (*in principio, circa principium, circa medium, in fine,* and so on). Only in *Titulus quartus,* part 12, could I find a theoretical development devoted to the contemplative life.[79]

For these four works, the following should be noted: Langtonian authenticity for the first two and clear dependence of the third upon them; and, the presence in the latter two of long sections devoted to preaching, where the dispersed chapters of the first two works are collected and ordered. We can also say that, while the *Summa de*

diuersis and the *Distinctiones,* together with the Chanter's *Verbum abbreviatum,* are the main sources for the material of the latter works, these latter works are original inasmuch as they organize sections specially devoted to preaching. Finally, the absence of prologues in all four of these texts is also worthy of note.[80]

<center>III</center>

3.1. The following part of this discussion will be based chiefly on the relevant chapters of the unquestionably authentic Langtonian works, the *Summa de diuersis* and *Distinctiones.*

The first observation is that these sections quite clearly depend on Peter the Chanter's *Verbum abbreviatum.* In fact, Peter's work devotes one section (chapters 6 to 9) to preaching and another (56 to 66) to prelates. The terminology shows clearly the dependence on Peter: he has, for instance, two chapters (62 and 63) about *taciturnitas,* which have parallels in the other texts (*Dist.,* n° 31; Nicholas of Tournai, n° 40; Bodley 3, 2; see Appendix I, 1.2).

On the other hand, we can say that the "Langtonian" texts, though mostly consisting of quotations, show a certain degree of originality in treating the subject. Although repeating similar themes, the emphasis is put on different aspects. Peter's interest is chiefly in canonical problems, while Stephen seems to be much more fascinated by the relationships between the life of the cleric and the Word of God. For both Peter and Stephen, the appropriate attitude of the prelate consists of two things: pure, spotless life, and, service to the Word of God by preaching. In the *Summa de diuersis,* this attitude is illustrated by expounding the biblical passages built on the number "two": the double curtains at the entrance of the tabernacle; the two leaves of the door, the double dress, that the strong woman of the book of Wisdom provides for her servants; the sheep that come two by two from the bath in the river. All this represents, in Stephen Langton's view, the need for the prelate to have both "doctrine" and "life." And while Peter developed the same topic in a more moralistic way, by insisting on the need of a pure life for the preacher, with corresponding reproaches against people behaving in a different way, Stephen points out the second part of the pair. In fact, the representation of the binary image changes quickly from the moral idea to the evocation of the two Testaments: these are the two jaws of the tongs held by the angel in the Apocalypse, the two horns of the mitre of patriarchs and bishops. Purity of life remains in the background. Among the duties of the shepherd, the one that is here underlined is to obtain an accomplished knowledge of Holy Scripture. And this accomplished knowledge consists simply in the capacity to find the correspondences between the two parts of Scripture, the Old and the New Testament. The duty of the prelate is to grasp and reveal the moral teaching hidden in the words of the Bible, through typological reading. The Word of God itself is hidden in the words of the Bible: it is represented by the *water* of Marath, by the *bread* which the psalmist forgot to eat, by the *vineyard* given to the vine dresser to be worked, by the *doors of heaven* which open and send us the manna, that is, Christ. But *manna* is itself the Holy Scripture, a food in which the sinner can find remedy for his sins; it is the *lamp* that lights the house until the sun—that is Christ—rises; it is the *wine cellar* where the strong wine which, according to

Peter Comestor, *sic inebriat ut sobrios reddat,* is kept;[81] this is the *book* given to Ezechiel to be eaten, that is, to be incorporated in the substance of the man who reads it; it is the *table of the banquet;* it is the *river* where the elephant bathes and the lamb swims, the *garden* where Jesus prays with the apostles.

3.2. What is important in the Holy Scripture is not its surface, but what is found deep in it. As we have seen, this idea emerges each time the reader meets the image of a "pit." Ysaac commands the digging of pits, that is, bids one to understand the deep mysteries of the Holy Scripture. The same meaning is found in the pit of the oath, the pit of Jacob, where Jesus met the Samaritan woman, and in the pit in the land of Madian, where Moses stopped when escaping from Egypt.

3.3. I do not want to burden the reader with a long catalogue of images, but I think it is possible to obtain from all of this material a complete sketch of what is needed in a good preacher:

First comes purity of life, the moral requirement for everything which follows;

Second, there is the knowledge of the Holy Scripture, acquired through long reading and meditation;

Third, there is the comprehension of the same Holy Scripture in the literal (philological), historical, and, then, in the allegorical and moral sense. Several chapters deal with the problem of the *intellect.* The prelate must have an intellectual knowledge of the Holy Scripture: *<prelatus> debet habere scientiam per intellectum.*[82]

Fourth, he must be conscious of his role: "separatus in uita super omnes subditos suos et eleuatus super omnes in scientia";[83] at the same time he must be humble, because pride would destroy any positive effect of his preaching. In Nicholas's *Compilatio,* this idea has been developed in two interesting schematic *Distinctiones* (nn. 21, 35):

<Ex Nicolai de Tornaco *Compilatione*>[84]

NUM.: 21
TIT.: quod uita debet precedere predicationem
FOL.: 63^{ra}
INC.: Actuum i[1]: Cepit Iesus facere et docere
. . . Gregorius: Illa uox corda auditorum penetrat que quod ore sonat opere complet

Prelatus debet esse celum — mundus per continenciam
— altus per contemplacionem
— clarus per bonam famam
— calidus per caritatis ardorem unde: Sagittas suas ardentibus effecit [Ps. 7:14]

———

NUM.: 35
TIT.: quales et qualiter instituendi sunt prelati

FOL.: 63^va
INC.: Gen. xi: Pharao ad Ioseph
. . . In Leuitico [20: 26] dominus ad prelatos: Separaui uos de medio populi, et essetis
etcetera

Separaui

Conuersatione ut: Sitis honeste conuersationis ubi non sunt uagus

Occupatione ut: In sudore uultus et labore u<esceris> p<ane> s<udoris> [Gn. 3: 19]

Secretorum reuelatione: Iohannes [15: 15]: Iam non dixi uos seruos sed a<micos>

Potestatis collatione, sed ex potestate multotiens sunt austeri et sic odiosi subditis. Ex hoc accidit quod lupus dissipat gregem

Fifth, he must have the will to preach: in the Old Testament, the priest was to announce his entrance and his exit from the tabernacle through the sound of trumpet; the prelate must come in the same way by giving voice to the melody of preaching. The ancient priest had little bells on his shoulders, which announced his presence: the prelate does not live for himself, but for teaching others. If he does not do so, he is a dumb dog, unable to bark; he is no longer useful for the people of God, which involves the danger of falling into heresy. The wolves (that is, heretical preachers) must be repelled by the stock of the shepherd and by the barking of the dogs.

Intellectual and moral virtues are ordered to fulfilling this duty. The prelate may not omit preaching from ignorance, laziness, fear of powerful people, mixing himself up in secular tasks, or the pursuit of money. Through fasting, he must forget to fill his stomach with material food, in order to fill up his heart with the bread of God's Word.

Moral virtues and ascetic life put the prelate in the right condition to preach, giving him time to read and meditate on the Holy Scripture. They free him from secular interests in his preaching, and confirm his words through the example of a pure life. But preaching itself remains at the center of Langton's attention. Nothing can replace it. If a holy prelate remains silent, he does not fulfill his task: *quantum prodest exemplo, tantum obest silentio* (Langton, *Summa de diuersis*, n° 35 and n° 82).

IV

Finally, there remains the task of comparing the results of this inquiry with Humbert of Romans's treatise *De eruditione praedicatorum*. This is a long work, with a complex structure. It was never printed in its entirety, and according to Father Tugwell[85] there is no known surviving manuscript which contains it in complete form. The treatise is divided into 51 chapters, subdivided in seven parts. The last six chapters of the seventh part are actually constituted by material for nearly 400 sermons. In opposition to the author's intention, this part of the work had a vulgated tradition as book two of the *De eruditione praedicatorum*, and was printed quite often in this form. The first seven parts, without the sermon material, were printed at the end of the last century

under the direction of J. J. Berthier in Rome; my analysis will be based upon this edition.[86]

At first glance, Humbert's treatise does not resemble very much any of the works so far presented. The main constituents of those were titles and biblical quotations; the latter, in fact, constitute the body of the text, while its sense is given by the way the quotations are organized and linked one to another in dependence on a title, often a single word. What we find in Humbert, on the other hand, is a real speech, an articulated argumentation, though very concise, in which any single step is supported (or even suggested) by a biblical verse. Humbert is not following the thematic associations suggested by the texts he meets: he has previewed the whole matter he is going to treat and its subdivisions. The *De eruditione praedicatorum* was probably written after 1265, in the last decade of Thomas Aquinas's life, and we would wonder if it did not manifest this more developed "scholastic" attitude in treating its subject.

If we look at the individual parts of this treatise more closely, we can find many points with which we are already familiar. Speaking of the need for preaching, Humbert remembers the famine, of which there is often question in Scripture. As in Stephen Langton and Hugh in commenting Ruth, to Humbert too famine represents the spiritual poverty caused by the lack of (good) preachers.[87] Speaking further of the preacher's gain, Humbert introduces a comparison between the preacher and the sky: "Et notandum quod . . . praedicatores dicuntur coeli, quia sicut coeli ornati stellis, ita et ipsi virtutibus variis,"[88] which we can also find in one schematic *Distinctio* by Nicolas of Tournai (see the text published above). The comparison between the Word of God and the good strong wine, capable of inebriating the drinker, is to be found in both Stephen and Humbert.[89] To remain in the field of culinary metaphors, the Word of God is seen by both of our authors in the book given to Ezechiel to be eaten (Ez. 3), i. e., for Stephen, "cuilibet nostrorum ad incorporandum" (*Summa de diuersis*, chapter 84), for Humbert quoting Jerome, "Sermones Dei corde sunt comedendi, et diligentius attendendi, et sic ad populum proferendi."[90]

After illustrating in terms reminiscent of Langton the need for scientific knowledge of both Old and New Testament, Humbert considers what sort of person the preacher should be. He discusses the problem of the age and dignity of the chosen person in the very same terms, of Gregorian origin, that we meet in Peter the Chanter, Stephen Langton and Nicholas of Tournai.[91] Let me note that the Gregorian quotation, "cuius vita despicitur restat quod eius praedicatio contempnatur," will accompany the presentation of the spiritual teacher down to the time of Thomas Aquinas.[92] Humbert further presents a collection of images which can fit the preacher. Among them, we find some with which we became acquainted in the *Summa de diuersis* and the *Distinctiones* by Langton: the skies again, the clouds and the thunder (present in the *Distinctiones*[93]) the mountains, the cock (Gregory again, present in the *Summa de diuersis* with the title *Quod praedicator dicitur gallus*)[94] and finally the dogs, with the familiar quotations.[95]

There is one point at which perhaps we can find an use made by Humbert of one theoretical argument developed by Stephen in his *Quaestiones theologiae*. Chapter 21 of *De eruditione praedicatorum* is an exhortation to those who have sufficient grace to be dutiful in preaching. In two paragraphs in succession, Humbert maintains the su-

periority of preaching over both deeds of mercy and praying.[96] Now, we have among the
quaestiones of Stephen one that asks whether the active life is to be preferred to the
contemplative. Stephen does not decide the *quaestio*, by giving the preference to active
or contemplative life in general. However, he does distinguish among the single deeds
of both (*Considerationibus diuersis excedit se et excedunt a se contemplatiua et ac-
tiua*). The *opera contemplative* are *lectio, oratio ed meditatio;* the *opera active* are
elemosyna, predicatio et martyrium. For Stephen, in order to decide the question we
must compare what in both groups is the best (*optimum*), because *optimum opus ac-
tive melius est optimo contemplative.* Now, while *optimum contemplatiue est medi-
tari, optimum actiue est predicare et subire martirium.* In this way a foundation has
been established to maintain the superiority of preaching over other deeds of mercy
(like burying the dead, according to Humbert's example) as also over contemplative
works of devotion, like praying.[97]

Finally, in the fourth part of the *De eruditione praedicatorum,* the long first chap-
ter illustrates the bad reasons that lead some prelates not to preach. The whole treat-
ment is introduced by the image, already known from Langton, but which finds its
origin at chapter 6 of *Verbum abbreviatum,* of the mosaic priest who could not enter
the tabernacle without letting his bells sound, i. e., without preaching.[98] Here, I want
to note that the preacher is called *praelatus,* just as he is called at chapter 22[99] where
it is a question of the lack of preaching which can occur *ex defectu praelatorum.* At
chapter 18, he is called *doctor.*[100] This shift between *praelatus* and *praedicator* is typi-
cal in the *Compilatio* of Nicholas of Tournai, and seems to me to be a sign that this
work is exploiting two different sections of the *Verbum abbreviatum,* the one that
actually deals with preaching (chapters 6 to 9), the other that deals with prelates (56 to
66). In the *De eruditione praedicatorum,* in fact, there is never question of something
like *fratres praedicatores.* Only twice is it possible, perhaps, to recognize the echo of
the mendicants' polemic: at one point Humbert disapproves of the "perversitas Ecclesie
rectorum, qui frequenter impediunt praedicationem, quam promovere deberent,"[101]
and at another, of those "praelati, qui non solum non praedicant, sed etiam ne alii, qui
hoc laudabiliter possunt facere, faciant impediunt."[102]

V

I apologize for having lingered on less familiar texts. Perhaps I have not even achieved
my aim of showing Stephen Langton's *influence* on later authors; perhaps I have simply
shown some differences in treating the same themes. However, beyond these differ-
ences the point remains that interest in preaching was central for Stephen Langton too:
he is surely part of the movement of "evangelical awakening" in which the rise of the
mendicant orders can be placed. Langton also goes further than Peter the Chanter,
underlining the dignity of an intellectual approach to the Holy Scripture. We can see
a certain continuity between this attitude and the intellectual skill that early Domini-
cans tried to attain in order to be effective in their pastoral activity.

Stephen Langton is in this sense definitely not part of the environment which
produced monastic theology. When he thinks of a renewed *vita apostolica* he thinks
of a pastoral action directed by the bishops. He recognizes the poor quality of many

prelates of his time, but he hopes to reform them in the spirit of Gregory the Great's *Regula pastoralis.* On the other hand, with regards to his theological production, we must recognize with Gilbert Dahan that "nombreuses sont dans son oeuvre les passages à avoir la saveur particulière des commentaires monastiques du XIIe siècle."[103] I do not think we can say the same for Hugh of Saint-Cher.

As regards his undoubted use by later theologians, it is not so much his personal contribution which is exploited as some more traditional ideas, which go back to Peter the Chanter and, through him, very often to Gregory the Great. The author of the *Moralia* is also to be seen behind the moral exegesis of Langton, although exceptionally developed.

Finally, I think that the textual tradition of his works will offer us new surprises. If we look at the section of his *Distinctiones,* where each chapter begins with a Psalms-quotation, in biblical increasing order, and then consider the coincidences between biblical moral commentaries and the chapters of the *Summa de diuersis,*[104] we gain a glimpse into Stephen's working methods. He probably first noted the moral interpretations alongside his commentaries, then he (or some of his pupils) collected them as aids for preachers. In his *Distinctiones* we perhaps have the result of such a procedure made alongside the commentary on a Psalm. Although an assuredly Langtonian psalm-commentary has yet to be found,[105] our *Distinctiones* are perhaps an indication of the existence of such a work and a tool for recognizing it when it is eventually discovered.[106]

NOTES

1. The *Summa* is contained in the following manuscripts: Bamberg, Staatsbibliothek, Patr. 136 (the whole ms.); Oxford, Bodleian Library, Laud. Misc. 80, fols. 117–200 (complete text, but different redaction from Bamberg); Toledo, Cabildo, 18–19 (Stegmüller, RCS I, n° 829, 388, lists this as Ms. 18–18; I was able to identify the right witness thanks to some handwritten notes of John N. Garvin, found in his Nachlass housed in the Archives of the University of Notre Dame); Cambrai, Bibliothèque Municipale, 402 (378), fols. 98–117 (fragment); Paris, Bibliothèque Nationale, lat. 3237, fols. 89r–96v (fragment); Escorial, Bibliotéca del Real Munasterio, G. IV. 14, fols. 112[r]–115 (fragment); about relationships among the mss., author and dating, see R. Quinto, *"Doctor Nominatissimus." Stefano Langton (+1228) e la tradizione delle sue opere* (BGPTMA N.F. 39, Münster i.W., 1994), 43–53; Quinto, "*Trivium* e teologia: l'organizzazione scolastica nella seconda metà del secolo XII e i 'maestri della *sacra pagina*,'" in *Storia della teologia nel medioevo.II: grande fioritura,* a cura di G. d'Onofrio (Casale Monferrato, 1996), 35–68.

2. Cf. Kaeppeli, *Scriptores* 2: 280 n° 1191A: "*Inc. serm. de epist. dom.:* Hora est iam nos de somno surgere . . . Dicit glossa: Hora est. Cum sit brevis vita nostra. Iob xiv: Breves dies hominis sunt."

3. Thomas de Chobham, *Summa de arte praedicandi* 4, lin. 37–39, ed. F. Morenzoni, CCCM 82 (Turnhout, 1988).

4. PL 205: 199 D.

5. Cf. Kaeppeli, *Scriptores* 2: 269–81 n[os] 1983–94, with the additions to be found in Kaeppeli and Panella, *Scriptores* 4: 124–26.

6. *Der Sentenzenkommentar des Kardinals Stephan Langton,* ed. A. M. Landgraf (BGPTMA 37/1, Münster i.W., 1952; repr. Münster, 1995).

7. For an updated list of manuscripts, see Quinto, *Doctor Nominatissimus,* 35.

8. I quote from the edition of Venice 1732, apud Nicolaum Pezzana. About editions, see Kaeppeli, *Scriptores* 2: 275.

9. Extracts can be found in R. Balduccelli, *Il concetto teologico di carità attraverso le maggiori interpretazioni patristiche e medievali di I ad Cor. XIII* (Studies in Sacred Theology, Second Series 48, Washington, D.C., 1951), 209–25; R. Quinto, *Die* Quaestiones *des Stephan Langton über die Gottesfurcht* (eingeleitet und herausgegeben von R. Q.) (CIMAGL 62, Copenhagen, 1992), 77–165, at 113–19.

10. G. Lacombe and B. Smalley, "Studies on the Commentaries of Cardinal Stephen Langton," AHDLMA 5 (1930): 5–182; transcription of the commentary at 86–126.

11. *Stephen Langton. Commentary on the Book of Chronicles*, ed. A. Saltman (Ramat-Gan, 1978).

12. See Kaeppeli, *Scriptores* 2: 273.

13. Cf. R. H. and M. A. Rouse, "The Verbal Concordance to the Scriptures," AFP 44 (1974): 5–30.

14. Cf. Quinto, *Doctor Nominatissimus*, 33–34.

15. For this work, see further in the text.

16. A list of these *Distinctiones* can be found in Quinto, *Doctor Nominatissimus*, 62–71.

17. Text to be found in Oxford, Bodleian Library 1954 (Ms. Bodley 631), fols. 1–183r; cf. Quinto, *Doctor Nominatissimus*, 35–36. Additional information about this work is given in Appendix II.

18. *Questio de beneficiis ecclesiasticis*, ed. F. Stegmüller, *Historisches Jahrbuch* 72 (1953): 184–202.

19. J.-P. Torrell, *Théorie de la prophétie et philosophie de la connaissance aux environs de 1230. La contribution d'Hugues de Saint-Cher (Ms. Douai 434, Question 481)* (Spicilegium sacrum Lovaniense 40, Louvain, 1977).

20. S. Ebbesen and L. B. Mortensen, *A Partial Edition of Stephen Langton's Summa and Quaestiones with Parallels from Andrew Sunesen's Hexaemeron* (CIMAGL 49, Copenhagen, 1985), 25–224; Quinto, *Die* Quaestiones *des Stephan Langton*.

21. Kaeppeli, *Scriptores* 2: 276–80.

22. Cf. Schneyer, *Repertorium* 2: 758–85; Kaeppeli, *Scriptores* 2: 280.

23. Cf. P. B. Roberts, *Stephanus de Lingua-Tonante. Studies in the Sermons of Stephen Langton* (Pontifical Institute of Medieval Studies, Studies and Texts 16, Toronto, 1968); for a list of published sermons, see Quinto, *Doctor Nominatissimus*, 31.

24. *Acta Stephani Langton Cantuariensis Archiepiscopi*, ed. K. Major (History of English Dioceses, Canterbury and York Series, 50, Oxford, 1950).

25. Cf. Kaeppeli, *Scriptores* 2: 280.

26. Cf. Quinto, *Doctor Nominatissimus*, 41.

27. A. M. Landgraf, "The First Sentence Commentary of Early Scholasticism," *The New Scholasticism* 13 (1939): 101–32; cf. Landgraf, *Introduction à l'histoire de la littérature théologique de la scolastique naissante* (German ed. Regensburg, 1948), éd. française par les soins de A. M. Landry et L. B. Geiger (Publications de l'Institut d'Études médiévales de Montréal 22, Montréal-Paris, 1973), 169.

28. Landgraf, *Introduction*, 170: "Le *Commentaire* paulinien d'Hugues de Saint-Cher . . . est entièrement imprégné du texte du *Commentaire* de Langton."

29. For the systematic plan of the *Quaestiones*, see Quinto, *Doctor Nominatissimus*, 156–66.

30. For a classification of concordances, see R. Quinto, "Estratti e compilazioni alfabetiche da opere di autori scolastici," in *Fabula in tabula. Una storia degli indici dal manoscritto al testo elettronico* (Atti del Convegno di studio della Fondazione Ezio Franceschini e della Fondazione IBM Italia, Certosa del Galluzzo 21–22 ottobre 1994), a cura di C. Leonardi, M. Morelli, F. Santi, (Spoleto, 1995), 119–34; see 120–21.

31. A. Saltman, Introduction, *Stephen Langton. Commentary on the Book of Chronicles*, 22.

32. Langton, *Moral Commentary in I Paralipomenon* [pref.] (ed. Saltman, 211).

33. Ibid., *In* 4:21 (213, lin. 15–16).

34. Ibid. (213, lin. 18).

35. Quinto, *Die* Quaestiones *des Stephan Langton*, 124.

36. Petrus Cantor, *Verbum abbreviatum* 62 (PL 205: 189).

37. Langton, *Moral Commentary in I Paralipomenon* 6: 31 (ed. Saltman, 216, lin. 9–19): "*Asaph. Emam. Ethan. Hii tres principes erant super cantores*. Tales debent esse prelati. *Asaph*, qui interpretatur "colligens" vel "congregans", quia alios verbo predicacionis congregare debent. *Ethan* quod "ascendens" vel "fortis" dicitur. Et prelati per exemplum bone vite ascendere debent et in conversacione bona fortes esse. *Emam*, quod "frater eius" dicitur, quia prelati subditos debent fraterno amore dirigere et temporali alimonia misericorditer reficere, quia per hoc sunt filii dei. Unde ipse ait: *Estote misericordes sicut et pater vester misericors est*. Hoc est quod Dominus aiu Petro et prelatis omnibus in

Petro: *Pasce oves meas* etc. *Pasce* verbo, ut sis Asaph "colligens"; *pasce* exemplo, ut sis Ethan "ascendens"; *pasce* temporali subsidio, ut sis Emam "frater" Christi et suorum."

38. Ibid., *In* 16:4 (ed. Saltman, 220).

39. *Moral Commentary in II Paralipomenon* 12: 9–10 (ed. Saltman, 229).

40. Ibid.

41. See Appendix I, n° 35.

42. A. Saltman, Introduction, *Stephen Langton. Commentary on the Book of Chronicles*, 44–46.

43. Ibid., 21–23.

44. Lacombe, "Studies on the Commentaries," 91.

45. Ruth 1: 8–12 (I quote the English text according to the King James Version of *The Holy Bible*).

46. Hugo a S. Caro, *Postilla libri Ruth*, 1: 214 (see n.8 above).

47. Cf. J. Leland, *Commentarii de scriptoribus Britannicis*, ed. A. Hall (Oxford, 1709), 249: "Fratrem habuit non omnino illitteratum, hominem ambitiosum. is enim instructus animum ad archiepiscopatum Eboracensem adjecit; quem & accepisset, nisi principis iudicium praevidisset, non esse publicae utilitatis, ut universa ecclesiae Anglicanae jurisdictio duobus germanis fratribus, Romani episcopi fautoribus, cederet."

48. *Memoriale fratris Walteri de Coventria*, ed. W. Stubbs (London, 1872–73), 2: 227–28), ad ann. 1215: "Interea Romae celebratum est concilium generale sub papa Innocentio III in basilica quae appellatur Constantiniana . . . Ibi promotus est Walterius de Grey a Wygornensi episcopo in archiepiscopum Eboracensem, cassata prius electione magistri Simonis de Languentone, unanimiter ut fertur electi, qui frater Stephani Cantuariensis archiepiscopi erat. Suggestum est autem domino papae quod dominus Cantuariensis incentor esset huius tumultus in Anglia orti . . . "

49. Ruth 2: 18.

50. Langton, *In Ruth* 2: 17 (Lacombe, "Studies," 111): "*Quasi ephi mensuram*, que continet tres modios, una ergo fuit mensura, et tres modii. Invenire ergo ephi est invenire fidem Trinitatis in Scriptura."

51. Langton, *In Ruth* 3: 4 (Lacombe, 111–12): "*Discooperiens pallium*, id est misterium incarnationis. *A parte pedum*, id est per fidem passionis et nature humane . . . Vel secundum glossam: Pallium est velamen littere quia discoopertum est post Passione a parte pedum, id est per hoc quod gessit in humanitate."

52. Ibid., 111.

53. Ibid., 98.

54. Cf. Paris, BN, Ms. lat. 3143, fol. 2r; Ms. lat. 15747, fol. 2r; Avranches, BM. Ms. 121, fol 2r.

55. Philip the Chancellor, *Summa de bono*, ed. N. Wicki, 2 vols. (Opera Philosophica Mediae Aetatis Selecta 2, Bern, 1985): 3. For the theologian as collector of fragments, see as well G. R. Evans, "Crumbs, Gleanings and Fragments: An Exegetical Topos," RTAM 50 (1983): 242–45 and the *Einführung* of R. Heinzmann, *Die Summe 'Colligite Fragmenta' des Magister Hubertus* (Veröffentlichungen des Grabmann-Institutes, 24, Munich, 1974).

56. Langton, *In Ruth* 3: 15 (Lacombe, "Studies," 118).

57. Jd. 3: 31.

58. Jd. 3: 21. Cf. Hugo, *Postilla in Ruth* I: 215v (see n.8 above).

59. See n.1.

60. I now think that this is the less inappropriate title for this work, as I have tried to demonstrate in "Il codice 434 di Douai, Stefano Langton e Nicola di Tournai," *Sacris Erudiri* 36 (1996): 233–361. It is in any case the same work discussed in my *Doctor Nominatissimus*, 77–90, under the designation of *Summa De uitiis et uirtutibus*. In addition to the reasons given in "Il codice 434," 302–4, I prefer to refrain from using the title of *Summa De uitiis et uirtutibus* until the problem of the authenticity of a work contained in Cardiff, Central Public Library, Ms. 3833, fols. 150ra–164ra is solved. The rubric of that work reads: "Summa magistri Stephani de Langedon Archiepiscopi de uiciis et uirtutibus." Thanks to Joseph Goering, I could read this text in the transcription by Barbara Tarbuck.

61. Cf. *Doctor Nominatissimus*, 77–86, lists 14 MSS, to which must be added London, BL, Ms. Harley 2360, fols. 3v-80r, brought to my attention by H. Siddons.

62. Cf. *Registrum Angliae de libris doctorum et auctorum veterum*, ed. R. H. Rouse, M. A. Rouse and R. A. B. Mynors, (London, 1991), 208.

63. Cf. *Doctor Nominatissimus*, 86–88; "Il codice 434," 311.

64. Cf. the text published in "Il codice 434," 307, with Langton, *Moral Commentary in I Paralipomenon* 26: 12 (ed. Saltman, 224): "*Hii divisi sunt janitores*. Nota—Janitores divisi erant ad quatuor partes mundi, scilicet orientem, occidentem, meridiem et aquilonem. Oriens significat judic-

ium, austrum—beneficium Dei, aquilo—memoriam peccati, occidens—memoriam mortis. Per has partes introducere debent venientes, scilicet per terrorem iudicii, per memoriam mortis, per recordationem peccati et per memoriam beneficiorum Dei."

65. Cf. the text published in Appendix I, NUM.: 35, with Langton, *Moral Commentary in II Paralipomenon* 12: 9–10 (ed. Saltman, 229).

66. Amiens, Bibliothèque Municipale, Ms. 272. The complete list of these chapters is published in "Il codice 434," 317–61.

67. The complete list of these *Distinctiones* is published in *Doctor Nominatissimus*, 62–71, where references for the numeration used here are given.

68. N^{os} 53–54.

69. N^{os} 74–76.

70. N^o 73.

71. N^o 78.

72. N^o 33. Please note the striking similarity between this *distinctio* and the *Tractatus de confessione* attributed (doubtfully) to Hugh of St.-Cher, beginning: "Confessio debet esse previsa, amara, verecunda, discreta, integra," published by P. Michaud-Quantin, "Deux formulaires pour la confession du milieu du XIIIe siècle," RTAM 31 (1964): 48–57.

73. These chapters are also listed in "Il codice 434," 258–85, with references to the *Distinctiones* and the chapters of the *Summa de diuersis*.

74. Cf. P. Glorieux, *Répertoire des Maîtres en théologie de Paris au XIII siècle* (Paris 1933), 1: 296–97; J. Picke, *Répertoire biographique des chanoines de Notre-Dame de Tournai, 1080–1300* (Recueil de Travaux d'Histoire et de Philologie, 6ᵉ Série, 35, Louvain-la-Neuve—Bruxelles, 1988), 22–25.

75. Cf. Quinto, "Il codice 434," 297–98.

76. Published in "Il codice 434," 299–300.

77. I. Balaeus [John Bale, Bishop of Ossory], *Scriptorum Illustrium Maioris Brytanniae Catalogus* 1: 273–75 (Basileae, apud I. Oporinum, 1557). The chapter can also be found in my *Doctor Nominatissimus*, XXVIII–XXX.

78. J. Bale, *Index Britanniae Scriptorum: John Bale's Index of British and other Writers*, ed. R. L. Poole and M. Bateson (Oxford, 1902), 416–17.

79. Oxford, Bodleian Library, 1954 (Ms. Bodley 631), fol. 38^v–39^r: "Contemplatio est libera mentis perspicacia in sapientie spectacula cum admiratione suspensa. Huius sex sunt genera. Primum consistit in ymaginatione tantum et secundum ymaginationem tantum formatur, in quo quicquid v sensibus proprie et immediate percipitur officio ymaginationis representatur intelligentie. Secundum consistit in ymaginatione set secundum rationem, in quo sensibilium causa, ratio, ordo, dispositio, utilitas, uanitas et similia uisibilium et inuisibilium considerantur. Tertium in ratione uersatur, set secundum ymaginationem, in quo per collationem uisibilium ascenditur ad agnitionem inuisibilium nostrorum uel celestium. Quartum consistit in ratione et secundum rationem, in quo intelligentia quasi in se reflexo radio uisibiles <et> inuisibiles substantias creatas et earum uisibilia in considerationem adducit. Quintum consistit supra rationem non tamen preter rationem, in quo dei inuisibilia, maxime que ad unitatem essencie pertinent, in contemplationem adducuntur; que licet a ratione integre comprehendi et inuestigari non ualeant, eius tamen attestationem congre admittunt. Sextum est supra rationem et quasi contra uel preter rationem in quo inuisibilia dei, maxime que ad personarum distinctionem et originem pertinent et ad unionem uerbi cum natura humana que uidentur omnem rationem calcare et confundere. Ad primum pertinent sacre $[39^r]$ historie et testimonia scripture que ad sensibilem, simplicem et ymaginariam considerationem non transumuntur."

80. As we will see in Appendix II (2.1.1), the text of Ms. Bodley 631 is preceded by a treatise about eight possible ways to enlarge a sermon. It is possible to identify its author as Richard of Thetford; this text does not seem to have more than a material relationship with the collection of *Distinctiones* which follows.

81. Petrus Comestor, *Hist. Schol.*, Prol. (PL 198: 1058); cf. Langton, *Summa de diversis*, c. 84, in Appendix I.

82. Cf. Nicholas of Tournai, *Compilatio*, ch. 20, in Quinto, "Il codice 434," 260 and Appendice I, 312.

83. Langton, *Summa de diuersis*, cap. 82 (according to Amiens, Bibliothèque Municipale, Ms. 272, fol. 56^{va}), published below in Appendix I.

84. From Douai, Bibliothèque Municipale, Ms. 434, vol. 3.

85. S. Tugwell, "Humbert of Romans's Material for Preachers," in *De Ore Domini. Preacher and Word in the Middle Ages*, ed. T. L. Amos, E. A. Green and B. Mayne Kienzle, (Kalamazoo, 1989), 105.

86. Humbert of Romans, *De eruditione praedicatorum*, in *Opera de vita regulari*, (Rome, 1889), 2: 373–484. Additional texts by Humbert can be found in *Prediche alle donne del secolo XIII: Testi di Umberto da Romans, Gilberto da Tournai, Stefano di Borbone*, ed. C. Casagrande (Milan, 1978), which still considers the work as divided into two books, giving at 141–45 the titles of the first hundred *Sermones ad omnes genus hominum*.

87. Humbert of Romans, *De eruditione praedicatorum*, 379: " . . . sicut olim frequenter dicitur invaluisse fames in mundo, ita deficiente praedicatione invalescit fames spiritualis. *Luc. 15:* Facta est fames valida. *Glossa:* Deficientibus praedicationibus fit fames, quia non in solo pane vivit homo, sed in omni verbo quod procedit de ore Dei."

88. Ibid., 385–86; and, 400: "Sicut enim praedicans in alto stat, ita debet esse in alto statu vitae. *Is. 40:* Super montem excelsum ascende, tu qui evangelizas Sion." It is possible to discern an additional point of contact between Humbert and earlier authors such as Stephen Langton and William de Montibus. The similitude between the preachers and the skies, introduced by *sicut . . . ita*, leads me to think of such repertories of similitudes as the *Similitudines* of William de Montibus and the *Similitudinarium* of Stephen Langton, found in Lincoln, Public Record Office, Ancaster Ms. 16/1, fols. 76rb–92rb and Cambridge, Peterhouse Library, Ms. 255, fols. 107v–127r. Cf. P. B. Roberts, *Stephanus de Lingua-Tonante*, 89–94; J. Goering, *William de Montibus (c. 1140–1213). The Schools and the Literature of Pastoral Care*, (Pontifical Institute of Mediaeval Studies, Studies and Texts 108, Toronto, 1992), 304–33; Quinto, *Doctor Nominatissimus*, 76.

89. Humbert of Romans, *De eruditione praedicatorum*, 391–92.

90. Ibid., 394. For Langton, see the text published below in Appendix I.

91. Cf. Petrus Cantor, *Verbum abbreviatum*, 61 (PL 205: 185): *Contra praelatos pueros, vel novitios*; Nicolaus Tornacensis, *Compilatio*, 31 (according to Paris, BN, Ms. Nouv. acq. lat. 999, fol. 35): cf. Quinto, "Il codice 434," 262, n. 27.

92. Gregorius, *Super Euangel.* I hom. 12 n. 1 (PL 76: 1119 A); Petrus Cantor, *Verbum abbreviatum*, 6 (PL 205: 37); Humbert of Romans, *De eruditione praedicatorum*, 407; Thomas Aquinas, *Contra impugnantes Dei cultum et religionem*, c.7 #11, ed. H.-F. Dondaine, Leonine Edition 41 (1970): A122, lin. 1524–25.

93. Langton, *Distinctiones*, n° 3 in Quinto, *Doctor Nominatissimus*, 63.

94. Chapter 103, published in Quinto, "Il codice 434," 335.

95. Humbert of Romans, *De eruditione praedicatorum*, 407–11. Cf. Petrus Cantor, *Verbum abbreviatum*, 62 (PL 205: 189–92).

96. Humbert of Romans, *De eruditione praedicatorum*, 431–32.

97. The text of this question (N° 109 in Quinto, *Doctor Nominatissimus*, 232) is transcribed from Avranches, Bibliothèque Municipale, Ms. 230 by F. Ravaisson, *Rapport au Ministre de l'instruction publique sur les bibliothèques des départements de l'Ouest* (Paris, 1841), 407–9.

98. Humbert of Romans, *De eruditione praedicatorum*, 416. Cf. Petrus Cantor, *Verbum Abbreviatum*, 6 (PL 205: 37C).

99. Humbert of Romans, *De eruditione praedicatorum*, 435.

100. Ibid., 422.

101. Ibid., 419.

102. Ibid., 435.

103. G. Dahan, "Exégèse et polemique dans les commentaires de la "Genèse" d'Étienne Langton," in *Les Juifs au régard de l'histoire, Mélanges en l'honneur de B. Blumenkranz*, ed. G. Dahan (Paris, 1985), 131.

104. As an example of this parallelism, compare the moral commentary on Gn. 3:9 (*Adam, ubi es?*) and the third chapter of the *Summa de diuersis*, which begins with the same quotation. Cf. "Il codice 434," 305–10.

105. Cf. Stegmüller, RB 5: nos 7799–7800,2.

106. The present article contains in revised form some material from a paper, "Apostolic Life' and Preaching at the Turn of the 12th Century: Some Works for Preachers from Stephen Langton's Circle," which I delivered at the International Medieval Sermons Symposium held at University College, Dublin (July 7–10, 1994); those proceedings will not be published. I wish to thank the Consul General of Italy in Zürich for giving me permission to attend the Notre Dame symposium. This work, written while I was Headmaster of the Italian school in Winterthur (Switzerland), is dedicated to the Rvd. Fr. Carlo Pepe OFM Cap., director of the Italian Catholic Mission there.

APPENDIX I

The chapters about preaching from the *Summa de diuersis* and the *Distinctiones*
by Stephen Langton

1.1. The text of the *Summa de diuersis* is established according to the following two
manuscripts:[1]
 A = Amiens, Bibliothèque Municipale, Ms. 272
 M = Milano, Biblioteca Nazionale Braidense, Cod. AF XII 36
 Chapter-numbering and orthography follow A

> NUM.: 34—M: 33
> TIT.: de prelatis quales esse debent
> FOL.: 29ra—M: 22vb
> INC.: [Eccli. 28:29][2] Aurum et argentum tuum confla et facito uerbis tuis stat-
> 5 eram, id est doctrine tue premisce bonam operationem et sic habebis pondus
> in uerbis. [Jeronimus] Illa namque uox audientium corda uberius penetrat
> quam proferentis uita commendat, quia quod liquido imperat, ostendendo
> adiuuat ut fiat. Vnde in lege precipiebatur armum dextrum sacerdotibus dari
> [Lv. 7: 32]: per armum operatio que bona debet esse in illis intelligitur. [Salo-
> 10 mon in cantico (3: 7–8)] Lectulum Salomonis lx fortes ambiunt ex fortissimis
> Israel, omnes tenentes gladium et ad bella doctissimi uniuscuiusque ensis
> super femur suum propter timores nocturnos: *Lectulum Salomonis* est eccle-
> sia in qua christus quiescit dum sui fideles bene operantur, unde dicit per
> Ysayam [28:12]: Hec est requies mea, scilicet uos benefacientes, hoc est refrig-
> 15 erium meum <uera bona opera;[3] reficite lassum, scilicet me <quem laborare
> fecistis,[4] qui laboraui sustinens apostolum(?)>;[5] *lx:* Sexagenarius numerus est
> perfectionis, per quem significatur uita perfecta prelatorum, que debet esse
> *ex fortissimis Israel,* id est deum contemplantium, *et tenentes gladium,* de
> quo dicit apostolus [Hebr. 4:12]: Viuus est sermo dei et efficax et penetrabilior
> 20 omni gladio ancipiti; *ad bella doctissimi,* ut occidant uitia in subditis, ut
> sciant in se et in aliis uerbo et exemplo predicare, id est castitate et bona uita
> ut subditi eorum exemplo insidias dyaboli caueant. Salomon in cantico: Os-
> tende mihi faciem tuam, sonet uox tua in auribus meis, facies enim tua
> decora et eloquium tuum dulce [Cant. 2: 14]: vox est sponsi ad sponsam, id
> 25 est christi ad ecclesiam; *ostende mihi faciem:* sicut homo exterior facie, ita
> homo interior manifestatur bono opere; *sonet uox tua in auribus meis,* ut
> experiar bonum quod est in te; *facies enim etc.:* tunc accepta est et dulcis
> predicatio quando uirtutum et bonorum operum ornatur decore. Vi[A: fol.

[1]For the other witnesses of the text, see Quinto, *Doctor Nominatissimus,* 77–90; the complete list of
the 258 chapters can be read in Appendix II of "Il codice 434," 317–61, where chapters 2 (302–3, n. 64),
3 (305–10) and 17 (303 n. 65) are also published. The present edition is not a critical one: not every
variant reading has been noted, nor every quotation identified. I simply want to offer the reader a com-
prehensible text of the chapters upon which my report is based. The identifications of authorities placed
between square brackets are found in the margin of Ms. A.
[2]*mg. ms.*
[3]*add. mg.>*
[4]*add. mg.*
[5]reficite . . . apostolum *M: deest A*

29v]tulus in holocaustum offerebatur ad hostium tabernaculi[6] quia in celis
30 debet esse conuersatio[7] prelatorum qui christum deo patri offerunt cotidie in
altari. In eodem precipitur Aaron et filiis eius offerre holocausta mane et
uespere,[8] ut sacerdos a perfecta uita incipiat et ad perfectam uitam finiat.
Ideo omne sacrificium igne consumetur nec quicquam comedet ex eo.[9] Item
comesturis filiis Israel dicitur [Lv. 8:31] *Coquite carnes*, id est opera igne cari-
35 tatis; *ante fores tabernaculi*, id est celi, *et comedite eas*, ut plus interiores
fiant.

NUM.: 35—M: 34
TIT.: contra prelatos malos
FOL.: 29va—M: 23ra
40 INC.: Ossa uehemot uelud fictile[10] eris [Iob 40: 13]; fistula sonitum habet set non
sensum; Es forte est. Tales sunt membra diaboli, qui sonum bene loquendi
habent, set sensum bene operandi non retinent.[11] Argentum tuum uersum
est in scoriam, uinum tuum mistum est aqua, principes tui infideles, socii
furum, omnes diligunt munera et secuuntur retributiones [Is. 1: 22–23] [Et
45 est ultimum glosa<e> precedentis]. Idem: Caupones tui miscent aquam uino,
id est predicatores predicationi cupiditatem. Idem [Is. 56].[12] Omnes bestie
agri—id est demones—uenite ad deuorandum quia speculatores eius ceci
omnes, canes muti non ualent<es> latrare, dormientes et amantes sompnia
et uidentes uana, scilicet temporalia et ceci ad uidendum spiritualia. Inno-
50 cens et absque sermone conuersatio quantum prodest exemplo, tantum obest
silentio, nam latratu canis et baculo pastoris arcendi sunt lupi. Vnde
Ezechiel: Maledictus canis non ualens latrare. Peccata populi mei comedunt
et ad iniquitates subleuant animas eorum. Idem: Ve qui iustificatis impium
pro muneribus [Is. 5: 23]. Nota quod peccata populi comedere est peccata
55 delinquentium fouere adulatione ne temporalia amittantur stipendia, quod
faciunt qui adulationibus uiuunt et peccata tacent: quod comedimus dente
com<m>inuimus, hoc est cum alicui adulando peccata sua ei minora quam
sint [A: fol. 30r] facimus. Item. Puluis eleuatus in uentum dispergitur et hic
subditum suum terre inherentem et aridum ab humore gratie quasi in uen-
60 tum tollit, id est omnium peccatorum impulsui eum exponit, dum per adu-
lationem eius peccata adtenuat [Ecclesiasticus] Quis medebitur[13] incantatori
a sepente percusso <?> [Eccli. 12: 12]. Idem est in euangelio: Si sal infatuatum
fuerit, in quo salietur <?> [Mt. 5: 13] Quod est: si prelatus qui aliis exemplo
bono condimentum boni operis debet esse, et aliis uerba salutifera proferre,
65 ueneno diaboli fuerit corruptus, quis eum liberabit <?> Vt quid facit dilectus
meus in domo mea scelera multa <?> [Jer. 11: 15]. Item [Is. 65:3]: Populus qui
ad iracundiam me prouocat ante faciem meam semper. Quere in Osea de

[6]Cf. Lv. 4: 4.
[7]Cf. Phil. 3: 20.
[8]Num. 28: 4.
[9]Cf. Lv., cc. 1 et 3.
[10]fictile *mss.*: fistule *Vulg.*
[11]*Verbatim ex* Langton, *Moral Commentary in II Paralipomenon* 12: 9–10 (ed. Saltman, 229, lin. 33–36). Cf. Gregorius, *Moralia in Job* (PL 76,: 654 C).
[12]Cf. Petrus Cantor, *Verbum abbreviatum* 62 (PL 205: 189 B).
[13]medebitur : miserebitur *Vulg.*

utroque. Item: Quia faciunt filii Juda malum in oculis meis semper etcetera
[Ezech. 34:2–5].[14] Ve pastoribus Israel qui pascunt semetipsos. Nonne greges
70 pascuntur a pastoribus? Lac comedebatis et lanis operiabamini; quod cras-
sum erat occidistis, quod infirmum erat non consolidastis, quod egrotum non
sanastis, quod fractum non alligastis, quod perierat non quesistis, quod abiec-
tum erat non reduxistis, set cum austeritate et potentia eis imperabatis, et
ducte sunt oues in deuorationem omnium bestiarum agri. Item: Uos estis
75 rete expansum super montem Thabor. [Os. 5:1] Thabor interpretatur uehe-
mens lumen quod est sacramentum altaris in quo uenit ad uos lumen chris-
tus. Ipsi autem mysterium nostre redemptionis conuertunt in mysterium sue
cupiditatis quod notatur per rete. [Amos (6: 1)] Ve qui opulenti estis in Syon
et confiditis in monte Samarie, opprimentes capita populorum, ingredientes
80 pompatice domum domini: *in Sion* id est in ecclesia; *opulenti* de patrimonio
crucifixi, cum sui heredes tam spirituali quam corporali fame pereant. Vnde
notandum quod si prelatus sit delicatus non potest bene circumspicere,
immo oportet eum dormire, et ita frequenter a latrunculis spoliatur gratuitis;
confiditis in monte Samarie: gloriando in potentia dignitatis; *opprimentes,* id
85 est uos reputando magnos; *capita populorum,* id est dominantes in clero;
ingredientes <pompatice>, scilicet cum magno fastu uestium et sacrorum;
domum domini, que scilicet deberet esse domus domini, set uos facitis eam
speluncam latronum.

NUM.: 36—M: 35
90 TIT.: de bonis prelatis
FOL.: 30rb—M: 23va
INC.: Vbi legitur de [A: fol. 30v] uestibus pontificalibus dicitur de cocco bis tincto
[cfr. Ex. 28]; coccus ignei est coloris. Ignis ardet urit et lucet: sic prelatus
ardere debet per bonam uitam in se, lucere per bonam doctrinam aliis. Vel
95 aliter: urere debet increpando, lucere excecando uel instruendo. Ibidem dicit
beatus Gregorius: Qui sermonem facit ad populum, nec solum increpandis
uocibus nec solum in reserandis scripture sententiis debet instare, ne tantum
de peccatorum increpatione disputans minus audiatur, uel misteriorum se-
creta tantum reserans minus prosit; temperet ergo ex utroque sermonem et[15]
100 secretorum celestium pandat suauitatem quasi bis tinctum in suo habitu
coccum demonstrans [Apocal. 4:3] Yris in circuitu sedis erat. Yris colorem
habet igneum et aquaticum: ignis urit, aqua refrigerat: hic iterum est coccus
bis tinctus. [Exodus 28: 6] In ueste sacerdotali erat byssus retorta per quam
continentia intelligitur: retorta, quia in corpore et mente habenda. [Magister]
105 Nota quod byssus genus est lini; linum uero in aqua mittitur ut putrifiat et
ibi aliquantulum moratur, ut ita loquar; extrahitur et reficitur et postea mul-
tis torsionibus et laboribus dealbatur. Per linum intelligitur mortificatio car-
nis, que inmergitur aqua uoluptatis, scilicet concupscentie per exprobra-
tionem, cum scilicet illud fetet homini ex recordatione uoluptatis preterite.
110 [Aggeus 2:12] Interroga sacerdotem legem, glosa: cuius est scire [Apostolus
Tit. 1:9] Oportet episcopum esse eum qui secundum doctrinam est ut potens

[14]Vt quid . . . oculis meis semper etcetera *M: deest A.*
[15]et *coni.:* nec *A* om. *M.*

sit exhortari in doctrina sana, et eos qui contradicunt arguere. [In Deutero-
nomio] Si quid difficile et ambiguum iudicium apud te esse prospexeris, uel
inter sanguinem et sanguinem, uel inter lepram et lepram, uade ad sacer-
115 dotes et ipsi iudicabunt te ueritatem et iudicium; quod si superbus noluerit
obedire eius imperio moriretur [Deut. 17: 8–13]. Labia sacerdotis custodient
scientiam et legem requirent de ore eius, quia angelus domini exercituum est
[Mal. 2: 7.] Ibi dicit Ieronymus in glosa: Si sacerdos de lege interrogetur, do-
ceat, resistentes conuincat alioquin frustra se iactat habere [A. fol. 31r] dig-
120 nitatem cuius non habet operationem. Ibidem in originali: Frequenter iudicio
dei et suffragio populi solent simplices elegi; hoc saltem habeant ut cum sac-
erdotes extiterint discant legem dei ut possint docere quod didicerint et
augeant scientiam magis quam opes. Magis autem noctes et dies in scrip-
turarum tractatu quam in ratiociniis et supputationibus expendant. [Exodus
125 28: 38] Aaron portabat iniquitates filiorum Israel coram domino in cunctis
muneribus et donariis que filii Israel sacrificauerunt domino, ubi dicit Beda:
Portat sacerdos peccata in muneribus et do<nariis> etcetera cum pro fruc-
tibus digne penitentie ceteris operibus iustitie que faciunt penitentie eius a
sceleris reatu absoluunt. Proh dolor, quidam exiguunt munera nec peccata
130 populi asportant nec cum delinquunt castigant. Item auctor super euan-
gelium ibi: Qui audierit me et uerba mea in eo manebo, ibi dicit auctoritas:
Verba dei in eo manent qui facit quod precipit et diligit quod promittit et
diligit quod precipit. Qui autem precipit quod non facit, uerba dei sunt in eo
non ad beneficium set ad dampnationis testimonium. [Exodus 28:4] Sacerdos
135 habuit lineam strictam, genus uestibus est de lino; ibi auctoritas: linea stricta
debet stringere manus et brachia sacerdotis ne quid inutile faciat, pectus ne
quid inane cogitet, uentrem ne sit gulosus, genua ne ab omni instantia tor-
peat, tibias et pedes ne ad malum currat. [Ezechiel 33:31]. Audiant sermones
meos et non faciunt eos; in canticum oris eorum uertunt eos. [Jeronimus]
140 Adamas non dissoluitur nisi sanguine yrcorum et ecclesia non dissoluitur
nisi luxuria prelatorum.

NUM.: 82—M: 77
TIT.: quod sacerdos debet habere doctrinam et uitam
FOL.: 56va—M: 42r
145 INC.: [Exodus] Saga dupplicabantur in fronte tabernaculi. Prelati enim debent
esse ualue[16] dupplices ut scilicet per uitam et doctrinam eorum ingressus
habeatur ad patriam. [Salomon] De laude mulieris fortis: Non timebit domui
sue a frigoribus niuis illius, scilicet de quo Job dicit: Qui timent pruinam,
irruet super eos nix, id est uindicta iudicii; omnes enim domestici[17] eius ues-
150 titi sunt duplicibus. [In cantico] Dentes tui sicut grex tonsarum ascenden-
tium de lauacro; omnes gemellis fetibus et sterilis non est inter ipsos [Cant.
6: 6]. Forcipes ad extrahendas carnes de lebete in manibus tenebantur. For-
cipes que manibus tenebantur sunt duo testamenta que prelatus debet tenere
manibus cum extrahit carnes, id est quod docet alios ore debet habere in
155 opere. [Euangelium] De Iohanne baptista dicitur: Ille erat lucerna lucens et

[16]ualue *s. A:* ualle *p. A*
[17]domestici *M:* modesti *A*

ardens. [Ieronimus] Non putes simplicitatem et abstinentiam ciborum[18]
sufficere in agro domini, nisi quod facere possit et alios erudire quia inno-
cens et absque doctrina conuersatio quantum prodest exemplo tantum nocet
silentio: latratu enim canis et baculo pastoris et clamore sancte doctrine ar-
160 cendi sunt lupi ab ouibus. [Euangelium] Cepit Ihesus facere et docere. Alibi:
Attendite uobis et uniuerso gregi. [Apostolus[19]] Prouide tibi doctrine.[20]
[Psalmus] Credidi propter quod loquutus sum. In exodo [28:33–34]: In ueste
summi pontificis erant mala granata cum tintinnabulis. [In cantico] Ostende
michi faciem tuam, sonet uox tua in auribus meis: facies enim tua decora et
165 eloquium[21] tuum dulce. Item: In mitra pontificali duo sunt cornua, que sig-
nificant duo testamenta, et lingule ab ilis dependent in humeros: per hoc
significatur quod id quod habet in ore docendo debet gestare in humeris op-
erando.[22] [Iob] Arcus meus in manu mea instaurabitur, id est uerba scripture
que loquendo profero, operibus adimplere laboro. [Gregorius] Tanto citius
170 predicatores ad sequendum dominum alios inuitant, quanto auditoribus in se
ipsis monstrant que narrant. [Exodus 16:16] Dominus ad Moysen: Eleua uir-
gam tuam in uerba legis, id est predicatione, et extende manum tuam in bona
opera super mare, id est super [A: fol. 57r] fluctus contradictionum. [Exodus]
Sacerdos ingrediens uel egrediens tabernaculum sine sonitu moriatur [Ex. 28:
175 35], ubi dicit Gregorius: Sacerdos egrediens uel ingrediens moritur si de eo
sonitus non audiatur, quia iram contra se oculti iudicis erigit, si sine predi-
cationis sonitu incedit. Apte tintinnabula uestimentis illius inserta dicuntur
quia sacerdotis uestimenta sunt recta opera, unde sacerdotes tui induantur
in uestimentis; ergo tintinnabula iubentur ut uite uiam cum lingue sonitu
180 ipsa quoque opera sacerdotis clament. Item tintinnabula dependebant a ueste
sacerdotali, et predicatio debet pendere a uita.[23] [Psalmus] Beati inmaculati
in uia [Ps. 118: 1]: Ecce uita. Beati qui scrutantur <testimonia eius> [ibid.]:
Ecce doctrina. Pulcher[24] ordo plenus doctrine et gratie. Ante est uita quam
doctrina, unde apostolus describens pontificem eligendum prius dicit de uita:
185 Oportet episcopum esse irreprehensibilem, sobrium, pudicum [1 Tim. 3: 2];
hoc ad uitam pertinet; deinde subiungit de doctrina: Doctorem etcetera, ut
prius consuescat bona agere quam presumat docere. Iudeus etiam legalis sac-
erdos prius induebat se superhumerale, deinde rationale. Sola enim bona uita
gratiam habet, doctrina non sine ea. [Exodus] In parte sacerdotis cedebat ar-
190 mus separationis et penisculum eleuationis: hoc supra expositum est de pre-
latis. Quia[25] summus sacerdos et minister debet esse separatus in uita super
omnes subditos suos et eleuatus super omnes in scientia, que notantur in

[18]ciborum *M: om. A*

[19]Apostolus *M: om. A*

[20]For this and following paragraphs, see Petrus Cantor, *Verbum abbreviatum* 6 (PL 205: 37 A–C).

[21]eloquium *ms.:* uox *Vulg.*

[22]For the survival of this image in a quite unexpected environment, see Erasmus, *Moriae encomium*,
ed. C. H. Miller (in *Opera omnia*, ordinis iv tomus iii, Amsterdam and Oxford, 1979): 170, lin. 742–
743: " . . . quid sibi velit mitra bicornis, vtrunque fastigium eodem cohibente nodo, puta noui pariter
ac veteris instrumenti absolutam scientiam". The *adparatus fontium* of Miller's edition quotes Inno-
cent III, *De sacro altaris mysterio* (PL 217: 795).

[23]Item tintinnabula . . . uita *M: om. A*

[24]Pulcher *M:* Congruus *A*

[25]Quia *usque ad finem capitis M: om. A*

pectore et dicitur penisculum ut diminutiuum doceat modestiam humilita-
tis quam scientia et uita debe<n>t obseruare. Item: Ve mihi quia tacui. Super
195 Matheum: Vos estis lux mundi, ibi dicit glosa: Vere docet qui facit quod docet,
aliter se ipsum condempnat, id est condempnabilem se ostendit. Item Ioseph
precepit poni sciphum argenteum in ore sacci Beniamin [Gen. 44: 1-2]. Be-
niamin, id est predicator, debet habere argentum in ore, quod sonet in predi-
catione; in sacco, id est in corpore, frumentum, id est bona opera. Eruere
200 quasi damula de manu captantis et quasi auis de insidiis aucupis [Prov. 6: 5].
Damula inmundum animal est, nam uelox cursu, uisu acerrimum, unde et
grece apothoidortem, id est a uidendo dorcas nuncupatur. [Beda] Auis autem
uolando alta petere consueuit, sic tu et in docendis subditis [M: fol. 43ra]
occuparis, mundus peccatis, strenuus operibus, perspicax in deprehendendis
205 malorum insidiis, et uirtutum pennis tutus esse satage, ut expleto predica-
tionis negotio ad superna transuolare et celestis uite pasqua merearis intrare.

NUM.: 84—M: 79
TIT.: quod necessaria sit frequens meditatio sacre scripture
FOL.: 57va—M: 43rb
210 INC.: Otium sine litteris mors est. Augustinus: Nescit litteras qui sacras litteras
ignorat. [Isa. 55: 2] Quare argentum uestrum appenditis non in panibus, id est
sensum et eloquentiam uestram in meditatione scripture, et laborem ues-
trum non in saturitate. Item: Columba, id est fidelis, sedet super aquas sacre
scripture, ut preuisa in aqua umbra accipitris, id est dyaboli, ipsum declinet.
215 [Exodus] Moyses et populus Israel castrametati sunt iuxta aquas Marath, quia
qui uiri israhelite uolunt fieri sepe intuentur doctrinam scripture [cf. Ex. 15].
[Psalmus] Aruit cor meum quia oblitus sum comedere panem meum [Ps. 101:
5], id est meditationem scripture. [Ysaias] Diuicie salutis sapiencia et scientia.
Item: Omnis doctrina sine christo insipida est. [Salomon] Cum defecerint
220 ligna [Prov. 26: 20], id est exhortationes scripture, deficit ignis, id est caritas.
Idem: Ornamentum aureum prudenti doctrina. [Genesis] Rebecca, id est
quilibet fidelis, uiso Ysaac, id est christo, per gratie infusionem querit a
puero, id est a sermone prophetarum, quis ipse sit. [In eodem] Item: Ysaac, id
est quicumque iustus, habitauit iuxta puteum uiuentis et uidentis. Glosa ibi:
225 id est in difficultatibus scripture discutiendis. [In eodem] Eliezer, id est sacra
scriptura, quia Eliezer 'dei mei adiutorium' interpretatur, ducit Rebeccam, id
est animam fidelem, ad Ysaac, id est ad christum. Ysaac precepit puteos
fodere, id est alta scripture penetrare. Dominus apparuit Ysaac in Bersabee,
id est in sacra scriptura. Item: Iacob, id est luctator cum uitiis et concupis[A:
230 fol. 58r]centiis, ueniens ad Ioseph, id est ad christum, uenit ad puteum iura-
menti, id est ad profunditatem sacre scripture, uel per puteum iuramenti, id
est per sacram scripturam. [Rgum ii] Ioab, id est dyabolus, occulte interfecit
Abner, id est uirum eruditum, reconciliatum Dauid, id est christo, sed non
nisi educto de cisterna syra, id est de sublimi humilitate[26] sacre scripture.
235 Dominus inuenit samaritanam iuxta puteum; incipiens a Moyse et omni-
bus prophetis interpretabatur ei scripturas. Ibi dicit auctoritas: Quomodo
gloriatur se esse christianum qui neque in scripturis qualiter ad christum

[26]humilitate *A:* uirtute *M*

perueniatur inuestigat neque ad gloriam quam in christo habere cupit per
passiones attingere desiderat <?>. Dominus daturus legem in igne et fumo

240 descendit, ubi dicit Gregorius:[27] Quia humiles per claritatis sue ostensionem
illustrat, et superbos per caliginem erroris obscurat. Primo ergo mens ab ap-
petitu glorie temporalis et obscuritate concupiscentie carnis tegenda est et
tunc ad aciem contemplationis erigenda; unde cum lex accipitur, populus ad
montem appropinquare prohibetur, ut qui adhuc infirma mente terrena

245 desiderat rapere, sublimia non presumat penetrare, unde si bestia tetigerit
montem lapidabitur: bestia autem montem tangit cum mens irrationabilis
desideriis subdita ad contemplationis alta se erigit. Sed tunc[28] lapidibus
obruitur quia summa non sustinens superni ponderis ictibus uel tactu[29] ne-
catur. Moyses uir iustus fugiens de Egipto, id est de mundo, in terram Madian

250 sedebat iuxta puteum, id est iuxta sacram scripturam. Super speculam meam
ego sum stans iugiter etcetera [Is. 21: 8–Hab. 2: 1]. Super custodiam meam
stabo et super munitionem meam figam gradum etcetera. Item: Beatus qui
sedet super domum sapientie et in partibus eius figit gradum [Ecclesiasticus
48]. [Ex. 13: 21] Columna nubis precedebat filios Israel in die, culomna ignis

255 in nocte, quia sacra scriptura refrigerium prestat contra incentiua uitiorum,
et dicitur eadem columpna ignis quia accendit et illuminat fugando geli-
cidium peccatorum. [Euangelium] Auferetur a uobis regnum dei et dabitur
genti facienti fructus eius [Mt. 21: 43]. Auctoritas ibi:[30] Ista est uinea quam
tradidit dominus agriculis et uineecultoribus, in qua qui operati sunt num-

260 mum tantum[31] habentes scripturarum uinee fructum perdituri sunt.
[Psalmus] Ianuas celi aperuit, id est sacras scripturas [A: fol. 58v], per quas ad
nos egressus est christus, id est noticiam christi, et pluit illi manna, id est
christum, quem in noticia scripture suscepimus. Hoc manna est sacra scrip-
tura in qua peccator contra morbum peccati remedium potest inuenire.[32] Hec

265 est lucerna lucens in loco caliginoso donec illucescat dies et lucifer, id est
christus, oriatur in cordibus nostris. [Apostolus] Omnis scriptura diuinitus
inspirata utilis est ad docendum, ad arguendum, ad erudiendum, ad corripi-
endum [2 Tim. 3: 16]. Item: Posuit dominus duo luminaria magna in firma-
mento celi ut d<iuiderent> te<nebras> [Gn. 1: 16–18] Introduxit me in cellam

270 uinariam [Cant. 2: 4], id est in sacram scripturam, que sic inebriat ut sobrios[33]
reddat.[34] [Ezechiel] Hic liber datum Ezechieli ad deuorandum, sic cuilibet
nostrum ad incorporandum. Vnde uersus: Mentis in excessu liber est datus
Ezechieli. Luctum carmen et ue scripta legebat. Pagina sacra est liber qui[35]
predicat hec tria nobis: in terris luctus compuncti<on>is; in paradyso carmen

275 leticie; reprobis mala ueque gehenne.[36] Item sacra scriptura flumen est ubi
elephans natat, agnus leuiter transit. [Psalmus] Verbo domini celi firmati
sunt, id est sacra scriptura uiri spirituales corroborantur. Item: Iustum de-

[27]Gregory, *Moralia in Job* (PL 75: 763 B).
[28]tunc *M:* cum *A*
[29]uel tactu *add. M*
[30]Auctoritas ibi *A:* Ibi glosa *M*
[31]nummum tantum *M:* nomen tuum *A*
[32]Hoc . . . inuenire *M: om. A*
[33]sobrios *M:* sobria *A*
[34]Cf. Petrus Comestor, *Historia Scholastica* Prol. (PL 198: 1053).
[35]qui *M:* que *A*
[36]Cf. Petrus Cantor, *Verbum abbreviatum* 7 (PL 205: 38 D); Quinto, "Il codice 434," para. 8.11, 253.

duxit dominus per uias rectas et ostendit illi regnum dei, id est intelligen-
ciam scripture[37] [Sap. 10: 10]. Parasti in conspectu meo mensam, id est sac-
280 ram scripturam [Ps. 22: 5]; hec est mensa propositionis de qua dicitur in
exodo.[38] Angelus apparuit Agar[39] ad puteum uiuentis et uidentis id est chris-
tus anime peccatrici in meditatione sacre scripture, que docet recte uiuere et
recte intelligere.[40]

NUM.: 101-bis [subdiuisio capitis, in tabula non signata]—M: 102
285 TIT.: contra clericos
FOL.: 65vb—M: 49va
INC.: [Ieremia in trenis 4:1] Dispersi sunt lapides sanctuarii in capite omnium
platearum, id est: clerici facti sunt negotiatores secularium. Quid est quod
dilectus meus in domo mea facit scelera multa? [A: fol. 66r] [Isaia] Omne
290 caput languidum et omne cor merens; a plantis pedum usque qd uerticem
capitis non est in eo sanitas. Item in deutero<nomio>: aduena qui tecum
moratur semper superior te erit; fenerabit tibi et tu non ei.[41] [Idem[42]] Quis
cecus nisi seruus meus, quis surdus nisi ad quem misi nuntios. Eiusdem iudi-
tii sunt negotiatio in clerico et usum in laico.[43] [Euangelio] Auferetur a no-
295 bis—clericis—regnum dei et dabitur genti, id est laicis facienti<bus> fructus
eius, unde psalmus [131: 6] Ecce audiuimus eam in Effrata, id est 'sedem dei',
in clericis, inuenimus eam in campis silue, id est in laicis, qui sunt rudes ut
campi silue, quasi dicat: Quesiuimus religionem in clericis et inuenta est in
laicis. Ieremia: Filii tui proiecerunt te et dormiuerunt in capite omnium
300 uiarum.[44] [Isaia] Erubesce Sydon ait mare: per mare laici, per Sydon clerici;
Sydon enim 'uenatio' interpretatur et clerici alios uenari tenentur. Laici, qui
in amaritudine mundi positi sunt, possunt dicere clericis: Erubescite, quia
nos qui laici sumus, melioris conuersationis sumus quam uos clerici. [Ionas]
Infidelis gubernator dixit Ione dormienti in naui: Quid sopore deprimeris, sic
305 tu subdito. Item.[45] Petrus negauit ad uocem unius ancille uel Malchi dicentis:
Nonne te uidi in <h>orto cum illo? Malchus 'rex' interpretatur et regum et
diuitum cognata est superbia; multi, quia in <h>orto—id est in amenitate
sunt sacre scripture cum Iesu, ideo superbiunt. Item Ysaia: Ve qui trahitis
iniquitatem in funiculis uanitatis et quasi uinculum plaustri in rota. Item
310 Sophonia ubi f<r>enum circulum cum circulo et capite rote etcetera.
(M: 49vb)

NUM.: 103—M: 104
TIT.: quod predicator gallus dicitur
FOL.: 66vb—M: 50va

[37]Item . . . scripture *M: om. A*
[38]Cf. Langton, *Prologus generalitatum*, in Quinto, "Stefano Langton e i quattro sensi della Scrittura,"
Medioevo. Rivista di storia della filosofia medievale 15 (1989): 103–109.
[39]Agar *M: om. A*
[40]*capitulum breuius iterat M, fols. 75rb–vb, intra capita cci–ccii; in margine:* Istud capitulum non est
in illo magistri
[41]Item . . . ei *M: om. A*
[42]Idem *A (scil. Isaias)*
[43]Eiusdem . . . laico *M: om. A*
[44]Ieremia . . . uiarum *M: om. A*
[45]Item *exinde usque ad finem capitis M: om. A*

315 INC.: Quis posuit in uisceribus hominis sapientiam aut quis dedit gallo intelli-
 gentiam [Iob 38: 36], ubi dicit Gregorius [in moralibus super illum locum
 'quis posuit']: gallus intelligentiam accipit ut prius horas nocturni temporis
 discutiat, deinde uocem excitationis emittat, quia sanctus predicator [A: fol.
 67r] cum in auditoribus suis qualitatem uite considerat, tunc demum ad
320 erudiendum congruam uocem predicationis format. Item profundioribus
 horis noctis, cantus productiores edit, cum uero tempus matutinum appro-
 pinquat, leuiores et minores uoces format; sic sancti cum iniquis mentibus
 predicant, altis et magnis uocibus eterni iudicis intonant; cum uero audi-
 torum cordibus ueritatis lumen adesse cognoscunt, clamoris magnitudinem
325 in leuitatis dulcedinem uertunt. Cum cantus edere parat, prius alis se excitat,
 et semetipsum feriens uigilatorem reddit. Ita predicatores delicta propria
 curent punire, et tunc que aliorum sunt punienda denuntient. Prius enim
 intonat quam cantus emittat, quia predicatores antequam uerba exhorta-
 tionis proferant, omne quod locuntur operibus clament [GREG., *Mor. in Job,*
330 XXX, iii, 11 (CCL 143 B, p. 1499)].

 NUM.: 140—M: 141
 TIT.: de prelatis [deest in tabula]
 FOL.: 81rb—M: 62va
 INC.: Quanto quisque secularis honoris amplius dignitate sublimatur, tuanto
335 grauius curarum ponderibus aggrauatur. Quanto quis curis mundi maioribus
 occupatur, tanto facilius uitiis deprimitur; reges a recte uiuendo uocan-
 tur, ideoque recte faciendo nomen regis tenetur. Quanto quis in superiori
 constituitur loco, tanto maiori periculo uersatur. Cui enim plus committi-
 tur, plus exigitur ab eo, etiam cum usura penarum. Cognoscant principes
340 seculi deo debere se rationem reddere propter ecclesiam quam a christo tuen-
 dam accipiunt.

 NUM.: 194—M: 191
 TIT.: de claustralibus <uel secular<ibus> boni<s>>
 FOL.: 95ra/va—M: 73va
345 INC.: [In cantico 5:5] Manus mee distillauerunt myrram, digiti mei pleni sunt
 myrra probatissima. Notandum quod myrra probata debent esse laici, myrra
 probatior clerici in seculo, mirra probatissima prelati et claustrales [reliqua
 omittuntur]

 NUM.: 211—M: 207
350 TIT.: contra superbiam claustralium
 FOL.: 98ra—M: 76rb
 INC.: Iacob, id est christus, dixit [Gen. 48:5]: Mei erunt Effraim et Manasses, id
 est seculares fructificantes et contemplatiui sicut Ruben et Simeon, id est
 claustrales Ruben 'uisionis filius,' Symeon 'tristiciam audiens'. Numquid
355 non Israel ascendere feci de terra Egipti, et Palestinos de Cappadocia et Syros
 de Cyrene <?> [Amos 9:7] In Luca [14:8] Cum inuitatus fueris ad nuptias non
 discumbas in primo loco etcetera. Glosa: honoratiori post[46] inuitato dat lo-
 cum qui de sue longe conuersationis confidentia securior factus; ita illorum

[46]post *s. A:* prius *p. A M*

360 qui se in christo securi sunt agilitate preitur, et cum rubore nouissimum locum tenet, cum de aliis meliora agnoscens quicquid de sua conuersatione altum senserat humiliat cum propheta dicens: Ego autem exaltatus, humiliatus sum et confusus. Item: Linum Egipti grando lesit quia folliculos germinauit. Linum est castitas quia multa ablutione transit in candorem; foliculi sunt inflationes superbie. Item in exodo: Dominus eduxit filios Israel per tur-
365 mas suas. Glosa: id est per diuersos ordines, sexus, professionis [sic]. Item dominus iussit homines recumbere per contubernia sua centenos et quinquagenos.

NUM.: 212—M: 208
TIT.: quod clerici peiores sunt laicis
370 FOL.: 98rb—M: 76va
INC.: Erubesce Sydon ait mare; per Sydonem clerici, per mare laici; quia tunc clerici possunt erubescere quando committunt peccata que laici erubescunt et abhorrent committere. Ezechiel ad ecclesiam [16: 27]: Dabo te in manus odientium te filiorum Filistinorum qui erubescunt a uia tua scelerata. In deu-
375 teronomio: Aduena qui tecum morabitur super te erit; ipse fenerabitur tibi, tu non ei. Osee [8: 8]: Deuoratus est Israel, factus est in nationibus quasi uas inmundum. Petrus Balaam habuit sue uexanie correctionem sub iugale mutum. Item fidelis gubernator dixit Ione dormienti in fundo maris: Quid sopore deprimeris? Item: Egyptii cogebant filios Israel exire de Egipto.

380 NUM.: 226—M: 222
TIT.: de tribus generibus hominum
FOL.: 101rb—M: 76ra
INC.: Quidam habitant in monte, quidam in Segor, quidam in Sodomis, id est: quidam sunt perfecti, quidam imperfecti, quidam peccatores. Item: quidam
385 moriuntur in terra promissionis, quidam in deserto, quidam in Egypto. Item: quidam cantant cantum, quidam lamentum, quidam ue.[47] Item: quidam implent dies suos, quidam dimidiant, quidam inchoant.

NUM.: 247—M: 237
TIT.: de contemplatione <et actione>
390 FOL.: 104va—M: 81ra
INC.: Actiua uita innocentia est bonorum operum, contemplatiua speculatio supernorum: illa communis, ista uero paucorum. Actiua uita mundanis rebus utitur bene, contemplatiua uero mundo renuntians soli deo uiuere delectatur. Qui prius in actiua proficit, ad contemplatiuam bene conscendit. [Gre-
395 gorius[48]] Ille perfectus est qui huic seculo corde et corpore discerptus est; si semel cor in celestibus figitur, mox que terrena sunt abiecta cernuntur, que prius alta uidebantur.[49]

1.2. Chapter 31 from Langton's *Distinctiones* (Paris, Bibliothèque Nationale, Ms. lat. 14526, and Ms. lat. 393 [Z]):

[47]Cf. *supra*, n. 36.
[48]Gregorius *M: deest A*
[49]si semel . . . uidebantur *M: om. A*

NUM.: xxxi TIT.: <contra taciturnitatem predicatorum>[50]

FOL.: 164rb–va—Z: 24va–vb

INC.: M<ateus> c. v ibi [14]: Vos estis lux mundi, non potest ciuitas abscondi supra montem posita neque accedunt ad lucernam et ponent eam sub modio.

5 In eodem, c. xxv ibi [24]: Accedens qui unum talentum acceperat ait: Domine, scio quia homo durus es, metis ubi non seminasti, congregas ubi non sparsisti, et timens abii et abscondi tuum talentum in terra. Ecce, quod tuum est habes.

S[a] eodem c. x ibi [26]: Nichil occultum quod non reueletur, uel opertum quod non

10 sciatur; quod disco uobis in tenebris, dicite in lumine, et quod auditis aure predicate super tecta.

S[a] eodem c. ii ibi [11]: Apertis thesauris suis obtulerunt christo aurum thus et mirram.

I[a] eodem [*rectius* Joan.] c. xviii in medio ibi [20]: Ego palam locutus sum mundo,

15 et in occulto locutus sum nichil.

I[a] Amos c. ii in medio ibi [2]: Mittam ignem in Moab et deuorabit edes Carioth, et morietur in sonitu[51] Moab in clangore tube.

S[a] Y<saia> c. lviii, in principio ibi [1]: Clama, ne cesses, quasi tuba exalta uocem tuam et adnuncia scelera eorum et domui Jacob peccata eorum.

20 I[a] eodem, c. lx in fine ibi [11]: Aperientur porte tue iugiter, die ac nocte non claudentur, ut auferatur a[52] fortitudo gentium.

I[a] in Ioele, c. ii in principio ibi [15]: Canite tuba in Sion, sanctificate ieiunium, uocate cetum, congregate populum, sanctificate ecclesiam.

S[a] Genesis c. xxix in fine ibi [10 s.]: Admouebit Iacob lapidem quo[53] puteus

25 claudebatur et adaquato grege osculatus est Rachelem.

I[a] eodem c. xli in fine ibi [56]: Aperuit Ioseph uniuersa horrea et uendebat Egiptiis: nam et illos oppresserat fames.

I[a] Marcum c. v in medio ibi [30 s.]: Quis tetigit uestimenta mea? Dicebant ei discipuli: Vides turbam comprimentem te et dicis: Quis me tetigit?

30 I[a] e<pistola> ad Thessalonicenses <I> c. ultimo ibi [27]: Adiuro uos ut legatur epistula hec omnibus sanctis fratribus.

I[a] Matteum c. penultimo in fine ibi [51 s.]: Mota est terra, petre scisse sunt et monumenta aperta sunt et multa corpora sanctorum qui dormierant[54] resurrexerunt.

[50]Cf. Petrus Cantor, *Verbum abbreviatum* 62: "Contra malam taciturnitatem, maxime praelatorum" (PL 205: 189–93).

[51]sonitu: sonita *ms.*

[52]auferatur a *mss.:* afferatur ad *Vulg.*

[53]quo *coni.:* que *mss.*

[54]dormierant: qui *add. mss.*

APPENDIX II

A short description of the *Distinctiones* from Oxford,
Bodleian Library, Ms. Bodley 631 (SC 1954), fols. 1–183r

2.1. The manuscript contains three texts:[1]

2.1.1. fol. IV[v]: <Abbreviation of Richard of Thetford's *Ars praedicandi*[2]:

— Primo per qualemcumque termini notificationem; uerbi
gratia: Iustus ut palma florebit; Iustus est qui reddit utri-
cuique quod suum est: Superioribus, Equalibus, Inferiori-
bus.

— Per diuisionem, uerbi gratia: Si in themate sit caput, Caput 5
dicitur christus, prelatus, mens, operatio.

— Per ratiocinationem uicissim, scilicet ratiocinando de con-
trariis, unum approbando et aliud detestando. Vt: Si quis
uelit laudare castitatem, potest per detestationem oppo-
siti. Ad eundem pertinet ratio per similia. Vt: Stultus esset 10
qui funem texeret quo suspenderetur, ergo stultus est pec-
cator qui peccatum facit quo dampnetur. Ad eundem
etiam pertinet ratio per exempla. Vt: Christus innocens
per tribulationes intrauit in regnum suum, ergo multo
magis peccator in regnum alienum. 15

— Per concordantias. Vt Beatus uir qui suffert temptationes.
De eodem. Beatus uir qui in sapientia morabitur.

Istis modis — Per ea que conueniunt in radice, licet diuersificentur in
potest quis modo, ut cum sit processus de comparatiuo ad superlati-
habundare in uum. Vt: Accingere gladio tuo super femur tuum potentis- 20
themate sime: Potenter coniugati, potentius continentes, potentis-
sime uirgines. Ad eundem pertinet processus per diuersas
comparationes. Vt: Querite faciem eius semper. Queritur
deus in baptismo. Requiritur in penitentia. Exquiritur per
bona opera. Inquiritur meditando de lege diuina. Adquiri- 25
tur in patria.

— Per proprietates rei. Vt hic: Iustus germinabit sicut lilium.
Iustus lilio comparatur. Quia lilium candidum, odorif-
erum, crescit iuxta aquas. Similiter iustus candidus per
castitatem, odorifer per bonam famam, proficit iuxta 30
aquam tribulationum uel gratiarum.

[1]For a description, see F. Madan and H. H. E. Craster, *A Summary Catalogue of Western Manuscripts
in the Bodleian Library at Oxford*, 2, part 1, N[os] 1–3490 (Oxford, 1922), 131–32.
[2]Cf. T. M. Charland, *Artes Praedicandi. Contribution à l'histoire de la rhéthorique au moyen âge*
(Paris-Ottawa, 1936), 77–80. The same abridgment is also found in Paris, BN, Ms. Nouv. acq. lat. 280,
fol. 1r-v, and Wien, ÖNB, Cod. lat. 4164, fols. 187–88.

— Per quadruplices generales expositiones, scilicet Historialiter, Allegorice, Moraliter, Anagogice. Vt: Ierusalem que edificatur ut ciuitas. Historialiter: de terrestri Ierusalem. 35
Allegorice: de ecclesia militanti. Moraliter: de anima fideli. Anagogice: de ecclesia triumphante [!].

— Per causas et effectus. Vt si sit sermo de humilitate. Que erant cause humilitatis: Vt dei potentia, miseria propria et huiusmodi. Item per effectus. Vt sic. Humilitas illuminat, 40
impetrat, gratiam adquirit, conseruat, exaltat, glorificat, liberat. Vnde: Humiliatus sum et liberauit me. Illuminat per intelligentiam. Vnde: Intellectum dat paruulis. Impetrat. Vnde: Respexit in orationem humilium. Et ecclesiasticus: Oratio humiliantis se. Gratiam adquirit. Vnde 45
Petrus: Humilibus dat gratiam. Conseruat. Gregorius: Humilitas conseruat in omni temptatione, ut illi non crepent in fornace qui non tument uento superbie. Exaltat. Vnde: Qui se humiliat exaltabitur. Glorificat. Vnde Iob: Qui humiliatus fuit erit in gloria.

2.1.2. Fols. 1–183r: *<Concordancie bibliothecae>*. Fols. 1r–3r: Tabula Inc. (fol. 1r): *Titulus Primus: De uitando consortio consilio colloquio et exemplo malorum* Expl. (fol. 3r): [*Tituli XIX*] *Pars viiia: Quod integra sit confessio, scilicet de cogitatione, loqutione, opere et circumstanciis.* Fols. 3v–183r: Text: Rubr. (fol. 3v): *Titulus Primus: De uitando consortio consilio colloquio et exemplo malorum* Inc. (*ibid.*): *Psalmus i [1]: Beatus uir qui non abiit in consilio impiorum* Expl. (fol. 183r): (*Ad Ephes. c. v*) *Fornicatio et omnis inmundicia aut auaricia nec nominetur in uobis, sicut decet sanctos aut turpitudo aut stultiloquium aut scurrilitas que ad rem non pertinet; sed magis gratiarum actio.* The same text is to be found in another two copies (London, British Library, Harley 658, fols. 57ra-72ra; Nürnberg, Stadtbibliothek, Cod. Cent. V, 83, fols. 126r-136v), and it must have existed as Ms. 1229 of the Cathedral Chapter Library at Canterbury (cf. M. R. James, *Ancient Libraries of Canterbury and Dover*, Cambridge, 1903, 108).

2.1.3. Fols. 183v–200: Rubr. (fol. 183v): *Libellus domini Roberti <Grosseteste> Lincolniensis qui intitulatur Templum Dei.* Ed.: Robert Grosseteste, *Templum Dei*, ed. J. Goering and F. A. C. Mantello (Pontifical Institute of Mediaeval Studies, Toronto Medieval Latin Texts, 14, Toronto 1984).[3]

2.2. A list of the contents of the *Concordancie bibliothecae*

Titulus Primus De uitando consortio consilio colloquio et exemplo malorum

Titulus Secundus De celeri conuersione a seculo uel a peccato

Tituli tercii pars i–a Contra prauos prelatos et doctores

[3] A List of other manuscripts at 16, notes 45 and 46.

Pars ii Contra taciturnitatem prelatorum

 iii Contra adulatores prelatos uel quoslibet alios adulatores

 iiii De corruptione subditorum per malos prelatos

 v De simoniacis prelatis uel aliis

 vi De eiectione malorum prelatorum

 vii Contra institutiones malorum prelatorum

 viii Quod merito malorum prelatorum puniuntur subditi

 ix Quales et qualiter eligendi sunt prelati

 x Quod merito ex exemplo boni prelati saluantur subditi

 xi De affectu prelatorum in subditos

 xii De sollicitudine prelatorum

 xiii De condescensu prelatorum

 xiiii De zelo prelatorum

 xv Quod dominus ex ira subtrahit predicationem

 xvi Quod dominus ex gratia dat predicationem

 xvii Quod prelatus uel predicator debet prius discere quam docere

 xviii Quod merito malorum operum peruertitur intellectus

 xix Quod merito bonorum operum humilibus datur intellectus

 xx Quod predicator debet habere uerbum dei in affectu

 xxi Quod prelatus uel predicator debet habere uerbum dei in intellectu ct per intellectum

 xxii Quod uita bona debet precedere et comitari predicationem

 xxiii Quod prelatus uel predicator debet ceteris preminere

xxiiii Quod continentia necessaria est prelato uel predicatori

lectificat, confortat, et quod precipua est gratiarum

xii Quod duplex est uirtus uite contemplatiue, que dicitur portio Marie: inflammat enim affectum per dei dilectionem, illuminat intellectum per inuisibilium cognitionem

xiii De pertinentibus ad primum genus contemplationis

xiiii De pertinentibus ad secundum genus

xv De pertinentibus ad tertium genus

xvi De pertinentibus ad quartum genus

xvii De inuisibilibus uiciis quorum utilis est consideracio. Primo de mortalibus. Contra superbiam, que caput est vii principalium uiciorum

xviii Contra inanem gloriam

xix De fine et breuitate temporalis glorie

xx De inepta leticia et contra eandem

xxi Contra peccatum ire

xxii Contra inuidiam

xxiii Contra auariciam

xxiiii Contra acceptionem munerum

xxv Contra raptores

xxvi Contra acceptionem personarum

xxvii Contra accidiam

xxviii Contra gulam

xxix Contra fornicationem

xxx Contra spiritualem fornicationem

xxxi De multiplici enumeratione uiciorum

xxxii De spiritualium pestium eiectione

xxxiii De modo eiciendi uitia

xxxiiii De confessione peccatorum

xxxv Qualis debeat esse confessio [fols. 74ᵛ–75ʳ][4]: prouida

[4]Cf. Langton, *Distinctiones*, n° 33 (Quinto, *Doctor Nominatissimus*, 65–66); Nicolaus Tornacensis, *Compilatio*, c. 133 (Quinto, "Il codice 434," 274).

lv[5] De multiplici enumeratione uirtutum

lvi[6] De donis dei

lvii[7] De hiis que pertinent ad quintum gradum, ad quem pertinent maxime inuisibilia dei essentialia, ut eternitas, trinitas, unitas, potentia creandi animas et huiusmodi

lviii[8] De pluralitate personarum que pertinent[!] ad sextum gradum

lix[9] Quod infatigabili mentis suspensione querenda est diuinitatis agnitio

lx[10] De stupore contemplatiuorum

lxi[11] Contra stulte et presumptuose scrutantes celestia

Titulus quintus · Quod semper proficiendum sit in melius

Titulus vi · De perseuerantia in bono

ii · De perseuerantia in loco primo

Titulus vii · De elemosina

Titulus viii

Pars i · De custodia lingue

Pars ii · Contra linguam dissolutam

iii · Contra litigiosam et contumeliosam linguam

iiii · Contra linguam peruertentem et corrumpentem

v · Contra linguam mendacem

vi · Contra linguam magniloquam

vii · Contra linguam detrahentem

viii · Contra susurrones, bilingues et seminantes discordiam

ix · Contra linguam dolosam

x · Contra murmurantem

[5] in tabula liiii
[6] in tabula lv
[7] in tabula lvi
[8] in tabula lvii
[9] in tabula lviii
[10] in tabula lix
[11] in tabula lx

Titulus xii

 Pars i De uerbo eterno et eius eterna generatione

 ii De uerbo incarnato

 iii De passione domini

 iiii De misteriis et uirtute crucis

 v De resurrectione domini

 vi De ascensione domini

 vii De missione spiritus sancti

Titulus xiii

 Pars i Quod multe sunt tribulationes iustorum et de omnibus liberabit eos dominus

 ii Quod dominus quos diligit tribulationi sepe exponit

 iii Quod iusti gaudent et consolantur de tribulatione

 iiii Quod amplectenda est pro deo a deo missa tribulatio

 v Quod multiplex est sacre scripture solatium in quacumque tribulatione interiore uel exteriore

Titulus xiiii

 Quod mali despiciunt persequntur et detestantur bonos

Titulus xv

 Pars i De seueritate et equitate diuine iusticie
 ii De dulcedine diuine misericordie
 iii De coniunctione misericordie et iusticie

Titulus xvi

 Pars i De securitate iustorum

 ii Quod dominus pugnat pro sanctis

 iii Quod deo attribuenda est uictoria corporalis uel spiritualis

 iiii De pusillanimitate reproborum

Titulus xvii

 Pars i Quod redeuntibus ad deum uel desiderantibus et disponentibus conuerti post collatam gratiam grauius insurgunt demones et temptationes

vii De bono ternario contritionis, confessionis, satisfactionis

viii Quod integra sit confessio: de cogitatione, locutione, opere et circumstanciis

Christ as Model of Sanctity in Humbert of Romans

Simon Tugwell, O.P.

I N THIS PAPER I want to probe a question which struck me when I was editing the section on Dominic in Bernard Gui's *Speculum sanctorale.*[1] I noticed that Gui eliminated almost all references to Christ as Dominic's model and could not help wondering whether this was significant.

The first example occurs in connection with Dominic's time at Osma. Gui's source here is Humbert of Romans. Humbert says that Dominic frequently made a special prayer that God would give him charity with which to obtain more effectively the salvation of his neighbors, "exemplo eius uidelicet qui se totum nostram obtulit in salutem." Gui omits this last phrase entirely. Humbert's own source is Petrus Ferrandus, and the passage ultimately derives from Jordan of Saxony, who makes the point rather more emphatically:

> Fuit autem ei frequens et specialis quedam ad deum petitio, ut ei largiri dignaretur ueram caritatem curande et procurande saluti hominum efficacem, arbitrans sese tunc primum fore ueraciter membrum Christi cum se totum pro uiribus lucrifaciendis animabus impenderet, sicut saluator omnium dominus Ihesus totum se nostram obtulit in salutem.

Gui, however, was not the first to omit the reference to Christ as model; the same thing had already been done by Constantine of Orvieto.[2]

Gui drops another three references to Christ as model, where his immediate source, Humbert, contains them. All three derive originally from Ferrandus, who points to Christ as Dominic's exemplar in courting martyrdom, in offering to sell himself in order to rescue someone whose poverty made him dependent on the heretics, and in sleeping on bare boards as part of a display of competitive austerity designed to win over some supporters of the heretics. On each occasion Constantine had already suppressed the reference to Christ as model.[3]

The only time Gui retains a reference to Dominic as "imitator of the Lord" occurs in a story from Gerard of Frachet's *Vitae fratrum Ordinis Praedicatorum*, in which Dominic imitates Christ by miraculously multiplying bread.[4] Jordan does not elaborate on the point, but it is hard to avoid the impression that for him Dominic's special prayer at Osma in some way provides a key to his subsequent life. And Ferrandus seems keen to spell this out by showing in more detail how Dominic did spend himself for others in imitation of Christ. Constantine and Gui, by contrast, evidently found this idea uninteresting, irrelevant or perhaps even misleading. Humbert reinstated Ferrandus's references to Christ as Dominic's model, but this does not necessarily tell us

much about Humbert's own position, since his *Legenda* is constructed essentially on the basis of Ferrandus, with Constantine serving only as a supplementary source.[5]

There is no explicit link in Jordan or Ferrandus between the exemplarity of Christ in Dominic's life and the specificity of the Dominican Order; but such a link could certainly have been established, as we can see from a story told by Stephen of Bourbon about a Dominican novice who defended his choice of order against some monks on the basis that Christ is the supreme *forma bene vivendi:* "Ergo, cum legerim Dominum Ihesum non fuisse monachum album vel nigrum sed fuisse pauperem predicatorem, volo pocius eius sequi vestigia quam alterius."[6]

There can be no doubt that Jordan had a vivid sense of the novelty involved in the Dominicans' commitment to apostolic usefulness; he parades it as a response to people who fight shy of religious life on the grounds that they would be "shut in" and have no opportunity to "bring forth fruit": now, in the Dominican Order they can "study and preach."[7] But he was also sensitive to the other side of the original Dominican undertaking, poverty. It is "to the poverty of Christ" that Dominic is said to have invited Reginald of Orleans, and later on Jordan stresses the importance of poverty in the short Dominican career of Everard of Langres. In particular, poverty ("quam in seipso Christus exhibuit et sui sequaces apostoli tenuerunt") is central to the difficult vocation of Jordan's friend, Henry of Cologne. And we may suspect that there is more than a touch of autobiography in what Jordan says about Henry, and that he too was drawn particularly to the "pauperum Christi collegium."[8] It was, after all, Reginald, not Dominic, who brought him into the Order, however impressed he may have been by Dominic, and it was, almost certainly, Reginald who persuaded abbot Matthew and the other brethren in Paris to re-espouse the radical poverty which they thought they had left behind in Toulouse.[9]

The situation in the mid 1240s, when Constantine was commissioned to write a new *legenda*, was significantly different. This was a period of intense rivalry between Dominicans and Franciscans, and the timing suggests that the Dominicans wanted a new *legenda* of Dominic, with an emphasis on his miracles, precisely because the Franciscans had called for a new *legenda* of Francis with an emphasis on *his* miracles.[10] Constantine was probably aware of the need to present a Dominic who could hold his own against Francis; he certainly includes a miracle-story about a Franciscan who denied Dominic's sanctity and was duly punished from on high until he repented.[11]

Any Dominican appeal to the model of Christ could easily backfire in the new context of competition with Franciscans. This can be seen with particular clarity in Robert Kilwardby's letter to Dominican novices (ca. 1270) and in John Pecham's vicious reply to it.[12] Kilwardby advances the claim that the Dominican way of life is the closest to that of the apostles and of Christ himself, but, when he touches on the Order's practice of poverty, he has to adduce the example of Christ to justify a moderate poverty over against the more extreme practice, or at least theory, of the Franciscans. Armed with the diplomatic conclusion to the feud between the two orders which had rocked Oxford in 1269,[13] he concedes that the Franciscan profession is what they claim it is and that they do well in keeping it; nevertheless, he goes on, "nobis sufficit in hoc articulo perfectionem apostolice paupertatis non excedere, quam Christus in evangelio docuit." This may be a necessary gambit in the battle, but it is hardly inspirational.

And it certainly infuriated Pecham, who denies that the Dominicans even have any right to be called *Ordo Predicatorum* on the grounds that their way of life is not in conformity with that of Christ or the apostles, but is, in fact, monastic. In succeeding decades the argument degenerated into an ever more stupid controversy about the poverty of Christ, with its tragic dénouement under John XXII precisely in the time of Bernard Gui.

Humbert's attitude towards the Franciscans was irenic. In 1255, in face of the secular attack on the mendicants, he tried to patch up a joint front with the Franciscans[14] and, in his *Legenda* of St. Dominic, he rewrote Constantine's anti-Franciscan miracle-story in such a way as to suppress the fact that its anti-hero was a Franciscan.[15] But he seems remarkably reluctant to admit any Franciscan claim on Christ as model, either because he was aware of how it could be turned against the Dominicans or perhaps because he was conscious of its explosive potential within the Franciscan Order itself.

The idea of *sequela Christi,* clearly understood as imitation of Christ or conformity with Christ, plays a prominent role in the *Regula non Bullata* and in Franciscan hagiography, up to and including Bonaventure. The *Regula non Bullata* begins with the statement, "Regula et vita istorum fratrum haec est, scilicet vivere in obedientia, in castitate et sine proprio, et Domini nostri Jesu Christi doctrinam et vestigia sequi"; and this was taken over by Thomas of Celano as the key to Francis's own life: "Summa eius intentio, praecipuum desiderium, supremumque propositum eius erat sanctum Evangelium in omnibus et per omnia observare ac perfecte . . . Domini nostri Iesu Christi doctrinam sequi et vestigia imitari." This was translated into terms of "conformity with Christ" by Julian of Speyer who says, in connection with Francis's decisive renunciation of all his goods, including even his clothes, "iam se vir Dei nudus in cruce nudato conformat." This idea was generalized by Bonaventure in his résumé of Francis's ideals: "Voluit certe per omnia Christo crucifixo esse conformis. . . . O vere christianissimum virum, qui et vivens Christo viventi et moriens morienti et mortuus mortuo perfecta esse studuit imitatione conformis."[16] Thus even Bonaventure, who did his best to promote an image of Francis that would calm the controversies generated by radical and extremist interpretations of him,[17] places conformity with Christ at the heart of his *Legenda.*

In the Dominican lectionary compiled by Humbert there is not a trace of this idea.[18] Admittedly the immediate source of the readings in Humbert's lectionary no longer exists, but even if this source (which was not Franciscan) had already managed to present Francis without any mention of what Franciscan hagiography regarded as the essential key to his life, Humbert's decision to construct readings from this source rather than from any other might well be regarded as significant.

The section on Francis in the *materia praedicabilis* in Humbert's *De eruditione praedicatorum* is even more strange. The failure to mention Christ as Francis's model is made more striking by the fact that almost half the chapter consists of scriptural prefigurations of Francis and his order, at the end of which Humbert remarks, "Sunt autem et alia multa in scripturis sacris que ei possunt aptari, que prestant ei non modicam auctoritatem."[19] These alleged biblical prefigurations are of various kinds, including even an anticipation of Zeffirelli's Francis: the birds that are mentioned in the parable of the mustard seed in Luke 13:19 are interpreted as Franciscan friars "qui uitam

uolucrum ducunt." But it is surely tendentious in such a context not to suggest that considerable authority is given to Francis and his order precisely by the evangelical injunctions which Francis tried to follow and by the example of Christ which he strove to imitate.

Similarly in Humbert's material for sermons addressed to Franciscans,[20] which he perhaps rather optimistically suggests might be used by a Franciscan superior addressing his own friars, there is no reference to *imitatio Christi*. Humbert in fact outlines two different possible sermons. The first evokes Francis as the model for Franciscans, and notes the virtues which this implies, including fidelity to the Gospel, which Francis particularly wished them to observe, and this not only in easy things, but also in harder demands, such as the requirement to turn the other cheek. But this is the nearest Humbert comes to suggesting that, through Francis's exemplarity, the friars are meant to conform themselves to Christ.

The second suggested sermon material is entirely devoted to fear of the Lord, and its connection with the Franciscans is hinted at only in the proposed text from Tobit 4:23, "Nolite timere filii mei; pauperem quidem uitam gerimus, sed multa bona habebimus si timuerimus deum." One cannot help but feel that Humbert was being rather tactless in pointing out that one of the benefits that the Bible promises to those who fear the Lord is "habundantia temporalium." Maybe, for all his diplomacy, Humbert shared the conviction of his brethren in Oxford that, notwithstanding their ideology of radical poverty, the Franciscans managed to be quite rich in reality.

Humbert's sermon material on Dominicans is very meagre.[21] There is an appeal to the model of the apostles, but with no suggestion of the more radical implications of *vita apostolica*; no mention is made of Christ as model. The most interesting thing about this section is actually its location in the part of the the *materia praedicabilis* devoted to religious. The Dominicans are placed within the class of religious "qui addiderunt super regulam beati Augustini," whereas the Franciscans, together with the Trinitarians, follow hermits and eremitical orders. This structure does not suggest any particular affinity between Dominicans and Franciscans. Yet in his joint encyclical with John of Parma in 1255 the two orders are effectively presented as twins:

> Pensate, dilectissimi, pensate quantum debet inter vos dilectionis sinceritas habundare, quos eodem tempore genuit mater ecclesia, quos ad idem opus scilicet salutem animarum communiter operando eterna caritas ordinavit, quos professiones in modico differentes sic assimilant, ut tamquam animalia similia nos intime diligamus.[22]

And in the *Opus tripartitum*, written for Gregory X before the second Council of Lyons, Humbert recognizes the category of *religiosi pauperes*, even if only to complain that there are now too many of them.[23] But on both occasions there was a strategic need to assimilate Dominicans and Franciscans: in 1255 because of secular attacks on the mendicants, and in the early 1270s because of the risk posed to the two main mendicant orders by the excessive number of their rivals. When he was not influenced by strategic considerations, Humbert seems to prefer to keep Dominicans and Franciscans apart in separate categories and to retain the Dominican claim to belong essentially to the Augustinian family.[24]

In the sermon material on St Dominic there is equally no mention of Christ as model.[25] And Humbert's world seems to be far removed from that of the novice cited by Stephen of Bourbon. Dominic, he says, became a religious and, unlike many, he made good progress in religious life. Furthermore, unlike some good religious whose love of the contemplative life leads them to neglect the salvation of their neighbors, Dominic was specially keen to be useful to the souls of others. There is no question here of defining a boundary between Dominican life and the life of other orders; as far as Humbert is concerned, there is a straightforward moral issue, addressed to all religious equally: those who have the necessary gifts to work for others *should* work for others.

Again it is pertinent to note how Humbert situates the Dominicans with regard to other religious. He not merely presents them as belonging to the class of those who have "added" to the Rule of St. Augustine, he claims that they combine all that other such religious have separately added to the Rule:

> Supra regulam addiderunt uel pulcherrimas obseruantias ut Premonstratenses, uel studium ut fratres de Valle Scolarium, uel asperitatem ut fratres de Sacco, uel cum omnibus istis predicationem ut fratres predicatores.[26]

Elsewhere in *De eruditione praedicatorum* Humbert does in fact allude to Christ as a model for preachers and, in particular, as an example for preachers committed to poverty.[27] But he shows no sign of wanting to use such a model to interpret or validate anything specifically Dominican.

In the first place, *De eruditione praedicatorum* is not addressed exclusively to Dominicans; it is meant for any preacher in the Church and, judging from some of the sermon material, Humbert has his eye not least on senior ecclesiastics, including even the Pope.[28]

Secondly, it may be true that Humbert is implicitly providing a much-needed theoretical basis for the Dominican Order in his portrayal of a life totally dedicated to preaching as the best possible form of Christian life, and it may also be true that such a vision was at odds with conventional monastic wisdom and with generally accepted views of the superiority of the contemplative life. Nevertheless Humbert was not consciously defining, let alone defending, some peculiarly Dominican identity against more traditional ideologies, nor, I suspect, was he consciously innovating. He was, if anything, defending a rather old-fashioned position. In terms of the shifting perceptions of sanctity documented by André Vauchez,[29] Humbert belongs to the world which was passing, in which prime candidates for canonization were public figures like bishops, rather than the new world in which sanctity was associated more with personal spiritual prowess and in which people, including some Dominicans, were fascinated by visionaries and ecstatics.

As Humbert uses it, the appeal to Christ as model has nothing to do with the specificity of the Dominican Order; it is a way of reinforcing a general appeal to people to do their duty and in particular an appeal to religious to be faithful to their state. This is clear from the so-called letter on the three vows. After the prologue, Humbert says, "Diligenti studio, fratres carissimi, satagamus virtutum exercitiis insistere, quibus Christo conformemur." In the course of his exposition, he invokes the model of Christ

in connection with obedience, poverty, humility and so on.[30] On the other hand, when he comments on the specificity of the Dominicans in his commentary on the Constitutions, his main interest is in securing respect for the title, *Ordo Praedicatorum*, and to this end he cites a barrage of *auctoritates*, many from the *Glossa ordinaria*; he says nothing about Christ as model.[31]

To conclude, we may say that, in the early years of the Dominican Order, the appeal to Christ as the model of the poor preacher could be useful in validating the new order's way of life against the exponents of more traditional forms of religious life. But as the Order became more established and in particular as the ideological attack to which it was exposed shifted away from the challenge of the older monastic orders to the challenge of more radical Franciscan appeals to Christ as their model, at least some Dominicans found it less useful, if not actually dangerous, to make a similar appeal themselves. Humbert was quite willing to use the idea of Christ as model, but it did not serve to define or vindicate any particular way of life, whether Dominican or Franciscan. It may well be that this shift explains why Christ as model was important in the earliest Dominican hagiography, but then tended to disappear.

NOTES

1. References to this text by Bernard Gui are given in accordance with the paragraph numbers in my own forthcoming edition, due to be published by Éditions du Cerf. In the essay, I shall refer to the following works, all edited in MOPH 16 (1935): Jordan of Saxony, *Libellus de principiis Ordinis Praedicatorum*, ed. H.-C. Scheeben (1–88); Petrus Ferrandus, *Legenda S. Dominici*, ed. M.-H. Laurent (197–260); Constantine of Orvieto, *Legenda S. Dominici*, ed. H.-C. Scheeben (263–352); Humbert of Romans, *Legenda S. Dominici*, ed. A. Walz (355–433). I refer to all of these according to the paragraph numbers in the editions in MOPH 16 (page numbers are in parentheses), though in the case of all of them except Constantine I make use of my own provisional texts.

2. Jordan of Saxony, *Libellus* 13 (32–33); Petrus Ferrandus, *Legenda* 10 (215–16); Constantine of Orvieto, *Legenda* 11 (292–93); Humbert of Romans, *Legenda* 9 (376); Bernard Gui, *Speculum* 9.

3. Petrus Ferrandus, *Legenda* 20–22 (222–26); Constantine of Orvieto, *Legenda* 16–17, 19 (297–98, 299–300); Humbert of Romans, *Legenda* 23, 25–26 (384–88); Bernard Gui, *Speculum* 19–21, 24.

4. Gerard of Frachet, *Vitae fratrum Ordinis Praedicatorum* 2.20, ed. B. M. Reichert, MOPH 1 (1896): 80; Bernard Gui, *Speculum* 52.

5. It is perhaps worth remarking that, in the abridged version of Ferrandus which he produced for his first revision of the lectionary, Humbert omitted all references to Christ as model; but this could be due to the need for brevity, since, at this stage, Humbert was trying to reduce the size of the *legenda* so that there would be nothing more than was needed for liturgical use on the feasts and during the octave of St. Dominic. Humbert's abridgment is edited by Hilarius Barth, O.P., "Die Dominikuslegende im ersten Lektionar Humberts von Romans," AFP 54 (1984): 101–12.

6. A. Lecoy de La Marche, *Anecdotes historiques, légendes et apologues, tirés du recueil inédit d'Étienne de Bourbon, Dominicain du XIII^e siècle* (Sociéte de l'histoire de France 185, Paris, 1877), 73–74 n° 74.

7. The relevant extract from one of Jordan's sermons is printed by Thomas Kaeppeli, "Un recueil de sermons prêchés à Paris et en Angleterre, conservé dans le ms. de Canterbury, Cathedr. Libr. D 7 (Jourdain de Saxe O.P., Thomas de Chabham, etc.)," AFP 26 (1956): 180.

8. Jordan of Saxony, *Libellus* 56, 89–90, 71–72 (51–52, 67–68, 58–59).

9. See my article, "Notes on the Life of St. Dominic," AFP 65 (1995): 5–169.

10. The Franciscan General Chapter in 1244 called for miracles of Francis to be collected, and the

resulting material was passed on to Thomas of Celano who, on the orders of the Chapter and the Minister General, composed his second life of Francis in 1246–1247; see Roberto Paciocco, *Da Francesco ai 'Catalogi Sanctorum'* (Assisi, 1990), 62–63. In 1245 the Dominican General Chapter made a similar call for miracles of Dominic to be collected; see vol. 1 of *Acta Capitulorum Generalium*, ed. B. M. Reichert, MOPH 3 (1898): 33. The resulting material was passed on to Constantine of Orvieto who, at the demand of the Master of the Order, composed a new *legenda* of Dominic in 1246–1247 (MOPH 16: 281–83, 286).

11. Constantine of Orvieto, *Legenda* 119 (349–50).

12. Kilwardby's letter is only known from Pecham's reply; the text is edited in C. L. Kingsford, A. G. Little and F. Tocco, *Fratris Johannis Pecham Tractatus tres de paupertate* (Aberdeen, 1910), 121–47; for the points cited here, see especially 122–28, 131–40.

13. See the document edited by A. G. Little in *The Grey Friars in Oxford* (Oxford, 1892), 320–35. The row was sparked off by a Dominican saying to the Franciscans that they accepted money contrary to their profession and were therefore *in statu dampnacionis* (320–21). Peace was restored at last on the basis of the same friar agreeing to declare that he had not meant "quod vos receperitis vel recipitis per vos vel per alios peccuniam contra regulam vestram et eius interpretacionem" (335); which in effect left the Dominicans free to go on believing that the Franciscans did receive money (but in a way which did not contradict their Rule or its interpretation). This compromise seems to underly the rather cryptic comment in Kilwardby's letter, "Contentionibus inservire nolumus nec debemus; unde bene concedimus talem eorum professionem esse qualem asserunt, et bene fecerint eam intime custodiendo" (ed. Kingsford et al., *Fratris Johannis Pecham Tractatus*, 136); this is why I date the letter to ca. 1270 (Kilwardby was provincial of the English Dominicans from 1261 until his election as archbishop of Canterbury in 1272). Kilwardby, as provincial, had been drawn into the dispute in Oxford in 1269, and admitted that he was unable to fathom the Franciscan claim not to accept ownership of money, since money was often deposited for their use in such a way as to leave no other possible owner. When his Franciscan interlocutor explains that the friars acquire no proprietorial rights over such money, Kilwardby exclaims, "Vere si hoc constaret mundo, non sic habundaretis sicut habundatis" (Little, *The Grey Friars*, 326–27). There is nothing in the text to indicate that Kilwardby was not present in Oxford when the dispute was finally resolved. Pecham, on the other hand, was still in Paris at least until late 1270; see Decima L. Douie, *Archbishop Pecham* (Oxford, 1952), 26–34.

14. See his joint letter with the Franciscan Minister General, John of Parma, in *Litterae encyclicae magistrorum generalium Ordinis Praedicatorum ab anno 1233 usque ad annum 1376*, ed. B. M. Reichert, MOPH 5 (1900): 25–31.

15. Humbert of Romans, *Legenda* App. 57 (but unfortunately the editors of MOPH 16 decided not to print the text, so Humbert's suppression of the identity of the Franciscan is itself in effect suppressed).

16. All of these texts are cited from the editions in *Analecta Franciscana* 10, ed. Fathers of the College of St. Bonaventure (Quaracchi, 1926–1941): Thomas of Celano, *Vita prima S. Francisci* 84 (63); Julian of Speyer, *Vita S. Francisci* 9 (339–40); Bonaventure, *Legenda maior S. Francisci* 14.4 (622).

17. See Paciocco, *Da Francesco*, 82–83.

18. The text is edited in *Analecta Franciscana* 10: 533–35.

19. Although the six sections of *materia praedicabilis* are all really part 9 of section 7 of *De eruditione praedicatorum*, it will be more convenient to treat them as a separate entity; so I refer to them as *MP*, followed by the section number and the number of particular headings (which I loosely refer to as 'chapters') within the section. *MP* 1 and 2 were printed under the misleading title, *Sermones ad diuersos status*, and the equally misleading heading, *De modo prompte cudendi sermones ad omne genus hominum* (Hagenau, 1508); this edition (neither foliated nor paginated) was reprinted several times, with varying degrees of editorial ingenuity but no fresh use of any manuscripts. *MP* 3, 4 and 6 have mostly not been printed, and *MP* 5 is not known to exist. I use my own provisional edition. The reference here is to *MP* 6.58.

20. *MP* 1.26.

21. *MP* 1.14.

22. In *Litterae encyclicae*, ed. Reichert (MOPH 5: 26–27).

23. The full text of Humbert's *Opus tripartitum* is known only from the edition by P. Crabbe in vol. 2 of *Conciliorum omnium tam generalium quam particularium* (Cologne, 1551), 967–1003. The passage cited here is in *Op. trip.* 3.3.

24. Humbert resisted moves to oust the Rule of St Augustine in favour of a new, specifically Dominican Rule; see R. Creytens, "Les commentateurs dominicains de la Règle de S. Augustin du XIIIe

au XVI^e siècle," AFP 33 (1963): 138. Humbert evidently considered it significant that the original Dominican Constitutions were essentially taken from those of the Praemonstratensians, whose particular "additions" to the Rule he praises in *MP* 1.10–11; see Humbert's *Expositio super constitutiones Fratrum Praedicatorum*, in vol. 2 of *Beati Humberti de Romanis quinti Praedicatorum magistri generalis Opera de vita regulari*, ed. J. J. Berthier (Rome, 1889), 2–3. This edition is hereafter cited as 'Berthier'.

25. Humbert of Romans, *MP* 6.43.

26. Ibid. 1.10.

27. Cf. Berthier 2: 419, 433.

28. Particularly in *MP* 2 Humbert goes beyond providing material for sermons and covers all sorts of occasions which call for something to be said, including, for instance, the various stages involved in the resignation of a bishop, which only the Pope can grant, and the sending of a papal legate; the only possible person who could make use of the ideas Humbert suggests for these occasions is the Pope himself (*MP* 2.73–76).

29. André Vauchez, *La Sainteté en Occident aux derniers siècles du Moyen Age* (Rome, 1981).

30. Ed. in Berthier 1 (Rome, 1888): 2, 10, 21.

31. Berthier 2: 38–41.

The Importance of Christ in the Correspondence between Jordan of Saxony and Diana d'Andalo, and in the Writings of Mechthild of Magdeburg

Margot Schmidt

ACCORDING TO CONTEMPORARY accounts, Jordan of Saxony was a highly gifted young man whose charm and power with words scarcely anyone could resist.[1] This count, born into the noble family of Eberstein in 1185 in Borgentreich near Paderborn in Westphalia, seemed destined for an academic career after his studies of the liberal arts and theology at Paris. But such was not to be. In 1219 he met St. Dominic in Paris. Just a year later on 12 February 1220, he entered into the newly-founded Order of Preachers. The idea of an Order in the world, in imitation of the apostles as itinerant preachers working against the heretical groups of Albigensians and Waldensians, set Jordan on fire. His extraordinary talents quickly led him to assume positions of leadership in the Order. On 30 May 1221, at the General Chapter held in Bologna *in absentia* he was named Provincial of the Dominican province of Lombardy. Later that year after St. Dominic had died, at the General Chapter held in Paris Jordan was elected unanimously to be Master of the Order (22 May 1222). From that moment on he spent his life almost uninterruptedly in travels at the service of the Order, whether it meant preaching (as he liked to do) to the young students at the university centers of Padua, Vercelli, Bologna, Paris and Oxford in order to win them to his Order, or whether it meant making new foundations throughout Europe and visiting them as far away as in Russia or Jerusalem. At his death after fifteen years as Master General, the Order numbered more than a thousand brothers and sisters, that is, at least ten times the number at the death of the founder. Thus Jordan is rightly called "the second founder of the Order." By his efforts he led the Order to assume its world-wide historical importance and developed it into a spiritual force at least equal to that of the Franciscans, who had already drawn thousands into their circle of influence. The motto of the Order, *Veritas*, meant to signify the apostolic truth in its fullness, implies the learning necessary to fulfill its mission. The Dominicans were a learned Order. By his preaching at Padua in the summer of 1223, Jordan won over Albert von Bollstädt, the son of a count and better known to history as Albert the Great, along with twenty-three other students to the Order. Jordan supported the erection of two chairs of study for Dominicans at the University of Paris and also supported the center of studies for German Dominicans at Cologne. At this newly founded *Studium generale* in Cologne Albert the Great would later teach from 1247 to 1254, during which time Thomas Aquinas and Ulrich of Strassburg were among his students.

At the request of Dominic, Jordan continued to try to fulfill the desire of Diana d'Andalo to establish a monastery of Dominican nuns in Bologna.[2] This foundation could not be realized during Dominic's lifetime because of initial difficulties on the part of the d'Andalo family. However, Jordan and Diana continued to work together to bring this plan to completion. Diana and four companions professed their vows to Jordan on 29 June 1223. From 1223 until Jordan's death in 1237, the Dominican monastery of St. Agnes in Bologna grew to number about fifty nuns. It was during this period that Jordan and Diana corresponded.

According to Wilhelm Oehl, the correspondence of Jordan of Saxony holds "a unique place" among the rich number of writings in the thirteenth century.[3] Judging the letters to be among the "most outstanding" literary monuments that express "an individual, personal piety," he regrets that they have remained "almost completely unnoticed."[4] In this he agrees with the editor of Jordan's letters, Berthold Altaner.[5] Altaner sees in Jordan a representative of true mysticism, which the German spiritual leader labored to introduce into the monastery of Italian Dominican nuns. Of his fifty-six extant letters, fifty were sent to the Monastery of St. Agnes, thirty-seven of which were addressed directly to his soul-friend Diana. According to Altaner, these letters are the most noteworthy, for they "are the source of our knowledge of a holy friendship between two individuals." He emphasizes that Jordan's letters preserve for us wonderful evidence of "the possibility and the reality of great, deep and pure friendship between man and woman," and he adds: "The non-literary character of the letters, which were written without any thought that they would one day be open to public scrutiny, is the best guarantee that not only the religious thoughts and practical suggestions, but also the feelings and states of mind of a personal friendship and love would be expressed truly and unadulterated in form."

The firm foundation upon which Jordan and Diana built their spiritual friendship was a shared, absolute longing for a great love of God and Christ that avoided no sacrifice. Already as a young woman Diana possessed such a longing. After she had heard the preaching of St. Dominic, she strove passionately to live a life centered on Christ. Her wish was to establish a monastery of nuns in the Dominican spirit at Bologna. With all her might she opposed the efforts of her father to arrange a marriage for her. Twice she fled from her family castle to the monastery of Ronzano near Bologna. The first time she was brought back by force, but the second time she was allowed to follow her own will. In the meantime Dominic had died, having left Jordan the responsibility for Diana's protection. In pious obedience to his predecessor, and probably also because he was well aware that Diana, like himself, wanted to lead a religious life unbounded by time and place according to the ideals of the Order, Jordan turned his whole attention to the efforts of Diana.

Besides their common spiritual goals, in their letters Jordan and Diana again and again express the desire to be near or actually present to each other. This shows that love between individuals who have chosen a religious life involves the whole person, in all her being and senses. The correspondence between Jordan and Diana is a unique document in the history of holy friendships, revealing the actualization of a spiritual relationship that occurs on a level completely different from that found in the union of married love. Unhappily, the correspondence survives only by half. We know only

Jordan's responses to Diana's letters; none of the letters that she wrote by herself is extant.

From the perspective of spiritual history, the Dominicans, like the Franciscans, were founded as a "protest movement against a mode of Christian existence increasingly called into question in the thirteenth century."[6] They both preached the courage to live in radical insecurity as the way of life intended by Christ. From this tension, members of both Orders developed a many-sided piety centered on Christ. In this essay, I shall show the rich understanding of Christ mirrored in the letters of Jordan of Saxony to Diana of Andalo. I shall develop three themes in the letters: (1) Christ as the "bond of love," and the incarnational character of love; (2) Christ the Way and devotion to the Passion; (3) Christ as the Book of Life.

CHRIST AS THE BOND OF LOVE

Jordan frequently uses the image of the bridal love between Christ and the soul. Like Bernard of Clairvaux, he identifies Christ as the Bridegroom and the soul as the Bride in order to make clear the interiority and strength of the love of God and Christ. For Jordan, the power of this love is independent of consolations of any kind, because it is grounded in Christ. According to Jordan, a love rooted in Christ can withstand any separation, whether it be the perceived absence of God or the separation of two human beings who love each other. From this conviction he writes to his soul-friend Diana, addressing a very concrete situation:[7]

> whatever is missing for you because of my presence, which you cannot (now) have, will be made up by your better friend, your bridegroom Jesus Christ, whom you can have more frequently in your presence, "in spirit and in truth" (Jn 4:23), and who can speak to you more pleasantly and with greater benefit than I. And if he sometimes turns his face away from you and appears to be far from you, then know, that also is a grace and not a punishment. Christ is our bond, through which my spirit is bound to your spirit and in whom you "are present to me without interruption" (2 Tim 1:3), and to whom I also go.

We see what a high culture of love Jordan fosters when he elevates the pain of God's absence or earthly separation to the order of grace, in order to strengthen it and make it faithful. For Jordan, moreover, human as well as divine love is justified, and has great value. He demonstrates how human love is anchored in divine love in Christological terms. In a letter to a canoness who was particularly bound to him,[8] he writes:

> What then should I say to you about the exceedingly great love with which I love you in Jesus, who is the mediator not only between human beings who love each other in Christ (1 Tim 2:5), but also between God and human beings, "uniting both parts together" (Eph 2:14); he has united them so that God may be human and human beings may be God, so that they love God in other human beings, and other human beings in God. That is the loved Love and always loving Love with which he embraced not the angels but rather the children of Abraham. So "let us love one another" (1 Jn 4:7) and let us love "in him and through him and for him" (Doxology from the Canon of the Mass). The Incarnation of the Son of God in

Jesus Christ also gives to human love a divine spark which leads through humanity to unity with the divine, a way not open to the angels, but only to human beings for whom Jesus, precisely as leader, is "the way, the truth and the life" (Jn 14:6).[9]

Because human beings are "created in God's image" (Gen 1:27),[10] and because by the Incarnation a certain fixed harmony between human and divine longing exists in Christ Jesus, the yearning becomes constitutive for human as well as divine love. This double yearning defines the relationship between Jordan and Diana. Jordan speaks repeatedly about it, not in speculative terms (which would include questions about the *desiderium naturale*, or natural desire for God), but rather as an experiential earthly and heavenly power, which determined his life, and about which he exchanged letters with Diana. The original human yearning is "directed toward heaven"; heavenly desire should always be nourished in the heart as a "glowing yearning."[11] The spirit, in its eternal yearning, desires other nourishment than the body. Jordan writes to Diana: "Who is the unfortunate one, who starves to death because of lack of this food, which is to be obtained only by longing? Therefore, say along with the prophet: 'My eyes are fixed on the Lord!' (Ps 24:25)."[12] Like Gregory of Nyssa before him, Jordan teaches that satisfaction in this life is obtained only by an ever greater yearning for God. In this regard, Diana may have been more advanced than Jordan, as he implies at the end of one of his letters to her: "When you, dearest one, linger in such a holy yearning, do not forget your poor correspondent."[13]

The advanced state of Diana's interior life is implied in another letter, in which Jordan addresses her in the words of the Song of Songs: "She may be led by her Bridegroom into the wine cellar" (Cant 2:4).[14] This metaphor, drawn from the exegetical tradition of the Song of Songs, conveys an especially high level of divine blessedness or ecstasy. One may surmise that Jordan obtained knowledge of these sorts of interior experiences from Diana's letters or from his occasional visits, and he wished her a deepening in these graces in order to share in them himself. In merging the wine metaphor with Mt 20:22, Jordan refers to the eschatological fulfillment of all yearning as a promise of the Lord, writing that we will one day "drink from the unmixed chalice of eternal joy."[15] This unusual expression "unmixed chalice" appears later, in a slightly altered form and meaning, as "unmixed wine" in the writings of Mechthild of Magdeburg, whose use of the metaphor I shall discuss presently.

CHRIST THE WAY AND PASSION-MYSTICISM

According to Jn 14:6, Christ is absolutely the Way. Thus he determines the direction of the imitation of him, to which Jordan expressly summons us until we "are set free in order to be with Christ" (Phil 1:23).[16]

The image of Christ as the Way emphasizes his power and strength, illustrated by the words of the Psalms, which flow from Jordan's pen as naturally as if they were his own. Christ is "the voice of power" (Ps 67:34), the "strong helper" (Ps 70:7) in "whose hand are all the depths of the earth" (Ps 94:4); we "should be strong in Christ," who is "wonderful in his saints" (Ps 67:16). Jordan writes to Diana:[17]

Become strong in Christ; "may he himself always dwell in your heart" (Eph 6:10; 3:17). Because a heart, which is deprived of Christ, is like a husk without corn. It will be blown away by the wind, because it has been whirled about by temptation. The corn, however could withstand the wind. So also would any heart in which Christ dwells be made secure so that it would not be tossed about or carried away by temptation. Therefore say, "my blessedness is to cling to God" (Ps 72:28), or "my soul clings to you" (Ps 62:9). . . . So that we may cling firmly to him, he has bound us securely with the firm waistcloth of his love, as he speaks through the prophet, "With a waistcloth I have made the house of Israel cling to me" (Jer 13:11), that is, the heart of those who look upon the Lord (i.e., the house of Israel), "who behold the Lord at all times" (Ps 15:8). Just as he wished to bind us to himself, so may he also draw us graciously to himself.

The reference to Jeremiah ("With the waistcloth [love] Christ has bound those who look upon the Lord to himself") stresses the fact that human beings are always loved by God first and are drawn by his grace; for this reason we pray, "May he draw us graciously to himself."

To be drawn by Christ also means to love "the poverty of Christ" and to "consider the riches of the world as nothing,"[18] according to the words of the Bridegroom: "Blessed are the poor in spirit, for theirs is the kingdom of heaven" (Mt 5:3). The concept of poverty in spirit leads to Passion-Mysticism. Jordan writes to Diana: "You are no beggar, because you possess in abundance of the glory and the 'riches of his house' (Ps 111:3); because you have the king of heaven, you are no poor woman, but a queen, because you have a kingdom." This text, enlivened by the language of the Psalms, reveals yet again how much Jordan stood in awe of Diana's grace-filled spiritual experiences. He spurs her on to imitate the Passion of Christ: "Sit at the right of your Bridegroom attired in gold . . . (Ps 111:3), brilliantly red (Cant 5:10) from the ardor and fervor of Christ."[19]

The gold of "genuine love" (2 Cor 6:6) comes from the land of Havilah (Gen 2:11), which is translated as "Kingdom of Sorrow." It is Christ who said: "Note well and see if there is any sorrow like my sorrow" (Lam 1:12). According to this text, the greatest love lies in the way of the Cross, in the offering up of one's life, for "no one has greater love than the one who gives up his life for his friends" (Jn 15:13).

Thus, the gold mine of greatest love is contemplation of the wounds of Jesus, according to the words, "They have pierced my hands and my feet" (Ps 21:17).[20] By venerating the wounds of Christ, one perceives the perfect model of self-sacrifice and service to one's brothers and sisters. Using the language of the Song of Songs, Jordan writes to Diana: "You should live like a friend and dove (that is, like one filled with yearning), 'in the clefts of the rocks' (Cant 2:14). 'The rock is Christ'[21] (1 Cor 10:14), and the clefts are the five wounds of Christ." In a special way, contemplation of the wounded heart of Jesus offers a source of grace:[22]

> Therefore, when you stand "at the right side" you will be gilded by the stream flowing from the right side . . . and may you be poured upon richly and your clothes become red from the "wine treader" (Is 63:2). At the right side always stand the saints with the queen (Ps 44:10), their mother, the Church, and these have washed their clothes in the blood of the Lamb (Rev 22:14).

In this passage, Jordan renews the teaching that the Church was born from the wounded side of Christ as his own original foundation. The way of imitation passes through poverty in spirit and suffering that depends on the suffering of Christ.

CHRIST AS THE BOOK OF LIFE

Especially striking is the beginning of another letter, in which Jordan addresses Diana as one who possesses the "the sweet blessings of the Spirit of the knowledge of God" (2 Cor 11:31).[23] This can mean nothing other than that he stands in awe before Diana's graced knowledge of God; drawing himself back, he continues:

> To what end should I write to you for the consolation of your heart, since you will indeed be more nobly and sweetly consoled by that book that you have daily before the eyes of the spirit, the book of life, the tablets "of the purest law, that excites the soul." This "pure law" (Ps 18:8) . . . is love, when you behold Jesus your redeemer with arms outstretched on the Cross, written with his wounds, painted with his holy blood. . . . No book can lead more compellingly to love.[24]

The 'Book of Life' contemplated in Christ's Passion is the perfect book, in which "the wisdom of the saints in the school and power of the Son of God, Jesus Christ, is learned."[25] The book of Christ's Passion yields not only knowledge, but also the acquisition of wisdom in the way of holiness and truth, which pertains also to the praise of God. Such wisdom is not merely theoretical and abstract, but rather a practical way of life encompassing the entire human person in daily imitation of, and association with, the crucified Christ. Thus, the wisdom acquired in the Book of Life has a Christological character. According to longstanding Christian tradition, wisdom is attributed to the Son of God, the second person of the Trinity, in a special way. Likewise, Jordan understands Jesus Christ, the Son of God, to be the very wisdom of God incarnate, and he accords to the humanity of Christ a central position in his life. This Christological interpretation of wisdom will be expanded later by the Dominican friar Henry Suso, in his *Horologium sapientiae* and in *The Little Book of Eternal Wisdom*.[26]

No matter what tensions were caused by the high ideals of their relationship, throughout their lives Jordan and Diana preserved a spiritual attitude that fulfilled them both and a strong love that bound them together inseparably. Jordan wrote Diana for the last time (1237) before his journey to Palestine, upon which his ship sank off the coast of Syria and he and his companions were drowned. This letter reveals a mood filled with intimations of death, and expresses both the uprightness and power of Jordan's spirit and the tenderness of his heart:

> That which we have been able to say over the course of time in letters, dearest friend, was actually very little; deep in our hearts burned the flame of holy love, and so you were able to hold continuous confidential discourse with me and I with you, and this discourse is so totally filled with such burning love that it cannot really be exhaustively expressed either in words or in letters. Yes, Diana, poor is our earthly lot, because even our love is necessarily bound up with pain and anxiety and agitation. You take it hard and are unsettled because you cannot

see me continuously, and in just the same way I too suffer in my soul because it is granted to me so seldom to remain in your presence.

The lines that follow testify that only hope and heavenly yearning for a better life to come gives strength to bear the unresolvable spiritual tensions of their friendship. The idea of heavenly desire as a special divine power into which all earthly desire is fused runs through Jordan's letters like a golden thread. It is this desire, together with the divine power of faith "in the joy measured out to us (Mt 7:2), which the Son of God, Jesus Christ, infuses into us," that enables one to endure all of the vicissitudes of life.[27]

THE INFLUENCE OF THE EARLY DOMINICANS ON MECHTHILD OF MAGDEBURG

Mechthild of Magdeburg's relations with the Dominican friars in Magdeburg and elsewhere appear to have been extensive. Jordan of Saxony stayed in Magdeburg on 21 September 1225, where he presided over the first provincial chapter of the German province.[28] Joseph Mothou reports that after the General Chapter of 1224 in Paris, Jordan sent friars to Strassburg, Trier and Magdeburg with the goal of making new foundations.[29] The monastery at Magdeburg was erected at the request of the Bishop of Magdeburg, and was placed under his protection. While visiting various new foundations in Germany, Jordan traveled to Magdeburg in 1225, immediately after the General Chapter in Bologna, accompanied by the German provincial authorities, Brother Konrad, the prior of Cologne, Brother Henry and Brother Bernard. The construction of the monastery in Magdeburg had progressed so far that the German Dominicans found lodging there, and held their first provincial chapter, at which Jordan presided.

Thus, when Mechthild fled to Magdeburg around 1230, a vibrant and growing monastery of Dominican friars already existed there. In book 4, chapter 2 of *The Flowing Light of the Godhead*, Mechthild says that because of the "divine greeting" she received, and because she was continuously overwhelmed by divine grace, she had severed all bonds with her family and homeland and had left behind "everything that she could have" in order to lead the life of a Beguine, poor and abandoned in a "foreign city."[30] The Beguines of Magdeburg were under the direction of Dominicans. Further, a brief Latin and Middle High German introduction to *The Flowing Light* in Einsiedeln, Benediktinerstift, Cod. 277 remarks that Mechthild followed "the direction and teachings of the Dominicans completely for more that forty years" in a foreign place, that is, in Magdeburg, and says that "a friar of that same Order" (probably Henry of Halle) "collated and wrote down her book."[31] How much Mechthild was bound to the Dominican Order is evident in a series of chapters in books 3 and 4 of *The Flowing Light*, and in other places as well, where she praises St. Dominic, whom she revered. She knows that 4 August is the feastday of St. Dominic, whom she "loves above all saints" (4.20). Dominic is the model of her insatiable love-longing, which led her to "offer up her heart's blood beneath the feet of unbelieving heretics" (2.24). Elsewhere I shall investigate the degree to which her elaborate songs in praise of St. Dominic were inspired by the friars' oral transmission of texts composed by Jordan of Saxony.

Besides her devotion to the founder, Mechthild speaks often of the Order of Preachers, which she both praises and criticizes.[32] She praises the astonishing early success

of the followers of Dominic, for example, and she describes "sixteen things that God loves in the Order of Preachers" (4.21), but complains "how much of that has been lost!" (5.25) and compares the friars of her time unfavorably with their forebears: "Oh, you Preachers, how unwilling do you use your tongues now and how reluctantly do you turn your ears to the mouth of a sinner!" (3.1). She asks the Lord "to protect his own honor in this Order," and he promises her: "Yes, they will continue until the end of time. But new religious will come. They will be . . . wiser and mightier, . . . poorer in earthly needs and more fiery in the Holy Spirit because of the terrible need which will break upon the holy Church" (4.27).

Mechthild's relationship with the Order of Preachers is also documented in the fragments of a letter of consolation to her Brother Balduin (4.26) who had become sub-prior of the Dominican monastery at Halle through her influence. Moreover, her affinity with the Order is suggested by a fragmentary copy of *The Flowing Light of the Godhead* in Colmar, Bibliothèque de la Ville, Ms. 2137, which contains about one-third of Mechthild's book. The text begins with those chapters from books 3 and 4 in which Dominic and his Order are particularly discussed.[33] Finally, Mechthild's association with the history of the Dominican Order was assured by Dietrich of Apolda, who included portions of *The Flowing Light* in his *Vita S. Dominici*, completed in 1298 soon after Mechthild's death. Dietrich said that her writings bore testimony "ex verissima revelatione."[34]

THE MEANING OF CHRIST IN *THE FLOWING LIGHT OF THE GODHEAD*

In the *The Flowing Light of the Godhead*, Mechthild of Magdeburg reports mystical experiences for the first time in the German language. "Unity with God experienced sensually is the subject of the writings," states Klaus Grubmüller, who emphasizes Mechthild's forceful legitimation and passionate sense of her writing, which goes far beyond the "topos of the command to write."[35] As a compelled poet, Mechthild seeks to capture in verse the magic of heavenly music and the deepest joys of her meeting with God. Her extraordinary messages and way of transmitting them captivate many while irritating others. She clearly states the purpose of her writing in the beginning: "I am sending this book as a messenger to all spiritual persons, to the good as well as to the bad, because when the pillars fall, the building will not survive. It is published by me alone and reveals for glorification my secret (with God)."

Mechthild's highly personal love of God, experienced in all the senses, establishes her as someone who has been grasped totally by the Holy Trinity. In these terms, she describes, for example, the unity achieved in the sacramental reception of the Eucharist: "The Godhead unites itself with our soul, God's humanity with our body, in this way the Holy Spirit takes up a dwelling place in our faith" (6.8). In this description of the hidden process of sacramental union, she expresses not only the bodily experience of eating and the nourishment and strengthening acquired in the reception of Christ's Body itself, but also, under the image of indwelling, the spiritual reception of an ever more firm faith. Her sensitive expression also bespeaks the blessedness of mystical union with the trinitarian persons: "the playing sun of the living Godhead shines through the clear water of fortunate humanity, and the sweet delight of the Holy Spirit

... has overwhelmed me" (4.12). Concerning this process of transformation, Mechthild exclaims, "Lord, heavenly Father ... I have flowed out of your heart in a spiritual way. Lord Jesus, I was born from your side in a bodily way, ... through the Spirit of both of you I am purified," and she cries out in praise: "Lord, heavenly Father, you are my heart! Lord Jesus Christ, you are my body! Lord, Holy Spirit, you are my breath!" (5.6). This threefold action allows the intimacy and totality of the union to be experienced first-hand as life pulsating in the Trinity.

Mechthild subordinates her devotion to Christ to the Trinity, and never separates the one from the other. From "the high palaces of the Most Holy Trinity" Christ "has come down into this corrupted world."[36] Throughout her book, Mechthild characterizes the Son in various threefold terms and by various attributes and titles, some of which are conventional and others of which she herself devises: wisdom (twice), will, savior, truth, knowledge, chastity, sorrow (thrice), yearning, works, ever-recurring wealth.[37] Her increasingly emotional expressions are strengthened by verbal turns of phrase. The activities of the Son are expressed in terms of "greetings" (grace-filled forms of address), ecstasy, singing, pouring into, recognizing, glorifying, meriting, embracing. These terms express an intense, even "mystical" piety and devotion to Christ.

Mechthild's expressions of piety are intensified even more by color symbolism. Her threefold formulation, "the White-the Green-the clear sun" (4.3) seems to echo the richly developed color symbolism of Hildegard of Bingen, for whom "Green" signifies a specific spectrum of meaning.[38] As for Hildegard, so for Mechthild the color green represents the divine Word as the Logos of the Godhead, and as the most-potent principle and source of life that creates and penetrates everything. So the power of the Father is also included in the symbolic color green. Mechthild also represents Christ as the power of the Father under another image, as a giant. This image derives from the *gigas* of Psalm 18:6 and its traditional exegesis from Augustine onwards through the Middle Ages. For Hildegard of Bingen the Giant Christ, the *virtus Dei* and *vis divinitatis*, plays a commanding role as leader of the virtues against the vices.[39] For Mechthild, this image conveys a mystical meaning; her inextinguishable longing for love cannot of itself attain the power of the Giant Christ (2.25). In this usage she stands in the tradition of Bernard of Clairvaux.[40] The Bride runs after the Giant and wants to catch up, but she is not able to keep the pace. She cannot match his speed; she simply does not have the strength. She cannot follow Christ, who according to an ancient image she employs is the "leader of the dance," and because all the virtues of the elect are not sufficient for her, she says to Christ: "I cannot dance, Lord. Lead me then. For me to jump high you must jump first. Then I shall jump into love, and from love to knowledge, and from knowledge to delight, and from delight to go beyond all human senses. There I wish to remain and yet press on higher still" (1.44).[41] Only Christ as leader of the dance can lead the soul beyond its own limited possibilities.

In a discourse with Mechthild, Christ describes himself as the "noble, costly fragrant vessel: *here desemvas*" (1.31). Behind this encoded expression lies the traditional patristic and medieval image of Christ as the "original fragrance," used especially by commentators on the Song of Songs. In the exegetical and liturgical tradition deriving from pseudo-Dionysius the Areopagite, Christ is the "original fragrance," who in his

self-offering as incarnate Logos spreads wide the blessings of God. In this tradition, the image of Christ as "the noble fragrant vessel" refers to the self-revealing divinity of Christ. In his explanation of Cant. 1:2, Gregory the Great compares the divinity of Christ with a fragrant vessel, and says that "the fragrance of the scented oil is Christ's presence." The fragrance diffuses itself in the flowing forth and pouring out that occurs when God becomes man; only in the Incarnation is God made visible and knowable.[42]

In another discourse, God characterizes Christ as a fruit-bearing tree, which in Mechthild's trinitarian thought becomes the tree of life: "I bend the highest tree of the Holy Trinity down to you, and you pick the green, white and red apples of my luscious humanity, protected by the shade of the Holy Spirit from all earthly sorrow" (2.25). Each of the trinitarian persons is characterized precisely: the bending of the highest tree symbolizes the might of the Father, the breaking of the fruit and the green, white and red apples refer to the divine union with the humanity of Christ, which is protected in the shadow of the Holy Spirit, so that human nature may be able to bear the union. By the humanity of Christ the divinity adapts itself to human beings. In this image, the red of the apple, as well as the bending tree, alludes to the cross of Christ;[43] thus the holy nourishment provided by the God-Man Christ and union with him include his sufferings.

Mechthild's mystical expressions, which were known by Jordan of Saxony, are stamped with the language of the Song of Songs. The metaphor of wine is more strongly developed by Mechthild than by Jordan. Jordan, we shall remember, uses the image of the "unmixed chalice of eternal joy" to refer to the eschatological fulfillment of all human longing. Because of her great, immediate longing for unity with the Son of God, Mechthild adds another dimension in her treatment of the image of "unmixed wine." She desired only to follow Christ, the leader of the dance, in whose leading she discerned a new way of life. Exhausted by the dance and wishing to be refreshed, she turns to, and speaks with, her senses. These offer her refreshment, in the penitential tears of love of Mary Magdalen. The refusal by the soul sounds like a reproach: "Be silent, you lords! You do not know what I mean! Let me proceed unhindered. I want to drink a while from the unmixed wine" (1:44). The expression "unmixed wine" is unusual in commentaries on the Song of Songs. Mechthild's usage stands outside the tradition.[44] By this image, she expresses her longing for direct experience of God through Christ the Son. She describes this experience completely in the course of the chapter, and concludes following Rev 8:1: "Then a holy silence occurs, and it becomes the will of both of them." Both Jordan and Mechthild use the adjective "unmixed" to refer to the pure and holy union between God and man in Christ. But whereas Jordan refers the image of Christ as the "unmixed chalice of eternal joy" and the union it signifies to the life to come, Mechthild refers the image of Christ the "unmixed wine" to the union between God and man possible already in this life.

By another title Christ is called physician.[45] The motif of Christ as physician originates in the sacred Scriptures, where it applies to Christ especially as savior and redeemer. This meaning of the image is developed by the fathers and in the liturgy. To this traditional meaning, Mechthild adds for the first time a mystical sense, referring to the *unio mystica*. The soul, sick from love and yearning, receives its healing and

fulfillment only in union with Christ the physician (7.58). The reverse of the motif is found in book 3, chapter 2, where the Lord is love-sick for the soul and she must become his physician. Further, mystical union is also signified by Christ's activity of anointing with oil (2.25 and 3.2).

Mechthild applies yet another ancient title, "angel of great counsel," to Christ.[46] Like the image of Christ as the "costly fragrant vessel" (still invoked in the Litany of the Name of Jesus), this title signifies that Christ's purpose in becoming man is to be the revealer of God. Further, Mechthild designates Christ as the judge of the world: "Judgment is held in his hands."

Especially noteworthy is Mechthild's emphasis on the eternity of the Son. She apparently follows the tradition of the absolute Incarnation of Christ,[47] according to which God would have become Man even without the Fall, a position not universally held in her day. Mechthild's belief in the absolute sovereignty of love led her logically to this theological opinion, which understands the Incarnation as the outpouring of divine glory and love upon human beings created in the perfect image of God. Because the humanity of the Son "was without beginning in the eternal Godhead,"[48] and the Son "is the unoriginate wisdom of the uncreated God,"[49] the image of human beings is grounded in the eternal Son. In the dramatic dialogue of the *Consilium Trinitatis*, the eternal Son says to the Father before creation: "Let us make human beings like me, even though I foresee great lamentation, I will always have to love human beings." Theologically this means that human beings are connected with God from eternity. The idea of the *desiderium naturale*, of man's original and necessary longing for God, is rooted in this theological notion. In every hymn of praise of love, Mechthild's soul yearns "to love unto death, without measure or ceasing" (1.28), so that through the human Christ she may once more unite her longing to the divine Trinity. So she cries out to Christ: "Now send me the sweet rain of your humanity and the hot sun of your living divinity and the rich dew of the Holy Spirit."[50] Christ reveals to the soul its trinitarian form. In a dialogue Christ says to the soul, "O you image of my divinity, honored through my humanity, adorned with the holy Spirit,"[51] and he shows Mechthild the human face in the Trinity: "A spiritual image of my humanity is suspended without beginning in my eternal Godhead."[52] Christ calls one to imitate him in soul and body, for "the body receives its dignity from the Son";[53] thus the entire human person is required to give answer to Christ. As for Hildegard, so for Mechthild the body receives its own value through the Incarnation of God's Son.

For Mechthild the imitation of Christ consists above all in the sufferings of love for God, which she describes impressively through images of the Passion expressing a complete Passion-Mysticism in book 1, chapter 29 and book 3, chapter 10.[54] Concerning externally induced suffering, she teaches: "To the degree we suffer poverty, scorn, rejection and pain, to that same degree we resemble the true Son of God."[55] Mechthild claims this identification in the sense of Paul: "Such a man should be a Christ in himself, so that he lives in God and not in himself."[56]

I have not been able to treat every aspect of Mechthild of Magdeburg's mystical love of Christ in this essay. Suffice it to say that the many discourses of the Lord interspersed through *The Flowing Light of the Godhead* attest to the central importance of Christ within the context of Mechthild's trinitarian belief.[57]

NOTES

1. H. C. Scheeben, "Der Literarische Nachlass Jordans von Sachsen," *Historisches Jahrbuch der Görresgesellschaft* 52 (1932): 56–71; *Jordan der Sachse* (Leipzig, 1937); *Beiträge zur Geschichte Jordans von Sachsen* (QF 35, Leipzig, 1938). See also *Deutsche Mystikerbriefe des Mittelalters 1100–1550*, ed. Wilhelm Oehl (Darmstadt, 1931; reprt. 1972), 152–86 (with translations of selected literary texts); André Duval, "Jourdain de Saxe (bienheureux)," DS 8 (1974): 1420–23; Kaeppeli, *Scriptores* 3: 53–55.

2. Regarding Diana d'Andalo see André Duval, "Diane d'Andalo (bienhereuse)," DS 3 (1957): 853–55; M. G. Gambria, *Diana degli Andalo* (Bologna, 1972).

3. *Deutsche Mystikerbriefe*, ed. Oehl, 155.

4. Ibid.

5. *Die Briefe Jordans von Sachsen des zweiten Dominikanergenerals (1222–1237): Texte und Untersuchungen*, ed. with German translations by Berthold Altaner (Leipzig, 1925); A. Walz, *Beati Jordani de Saxonia Epistulae* (Rome, 1951); Regine Pernoud, "Amities spirituelles: Les lettres de Jourdain de Saxe a Diane d'Andalo," *La Vie Spirituelle* 61 (1979): 817–30. Unless I indicate otherwise, I cite Jordan's letters from the edition and translation of Altaner.

6. Winfried Zeller, *Theologie und Frömmigkeit. Gesammelte Aufsätze*, ed. Bernd Jaspert (Marburg, 1971), 17 (with regard to the understanding of Christ in the Middle Ages).

7. *Ep.* 48 (ed. Altaner, 49, lin. 6–10); cf., Gilles Emery O.P., "Amitié et vie spirituelle: Jourdain de Saxe et Diane d'Andalo," *Sources* 18 (1992): 97–108.

8. *Ep.* 52 (ed. Altaner, 53, lin. 34,-54, lin. 5).

9. Ibid. (54, lin. 6f.).

10. *Ep.* 34 (ed. Altaner, 38, lin. 17).

11. *Ep.* 51 (ed. Altaner, 53, lin. 1–7).

12. Ibid. (53, lin. 8–10).

13. Ibid. (53, lin. 19–21).

14. *Ep.* 22 (ed. Altaner, 25, lin. 31–33).

15. *Ep.* 36 (ed. Altaner, 29, lin. 34f.).

16. *Ep.* 23 (ed. Altaner, 27, lin. 1).

17. Ibid. (33, lin. 1–16).

18. *Ep.* 17 (ed. Altaner, 21, lin. 7–16).

19. Ibid. (21, lin. 22–24).

20. Ibid. (21, lin. 31f.).

21. Ibid. (21, lin. 33f.).

22. Ibid. (22, lin. 5–10).

23. *Ep.* 15 (ed. Altaner, 18, lin. 18).

24. *Ep.* 15 (ed. Altaner, 18 lin. 20–29); J. R. Bouchet, "Le Christ 'livre de vie': La dévotion au Crucifié chez les premiers Precheurs," *La Vie Spirituelle* 67 (1987): 126–35.

25. *Ep.* 15 (ed. Altaner, 19, lin. 7–9).

26. Markus Enders, *Das mystische Wissen bei Heinrich Seuse* (Veröffentlichungen des Grabmann-Institutes N.F. 37, Paderborn, 1993); see the subject index. Cf., Philipp Kaiser, "Die Christozentrik in der Philosophia spiritualis Heinrich Seuses" in *Heinrich Seuses Philosophia spiritualis. Quellen, Konzept, Formen und Rezeption*, ed. Rüdiger Blumrich and Philipp Kaiser (Wiesbaden, 1994), 112f.

27. *Ep.* 13 (ed. Altaner, 16, lin. 36,-17, lin. 22). This translation follows Altaner, 124f.

28. Altaner, 117; Engelbert Krebs, "Jordan von Sachsen," VL 5 (1955): 480–85, esp. 481 (Lit.); Dieter Berg, VL2 4 (1982): 861–64 (Lit.); Kaeppeli and Panella, *Scriptores* 4: 482f.

29. Joseph Mothou, O.P., *Das Leben des seligen Jordanus von Sachsen*, trans. from the French (Dülman b. Münster, 1984), 43f., and Appendix 1, 308–25, offers an overview of the spread of the Order, which had been divided into twelve provinces by the time of Jordan's death. For the German province, scc 318–20. The province was founded under the name Teutonia at the General Chapter of 1222. At that time it consisted of only one monastery, at Friesach, but by the time of Jordan's death it comprised twenty-five monasteries. By the end of the thirteenth century, there were approximately 100 monasteries for men and 75 for women.

30. Hans Neumann, "Beiträge zur Textgeschichte des 'Fliessenden Lichts der Gottheit' und zur Lebensgeschichte Mechthilds von Magdeburg," *Nachrichten der Akademie der Wissenschaften in Göttingen* (phil. histor. Klasse 1954 n° 3, Göttingen, 1954), 27–80. For an abbreviated and clear version, see

Altdeutsche und altniederländische Mystik, ed. Kurt Ruh (Darmstadt, 1964), 213. For Mechthild 4.2, compare the text in Hans Neumann, *Mechthild von Magdeburg "Das fliessende Licht der Gottheit" nach der Einsiedler Handschrift im kritischen Vergleich mit der gesamten Überlieferung. I: Text,* ed. Gisela Vollmann-Profe (Munich, 1990), 109–10, and the new translation with introduction and commentary by Margot Schmidt, *Mechthild von Magdeburg. Das fliessende Licht der Gottheit 2* (MyGG I/11, Stuttgart, 1995), 119–20. Hereafter I cite the text and translation of Neumann simply as 'Neumann'. A new English translation of the text, with an introduction by Frank Tobin and preface by Margot Schmidt, is forthcoming (Paulist Press, New York, 1998).

31. Neumann 1: 1, lin. 4–8, 36–39; *Das fliessende Licht* (trans. Schmidt, 5, lin. 8–13, and 6, lin. 11–16). With regard to Neumann's cautious judgment as to whether Henry of Halle was actually the redactor of Mechthild's book, see his "Beiträge zur Textgeschichte," 193, 227.

32. For Dominic, see Schmidt, trans., *Das fliessende Licht,* Register, 425. For the Order of Preachers in general, see Mechthild of Magdeburg, *Das fliessende Licht* 3.1 (trans. Schmidt, 80, lin. 15–37); 4.21 (149–50), 4.22 (150, lin. 7,-152, lin. 2), 4.26–27 (154, lin. 16,-161, lin. 1—the end of the Order of Preachers). See also Marianne Heimbach, *"Der ungelehrte Mund" als Autorität. Mystische Erfahrung als Quelle kirchliche-prophetischer Rede im Werk Mechthilds von Magdeburg* (MyGG I/6, 1989), 133–41.

33. Neumann 1: xv and 2: 235.

34. AA.SS 35: (4 August) 558–628; Schmidt, trans., *Das fliessende Licht,* xv; Kurt Ruh, *Geschichte der abendländischen Mystik* 2 (Munich, 1993): 290.

35. Klaus Grubmüller, "Sprechen und Schreiben. Das Beispiel Mechthilds von Magdeburg," in vol. 1 of *Festschrift Walter Haug und Burghart Wachinger,* ed. J. Janota et al. (Tübingen, 1992), 337, 339.

36. *Das fliessende Licht* 6 (trans. Schmidt, 213, lin. 16f.).

37. See Schmidt's introduction to *Das fliessende Licht,* xxxif., with complete references and citations.

38. With regard to the subsequent use of the color "green" see Heinrich Schipperges, *Hildegard von Bingen, Heilkunde, Das Buch von dem Grund und Wesen und der Heiling der Krankheiten* (Salzburg, 1957), 301–10. With regard to colors in general and "green" in particular, see Christel Meier, "Die Bedeutung der Farben im Werk Hildegards von Bingen," *Frühmittelalterliche Studien* 6 (1972): 245–355; Christel Meier and Rudolf Suntrup, *Lexikon der Farbendeutungen im Mittelalter* (Cologne etc., 1998). For a cultural-historical perspective, see John Gage, *Color and Culture. Practice and Meaning from Antiquity to Abstraction* (Boston, 1993).

39. Christel Meier, "Eriugena im Nonnenkloster? Überlegungen zum Verhältnis von Prophetentum und Werkgestalt in den *figmenta prophetica* Hildegards von Bingen," *Frühmittelalterliche Studien* 19 (1985): 488 (and n. 80).

40. Bernard of Clairvaux, *Super Cantica in Cant.* Sermo 21 n° 9; see Schmidt, trans., *Das fliessende Licht,* 363 n. 88. Bruno Herbipolensis and Cassidorus also expound the giant of Psalm 18:6 as Christ, who by the greatness of his power overwhelms human nature.

41. Schmidt, trans., *Das fliessende Licht,* 353f. (n. 36 for sources).

42. Ibid., 359 n. 28 (citations).

43. Ibid., 364 n. 92.

44. Ibid., 354 n. 38.

45. Ibid., 397–400 and n. 296.

46. Ibid., 378 n. 154.

47. Ibid., 376f., 393, 396 (see nn. 152, 258, 283).

48. Mechthild of Magdeburg, *Das fliessende Licht* 6.24 (trans. Schmidt, 244, lin. 47).

49. Ibid. 4.14 (140, lin. 9f.).

50. Ibid. 4.5 (131, lin. 12–14).

51. Ibid. 1.41 (29, lin. 1–5).

52. Ibid. 6.24 (224, lin. 30); cf. 6.16 (236–37, lin. 2).

53. Ibid. 6.31 (249, lin. 32).

54. See Margot Schmidt, " 'Frau Pein, Ihr seid mein nächstes Kleid'. Zur Leidensmystik im 'Fliessenden Licht der Gottheit' der Mechthild von Magdeburg," in *Die dunkle Nacht der Sinne. Leiderfahrungen und christliche Mystik,* ed. Gotthard Fuchs (Düsseldorf, 1989), 63–107.

55. *Das fliessende Licht* 6.32 (trans. Schmidt, 250, lin. 26–34).

56. Ibid. 6.4 (221, lin. 16–18).

57. I wish to thank Professor Leonard Hindsley, O.P., of Providence College for his translation of my German text, and Professor Kent Emery, Jr. for his careful editing of the English text.

The History of Christ in Vincent of Beauvais' *Speculum historiale*

Monique Paulmier-Foucart and Alain Nadeau

A COMPREHENSIVE UNDERSTANDING of the epistemological status of the history of Christ in the *Speculum historiale* can hardly be achieved without first introducing the general project pursued by Vincent of Beauvais in his *Speculum maius*.[1] Made up of three individual works, titled *Speculum historiale, Speculum naturale* and *Speculum doctrinale*, the *Speculum maius* is an immense compilation put together by a professor, or *lector*, for the benefit of his fellow Dominican friars. If the *Speculum maius* indeed achieved a measure of success within Vincent's Order, it was also read and adopted in monastic milieux, for example in the Cistercian abbey of Royaumont, where, from 1246 onwards, Vincent held the position of *lector*, and where he met King Louis IX and became one of his familiars. The *Speculum maius* was later popular among the nobility and the educated bourgeoisie.[2]

The *Speculum maius* is a didactic work; it is not an "encyclopedia." Not unlike numerous similar contemporary works—many of which were written by other Dominicans—the *Speculum maius* is more adequately described by the term *Summa*. It strives to collect all the material a Dominican teacher might ever need in the accomplishment of his duties as lecturer in a convent. The extent to which Vincent's *opus* actually served that particular purpose is still uncertain, but the *Speculum maius* was certainly brought into existence as an immense *florilegium*, the purpose of which was to embrace all the literature, didactic or otherwise, a competent lecturer would need. It is, in a word, a portable library holding all the material necessary for the adequate instruction of the *fratres communes*.[3]

It is therefore inappropriate to chastise the work (as many have) for its intellectual indigence, for being but an overly conservative compilation, and for having failed to reverberate the intellectual debates taking place at Saint-Jacques in Paris. The purpose of the *Speculum maius* is of a completely different nature (although it does, in many respects, manifest the spirit of *novitas* current at the University of Paris): it embodies in book-form the intellectual program laid out by the Dominican Order in its Constitutions and Chapters. These repeatedly maintain—as does, for example, the chapter *De officio lectoris* in Humbert of Romans' *De officiis ordinis*—that only such teachings that are widely recognized and approved may be dispensed to the Friars.[4] This principle is clearly set out by the General Chapter held at Bologna in 1244: "Monemus lectores quod novas opiniones non inveniant sed communiores et magis approbatas sequantur."[5] The intellectual project underpinning the *Speculum maius* is a response to this mandate; Vincent's "Summa"—the *Speculum historiale* in particular—is a repository of common knowledge. Only in this context may one properly understand the whole enterprise.

In this study we shall first attempt to describe in quantitative terms the space occupied by the history of Christ in the *Speculum historiale*. This will be followed by a qualitative examination of the material and its sources. In conclusion, we shall propose what might be termed the "specificity" of Vincent's discourse on the historic persona of Christ. A theological examination of this material is beyond our competence, and we shall not attempt such here. A few random tallies allow us at least to suggest that, *a priori*, Vincent's text appears to reflect contemporary traditional views, in line with Peter Lombard's *Sententiae* and William of Auxerre's *Summa aurea*.

A QUANTITATIVE APPROACH

Vincent and his brothers started compiling the *Speculum historiale* in the early 1240s. A first version was completed in 1244, and subsequently presented to King Louis IX. The text was afterwards continually modified, and remained a work in progress until 1254, when the last version was completed. The overwhelming majority of manuscript copies of the *Historiale* bears witness to this ultimate reworking; this is also the version used in the Douai edition of 1624,[6] the edition most commonly used by scholars. Among these various versions the story of Christ, however, remains unchanged.

As with other parts of the *Speculum maius*, the *Historiale* is divided in books (31 in all) and chapters (more than one hundred in each book). It describes man's journey on earth from the Creation to the Last Judgment. It is at once a universal chronicle, an ecclesiastical history, and, as suggested earlier, a *Summa*; it combines historiographical texts—in the strictest sense of the word—with a large collection of hagiographical material, together with important *florilegia* of classical, patristic and medieval authors. Regardless of the multitude of literary genres comprised in such a work, one would logically expect that the story of Christ, his birth, public life, Passion and Resurrection, would constitute a major milestone in the internal organization of historical material. This is not, however, the case. As we shall see, the chronological elements structuring the arrangement of books rest on the sequence of historical empires, as well as on the history of the Jewish people.[7] Far from making up one whole textual aggregate, the life of Christ is partitioned out between books 6 and 7, and organized in the following way:

LIBER VI

cap. 1 sq.	Res publica romana. Julius Caesar.
cap. 6 sq.	Flores Tullii; historia romana et judaea; flores . . .
cap. 62–63	Flores Virgilii
cap. 64–66	Maria virgo
cap. 67–70	Flores Horatii
cap. 71	Pax romana
cap. 72–77	Maria et Josephus/ Joachim et Anna
cap. 78–84	Theological treatise *De incarnatione*
cap. 85–95 et 103–4	Birth and Childhood of Christ
cap. 96–104	Historia judaea/ Historia Christi
cap. 105	Historia romana

| cap. 106–122 | Flores Ovidii |
| cap. 124–129 | Flores Valerii Maximi |

LIBER VII

cap. 1–6	Historia romana et judaea
cap. 7–64	Historia Christi (usque ad Ascensionem), with two theological sections, c. 14–17 and 51–52
cap. 65 sq.	Ecclesia apostolica
cap. 75–80	Assumptio Virginis
cap. 81–121	Miracula Virginis
cap. 122–136	Historia romana

Book 6 begins with a narration of events in the Roman empire since the death of Julius Caesar, followed by a retrospective account of the history of Rome since its foundation. Then follow *florilegia* of Cicero and Virgil, a note on the Virgin Mary's birth, and a *florilegium* of Horace. These various textual segments take the reader to chapter 71, titled "De triumphis Romanorum et pacatione orbis sub Augusto." This historiographical section establishes the political conditions of the Incarnation—the *pax romana*[8]—and may therefore be seen as the beginning of the story of Christ. The narrative thereafter covers the conception of John the Baptist, the Annunciation and, in chapter 78, the Incarnation, which marks the actual beginning of the earthly life of Christ. This momentous event is introduced by a short treatise on the Incarnation, followed by the birth of Christ, a long digression on the history of the Jews (Herod, etc.), Jesus among the wise men (chapter 104), and the death of Augustus. Two important *florilegia* of Ovid and Valerius Maximus conclude book 6.

The life of Christ is thus set within the continuum of imperial history and bound by *florilegia* from major pagan Latin poets and moralists. We may also notice that a rather lengthy history of the Virgin Mary acts as a prologue to the history of Christ. We will see later that the Virgin Mary plays an eminent role in the *Speculum historiale*.

Book 7 opens as expected with Roman imperial history: "De imperio Tiberii Caesaris et bonis eius initiis . . . et cetera." This takes the reader to chapter 7, where the preaching of John the Baptist and the baptism of Christ are described. The next 57 chapters present the entire history of the Lord, up until the Ascension, the physical disappearance of Christ. Book 7 carries on with a few chapters on the beginnings of the Christian Church, followed by the Assumption of Mary (chapters 75 to 80). The remainder of the book is almost exclusively taken up with the miracles of the Virgin (chapters 81 to 121), all of which add up to a total of 47 chapters dedicated to Mary. Book 7 ends with a description of historical events leading up to the death of the Emperor Caligula.

Set once again between the bounds of imperial history, book 7 exhibits two dominant textual segments of nearly equal quantitative importance: on the one hand, the public life of Christ, his death and Resurrection; on the other hand, the life, death and miracles of the Virgin.[9]

We are well aware of the limited meaningfulness of such quantitative approaches. We believe, however, that in this particular instance, the following observations are not insignificant. In the *Historiale,* a major portion of the narrative is taken up with a description of the earthly life of Christ. This does not altogether come as a surprise, but we will see in a moment that this was far from being the rule among medieval historiographers. The *Historiale,* furthermore, allocates to the Virgin Mary as much material as it does to her son. We suggest that this reciprocity mirrors the spirituality of the common folk; while the intended readers of the *Speculum maius* were Dominican preachers, it was the common people, the friar's audience, who were the ultimate recipients of its contents. We shall later return to this observation concerning the influence of popular spirituality.

THE STORY OF CHRIST IN TWO UNIVERSAL CHRONICLES, AND IN AN *HISTORIA ECCLESIASTICA*

The story of Christ comprises around one hundred chapters. This is the near equivalent of one whole book of the *Historiale.* How does this compare with universal chronicles written in the first half of the thirteenth century? For the sake of such a comparison we will refer to two contemporary works, one Cistercian, the other from the Order of Prémontré. They are both quite extensive, albeit far from approaching the size of the *Speculum historiale.*

The Cistercian monk Aubri of Troisfontaines wrote his chronicle between the years 1227 and 1241. He grants only a few lines to the life of Christ and is evidently strictly concerned with matters of chronology, in particular with the problem of getting the prophecies of Daniel to agree with the chronological data in Eusebius and the pagan Greek and Latin historians. This he fails to achieve, and concludes with a call to the reader: "Should anyone with the help of God have a better solution, it will be welcomed."[10] Vincent, to be sure, is also concerned with the issue of chronological concordance. Accordingly, he dedicates one chapter to the matter (*Historiale,* book 6, chapter 88: "De chronicis ab initio mundi usque ad illud tempus"), in which he discusses the disagreements between the short Jewish chronology followed by Jerome, and the long chronology of the Septuagint, favored by Bede.[11] This notwithstanding, the discussion on chronology takes up but a comparatively modest place in the account of the history of Christ. On the other hand, it must be said that a comparison between Vincent's and Aubri's texts is not altogether well-founded, since the latter's coverage of the whole period before the time of Saint Benedict is extremely superficial. The case in point does however remain true: Aubri of Troisfontaines is mute as far as the childhood, the public life and the Passion of Christ are concerned. His chronicle is first and foremost the work of a chronologist; as such, the Incarnation and the Resurrection are only alluded to as they happen in the unfolding of time, and solely for their chronological relevance.[12]

Robert of Auxerre, from the Order of Prémontré, wrote his chronicle between the end of the twelfth century and the year 1211.[13] His approach is somewhat different from that of Aubri, but he too lacks Vincent's thoroughness. Robert dedicates barely a

few lines of his chronicle to the birth of Christ, the flight to Egypt, John the Baptist, the baptism of Jesus, the apostles, the Passion, and the various historical testimonies concerning Jesus (the *Testimonium flavianum*, to which, incidentally, Vincent also refers). All this is swiftly dispatched, and occupies scarcely more than two or three columns of text,[14] while the entire chronicle covers more than two hundred pages!

These two examples are eloquent witnesses of how, as a genre, universal chronicles need not make allowance for every discursive element linked to the life of Christ. Might one not then suppose that, in this particular instance, Vincent borrowed his model from an "historia ecclesiastica," for instance from the chronicle of Hugh of Fleury (completed in 1110), from which he otherwise regularly borrows? As interesting as this hypothesis might be, it is in fact inaccurate: the chapters of the *Speculum historiale* under examination scarcely mention Hugh of Fleury at all, nor do they make much use of the great Eusebius of Caesarea. This is not unexpected. Hugh of Fleury grants merely a passing glance at the history of Christ, with a short note roughly the size of Robert of Auxerre's, a straightforward observation carefully situated amidst the few major historical events that took place during the years of the Incarnation.[15] Vincent of Beauvais' lengthy treatment might therefore represent a distinctive feature of the historiographical discourse proposed by this Dominican *lector et compilator*.

Perhaps another text is the true model used by Vincent in his history of Christ: Peter Comestor's *Historia scholastica*, one of the major sources of the *Historiale*. This is certainly more conceivable, as an examination of the precise relationship between the two works will show.

«Actor» and «Comestor»

Throughout the one hundred chapters of the *Historiale* dedicated to the story of Christ, Vincent of Beauvais is constantly at pains to disclose the sources from which he quotes. Therein lies the fundamental quality of his work as a compiler.[16] Of his many sources, two are more frequently called upon than all the rest: *Actor*, adduced more than fifty times, and Peter Comestor, Vincent's source in more than sixty instances.

As Vincent declares in the *Libellus apologeticus*, he himself is *Actor*: "I have put under my name what I have learned from my masters, the doctors of our day, or what I have found of interest in a number of anonymous works."[17] Among the chapters dedicated to the story of Christ, passages attributed to *Actor* come in two different genres: they either form extensive treatises, or are but one textual element amid a number of sources, often intertwined with excerpts from Peter Comestor.

Although we shall not examine here the theological significance of the two treatises by *Actor*, we shall attempt to evaluate the significance of their presence amidst the historical narrative. It appears that *Actor*'s interventions serve the purpose of declaring the theological status of a particular historical event before its actual sequential description. The two treatises are in fact closely linked to two earlier works by Vincent of Beauvais. The first one is a short exposé on the Lord's Prayer (book 7, chapters 15–17), and is taken from Vincent's *De oratione dominica*.[18] In the prologue to this modest work, Vincent writes: "I, the lowest among Friars Preachers, thought it would be useful

to explain the deeper significance of the Lord's Prayer for the benefit of those among the faithful who, while they pronounce the words, have no complete understanding of their meaning."[19] The anticipated readers of the work are obviously not the faithful themselves, but Vincent's own Dominican brothers, who in turn will transmit their learning through preaching. Vincent clearly wants his written works to act as mediators between the learning of the friars and popular culture. The other treatise by *Actor* included in the story of Christ—on the Incarnation (book 6, chapters 78–84, and book 7, chapters 51–52)—although closely related to the subject-matter of Vincent's *Liber gratiae redemptoris*,[20] is not directly copied from it, as was the case with the previous treatise. Whereas the *Liber gratiae* is a collection of patristic excerpts assembled together within thematic chapters, the treatise on the Incarnation in the *Speculum historiale* is a genuine scholastic tractate, a true theological synthesis, derived directly from book 3 of Peter Lombard's *Sententiae*. It is true that some patristic excerpts from the *Liber gratiae* made their way into the *Historiale*,[21] but only within the historical discourse, that is, not within the treatise we are presently examining. Even with this taken into account, major differences exist between the two works in the presentation of identical subject matter,[22] as if each work had been drafted with a specific audience in mind. On the one hand, Vincent assembles an aggregate of authoritative excerpts, and on the other he compiles a collection seemingly aimed at assisting preachers, one which appears to reflect the audience's expectations. Another difference is that, whereas the *Liber gratiae* never makes use of apocryphal literature, the *Historiale* does, as we shall see presently. One should note that the two-part treatise on the Incarnation (a first part is inserted at the birth of Christ, and the second upon the Resurrection) testifies to the hierarchical organization of the *Historiale*'s discourse. The historical narrative is introduced and followed by theological essays, the role of which is to elucidate the context of the forthcoming events, and to reaffirm in closing their theological significance. Vincent's treatise bears exemplary testimony to a Dominican historian's activity: to ponder the course of history under the light of theological truth.

Besides the various issues pertaining to the two treatises, the passages by *Actor* pose the question of the exact relationship between Vincent of Beauvais and Peter Comestor. The *Historia scholastica* is a "history" only in a very specific sense. It is first and foremost a literal commentary of Scriptures, harking back to Hugh of Saint-Victor's recommendations concerning the study of the Bible. Hugh considered such a literal reading a fundamental requirement to an adequate understanding of the sacred texts: "Sic nimirum in doctrina fieri oportet, ut videlicet prius historiam discas et rerum gestarum veritatem a principio repetens usque ad finem quid gestum sit, quando gestum sit, ubi gestum sit, et a quibus gestum sit, diligenter memoriae commendes. . . ."[23]

More often than not, the passages by *Actor* found in the *Speculum historiale* are little more than a much condensed abridgment of Comestor, sometimes reduced to a mere register of historical events. This is precisely the case with the passages describing the public life of Christ, in which large excerpts from the *Historia scolastica* are always correctly ascribed to Comestor, whereas abridged elements are introduced un-

der the name of *Actor*. These particular passages by *Actor* exhibit the additional and distinctive feature of being supplemented with ancillary patristic material (already present in the *Liber gratiae*[24]) as well as, interestingly enough, with excerpts from the *Glossa ordinaria*. This technique is used for instance in book 7, chapter 8 of the *Historiale* (on the Baptism of Christ), in which the string of authorities consists of Comestor/*Actor*/Comestor; in this passage by *Actor*, three quotations are adduced from the *Glossa*: "Dicit Glosa quod. . . ," "Sed dicit Glosa. . . ," "Dicit Glosa . . . "[25] Comestor's yarn is evidently insufficient to Vincent, and consequently his treatment of the *Historia scholastica* often modifies its status as a strictly historical commentary by introducing allegorical and moral meanings.

Indeed, in the early thirteenth century, the curriculum of any master of theology included readings and comments from the *Historia scholastica*. Dominican constitutions point out that Comestor's work is one of three books—together with Peter Lombard's *Sententiae* and the *Glossa*—the friars were required to have at their disposal.[26] Hugh of Saint-Cher wrote a commentary of the *Historia scholastica*,[27] although he was among the last masters to have done so. In 1223, William of Auvergne observed that nowadays many students show little interest in studying Comestor's *Historia*: "Quidam enim contenti sunt vel initialia sacre scripture audisse sicut Historias aut aliaqua alia. Alii vero negligunt."[28] Vincent's intensive use of Peter Comestor would seem to indicate that his primary intention was to provide a basic introductory work. His very conventional presentation, as we just remarked, is firmly secured on Comestor's manual, and completed with patristic quotations and excerpts from the *Glossa*. Vincent avoids any unhealthy speculation or new-fashioned idea, in precise accordance with the Order's recommendations.[29]

Vincent of Beauvais' personal interventions as *Actor*, together with Peter Comestor's decisive role as pivotal *auctoritas*, constitute the backbone of the *Speculum historiale*'s presentation of the Life of Christ. A further quantitative examination of the text will allow us to refine these first formal conclusions. If we divide the Life of Christ into three major chronological periods, and examine how these three segments are treated quantitatively in Peter Comestor and Vincent of Beauvais, we obtain the following results:

	Comestor	Vincent of Beauvais
From the Annunciation to the Baptism of Jesus	8%	21%
Public life of Jesus, up to the condemnation by the Pharisees	50%	22%
From the entrance into Jerusalem to the Ascension	25%	28%
Other themes ("Treatises" in the *Hist.*; historical chapters in Comestor)	17%	29%

The disparities are obvious. Vincent of Beauvais devotes a larger proportion of his treatment to Jesus' birth and childhood, while displaying a more moderate interest in his public life. The *Speculum historiale* evidently is not conceived as a repository of

Christ's *gesta et dicta*. Moreover, many chapter-titles suggest further that, in this particular instance, Vincent simply wishes to call the facts to mind:

7 c.11 **De ordine hystorie** abhinc usque ad incarcerationem Iohannis.

7 c.18 **De ordine hystorie** post sermonem domini ad questionem Iohannis.

7 c.21 **De ordine hystorie** post questionem Iohannis usque ad eius decollationem.

7 c.24 **Hystorie series** post Iohannis decollationem usque ad Domini transfigurationem.

7 c.25 **Ordo hystorie** abhinc usque ad scenopegiam.

7 c.26 **A** scenopegia **usque ad** encenia.

While these chapters offer highly abridged versions of Comestor's *Historia*,[30] it is interesting to note that the structuring element, as disclosed by the chapter-headings, appears to be the story of John the Baptist, the preacher *par excellence* who recognized and announced the Messiah.

The *Speculum historiale*'s account of Christ's public life, if tightly condensed, at times displays a distinctive interest in a number of particular events: the *vocatio apostolorum et discipulorum*, for instance, or the Sermon on the Mount and the Lord's Prayer, as well as the resurrection of Lazarus. It is precisely in the narration of this last event that Vincent introduces a substantial excerpt from a sermon by Peter of Ravenna,[31] wherein is narrated Christ's descent into Hell to retrieve the soul of Lazarus. This motif thereafter becomes a central discursive element; let us recall that only thirty years earlier, the fourth Lateran Council (1215) had given its canonical confirmation to the Descent to Hell.

The third part of the Life of Christ—the events of Holy-week and the time leading up to the ascension of Christ—is presented, quantitatively, in a similar manner in both the *Historia scholastica* and the *Speculum historiale* (respectively 25% and 28% of the text). Qualitatively, however, the two works betray profound differences. By introducing the apocryphal correspondence between John and King Abgar of Edessa,[32] Vincent emphasizes the events following the death of Christ: the descent into Hell and the redeeming of souls. The apocryphal Gospel of Nicodemus is here a leading source.

THE PLACE OF APOCRYPHAL LITERATURE

In our examination of Vincent of Beauvais' use of apocrypha we mean of course the texts he himself knew to be apocryphal. The history of the birth of Christ, as narrated by Vincent, is in this regard exemplary. His account is not taken from Luke but from the Gospel of James, son of Joseph (known as the pseudo-Gospel of Matthew), a text probably compiled in the ninth century by Paschasius Radbertus from the proto-Gospel of James.[33] It narrates how Mary and Joseph on their way to Bethlehem were stopped by a vision, and how Mary thereafter entered an illuminated grotto in which she gave birth to her son. She left the grotto three days later, and arrived in Bethlehem where she laid the child between the ox and the ass.[34] Vincent returns at this point to Peter Comestor, who does not directly use apocryphal material concerning the child-

hood of Christ, but who does refer to painted scenes from these gospels found in many churches, which, he says, "are like books to the common people."[35]

Vincent afterwards follows this same "Gospel of James, son of Joseph," in describing the flight to Egypt.[36] Another apocryphal Gospel, that of Nicodemus, is put to use in describing events leading up to and following the Crucifixion and Resurrection of Christ, as well as the descent into Hell.[37] Vincent of Beauvais uses apocrypha to introduce and conclude his relation of Jesus' life on earth. One may understand such passages as counterweights to the theological chapters described above. The internal structure would therefore be:

- Theological presentation of the Incarnation
- Popular account of the birth and childhood
- Historical/biblical narrative (from Comestor)
- Theological epilogue on the Incarnation
- Popular account of the Resurrection

Any attempt at understanding Vincent of Beauvais' intensive use of apocryphal literature must take the following into account. First of all, Vincent readily admits in the *Libellus apologeticus* that he grants much value to apocryphal texts. In a chapter titled *Apologia de Apocryphis* (chapter 9), he writes that *Apocrypha* are like pagan books: they have no authority for the Christian Church, but, nevertheless, even sacred authors have sometimes made use of them (Paul and Jude, for instance). One may read them and believe what they say as long as they do not disagree with Catholic faith. Some among them are indeed heretical, and they must be destroyed, but some say nothing but the truth, and they are acceptable: "licet veritatem puram contineant." Vincent goes on to provide a list of such texts, all of which he has used in the *Speculum historiale.* His model is Jerome, who, in his book on the Assumption of the Virgin (which we know now to be spuriously attributed to him), recounts how, as a young man, he had enjoyed reading the stories on the childhood of Mary and Jesus.[38] One may readily believe that Vincent had heard these stories as well, just as he saw their visual depiction in the ornamentation of so many medieval churches. Apocrypha they may have been, but these highly popular tales unquestionably belonged to contemporary popular culture.

On the other hand, Vincent includes in the *Libellus apologeticus* a transcription of pseudo-Gelasius' eminently harsh decree sentencing to Hell all readers of such texts, although he distances himself somewhat from the letter of the decree: "I insert here the *Decretum Gelasii* so that the reader may easily distinguish between authentic and apocryphal writings; in accordance with his reason (*rationis arbitrio*) he may thereafter decide what he does and does not wish to read."[39]

Vincent returns to this topic in the *Speculum historiale* itself, where, having just presented the story of the Assumption of Mary, he comments: "Quid de praefata historia sentire liceret?" He then observes, more explicitly than in the *Libellus apologeticus,* that "this story, to be sure, is apocryphal, but, still, it is both devout and useful (*pia ad credendum et utilis ad legendum*)."[40] In a similar manner, Hugh of Saint-Cher's opinion on apocrypha, to take an example from among Vincent's Dominican brethren, was not wholly unfavorable; in the prologue to his *Postilla* on the Gospels he

asks: "Why should we accept some gospels and reject others?" to which he does not specifically reply, saying only that the four canonical Gospels follow the history more closely, but stopping short of formally condemning apocrypha.[41] In his *Legenda aurea*, James of Voragine also employs apocrypha; he writes at one point: «this story was taken from an apocryphal story; we leave it to the reader to decide whether he should read it out (*recitare*)."[42] That is precisely Vincent of Beauvais' opinion on the matter: his task as a compiler is to present his fellow Dominicans with a complete dossier. It is up to the Dominican brother, using his own reason and sense of necessity, to decide, depending on the circumstances, whether a particular portion of text should or should not be used.

RECAPITULATION AND CONCLUSION

Among contemporary works of historiography (that is, universal chronicles), the *Speculum historiale* is unique in its markedly broad treatment of the humanity and temporality of Christ. Neither the Cistercian Aubri of Troisfontaines nor the Prémontré canon Robert of Auxerre shows a particular interest in the earthly history of Christ. Their concern is that of chronologists: they strive to establish accurately the historical event of the Incarnation in the chronology of mankind. This having been done, the event thereafter plays no part in the chronological organization of their narratives.

Vincent of Beauvais' account includes vast borrowings from Peter Comestor's *Historia scholastica*; as we have said, this accords well with the Victorine atmosphere still pervading the *Speculum maius*. On second thought, however, the goal pursued by the Victorine *Histories*—to open up, by way of literal exposition, all other inroads to the Scriptures[43]—no longer fits the *Historiale*. Vincent's historical *Summa* does not claim such an epistemological status. Its sole aspiration is to hold, classify and remember these various scriptural events. It clears the way for a new and different reading of Scripture, one which the Dominican friars were called upon to preach and promote.

For want of a better, less hackneyed word, we would call this type of reading "popular." The validity and implications of such "exposition" need to be explored further, but the fact remains that Vincent of Beauvais parallels the sacred history of Christ with extensive quotations from apocrypha and the history of the Virgin Mary. Émile Mâle's brilliant intuition, linking the decorative and didactic programs of medieval churches with the intellectual program pursued in the *Speculum maius*, should certainly be reevaluated.[44] The gates, walls, pillars and stained-glass windows of gothic churches display with equal status and refinement both the approved and the apocryphal: they are indeed "quasi libri laicorum."

This discourse of Dominican preachers, aimed at their audience, required sturdy and authoritative theological foundations, free of any superfluous *curiositas* or *novitas*. While it needed to be anchored in popular culture, it needed also to conform to tradition, that of the Fathers and the *Glossa ordinaria*. The short theological treatises with which Vincent of Beauvais encloses the story of Christ served this purpose.

This alliance between clerical and popular culture is a Dominican response to the Order's particular mission to shape, transform and control popular faith. These various elements outline the epistemological significance of the *Speculum maius*. As a cul-

tural device, the *Speculum* lies at the crossroads where popular culture meets the intellectual requirements of the Preachers.

<center>NOTES</center>

1. This introduction takes into account the most recent scholarship on Vincent, as presented in the conference "Vincent de Beauvais, un dominicain et son milieu intellectuel," held at Royaumont on 9–11 June 1995.

2. On the history of the *Speculum maius,* see the study by M. Paulmier-Foucart and S. Lusignan, "Vincent de Beauvais et l'histoire du *Speculum maius,*" *Journal des Savants* (1990): 97–124, together with J. B. Voorbij, *Het "Speculum Historiale" van Vincent van Beauvais. Een studie van zijn onstaansgeschiedenis* (Groningen, 1991, with an English summary, 389–94).

3. L. E. Boyle, "Notes on the Education of the *Fratres communes* in the Dominican Order in the Thirteenth Century," in *Xenia medii aevi historiam illustrantia, oblata Thomae Kaeppeli O.P.,* ed. R. Creytens, O.P., and P. Künzle, O.P. (Rome, 1978), 249–67.

4. In vol. 2 of *Beati Humberti de Romanis quinti Praedicatorum magistri generalis Opera de vita regulari,* ed. J. J. Berthier (Rome, 1889), 254–55: "Officium boni lectoris est conformare se capacitati auditorum; et utilia et expedientia eis faciliter et intelligibiliter legere; opiniones novas refugere, et antiquas et securiores tenere; ea quae non bene intelligit nunquam dicere. . . . Cavendum est etiam . . . a frivolis expositionibus, et similibus, quae certam veritatem non habent, et cogunt saepe dicere alia quam sanctorum vel glossarum expositiones contineant, quae maxime sunt sectandae." See also Humbert's *Expositio Regulae beati Augustini* c.148 ("De reprehensibilibus circa studium"), in vol. 1 of *Beati Humberti . . . Opera de vita regulari,* ed. Berthier (Rome, 1888), 448: "Sic igitur patet quod studium est reprehensibile quia versatur vel circa nimis alta, vel circa nimis subtilia, vel circa vires excedentia, vel circa curiosa, vel circa nova, vel circa nimis multa. . . . "

5. *Acta capitulorum generalium ordinis praedicatorum. I: 1220–1303,* ed. B. M. Reichert, MOPH 3 (1898): 29. As early as 1243, the General Chapter held in Paris declared that "Fratres non studeant in libris philosophicis, nisi secundum quod scriptum est in constitutionibus, nec etiam scripta curiosa faciant" (MOPH 3: 26).

6. In quoting from the *Speculum historiale* we shall use the book numbering in the Douai edition of 1624 (reprt. Graz, 1965); most manuscripts use a different numbering since they count the *Libellus apologeticus* as the first book; book 1 in the Douai edition is therefore book 2 in most manuscripts etc.

7. History begins with the account of the generations from Adam to Abraham, followed by the Patriarchs (book I), then the time from Moses to Israel's Captivity (book 2); the imperial era, from Cyrus to Alexander the Great, the Ptolemies (books 3–5), and, finally, the Roman empire, from Julius Caesar to Frederick II (books 6–30); book 31, which concludes the *Historiale,* recounts the *vacatio imperii* following the deposition of Frederick II at the Council of Lyon (1245), as well as proclaims the impending end of time. This internal organization is invariably echoed in the running titles of most manuscripts.

8. See J. Sirinelli, *Les vues politiques d'Eusèbe de Césarée durant la période prénicéenne* (Paris, 1961), 387–411.

9. Miracles of the Virgin are found elsewhere in the *Historiale,* for example in 21 cc.69–70, 78; 26 c.7; 27 cc.2–4; 29 cc.4–10; 30 c.70, etc., but their imposing presence within the historical framework of the Incarnation is certainly meaningful.

10. *Chronica Albrici monachi Trium Fontium,* ed. P. Scheffer-Boichorst, MGH.SS 23 (1874): 678–79: "Anno ab urbe condita DCCLII, olimpiadis CXCIIII anno tertio, Augusti XLII, natus est dominus noster Iesus Christus, ebdomada LXVI, tertio scilicet anno ipsius ebdomade. Anno Augusti XL fuit primus annus LXIIII ebdomade Danielis. Quomodo ergo stare potest Dominum fuisse natum anno tertio LXVI ebdomade? . . . Anno nativitatis Domini XXXIIII, Tyberii vero XIX, passio Domini. De anno dominice passionis hic aliqua inserenda sunt. . . . Et quia multa nostris temporibus revelata sunt et cotidie revelantur, si aliquis vel etiam aliqua inveniatur, cui Dominus ista revelare dignatur, ita quod sit concordancia et arti, et rationi, et auctoritatibus, hoc potissimum inter alia petere debemus." On the life and career of Aubri, see vol. 2 of Mireille Chazan's Doctorat d'État dissertation, *L'idée d'Empire*

dans les chroniques universelles écrites en France (fin XIIe-début XIVe siècles) (Université de Paris I/ Panthéon-Sorbonne, 1995), 541–48.

11. " ... iuxta eiusdem Hieronymi ac caesariensis Eusebii, et ipsorum Hebraeorum computa-tionem qui omnes historiis gentilium concordant. . . . Nos tamen iuxta minorem numerum quem hu-cusque secuti sumus cetera prosequemur."

12. An examination of another major contemporary Cistercian chronicle, that of Helinand of Froidmont, would have been equally interesting, since it is one of the *Historiale*'s major sources. Un-fortunately, however, that portion of Helinand's chronicle is now lost; see M. Paulmier-Foucart, "Écrire l'histoire au XIIIe siècle: Vincent de Beauvais et Hélinand de Froidmont," *Annales de l'Est* (1981): 49–70. M. Woesthuis, of Groningen, is preparing a study of the Chronicle of Helinand of Froidmont.

13. For a presentation of the author and his chronicle, see M. Chazan, *L'idée d'Empire* 2: 647–53.

14. Auxerre, Bibliothèque Municipale, Ms. 145, pp. 127–128. Robert's account delivers few his-torical details but is relatively comprehensive on matters of theological doctrine, for example: "Chris-tus filius dei in Bethleem Iude nascitur, deus occultus, homo manifestus, de deo patre, homo de virgine matre. . . . Ad passionem venit secundum prophecias que de eo fuerant prelocute anno etatis sue tri-cesimo quarto iam ex parte exacto, imperii vero Tyberii octavo decimo. . . . "

15. Paris, Bibliothèque Mazarine, Ms. 2013, fols. 71v–74r. The account is somewhat more exten-sive than that found in the two chronicles, especially on the childhood of Christ, but it lacks any allusion to the Passion: " ... eodem anno quo capite cesus est sanctus Iohannes baptista, ipso eodem anno VIII0 kal. aprilis in quo Adam extiterat formatus, peractis annis quinque milia centum octoginta, passus est Ierosolimis dominus noster Ihesus Christus sponte sua sub Pontio Pilato preside et Caipha pontifice."

16. As Vincent himself says in the *Libellus apologeticus* c.2 (3) ("De modo agendi et titulo libri"), ed. S. Lusignan, *Préface au «Speculum maius» de Vincent de Beauvais: réfraction et diffraction* (Ca-hiers d'Études Médiévales 5, Montréal, 1979), 117: " ... Denique, quoniam, ut superius dictum est, ex diversis auctoribus hoc opus contextum est, ut sciatur quid cuius est, singulorum dictis eorum nomina annotavi. . . . "

17. "Interdum etiam ea, que ipse vel a maioribus meis scilicet modernis doctoribus didici, vel in quorumdam scriptis notabilia repperi, nomine meo id est actoris intitulavi," (ed. Lusignan, *Préface,* 117).

18. Published under the name of Albert the Great in *Beati Alberti Magni episcopi quondam Ra-tisbonensis Tractatus de forma orandi,* ed. A. Wimmer (Regensburg, 1902). We quote from Paris, Bibio-thèque Nationale, Ms. lat. 14958. The *De oratione dominica* is made up of 18 short chapters, two of which were later included in the *Speculum historiale* c.6, "De coniunctionibus interpositis et posses-sivis appositis" (*Spec. hist.* 7 c.17: "De coniunctionibus illic insertis et de possessivis"), and c.7, "De septem donis in eadem oratione petitis et de conclusione orationis" (*Spec. hist.* 7 c.16: "De adaptatione VII petitionum ad VII dona").

19. Paris, BN, Ms. lat. 14958, fol. 122r: " ... michi omnium fratrum ordinis praedicatorum min-ima utile atque salubre visum est precipue propter fideles simplices qui verba eius assidue tenent et intelligentiam non habent sensum eius profunditatem iuxta doctorum catholicorum doctrinam expo-nendo utrumque declarare quia, sicut ait beatus Ieronimus in quodam prologo: quod melius intelligi-mus melius etiam proferimus, melius inquam non quantum ad vocis sonum set quantum ad mentis affectum. . . . "

20. *Vincentius Opuscula, scilicet libri de gratia, libri laudum Virginis gloriose, liber de sancto Johanne evangelista, liber de eruditione puerorum regalium, liber consolatorius de morte amici,* ed. Iohannes Amerbach (Basel, 1481; Copinger no 6259; Polain no 3936).

21. For example *Liber gratiae* 1 c.39 ("Cur tamdiu post hominis lapsum incarnari distulit") is present in *Hist.* 6 c.84; the excerpts taken from Jerome in *Liber gratiae* 2 c.134 ("De pulchritudine faciei eius") are partially reemployed in *Hist.* 7 c.23; the letter ascribed to Peter of Ravenna found in *Liber gratiae* 2 c.152 ("De gratiarum actione in Lazari suscitatione") reappears in *Hist.* 7 c.28.

22. The following example will illustrate the case in point: both *Liber gratiae* 2 c.132 and *Histo-riale* 6 c.104 are titled "De inventione eius (domini Iesu) in medio doctorum," but in the *Liber gratiae* it is made up of two excerpts from Bede, while in the *Historiale* it quotes from the *Glossa ordinaria,* Jerome (*Ep.* 53) and Bernard of Clairvaux (*Sermo 1 in epiphania domini*).

23. *Hugonis de Sancto Victore Didascalicon* 6 c.3 ("De historia"), ed. Ch. Buttimer (Washington D.C., 1939), 113–14, where Hugh writes that those neglecting the historical sense are like donkeys: "quorum sciencia formae asini similis est."

24. See n. 21 above.

25. *Historia scholastica, Hist. evang.* c.34 (PL 198: 1555–56), and *Glossa ordinaria in Matth.* (PL 114: 83). The additions made to these excerpts from the *Glossa* justify the *Actor* subheading.

26. As proclaimed by the General Chapter of 1228 held in Paris (CUP 1: 112): "Statuimus autem ut quelibet provincia fratribus suis missis ad studium ad minus in tribus libris theologie providere teneatur; et fratres missi ad studium in Ystoriis, et Sententiis et Textis et Glosis precipue studeant et intendant." In his *De officiis ordinis,* Humbert of Romans writes "quod auditores sub eo (lectore) proficiant ad sciendum Bibliam et Historias et Sententias. . . . " (*Beati Humberti . . . Opera de vita regulari,* ed. Berthier, 2: 254).

27. See M.-D. Chenu, "Maîtres et bacheliers de l'Université de Paris vers 1240," in vol. 1 of *Études d'histoire littéraire et doctrinale du XIII^e siècle* (Paris-Ottawa, 1932), 11–39. See also Kaeppeli, *Scriptores* 2: 273–74 with a list of five manuscripts containing Hugh of Saint-Cher's *Postilla super Historia scholastica.*

28. Quoted by B. Smalley, "Some Thirteenth-Century Commentaries on the Sapiential Books," *Dominican Studies* 2 (1949): 329.

29. See n. 4 above.

30. *Hist.* 7 c.11 = Comestor, *Hist. evang.* 37/43–44; *Hist.* 7 c.18 = Comestor 50–65; *Hist.* 7 c.21 = Comestor 67–72; *Hist.* 7 c.24 = Comestor 75–85; *Hist.* VII, 25 = Comestor 86–95; *Hist.* 7 c.26 = Comestor 96–106.

31. *Sermo* 65 (PL 52: 385–86).

32. *Hist.* 7 c.29: "De mutuis epistolis domini Ihesu et Abgari regis Edisse"; 7 c.30: "De Thaddeo apostolo post assumptionem domini ad eundem regem misso." The story is already present in Eusebius-Rufinus, *Historia ecclesiastica* 1.16; it had been declared apocryphal by the *Decretum gelasianum;* see n. 39 below.

33. See Stegmüller, RB 8 n° 168; see also J. K. Elliot, *The Apocryphal New Testament. A Collection of Apocryphal Christian Literature in an English Translation* (Oxford, 1993), 84.

34. The structure of *Hist.* 6 c.87 ("De decriptione orbis et ortu Salvatoris"), and 6 c.89 ("De duobus animalibus eum adorantibus in praesepio"), is the following: Hugo Floriacensis (*pax romana*) / Comestor, *Historia evang.* c.4 / Iacobus / Comestor c.5 / Bernardus, *Sermo 1 in nativitate domini* / Comestor c.6 / Beda, *Expositio in Luc.* The pseudo-Gospel's account is the following: "Cum autem irent in Bethleem dixit Maria ad Ioseph: duos populos video ante me, unum flentem et alium gaudentem. Que verba cum putaret Ioseph esse superflua, apparens ei iuvenis in veste splendida, interpretatus est dicens eam vidisse populum Iudaeorum flentem, et populum gentium gaudentem. Tunc iussit iumentum stare, et Mariam de eo descendere, atque ingredi speluncam tenebrosam, quae lumen diei penitus non habebat. Sed in ingressu Mariae coepit tota splendere, quasi esset ibi hora diei sexta, nec defecit illa lux die vel nocte, donec Maria peperit masculum suum. Quem nascentem circumdederunt angeli et natum statim adoraverunt, dicentes: *Gloria in excelsis Deo.* . . . Pastores quoque ovium asserebant se angelos vidisse in media nocte, hymnum dicentes deo et ab eis audisse quod natus esset salvator hominum in quo restitueretur salus Israel. Tertia autem die nativitatis domini, egressa est Maria de spelunca, et ingressa stabulum, posuit in presepio puerum, et bos atque asinum genuflectantes adoraverunt eum, et ipsa animalia in medio eum habentia, sicut predictum est: *in medio duorum animalium innotesceris,* incessanter adorabant eum."

35. *Historia evang.* c.5, "De nativitate salvatoris" (PL 198: 1539–40). In order to justify the presence of the two animals framing the Christ child's crib, Comestor summons Old Testament prophecies from Isaiah 1:3 ("cognovit bos possessorem suum et asinus praesepe domini sui"), and from Habakkuk 3:17 ("abscindetur de ovili pecus et non erit armentum in praesepibus"). He then adds: "Etiam in picturis ecclesiarum, quae sunt quasi libri laicorum hoc repraesentatur nobis." Vincent of Beauvais took the whole passage—without the excerpt from Habakkuk—into the *Speculum historiale.*

36. *Hist.* 6 c.94 ("De fuga domini in Egiptum et eventibus itineris"); 6 c.95 ("De ruina ydolorum Egyptii ad eius ingressum").

37. The very long excerpt taken from the Gospel of Nicodemus (*Hist.* 6 cc.48, 56–63) is introduced in a passage by *Actor* with the words "Fuerunt et qui dicerent," which eloquently outline its apocryphal status: "Fuerunt et qui dicerent Ioseph eadem vespera qua sepelivit dominum a Iudaeis incarceratum et Nicomedum latuisse ac deinde factum discipulum. Et ante alios statim apparuit Ioseph ad consolandum eum. . . . " On this Gospel of Nicodemus, closely linked to the *Acta Pilati,* see vol. 1 of J. Quasten, *Initiation aux Pères de l'Eglise* (Paris, 1955), 133–36, as well as Elliott, *The Apocryphal New Testament,* 164f.

38. *Libellus apologeticus* (ed. Lusignan, *Préface,* 124): " . . . quorum primum scripsit Ieronimus ad petitionem Helyodori episcopi, prout ipsam narrationem de Ioachim et Anna et de ortu Virginis se

quondam adhuc adulescentulum in quodam libello legisse meminit. Hec ipsa tamen que scribit nec vera nec falsa esse asserit, sed tantummodo sive vera sive falsa sint, ea salva fide ac sine periculo anime et credi et legi posse ab hiis qui credunt Deum hec omnia facere potuisse."

39. *Libellus apologeticus* c.10 (13) (ed. Lusignan, *Préface,* 127): "Denique Decretum Gelasii pape, quo scripta quedam reprobantur quedam vero approbantur, hic in ipso operis principio ponere volui, ut lector inter autentica et apocrifa discernere sciat, sicque rationis arbitrio quod voluerit eligat, quod noluerit reliquat." The decretal is reproduced in chapters 11 (14) and 12 (15) of the *Libellus apologeticus* (ed. Lusignan, 127–29).

40. *Hist.* 7 c.79: "*Actor.* Haec historia licet inter apocriphas scripturas reputatur pia tamen videtur esse ad credendum et credentibus utilis ad legendum. Hoc autem solum ibi videri potest a veritate dissonum quod apostoli tam cito dispersi fuerunt post ascensionem Domini. . . . " This is followed by a discussion on the "dispersio per regiones Iudeae et ad gentes." As far as the assumption of the Virgin is concerned, Vincent further remarks that "Ecclesia quidem non asserit," but, on the other hand, "apostolisque tamen magnis et orthodoxis viris pie creditum est et fideliter praedicatum."

41. *Postillam super quattuor evangelistas, Prologus,* ed. Iohannes Amerbach (Basil, 1504), fol. 3ra: "Solet tamen queri quare istorum evangelia recepta sunt et non aliorum, ut Bartholomei, Thome et Pauli et Nazareorum. Solutio: quia isti evangelicam historiam diligentius sunt prosecuti et licet diversa dixerint non tamen adversa."

42. *Jacobi a Voragine Legenda Aurea, vulgo Historia Lombardica dicta,* ed. Th. Graesse (Dresden-Leipzig, 1890), 234; see also Alain Boureau, *La légende dorée. Le système narratif de Jacques de Voragine (†1298)* (Paris, 1984), 22.

43. See Beryl Smalley, *The Study of the Bible in the Middle Ages,* 3rd rev. ed. (Oxford, reprt. 1984), 214.

44. Émile Mâle, *L'Art religieux du XIIIe siècle en France* (Paris, 1948; reprt. in 2 vols. Paris, 1958), 1: 59–63: "Le plan de Vincent de Beauvais est le plan même de Dieu, tel qu'il apparaît dans l'Écriture. . . . Un semblable livre est donc le guide le plus sûr que nous puissions prendre pour étudier les grandes idées directrices de l'art du XIIIe siècle. Il est difficile de ne pas remarquer, entre l'économie générale du *Speculum majus,* et le plan qui a été suivi aux porches de la cathédrale de Chartres, par exemple, des analogies frappantes. . . . Il est bien évident que l'ordonnance du *Speculum majus* n'appartient pas en propre à Vincent de Beauvais, mais au Moyen Âge tout entier. C'étaient là les formes qui, au XIIIe siècle, s'imposaient à toute pensée réfléchie. Le même génie a disposé les chapitres du *Miroir* et les statues des cathédrales. . . . "

Christ in Dominican Catechesis:
The Articles of Faith

Joseph Goering

T HIRTY-FIVE YEARS AGO, in 1962, Ludwig Hödl published a short study which he hoped would stimulate further research into an important and much neglected topic in medieval thought, the Articles of Faith.[1] Today, we can scarcely be said to have gone beyond Hödl's pioneering investigation. This may seem strange, especially since medieval theologians made large claims for the importance of the Articles of Faith, asserting, for example, that they are like the first principles of a science, and that all of sacred doctrine is derived from them. In taking up Monsignor Hödl's project again, I will address two questions: What are the Articles of Faith? and How did they function in medieval Dominican theology? I hope, in passing, to suggest some of the reasons that the Articles of Faith have been much ignored by modern scholars, and also to shed a little light on the issue that inspired this volume: The place of Christ in the theology of the medieval Dominicans.

The starting point of Hödl's study was the observation, almost as surprising today as it was thirty years ago, that the origins of the term "Articles of Faith" is to be found in the theology of the twelfth century, and that it only became a topic of careful consideration in the early years of the thirteenth. Indeed, perhaps the earliest listing of the Articles of Faith, as such,[2] is in a little treatise once thought to have been written by the famous Parisian theologian, Praepositinus of Cremona, and known in the literature as the *Summa de poenitentia iniungendi.* This text, written ca. 1200, is actually by a Parisian canonist named Richard (perhaps "Richard of Saint-Victor," but not to be confused with the more famous Richard of Saint-Victor who died in 1173).[3] It is addressed to two friends of the author who have been recently ordained to the priesthood, and is intended to teach them how to carry out their sacerdotal, and especially their pastoral, duties.

This Richard writes about theological matters with the freedom and ingenuity of a canonist. For example, in chapter three, concerning the traditional topic of the seven (or eight) deadly sins, he avers: "Having perused thoroughly the books of sacred Scripture, and pondered the question long and hard, I have discovered eighty-one types of mortal sin." These he proceeds to enumerate, in no discernible order.[4]

Richard discusses the Articles of Faith in chapter six. He begins:

> I have been unable to discover a determination by any of the saints concerning the number of the Articles of Faith, and therefore perhaps it would be presumptuous to impose a certain number on them. But it can be said without fear of contradiction that there are seven Articles of Faith. The first is to believe that God is one in substance and three in persons. The second, that Christ was born of the

Virgin Mary. Third, that bread is transubstantiated into the body of Christ, and wine into his blood, through the agency of the priest. Fourth, that Christ died and was buried. Fifth, that he arose from the dead. Sixth, that he ascended into heaven. Seventh, that he will come again to judge, and that all men will be resurrected.

Richard continues:

There are many other things which prelates and theologians, when they dispute about these things, are bound to hold. For example, that God is eternal, the Creator of all things, the author of the Old and New Testaments . . . and also that all heresies should be detested.

"Or," he concludes, "one can say that the Articles of Faith are those which are contained in the (Apostles') Creed."[5]

Richard provides us, here, with the major elements which will shape the subsequent discussions of the Articles of Faith until the end of the Middle Ages: first, a listing, often idiosyncratic, of certain numbered articles; second, a reminder that there are more articles than are contained in any specific list; third, a presumption that the Apostles' Creed is an authoritative collection, containing all of the Articles, either explicitly or implicitly.

During the first two decades of the thirteenth century, discussions of the articles began to multiply. William de Montibus, who taught theology in Paris during the 1180s, before taking charge of the important cathedral school in Lincoln, England, where he taught until his death in 1213, provides two different formulations of the Articles of Faith. In his *Tractatus metricus* (ca. 1200) he included a chapter titled: "That the twelve Prophets foretold the twelve Articles of Faith, which afterwards the twelve Apostles, acting together, composed."[6] The tradition that the twelve Apostles each contributed a "sentence" to the creed which bears their name is an old one, and was known already to St. Ambrose of Milan. It was adapted to the new language of the "Articles of Faith" and popularized by Lothar of Segni (Pope Innocent III) in his *De missarum mysteriis* (ca. 1195).[7] William de Montibus' treatment goes beyond Innocent's by adding a sentence from the twelve Prophets for each article. For example, to the apostle Peter's words, "I believe in God the Father almighty, Creator of heaven and earth," William juxtaposes the words of Jeremiah (3:19): "You will call me Father."[8] This tradition of dividing the Creed into twelve articles and assigning each to one of the Apostles continues throughout the thirteenth century and beyond. We note here only that there is no authoritative formulation of this tradition, and that it is very difficult to find any two authors who agree in the specific divisions of the articles or in the assignment of these to the individual Apostles. But the number twelve remains a constant, if not a consistent, element of many subsequent expositions of the Articles of Faith.

William de Montibus' most influential contribution to the discussion of the Articles of Faith was of another sort. In his popular summa, the *Numerale*, he devotes the longest chapter of the final book to the twelve Articles of Faith.[9] There he emphasizes not their Apostolic authorship, but rather their theological content. First is faith in the Trinity; second, faith in the Incarnation; third, faith in the Nativity and Virgin Birth;

fourth, faith in the Passion or death of Christ, and so on. The twelfth and final article in William's list is devoted to faith in the Church's seven Sacraments, an article that finds no explicit mention in the Apostles' Creed. He goes on to provide scriptural authorities for each article, and also what he calls "similitudes" (*similitudines*), that is, examples from the natural world which can be used in teaching, preaching, and study, to confirm and to elaborate each of the Articles of Faith.

William's formulation of the twelve articles was taken up by his student, Richard of Wetheringsett, who gave it widespread currency through his very popular summa, *Qui bene presunt* (ca. 1220).[10] Richard's summa represents one of the first attempts to collect and organize "modern" (i.e., thirteenth-century) preaching materials in a systematic way. As such, it was popular not only among the secular preachers in medieval England, but also among the preaching friars.[11] Richard presents William's list of twelve articles, adding to the authorities and elaborating the similitudes and exempla. He then returns to the articles, and advises that the preacher should pay special attention to three of them: Christ's Nativity, his Passion, and his Second Coming. All the other articles, Richard explains, can easily be reduced to these three, a claim which he substantiates in elegant detail in the paragraphs that follow.[12] These three articles are, indeed, the three themes that come especially to characterize later medieval preaching, Dominican as well as Franciscan and secular. Later writers will, like Richard, find a special place for meditations on Christ's Nativity, his Passion, and his Judgment at the end of time.

During the earliest years of the Dominican missions in Europe, the Friars relied perforce on the secular clergy not only for protection, but also for instruction. Among their more notable defenders in England was Robert Grosseteste, the scholar-Bishop of Lincoln, who was also responsible for a unique and influential presentation of the Articles of Faith. In his most popular pastoral handbook, titled *Templum Dei* (1220 × 1230), Grosseteste describes the Articles of Faith as the twelve foundation stones upon which is built the spiritual temple, which each Christian embodies. The first five stones or articles concern (1) the Trinity, (2) the Incarnation, (3) the Passion, death and burial, (4) the Resurrection, and (5) the Ascension.[13] To these five articles concerning God and Christ, Grosseteste adds another seven, to reach his total of twelve foundation stones of the spiritual temple. These seven are the Church's seven sacraments: Baptism, Confirmation, Penance, Eucharist, Holy Orders, Marriage, and Extreme Unction.

This unusual enumeration of the Articles, five concerning God and Christ, and seven concerning the sacraments, became very popular, especially among Grosseteste's episcopal colleagues in England. It is repeated by Edmund of Abingdon, Archbishop of Canterbury, by Walter of Cantilupe, Bishop of Worcester, and later, by Peter Quinel, Bishop of Exeter (1287), and in the anonymous English treatise *Speculum christiani*, of the fourteenth century.[14] If it is not found, in precisely this form, in the thirteenth-century Dominican writings, it nevertheless represents an important part of the tradition from which the Dominican writers drew their inspiration.[15]

At about the same time that Grosseteste's unusual list of twelve articles began to circulate in Europe, a new formulation emerged, probably in the Parisian schools during the 1220s, which would remain influential throughout subsequent centuries. This list identified fourteen Articles of Faith, seven pertaining to the Godhead and seven to

the humanity of Christ. The originator of this formulation is unknown, but it was familiar already to Philip the Chancellor, who describes it in his *Summa de bono* (ca. 1230).[16] The Dominican Master Hugh of Saint-Cher, in his commentary on Peter Lombard's *Sentences* (ca. 1230), implies that this fourteenfold division is the "common" usage. In his question "De numero articulorum," Hugh asks: "How many are the Articles?" And he replies: "It is said commonly (*communiter*) that there are fourteen." He then presents objections: "But it seems that there are only twelve, because the Apostles' Creed contains all the articles necessary, and there are twelve Apostles, therefore. . . . " Or one might argue that there are more than fourteen articles: "Just as God is said to be omnipotent, so too is he omniscient, and so on." Hugh concludes: "We say that there are fourteen articles, to which all the other articles can be reduced, seven that pertain to the divinity and seven to the humanity <of Christ>, and these are plainly distinguished in the Apostles' Creed."[17]

The fourteen articles as enumerated by Philip the Chancellor and Hugh of Saint-Cher are virtually identical; they are simply a reordered version of the Apostles' Creed. The seven pertaining to the divinity are: (1) I believe in God, (2) the Father omnipotent, (3) in Jesus Christ, (4) in the Holy Spirit, (5) in the holy catholic Church, the communion of saints, and the remission of sins, (6) in the resurrection of the body, and (7), in life eternal. The seven pertaining to Christ's humanity are: (1) conceived by the Holy Spirit, (2) born of the virgin Mary, (3) suffered under Pontius Pilate, crucified, died and was buried, (4) descended into Hell, (5) arose from the dead, (6) ascended into heaven, seated at the right hand of the Father, (7) will come again to judge the living and the dead.

This division of the articles into fourteen, seven pertaining to the Godhead and seven to the humanity of Christ, became extremely popular in the thirteenth century. It is repeated, alongside a twelvefold formulation which also divides the articles into two groups: six articles pertaining to the Godhead and six to the humanity of Christ, for example, by John of La Rochelle, Odo Rigaldus, Bonaventure, and the authors of the *Summa Fratris Alexandri,* among the Franciscans, and by Richard Fishacre, Thomas Aquinas, Vincent of Beauvais, and Robert Kilwardby,[18] among the Dominicans. John Pecham, the Franciscan Archbishop of Canterbury, gave the fourteenfold division special prominence in England by including a version of it in his famous syllabus (1281) of those things to be preached frequently in the parishes throughout the province of Canterbury.[19]

Each of these writers adopted the division of the articles into two categories, those pertaining to the Godhead and those to the humanity of Christ, but they are relatively unconstrained by any normative formulation of the articles themselves. One is struck, rather, by the uncomplicated and unproblematical way in which each author picks and chooses among the phrases of the creeds, elaborating now one aspect and now another, in his lists of the Articles of Faith.

A sense of the range of acceptable diversity in presenting the articles can be gained by reviewing Thomas Aquinas' writings on the subject. During the twenty-five years of his literary activity, spanning the third quarter of the thirteenth century, Thomas reprises many of the themes discussed thus far. He lists the articles on six different occasions, and no two of his lists are the same. In book three of his *Scriptum super*

Sententiis (ca. 1256), he explains that the Articles of Faith are distinguished either insofar as they are things capable of belief (*credibilia*), and in this way there are fourteen articles, or in respect to those who distinguished them, and in this way there are twelve articles according to the number of the twelve Apostles.[20] Thomas first explicates the fourteen articles in a form that differs slightly from that proposed by Hugh of Saint-Cher, and which corresponds to the division proposed by his contemporary at Paris, Bonaventure.[21] The first article pertains to the order of nature (*ratio naturae*) in the Godhead: I believe in one God. The next three articles concern the persons (*ratio personae*) and refer to the Father, the Son and the Holy Spirit. The last three of the first seven articles refer to the effects of the Godhead (*ratio effectus* or, in Bonaventure's formulation, the works of the divine essence—*divinae essentiae operationes*): (5) the works of nature: Creator of heaven and earth; (6) the works of grace: Holy catholic church, communion of saints, remission of sins; (7) the works of glory: Resurrection of the body, and life everlasting. The second set of seven articles, concerning Christ's human nature, follow the order of the Apostles' Creed, and correspond to the division adopted by Hugh of Saint-Cher earlier in the century.

Thomas follows this fourteenfold division of the articles in the *Scriptum* with an account of how the twelve Apostles composed them. "Peter," he tells us, "combined the first three articles into one. . . . John posited the article concerning the person of the Son. James joined together the articles concerning the conception and the nativity, . . . " and so forth.[22] One might call Thomas's formulation of the Apostolic tradition idiosyncratic, in that it corresponds to no other account that we have examined, but in this Thomas's idiosyncracy is entirely normal. There seems to have been no interest, during the Middle Ages, in producing an authoritative and normative assignment of articles to the individual Apostles.

The *Compendium theologiae,* on faith, hope, and charity, begun some time after 1259, was written by Thomas for his *socius,* Reginald of Piperno. The treatise was unfinished at the time of Thomas's death, only the first part, *De fide,* was completed. Thomas divided the treatment of faith into two sections: In the first 184 chapters he discusses questions concerning the Godhead, and in chapters 185–245 questions concern the humanity of Christ.[23] In chapter 246 Thomas summarizes the treatise by showing how all of the aforesaid material can be conveniently reduced to certain Articles of Faith. He reports two methods of doing so, one that includes everything under fourteen articles, seven pertaining to the divinity and seven to the humanity of Christ, and another "sufficiently reasonable" list (*satis rationabiliter*) of twelve articles, six pertaining to the divinity and six to the humanity of Christ.[24] He makes no mention of the twelve Apostles or their Creed in this treatise.

His *De articulis fidei et ecclesiae sacramentis,* written during the 1260s for the Archbishop of Palermo, was one of Thomas's most popular works.[25] It survives in 277 manuscript copies, more than any other text of St. Thomas except the *Secunda secundae* of his *Summa theologie* (280 manuscripts). Thomas mentions both the twelvefold (6+6) and the fourteenfold (7+7) division of the articles, but the twelvefold division is the norm that he adopts here. In each chapter of the first part of the treatise he states briefly the Article of Faith, and then expounds at length the various errors that have arisen concerning that article. For example, he states in a single sentence the first arti-

cle: "That we should believe in the unity of the divine essence, as in Deuteronomy 6:4: 'Hear O Israel, the Lord your God is one God'." He then discusses five errors concerning this article, including those of the "gentiles and pagans," of the Manicheans, of the Epicureans, and of the "gentile philosophers."[26] The fourth article, in this formulation, pertains to the effects of grace by which we are justified. Under this article Thomas includes the Church's Sacraments, as well as the gifts of the Holy Spirit, and all that pertains to the unity of the Church, and even human justice.[27] In the second part of the treatise he returns to the Sacraments, noting that, although they are all comprehended under the fourth article, the Archbishop had asked about them specifically and therefore Thomas accords them a separate treatment. In doing so he is in the tradition of Richard of Saint-Victor (the canonist), William de Montibus, Robert Grosseteste, and others who, since the beginning of the century, had accorded the Sacraments special attention among the Articles of Faith.

Thomas's *Expositio primae decretalis*, also composed during the 1260s, is an exposition of the new Creed, *Firmiter credimus*, promulgated at the Fourth Lateran Council in 1215.[28] As in the *Compendium theologiae*, he describes first the fourteenfold division, and then adds that "others posit twelve articles."[29] Here it is the fourteen articles, seven pertaining to the divinity and seven to the humanity of Christ, that he uses to organize his exposition. He performs his task by placing each of the new Creed's provisions into the context of the "traditional" discussions of the fourteen Articles of Faith.

Thomas next discusses the Articles of Faith in the *Secunda secundae* of his *Summa theologiae*, written in 1271 and 1272.[30] He asks "whether the Articles of Faith are fittingly enumerated," and responds by endorsing the division into fourteen articles, seven pertaining to the divine majesty and seven to the mystery of Christ's humanity. He notes that others distinguish twelve articles, and explains how they reach that number. Thomas then discusses (articles 9–10) the relation of these Articles of Faith to the teachings of sacred Scripture, and to the various creeds which have been promulgated by the authority of the Church.

His final discussion of the Articles of Faith is found in his Lenten *Collationes* on the Apostles' Creed, preached to the people of Naples in 1273, less than a year before his death.[31] Because his task was to expound the Apostles' Creed, one might expect to find a twelvefold division of the articles, but Thomas surprises us again. Although he follows the order of the Apostles' Creed, he divides it into fourteen articles rather than twelve, devoting one sermon to each. Moreover, the fourteen articles thus identified correspond neither to the divisions proposed elsewhere by Thomas, nor, seemingly, to any division of the *Credo* as expounded by other commentators. And finally, as if to emphasize the elasticity of the articles, Thomas concludes his final sermon in the series by explaining that, according to some authors, there are twelve Articles of Faith, six pertaining to the divinity and six to the humanity of Christ, which he then briefly enumerates. Perhaps this last twist was too much for modern editors; it was either ignored or mentioned only in a footnote in all printed editions, before being restored to the body of the text by Fr. Hyacinthe Dondaine in the forthcoming Leonine text.[32]

This brief survey has attempted to dispel several notions about the Articles of Faith: First, that this is an old and time-honored way of speaking and thinking about

the content of the Christian faith. On the contrary, the term itself, and the questions raised by thinking about belief in terms of "articles," are new in the twelfth and thirteenth centuries. Lists of Articles of Faith rivalled, and even superseded, the traditional Creeds in catechetical writings of the thirteenth century, and the term "Articles of Faith" became so successful that it is practically impossible for us, today, to talk about catechesis or creeds without thinking in terms of the usage developed in the thirteenth century.

Second is the notion that the articles comprise a fixed, clearly defined, and authoritatively determined list of fundamental beliefs. Rather we have found the articles to be elastic, and capable of a number of equally acceptable formulations. None of the medieval discussions of the Articles is marked by close argument and precise reasoning about definitions, and nowhere do we find heated disputes, such as we have come to expect from theologians, about the number, form and content of these fundamental doctrines. One is struck, instead, by the unproblematical way in which they are presented, and by the sense that the articles are seen as encompassing, on the one hand, the bare bones and irreducible essence of the Christian revelation, and on the other, the entire content of theology or *sacra doctrina*.

The question arises, then, of how the Articles of Faith functioned in thirteenth-century theology, if at all. I will suggest briefly that, in spite of the absence of clarity and distinction concerning the number and definition of these articles, they are the foundation of the theological enterprise; that as such they distinguish it clearly from philosophy; and that these revealed articles are central to the medieval claim for a scientific status, indeed the highest scientific status, for theology.

Two secure points emerge from the various discussions of the thirteenth century. First of all, the articles, whatever they are, represent the irreducible elements of the faith. In this way, they function like the first, and undemonstrable, principles of geometry and other sciences. Second, the articles are divinely revealed, and thus a part of sacred doctrine.[33] It is these points that inform Thomas Aquinas's discussion of sacred doctrine in the beginning of his *Summa theologiae*. "The whole of a science," Thomas tells us, "is contained in its principles," and "the principles of this science" (*sacra doctrina*) are "the Articles of Faith."[34] These articles, he adds, are not to be proven; rather arguments proceed from them, just as in the other sciences.[35] And this science receives its first principles directly from God, through revelation.[36]

Thomas adds to this common tradition the argument that sacred doctrine, or theology, is a science in the full Aristotelian sense of the term. His argument is well known,[37] but its debt to the widely circulated commentary on Aristotle's *Posterior analytics* written by Robert Grosseteste (ca. 1230) has, perhaps, not been often noted. Grosseteste, in his commentary, is concerned not with theology, but with the status of the so-called "intermediate" sciences—those sciences like optics, astronomy and harmonics, whose principles are not self-evident but are derived from the higher sciences of geometry and arithmetic.[38] He describes these intermediate sciences as "subalternated" to the pure ones. (Grosseteste seems to have been the first author to use the word "subalternation" in this way.) By this he means that the intermediate sciences share the principles, demonstrations, and middle terms of the higher sciences to which they are subalternated, but the subalternated sciences make use of an "added condi-

tion" that is not present in the higher science. For example, the science of optics (or *perspectiva*), is subalternated to the pure science of geometry; it draws its arguments and its probative force from the higher science, adding only the condition that the immaterial lines and angles of geometry are "radiant" lines and angles in the science of optics.[39]

Thomas's answer to the question of whether sacred doctrine is a science reads like a reprise of Grosseteste's commentary on Aristotle. He argues that the principles of sacred doctrine are not self-evident to the human intellect, like those of geometry and arithmetic, but rather that "they proceed from principles known in the light of a higher science, as perspectiva proceeds from principles known in geometry, and music from principles known in arithmetic." The higher science to which sacred doctrine is subalternated is, according to Thomas, "the knowledge (*scientia*) of God and of the blessed in heaven," and the added condition in this subalternated science of theology is that of revelation. "In this way," he concludes, "sacred doctrine believes the principles revealed to it by God."[40]

The principles thus revealed are the Articles of Faith. They are incapable of discovery by the unaided human intellect, and indemonstrable by any of the human sciences. They depend for their probative force on the higher science, that which is possessed by God and the blessed, which has been revealed by the Apostles and the Prophets; the scientific arguments of theology, properly speaking, are arguments from authority.[41] All this, of course, may be granted by modern scholars, but the science thus described seems quite foreign to our common understanding of the nature and the practice of Scholastic theology. We are entitled to ask whether this understanding of theological science had any significant effect on the way medieval theologians carried on their work. How often, for example, do we see them basing their arguments on the Articles of Faith and the authority of Scripture, rather than on the human sciences and on philosophical arguments demonstrable by the natural light of reason?

We may readily admit that the Articles of Faith, and the arguments from authority that they imply, seem to play a small part in the most frequently studied writings of the thirteenth-century Dominican theologians. The task of the theologian, as René Gauthier has recently reminded us, was twofold:[42] The first was to contemplate the truth, and the second to refute errors concerning it. Increasingly, in the thirteenth century, the second task was carried out in the light of the human sciences as explicated by Aristotle. This meant prescinding from all sources of knowledge that were not shared by one's interlocutors, and arguing with them on their own terms. Theologians of the Dominican Order were in the vanguard of this project, and the preponderance of their published writings bears witness to their interest in, and their facility with, philosophical arguments. Their success has helped to shape much subsequent work in theology, philosophy, and biblical exegesis to the present day. The model practitioner of these arts is the one who is a master of the philosophical and critical sciences and who can interact with other practitioners of these human arts and sciences on their own terms.

But to emphasize this second task of the theologian at the expense of the first is to stand medieval Dominican theology on its head. The first task of the theologian is to contemplate the truth as revealed by the Apostles and Prophets. The Dominican friars

learned to do this in their liturgy, in their fourfold reading of Scripture, and in their catechesis centered on the Articles of Faith. Some of the friars went on to *studia provincialia*,[43] where they learned to argue in the mode of Aristotle, and some of these went on to *studia generalia*, where they applied these skills to discussions of "difficult questions concerning the Articles of Faith" (this is Richard Fishacre's term for the subject matter of lectures on Lombard's *Sentences*).[44] But all of the friars, from the best trained scholars to the lowliest brothers, were expected to be good theologians, and to have a solid foundation in the Articles of Faith. If we are to appreciate the work of Dominican theologians on its own terms, we will have to look behind their controversial and argumentative treatises, to their unproblematical expositions of theology, properly speaking, which are the foundation on which all their work was built.

This conclusion seems to bear directly on the question that inspired this volume. How should we make sense of the impression that Christ was relatively unimportant in medieval Dominican theology? Surely this once-widely-held opinion is not simply perverse and without any basis in the medieval evidence. If we focus on the second part of the theologian's task, that of refuting errors and resolving difficult questions concerning the Articles of Faith, then this view has much to be said for it. The difficult questions that most engaged thirteenth-century Scholastic theologians were those arising from the encounter with Aristotle, and Aristotle had precious little to say about Christ. It is not surprising that questions about the natural world (its creation, eternity, etc.), about truth (and human knowing), and even about natural theology should dominate much of the controversial literature and the mainstream scholarly debates of the schools; Christological questions simply took their place alongside these other topics of investigation, and were given no special prominence. Nevertheless, we will misconstrue both the nature and the force of medieval theological arguments if we begin with this second part of theology and pass lightly over the primary and formative stage. A proper understanding of the science of theology should begin with an appreciation of Dominican catechesis, in the broadest sense. There is abundant evidence that Dominicans understood the liturgy as a continuous meditation on, and recreation of, the acts revealed in the Articles of Faith; that they read the Bible not as a secular history book, but as a multifaceted revelation of Christ; and that their devotions, and even the daily routines of their conventual life, were designed to steep the brothers in the life of Christ. It is here that the Articles of Faith were inculcated, and here that the normative principles of Christian theology were learned. It is only on the basis of these that the friars could go on to preach and teach, and then to argue with heretics, infidels, pagans, and other colleagues.

We would not be far wrong if we were to imagine as the model of the medieval Dominican theologian not an Aristotle, who could argue persuasively using only the natural light of the human intellect, but rather as St. Thomas the Apostle. Thomas Aquinas tells us in his commentary on John's Gospel that, when Thomas the Apostle touched the wounds of the resurrected Christ, overcoming his doubts and exclaiming: "My Lord and my God," he became a "good theologian" (*bonus theologus*), confessing both the humanity and the divinity of Christ.[45]

Such a formulation of medieval theology is particularly difficult for us in the modern academic world to appreciate. We are sons and daughters of the heroic Cartesian

project. Starting with doubt (our own, as well as others'), we bravely reason our way toward the truths of the natural world and of the Faith. For the medieval Dominicans it was the other way round. It was not the doubt of the modern academy, but the christological faith of the doubting Thomas which was the touchstone of their theology.

Notes

1. Ludwig Hödl, "Articulus fidei: Eine begriffsgeschichtliche Arbeit," in *Einsicht und Glaube,* ed. Joseph Ratzinger and Heinrich Fries (Freiburg, 1962), 358–76.

2. Hödl, "Articulus fidei," 363 n. 19, 367–69.

3. An edition and study of the *Summa de poenitentia iniungendi,* along with evidence for its date and authorship, is in preparation.

4. *Summa de poenitentia iniungendi* (Stuttgart, Württembergische Landesbibliothek, HB I 70, fol. 4r–v): "<3> DE GENERIBUS MORTALIUM PECCATORUM. Revolutis sacre scripture libris, diutius excogitando inveniri possunt octoginta unum genera mortalium peccatorum, licet forte se quedam habeant ut genera et species."

5. Ibid. (Stuttgart, HB I 70, fols. 14v–15r): "<6> QUOT SUNT ARTICULI FIDEI QUOS QUILIBET CREDERE DEBET. Sane quot sint articuli fidei non invenio ab aliquo sanctorum determinatum, et ideo forte non sine temeritate eis numerus certus imponitur. Potest tamen dici sine temeritate quod septem sunt articuli fidei. Primus est credere Deum esse unum in substantia et trinum in personis. Secundus, credere Christum natum ex Maria virgine. Tertius, panem transubstantiari in carnem Christi et vinum in eius sanguinem per ministerium sacerdotis. Quartus, Christum fuisse mortuum et sepultum. Quintus, Christum resurrexisse a mortuis. Sextus, Christum ascendisse ad celos. Septimus, Christum venturum ad iudicium et omnes homines resurrecturos. Hi septem articuli fidei ideo dicuntur quia nos artant ad ista credenda, et non sufficit in his, eis auditis, non obicere contrarium voluntati, sed quilibet tenetur moveri aliquando ad credendum.

Sunt adhuc preter ista multa alia que prelati et theologi, cum ea legunt vel de eis disputant, credere tenentur, scilicet Deum esse eternum, creatorem omnium, auctorem veteris et novi testamenti, Christum esse baptizatum et vim regenerativam aquis contulisse, et huiusmodi; et etiam omnes hereses debent detestari.

Vel potest dici quod illi sunt articuli fidei qui in simbolo continentur."

6. "Quod duodecim prophete predixerunt duodecim articulos fidei, quos duodecim Apostoli concordantia eorum sic postea scribendo composuerunt"; in Joseph Goering, *William de Montibus (c. 1140–1213): The Schools and the Literature of Pastoral Care* (Studies and Texts 108, Toronto, 1992), 177.

7. *De missarum mysteriis* (PL 217: 827–29). A critical edition of books 2–3 and 5–6 has been produced as a Ph.D. dissertation (University of Notre Dame, 1977) by David Frank Wright: "A Medieval Commentary on the Mass: *Particulae* 2–3 and 5–6 of the *De missarum mysteriis* (ca. 1195) of Cardinal Lothar of Segni (Pope Innocent III)"; see 152–56.

8. Goering, *William de Montibus,* 177.

9. Ibid., 259.

10. See Joseph Goering, "The Summa 'Qui bene presunt' and Its Author," in *Literature and Religion in the Later Middle Ages: Philological Studies in Honor of Siegfried Wenzel,* ed. Richard G. Newhauser and John A. Alford (Binghamton, New York, 1994), 143–59.

11. Richard's work was used extensively by the anonymous (probably Dominican) author of the mid-thirteenth century *Speculum iuniorum,* by Richard Fishacre, O.P. (ca. 1245), and by the master of the Dominican Province of Dacia, Aag of Denmark, in his *Rotulus pugillaris* (ca. 1260). The anonymous author of a pastoral handbook written in England ca. 1260, incipit *Omni vita tua,* draws his discussion of the Articles of Faith from his Dominican confrères, Hugh of St.-Cher and Richard Fishacre, but he was aware of the summa *Qui bene presunt:* "Dominus Robertus episcopus Lincolniensis, et Cancellarius Parisiensis, et magister Ricardus de Weberinglete [= Wetheringsett] distinguit ar-

ticulos duodecim, quilibet suo modo, que causa brevitatis pertranseo" (London, British Library, Ms. Arundel 332, fol. 10v).

12. Cf. Goering, "The Summa 'Qui bene presunt'," 147–48.

13. Robert Grosseteste, *Templum Dei*, ed. Joseph Goering and F. A. C. Mantello (Toronto Medieval Latin Texts 14, Toronto, 1984), 32–33. See also 43–45, where Grosseteste discusses the vivifying of the faith by works appropriate to each of the articles.

14. See Siegfried Wenzel, "Robert Grosseteste's Treatise on Confession, *Deus est*," *Franciscan Studies* 30 (1970): 233 n. 38; Wenzel also notes its use in the fourteenth-century theological miscellany contained in Oxford, Bodleian Library, Ms. Bodley 857, fol. 113v.

15. It is known, for example, to author of *Omni vita tua;* see n. 11 above.

16. *Philippi Cancellarii Parisiensis Summa de bono*, ed. Nikolaus Wicki, 2 vols. (Corpus philosophorum Medii Aevi: Opera philosophica Mediae Aetatis selecta 2, Bern, 1985), 2: 626–28.

17. Hugh of St.-Cher, *In III Sent.* d.25 (Brugge, Stadsbibliotheek, Hs. 178, fols. 85vb–86ra): "Circa secundum, quaeritur de numero articulorum. . . . Item, quaeritur, quot sint articuli, et dicitur communiter quod xiiii. Sed probatur quod tantum xii: Nam symbolum Apostolorum sufficienter continet articulos. . . . Item, videtur quod plures sint quam xiiii. . . . Dicimus quod xiiii sunt articuli, ad quos omnes alii reducuntur, septem quae pertinent ad divinitatem et septem ad humanitatem, quae in symbolo Apostolorum plane distinguuntur."

18. For the Franciscans, see *Summa Halensis* (Quaracchi Edition 4: 1122–23, and 1122 nn. 1–3); Richard Fishacre, *In III Sent.* d.25 (London, British Library, Ms. Royal 10.B.VII, fol. 234ra); Thomas Aquinas, *In III Sent.* d.25 q.1 a.2 (*Scriptum* 3: 789–90); Vincent of Beauvais, *Speculum morale*, in vol. 3 of *Speculum quadruplex sive Speculum maius* (Douai, 1624; reprt. Graz, 1964), 212–13; Robert Kilwardby, *Quaestiones in Librum Tertium Sententiarum. Teil 2: Tugendlehre*, ed. Gerhard Leibold (Munich, 1985), 27–28.

19. *Councils & Synods, with Other Documents Relating to the English Church. II: A.D. 1205–1313*, ed. F. M. Powicke and C. R. Cheney (Oxford, 1964), 900–1.

20. Thomas Aquinas, *In III Sent.* d.25 q.1 a.2 (*Scriptum* 3: 789).

21. Bonaventure, *In III Sent.* d.25 a.1 q.1 (Quaracchi Edition 3: 537–38).

22. Thomas Aquinas, *In III Sent.* d.25 q.1 a.2 (*Scriptum* 3: 790).

23. Thomas Aquinas, *Compendium theologiae, seu brevis compilatio theologiae ad Fratrem Raynaldum*, ed. G. de Grandpré, Leonine Edition 42 (1979): 2–205; see 1 cc.1–2 (83–84).

24. Thomas Aquinas, *Compendium* 1 c.246 (Leonine Edition 42: 191).

25. Thomas Aquinas, *De articulis fidei et ecclesiae sacramentis, ad Archiepiscopum Panormitanum*, ed. H.-F. Dondaine, Leonine Edition 42 (1979): 207–57.

26. Ibid. (245–46).

27. Ibid. (247): "Quartus articulus pertinet ad effectus gratie per quam iustificamur a Deo. . . . Et sub hoc articulo comprehenduntur omnia sacramenta Ecclesie, et quecumque pertinent ad Ecclesie unitatem et dona Spiritus Sancti et iustitiam hominum. Et quia de sacramentis Ecclesie postea erit agendum, de hiis interim supersedeamus et alios errores contra hunc articulum exponamus."

28. Thomas Aquinas, *Expositio super primam et secundam decretalem, ad Archidiaconum Tudertinum*, ed. H.-F. Dondaine, Leonine Edition 40 (1969): E1–E44.

29. Ibid. (E31): "Ulterius autem considerandum est quod fidei Christianae articuli a quibusdam duodecim, a quibusdam quatuordecim computantur. Secundum enim illos qui computant quatuordecim, septem articuli pertinent ad divinitatem, septem vero ad humanitatem. . . . Alii vero ponentes duodecim articulos ponunt unum articulum de tribus personis . . . et sic etiam articuli de humanitate sunt sex; unde omnes sunt duodecim."

30. *S. Thomae Aquinatis Doctoris Angelici Summa theologiae . . . cum textu ex recensione Leonina*, ed. P. Caramello, 3 vols. (Turin-Rome, 1948–1950); see ST 2-2 q.1 a.8 (2: 17–18).

31. Thomas's *De decem praeceptis* and *Super Credo* will be edited in Leonine Edition 44. The translation by Nicholas Ayo, *The Sermon-Conferences of St. Thomas Aquinas on the Apostles' Creed* (Notre Dame, 1988) is based on the revised Leonine text.

32. Ayo, *Sermon-Conferences on the Creed*, 6–8, 18.

33. See Hödl, "Articulus fidei," 370.

34. Thomas Aquinas, ST 1 q.1 a.7 corp.: "Omnia autem pertractantur in sacra doctria sub ratione Dei vel quia sunt ipse Deus, vel quia habent ordinem ad Deum ut ad principium et finem. Unde sequitur quod Deus vere sit subiectum huius scientiae. *Quod etiam manifestum fit ex principiis huius scientiae, quae sunt articuli fidei, quae est de Deo: idem autem est subiectum principiorum et totius scientiae, cum tota scientia virtute contineatur in principiis*" (emphasis added).

35. ST 1 q.1 a.8 corp.: "Sicut aliae scientiae non argumentantur ad sua principia probanda, sed ex principiis argumentantur ad ostendendum alia in ipsis scientiis, ita haec doctrina non argumentatur ad sua principia probanda, quae sunt articuli fidei, sed ex eis procedit ad aliquid aliud ostendendum."

36. ST 1 q.1 a.5 ad 2: "Non enim accipit sua principia ab aliis scientiis, sed immediate a Deo per revelationem."

37. See Etienne Gilson, *Elements of Christian Philosophy* (New York, 1960), 22–42.

38. For what follows, see the study by W. R. Laird, "Robert Grosseteste and the Subalternated Sciences," *Traditio* 43 (1987): 147–69.

39. Ibid., 154–61.

40. Thomas Aquinas, ST 1 q.1 a.1 corp.: "Respondeo dicendum sacram doctrinam esse scientiam. Sed sciendum est quod duplex est scientiarum genus. Quaedam enim sunt, quae procedunt ex principiis notis lumine naturali intellectus, sicut arithmetica, geometria, et huiusmodi. Quaedam vero sunt, quae procedunt ex principiis notis lumine superioris scientiae: sicut perspectiva procedit ex principiis notificatis per geometriam, et musica ex principiis per arithmeticam notis. Et hoc modo sacra doctrina est scientia: quia procedit ex principiis notis lumine superioris scientiae, quae scilicet est scientia Dei et beatorum. Unde sicut musica credit principia tradita sibi ab arithmetico, ita doctrina sacra credit principia revelata sibi a Deo."

41. ST 1 q.1 a.8 ad 2: "Ad secundum dicendum quod argumentari ex auctoritate est maxime proprium huius doctrinae: eo quod principia huius doctrinae per revelationem habentur, et sic oportet quod credatur auctoritate eorum quibus revelatio facta est. Nec hoc derogat dignitati huius doctrinae: nam licet locus ab auctoritate quae fundatur super ratione humana, sit infirmissimus; locus tamen ab auctoritate quae fundatur super revelatione divina est efficacissimus."

42. See the chapter titled "Le métier de sage," in René-Antoine Gauthier, *Saint Thomas d'Aquin, Somme contre les gentils: Introduction* (Paris, 1993), 143–76.

43. For recent work on the Dominican system of schools, see M. Michèle Mulchahey, "The Dominican *studium* system and the universities of Europe in the Thirteenth Century," in *Manuels, Programmes de cours et techniques d'enseignement dans les universités médiévales* (Louvain-la-Neuve, 1994), 277–324.

44. See Stephen F. Brown, "Richard Fishacre on the Need for Philosophy," in *A Straight Path: Studies in Medieval Philosophy and Culture (Essays in Honor of Arthur Hyman)*, ed. R. Link-Salinger, J. Hackett, M. S. Hyman, R. J. Long, and C. H. Manekin (Washington D.C., 1988), 23–36.

45. Thomas Aquinas, *In Ioannem* 20:3 lect.6 (*Super Ioan.* 473 n° 2562): "Consequenter cum dicit *Respondit Thomas* etc., ponitur Thomae confessio: ubi apparet quod statim factus est Thomas bonus theologus, veram fidem confitendo: quia humanitatis Christi, cum dicit *Dominus meus . . .* Item divinitatis: quia *Deus meus.*" See Jean-Pierre Torrell, *Initiation à saint Thomas d'Aquin: Sa personne et son oeuvre* (Fribourg Suisse, 1993), 288–92.

Splendor gloriae Patris: Deux collations du *Super Isaiam* de S. Thomas d'Aquin[1]

Denise Bouthillier

L ES COLLATIONS INCLUSES dans l'*Expositio super Isaiam ad litteram*[2] de saint Thomas d'Aquin ont déjà fait l'objet de deux articles de notre part.[3] Le premier présentait les vingt-quatre *collationes* disséminées dans les seize chapitres de ce commentaire, c'est-à-dire dans les chapitres XXXIV à L, qui constituent la partie conservée de l'autographe. Après avoir dégagé vingt-sept collations centres de façon spécifique sur le Christ,[4] le second se concentrait sur l'une d'entre elles particulièrement axée sur le mystère du Verbe incarné.[5]

Après avoir dans le premier de ces articles fait l'état de la question,[6] chacun d'entre eux s'est attaché à situer l'ensemble des collations de S. Thomas dans leur contexte historique et textuel. Les grands thèmes spirituels présents dans les passages étudiés y ont de même été dégagés et la réflexion à laquelle ils invitent, poursuivie à travers l'ensemble des oeuvres du Maître d'Aquin.

Nous n'avons pas l'intention de revenir ici sur ces données considérées comme acquises, mais bien plutôt de prolonger la réflexion amorcée dans "Le Christ en son mystère," tout en restant dans la ligne de la pensée de S. Thomas.[7] La richesse des collations se rapportant au Verbe dans le sein du Père et à son envoi *ad extra* évoquées au début de cet article,[8] nous invite une fois de plus à nous limiter à deux d'entre elles. Il s'agit des collations 21 et 22—les deux premières alors mentionnées—où le Verbe, Fils du Père, est proclamé selon He 1,3: *Splendeur de sa gloire* et *effigie de sa substance*.[9]

Sans plus tarder, nous en donnons ci-dessous le texte latin de l'édition Léonine pour lequel nous proposons une traduction.

(*Collatio* 93, 243b, lin. 84–93)
[Collation 21, Super Is LXII 1: *Propter Syon non tacebo et propter Ierusalem non quiescam, donec egrediatur ut splendor iustus eius et saluator eius ut lampas accendatur.*]
Item super illo uerbo *donec egrediatur ut splendor,* quod Christus splendet

 primo Patris ymagine,
 Hebr. I 3 "Cum sit splendor glorie et figura substantie eius";
 secundo sanctorum lumine,
 Ps. "In splendoribus sanctorum ante luciferum genui te";

tertio glorie plenitudine,
 Matth. XVII 2 "Resplenduit facies eius sicut sol";
quarto doctrine rectitudine,
 supra LX 3 "Ambulabunt gentes in lumine tuo et reges in splendore ortus tui."

[*Sur Is 62, 1:* Pour Sion je ne me tairai point et pour Jérusalem je ne prendrai aucun
repos jusqu'à ce que sa justice surgisse telle une splendeur et que son salut flamboie
comme une torche.]
<Il faut noter> de même au sujet de cette parole: *jusqu'à ce que surgisse comme une
splendeur,* que le Christ resplendit,

 premièrement de l'image du Père,
 He 1,3: "Splendeur de sa gloire, effigie de sa substance, <ce Fils> qui soutient
 l'univers par la parole de sa puissance . . . s'est assis à la droite de la Majesté
 dans les hauteurs . . . ";
 deuxièmement de la lumière des saints,
 Ps 110,3: "A toi la souveraineté au jour de ta puissance dans la splendeur des
 saints";
 troisièmement de la plénitude de la gloire,
 Mt 17,2: "Il fut transfiguré devant eux; alors son visage resplendit comme le
 soleil et ses vêtements devinrent éblouissants comme la neige";
 quatrièmement de la rectitude de la doctrine,
 Is 60,3: "Les nations marcheront dans ta lumière, les rois dans la splendeur de
 ton orient."

(*Collatio* 94, 245a, lin. 75–84)
[Collation 22. Super Is LXIII 1: *Quis est iste qui uenit de Edom tinctis uestibus de
Bosra? Iste formosus in stola sua, gradiens in multitudine fortitudinis sue. Ego qui
loquor iustitiam et propugnator sum ad saluandum.*]
Nota super illo uerbo *Iste formosus,* quod Christus est formosus

 primo quia rutilans splendore diuinitatis,
 Hebr. I 3 "Cum sit splendor glorie et figura substantie eius";
 secundo quia figuratus conformitate unionis,
 Ps. "Speciosus forma pre filiis hominum";
 tertio quia distinctus diuerso colore uirtutis,
 Cant. V 10 "Dilectus meus candidus et rubicundus";
 quarto quia uestitus honestate conuersationis,
 Iob XL 5 "Esto gloriosus et speciosis induere uestibus."

[*Sur Is LXIII 1:* Qui est donc celui-ci qui vient d'Edom, de Bosra en habits tachés de
pourpre? Celui-ci, magnifique en son vêtement, qui s'avance dans la plénitude de sa
force. C'est moi qui professe la justice et combat pour sauver.]
Note au sujet de cette parole: *Celui-ci magnifique en son vêtement,* que le Christ est
magnifique,

premièrement parce qu'il est éclatant de la splendeur de la divinité,

He 1,3: "Resplendissement de sa gloire, effigie de sa substance . . . ";

deuxièmement parce que façonné par la conformité de l'union,

Ps 45,3: "Plus beau que les fils des hommes, la grâce coule de tes lèvres";

troisièmement parce que paré des diverses couleurs de la vertu,

Ct 5,10: "Mon bien-aimé est éblouissant de blancheur et vermeil; unique parmi des myriades";

quatrièmement parce que revêtu de la sainteté de sa vie,

Jb 40,10 (Vulg. v.5): "Entoure-toi de beauté et élève-toi très haut, sois glorieux et revêts-toi d'habits précieux."

Présentation des collations

Dans son commentaire d'Isaïe, au chapitre 63, le premier verset, *Qui est iste qui uenit de Edom tinctis uestibus de Bosra?* renvoie d'emblée Thomas a un problème débattu de longue date par les Pères de l'Eglise; problème qui perdura durant tout le Moyen Age sans qu'un consensus soit atteint à son sujet. Il s'agissait de savoir quelle connaissance des mystères divins, en particulier celui de l'incarnation du Verbe, peuvent avoir les anges. Le jeune bachelier commence donc par donner sa propre exégèse *ad litteram* de ce verset initial[10] qui lui inspirera la collation 22.

Le Christ devient alors le centre de sa réflexion en vertu même de la finale de ce verset qui professe un superbe *Ego . . . sum ad salvandum* qui le désigne sans équivoque. C'est bien lui "le magnifique" au "manteau . . . trempé de sang" dont le nom est "Verbe de Dieu" (Ap 19,13). Il est "le magnifique," poursuit-il, car *image* du Père, et dès lors "*splendeur* de sa gloire et *effigie* de sa substance" (He 1,3; collation 22).

La précédente collation (21), inspirée d'Is 62,1, ne présentait pas autrement celui qui est justice et salut pour Sion. C'est bien le Christ que le prophète voit surgir *telle une splendeur* et flamboyer *comme une torche.* Mais le sens "mystique,"[11] inclus dans le commentaire littéral de ce verset, donnait déjà à ce passage sa dimension christique avec rappel de la grande vision angélique de Daniel 10,6 qui annonce un sauveur au *visage à l'aspect de l'éclair.*[12]

En réalité, les métaphores d'Hébreux 1,3, citées dans ces deux collations, plongent Thomas au coeur même de la vie intratrinitaire. Et l'on sait à quel point ce mystère constitue l'axe central de sa synthèse théologique.[13]

L'Au-Delà de tout nom

Dans l'Ancien Testament, la Sagesse qui annonce le Verbe est appelée **éclat** (ἀπαύγασμα) de la lumière éternelle, **miroir** (ἔσοπτρον) *sans tache de la divinité de Dieu* et **image** (εἰκών) de son excellence (ἀγαθότητος) (Sg 7,26). Sans nous éloigner de notre propos, rappelons que la théologie alexandrine voyait déjà en ces termes l'expression analogique de l'identité de nature entre le Père et le Fils autant que la distinction des personnes.[14]

Le Nouveau Testament pour sa part, au prologue de l'épître aux Hébreux, mentionne trois appellations différentes du Verbe. Il y est désigné sous les termes de

Fils (ἐν υἱῷ—*in Filio*) (1,2), de *resplendissement* (ἀπαύγασμα—*splendor*) et d'*effigie* (χαραχτὴρ—*figura*) (1,3). Cette diversité de substantifs n'a rien d'étonnant, car il est impossible de trouver un nom unique capable de désigner toute la perfection du Verbe de Dieu. C'est pourquoi:

> pour faire ressortir qu'il est consubstantiel au Père, on l'appelle *Fils*; parce qu'il lui est coéternel, on l'appelle *splendeur*; parce qu'il lui est totalement semblable, on l'appelle *image*; parce qu'il est engendré de manière immatérielle, on l'appelle *Verbe*.[15]

Chacun de ces noms ouvre évidemment la voie à une méditation ou contemplation de l'aspect du mystère qu'il évoque; méditation et contemplation qui conduisent Thomas vers diverses autres appellations dont nous retrouverons certaines ultérieurement.

Splendor

Un terme qui revient à plusieurs reprises dans les deux collations retenues est celui de "splendeur." La justice de Jérusalem que le prophète désire voir surgir telle une splendeur, c'est le Christ (collation 21), parce qu'il est avant toutes choses "éclatant de la splendeur de la divinité" (coll. 22). Et cela non point en raison d'une simple communion à la divine bonté, ainsi qu'il est écrit des saints que Dieu rend *participants de la nature divine, en (les) soustrayant à la corruption de la convoitise qui règne dans le monde* (2 P 1,4),[16] mais bien parce qu'il est l'image du Père, *effigie de sa substance* (He 1,3, collation 21).

Dès l'Ancien Testament, cette splendeur rayonna, bien que de façon voilée, dans la lumière créée de la Genèse (Gn 1) et la nuée lumineuse présente tout au long de l'Exode. De même sur le visage des amis de Yahvé, tels Moïse (Ex 34), Judith (Ju 10,7) et David;[17] ou encore dans le parvis du temple (Ez 10,4), sans oublier la lumière infuse de la Parole donnée aux prophètes pour leur en révéler l'intelligence.[18] Mais aux Temps Nouveaux, plus que jamais, cette splendeur *resplendit comme le soleil* sur le visage du Christ (Mt 17,2)[19] afin que brille *l'Evangile de la gloire* (2 Co 4,4).[20]

Il n'en serait rien cependant, si de toute éternité la personne du Verbe ne manifestait la Sagesse de Dieu qui est son essence même, car il est lui-même la Sagesse conçue ou engendrée:

> (Cette) divine sagesse reçoit le nom de lumière pour autant qu'elle consiste dans un acte pur de connaissance . . . (et) la manifestation de la lumière est la splendeur même qui en procède, (c'est pourquoi) il convient que le Verbe de la divine sagesse soit appelé la *splendeur de la lumière*.[21]

Ce passage s'inspire sans doute de Saint Augustin qui essayait de faire comprendre à son auditoire comment le Fils a pu naître du Père de façon à être contemporain de celui de qui il était né. La création n'offrant en exemple rien de coéternel, puisqu'il n'y a rien d'éternel en elle, il se tourne vers l'Ecriture. S'inspirant alors du passage déjà cité où *la sagesse* est dite **éclat** *de la lumière éternelle*, **miroir** *sans tache de l'activité de Dieu*, **image** *de son excellence* (Sg 7,26), il exploite ces trois figures à partir d'expériences sensibles. La première comparaison met particulièrement en évidence la coéternité du

Père et du Fils, mais aussi le caractère d'origine du Père dans la génération. Voici comment s'exprimait l'évêque d'Hippone:

> Personne n'ignore que c'est du feu que vient l'éclat de la lumière; prenons donc le feu pour le père de cet éclat; au moment où j'allume une lampe, j'ai l'éclat et le feu en même temps. Donnez-moi du feu sans lumière, et je vous concède un Père sans Fils.[22]

Si saint Jean appelle "lumière" le Fils unique du Père (1 Jn 1,5), c'est qu'en effet la lumière naît du soleil, et comme vient de le démontrer Augustin, la pensée ne peut concevoir en quoi elle lui est postérieure.[23]

Notons au passage que S. Thomas considère la lumière comme "le plus spirituel des effets sensibles"; aussi utilise-t-il souvent cette comparaison qu'il croit la "plus efficace pour conduire à la connaissance des choses intelligibles."[24] Ainsi afin de mieux manifester le fait que le Père a engendré dès le commencement et continue sans cesse, que le Fils naît et le Saint-Esprit procède sans cesse et sans fin, S. Thomas fait de nouveau appel à l'analogie du rayon du soleil.

Dès que le soleil paraît, dit-il, le rayon procède de lui, et du soleil et de son rayon procède la chaleur; de plus cette double procession ne cessera point tant que le soleil brillera à l'horizon. De même le Fils procède du Père dont il est la splendeur, et le Saint-Esprit procède de l'un et de l'autre comme la chaleur procède du soleil et du rayon, ainsi qu'il est dit au Psaume 18,7: *Il n'y a rien qui soit soustrait à sa chaleur.* L'exemple est défectueux évidemment puisque le soleil n'a pas toujours existé, ni le rayon toujours procédé de lui. "En Dieu (par contre) le Père a été de toujours, le Fils a toujours procédé de lui et le Saint-Esprit de l'un et de l'autre."[25]

S. Thomas, on le voit, affectionne l'analogie de la lumière pour éclairer diverses facettes du mystère intratrinitaire. Sa richesse indéniable l'invitera à l'exploiter à nouveau pour éclairer la participation des créatures à ce mystère.

Splendor sanctorum

Puisque c'est en cette splendeur de *l'image du Père* que *toutes choses ont été faites* (Jn 1,3), le Fils de Dieu est donc l'exemplaire primordial qu'imitent toutes les créatures comme la véritable et parfaite image du Père:

> D'une certaine manière (toute) spéciale cependant, il est l'exemplaire des grâces spirituelles qui éclairent les créatures spirituelles, suivant qu'il est dit au Ps 109,3 (Vulg., collation 21): *Au milieu des splendeurs des saints, je t'ai engendré de mon sein avant l'étoile du matin,* c'est-à-dire parce qu'il a été engendré avant toute créature par une grâce lumineuse, ayant en lui-même l'exemplaire des splendeurs de tous les saints.[26]

Si, en tant qu'il est Dieu, le Fils est la gloire de son Père, il est aussi la gloire de tous ceux qui sont *dans ce Fils Jésus-Christ* (Jn 5,20) par participation à sa vie divine. C'est à l'accueil d'une telle promesse que convie l'Apôtre lorsqu'il prie *le Père de la gloire* d'illuminer les yeux de notre coeur pour nous faire voir *quels trésors de gloire renferme son héritage parmi les saints* (Eph 1,17–18).[27]

Tout le Corps du Christ, son Eglise dont il est la tête, répand donc aussi cette lumière *de sagesse et de grâce*.[28] C'est pourquoi, en lui *les justes resplendissent comme le soleil dans le royaume de leur Père* (Mt 13,43) et par sa lumière, voient la lumière (cf. Ps 36,10). Le langage poétique de l'Ecriture n'hésite pas à les comparer à *une couronne de splendeur dans la main de Dieu* (Is 62,3) où ils *resplendissent comme des étincelles qui courent à travers le chaume* (Vulg., Sg 3,7).[29]

Cette splendeur toutefois ne brille point uniquement pour ceux qui jouissent de la vision de Dieu, mais déjà ici-bas pour les *viatores.* Car ce sont bien eux que S. Paul invite à rendre grâce au *Père qui nous a permis de partager le sort des saints dans la lumière* (Col 1,12).[30] *Nous avons tous reçu de sa plénitude* (Jn 1,16), aussi sommes-nous appelés "saints," mais Le Fils de Dieu, Lui, est "le Saint des saints, car il est la source de toute sainteté."[31]

Même lorsque les ténèbres se répandent sur la terre—comme au temps de Moïse sur les Egyptiens, ou à la mort de Jésus sur la Judée "privée (momentanément) de la lumière de Dieu le Père, de la splendeur du Christ et de l'illumination de l'Esprit-Saint"—la lumière ne cesse jamais d'éclairer en tout lieu l'Eglise de Dieu en son Christ.[32] Et cela vaut pour tout être humain et *tous les jours jusqu'à la fin des temps* (Mt 28,20). Il est vraiment *Dieu-avec-nous* aujourd'hui pour conduire tout son Peuple dans la gloire de la maison du Père.[33]

Doctrine rectitudine

C'est au coeur de ce Peuple que brille la splendeur de "la rectitude de sa doctrine" (collation 21). S. Thomas a plus d'une fois parlé du Christ comme *doctor,* c'est-à-dire "maître"; plus précisément encore "maître de justice," d'après le titre messianique de *Joël* 2,23.[34] Il est en effet le "principe de notre sagesse,"[35] c'est pourquoi il est dit que:

l'Evangile est la connaissance de la lumière du Christ et cette connaissance a une vertu illuminative (car) *la sagesse est lumineuse et elle ne se flétrit pas* (Vulg.,Sg 6,13). Autant qu'il est en elle, elle brille pour tous les humains, et elle les illumine tous, mais ceux qui lui font obstacle ne sont pas illuminés . . . L'Evangile est lumineux parce qu'il est la gloire du Christ, c'est-à-dire son éclat.[36]

Cette splendeur divine, seule *lumière véritable qui éclaire tout homme* (Jn 1,9),[37] manifeste donc la sagesse même du Verbe qui l'imprime en tout esprit créé. Même en l'esprit de ceux *qui tiennent la vérité captive dans l'injustice; car ce qu'on peut connaître de Dieu est pour eux manifeste . . . à travers ses oeuvres* (Rm 1,18–20).[38] Il est vrai que même dans la foi, l'homme avance vers la vérité *comme à tâtons en plein midi* (Dt 28,29), mais *pour la trouver* (Ac 17,27), car sa raison ne saurait être en contradiction avec le donné révélé, pour autant qu'il y réfléchit. La finalité de toute personne humaine étant de connaître Dieu, chacune reçoit en effet de lui dès ici-bas la lumière nécessaire pour cheminer vers ce terme ultime.[39]

L'éclat de la splendeur du Fils "façonné à la conformité de l'union" (collation 21), rejaillit donc ainsi sur ceux qui deviennent par lui fils de Dieu. Car l'image créée par Dieu et recréée par lui réfléchit *comme en un miroir la gloire du Seigneur.* C'est ainsi

que *nous sommes transformés en cette même image, toujours plus glorieuse, comme il convient à l'action du Seigneur, qui est Esprit* (2 Co 3,18).[40]

Imago Dei invisibilis

Dans son commentaire de la seconde épître aux Corinthiens 4,4 où le Christ est dit *l'image de Dieu*, S. Thomas rappelle d'abord que Dieu le Père est la source de toute lumière. *Dieu est lumière*, déclare saint Jean (1 Jn 1,5) "et de cette source lumineuse procède l'image de cette lumière, c'est à dire son Fils, le Verbe de Dieu."[41]

L'homme il est vrai est aussi dit *image de Dieu* (I Cor 11,7), mais il ne peut nous apprendre "ce qu'est" (*quid est*) Dieu car "aucune substance créée ne peut être l'image adéquate de la substance divine."[42] Le Christ par contre est l'*image* adéquate *du Dieu invisible* (Col 1,15):

> Et pour qu'on ne pense pas qu'il s'agit d'une image déficiente, incapable de re-présenter la substance même de Dieu et de faire connaître de Dieu ce qu'il est . . . l'Apôtre montre qu'il s'agit bien d'une image parfaite et qui représente la sub-stance de Dieu, quant il dit qu'*il est le rayonnement de sa gloire et l'empreinte de sa substance.*[43]

Pour que quelqu'un soit l'image parfaite d'un autre, commente Thomas, trois choses sont nécessaires: d'abord la similitude, puis l'origine, enfin l'égalité, et chacune doit l'être de façon parfaite. Pour illustrer son propos, il donne l'exemple de l'effigie d'un roi sur un denier:

> (Cette effigie) ne peut être dite image parfaite du roi, car il n'y a pas là égalité de nature, mais la similitude du roi en son fils est dite parfaite image du roi.

On trouve ici les trois choses ci-dessus mentionnées. Or elles le sont de même dans le Christ, Fils de Dieu, parce qu'il est vraiment image du Père, qu'il s'origine de lui et lui est parfaitement égal. Il est donc la véritable et parfaite image de Dieu.[44]

L'essence divine toutefois étant la similitude de toutes choses, son Verbe, en qui Dieu se dit, est non seulement la similitude de Dieu lui-même, mais encore celle de la multitude des êtres.[45] C'est bien en vertu de cette similitude du Verbe à Dieu, qu'il est dit "image" de Dieu; quant à la créature humaine, elle est dite "à l'image" de Dieu.[46]

Dans son *De veritate*,[47] toujours en relation avec le thème du Verbe image de Dieu, Thomas s'était déjà penché sur une interprétation d'Hébreux 1,3 propre à l'Eglise d'Orient.[48] Celle-ci en effet applique au Saint-Esprit les noms de "verbe" et d'"image." De façon claire et concise il y rappelle que *verbum* et *imago* sont deux termes différem-ment utilisés par les Pères latins et Grecs. Pour bien comprendre la pensée de ces derniers, il faut savoir qu'ils les appliquent à tout ce qui procède en la divinité; aussi appellent-ils "Verbe" et "Image" tant le Fils que l'Esprit-Saint. Les latins par contre réservent ces noms au Fils engendré du Père et ce n'est que dans un sens métaphorique qu'ils peuvent être appliqués à l'Esprit. Notre auteur fera appel à l'autorité de saint Augustin[49] pour contrer l'interprétation élargie attribuée en partie à saint Basile de Césarée.[50]

Dans son épître aux Colossiens (1,15), S. Paul précise que le Verbe est l'image d'un Dieu "invisible." Ce Dieu surpasse en effet:

> la capacité de la vision de toute intelligence créée; en sorte qu'aucune de ces intelligences ne peut, d'une connaissance naturelle, atteindre son essence. *Dieu est grand* (s'exclamait Job), *il dépasse notre science* (36,26). Lui seul *habite une lumière inaccessible, (lui) que nul d'entre les hommes n'a vu ni ne peut voir* (1 Tm 6,16). Si donc les bienheureux le voient, c'est par grâce et non par nature— Denys [l'Aréopagite] en donne cette raison: c'est que toute connaissance se termine à ce qui existe, c'est-à-dire à quelque nature qui participe à l'être. Or Dieu est l'être même, il n'y participe point; il est donc inconnaissable.[51]

Et le Fils de Dieu, en tant que *figure de sa substance,* est lui-même tout aussi invisible que le Père.[52]

Figura substantiae Patris

Reflet de la gloire du Père, *Lumen de Lumine,* le Fils est bien *figure de sa substance.* Le grec dit χαραχτὴρ de la substance comme s'il s'agissait d'une image sculptée qui rend la forme. On peut aussi penser à une "effigie" qui marque sa nature telle l'empreinte d'un sceau, mais l'expression est moins forte.

C'est bien là ce qui le distingue des *enfants du Très-Haut* (Ps 81,6) à qui a été *donné le pouvoir de devenir enfants de Dieu* (Jn 1,12); de ces fils *qui se glorifient dans l'espérance de la gloire* (Rm 5,2). Car le vrai Fils de Dieu, lui, a été établi héritier et Seigneur de toutes choses. Il est vraiment le Fils dans sa maison, cette maison que nous sommes[53] puisque c'est par lui que Dieu a tout créé. Les autres fils portent en eux *la parole de vie* (Ph 2,15), mais Lui *soutient tout par la puissance de sa parole* (He 1,3).[54]

Il est vrai que le mystère de l'incarnation nous révèle un Fils qui *s'anéantit lui-même* (Ph 2,7), se dépouillant de toute la gloire qui normalement aurait dû rejaillir sur son humanité en vertu même de la nature divine qui demeure toujours sienne. Pour conforter la foi des siens cependant, cette gloire éclatera le jour où il sera transfiguré à leurs yeux, mais ce sera l'exception.

Dans sa kénose, le Fils n'en demeure pas moins égal au Père, car c'est l'unique et même personne du Verbe qui est dans le sein du Père et en Jésus. En s'incarnant, le Verbe "est demeuré ce qu'il était, mais il est devenu ce qu'il n'était point," c'est-à-dire "qu'il est descendu des cieux, sans qu'il ait cessé d'y être," et que sans déposer la nature divine, il s'est uni à la nature humaine. Il a uni cette "nature à sa propre personne, afin que le même fût dans sa personne et Fils de Dieu et Fils de l'homme."[55]

L'apôtre saint Jean ne dit-il pas que la gloire du Christ est *celle qu'un Unique-engendré tient de son Père* (1 Jn 1,14)? Et cet Unique-engendré n'est autre que *le Fils qui est dans le sein du Père* (1,18). Nous le croyons, ajoute l'apôtre, car *lui-même nous l'a raconté* (ibid.).[56]

Ce seul passage johannique manifeste déjà qu'il y a en Dieu génération, paternité et filiation. Car celui-là qui accorde la fécondité à autrui n'est point stérile, affirme S. Thomas. "Tout se trouve (même) nécessairement en un état plus noble dans la cause que dans les effets."[57]

Primogenitus . . .

De l'Ancien Testament, scruté à la lumière du Nouveau, surgissent ici spontanément le Psaume 2,7: *Le Seigneur m'a dit : tu es mon Fils, aujourd'hui je t'ai engendré,*[58] et tel un répons, le Psaume 89,7: *Il m'a invoqué : tu es mon Père.*

Les mots "père" et "fils" tirent en effet leur origine d'une certaine "génération" dont on trouve l'expression dans l'Ecriture, comme on vient de le voir. Bien d'autres passages de l'Ancienne Alliance l'évoquent de même,[59] en particulier les *Proverbes* 8,25 : *Avant toutes les collines, le Seigneur m'a engendrée.*[60]

Il ne peut s'agir ici évidemment d'une génération charnelle, mais bien spirituelle et intellectuelle puisque *Dieu est esprit* (Jn 4,24). Pour mieux manifester cette vérité de foi, dans la conviction profonde qu'aucun argument de raison ne peut l'emporter sur cette dernière,[61] Thomas pose d'abord le principe suivant:

> Dans le réel, la diversité des modes d'émanation suit la diversité des natures; plus une nature est noble, plus ce qui émane d'elle lui est intérieur.[62]

Après avoir amplement illustré ce principe en passant en revue tous les règnes de la création, depuis les corps inanimés à commencer par le feu, jusqu'aux êtres les plus spirituels que sont les anges, il en vient à la conclusion que le plus haut degré de perfection de la vie appartient à Dieu, en qui l'acte d'intellection ne diffère point de l'acte d'être, d'où il découle que l'objet d'intellection est nécessairement l'essence divine elle-même.[63] Quoi de plus intérieur?

. . . omnis creaturae

Dieu qui voit donc tout dans son essence, connaît sa créature de la même manière qu'il se connaît lui-même et qu'il connaît son Fils. Ce Fils, nous l'avons vu, Dieu l'a "conçu en se parlant à lui-même" pour ainsi dire, "et cette conception a été unique, éternelle." *Dieu parle une fois et ne se répète pas* dit Job (Vulg. 33,14).[64]

Or c'est en ce Fils qui est "la conception intellectuelle de Dieu en tant qu'il se connaît lui-même," que Dieu connaît toute créature. Le Verbe, ainsi engendré dans le sein du Père, est en effet "celui qui représente toute créature, et (en tant que tel) il est lui-même le principe de toute créature." Il n'est pas seulement le premier-né du Père, mais il est aussi le premier-né de toute créature comme il est dit de la sagesse dans l'Ecclésiastique 24,5 (Vulg.): *Je suis sortie de la bouche du Très-Haut, je suis née avant toute créature.*[65]

C'est pourquoi la création est une relation réelle de dépendance dans l'être de la créature à l'égard du Créateur. Cette relation du créé au Créateur est en effet participation aux relations d'origine intradivines Père-Fils-Esprit. Là se trouve son principe, car elle est l'expression *ad extra* de ce qui dans la Trinité est sa source *ad intra.*[66]

C'est de même en ce Verbe, Fils du Père, que par amour Dieu prédestine tout homme à devenir conforme à l'image de celui qui est *l'aîné d'une multitude de frères* (Rm 8,29) et qui ne rougit point de les appeler fils de ce Père unique.[67] Eux ne peuvent obtenir la gloire et l'héritage que par celui à qui par nature appartient l'héritage et la

splendeur de la gloire. Ce n'est vraiment qu'en lui que chaque être humain devient fils adoptif, est appelé, justifié et glorifié.[68]

Omnia in ipso constant

Afin qu'aucun doute ne subsiste sur la nature de ce Fils, l'épître aux Hébreux 1,3 ajoute qu'il *soutient toutes choses par la parole de sa puissance.*

Ces mots n'exclut nullement la puissance du Père;[69] ils n'affirment pas non plus que le Fils soutient l'univers par sa propre puissance car la puissance du Père et celle du Fils sont en fait une seule et même puissance. Le Père produit toutes choses par son Verbe nous dit le Psaume 32,9: *Il dit, tout est; il ordonne, tout naît.* De même le Fils produit toutes choses *par sa parole.*[70]

Cela implique que soit conservé ce qui a été posé dans l'être. En réalité, il suffit que la créature soit posée pour demeurer,

> car la conservation des choses par Dieu ne suppose pas une nouvelle action de sa part, mais seulement qu'il continue à donner l'être, ce qu'il fait en dehors du mouvement et du temps. Ainsi la conservation de la lumière dans l'air se fait par la continuation de l'influx solaire.[71]

> Il faut le reconnaître: tant du point de vue de la foi que du point de vue de la raison, les créatures sont conservées dans l'être par Dieu . . . L'être des créatures en effet dépend à tel point de Dieu qu'elles ne pourraient subsister un instant et seraient réduites au néant si, par l'opération de la divine puissance, elles n'étaient pas conservées dans l'être . . . [comme] la lumière disparaît dès que cesse l'action du soleil.[72]

Cette comparaison est un legs de S. Augustin qui remarquait que Dieu ne travaille pas l'homme comme un paysan travaille la terre pour la rendre fertile. Pour ce dernier, l'oeuvre accomplie demeure lorsqu'il s'en va. Mais quand Dieu travaille le juste, il en va plutôt comme de l'air qui en présence de la lumière est lumineux, mais qui en son absence devient nuit; ainsi l'homme, en présence de Dieu, se trouve illuminé; mais si par l'aversion de sa volonté, Dieu lui est absent, il retombe aussitôt dans les ténèbres.[73]

S. Thomas exploite davantage encore cette analogie du soleil (cause équivoque) dont dépend entièrement l'effet d'illumination (être accidentel). Aussi ajoute-t-il:

> Le soleil, de par sa propre nature, est étincelant de lumière; l'atmosphère devient lumineuse en participant à la lumière du soleil, sans pour autant participer à sa nature. Ainsi Dieu seul est être par essence, car son essence est d'exister; toute créature au contraire est être par participation, du fait qu'il n'est pas de son essence d'exister.[74]

Omnia perseverant in aeternum

Mais qu'adviendra-t-il à la fin des temps de ce que Dieu a créé? Tout cela retournera-t-il au néant? Le sage ne dit-il pas: *Tout ce que Dieu a fait dure toujours?*[75] A cette question, Thomas répond en substance ce qui suit:

Que les choses soient produites après ne pas avoir été, cela montre la puissance de leur Auteur. Mais leur réduction au néant ferait obstacle à cette manifestation, car c'est par la conservation des choses dans l'être que la puissance de Dieu est manifestée au maximum, selon cette parole de l'Apôtre: *Il soutient toutes choses par la parole de sa puissance* (He 1,3).[76]

Puisque les créatures, tant immatérielles que matérielles, n'ont pas en elles-mêmes de puissance au pur non-être, on ne saurait parler d'anéantissement. La disparition de ces dernières peut soit venir d'un contraire, soit être un retour pur et simple à la potentialité universelle. Dieu en effet ne s'oppose pas aux lois qui régissent la génération et la corruption dans l'univers matériel. Au contraire, il le conserve en acte tout en respectant l'ordre qu'il a lui-même établi.[77]

Alors lorsque son jour se lèvera et que toute chair ressuscitera, chacun verra le Fils de l'homme glorifié dans toute sa splendeur de Fils du Père.

Candidus et rubicundus

Qui est donc celui-ci qui vient d'Edom, de Bosra en habits tachés de pourpre demande Isaie (63,1; collation 22)? A cette interrogation, Thomas voit une réponse dans l'émerveillement de l'auteur du Cantique 5,10: C'est *mon bien-aimé . . . éblouissant de blancheur et vermeil; unique parmi des myriades,* car "paré des diverses couleurs de la vertu" (collation 22). Il s'agit bien sûr des vertus divines que le Verbe incarné a manifestées parmi les hommes à titre d'exemplaire. Et tout en leur montrant ainsi le chemin vers Dieu, il leur faisait don de sa vie, don indispensable à leur cheminement vers la maison du Père.

Il arrive cependant que l'homme cherche en lui-même les ressources nécessaires à ce retour vers sa fin ultime. Nous en avons un exemple étonnant au chapitre 40 du livre de Job. Dans un discours plein de sagesse, Dieu défie alors Job de mettre en échec son plan de salut, où plutôt de le réaliser par lui-même: *Si tu as un bras comme Dieu,* lui dit-il, et bien *entoure-toi de beauté et élève-toi très haut et sois glorieux et revêts-toi d'habits précieux . . . disperse les superbes . . . écrase les impies . . . et j'avouerai que ta main peut te sauver.*[78]

Ce passage souligne à souhait que l'homme ne peut atteindre la beauté, la grandeur, la bonté, la puissance, ni aucune vertu ni au terme sa fin, que dans la mesure de sa participation à la vie de Dieu. Et cette participation n'a point pour source et mesure son intelligence ou sa volonté, mais bien l'amour infini et miséricordieux de son créateur et sauveur.[79]

Après avoir rappelé le verset 5: *revêts-toi d'habit précieux,* Thomas souligne que les justes eux-mêmes sont précieux pour Dieu par participation à sa sagesse et à sa justice:

De même que l'homme s'orne de la beauté d'un vêtement, ainsi toute la beauté des saints, anges ou hommes, retombe en ornement sur Dieu en tant que se recommande ainsi la beauté divine, comme il est dit in Isaïe (49,10) : *Tu seras vêtu de tous ceux-ci comme d'un ornement.*[80]

Si c'est par la foi, l'espérance et l'amour que les frères du Christ sont sanctifiés,[81]

c'est en Dieu seul qu'ils seront glorifiés. Pour les noces de l'Agneau, l'on donnera en effet à l'épouse de se revêtir *de lin d'une blancheur éclatante* (Ap 19,8) pour aller à la rencontre du Verbe de Dieu drapé dans un *manteau trempé de sang* (Ap 19,13).[82]

CONCLUSION

L'étonnante richesse des quelques thèmes auxquels renvoient une source aussi restreinte que deux collations du *Super Isaiam*, démontre déjà l'intérêt qu'il y a à y puiser. Ces thèmes n'ont évidemment pu être développés ici que de façon succincte alors que chacun d'entre eux pourrait devenir le point de départ d'un exposé théologique élaboré.

Ces collations brièvement traitées sont cependant de nature à témoigner de l'esprit contemplatif de S. Thomas. L'on y voit en effet sa pensée se dérouler comme en spirale autour d'un axe central, ici le Christ, pour atteindre une profondeur sans cesse croissante. Il nous semble alors le saisir en acte de toujours mieux connaître *avec tous les saints, ce qu'est la largeur, la longueur, la hauteur et la profondeur* (Eph 3,18) de l'amour du Christ.

Sa personnalité théologique et spirituelle s'y révèle comme en tension vers sa fin ultime: la vision de Dieu. Quoi d'étonnant donc si, dans la certitude que le Christ est lui-même Chemin de Vérité, il s'écrie dans l'hymne *Sacris solemniis:* "Par tes sentiers conduis-nous où nous tendons/ à la lumière que tu habites."[83]

NOTES

1. Le texte de cet article n'a pas été prononcé lors du colloque; en le sollicitant, les éditeurs ont désiré honorer une source encore peu exploitée de la christologie dominicaine.

2. Thomas d'Aquin, *Expositio super Isaiam ad litteram*, éd. H. F. Dondaine et L. Reid, Édition Léonine 28 (1974); désormais *Super Is.*; pour la datation, l'intention de l'auteur et le contenu des oeuvres de S. Thomas d'Aquin citées dans cet article, cf. J.-P. Torrell, *Initiation à saint Thomas d'Aquin, sa personne et son oeuvre* (Paris, 1993).

3. "Quand saint Thomas méditait sur le prophète *Isaïe*," *Revue Thomiste* 90 (1990): 5–47 (en collaboration avec J.-P. Torrell; désormais: "Quand saint Thomas méditait"), et "Le Christ en son mystère dans les *collationes* du *super Isaiam* de saint Thomas d'Aquin" (désormais: "Le Christ en son mystère"), dans *Ordo sapientiae et amoris: Image et message de saint Thomas d'Aquin à travers les récentes études historiques, herméneutiques et doctrinales. Hommage au professeur Jean-Pierre Torrell*, éd. par C.-J. Pinto de Oliveira (Studia friburgensia N.S. 78, Fribourg, 1993), 37–64.

4. Pour la liste de ces 27 collations du *Super Isaiam*, et la numérotation qui les distingue, cf. "Le Christ en son mystère," 39, note 14.

5. Il s'agissait de la collation du *Super Is.* 9,6 (Édition Léonine 28: 69, lin. 172–193, n° [3]), qui déploie neuf superbes titres christologiques du Messie.

6. Pour le *status quaestionis*, cf. "Quand saint Thomas méditait," 5–8.

7. Nous avions d'ailleurs annoncé ce prolongement dans "Le Christ en son mystère," 39, n.15.

8. Cf. "Le Christ en son mystère," 40–41.

9. Ibid., 40.

10. *Super Is.* 63,1 (Édition Léonine 28: 244); S. Thomas revint à plusieurs reprises sur cette exégèse qui demeure cependant hors de notre propos immédiat : cf. par exemple *In II Sent.* d.11 q.2 a.4

(*Scriptum* 2: 288–91); *In ad Ephesios* 3,10, lect. 3 (*Super epp.* 2: 39–41); *Contra errores Graecorum* Pars Prior, c.26, éd. H. F. Dondaine, Édition Léonine 40 (1967): A84–A85 où il répond au *Libellus* 48, 19–22, A133; ST 1 q.57 a.5 sed c.; ST 3 q.30 a.2 arg.3 et ad 3.

11. Au sujet des divers sens de l'Ecriture chez S. Thomas, cf. ST 1 q.1 a.10 et l' "Appendice II" (éd. Revue des Jeunes; Paris, 1925-) de H.-D. Gardeil, II 2c: "S. Thomas et le problème des sens de l'Ecriture," 148–54; H. de Lubac, *Exégèse médiévale. Les quatre sens de l'Ecriture*, 4 vols. (Paris, 1959–64); pour le sens "mystique," voir la Préface de M.-D. Philippe au *Commentaire sur l'évangile de saint Jean* de S. Thomas d'Aquin (Les amis des Frères de Saint Jean, Versailles, 1981[2]), 1: 28–48.

12. Dn 10,6 : *Et facies eius velut species fulguris, et oculi eius ut lampas ardens;* cf. *Super Is.* 62,1 (Édition Léonine 28: 242, lin. 10).

13. Ceci est particulièrement vrai de ses grandes synthèses théologiques, la *Somme contre les Gentils* et la *Somme de théologie;* cf. Gilles Emery, "Le Père et l'oeuvre trinitaire de création selon le Commentaire des Sentences de S. Thomas d'Aquin," dans *Ordo sapientiae*, 85–117.

14. Cf. He 1,3, Bible de Jérusalem, note c.

15. ST 1 q.34 a.2 ad 3: "Nam ut ostendatur connaturalis Patri, dicitur "Filius"; ut ostendatur coaeternus, dicitur "splendor"; ut ostendatur omnino similis, dicitur "imago"; ut ostendatur immaterialiter genitus, dicitur "Verbum." Non autem potuit unum nomen inveniri, per quod omnia ista designarentur"; cf. *In Ioannem* 1,1 lect. 1 (*Super Ioan.* 11 n°42).

16. Au sujet de Photin et de ses disciples, Thomas déclare dans le SCG 4 c.4 (*Liber CG* 3:247 n°3360): "Opinantes Jesum Christum purum hominem esse, et ex Maria Virgine initium sumpsisse, et per beatae vitae meritum divinitatis honorem prae ceteris fuisse adeptum, aestimaverunt eum, similiter aliis hominibus, per adoptionis spiritum Dei filium; et per gratiam ab eo genitum; et per quandam assimilationem ad Deum in Scripturis dici Deum, non per naturam, sed per consortium quoddam divinae bonitatis, sicut et de sanctis dicitur II *Pet.* I,4 : *ut efficiamini divinae consortes naturae, fugientes eius quae in mundo est concupiscentiae corruptionem.*" Sur Photin et sa réfutation par l'Aquinate, cf. Gilles Emery, "Le photinisme et ses précurseurs chez saint Thomas. Cérinthe, les Ebionites, Paul de Samosate et Photin," *Revue Thomiste* 95 (1995): 371–98.

17. Cf. *In Psalm.* 2, praem., Parma Édition 14 (1863), 152: "Dicitur etiam David aspectu desiderabilis, et Christus *splendor gloriae* (Heb 1,3). Ipse est *in quem desiderant Angeli prospicere* (1 Pet 1,12)."

18. Pour une approche des manifestations de la "gloire de Yahvé" dans l'A.T., cf. Ex 24,16, Bible de Jérusalem, note a.

19. Cf. *In ad Hebraeos* 1,3 lect. 2 (*Super epp.* 2: 342 n°26): "Sola cognitio Dei de seipso perfecte dicitur gloria, quia perfectam notitiam habet et clarissimam de seipso. Quoniam autem splendor est illud quod a fulgente primo emittitur, sapientia vero est quidam fulgens—Eccli. VIII 1: *Sapientia hominis lucet in vultu eius*—inde est quod prima conceptio sapientiae est quasi quidam splendor. Verbum ergo Patris, quod est quidam conceptus intellectus eius, est splendor sapientiae, qua se cognoscit."

20. Cf. *Catena*, Jn 13,31 (2: 511, n°5): "Origenes *In Ioannem* (tom. 32). Vel aliter. Nomen gloriae non hic accipitur iuxta quosdam paganorum qui definiunt gloriam esse a pluribus collata praeconia. Palam est enim quod in Exodo (40, 32–33) dicitur, quod gloria Dei repletum est tabernaculum, et quod aspectus Moysi glorificatus erat: quantum enim ad corporalia divinior quaedam apparitio contigit in tabernaculo, necnon in facie Moysi cum Deo locuti; quantum ad anagogiam vero gloria Dei dicitur esse quae apparuit: quoniam deificatus ac transcendens cuncta materialia intellectus, ut scrutetur divinam visionem in his quae cernit, deificatur : ut hoc sit tropice quod glorificata est facies Moysi, eo facto divino secundum intellectum. Nulla autem comparatio fuit excellentiae Christi ad cognitionem Moysi glorificantem faciem animae eius : totis enim divinae gloriae fulgorem esse Filium aestimo, dicente Paulo: *Qui cum sit splendor gloriae et figura substantiae eius. . .* "

21. SCG 4 c.12 (*Liber CG* 3: 270–71 n°3483): "Quia ergo divina sapientia lux dicitur, prout in puro actu cognitionis consistit; lucis autem manifestatio splendor ipsius est ab ea procedens : convenienter et Verbum divinae sapientiae *splendor lucis* nominatur, secundum illud Apostoli de Filio dicentis: *Cum sit splendor gloriae* (He 1,3)."

22. S. Augustin, *Sermo* 38, in *Catena*, Jn 1,1 (2: 328 n°1): "Nemo autem dubitat, quod splendor de igne exit. Ponamus ergo ignem patrem illius splendoris: mox quidem ut lucernam accendo, simul cum igne et splendor existit. Da mihi hic ignem sine splendore, et credo tibi Patrem sine Filio fuisse."

23. Cf. ci-dessus n.14 et *Catena*, Jn 1,1, n°1 (2: 328) *Ex Gestis Conc. Ephes.*: "Splendorem vocat Unigenitum Patris: splendor enim nascitur quidem ex sole, non autem intelligitur sole posterior. Coexistere ergo semper Patri Filium splendor tibi denuntiet."

24. *Super Iob* 36,32, éd. A. Dondaine, Édition Léonine 26 (1965): 191f.; voir c.37 (26: 193, lin. 19–21): "Inter omnes autem sensibiles effectus spiritualior est lux, unde et efficacior est ad perducendum in intelligibilium cognitionem, inquantum scilicet visus, cuius cognitio per lucem perficitur, plurimum intellectualem cognitionem iuvat"; pour une étude sur le thème de la lumière chez saint Thomas, voir Josef Kieninger, *Das Sein als Licht in den Schriften des hl. Thomas von Aquin* (Studi tomistici 47, Città del Vaticano, 1992) et le CR de S.-T. Bonino dans *Revue Thomiste* 95 (1995): 501–2.

25. Pour cette analogie, cf. *Super decretalem* I, éd. H. F. Dondaine, Édition Léonine 40 (1969): E33–34, lin. 327–52; en finale on trouve la citation: "quia vero Deus Pater semper fuit, semper ab eo processit Filius, et ab utroque Spiritus Sanctus."

26. *In ad I Cor.* 11,1 lect. 1 (*Super epp.* 1: 343 n°583): "Primordiale autem principium totius processionis rerum est Filius Dei, secundum illud Io. 1,3: *Omnia per ipsum facta sunt.* Et ipse ideo est primordiale exemplar, quod omnes creaturae imitantur tamquam veram et perfectam imaginem Patris. Unde dicitur Col. 1,15[–16]: *Qui est imago Dei invisibilis, primogenitus omnis creaturae; quoniam in ipso condita sunt universa.* Speciali tamen quodam modo exemplar est spiritualium gratiarum, quibus spirituales creaturae illustrantur, secundum illud quod in Ps 109,3 dicitur ad filium: *In splendoribus sanctorum ex utero ante luciferum genui te,* quia scilicet genitus est ante omnem creaturam per gratiam lucentem, habens exemplariter in se splendores omnium sanctorum."

27. Cf. *In ad Ephesios* 1,16–17 lect. 6 (*Super epp.* 2: 14 n°49): "Secundum quod (Jesus Christus) est Deus, est gloria Patris. Hebr I,3: *Qui cum sit splendor gloriae,* etc. Est etiam gloria nostra, quia ipse est vita aeterna. I Io. c. ult., 20: *Simus in vero Filio eius, hic est verus Deus, et vita aeterna.* Sic ergo dicit ut Deus Domini nostri Iesu Christi, secundum quod est homo, et pater eiusdem, secundum quod est Deus; pater, inquam, gloriae, scilicet Christi, qui est gloria eius, Prov. X,1: *Gloria patris filius sapiens,* etc., et gloriae nostrae, inquantum dat omnibus gloriam."

28. Cf. *In ad Romanos* 8,29 lect. 6 (*Super epp.*1: 127 n°704): "Ipse (Christus) enim est genitus a patre tamquam splendor gloriae eius, Hebr. I,3. Unde per hoc quod sanctos illuminat de lumine sapientiae et gratiae, facit eos fieri conformes sibi. Unde in Ps CIX,4 (Vulg. v.3) dicitur: *In splendoribus sanctorum ex utero ante Luciferum genui te,* id est, profundentem omnem splendorem sanctorum."

29. Cf. *In Matt.* 13,43 lect. 3 (*Super Matth.* 183 n°1185) (*Et implebit splendoribus animam tuam* = Is 58,11, Vulg.); *In ad Romanos* 8,29 lect. 6 (*Super epp.* 1: 126–27 n°701–6); *Catena,* Jn 13,5 (2: 510–12 n°5); *Super Is.* 62,3 (Édition Léonine 28: 242, lin. 23–31).

30. Cf. *In ad Colossenses* 1,12 lect. 3 (*Super epp.* 2: 131 n°23–25).

31. Cf. *In ad Hebraeos* 1,9 lect. 4 (*Super epp.* 2: 350 n°65): "Unde alii dicuntur sancti, ipse vero sanctus sanctorum. Ipse enim est radix omnis sanctitatis."

32. Cf. Origene, *In Matth.* (*Tract.* 35), in *Catena,* Mt 27,45 (1: 411 n°9): "Item sub Moyse factae sunt tenebrae super omnem terram Aegypti tribus diebus; omnibus autem filiis Israël erat lumen; sub Christo autem factae sunt tenebrae super omnem Iudaeam tribus horis: quoniam propter peccata sua privati sunt a lumine Dei Patris, et a splendore Christi, et ab illuminatione Spiritus sancti. Lumen autem super omnem reliquam terram, quod ubique illuminat omnem Ecclesiam Dei in Christo. Et si usque ad horam nonam tenebrae factae fuerunt super Iudaeam, manifestum est quoniam iterum eis lumen refulsit : quia *cum plenitudo Gentium intraverit, tunc omnis Israël saluus fiet* (Rm 2,25)."

33. Cf. *In Matth* 28,20 lect. <unica> (*Super Matth.* 378 n°2469): "Et notate quod sicut mandatum ponitur transire in omnes, sic et auxilium; quia promittit Apostolis et aliis simile exequentibus . . . [Io. XVII 20]: *Non pro eis autem rogo tantum,* scilicet discipulis, *sed et pro his qui credituri sunt per verbum eorum in me.* Unde omnibus communiter promittit; Io XIV 12: *Qui credit in me, opera quae ego facio, et ipse faciet et maiora horum faciet.* Item per omne tempus . . . Unde etiam Is. VII 14 dicitur quod *vocabitur nomen eius Emmanuel,* quod interpretatur Nobiscum Deus, *usque ad consummationem saeculi.*"

34. Cf. *Super Is* 9,6 (Édition Léonine 28: 69, lin. 172–193) et notre article: "Le Christ en son mystère," 45–47.

35. Cf. *In Ioannem* 1,1 lect. 1 (*Super Ioann.* 10 n°34): "Principium sapientiae nostrae est Christus, inquantum est sapientia et Verbum Dei, idest secundum divinitatem."

36. *In ad II Cor.* 4,4 lect. 2 (*Super epp.* 1: 467 n°125): "Evangelium dicitur notitia claritatis Christi, quae quidem notitia virtutem habet illuminativam. Sap. VI 13: *Clara est et quae numquam marcescit sapientia,* etc. Et quidem, quantum est de se, in omnibus refulget et omnes illuminat, sed illi qui praebent impedimentum, non illuminantur . . . Quod quidem est illuminans, quia est gloria Christi, id est claritas."

37. Cf. *In Ioannem* 1,4 lect. 3 (*Super Ioann.* 20–22 n°95–107); *In* 1,9 lect. 5 (26–28 n°124–32); *In Matth.* 22,44 lect. 4 (*Super Matth.* 280 n°1825); *In Psalm.* 44,1 (Parma Édition 14: 319).

38. Cf. *In Psalm.* 44,2 (Parma Édition 14: 320); *In ad Romanos* 1,18–20 lect. 6 (*Super epp.* 1:21–22 n°109–117 et Si 1,1–10); sur la possibilité d'atteindre certaines vérités divines par voie démonstrative et l'impossibilité d'un conflit entre la raison et la foi, cf. SCG 1 cc.1–9 (*Liber CG* 2: 1–12 n°s1–58); sur le témoignage paulinien, cf. Denis Biju-Duval, "Dieu avec ou sans l'être," *Revue Thomiste* 95 (1995): 549–51.

39. Cf. *In Librum beati Dionysii de divinis nominibus expositio*, 4 lect. 4, éd. C. Pera et al. (Turin-Rome, 1950): 107–8 n°327): "Non enim omnis nescientia ignorantia dici potest, sed solum nescientia eorum ad quae quis natus est et debet scire. Secundum est : quod *tradit sanctum lumen;* et nota quod dicit: *sanctum lumen,* tum quia a Deo immittitur, tum quia ad Deum cognoscendum nos ordinat. Et notandum quod non fuit usus verbo impletionis, sed simplicis traditionis, ad ostendendum quod cognitio veritatis est imperfecta in animabus in comparatione ad illam plenitudinem quam Angeli a Deo possident"; il faut noter cependant que l'union à Dieu ne se parfait pas dans l'intellect spéculatif mais dans la volonté: "coniunctio non perficitur ad Deum in intellectu sed in affectu," *Quaestiones disputatae De veritate* q.18 a.6 ad 10, éd. A. Dondaine, Édition Léonine 22 (1970–74): 554.

40. Cf. *In ad II Cor.* 3,18 lect. 3 (*Super epp.* 1; 464 n°s113–15) et *Quaestiones disputatae De potentia* q.9 a.9 resp., éd. P. Bazzi et al. (Turin-Rome, 1949[8]), 249: "Cuius quidem ternarii similitudo in creaturis apparet tripliciter: Primo quidem sicut effectus repraesentat causam; . . . Alio modo secundum eamdem rationem operationis; . . . Tertio modo per unitatem obiecti, in quantum creatura rationalis intelligit et amat Deum; et haec est quaedam unionis conformitas, quae in solis sanctis invenitur qui idem intelligunt et amant quod Deus. . . . De tertia II *Cor.* III, 18: *Nos enim omnes revelata facie gloriam Domini speculantes, in eamdem imaginem transformamur;* et haec dicitur imago recreationis."

41. *In ad II Cor.* 4,4 lect. 2 (*Super epp.* 1: 467 n°125): "Ubi sciendum est, quod Deus Pater est fons totius luminis. I Io. 1,5: *Deus lux est, et tenebrae in eo non sunt,* etc. Ex hoc autem fontanoso lumine derivatur imago huius luminis, scilicet Filius verbum Dei. Hebr. c. 1,3: *Qui cum sit splendor,* etc . . . "

42. SCG 4 c.7 (*Liber CG* 3: 254 n°3416): "Nulla substantia creata repraesentat Deum quantum ad eius substantiam: quicquid enim ex perfectione cuiuscumque creaturae apparet, minus est quam quod Deus est; unde per nullam creaturam sciri potest de Deo *quid est.* Filius autem repraesentat Patrem: dicit enim de eo Apostolus, ad *Coloss.* I 15, quod *est imago invisibilis Dei.*"

43. Ibid.: "Et ne aestimetur esse imago deficiens, essentiam Dei non repraesentans, per quam non possit cognosci de Deo *quid est* . . . ostenditur perfecta esse imago, ipsam Dei substantiam repraesentans, He 1,3, dicente Apostolo: *Cum sit splendor gloriae, et figura substantiae eius.* Non est igitur Filius creatura"; cf. *In ad Hebraeos* 1,3 lect. 2 (*Super epp.*2: 341–43 n°s24–34). Le thème de l'image est particulièrement traité dans ST 1 qq.35 et 93; il l'avait déjà été dans les *In I Sent.* d.3 q.3 a.1 (*Scriptum* 1: 109–11) et q.4 a.4 (1: 119–21); d.28 q.2 a.1–3 (1: 677–83); *In II Sent.* d.16 q.1 (2: 396–406); on le trouve de même au *De veritate* q.10 (Édition Léonine 22: 295f.); *Contra errores Graecorum* Pars Prior c.10 (Édition Léonine 40: A77–78); *In ad I Cor.* 11,4–7 lect. 2 (*Super epp.* 1: 347, en particulier n°604); *In ad I Cor.* 11,7 lect. 2 (1: 347 n°s603–5); *In II Cor.* 4,4 lect. 2 (1: 467 n°s125–26); *In ad Colossenses* 1,15 lect. 4 (2: 132–33 n°s29–35).

44. Cf. *In ad II Cor.* 4,4 lect. 2 (*Super epp.* 1:467 n°126): "Nota, secundum Glossam, quod Christus perfectissima imago Dei est. Nam ad hoc quod aliquid perfecte sit imago alicuius, tria requiruntur, et haec tria perfecte sunt in Christo. Primum est similitudo, secundum est origo, tertium est perfecta aequalitas. Si enim inter imaginem et eum, cuius est imago, esset dissimilitudo, et unum non oriretur ex alio, similiter etiam si non sit aequalitas perfecta, quae est secundum eamdem naturam, non esset ibi perfecta ratio imaginis. Nam similitudo regis in denario, non perfecte dicitur imago regis, quia deest ibi aequalitas secundum eamdem naturam; sed similitudo regis in filio dicitur perfecta imago regis, quia sunt ibi illa tria quae dicta sunt. Cum ergo ista tria sint in Christo filio Dei, quia scilicet est similis Patri, oritur a Patre, et aequalis est Patri, maxime et perfecte dicitur imago Dei"; cf. *In ad Colossenses* 1,15 lect. 4 (*Super epp.* 2: 132 n°31); *In ad Hebraeos* 1,3 lect. 2 (2: 342 n°s27–29).

45. Cf. SCG 1 c.53 (*Liber CG* 2: 65 n°445): "Intellectus autem divinus nulla alia specie intelligit quam essentia sua, ut supra (I 46) ostensum est. Sed tamen essentia sua est similitudo omnium rerum (I 29). Per hoc ergo sequitur quod conceptio intellectus divini, prout seipsum intelligit, quae est verbum ipsius, non solum sit similitudo ipsius Dei intellecti, sed etiam omnium quorum est divina essentia similitudo. Sic ergo per unam speciem intelligibilem, quae est divina essentia, et per unam intentionem intellectam, quae est verbum divinum, multa possunt a Deo intelligi."

46. Cf. ci-dessus, n.36.

47. Cf. *De veritate* q.4 a.3 sed c. et resp. (Édition Léonine 22: 126), où Thomas résume avec la clarté qu'on lui connaît la position grecque et latine; quelques années plus tard, la rédaction du *Liber* . . .

contra errores infidelium l'amènera à appuyer ce double point de vue de multiples textes patristiques; cf. *CEG* Pars Prior c.10 (Édition Léonine 40: A77–78).

48. Nous venons de le voir, certains textes de S. Thomas sont particulièrement attentifs à la pensée des Pères grecs et l'on sait à quel point la Tradition patristique orientale a nourri sa réflexion croyante, principalement après sa composition de la *Catena aurea* et la rédaction du *Contra errores Graecorum*.

49. Cf. *De veritate* q.4 a.3 sed c. (Édition Léonine 22: 126) qui cite de façon non littérale S. Augustin, *De Trinitate* 7.2.3, (Bibliothèque Augustinienne 15: 516–17); la problématique du *De Trinitate* n'est pas ici directement celle de la génération, mais bien de l'identité du Père et du Fils dans leurs attributs essentiels et non dans leurs propriétés personnelles; S. Thomas cependant en retient l'idée: "quod *Filius eo dicitur Verbum quo Filius*; sed Filius dicitur Filius eo quod genitus; sed Spiritus Sanctus non est genitus; ergo non est verbum."

50. Il n'est pas sans intérêt de noter avec B. Jollès, Saint Thomas d'Aquin, *Questions disputées sur la vérité*, Question IV: Le Verbe (Bibliothèque des Textes philosophiques, Paris, 1992), 105, n.58, que le texte attribué à S. Basile de Césarée (cité dans le *De veritate* q.4 a.3 arg.1 (Édition Léonine 22: 126) et le *Libellus*, 58, lin. 1–5 auquel répond le *CEG*, Pars Prior, c.12 (Édition Léonine 40: A79 lin. 5–10) et Pars Altera c.27 (A98 lin. 40–42), est une juxtaposition de deux passages dont le premier s'inspire de son *De Spir. sancto*, c.17 43 (PG 32: 147–48 A), et le suivant de l'*Adversus Eunomium* V (PG 29: 732 A): "le membre de phrase issu du *De Spir. Sancto* est lui-même une citation très fidèle d'Athanase, *Epist. I ad Ser.*, c.21; voir aussi *Epist. III ad Ser.*, c.1." Le livre 5 de l'*Adv. Eun.* pour sa part, demeure d'authenticité douteuse (cf. B. Sesboüé, SC 299, 61–64); sur le Saint-Esprit image du Fils, voir *CEG* Pars Prior, c.10 (Édition Léonine 40: A77–78; *In ad Hebraeos* 1,3 lect. 2 (*Super epp.* 2: 343 n°34).

51. *In ad Colossenses*. 1,15 lect. 4 (*Super epp.* 2: 132 n°30): "Notandum est quod Deus dicitur invisibilis, quia excedit capacitatem visionis cuiuscumque intellectus creati, ita quod nullus intellectus creatus naturali cognitione potest pertingere ad eius essentiam. Iob XXXVI 26: *Ecce Deus magnus vincens scientiam nostram*. I Tim. ult. [VI 16]: *Lucem habitat inaccessibilem*. Videtur ergo a beatis ex gratia, non ex natura.—Ratio huius assignatur a Dionysio, quia omnis cognitio terminatur ad existens, id est ad aliquam naturam participantem esse. Deus autem est ipsum esse non participatum ergo est incognitus. Huius ergo Dei invisibilis Filius est imago."

52. Ibid. (2: 132 n°32).

53. Cf. He 3,5: *Christus vero tamquam filius in domo sua, quae domus sumus nos*; cité dans *In Psalm*. 2,6 (Parma Édition 14: 154).

54. Cf. *In ad Hebraeos* 1,3 lect. 1 (*Super epp.* 2: 339–40 n°18).

55. Cf. *In ad Philippenses* 2,6 lect. 2 (*Super epp.* 2: 101–2 n°s54–62).

56. Cf. SCG 4 c.2 (*Liber CG* 3: 246 n°3354 d): "*Ioan.* etiam dicitur: *Vidimus gloriam eius quasi Unigeniti a Patre*; et iterum: *Unigenitus Filius, qui est in sinu Patris, ipse enarravit*."

57. SCG 4 c.2 (*Liber CG* 3: 246 n°3354 c): "Nec esset conveniens ut qui alios vere generare facit, ipse non vere, sed per similitudinem generet: cum oporteat nobilius esse aliquid in causa quam in causatis, ut ostensum est"; cf. *In Ioan*. 5,20, lect. 3, n° 753 : "Dionysius dicit, VI cap. *De divinis nominibus*, quod divinus amor non permisit eum sine germine esse."

58. Dans le prolongement de He 1,3 évoqué dans les collations [21 et 22], on peut lire le commentaire d'He 1,5 qui reprend ce verset 7 du Ps 2, à la lect. 3 (*Super epp.* 2: 346 n°49) et *In Psalm*. 2 n°5 (Parma Édition 14: 154).

59. Cf.SCG 4 c.2 (*Liber CG* 3: 245–46 n°s3352–3354) où sont cités plusieurs passages de l'A.T. relatifs à la génération divine; voir encore *In I Sent*. d.3 q.1 a.4 (*Scriptum* 1: 97–99); d.4 q.1 a.1 (1: 130–33); *De divinis nominibus expositio* c. 2, lect. 4 (54 n°s181–84); *In Ioannem* 1,18 lect. 11(*Super Ioann*. 44 n°218); *Super decretalem* I (Édition Léonine 40: E30, lin. 40–78; E32, lin. 244–249); *Super decretalem*. II (Édition Léonine 40: E41, lin. 1–17; E43–44, lin. 232–58); *Super Boetium De Trinitate* Prooem. q.1 a.4, éd. P.-M. Gils, Édition Léonine 50 (1992): 88–91; *De veritate* q.10 a.13 (Édition Léonine 22: 343–46).

60. *Pr* 8,25 (*LXX*): πρὸ δὲ πάντων βουνῶν γεννᾷ με dans SCG 4 c.2 (*Liber CG* 3: 245 n°3354 b): *ante omnes colles generauit me Dominus*; Vulg.] *ante colles ego parturiebar*.

61. Cf. SCG 4 c.10 (*Liber CG* 3: 264 n°3460 b): "Sed quia veritas in seipsa fortis est, et nulla impugnatione convellitur, oportet intendere ad ostendendum quod *veritas fidei ratione superari non possit*."

62. SCG 4 c.11 (*Liber CG* 3: 264 n°3461): "Principium autem huius intentionis hinc sumere oportet, quod secundum diversitatem naturarum diversus emanationis modus invenitur in rebus; et quanto aliqua natura est altior, tanto id quod ex ea emanat, magis ei est intimum."

63. Cf. SCG 4 c.11 (*Liber CG* 3: 265 n°3465 c): "Ultima igitur perfectio vitae competit Deo, in quo non est aliud intelligere et aliud esse, ut supra ostensum est, et ita oportet quod intentio intellecta in Deo sit ipsa divina essentia"; cf. ibid. 1 c.45 et *In ad Colossenses* 1,15 lect. 4 (*Super epp.* 2: 133 n°34).

64. Cf. *In ad Hebraeos* 1,1 lect. 1 (*Super epp.* 2: 338 n°15): "Deus ergo loquendo, primo concepit, cuius conceptio una fuit, et ab aeterno—Iob c. XXXIII 14: *Semel loquitur Deus* —, et haec aeterna fuit Filii generatio, de qua in Ps II 7: *Dominus dixit ad me: filius meus es tu, ego hodie genuit te*"; il faut se rappeler que ce passage n'est pas de S. Thomas, mais bien de Rémi de Florence à qui l'ont doit d'autres interpolations, cf. ibid., 338 note; *In* 7,1 lect. 1 (2: 407 n°326, note et *Super epp.* I, *Praef.*, X; dans son commentaire *Super Iob* 33,14 (Édition Léonine 26: 175) S. Thomas donne une autre interprétation de ce verset.

65. Cf. *In ad Colossenses* 1,15 lect. 4 (*Super epp.* 2: 133 n°35): "Secundo videndum est quomodo dicatur primogenitus. Deus enim non alio se cognoscit et creaturam, sed omnia in sua essentia, sicut in prima causa effectiva. Filius autem est conceptio intellectualis Dei secundum quod cognoscit se, et per consequens omnem creaturam. Inquantum ergo gignitur, videtur quoddam verbum repraesentans totam creaturam, et ipsum est principium omnis creaturae. Si enim non sic gigneretur, solum Verbum Patris esset primogenitus Patris, sed non creaturae. Eccli. XXIV 5: *Ego ex ore Altissimi prodii, primogenita ante omnem creaturam*, etc."; cf. ibid., n°36–40; ST 1 q.34 a.3.

66. Cf. G. Emery, *La Trinité créatrice, Trinité et Création dans les commentaires aux Sentences de Thomas d'Aquin et de ses précurseurs, Albert le Grand et Bonaventure*, (Bibliothèque thomiste 47, Paris, 1995) et le CR de S.-T. Bonino, *Revue Thomiste* 95 (1995): 508–11.

67. Cf. Ml 2,10 et "Le Christ en son mystère," 43–45.

68. Cf. *In ad Hebraeos* 2, 10–12 lect. 3 (*Super epp.* 2: 364–66 n°127–31).

69. Cf. ST 1 q.104 a.1 sed c.

70. Cf. *In ad Hebraeos* 1,3 lect. 2 (*Super epp.* 2: 342–43 n°31–33).

71. ST 1 q.104 a.1 ad 4: "Conservatio rerum a Deo non est per aliquam novam actionem; sed per continuationem actionis qua dat esse, quae quidem actio est sine motu et tempore. Sicut etiam conservatio luminis in aere est per continuatum influxum a sole"; cf. SCG 3 c.65 (*Liber CG* 3:88–90 n°2397–2406); *De potentia* q.5 a.1 (éd. Bazzi, 129–33); *In Ioannem* 5,17 lect. 2 (*Super Ioan.* 138 n°738–40); *In ad Hebraeos* 1,3 lect. 2 (*Super epp.* 2: 342–43 n°30–33); voir encore Ch.-V. Héris, "Appendice II": "La conservation des êtres par Dieu" dans ST 1 q.104 aa.1–2 (Revue des jeunes, Paris, 1925), 253–67.

72. ST 1 q.104 a.1 corp.: "Necesse est dicere, et secundum fidem et secundum rationem, quod creaturae conservantur in esse a Deo . . . Dependet enim esse cujuslibet creaturae a Deo, ita quod nec ad momentum subsistere possent, sed in nihilum redigerentur, nisi operatione divinae virtutis conservarentur in esse, sicut Gregorius dicit [*Moral.*, lib. 16, c. 37] . . . [sicut] statim cessat lumen, cessante actione solis," (SC 221, XVI, xxxvii, 45, p. 206–209); cf. *In ad Colossenses* 1,17 lect. 4 (*Super epp.* 2: 134 n°44).

73. Cf. S. Augustin, *De genesi ad litteram* 8.12 (Bibliothèque Augustinienne 49: n°26): "Neque enim, ut dicebamus, sicut operatur homo terram, ut culta atque fecuna sit, qui cum fuerit operatus abscedit, relinquens eam uel aratam uel satam uel rigatam uel si quid aliud, manente opere, quod factum est, cum operator abscesserit, ita Deus operatur hominem iustum, id est iustificando eum, ut, si abscesserit, maneat in abscedente quod fecit : sed sicut aer praesente lumine non factus est lucidus, sed fit, quia, si factus esset, non autem fieret, etiam absente lumine lucidus maneret, sic homo Deo sibi praesente, inluminatur, absente autem continuo tenebratur, a quo non locorum interuallis, sed uoluntatis auersione disceditur."

74. ST 1 q.104 a.1 corp.: "Sicut enim sol est lucens per suam naturam, aer autem fit luminosus participando lumen a sole, non tamen participando naturam solis; ita solus Deus est ens per essentiam suam, quia ejus essentia est suum esse; omnis autem creatura est ens participative, non quod sua essentia sit ejus esse."

75. Qo 3,14 Vulg., cité dans ST 1 q.104 a.4 sed c.: *Didici quod omnia opera quae fecit Deus, perseverant in aeternum*; Vulg. *Didici . . . perseverent in perpetuum.*

76. ST 1 q.104 a.4 ad 1: "Quod res in esse productae sunt, postquam non fuerunt, declarat potentiam producentis. Sed quod in nihilum redigerentur, hujusmodi manifestationem impediret : cum Dei potentia in hoc maxime ostendatur, quod res in esse conservat, secundum illud Apostoli [v.3]: *Portans omnia verbo virtutis suae.*"

77. Cf. ibid., ad 2 et ad 3.

78. Cf. Jb 40,1–9.

79. Cf. *Super Iob*, 40,1–9 lect. 1 (Édition Léonine 26: 213–214, lin. 72–105).

80. Ibid. (26: 214, lin. 115–23): "Quantum ad bonos cum dicit *et speciosis induere uestibus.* Om-

nes enim boni tam angeli quam homines speciosi sunt ex participatione divinae sapientiae et iustitiae, et sicut homo ornatur ex specioso vestimento, ita omnis decor sanctorum angelorum et hominum redundat in ornatum Dei inquantum ex hoc Dei bonitas commendatur, per modum quo dicitur Is. XLIX 18 'His omnibus velut ornamento vestieris'."

81. Cf. *In ad Hebraeos* 9,19 lect. 4 (*Super epp.* 2: 436–37 n°457).

82. Ce passage de l'*Apocalypse* est précisément un écho d'Is 63,1.

83. Cf. la finale de l'hymne *Sacris solemnis* de l'*Officium de festo Corporis Christi ad mandatum Urbani Papae:* "Per tuas semitas duc nos quo tendimus/ ad lucem quam inhabitas."

Poetry and Theology in the *Adoro te deuote:* Thomas Aquinas on the Eucharist and Christ's Uniqueness

Robert Wielockx

I. The Text of the *Adoro te deuote*

THE TEXT OF THE *Adoro te deuote* that I present in this paper (Appendix I) is based on a personal collation of 51 witnesses, 48 among which are manuscript copies. The critical text rests basically on William of Tocco's fourth and last version of the *Ystoria sancti Thome de Aquino.* Whenever this version diverges from earlier versions, it does so on the basis of information from people who lived in and around Naples.[1] More particularly, at Naples, where William of Tocco had been Thomas's disciple and confrère before becoming a prior, was the convent in which Thomas's belongings supposedly remained after his death.[2]

One of the most important differences between the text presented in this essay and that printed by André Wilmart pertains to its poetic form.[3] Wilmart continued to circulate a text of the poem subdivided into stanzas, as it was printed in some post-medieval editions. This form, however, is not attested by the manuscript and incunabula tradition, except in the irrelevant and isolated witness, Paris, Bibliothèque Mazarine, Ms. 3897. The original form, as attested by the representative manuscript tradition, consists of fourteen distichs.

II. Some Remarks on Authorship

External evidence, which must be given priority in sound criticism, wholly favors Thomas Aquinas's authorship of the poem. Of the 51 witnesses known, 44 bear Thomas's name; no witness ascribes the prayer to someone other than Thomas Aquinas.

The geography of the manuscript tradition provides a second argument. The best text of the poem is to be found in William of Tocco's *Ystoria,* which is connected to Naples, and in a parallel tradition, which characteristically originated in Dominican circles, more specifically in Naples.

In the light of this external evidence, internal criticism is hardly necessary to establish Thomasian authorship, but serves simply to confirm it. Without my entering into all the details now, it is enough to note that both the poetic form (scansion, rhyming, structuring) and the theological content of the text confirm Thomasian authorship in every respect.[4]

The difficulty raised by Wilmart and others can be resolved on two grounds.[5] First, as L. Richard pointed out, the *fallitur* in verse 5 is not absolute but relative: it regards

simply the Person addressed (*in te*).[6] Of course, this Person, in his Godhead, in his human mind and in his human body, insofar as the latter is in the Sacrament, is beyond the capacities of our sense perception. Hence the text does not contradict the continuous teaching of Thomas according to which the senses are not wrong when they judge their proper object, which, as far as the Eucharist is concerned, is only the sacramental species.

Second, not only does the text not contradict Thomas's doctrine of the relative inerrancy of the senses in respect of the Eucharist, but it actually presents it. In Thomas's view, the proper object of sense perception is inseparable from the individual *here*. This proper object is expressly mentioned and emphasized in the text. After a decisive reference in verse 2 (*his*), the term appears again in adverbial form (*hic*) in verse 10. (A structural analysis of the poem shows, moreover, that verse 10 is in a strict parallel with verse 2.) One should notice that, in Thomas's other writings as in the *Adoro te deuote* (see *sub his formis* in verse 2), sense experience is obviously not the perception of a bare *here*, but the perception of a *here* further specified by such forms as extension, surface, color and the like. Not only do the senses not err in their perceptions, without this sense perception of the sacramental species, faith and adoration, as the author understands them here, would be impossible. Thus the prayer is in perfect harmony with Thomas Aquinas's constant insistence on the relative inerrancy of the senses as regards the Eucharist.[7]

III. A Method of Structural Analysis

The first requirement for an understanding of a text in its entirety is to know where its constitutive parts begin and end. To be an 'authentic part' is to exhibit qualities not found in other parts of the text. By definition, the occurrence of a single element would not suffice to establish that one is dealing with an authentic part. But when a particular element is repeated, and that repetition does not occur elsewhere in the text, then one may speak of an 'authentic part'.

Granted the existence of distinct authentic parts in a text, it is all the more significant that certain elements are common to different parts, that these shared elements bind the discrete parts into units, and that they establish an overall unity of the text taken as a whole. It is vital, then, that one focus on elements common either to several parts of the text or, more especially, to all of its parts. Only by doing this can one discover the motifs that run through the text.

An analysis of the poetic and linguistic form of the *Adoro te deuote* will prepare us for a theological understanding of the poem as a whole, when we turn our attention to the ideas involved in the structural motifs that are uncovered by the analysis.

IV. The Poetic Structure

(1) The Division of the Poem into Two Parts: Verses 1–14 and 15–28

The whole text of the *Adoro te deuote* is clearly divided into two equal parts: verses 1–14 and verses 15–28. The division is easily recognizable: verses 1–14 all end in consonants, whereas verses 15–28 all end in vowels.

(2) The Subdivision of Verses 1–14

The end-rhyme -*itas* is proper to verses 1–2 and 9–10. This repetition of rhyming has two immediate effects. First, verses 1–2 and 9–10 form an 'inclusion' around verses 3–8, so that the including verses and the verses included are distinguished from each other. Second, since the repetition of the rhyming -*itas* does not involve verses 11–14, neither as including nor as included verses, a further separation in the text, of verses 1–10 from verses 11–14, is at once evident. Verses 11–14 constitute, so to speak, the 'cadenza' of verses 1–14. For the sake of simplicity, I shall call this particular way of subdividing 'inclusion with simultaneous exclusion'.

(3) The Subdivision of Verses 15–28

The subdivision of verses 15–28 shows a variant of 'inclusion with simultaneous exclusion'. The -*ere* end-rhyme of verses 15–16 is repeated in verses 19–20 and 23–24. This repetition establishes verses 15–16, 19–20 and 23–24 as including verses, which surround verses 17–18 and 21–22. The number of including verses rises from four in verses 1–10 to six in verses 15–24. Accordingly, instead of the one undivided block of included verses found in verses 3–8, we find here a double group of included verses, verses 17–18 on the one hand, and verses 21–22 on the other. By the same repetition of the rhyming -*ere*, the poet also achieves the separation of verses 15–24 from verses 25–28. One may note a perfect parallel with verses 1–14, which likewise end with a 'cadenza' in the last four verses.

(4) The Subdivision of Verses 15–24

The technique of 'inclusion with simultaneous exclusion' recurs finally in a third and unparalleled subdivision within verses 15–24. Verses 15–20—and they alone—offer a threefold cluster of rhyming and assonance involving in different ways the first hemistiches.

(a) Verses 15–16 and 19–20—and they alone—show rhyming (vv. 15, 19, 20) and assonance (v. 16) among the first hemistiches. The rhyming is obvious: *semper* (v. 15), and *michi semper* (vv. 19–20). As to the assonance, the two syllables composing *semper* occur again at the end of the first hemistich of verse 16. Indeed, the last characters of this hemistich, -*re*, their order excepted, are also those of the first hemistich of verses 15, 19 and 20. The remaining characters of the word *semper*, moreover, reappear in the *spem* of the first hemistich of verse 16. The two parts of the word *semper* undergo a metathesis of characters as they recur in the first hemistich of verse 16.

(b) The first hemistich of verse 16, which in the first play of rhyme and assonance is excluded from the rhyme scheme and evinces only assonance, now, as it were, takes its revenge. For the first hemistich of verse 16 rhymes with the second hemistich of the same verse (*habere,...diligere*). This is the only instance of *versus leoninus* in the entire poem.[8] Moreover, there is assonance (*er/re*), exclusive in all the poem, between the first and second hemistich, respectively, of verses 15, 19 and 20.

(c) The ending of the first hemistich of verse 15 (*me tibi semper*) exhibits an obvi-

ous cross-parallelism with *te michi semper* in verse 20. Moreover, the first hemistiches of verses 16 and 19 are not excluded, since they also, when taken together, offer the two elements of the cross-parallel phrase in verse 20, *te michi semper.* Verse 16 offers the *te,* and verse 19 adds the *michi semper.*

V. THE LINGUISTIC STRUCTURE

In order to confirm the structure established above, first I shall analyze the whole poem (vv. 1–28), and then each of its three subdivisions: verses 1–14, verses 15–28, and verses 15–24. Each of these four analyses will proceed in two steps. First, I shall establish what is proper to the separate parts. Secondly, I shall examine elements common to two or more parts.

(1) The Linguistic Structure of Verses 1–28

(a) Elements proper to verses 1–14

Four features of vocabulary are proper to verses 1–14. The substantive *ueritas* or *ueritatis* (vv. 1, 8), its adjectival form *uerius* (v. 8), and its adverbial recurrence *uere* (vv. 2, 11), do not occur elsewhere in the poem. The substantive *deus,* which we encounter once in the genitive (v. 7) and once in the accusative case (v. 14), is also proper to the part constituted by verses 1–14. Likewise, the possessive pronoun *meum,* which appears in verse 3 and recurs in verse 14, is exclusive to this part of the text. Finally, this part of the text is characterized by the use of particles expressing negation (*nichil* in v. 8, *non* in v. 13), adversity (*sed* in vv. 6, 10), exclusion (*solo* and *sola* in vv. 6, 10), or opposition (*tamen* in v. 14).

(b) Elements proper to verses 15–28

Particular moods are proper to verses 15–28. Only in these verses does one find the imperative (*Fac* in v. 15, *Presta* in v. 19, *munda* in v. 22), and the subjunctive (*posset* in v. 24, *sim* in v. 28). Likewise, only in these verses does one find the future tense (*fiet* in v. 26). Further, as regards vocabulary, only in these verses does one encounter the name of Jesus (*Ihesu* in vv. 21, 25). Finally, only in this part of the poem does one meet the possessive pronoun in the second person singular (*tuo* in v. 22, *tue* in v. 28).

(c) Elements common to verses 1–14 and 15–28

There is also a vocabulary common to verses 1–14 and 15–28. No form is used more than the second person singular personal pronoun. The word *te* occurs five times in Part One of the poem (vv. 1, 2, 4, 5, 14) and equally five times in Part Two (vv. 16, 16, 19, 20, 27). The repeated presence of this word and its equal distribution over Parts One and Two indicate its major significance. The form *tibi* occurs once in Part One (v. 3) and once in Part Two (v. 15). Numerically, this recurrence seems to be insignificant. Yet their equal distribution over Parts One and Two integrates the two occurrences of *tibi* with the ten occurences of *te,* which likewise are distributed equally in each of the two parts.

The verb *credere* links the two major parts of the poem (vv. 1–14 and vv. 15–28) in a progressive series, in which each new reference to faith offers a new development of its causality: instrumental cause (v. 6), material cause (v. 7), material cause of faith in the Eucharist (v. 11), and formal cause (v. 15). This gradual development brings divine faith to a gentle landing on the ground proper to Part Two.

The twelve occurrences of *te-tibi* and the four occurrences of the verb *credere* constitute two significant series. Against this background, the fact that other phrases or terms occur at only one place in Part One (vv. 1–14) and again at only one place in Part Two (vv. 15–28) deserves attention. Moreover, analyses of the places in Part One and Part Two where the phrases or terms appear turn out to be mutually illuminating.

The phrase *in te* is found in verses 5 and 16, and in these verses alone. In passing from the first occurrence, *in te fallitur,* to the second, *in te spem habere,* we pass from deficiency to the firm possession of hope.

The word *totum* occurs in verses 3–4, and again in verse 24. It occurs nowhere else in the poem. The total insufficiency of human inwardness (vv. 3–4) contrasts sharply with a power that is sufficient to save all the world (v. 24).

There are only two references to sight in the poem (*uisus* in v. 5, *uisu* in v. 28). An antithetical parallelism links the two occurrences of the word. When it is used first in Part One (v. 5), it expresses the inability of the sense of sight to discern anything beyond the sacramental species. In Part Two (v. 28), it expresses the role of sense perception in the beatific vision, inasmuch as one of the privileged objects of this act is the gloriously risen Jesus.

(2) The Linguistic Structure of Verses 1–14

Verses 1–2 and 9–10, as we have seen, occupy a crucial position in the 'inclusion with simultaneous exclusion' that governs the subdivision of verses 1–14.

(a) Elements proper to verses 1–2 and 9–10

The crucial position of these verses is confirmed especially by the vocabulary. Only in these verses does one find forms of the verb *latere,* and they alone exhibit the demonstrative pronoun *his* and its adverbial form, *hic.* Forms of the verb *latere* occur four times. No verb—not even *credere,* which also occurs four times—occurs more frequently in all the poem. One should observe that the distribution of the four forms of *latere* is quite deliberate, and that it emphasizes, visibly, the special position of verses 1, 2, 9 and 10. Each of the four verses, indeed, receives one of the four forms of the verb: *latens* (v. 1), *latitas* (v. 2), *latebat* (v. 9), *latet* (v. 10).

(b) Elements proper to verses 11–14

An analysis of vocabulary proper to these verses confirms that they serve as a 'cadenza' to the division, verses 1–14. Nowhere else in the entire poem do we find the verb *confiteri* (vv. 11, 14), just as nowhere else is the verb *petere* used (twice in v. 12). One should notice that this is not only a matter of vocabulary, but also of semantic reference. All of these verbs at once signify mental acts and their outward expressions: *confiteri, petere, penitere.* The only exception, *intueor* (v. 13), which signifies not an

act of expression but of perception, significantly is preceded by the somewhat abrupt negation-particle, *non*.

(c) For linguistic elements common to verses 1–10 and 11–14, see section V.1.a, above.

(3) The Linguistic Structure of Verses 15–28

The subdivision of verses 15–28 into a main part (vv. 15–24) and a cadenza (vv. 25–28) operates because of an inclusion, whereby verses 15–16, 19–20 and 23–24 surround the included verses 17–18 and 21–22. At the same time, this inclusion works to set apart verses 25–28, which are not involved in the inclusion.

(a) Elements proper to verses 15–16, 19–20 and 23–24

The essential part played by the including distichs 15–16, 19–20 and 23–24 finds a significant expression in the use of moods. Nowhere else in the entire poem except in these distichs does one encounter the infinitive form of verbs: *credere* (v. 15), *habere* (v. 16), *diligere* (v. 16), *uiuere* (v. 19), *sapere* (v. 20), *facere* (v. 23).

(b) Elements proper to verses 17–18 and 21–22

The included distichs 17–18 and 21–22 are, in turn, the only ones in the entire poem where the Lord is mentioned in his capacity as Lord (*domini* in v. 17, *domine* in v. 21).

(c) Elements proper to verses 15–24

The verb *facere*, which occurs in verses 15 and 23, does not appear elsewhere in the poem. The first person personal pronoun, in the accusative case (cf. vv. 15 and 22), is also proper to this part of the text.

(d) Elements proper to verses 25–28

Verses 25–28 differ from verses 15–24, from verses 1–10, and from verses 11–14. As regards their difference from verses 15–24, only in verses 25–28 is the name of Jesus expressed without qualification: *Ihesu* in verse 25. In verse 21, Jesus is addressed by his name accompanied by his title as an epithet: *ihesu domine*. In verse 17, no name is mentioned, but only the title, *domini*.

In this respect, the contrast of verses 25–28 with verses 1–10 is total, since no personal name occurs in that part of the poem. The comparison of these verses with verses 11–14 is significant from more than one point of view. First, the two cadenzas (vv. 11–14, vv. 25–28) parallel each other, inasmuch as only in them do personal names occur without qualification: *Thomas* (v. 13), *Ihesu* (v. 25). In respect of Thomasian authorship of the *Adoro te deuote*, one might note in passing that the name *Thomas* is the only other personal name, besides the name of Jesus, that appears in the poem, and that both names, when used without qualification, are to be found at significant places, respectively, in the two cadenzas of verses 1–14 and 15–28. In terms of semantic refer-

ence, there are further elements of comparison between verses 11–14 and 25–28. In verses 11–14, as we have seen, there are no other verbs except those that signify outward acts of expression or an act of sense perception significantly preceded by the negation-particle *non*. In verses 25–28, on the other hand, the poet employs verbs that do signify acts of sense perception: *aspicio, sicio, cernens.*

(e) For linguistic elements common to verses 15–24 and 25–28, see section V.1.b, above.

(4) The Linguistic Structure of Verses 15–24

(a) Elements proper to verses 15–16 and 19–20

Whereas in verses 1–14 personal and possessive pronouns coexist, as they coexist in verses 21–28, only personal pronouns figure in verses 15–16 and 19–20. Elsewhere in the poem (v. 3) one occasionally finds a personal pronoun in the third person singular. In verses 15–16 and 19–20, however, there are no personal pronouns except those in the second and first person singular. Moreover, the total number of personal pronouns occurring elsewhere in the poem is eight (or nine, if we count the one occurrence of a personal pronoun in the third person singular in verse 3); in verses 15–16 and 19–20 alone, there are eight occurences of the personal pronoun.

The exclusion of possessive pronouns from this section deserves attention. When it occurs, the possessive pronoun exercises a double function: it qualifies the noun to which it belongs and it denotes another one, as in the phrase "his father" the possessive pronoun qualifies the noun "father" and denotes his father's son. In each of its two instances, the term *meum* (vv. 3, 14) denotes the author of the *Adoro te deuote,* who is obviously a human person, that is to say, according to good Thomasian anthropology, a unity of both spiritual soul and material body. Each *meum* qualifies a substantive that signifies a purely spiritual reality: *cor* (v. 3) and *deum* (v. 14).[9]

The two possessive pronouns of the second person, *tuo* (v. 22) and *tue* (v. 28), denote Jesus, who by definition is not only the divine Word, but also the incarnate and sacramental Word. Both nouns qualified by *tuo* and *tue* in the phrases *tuo sanguine* and *tue glorie* signify corporeal realities: the blood or the glory of Jesus. The glory of Jesus is at once spiritual and corporeal: it involves inseparably both the beatific glory of his Godhead and the corporeal glory of his humanity, in which his divine glory is perceived, just as life is perceived in language.[10] Thus, the noun "glory" as well as the noun "blood," each of which is qualified by the second person singular possessive pronoun, signifies a corporeal reality.

In sum, then, each time in the *Adoro te deuote* that the first person singular possesive pronoun is used, it emphasizes the fact that purely spiritual realities, such as God or the highest intellectual faculties in man, are never what Thomas *is*, but merely what he *has*. In turn, each time that the second person singular possessive pronoun is used, it draws attention to the fact that such corporeal realities as Jesus' blood or glory are never what Jesus *is*, but merely what he *has*.

Accordingly, the exclusion of possessive pronouns from verses 15, 16, 19 and 20,

and the use of personal pronouns in the same verses must mean that the author refers in these verses not to what Jesus and Thomas *have*, but to what they *are*: integral human beings, who realize an essential union of spiritual and corporeal reality.

The crucial position of verses 15–16 and 19–20 is further confirmed by the three-fold occurrence of the word *semper* (vv. 15, 19, 20), which one meets nowhere else in the poem. Similarly, the word *michi* occurs twice in this section of the poem (vv. 19, 20), and cannot be found elsewhere.

(b) Elements proper to verses 15–20

The term *uita*, in its substantive (*uitam*, v. 18), adjectival (*uiuus*, v. 18) and verbal (*uiuere*, v. 19) forms, is proper to this central part of the poem. Likewise, the verb *prestare* can be found only in this part of the poem (vv. 18, 19).

(c) Elements proper to verses 21–24

The threefold assonance *immundum, munda, mundum* (vv. 22, 24) markedly distinguishes these verses from all the others.

(d) For linguistic elements common to verses 15–20 and verses 21–24, see sections V.3.a–c, above.

VI. THE THEOLOGICAL STRUCTURE

(1) The Theology Proper to the Separate Parts

The three distichs 3–4, 5–6 and 7–8, included by the distichs 1–2 and 9–10, refer to, in order, the insufficiency of the highest rational faculties, the deficiency of the senses, the capacity of faith to attain all truth. The three thematic elements of this series do not occur only here in Thomas's writings; one discovers all of them, notably, in the hymns *Pange lingua* and *Lauda Sion*. In *Pange lingua*, the three elements of the series are present, but in a slightly different order: here the deficiency of the senses comes first, and only then is treated the "fine point of the soul" (*cor*), which wants firmness. This firmness comes with faith, which alone suffices: "Et si sensus deficit / Ad firmandum cor sincerum / Sola fides sufficit." One finds the same three elements in *Lauda Sion*, this time in exactly the same order as in the *Adoro te deuote*: "Quod non capis, quod non uides / Animosa firmat fides."

In the *Adoro te deuote*, the included distichs 17–18 and 21–22, which unlike verses 3–8 do not constitute one block but two, refer explicitly to the sacramental species of bread (vv. 17–18), and allude to the sacramental species of wine (vv. 21–22).

(2) The Theology of the Interrelated Parts

Verses 25–28 refer to Thomas's beatific-bodily vision of the risen Jesus. As such, they provide a specific contrast with all the other parts of the poem, which treat faith in the Eucharist (vv. 1–10), Thomas's profession of this faith (vv. 11–14), and the sacramental grace of the Eucharist (vv. 15–24). The contrast is quite specific, because in each case

it works in the same way: the bodily-beatific vision of Jesus not only consummates but transcends faith, its profession and the Sacrament alike.

In its intuitive simplicity, this beatific vision transcends the complexity of eucharistic faith, which reflects the complexity of its object. The true existence of the Body of Christ in the Sacrament, on the one hand, and the sacramental species of bread and wine, on the other, are not perceived as one by the believer's senses. Nor can the believer's mind understand how Christ's body truly exists as the one substance under accidents that are not its own. In the beatific-bodily vision of Jesus, on the contrary, the object seen by the senses is no longer something alien to him, as are the sacramental species of bread and wine, but the visible Jesus himself. Moreover, the consummate grace of God manifested in the risen Christ is perceived in such a vivid and immediate way that it occurs not *through* the perception of Christ's risen body, but *in* this perception itself.[11]

The beatific-bodily vision of Jesus transcends the economy of the sacramental order, because, unlike the Eucharist, which is the perfection of the sacraments, it fully realizes its grace. The Eucharist, to be sure, is universal grace that embraces both the spiritual life of the believer and the resurrection of the believer's body. Nevertheless, this grace is not immediately realized but only pledged by the Eucharist. Thus, this Sacrament does not remove the thirst (cf. v. 26) for the revelation of the mystery.

The tension between faith and sacramental order, on the one hand, and the beatific vision and resurrection, on the other, is the main theological idea involved in the overall structure of the *Adoro te deuote*.[12]

(3) The Theology in the Motifs of the Text as a Whole

(a) Fides divina

From our poetical and linguistic analysis of the poem, we see that the presentation of faith proceeds in four steps and that each of them is intended to highlight further elements of the *analysis fidei*.

The first reference to faith (v. 6) pertains to its most outward aspect: not its content, nor its motivation, but simply the acoustic means through which belief is received. *Auditu creditur:* through hearing one believes. The Latin passive form is worth noticing, for it expresses judiciously the relatively impersonal character of this aspect of belief. Whether the faithful do or do not develop their lives of faith, they have all made a beginning by simply hearing the preaching of faith in the Eucharist. However external and impersonal it may be, believing through hearing is reliable (*tute creditur*), insofar as by this means one acknowledges things to be true that will in fact manifest their truth. Moreover, as the *solo* in the phrase *auditu solo* makes clear, there is no need to depend on other sense experience. Even someone like the blind Bartimaeus, who believes simply on the basis of hearing, and who, when hearing Jesus' call, throws away the mantle of the poor, his only possession (Mc 10:46–52, especially 50), will be saved because of his faith and will recover sight.

The second reference to faith (v. 7) leaves behind impersonal faith and its outward means. Here faith is expressed by the active voice of a verb in the first person singular

(*Credo*); moreover, attention is focussed on the content itself of faith, namely its material object against the background of its formal object or motive. The material object, or rather, the many material objects mentioned here (*quicquid*) are not specified, except by the fact that they are all believed on the basis of what God's Son has said (*quicquid dixit dei filius*).

Faith described in this way has two negative aspects. First, its object is described as a word rather than a reality. Moreover, the word concerned is one uttered in the distant past (*dixit*). In this way, there is a close parallel with the adoring and especially with the beseeching referred to, respectively, in verses 1 and 12. The object of adoration, far from being directly reached, is truly hidden under things that obstruct free access. In turn, the act of beseeching ("peto quod petiuit latro penitens") is simply described as the beseeching for something for which someone else (the thief by Jesus' side) besought in the distant past.

There are positive elements, however, in the faith referred to in verses 7–8. The many material (as distinct from formal) objects of belief are not merely many. The many truths accepted on the testimony of the One Word of Truth begin to share in the intuitive simplicity of divine Truth itself.

The third reference to faith specifies the material object of the act of faith in the Eucharist. Thomas truly (*uere*) believes that not only on the cross was the invisible God hidden in the then visible Jesus, but also that, in the sacramental species here and now, both the invisible God and the visible Jesus exist truly and imperceptibly. We have turned from the many material objects to be believed on the authority of God's Son who reveals them to a particular and precise object of faith. Not unlike Jesus, who proclaims that God's eschatological sovereignty begins in his own actions here and now, Thomas confronts us with the paradoxical claim that the One Simple Truth joins with us in the most extreme *here and now* of the sacramental species.

The fourth reference to faith is found, significantly, in the first line of Part Two of the poem (v. 15). Unlike Part One (vv. 1–14), in which only Truth is mentioned, Part Two (vv. 15–28) is devoted to the Truth that is Life (vv. 18–19). This location in the poem is significant from two points of view. First, it suggests that there is something in divine faith that constitutes the beginning of eternal life. When one believes something to be true because God is Truth itself, one begins to know all the rest in virtue of one's knowing God. Thereby one begins to know in a way similar to the way God knows. For God characteristically knows all that is true by knowing—or rather by being—his own Truth. His knowing of all truth is not, and cannot be, a second act of knowledge resulting from the act by which he knows himself. It is rather because the act by which he knows himself is immediately his knowing of all that is, and of all that can be, that God's knowledge is Life itself. When it is unrestricted, Life itself is indeed sovereign being, whose nature is intellection and is not determinable by anything else.[13]

There is a second, significant aspect to this fourth and last reference to divine faith, which, according to its place in the order of the poem, lies just beyond the threshold that separates bare Truth from Truth that is Life. As stated, something in divine faith is already eternal life in us. Faith, however, is only its beginning, not its perfection. God's eternal life becomes definitively and integrally ours only when vision re-

places faith, and only when the resurrection allows us to share corporeally in blessedness. Only then do we re-join Christ, who, as the incarnate and sacramental God, first joined with us, especially by means of the fullness of sacramental grace that is the Eucharist.

(b) The Undiminished Christ

That Thomas Aquinas agrees with the teaching of pseudo-Dionysius the Areopagite, according to which the Eucharist is not a sacrament like others but the very perfection of the sacramental order, is scarcely surprising. For in his own handwriting, Thomas had written the archetype of Albert the Great's commentary on pseudo-Dionysius's *De ecclesiastica hierarchia.*[14] In so doing, he profoundly assimilated two connected motifs, as is clear from his constant teaching.

It is not the case that only some particular power of Christ (for example, his power to regenerate spiritually), nor, even, only his integral power (that is, a power distinct from and less than Christ's being itself), is contained in the Eucharist. The reality contained and signified (*res et sacramentum*) in this Sacrament is not just a part of his substance—as would be his mind alone or his body alone—but the very substance of Christ, Christ as such, pure, unrestricted and, in this sense, *per essentiam.*[15] Similarly the *res tantum*, which is signified without being contained, is not just any part of the Mystical Body of Christ, but its undiminished totality: head and members, angels and human creatures, the local and universal Church, the pilgrim Church on earth and the heavenly Church in glory.[16]

One finds both of these motifs in the *Adoro te deuote.* The first concerns the undiminished Christ—Godhead, human mind and body—who unites with the integral Thomas, the resurrection of whose body, *ceteris paribus*, is included in the full grace of this Sacrament. Possessive pronouns that qualify parts of Christ, such as his body, or parts of the believer, such as his spiritual faculties, cannot adequately express the undiminished Christ or the integrity of the effects of his grace on the believer. Only personal pronouns that denote the whole Christ and the integral believer are appropriate. For this reason, only personal pronouns, and no possessive pronouns, are used in verses 15–20; only in these verses are personal pronouns used exclusively and so frequently.[17]

The particular wording of these verses deserves attention. The phrase *te michi semper* (v. 20) almost literally echoes Hosea 2:19 (Vulgate): *Sponsabo te mihi in sempiternum.* This nearly literal correspondence is even closer if one considers that both phrases refer to faithfulness: *Fac me tibi semper magis credere* (v. 15), on the one hand, *Sponsabo te michi in fide* (Hosea 2:20), on the other. That Thomas knows the motif, also known to his contemporaries, according to which divine faith and charity are defined, respectively, as the first and second unions of the Christian soul with God, is not so significant. It is significant, however, that, unlike his contemporaries, he quotes Hosea 2:20 (*Sponsabo te michi in fide*) when he treats faith as the first union of the soul with God. He does so, not only in his commentary on the *Sentences* (where, in the parallel passages, Albert the Great does not quote the text from Hosea),[18] but also in his first sermon on the Creed. In this sermon, he opens the marvelous survey of his theology of faith by saying:

Fides facit quattuor bona. Primum est quod per fidem anima coniungitur ad Deum: nam per fidem anima christiana facit quasi quoddam matrimonium cum Deo: Osee II, 20: "Sponsabo te mihi in fide."[19]

If, as seems likely, Thomas has in mind the text from Hosea when in the *Adoro te deuote* he writes the phrases *me tibi semper* and *te michi semper* (vv. 15, 20), it would seem that those verses express his prayer that Jesus' union with Thomas in the Eucharist be consummated by Thomas's union with Jesus through divine faith and in charity.

The second motif I have indicated, namely, the full grace of the Eucharist in relation to the Mystical Body, is also obviously present in the *Adoro te deuote*. Following Nicholas of Clairvaux (often quoted under the name of Bernard) and Henry of Segusia (in his *Summa aurea*), Thomas underscores in more than one of his writings what he states in the *Adoro te deuote*: one single drop of Christ's blood would suffice to bring about the salvation, not merely of this or that human being, but of the whole universe. Moreover, one drop of Christ's blood would suffice to bring deliverance not just from some particular sins, but from all sins, however grave they may be.[20]

There is a nuance in the *Adoro te deuote*, however, which qualifies this common theology. As mentioned above, there is a significant repetition of the word *totum* that makes verse 24 parallel with verses 3–4 and picks up the vocabulary common to Part One (vv. 1–14) and Part Two (vv. 15–28). In light of their respective contents, verses 3–4, on the one hand, and verse 24, on the other, constitute an antithetical parallelism: *se cor meum totum subicit, quia . . . totum deficit* is the counterpart of *una stilla saluum facere totum . . . posset*. As completely deficient as is the apogee of human interiority, so totally sovereign is the nadir of exteriority—a single drop of blood—provided it be shed by Jesus. This idea dramatically represents a fundamental principle of pseudo-Dionysian hierarchy: the lowest degree of a higher level is more powerful than the highest degree of a lower level.[21]

The universality of these effects of grace is due to the universality of Christ's causal power, which reaches spiritual and corporeal reality, the whole person of the believer and the entire Mystical Body. There is no doubt that for Thomas, who fully agrees on this point with pseudo-Dionysius and Albert the Great, the integrity of this causal power finds its origin in the purity, in the simplicity of Christ's unparticipated essence. This brings us to Thomas's contribution to the understanding of Christ's uniqueness.

By his undiminished being, God's Son remains unconfused purity and strength, notwithstanding his union with this concrete human being. Christ is *eo ipso* unique in the most unique of ways. Should we thoughtlessly confuse his uniqueness with the universal fact that no concrete substance is any other substance, we would reach the disappointing conclusion that the uniqueness of Christ is as common and banal as that of any other existent being, since there is strictly nothing, not even an individual fly, that is not unique in this sense. Nor can we reasonably understand Christ's uniqueness as referring to a kind of platonic idea of humanity, an ideal model of all human beings. When we acknowledge that in some way Christ is like all other human beings, we must then cope with the scientific evidence that the historical Jesus was also strikingly dissimilar from other human beings in general and from his contemporaries, including

Jews and early Christians, in particular.[22] To discern the quality of Christ's uniqueness as Thomas, following pseudo-Dionysius and Albert the Great, suggests, we must leave behind the conception of uniqueness proper to a supposedly subsistent idea of the human species. Indeed, we must go beyond the conception of any species or genus, because there is no species nor even a supreme genus that is not at once finite and infinite. And we must go beyond the universe of extant and possible species, for a universe of this kind only integrates species that are as finite as they are infinite.[23] The quality of Christ's uniqueness, then, is neither that of an individual among others, nor that of a species, nor even that of the universe of extant and possible species; it is truly individuality as such, infinity unrestricted by any finiteness whatsoever.[24]

(c) Sense Perception as an Integral Part of Faith and of the Beatific Vision

Because it recurs in Part Two of the *Adoro te deuote* (v. 28) after having first appeared in a famous and sensitive context of Part One (v. 5), the term *uisus* commands our attention. In Part One, verse 5, the term evokes two related ideas in the teaching of Thomas Aquinas: the senses do not err when they judge their proper object, and sense perception is an integral part of the act of faith in the Eucharist.

Thomas teaches that sense perception is perception of a concrete *here*; such perception is the basis upon which rests every other element of the senses' perception of their proper object. Did not the senses perceive a concrete *here*, they would not perceive this *here* as having a surface, as being colored in this or that way, and so on. These sensible species in actuality are, of course, sense perceptions in actuality. That is exactly what Thomas expresses in verse 2, with the phrase *sub his formis,* and in verse 10, in the adverbial form *hic.*

Not only does the relative inerrancy of the senses mean something positive as regards the cognitive capacity of the senses themselves, it also means something as regards the economy of faith. Were the senses not right in judging their proper object, not only would sense perception be impossible, so too would be the concrete act of eucharistic faith and adoration. Indeed, in order for one to believe that the whole Christ, in his Godhead and humanity, does not only exist in a general way somewhere under some sacramental species, but that he is truly in this very sacramental species *here and now,* one must necessarily integrate within one's act of faith an act of sense perception, which is the only act capable of perceiving the concrete *here and now* of the sacramental species.

The term *uisu* appears again in verse 28, in the context of the four verses that constitute the cadenza of Part Two (vv. 25–28). These verses treat the beatific vision; as we have seen, only here in the entire poem does one find verbs that signify perception (*aspicio, sicio, cernens*). When Thomas refers to the beatific vision in verse 28, he does not do so merely in terms of formal beatitude, which is the intuitive intellection of God. Rather, he refers to the beatific vision under a particular aspect, which he clearly and repeatedly expresses in his commentary on the *Sentences:* after the resurrection of the body, the beatific vision will be accompanied by an act of sense perception by which one sees Jesus. In verse 5, the sense of sight (as well as touch and taste) is said to fail in perceiving Jesus under the sacramental species. It is significant that the term *uisus* is not discarded but appears at the culmination of the poem, indicating the place of sight in the eschatological fulfillment of the economy of salvation.

According to Thomas, sense perception and the beatific vision particularly are linked. The act of sense perception whereby one sees Jesus in beatitude is not just an exercise of sense experience, nor is it a more or less gratuitous act, which, should it be lacking, the blessed intellect would nonetheless experience an equal beatitude. Thomas is clear about this in his commentary on the *Sentences:* blessedness is the achievement of the whole human being, soul and body. Although blessedness is essentially an act of the soul, the body will possess some kind of blessedness, insofar as the beatified person will see God in his visible creatures and, above all, in the body of Christ.[25] So, not only is sense perception an integral part of the beatific vision, it is itself a kind of blessedness. In another text, Thomas states clearly that the beatified intellect will not be engaged only in contemplation of the divine essence as such, but that it will also perceive God in the corporeal realities it sees, just as one perceives life in perceiving language.[26] Here lies the significance of the formulation that concludes the poem, *Adoro te deuote: uisu sim beatus tue glorie,* "that at the *sight* of your glory I may be *blessed."*

In short, without the specific integration of sense perception, faith proves impossible, and the beatific vision unreal.

NOTES

1. C. le Brun-Gouanvic, *Ystoria sancti Thome de Aquino de Guillaume de Tocco (1323).* Edition critique, introduction et notes (Studies and Texts 127, Toronto, 1996), 72–75.

2. J.-P. Torrell, *Initiation à saint Thomas d'Aquin, sa personne et son oeuvre* (Vestigia: Pensée antique et médiévale 13, Paris, 1993), 401 n. 34.

3. A. Wilmart, "La tradition littéraire et textuelle de l'*Adoro te devote,"* RTAM 1 (1929): 21–40, 149–76, and *Auteurs spirituels et textes dévots du moyen âge latin* (Paris, 1932), 361–414.

4. The scansion of Thomasian poetry has a constancy. When the second hemistich contains an odd number of syllables, it always ends with a proparoxyton; the first hemistich then always contains an even number of syllables and ends with a paroxyton.

5. See n. 3 above.

6. L. Richard, "D'un désaccord entre saint Thomas poète et saint Thomas théologien," *Recherches de science religieuse* 5 (1914): 162.

7. Thomas Aquinas, *In IV Sent.* d. 11 q.1 a.1 (*Scriptum* 4: 437 n° 31); SCG 4 cc.62–63; *Sapientia,* ed. C. Lambot in "L'Office de la Fête-Dieu. Aperçus nouveaux sur ses origines," *Revue Bénédictine* 58 (1942): 116–17 n° 46, lin. 594–601; *Sacerdos,* ed. P. M. Gy in *La liturgie dans l'histoire* (Paris, 1990), 244 (*Lectio secunda*); ST 3 q.75 a.5; ST 3 q.76 a.8; ST 3 q.77 aa.2,7.

8. D. Norberg, *Introduction à l'étude de la versification latine médiévale* (Studia Latina Stockholmiengia 5, Stockholm, 1958), 46–47.

9. We are in a biblical and patristic context: *cor* corresponds with לב of the Psalter, with ἡ καρδία of Origen and the Fathers and with 'la fine pointe de l'âme' of St. Francis of Sales. It designates those highest intellectual faculties in the human being, which are at the same time also the seat of the image of God.

10. Thomas Aquinas, *In IV Sent.* d.49 q.2 a.2; see the conclusion of this essay.

11. Thomas Aquinas, *In IV Sent.* d.49 q.2 a.2: "Sicut homines mox ut aspicimus, non credimus vivere, sed videmus." Thomas here abbreviates Augustine, *De civ. Dei* 22.29.

12. P. M. Gy, *La liturgie dans l'histoire,* 275–78, shows that Thomas's emphasis in eucharistic theology on the tension between faith and the beatific vision is characteristic in two different ways. First, his contemporaries do not share this emphasis. Secondly, it is an emphasis proper to his later writings (1264–1274).

13. Thomas Aquinas, ST 1 q.18 a.3: "Illud cuius sua natura est ipsum eius intelligere, et cui id quod naturaliter habet, non determinatur ab alio, hoc est quod obtinet summum gradum vitae."

14. *Pace* L. E. Boyle, "An Autograph of St. Thomas at Salerno," in *Littera, Sensus, Sententia: Studi in onore del Prof. Clemente J. Vansteenkiste O.P.* (Studia Universitatis S. Thomae in Urbe 33, Milan, 1991), 117–34.

15. Thomas Aquinas, ST 3 q.65 a.3: "Simpliciter loquendo, sacramentum Eucharistiae est potissimum inter alia sacramenta. Quod quidem tripliciter apparet. Primo quidem, ex eo quod in eo continetur ipse Christus substantialiter: in aliis autem sacramentis continetur quaedam virtus instrumentalis participata a Christo. . . . Semper autem quod est per essentiam, potius est eo quod est per participationem."

16. Thomas Aquinas, *In Ioannem* 6:7 lect.6 (*Super Ioan.* 181 n[os] 963–64): "Utilitas autem huius sacramenti . . . est . . . universalis . . . quia vita quam confert, non solum est vita unius hominis, sed quantum in se est, totius mundi. . . . Notandum autem est quod aliter est in isto sacramento et aliter in aliis; nam alia sacramenta habent singulares effectus, sicut in baptismo solus baptizatus suscipit gratiam; sed in immolatione huius sacramenti est universalis effectus . . . et Ecclesia tota, tam vivorum, quam mortuorum. Cuius ratio est quia continetur in ipso ipsa causa universalis omnium sacramentorum, scilicet Christus."

17. The exclusive use of personal pronouns does not occur in vv. 15–24 but in vv. 15–20. Verses 15–24 are devoted to the two sacramental species: bread (vv. 17–18) and wine (vv. 21–22). Verses 15–20 concentrate only on the species of bread. The whole Christ is contained under each separate species and, under either species, this sacrament realizes its effects on the believer's soul and body. Given that the whole Christ and the integrity of his grace are referred to here, why does Thomas use exclusively personal pronouns in vv. 15–20? Why not in vv. 15–24? There is a good reason for the privileged treatment of the species of bread. According to a very ancient tradition, retraceable to Ambrosiaster, *Super I Cor.* 11:20 (PL 17: 256) and codified by Peter the Lombard (*IV Sent.* d.11 c.4), the species of bread signifies that this sacrament will bring about the salvation of the believer's (animate) body (by the blessed resurrection), whereas the species of wine signifies simply the salvation of the soul. This tradition is constantly present in Thomas's writings: *In IV Sent.* d.11 q.2 a.1 (*Scriptum* 4: 460 n° 149); ibid., d.11, *Exp. textus* (*Scriptum* 4: 489 n° 326), *Sapientia* and *Sacerdos*, ed. C. Lambot, "L'Office," 117 n° 47, lin. 606–17; ST 3 q.74 a.1. It may be noted that, of the two sacramental species, the species of bread alone is expressly mentioned (v. 18), whereas the species of wine is alluded to without being mentioned explicitly (v. 22).

18. Albert the Great, *In IV Sent.* d.39 a.2 arg.3 and ad 3 (Borgnet 30: 428–29); Thomas Aquinas, *In IV Sent.* d.39 q.unica a.6 ad 2.

19. Thomas Aquinas, *In Symbolum Apostolorum* prol., ed. R. M. Spiazzi, *S. Thomae Aquinatis Doctoris Angelici Opuscula theologica* 2 (Turin-Rome, 1954): 193 n° 860.

20. Thomas Aquinas, *In III Sent.* d.20 q.unica a.3 arg.4 (*Scriptum* 3: 620 n° 50); Thomas Aquinas, *Quodlibet II* q.1 a.2 sed c. 2 ed. R.-A. Gauthier, Leonine Edition 25.2 (1996): 213; Nicholas of Clairvaux, *Sermo de exaltatione sanctae crucis* (PL 144: 762B); Henry of Segusio, *Summa aurea V: De remissionibus* (Lyon, 1556), fol. 430a; (Venice, 1574), col. 1871.

21. The idea of sovereign power is well understood and judiciously expressed by one of the English 'Metaphysical Poets', Richard Crashaw, who translated *Adoro te deuote* (vv. 23–24) in this way: "That blood, whose least drops sovereign be / To wash my worlds of sins from me"; cf. *The Poems, English, Latin and Greek, of Richard Crashaw*, ed. L. C. Martin, 2nd ed. (Oxford, 1957), 293, lin. 49–50.

22. R. Latourelle, *L'accès à Jésus par les évangiles. Histoire et herméneutique* (Paris-Tournai-Montréal, 1978); J. Gnilka, *Jesus von Nazaret, Botschaft und Geschichte* (Freiburg i.B., 1991); J.-P. Meier, *A Marginal Jew: Rethinking the Historical Jesus. I: The Roots of the Problem and the Person II: Mentor, Message, and Miracles* (New York, 1994).

23. By "only integrates" I mean that the *totalitas ex partibus* is metaphysically dependent on the *totalitas ante partes*. Cf. Thomas Aquinas, *In librum beati Dionysii De divinis nominibus Expositio* 2.1, ed. C. Pera (Turin-Rome, 1950), 38–39 n° 113.

24. Thomas Aquinas, ST 1 q.7 aa.1–2.

25. Thomas Aquinas, *In IV Sent.* d.49 q.2 a.2 ad 6: "Quaedam tamen beatitudo corporis nostri erit inquantum Deum videbimus in sensibilibus creaturis, et praecipue in corpore Christi."

26. Ibid., *In IV Sent.* d.49 q.2 a.2 corp.: "Cum ergo visus et sensus sit futurus idem specie in corpore glorioso, non poterit esse quod divinam essentiam videat sicut visibile per se; videbit autem eam sicut visibile per accidens, dum, ex una parte, visus corporalis tantam gloriam Dei inspiciet in corporibus, et praecipue gloriosis, et maxime in corpore Christi, et, ex alia parte, intellectus tam clare videbit Deum quod in rebus corporalibus visis Deus percipietur, sicut in locutione percipitur vita."

APPENDIX I

Adoro te deuote
The Text in its Structure[*]

Adoro te deuote, latens ueritas,
 te que sub his formis uere latitas.

Tibi se cor meum totum subicit,
 quia te contemplans totum deficit.
5 Visus, tactus, gustus, in te fallitur,
 sed auditu solo tute creditur.
Credo quicquid dixit dei filius,
 nichil ueritatis uerbo uerius.

In cruce latebat sola deitas,
10 sed hic latet simul et humanitas.

Ambo uere credens atque confitens,
 peto quod petiuit latro penitens.
Plagas sicut Thomas non intueor,
 deum tamen meum te confiteor.

15 Fac me tibi semper magis credere,
 in te spem habere, te diligere.

O memoriale mortis domini,
 panis uiuus uitam prestans homini.

Presta michi semper de te uiuere,
20 et te michi semper dulce sapere.

Pie pellicane, Ihesu domine,
 me immundum munda tuo sanguine.

Cuius una stilla saluum facere,
 totum mundum posset omni scelere.

25 Ihesu, quem uelatum nunc aspicio,
 quando fiet illud quod tam sicio?
Vt te reuelata cernens facie,
 uisu sim beatus tue glorie.

[*] Several anomalies affect the first hemistich: (1) seven syllables; (2) the stress on the second, fourth and sixth; (3) the location of the first person singular (indicative) form of the verb right at the beginning. In the present state of research, the crux cannot be resolved definately.

APPENDIX II

Albertus Magnus, *Super Dionysium De ecclesiastica hierarchia,* cap. 3
Napoli, Biblioteca Nazionale, Ms. I.B.54, fols. 51r–51v

I

<Utrum eucharistia sit dignior inter alia sacramenta>

Solutio. Dicendum quod eucharistia est dignissimum sacramentorum quantum ad id quod in se continet: continet enim in se totum Christum, secundum diuinitatem et humanitatem, cum alia non contineant nisi aliquam gratiam; et hoc est simpliciter esse nobilius. Alia autem possunt esse nobiliora secundum quid, scilicet secundum effectum quem habent maiorem et digniorem in recipiente. Nec tamen hoc est ex defectu eius quod continet sacramentum, quia illud secundum efficaciam et substantiam et quolibet modo nobilius est, sed propter institutionem, quia scilicet non fuit ad illos effectus institutum.

II

<Utrum eucharistia debeat specialiter dici communio>

Solutio. Dicimus quod propter tria hoc sacramentum specialiter dicitur communio: propter effectiuum communionis, propter id in quo communicatur et propter communicantes.

Esse enim effectiuum communionis per se secundum speciem uisibilem conuenit soli isti sacramento: est enim sacramentum, ut dicitur in iiii° Sententiarum, eius rei causa cuius ymaginem gerit. Unde causalitas sacramenti per se non fertur (habetur?) ultra suam significationem. In speciebus autem istius sacramenti significatur communio, que est unio multorum in uno, scilicet in pane et uino: ex multis enim granis conficitur unus panis, et ex multis uuis colligitur uinum. Et ideo per se causat communionem. In nullo autem aliorum sacramentorum species componitur ex multis concurrentibus in unum. Et ideo non significant communionem nec causant eam, nisi per accidens, secundum scilicet quod consequitur gratia, que est res cuiuslibet sacramenti.

Illud autem unum in quo omnes communicantes uniuntur est Christus totus secundum humanitatem et diuinitatem. Et hoc est res contenta huius sacramenti.

Communicantes uero sunt fideles qui sunt corpus mysticum. Et hec est res huius sacramenti, non contenta, sed significata. Et ideo dicitur communio quia complectitur in se omne quod exigitur ad communionem, quod non est in aliis sacramentis.

Ad primum igitur dicendum quod communio non perficitur nisi secundum quod unum numero participatur a multis. In re autem contenta istius sacramenti, quod est corpus christi uerum, omnes uniuntur sicut in eo quod est idem numero, quod ultimum est in quo sicut in fine colliguntur. Et ideo communio perficitur in hoc sacramento, in aliis autem sacramentis non percipitur idem numero ab omnibus, sed eadem gratia specie, que est ut dispositio ad perfectam communionem. . . .

Ad tertium dicendum quod licet per baptismum separetur quis a multis, tamen non perficitur per ipsum communio, quia non dat id quod est terminus motus qui est de multis ad unum, sed tantum disponit ad illud.

Ad quartum dicendum quod hoc sacramentum est maxime dilectionis quia in eo est rememoratio dominice passionis. Nichilominus aliter est dilectio causa communionis et aliter hoc sacramentum: dilectio enim facit communionem ut inclinans ad illam, sed hoc sacramentum ut coniungens illi uni, in quo omnes uniuntur.

III

<UTRUM EX HOC SACRAMENTO SIT PERFECTIO IN ALIIS>

Et dicendum quod quodlibet sacramentum perfectum est secundum uirtutem et operationem suam essentialem, sed quantum ad coniunctionem ad finem ultimum recipiunt perfectionem ab hoc sacramento, quia continet in se ipsum unum <,> quod est ultimus finis, scilicet Christum, et quantum ad significationem etiam per se totum <significat> communionem, ut prius dictum est. Hoc autem non est in aliis sacramentis; et ideo perfectionem que est in coniunctione ad ultimum finem recipiunt ab isto.

Wisdom in the Christology of
Thomas Aquinas

Joseph Wawrykow

Tʜᴇ ꜰᴏᴄᴜꜱ ᴏꜰ this essay is the third question of the massive treatise on Christ (qq.1–59) in the Third Part of Aquinas's *Summa theologiae,* a question that has as its topic the divine Person to whom human nature is assumed in the Incarnation. Informing the study is the conviction that this particular question deserves a place of prominence in accounts of Thomas's theological achievement. Readers of Aquinas are increasingly aware of the care with which he has in his various writings presented his theology, and are correspondingly more attentive to the ways in which what might be called Thomas's literary decisions have shaped and promoted his thought.[1] ST 3 q.3 offers ample testimony to Thomas's skill as a writer and repays careful study. In his use of authorities in the question, Thomas adroitly links up with other theologians who had also treated his topic, retaining where feasible their main insights without merely repeating them.[2] The organization of the eight articles of the question discloses in striking fashion Thomas's effectiveness in presenting difficult material: although he has learned much from his fellow scholastics about his topic and in spots can rehearse their arguments as his own, in establishing these articles in the order found in the *Summa,* Thomas has proceeded distinctively, thus moving the analysis to a new level of clarity.[3] And, in his decisions about what to include in the question and so which tasks to pursue as he reflects on the divine person who assumes human nature, Thomas at the same time instructs the reader on what is suitable in scholastic discourse. But, while I am in this study especially interested in the literary features of Thomas's work—the use of authorities; the structuring of the question; the contribution of discrete articles to the argument of the question as a whole—this is not at the expense of the ideas that Thomas expresses about the Word who becomes incarnate. Indeed, it is precisely through the examination of the literary dimensions of Thomas's work that we are able to grasp the more adequately his most important convictions about Jesus Christ.

My investigation of *Summa theologiae* 3 q.3 falls into four main parts. The first two parts are concerned with the final articles of the third question: part one of the essay discusses the rather challenging sixth (and to a lesser extent seventh) article of the question; part two, the eighth article, in which Thomas urges the greater appropriateness of the assumption of human nature to the person of the Word. The final two parts of the essay consider some of the larger ramifications of the teaching about Christ in 3 q.3 (especially its eighth article). The third part suggests how this question is meant by Thomas to condition the reading of the rest of the treatise on Christ. The fourth part is more speculative in tone, as I attempt to show how 3 q.3 can deepen the

reading of the very first question of the *Summa*, devoted to sacred doctrine and the theology that pertains to sacred doctrine.

I. ST 3 Q.3 AA.6–7

Q.3 belongs to a group of questions, beginning with q. 2 and running through q. 15, that look at the "mode of union of the Word Incarnate." While the second question examines the union of the two natures in itself, subsequent questions look in turn at the two sides of the union: in qq. 4 through 15, at the human nature that is assumed, in our question (3), at the person assuming.[4] Question 3 owes a great debt to q.2. In the second question, Thomas has introduced and clarified the meaning of the principal terms in his Christology: nature, person, union, assumption (to name but the most important). Hence, in looking in q.3 at the union of the two natures on the part of the person assuming, Thomas can take for granted a basic terminological sophistication, including (on the basis of q.2 a.8) a grasp of the different nuances of the terms "union" and "assuming." Q.2 has also considered, in order to dismiss, various ways of portraying the truth of Christ. Hence, he shows, against monophysites, why union in the nature fails as an account of Christ; likewise, he is able to show the weaknesses in an adoptionist or Nestorian position.[5] Thus, by virtue of q. 2, he is able in q.3 to keep the focus on the union of the two natures in the person of the Word.

For the most part, the analysis in the third question is quite sober, grounded in an obvious way in the actual revealed order. Much of the third question is given over to showing what it means to say that human nature has been assumed by the second person of the trinity, the Word of God, and the entire question concludes in a.8 by showing why it was more appropriate for the union of the two natures to occur in this divine person. Against this background, the sixth and seventh articles can strike one as peculiar, crying out for explanation. For the moment, at least, Thomas shifts the attention away from the actual Christian dispensation, and engages in what might be characterized (at first glance) as wild speculation. Rather than deepening the portrayal of the Word who takes up human nature, now Thomas asks whether two of the divine persons could have assumed one individual human nature (a.6), and whether one divine person could have assumed human nature distinct in number (a.7). To a newcomer to scholastic discourse who might open the *Summa* for the first time precisely at this juncture, these articles may seem to confirm the judgment, made by opponents of the scholastics, that the scholastics were merely engaged in idle and vain and pointless speculation. Since two persons did not in fact assume human nature, nor did one divine person assume two distinct natures, why bother to ask these questions?

Even for someone who has begun the reading of the Christology of Aquinas at the beginning—that is, at Tertia Pars q.1 a.1—the present articles can be quite jarring, a departure from what one has come to expect from Thomas as he articulates his teaching about Christ. The discussions in q.1, on the fittingness of the Incarnation because of the close connection between Incarnation and the working out of human salvation, and, in q.2, a general discussion of the union of the two natures, have in fact been quite moderate and sensible. In those questions, Thomas has restricted himself to the actual Christian order, in which it is the Word who becomes incarnate for human salvation.

Asking about the fittingness (or wisdom or meaning) of details of the Christian dispensation, and, offering crucial terminological precisions of the main terms in talking about Incarnation,[6] these opening questions disclose, I would think, Thomas's general adherence to a by-now traditional understanding of theology as "faith seeking understanding." What, then, is going on in aa. 6 and 7? If there is new understanding to be won through these articles, the initial impression is that it would be understanding of a faith that Christians do not actually hold. Has Thomas, then, made a mis-step in including these articles in this question, departing radically from his more accustomed procedure?

I am finding it increasingly helpful in studying the Christology of the *Summa* to ask three basic questions of each of the questions that constitute the treatise on Christ. The first asks about the *starting-point* of the inquiry of a particular question: What knowledge does Thomas assume or take for granted in the readers of his question? The second asks about the *pay-off* of the inquiry conducted in a given scholastic question: How is the knowledge with which one begins the scholastic question deepened through the exercises that are found in the question? And, the third evaluates Thomas's strategy for realizing the end of the question by asking, how, precisely, the articles contribute to attaining this end. The value of these questions is twofold. On the one hand, they neatly disqualify from the outset a quaint misunderstanding of Thomas's work. Thomas is hardly attempting to "teach the Christian faith" to newcomers[7] to the religion, to people with little or no previous exposure to Christianity. The *Summa* would fail if judged according to the demands of catechesis: not only is the dialectical form into which each article is cast out of keeping with straightforward proclamation; each question of the *Summa* clearly demands a great deal on the part of the reader. For the questions to work, Thomas appears to be taking for granted a certain level of familiarity with the claims dear to Christians. Hence, my first question in particular is designed to bring to the surface this knowledge of the religion presupposed in Thomas's readers. On the other hand, these three questions are also valuable because they emphasize the pedagogy of the text. They are designed to highlight Thomas's skills as a teacher with precise goals in mind in constructing an individual question on Christ. To my mind, a more satisfactory characterization of Thomas's work in the *Summa* is to say that he is writing as an informed and reflective Christian for the benefit of others who bring to the Christological questions a sound knowledge of Christian faith. The *payoff* of Thomas's writing will be to bring those readers willing to follow his lead through the question to a more reflective grasp of the faith that they hold. Individual articles in the scholastic question will be warranted precisely to the extent that they facilitate in their distinctive ways the attainment of this more thoughtful understanding of the faith. To the extent that the inclusion of individual articles, as well as precise placement in a scholastic question, is shown to be justified, we shall become the more convinced of Thomas's skill as a teacher.

In terms of the third question of the treatise on Christ in the *Summa*, for this question to work Thomas must be presupposing a sound knowledge of the Christian faith about the agent of Incarnation. The exercises of the third question will profit most the reader who comes armed with the knowledge that in Jesus Christ, it is the second person of the Trinity, the Son/Word of God, who from eternity is fully God and a dis-

tinct person in the Godhead, who without loss to itself has entered history and taken up everything that is essential to being human, so coming to express human nature as well. The *payoff* of the inquiry will be a refined understanding of hypostatic union on the part of the Word who assumes human nature: by the end of 3 q.3, readers will have a better sense of what is, and what is not inevitable, in saying that human nature is joined to the person of the Word. It is the steps in this inquiry (my third question, about *means*) that will hold our attention for the rest of this part of the essay.

Running through the third question of the treatise on Christ is the fundamental distinction between the principle (*principium*), and, the term (*terminus*) of assuming; by showing how useful the distinction is in handling the discrete issues found in the articles of the third question, Thomas at the same time will clarify what is, and what is not, involved in saying that it is in the Word that the two natures are united. By "principle," Thomas is referring to the power by which human nature is assumed to the Word. By "term," Thomas is indicating that to which human nature is assumed. Does it befit a divine person to assume? (a.1) If we are thinking of the principle of assuming, the answer is no: the divine power is not peculiar or restricted to the second person, but is affirmed of all three persons of the Godhead. On the other hand, if we are thinking of the term of assumption, the answer is yes: by the divine power, human nature is taken to a person, the divine Word. Does it befit the divine nature to assume? (a.2) If we are thinking of the term of the assuming, the answer is clear enough from the second question of the treatise on Christ: union is in the person, not the nature. But, if we are talking of the principle of assuming, then it clearly does pertain to the divine nature to assume: the power by which assuming occurs is ascribed to the divine essence. In like fashion, this fundamental distinction figures in the fourth article, where Thomas asks whether one divine person without another can assume created nature. If we are thinking of the principle of assuming, the answer, as should be obvious by now, is no: power pertains to all three persons in God. But, the term of the assuming is in fact one divine person, to whom alone human nature has been joined.

With the fifth article of the third question, Thomas embarks on a more speculative enterprise; I hasten to add, however, that compared to what will immediately follow in the question, the speculation in a.5 is muted and restrained. To this point in the question, the articles have concentrated on the Word as the term of the assumption of human nature, exploring as well the way in which assuming is the work of the entire Trinity. In the fifth article, Thomas is asking whether the term of the assuming *need* have been the second person of the Trinity: Could one of the other divine persons become incarnate? The corpus once again trades on the distinction between principle and term, and Thomas concludes that indeed the term of the assumption could be one of the other divine persons.[8] The upshot of this discussion is to distinguish what actually has happened from what must happen of necessity. It is in fact the Word in whom human and divine natures are united; this need not have been the case.

I believe that we are perfectly justified in thinking that apart from its intrinsic value, the fifth article has been included in the question with an eye to the eighth article. In that later article, Thomas will allege the (greater) fittingness of union of the two natures in the Word. For a variety of reasons, as we shall see in the second part of this essay, the Word is the more fitting term of the assuming of human nature. But, in

light of the fifth article, we will be less likely to misunderstand the import of the eighth article. "Fittingness" or "appropriateness" is not the same as "necessity," and the comments in the eighth article are not meant to suggest that only the Word could have become incarnate. By that point in the question, we know that that is not the case. Indeed, it is possible to detect a parallel between the fifth and eighth articles that suggests that they are meant to be read together, as complementary and as mutually informing. In the objections that open a scholastic article, the author introduces important ideas on the point under consideration that should be pondered but of themselves do not settle the issue: to some extent, in fact, they run contrary to what the author will argue in the corpus of the article, and in the responses with which the article concludes, the author will handle these opening arguments in the light of what he has himself taught in the corpus. In the fifth article, devoted to the issue of whether another divine person could become incarnate, the logic of the opening objections is to insist on the *necessity* of the Word, rather than the Father or the Spirit, becoming incarnate.[9] In the corpus of this fifth article, Thomas will reject such a claim of necessity, and in the responses to the objections (as is especially clear in ad 2), will advert to the sensibility/meaning that could be elicited from one of the other divine persons being the term of the assuming of human nature (if that had been the case).[10] In the eighth article, devoted to the fittingness of the Word becoming incarnate, the logic of the objections is to argue that it would have been more appropriate for one of the other persons to be the term of the assumption of human nature.[11] In the corpus and in the responses to the objections, Thomas will allow the *possibility* that another could have been the term of the assuming, without allowing the greater appropriateness of the alternate scenario. *That* is a separate issue. The ease with which Thomas can make the point— that it is more fitting, although not necessary, for the Word to assume human nature— is testimony to the effectiveness of the earlier discussion in a.5. By the fifth article, we seem well prepared to handle the adjacent teaching of the eighth; apparently, if he had wished, Thomas could have moved directly from article five to the eighth article of this question.

Yet, Thomas doesn't. Interposed between these two articles are (obviously) articles 6 and 7. Why has Thomas introduced these articles? What does he get from raising their issues?[12] (Again, the reference is to the third of my questions, on strategy and the contribution of individual articles to the realization of Thomas's goals in constructing a question). Article 6, in fact, follows nicely on the articles that precede it. Article 6 complements article 4, in which Thomas had argued that one divine person without another can assume a created nature. When he asks in a.6 whether several divine persons can assume one and the same individual created nature, he in effect is precluding a possible misunderstanding of a.4. Granted that one divine person without another divine person can assume a created nature, does this mean that there can be one and only one divine person as the term of assuming? The answer is no (6 corp., and especially ad 2):[13] it follows on divine power that more than one divine person can be the term of the assumption.

Once we get past the shock of the issues raised in aa. 6 and 7, it thus becomes possible to view them as continuing the work initiated in earlier articles, albeit in a more hypothetical mode. As had the earlier articles, so aa. 6 and 7 trade on the funda-

mental distinction between principle and term. These articles constitute virtuoso, yet quite legitimate, applications of the distinction. Both articles insist on the divine power: it lies in God's power to join human nature to two divine persons (a.6); it is possible for two distinct human natures to be assumed to one divine person (a.7). These articles thus offer further commendation of the value of this distinction. The articles also extend the lesson introduced in a.5 about the difference between possibility and necessity, on the one hand, and fittingness, on the other. As a.8 will insist, it is more appropriate for the term of the assuming to be the Word than the Father or the Spirit. But, after aa. 6 and 7, it will be exceedingly unlikely that one will conclude that what is "better" is the only possible order; things could have been otherwise.

When due attention is thus given to the contribution of even these articles to the overall flow of the analysis in the third question on Christ, it is possible to get past their strangeness and to assimilate them to the adjacent articles in the question. Indeed, on the basis of the sixth and seventh articles, it is easier to see why as deployed by Aquinas hypothetical questioning fits in nicely with the overall ambitions of the treatise on Christ.

First, the rhetoric of these discussions, as indeed of the entire treatise on Christ, is that of one Christian writing for others. Even at his most speculative, Thomas's concerns remain the actual revealed order. The point of the questioning of aa. 6 and 7 is not some other world considered and valued for its own sake, but rather to shed new light on the actual Christian dispensation. Only one who affirms and appreciates the strengths of portraying Christ in terms of hypostatic union, and of locating the union in the person of the Word, could so surefootedly engage in such speculation; only those who share this affirmation and want to grow in their appreciation of this truth would benefit from such writing. The point can be made in a slightly different way by considering how confusing the teaching of aa. 6 and 7 would be for someone with little or no prior knowledge of this aspect of Christian faith (hypostatic union).

Second, Thomas's practice reveals the soundness of his theological instincts. While reflection on alternate scenarios has its place, it probably should not become the sum total of theological method. In Thomas, it doesn't. It remains for him but one of the tools in a vast arsenal, used only occasionally and as circumstances demand—that is, when attending to a hypothetical situation would in fact contribute to the firmer grasp of Christian truth. Consideration of an earlier article in the treatise on Christ helps to confirm the point, an article where Thomas *refuses* to enter into a speculative mode on a particular issue. In ST 3 q.1 a.3, he is considering a traditional topic, whether the Word would have become incarnate if there had been no sin.[14] As Thomas notes at the end of the corpus, that does lie within God's power. But, Thomas does not want in fact to speculate about other reasons (that is, other than overcoming sin) that might have occasioned the Incarnation. Since everywhere in scripture human sin is cited as the reason for the Incarnation, there is in fact no point in speculating about other motives; Thomas will not pass beyond what scripture explicitly teaches. What, then, is the difference between 3 q.1 a.3, where he forgoes speculation, and 3 q.3 aa.6–7? It may very well be that Thomas's reticence in the earlier article is due to his sense that posing that alternate scenario would be counter-productive, feeding into the biases of theologians who may be inclined to dismiss or downplay the problem of sin and so reluctant to link the Incarnation as closely as Thomas wants to the overcoming of sin.

Thomas's willingness to enter into a more speculative mode in q.3 may, thirdly, reflect the progress that has been made by this stage in the treatise on Christ. In q.1, such speculation may have appeared to Thomas as premature, beyond the skills of his readers. The inclusion of the more hypothetical considerations in q.3 may reflect Thomas's judgment that the exercises of the opening questions will have succeeded in preparing for the more challenging discussion of the present articles. In this way, then, his inclusion of these articles would emerge from Thomas's pedagogical judgment: by introducing these considerations Thomas is showing how much he can now expect from those who have submitted to his schooling. If this is the case, then modern read-ers of Thomas, so accustomed to simply dip at whim into scholastic texts, would be receiving added encouragement to pursue an integrated reading of Aquinas, in which each article is read as part of its question and is seen in its intended relations to other passages in the treatise to which it belongs.

Finally, as these articles in particular disclose, hypothetical questioning is war-ranted, ultimately, by the light it can shed on the actual Christian dispensation. As intriguing and important as articles six and seven are in themselves, their most basic value is in contributing to the overall analysis of the question in which they are in-cluded. I have already indicated how these articles in effect clarify and extend the teaching of the articles that immediately precede them. But, in like fashion they are also valuable because they set up the final article of the question. I would go so far as to say that the eighth and final article of the question, on the greater fittingness of assumption of human nature to the Word, is in fact the main point of the entire ques-tion. The sixth and seventh articles are designed to prepare for this final discussion, and they have served their function inasmuch as the teaching of the eighth article is set in its proper relief. The point can be underscored by considering the parallel discus-sion in the much earlier *Scriptum* on the *Sentences*, in *In III* d.1 q.2. There are, of course, other differences between the two discussions. For example, in the much ear-lier *Scriptum*, the distinction between principle and term, while present, recedes in prominence.[15] But, the most important way in which the two discussions of the topic differ has to do with organization. That in the *Scriptum* follows a different order: in summary, in that work Thomas puts the considerations that will constitute the eighth article of q.3 in the *Summa* roughly in the middle of the treatment in the *Scriptum*, preceded by the *Scriptum*'s equivalent of the *Summa*'s 3 q.3 a.4 (on whether one person can assume flesh without another person) and followed by the treatment of the equiva-lent of the *Summa*'s aa.5, 6, and 7 (that is, the *Summa*'s more speculative question-ing).[16] The consequence of this different ordering in the *Scriptum* is to muffle the teaching about the greater appropriateness of assumption of human nature to the sec-ond person of the Trinity. That teaching, because of the different placement, is in dan-ger of being lost in the shuffle, made subordinate to the hypothetical questionings im-mediately surrounding that article in the *Scriptum*. Because of the ordering there, one might think—but wrongly—that the culmination of the exercise is in fact the hypo-thetical questioning. In the *Summa*, on the other hand, there is—structurally—less possibility for that error. Because of the reorganization, placing the discussion of the appropriateness of assumption to the Word in the final place (and here, this is definitely the place of honor), Thomas leaves no doubt about where he wants to put the stress: the actual Christian dispensation, understood in a more sophisticated manner. It is the

hypothetical questionings of the sixth and seventh articles that are now subordinated, placed into service to the meditation on the actual Christian dispensation with which the question culminates, in the eighth article of the question. Through these and the other meditations in the earlier articles of q.3, one is prepared to take the eighth in its proper terms and as Thomas intends. It is to this final article that we must now turn.

II. ST 3 Q.3 A.8

What, then, is the teaching of 3 q.3 a.8? Why is it more appropriate for the assumption of human nature to find its term in the second person of the Trinity? Thomas has organized the corpus of the article along two lines. On the one hand, Thomas looks at the assuming of human nature to the second person from three angles, arguing for the greater suitability of the second person of the Trinity as the term of assumption according, in turn, to (1) the union itself, (2) the end of the union, and, the union of the two natures in the second person (3) as the remedy for sin. On the other hand, Thomas reinforces this tripartite division of the corpus through reference to important names of Christ: he shows the greater appropriateness of the actual Christian dispensation by meditating, in particular, on the names of "Word," "Son," and, "Wisdom." In looking at the assumption in terms of the union itself, Thomas trades on the proper characteristics of the *Word* of God and here recalls what he had written of God's creating in the Prima Pars. His "argument" in the present instance will be that there should be a close correspondence between creating and salvation. Now, God's act of creating is not only free but intentional. Thus, all that God brings into being exists in accordance with God's plan formulated in wisdom. All that exists is patterned on God, each being manifesting outside of God some aspect of the divine goodness, doing so in the way that God has in wisdom determined for it. But, as in the Prima Pars, so too there is in the present article a distinctly trinitarian cast to the account of God's creating. Thus, Thomas reminds us here of the proper causality of the Father and of the second person of the Trinity: the first creation of things was made by the power of God the Father, through the Word of God, the eternal concept of God; the Word therefore stands as the exemplar (likeness) of all creatures. In this sense, as the corpus puts it, there is a great similarity between creatures and the Word of God on whom they are patterned. Human sin, of course, has deformed God's handiwork. Thus, just as the craftsman with regards to his handiwork, when it has fallen into ruin, restores it by the intelligible form of his art according to which it was first made, so, Thomas suggests, it is wholly fitting that the restoration of fallen humanity—or, as he puts it in the response to the second objection of the article, echoing the teaching of the first paragraph of the corpus—the "second creation," mimic the first. What holds in the first creation, ought to hold in the second creation. Salvation should be brought about through the Word, by the power of God the Father, and so it was most fitting for the assuming of human nature to find its term in the second person of the Trinity.[17]

In looking next at the assumption with respect to the end of the union, it is the name of "Son" that comes to the fore. Again, Thomas is insistent in connecting incarnation with soteriological considerations, here tying the assumption of human nature to the fulfillment of God's predestining plan. Human beings have been ordained by

God to eternal life. As the Apostle reminds us midway through the eighth chapter of Romans, heaven is given as an inheritance to those who are sons, to the children of God. Such sonship is by adoption, and means, as the Apostle teaches later in the eighth chapter of Romans, to be made conformable to the image of the natural Son. The working out of predestination, then, is through Christ; since the incarnation is geared to human salvation, it is thus most appropriate for the Son to assume human nature.[18]

Finally, Thomas shows in the corpus the special fittingness of assumption to the second person of the Trinity by contemplating the sin of the first people. Their sin, at least in this rendering, was due to an "inordinate thirst" for knowledge; the inordinateness, in all likelihood, covers both the seeking of knowledge in the wrong place, and, the seeking of knowledge for the wrong reason, out of desire for personal aggrandizement. Again, as in the first argument of the corpus, it is the name of "Word" that is prominent in Thomas's reflections, this time described as the "Word of true knowledge."[19] Thomas's comments here are somewhat terse and presuppose claims advanced earlier in the treatise on Christ—in particular, that in Christ one meets the full disclosure of the God who is the true end of human existence. It is especially appropriate then for the assumption to terminate in the Word because as Word, the Word incarnate reveals God anew and fully, thus calling people back to the end that alone can truly perfect them; as incarnate, the Word is the way to this end.[20]

Aspects of the eighth article of this question call for closer comment. First, the present article assumes much of the teaching found in earlier Parts of the *Summa*. For example, the meditation here on names of Christ presupposes the doctrine of God articulated in the Prima Pars; Thomas in the present discussion is the beneficiary of the more extensive reflections offered about "Word," "Son," and "Wisdom" in the First Part of the *Summa*, and in the present discussion is thus able to concentrate on what is directly pertinent to his topic.[21] Similarly, the present article presupposes and builds on what has been taught earlier about human beings, as made in the image of God and for God, as capable of God through their characteristic operations of knowing and loving, but as seriously flawed through their own introduction of the sin that blocks progress to God.[22] The present arguments for the special appropriateness of the Word as the term of the assumption of human nature will resonate in particular with those familiar with the details of this theological anthropology. One is tempted to add here that the ease with which Thomas in the present article is able to make his case for the appropriateness of the assumption to the second person is itself testimony to the wisdom of the overall organization of the entire *Summa*; the discussion of the "God-man,'" the principal subject matter of the Third Part of the *Summa*, can proceed apace and effectively, as in the present article, when it is preceded by a thorough discussion of God (Part One) and of the human person (in, especially, the Second Part of the *Summa*).

Second, the use of a saying from John of Damascus in the *sed contra* is especially clever. Through this quotation, Thomas is able to make clearer the progress of the analysis of the opening questions of the Tertia Pars. The quotation from the Damascene, to the effect that through the Incarnation, the power and wisdom of God are made known, has in fact appeared earlier in the Tertia Pars, in somewhat more expansive form (in the earlier use of this authority, divine goodness and justice, as well as power

and wisdom, are said to be revealed in the incarnation). The quotation from John has already been used in the sed contra of the very first article of the Third Part, in the consideration of whether it was fitting that God should become incarnate. In that instance, the saying from John is linked to Romans 1:20, in which it is stated that the invisible things of God are made known through visible things; hence it is fitting for God to use the visible—in this case, to become incarnate—precisely to make God known.[23] Thomas then goes on in the corpus to complete the point, by referring to God as the highest good. Since it pertains to goodness to communicate itself, it is thus fitting for God to communicate Godself by becoming incarnate.

In our article (3 q.3 a.8), the saying from John of Damascus is linked in the sed contra to a different Pauline verse, to I Corinthians 1:24, where Christ is called the "power of God and the wisdom of God." As John of Damascus has said, by the incarnation the wisdom and power of God are revealed. But, Thomas adds, power and wisdom are appropriated to the Son, as I Corinthians clearly states. Thus, the sed contra concludes on this basis to the greater appropriateness of the Son as Wisdom as the term of the assumption of human nature.[24] In this sense, the movement of the opening questions of the Tertia Pars is from the communication of divine goodness to the stress on the sapiential communication of this goodness, thus underscoring the Christic-shape of God's encounters with the world.

The citation of I Corinthians is significant, however, for another reason: it reminds us of the importance of *Wisdom* in Thomas's approach to Christ in the present article. Christ construed as Wisdom figures, explicitly or implicitly, in all three arguments in the corpus for the fittingness of assuming to the Word. Wisdom is prominent in the first argument where Thomas insists on the continuity between creating and saving. After showing the fundamental similarity that exists between all creatures and the Word, on Whom they are all patterned, Thomas adds that there is a particular agreement between the Word and human nature, thus heightening the appropriateness of the Word taking human nature to itself. The Word, Thomas points out in the continuation of the first argument of the corpus, is a concept of the eternal Wisdom, from Whom all of people's wisdom is derived. And so, he concludes, since the human person is perfected in wisdom (which is the proper perfection of the human person as rational) by participating the Word of God who is Wisdom, it was fitting for the consummate perfection of the human person that the very Wisdom of God be personally united to human nature.[25] The same point—that human perfection comes through participating the Word as Wisdom—lies in all likelihood behind the teaching of the third argument of the corpus as well, dealing with the Incarnation as the remedy of original sin. It is fitting for the assumption to find its term in the Word because as Wisdom, true knowledge of God is definitively revealed in the incarnate Word. The claim, incidentally, that the fulfillment of the human desire for wisdom comes precisely in knowing Christ is not unique to this article; readers of Thomas's biblical commentaries will have met it on more than one occasion (see, e.g., the first lecture on the second chapter of Colossians).[26]

The second argument of the corpus, dealing with predestination, also presupposes a Wisdom Christology. As the discussion in the Prima Pars reveals, Thomas also understands predestination in sapiential terms. The communication of God's goodness

entails more than the establishment of different creatures with their proper natures. By God's plan, it includes as well the ordination of creatures to their God-determined ends, and the working out of this ordination. In terms of predestination, God has willed the special end of life with God in heaven to rational creatures, which is implemented through the grace that brings the elect to heaven, all to proclaim outside of God the goodness that is God.[27] In our article, the claim that predestination is in Christ is but a restatement of the sapiential dimensions of this aspect of the communication of divine goodness.

But, to my mind, it is the biblical verse in the sed contra that is especially telling. The statement that Christ is "the power of God and wisdom of God" has rich associations, associations of which Thomas in his commentary on I Corinthians shows himself fully aware. In Thomas's reading in the commentary of the opening chapters of I Corinthians, Paul is concerned to pay tribute to the wisdom revealed by God's work in Christ. The world through reason can know much, but it cannot reason to what God has revealed in Christ. The central truths of the Christian religion, Thomas notes, transcend the capacities of reason; for acquaintance with them, people are fully dependent on revelation. In the commentary, Thomas will specify what Paul especially has in mind. That God has become human, that God has become human to die for sin, that God in a human state can die, and that God dies in this wretched way—on the cross—all these fully escape the capacities of reason to anticipate. Again, under the influence of the Pauline text, Thomas emphasizes the contrast between worldly wisdom and this divine wisdom. What is wisdom for God seems as foolishness to the world. But, it must be stressed, it *is* wisdom—*the* wisdom—thus relativizing all human thought and reasoning. And, once revealed it can be acknowledged as in fact full wisdom; by faith Christians recognize that Christ (the crucified Christ) has been made wisdom for them. Hence, although to many the cross remains foolishness, by faith there is a recognition that through Jesus Christ the wisdom of God has been fully and decisively revealed, and revealed in a way that meets well the human condition. Through incarnation, the Word as Wisdom identifies with humanity; and, by becoming visible, the Word adopts a 'medium' through which the invisible things of God can be revealed. By dying for sin, the incarnate Word takes up the punishment owed by fallen humanity, thus removing the debt owed by sin. The death of God incarnate reveals as well the depth of God's love, of God's commitment to bringing humankind to its God-determined end. All of this, Paul and Thomas insist, accords with God's Wisdom; it is all done by Christ, the Wisdom of God.[28]

To return to our article: in the coupling of I Corinthians 1:24 to the saying from John of Damascus, I think that Thomas in fact has the opening chapters of I Corinthians in mind. Placement, then, will have to be given its full due. Quoted in the sed contra, the saying from I Corinthians thus colors the specific arguments for fittingness offered in the corpus. What this means is that while it is important to reflect, say, on the cosmic dimensions of Christ's work as creator, it is at least as important to keep in mind the death of Christ on the cross. For, it is in the pouring out of his blood for sinful humanity on the cross, Thomas is saying in citing this Paul, that the Wisdom of God is fully revealed. To extend the thought: when he writes in the continuation of the first argument of the corpus of participating Christ as Wisdom as leading to human perfec-

tion, he means for us to understand that the way to perfection must inevitably pass through the Wisdom disclosed on the cross.

III. ST 3 Q.3 A.8 AND THE SUFFERING OF CHRIST IN THE TERTIA PARS

The questions on Christ in the Third Part fall into two main groupings: 1–26 and 27–59.[29] The second set of questions is itself divided into four sections. In those questions Thomas in effect rehearses the story of Jesus, beginning with his conception and entry into the world (27–39), continuing with his life and doctrine (40–45), and, his departure from this world (46–52), and culminating (53–59) with his exaltation after this life. The discussion in qq.27–59 is insistently scriptural. Thomas in large part follows the scriptural order and employs scriptural verses in recounting the story of Jesus, raising along the way questions and difficulties that arise due to the diversity of witnesses in the New Testament. The first main set of questions (1–26) takes a somewhat different approach and is not bound to the scriptural order in raising its considerations. In these questions, Thomas provides an overview and investigation of the orthodox proclamation about the person and natures of Jesus, stressing, as is obvious by now, the hypostatic union of the natures. Hence, after the opening question on the soteriological context of the orthodox affirmations about Christ, he discusses hypostatic union, both in terms of the person assuming (3) and the nature assumed (4f.), including a treatment of what is not essential to human nature but is co-assumed with it (7–15) by the Word who becomes human—the perfections (7–13) and the defects, both of body (14) and of soul (15) that are suited, because of Jesus's role in salvation, to the Word incarnate. The first main set of questions concludes with the examination of the consequences of the union, looking in turn at what belongs to Christ in himself (16–19), in relation to the Father (20–24), and in relation to the rest of the human race (25–26). Although less obviously and less insistently scriptural in language and tone than the second main group of questions in the treatise on Christ, Thomas would maintain that the principal claims contained in qq.1–26 do have scriptural roots.[30] One way of describing qq.1–26 is to say that here Thomas in accordance with his own intuitions as a teacher is summarizing the principal conclusions about Christ offered by the Christian traditions in theology that precede him, with pride of place accorded to the great theologians of the patristic age.[31] For Thomas, these theologians are worthy of respect and are accorded authority not so much for their metaphysical acumen as for their skill as interpreters of scripture: they have been recognized by later generations of Christians as especially good readers of scripture, able to grasp the Word of God revealed in scripture and to restate it in terms meaningful to their own time. The use of non-scriptural terms such as "person" and "nature" in the service of Christian faith is in the final analysis justified by their power to capture and preserve what is most important in the scriptural message about God and Christ.[32]

Although proceeding in their distinct ways, the two main sets of questions are closely related and should be read together. An especially plausible way of portraying their unity is to describe qq.1–26 as providing the "grammar" by which the scriptural material that is recounted in qq.27–59 can most adequately, and safely, be read.[33] Here as elsewhere placement is key. By putting the material of qq.1–26 before that in qq.27f.,

Thomas shapes our reading of the gospel accounts of Christ in those later questions, in the process ruling out from the outset certain errors that might arise in grappling with individual verses in the Bible while helping the reader grasp what is in fact crucial in scripture about Christ.

In showing the virtues of the dogmatic formulation about hypostatic union, and, in establishing the grammar of Christ, 3 q.3 a.8 is of great importance. According to Thomas's own organizational comments, that article marks the end of one subsection in the group of questions that treat directly the Incarnation in itself; with q.4, Thomas moves to the nature that is assumed. And yet, what Thomas has written in q.3 about the person assuming—about *this* person assuming—inevitably informs the limning of the rest of the grammar of Christ in the first main set of questions. In talking about the full human nature that is assumed and which serves as the conjoined instrument of the divinity[34] by which human salvation is established, and, in enumerating and explaining those perfections and defects that are co-assumed in order to promote human salvation, it remains clear throughout that the human nature assumed is that of the Word as incarnate—the Word to whom assumption is eminently appropriate. Thus, even though in qq.4–15 the focus has shifted to the other nature, the depiction of Christ's human nature owes much to q.3 and in particular the Wisdom Christology of its final article. Later questions presuppose that question and in large measure simply clarify and apply its lessons.

The formative power of the teaching about Christ advanced in 3 q.3 a.8 can be illustrated by looking at Thomas's treatment of a theme that weaves its way through both main groups of questions that make up the treatise on Christ, the question of Christ's suffering unto death.[35] The suffering of Christ was by Thomas's time a traditional topic for theological investigation, as theologians asked, among other things, about the extent and the uniqueness of Christ's sufferings.[36] Thirteenth-century Christians in general were much intrigued by Christ's suffering. As the researches of Caroline Walker Bynum and others on medieval religious women have shown, discipleship was especially Christ-centred, and emphasized the human, suffering Christ;[37] Thomas too recognized the appeal of portraying the movement to God as end through the Christ that suffers. And, Thomas's own researches as an historian added impetus to a careful discussion of Christ's suffering which would offer added recommendation of the dogmatic formulation about the union of the natures in the Word. It is by now an accepted tenet in the study of Aquinas that at some point in the 1260s while in Italy, Thomas had come across Latin translations of Greek patristic material—the acts and proceedings of the early ecumenical councils (including Ephesus and Chalcedon) as well as of supporting documentation (e.g., letters and treatises of such principal players in the early disputes as Cyril and Nestorius).[38] Due to the vagaries and vicissitudes of manuscript transmission, this early material had gone unnoticed by the high middle ages, with the result that twelfth and thirteenth-century theologians in the largely Greekless West had worked out their theologies in ignorance of the details of the patristic debates and their resolution at the councils. In rediscovering this material in translation, Thomas was led to revamp his Christology. He became more attentive to the flaws of certain contemporary Christologies, denouncing them as unwitting relapses[39] into positions long ago condemned by the church meeting in council; and, I

would insist, he became in the works written after his discovery even more sensitive to the virtues of hypostatic union in proclaiming Christ and his saving work, here echoing the teaching of such great predecessors as Cyril of Alexandria.

Thomas, in fact, adopts in the *Summa* Cyril's harshly anti-Nestorian tone. Thomas seems keenly aware of the surface attractiveness of a Nestorian position, that it allows in Christ a person that is "human" in precisely the same way as in others who share the nature.[40] Yet, Thomas resists the temptations of multiplying persons in Christ and resolutely combats Nestorian teaching throughout the treatise on Christ. In Nestorius, the divine and the human remain neatly segregated; it is the human person alone who suffers and dies. In Thomas, on the other hand, there is diversity in Christ, in accordance with the two natures, and some things are said of Christ with respect to the divine nature, others with respect to the human nature. But, there is a single subject of these two sets of essential predications, in accordance with the teaching on hypostatic union. It is one and the same Word of God, who from eternity is fully God and a distinct person in the Godhead, who has come to bear and express human nature and so to do and suffer human things as well. Thus, while as God, the Word does not suffer or experience death, it is the Word—as incarnate—who suffers unto the death on the cross, in accordance with God's plan for salvation. By insisting on the genuine suffering and death of the Word as human, Thomas can in fact show the preferability of Cyril's position as articulated against Nestorius and embraced at Ephesus and Chalcedon. Due to the depths of God's love for humans, God has identified with humanity to the point of taking up the penalty (death) owed by people for sin, thus facilitating the realization of the plan for salvation that is part of God's creative activity.[41] The same Word through whom all things are created has as human died on the cross.

The detailed discussion of Christ's suffering and death in the Third Part nicely extends the lessons of 3 q.3 a.8. To restrict myself to a few examples connected with the cross, when he examines Christ's ability to suffer (as in q.14, where the topic is the defects of body that have been freely contracted by Christ), or the death itself (as in q. 46), Thomas of course frees God from any "necessity" in the strict sense. Must Christ have suffered? No, for the defects that accrue to other humans come to them as the consequence of sin, and Christ was sinless. Need Christ have died? and, died on the cross? Again, no, for it lies within God's power to work out salvation by some other means. But, that Christ was able to, and did, suffer makes much sense and discloses God's wisdom; so too—indeed preeminently—the death of the God-become-human on the cross. In short, in the subsequent ruminations on individual aspects of Christ's life and death, Thomas gives full play to his conviction that the Wisdom of God is definitively expressed by Christ; his principal concern is to show in detail that what God has done in Christ is well-conceived and perfectly tailored to the human condition.[42]

To all this, of course, it may be objected that in fact God's message in Christ to humanity has been rather inept, that the Word-as-Wisdom-made flesh has been quite ineffective. Is it really wise for the Wisdom of God to be disclosed through an ultimately pathetic, suffering, crucified man? Some facts of Christian history would seem to suggest that God's message could have been more wisely ordered. Far from overcoming sin, far from restoring people to their proper order to God and facilitating the attainment of their end, Christ—the suffering, human Christ—has become the occasion

of new sin. In the middle ages, one might think in this respect of blood libel or charges of host desecration against those outside of the mainstream Christian community, with all of their dire consequences.[43] Is this really the "Wisdom" of God? Thomas's response, I would think, would proceed along two lines. First, it is useful to recall here a comment that he makes in answering the first objection in the article that has concerned me most (3 q.3 a.8). To the suggestion in the first objection that it would have been preferable for the assumption to find its term in the Father (for then it would have been less likely that people would have fallen into error when thinking about the incarnation), Thomas responds that even if the Father had become incarnate, some people would still have erred. For, he observes, there is nothing that human malice cannot abuse; indeed, as Romans 2 shows, by their malice people can despise the goodness of God itself.[44] In terms of what God has in fact done in Christ and the use that people have made of God's Word, failure is to be ascribed not to God but to people. While the message is well-formed, God does not compel its acceptance; that remains in human hands, and when the message is distorted—as it is when the Christ who dies for sins is alleged as the motive for new sin—that is wholly, as Thomas would say, a human accomplishment. Secondly, such behavior runs counter to the inner logic of the Christology advanced by Aquinas. What Christians meet in the cross is the unconditional love of God for humanity, a love that culminates in the supreme self-giving of a death offered up for others. The appropriate response to this self-offering, to this manifestation of divine Wisdom, is not renewed strategies for self-aggrandizement but, rather, love in return for the one who has thus proven God's love. Moreover, as Thomas never tires of reminding us in his various meditations in the Tertia Pars about the fittingness of various details of the actual Christian dispensation, everything about Christ, including the death for others, calls for emulation.[45] In this sense, the Christology of Aquinas offers resources for a critique of sinful behavior alleged on the basis of Christ and a supposed identification with the suffering Christ. To the extent that Christians sin in the name of Christ, they show how little of the message of God in Christ on the cross that they have in fact assimilated.

IV. ST 3 Q.3 A.8 AND ST 1 Q.1 A.1

While ST 3 q.3 a.8 without doubt illuminates the rest of the Tertia Pars, it may also deepen our understanding of a much earlier question in the *Summa*, the very first question which deals with sacred doctrine. In particular, this article from the Tertia Pars may facilitate a surer grasp of Thomas's teaching in the first article of the question on sacred doctrine, in which Thomas shows why sacred doctrine is "necessary."[46]

On the face of it, the likelihood that 3 q.3 would illlumine 1 q.1 a.1 might seem to be minimal. Although there are a few points in the entire question on sacred doctrine at which Christ appears,[47] for the most part the focus remains squarely on God—rather than referring to the Word or the Word Incarnate, Thomas prefers in q.1 to talk of *God* revealing the truths necessary for salvation (a.1), of *God* providing the subject matter of sacred doctrine (a.7), of *God* providing its formal unity (a.3). Indeed, in a review of ways suggested by earlier theologians of portraying the unity and subject matter of sacred doctrine, Thomas would seem to go out of his way to deny the importance of

Christ.[48] Why then think that the *Summa*'s opening article should be seen in relation to 3 q.3 a.8?

For Aquinas, the necessity of sacred doctrine is tied to salvation. Only through the revelation that stands at the center of sacred doctrine can people know of their transcendent, beatifying end in God. In the corpus of the first article of the *Summa*, Thomas goes on to note that two kinds of truth are in fact found in sacred doctrine. Both kinds are revealed by God. But, one, the preambles of faith, can also be demonstrated by reason (although only with great difficulty and by the few who have the leisure and intelligence for such inquiry). The other kind of truth in sacred doctrine is revealed by God and cannot be demonstrated by reason; these truths (the articles of faith) must be held by faith alone. In illustrating this kind of truth in sacred doctrine, Thomas has recourse to the sixty-fourth chapter of Isaiah, in which the prophet states: "the eye has not seen, O God, besides Thee, what things You have prepared for those that wait for thee." In this article, Thomas himself refers to the saying as coming from Isaiah; and, students of Thomas have generally been content to leave it at this. However, these words of Isaiah actually also appear in a second place in the bible: the Apostle quotes them in the second chapter of I Corinthians (v. 9), in the course of his reflections on the wisdom of God that is disclosed in the cross of Christ. In light of ST 3 q.3 a.8, in which the opening of I Corinthians is so significant, we are justified in asking whether Thomas has Paul's usage in mind when he quotes the saying in the first article of the *Summa*. In that case, Thomas even here would be implying that the way to God as the beatifying end of human beings runs through the cross of Christ.

Evidence from Prologues lend some credence to this suggestion. For one thing, as stated in the brief preface to the second question of the First Part, in which Thomas announces the broad organization of the rest of the work, Jesus Christ *secundum quod homo* is the way to God as the beatifying end of the rational creature; the point about Jesus as the Way is repeated at the head of the Tertia Pars.[49] Secondly, in the somewhat perfunctory Prologue that introduces the entire *Summa* (and which comes just before the first article of the *Summa*), Thomas in fact quotes I Corinthians, from the third chapter in which Paul acknowledges his debt to those who are young in the faith (this, incidentally, is the only quotation from scripture to be found in this Prologue).[50] That citation should, probably, color our reading of the first article: as in the Prologue, so in that article Thomas would have I Corinthians in mind in advancing the case for the necessity of sacred doctrine.

But, it is a third Prologue, that to the much earlier *Scriptum* on the *Sentences* of Peter Lombard, that makes it most probable that in ST 1 q.1 a.1 corp., Thomas is implicitly referring to the opening of I Corinthians. Compared with that to the entire *Summa*, the Prologue to the *Scriptum* is a much more sustained and ambitious introduction to the entire work.[51] Before he gets into the discussion of sacred doctrine and theology in the first question of the *Scriptum* (which parallels in its topic the first question of the *Summa*), Thomas in this earlier Prologue wants to locate all of theological discourse under the sign of "Wisdom" and to tie theological wisdom to the Christ who is the "Wisdom of God." For Aquinas, all of the material in the four books of *Sentences* of Peter Lombard that stand at the basis of his own work in the *Scriptum* has to do with Wisdom: the first is on the work of Wisdom in revealing the hidden

things of God; the second, on the creative work of Wisdom; the third on the restoration of fallen humanity by the Wisdom who is also responsible as exemplar for the establishment of all things; and, the fourth, on the perfective work of Wisdom. But, notes Thomas in the opening sentence of the Prologue, "Wisdom" is appropriated to the second person of the Trinity—this, he observes, is what the Apostle teaches in the first chapter of I Corinthians (vv. 24, 30), where Paul calls Christ "the power of God and the wisdom of God, who has been made wisdom for us by God." Thus, for Aquinas, all of the *Sentences* and all of his own writing on the *Sentences* will be especially concerned to depict the work, in its various dimensions, of Christ, the Wisdom of God.

Has Thomas in the later *Summa* abandoned this understanding of the centrality of Christ as Wisdom? Hardly. It *is* clear that in the *Summa*, Thomas offers a much more restrained Prologue to the entire work. Hence, in that Prologue, he does not linger on the actual organization of the entire work (that comes a bit later) or on the overall conception that will tie together the different parts of this writing. But, this decision about the requirements of a Prologue cannot possibly be taken as a rejection by the time of the *Summa* of the claims advanced about Christ as Wisdom in the Prologue to the *Scriptum* on the *Sentences*. ST 3 q.3 a.8 shows that this is simply not the case. Hence, in light of that article in the Third Part as well as the musings on Christ as Wisdom in the *Scriptum*, it is quite likely that Thomas expects the reader of the opening article of the *Summa* to perceive the Christological dimension of the citation from Isaiah and to give it its full weight. In that case, Christ—the crucified Christ—would indeed be present from the very beginning of Thomas's masterwork, lying behind and shaping the discrete analyses of even its opening Parts.

NOTES

1. See the suggestive comments in Mark D. Jordan, "The Alleged Aristotelianism of Thomas Aquinas" (The Etienne Gilson Series 15, Toronto, 1992), 21–22, and especially Jordan's "The Competition of Authoritative Languages and Aquinas's Theological Rhetoric," *Medieval Philosophy & Theology* 4 (1994): 71–90. See as well W. G. B. M. Valkenberg, *Did Not Our Heart Burn? Place and Function of Holy Scripture in the Theology of St. Thomas Aquinas* (Utrecht, 1990), ch.1.

2. The scholastic discussion of the person in whom divine and human natures are joined comes as a rule in connection with Peter Lombard, *Sententiae* 3 d.1 (Quarrachi Edition 2: 23–27). Peter's own text, however, lacks mention of the material covered in Thomas's ST 3 q.3 aa.6–7. For an especially influential treatment of the topic, see *Summa Halensis* 3 tr.1 q.2 tit. 1 d.2 membrum 1 cc.1–4 (Quarracchi Edition 4: 26–32); for the discussion in this work of some of the challenging material covered in the first main part of this essay, see c.3 (4:28–30). Also significant for the issues raised by Thomas in ST 3 q.3 are two works by Anselm: *Epistola de incarnatione verbi* ed. F. S. Schmitt, *S. Anselmi Cantuarensis Archiepiscopi Opera omnia* (Edinburgh, 1946), 2: 21f. and *Cur Deus Homo* 2 c.9 (2: 106). Thomas quotes *CDH* 2 c.9 at ST 3 q.3 a.6 corp.

3. As we shall see, the order in which Thomas approaches his topic in ST 3 q.3 differs even from that in his own first discussion of the topic, in *In III Sent.* d.1 q.2 (*Scriptum* 3: 28–47).

4. I will offer at the beginning of part three of this essay a more complete description of the organization of the treatise on Christ in the ST.

5. For the argument against a monophysite position, see, e.g., 3 q.2 a.1 corp.; for the rejection of an adoptionist or Nestorian position, in which an already existing human person would be joined to

the person of the Word, see 3 q.2 a.3 corp. In 3 q.2 a.6 corp., Thomas offers a global rejection of different early Christological heresies. At the end of 3 q.3 a.6 corp., Thomas repeats the claim against a Nestorian position, now rejected in connection with the hypothetical situation addressed in this article. I return to the question of Thomas's attitude towards Nestorius in the third part of this essay.

6. ST 3 q.1 asks about the *convenientia* of the Incarnation; a.1 asks why it was "convenient" for God to become incarnate; aa.5–6 consider why the timing of the Incarnation was sound. 3 q.2 1 corp. examines, for example, "nature" as employed in a Christological context; a.2 looks at "person."

7. I am of course recalling the language of the Prologue to the entire *Summa,* where Thomas refers to the *incipientes* for whom he is writing. There has been considerable debate about the identity of these "newcomers": e.g., newcomers to the technical discipline of theology? or, as in Leonard E. Boyle, "The Setting of the *Summa theologiae* of Saint Thomas" (The Etienne Gilson Series 5, Toronto, 1982) the average Dominicans engaged in pastoral work for whom Thomas wishes to locate pastoral and ethical issues in a more complete and insistent theological setting (i.e., in relation to talk about God and about Christ)?

8. ST 3 q.3 a.5 corp.: "assumptio duo importat: scilicet ipsum actum assumentis et terminum assumptionis. Principium autem actus est virtus divina; terminus autem est persona. Virtus autem divina communiter et indifferenter se habet ad omnes personas. Eadem etiam est communis ratio personalitatis in tribus personis, licet proprietates personales sint differentes. Quandocumque autem virtus aliqua indifferenter se habet ad plura, potest ad quodlibet eorum suam actionem terminare; sicut patet in potentiis rationalibus, quae se habent ad opposita, quorum utrumque agere possunt. Sic ergo divina virtus potuit naturam human unire personae Patris vel Spiritus Sancti, sicut univit eam personae Filii. Et ideo dicendum quod Pater vel Spiritus Sanctus potuit carnem assumere, sicut et Filius."

9. For example, in the first objection of the fifth article, it is observed that by virtue of assumption, God is the Son of Man; if the Father or the Spirit were through assumption to become the "Son" of Man, there would be a genuine risk of confusing the persons; and so neither could (potuit) assume human nature. The second objection of the article observes that adoptive sonship follows on natural sonship, which does not belong to the first or third divine persons but to the second alone; thus neither of the others could assume human nature. The final objection notes that the Son inasmuch as he becomes incarnate is said to be "sent" and to undergo a temporal birth; since the Father is *innascibilis,* it does not belong to the Father to be sent, and thus the Father could not become incarnate.

10. ST 3 q.3 a.5 ad 2: "filiatio adoptiva est quaedam participata similitudo filiationis naturalis; sed fit in nobis appropriate a Patre, qui est principium naturalis filiationis; et per donum Spiritus Sancti, qui est amor Patris et Filii, secundum illud Gal. IV: 'Misit Deus Spiritum Filii sui in corda nostra, clamantem: Abba, Pater.' Et ideo sicut Filio incarnato, adoptivam filiationem accipimus ad similitudinem filiationis naturalis eius; ita Patre incarnato, adoptivam filiationem reciperemus ab eo tanquam a principio naturalis filiationis, et a Spiritu Sancto tanquam a nexu communi Patris et Filii."

11. The first objection of the eighth article argues that it would have been more appropriate for the Father to have become incarnate. For, by the Incarnation of God the true knowledge of God is increased. But the Incarnation of Son has not been conducive to increasing knowledge of God; rather it has led to new error, as in the case of Arius, who posited an inequality between Father and Son. It would have been impossible to think of the Father as lesser, for no one would think that a Father is less than his son; and so the Father should have become incarnate. (I will turn to Thomas's response to this objection toward the end of the third part of the essay.) The third objection of a.8 argues that the Holy Spirit should have become incarnate. For, Incarnation is ordered to the forgiveness of sins, which is attributed to the Spirit.

12. Thomas was hardly the first to introduce such questionings into the treatise on Christ; earlier scholastics in commenting the Lombard's text (see note 2 above) had already engaged in such speculation, and so in a sense Thomas here is simply examining some possibilities that others had also considered. Of course, my inquiry in the first part of the paper into the function that these articles play in q.3 is justified precisely because Thomas was under no obligation to include such a discussion in his own work; he was free to ignore such musings, if he had wished. That he turns to these possibilities indicates his sense of the value at this particular juncture of considering them. The examination of earlier high medieval discussions to which Thomas might be responding might shed additional light on Thomas's literary relations with other scholastics in his Order. In the present articles, Thomas is in effect employing the dialectic of the two powers of God in a Christological setting. As W. J. Courtenay argues in his book *Capacity and Volition: A History of the Distinction of Absolute and Ordained Power* (Bergamo, 1990), 73, it was, contrary to common scholarly wisdom, especially the early Domini-

cans who used the dialectic in a variety of theological settings. It would be worthwhile to complete Courtenay's study by looking at the use of the dialectic by early Dominicans in their Christologies, and then to show the continuity or disjunction between those early dialectical exercises and Thomas's here. Such an investigation, however, goes well beyond the scope of this essay.

13. ST 3 q.3 a.6 ad 1 is worthy of close study: Thomas here explains in what sense one might still refer in this scenario to "unus homo."

14. For successive discussions of the topic by Robert Grosseteste, see Dominic Unger, "Robert Grosseteste Bishop of Lincoln (1235–1253), On the reasons for the Incarnation," *Franciscan Studies* 16 ((1956): 1–36 (texts at 3–25); Bonaventure addresses the topic at *In III Sent.* d.1 a.1 q.2 (Quarrachi Edition 3 [1887]: 21–28); for Albert, see *In III Sent.* d.20 a.4 (Borgnet Edition 28 [1894]: 360–62). For a comparison of Thomas's teaching on the matter with that of his teacher, see Donald Goergen, "Albert the Great and Thomas Aquinas on the Motive of the Incarnation," *The Thomist* 44 (1980): 523–38.

15. See *In III Sent.* d.1 q.2 a.1 ad 2 (*Scriptum* 3: 30–31), where he distinguishes between *actio* (presupposing a principle of acting) and *terminus.*

16. *In III Sent.* d.1 q.2 consists of the following five articles: (1) utrum una persona possit assumere carnem, alia non assumente; (2) si sic, quare magis Filius carnem assumpsit; (3) utrum Pater vel Spiritus sanctus potuerint vel possint assumere carnem; (4) si sic, an potuerint eamdem numero naturam humanam assumere; (5) utrum una persona possit duas numero naturas humanas assumere.

17. ST 3 q.3 a.8 corp.: "convenientissimum fuit personam Filii incarnari. Primo quidem ex parte unionis. Convenienter enim ea quae sunt similia uniuntur. Ipsius autem personae Filii, qui est Verbum Dei, attenditur uno quidem modo communis convenientia ad totam creaturam. Quia verbum artificis, idest conceptus eius, est similitudo exemplaris eorum quae ab artifice fiunt. Under Verbum Dei, quod est aeternus conceptus eius, est similitudo exemplaris totius creaturae. Et ideo sicut per participationem huius similitudinis creaturae sunt in propriis speciebus institutae, sed mobiliter; ita per unionem Verbi ad creaturam non participatam, sed personalem, conveniens fuit reparari creaturam in ordine ad aeternam et immobilem perfectionem; nam et artifex per formam artis conceptam qua artificiatum condidit, ipsum, si collapsum fuerit, restaurat." ST 3 q.3 a.8 ad 2: "prima rerum creatio facta est a potentia Dei Patris per Verbum. Unde et recreatio per Verbum fieri debuit a potentia Dei Patris, ut recreatio creationi responderet, secundum illud II Cor. V: 'Deus erat in Christo mundum reconcilians sibi.'"

18. ST 3 q.3 a.8 corp.: "secundo, potest accipi ratio huius congruentiae ex fine unionis, qui est impletio praedestinationis; eorum scilicet qui praeordinati sunt ad hereditatem caelestem, quae non debetur nisi filiis eius, secundum illud Rom. VIII: 'Si filii et heredes.' Et ideo congruum fuit ut per eum qui est Filius naturalis, homines participarent similitudinem huius filiationis secundum adoptionem, sicut Apostolus ibidem dicit: 'Quos praescivit et praedestinavit conformes fieri imagini Filii eius.'"

19. ST 3 q.3 a.8 corp.: "Tertio potest accipi ratio huius congruentiae ex peccato primi parentis, cui per incarnationem remedium adhibetur. Peccaverat enim primus homo appetendo scientiam, ut patet ex verbis serpentis promittentis homini 'scientiam boni et mali.' Unde conveniens fuit ut per Verbum verae sapientiae homo reduceretur in Deum, qui per inordinatum appetitum scientiae recesserat a Deo."

20. See, e.g., 3 q.1 a.2 ob 3 and ad 3. The objection argues that it was not necessary for God to become incarnate for there to be salvation, because salvation lies chiefly in offering reverence to God; but the more remote something is, the more it is revered, and so God should not have "come near," in the Incarnation. In the response, Thomas nicely argues that it is because God comes to be known more through the Incarnation that God is in fact the more revered: "Deus, assumendo carnem, suam majestatem non minuit, et per consequens non minuitur ratio reverentiae ad ipsum. Quae augetur per augmentum cognitionis ipsius. Ex hoc autem quod nobis appropinquare voluit per carnis assumptionem, magis nos ad cognoscendum atrtaxit." See as well 3 q.3 8 ob 1, to which reference has been made in note 11 above.

21. See, e.g., ST 1 qq.34–35 for a detailed discussion of the second person; see too the discussion of appropriation in 1 q.39 a.7.

22. See, e.g., ST 1 93, and the opening questions of ST 1–2.

23. ST 3 q.1 a.1 sed c.: "Illud videtur esse convenientissimum ut per visibilia monstrentur invisibilia Dei; ad hoc enim totus mundus est factus, ut patet per illud Apostoli, Rom. 1: 'Invisibilia Dei per ea quae facta sunt, intellecta conspiciuntur.' Sed sicut Damascenus dicit in principio III libri, per incarnationis mysterium monstratur simul bonitas et sapientia et iustitia et potentia Dei, vel virtus: bonitas quidem, quoniam non despexit proprii plasmatis infirmitatem; iustitia vero, quoniam homine

victo, non alio quam homine fecit vinci tyrannum, neque vi eripuit ex morte hominem; sapientia vero, quoniam invenit difficillimi pretii decentissimam solutionem; potentia vero, sive virtus, infinita, quia nihil est maius quam Deum fieri hominem.' Ergo conveniens fuit Deum incarnari."

24. ST 3 q.3 a.8 sed c.: " . . . quod Damascenus dicit, in III libro: 'In mysterio incarnationis manifestata est sapientia et virtus Dei: sapientia quidem, quia invenit difficillimi solutionem pretii quam decentissimam; virtus autem, quia victum fecit rursus victorem.' Sed virtus et sapientia appropriantur Filio, secundum illud I Cor. 1: 'Christum Dei virtuem et Dei sapientiam.' Ergo conveniens fuit personam Filii incarnari."

25. After the words quoted in note 17 above, Thomas writes in ST 3 q.3 a.8 corp.: "Alio modo, habet convenientiam specialiter cum humana natura; ex eo quod Verbum est conceptus aeternae sapientiae, a qua omnis sapientia hominum derivatur. Et ideo per hoc homo in sapientia perficitur, quae est propria eius perfectio prout est rationalis, quod participat Verbum Dei; sicut discipulus instruitur per hoc quod recipit verbum magistri. Unde Eccli. 1 dicitur: 'Fons sapientiae Verbum Dei in excelsis.' Et ideo ad consummatam hominis perfectionem, conveniens fuit ut ipsum Verbum Dei humanae naturae personaliter uniretur."

26. See *In ad Colossenses* 2: 2–3 lect.1 (*Super epp.* 2: 142 nos 80–82).

27. See the treatment of providence and predestination in ST 1 qq.22–23; I discuss their sapiential dimension in my book, *God's Grace & Human Action: 'Merit' in the Theology of Thomas Aquinas*, (Notre Dame, 1995), 153–64.

28. See *In ad I Cor.* 1: 17–25 lect. 3 (*Super epp.* 1: 241–44), *In* 1: 26–31 lect. 4 (1: 244–46 nos 63–72), and, *In* 2: 8–9 lect. 2 (1: 250–52 nos 89–98).

29. The following description is based on Thomas's own organizational comments given in opening and transitional paragraphs throughout the treatise on Christ.

30. For the detailed and sustained argument that dogmatic formulation is rooted in scripture and is designed to summarize the essentials of the scriptural message on important Christological matters, see SCG 4 cc. 27–39 (*Liber CG* 3: 301–28), where Thomas shows how the teaching about hypostatic union of the two natures is rooted in certain key passages such as John 1 and Philippians 2. These chapters are also interesting because Thomas includes a discussion of misreadings of scripture that lie behind the different Christological heresies, including that of Nestorius (c.34) and his medieval successors (cc.37–38), in order to show the preferability of the orthodox consensus on the scriptural teaching.

31. The material in the text is based on passages such as ST 1 q.1 a.8 ad 2, in which Thomas recounts the hierarchy of authorities in sacred doctrine, moving from the God who reveals saving truths in scripture (Whose authority is intrinsic to sacred doctrine and absolutely certain) and the human authors of scripture to whom revelation has been made (and so whose authority is that of God), through the church doctors, whose authority is intrinsic but only probable (presumably because they can make mistakes in their study of God's Word in scripture) to the philosophers, whose authority is extrinsic (because they are not principally concerned with sacred doctrine) and probable. See as well Thomas's Inaugural Lecture (1256), in *Albert & Thomas: Selected Writings*, ed. and trans. S. Tugwell (New York, 1988), 355–60.

32. Thomas nicely makes the point with regard to "person" in the course of his discussion of the Trinity at ST 1 q.29 a.3 ad 1.

33. Cf. the insightful comments of John F. Boyle, "The Twofold Division of St. Thomas's Christology in the *Tertia Pars*," *The Thomist* 60 (1996): 444–45: "The second part presents the life and mission of Christ; the first part sets forth the categories and principles according to which that life and mission are to be understood. Thomas considers what it means for God to become man for man's salvation: he considers what it means for Christ to have grace, he explains the great biblical notions of Christ as head of the church, Christ as mediator, and Christ as priest. In doing this, he arms his reader with an understanding of who and what Christ is so as to grasp more profoundly the meaning of what Christ does. Thomas divides what his predecessors had tried to make fit within a single temporal sequence. The simplicity of this arrangement is striking: the categories according to which Christ is to be understood; followed by the life of Christ, which is explained by these categories."

34. See, e.g., T. Tschipke, *Die Menschheit Christi als Heilsorgan der Gottheit, unter besonderer Berücksichtigung der Lehre des heiligen Thomas von Aquin* (Freiburg i. Br., 1940).

35. One way of gauging the importance of the theme to Thomas is to note how he introduces the second main group of questions in the treatise on Christ (ST 3 q.27 pref.): "Post praedicta, in quibus de unione Dei et hominis, et de his quae unionem consequuntur, tractatum est, restat considerandum de his quae Filius Dei incarnatus in natura humana sibi unita gessit vel passus est."

36. See section II of the essay by Richard Schenk in this volume. For Thomas's discussion of the extent and intensity of Christ's suffering, see ST 3 q.46 aa.5–7.

37. Caroline Walker Bynum, *Holy Feast and Holy Fast: The Religious Significance of Food to Medieval Women* (Berkeley, 1987). Bynum emphasizes how medieval women used food and food practices in their discipleship to Christ. For an apt summary of her principal thesis in this book, see 186: "What ties these distinctive spiritualities together is the same pattern we find in women's lives, as seen by themselves and by male biographers. It is a threefold pattern: women fast, women feed others, and women eat (but never ordinary food). Women fast—and hunger becomes an image for excruciating, never-satiated love of God. Women feed—amd their bodies become an image of suffering poured out for others. Women eat—and whether they devour the filth of sick bodies or the blood and flesh of the eucharist, the foods are Christ's suffering and Christ's humanity, with which one must join before approaching triumph, glory, or divinity."

38. See, e.g., G. Geenen, "En marge du Concile de Chalcédoine. Les textes du Quatrième Concile dans les oeuvres de S. Thomas," *Angelicum* 29 (1952): 43–59; René-Antoine Gauthier, *Somme Contre Les Gentils* (Paris, 1993), 101–4.

39. ST 3 q.2 a.6 corp.: " . . . quidam autem posteriores magistri putantes se has haereses declinare, in eas per ignorantiam inciderunt."

40. Although in the ST Thomas often names Nestorius and explicitly denounces this Christology as Nestorius's, in some passages Thomas attacks the position without bothering to ascribe it to Nestorius. See, e.g., ST 3 q.2 a.2 ob 2 and ad 2, to which reference is made in the text. In ad 2, Thomas explains why Christ is not inferior because his person is that of the Word: "personalitas intantum pertinet ad dignitatem alicuius rei et perfectionem, inquantum ad dignitatem alicuius rei et perfectionem eius pertinet quod per se existat; quod in nomine personae intelligitur. Dignius autem est alicui quod existat in aliquo se digniori, quam quod existat per se. Et ideo ex hoc ipso humana natura dignior est in Christo quam in nobis, quia in nobis quasi per se existens propriam personalitatem habet, in Christo autem existit in persona Verbi. Sicut etiam esse completivum speciei pertinet ad dignitatem formae; tamen sensitivum nobilius est in homine propter coniunctionem ad nobiliorem formam completivam, quam sit in bruto animali, in quo est forma completiva."

41. See, e.g., ST 3 q.4 a.5 ad 2: "dilectio Dei ad homines manifestatur non solum in ipsa assumptione humanae naturae, sed praecipue per ea quae passus est in humana natura pro aliis hominibus, secundum illud Rom. 5: 'Commendat autem Deus caritatem suam in nobis, quia, cum inimici essemus, Christus pro nobis mortuus est.' "

42. See, for example, 3 q.14 a.1 corp., where Thomas argues, on three grounds, for the fittingness of Christ's body being subject to certain infirmities and defects, and so liable to suffering; a.3 corp., where Thomas allows that Christ's human nature might well have been kept free of the defects that permit suffering and adds that his human nature was in fact so subject is due to the divine will; a.4 corp., where Thomas explains why it would have been inappropriate for Christ to take up all of the defects and infirmities associated with human nature under sin, given Christ's salvific role; q.46 a.1 corp., where Thomas explains in what sense Christ's suffering was, and was not, necessary for the salvation of the race; a.2 corp., where he explains why suffering unto death on the cross was not the only possible way for God to deliver the race, although a solid case can be made (a.3 corp.) that in light of the human condition there was no more suitable way of bringing salvation.

43. See the extended critique of Bynum's *Holy Feast and Holy Fast* (see note 37 above) offered by Kathleen Biddick, "Genders, Bodies, Borders: Technologies of the Visible," *Speculum* 68 (1993): 389–418. For Biddick, Bynum is insufficiently inattentive to the connection between these women (as used and approached by those, especially male associates, who championed them) and the construction of Christendom, which in this article is portrayed in chiefly negative terms (as exclusionary and oppressive). In this regard, Biddick emphasizes what in her telling is the close connection between the spirituality of these women, in which the Eucharist is prominent, and the persecution of the 'other' (see, e.g., 403). The effectiveness of Biddick's critique is undermined, however, by the gaps in the article. In rendering visible what remains ignored or at best indistinct (in her opinion) in the Bynum, Biddick herself renders much invisible. The Bynum thesis is but imperfectly rendered by saying that it is about "woman as body and as food" (390); Bynum herself is quite careful to relate their food practices to discipleship to the human, suffering Christ. Similarly, little mention is made of the positive dimensions of the spirituality of these women; one of the great strengths of *Holy Feast and Holy Fast*, however, is Bynum's ability to show how the humiliated, defeated Christ empowers those who are faithful to him. And, finally, Biddick seems unaware of the full range of Christian rhetoric about those "responsi-

ble" for crucifying Christ, the Christ present in the Eucharist. The Christians studied by Bynum spoke not only of Jews or Romans crucifying Christ; all who sin, including modern Christians, kill Christ anew by their sin. Hence, eucharistic devotion would not, contrary to what Biddick seems to be insinuating in this critique of Bynum, inevitably lead to persecution of others, in some imagined defense of Christ.

44. ST 3 q.3 a.8 ad 1: "nihil est quo humana malitia non posset abuti, quando etiam ipsa Dei bonitate abutitur, secundum illud Rom. II: 'An divitias bonitatis eius contemnis?' Unde etiam si persona Patris fuisset incarnata, potuisset ex hoc homo alicuius erroris occasionem sumere, quasi Filius sufficere non potuisset ad humanam naturam reparandam."

45. See, for example, ST 3 q.46 a.4 corp., the discussion of why it was most fitting for Christ to have suffered on the cross—the first of the seven reasons given in the corpus is that the suffering on the cross provides an example of virtue, a point secured by quoting Augustine about the moral exemplarity of the Wisdom of God-become-human who dies in this way.

46. I wish to stress here that the argument of the final part of this essay is provisional and tentative; I am only raising a possibility. Insisting on the tentative nature of this proposal seems advisable given the peculiar reception given one of my earlier articles, "The *Summa Contra Gentiles* Reconsidered: On the Contribution of the *De Trinitate* of Hilary of Poitiers," *The Thomist* 58 (1994): 617–34. My intention there was to secure the identification of the SCG as a primarily theological work, contrary to occasional claims about its 'philosophical' nature, by showing the continuity between that writing and the work of an important patristic predecessor. In highlighting Thomas's debt to Hilary, I in effect was developing a comment made in passing by Chenu (see 622, n.9). At no point in the article did I claim that the dependence was exclusive, that Hilary was the only source for this intriguing writing of Aquinas; indeed, I suggested in more than one place the value of attending to other patristic sources for this work (see, e.g., 633 and n.32). Yet, that is how some have read the article, as if I were unaware of the breadth of Thomas's reading or of the gulf that separates a thirteenth-century scholastic from a fourth-century Bishop. See, e.g., BTAM 16 (1996): n° 417, and two articles by Gilles Emery, "Le photinisme et ses précurseurs chez saint Thomas," *Revue Thomiste* 95 (1995): 398, n. 157, and, "Le Traité de Saint Thomas sur la Trinité dans la Somme contre les Gentils," *Revue Thomiste* 96 (1996): 16, n. 40. Thus, to repeat, the proposal with which the present essay concludes is wholly provisional, designed primarily to stimulate further reflection on the Christic dimensions of Thomas's entire theological work.

47. See, e.g., ST 1 q.1 a.10 corp., on the many levels of meaning in scripture.

48. ST 1 q.1 a.7 corp.

49. ST 1 q.2 prol.: "Quia igitur principalis intentio huius sacrae doctrinae est Dei cognitionem tradere, et non solum secundum quod in se est, sed etiam secundum quod est principium rerum et finis earum, et specialiter rationalis creaturae . . . ad huius doctrinae expositionem intendentes, primo tractabimus de Deo; secundo, de motu rationalis creaturae in Deum; tertio, de Christo, qui secundum quod homo, via est nobis tendendi in Deum." See too ST 3, prol.: "Quia Salvator noster Dominius Iesus Christus, teste Angelo, 'populum suum salvum faciens a peccatis eorum,' viam veritatis nobis in seipso demonstravit, per quam ad beatitudinem immortalis vitae resurgendo pervenire possimus . . . "

50. ST 1 prol.: "Quia catholicae veritatis doctor non solum provectos debet instruere, sed ad eum pertinet etiam incipientes erudire, secundum illud Apostoli I ad Cor. III: 'Tanquam parvulis in Christo, lac vobis potum dedi, non escam' . . . "

51. *In I Sent.* Prologus (*Scriptum* 1: 1–5).

Le Christ dans la 'spiritualité' de saint Thomas

Jean-Pierre Torrell, O.P.

LE SIMPLE TITRE de cet exposé suppose que l'on accepte de parler d'une spiritualité chez saint Thomas. Dans ma pensée, cela ne veut pas dire que Thomas a écrit des oeuvres spirituelles, mais bien que sa théologie a une dimension spirituelle incontestable. J'ai déjà eu l'occasion d'en présenter les traits principaux dans mon article du *Dictionnaire de Spiritualité*,[1] et je suis en train d'achever un livre qui reprend et amplifie ces premières données. Sans m'y attarder, je suppose donc que cela est acquis et je vais simplement essayer de dégager la place qui revient au Christ dans sa vision de la foi et de l'agir chrétiens.

Il y a, me semble-t-il, quatre thèmes principaux qui permettent de se rendre compte que le Christ occupe une place de tout premier plan dans la théologie spirituelle de Thomas d'Aquin. Les deux premiers entrent dans la construction de sa théologie et ils appartiennent à la structure même de sa pensée; on ne saurait donc les méconnaître sans défigurer sa doctrine. Les deux derniers relèvent plutôt de sa théologie morale proprement dite, c'est-à-dire de la façon dont il voit et motive l'agir de l'homme chrétien dans sa quête de la béatitude. Avec eux nous entrons dans la finalité pratique de la théologie, mais il va de soi qu'ils sont en parfaite continuité avec les options structurelles exprimées par les deux premiers.

(1) LA VOIE QUI MÈNE VERS DIEU

La question de la place du Christ chez Thomas se pose généralement à propos du plan de la *Somme*. Je n'entrerai pas dans les diverses théories qu'on a échafaudées à ce sujet,[2] mais il est important de rappeler que Thomas propose un enseignement clair et fourni et qu'il donne déjà des indications très fermes aux endroits névralgiques de son oeuvre: «Dans son humanité, *le Christ est pour nous la voie qui mène vers Dieu*».[3] Forte mais brève, cette affirmation du Prologue général est plus amplement développée au début de la Troisième Partie:

> Puisque notre Sauveur, le Seigneur Jésus, 'en délivrant son peuple de ses péchés' (Mt 1,21) . . . nous a montré en sa personne la *voie* de la *vérité* par laquelle nous pourrons parvenir en ressuscitant à la béatitude de la *vie* immortelle, il est nécessaire pour l'achèvement de notre entreprise théologique, qu'après avoir traité de la fin ultime de la vie humaine, des vertus et des vices, nous considérions maintenant le Sauveur de tous en lui-même et les bienfaits dont il a gratifié le genre humain.

Ce texte rappelle à grands traits le chemin parcouru, mais il annonce surtout celui qui reste à parcourir, et il le fait avec les mots mêmes de Jésus dans le quatrième évangile (Jn 14,6): «Je suis la *voie*, la *vérité*, la *vie*.» Il est frappant de constater, ici comme ailleurs, que le maître dominicain est à l'écoute de l'Ecriture et qu'il l'insère dans son texte sans solution de continuité, en combinant dans une seule phrase l'aspect «négatif» de l'oeuvre du Christ, la délivrance du péché, à son aspect «positif», le retour vers le Père, la voie que le Christ incarne en sa personne: «Nul ne va au Père que par moi.» On comprend mieux après cela qu'il puisse parler d'*achèvement* de l'entreprise théologique: toute la *Somme* tend vers le Christ.

Cependant, cette situation singulière du Christ en finale de l'oeuvre a constitué pour les théologiens un sujet d'interrogation. Elle continue à faire question aussi longtemps qu'on n'en voit pas les raisons profondes. Ces raisons, on le sait, sont à la fois d'ordre théologique et d'ordre pédagogique, et c'est à leur propos qu'on saisit au mieux la manière dont s'articulent morale et christologie dans la vision d'ensemble.[4] Je ne m'attarderai pas à parler des raisons pédagogiques,[5] mais il est capital de bien voir l'option théologale.

Au moment où Thomas songeait à synthétiser à sa manière le savoir théologique, il trouvait déjà dans les *Sentences* de Pierre Lombard deux grands ensembles de questions morales. Le premier se trouve dans le Deuxième Livre (distinctions 24–44): après la création et le péché du premier homme, le Lombard y avait regroupé diverses considérations sur la grâce et le libre arbitre, le péché originel et sa transmission, le bien et le mal dans les actes humains, etc. Le traitement du reste de la matière venait dans le Troisième Livre (distinctions 23–40), après la christologie; c'est alors que le Maître des *Sentences* parle des vertus théologales et morales, des dons du Saint-Esprit, des états de vie, des commandements. Les familiers de la *Somme* reconnaîtront sans trop de peine dans ces deux ensembles les deux grands pôles autour desquels a été rassemblée la matière de la *Prima Secundae* et de la *Secunda Secundae*. Elle y est considérablement enrichie et réorganisée selon un plan qui ne doit plus grand-chose au Lombard, mais c'est là qu'on en trouve une première esquisse.

Deux options étaient donc possibles. La première aurait consisté à regrouper toute la théologie morale à la suite de la christologie (deuxième pôle des *Sentences*). Thomas aurait ainsi pu organiser toute sa morale en fonction du Christ. Ce choix aurait eu l'avantage de mettre la figure du Christ au premier plan dans l'organisation de la théologie morale comme elle l'est dans la vie chrétienne. Selon les termes mêmes de Thomas, en sa qualité de Fils de Dieu, le Christ est en effet «le Modèle absolu que toutes les créatures imitent à leur manière, car il est la véritable et parfaite image du Père».[6] Mais cette première option aurait eu le désavantage de ne pas bien s'intégrer dans la vision d'ensemble de la *sacra doctrina*. En effet, le théocentrisme absolu de la *Somme* résulte du fait que seul Dieu est un principe assez explicatif pour pouvoir être placé à la clé de voûte de tout le savoir théologique. S'il est vrai que la synthèse théologique vise à retrouver l'ordre et la cohérence du plan divin, sans chercher à lui imposer une logique qui ne serait pas la sienne, alors il faut nécessairement que la Trinité soit première dans l'explication comme elle l'est dans la réalité. C'est vrai pour l'oeuvre de la création; ça l'est tout autant pour celle de la re-création: le théologien ne peut oublier

le rôle médiateur de l'humanité du Christ, mais il est invité à remonter par elle jusqu'à la seule source principale de la grâce et du salut, Dieu lui-même.

Thomas a donc opté pour un deuxième parti, qui consiste à placer la théologie morale après avoir parlé de la création et du gouvernement divin (premier pôle du Lombard). Au lieu de centrer sa théologie morale sur le Christ, il la rattachait donc à la Trinité par le biais de la doctrine biblique de l'homme comme image de Dieu. Car c'est bien de cet homme-là qu'il veut décrire le retour (*reditus*) vers son créateur après en avoir décrit la sortie (*exitus*). Il ne renonce pas pour autant aux avantages de la première alternative car il peut l'intégrer sans peine. Parler de l'homme comme image de Dieu c'est en effet être conduit à évoquer l'Exemplaire d'après lequel il est fait et auquel il doit ressembler, et c'est exactement cela qu'exprime le Prologue de la Deuxième Partie: «Après avoir parlé de *l'Exemplaire*, c'est-à-dire de *Dieu* . . . il reste à parler de son *image*, c'est-à-dire de *l'homme* . . . ». Mais ce but ultime ne peut être atteint que par le Christ, car l'image ne trouve sa ressemblance que «par conformité de grâce»,[7] et cette grâce ne peut s'obtenir que par sa médiation car il est «comme la source de la grâce».[8] Le Christ sera donc structurellement présent partout où sera la grâce, et la même chose vaut du Saint-Esprit: «Unis par le Saint-Esprit . . . nous avons accès au Père par le Christ puisque le Christ opère par le Saint-Esprit . . . Et c'est pourquoi tout ce qui est accompli par l'Esprit-Saint est accompli aussi par le Christ».[9]

S'il est donc bien vrai que la personne du Christ ne joue pas seule le rôle central dans la construction de la *Somme* ni dans l'organisation de la morale thomasienne, ce n'est pas par choix dépréciateur, mais bien comme conséquence d'une option premièrement trinitaire. Ce choix, il est important de le souligner—et on ne rendrait pas justice à Thomas si l'on ne le faisait pas—est entièrement conforme au donné biblique. Il est dicté par le récit de la Genèse sur l'homme à l'image de Dieu, mais il est aussi imposé par le Sermon sur la montagne: «Vous serez parfaits comme votre Père céleste est parfait» (Mt 5,48), et par saint Paul qui répète: «Cherchez à imiter Dieu comme des enfants bien-aimés» (Ep 5,1).

Au moment où il en vient à parler du Christ, Thomas a déjà parlé dans la *Prima Pars* de la présence de Dieu au monde et de la manière nouvelle dont elle se réalise par la grâce et par les missions divines. En situant le Christ au sommet de cet univers habité par la Trinité, Thomas introduit dans cette doctrine tout le dynamisme d'un *reditus* évangéliquement rectifié. Il ne s'effectue pas seulement par le Verbe, mais bien par le Verbe *incarné* qui continue à nous envoyer son Esprit. Médiateur unique par lequel nous parvient la grâce reçue de la Trinité, il est aussi le guide suprême qui prend la tête de notre retour vers Dieu: «Il convenait en effet que voulant conduire à la gloire un grand nombre de fils, Celui par qui et pour qui sont toutes choses rendît parfait par des souffrances *le chef qui devait les guider vers leur salut*» (He 2,10).

Ces explications sur le plan de la *Somme* devraient aider à comprendre la place structurelle qu'occupe le Christ chez Thomas. Le Christ n'est pas simplement ici ou là dans un secteur de sa théologie. Même quand il n'est pas explicitement question de lui, il est partout comme celui qui rend possible le retour vers Dieu. Mais s'il en est ainsi dans la *construction* de la *Somme*, c'est bien par ce que Thomas a perçu cette vérité dans ce que lui apprend la révélation. On le perçoit au mieux dans la façon dont

il parle d'une question célèbre entre toutes: le motif de l'incarnation. Ce sera notre deuxième grand point.

(2) Une voie nouvelle

Le motif de l'incarnation a été de tout temps une occasion de dispute entre scotistes et thomistes, mais cette dispute même a voilé un aspect important des réponses que propose Thomas à la question du *Cur Deus homo?*. On sait qu'il refuse de parler d'une nécessité pure et simple de l'incarnation—puisque nous ne pouvons mettre de bornes à la toute-puissance de Dieu et qu'il pouvait nous sauver de toute autre façon.[10] Il cherche plutôt les raisons de convenance qui peuvent aider à saisir quelque chose de l'incompréhensible amour qui a poussé Dieu à une telle extrémité. A la suite de saint Augustin, de saint Anselme et de tant d'autres,[11] que l'Ecriture orientait dans cette direction, il en appelle donc à la guérison de la blessure causée par le péché (*remedium peccati*), à la restauration (*reparatio*) de l'humanité dans l'amitié avec Dieu, à la satisfaction pour le péché, qui apparaissent donc comme des motifs constants et qui ne cessent de provoquer de nouvelles études. C'est ainsi que le thème de la satisfaction, présent dans les *Sentences*, et parfaitement formulé dans le *Compendium theologiae*, persiste encore dans la *Somme de théologie*.[12]

Malgré sa pertinence et sa persistance, ce thème de la réparation de l'équilibre perdu par le péché est toujours en danger de favoriser une vue anthropocentrique des choses: le péché semble imposer à Dieu une finalité non prévue par lui. A la recherche d'une voie nouvelle, Thomas semble l'avoir trouvée dans la *Somme contre les Gentils*, où sans répudier l'héritage traditionnel, il se libère quelque peu du carcan trop serré des autorités, pour faire oeuvre personnelle. Il propose alors un argument qui, au moins sous cette forme, semble assez inédit dans ce contexte; *il convenait que Dieu se fasse homme pour donner à l'homme la possibilité de voir Dieu.* Il suffira de rappeler l'un ou l'autre texte:

> Tout d'abord, l'incarnation apporte à l'homme en route vers la béatitude (*ad beatitudinem tendenti*) une aide efficace au plus haut degré. On l'a déjà dit [cf. SCG 3 c.48ss.], la béatitude parfaite de l'homme consiste dans la vision immédiate de Dieu. En raison de l'immense distance des natures, il pourrait sembler impossible que l'homme puisse atteindre un tel état où l'intellect humain est uni à l'essence divine elle-même de façon immédiate, comme l'intellect à l'intelligible. Paralysé par le désespoir, l'homme alors se relâcherait dans sa quête de la béatitude. Mais le fait que Dieu ait voulu s'unir en personne à la nature humaine, démontre à l'évidence aux hommes qu'il est possible d'être immédiatement uni à Dieu par l'intelligence, en le voyant sans intermédiaire. *Il convenait donc au plus haut point que Dieu assume la nature humaine afin de raviver l'espérance de l'homme en la béatitude.*[13]

Il suffit de se souvenir du rôle structurant de la béatitude dans la théologie morale de Thomas pour comprendre aussitôt la portée de son argument. Si le Christ est celui qui apprend à l'humanité que la béatitude est possible et lui donne les moyens d'y

parvenir, Thomas ne pouvait dire rien de plus fort pour montrer la nécessité de l'incarnation. Et, de fait, il continue par des arguments de même sens qui lui permettent de conclure: «C'était donc une exigence pour l'homme en marche vers la béatitude que Dieu s'incarnât».[14] La liturgie de Noël apporte ici un confirmatur précieux puisqu'elle voit dans l'incarnation une preuve de la pédagogie divine qui accoutume l'être humain à reconnaître Dieu: «De sorte que connaissant Dieu sous une forme visible, nous soyons ravis par lui dans l'amour de l'Invisible (*Dum uisibiliter Deum cognoscimus, in inuisibilium amorem rapiamur*)».[15]

Ce recours à la Préface de la Nativité se trouve déjà dans les *Sentences*.[16] Sans la référence liturgique, le thème reparaît dans la *Somme de théologie*. De façon plus brève sans doute, comme toujours dans la *Somme*, mais il reste bien présent:

> La cinquième raison (de l'incarnation) se rapporte à notre pleine participation à la divinité, ce qui est *la béatitude de l'homme et la fin même de la vie humaine*. Et ceci nous a été accordé par l'humanité du Christ. C'est encore saint Augustin qui l'a dit: 'Dieu s'est fait homme pour que l'homme devienne Dieu' (*Factus est Deus homo, ut homo fieret Deus*).[17]

La finale de ce texte est un bien commun de la patristique et notre auteur n'a rien ici d'original, mais la mention de la béatitude dans ce contexte est un thème beaucoup plus personnel. Par rapport à une motivation trop étroitement anthropocentrique de l'incarnation par le péché de l'homme, la grande différence réside dans le désir de voir Dieu, désir qui est le creux laissé en lui par son Créateur. L'amour que Dieu porte à l'homme ne se borne pas à rétablir en stricte justice l'équilibre détruit par le péché, il veut bien davantage la réussite de son plan de salut. C'est ainsi que l'incarnation est vue comme une *manuductio*:[18] Dieu prend l'homme par la main, pour ainsi dire, pour le conduire sur ses chemins. C'est bien là la «voie nouvelle et vivante» dont parle l'épître aux Hébreux (10,20):

> (L'Apôtre) montre comment nous avons la confiance de nous approcher, car le Christ par son sang a *inauguré* (*initiauit*), c'est-à-dire commencé (*inchoauit*), *pour nous une voie nouvelle*. . . . C'est donc la voie qui mène au ciel. Elle est *nouvelle*, parce qu'avant le Christ, nul ne l'avait trouvée: 'Personne ne monte au ciel, sinon celui qui descend du ciel' (Jn 3,13). C'est pourquoi celui qui veut monter doit s'attacher à lui comme un membre à sa tête . . . Elle est *vivante*, c'est-à-dire qu'elle dure toujours, du fait que s'y manifeste la fécondité (*uirtus*) de la déité qui vit toujours. Quelle est cette voie, l'Apôtre le précise quand il continue: 'à travers le voile, c'est-à-dire sa chair'. De même que le grand-prêtre pénétrait dans le Saint des saints par-delà le voile, de même si nous voulons entrer dans le sanctuaire de la gloire, nous devons passer par la chair du Christ qui fut le voile de sa divinité. 'Tu es vraiment un Dieu caché!' (Is 45,15). Il ne suffit pas de croire en Dieu si l'on ne croit pas en l'incarnation.[19]

On retrouve dans ce texte une triple thématique qui affleure dans bien des textes de Thomas: celle du chemin dont on souligne trop peu l'importance; celle du désir de la béatitude qui traverse de part en part l'oeuvre de Thomas; et, finalement, celle du

mouvement circulaire dont on connaît la fécondité. Ce dernier motif permet de mettre
en valeur le caractère central de l'intuition:

> (Par l'incarnation) l'homme reçoit un exemple remarquable de cette union bien-
> heureuse par laquelle l'intellect créé sera uni par son intelligence à l'intellect
> incréé. *Depuis que Dieu s'est uni à l'homme en assumant sa nature, il n'est plus
> désormais incroyable que l'intellect créé puisse être uni à Dieu en voyant son
> essence.* C'est ainsi que s'achève en quelque sorte l'ensemble de l'oeuvre de Dieu,
> lorsque l'homme, créé en dernier lieu, revient à son principe par une espèce de
> cercle, en étant uni au principe des choses lui-même par l'oeuvre de l'incarna-
> tion.[20]

Ce petit choix de textes pourrait être considérablement étoffé. Tel qu'il est, il dev-
rait suffire à renforcer encore ce que nous disions de la place du Christ dans le plan de
la *Somme.* Le théocentrisme de frère Thomas ne rejette pas le Christ à la périphérie. Il
est exactement à la place où il doit être: au centre parfait de notre histoire, à la jonction
entre Dieu et l'homme. Non pas comme un milieu statique, mais comme le chemin
qui monte vers la patrie céleste, comme «le chef de notre foi et celui qui la mène à la
perfection» (He 12,2), qui nous entraîne à sa suite avec la force irrésistible qui anime
sa propre humanité vers le Père.[21]

(3) L'EXEMPLARITÉ CHRISTIQUE

Pour introduire le troisième thème dont je voudrais parler, je ferai appel à un texte du
commentaire de la première épître aux Corinthiens; il est décisif car il montre que
l'appel à l'exemple du Christ ne relève pas seulement de l'exhortation morale. Il est
profondément inséré dans la structure même de la théologie de frère Thomas, qui ex-
plique que si le Christ est la réalisation exemplaire de toutes les vertus, c'est parce qu'il
est le Verbe incarné qui, en son éternité, préside déjà à la création de toutes choses:

> Le principe premier de toute la procession des choses est le Fils de Dieu: 'Par lui
> tout a été fait' (Jn 1,3). C'est pourquoi il est aussi le Modèle originel (*primordiale
> exemplar*) que toutes les créatures imitent, comme la véritable et parfaite Image
> du Père. D'où l'expression de *Colossiens* (1,15): 'Il est l'Image du Dieu invisible,
> le Premier-né de toute la création, car en lui ont été créées toutes choses.' D'une
> façon spéciale il est aussi le modèle (*exemplar*) de toutes les grâces spirituelles
> dont resplendissent les créatures spirituelles, selon ce qui est dit au Fils dans le
> *Psaume* (109,3): 'Du sein de l'aurore aujourd'hui je t'ai engendré dans les splen-
> deurs des saints'. Puisqu'il a été engendré avant toute créature par la grâce resplen-
> dissante, il a en lui de façon exemplaire (*exemplariter*) les splendeurs de tous les
> saints. Cependant ce modèle divin était très éloigné de nous . . . C'est pourquoi
> il a voulu devenir homme pour offrir aux hommes un modèle humain.[22]

Le commentateur continue par quelques exemples d'applications pratiques, que
nous pouvons laisser de côté ici. Il est plus important de remarquer qu'à partir d'un
texte comme celui-ci une double piste s'ouvre à la méditation et à la contemplation.

(a) L'exemplarisme moral

L'indication la plus immmédiatement perceptible est celle de *l'exemplarisme moral*, elle met l'accent sur le Christ incarnation vivante des vertus évangéliques et sur l'effort de l'homme qui collabore avec Dieu par la grâce qu'il en a reçue. Plutôt homilétique, ce thème est abondamment présent dans les commentaires scripturaires, mais il est loin d'être absent des autres oeuvres.[23] Je me contenterai de citer ici un texte tout à fait typique dans lequel, comme un vrai maître spirituel, Thomas ne craint pas d'insister sur l'aspect pratique:

> (Le Christ Jésus) a donc dit: 'J'ai fait cela pour vous donner l'exemple, c'est pourquoi *vous devez vous laver les pieds les uns aux autres*, car c'est cela que je visais en agissant ainsi.' En effet, dans l'agir des hommes, les exemples sont plus efficaces que les paroles (*plus mouent exempla quam uerba*). L'homme agit et choisit selon ce qui lui paraît bon; c'est pourquoi du fait même qu'il choisit ceci ou cela il montre que cela lui paraît bon, bien davantage que s'il disait qu'il faut le choisir. Il s'ensuit que si l'on dit quelque chose alors qu'on en fait une autre, ce que l'on fait persuade les autres bien davantage que ce que l'on dit. C'est pourquoi il est de la plus haute nécessité de joindre l'exemple à la parole.
>
> Mais l'exemple d'un homme, simplement homme, ne suffisait pas à l'imitation de tout le genre humain, soit parce que la raison humaine est incapable de concevoir le tout [de la vie ou du bien], soit parce qu'elle se trompe dans la considération des choses elles-mêmes. C'est pourquoi nous est donné l'exemple du Fils de Dieu qui, lui, ne peut se tromper et qui est plus que suffisant en tous domaines. Si saint Augustin assure 'que l'orgueil ne peut être guéri que par l'humilité divine', il en va de même pour l'avarice et les autres vices.
>
> A bien y réfléchir, il était hautement 'convenable' que le Fils de Dieu nous soit donné en exemple de toutes les vertus. Il est en effet l'Art du Père et donc, *de même qu'il a été l'exemplaire premier de la création, il est aussi l'exemplaire premier de la sainteté* (1 P 2,21): '*Christ a souffert pour nous, vous laissant un exemple afin que vous marchiez sur ses traces*'. . . . [24]

La formule *Plus mouent exempla quam uerba* est assez familière à Thomas. On peut déjà la lire parmi les motifs de l'incarnation rassemblés dans le *Contra Gentiles*,[25] et elle est reprise textuellement dans la *Somme de théologie* avec un appel significatif à l'expérience commune.[26] Sans doute il s'agit là d'un lieu commun de la sagesse humaine, mais est-ce trop s'aventurer que de penser à l'héritage dominicain de notre Docteur, puisqu'on répète de saint Dominique qu'il prêchait par l'exemple autant que par la parole (*uerbo et exemplo*).[27]

L'exemplarité du Christ et de son agir pour toute la vie chrétienne se retrouve dans de nombreuses oeuvres, notamment dans les opuscules écrits en défense de la vie religieuse. On pourrait aussi glaner dans la Deuxième Partie de la *Somme* un ensemble de textes qui montrent bien que Thomas ne la perd jamais de vue. Mais ce travail étant déjà bien fait,[28] il sera plus fécond de suivre le déroulement de la Troisième Partie pour y relever quelques-unes des mentions répétées des vertus illustrées par le Christ et proposées à l'imitation des siens. Ainsi, dans le prolongement des raisons de l'incarnation, Thomas explique qu'il convenait que le Christ prît un corps passible, «pour nous

donner un exemple de patience en supportant avec courage les souffrances et les limites humaines».[29] A l'inverse, il ne voulut pas assumer le péché, car en cela il n'aurait pu donner ni exemple d'humanité—car le péché n'appartient pas à la définition de la nature humaine—, ni exemple de vertu, puisque le péché lui est contraire.[30] En revanche, s'il a voulu prier, c'était bien pour nous inviter à la prière confiante et répétée;[31] s'il a accepté de se soumettre à la circoncision et aux autres préceptes de la loi, c'était pour nous donner un exemple vivant d'humilité et d'obéissance;[32] de même, son baptême nous incite par l'exemple à recevoir le baptême à notre tour.[33]

Chaque évènement de la vie de Jésus (jeûne, tentations, vie au milieu de la foule) donne lieu à semblables remarques; en sorte que Thomas peut résumer: «Par la manière dont il a vécu (*conuersatio*), *le Seigneur a donné à tous l'exemple de la perfection* en tout ce qui de soi appartient au salut».[34] Mieux encore, il a cette formule frappante: «L'agir du Christ fut notre enseignement (*Christi actio fuit nostra instructio*)».[35] Sous une forme légèrement différente selon les contextes, cet axiome que Thomas reçoit de Cassiodore à travers Pierre Lombard, revient dix-sept fois dans son oeuvre.[36] Même s'il prend soin de souligner qu'il n'en va pas exactement de même dans le cas du Christ et dans le nôtre et qu'il est nécessaire de lire cette assertion à la lumière de la vraie foi pour bien la comprendre, il n'en conteste jamais la vérité fondamentale, et cette fréquence est tout à fait significative de sa volonté de prendre au sérieux l'agir concret du Christ tout autant que son enseignement.

Cette valeur exemplaire de l'agir du Christ culmine, c'est trop clair, dans les derniers jours de sa vie terrestre. A la question de savoir s'il y avait un moyen plus approprié que la passion pour libérer le genre humain, Thomas répond comme à son habitude par toute une série de convenances. En premier lieu, et cette priorité est significative, la passion montre à l'homme «combien Dieu l'aime, provoquant ainsi en retour son propre amour, en quoi consiste la perfection du salut». Mais en second lieu le Christ nous a donné par sa passion «un exemple d'obéissance, d'humilité, de constance, de justice et d'autres vertus manifestées alors, qui sont elles aussi nécessaires au salut de l'homme. C'est pourquoi saint Pierre écrivait (1 P 2,21): *Le Christ a souffert pour nous, vous laissant un exemple afin que vous suiviez ses traces*».[37] Ces pages où transparaît l'amour de la croix du frère dominicain ne sont pas passées inaperçus de tous ses lecteurs et quelqu'un comme Louis Chardon a su en faire son profit.[38]

Thomas n'arrête pourtant pas là sa considération du mystère du Christ. Après la passion et la croix, viennent évidemment la résurrection, l'ascension et l'exaltation du Christ à la droite du Père. L'approche en sera différente et nous le verrons bientôt, mais il faut déjà savoir que Thomas ne laisse rien de côté de la Pâque du Christ. Il est en cela fidèle au programme qu'il s'est tracé dans son étude: prendre en compte tout ce que le Christ a fait et souffert pour nous (*acta et passa Christi in carne*).[39]

(b) L'exemplarité ontologique

L'exemplarité morale est l'aspect le plus évident sous lequel se présente le Christ à la considération du spirituel. Quand il s'agit de vie chrétienne, l'imitation du Christ est bien la voie du salut. Mais saint Thomas ne s'en tient pas là et il explique que cette

imitation du Christ n'est rendue possible que par la grâce qu'il nous donne et qui nous a déjà conformés à lui. Suivant une belle représentation que l'on trouve au portail nord de la cathédrale de Chartres, Dieu créant le premier homme, a les yeux fixés sur le Nouvel Adam et c'est à son image qu'il le façonne. Ici, l'accent est mis non plus sur l'effort de l'homme, mais sur l'oeuvre de Dieu en lui. C'est ce que je propose d'appeler l'*exemplarisme ontologique*.

La référence scripturaire immédiate est l'enseignement si fréquent chez saint Paul selon lequel nous sommes intérieurement modelés, 're-formés' à l'image du Fils bien-aimé par la grâce dont il est le médiateur: «Ceux que d'avance il a discernés, (le Père) les a aussi *prédestinés à être conformes à l'image de son Fils,* afin qu'il soit l'aîné d'une multitude de frères».[40] En langage plus technique, les théologiens disent de la grâce qu'elle est une réalité «christoconformante». Le mot parle de lui-même et la doctrine est aussi simple que belle. Elle met en oeuvre deux grandes données: Dieu seul est à la source de la grâce, mais elle nous parvient par la médiation du Christ et elle porte son empreinte.

Le principe de base est donc que Dieu seul peut donner la grâce. La raison va de soi, la divinisation est l'oeuvre de Dieu seul.[41] Mais Thomas précise aussi que cette divinisation est réalisée par la médiation du Christ car, selon le mot technique souvent employé dans l'oeuvre thomasienne, il en est «l'instrument».[42] Or, suivant sa doctrine constante, l'instrument «modifie» l'action de la cause principale.[43] On peut ne pas se servir d'un instrument, mais si l'on s'en sert, il laissera sa marque sur l'effet produit. Il est vrai que l'instrument ne fait rien tout seul, mais il fait quelque chose et le résultat final porte sa trace. Cette doctrine générale s'applique de façon éminente à l'humanité du Christ et à son agir. Puisque chacune des deux natures du Christ a son opération propre, explique saint Thomas, l'agir de l'humanité n'est pas évacué par son union à la nature divine dans la personne du Verbe,

> . . . cependant la nature divine se sert de l'opération de la nature humaine, à la manière dont l'agent principal utilise l'opération de son instrument; . . . L'action de l'instrument comme instrument n'est pas différente de l'action de l'agent principal, mais cela ne l'empêche pas d'avoir son opération propre. Dès lors, dans le Christ, l'opération de la nature humaine, en tant qu'elle est l'instrument de la divinité, ne diffère pas de l'opération divine: notre salut est l'oeuvre unique de l'humanité et de la divinité du Christ. Mais la nature humaine du Christ, en tant que telle, a une opération différente de celle de la nature divine.[44]

Sans perdre sa qualité divine, la grâce aura donc aussi un caractère christique. Cette doctrine est mise en valeur dans la *Tertia Pars* et particulièrement dans la partie consacrée aux mystères de la vie du Christ.[45] En trente-trois questions, et selon un schème circulaire qui lui est familier,[46] Thomas prend en examen tous les actes significatifs qui ont marqué son existence et s'interroge sur leur signification pour le salut. Loin de restreindre l'oeuvre salutaire du Christ aux épreuves de ses derniers jours et à sa mort sur la croix, Thomas pense que rien de ce qu'a vécu le Verbe incarné n'est sans signification pour le salut; au contraire, tout cela trouve son retentissement dans la vie du chrétien aujourd'hui.

Longtemps négligée, cette partie de la *Somme* commence à recevoir l'attention qu'elle mérite,[47] et c'est à juste titre, car elle est exemplaire de la méthode théologique du Maître d'Aquin. C'est aussi sans doute l'endroit où l'on voit au mieux la répercussion dans le domaine spirituel d'une option théologique décisive, car c'est ici qu'il met en oeuvre de façon décidée sa doctrine de l'instrumentalité de l'humanité du Christ. Selon lui, tous et chacun des actes que le Christ a posés dans son humanité ont été et continuent à être porteurs d'une efficacité salutaire:

> (Selon Aristote), 'ce qui est premier dans un genre donné est cause de tout ce qui en fait partie'.[48] Or, dans l'ordre de notre résurrection, ce qui est premier c'est la résurrection du Christ. Il faut donc que la résurrection du Christ soit la cause de la nôtre. . . . A proprement parler, la résurrection du Christ n'est pas la cause méritoire de la nôtre, mais bien la cause efficiente et exemplaire. Elle en est tout d'abord la cause efficiente: *l'humanité du Christ, selon laquelle il est ressuscité, est d'une certaine manière l'instrument de sa divinité et agit par sa vertu*, ainsi qu'on l'a déjà dit [cf. ST 3 q.13 a.2; q.19 a.1; q.43 a.2]. Voilà pourquoi, *tout ce que le Christ a fait ou souffert dans son humanité nous étant salutaire par la 'vertu' de sa divinité*, comme on l'a déjà établi [cf. ST 3 q.48 a.6], *la résurrection du Christ est aussi la cause efficiente de notre résurrection* par la 'vertu' divine, dont le propre est de rendre la vie aux morts. *Cette 'vertu' atteint par sa présence tous les lieux et tous les temps et ce contact 'virtuel' suffit pour qu'il y ait véritable efficience*. Par suite, on vient de le dire [cf. ST 3 q.56 a.1 ad 2], la cause primordiale de la résurrection des hommes est la justice divine, en vertu de laquelle le Christ a le pouvoir de faire le jugement, en tant que Fils de l'homme [cf. Jn 5,27], et la 'vertu' efficiente de sa résurrection s'étend non seulement aux bons, mais aussi aux méchants, qui sont soumis à son jugement.[49]

La multiplicité des renvois où l'auteur assure avoir déjà parlé de l'un ou l'autre aspect de cette doctrine montre que nous sommes à un lieu stratégique de sa réflexion. Ce texte est celui auquel on revient toujours, car il est le plus explicite, mais il est loin d'être le seul, car Thomas parle de même à propos de la passion: «(La passion agit) par mode d'efficience: dans la mesure où la chair, dans laquelle le Christ a souffert sa passion, est l'instrument de sa divinité. . . ».[50] La même chose est dite de la mort et même du corps mort du Christ, «car ce corps était l'instrument de la divinité qui lui était unie; agissant par la vertu divine, même mort».[51] A qui s'en étonnerait, Thomas précise que dans l'état de mort, le corps du Christ ne pouvait certes plus être instrument de mérite, mais qu'il pouvait très bien être instrument d'efficience, en raison de la divinité qui lui demeurait unie (rejoignant ainsi les données dogmatiques les mieux assurées: la personne du Verbe n'a pas abandonné son corps durant le *triduum mortis*). La même précision est donnée à propos de l'ascension: «L'ascension du Christ est cause de notre salut, non par mode de mérite, mais par mode d'efficience, ainsi qu'on l'a montré pour la résurrection».[52]

Ce ne sont pas seulement les grands moments du mystère pascal qui se trouvent dans ce cas, Thomas étend cette doctrine à tout ce que le Christ a fait et pâti: «Toutes les actions et passions du Christ agissent instrumentalement en vertu de la divinité pour le salut des hommes».[53] Thomas défendait l'efficience salvifique des actions du Christ dès ses écrits de jeunesse et on la retrouve dans ses commentaires scripturaires.

L'affirmation est donc aussi constante que claire et nous pouvons nous dispenser ici d'entrer dans les désaccords postérieurs des thomistes sur la manière de l'expliquer.[54] Thomas est fort clair à ce sujet: c'est bien *le Christ en acte de résurrection* qui nous sauve. Sa position est déjà arrêtée dans les *Sentences:* «Selon qu'il est Dieu et homme ressuscitant (*homo resurgens*) le Christ est la cause prochaine et pour ainsi dire univoque de notre résurrection».[55] On la retrouve dans les Commentaires sur l'épître aux Romains ou sur le livre de Job où Thomas parle toujours de la résurrection en devenir,[56] et, naturellement, dans la *Somme.*[57] Comme action passée elle a bien cessé d'exister, mais son influx instrumental demeure efficace sous la motion divine. L'efficience actuelle des mystères passés de la vie du Christ leur vient de la puissance divine qui atteint tous les temps et tous les lieux; et ce contact «virtuel», c'est-à-dire selon la *uirtus,* suffit à rendre compte de cette efficience.[58]

Nous ne pouvons entrer dans le détail de cette doctrine, mais si nous nous interrogeons maintenant sur ce que les mystères réalisent en nous en vertu de leur efficacité instrumentale, il faut reprendre une de ces explications familières au Maître d'Aquin, dans laquelle il transpose hardiment un principe reçu d'Aristote pour le mettre au service d'une réalité que celui-ci ne pouvait même pas imaginer. Il s'agit de la grande loi selon laquelle l'agent efficient ne peut produire que du semblable à lui en sorte qu'il y a dans tout agir une certaine assimilation de l'effet à sa cause. En termes clairs, cela veut dire ici que les mystères sont réalisateurs d'une assimilation à Jésus d'abord et, par lui, à Dieu lui-même. Ou plus exactement: Dieu le Père agissant en nous par la grâce qu'il nous accorde par la médiation du Christ nous conforme ainsi à l'image de son Fils premier-né. Notre grâce est une grâce de fils adoptifs, mais aussi de souffrance, de mort, de résurrection et d'ascension par lui, avec lui et en lui. Nous sommes ici au coeur de l'exemplarisme ontologique et du mystère de la grâce christoconformante.

L'importance concrète de ce thème ressort avec force de quelques chiffres. Le vocabulaire de la *conformitas* revient en effet avec une constance impressionnante.[59] On peut relever un total de 435 occurrences de *conformitas* et des mots apparentés. Pour un peu plus de la moitié (236), il s'agit de la conformité de la créature à Dieu ou à sa volonté. On le comprend après tout ce que nous avons dit, Thomas ne perd pas de vue le thème de l'image et de son modèle dernier. Pour le Christ, restent 199 emplois, dont 102 visent la conformité au Christ en général, et le reste à différents mystères: en particulier sa mort,[60] sa sépulture,[61] et, à bien plus forte raison sa résurrection.[62] Le traité des sacrements est particulièrement riche en notations de ce genre, car si «par le baptême l'homme est incorporé au Christ et devient son membre . . . , *il convient que ce qui s'est accompli dans la Tête se produise aussi dans le membre qui lui est incorporé».*[63] Dans ce contexte, les prolongements très concrets ne manquent pas d'apparaître, ainsi lorsqu'on en vient à parler du sacrement de pénitence.[64]

On ne saurait citer tous les textes, nous en reproduisons l'un ou l'autre en annexe. Si on ne l'avait compris depuis longtemps, ce serait le moment de souligner l'inspiration profondément paulinienne de cette doctrine. Nulle part, le théologien Thomas ne se révèle plus à l'écoute de l'Écriture que lorsqu'il s'agit du Christ, et le lecteur attentif ne peut manquer d'être impressionné par l'aisance avec laquelle la technique la plus rigoureuse est mise au service d'une profonde vie de foi. Sa façon de présenter le Verbe incarné, à la fois *exemplar* d'après lequel nous avons été créés et recréés, et *exemplum*

que nous devons imiter par notre agir, permet à Thomas de souligner avec force la place du Christ dans notre vie chrétienne et de tenir simultanément pour une vie spirituelle pleinement trinitaire.[65]

La doctrine du Christ modèle est donc bien un de ses grands thèmes spirituels, mais, par le thème de l'image qui sous-tend ces développements, nous retrouvons sans hiatus aucun l'Exemplaire dernier: «Étant donné que c'est par son égalité dans l'essence que le Fils est semblable au Père, *il est nécessaire, si l'homme a été fait à la ressemblance du Fils, qu'il ait été fait aussi à l'image du Père*».[66]

Par souci de complétude, et même s'il n'est pas possible d'entrer maintenant dans un nouveau sujet, il faut au moins signaler en terminant que le Saint-Esprit n'est pas absent de ce processus de conformation au Christ et à Dieu, car il en est l'agent.[67] C'est donc à l'image de la Trinité toute entière que nous sommes conformés.[68]

ANNEXE

Textes choisis

L'incarnation du Verbe donne à l'homme la possibilité de voir Dieu

«Si l'on contemple avec attention et piété le mystère de l'incarnation, on y découvre un tel abîme de sagesse que la connaissance humaine en est submergée. L'Apôtre l'a bien dit (1 Co 1,25): *La folie de Dieu est plus sage que les hommes.* C'est pourquoi à celui qui considère les choses avec piété les raisons de ce mystère apparaissent de plus en plus admirables.

Tout d'abord, l'incarnation apporte à l'homme en route vers la béatitude (*ad beatitudinem tendenti*) une aide efficace au plus haut degré. On l'a déjà dit [cf. SCG 3 c.48ss.], la béatitude parfaite de l'homme consiste dans la vision immédiate de Dieu. En raison de l'immense distance des natures, il pourrait sembler impossible que l'homme puisse atteindre un tel état où l'intellect humain est uni à l'essence divine elle-même de façon immédiate, comme l'intellect à l'intelligible. *Paralysé par le désespoir, l'homme alors se relâcherait dans sa quête de la béatitude.*[69] Mais le fait que Dieu ait voulu s'unir en personne à la nature humaine, démontre à l'évidence aux hommes qu'il est possible d'être immédiatement uni à Dieu par l'intelligence, en le voyant sans intermédiaire. Il convenait donc au plus haut point que Dieu assume la nature humaine afin de raviver l'espérance de l'homme en la béatitude. Aussi après l'incarnation du Christ, les hommes ont-ils commencé d'aspirer plus ardemment à la béatitude céleste, selon ce qu'il dit lui-même (Jn 10,10): *Je suis venu pour qu'ils aient la vie et qu'ils l'aient en abondance.*

Puisque l'homme trouve sa béatitude parfaite dans la jouissance (*fruitio*) de Dieu, il fallait que son affectivité fût préparée au désir de cette divine fruition, désir naturel de la béatitude dont nous constatons l'existence en l'homme. Or c'est l'amour pour une chose qui éveille le désir d'en jouir. Il fallait donc que l'homme, en marche vers la béatitude parfaite, fût amené à aimer Dieu. Mais rien ne nous provoque autant à aimer quelqu'un que de faire l'expérience de son amour pour nous. Les hommes ne pouvaient donc attendre de preuve plus efficace de l'amour de Dieu pour eux que de voir Dieu s'unir à l'homme personnellement, puisque le propre de l'amour est d'unir autant qu'il est possible l'amant à l'aimé. C'était donc une exigence pour l'homme en marche vers la béatitude que Dieu s'incarnât.

Puisque l'amitié réside dans une certaine égalité, il n'est pas possible que des êtres trop différents puissent s'unir d'amitié. Afin donc que l'amitié entre Dieu et l'homme fût plus intime, il fut donc opportun pour l'homme que Dieu se fasse homme, puisque l'homme est pour l'homme un ami naturel. De sorte que *connaissant Dieu sous une forme visible, nous soyons ravis par lui dans l'amour de l'Invisible*».[70]

Quelques textes sur l'exemplarisme moral

Les brèves notations de la *Somme* suffisent sans doute à nous assurer que l'exemplarisme christique est sans cesse présent à la réflexion de Maître Thomas, mais elles

ne trahissent guère l'émotion qui peut l'animer quand il en parle dans ses cours ou dans sa prédication. On aimera donc lire en annexe à cette étude l'une ou l'autre de ces pages qui permettront de mieux la percevoir.

Aller vers Dieu en suivant le Christ

«(Cette scène montre diverses choses), la quatrième concerne la sainteté du Christ, car *il va vers Dieu*. C'est en cela que consiste la sainteté de l'homme: aller vers Dieu. C'est pourquoi, il (Jésus) va bientôt le dire: puisqu'il va lui-même vers Dieu, il lui appartient de conduire les autres vers Dieu. Cela, il le réalise de manière spéciale par l'humilité et la charité, et c'est pourquoi il leur donne cet exemple d'humilité et de charité».[71]

Une obéissance inspirée par l'amour

«L'observation des commandements est un effet de la divine charité. Non seulement de celle par laquelle nous aimons, mais de celle par laquelle (Jésus) nous a aimés. Du fait même qu'il nous aime il nous provoque et nous aide à observer ses commandements, qui ne peuvent l'être que par grâce. *'En cela consiste son amour: ce n'est pas nous qui avons aimé Dieu, c'est lui qui nous a aimés le premier'* (1 Jn 4,10).

A cela il ajoute l'exemple en disant: *'Comme j'ai moi-même gardé les commandements de mon Père'*. En effet, de même que l'amour dont le Père l'aime est l'exemple de l'amour dont il nous aime, de même il a voulu que son obéissance soit l'exemple de la nôtre. Le Christ montre ainsi qu'il demeure dans l'amour du Père par le fait qu'il garde ses commandements en toutes choses. Car il est allé jusqu'à la mort (Ph 2,8): *'Il s'est fait obéissant jusqu'à la mort, et la mort de la croix'*; il s'est abstenu du péché (1 P 2,22): *'Il n'a pas commis de péché, et sur ses lèvres aucune fourberie'*. Il faut comprendre cela du Christ selon son humanité (Jn 8,29): *'Il ne me laisse jamais seul, car je fais toujours ce qui lui plaît'*. C'est pourquoi il peut dire: Je demeure dans son amour, car il n'y a rien en moi (toujours selon son humanité) qui soit contraire à son amour».[72]

La croix résumé de toutes les vertus

«Ainsi que le dit le bienheureux Augustin, la passion du Christ suffit pour nous instruire complètement sur notre manière de vivre. Quiconque veut mener une vie parfaite n'a rien d'autre à faire que de mépriser ce que le Christ a méprisé sur la croix et de désirer ce qu'il a désiré.

Il n'y a pas en effet un seul exemple de vertu que ne nous donne la croix. Cherches-tu un exemple de charité? *'Il n'y a pas de plus grand amour que de donner sa vie pour ceux qu'on aime'*. Et le Christ l'a fait sur la croix. . . .

Cherches-tu un exemple de patience? Le plus parfait se trouve sur la croix . . . Un exemple d'humilité? Regarde le Crucifié . . . Un exemple d'obéissance? Mets-toi à la suite de celui qui s'est fait obéissant au Père jusqu'à la mort . . . Un exemple de mépris des choses terrestres? Marche derrrière celui qui est le Seigneur des Seigneurs et le Roi des rois, en qui se trouvent tous les trésors de la sagesse et qui cependant, sur la croix,

apparaît nu, objet de moqueries, conspué, frappé, couronné d'épines, abreuvé de fiel et de vinaigre, mis à mort».[73]

La porte des brebis

Selon saint Jean Chrysostome, la porte des brebis (Jn 10,1–10) ce sont les Ecritures saintes,[74] mais Thomas connaît encore une autre exégèse:

«Selon saint Augustin,[75] toutefois, le mot porte s'applique d'abord au Christ, car selon l'*Apocalypse* (4,1: *Une porte était ouverte au ciel*), c'est par lui qu'on entre. Quiconque donc veut entrer dans la bergerie doit entrer par la porte, le Christ, et non par une autre ouverture. Il faut pourtant remarquer que ce sont aussi bien les brebis que le pasteur qui entrent dans la bergerie : les brebis pour y être à l'abri, le pasteur pour les y garder. Si donc tu veux y entrer comme une brebis pour y être protégé, ou comme un pasteur pour protéger les brebis, il faut que tu passes par le Christ-porte et non par une autre voie. [Après un assez long passage où Thomas donne les caractéristiques de mauvais bergers, il conclut:] Il faut savoir en effet que, tout comme il est impossible d'être protégé comme brebis si l'on n'entre pas par la porte, de même on ne peut protéger comme pasteur si l'on n'entre pas par cette même porte, le Christ. . . . Les mauvais pasteurs ne passent pas par cette porte, mais par celle de l'ambition, du pouvoir séculier et de la simonie; ce sont des voleurs et des brigands. . . . Etant donné que le Christ, cette porte, s'est fait petit par son humilité,..ne pourront entrer par elle que ceux qui imiteront l'humilité du Christ. Ceux qui n'entrent pas par elle, mais par une autre voie, ce sont les superbes, qui n'imitent pas celui qui étant Dieu s'est fait homme et ne reconnaissent pas son humilité.

Si le Christ est la porte il s'ensuit que pour entrer dans la bergerie il passe par lui-même. Sans doute, mais c'est le propre du Christ. Personne en effet ne peut passer la porte qui conduit à la béatitude, si ce n'est par la vérité, car la béatitude n'est rien d'autre que la joie de la vérité (*gaudium de ueritate*). Or le Christ, en sa divinité, s'identifie à la vérité; c'est pourquoi, en son humanité, il entre par lui-même, c'est-à-dire par la vérité qu'il est en sa qualité de Dieu. Nous, par contre, nous ne sommes pas la vérité, nous sommes seulement des fils de lumière par notre participation à lumière véritable et incréée; c'est pourquoi il nous faut passer par la vérité qu'est le Christ».[76]

Je suis le Chemin, la Vérité et la Vie

«Le Christ avait déjà appris bien des choses aux siens au sujet du Père et du Fils, mais ils ignoraient que c'est au Père que le Christ allait et que le Fils était le chemin par lequel il irait. Il est difficile en effet d'aller au Père. Rien d'étonnant s'ils l'ignoraient! Car si le Christ en son humanité leur était bien connu, ils ne connaissaient que très imparfaitement sa divinité. . . .

Je suis le Chemin, la Vérité et la Vie, répond Jésus. D'un coup, il leur dévoile la route et le terme de la route. . . . *La route*, nous l'avons vu, c'est le Christ. . . . Cela se comprend car *c'est par lui que nous avons accès au Père* (Ep 2,18). . . . Mais ce chemin n'est

pas éloigné de son terme, il le touche; c'est pourquoi le Christ ajoute: *la Vérité et la Vie*; il est à la fois l'un et l'autre: la route selon son humanité; le terme selon sa divinité. . . .

Le terme de cette route, c'est la fin de tout le désir humain. L'homme en effet désire deux choses par-dessus tout; l'une qui lui est propre: connaître la vérité, l'autre qu'il partage avec tout ce qui est: demeurer dans l'être. Or le Christ est la voie pour parvenir à la vérité puisqu'il est la Vérité; . . . il est aussi la voie pour parvenir à la vie puisqu'il est lui-même la Vie. . . . Ainsi donc le Christ s'est désigné lui-même comme la voie et comme le terme; il est le terme car *il est par lui-même tout ce qui peut être objet de désir*: la Vérité et la Vie.

Si donc tu cherches ta voie, passe par le Christ: il est le Chemin. Isaïe (30,21) prophétisait: 'C'est le chemin, suivez-le'. Comme dit saint Augustin: *'Passe par l'homme pour aboutir au Dieu'. 'Mieux vaut claudiquer sur la route que de s'égarer fermement à côté.'* Même s'il n'avance pas vite, celui qui boitille sur le bon chemin s'approche du but; celui qui marche en dehors de la route s'en éloigne d'autant plus qu'il court plus vite.

Si tu cherches où aller, attache-toi au Christ: il est la Vérité que tous nous désirons atteindre. . . . *Si tu cherches où te reposer, attache-toi au Christ,* car il est la Vie. . . . *Attache-toi donc au Christ si tu veux être en sûreté;* tu ne pourras dévier car il est la voie. Ceux qui s'attachent à lui ne marchent pas dans le désert mais sur une route bien tracée. . . . De même, tu ne pourras être trompé car il est la vérité et enseigne toute la vérité. . . . Pas davantage, tu ne pourras être ébranlé, car il est la vie et il donne la vie. . . . Comme le répète saint Augustin, quand le Seigneur dit: Je suis la Voie, la Vérité et la Vie, c'est comme s'il disait: Par où veux-tu aller? Je suis la Voie. Où veux-tu aller? Je suis la Vérité. Où veux-tu demeurer? Je suis la Vie».[77]

L'EXEMPLARISME ONTOLOGIQUE

La conformité au Christ premier-né

«*Ceux que d'avance il a connus, il les a aussi prédestinés à être conformes à l'image de son Fils* . . . [Contre 'certains' qui prétendent que la préconnaissance par Dieu des mérites à venir d'une personne est la raison de sa prédestination et qui veulent comprendre ainsi saint Paul: 'Ceux qu'il a sus d'avance devoir être conformes à l'image de son Fils, Dieu les a prédestinés . . . ', Thomas réplique:] On pourrait dire cela de façon fondée si la prédestination visait seulement la vie éternelle, qui répond au mérite; mais c'est en réalité tout bienfait salutaire prévu pour l'homme de toute éternité qui relève de la prédestination; c'est la raison pour laquelle tous les bienfaits qui nous sont accordés dans le temps ont été préparés de toute éternité. Assurer qu'un mérite quelconque de notre part est présupposé, qui serait la raison de notre prédestination, cela revient à dire que la grâce est donnée en vertu de nos mérites, que nous sommes au principe de nos bonnes oeuvres et que seul leur achèvement revient à Dieu.

C'est plutôt ainsi qu'il faut lire le texte: 'Ceux que d'avance il a connus, ce sont ceux-là qu'il a prédestinés à être conformes à l'image de son Fils'. *Cette conformité n'est pas la raison de la prédestination, mais son terme, son effet.* L'Apôtre dit bien ailleurs (Ep 1,5): 'Il nous a prédestinés à être des fils adoptifs'. *L'adoption filiale n'est rien d'autre que cette conformité. Celui qui est adopté comme fils de Dieu est conformé à son vrai Fils.*

[Cela se produit] d'abord par le droit de participer à l'héritage, ainsi qu'il a été dit plus haut (Rm 8,17): 'Fils et héritiers, héritiers de Dieu, cohéritiers du Christ'. Ensuite par une participation à sa gloire. Il a en effet été engendré par le Père comme le 'resplendissement de sa gloire' (He 1,3). C'est pourquoi *du fait même qu'il illumine les saints de la lumière de sa sagesse et de sa grâce il les rend conformes à lui.* C'est pourquoi il est dit dans le Psaume (109,4): 'Du sein de l'aurore je t'ai engendré avant la lumière dans les splendeurs des saints', c'est-à-dire en répandant la splendeur des saints. . . .

Quant à la conséquence de cette prédestination, Paul ajoute: 'Afin qu'il soit l'aîné d'une multitude de frères'. De même en effet que Dieu a voulu communiquer sa nature à d'autres en les faisant participer à la similitude de sa bonté, de sorte qu'il soit non seulement bon mais encore auteur de bontés, de même le Fils de Dieu a voulu communiquer la conformité de sa filiation, de sorte qu'il ne soit pas seul fils mais le Premier-né des fils. C'est ainsi que celui qui est unique par sa génération éternelle, selon Jean (1,18), 'le Fils unique qui est dans le sein du Père', devient par la communication de la grâce 'le Premier-né d'une multitude de frères': 'Celui qui est le Premier-né d'entre les morts, le Prince des rois de la terre' (Ap 1,5).

Nous sommes ainsi les frères du Christ, tant par le fait qu'il nous a communiqué la similitude de sa filiation, comme on le dit ici, que par le fait qu'il a assumé la similitude de notre nature, selon l'épître aux Hébreux (2,17): 'Il a dû devenir en tout semblable à ses frères' ».[78]

Membra oportet capiti conformari

«La satisfaction du Christ obtient en nous son effet selon que nous lui sommes incorporés comme des membres à leur tête. . . . Or il faut que les membres se conforment à la tête (*membra autem oportet capiti conformari*). Par conséquent, de même que le Christ commença par recevoir, en même temps que la grâce, la passibilité du corps, et, par sa passion, parvint à la gloire de l'immortalité; de même, nous autres qui sommes ses membres nous sommes bien délivrés par sa passion de toute peine, mais de telle façon que nous recevons d'abord dans notre âme *l'Esprit des fils adoptifs* (Rm 8,15) grâce auquel nous est attribué un héritage de gloire immortelle, alors que nous sommes encore dans ce corps passible et mortel. Ce n'est qu'ensuite, après avoir été *configurés aux souffrances et à la mort du Christ* (Ph 3,10), que nous serons conduits à la gloire immortelle, selon ce que dit l'Apôtre (Rm 8,17): *Fils de Dieu et donc héritiers, héritiers de Dieu et cohéritiers du Christ, si du moins nous souffrons avec lui pour être glorifiés avec lui* ».[79]

NOTES

1. J.-P. Torrell, «Thomas d'Aquin (Saint)», DS 15 (1991): 718–73; cf. surtout 749–73.
2. Voir le bref rappel que j'en ai fait dans *Initiation à saint Thomas d'Aquin, sa personne et son oeuvre* (Paris, 1993), 219–23.

3. ST 1 q.2 prol.

4. On verra ici l'étude éclairante de L.-B. Gillon, «L'imitation du Christ et la morale de saint Thomas», *Angelicum* 36 (1959): 263–86; cette étude a été reprise en italien, *Cristo e la teologia morale* (Rome, 1961), et en anglais, *Christ and Moral Theology* (Staten Island, 1967).

5. Elles ne sont pourtant pas sans importance. L'auteur ne pouvait pas donner dès le début de sa morale sa référence à l'exemplarité christique, car il devait d'abord dégager les structures essentielles de l'agir humain. Ces structures sont assez universelles pour s'appliquer à l'humanité du Christ elle-même, puisqu'elle reste inchangée en sa constitution intime malgré son assomption par le Verbe. Il suffit de lire un peu attentivement ce que dit la *Tertia Pars* sur les actes humains du Christ (liberté, mérite, passions, vertus) pour être renvoyé constamment à ce qui est dit dans la *Prima Secundae*. Sans doute, cette humanité absolument unique appelle des précisions qui ne valent que pour elle, mais bien des choses dites à propos de l'agir humain en général se retrouvent en celui qui a pris notre condition en toutes choses «sauf le péché». Il est clair qu'elles valent donc aussi pour le Christ, mais Thomas n'aurait pu parler de lui en premier lieu sans être conduit par la suite à faire d'innombrables répétitions. Ce choix est d'ordre technique, mais il n'est pas arbitraire, il est dicté par la matière.

Cela ne signifie pas pour autant que les structures de la morale générale (*Prima Secundae*) se développent hors de toute référence au Christ et à sa grâce. Malgré tous ses emprunts aux sages de l'Antiquité, le traité des vertus fourmille de notations proprement chrétiennes. Il est suivi d'un exposé sur les dons du Saint-Esprit et d'un commentaire du Sermon sur la montagne qui suffiraient à montrer que le Christ exerce déjà son rayonnement avant même qu'on ne parle explicitement de lui (ST 1–2 qq. 68–70). Il en va de même pour le traité de la loi ancienne, dont l'auteur souligne fortement le rôle préfigurateur du mystère du Christ (ST 1–2 qq.98–105), et pour celui de la loi nouvelle, dont l'essentiel est la grâce du Saint-Esprit qui s'obtient par la foi au Christ (ST 1–2 qq.106–8). L'ensemble est couronné par l'étude de la grâce proprement dite, qui reprend et porte à son achèvement tout ce qui a été dit jusqu'alors concernant les actes humains et les vertus (ST 1–2 qq.109–14). Tout cela nous invite à ne pas mal comprendre le propos de Thomas: la situation du Christ en Troisième Partie de la *Somme* ne signifie pas une incompréhensible mise entre parenthèses du spécifique chrétien, mais bien une volonté délibérée de mettre en valeur son rôle dans le mouvement de retour de la créature vers Dieu et dans l'achèvement de l'histoire du salut.

6. *In ad I Cor.* 11,1 lect.1 (*Super epp.* 1: 343–44 n° 583): «Primordiale exemplar quod omnes creaturae imitantur tanquam ueram et perfectam imaginem Patris»; on lira un peu plus loin l'inté-gralité de ce passage.

7. Cf. ST 1 q.93 a.4.

8. *In Ioannem* 1,16 lect.10 (*Super Ioan.* 40–41 n° 201): «quasi auctori gratiae».

9. *In ad Ephesios* 2,18 lect.5 (*Super epp.* 2: 31 n° 121).

10. ST 3 q.1 a.2.

11. Cf. Anselme de Cantorbéry, *Pourquoi Dieu s'est fait homme*, éd. R. Roques (SC 91, Paris, 1963); pour une comparaison on peut voir J. Bracken, «Thomas Aquinas and Anselm's Satisfaction Theory», *Angelicum* 62 (1985): 501–30, qui oppose cependant les deux auteurs de manière trop sys-tématique.

12. ST 3 q.1 a.2: «L'incarnation libère l'homme de la servitude du péché. Comme le dit saint Augustin, 'il a fallu que le démon fût vaincu par la justice de l'homme Jésus-Christ'. Et cela s'est produit par la satisfaction du Christ pour nous. L'homme, simplement homme, *ne pouvait pas* satisfaire pour tout le genre humain; Dieu, lui, *ne devait pas*; il fallait donc que Jésus-Christ fût à la fois Dieu et homme (*Homo autem purus satisfacere non poterat, Deus autem satisfacere non debebat*). [Le balance-ment des formules suffirait à révéler la frappe d'origine, Anselme n'ayant été ici qu'un intermédiaire. Loin de la dissimuler, Thomas l'affiche, et, après avoir cité Augustin, continue par Léon:] 'La force s'est revêtue de faiblesse, la majesté d'humilité; car il fallait pour nous guérir qu'*un seul et même médiateur de Dieu et des hommes* (1 Tm 2,5) puisse d'une part mourir et de l'autre ressusciter. Vrai Dieu il apportait le remède; vrai homme, il nous offrait l'exemple'»; cf. *In III Sent.* d.1 q.1 a.2 (*Scriptum* 3: 11–14); *Compendium theologiae* 1 c.200, éd. H.-F. Dondaine, Édition Léonine 42 (1979): 158; parmi les travaux récents sur le sujet, on verra R. Cessario, *The Godly Image: Christ and Salvation in Catholic Thought from St Anselm to Aquinas* (Petersham, Mass., 1990), et l'étude de A. Patfoort, «Le vrai visage de la satisfaction du Christ selon St. Thomas. Une étude de la Somme théologique», dans *Ordo sapien-tiae et amoris: Image et message de saint Thomas à travers les récentes études historiques, herméneu-tiques et doctrinales. Hommage au Professeur J.-P. Torrell*, éd. C.-J. Pinto de Oliveira (Studia friburgen-sia N.S. 78, Fribourg, 1993), 247–65; on peut hésiter toutefois à reconnaître à la satisfaction une place aussi centrale que celle que ces auteurs lui accordent.

13. SCG 4 c.54 (*Liber CG* 3: 348 n° 3923); ce texte est plus amplement cité en annexe.

14. SCG 4 c.54 (*Liber CG* 3: 350–51 n° 3926).

15. SCG 4 c.54 (*Liber CG* 3: 350 n° 3927).

16. *In III Sent.* d.1 q.1 a.2 (*Scriptum* 3: 11–19); ce thème d'une accoutumance progressive aux réalités divines à partir de ce que l'être humain peut expérimenter est familier à Thomas, on le retrouve dans le *De rationibus fidei* dont un chapitre (c.5) est consacré aux motifs de l'incarnation, éd. H.-F. Dondaine, Édition Léonine 40 (1968): B62 n° 976: «Etant donné que l'homme a une intelligence et une affectivité immergées dans la matière, il ne pouvait facilement s'élever aux réalités d'en-haut. Il est aisé à l'être humain de connaître et d'aimer un autre être humain, mais il n'est pas donné à tous de contempler la sublimité divine et de se porter vers elle par l'élan d'un amour rectifié; seuls y parviennent avec l'aide de Dieu, grand labeur et application, ceux qui se détournent des choses corporelles pour s'élever aux spirituelles. C'est donc afin d'ouvrir pour tous une voie d'accès facile vers Dieu que Dieu voulut devenir homme, *afin que même les petits puissent contempler et aimer quelqu'un qui leur serait pour ainsi dire semblable;* de sorte que, par ce qu'ils pouvaient saisir, ils progressent peu à peu vers ce qui est parfait.»

17. ST 3 q.1 a.2; il s'agit ici d'un apocryphe de saint Augustin; cf. *Sermon 128* (PL 39: 1997). On aimera savoir que les quatre raisons précédentes de cette série de convenances, qui ont trait à «notre progrès dans le bien», envisagent successivement le profit qui en résulte pour notre *foi*, notre *espérance*, notre *charité* et notre pratique de la *vertu;* la béatitude apparaît donc comme le terme d'un chemin parcouru selon toutes les vertus de la vie chrétienne.

18. ST 2–2 q.82 a.3 ad 2: l'humanité du Christ est une pédagogie suprêmement adaptée pour conduire à sa divinité.

19. *In ad Hebraeos* 10,20 lect.2 (*Super epp.* 2: 446 n° 502).

20. *Compendium theologiae* 1 c.201 (Édition Léonine 42: 158). L'importance du mouvement circulaire dans la pensée de Thomas est de plus en plus reconnue, cf. Torrell, *Initiation,* 223–28; J. Aertsen, «The Circulation-Motive and Man in the Thought of Thomas Aquinas», dans *L'homme et son univers au Moyen Age,* éd. Chr. Wenin, tome 1 (Louvain-la-Neuve, 1986), 432–39; Aertsen, *Nature and Creature: Thomas Aquinas's Way of Thought* (Studien und Texte zur Geistesgeschichte des Mittelalters 21, Leiden, 1988).

21. Renvoyons ici au commentaire sur Jn 6,44: «Nul ne vient à moi si mon Père ne l'attire», où Thomas explique que «ceux qui suivent le Christ . . . sont attirés par le Père», sans violence, car c'est l'accomplissement de leur désir, *In Ioannem* 6,44 lect.5 (*Super Ioan.* 176 n° 935ss.); on pourra voir la belle étude de R. Lafontaine, «La personne du Père dans la pensée de saint Thomas», dans R. Lafontaine et al., *L'Ecriture âme de la théologie* (Institut d'études théologiques 9, Bruxelles, 1990), 81–108.

22. *In ad I Cor.* 11,1 lect.1 (*Super epp.* 1: 343–44 n° 583); la même argumentation se retrouve notamment dans le *De rationibus fidei* c.5 (Édition Léonine 40: B61 n° 973): toutes choses ayant été créées par le Verbe, il convenait qu'elles fussent aussi réparées par lui; voir aussi ci-dessous le commentaire sur Jn 13,15.

23. On verra par exemple SCG 4 c.54 (*Liber CG* 3: 350 n° 3928) et ST 3 q.1 a.2 en relation au motif de l'incarnation; le thème revient plus allusivement dans le *Compendium theologiae* 1 c.201 (Édition Léonine 42: 158). Mais il faut voir aussi ST 1–2 q.61 a.5 qui donne le fondement trinitaire de l'exemplarité christique. Cf. aussi J.-P. Torrell, «Imiter Dieu comme des enfants bien-aimés. La conformité à Dieu et au Christ dans l'oeuvre de saint Thomas», dans *Novitas et veritas vitae: Aux sources de renouveau de la morale chrétienne. Mélanges offerts au professeur Servais Pinckaers,* éd. C.-J. Pinto de Oliveira (Fribourg Suisse, 1991), 53–65.

24. *In Ioannem* 13,15 lect.3 (*Super Ioan.* 333 n° 1781); cf. *In Ioannem* 13,3 lect.1 (326 n° 1743); 13,34 lect.7 (345 n° 1838); 14,6 lect.2 (351–52 n°ˢ 1870–71); 15,10 lect.2 (378 n°ˢ 2002–3).

25. SCG 4 c.55 (*Liber CG* 3: 355–56 n°ˢ 3950–51): «Il n'est pas inconvenant d'assurer que le Christ a voulu souffrir la mort de la croix pour nous donner un exemple d'humilité [Il s'agit sans doute d'une vertu qui ne convient pas à Dieu, mais en son humanité le Verbe pouvait l'assumer] . . . Bien que les hommes eussent pu être formés à l'humilité par les enseignements divins,..les faits provoquent davantage à l'action que les paroles (*ad agendum magis prouocant facta quam uerba*), et ceci d'autant plus efficacement que la réputation de vertu de celui qui agit ainsi est mieux assurée. Ainsi, bien que l'on trouve chez d'autres hommes de nombreux exemples d'humilité, il était donc extrêmement à propos d'y être provoqué par l'exemple de l'Homme-Dieu, dont on sait qu'il n'a pu se tromper et dont l'humilité est d'autant plus admirable que sa majesté est plus sublime»; on verra les notes de P. Marc (*Liber CG* 3: 355–56) sur ce passage, qui indiquent les antécédents classiques et patristiques.

26. ST 1–2 q.34 a.1: «Dans le domaine des actions et des passions humaines, où l'expérience du plus grand nombre compte pour beaucoup, *magis mouent exempla quam uerba*».

27. Cf. M.-H. Vicaire, *Histoire de saint Dominique,* tome 1 (Paris, 1982), 279.

28. Cf. A. Valsecchi, «L'imitazione di Cristo in san Tommaso d'Aquino», dans *Miscellanea Carlo Figini*, éd. G. Colombo, A. Rimoldi et A. Valsecchi (Venegono Inferiore, 1964), 175–203; l'auteur s'étonne à juste titre qu'on ait pu laisser croire que saint Thomas ne connaissait pas le thème de l'imitation du Christ; le même auteur a replacé l'enseignement de Thomas dans le contexte plus large de la tradition scripturaire et patristique dans un éclairant article: «Gesù Cristo nostra legge», *La Scuola Cattolica* 88 (1960): 81–110; 161–190, où il montre notamment que nombre de ces idées, appartenant au fond commun de la pensée chrétienne, se retrouvent aussi chez d'autres auteurs et notamment chez S. Bonaventure.

29. ST 3 q.14 a.1: «*propter exemplum patientiae* quod nobis exhibet passiones et defectus humanos fortiter tolerando.»

30. ST 3 q.15 a.1.

31. ST 3 q.21 a.3.

32. ST 3 q.37 a.4.

33. ST 3 q.39 a.2 ad 1; cf. a.1 et a.3 ad 3: *Christus proponebatur hominibus in exemplum omnium.*

34. ST 3 q.40 a.2 ad 1.

35. ST 3 q.40 a.1 ad 3.

36. On verra ici l'étude précise et suggestive de R. Schenk, «*Omnis Christi actio nostra est instructio. The Deeds and Sayings of Jesus as Revelation in the View of Thomas Aquinas*», dans *La doctrine de la révélation divine de Saint Thomas d'Aquin* (Actes du Symposium sur la pensée de Saint Thomas d'Aquin, tenu a Rolduc, les 4 et 5 Novembre 1989), éd. A. Blanco et al. (Studi Tomistici 37, Rome, 1990), 103–31. L'emploi de la formule est plus fréquent dans les *Sentences* que dans la *Somme* (seul emploi cité ci-dessus), mais il se retrouve à différents autres endroits (cf. Schenk, 111 n. 51). On trouve dans le sermon *Puer Iesus* (Busa 6: 33a) une formule équivalente: *Cuncta quae Dominus fecit uel in carne passus est, documenta et exempla sunt salutaria.*

37. ST 3 q.46 a.3; autres mentions analogues: ST 3 q.46 a.4; q.50 a.1; q.51 a.1, etc.

38. Cf. L. Chardon, *La croix de Jésus* (Paris, 1647), nouvelle édition, Introduction par F. Florand (Paris, 1937), XCVI–CV; on verra aussi D. Bouthillier, «Le Christ en son mystère dans les *collationes* du *super Isaiam* de saint Thomas d'Aquin», dans *Ordo sapientiae et amoris*, 37–64.

39. Cf. ST 3 prol.; q.27 prol.; q.48 a.6: «*omnes actiones et passiones* Christi instrumentaliter operantur in uirtute diuinitatis ad salutem humanam».

40. Rm 8,29; d'après la traduction de la TOB, plus proche aussi bien de l'original grec que du texte latin que Thomas avait à sa disposition.

41. ST 1–2 q.112 a.1: «Le don de la grâce est au-delà des forces de toute nature créée, car elle n'est rien d'autre qu'une certaine *participation à la nature divine* (2 P 1,4) qui transcende toute créature. Il est donc impossible qu'une créature quelconque puisse causer la grâce. *Il est donc nécessaire que Dieu seul déifie (deificet)*, communiquant en partage (*consortium*) la nature divine sous la forme d'une certaine participation par mode d'assimilation . . . »; sans l'emploi de *deifico*, c'est aussi la conclusion très ferme du *De ueritate* q.27 a.3. Sans entrer ici davantage dans cette question, renvoyons à l'ensemble des textes rassemblés par H.-T. Conus, «Divinisation (Saint Thomas)», DS 3 (1957): 1426–32.

42. ST 1–2 q.112 a.1 ad 1: «Ainsi que le dit saint Jean Damascène, l'humanité du Christ est comme 'l'*instrument* de sa divinité'. Or l'instrument ne produit pas l'action de l'agent principal en vertu de sa propre efficacité, mais seulement par la motion de cet agent principal. C'est pourquoi l'humanité du Christ ne cause pas la grâce par elle-même, mais seulement par la divinité à laquelle elle est unie et qui fait que ces actions sont salutaires»; cf. S. Jean Damascène, *De fide orthodoxa. Versions of Burgundio and Cerbanus* cc.59, 63, éd. E. M. Buytaert (St. Bonaventure, New York, 1955), 239, 258 (PG 94: 1060, 1080). Thomas n'est pas parvenu du premier coup à cette doctrine; suivant saint Augustin, il ne parlait dans les *Sentences* (*In III Sent.* d.13 q.2 a.1; *Scriptum* 3: 405–10) que d'une causalité *dispositive* ou *ministérielle* de l'humanité du Christ: Dieu produisant la grâce *à l'occasion* de l'agir du Christ. Le passage à une véritable causalité instrumentale ne s'est effectué qu'entre les qq.27 et 29 du *De ueritate*: désormais l'humanité du Christ concourt réellement à la production de la grâce et y laisse sa marque; désormais la grâce n'est plus seulement divine, elle est aussi «chrétienne»; J. R. Geiselmann, «Christus und die Kirche nach Thomas von Aquin», *Theologische Quartalschrift* 107 (1926): 198–222; 108 (1927): 233–55, a bien étudié cette évolution.

43. ST 3 q.62 a.1 ad 2: «L'instrument a une double action: une action instrumentale selon laquelle il opère non pas par sa vertu propre, mais par la vertu de l'agent principal, et aussi une action propre qui lui revient en vertu de sa forme propre. Ainsi, en raison de son tranchant, il revient à la hache de couper, mais comme instrument utilisé par un artisan il lui revient de faire un meuble. *Toutefois, elle*

n'accomplit son action instrumentale qu'en exerçant son action propre: c'est en coupant qu'elle fait le meuble»; même doctrine en ST 1 q.45 a.5 et, plus explicite encore, dans SCG 4 c.41 (*Liber CG* 3: 331–32 nos 3798–3800).

44. ST 3 q.19 a.1 et ad 2; le texte de cette question est trop long pour être cité intégralement, mais c'est le lieu décisif pour le sujet. Thomas n'a pas toujours aussi bien vu la causalité efficiente instrumentale de l'humanité du Christ (cf. ci-dessus n. 42); dans *In III Sent.* d.18 a.6 qc.1 sol.1 (*Scriptum* 3: 576), il concevait encore le rôle de l'humanité du Christ dans la ligne de la causalité méritoire; à une seule exception près (ST 3 q.1 a.2 ad 2), liée au contexte anselmien de la satisfaction, ce langage n'est plus celui de la *Somme*.

45. On trouvera quelques détails supplémentaires à ce sujet dans notre *Initiation*, 381–89.

46. Ce schème circulaire est développée dans les trois premières parties: (1) entrée (*ingressus*) du Fils de Dieu en ce monde, qui coïncide en fait avec le mystère de l'incarnation (qq.27–39); (2) déroulement (*progressus*) de sa vie terrestre en passant par tous ses moments majeurs (qq.40–45); (3) sortie (*exitus*) de ce monde, c'est-à-dire passion et mort (qq. 46–52); la quatrième partie (qq.53–59), la vie céleste de Jésus glorifié (*exaltatio*), sans entrer directement dans le mouvement circulaire, en décrit le terme et le déploie selon toute son ampleur. C'est précisément cette dernière considération qui montre l'impropriété de l'expression «Vie de Jésus».

47. Pour les antécédents patristiques, cf. A. Grillmeier, «Généralités historiques sur les mystères de Jésus», dans *Mysterium salutis*, tome 11 (Paris, 1975), 333–57. Pour Thomas, on verra ici l'importante étude de L. Scheffczyk, «Die Stellung des Thomas von Aquin in der Entwicklung der Lehre von den Mysteria Vitae Christi», dans *Renovatio et Reformatio: wider das Bild vom "finsteren" Mittelalter. Festschrift für Ludwig Hödl zum 60. Geburtstag*, éd. M. Gerwing et G. Ruppert (Münster, 1986), 44–70. Signalons encore R. Lafontaine, *La résurrection et l'exaltation du Christ chez Thomas d'Aquin. Analyse comparative de S. Th. IIIa q.53 à 59* (Excerpta ex Diss. P.U.G., Rome, 1983; on se référera ici à la thèse originelle, de même titre, mais plus complète que l'extrait publié); L. Scheffczyk, «Die Bedeutung der Mysterien des Lebens Jesu für Glauben und Leben der Christen», dans *Die Mysterien des Lebens Jesu und die christliche Existenz*, éd. Scheffczyk (Aschaffenburg, 1984), 17–34. I. Biffi, *I Misteri di Cristo in Tommaso d'Aquino*, tome 1 (Biblioteca di cultura medievale 339, Milan, 1994), a commencé à rassembler une série d'études où il montre l'omniprésence du thème et sa fécondité dans toutes les oeuvres de Thomas; on peut voir aussi, mais dans une ligne rahnérienne, G. Lohaus, *Die Geheimnisse des Lebens Jesu in der Summa Theologiae des hl. Thomas von Aquin* (Freiburger theologische Studien 131, Freiburg i.B., 1985).

48. On reconnaît ici une application du principe du *maxime tale* dont Thomas fait un usage aussi abondant que personnel (puisqu'il inverse le sens aristotélicien d'origine): ce qui est premier dans un genre donné est principe et cause à l'égard des autres éléments du même genre. On peut voir les travaux déterminants de V. de Couesnongle, «La causalité du maximum. L'utilisation par saint Thomas d'un passage d'Aristote», et «La causalité du maximum. Pourquoi saint Thomas a-t-il mal cité Aristote?» *Revue des sciences philosophiques et théologiques* 38 (1954): 433–44; 658–80, complété par L. Somme, *La filiation divine par adoption dans la théologie de saint Thomas d'Aquin* (Diss., Fribourg Suisse, 1994), 437–42.

49. ST 3 q.56 a.1 et ad 3; Thomas a déjà expliqué précédemment (ST 3 q.53 a.1) que la résurrection du Christ était une oeuvre de la justice divine, car il convenait d'exalter celui qui s'était humilié; selon Lc 1,52 qu'il cite ici, c'est ce qu'on peut appeler la logique du Magnificat: «Il renverse les puissants, il élève les humbles»; quant à l'oeuvre qui revient ici au Fils de l'homme, on verra le Commentaire *In Ioannem* 5,21 lect.4 (*Super Ioan.* 143–44 n° 761).

50. ST 3 q.49 a.1; cf. ST 3 q.48 a.6 ad 2: «La passion du Christ, bien que corporelle, a cependant une vertu spirituelle en raison de l'union à la divinité; elle obtient son efficacité par contact spirituel, c'est-à-dire par la foi et les sacrements de la foi. . . . »

51. ST 3 q.50 a.6 et ad 3; c'est ici qu'on vérifie au mieux que Thomas ne pense pas seulement aux actions strictement volontaires de l'humanité du Christ.

52. ST 3 q.57 a.6 ad 1.

53. ST 3 q.48 a.6: «omnes actiones et passiones Christi instrumentaliter operantur in uirtute diuinitatis ad salutem humanam».

54. La question qui se pose est de savoir s'il faut entendre ces textes comme s'ils parlaient de la résurrection ou des divers «mystères» dans leur réalité déjà advenue (*in facto esse*, suivant le langage reçu parmi les spécialistes), ou bien de leur réalité en devenir (*in fieri*). En termes plus simples, est-ce le Christ *ressuscité* qui nous sauve aujourd'hui ou le Christ *ressuscitant*? Cf. J. Gaillard, «Chronique de liturgie. La théologie des mystères», *Revue Thomiste* 57 (1957): 510–51; l'auteur passe en revue les

positions principales à l'occasion de diverses publications: pour l'opinion dite 'traditionnelle', voir 538; pour la vraie position de Thomas, 539–40, et le prolongement que lui donnent certains auteurs par un appel à la vision béatifique dont jouissait le Christ selon Thomas, 540–42.

55. *In IV Sent.* d. 43 q.1 a.2 sol.1; cf. ad 3: *mediante Christo homine resurgente.*

56. *In ad Romanos* 6,10–11 lect.2 (*Super epp.* 1: 88 n° 490): «uita quam *Christus resurgens* acquisiuit»; n° 491: «ut (fidelis) conformetur uitae *Christi resurgentis*»; *Super Iob* 19,25, éd. A. Dondaine, Édition Léonine 26 (1965): 116, lignes 268–70: «Vita *Christi resurgentis* ad omnes homines diffundetur in resurrectione communi»; pour le commentaire de Thomas sur ce verset, on verra D. Chardonnens, «L'espérance de la résurrection selon Thomas d'Aquin, commentateur du Livre de Job», dans *Ordo sapientiae et amoris,* 65–83.

57. ST 3 q.56 a.2 ad 2.

58. ST 3 q.56 a.1 et ad 3: «Virtus diuina praesentialiter attingit omnia loca et tempora. Et talis contactus uirtualis sufficit ad rationem efficientiae.»

59. On y ajoutera celui de la *configuratio* qui permet des constatations analogues; on compte 57 entrées: 10 pour la configuration à Dieu, 15 pour le Christ en général, 12 à sa passion, 10 à sa mort et à sa sépulture, 6 à sa résurrection, 4 à d'autres aspects de son mystère (sacerdoce ou sainteté).

60. *In ad Romanos* 6,3 lect.1 (*Super epp.* 1: 85–86 n° 473).

61. Ibid. (*Super epp.* 1: 86 n° 474): «Par le baptême les hommes sont ensevelis dans le Christ (*sepeliuntur Christo*), c'est-à-dire *conformés à sa sépulture*»; le texte continue en soulignant que s'il y a une triple immersion dans le baptême, ce n'est pas seulement à cause de la Trinité, *sed ad repraesentandum triduum sepulturae Christi.*

62. Ibid. (*Super epp.* 1: 86 n° 477): «Après être mort le Christ est ressuscité; il 'convient' donc que ceux qui ont été *conformés au Christ quant à sa mort* par le baptême, soient *conformés aussi à sa résurrection* par l'innocence de leur vie.»

63. ST 3 q.69 a.3; cf. a.7 ad 1: «Le baptême ouvre au croyant la porte du royaume des cieux dans la mesure où *il l'incorpore à la passion du Christ* en lui appliquant sa 'vertu'»; q.73 a.3 ad 3: «Le baptême est le sacrement de la mort et de la passion du Christ en tant que l'homme est régénéré dans le Christ en vertu de sa passion. Tandis que l'eucharistie est le sacrement de la passion du Christ en tant que l'homme est rendu parfait par l'union au Christ dans sa passion.»

64. *In III Sent.* d.19 q.1 a.3 sol.2 (*Scriptum* 3: 595–96): «Pour que quelqu'un soit libéré efficacement des peines [temporelles], il faut qu'il soit rendu participant de la passion du Christ, ce qui se réalise de deux manières. Premièrement, par le sacrement de la passion, le baptême, par lequel [le baptisé] est enseveli avec le Christ dans la mort, selon Rm 6,4, et dans lequel opère la vertu divine qui ne connaît pas d'inefficacité; c'est pourquoi de telles peines sont enlevées au baptême. Deuxièmement, *quelqu'un devient participant de la passion du Christ par une réelle conformité à elle, c'est-à-dire quand nous souffrons avec le Christ souffrant:* cela se réalise par la pénitence. Cette dernière conformité se produit par notre propre opération et c'est pourquoi elle peut être parfaite ou imparfaite. . . . »

65. Cf. G. Re, *Il cristocentrismo della vita cristiana* (Brescia, 1968).

66. ST 1 q.93 a.5 ad 4; cf. É. Bailleux, «A l'image du Fils premier-né», *Revue Thomiste* 76 (1976): 181–207, esp. 192–203.

67. «On lit dans l'Écriture que *nous sommes configurés au Fils par la médiation du Saint-Esprit.* Témoin ce texte de la Lettre aux Romains (8,15): 'Vous avez reçu un Esprit qui fait de vous des fils adoptifs', et ce texte de la Lettre aux Galates (4,6): 'parce que vous êtes ses fils, Dieu a envoyé dans vos coeurs l'Esprit de son Fils'. Or rien ne se conforme à quelque modèle que par le moyen de son propre sceau. On le constate dans les natures créées, où ce qui rend semblable au modèle procède de lui; ainsi le *semen* humain qui procède de l'homme rend semblable à l'homme. Or le Saint-Esprit procède du Fils comme son propre caractère. En conséquence, on dit du Christ: 'il nous a marqués de son sceau, de son onction, il nous a donné comme gage le Saint-Esprit présent en nos coeurs'» (*De potentia* q.10 a.4, d'après la traduction d'É. Bailleux, «A l'image», 202–3).

68. On verra ici D. J. Merriell, *To the Image of the Trinity: A Study in the Development of Aquinas' Teaching* (Studies and Texts 96, Toronto, 1990).

69. Serait-ce faire une lecture trop psychologisante de cette phrase que d'y voir un écho au célèbre passage où Thomas compatit à «l'angoisse de ces grands esprits» (*quantam angustiam patiebantur . . . eorum praeclara ingenia*; Alexandre d'Aphrodise, Averroès, Aristote) qui ne savaient où placer la béatitude de l'homme faute de connaître l'immortalité de l'âme? Cf. SCG 3 c.48 (*Liber CG* 3: 65–66 n° 2261).

70. SCG 4 c.54 (*Liber CG* 3: 348 n° 3922–23, 349–50 n° 3926–27); cf. la Préface liturgique de la

Nativité; *De rationibus fidei* c.7 (Édition Léonine 40: B66); Aristote, *Ethique à Nicomaque* 8.1.3 (1155a) et 5.5 (1157b).

71. *In Ioannem* 13,3 lect.1 (*Super Ioan.* 326 n° 1743).

72. *In Ioannem* 15,10 lect.2 (*Super Ioan.* 378 n^{os} 2002–3).

73. *In Symbolum Apostolorum* a.4, éd. R. M. Spiazzi, *S. Thomae Aquinatis Doctoris Angelici Opuscula theologica*, tome 2 (Turin-Rome, 1954), 203–4 n^{os} 919–24; ce passage pourrait avoir été très lointainement inspiré par S. Augustin, *Enarratio in Psalm.* 61,22 (PL 36: 745–46), mais la formulation semble bien être propre à Thomas. On peut voir encore *Enarratio in Psalm.* 48, ser. 1, 11 (PL 35: 551), mais si l'inspiration augustinienne du commentaire de Thomas sur Jean est évidente, nous n'avons pas su trouver de parallèle évident pour cette envolée thomasienne; il y a d'autres très beaux textes sur la croix chez Thomas: *In ad Galatas* 6,14 lect.4 (*Super epp.* 1: 647 n° 371); *In ad Ephesios* 2,13 lect.4 (*Super epp.* 2: 28 n° 109); 3,19 lect. 5 (2: 45–46 n° 180); *In ad Hebraeos* 12 lect.1 (*Super epp.* 2: 443 n° 667); ST 3 q.46 a.3 ad 2; cf. B. Gherardini, «La Croce nella teologia di San Tommaso», *Studi tomistici* 10 (1981): 314–36, et «De crucis theologia apud sanctum Thomam», *Divinitas* 25 (1981): 16–21.

74. *In Ioannem* 10,1 lect.1 (*Super Ioan.* 255–56 n° 1366); cf. *Contra errores graecorum* c.1, éd. H.-F. Dondaine, Édition Léonine 40 (1967): A72.

75. Cf. *Homélies sur l'évangile de saint Jean, tractatus 45, 6 et 15* (Bibliothèque augustinienne A 73B, Paris, 1989), 55 et 83–85.

76. *In Ioannem* 10,1 lect. 1 (*Super Ioan.* 256 n^{os} 1368–69); cf. J. C. Smith, «Christ as 'Pastor', 'Ostium' and 'Agnus' in St. Thomas Aquinas», *Angelicum* 56 (1979): 93–118.

77. *In Ioannem* 14,6 lect.2 (*Super Ioan.* 350–51 n^{os} 1865–70); cf. P. de Cointet, «'Attache-toi au Christ!' L'imitation du Christ dans la vie spirituelle selon S. Thomas d'Aquin», *Sources* 12 (1989): 64–74. L'influence augustinienne est ici bien réelle, mais il y a peu de citations littérales. Le passage le plus proche est le *Sermon 141* 4.4 (PL 38: 777–78), auquel sont empruntées deux citations littérales: «Ambula per hominem, et peruenis ad Deum»; «Melius est enim in uia claudicare, quam praeter uiam fortiter ambulare.» On peut voir encore *In Epistolam Ioannis ad Parthos decem* 10.1, éd. et trad. P. Agaesse (SC 75, Paris, 1984), 408–10; *Enarratio in Psalm.* 66,3,5 (PL 36: 807, etc.); on verra l'étude de M.-F. Berrouard, «Saint Augustin et le mystère du Christ Chemin, Vérité et Vie. La méditation théologique du *Tractatus 69 in Iohannis Euangelium* sur Io. 14,6a», dans *Collectanea Augustiniana, Mélanges T. J. Van Bavel*, éd. B. Bruning et al., tome 2 (Louvain, 1991), 431–49.

78. *In ad Romanos* 8 lect.6 (*Super epp.* 1: 126–27 n^{os} 703–6); c'est aussi ce passage de Rm 8,29 qui commande la réflexion de la *Somme* sur la prédestination, cf. ST 1 q.23, en particulier l'article 5.

79. ST 3 q.49 a.3 ad 3; dans le même sens exactement, on peut encore citer ST 3 q.56 a.1 ad 1: «Il faut d'abord que nous soyons conformés au Christ souffrant et mourant dans cette vie passible et mortelle pour parvenir ensuite à participer à la ressemblance de sa résurrection»; cf. ST 1–2 q.85 a.5 ad 2; ST 3 q.66 a.2; SCG 4 c.55 (*Liber CG* 3: 354–55 n° 3944 in fine); *In ad Romanos* 8 lect.3 et 4 (*Super epp.* 1: 118–19 n^{os} 651–53); cf. J.-P. Torrell, *Inutile sainteté?* (Paris, 1971), 49–64.

Thomas Aquinas and His Contemporaries on the Unique Existence in Christ

Stephen F. Brown

I F IT IS A matter of Christian belief that in Christ there are two natures, a divine nature and a human nature, then must one admit that there are two existences in Christ? Is there an existence corresponding to the human nature in Christ in addition to the existence that corresponds to the divine nature? In almost every discussion of this matter, Thomas Aquinas seems to assign only one existence to Christ, the existence that belongs to the eternal Word. This is his position in his commentary on the third book of the *Sentences* (1256), in *Quodlibet IX* (Easter, 1258), in book four of the *Summa contra Gentiles* (1263), in chapter 212 of his *Compendium theologiae* (ca. 1270), and in the third part of the *Summa theologiae* (1272). The *Compendium theologiae* expresses Thomas's common position in the simplest terms:

> Whatever belongs to the supposit or hypostasis must be acknowledged to be but one in Christ. Wherefore, if existence is understood in the sense that one supposit has one existence, it seems that we must say that there is only one existence in Christ. It is clear that when a whole is divided each of its separate parts has its own proper existence; but insofar as parts are considered in the whole, each does not have its own existence, for they all exist through the existence of the whole. So then, if we consider Christ as an integral supposit having two natures, his existence will be but one, just as the supposit also is one.[1]

It is only in his *Quaestio disputata De unione Verbi incarnati* (1272) that Thomas may be seen to defend a different position: "There is another existence that belongs to this supposit, not insofar as it is eternal but insofar as it becomes man in time. Now this existence, although it is not accidental, is nonetheless not the principal existence of its supposit, but a secondary existence."[2]

The problem of how to explain Thomas's position was raised in a number of articles by Dom Herman-Michel Diepen in the middle of our century. Rejecting the traditional interpretation of Thomas's teaching that derived from Cajetan, Diepen held that the true view of Aquinas was the one found in *De unione Verbi incarnati*. There, in a way consistent with his other writings, according to Diepen, Thomas admitted that the humanity of Christ had an *esse secundarium*. To deny a proper, though not independent, substantial existence to the humanity of Christ would be equivalent to reducing this humanity to nothing.[3] In summing up the reaction to Diepen's position, Jean-Hervé Nicholas informs us that the respected Benedictine theologian caused a true scandal among contemporary Thomists when he attempted to explain how Aquinas's theory of existence was applied to Christ.[4] The reaction against, and defense of, Diepen's thesis was long-lasting and has been well-chronicled by Jean-Pierre Torrell.[5]

The task of the present study is an historical effort: to examine how Thomas's position on the unique existence in Christ was understood not by twentieth-century theologians but by theologians in his own time and shortly after his death. I shall examine the treatment given to the questions related to this issue in the writings of three critics of Thomas in the late thirteenth century: Henry of Ghent, Godfrey of Fontaines and Matthew of Aquasparta. First, I shall show how they represented Thomas's position; then I shall examine their criticisms of Thomas's arguments; finally I shall study the efforts of some authors who supported Thomas to respond to their objections.

THE POSITION OF THOMAS AQUINAS AS REPRESENTED BY THREE OPPONENTS

Thomas Aquinas's teaching concerning the *esse* of Christ directly touches the central mystery of Christian faith and involves highly disputed philosophical notions. The impact of his teaching was immediate, not only among Dominican followers and Franciscan opponents but also among secular masters of the University of Paris and theologians from other religious orders. Responses to Thomas's arguments for a unique *esse* in Christ ranged from direct opposition to reinterpretation to modified or complete acceptance.

Henry of Ghent (†1293) is generally regarded as an opponent of Thomas Aquinas. In treating the problem of the number of existences in Christ, however, Henry never mentions Thomas. In fact, in the second question of *Quodlibet III* (1278), Henry himself defends the position that in Christ there is only one existence, so that on this question he agrees basically with the position that dominates Thomas's writings.[6] However, when Henry again takes up the discussion in the eighth question of *Quodlibet X* (1286/87), he alters his position and defends the thesis that there are two existences in Christ. Here, however, his main focus seems to be more on Giles of Rome's commentary on book 3 of the *Sentences* than on any work of Thomas, even though Henry's general criticism could be aimed at Thomas as well. The criticism that Henry brings against those who hold that there is a unique existence in Christ—the existence belonging to the divine Word—is that if the humanity of Christ lacks its own proper existence, then were Christ to set aside his human nature (which he could do if he wanted to) this nature would obtain an existence that it did not previously have, yet there is no possible way of explaining how it could obtain such a new existence. Furthermore, if the human nature in Christ were to lack its own proper existence and only have the existence of the divine supposit, then the humanity of Christ would not have any created existence at all, and thus Christ would not be a creature according to his human nature, because something is not a creature if it does not participate in created existence.[7]

Godfrey of Fontaines (†1306) was both an admirer and an opponent of Thomas Aquinas. In the first question of his *Quodlibet VIII* (1292/93), concerning Christ's *esse*, Thomas's presence is definite. The source Godfrey uses for Thomas's teaching on the unique existence in Christ is the *Summa theologiae*. Borrowing statements from question 17 of the *Tertia pars*, Godfrey notes that it seems to some that although in Christ there are two natures, and that therefore from a certain perspective Christ in terms of his twofold nature is two things, still one cannot say unqualifiedly that he is

two things. Duality can be attributed to Christ only because of, or in regard to, his natures. However, the two natures, the divine and the human, are not predicated of Christ in equal ways. The divine nature may be predicated of Christ in the abstract as well as in the concrete: "Christ is his divine nature" and "Christ is God." We cannot in a parallel way predicate "human nature" of Christ in the abstract, saying, "Christ is his human nature." We can only predicate human nature of Christ in the concrete, saying, "Christ is man." In other words, if both natures could be predicated of Christ in the abstract, it would follow that Christ is unqualifiedly two things. Nonetheless, it is because both natures have a common supposit that they are one thing in an unqualified sense, although in a certain sense they may be said to be two things, because Christ, the one supposit, has both natures, though he has the divine nature in terms of identity whereas he is not identical with his human nature.[8]

If in Godfrey's representation of Thomas Christ is unqualifiedly one although in a certain sense he is two, how does this work out in terms of existences? Since Christ, because of his twofold nature, is in a certain sense two, does he have a twofold existence? Or does Christ, because of the unity of his supposit, have a unique existence? Godfrey explains Thomas's position in book three of the *Summa*, question 17, article 2, in the following way:

> The existence of a form or nature that does not belong to the personal existence or the existence of the subsistent hypostasis is not said to be the existence of that being purely and simply, but only in a certain sense, in the way that white existence is an existence of Socrates not insofar as he is Socrates but insofar as he is white. In the white Socrates, then, there is a twofold existence: one insofar as he is Socrates and another insofar as he is white. Thus, if human nature were to be united to the Son of God not hypostatically or personally, but accidentally, then there would be a need to admit in Christ a twofold existence: one by which he would be God and another by which he would be man. Because, in fact, human nature is united to the Son of God hypostatically—and thus is united to his personal existence—and not accidentally, it seems to follow that in regard to his human nature he does not acquire a new personal existence but only a new relation of his already preexisting personal existence to his human nature, so that this person is said to subsist not only according to his divine nature, but also according to his human nature.[9]

Godfrey supplies an example given by Thomas to illustrate the difference between an accidental addition that would require a second kind of existence in the way that white adds an accidental existence to the personal existence of Socrates. To be white adds a new existence to the personal existence of Socrates, but to be endowed with a head, or to be corporeal, or to be animated does not add a new existence to the personal existence of Socrates. If we imagine that Socrates was born blind and then later received sight, he would not add some new existence to his personal existence the way that whiteness adds some new existence. To be corporeal, to be animated, to be endowed with a head, feet, hands and eyes belongs to his personal existence. If it could happen that after he was constituted as a person Socrates then received these endowments, he would not gain a new form of existence, but he would only gain a new rela-

tion, so that he would not only have existence as he had it prior to the reception of such endowments but would now have it in relation to the endowments that came later.[10]

Godfrey follows the *Summa theologiae* closely, though he does not mention the work explicitly. He seems also to know Thomas's disputed question *De unione Verbi incarnati*, as we shall see. Here, however, he presents Thomas's position according to the version in the *Summa*, and contends that for Thomas there is a unique existence in Christ.

Another contemporary opponent, the Franciscan Matthew of Aquasparta (†1302), interprets Thomas's position in the same way. He announces that Thomas's teaching is the position of one of the greats, that it is subtle and seems probable.[11] Matthew takes his version of Thomas's position from the latter's commentary on the third book of the *Sentences*.[12] He also represents Thomas as holding that there is only one existence in Christ. The reason for this is that for Thomas only the subsistently existing suppposit has existence in the proper sense of the term. A nature or essence is said to exist only if we speak improperly, just as component parts or accidents are not said to have existence properly speaking, but have existence only in another. Because there is only one suppposit or subsistently existing being in Christ, then in Christ there is only one 'existence' in the proper sense of the term.

Furthermore, unity is tied to being, so in one existing being it is impossible to have many substantial existences. If in one existing being there were many substantial existences, in the sense that each substantial existence would be existing in the proper sense of the word and not only existing in another, then that one, existing being could not properly be called 'one'. So, if there were many such existences in Christ, he would not truly be one. If he is truly one, then he has only one substantial 'existence' in the proper meaning of that term.

Matthew completes the picture of Thomas's doctrine. Although in Christ there is, properly speaking, only one existence, yet that one being, Christ, has different relations to his divine nature and his human nature. That the existence of one subsistent being has relations to many things is not at all unseemly. This happens, for example, in the case of the one existence of Peter, which has relations to the different principles that make it up, such as body and soul. According to Matthew, then, Thomas's position is that there is only one subsistent existence in Christ, namely, the existence of the divine suppposit. The human nature in Christ does not have its own proper existence, nor does it give any existence; rather, its existence is communicated to it by the divine suppposit.[13]

In sum, each of these three opponents presents Thomas as holding that there is a unique existence in Christ. We will now look at the way that each of them criticizes Aquinas's position.

THE POSITION OF THOMAS AQUINAS AS CRITICIZED BY THE SAME OPPONENTS

In his *Quodlibet X*, as we have seen, Henry of Ghent gave a general critique of the theory that there is a unique existence in Christ. Unless Christ's human nature had a created existence, he would not truly be a creature, since it is of the very nature of a creature to have a created existence.

Godfrey of Fontaines makes a very specific critique of Thomas's position as it is found in the *Summa theologiae*. According to Godfrey's understanding of Thomas's position, the human nature of Christ is not united to the Son of God accidentally, in the way that white is united to the white Socrates, but rather is united to him hypostatically or personally. In the latter case, there is no addition of another existence, but rather the addition of a new relation of the Word to a human nature that the Son of God did not previously have.

Godfrey counters that this reasoning does not apply in the case where we are dealing with unqualified existence (*esse simpliciter*). A real and proper existence belongs to a substantial nature, such as the human nature of Christ, and it does so in this case more than in the case of any accident. Godfrey here assumes that Thomas does indeed assign proper existences to accidents, and that he denies such a proper existence to the human nature of Christ. But, if Thomas has admitted that an accidental nature or form has its proper accidental existence, how then can he deny that the human nature of Christ, which has more reality than an accident, does not also have its own proper existence?

Such argumentation, Godfrey contends, rather shows that the human nature of Christ does not bring with it a merely accidental existence, since it is neither an accident in itself nor another substance that unites accidentally with the Word. According to Godfrey, Christ's human nature communicates substantial existence, to be sure, but not independently and in itself. It does so only in dependence upon the divine supposit. Because it does not communicate existence independently and in itself but only in dependence upon the divine supposit, the substantial existence of the human nature of Christ is not subsistence, and thus the human nature of Christ is not a human person.[14]

In conclusion, Godfrey insists that because there are two natures in Christ there must also be two existences. By assuming a human nature in the Incarnation, the Word not only assumed a new nature but a new existence as well. In defending the plurality of existences in Christ, Godfrey acknowledges that there can only be one subsistence in any given being. Hence, he concedes that if one should restrict the meaning of the term 'existence' to signify subsistence, that is, the existence of a supposit, one would need to conclude that there is only one existence, that is, one subsistence, in Christ. In a way that would save Thomas from his criticism or bend him toward his interpretation, Godfrey even suggests that this might be what those who deny the plurality of existences in Christ had in mind. In other words, this is what Thomas might have meant—or should have meant.[15]

Given his position that there are two existences in Christ, Godfrey must face an obvious difficulty. If the human nature of Christ enjoys its own proper existence, how does he avoid the conclusion that the same human nature also enjoys its own subsistence, and is, therefore, a human person? In all other instances of human nature, Godfrey maintains that essence, existence, and subsistence are one and the same: Why not in the case of Christ's human nature?

Godfrey meets this difficulty by returning to the theory he developed in the fifth question of *Quodlibet VII* (1290/91 or 1291/92). In some way, subsistence does add something or implies something more than does existence. But, Godfrey claims, it

does so only extrinsically and in terms of connotation. The term 'existence' simply signifies the actual existence of an essence or nature, without determining whether that nature does or does not depend upon something else. Therefore, variation in its state of depending or not depending upon something else will not change the nature in itself or in terms of its actual existence. Now, 'subsistence' signifies the actual existence of an essence or nature with the added connotation that it does not depend on something else, and thus does not unite with it as a part or quasi-part. Therefore, there can be a variation in this connotation and a variation in regard to subsistence without there being any corresponding variation in regard to essence and existence. The human nature of Christ thus enjoys its own proper human existence but cannot be said to have a human subsistence, because it does not exist independently. And this is the case precisely because it is united with the Word and depends upon the latter's subsistence. Should it ever be separated from the Word and yet continue in existence, then this human existence would also be a human subsistence and the human nature of Christ would be a human person.[16]

According to his thesis concerning the two 'existences' of the divine and human natures in Christ, then, Godfrey carefully notes that there are not two 'subsistences' in Christ. It is in explaining the character of the two existences that he shows his knowledge of Thomas's disputed question *De unione Verbi incarnati.* It is only in this work that Thomas contrasts the principal existence that belongs to Christ as the eternal Son of God and the secondary existence that belongs to Christ, the Son of God, insofar as he is temporally united with his human nature. If we remember how Godfrey interpreted Thomas's claim that there is only one existence in Christ to mean that there is only one subsistence in Christ, it seems plausible that, in *Quodlibet VIII,* he is adjusting Aquinas's meaning for principal and secondary existence to his own theory:

> And therefore we must say, furthermore, that in Christ there is only one existence that is subsistence or subsistent existence, that is, there is only one supposit or one existence that is the existence of a supposit, because that is called subsistence or the existence that belongs to a supposit when we are dealing with the existence of a being that is complete in itself and exists on its own and without dependence on another. And in Christ this is the eternal supposit of the Word to which as to something more principal human nature is joined. And this human nature, because it does not exist on its own in a separate way but exists in another, that is, in the hypostasis of the Word of God—not indeed as an accident exists in a subject or, speaking properly, as a part exists in a whole, but through an ineffable assumption or union—thus it itself has an actual existence in Christ which is not distinct from its essence but yet is not a subsistent existence, because it does not have its existence as an independent being in the way we described above.[17]

This paragraph should be read in terms of Godfrey's statement a few pages earlier:

> And so in considering the human and divine natures in Christ, it is necessary to admit many existences in Christ, corresponding to these two natures, but one of these existences is in a way (*quasi*) substantial and principal and the other is in a

way (*quasi*) accidental and secondary. For, insofar as the human nature of Christ is joined to an eternal preexisting supposit it is said to have in respect to the eternal Word something of the character of an accident. Surely this human nature is not an accident, since it is a true substance; nor does it, properly speaking, join with the eternal Word in an accidental manner—but rather hypostatically—because it is a nature which on its own terms is capable of constituting a supposit. In the present instance, however, it is joined to another supposit and is united to it in such a manner that it subsists and is sustained more perfectly than if it were to exist on its own.[18]

It seems, then, that Godfrey bends Thomas's teaching in *De unione Verbi Incarnati* in the direction of admitting a twofold existence in Christ; but we must remember that Godfrey also bent Thomas's theory of a unique existence in Christ in the *Summa theologiae* in the same direction. According to Godfrey, what Thomas said—that there is a unique existence in Christ—is not what he should have said: that there is a unique subsistence, but a twofold existence, in Christ.

Matthew of Aquasparta, as we have seen, interpreted Thomas as teaching that there is a unique existence in Christ. He said that this was the position held by one of the greats, that it is a subtle position, and that it has probability on its side. Nevertheless, he adds that Thomas's theory undercuts the truth of the Incarnation, the fullness of perfection in Christ, and the truth about Christ's life and death.[19] Admirable though it may be, Thomas's teaching is seriously wrong.

Matthew considers Thomas's theory of a unique existence in Christ to be against the truth of the Incarnation because the Son of God truly took to himself a human nature. So, we can say truly that Christ is man on account of his human nature and that he is God on account of his divine nature. These statements are true not merely in terms of the communication of idioms, whereby we say that "God is man" and "Man is God." 'Christ' is the name for the supposit or person with both natures. Christ has his being as a man (*esse hominem*) through the true human nature that he assumed, and he has his being as God (*esse Deum*) through the true divine nature which he has had from eternity. Thus, Christ has had his divine existence from eternity through his divine nature and essence, and he has his human existence in time through his human nature. The one is an eternal existence; the other is a temporal existence. There are necessarily two existences in Christ.[20]

Thomas's position, according to Matthew, also undercuts the fullness of Christ's perfection. Christ is perfect God and perfect man, so that nothing is deficient in regard to the integrity of his divine and human natures. Christ is perfect man, that is, he subsists with "a rational soul and human flesh, both of which are necessary for human fullness, for the soul is the form and the flesh or body the matter that make up the composite. It is manifest, then, that there would be no composition, and thus no composite of matter and form, unless the form would give some existence to the matter or to the composite, or unless some existence would result from the union of matter and form. If, therefore, Christ is perfect man, composed of body and soul and subsisting with a body and soul, then the human soul necessarily gives existence to that composite and some existence results from its union with the body. Now the existence that results is certainly not the divine existence; so it must be a human existence. In Christ, then, there is truly a human existence given by the rational soul. And in Christ

there is also a divine existence given by the divine nature. Therefore, there is not one but many existences in Christ.[21]

Thirdly, Thomas's position goes against the truth concerning Christ's life and death. He truly lived a human life and a divine life. Now, in book 2 of *De anima* Aristotle tells us that "living for a living being is its existence." So, just as in Christ there is a twofold kind of living and yet only one living being, so there is in him a twofold kind of existence because of his twofold nature and yet only one existing being.[22]

If we recall Matthew's presentation of Thomas's position, we can note that he comments on each of its points in the following way:

(1) When Thomas contends that there can be in one being only one existence just as there can be only one form, Matthew makes explicit the parallel Thomas follows between the theory of the unicity of form and the unicity of existence. Matthew, however, contends that in the same being there can be many forms, ordered to one another, and many existences, also ordered to one another. Nonetheless, these many existences ordered to one another do not multiply or pluralize the one existing being.[23]

(2) When Thomas declares that the human nature or human form of Christ gives no existence, he is clearly wrong from Matthew's perspective, for to give existence belongs to the very nature of a form. The human nature or essence is that by which a thing comes to be. If Christ's human nature does not give any existence or make him to be man, then he would not truly be man. If he is truly man, and is so only because of his human nature or form, then the human form or nature gives existence.[24]

(3) When Thomas adds that the human nature of Christ does not give existence, but that through his human nature Christ acquires only a relation to the eternally existing supposit, then the proposition "Christ is man" would involve only a relative predication, which is false. "Christ is man" is truly a substantial predication. It is not just a matter of acquiring a relation; the human form gives substantial existence, so that man is predicated substantially of God.[25]

(4) Thomas's last point, that the human nature of Christ does not have an existence of its own but only the existence communicated to it by the divine supposit, is unsuitable according to Matthew. If the human nature gave existence to nothing, but rather received it from the divine supposit, then Christ would not be man by his humanity, but by his divinity.[26]

Thus, for Matthew, as for Henry of Ghent and Godfrey of Fontaines, Thomas is the great defender of a unique existence in Christ. If his opponents interpreted Thomas's teaching in this way, how did his followers understand it?

THE POSITION OF THOMAS AQUINAS AS PRESENTED AND DEFENDED BY HIS EARLY FOLLOWERS

More than any other of his writings, Thomas's *Quaestio disputata de unione Verbi incarnati* gives rise to the view that he taught there to be many existences in Christ. When Franz Pelster searched for quotations from this work by Thomas's early follow-

ers, he discovered that this disputed question was really the last question of Aquinas's *Quaestiones de virtutibus*.[27] He also found that most early followers of Thomas (Bernard of Trilia, Robert of Orford, Remigius Girolami, John of Paris, Thomas Sutton, and William Peter of Godino) maintained the theory of a unique existence in Christ.[28]

If we examine some of the other early followers of Thomas more closely, however, we find that although they preserve the theory of a unique existence in Christ, they introduce special elements of their own. Others, as we shall see, switch to the twofold existence thesis and hold that this was Thomas's position. In doing so, some base themselves explicitly on the *De unione Verbi incarnati*, whereas others adopt the twofold existence view without explicitly appealing to this text. Why did some of Thomas's followers think it necessary to adjust the more traditional interpretation of his position or depart from it altogether? At least in part, the answer might be found in the necessity on the part of the earlier followers of Thomas to respond to the criticisms of Henry of Ghent, Godfrey of Fontaines and Matthew of Aquasparta. Principally, they responded to Henry and Godfrey, but some of Matthew's theses might well be associated with the position of Henry, especially the elements linked with the plurality of forms.

Giles of Rome (†1316) was an Augustinian Hermit and an associate of Thomas Aquinas. Weeks after the Paris condemnations of 1277, he was personally condemned and denied the license to teach until 1285, when Pope Honorius IV admitted him to the rank of Master of Theology. Thomas Aquinas, deceased in 1274, was also threatened at the same time with personal censure, but whether an actual censure was ever brought against him is still debated.[29] In explaining the union of the Son of God with his human nature, Giles follows Thomas by saying that the human nature of Christ is not an accident, even though in a certain way it resembles an accident. Christ's human nature, Giles explains, does not exist in a created supposit the way that other human natures exist in created supposits, but is joined to the uncreated *esse* of the divine supposit; for this reason it is well said that Christ's human nature is not an accident. Yet Christ's human nature resembles an accident because like an accident it is substantiated in a supposit, namely the divine supposit, which already exists. The human nature of Christ, then, resembles an accident because it subsists in another that has its own proper existence.[30] An accident for Giles does not have its own proper existence. It exists but does not subsist, since it exists in another.[31] Christ's human nature likewise does not have its own proper existence but exists through the existence of the divine eternal supposit that received the human nature in time.[32] If there is a difference between Giles's treatment of the issue in his commentary on the third book of the *Sentences* and his later *Quodlibet II*, it is that in the latter he much more strongly stresses the real distinction between essence and existence, insists more firmly on the unique existence in Christ, and responds directly to the criticisms that Henry of Ghent brought against the unique existence theory.[33]

In his *Improbationes contra Godefridum*, Bernard of Auvergne, O.P. (fl. 1295–1305), defends Thomas in a different manner than Giles, since he faces the criticisms of Godfrey rather than Henry of Ghent. Bernard disagrees with Godfrey on many particulars where the latter criticizes Thomas's positions and arguments. At times, however, he seems to adjust Thomas's position to meet Godfrey's critiicisms and he ex-

plains Thomas's position in a way that avoids Godfrey's vocabulary while substituting synonyms. He replaces Godfrey's distinction between subsistence and existence with a parallel distinction between existence in the full sense of the term (*esse existentiae simpliciter*) and existence of a particular formal kind (*esse existentiae ex consequenti et quasi per accidens*). The human nature of Christ, according to Bernard, has an existence, but it is an existence of the kind that belongs to a substantial form in a supposit. Now the kind of existence that is due to a substantial form in a supposit is not existence in the full sense of the term or existence *per se*. Such *per se* existence belongs only to a supposit. It belongs to a form or nature *ex consequenti et quasi per accidens*, that is, it makes it a particular kind of existing being without making it exist in the primary sense of the term.[34]

What does this mean? "In Christ," Bernard explains, "human nature in some way resembles an accident, since it comes to a supposit that already has existence on its own (*esse simpliciter*). Thus, the human nature of Christ does not give existence in the sense of making the Son of God to exist. Rather it gives to the Son of God, that is, to a supposit that already exists, a specific way of existing, a human way of being, which may be described as an 'accidental' being. Yet, this kind of existence that human nature gives, although in a way it qualifies a being that already exists in act, is not truly accidental according to Bernard. Surely, it is not like a categorical quality, as is the color 'white' that makes Christ to be white. It really is more like a substance, since it makes the Word to be human. The human nature of Christ, then, is not a substance in the sense of an independently existing human being. We might say that it is in the category of substance by reduction. Christ's human nature makes the Word *formally* to be human. It does not make him exist in the full sense of the term, because the Son of God already exists eternally. The human nature of Christ does not give existence as such, because his existence as such is eternal. Rather, it makes the eternal, divine existent being formally to be human. In all other cases except in Christ, the human nature does both: it makes a man exist and it makes this existing being to be formally human. In Christ, human nature does only one of these two, since the human nature in Christ comes to a supposit that already has true existence.[35]

Both Giles and Bernard have created a new vocabulary in their efforts to defend Thomas Aquinas against the attacks of Henry of Ghent and Godfrey of Fontaines. Despite these alterations, both men still attempt to present and defend Thomas's position as one that holds only a unique existence in Christ.

In his commentary on the third book of the *Sentences*, Hervaeus Natalis, O.P. (Hervé de Nedellec, †1323), explicitly contends that Thomas's true position is that there are two existences in Christ. Quite likely under the influence of Godfrey of Fontaines, who suggested a rereading of the position defending the unique existence in Christ, Hervaeus thus initiates an interpretation of Thomas's teaching that will become more prevalent in the early fourteenth century. Certainly, Hervaeus does not cite overtly the disputed question *De unione Verbi incarnati*, but there is no doubt that he defends both a twofold existence in Christ and argues that this is the position found in Thomas's *Quodlibet IX* and the *Tertia pars* of the *Summa theologiae*. Let us examine his claim.

Hervaeus certainly manifests a break in the interpretation of Thomas. He recounts

a position that claims to follow Aquinas, holding that because the human nature of Christ is assumed to the existence of another supposit, therefore the human nature in Christ lacks its own proper existence. It is impossible that there be many substantial existences in Christ, for this would lead to the admission of many supposits in Christ. Those who hold this position also want to attribute it to Thomas, since his words lead in this direction.[36]

Although this has been the dominant way of interpreting Thomas's position, Hervaeus favors another approach. He presents it as an already existing position that he accepts—a position closely resembling the interpretation given by Godfrey of Fontaines to Aquinas's teaching. The human nature of Christ does have its own proper existence, although this proper existence is not existence in the full sense of the term (*esse simpliciter*) or existence in the sense of subsistence.[37]

Those who hold this position would say that the human nature of Christ does not subsist or exist in the full sense of the term through its proper existence. Rather existence in relation to the human nature of Christ has the meaning of "existing in" (*inesse*), in the sense of existing in another. The proper existence that belongs to Christ's human nature does not belong to it as something independent, since the human nature of Christ does not exist in itself or on its own. It exists in relation to something else in which it is present.[38] Hervaeus tries to establish the reasonable character of his claim by setting up the following parallel: just as a substantial nature, which on its own is capable of constituting a being that exists in the full sense of the term, can by God's power be made to be something that inheres in another, so also is it not unsuitable that by God's power a substantial created existence, which can exist on its own in the full sense of the term, be made to exist as something that inheres in another. In such a case the "existing in" that belongs to such a human nature does not join with the divine existence to make two supposits. They concur to make one supposit, in a way that one of them exists in the full sense of the term and the other exists in the one that exists in the full sense of the term.[39]

Hervaeus considers this the more probable position concerning existence in Christ, and claims that this approach is more in accord with the mind of Thomas Aquinas. In the second question of *Quodlibet IX*, Aquinas concludes that there is only one personal existence in Christ. But in the *Tertia pars* of the *Summa theologiae* Thomas also insists that if the human nature of Christ were joined to the divine person accidentally, there would be in Christ many existences. In saying so, however, Thomas did not mean that existence in no way remained in Christ's human nature. Surely, Thomas did not admit that existence in the sense of subsistence remained in Christ's human nature, nor did he wish to say that the kind of existence that remained was accidental in the way that an accident such as 'white' has existence in the white Socrates. There is, none the less, another way in which "existence in" (*inesse*) can take place. The proper existence that is characteristic of Christ's human nature is that it is joined to the Son of God as a substantial type of existence. It is not a supposit or something existing on its own, but it "exists in" the Word in somewhat the way that clothes exist in relation to the person who wears them. By this analogy Hervaeus does not mean that in Christ there are two substances (as man and clothing), but rather wishes to suggest an accidental link that does not connote the kind of inherence that 'white' has in the white Socrates.

He does not want to claim that Christ's human nature is a separate independent substance like the clothing someone wears, but he does want to say that the union of Christ's human nature to the divine supposit is such that even though one cannot establish an exact parallel between this union and the relation between a man and his clothing, one can make a parallel between a clothed man (*homo vestitus*) and the "humaned" Son of God (*Filius Dei humanatus*).[40]

Hervaeus's way of intepreting Thomas was followed by other Dominicans in the early fourteenth century. Both John Picardi of Lichtenberg (fl. 1303–1313) and John of Naples (†ca. 1350), for example, maintained that Thomas taught there to be a twofold existence in Christ. John Picardi refers explicitly to *De unione Verbi incarnati*.[41] This interpretation of Thomas seems to have originated with Godfrey of Fontaines. Hervaeus's presentation of this interpretation, significantly, does not depend on the disputed question *De unione Verbi incarnati*, as one might have expected, but rather is based on a more exact reading of *Quodlibet IX* and the *Tertia pars* of the *Summa theologiae*. The Dominican Durandus of Saint-Pourçain (†1334) neatly formulates the newer interpretation, which seems persuasive *a fortiori*:

> The second point is clear in two ways. First, because it pertains in a greater way to the human nature in Christ to have its proper existence besides the existence belonging to the supposit than it pertains to an accident to have its proper existence in a subject besides the existence that belongs to the subject. Now, an accident has its proper existence in a subject besides the existence belonging to the subject; therefore, the human nature in Christ has a proper existence besides the existence belonging to the supposit.[42]

Whether Durandus's argument will have authority with modern interpreters of Thomas Aquinas is another question:

> Durus Durandus jacet hic sub marmore duro,
> An sit salvandus ego nescio, nec quoque curo.[43]

NOTES

1. Thomas Aquinas, *Compendium theologiae* c. 212, ed. G. de Grandpré, Leonine Edition 42 (1979): 165a: "Ea vero quae ad suppositum sive hypostasim pertinent, unum tantum in Christo confiteri oportet. Unde si esse accipiatur secundum quod unum esse est unius suppositi, videtur dicendum quod in Christo sit unum tantum esse. Manifestum est enim quod partes divisae singulae proprium esse habent, secundum autem quod in toto considerantur non habent singulae suum esse, sed omnes sunt per esse totius. Sic igitur si consideremus ipsum Christum ut quoddam integrum suppositum duarum naturarum, erit eius unum tantum esse, sicut et est unum suppositum."

2. Thomas Aquinas, *Quaestio disputata De unione Verbi incarnati* q.unica a.4, ed. P. Bazzi et al., in vol. 2 of *Quaestiones disputatae S. Thomae Aquinatis* (Turin-Rome, 1953), 432: "Est autem et aliud esse huius suppositi, non in quantum est aeternum, sed in quantum est temporaliter homo factum. Quod esse, etsi non sit esse accidentale—quia homo non praedicatur accidentaliter de Filio Dei, ut supra habitum est—non tamen est esse principale sui suppositi, sed secundarium."

3. H.-M. Diepen, "Un scotisme apocryphe, la christologie du P. Déodat de Basly, o.f.m.," *Revue Thomiste* 49 (1949): 428–92; "La critique du baslisme selon saint Thomas d'Aquin," *Revue Thomiste*

50 (1950): 82–118, 290–329; "La psychologie humaine du Christ," *Revue Thomiste* 50 (1950): 515–62; "L'unique Seigneur Jésus-Christ. Bilan d'une étude christologique," *Revue Thomiste* 53 (1953): 28–80. See also his *La théologie de l'Emmanuel: Les lignes maîtresses d'une christologie* (Bruges, 1960).

4. J.-H. Nicolas, "L'unité d'être dans le Christ d'après saint Thomas," *Revue Thomiste* 65 (1965): 229: "Quand le regretté Dom Diepen commença dans cette *Revue*, en 1950, à contester la thèse de 'l'extase de l'être' dans le Christ et à mettre en doute qu'elle ait été enseignée par saint Thomas lui-même, ce fut un vrai scandale parmi les thomistes."

5. J.-P. Torrell, "Le thomisme dans le débat christologique contemporain," in *Saint Thomas au XXe siècle* (Actes du colloque du Centenaire de la *Revue Thomiste*: 25–28 mars, 1993—Toulouse), ed. S.-T. Bonino (Paris, 1994), 383–87.

6. Henry of Ghent, *Quodlibet III* q.2, ed. I. Badius Ascensius, *Quodlibeta Magistri Henrici Goethals a Gandavo, doctoris Solemnis, socii Sorbonici et archidiaconi Tornacensis cum duplici tabella* (Paris, 1517; reprt. Louvain, 1961), vol. 1, fols. 49r–50r, esp. fol. 49v: "Cum ergo quaeritur absolute utrum in Christo sit unum esse vel plura, si loquamur de esse naturae et essentiae rei in Christo, dicendum quod duo sunt esse in Christo, quia duae sunt naturae manentes in eo distinctae et diversae per essentiam quamquam unitae in unitate suppositi: non enim transit humana natura assumpta in divinam, nec e converso. Si vero loquamur de esse actualis existentiae, de tali esse sciendum quod nulli proprie attribuitur nisi illi quod ipsum habet in se et absolute tamquam ens distinctum ab alio, non autem illi quod habet ipsum in alio vel ex unione cum alio quod habet ipsum per se et de se. Verbi gratia: forma et materia, quia non habent existentiam in actu nisi in composito quod per se et in se absolute existit et subsistit, ideo non dicuntur per se et proprie existere in actu, sed solum compositum et materia et forma nonnisi quia sunt in composito quod per se et proprie existit in actu. Similiter accidens, quia non existit nisi in alio ut in subiecto, non dicitur esse in actu per se et proprie nisi quia in subiecto quod existit in actu per se. Cum igitur humanae naturae in Christo nullum poterit attribui esse actualis existentiae secundum se et separatum, quia numquam habuit esse tale, scilicet in se terminatum, nec potuit habere postquam ad divinam naturam fuit assumpta: aliter enim filius Dei vel assumpsisset vel haberet iam assumptam non solum naturam humanam sed etiam personam, ut alibi habet determinari. Sed quod humana natura in Christo habet esse actualis existentiae, hoc habet solum in illo cui unita et in quo assumpta est. Idcirco absolute dicendum est quod Christus ratione humanae naturae nullum habet ex se esse actualis existentiae, sicut nec accidens quod est in subiecto vel materia quae est in composito; sed solum habet Christus esse existentiae ratione suae divinae naturae quod communicatur naturae humanae per assumptionem ad ipsam in unitate suppositi sicut accidenti communicatur esse actuale subiecti vel materiae communicatur esse actuale compositi,— non quod humana natura sit accidens vel materia divinae naturae. Absit hoc sentire!"

7. Henry of Ghent, *Quodlibet X* q.8, ed. R. Macken, *Henrici de Gandavo Opera omnia* 14 (Leuven-Leiden, 1981): 211–12: "Si enim humanitas Christi in Christo assumpta a Verbo nullum habet esse proprium praeter esse suppositi increatum, manente assumptione, tunc si illam humanam naturam dimitteret, sicut posset si vellet, cum ipsa esse haberet tunc quod prius non habuit, est ergo ei acquisitum de novo, quod est impossibile, quia nec per generans nec per creans nec per removens prohibens ut prius. . . . Praeterea, si humana natura in Christo nullum haberet esse proprium sed solum divini suppositi, cum illud non sit nisi esse increatum, humanitas ergo Christi nullum haberet esse creatum omnino et sic non esset Christus creatura secundum humanam naturam, quia nec est creatura nisi participando esse creatum. Consequens falsum est. Ergo etc."

8. Godfrey of Fontaines, *Quodlibet VIII* q.1, ed. J. Hoffmans, *Le Huitième Quodlibet de Godefroid de Fontaines* (Les Philosophes Belges 4/1, Louvain, 1924), 7–8: "Sed videtur aliquibus quod, licet in Christo sint duae naturae et sic Christus sit duo secundum naturam et sic secundum quandam determinationem, non tamen debet dici quod sit duo simpliciter, quia numerus dualitatis non potest poni circa Christum nisi ratione naturarum sive circa ipsas naturas; sed ambae naturae non praedicantur in abstracto, prout scilicet ipsa natura nomine absoluto dicitur significari, sed una sola natura, scilicet divina, non autem natura humana, sed solum in concreto; unde non dicitur quod Christus sit natura humana, sed bene dicitur quod Christus est homo; homo autem significat habentem humanitatem. Quamvis ergo, si ambae naturae praedicarentur de Christo, sequeretur quod Christus esset duo, tamen quia non utraque praedicatur in abstracto non debet concedi quod sit duo simpliciter; sed oportet secundum rationem suppositi praedicari de Christo unum vel duo. Qui ergo poneret in Christo esse duo supposita, diceret Christum esse duo neutraliter. Quia nos ponimus in Christo esse unum solum suppositum, videtur quod Christus dicendus est non solum unus masculine, sed etiam unum neutraliter." Cf. Thomas Aquinas, ST 3 q.17 a.1 resp.

9. Godfrey of Fontaines, *Quodl. VIII* q.1 (ed. Hoffmans, 13–14): " . . . Quia enim esse formae vel

naturae quae non pertinet ad esse personale vel hypostasis subsistentis non dicitur esse illius per se simpliciter, sed secundum quid, sicut esse album est esse Socratem non in quantum est Socrates, sed in quantum est albus; et ita in Socrate albo est duplex esse: unum secundum quod est Socrates et aliud secundum quod est albus. Ideo quidem si natura humana adveniret filio Dei non hypostatice vel personaliter sed accidentaliter, sic etiam in Christo poneretur duplex esse: unum secundum quod est Deus, aliud secundum quod est homo. Quia igitur natura humana advenit filio Dei hypostatice et pertinet ad esse personale Christi et non accidentaliter, consequens videtur quod secundum naturam humanam non adveniat sibi novum esse personale, sed solum nova habitudo esse personalis praeexistentis ad naturam humanam, ut scilicet persona illa iam dicatur subsistere non solum secundum naturam divinam, sed etiam secundum humanam." Cf. Thomas Aquinas, ST 3 q.17 a.2 resp.

10. Godfrey of Fontaines, *Quodl. VIII* q.1 (ed. Hoffmans, 13–14): "Et ponitur exemplum: quia esse capitatum et cetera, pertinet ad unam personam Socratis, ideo ex omnibus istis non fit nisi unum esse in Socrate. Et si contingeret quod post constitutionem personae Socratis adveniret ei manus vel pedes, ex his non accresceret Socrati aliud esse, sed solum relatio quaedam ad huiusmodi, quia diceretur esse non solum secundum ea quae prius habebat, sed etiam secundum ea quae post modum sibi adveniunt." Cf. Thomas Aquinas, ST 3 q.17 a.2 resp.

11. Matthew of Aquasparta, *Quaestiones de incarnatione* q.9, in *Quaestiones diputatae de incarnatione et e lapsu aliaeque selectae de Christo et de eucharistia* (Bibliotheca Franciscana Scholastica Medii Aevi 2, Quaracchi, 1957), 177: "Ista autem positio, quamvis magnorum sit et multum subtilis et probabilis videatur. . . . "

12. Matthew of Aquasparta, *Quaestiones de incarnatione* q.9 (ed. Quaracchi, 176–77). Cf. Thomas Aquinas, *In III Sent.* d.6 q.2 a.2 resp. (*Scriptum* 3: 238–39).

13. Matthew of Aquasparta, *Quaestiones de incarnatione* q. 9 (ed. Quaracchi, 177): "Alio modo accipitur esse proprie, prout est actus entis, sicut lucere est actus lucentis; et si de hoc esse actuali loquamur, quod proprie est in re et ad naturam rei pertinet, sic utique, ut dicunt, in Christo non fuit nisi unum esse. Cuius ratio est quoniam hoc modo tantum subsistens sive suppositum habet esse; natura autem sive essentia improprie esse dicitur, sicut et partes et accidentia, quia non habent esse nisi in alio. Et quoniam in Christo unum tantum fuit suppositum sive subsistens, propterea in Christo tantum fuit unum esse. —Praeterea, 'unum' fundatur super 'ens'; ergo in uno exsistente impossibile est esse plura esse substantialia. Si enim in uno exsistente essent plura esse substantialia, secundum quae aliquid dicitur esse simpliciter, non posset dici vere unum; ergo si in Christo fuissent plura esse, Christus non fuisset vere unum. Si igitur Christus vere unum est, ergo unum tantum habet esse substantiale. Quamvis autem in Christo non sit nisi unum esse, tamen illud unum habet respectum ad diversa, scilicet ad divinam essentiam et humanam. Hoc autem non est inconveniens, ut esse unius subsistentis sit per respectum ad plura, sicut esse Petri unum est, habens respectum ad diversa principia ipsum constituentia. Sic ergo dicunt quod in Christo non fuit nisi unum esse, scilicet esse divini suppositi; nec essentia humana in Christo habuit proprium esse, nec aliquod dedit esse, sed habuit esse communicatum a divino supposito." Cf. Thomas Aquinas, *In III Sent.* d.6 q.2 a.2 resp.

14. Godfrey of Fontaines, *Quodl. VIII* q.1 (ed. Hoffmans, 14): "Sed sic non oportet dicere in proposito considerando ipsum esse ut est esse existentiae simpliciter. Cum enim, ut dictum est, in assumptione naturae humanae advenit supposito divino aliqua res et natura substantialis cui non minus, immo magis convenit esse existentiae reale proprium quam cuicumque accidenti, si concedatur quod natura accidentis adveniens dat aliquod esse, licet imperfectum quia est natura imperfecta, quomodo dicetur quod natura humana in Christo nullum esse proprium haberet? Ex simili ergo, tali de accidente non potest concludi nisi quod non dat esse accidentale, quia nec est accidens informans et inhaerens, ut albedo, nec est substantia accidentaliter adveniens quasi ex habitudine eius ad ipsum cui advenit aliquod esse accidentale consurgat, sicut de vestimento respectu vestiti, sed dat esse substantiale, non quidem secundum se; et ideo non dat novam rationem suppositi vel personae, sed verum esse existentiae substantiae alteri perfectiori cui in ratione suppositi innititur; et sic non habet Christus ratione humanae naturae esse sub ratione subsistentiae. Bene enim verum est quod per advenientem naturam humanam non advenit Christo novum esse personale, sicut nec nova relatio filiationis realis. Sicut tamen natura alia vel essentia ei advenit et alia nativitate vel generatione, ita etiam et aliud esse existentiae. Omnis enim generatio terminatur ad aliquod esse reale; et, si illud sit ens secundum se, est hypostaticum per se; si non, tunc: aut est esse accidentale quod non est natum esse hypostaticum secundum se, et tunc etiam illud non cedit in esse hypostaticum cum illo cui advenit, sicut convenit in omnibus accidentibus respectu substantiae; aut est esse substantiale quod est natum esse hypostaticum secundum se, sed sic in esse non constituitur, sed unitum alteri subsistenti cui innititur; et tunc illud esse novum est novum esse existentiae simplicis, sed non novum esse personale vel suppositi, sed cedit

quasi in esse hypostaticum praeexistens in quantum nullam habet rationem hypostasis vel personae nisi illius suppositi."

15. Godfrey of Fontaines, *Quodl. VIII* q. 1 (ed. Hoffmans, 15): "Et ideo ulterius est dicendum quod in Christo non est nisi unum esse subsistentiae, id est, non est nisi unum suppositum sive esse suppositi, quia esse suppositi vel subsistentiae dicitur esse alicuius entis complete in se et per se existentis et nulli alii innitentis. . . . Sed illud non est sibi esse subsistentiae, quia illud non habet secundum se modo supradicto. Sic patet quod si accipiatur esse secundum rationem perfectam, id est, ut est entis perfecti et completi secundum se et in se existentis, cum tale sit esse substantiae alteri non innitentis et hoc est ens subsistens sive suppositum per se existens, sic non est nisi unum esse in uno, quia illi naturae sic alteri non innitenti convenit per se existere et subsistere, omnibus quae sunt in ipso per illud convenit et communicatur; ipsum enim suppositum per se et exsistit et subsistit; omnia autem alia sunt et substant in illo et per illud.

Et ad hoc forte attendunt dicentes simpliciter quod in Christo non sunt plura esse. Sed, si accipiatur esse simpliciter et absolute, ut est actualitas essentiae vel naturae actum essentiae vel naturae importans non differens realiter ab ipsa, sic oportet esse multiplicari secundum multiplicationem essentiarum vel naturarum."

16. Godfrey of Fontaines, *Quodlibet VII* q. 5, ed. M. De Wulf and J. Hoffmans, *Les Quodlibets V, VI, VII de Godefroid de Fontaines* (Les Philosophes Belges 3, Louvain, 1914), 310–11: "Et ideo, ad evidentiam horum quare est hoc, scilicet quod supposito convenit agere non naturae, et Christus dicitur assumpsisse non hominem qui significat per modum suppositi, sed humanitatem quae significat per modum naturae, sed tamen suppositum et natura sunt idem et unum secundum rem, —est intelligendum quod, ut dictum est, licet nomine suppositi non significetur primo et principaliter nisi id ipsum quod significatur nomine naturae et e converso, tamen aliud connotatur nomine suppositi quam nomine naturae; sicut etiam esse substantiae singularis et subsistentiae eius sunt idem realiter, et tamen ratione diversorum connotatorum esse naturae humanae in Christo non est esse subsistentiae et tamen, si esset a persona divina separata, illud idem esset esse subsistentiae." On Godfrey's doctrine concerning subsistence, supposit, and nature, and its application to his Christological teaching, see John F. Wippel, *The Metaphysical Thought of Godfrey of Fontaines* (Washington, D.C., 1981), 225–46.

17. Godfrey of Fontaines, *Quodl. VIII* q.1 (ed. Hoffmans, 15): "Et ideo ulterius est dicendum quod in Christo non est nisi unum esse subsistentiae, id est, non est nisi unum suppositum sive esse suppositi, quia esse suppositi vel subsistentiae dicitur esse alicuius entis completi in se et per se existentis et nulli alii innitentis. Hoc autem in Christo est suppositum aeternum Verbi, cui tanquam principaliori advenit natura humana; quae quidem, quia non per se separatim existit, sed in alio, id est in hypostasi Verbi Dei, non quidem sicut accidens in subiecto neque proprie sicut pars in toto, sed per ineffabilem assumptionem vel unionem, ideo natura ipsa in Christo habet esse existententiae, quod est idem cum sua essentia; sed illud non est sibi esse subsistentiae, quia illud non habet secundum se modo supradicto."

18. Godfrey of Fontaines, *Quodl. VIII* q.1 (ed. Hoffmans, 13): "Et sic considerando in Christo naturam humanam et divinam, secundum illas oportet ponere plura esse in Christo, sed unum quasi substantiale et principale et aliud quasi accidentale et secundarium. In quantum enim natura humana advenit supposito praeexistenti aeterno dicitur habere respectu illius modum accidentis. Non est tamen accidens, cum sit vera substantia; nec proprie accidentaliter advenit, sed hypostatice, quia est natura quae secundum se nata est constituere suppositum. Nunc tamen alteri supposito coniuncta est et unita in quo perfectius subsistit et sustentificatur quam in se ipsa sibi derelicta."

19. Matthew of Aquasparta, *Quaestiones de incarnatione* q.9 (ed. Quaracchi, 177): "Ista autem positio . . . probabilis videatur, tamen, sine praeiudicio, non est multum secura, quoniam repugnat veritati incarnationis, integritati perfectionis in Christo et veritati vitae et mortis, quae tria manifeste convincunt in Christo fuisse et esse plura esse et ipsum plura esse habuisse."

20. Matthew of Aquasparta, *Quaestiones de incarnatione* q.9 (ed. Quaracchi, 178): "Et primo Christum habuisse plura esse convincit veritas incarnationis. Filius enim Dei, Verbum Dei, vere assumpsit et univit sibi naturam humanam, per quam unitionem et assumptionem ista est praedicatio vera et per se: 'Christus est homo propter naturam humanam et Christus est Deus propter naturam divinam'; nec tantum est vera propter idomatum communicationem, sicut ista: 'Deus est homo' vel 'homo est Deus'; quoniam Christus nominat suppositum sive personam in utraque natura, ita quod nec divinitate est homo nec humanitate est Deus. Habet igitur 'esse hominem' per veram naturam humanam et essentiam quam assumpsit, et 'esse Deum' per veram naturam divinam et essentiam quam ab aeterno habuit; ergo habuit esse divinum ab aeterno per essentiam et naturam divinam, habuit esse humanum ex tempore per naturam et essentiam humanam; et illud aeternum, istud autem temporale, et ideo necessario duo; ergo necessario duo esse erant in Christo."

21. Matthew of Aquasparta, *Quaestiones de incarnatione* q.9 (ed. Quaracchi, 179): "Secundo hoc convincit integritas perfectionis. Nam secundum Sanctos et secundum catholicam veritatem confitemur Christum 'perfectum Deum, perfectum hominem', ita quod nihil sibi defuit pertinens ad perfectionem utriusque naturae. Perfectus igitur est homo Christus 'ex anima rationali et humana carne subsistens'; quae duo sunt de integritate humanae naturae, ita quod anima sicut forma, caro sive corpus velut materia, quoniam secundum Philosophum, II *De anima* (412a 27–28), 'anima est actus corporis' etc. Sed manifestum est quod nulla esset compositio, nec esset aliquod compositum ex materia et forma, nisi forma aliquod esse resultaret. Si igitur Christus est perfectus homo, compositus et subsistens ex anima et carne, necessario anima dat esse illi composito et ex unione sui cum corpore aliquod esse resultat. Sed certum est quod non esse divinum; ergo esse humanum. Ergo in Christo vere est esse humanum et perfectum per animam rationalem; et certum est quod est ibi esse divinum per naturam divinam; ergo vere sunt ibi plura esse."

22. Matthew of Aquasparta, *Quaestiones de incarnatione* q.9 (ed. Quaracchi, 181): "Tertio hoc convincit veritas vitae et mortis. Christus enim secundum catholicam fidem vere fuit vivus et vere mortuus, ita quod vere vixit vita humana et vere vixit vita divina, vita creata et vita increata. Sed 'vivere viventibus est esse', secundum Philosophum, II *De anima* (415b 13); ergo sicut duplex vivere ex duplici vita, et tamen unum vivens, ita duplex esse ex duplici essentia, et tamen unum exsistens."

23. Matthew of Aquasparta, *Quaestiones de incarnatione* q.9 (ed. Quaracchi, 182): "Contrarium vero omnino iis repugnat, sicut ostensum est; modus autem ponendi omnino videtur esse frivolus. Supponit enim quod in uno non potest esse nisi unum esse sicut nec [nisi] una forma, cuius contrarium est ostensum. Nam et in eodem ponimus plures formas, tamen ad invicem ordinatas, et plura esse eodem modo ad invicem ordinata, quae tamen non plurificant ens sive exsistens."

24. Matthew of Aquasparta, *Quaestiones de incarnatione* q. 9 (ed. Quaracchi, 183): "Quod ulterius ponit, quod essentia humana vel humana forma non dat esse, manifeste convincitur esse falsum, quoniam dare esse est de ratione formae, et essentia est illud quo res est; si autem forma non dat esse nec essentia ipsa vel per ipsam aliquid est, igitur et forma cadit a ratione formae et essentia a ratione essentiae. Et cum hoc, si non dat esse aliquod nec facit esse hominem, tunc Christus non esset vere homo, quod omnino haereticum est et falsum; si autem vere homo est, et nonnisi per essentiam et formam humanam, ergo forma et essentia dant vel faciunt esse."

25. Matthew of Aquasparta, *Quaestiones de incarnatione* q.9 (ed. Quaracchi, 183): "Quod vero addit, quod non dat esse, sed per illam acquiritur respectus tantum exsistenti, vel per illam fit ut subsistens vere, esse veri subsistentis, habeat respectum ad plura, videtur esse magis vanum, quoniam secundum hoc ista propositio 'Christus est homo' esset praedicatio tantum relativa; quod falsum est, quoniam est vere praedicatio substantialis. Ergo non tantum acquiritur respectus, sed vere ista forma vel essentia dat esse substantiale, ratione cuius substantialiter homo praedicatur de Christo."

26. Matthew of Aquasparta, *Quaestiones de incarnatione* q.9 (ed. Quaracchi, 183): "Quod tandem ponit, quod natura vel essentia humana in Christo esse non habuit nisi communicatum a divino supposito, inconveniens sequitur evidenter. Si enim essentia humana nulli dat esse, immo potius a divino supposito esse recipit, tunc Christus non esset homo humanitate, sed divinitate."

27. F. Pelster, "La quaestio disputata de Saint Thomas 'De unione Verbi incarnati'," *Archives de Philosophie* 3 (1925): 198–245. For excellent historical sketches of the different theories concerning the existence of Christ, see P. Bayerschmidt, *Die Seins- und Formmetaphysik des Heinrich von Gent in ihrer Anwendung au fie Christologie* (Münster i.W., 1941): 46–65 and L. De Raeymaeker, vol. 2 of *Metaphysica generalis* (Louvain, 1935), 426–48.

28. Pelster, "La quaestio," 233–37.

29. On this debate, see R. Wielockx, ed., *Aegidii Romani Opera Omnia III.1. Apologia* (Florence, 1985), 75–120; R. Hissette, *Enquête sur les 219 articles condamnés à Paris le 7 mars 1277* (Philosophes médiévaux 22, Louvain, 1977): 315–16; "Saint Thomas et l'intervention épiscopale du 7 mars 1277," *Studi* (Instituto SanTommaso, Roma) 2 (1995): 204–58; "Philosophie et théologie en conflit. Saint Thomas a-t-il été condamné par les maîtres parisiens en 1277"," *Revue théologique de Louvain* 28 (1997): 216–26; "L'implication de Thomas d'Aquin dans les censures parisiennes de 1277," in RTAM 54 (1997): 3–31; J. F. Wippel, *Mediaeval Reactions to the Encounter between Faith and Reason* (The Aquinas Lectures 59, Milwaukee, 1995); "Thomas Aquinas and the Condemnation of 1277," *The Modern Schoolman* 72 (1995): 233–72; "Bishop Stephen Tempier and Thomas Aquinas: A Separate Process against Aquinas?," FZPhTh 44 (1997): 117–36; J.M. M. H. Thijssen, "1277 Revisited: A New Interpretation of the Doctrinal Investigations of Thomas Aquinas and Giles of Rome," *Vivarium* 35 (1997): 72–101.

30. Giles of Rome, *Quodlibet II* q.2, in *Fertilissima Aegidii Romani quolibetta castigatissima Laurentii Amolini Rhodigini opera* (Venice: B. Locatellus, 1504), fol. 13ra: "In aliis ergo hominibus et

etiam in Christo natura humana existit, quia est coniuncta alicui esse; aliter tamen et aliter, quia in aliis hominibus natura est coniuncta esse creato et sustentatur in supposito creato, sed in Christo natura humana est coniuncta esse increato et esse divino et sustentatur in supposito increato sive in supposito divino; propter quod bene dictum est quod natura humana in Christo non est accidens. Sed habet quendam modum accidentis, quia sicut accidens non constituit aliquod suppositum sed sustentatur in supposito iam constituto in esse, et hoc modo existit per esse suppositi, ita quod accidens non est existens nisi quia est existentis, sicut humana natura in Christo non constituit aliquod suppositum sed sustentatur in supposito divino iam constituto in esse et existit per esse illius suppositi."

31. Giles of Rome, *Quodl. II* q.2 (Venice, 1504, fol. 12v): "Aliter enim dicimus existere substantiam et aliter accidentia. Substantia quidem existit quia habet suum proprium existere; ideo dicitur per se esse quia esse per se competit ei. Non est enim substantia, loquendo de substantia composita per esse in alio vel per esse alterius, sed per suum esse proprium. Accidentia autem existunt non quod habeant per se esse nec quod habeant proprium existere sed quia sunt in existente et existunt per existere subiecti. Substantia ergo per suum esse existit et subsistit; accidentia vero per illud idem esse et per illud idem existere existunt sed non subsistunt."

32. Giles of Rome, *Quodl. II* q.2 (Venice, 1504, fol. 13ra): "Sic itaque in Christo est unum suppositum, scilicet divinum sive suppositum increatum, ut omnia dicta Sanctorum canunt, et in illo supposito divino ab aeterno producto per eius esse sustentatur natura humana quam accepit in tempore."

33. Giles of Rome, *Quodl. II* q.2 (Venice, 1504, fol. 12vb): "Sicut ergo si albedo deberet separari a subiecto non posset per se existere nisi ei communicaretur aliquod esse vel nisi separaretur cum esse quod habet in subiecto, quia essentia creata non potest existere sine esse. Nunc autem existens in subiecto existit, quia est in existente et existit per esse subiecti. Sed si humana natura deberet separari a supposito Verbi, tunc faceret suppositum et existere per esse proprium. Nunc autem coniuncta Verbo existit per esse Verbi." Cf. Giles of Rome, *In III Sent.* d.6 p.3 q.unica a.2, *In tertium librum Sententiarum eruditissima commentaria cum quaestionibus* (Rome, 1623), 257–62.

34. Bernard of Auvergne, *Improbationes contra Godefridum*, ed. E. Hocedez, in *Quaestio de unico esse in Christo a doctoribus saeculi XIII disputata* (Rome, 1933), 108–9: "Dicendum quod natura humana in Christo habet existere quale debetur formae in supposito, ut dictum est. Non autem debetur formae substantiali in supposito per se existere, sed ipsi supposito, et ex consequenti formae, et quasi per accidens." Bernard (*Improbationes,* 111) distinguishes *esse ex consequenti et quasi per accidens* from *esse secundum quid* to distinguish between the kind of existence that the human nature of Christ gives and the kind of existence that an accidental form gives.

35. Bernard of Auvergne, *Improbationes* (ed. Hocedez, 109–10): "Et sic omnino est in Christo. Unde dicendum quod habet natura humana in Christo esse formaliter, sicut in aliis, id est: esse suppositi; ex consequenti ipsa dat etiam supposito esse essentiae, quia facit illud suppositum hominem formaliter, et animal, et sic de aliis quae sunt essentialia homini. Sed quod dicit: quod, cum forma humana informet materiam, oportet quod det esse; —dicendum quod, quando forma humana sic informat materiam, quod non supponit aliquid quod habeat esse simpliciter quod tamen non est ipsius, sed suppositi. Sed in Christo aliquantulum degenerat natura in accidens, secundum Damascenum, quia advenit supposito habenti esse simpliciter et ideo non dat sibi esse simpliciter, sed esse hoc, id est humanum; sicut etiam forma accidentalis, quia advenit habenti esse simpliciter: et ideo non dat sibi esse simpliciter, sed esse hoc, id est humanum; sicut etiam forma accidentalis, quia advenit habenti esse simpliciter, non dat esse simpliciter, sed esse hoc, scilicet accidentale esse. Hoc tamen [esse] quod dat natura humana, licet adveniat enti in actu, non est accidentale, id est quod sit in genere accidentis, sicut esse album quod albedo dat Christo; sed est in genere per reductionem; sicut ipsa essentia quam natura humana dat Christo, est per se in genere vel facit Christum per se esse in genere substantiae, animalis, et corporis. Nec etiam est intelligendum quod illud esse humanum, quod formaliter dat natura humana, sit aliud ab esse simpliciter suppositi divini: immo est idem simpliciter; sed quod illud esse simpliciter, quod est divinum, refertur ad naturam humanam, ut sibi unitam, vel magis supposito divino cuius proprie est esse, secundum hoc dicitur humanum. Non ergo natura humana in Christo dat esse simpliciter, quia illud aeternum est, sed trahitur ad illud esse simpliciter; et ipsa facit formaliter illud esse divinum esse humanum; in aliis autem a Christo, facit utrumque, quia et dat esse simpliciter et illud esse simpliciter formaliter facit esse humanum; sed in Christo unum tantum propter hoc quod advenit habenti esse simpliciter."

36. Hervaeus Natalis, *In III Sent.* d.6 q.1 a.3, *In quatuor libros Sententiarum Commentaria, quibus adiectus est eiusdem auctoris Tractatus de potestate papae* (Paris, 1647), 295: "Dicunt aliqui quod licet necessarium esset esse sequi naturam humanam, tamen quia assumpta est ad esse alterius suppositi, ideo caret in Christo proprio esse. Quia impossibile est in eodem supposito esse plura esse

substantialia, quia tunc esset plura supposita. Et volunt imponere hoc scilicet Thomae, quia videtur verba sua hoc sonare, quia secundum eum impossibile est in eodem supposito esse plura esse simpliciter." The theory that holds for two existences in Christ was defended by other Dominicans (John Picardi of Lichtenberg, John of Naples). We shall return to this point at the end of our article.

37. Hervaeus Natalis, *In III Sent.* d.6 q.1 a.3 (Paris, 1647, 295): "Et ideo est alia opinio quae dicit quod esse humanae naturae remansit in Christo, sed non sub ratione esse simpliciter sive sub ratione eius quod est subsistere."

38. Hervaeus Natalis, *In III Sent.* d.6 q.1 a.3 (Paris, 1647, 295): "Dicunt ergo quod esse humanae naturae remansit in Christo non sub ratione esse simpliciter sive sub ratione subsistendi, sed sub ratione inessendi. Quia illud esse non est ipsius naturae in se, quia ipsa non est; sed est ens in ordine ad aliud cui innuitur."

39. Hervaeus Natalis, *In III Sent.* d.6 q.1 a.3 (Paris, 1647, 295): "Et [quod] hoc sit rationabile potest sic apparere. Quia sicut ens quod est substantia se habet ad hoc quod sit quoddam inens, ita esse substantiale se habet ad hoc quod possit esse quoddam inesse sive inexistere. Cum ergo natura substantialis quae secundum se nata est constitutere ens simpliciter, virtute divina fiat quoddam inens, ita etiam non est inconveniens si virtute divina esse substantiale creatum, quod de se natum est esse quoddam esse simpliciter, fiat quoddam inesse. Ita quod illud esse cum esse divino non faciant duo supposita, sed concurrant ad unum suppositum, ita quod unum eorum non sit esse simpliciter, sed inesse. Et haec positio videtur mihi probabilior."

40. Hervaeus Natalis, *In III Sent.* d.6 q.1 a.3 (Paris, 1647, 295–96): "Quod autem haec, et non alia immediate posita, fuerit de mente [fratris] Thomae patet respicienti ipsum in 9 Quodlibet q. 2 articulo primo et secundo, ex hoc quod semper in fine deductionum suarum concludit quod non est in Christo nisi unum esse personale. Sed quia ipse dicit in tertia parte quod si natura humana adveniret personae divinae accidentaliter essent ibi plura esse, nunc autem, quia in unitate supposti assumitur, non est ibi nisi unum esse simpliciter supposti sive esse personale.

Ex quo videtur quibusdam quod intentio eius sit quod actus essendi naturae humanae nullo modo manet, nec scilicet ut inesse, quia tunc esset accidentale; multo autem minus potest manere ut subsistere, sicut patet ex supradictis. Sed hoc dicentes non attendunt differentiam inter accidere quod convenit accidenti proprie dicto, sicut albedo dicitur accidere homini, et accidere substantiae secundum quod una substantia dicitur accidentaliter advenire alteri, sicut vestis advenit homini. Quia plurificato primo cui advenit esse, non plurificatur esse supposti, sicut in homine albo et calido non sunt duo esse supposti. Sed quando una substantia advenit accidentaliter alteri, ut vestis homini, non tollitur diversum esse supposti ex tali accidente, sive ex adiuncto accidentali. Unde homo [et] vestis sunt duo supposita. Unde homo non est vestis, licet sit vestitus. Similiter, si humana natura quae substantia quaedam est, adveniret accidentaliter personae divinae, sicut vestis advenit homini, tunc essent duo esse supposti, et duo esse simpliciter. Nec posset dici de homine, licet posset dici aliquo modo humanatus, id est, humanitati aliquo modo coniunctus, sicut non dicitur homo vestis sed vestitus."

41. In his *Quaestiones disputatae*, John Picardi of Lichtenberg defends a twofold existence in Christ and argues that this is Aquinas's position in *De unione Verbi incarnati* (BAV, Cod. Vat. lat. 859, fol. 157rb): "Considerandum tamen quod Thomas posuit in quaestionibus disputatis de virtutibus, quaestione ultima, articulo 4, in principali ratione, quod in Christo est duplex esse, [esse] supposti scilicet principale quod est aeternum, et secundarium quod est temporale." Likewise, John of Naples in his *Quaestiones variae Parisiis disputatae* q.9 (Naples, 1618, fol. 83rb) defends the same theory and interpretation of Thomas: "Illud in quo est duplex natura substantialis quantum ad rem, quarum una est substantialis quantum ad modum, alia non, et in quo est multiplex essentia accidentalis quantum ad rem et modum, est etiam multiplex esse per correspondentiam se habens ad praedictas essentias. Christus est huiusmodi. Ergo etc. Maior patet. Minor supponitur ex fide. Et haec sint dicta sine praeiudicio cuiuscunque, opinative, scilicet, absque assertione, maxime si contineret aliquid, quod videatur contrarium dictis reverendi Patris Doctoris omnium et Magistri fratris Thomae de Aquino."

42. Durandus, *In III Sent.* d.6 q.3, in *D. Durandi a Sancto Porciano ord. Praed. et Meldensis episcopi in Petri Lombardi Sententias theologicas commentariorum libri IIII*, 2 vols. (Venice, 1571), vol. 2, fol. 225ra: "Secundum patet dupliciter. Primo, quia magis competit naturae humanae in Christo habere proprium esse praeter esse supposti quam competat accidenti habere proprium esse in subiecto praeter esse subiecti; sed accidens habet proprium esse in subiecto praeter esse subiecti; ergo natura humana in Christo habet proprium esse praeter esse supposti."

43. Quoted in Etienne Gilson, *History of Christian Philosophy in the Middle Ages* (New York, 1954), 474.

Jesus as the First Dominican?
Reflections on a Sub-theme in
the Exemplary Literature of
Some Thirteenth-Century Preachers

Richard Newhauser

THE THEME OF Christian authority takes as its subject the authoritativeness of Jesus and who will speak for that power in the Christian life. As Gillian Evans has written:

> All talk of authority in the Church is concerned with the ways in which this authority operates in and through "the common life in the body of Christ," so that the community as a whole and every individual member may be equipped "so to live that the authority of Christ will be mediated through them."[1]

This mediation involves questions of leadership in belief as well as power over action; in the ideal of the Church, at least, there is an inevitable linkage between the two sides of this balance, that is, between "authority as truth-maintaining and authority as power to legislate and administer," a linkage which permeates every level within the community of the Church.[2] The vehicles mediating such authority from the leadership of the Church to the common people developed over time in the medieval period and were varied; they included, besides ecclesiastical functionaries among the secular clergy themselves, the figure of the teacher, or lay authors of many different types, and they eventually came to include the mendicant orders.

The pressures for reform in the elements of Christian authority were greatest where and when the perception of disparity between the authority of Jesus and that exercised by actual ecclesiastical institutions was the greatest. Such a moment, decisive in the development of the medieval Church, occurred in the period that led up to the founding of the Order of Preachers, when the leadership of the Church attempted to counteract the effects of a perceived indolence of the secular clergy and monastic orders in educating the community of Christians, and of such heresies as that of the Albigensians and others in southern France, by making room for apostolic movements within the structure of the Church's legitimate authority. Church leaders hoped that such accommodation would reestablish the institution's power among the broad masses.[3] The disparity between an "intellectual elite" in the centers of scholarship that had been established throughout the twelfth century, on the one hand, and the mass of uneducated Christians, on the other, is not simply testimony to a scholastic crisis, as Pierre Mandonnet termed it,[4] but also to a disparity in the elements of Christian authority. The efforts of the Church to reaffirm the bonds of its power at all levels in the early thirteenth century by reinstructing the common people in the faith and in

the need to combat vice—tasks begun at the Third Lateran Council (1178) and then officially established at the Fourth Lateran Council (1215)—deserve to be termed "popular" insofar as they were conceived with the needs of the common people in mind. (It is clear, however, that the moral impact of this ecclesiastical project on the Christian laity is rather difficult to measure in exact terms.[5]) Among the new structures established to participate in this project, the mendicant orders took it as their ideal to emphasize the pedagogic goals—as they perceived them—of the central figure of authority in Christianity, and to do so by incorporating the life of Jesus in their own lives. In the popular imagination of our own day, the Franciscans have long been viewed as the most successful in putting this ideal into practice, and in embodying most fully the life of Jesus in their own lives. Jaroslav Pelikan, for example, has written:

> in the life of Francis of Assisi the imitation of the life of Jesus and the obedience to his teachings (which were, at least in principle, binding on every believer) attained such a level of fidelity as to earn for him the designation, eventually made official by Pope Pius XI, of "the second Christ" [*alter Christus*].[6]

But the imaginative life of Dominic and his followers, expressed through the ideals of the apostolic calling and the task of preaching to the laity (which was specific to the Order and required its attention to a careful plan of education), was not molded any less by the authority of Jesus. Indeed, a number of the literary productions of thirteenth-century Dominicans and others attest to the perception of the Preachers as mediating the authority of Jesus to the Christian masses by appealing to specific qualities in the life of Jesus and the apostles.

As Jean-Pierre Renard has shown, apparently there are not many texts describing the formative period of the Dominican Order that explicitly refer to the imitation of Jesus, or to "following Jesus," as the authoritative model of Dominican behavior, however much this might be inferred from the actions of those involved in the earliest stages of the Order's development. There are, nevertheless, enough documents that invoke the idea of *imitatio Christi* in their description of the early Dominicans to show that they, as well as the Franciscans, were perceived as following in the footsteps of Jesus. In 1206, for example, Pope Innocent III wrote that in southern France, Diego of Osma, Dominic, and their companions were carrying out the task of preaching, and "imitating the poverty of the poor Christ, in clothes which are looked down on but with a glowing spirit, they are not afraid to go out among people who are looked down on."[7] Somewhat later, a charter of Bishop Fulk from June or July 1215, describing the friars of the community of Toulouse, notes that they, "choosing evangelical poverty for Christ, are exerting themselves and endeavoring to enrich each and every person with heavenly rewards by example and by teaching."[8] And in the period 1218–1219, one of the early papal bulls dealing with the Order described the Preachers as friars who "freely and faithfully declare the word of the Lord, and being eager for the perfection of souls, they who have followed the Lord himself alone have preferred the signs of poverty."[9]

Renard observed that in these early texts describing the specifically Dominican imitation of Jesus, as in most texts of the same kind written in the twelfth century and before, the concept of "following Jesus" is connected with the idea of poverty. This

remains true as well for other observers of the early Dominicans. About 1221 Jacques de Vitry described the Preachers in Bologna in this idealized way:

> Since they are so unimpeded, they hasten after the Lord and, naked, they follow the one who is naked, because they have entirely rejected the care for all external matters and the possession of worldly goods, considering as waste matter everything transitory, so that they might gain Christ.[10]

Such depictions are clearly modeled on the description of the evangelical calling in 1 Peter 2:21 ("For to this you have been called, because Christ also suffered for you, leaving you an example, that you should follow in his footsteps"), and they make clear the consciousness of the authoritative role played by the model of Jesus in accounts of the earliest Dominican activity.[11] They describe a number of qualities that characterize the Dominicans by their most fundamental mission, that is, preaching, and by their method of pursuing this mission, that is, through poverty and with glowing spirit, all of which are related to "following Jesus."

In treating the place of Jesus in the formative period of Dominican history, one must rely almost exclusively on external witnesses to the mission of the earliest Preachers, who left few texts of their own. After this period, however, the Dominicans soon produced a vast number of texts that reveal how they imagined the central figure of Christian authority in their practical work. A distinguishing mark of this literature, especially in preaching materials, is the use of *exempla*, which either employed a carefully developed narrative as a rhetorical device, or which proceeded more by allusion to already well-known actions and deeds from the biographies of exemplary people, especially the lives of Jesus and the apostles. The latter served the Preachers as models for behavior and raised the sermon narratives themselves to a sacramental level.[12]

These *exempla*, as all of the new sermon narratives developed by the mendicants in the thirteenth century, were intended in particular for the bourgeoisie or an urban aristocracy.[13] Among this audience, as Larry Scanlon has recently observed, the "sermon exemplum will amplify the deference to institutional authority already present in the monastic tradition, and it will make increasingly abstract the participation it allows in the sacral power of such authority."[14] One may note such abstraction in the way in which the early Dominican *exempla*-collections were organized around theological concepts, not set in the context of the *vitae* of individual speakers. The *exempla* in these texts carry further the same matrix of qualities operative in the Dominican imitation of Jesus and the apostles that the earliest observers of the Preachers had already identified.

Three early French Dominican writers on moral topics, which were prominent in the basic instruction to the *fratres communes* and thus in the pursuit of the Order's fundamental mission, stand out for their use of *exempla*. William Peraldus, Stephen of Bourbon and Humbert of Romans form a cohesive and intertwined group: they were connected through some of the same Dominican convents, served some of the same functions in the Order, and pursued many of the same literary goals. All three were born in France: Stephen about 1190–1195 in Belleville-sur-Sâone; William probably before 1200 in the village of Peyraut, near Vienne; and Humbert ca. 1200 at Romans, near Valence. Stephen and Humbert studied at the university in Paris; William may

have done so as well. It is possible that all three met at the priory of Saint-Jacques while they were in Paris, but they clearly did so in Lyon, because when William entered the order in that city in the 1230s, Stephen was already a friar there and Humbert was prior.[15] William himself was elected prior in Lyon in 1261 and may have served until 1266.[16] There is, of course, much that is individual in their careers—Humbert eventually became Master General of the Order, Stephen traveled extensively in France as an inquisitor, while William took no "public" role but remained a conduit of traditional theological literature at some distance from the activity of the universities—but all three testify to the importance of moral literature in Dominican instruction and the preparation of sermons. As stated, this literature above all was meant to benefit the *fratres communes*, who were carrying out the Order's specific tasks of hearing confession and, especially, preaching to the masses.[17]

William, Stephen and Humbert each wrote important texts to support the teaching of morality and basic instruction for preaching. The first section of William Peraldus's double *Summa*, which deals with the vices, was completed about 1236; the second part, which is devoted to the virtues, was finished ca. 1248. Both parts of the treatise circulated together by 1250. William's *Summa* is by far the most widely disseminated of any of the works by these three authors, or, for that matter, of any other treatise on vices and virtues produced in the Middle Ages. As Leonard Boyle has pointed out, it had a secure place in all Dominican libraries: Humbert noted, after he had retired from being Master General of the Order in 1263, that every priory should have good copies of basic texts used by the lectors for teaching, among them being Peraldus's *Summa de vitiis et virtutibus*.[18] For this reason, as well as because of its comprehensiveness, there are untold hundreds of copies of this work and a plethora of derivatives of it still to be examined.[19]

In its contents and structure, the *Summa de vitiis* is distinctive in the history of treatises on the vices. It is composed of three sections: one book on the vices in general, followed by seven books on the deadly sins, concluding with a book on the sin of the tongue (*peccatum linguae*). The books on the deadly sins do not follow the accepted order of vices inherited from Gregory the Great, but rather follow the order of gluttony, lust, avarice, sloth, pride, envy, wrath; this list, one should note, shows signs of contact with ascetic lists of sins in that it begins with the battle against corporeal vices. Peraldus's concluding book on the *peccatum linguae* is one of the most important early and extensive treatments of the subject and, along with the analysis found in the *Summa fratris Alexandri*, a major influence on later medieval pastoral literature dealing with this scheme of sins.[20] William's *Summa de virtutibus* documents how little unity was to be found in systems of the virtues independent of treatments of the vices, for it contains (1) an opening book on virtue in general; (2) one general tractate and three specific sections on the theological virtues; (3) one general and four specific tractates on the cardinal virtues; (4) one book on the gifts of the Holy Spirit, and (5) one book on the beatitudes. Besides being the basic Dominican textbook on vices and virtues, the *Summa de vitiis et virtutibus* also served as a storehouse of exemplary material, a fact that is demonstrated by the many notations drawing attention to its *exempla* in the margins of manuscripts of the work.[21]

Stephen of Bourbon's *De septem donis Spiritus Sancti*, composed between 1250

and the time of the author's death in 1261, is a carefully organized *exempla*-collection that contextualizes the narratives as part of a theological treatise, with generally brief introductions to the *exempla* describing their moral usefulness and giving them a thematic framework. Stephen focused his treatise on a topic that formed only one section of Peraldus's treatment of the virtues; he apparently had the same type of audience in mind, for in the prologue he says that he is writing *ad usum rudium*. As extensive as Stephen's work is, however, it is unfinished, probably (as has been argued by others) because he died before he was able to complete it. The gifts of understanding (*intellectus*) and wisdom (*sapientia*) are missing from what the prologue describes as a treatment of all seven gifts, so that the work treats only the five remaining gifts: fear of the Lord (*timor*), piety (*pietas*), knowledge (*scientia*), fortitude (*fortitudo*), and counsel (*consilium*).[22] Stephen names most of his sources in the prologue and at the beginning of the *exempla*; among these sources, he notes that he has taken material "from the *summae* and books of the masters, and chiefly from the *summae* on vices and virtues by brother William Peraldus of the Order of Preachers."[23]

Humbert of Romans' *Liber de dono timoris*, or *Tractatus de abundantia exemplorum*, is clearly related to Stephen of Bourbon's *De septem donis*, suggesting that Humbert wrote his work sometime during the period when Stephen was completing, or had completed, the first book of his *exempla*-collection. (Thomas Kaeppeli notes only that Humbert's *Liber de dono timoris* was composed ca. 1240–1277.) Humbert's text had a good deal of success among preaching aids in the thirteenth and fourteenth centuries. As William A. Hinnebusch has pointed out, at the beginning of his text Humbert announces briefly that he will treat all seven gifts; he apparently never carried out this plan beyond the *donum timoris*, which he terms the *prima pars* of his work, but which is the only one that he composed or is at least the only one that has survived. Immediately preceding the table of contents, Humbert notes:

> Still, since all the material in a sermon of edification can be reduced to the seven gifts of the Holy Spirit or to matters connected with them, the present treatise is divided into seven parts according to those gifts of the sevenfold Holy Spirit, which should be called upon in order to bring the task to a fruitful conclusion.[24]

In a number of cases Humbert and Stephen reproduce the same *exemplum*, but Humbert does not use the proper names found in Stephen's work, or he makes the events recounted more dramatic, and generally he presents the narratives in a much different and sometimes shorter form than Stephen.[25] Like William Peraldus and Stephen of Bourbon, Humbert also had in mind the task of preaching to a broad audience, for his prologue describes the efficacy of *exempla* in sermons meant for all types of people, and does so in words that are representative of the interest in *exempla* by all three of these writers:

> Since, according to Gregory, *exempla* are more moving than mere words and are more easily grasped by the intellect and are fixed deeper in the memory, and furthermore, since they are heard with greater pleasure by many and attract many more to sermons by the delight that they give, it is advantageous for men dedicated to the office of preaching to have an abundance of *exempla* of this kind, which they may use sometimes in popular preaching, sometimes in addresses to

people who are God-fearing, sometimes in informal discussions with every type of person, for the edification and salvation of all.[26]

In sum, William Peraldus's, Stephen of Bourbon's and Humbert of Romans' *exempla*-collections are rather closely related; all three writers designed their collections with similar intentions and for similar audiences, and they often used the same materials. William and Stephen give somewhat more space to *exempla* that present Jesus and the apostles as models for imitation than does Humbert, but all of them present enough *exempla* of this type.

As Bishop Fulk's early description of the Preachers in Toulouse intimated, and as the later words of the second Master General of the Order, Jordan of Saxony, concerning Dominic himself make explicit, the Dominican ideal was to "present oneself as a man of the Gospels in word and deed."[27] In part, what was at issue here was the legitimization of the Dominicans' apostolic life as a reform of those parts of the institutional Church that were perceived as having become too rich and too distant from the community of Christians to represent the authority of Jesus, especially in comparison with heretical movements that claimed as much apostolic authority as orthodox institutions. Stephen of Bourbon dramatizes this discrepancy between established religious institutions and the life of Jesus in a number of passages. In his treatment of the gift of *pietas*, for example, he writes of a novice,

> who had entered the Order of Preachers, and some monks wanted to remove him from it and get him to leave the order which he had entered and to entice him into their order. After they had said many things to him against the order he had joined and had mentioned many excellent qualities of their own order, he asked of them if the Lord Jesus Christ offered us a way of living righteously above all others and if his actions should be our custom. They said it was so. "Thus," he said, "since I read that the Lord Jesus Christ was not a white or black monk, but was a poor preacher, I choose to follow in his footsteps rather than those of anyone else."[28]

In his treatise on fortitude, Stephen applied this principle specifically to those who were preaching to the laity, noting that those who give a bad example should be ridiculed. The narrative which supports this statement, and which, besides in Stephen's work, was disseminated widely in other contexts, presents a high ranking cleric who preaches on Palm Sunday on the humility of Jesus and the humbleness of the donkey on which he rode, and who, after he has finished his sermon, mounts his horse in his fine robes. An old widow laughs at him to his face, asking, "O master, tell us, was this the kind of donkey and its rider or mounted figure about which you were speaking to us?"[29] Elsewhere, Stephen accounts for Diego of Osma's adoption of an apostolic way of life, and the origins of the Order of Preachers altogether, as a direct response to the challenge of Albigensians, who claimed for themselves the authority to preach on the model of Jesus's poverty, humility and abstinence.[30] Precisely the necessity of wedding speech and action in the apostolic calling was understood by Peraldus as deriving from the authority of Jesus himself, and not merely as a sign of sincerity. Thus, for example, among the illustrations of the foolishness of being with women who frequent dances,

which are presented in his treatise on lust in the *Summa de vitiis*, Peraldus uses the following material, some of which comes from the life of Jesus:

> Jeremiah was thinking of such a woman when he said, "Who will put water on my head and a fount of tears in my eyes, and I will weep for the dead of the daughter of my people?" [Jer 9:1]. Who would not shed tears where God himself admonishes to tears both by word and by deed? By word, as in Luke 6: "Blessed are you who weep now, since you will laugh" [Luke 6:21]. And afterwards: "Woe to you who laugh now, since you will mourn and weep" [Luke 6:25]. And by deed, as in Luke 19, where after the song and joy with which they received him when he arrived in Jerusalem, it is added, "And as he approached, he saw the city and wept over it, saying, 'If you, too, only knew,'" intimating that the song of this life and its joy proceed from blindness [Luke 19:41–42].[31]

There are, in fact, many more episodes from the life of Jesus and his interactions with his disciples that all three authors draw directly from scriptural accounts as *exempla* in order to present the biographies of Jesus and his apostles as a model for Christian behavior. In his *Summa de virtutibus*, Peraldus maintained that the example of Jesus' virtues is sufficiently efficacious to cure any vice.[32] One can note, as well, that the very rationale which Peraldus gives for the point at which his hamartiology begins is presented as an attempt to conform to the events of Jesus' life:

> As we are going to treat each of the vices, since the opportunity offers itself, we will begin with the vice of gluttony, and also because the *Gloss* says this about Matthew 4: "In Christ's conflict <with the devil>, the first action was taken against gluttony, since if this vice is not restrained first, one labors in vain against the other vices" [cf. Matt 4:3–4].[33]

This direct use of scriptural narrative supports the mendicant view that the authenticity of their actions was based on the fact that they lived their lives in conformity to the events recorded in the lives of Jesus and the apostles. As Alan Bernstein has noted, there is also a sacramental parallel between the Dominicans' insistence on *exempla* as the concrete embodiment of doctrine and the theological conception of Jesus as the incarnation of truth.[34] Even more, the central place of the life of Jesus in the exemplary literature of the early Dominicans also indicates an increased interest in the rhetorical and pedagogical value of the incidents of the life which Jesus lived as a man, the humanity of the figure of Jesus, as a model for the mendicants' own lives, and as a corrective to some of the beliefs of the Albigensians and other heretical movements. As Jaroslav Pelikan has written, again about Francis of Assisi but with nearly as much validity for the early Dominicans, "If Jesus were now finally to be taken with utmost seriousness, he had to have an authentic image here within human history."[35]

In early Dominican exemplary writings as in those texts by the Grey Friars evoked by Pelikan, one finds a comparable emphasis on *exempla* dealing with the most emotional and moving moments of Jesus' life: his infancy and the events surrounding his death. Taken as a whole, these reflections on the life of Jesus and the apostles as models for the behavior of the early Dominicans themselves form, if not a constantly reiterated theme, at least a frequent sub-theme in the works of the writers examined here. An entire section in Stephen of Bourbon's treatise on *pietas* is devoted to "the considera-

tion of the benefits of the Incarnation and Passion of Christ."[36] In this section, Stephen presents *exempla* that illustrate the efficacy of meditation on the innocence of Jesus' birth in producing remorse for sin and an acceptance of grace; for example, one story relates how a former secular cleric merely had to consider the infancy of Jesus for temptation to be no longer a threat to him, though this method for avoiding sin only became effective after he had joined the Order of Preachers. The suffering of the body that was to be endured in the apostolic life and in following Jesus deepened the friars' awareness of Jesus' suffering humanity. Humbert notes that "there are, moreover, many reasons why we ought to expose the body to afflictions and death, if this would be necessary for the service of Christ";[37] among those reasons, he gives the examples of acting out of the "consideration and future repayment by Christ, who for the base-born body consumed in his service will repay one more handsomely at the resurrection," and acting on the example "of the death of Christ, who 'surrendered himself' for us in death according to the Apostle in Ephesians 5" [Eph 5:2].[38]

The qualities of Jesus' life and the acts of the apostles emphasized by the early Dominicans in their *exempla* reflect the issues that moved them in their own study and preaching duties; to support these tasks, which were integral to their mission, they appealed to the authority of Jesus. In their vision of Jesus' human suffering, which framed part of the emotionality of his life, Dominican writers especially emphasized Jesus' poverty. Thus, for example, in his treatment of the sin of the *proprietarius* in his treatise on avarice, Peraldus rules out the possession of property by religious:

> The wisdom of Christ was to prefer poverty to riches, and being uncomfortable to pleasures. Whence in Hebrews 12 one reads about him that "for the joy that was set before him he endured the cross" [Heb 12:2]. About this passage Augustine says, "Christ as a man hated all worldly goods in order to demonstrate that they are worthy of contempt, and he endured all worldly evils, which he taught must be endured, so that happiness would not be sought in these things, nor unhappiness feared in them."[39]

What was most disruptive for Peraldus—who was thinking here of those members of the hierarchy of the church of his day who were not committed to the apostolic goals of the Dominicans—was the retailing mentality within the Church. In his treatment of the avarice of such retailers, which, as he notes, is very harmful to ecclesiastical institutions, he addresses the question of the poverty of the primitive church. Someone might inquire, Peraldus states, why Jesus did not want temporal matters to be connected with spiritual ones in the first church, since the spirit is connected to the flesh in human beings. Were not temporal matters put to the use of spiritual ends later on? This is true, Peraldus responds, but Jesus wanted ecclesiastical leaders to be free of the desire for wealth:

> For he wanted reprovers of temporal matters to be the rectors of his Church and not lovers of temporal matters. Whoever wants to guard himself from flies must guard himself from milk and from honey, which flies love. Christ foresaw that lovers of temporal matters would steal the Church from him, if they connected worldly profits with their spiritual duties. Whoever wants something to be torn to pieces by dogs should wrap it with meat. Whence, blessed Anthony taught a

monk who possessed money that he should buy pieces of meat with the money and carry them all over his naked body, and when the monk did so, he was torn to pieces by dogs. A fish gulps down a hook since it has been wrapped around with food, although its death lies hidden there. Similarly, hawks also swallow intestines. In the same way, lovers of temporal matters, to their damnation, take on church offices that are connected with worldly matters, and they seem to follow Christ, although they follow worldly matters alone.[40]

Peraldus was adamant about freeing mendicants from all direct concern for material goods, maintaining even that small, isolated priories where friars live alone or with only one other companion are spiritually dangerous, in part because of the necessity of having to deal with temporal matters all the time; in these small priories, Peraldus says, the spiritual life is destroyed, and in them one finds the vice of ownership, obedience dissipates, and chastity is easily endangered.[41]

However categorical Peraldus's statements about poverty may sound, he was in fact most concerned with correcting the vices associated with *excesses* in the ownership of property by Christians of every kind, not generally with the fact of possession itself. As he notes in writing of the remedies for gluttony, one must avoid superfluities connected with food, not attempt to fast as much as possible in ascetic denial:

> The seventh remedy is the consideration of the penury of Christ, both his own and that of the members of the Church. About the former we are warned in Lamentations 3: "Remember my poverty, and the transgression, and the wormwood and gall" [Lam 3:19]. His poverty, which was also in the members of the Church, ought very much to keep people from the superfluity that they create in their banquets, when they consider how much poverty Christ endures among the poor and those who are afflicted with fatal illnesses, who are sometimes scarcely able to possess any bread.[42]

The corollaries of this view of penury are that while enduring such poverty is part of the apostolic life, it is not a superhuman task, fit only for ascetics, and that wanting to avoid apostolic poverty is an indication of excessive fear itself. Humbert has this in mind when he points to the immoderate behavior to which the fear of poverty may lead someone:

> Likewise, to worldly fear pertains the immoderate fear of having to endure poverty, either because of shame or the difficulties of poverty or other causes less reasonable, and this fear is also always evil and in hard times it is the occasion for many unfortunate occurrences. For sometimes it is the occasion for the denial of God. An example of this is Theophilus who had been dispossessed of wealth and great honors into a state of severe poverty, and when the devil came into his presence and promised him riches and honors if he would deny Christ, he denied him so that he could avoid poverty in this way, just as it is said in the *Book of the Miracles of the Blessed Virgin*.[43]

There are, of course, limits to the property the early Dominicans would do without, as one might note from the kind of *exempla* they do not use. Peraldus's presentations of Jesus' poverty as a remedy for avarice draw ultimately on the arguments developed first

by anchoritic writers in late antiquity, as the reference to the hermit Anthony in the *exemplum* quoted earlier makes clear. But besides the avoidance of money, the ideal of total possessionlessness found among ascetic writers from the later fourth century to the end of the Middle Ages is also represented in a widely circulated apophthegm, often a companion of the *exemplum* about Anthony, which makes books just as suspect as money. The literal understanding of Matthew 19:21 in early ascetic communities is well illustrated by the anecdote of the monk who possessed only a copy of the Gospels. He disposed of it eventually, saying, "I have sold the word which said, 'Sell everything you have and give it to the poor.' "[44] Precisely the possession of books, on the other hand, was defended by the early Dominicans as essential for their task of preaching. Humbert, indeed, noted that one must concern oneself with the correct use of books, finding even for that a precedent in Jesus' life, namely the passage in Luke in which it is reported that Jesus read the text of Isaiah in the synagogue before preaching, and when he was finished, he carefully closed the book and gave it back to the attendant [Luke 4:20].[45] In fact, in early Dominican exemplary literature's treatment of Jesus' and the apostles' penury, and of their legitimate possession of some forms of material wealth, there is nothing that disagrees with later statements made by Robert Kilwardby. In his *Letter to Dominican Novices*, probably written about 1270 when he was Provincial of the English province, Kilwardby distinguishes Dominican attitudes towards poverty from more ascetic ones held by some Franciscans, among others:

> Who would dare deny that the poverty of Christ and his disciples was more perfect than that of any other? Well, we read that that most perfectly holy company of Christ and his disciples had purses and carried in them what they were given for their livelihood and bought food from them. . . . We know that the Order of Preachers lives in just the same way, with the addition that they own houses and gardens and schools to hold their teaching in.[46]

As Humbert's reference to Jesus' preparation for preaching intimates, early Dominican exemplary literature likewise supports the mission of preaching with the authority of Jesus and the apostles. In an overview of the use of *exempla* throughout history down to his own day, which he provides in the preface to his *Liber de dono timoris*, Humbert notes further that the authority of Jesus can support the use of *exempla* in preaching: "Did not the Savior himself," Humbert asks, "say almost everything through likenesses and *exempla?*"[47] The model of Jesus supplied Peraldus with the necessary connection between the afflictions of the apostolic life and the mission of preaching, which was one of the specific tasks of the Order. While treating one of the remedies for sloth in the *Summa de vitiis*, Peraldus quotes Bernard of Clairvaux on this subject:

> For the hatred of sloth, the examples of good people might also be fitting. And of the many, we will mention a few. . . . Concerning Christ one also reads in John 4 that he was "weary from the journey and sat down by a well" [John 4:6]. And in many other places in the Gospels one reads of his labor. Whence Bernard: "As long as I live I will remember the labors which Christ endured in preaching, the

weariness in discoursing, the temptations in fasting, the vigils in praying, the tears in showing compassion. . . . "[48]

Elsewhere, Peraldus supports the efficacy of apostolic afflictions in general by appealing to the authority of Jesus. Thus, he follows Gregory the Great in noting that although it might seem to someone in the throes of afflictions that he has been abandoned by Jesus, he is in fact being instructed:

> Thus, God acts towards the Church as one reads that Alexander acted, who encircled a certain wooded area with fire because of the snakes. Thus Christ encircles the Church with the fire of tribulation because of infernal snakes.[49]

Moreover, Peraldus supports the ennobling experience of countering temptation by referring to a well-known *exemplum* that relates Anthony's complaint to Jesus:

> Whence, one reads concerning the blessed Anthony that when he was being tortured by demons one night, suddenly a ray of light drove away both the demons and the darkness, and being healed immediately and understanding that Christ was present, he said, "Where were you, oh good Jesus, where were you? Why were you not present from the beginning to cure my wounds?" And a voice said to him, "Anthony, I was here, but I was waiting to see your struggle, and now that you have fought courageously, I will make you renowned throughout the entire globe."[50]

What the exemplary literature by the early Dominicans shows they wanted to achieve by their imitation of Jesus in poverty and their popular preaching was to inflame the hearts of their listeners with zeal for the teaching of the Church. Essentially, the Dominicans were continuing that characteristic which Innocent III had identified in the earliest mission of Diego of Osma and Dominic, namely, to go out among the community of Christians "with clothes that are looked down on but with glowing spirit." Obviously, their intent was to transmit this enthusiasm to those listening to their sermons, and as one might expect from all that we have seen so far, this goal too was supported by the authority of Jesus. Peraldus makes this plain in his treatise on lechery, in the chapter "On the sin of old wives who counsel others to commit villainy," where he uses the symbolism of the tongues of fire that appeared above the apostles (Acts 2:3):

> Such old wives appear to be from the devil's own retinue. And just as Christ wanted tongues of fire to appear above the apostles to demonstrate that it was their duty by their words to ignite people's hearts with a heavenly fire, so if the devil wanted to demonstrate to people the duty of these old wives, he would cause tongues of fire from the stinking fire of hell to appear above them.[51]

Stephen of Bourbon devotes the fifth chapter of his treatise on *pietas* to the "diverse effects brought about by the cross and Christ's Passion," noting that primary among the reactions to be achieved in the listeners is to cause them to be inflamed with love for Jesus. In one of the *exempla* he cites to support this idea, a number of the themes already identified in the exemplary texts by the early Dominicans converge in the emotional preaching inspired by Jesus' Passion, and show one way in which they were

envisaged to spill over to the listeners. The *exemplum* concerns a cleric who, in his sermon on the crucifixion, preached that he had read in a romance of King Arthur that Arthur would refuse to eat at feasts until some new or marvelous occurrence took place at his court. Once, while he was waiting for such a thing to happen, a ship sailed up without a helmsman, and Arthur's knights found a dead knight lying in the ship, wounded, pierced by a lance, and bleeding. In the dead knight's treasure chest they found texts relating that he had sought justice at a court where the courtiers had unfairly killed him. These texts so stirred up the members of the Round Table that they all took up arms to avenge this innocent man. If, notes Stephen, this narrative is not literally true, it is nevertheless true as a likeness:

> since Christ, our warrior, appears on the ship of the cross, killed for us in spite of his innocence by Jews and pagans, which events the holy Gospels show us, which went out from the treasure chest of his heart, as if from texts dealing with the deceit against him. These matters ought greatly to move noble hearts to take up arms to avenge this treachery.[52]

Stephen of Bourbon seems to have been writing here with the specific goal of inspiring crusaders, something which he does on numerous occasions elsewhere in his *exempla;* his transformation of an actual piece of Arthurian fiction, *La Vengeance Raguidel,* composed in the first quarter of the thirteenth century, perhaps by Raoul de Houdenc, is a clever appeal to those who would have been moved by stories of Arthur's knights to harness their energies for Christianity.[53] This is not the only *exemplum* in which Stephen used the figure of Arthur—he also adopted a story of Merlin and a young girl in tears as a narrative of the Last Judgment—nor is his transformation of a tale of Arthur and his knights in the service of Dominican spirituality isolated in the history of Arthurian literature in the thirteenth century. The *Queste del Saint Graal,* for example, also gives evidence, a few decades before Stephen's work, of a Christian, perhaps more specifically Cistercian, reconstruction of material in the cycle of Arthurian tales.[54] But beyond this, Stephen's *exemplum* is something of a model for the depth of emotionality to be elicited by the preaching of the Passion, placed in the human context of the suffering of Jesus. The exegesis on which it depends is another way of asserting the primacy of Christian authority by returning attention to the subject of that authority.

The image of Jesus that emerges from these practical-minded early Dominican writers of exemplary and moral literature emphasizes those traits they themselves were attempting to incorporate into their role as mediators of the Church's authority to the Christian masses, which they were carrying on from the earliest Dominican mission. They defended their authenticity by referring to the life they led in imitation of the life of poverty led by Jesus and the apostles, and by referring to scriptural images of preachers in the midst of the community who stirred people's hearts. These functional characterisitcs, which were closely comparable to the ideal of the early Dominicans' own role, were projected, as I hope to have demonstrated, in the model of Jesus which they emphasized in their exemplary literature. The result was a model which, if not in all details, at least in its major contours, had specific Dominican traits. In contrast, one should note how distant this image is from other models of Jesus available

to medieval writers, which are not found in the early Dominican *exempla* investigated here: the cosmic Christ of christianized Platonic philosophy, for example, or the bridegroom of the soul of Cistercian and other types of mysticism. The early Dominican model, in sum, was very much what was called for by practical-minded writers in a new institution charged with the practical tasks involved in reinvigorating the authority of the Church in thirteenth-century Christian society.

NOTES

1. Preface to *Christian Authority: Essays in Honour of Henry Chadwick*, ed. G. R. Evans (Oxford, 1988), v.

2. H. R. McAdoo, "The Influence of the Seventeenth Century on Contemporary Anglican Understanding of the Purpose and Functioning of Authority in the Church," in *Christian Authority*, ed. Evans, 253.

3. Simon Tugwell, Introduction to *Early Dominicans: Selected Writings*, ed. Tugwell (The Classics of Western Spirituality, New York etc., 1982), 10; Dieter Berg *Armut und Wissenschaft* (Geschichte und Gesellschaft 15, Düsseldorf, 1977), 16f.

4. Pierre Mandonnet, "La crise scolaire au début du XIIIe siècle et la fondation de l'Ordre des Frères-Prêcheurs," *Revue d'histoire ecclésiastique* 15 (1914): 34–49; reprt. in vol. 2 of Pierre Mandonnet, M. H. Vicaire and R. Ladner, *Saint Dominique: l'idée, l'homme et l'oeuvre* (Paris, 1938), 83–100.

5. For a reminder of the difficulty in quantifying this influence, see Rosalind and Christopher Brooke, *Popular Religion in the Middle Ages* (London, 1984), 123–25.

6. Jaroslav Pelikan, *Jesus Through the Centuries* (New Haven-London, 1985), 133.

7. *Monumenta diplomatica S. Dominici*, ed. Vladimír J. Koudelka, MOPH 25 (1966): 13 no 4 (Innocent III to Radulphus, Papal legate, 11 November 1206): "Quia vero zelus eius domus nos comedit, qui nobis immeritis concessit in eminenti specula residere, volumusque cum infirmantibus infirmari et apponere paterna consilia quibus exhibeatur vulneribus medicina, ut curam quantum in nobis fuerit suscipiat etiam plaga tumens, discretioni tue per apostolica scripta precipiendo mandamus quatinus viris probatis quos ad id videris idoneos exsequendum, qui paupertatem Christi pauperis imitando in despecto habitu et ardenti spiritu non pertimescant accedere ad despectos, in remissionem studeas iniungere peccatorum ut ad eosdem hereticos festinantes per exemplum operis et documentum sermonis eos concedente Domino sic revocent ab errore. . . . " See Jean-Pierre Renard, *La formation et la désignation des prédicateurs au début de l'Ordre des Prêcheurs (1215–1237)* (Fribourg Suisse, 1977), 142–43, for this and the following material in this paragraph.

8. *Monumenta diplomatica S. Dominici* (MOPH 25: 57 no 63; Fulk, Bishop of Toulouse, establishing Dominic and his companions as preachers in his bishopric, June-July 1215): "Cum enim iure cautum sit quod aliquanta pars decimarum debeat semper pauperibus asignari et errogari, constat illis pauperibus nos teneri partem aliquam decimarum potius asignare qui, pro Christo euuangelicam paupertatem eligentes, universos et singulos exemplo et doctrina donis celestibus nituntur et elaborant ditare. . . . "

9. *Monumenta diplomatica S. Dominici* (MOPH 25: 87 no 86; Honorius III to church prelates, 11 February 1218): "Rogamus proinde devotionem vestram et hortamur attente, per apostolica vobis scripta mandantes, quatinus fratres ordinis Praedicatorum, quorum utile ministerium et religionem credimus Deo gratam, in eorum proposito laudabili confoventes habeatis pro nostra et apostolice Sedis reverentia commendatos, in suis eis necessitatibus assistendo, qui verbum Domini gratis et fideliter proponentes, intendendo profectibus animarum ipsum Dominum solum secuti paupertatis titulum pretulerunt. . . . "

10. Jacques de Vitry, *Historia occidentalis* 27, ed. John Frederick Hinnebusch in *The Historia occidentalis of Jacques de Vitry* (Spicilegium Friburgense 17, Fribourg Suisse, 1972), 143: "Hii siquidem ita expediti post dominum currunt et nudi nudum secuntur, quod omnium exteriorum curam et temporalium possessionem a se penitus reiecerunt, omnia transitoria tamquam stercora reputantes, ut

Christum lucrifaciant." See also Mandonnet, "Les Chanoines-Prêcheurs de Bologne," in *Saint Dominique,* ed. Mandonnet et al., 243–44; Réginald Grégoire, "L'adage ascétique 'nudus nudum Christum sequi'," in vol. 1 of *Studi storici in onore di Ottorino Bertolini* (Pisa, 1972), 395–409.

11. Peraldus uses the passage from 1 Peter explicitly in his treatise on fortitude in *Summa de virtutibus* 3.4.6.2, in *Summa virtutum ac vitiorum Guilhelmi Paraldi episcopi Lugdenensis de ordine predicatorum* (Paris: Johannes Petit, Johannes Frellon, Franciscus Regnault, 1512), lib. 1, fol. 148rb–va.

12. Alan E. Bernstein, "The Exemplum as 'Incorporation' of Abstract Truth in the Thought of Humbert of Romans and Stephen of Bourbon," in *The Two Laws: Studies in Medieval Legal History Dedicated to Stephan Kuttner,* ed. Laurent Mayali and Stephanie A. J. Tibbetts (Studies in Medieval and Early Modern Canon Law 1, Washington, D.C., 1990), 82–96, here 91. See also Claude Bremond et al., *L'«exemplum»* (Typologie des sources du moyen âge occidental 40, Turnhout, 1982), esp. 82–83. On the rhetorical function of the *exemplum,* see Peter von Moos, "Das argumentative Exemplum und die 'wächserne Nase' der Autorität im Mittelalter," in *Exemplum et Similitudo: Alexander the Great and Other Heroes as Points of Reference in Medieval Literature,* ed. W. J. Aerts and M. Gosman (Mediaevalia Groningana 7, Groningen, 1988), 55–77.

13. Larry Scanlon, *Narrative, Authority, and Power: The Medieval Exemplum and the Chaucerian Tradition* (Cambridge Studies in Medieval Literature 20, Cambridge, 1994), 65; Barbara Rosenwein and Lester K. Little, "Social Meaning in the Monastic and Mendicant Spiritualities," *Past and Present* 63 (1974): 18–32.

14. Scanlon, *Narrative, Authority, and Power,* 65.

15. On the convent, see Marie-Philippe Fontalirant, *Notre-Dame-de-Confort. Sanctuaire des frères prêcheurs à Lyon* (Lyon, 1875; reprt. Nimes, 1992).

16. On Stephen's life and his *exempla* collection, see the many important studies by Jacques Berlioz: *Saints et damnés. La Bourgogne du Moyen Age dans les récits d'Étienne de Bourbon, inquisiteur (1190–1261)* (Dijon, 1989); "Étienne de Bourbon, l'inquisiteur exemplaire," *L'Histoire* 125 (1989): 24–30; "'Héros' païen et prédication chrétienne: Jules César dans le recueil d'*exempla* du dominicain Étienne de Bourbon (mort v. 1261)," in *Exemplum et Similitudo,* ed. Aerts and Gosman, 123–43; "'Quand dire c'est faire dire.' *Exempla* et confession chez Étienne de Bourbon (mort vers 1261)," in *Faire croire. Modalités de la diffusion et de la réception des messages religieux du XIIe au XVe siècle* (Actes de la Table ronde de Rome, 22–23 juin 1979, Rome, 1981), 299–335. See also Bernstein, "The Exemplum," 86–88; Kaeppeli, *Scriptores* 3: 354–55 n° 3633; J.-Th. Welter, *L'exemplum dans la littérature religieuse et didactique du moyen âge* (Paris-Toulouse, 1927), 215f.; J. A. Herbert, vol. 3 of *Catalogue of Romances in the Department of Manuscripts in the British Museum* (London, 1910; reprt. Bath, 1962), 78; Marie-Dominique Chapotin, *Histoire des Dominicains de la province de France. Le siècle des Fondations* (Rouen, 1898), 203. On William Peraldus's life, see Kaeppeli, *Scriptores* 2: 133; William A. Hinnebusch, vol. 2 of *The History of the Dominican Order* (New York, 1973), 242; Philippe Delhaye, "Guillaume Peyraut," DS 6 (1967): 1229–34; A. Dondaine, "Guillaume Peyraut, vie et oeuvres," AFP 18 (1948): 162–236. On Humbert's life, see the work by Edward Tracy Brett, *Humbert of Romans. His Life and Views of Thirteenth-Century Society* (Studies and Texts 67, Toronto, 1984), 3–11; see also Bernstein, "The Exemplum," 88–90; Tugwell, *Early Dominicans,* 31f.; Hinnebusch, *History* 2: 289f.

17. Leonard E. Boyle, "Notes on the Education of the *fratres communes* in the Dominican Order in the Thirteenth Century," in vol. 1 of *Xenia Medii Aevi Historiam Illustrantia oblata Thomae Kaeppeli O.P.,* ed. Raymund Creytens and Pius Künzle (Storia e Letteratura: Raccolta di Studi e Testi 141, Rome, 1978), 253.

18. Boyle, "Notes," 257.

19. Richard Newhauser, *The Treatise on Vices and Virtues in Latin and the Vernacular* (Typologie des sources du moyen âge occidental 68, Turnhout, 1993), 127–30; Siegfried Wenzel, "The Continuing Life of William Peraldus's Summa vitiorum," in *Ad litteram: Authoritative Texts and Their Medieval Readers,* ed. Mark D. Jordan and Kent Emery, Jr. (Notre Dame Conferences in Medieval Studies 3, Notre Dame, 1992), 135–63.

20. See the very instructive study by C. Casagrande and S. Vecchio, *I peccati della lingua. Disciplina ed etica della parola nella cultura medievale* (Bibliotheca Biographica: Sezione Storico-Antropologica, Rome, 1987), esp. chapter four.

21. See for example the following manuscripts in Paris, all of the thirteenth or early fourteenth century: Bibliothèque Mazarine, Mss. 627 (890), 791 (1245); Bibliothèque Nationale, Mss. lat. 10728, 12400, 14554, 14897, 15919, 16430, 16432, 18141.

22. Welter, *L'exemplum,* 215–16. A great number of extracts from the work were printed in

Étienne de Bourbon, *De septem donis Spiritus Sancti*, ed. A. Lecoy de La Marche, *Anecdotes histori-ques, légendes et apologues tirés du recueil inédit d'Étienne de Bourbon, dominicain du XIIIe siècle* (Sociéte de l'histoire de France 185, Paris, 1877).

23. *De septem donis Spiritus Sancti* prol.2, ed. Lecoy de La Marche, 8: " . . . de summis et libris magistrorum, et maxime de summis de Viciis et virtutibus fratris Willelmi de Peraldo, de ordine Pre-dicatorum."

24. *Liber de dono timoris* (Paris, Bibliothèque Nationale, Ms. lat. 15953, fol. 188r): "Adhuc quia omnis materia sermonis edificatorij reduci potest ad vij dona Spiritus Sancti uel annexa illis, presens tractatus diuiditur in vij partes secundum illa dona Spiritus Sancti septiformis, qui inuocandus est ad opus utiliter consummandum." The manuscript from which I quote is of the thirteenth century; it belonged to the library of Peter of Limoges, which he bequeathed to the Sorbonne at his death in 1306. On the treatise, see Hinnebusch, *History* 2: 291–92; Kaeppeli, *Scriptores* 2: 285–87 n° 2012. On the very close relationship between the work of Humbert and Stephen, see Bernstein, "The Exemplum," 89–90 n. 29, and the bibliography there.

25. See Brett, *Humbert*, 201–3, and the bibliography there.

26. *Liber de dono timoris* (Paris, Bibliothèque Nationale, Ms. lat. 15953, fol. 188r): "<Quonia>m plus exempla quam uerba mouent secundum Gregorium et facilius intellectu capiuntur et alcius memorie infiguntur, necnon et libencius a multis audiuntur suique delectacione quadam plures attra-hunt ad sermones, expedit viros predicacionis officio deditos in huiusmodi habundare exemplis, quibus utantur modo in sermonibus communibus, modo in collacionibus ad personas deum timentes, modo in familiaribus colloqucionibus ad omne genus hominum, ad edificacionem omnium et salutem."

27. Jordan of Saxony, *Libellus de principiis Ordinis Praedicatorum* 104, ed. H.-C. Scheeben in vol. 2 of *Monumenta historica sancti patris nostri Dominici*, MOPH 16 (1935): 74–75: "Ubicunque versare-tur sive in via cum sociis aut in domo cum hospite reliquaque familia, aut inter magnates et principes et prelatos, semper edificatoriis affluebat sermonibus, abundabat exemplis, quibus ad amorem Christi seculive contemptum animi flecterentur. Ubique virum evangelicum verbo se exhibebat et opere." One can note that almost the exact same words are used by Stephen of Bourbon to describe Dominic's use of *exempla*. The passage is cited by Stephen from Dominic's *Vita*; see *De septem donis Spiritus Sancti* prol.4, ed. Lecoy de La Marche, 13.

28. *De septem donis Spiritus Sancti* n° 74, ed. Lecoy de La Marche, 73–74: "Quidam novicius, cum intrasset ordinem Predicatorum, et quidam monachi vellent eum retrahere et extrahere ab ordine quem intraverat et attrahere ad ordinem suum, multa ei obloquendo de ordine quem intraverat, multa excellencia loquendo de ordine suo, quesivit ab eis si Dominus Jhesus Christus dedit nobis formam bene vivendi super omnes, et si ejus actio esset nostra institucio. Qui aiunt ita. 'Ergo,' ait ille, 'cum legerim Dominum Jhesum Christum non fuisse monachum album vel nigrum, sed fuisse pauperem predicatorem, volo pocius ejus sequi vestigia quam alterius.'" See Frederic C. Tubach, *Index Exem-plorum* (FF Communications 204, Helsinki, 1969; reprt. 1981), n° 989; Jacques Berlioz, "Étienne de Bourbon, *Tractatus de diversis materiis predicabilibus*," in Jacques Berlioz and Marie Anne Polo de Beaulieu, *Les Exempla médiévaux* (Carcassonne: Garae/Hesiode, n.d.), 140. In *De septem donis* n° 508, ed. Lecoy de la Marche, 439, Stephen repeats another *exemplum* attacking the pomp of monks as con-tradictory to the poverty and humility of Jesus, this time from the point of view of Peter Abelard; cf. Tubach, *Index Exemplorum* n° 1113; Berlioz and Polo de Beaulieu, *Les Exempla médiévaux*, 148.

29. *De septem donis Spiritus Sancti* n° 255, ed. Lecoy de La Marche, 217: "O magister, respon-deatis; fuit-ne talis asina et assessor vel ascensor ejus, de quibus nobis loqutus fuistis?" See Tubach, *Liber Exemplorum* n° 391; Berlioz and Polo de Beaulieu, *Les Exempla médiévaux*, 146.

30. *De septem donis Spiritus Sancti* n° 83, ed. Lecoy de La Marche, 79; see Tubach, *Index Exem-plorum* n° 1991; Berlioz and Polo de Beaulieu, *Les Exempla médiévaux*, 140. Note also that in n° 342, ed. Lecoy de La Marche, 290–93 (see Tubach, *Index Exemplorum* n° 2535, and Berlioz and Polo de Beaulieu, *Les Exempla médiévaux*, 145), Stephen reports that the Waldensians claimed that they were poor in spirit on the authority of the beatitude stating that the poor in spirit are blessed (Matt 5:3), although Stephen argues that they are only usurping the apostolic office. For more on the Albigensian use of the example of Jesus, see *De septem donis* n° 344, ed. Lecoy de La Marche, 300.

31. Peraldus, *Summa de vitiis* 3.4.3 (Paris, Bibliothèque Mazarine, Ms. 794 [= MS M], fol. 25va; Paris, Bibliothèque Nationale, Ms. lat. 15919 [= MS N], fol. 34vb): "Talia meditabatur Jeremias, cum diceret: 'Quis dabit capiti meo aquam et oculis meis fontem lacrimarum, et plorabo interfectos filie [*om.* N] populi mei?' <Jer 9:1>. Quis deflere non debeat, vbi ad fletum monet ipse Deus et uerbo et exemplo? Verbo, Luce vi: 'Beati, qui nunc fletis, quia ridebitis' <Luke 6:21>. Et post: 'Ve uobis, qui ridetis nunc, quia lugebitis et flebitis' <Luke 6:25>. Et exemplo [*enim add.* N], Luce xix, vbi post can-

tum et [cantum et N = tantum M] gaudium, cum quo susceperant eum in Ierusalem venientem, subi-ungitur: 'Et cum appropinquauit videns ciuitatem, fleuit super illam dicens: "Quia si cognouisses et tu,"' <Luke 19:41–42> innuens cantum huius uite et gaudium ex cecitate prouenire." I have cited the text, as indicated, from MS M, and have collated it with MS N; cf. *Summa virtutum ac vitiorum Guilhelmi Paraldi* (Paris, 1512), fol. 29ra–rb (hereafter, I shall refer to this text as 'Paris edition, 1512'). MS M is a *pecia* exemplar of Peraldus's *Summa de vitiis* of the thirteenth century; MS N is a deluxe copy of the text prepared for Stephen of Abbeville, also of the thirteenth century. The folios with the table of contents of the *Summa de vitiis* at the beginning of MS N were numbered by a modern hand; those with the text of the *Summa* follow the table of contents and were foliated by a medieval hand contemporary with that of the scribe. I have followed the medieval foliation here. The variants in square brackets refer only to the immediately preceding word in the text, unless otherwise stated; they indi-cate where a word in the text has been omitted by the other witness (*om.*), where it is followed by another word (*add.*), or where another word replaces the one represented in the text. Hereafter when I quote Peraldus from these manuscripts, I shall designate them by the sigla I have given them. On the connection of Jesus' words and deeds as a model for Dominican *exempla*, see also Stephen of Bourbon, *De septem donis Spiritus Sancti* prol.1, ed. Lecoy de La Marche, 4: " . . . ideo summa Dei sapiencia, Christus Jhesus, primo docuit factis quam verbis. . . . "

32. Peraldus, *Summa de virtutibus* 1.12 (Paris edition, 1512, lib. 1, fol. 12va): "Non parum efficax est exemplum virtutum Christi. . . . "

33. Peraldus, *Summa de vitiis* 1 (MS M, fol. 6rb; MS N, fol. 1rb–va): "Dicturi de singulis viciis, cum oportunitas se offeret, incipiemus a uicio Gule [quia locus se offert *add.* N], et quia [propter hoc quod N] dicit Glossa super Matthei iiij: 'In pugna Christi prius contra Gulam agitur, quia nisi hec prius refrenetur, frustra contra alia vicia laboratur'" (cf. Matt 4:3–4; Paris edition, 1512, lib. 2, fol. 8ra). The incident and the gloss on it is used again by Peraldus in his treatment of the sin of grumbling by monks in the treatise on the *peccatum lingue* in *Summa de vitiis*, 9.2.2 (MS M, fol. 215ra; MS N, fol. 326rb–va): "Notandum ergo [*om.* N], quod claustralis murmurans de cibo uel potu defecit [deficit N] in ipso principio belli spiritualis [quod est gula *add.* N]. Principium belli spiritualis est contra gulam [principi-um . . . gulam *om.* N], vnde super [illud *add.* N] iiij Matthei dicit Glossa: 'In pugna Christi prius contra gulam agitur [aguntur N], quia nisi prius [hec *add.* N] refrenetur, frustra contra alia uicia [*om.* N] laboratur'" (cf. Paris edition, 1512, lib. 2, fol. 213va).

34. Bernstein, "The Exemplum," 92–96.

35. Pelikan, *Jesus Through the Centuries*, 139. The Albigensians maintained, among other hereti-cal beliefs, that Jesus did not suffer bodily as a human being.

36. Stephen of Bourbon, *De septem donis Spiritus Sancti* n[os] 87f., ed. Lecoy de La Marche, 82–84, here 82: " . . . de consideratione beneficiorum incarnacionis et passionis Christi."

37. Humbert of Romans, *Liber de dono timoris* (Paris, Bibliothèque Nationale, Ms. lat. 15953, fol. 189r): "Sunt autem multe raciones, quare debemus corpus exponere affliccionibus et morti, si necesse fuerit in Christi seruicio."

38. *Liber de dono timoris* (Paris, Bibliothèque Nationale, Ms. lat. 15953, fol. 189r): " . . . a consid-eracione et retribucione Christi futura, qui pro corpore ignobili in suo seruicio consumpto reddet no-bilius in resurrectione;..a morte Christi, qui 'tradidit semetipsum' pro nobis in mortem secundum Apostolum, Ephesiorum v <Eph 5:2>."

39. Peraldus, *Summa de vitiis* 4.2.13 (MS M, fol.79rb; MS N, fols. 126vb–127ra): "Sapientia Christi fuit paupertatem diuiciis preponere et molestias deliciis. Vnde ad Hebreos xii legitur de ipso, quod 'proposito sibi gaudio sustinuit crucem' <Heb 12:2>. Super quem locum dicit Augustinus: 'Omnia terrena bona contempsit homo Christus, ut contempnenda monstraret, et omnia mala terrena sus-tinuit, que sustinenda precipiebat, vt nec in illis quereretur felicitas, nec in istis timeretur infelicitas'" (cf. Paris edition, 1512, lib. 2, fol. 86va). The citation from Augustine is taken from *De catechizandis rudibus* 22.

40. Peraldus, *Summa de vitiis*, 4.2.10 (MS M, fol. 65ra–rb; MS N, fol. 103rb–va): "Contemptores enim temporalium uoluit esse rectores ecclesie sue et non amatores [uoluit . . . amatores = scilicet et non amatores voluit Christus habere rectores N]. Qui uult sibi cauere a muscis, cauet sibi a lacte et a melle, que amant musce. Preuidebat Christus, quod amatores temporalium auferrent ei ecclesias, si spiritualibus officiis temporalia lucra connecterentur. Qui uult a canibus dilacerari aliquid, inuoluat in carne. Vnde beatus Antonius precepit cuidam monacho, qui pecuniam habebat, ut emeret inde car-nes, et super se nudum eas sibi afferret, quod faciens monachus a canibus dilaceratus est. Piscis ferrum transglutit [transglutiuit N], quia esca inuolutum est, liceat [licet N] mors sua lateat ibi. Similiter et milui intestina. Sic amatores temporalium officia ecclesie, quibus terrena adnexa sunt, assumunt ad

[et N] dampnacionem suam, et uidentur sequi Christum, cum sola temporalia secuntur" (cf. Paris edition, 1512, lib. 2, fol. 71vb).

41. Peraldus, *De professione monachorum,* ed. Bernhard Pez in *Thesaurus anecdotorum novissimus* (Vienna-Graz, 1721), 644: "In parvis Prioratibus religio annihilatur. Ibi enim vitio proprietatis appropinquatur, meritum obedientiæ minuitur, continentia facile periclitatur. Qui solus est in Prioratu vel cum uno socio, ut frequenter vere est proprietarius. Que habet, pro majori parte habet sibi." See Marie-Humbert Vicaire, *Dominique et ses prêcheurs* (Fribourg Suisse-Paris, 1977), 361; Dondaine, "Guillaume Peyraut," 214. I am grateful to Ms. Sylvia Metzinger of the Special Collections department at Tulane University Library for making the text of Peraldus's work available to me.

42. Peraldus, *Summa de vitiis* 2.4 (MS M, fols. 11vb–12ra; MS N, fol. 11ra–rb): "Septimum remedium est consideracio penurie Christi, et in se et in membris suis. Ad primum monemur Trenorum iij: 'Recordare paupertatis mee, et transgressionis, et absincii et fellis' <Lam 3:19>. Paupertas eciam [enim N] ipsius in membris suis multum deberet homines retrahere a superfluitate, quam faciunt in conuiuiis suis, cum cogitant, quantam paupertatem sustinet Christus in pauperibus et infirmis ad mortem, qui uix possunt panem interdum habere" (cf. Paris edition, 1512, lib. 2, fol. 14rb).

43. Humbert of Romans, *Liber de dono timoris* (Paris, Bibliothèque Nationale, Ms. lat. 15953, fol. 188v): "Item ad timorem mundanum pertinet timor immoderatus sustinende paupertatis uel propter uerecundiam uel angustias eius uel alias causas minus racionales, et iste timor est eciam semper malus et in malis occasio multorum malorum. Quandoque enim est occasio negandi Deum: exemplum de Theophilo, qui cum de diuiciis et honoribus [hominibus *scr.*] multis deiectus esset in grauem paupertatem, sibi astante dyabolo et promittente diuicias et honores si Christum negaret, negauit ipsum, ut sic euaderet paupertatem, sicut dicitur in Libello de miraculis Beate Uirginis." The story of Theophilus' denial of Jesus (and his later penitence and salvation) also forms part of Peraldus's treatment of the theological virtue of faith; see *Summa de virtutibus* 2.3.3 (Paris edition, 1512, lib. 1, fol. 75va–vb). See Tubach, *Index Exemplorum* n° 3572. On the fear of poverty among some preachers, see Humbert of Romans, *On the Formation of Preachers* 4.17.198, trans. Tugwell, *Early Dominicans,* 243.

44. Apophthegm 392 in F. Nau, "Histoires des solitaires égyptiens," *Revue de l'Orient Chrétien* 18 (1913): 144. Latin versions are in Paschasius of Dumium, *Apophthegmata patrum* 14.6, ed. J. Geraldes Freire in vol. 1 of *A Versão por Pascásio de Dume dos Apophthegmata Patrum* (Coimbra, 1971), 188, and *Vitae Patrum* 5.6.5 and 3.70 (PL 73: 889, 772–73). See also Theodore, 1 (PG 65:188); Paschasius, 14.5, ed. Freire in *A Versão* 1: 188; *Vitae Patrum* 5.6.6 (PL 73: 889). See Tubach, *Index Exemplorum* n° 2350.

45. Humbert of Romans, *Expositio Regulae B. Augustini* 141, ed. J. J. Berthier in vol. 1 of *B. Humberti de Romanis quinti Praedicatorum magistri generalis Opera de vita regulari* (Turin, 1956), 425: "Item, fiunt frequentes exhortationes ne male tractentur ab aliquo, exemplo Domini qui tam diligenter tractavit librum Isaiae sibi traditum, quod cum legisset in eo, plicavit eum diligenter et tradidit ministro, sicut dicitur *Luc.* 4" (cf. Luke 4:16–21). See Paul Amargier, *Études sur l'Ordre dominicain, XIIIe–XIVe siècles* (Marseille, 1986), 57.

46. The text of Kilwardby's letter survives only in quotations from it in a treatise by John Pecham, who attacks the letter. See *Tractatus contra fratrem Robertum Kilwardby, O.P.,* ed. Felice Tocco in *Fratris Johannis Pecham, quondam archiepiscopi Cantuariensis, Tractatus tres de paupertate,* ed. C. L. Kingsford, A. G. Little and F. Tocco (Aberdeen, 1910; reprt. Farnborough-Hants, 1966), 131–36: "Quis enim paupertatem Christi et discipulorum eius audeat negare perfectiorem ceteris? Legimus autem illam perfectissime sanctitatis cohortem Christi et discipulorum loculos habuisse et que eis ad victum mittebantur portasse et cibos emisse. . . . Novimus etiam ordinem predicatorum eodem modo victitare, hoc addito quod domos habent et ortos et collegia propter disciplinam continendam." I quote here the translation by Tugwell in *Early Dominicans,* 151. On Kilwardby, see Hinnebusch, *History* 2: 119–21.

47. Humbert of Romans, *Liber de dono timoris* (Paris, Bibliothèque Nationale, Ms. lat. 15953, fol. 188r): "Nonne et ipse saluator per similitudines et exempla fere omnia loquebatur?"

48. Peraldus, *Summa de vitiis* 5.1.1 (MS M, fol. 87ra–rb; MS N, fol. 140ra): "Ad detestationem eciam accidie possent [possunt N] ualere exempla bonorum. Et de multis pauca ponamus. . . . De Christo eciam legitur Johannis iiij quod ipse 'fatigatus ex itinere sedit super fontem' <John 4:6>. Et in multis aliis locis in ewangeliis legitur de labore ipsius. Vnde Bernardus: 'Quamdiu vixero, memor ero laborum, quos Christus sustinuit in predicando, fatigacionum in discurrendo, temptationum in ieiunando, vigiliarum in orando, lacrimarum in compaciendo'. . . . " (cf. Paris edition, 1512, lib. 2, fol. 94vb). The notation *exempla bonorum* occurs in the margin at this point in MS N. Peraldus also refers

to Jesus as a preacher in his treatment of the virtues; see, for example, *Summa de virtutibus* 2.3.1 and 3.3.12 (Paris edition, 1512, lib. 1, fols. 82va and 135ra).

49. Peraldus, *Summa de virtutibus* 3.4.6.3 (Paris edition, 1512, lib. 1, fol. 152ra): "Sic facit Deus ecclesie sicut Alexandrum fecisse legitur, qui cinxit quoddam nemus igne propter serpentes. Sic Christus igne tribulationis ecclesiam cingit propter serpentes infernales." Peraldus's material from Gregory immediately preceding this passage is taken from *Moralia in Job* 23.27.

50. Peraldus, *Summa de virtutibus* 3.4.6.5 (Paris edition, 1512, lib. 1, fol. 166va): "Unde legitur de beato Anthonio, quod cum quadam nocte a demonibus esset laceratus, subito radius quidam lucis et demones et tenebras effugavit, statimque sanatus Christum presentem intelligens dixit: 'Ubi eras, Iesu bone, ubi eras? Quare principio non affuisti, ut curares vulnera mea?' Et vox ad eum ait: 'Anthoni, hic eram, sed expectabam videre certamen tuum. Nunc autem, quia viriliter dimicasti, in toto orbe te faciam nominari.'" See Tubach, *Index Exemplorum* n° 277.

51. Peraldus, *Summa de vitiis* 3.3.2 (MS M, fol. 20rb–va; MS N, fol. 25ra): "Vetule tales proprie uidentur esse de familia dyaboli. Et sicut Christus uoluit, ut super apostolos apparerent lingue ignee ad ostendendum, quod officium eorum erat uerbis corda hominum igne celesti inflammare, sic diabolus, si uellet officium istarum [talium N] uetularum hominibus ostendere, linguas igneas igne fetido inferni faceret super eas apparere" (cf. Paris edition, 1512, lib. 2, fol. 23ra).

52. Stephen of Bourbon, *De septem donis Spiritus Sancti* n° 95, ed. Lecoy de La Marche, 87: " . . . quia Christus, pugil noster, in navicula crucis apparet, pro nobis innocenter occisus a Judeis et gentibus; quod ostendunt nobis euvangelia sacra, que de cordis ejus elemosynaria, tanquam hujus prodicionis littere, exierunt. Hec ad accipienda arma pro hac prodicione vindicanda corda nobilia debent multum movere." See Tubach, *Index Exemplorum* n° 4329; Berlioz and Polo de Beaulieu, *Les Exempla médiévaux*, 140.

53. *Die Vengeance Raguidel nach der Middleton-Handschrift*, ed. Mathias Friedwagner, Sonderabdruck aus *Zeitschrift für Romanische Philologie* 39 (Halle, 1918); Raoul de Houdenc, *La vengeance Raguidel, altfranzösischer Abenteuerroman*, ed. Mathias Friedwagner in vol. 2 of *Sämtliche Werke* (Halle, 1909). See David Trotter, "La mythologie arthurienne et la prédication de la croisade," in *Pour une mythologie du Moyen Age*, ed. Laurence Harf-Lancer and Dominique Boutet (Collection de L'École normale superieure de jeune filles 41, Paris, 1988), 155–77.

54. *La Queste del Saint Graal*, ed. Albert Pauphilet (Les Classiques Français du Moyen Âge 33, Paris, 1923; reprt. 1948). On Stephen's use of the narrative of Merlin, see Jacques Berlioz, "Merlin et le *ris antonois*. Un *exemplum* inédit du dominicain Étienne de Bourbon (mort vers 1261)," *Romania* 111 (1990): 553–63.

Christ, *Exemplar Ordinis Fratrum Praedicantium*, According to Saint Thomas Aquinas

Ulrich Horst, O.P.

THOMAS AQUINAS SPEAKS explicitly about his Order in only a few places. He never mentions the founder's name. This is a first important criterion that sets him apart from theologians of the Franciscan Order, who raised St. Francis and his canonization to the status of canonical authority. Nevertheless, Thomas not only discusses the nature of the state of perfection (*status perfectionis*) in general, but surprisingly often he speaks about the Friars Preachers, although mostly indirectly. This is certainly the case whenever he wishes to put distance between his own religious life and the way of life of the Franciscans or of the monastic orders.

The essential difference between the Dominicans and Franciscans may be defined by their different attitudes towards evangelical poverty. This dividing-line is sharpest whenever the question of poverty has ecclesiological or Christological implications, as was especially the case after 1269. In the following sections of this essay, I shall explore the ways in which Thomas Aquinas developed his ideas concerning evangelical poverty, and its relation to the "following of Christ," in a series of writings, which I shall treat in chronological order.

CONTRA IMPUGNANTES DEI CULTUM ET RELIGIONEM

In *Contra impugnantes* (1256), Thomas is mainly concerned with establishing a secure position for the new orders in the Church, and—less noticed by scholars—with securing the right of members of monastic orders to teach and give pastoral care within the universities. In *Contra impugnantes*, Christological arguments are of minor importance, with one exception: Thomas says that the mendicants are not only allowed to live from alms but also to beg for them. His argument, which he repeats in later works, seems rather remote. For proof, he adduces three texts from the Psalms and three from the New Testament, which are meant to show that Christ himself begged (e.g., Ps 39:18: "ego autem mendicus sum et pauper").[1] But begging "from door to door" as Christ sometimes did (although it cannot be proved), Thomas says, is at best a secondary means of income for a Dominican convent, which earns its living (*victus et vestitus*) first of all from providing for the spiritual needs of the people by preaching and teaching. For this work the friars receive wages (*merces*), which the faithful owe them (*debitum*).[2] The alms that in former times were given to beggars and outsiders have changed into fees. Thomas's short but important statement elucidates the social

change of the century as well as the distance of the Preachers from all other orders, including the Franciscans.

Quodlibet I, question 7 article 2

After he returned to Paris in 1268, where issues concerning the nature of religious life were being sharply disputed between seculars and mendicants, Thomas wrote a remarkable reflection on the nature of the *status perfectionis.* The question had been raised by the secular master, Gerard of Abbeville; Thomas addresses the question in *Quodlibet I* (q.7 a.2), disputed in the spring of 1269.[3] His treatment is based on two fundamental principles: the essence of perfection is charity, which unites man and God; the three religious vows are preparations for (*praeambulum et praeparatorium*), and instruments of, perfection (*perfectionis instrumenta*).[4] These principles, which Thomas had already established in *Contra impugnantes* and the *Summa contra gentiles,* run as a leitmotif through all of his later works. To illustrate his argument, Thomas refers to a text from Jerome: Peter did not only say, "We have left everything" (Mt 19:27), but he added, "we have become your followers" (*et secuti sumus te*).[5] Here Thomas introduces a key notion: Jerome's text indicates that the "following of Christ" (*sequela Christi*) is more important than "leaving everything." In the *Catena aurea,* referring to Jerome, Thomas elaborates the point. It is significant, he says, that in his answer Christ says "you my followers" and not "you who have left everything." For Socrates, the philosophers and many others, who despised their possessions, left everything, but they did not follow a master. "Following," therefore, is a distinguishing characteristic of the apostles and the faithful.[6] Thomas states the point even more concisely in his commentary on the Gospel according to Matthew, which he also wrote during his stay in Paris. The object of perfection lies in the call, "come, follow me," for by following the Lord, one imitates his life and Passion. This *imitatio* consists in a zeal for preaching, teaching and pastoral care ("in sollicitudine praedicandi, docendi et curam habendi").[7]

Thomas's emphasis upon the vows as instruments of perfection and as the best means for following Christ, rather than poverty, is best explained in the context of the controversies provoked by Gerard of Abbeville, on the one hand, and more by extreme Franciscan advocates of poverty, on the other. If perfection consisted essentially in the abandonment of one's goods ("in ipsa dimissione seu abdicatione omnium bonorum"), then Abraham and, more generally, every holder of possessions would be excluded from perfection; moreover, what is in no way less dangerous, bishops would also be excluded from the state of perfection. The same would be true for religious orders that hold property in common. Finally, since it is in the nature of an instrument to adapt to its object, the religious vows and their attendant and supporting observances (for example, fasts and vigils) must be practiced variously, as the different ways of life of different orders require. By implication, Thomas's argument confers theological justification upon the Dominicans' generous practice of granting dispensations, which was already established in the Order's oldest Constitutions.[8]

The originality and thrust of Thomas's ideas concerning the state of perfection is shown clearly by the Franciscans' subsequent, violent attacks against them. John

Pecham began these attacks, as soon as he became acquainted with Thomas's opusculum, *De perfectione spiritualis vitae*. At the time, however, no one would have imagined the conflicts that would be caused by different theories concerning religious vows.[9]

De perfectione spiritualis vitae

Thomas's conclusions concerning the state of perfection in *De perfectione spiritualis vitae* (1270) may be summarized as follows: the bishops and Christians in the world must put into practice God's words to Abraham, "ambula coram me et esto perfectus" (Gen 17:1), by intending in their inner hearts (*in praeparatione animi*) to renounce worldly goods and to give away everything, even life, if it should prove necessary. But this way is difficult and practicable for only a few; it is those who enter religious life who renounce all possessions to follow the Lord, according to Jesus' counsel to the rich young man in the Gospel (Mt 19:21).[10] This instrument of perfection is complemented by another, the renunciation of conjugal love.[11] Finally, religious benefit from a third instrument of perfection: the way of obedience, which is based on the example of Christ whose mission it was to do the Father's will. Because the vow of obedience touches man's innermost nature, it takes precedence (*votum praecipuum*) over the other two. The vow of poverty ranks last among the three. In passing, one should note that the formula of profession in the Dominican Order takes this into account, inasmuch as it does not mention poverty but only obedience.[12] Thomas's argument is noteworthy. In principle, the subordination of poverty to obedience follows from the nature of renunciation, which moves from the exterior to the interior; as a corollary, Thomas suggests that the most extreme poverty (*altissima paupertas*) cannot be the criterion for the excellence of an order, nor make one order better than another.

Contra doctrinam retrahentium a religione

In his treatise *Contra retrahentes* (1271 or 1272), as it is commonly called, Thomas confronts the arguments of those who disparage the value of the religious life. In this context, he clarifies the difference between religious precepts (*praecepta*) and counsels (*consilia*).[13] All precepts and counsels are directed towards the love of God and of one's neighbor, although in different ways. The necessity of keeping the precepts is comparable to the need for food, without which no one could live, whereas keeping the counsels, which is not required absolutely, offers an easier and safer way to the love of God.[14] This function of the counsels is evident in regards to the vows of virginity and poverty. Both of these vows, however, also refer to the love of one's neighbor: they help us to be ready in our hearts (*in praeparatione animi*) to fulfill, whenever necessary, Christ's most demanding teachings, as stated in Mt 5:38–40 (for example, in Mt:40: "If a man wants to sue you for your shirt, let him have your coat as well").[15] Thus, one may accomplish the perfect observance of the precepts with the help of the counsels, which are the way and the means (*instrumenta*) to accomplish perfect love, whereas those in

the world who are without the counsels ("in vita saeculari absque consiliis") may achieve only an imperfect observance of the precepts and an imperfect love.[16]

Contra retrahentes commands one's attention in another respect. Chapter 15 of this work has a very personal character; here Thomas seems to recall his youth. In this chapter, rational argumentation changes into a meditation on the poverty of Christ (*pauper Christus*) and those who follow him in this way of life. Thomas's emphatic language on this subject might lead one to think that he was a Franciscan. Who are those who "attain great dignity by following the poverty of Christ"?[17] Thomas does not say explicitly that he is speaking about his Dominican brothers, but it soon becomes obvious that he is addressing chiefly them. In its beginning, middle and end, Christ's life on earth was characterized by poverty, which condition therefore is insolubly connected with his person and teaching. In the beginning (*in ortu*) he chose a poor mother (*paupercula*); in his maturity (*in perfecta aetate*) he could not call even a hut (*hospitiolum*—Jerome) his home; one need not speak of his miserable death on the cross (*in ipso crucis occasu*). In sum, no one can deny that the Lord taught poverty in word and deed, and that therefore it is an essential part of perfection.

Thomas's application corresponds to his example. Referring to the counsel that Christ gave to the rich young man in the Gospel, he says that if "some" renounce their possessions, they achieve the highest perfection of poverty (*summa paupertatis perfectio*).[18] This phrase reminds one of the Franciscan ideal of *altissima paupertas*; likewise, Thomas's reference to the Gospel (Mt 19:21), which he does not expound, as well as his reference to the renunciation of possessions, which he does not explain in detail, can indeed give one the impression that he shares the Franciscan idea of poverty. His reference in the same passage to the purse (*loculi*) shared in common by the disciples, however, suggests that he has a different notion, as we shall see he does.

Christ's poverty reached its climax at the cross, where he was stripped naked and his garments were distributed among the soldiers. The Lord's nakedness and poverty have been shared in all periods of history, by those who have voluntarily taken the vow of poverty in order to follow "the nakedness of the cross," and especially (*praecipue*) by those who have renounced possessions and income from property (*possessiones et redditus*).[19]

To express the religious ideal, Thomas quotes a famous maxim of Jerome, to which the itinerant preachers of the twelfth century, who were the precursors of the mendicant movement, often appealed: *nudum Christum nudus sequi*, "to follow the naked Christ nakedly."[20] But who are those who follow the naked Lord in a special way (*praecipue*), by forsaking possessions and regular income (*possessiones et redditus*)?

Thomas distinguishes two groups of religious who choose voluntarily to follow Christ nakedly: on the one hand, there are those who have possessions and regular income, but who follow Christ (ascetically) by a *nuditas corporis*; on the other hand, there are those who do this, but go further by renouncing possessions and regular income. Thomas's distinction refers specifically to monks, who live by the income from landed property, and to mendicants—especially the Dominicans—who follow the "nakedness of the cross" more strictly. To have either possessions or income would give the friars a financial security that would contradict the character of their Order, which requires that the friars earn their daily living by the care of souls and studies.[21] Here

Thomas and his Order break decisively with medieval monastic forms of securing one's living, which were based on landed property and the capital and income derived from them, whether in natural produce or money.

The strongest authority for the mendicants' way of life is Christ himself, who, precisely, offered himself as an example (se praebens exemplar). Nowhere in the Scriptures does one read that Christ owned landed property (possessiones).[22] Significantly, however, Thomas does not state that Christ did not own anything. Rather, at least indirectly he maintains that Christ owned something, namely the purse that he and all the disciples held in common. Here Thomas clearly separates himself and his Order from the Franciscans' interpretation of Christ's and the disciples' absolute poverty and from the Franciscan ideal of altissima paupertas, which he knew in detail from Bonaventure's Apologia pauperum.[23]

Thomas justifies his interpretation of the key terms possessiones et redditus by reference to the commandment concerning property given to the apostles, and to the practice of the early Christians in the church of Jerusalem. These were prohibited from owning real estate, which might raise the suspicion that they were interested more in material goods than in preaching the Gospel. Moreover, the management of such fixed properties (bona immobilia) as fields, vineyards and the like, causes "anxious concern" (sollicitudo), which puts a heavy burden on religious life or even makes it impossible.[24] For this reason, the early Christians owned things necessary for subsistence "in common," and renounced real estate in every form.[25] That the early Christians of Jerusalem remained true to the apostles' way of life makes them an example for Dominican convents. Nor did this form of evangelical poverty disappear completely (non dormitavit) after the time of the early Christians, for it was later practiced in Egypt and other parts of the world. By evoking these precedents, Thomas emphasizes that the mendicants have not invented anything radically new or unheard-of, but are in fact followers of a longstanding Christian tradition. His argument is directed against Joachim of Fiore and his followers.[26]

If I am correct, as I am convinced I am, that chapter 15 of Contra retrahentes contains autobiographical references, one may infer that it was at the Dominican convent in Naples that Thomas discovered, and became fascinated by, the ideal, until then unknown to him, of following the naked Christ and of imitating the nakedness of the cross in every way (omnimoda nuditas crucis). Seen within the wider context of his times, Thomas's choice to enter the Order of Preachers was in all probability inspired by the new piety, which was bound to the example of Jesus as described in the synoptic Gospels. The ideal of the new piety, "to follow the naked Christ nakedly" (nudum Christum nudus sequi) by imitating his poverty of life, contrasts significantly with traditional reasons given for the vita monastica, which are more ascetic than Christological. This contrast is echoed in chapter 15 of Contra retrahentes, in which more than in any other work Thomas dissociates himself from the monastic way of life. In sum, Contra retrahentes especially reveals Thomas's embrace of a new religious ideal; from it, one may conclude that it was first of all the ideal of evangelical poverty, and not the desire for studies, that led Thomas to leave the Benedictine Order and to break with his family in order to enter the Dominicans.[27]

Yet, despite similarities of language, the evangelical poverty that Thomas has in mind in chapter 15 of *Contra retrahentes* is not the same as that promoted by the Franciscans. Thomas's treatise is a polemic aimed at Parisian opponents of the new orders, but his criticism also falls indirectly upon Bonaventure, whose *Apologia pauperum* had been published in the autumn of 1269. With an image of the Lord and the apostles that is as challenging as it is simple, Thomas confronts the complicated exegetical and legal distinctions introduced by Franciscan writers, which purport to explain how Christ could "own something"—for example, the purse (*loculi*)—without owning it in any ordinary sense of the term. Thomas's interpretation of the following of Christ (*sequela Christi*) involves only a few principles. Neither here nor elsewhere does he attempt to develop a special theory for the Dominican way of life. Rather, his theory depends on a general principle, which can be applied to other orders with similar aims. All the same, he knew that no other order of his time would identify with his solution. The monastic orders would not, for their way of life depended on possessions and income; much less would the Franciscans accept his resolution, for they believed that holding property in common, in the way Thomas had defended the practice since *Contra impugnantes*, was incompatible with following the example of Christ. It is not really surprising that Thomas's understanding of the religious vows soon would become the central focus of Franciscan criticism.[28]

Summae theologiae Secunda secundae

Thomas wrote the second part of the second book of the *Summa theologiae* at nearly the same time (1271–72) as *Contra retrahentes*. Thus, in this part of the *Summa*, one finds nothing that is fundamentally new concerning the religious vows or the following of Christ, although some of Thomas's statements are more precise than in *Contra retrahentes*. That these statements concern the problem of poverty is not surprising, in light of what we have seen so far. It is astonishing, however, that here Thomas associates preaching, confessing, the care of souls and teaching, which are the defining activities of the Dominican Order, only incidentally with the life of Christ. He reserves this theme for the third part of the *Summa*. In the *Secunda secundae* (q.187 a.5), however, he does treat begging, which is the mendicants' right, and which enables them to imitate Christ. That Christ begged (*mendicavit*) is deduced from only two verses of the Psalms, which, according to the Gloss, Christ applied to his own person. Interestingly, Thomas cites no texts from the New Testament, nor does he say that the apostles begged.[29] His reticence with authorities suggests his caution. Indeed, he does not emphasize the alms begged for but the humility brought about by begging. In the same article, he points out that the faithful owe to their preachers their means of subsistence. This suggests that the mendicants live principally by their own labor, although their begging for alms is justified as an act of humility.[30] We shall see presently the extent to which Thomas's understanding of the matter is based on Christ's life and behavior.

In another article (q.188 a.7), Thomas addresses a question sharply disputed by theologians of both mendicant orders in the last decades of the century (during the reign of Pope John XXII, these disputes became incredibly violent): Does holding com-

mon property diminish the perfection for which the orders strive? As we would expect, Thomas's answer is negative, if certain conditions are taken into consideration.

The detailed argumentation of this article yields a surprising solution, in both historical and rhetorical terms. Thomas does not think it necessary to discuss the Franciscan ideal of absolute poverty, even though its advocates strongly emphasized that it had received the Pope's approbation, and that therefore it could claim not only a legitimate but a privileged position in the Church. These arguments, and the ecclesiological problems that they entail, are simply ignored by Thomas, even though he had witnessed passionate discussions of the issues in Paris. His silence implies that, from the beginning, he judged that the Franciscans' understanding of poverty, which was a saliant feature of their Order, could neither be demonstrated theologically nor realized practically.

Owning things in common, whether they be moveable or immoveable property, does not diminish perfection in any essential way, but the practice among religious must have a special character that corresponds to the aims of the particular order. In itself, owning property in common neither diverges from the original ideal of religion nor does it merely make concessions to particular historical circumstances. The practice, however, has degrees, which must carefully be observed. An order dedicated to both contemplation and studies must take more care of spiritual things than a purely contemplative order. Therefore, such an order must adopt a kind of poverty that causes a minimum of "anxiety." A religious order dedicated to contemplation and preaching to others (as the Dominicans) must keep only modest (*modica*) stores, consisting of products of the season, which are laid up for a relatively short time. (Thomas does not refer to the ownership of convents, churches or books, probably because it was no longer disputed).[31]

There can be no objections against a convent practicing such poverty, Thomas says, for it corresponds to the intentions of the Gospel. Indeed, one may say that Christ taught this form of poverty by his own example ("hoc Dominus, paupertatis institutor, docuit suo exemplo"). This cannot be proved better than by the fact that he owned a purse, which he committed to the care of Judas. The purse contained the alms given to the Lord. According to the traditional interpretation, the contents of the Lord's purse were intended for the poor, but among the poor, Thomas says, one must "especially" include the disciples. (Thus the former relief fund for the poor has turned into a fund to support the disciples.) This is a new conception in Thomas's treatment of religious poverty, for in *Contra retrahentes* he does not mention that the disciples lived from the Lord's purse.[32] That these are not just off-hand remarks but careful expressions is clear when they are read from the point of view of a Franciscan, who doubtless would have found them provoking and scandalous. According to Thomas's teaching, money, which in monastic communities had long been considered a device of the evil world, can be accepted as a normal means for the maintenance of a convent or monastery, and, moreover, its use can be traced back to Christ himself. Over this point, it became evident that the two mendicant orders were polarized on an essential question and would go their separate ways.[33] For the Dominicans, Thomas's argument theologically justified the Order's statutes about properties owned by convents, which had been issued by the

General Chapters. Dominican convents, and even more, monasteries, were allowed to own money, and smaller or larger amounts of supplies; the monasteries could even possess landed property without jeopardizing the ideal of evangelical perfection.[34]

SUMMAE THEOLOGIAE TERTIA PARS

Thomas's pointed statements about his Order and the following of Christ in voluntary poverty ("sequela Christi in voluntaria paupertate") can be explained best against the background of the contemporary discussion, as I have tried to show. Although in the texts that we have discussed Thomas refers to the word and example of Christ, in them he does not develop fully the Christological dimensions of his views on poverty and property. He knew that it was not enough to interpret individual Gospel texts, for his opponents could likewise refer to words of the Lord that could not be ignored nor mitigated. Therefore, Thomas needed to discover a Christological principle that would uncover the true meaning of the pertinent scriptural texts, within a wider, more systematic context. He had not done so either in *Contra retrahentes* nor in the *Secunda secundae,* although his teaching in those texts concerning the instrumental character of the vows is essential for his understanding of the following of Christ (*sequela Christi*).

Appropriately, Thomas seeks the meaning of Christ's mission and the purpose of the poverty he practiced in his great Christological work, the third part of the *Summa theologiae,* which he wrote in the years 1271–1273. Specifically, he treats these topics in question 40, which concerns Christ's behavior on earth ("De modo conversationis Christi"). Doubtless, for a long time Thomas had envisioned the solution he offers here, and his former statements on the subject were surely conceived with this solution in mind. In his treatment in the *Tertia pars,* he shows how the following of Christ, in its many dimensions, must be practiced, and how it relates to preaching and teaching.

At the beginning of his reflection (q.40 a.1), Thomas states a principle that determines all further details. All of Christ's actions—especially his preaching and teaching—corresponded to the threefold intention of the Incarnation: to reveal the way of truth ("viam veritatis nobis in seipso demonstravit": ST 3 Prol.); to liberate human creatures from sin, and to grant access to God the Father.[35] From this follow several consequences. Christ could not lead the concealed life of a hermit; rather, he needed to appear in public and preach before the eyes of all. One who would free the people from sin must live among sinners and be an itinerant preacher. Thomas characterizes Christ's public activity by quoting a text from John Chrysostom that also characterizes the mendicants' care of souls, which had once been sharply criticized by William of Saint-Amour: "Walk about, and seek those who go astray."[36]

Thus, according to the threefold intention of the Incarnation, it is appropriate that Christ kept close company with the people, in order to draw them to himself by his human behavior. In more profound terms, the one who would reveal his divinity by way of his humanity must do so in a way that is comprehensible to those before whom he appears and to whom he speaks. Christ did this in a characteristic way, which set an example for all later preachers. That Thomas has the Dominicans in view is evident

from a famous sentence from the *Secunda secundae* (q.188 a.6) that he here repeats word-by-word, and traces back to Christ himself: "An active life in which one hands over what he has contemplated (*contemplata*) to others by preaching and teaching is more perfect than a solely contemplative life. . . . That is why Christ chose such a life." Strict solitude is incompatible with such a life, for a mind overflowing with an abundance of contemplation (*abundantiam contemplationis*) desires to communicate with others.[37] The conclusion is obvious: an order that adopts this way of life surely follows directly in the steps of Christ. Thomas relates Christ's way of acting even more directly to the Preachers: *actio Christi fuit nostra instructio*.[38] Following the Lord's example, at certain times the Preachers should withdraw from the public, in order to rest, to pray, to avoid the applause of the crowd and the temptation to turn their sermons into ostentatious displays. Thomas draws these specific instructions from a text of John Chrysostom, to which he appends this significant comment: all of this is very true, "especially when one must dispute *de necessariis*." We may interpret this comment as referring to masters in the schools. Thus Christ is as much an example for professors as for preachers.[39]

The answer to the question, Was it necessary for Christ to lead an austere life? (q.40 a.2), likewise serves as a means of instruction. Thomas's argument that the solitary life of a hermit is not appropriate to the intention of the Incarnation implies that Christ condescended to become an equal with those among whom he lived. That he did so was most appropriate (*convenientissimum*). The consequences for everyday life are obvious. For example, the Lord ate and drank in the common way of ordinary people.[40] His reason for doing so, according to Thomas, conforms to a principle that we have already encountered several times: Christ gave us an example of perfection only in such acts as are necessary for salvation. Again, Thomas leaves aside all the complicated arguments concerning an *opus interius*, which is always highly perfect, and an *opus exterius*, which is "sometimes" imperfect.[41]

Why did Christ freely choose to be like all the others? Thomas answers this question by referring to a crucial text of Augustine, which in turn expounds St. Paul (Rom 14:17): The kingdom of God does not consist in food and drink, but in equanimity, by which privation can be borne just as well as abundance.[42] This equanimity alone is important. One who possesses equanimity is neither made insolent by abundant riches nor weighed down by abject poverty. The quotation from Augustine also plays an important role in *De perfectione spiritualis vitae*; here Thomas says that religious acquire equanimity by poverty, the bishops by pastoral care.[43]

That Christ fasted and withdrew into the wilderness does not contradict the general principle, by which he lived fully amidst the people. On the contrary, fasting and withdrawing, on the one hand, and sharing the life of the people, on the other, form a circular movement, as is expressed in the formula, *contemplari et contemplata aliis tradere*. According to this circular pattern, the task of an ideal preacher is "first of all" contemplation, in order that he may "then descend" into communal life and public activity. Here again, Thomas refers not only to the life of Christ, but to those who would follow him as well. The Preachers, like Christ, should move between the "wilderness" and "public life."[44]

We arrive at a final question, already half-answered: Did Christ need to live a life of poverty? (q.40 a.3), or, according to the Franciscan version of the question, Did Christ live according to the highest standard of poverty by totally renouncing every kind of possession? In this question, Thomas has the Franciscan thesis clearly in mind, as is evident in an objection, where he uses the term *maxima paupertas* in contrast with the term *communis vita*. This seems to be Thomas's only direct allusion to the Franciscan thesis concerning poverty.[45]

First of all, Thomas says, Christ's poverty of life aided his preaching, enabling him to teach the Gospel in villages and towns. He obliged future preachers to dedicate themselves wholly to this task, and to avoid all worldly affairs. Moreover, that Christ's poverty was appropriate to his mission in the Incarnation is evident, for divinity shows its power most of all in weakness. In this article, Thomas does not allude to "Christ's nakedness," as he did so often in earlier writings, but the scriptural texts he quotes fully express the austerity of the Lord's poverty.[46] But how can such poverty be compatible with the idea of Christ's "ordinary life," which Thomas has so amply developed in previous questions? Does he retreat before the light of the Gospel texts?

The solution to this question can be found in Thomas's reply to the second initial objection, which claims that Christ followed the common way of life (*communis vitae modus*), and that this excluded the most extreme poverty (*maxima paupertas*), because it would be contrary to the closeness (*familiaritas*) with the people that was appropriate to his mission. Thomas does not contradict the objection, but adds an interesting and significant explanation. This explanation implies a parallel between Christ's life and a Dominican practice that Thomas obviously wished to legitimize. One can lead a common life if one's sustenance and clothing (*victus et vestitus*) come from one's own possessions. This is the case with most people. Apart from this there is another possibility: if one accepts the things he needs from others, for example, from women or the rich. Thomas deliberately uses the word "accept" (*accipiendo*) and not the word "beg for." He alludes here to the women who followed Christ and who served him with what they had. Instead of making an immediate application, Thomas develops his response with a cleverly chosen quotation from Jerome, which confirms the important conclusion he will reach by the authority of a father of the Church and thus safeguards it against objections. Thomas's tactical use of Jerome's authority is a sign that he expected vehement protest against his conclusion.

Why did women serve Christ with their own provisions? Jerome explains that "it was common among the Jews, and did not arouse suspicion, for women, following an old custom of the people, from their own property to offer sustenance and clothing to their teachers. But because this custom could cause offence to the Gentiles, Paul says that he rejected it."[47] In short, what the women gave Christ were not alms for a beggar, but, according to a traditional Jewish practice, a fee given to their teacher. A teacher could count on this fee and claim it as a certain right, and so Christ was entitled to receive it. Jerome's explanation serves Thomas well, for it easily applies to a community of preachers and professors, who, like Christ, have no possessions nor income, but who, also like Christ, are entitled to make a living from preaching and teaching.

At the beginning of his second Parisian regency, Thomas recognized that the

movement of evangelical poverty, to which he and his Order were deeply indebted, had
two faces: one that must be defended to the best of one's ability, in order to remain
faithful to an essential aspect of the Gospel, and another that showed dangerous and
illusory possibilities. The battles, however painful they might be, needed to be fought
on two fronts: on the one hand, the legitimacy of evangelical poverty as a Christian way
of life needed to be defended against its detractors among the secular priests; on the
other hand, that poverty could not be construed in such a way as to exclude ordinary
Christians—including bishops and monks, as well as the Dominicans themselves—
from access to spiritual perfection. The battles Thomas Aquinas fought have left deep
marks in his quodlibetal questions, opuscula, scriptural commentaries and in the
Summa theologiae, as I hope my analysis has shown. That the several elements of his
treatments of evangelical poverty and the following of Christ ultimately coalesced in a
few Christological articles of the *Tertia pars* is due not least to Thomas's need to con-
tradict the idea of *maxima paupertas.*

NOTES

1. *Contra impugnantes Dei cultum et religionem* c.7, ed. H.-F. Dondaine, Leonine Edition 41
(1970): A114 §8, lin. 745–800. For the background of the controversies, see M.-M. Dufeil, *Guillaume
de Saint-Amour et la polémique universitaire parisienne 1250–1259* (Paris, 1972), and J.-P. Torrell,
Initiation à saint Thomas d'Aquin, sa personne et son oeuvre (Fribourg Suisse-Paris, 1993), 110–22.
For the ecclesiological problems, see Y. Congar, "Aspects ecclésiologiques de la querelle entre mendi-
ants et séculiers dans la seconde moitié du XIII^e siècle et le début du XIV^e," AHDLMA 28 (1961):
35–151.
2. *Contra impugnantes* c.7 (Leonine Edition 41: A112 §7, lin. 624–27); "Ex quo patet quod prae-
dicatori quasi merces debetur victus ab his quibus praedicat. . . . "; Ibid. (Leonine Edition 41: A121 §12
[ad 4], lin. 1459–62): " . . . sed praedicantes qui non sunt praelati accipiunt sicut mercedem debitam,
unde habent potestatem accipiendi quamvis non coactivam. . . . " See U. Horst, *Evangelische Armut
und Kirche. Thomas von Aquin und die Armutskontroversen des 13. und beginnenden 14. Jahrhun-
derts* (QF N.F. 1, Berlin, 1992), 35–46.
3. *Quodlibet I* q.7 a.2, ed. R. M. Spiazzi, *S. Thomae Aquinatis Doctoris Angelici Quaestiones
quodlibetales* (Turin-Rome, 1949), 13f. For the dating, see Torrell, *Initiation,* 306.
4. *Quodl. I* q.7 a.2 ad 2 (ed. Spiazzi, 14): " . . . sicut praeambulum et praeparatorium ad perfec-
tionem, ut paupertas, castitas et huiusmodi, quibus homo retrahitur a curis saecularium rerum, ut
liberius vacet his quae Dei sunt; unde huiusmodi magis sunt quaedam perfectionis instrumenta. . . . "
5. *Contra impugnantes* c.1 (Leonine Edition 41: A54 §1, lin. 129–34): "Alia autem omnia quae
in religionibus reperiuntur sunt adminicula quaedam vel ad cavendum ea quibus per votum religionis
abrenuntiatur, vel ad observandum illud in quo homo per religionis votum Deo se serviturum promi-
sit." See also SCG 3 c.133 (*Liber CG* 3: 200–1 n° 3067): "Et quanto modus vivendi in paupertate mi-
norem sollicitudinem exigit, tanto paupertas est laudabilior: non autem quanto paupertas fuerit maior.
Non enim paupertas secundum se bona est: sed inquantum liberat ab illis quibus homo impeditur
quominus spiritualibus intendat." The quotation from Jerome, which supports the thesis may be found
in *Commentariorum in Matheum libri IV,* in *S. Hieronymi Presbyteri Opera* 1.7, ed. D. Hurst and
M. Adriaen, CCSL 77 (1969): 127: "Et quia non sufficit (Petro) tantum relinquere iungit quod perfectum
est: *et secuti sumus te* . . . Non dixit: qui reliquistis omnia, hoc enim et Crates fecit philosophus, et
multi alii divitias contempserunt, sed *qui secuti estis me,* quod proprie apostolorum est atque creden-
tium."
6. *Catena aurea in quatuor evangelia* (Catena 1: 288 n° 7). Cf. Thomas, *In Matth.* 19:21 (*Super
Matth.* 246 n° 1607): "Relinquere omnia non facit perfectionem, sed relinquere omnia et sequi Chris-

tum, quia multi philosophi reliquerunt omnia. . . . Sed Petrus magis *de affectu suo* laudatur quam de eo quod reliquit. . . . "

7. *In Matth.* 19:21 (*Super Matth.* 244 n° 1598): "*Et veni sequere me.* Hic est finis perfectionis. Unde illi sunt perfecti, qui toto corde sequuntur Deum. Unde Gen. XVII, 1: *Ambula coram me et esto perfectus. Et sequere me,* idest imitare vitam Christi. . . . Imitatio enim est in sollicitudine praedicandi, docendi, curam habendi." See *In Matth.* 16:24 (*Super Matth.* 215 n° 1408): " . . . quasi dicat: Oportet quod sitis parati ad passionem Christi imitandam."

8. *Constitutiones antiquae Ordinis Praedicatorum,* prol., ed. A. H. Thomas, *De oudste Constituties van de Dominicanen. Voorgeschiedenis: Tekst, bronnen, onstaan en ontwikkeling (1215–1237)* (Bibliothèque de la Revue d'histoire ecclésiastique 42, Leuven, 1965), 311. The problem whether the infractions of the rule are to be regarded as sin will be discussed by Thomas later (ST 2–2 q.186 a.9). See S. Tugwell, *Albert & Thomas. Selected Writings* (The Classics of Western Spirituality, New York-Mahwah, New Jersey, 1988), 601–5.

9. See U. Horst, *Evangelische Armut und Kirche,* 168–71, and *Evangelische Armut und päpstliches Lehramt. Minoritentheologen im Konflikt mit Papst Johannes XXI. (1316–34)* (Münchener Beiträge zur Kirchengeschichte 8, Stuttgart, 1995).

10. *De perfectione spiritualis vitae* c.8, ed. H.-F. Dondaine, Leonine Edition 41 (1971): B73, lin. 82–86: "Quae quidem quaestio solvi non posset, si perfectio christianae vitae in ipsa dimissione divitiarum consisteret; sequeretur enim, quod qui divitias possidet, non possit esse perfectus." For the problem of the *praeparatio animi* with the bishops, see *De perfectione* c.21 (Leonine Edition 41: B94). See Horst, *Evangelische Armut und Kirche,* 70–73. For Thomas's notion of *praeparatio animi,* see E. Sanchis, "Escritos espirituales de Santo Tomás," *Teología Espiritual* 6 (1962): 277–314, esp. 305–7. See also R. Guindon, "Le 'De sermone Domini in monte' de S. Augustin dans l'oeuvre de S. Thomas," *Revue de l'Université d'Ottawa* 28 (1958): 57*–85*. See also *De perfectione* c.8 (Leonine Edition 41: B74, lin. 161–63): "Haec est ergo prima via perveniendi ad perfectionem, ut aliquis studio sequendi Christum dimissis divitiis paupertatem sequetur." For *De perfectione,* see Torrell, *Initiation,* 122–31; Tugwell, *Albert & Thomas,* 229f.

11. *De perfectione spiritualis vitae* c.9 (Leonine Edition 41: B74, lin. 40–72).

12. *De perfectione spiritualis vitae* c.12 (Leonine Edition 41: B81, lin. 73–83): "Inter haec autem tria quae ad religionis statum diximus pertinere, praecipuum est obedientiae votum. . . . Sicut ergo inter humanis bona corpus praefertur exterioribus rebus, et anima corpori; ita votum continentiae voto paupertatis praefertur, votum autem obedientiae utrique." Cf. *Constitutiones antiquae O.P.* d.1 c.16 (ed. Thomas, 326f.) See A. H. Thomas, "La profession religieuse des Dominicains. Formule, cérémonies, histoire," AFP 39 (1969): 5–52.

13. See the Préface by H.-F. Dondaine, ed., to *Contra doctrinam retrahentium a religione,* Leonine Edition 41 (1970): C5–8, §§2–3, and Torrell, *Initiation,* 122–31. Hereafter I shall cite this work by its common title, *Contra retrahentes.*

14. *Contra retrahentes* c.6 (Leonine Edition 41: C47–48).

15. *Contra retrahentes* c.6 (Leonine Edition 41: C47, lin. 136–46). Cf. J.-P. Renard, "*La Lectura super Matthaeum* V, 20–48 de Thomas d'Aquin. (Edition d'après le ms. Bâle, Univ. Bibl. B. V. 12)," RTAM 50 (1983): 145–90, here 177–81.

16. *Contra retrahentes* c.6 (Leonine Edition 41: C48, lin. 190–98): "Sic igitur cum duplex sit modus observandi praecepta, perfectus scilicet et imperfectus, necesse est etiam duplex esse exercitium praeceptorum: unum quidem quo aliquis exercitatur in perfecta observantia praeceptorum, et hoc idem exercitium fit per consilia, sicut ex praemissis apparet; aliud autem est exercitium in imperfecta observantia praeceptorum, quod fit in vita saeculari absque consiliis." Cf. ST 2–2 q.189 a.1 ad 1.

17. *Contra retrahentes* c.15 (Leonine Edition 41: C68, lin. 12f.): "Ex quo his qui Christi paupertatem sequuntur magna dignitas accrescit." See U. Horst, "Mendikant und Theologe. Thomas von Aquin in den Armutsbewegungen seiner Zeit (zu *Contra retrahentes* c. 15)," MThZ 47 (1996): 13–31.

18. *Contra retrahentes* c.15 (Leonine Edition 41: C69, lin. 73–79): "Haec est igitur summa paupertatis perfectio, ut ad exemplum Christi aliqui homines possessionibus careant, et si aliqua reservent ad pauperum usum, praesertim quorum eis cura incumbit; sicut Dominus praecipue suos discipulos propter ipsum pauperes effectos, de his quae sibi dabantur reservans, sustentabat." In other words, in the first place the common purse was intended for the use of the disciples. In ST 2–2 q.188 a.7, Thomas states this even more clearly and explicitly includes money. He does not speak so decidedly, however, in his commentary *In Ioannem* 13:29 lect.5 (*Super Ioan.* 340 n° 1821): "Vel dicendum quod hoc quod dicit *Nihil tuleritis in via* referendum est ad singulares praedicatores et apostolos, qui nihil portare

debent quando ad praedicandum vadunt. *Non autem referendum est ad totum collegium, quod oportet aliquid habere et pro seipsis et pro egenis."* See Horst, *Evangelische Armut und Kirche,* 82f.

19. *Contra retrahentes* c.15 (Leonine Edition 41: C69, lin. 94–97): "Hanc autem crucis nuditatem per voluntariam paupertatem homines sequuntur, et praecipue qui possessionum redditibus carent."

20. J. Châtillon, *"Nudum Christum nudus sequere.* Note sur les origines et la signification du thème de la nudité spirituelle dans les écrits de Saint Bonaventure," in vol. 4 of *S. Bonaventura 1274–1974* (Grottaferrata, 1974), 719–72.

21. See Horst, *Evangelische Armut und Kirche,* 37–46, 51f., and W. A. Hinnebusch, *The History of the Dominican Order. I: Origins and Growth to 1500* (New York, 1966), 145–68.

22. *Contra retrahentes* c.15 (Leonine Edition 41: C69, lin. 126–136): "Qualis autem pauper spiritu praecipue sit, beatus Basilius ostendit dicens 'Beatus pauper, quasi Christi discipulus qui pro nobis paupertatem sustinuit; nam ipse Dominus quodlibet opus implevit quod ad beatitudinem ducit, se praebens exemplar discentibus.' Numquam autem Dominus legitur possessiones habuisse; non igitur beatitudinis detrimentum habet paupertas eorum qui possessionibus carere volunt propter Christum, sed magis beatitudinis augmentum."

23. Bonaventure, *Apologia pauperum contra calumniatorem* cc.7–11 (Quaracchi Edition 8: 272–316). See J. Bougerol, *Introduction à Saint Bonaventure* (Paris, 1988), 272–77; M. D. Lambert, *Franciscan Poverty. The Doctrine of the Absolute Poverty of Christ and the Apostles in the Franciscan Order 1210–1323* (London, 1961), 103–40; S. Clasen, *Der hl. Bonaventura und das Mendikantentum. Ein Beitrag zur Ideengeschichte des Pariser Mendikantenstreites (1252–72)* (Franziskanische Forschungen 7, Werl, 1940), 88–124; H. F. Schalück, *Armut und Heil. Eine Untersuchung über den Armutsgedanken in der Theologie Bonaventuras* (Paderborn, 1971).

24. *Contra retrahentes* c.15 (Leonine Edition 41: C69–70).

25. *Contra retrahentes* c.15 (Leonine Edition 41: C70, lin. 181–84): "Manifestum est igitur secundum expositiones praemissas apostolis interdictum fuisse ne agros, vel vineas, vel alia huiusmodi bona immobilia possiderent"; Ibid. (C71f., lin. 237–41): "Ex quo patet hanc esse evangelicae vitae observantiam ab apostolis observatam, ut ea quae ad necessitatem vitae pertinent, *possideantur communiter, possessionibus omnino abdicatis."*

26. *Contra retrahentes* c.16 (Leonine Edition 41: C73); cf. c.15 (C71–72). See Horst, *Evangelische Armut und Kirche,* 87–92. For Thomas and Joachim of Fiore, see H. J. Schachten, *Ordo salutis. Das Gesetz als Weise der Heilsvermittlung. Zur Kritik des hl. Thomas von Aquin an Joachim von Fiore* (BGPTMA N.F. 20, Münster, 1980); J. I. Saranyana, *Joaquín de Fiore y Tomás de Aquino. Historia doctrinal de una polémica* (Pamplona, 1979); M. Seckler, *Das Heil in der Geschichte. Geschichtstheologisches Denken bei Thomas von Aquin* (Munich, 1964), 189–95; J. Ratzinger, *Die Geschichtstheologie des heiligen Bonaventura* (Munich, 1959), 31–56, 113–17.

27. Now most scholars deny that Thomas was a Benedictine monk who had made solemn vows; see Torrell, *Initiation,* 7, and T. Leccisotti, *San Tommaso e Montecassino* (Miscellanea Cassinese 32, Montecassino, 1965), 37–47. Torrell, among others, refers to a phrase in William of Tocco's *Hystoria beati Thomae de Aquino* c.6, ed. A. Ferrua, in *S. Thomae Aquinatis vitae fontes praecipuae* (Alba, 1968), 35: "Abbas . . . provide ei (patri) consuluit, ut puer mitteretur Neapolim ad studendum. . . . Unde puer de utriusque parentis consilio Neapolim mittitur." From this, Torrell and others conclude that had Thomas been a monk the abbot would not have only "counselled" his father but would have simply "ordered" him. But is this argument really conclusive, considering William's notorious inaccuracy concerning details? What are the criteria for taking these statements as historical truth when William's historical veracity is denied in other cases? In ST 2–2 q.189 a.8, Thomas himself gives a laudable reason for changing from one order to another which might apply here: "Primo quidem zelo perfectioris religionis. Quae quidem excellentia . . . non attenditur secundum solam altitudinem; sed principaliter secundum id ad quod religio ordinatur."

28. See Horst, *Evangelische Armut und Kirche,* 168–89. The Franciscans' chapter general at Strassburg in 1282 decided that the provincials should take care that Thomas's *Summa theologiae* be read only by professors who had the necessary sense of judgment; see G. Fussenegger, "Definitiones Capituli Generalis Argentinae celebrati 1282," AFH 26 (1933): 139(2).

29. ST 2–2 q.187 a.5 sed c.

30. ST 2–2 q.187 a.5 ad 5: "Dicendum quod praedicantibus ex debito debetur victus ab his quibus praedicant. Si tamen non quasi sibi debitum, sed gratis dandum mendicando petere velint, ad maiorem humilitatem pertinet."

31. ST 2–2 q.188 a.7: "Manifestum est autem quod maiorem sollicitudinem spiritualium requirit religio quae est instituta ad contemplandum et contemplata aliis tradendum per doctrinam et praedi-

cationem, quam illa quae est instituta ad contemplandum tantum. Unde talem religionem decet paupertas talis quae minimam sollicitudinem ingerit. . . . Illis autem quae ordinantur ad contemplata aliis tradendum, competit vitam habere maxime ab exterioribus sollicitudinibus expeditam. Quod quidem fit dum modica quae sunt necessaria vitae, congruo tempore procurata, conservantur." Thomas never speaks about the ownership of books which represented considerable value, as generally he avoids casuistic problems. For contemporary discussions in the Order about this topic, see S. Axters, "Boekenbezit en boekengebruik bij de Dominikanen in de dertiende eeuw," in *Studia Mediaevalia in honorem admodum Patris R. J. Martin* (Bruges, 1948), 475–97, and more generally, I. W. Frank, "Die Spannung zwischen Ordensleben und wissenschaftlicher Arbeit im frühen Dominikanerorden," *Archiv für Kulturgeschichte* 40 (1967): 164–207. With regard to churches and buildings, see G. Meersseman, "L'architecture dominicaine au XIIIᵉ siècle. Législation et pratique," AFP 16 (1946): 136–90. Through Thomas of Cantimpré we know that the Dominicans collected stores in the late summer of 1260. See S. Tugwell, *Early Dominicans: Selected Writings* (Classics of Western Spirituality, New York etc., 1982), 134. This corresponds with what Thomas says in the text quoted above.

32. ST 2–2 q.188 a.7: "Et hoc Dominus, paupertatis institutor, docuit suo exemplo; habebat enim loculos, Iudae commissos, in quibus recondebantur ei oblata . . . inter illos pauperes praecipue erant eius discipuli, in quorum necessitates pecunia loculorum Christi expendebatur. . . . Ex quo patet quod conservare pecuniam, aut quascumque alias res communes, ad sustentationem religiosorum congregationis eiusdem, vel quorumcumque aliorum pauperum, est perfectioni conforme, quam Christus docuit suo exemplo. Sed et discipuli post Resurrectionem, a quibus religio sumpsit originem, pretia praediorum conservabant, et distribuebant unicuique prout opus erat."

33. See L. Hardick, "'Pecunia et denarii'. Untersuchungen zum Geldverbot in den Regeln der Minderbrüder," *Franziskanische Studien* 40 (1958): 193–217, 313–28; 41 (1959): 268–90; 43 (1961): 216–43.

34. Horst, *Evangelische Armut und Kirche,* 123–32.

35. ST 3 q.40 a.1. See L. Scheffczyk, "Die Stellung des Thomas von Aquin in der Entwicklung der Lehre von den Mysteria vitae Christi," in *Renovatio et Reformatio: wider das Bild vom "finsteren" Mittelalter. Festschrift für Ludwig Hödl zum 60. Geburtstag,* ed. M. Gerwing and G. Ruppert (Münster, 1985), 44–70.

36. ST 3 q.40 a.1: " . . . ut Chrysostomus dicit 'in eodem loco manendo posset Christus ad se omnes attrahere, ut eius praedicationem audirent . . . non tamen hoc fecit, praebens nobis exemplum, ut perambulemus et requiramus' pereuntem. . . . "

37. ST 3 q.40 a.1 ad 2: " . . . sed vita activa secundum quam aliquis praedicando et docendo contemplata aliis tradit, est perfectior quam vita quae solum contemplatur, quia talis vita praesupponit abundantiam contemplationis. Et ideo Christus talem vitam elegit."

38. See R. Schenk, "*Omnis Christi actio nostra est instructio.* The Deeds and Sayings of Jesus as Revelation in the View of St. Thomas," in *La doctrine de la révélation divine de saint Thomas d'Aquin* (Actes du Symposium sur la pensée de Saint Thomas d'Aquin, tenu à Rolduc, les 4 et 5 Novembre 1989), ed. A. Blanco (Studi Tomistici 37, Vatican City, 1990), 104–31.

39. ST 3 q.40 a.1 ad 3: "Dicendum quod actio Christi fuit nostra instructio. Et ideo ut daret exemplum praedicatoribus, quod non semper se darent in publicum, ideo quandoque Dominus se a turbis retraxit. . . . Chrysostomus [*In Matth.,* hom. 15; PG 57: 223]: 'Per hoc quod non in civitate et foro, sed in monte et solitudine sedit, erudivit nos nihil ad ostentationem facere, et a tumultibus abscedere, *et maxime cum de necessariis disputare oporteat.*' "

40. ST 3 q.40 a.2: "Dicendum quod congruum erat incarnationis fini ut Christus non ageret solitariam vitam, sed cum hominibus conversaretur. Qui autem cum aliquibus conversatur, convenientissimum est ut se eis in conversatione conformet. . . . Et ideo convenientissimum fuit ut Christus in cibo et potu communiter se sicut alii haberet."

41. ST 3 q.40 a.2 ad 1: "Dicendum quod Dominus in sua conversatione exemplum perfectionis dedit in omnibus quae per se pertinent ad salutem. Ipsa autem abstinentia cibi et potus non per se pertinent ad salutem." Cf. Bonaventure, *Apologia pauperum* cc.1 and 5 (Quaracchi Edition 8: 238f., 257–66).

42. ST 3 q.40 a.2 ad 1: "Et Augustinus dicit in libro De quaestionibus evangelii [liber 2 q.11; PL 35: 1338]. . . . Quia scilicet sancti Apostoli 'intellexerunt regnum Dei non esse in esca et potu, sed in aequanimitate tolerandi,' quos nec copia sublevat nec deprimit egestas."

43. *De perfectione spiritualis vitae* c.21 (Leonine Edition 41: B94, lin. 119–23): "Ad hanc autem aequanimitatem inopiam tolerandi religiosi perveniunt per exercitium nihil habendi; sed episcopi ad eam perduci possunt per exercitium circa curam Ecclesiae et dilectionem fraternam. . . . "

44. ST 3 q.40 a.2 ad 3: "Nec tamen incongruum fuit ut Christus post ieiunium et desertum ad

communem vitam rediret. Hoc enim convenit vitae secundum quam aliquis contemplata aliis tradit, quam Christus dicitur assumpsisse, ut primo contemplationi vacet, et postea ad publicum actionis descendat aliis convivendo."

45. ST 3 q.40 a.3 ob. 2: "Ergo videtur quod in divitiis et paupertate communem modum vivendi servare debuerit, et non uti *maxima paupertate.*"

46. ST 3 q.40 a.3.

47. ST 3 q.40 a.3 ad 2: "Dicendum quod communi vita uti quantum ad victum et vestitum potest aliquis non solum divitias possidendo, sed etiam a mulieribus et divitibus necessaria accipiendo. Quod etiam circa Christum factum est. . . . Ut enim Hieronymus dicit, Contra Vigilantium [*In Matth.* 4 <27:55>; CCSL 77: 277], 'consuetudinis Iudaicae fuit, nec ducebatur in culpam, more gentis antiquo, ut mulieres de substantia sua victum atque vestitum praeceptoribus suis ministrarent. Sed quia hoc scandalum facere poterat in nationibus, Paulus se abiecissse commemorat.' Sic ergo communis victus poterat esse sine sollicitudine impediente praedicationis officium, non autem divitiarum possessio." In the *Catena aurea,* Thomas continues with Jerome (*Catena* 1: 415): "Ministrabant autem Domino de substantia sua, ut meteret illarum carnalia, cuius illae metebant spiritualia: non quia indigebat cibis Dominus creaturarum, *sed ut typum ostenderet magistrorum,* quia victu atque vestitu ex discipulis deberent esse contenti."

Christ in Dominican Marriage Preaching

David L. d'Avray

Believing as any historian should in the power of negative thinking, let me start, before coming to the real argument, by criticizing two false antitheses and dismissing an interesting case as untypical.[1] The first antithesis is of "Christocentric" and "Theocentric" religious thought. As indicated in the Introduction to this volume, the conceptual distinctions behind these characterizations are theologically weak. Christ's humanity and divinity could not easily be separated once the Council of Chalcedon had defined of Christ that human nature had been united to the divine nature in the second Person of the Trinity. A theology of Christ could hardly help but be about God. It is true that one can envisage religious thought which is about God but not about Christ. One might argue that Meister Eckhart's most personal and original ideas move in that direction. His vernacular mystical works were radically original and different, however, not typical of Dominican theology in general.[2] Mainstream Dominican theologians were bound to study Christ and the Godhead together in their theological syntheses. In their sermons too: a passage from a marriage sermon by Jacopo da Varazze, whose sermons survive in an astonishing number of manuscripts, shows how naturally a preacher could slip from "Christ" to "God" and back. Jacopo is talking primarily about the marriage of God and the soul, but Christ comes in and out of the comparison. When the marriage of God and the soul is initiated through baptism, there is a betrothal of the bride who promises to renounce the devil and his pomps, and the bridegroom, who is Christ, gives his faith, because the Christian faith is received there. Again, under "consummation," Jacopo says that the soul should never withdraw from God—for Christ is never separated from the soul unless the soul first sends him away.[3] This passage is both "Christocentric" and "Theocentric," and should surprise nobody.

Probably few if any scholars think that the Dominicans ignored Christ, but there may be a more widespread idea that a vivid consciousness of Christ's humanity in the Franciscan order can be contrasted with a colder and more analytical Dominican tradition. This is the second false antithesis. The stigmata of St. Francis on the one hand, and abstract demonstrations of God's existence by Thomas Aquinas on the other—one could arrange a history of the friars around these two poles. Could do but should not, since the two orders for the most part shared a common ethos after the first generation. The aim of this paper is to apply a peculiar sort of aesthetic evaluation to the problem of "Christ and the Dominicans," but it is best to begin by clearing away the aesthetic but very unempirical contrast between popular, vivid, and concrete Franciscan preaching, on the one hand, and a more elitist, intellectualized, and abstract Dominican preaching, on the other. In fact no such contrast has ever been demonstrated, and the hypothesis which should hold the field, open to Popperian refutation of course, is that Franciscan and Dominican sermons are much more similar than different. After

almost twenty-five years of work on the Latin transmitted model sermons that consti-
tute the bulk of the evidence, I find it hard to think of any major differences between
their theological or religious style in the thirteenth century. The following analyses are
therefore a sort of synecdoche, where the Dominicans can be taken as a part standing
for thirteenth-century preaching as a whole. I doubt if the results of a study of Christ
in Franciscan marriage preaching would be very different. Neither seem violently emo-
tional (though no doubt more emotion could be injected when the model sermons were
turned into living speech), but both can impress ideas on the mind in a concrete and
vivid way. One of the ways in which they do so is by using similitudes, including the
marriage image which is the subject of this paper.

One thing Dominican and Franciscan sermons of the thirteenth century have in
common is that by and large they are a long way from the cutting edge of speculative
theology. For instance, the idea that marriage confers grace became the standard theo-
logical doctrine in the course of the thirteenth century (which in the preceding century
it had not been).[4] There is not much evidence of this doctrine in thirteenth-century
marriage preaching in France, familiar though it must have been among Paris academ-
ics.[5] One can find it, however, in sermons by two Florentine Dominicans, Remigio de'
Girolami[6] and Aldobrandino da Toscanella. (Both, incidentally, are more prone to in-
tellectualize their preaching than are their northern counterparts, but then the same
may be said of the thirteenth-century Franciscan Servasanto da Faenza,[7] so the ten-
dency is not specifically Dominican, and probably has a lot to do with Florence and its
educated lay public.)[8] Aldobrandino da Toscanella's doctrine of grace in marriage is
relevant to our theme because it is centered on Christ:

> Again, in marriage grace is conferred inasmuch as it is contracted in the faith of
> Christ. For it has that from which it can confer the grace which provides help in
> carrying out those things which are required in marriage. And we see an example
> of this thing in the realm of natural things, since whenever some capacity is
> given to someone by God, the kinds of help are also given with which man may
> conveniently use that capacity, so that it may pass over into act. So when the
> capacity to use his wife to procreate children is given to man in matrimony by
> divine institution, the grace without which he could not easily do that is also
> given. There is also a clear example with animals: when God gives to them the
> capacity to run, he gives protected feet so they are able to run; and to trees, to
> whom he gives the power of bearing fruit, he also gives the things through which
> they might be able to bear fruit [sic]; and so it is in the case in point. So matri-
> mony is a sacrament of the New Law. For it signifies the conjunction of Christ
> and the Church. So St. Paul says to the Ephesians: "This is a great sacrament: I
> mean in Christ and the Church." But a sacrament is a cause of grace.[9]

The reasoning at the end of the passage is implicitly syllogistic: Marriage is a sacrament
(because it signifies Christ's conjunction to the Church); but a sacrament is a cause of
grace. [Therefore marriage is a cause of grace.] This is speculative theology in a sim-
plified form—actually rather untypical of thirteenth-century preaching in general.

The other passages to be discussed are more characteristic of their time and genre.
The kind of categories scholars usually employ to analyse Aquinas et al cease to be
appropriate for such passages, where the theology is more aesthetic then speculative.
These passages and the kind of preaching they stand for are the real subject of this

paper. My aim is to show how Christ was made present to the imagination by Dominican sermons through the efficacious use of marriage symbolism. This symbolism combined with other influences (which will be analysed) to create concrete likenesses in the mind of listeners of the relation between Christ and the soul or of the two natures in Christ. I shall argue that these likenesses should be evaluated as aesthetic objects, since they involve more or less close correspondences between the message level and the image level.[10] The image which holds together the following passage from Gerard de Mailly[11] is that of the ideal husband.

> There are however seven conditions in Christ which are commonly required in a bridegroom, for the sake of which the soul should gladly contract a spiritual marriage with him. All of them are touched on in the beginning of the first letter to the Hebrews. The first condition is that he is very eloquent—in French, "biaus parliers." For he argued our case rationally through a beautiful speech on the cross—in French: he "deraina," and he continues to argue it in the heavenly court. "For we have an advocate with the Father, Jesus Christ the just," 1 John 2 [2], and he himself says of himself, Isaiah 63 [1]: "I that speak justice and am a defender to save"—in French: "j'ai derainie bien ma droiture et si me combat bien por mon aman a saver." This condition is touched on when it is said [Hebrews 1:1–2]: "at sundry times and in diverse manners," etc., " last of all he has spoken to us in his son."

Then other points about Christ are expressed through the metaphor of an ideal husband's qualities. He would have wealth: Christ is the "heir of all things;"—wisdom: God created the earth through Wisdom (i.e., the second person of the blessed Trinity);—beauty: Christ is "attractive in form beyond the sons of men, and the angels longed to look upon him" (Ps. 44:3 and 1 Peter 1:12);—power: Christ upholds all things by the word of his power;—nobility: he is higher than angels.[12]

The passage is aesthetically efficacious: it would have impressed some ideas about Christ firmly on the minds of many listeners. The passage about Christ's eloquence conveys the idea that Christ communicates between God and man, while the image would have been effective in a period when capacity to put a case well in court could on occasion have been more useful to a knight than physical strength. The idea of the beauty of Christ could hardly have been conveyed through a vivid visual description of his actual appearance (which seems not to be the point here), and the "ideal husband" image gets it over, especially since the use and choice of scriptural texts prevent it from becoming inappropriately concrete. I would suggest that hitting the right level of generality, directing the spotlight of metaphor in the right places, is a principal criterion for the efficacy of an image, and that this one passes the test.[13] Though the "bridegroom" image has a biblical origin, the passage is unlike anything in the Old or New Testament. The pragmatic and practical tone may also be felt to mark it off from the more exalted and high-flown Bernardine tradition of Bride mysticism: these are qualities for which a sensible girl might look in a husband. In short, if there were such a thing as a canon of thirteenth-century images, this would deserve a place in it.

However, we should probably not treat this as a case of individual creativity. The ideal husband passage is one of a whole series in the thirteenth century.[14] The foregoing piece of shameless and crudely unsophisticated aesthetic evaluation really applies to a

collective achievement. The image is more or less skillfully worked out from text to text, and the set of qualities is not identical from case to case, but in all or most it works well.

The image stands translation into other cultural worlds (such as our own) relatively well. Wealth, good looks, and even nobility might enhance a man's eligibility even today. Nevertheless, we had better not substitute twentieth-century images for the ones this passage could have evoked. It is possible that for some listeners at least the images evoked would be those of characters from courtly romances, such as Erec or Yvain or the father of Cliges.[15] Awareness of this possibility, and familiarity with passages in romances where heroines get to know the knight of their life, is a deterrent against imaginative anachronism.

Not only other genres, but also social structures, can help us understand the 'reception end' of preaching. Without at least an appreciation of the social and legal condition of thirteenth-century serfs, the following passage from a version of a sermon by Pierre de Reims[16] must lose some of its force. As transmitted by this manuscript, the metaphorical marriage seems to be between Christ and the person escaping from sin. Whereas in other marriages virginity is lost, in this marriage the corrupt find it again, and the waters of sadness are turned into the wine of joy. The water jars are the causes of sadness. This takes Pierre on to an evocation of the sadness of a sinner.[17] He compares it to the sadness of a peasant girl, poor and of servile condition, who has been betrothed to the son of a king, but then lost everything through her own fault. My translation deliberately reflects some awkwardness in the Latin wording, which should not divert attention from the aesthetic value of the passage:

> . . . for instance, if a poor little serf girl were betrothed [*or:* married] to the son of a king, and she disgraced him by prostituting herself, and had all her goods taken away from her, I think she would have many causes of sadness.
> First, because, as was said above, she has offended her bridegroom.
> Secondly, that she should not say: "Even if I have lost my bridegroom, I still have a good inheritance in my patrimony."—Truly, you have also lost your inheritance. Lamentations, final chapter [5:1]: "Our inheritance is turned to aliens, our houses to strangers."
> She will also say, thirdly, "I still have my movable goods, that is, many good works, even if I am deprived of my inheritance."—By no means, since, "because of the multitude of her iniquities, her children are lead into captivity" [Lamentations 1:5], that is, all her good works are destroyed. Lamentations 1[10]: "The enemy has put out his hand to all her desirable things," etc.
> But lest, fourthly, she might be able to rely on her beauty, so that as if on account of her attractive appearance she might be desired by another, she has lost even that, because "from the daughter of Sion all her beauty is departed," Lamentations 1[6], and her "face is now made blacker than coals," Lamentations 4[8]: this is the interior grace which is the loveliness of the soul, of which the Psalm [44:14] says "All the glory of the king's daughter is from [within]."
> Fifthly, I do not allow that there should be something, even after she has lost all these things, if she were to have some good friends who would receive her; but for certain she has lost them all, because "all her friends," that is the angels and saints, "have spurned her," and not only spurned her, but "also have turned into

her enemies," Lamentations 1[2]; and Isaiah 33[7], "the angels of peace have wept[18] bitterly."

But still, at the last, if she were free and had her own law, after all these things she could still acquire a means of living for herself from somewhere or other; but it is not so, because she has fallen into "a greatness of bondage"; Lamentations 1[3]: "Juda hath removed her dwelling place, because of her affliction and the greatness of her bondage" etc. Jeremiah 16[13]: "You will serve alien gods who will not give you peace," etc.

Therefore those six losses are the six water-jars in the present marriage, which is celebrated in true penitence.

(Paris, BN, Ms. lat. 12417, fol. iiiira)[19]

The scenario of so unequal a marriage is unrealistic, but put together from realistic elements. It could hardly have happened but could easily have been imagined in the thirteenth century. (Even in the twentieth century a whole genre of cheap romances has concentrated on the courtship of ordinary girls by men much richer and more success-ful than they are.) As for the list of losses, part of that too is timeless. A woman could lose her fiancé, her looks, and her friends in the twentieth century as well. The last item on the list is specific to its period: "if she were free and had her own law . . . she could still acquire a means of living for herself from somewhere or other." Without some research on the social history of the peasantry in the thirteenth century most of the force of this is lost on the modern reader (rather an historian from the U.S.A. might have to do some research to realise the difference between British Passports of the 1970s with or without the stamp "right of abode"). Servile status was not just a matter of material well-being, for a serf or *nativus* could easily be more prosperous than a freeman, yet bond men were still eager to be free. W. C. Jordan has captured for one region of France an attitude to unfreedom which transcended economic considerations.

> The Senonais evidence is eloquent that serious people in a real world, desperately wanting freedom, knew that their indebtedness would be heavy if they got it, knew that the likelihood of unspecified residual rights complicating their lives was too great to be ignored, knew, finally, that the financial price of freedom might mean putting even their patrimonies at risk. The wonder, perhaps, is not that a few balked, but that so many played out their parts in a drama whose epi-logue might last longer and be of nearly as much consequence as the play itself.[20]

He remarks that "not one of the people manumitted whose successors in tenancy can be identified from charters or obituary books had a single heir named "Félis" or "Félise," names common among the unfree."[21] "The explanation for this develop-ment—assuming it is not a ghost produced by the sketchy evidence—is the simple one: people realized that the name smacked of servitude which was vile (*vilibus sertitutibus et costumis*)."[22] (Jordan makes a striking comparison with the history of the name "Pleasant" in the American South.[23]) One should pause for a moment to reflect on the implications of this. In Pierre's sermon—at least in this manuscript's version of it—the economic disadvantages are the foundation of this part of the symbolic structure. The opportunity to strengthen the symbolism by allusion to other disadvantages, beyond the economic order, would be missed by a preacher who stuck closely to this model.

An aesthetic opportunity lost by the writer and the preacher could still have been re-
covered in the process of the sermon's reception by the audiences who heard it, how-
ever, for some members of at least some congregations could well have been highly
sensitized to all the implications of unfreedom. When the symbol that was preached
was combined with their social experience, it could have taken on a degree of aesthetic
value far beyond that which the text contains. This conclusion can be put together
with the similar one about the sermon by Gerard de Mailly. In both cases, the aesthetic
adequacy of an image, its power to hit home to the imagination, is carried only partly
by the words of the text, while some of its force could have been supplied at the recep-
tion end: by familiarity with romances in the case of the ideal husband image of Gerard
de Mailly, or by knowledge of the social nuances of serfdom in the other case. In the
first case it is possible that the author intended to draw on the audience's resources, but
in the second case the written version studied seems to have missed a trick which
could have been recovered at the reception stage.

The foregoing remarks about Gerard de Mailly and Pierre de Reims have a lot in
common with an old-fashioned sort of evaluative literary criticism. However, they are
not quite like criticisms of individual literary texts. In the case of the ideal husband
passage, the object of criticism is a topos shared by a number of texts. In both the ideal
husband and serf girl passages, furthermore, the aesthetic value is not wholly located
in the text. In this respect the interpretation offered here has more in common with a
somewhat less old-fashioned, though solidly established type of literary criticism, re-
ception-aesthetics.[24]

The passages just discussed are at some distance from either end of a sliding scale.
What we call "classics" are usually works in which most of the aesthetic impact is
encapsulated in the text itself, so that it can be enjoyed without expert background
knowledge in completely different cultures and societies. (Here is a litmus test: could
the work be published in *Penguin Classics?*) At the other end of the scale, the text
merely presses buttons that activate images current in its particular society and time
but not most other societies or periods. The appeal of such texts is ephemeral but can
be enormous for a time. Best-selling authors often achieve their successes by knowing
which buttons to press. They have the gift of calling up images which are already lying
around in the minds of their public. Before we get too condescending about such works,
we should remember that these ephemeral texts may produce imaginative effects of
real if not lasting aesthetic value, even if this is located mainly at the reception end of
the act of communication. It follows from this that the aesthetic value of a metaphor
or image may change over time while the words stay the same; also that historians have
a certain power to do restoration work on metaphorical images, and to restore some of
their aesthetic value to them.

Take the following passage from Guillaume Peyraut, whose sermons were widely
copied in the Middle Ages. He is trying to make accessible to the imagination the
union of the human and divine natures in the one person of Christ, while linking the
doctrine to high points in salvation history: the prophets and patriarchs of the Old
Testament, the Annunciation, the Incarnation, and the Ascension. So far as the Ascen-
sion is concerned, Christ's human nature is the bride being brought back to the bride-
groom's house, i.e., heaven. I will concentrate, however, on the first three stages,
marked by the words "initiated," "ratified," and "consummated."

"There was a marriage," etc. It should be noted that marriage is threefold: [the marriage of] the flesh, between man and woman, to which the marriage in question here [i.e., in the reading] pertains, and a spiritual marriage between God and the soul, and a marriage which is as it were in the middle between the son of God and human nature.

In respect of the last marriage, it is said of Christ, Ps. [19:6]: "he, as a bridegroom," etc.; and Hebrews [2:16]: "He does not take hold of the angels, but of the seed [of Abraham he takes hold]."

This marriage had been initiated with the patriarchs and prophets, ratified in the salutation of the angel [=the Annunciation], consummated in the taking of the flesh. But the bride was handed over into the house of the bridegroom in the Ascension. [*col. b*] Water was changed into wine because the insipidity of the letter was changed into the sweetness of spiritual intelligence—or the water of fear was changed into the wine of love. For a terrible lord became a lovable spouse. Song of Songs [2:4]: "The king led me into the cellar of wine, he set in order charity in me."[25]

The words "initiated," "ratified," and "consummated" might have some impact as a metaphor today, but in the thirteenth century there would be extra overtones, especially with respect to the last two stages (the social basis of the distinction between initiation or betrothal and ratification is more obvious). Firstly, there could be considerable time-lag between the celebration of a marriage and consummation. British Library Harley Charter 45.F11,[26] and also a case from the Berkshire Eyre of 1248,[27] make this clear, and no doubt there is much more of such evidence to be found. Secondly, the distinction had a real basis in thirteenth-century Canon Law, which controlled the practice of marriage in this period. Even after the words of present consent had been exchanged, a marriage was not actually indissoluble. It could be dissolved if one party entered a religious order. In that case the other could remarry.[28] Stephen Langton said that before Pope Alexander III had made this decision, no one would have thought that the papacy had the power to make it;[29] but that became the law and doctrine and so it remained. (Note that this teaching had nothing to do with impotence and annulment, a quite separate question.)

How many laypeople knew about this ruling is anybody's guess. A wider circle may have realised that consummation continued to matter to their pastors, and that it had great ecclesiastical and religious significance. The "initiation-ratification-consummation" formula is sufficiently common in marriage sermons for it to have embedded itself among the social categories of the laity—and such categories are an integral part of social structure, not just the icing but mixed into the batter.[30] Once part of social consciousness, these categories would have in time affected the reception of the metaphor in later sermons. I am suggesting that there was a helical process going round: from preaching to social categories to the subsequent reception of preaching.

The initiation-ratification-consummation formula was used symbolically often enough to be regarded as a metaphor-topos, like the "ideal husband" image. Here again the aesthetic and imaginative efficacy of the metaphor is not the achievement of one individual, nor does it depend only on the texts themselves.

In the passage from Peyraut, the lasting and unbreakable unity of marriage is integral to the metaphor. In this respect too the aesthetic power of the metaphor depended

on factors outside the text or the oral sermon based on it. The metaphor would have carried a far heavier charge in the thirteenth century than in either the twelfth or the twentieth. In the twentieth century, the social practice of marriage is a somewhat shaky platform for a metaphorical message about permanent union. In the twelfth century an annulment on grounds of consanguinity was a common way of breaking up a marriage. In the twelfth century men worked the system cynically. The consanguinity prohibition was so broad that there was a good chance of finding that they were related to their wives within the forbidden degrees. They could have been aware of it from the beginning, and have kept the knowledge up their sleeve in case they should want a way out. If not really related, they could produce a false genealogy which nobody would be able to check.[31] Then as now the metaphor was undermined by social facts.

In the thirteenth century, after 1215, the contrary holds. The consanguinity loophole was more or less closed at the Fourth Lateran Council. (The Paris theologian Peter the Chanter may have convinced the future Pope Innocent III, while still a student, of the need for a change in the law.) To judge from the church court records which historians have analysed properly, annulments were not particularly common in the period which felt the impact of the Fourth Lateran Council. On the other hand, church courts often had to deal with cases where a previous clandestine marriage was alleged. If the claim could be proved, the clandestine marriage overrode a later marriage, even if celebrated before an archbishop. These cases only served to emphasize the indissoluble unity of marriage, which was so sacred that the exchange of consent at some quite informal social occasion could not be set aside by the most solemn subsequent ceremony. The thirteenth century was a period when the metaphor of spiritual marriage was strengthened rather than weakened by social patterns.

I have tried to illustrate ways in which the old metaphor of spiritual marriage was used by Dominicans to make ideas about Christ vivid and real to the sermon-hearing public. Analysis with a literary flavor has been spiced with a little social history. That could be a rubric for a current fashion in the humanities, so this paper might be regarded as yet another manifestation of an intellectual *Zeitgeist*. However, in some respects the method used here is at odds with conventional trends (except perhaps with some German Reception theory), and it is worth isolating these departures if only to stimulate constructive dissent. Firstly, it involves aesthetic evaluation, plenty of which goes on in some of the older quarters of academe, but not perhaps among the Franco-American *avant-garde*. Secondly (and here some inhabitants of the old quarter may feel less friendly), the object of aesthetic evaluation is not necessarily an individual achievement: it may be a metaphor-topos, as with the ideal husband and with initiation-ratification-consummation symbolism. Nor is it necessarily constituted by words—even if we count the oral sermon delivered on the basis of a model as a kind of text. The object of evaluation is the experience of the listeners, which depended not only on the words of the preacher but on other things in their minds, such as the social categories which help make up a social structure. In particular, I have argued that social realities may have put more force into an image relating to serfdom than the preacher intended himself; and also that the penetration of the indissolubility principle into practice after Lateran IV gave a firm base to the metaphor of marriage.

NOTES

1. I am grateful to Dr. Julia Walworth for helpful suggestions about structure.

2. See, however, the contribution by Édouard-Henri Wéber in this volume.

3. I plagiarize my paraphrase in David L. d'Avray, "Marriage Sermons in the C Collection: Degrees and Forms of Symbolism," in *A Catalogue and Its Users. A Symposium on the Uppsala C Collection of Medieval Manuscripts*, ed. Monica Hedlund (Uppsala, 1995), 81–89, at 84 (I used Uppsala Univ. Ms. C 406, fol. 17r).

4. D. Burr, *The Persecution of Peter Olivi* (Transactions of the American Philosophical Society, N.S. 66, part 5, Philadelphia, 1976), 45–46.

5. David L. d'Avray, "The Gospel of the Marriage Feast of Cana and Marriage Preaching in France," reprinted in *Modern Questions about Medieval Sermons. Esaays on Marriage, Death, History, and Sanctity*, ed. D. L. d'Avray and N. Bériou, with P. Cole, J. Riley-Smith, and M. Tausche (Bibliotheca di Medioevo Latino, Collana della Societa Internazionale per lo studio del Medioevo Latino 11, Spoleto, 1994), 135–53, at 148.

6. Ibid., at 148–49, note 45.

7. Cf. David L. d'Avray, "Philosophy in Preaching: the Case of a Franciscan Based in Thirteenth-Century Florence (Servasanto da Faenza)," in *Literature in the Middle Ages. Philological Studies in Honor of Siegfried Wenzel*, ed. Richard G. Newhauser and John A. Alford (Medieval and Renaissance Texts and Studies, Binghampton, New York, 1995), 263–73.

8. Cf. David L. d'Avray, "Some Franciscan Ideas about the Body," reprinted in *Modern Questions*, 155–74, especially 164–72.

9. See Appendix, Transcription 1.

10. See David L. d'Avray, "Method in the Study of Medieval Sermons," in *Modern Questions*, 3–29, at 18–20.

11. The author was known until recently as Guillaume de Mailly. This long-standing error was corrected by L. J. Bataillon and Nicole Bériou, "'G. de Mailly' de l'ordre des frères prêcheurs," AFP 61 (1991): 5–88. In the same study they proved that he really was a Dominican.

12. Nicole Bériou and David L. d'Avray, "The Image of the Ideal Husband in Thirteenth-Century France," in *Modern Questions*, 31–69, at 65–67 (the passage was Bériou's discovery).

13. Ibid., 48–49.

14. Ibid., 31–69, passim.

15. Ibid., 42–45.

16. I have used Paris, BN, Ms. lat. 12417, which J. B. Schneyer marked in heavy ink in his list of manuscripts for this collection of sermons by Pierre; it should be noted that there are considerable variations between manuscripts. In the Appendix, I give the Latin of both this Paris ms. and of British Library, Ms. Arundel 206. It will be noted that in the latter the image relates to God rather than specifically to Christ. Until more detailed work has been done on the textual tradition of the sermons of Pierre de Reims, therefore, one must reckon with a possibility at least that the passage I have translated is the work of an anonymous adaptor, who does not have to have been a Dominican. That does not affect the argument of this paper, but it would make the passage less relevant to a book about Dominicans.

17. Paris, BN, Ms. lat. 12417, fols. iiivb–iiiira: " . . . in coniugio carnali uirgines corrumpuntur [fol. iiiira] sed in suis nupciis corrupte uirgines efficiuntur quantum ad reputaciones. Iere. iii [1–4]: "si dimiserit uir u[xorem] s[uum]" et cetera, usque: "voca me amodo pater meus dux uirginitatis mee tu es." In istis nupciis aque tristicie in uinum spiritualis leticie conuertuntur. vi idrie sunt vi cause tristicie de peccato exurgentis. Prima est quia deum offendit . . . "

18. In Vulgate, "will weep."

19. See Appendix, Transcription 2.

20. W. C. Jordan, *From Servitude to Freedom: Manumission in the Senonais in the thirteenth century* (Philadephia, 1986), 79.

21. Ibid., 94.

22. Ibid., 95.

23. Ibid., 94: " . . . we would find that Pleasant was the third most popular name among descriptive, episodic, and occupational first names among male slaves, while its incidence among free blacks (many of whom had been born slaves) was decidedly less though not as low as among free whites where the name was nearly nonexistent."

24. See for instance *Rezeptionsaesthetik: Theorie und Praxis*, ed. R. Warning (Munich, 1979[2]).

Historians can learn much from this German school, which is far removed from the radical subjectivism of the Franco-American theories which were fashionable at around the same time.

25. See Appendix, Transcription 4.

26. British Library Harley Charter 45.F11, lin. 22–23: "E la dite Maude demorra en la garde le dite mons' Barthe' a ses custages un an apres le iour du mariage . . . "

27. *The Roll and Writ File of the Berkshire Eyre of 1248* (London, 1973), 195, ed. by M. T. Clanchy: "Et Alexander venit et deffendit vim et injuriam quando etc., et dicit quod nulla catalla predicti Stephani ei detinet immo dicit quod revera predictus Stephanus disponsavit filiam predicti Walteri, et quia idem Stephanus noluit predictam uxorem suam postquam ipsam desponsaverat ad hospicium suum ducere donec predictus Walterus redderet ei xx solidos quod ei debuit . . . "

28. *Corpus iuris canonici*, ed. Aemilius Friedberg, (Leipzig, 1879–81), 2: Decretal. Gregor. IX, Lib. III, Tit. XXXII Cap. II col. 579.

29. F. M. Powicke, *Stephen Langton* (Oxford, 1928), 140.

30. Cf. P. Winch, *The Idea of a Social Science and its Relation to Philosophy* (London, 1958), passim, and A. Giddens, *New Rules of Sociological Method. A Positive Critique of Interpretative Sociologies* (2nd ed.; Cambridge, 1993), e.g., 58–9, 85–6.

31. John W. Baldwin, *Masters, Princes and Merchants. The Social Views of Peter the Chanter and his Circle*, 2. vols. (Princeton, 1970), 1: 333–5 and G. Duby, *Le Chevalier, la femme et le Prêtre. Le mariage dans la France féodale* (Paris, 1981), 220–21 (following Baldwin).

APPENDIX

TRANSCRIPTION 1
ALDOBRANDINUS DE CAVALCANTIBUS
(BIBLIOTECA APOSTOLICA VATICANA,
COD. OTTOBONIANUS LAT. 557, FOL. 63VA–VB)

Item in matrimonio confertur gracia, in quantum in fide Christi contrahitur. Habet enim unde conferat graciam adiuuantem ad illa operanda que in matrimonio requiruntur. Et huius rei exemplum uidemus in naturalibus, quia cuicumque datur diuinitus aliqua facultas, dantur eciam auxilia quibus homo conuenienter uti possit facultate illa, ut in actum exire possit. Unde cum in matrimonio detur homini ex diuina institucione facultas utendi uxore sua ad procreacionem prolis, datur eciam gracia sine[1] qua conuenienter id facere non [col. b] posset. Patet eciam exemplum in animalibus: quibus deus dat uirtutem currendi, dat pedes calciatos ut possint currere; et arboribus quibus dat uirtutem fructificandi, dat eis per que possint fructificare, et sic est in proposito. Unde matrimonium est sacramentum noue legis. Significat enim coniunctionem Christi et ecclesie. Unde dicit Apostolus, ad Ephe. [5:32]: "Sacramentum hoc magnum est, ego autem dico in Christi et ecclesia." Sed sacramentum est cause gracie.

TRANSCRIPTION 2
PETRUS DE REMIS
(PARIS, BIBLIOTHÈQUE NATIONALE, MS. LAT. 12417, FOL. 4RA)

. . . uerbi gracia si ancilla[2] paupercula et seruilis condicionis filio regis esset desponsata, et ipsa in ignominiam uiri sui scortata esset et bonis omnibus[3] spoliata, multas puto causas tristicie haberet:

[1]sine] secundum *scr.* ?
[2]ancilla] ancella *sed corr.*
[3]omnibus] operibus *sed corr.*

Primo quia ut predictum est sponsum suum offendit.[4]

Sed[5] secundo ne dicat:[6] "Et si sponsum[7] perdidi, habeo tamen in[8] patrimonio meo hereditatem bonam."—Certe etiam hereditatem perdidisti. Tren. ult. [5:2] "Hereditas nostra uersa est ad alienos."

Dicet eciam tercio: "Mobilia adhuc habeo, scilicet bona opera multa, etsi heredi-tate sim priuata."—Nequaquam, quia propter multitudinem iniquitatum eius paruuli eius[9] ducti sunt in captiuitatem,[10] id est, omnia opera bona mortificata. Tren.[11] i[10] "Manum suam misit hostis[12] ad omnia desiderabilia eius," et cetera.

Sed ne quarto in sua pulcritudine posset confidere, ut quasi propter speciositatem con-cupisceretur ab alio, eciam ipsam perdidit, quia "egressus est[13] a filia Syon omnis de-cor eius," Tren. 1 [6], et "denigrata est super carbones facies" eius, Tren. iiii [8]:—hec est gracia interior que est decor anime, de qua Ps [44:14]: "Omnis gloria eius fi[lie] r[egis] a[b intus]."

Quinto ueto quia eciam post hec omnia perdita, si amicos bonos, qui eam reciperent,[14] haberet, aliquid esset; sed certe omnes amisit, quia "omnes amici eius," id est, angeli et sancti, "spreuerunt eam," et non solum spreuerunt, sed "et facti sunt ei inimici," Tren. i [2]; et Ysa xxxiii [7]: "angeli pacis amare flebant."[15]

Sed adhuc[16] tandem si esset libera et sui iuris,[17] post hec omnia adhuc posset sibi un-decumque uictum acquirere; sed non est ita, quia in[18] "multitudinem[19] seruitutis" in-cidit: Trenis i [3] "migrauit Iuda propter affliccionem, et multitudinem seruitutis" et cetera. Ier. xvi [13] "seruietis diis alienis, qui non dabunt uobis requiem," et cetera. Ista igitur vi dampna sunt vi ydrie in presentibus nupciis que celebrantur in uera peni-tencia.

TRANSCRIPTION 3
PETRUS DE REMIS
(LONDON, BRITISH LIBRARY, MS. ARUNDEL 206, FOL. 4VB)

Et tunc aqua tristicie conuertitur in uinum letitie, iuxta illud Ps. [29:12]: "conuertisti pl[anctum] m[eum] in g[audium] michi." vi ydrie sunt cause tristicie, que sunt

 quia deum offendit
 graciam amisit
 opera perdidit
 suffragia irritauit

[4]offendit] *dub.*
[5]Sed] *interl.*
[6]ne dicat] *inepte corr.*
[7]sponsum] sposum *scr.*
[8]in] *interl.*
[9]eius] due (?) sunt (?) *add. sed del.*
[10]ducti . . . captiuitatem] *in marg.*
[11]Tren.] Trenis *scr.?*
[12]hostis] homo *scr.?*
[13]est] *interl.*
[14]reciperent]*corr.*
[15]flebant] flebunt *in Vulgate*
[16]adhuc] ad hc *scr.*
[17]sui iuris] sui uiris *scr.?*
[18]in] *interl.*
[19]multitudinem] multitudine *scr.*

seruitutem incidit
hereditatem amisit

—*Deum offendit,* Osee 12 [14]: "Ad iracundiam prouocauit me Effraym in amaritudini-
bus suis, et sanguis eius super eum ueniet et obprobrium eius restituet ei dominus
suus." Iob 36 [13–14]: "Simulatores et callidi prouocant iram dei, neque clamabunt
cum uincti fuerint; morietur in tempestate anima eorum[20] et uita eorum inter effemi-
natos."
—*Graciam amisit,* que est decor. *Tren. i [6]: "Et egressus*[21] est a filia Syon omnis decor
eius; facti sunt principes eius uelud arietes non inuenientes pascua, et abierunt absque
fortitudine ante fa[ciem] subsequentis." Ps. [44:14]: "Omnis gloria eius fi[lie] re[gis] ab
[intus]."
—*Opera perdidit.* Unde ibidem [Thren. 1:5]: "Propter multitudinem iniquitatum eius
paruuli eius," id est, opera, "ducti sunt ad[22] captiuitatem."
—Quarto debet contristari quia amicorum *suffragia irritauit.* In Tren. e.[23] [1:2]: "Om-
nes amici eius spreuerunt eam et facti sunt ei inimici," uel "non est qui consoletur
eam ex omnibus ca[ris] eius."
—Quinto *propter duram seruitutem.* Tren i [3] "Migrauit Iuda propter afflic[cionem]
et multit[udinem] seruitutis; habita[uit] inter gen[tes] nec inu[enit] re[quiem]." Io. 8
[34]: "qui facit peccatum seruus est peccati."
—Sexto, *quia hereditatem amisit.* Tren. v[24] [5:2] "Hereditas" mea[25] uersa est ad ali-
enos."

<center>TRANSCRIPTION 4</center>
<center>GUILLEMUS PERALDUS</center>
<center>(LONDON, BRITISH LIBRARY, MS. ARUNDEL 365, FOL. 24VA–VB)</center>

"Nupcie facte sunt" etc. Notandum quod triplex est matrimonium: carnale, inter
uirum et mulierem, ad quod pertinent nupcie de quibus hic agitur, et matrimonium
spirituale inter deum et animam, et matrimonium quasi medium inter filium dei et
humanam naturam.
Secundum ultimum matrimonium dicitur de Christo, P[s. 18:6]: "Et ipse tam[quam]
spon[sus]" etc.; et Hebre[eorum 2:16] "Non enim angelos apprehendit, sed semen
[Abrahe apprehendit]."[26]
Hoc matrimonium iniciatum fuit in patriarchis et in prophetis, ratificatum in angeli
salutacione, consumatum in carnis assumpcione. Sponsa uero traducta est in domum
sponsi in ascensione. [col. b] Aqua in uinum mutata est quia insipiditas littere mutata
est in dulcedinem[27] spiritualis intelligencie, uel aqua timoris mutata est in uinum
amoris. Dominus enim terribilis est sponsus factus amabilis. Cant. [2:4] "Introduxit
me rex in cellam ui[nariam], or[dinauit] in me cari[tatem]."

[20]eorum] earum *scr.*
[21]egressus] egressa *sed corr.*
[22]ad]in *in Vulgate*
[23]Tren. e.]*scr.*
[24]v] *dub.*
[25]mea] m. *scr.;* nostra *in Vulgate*
[26]A *cum ductu transverso in marg.*
[27]dulcedinem] dulcedine *scr.*

Rudolph of Schlettstadt, O.P.:
Reporter of Violence, Writer on Jews

Miri Rubin

WHAT WAS THE nature of relations which developed between Dominicans and the acts and beliefs of the lay communities within which they dwelt, to which they appealed? How did Dominican preachers and writers respond to political events of great urgency, to contingency around them? The author whose tales form the subject of this paper, Rudolph, prior of the Dominican convent of Schlettstadt in Alsace (after 1294–after 1303), had witnessed from a short distance the bloody events which engulfed Franconia in 1298, the wave of massacres of Jews led by one Rintfleisch following an accusation of host desecration, which was multiplied manifold in the region. Rudolph produced a string of tales which recorded and interpreted the events with great and gory detail. These tales are not simply contiguous or adjacent to social life, like the marriage sermons discussed by David d'Avray in this volume. Rather, they possess a deep moral embeddedness within the world of assumptions and beliefs that could stir the violence against Jews. Far from the great centers of learning, far even from the provincial convents which produced important historical works, Rudolph put his skills to the recording of recent events. He spent his intellectual energy in an attempt to lend coherence and justification to the banality of violence around him: gross, sudden, visceral.

The text known as the *Historiae memorabiles* is contained in a unique copy and forms part of a mid-sixteenth century codex, manuscript 704 of the Donaueschingen Library of the Fürstenbergs.[1] This manuscript was compiled by a most fascinating character, Count Wilhelm Werner von Zimmern (1519–66), a zealous Calvinist witch-hunter, who also experimented in history writing, and who collected material which served the elucidation of "superstition."[2] In 1562 he compiled the collection in this codex, which includes materials emanating from a Dominican, medieval provenance. The *Historiae*, which appear on folios 198r–225r, are introduced as a collection of tales about Jews:

> Modo agetur de Judeis quam impie [et] crudeliter summa cum acerbitate sinaxim sacramentum eucharistie corporis et domini nostri Jhesu Cristi defedarint . . . cuius testimonium facit Rûdolphus prior ordinis Predicatorum in Schletstat, qui, [quod] in eo tempore incidit, partim seipsum vidisse, partim de honestis accepisse viris sedule affirmat.[3]

The collection of tales is preceded, with a break in quires, by the *Annals* of Colmar, the neighboring Dominican convent, and one which boasted an important historical tradition.

If the sixteenth-century copy indeed reproduces the text of Rudolph's tales, then it

would have been composed after 1298 (the year of the events) and before his death around 1303. We know little of the circumstances of the composition of the tales, of their possible origin in a master-text from Franconia, since the manuscript collection of the Schlettstadt convent was almost completely destroyed by the late eighteenth century, having all but perished in a fire in 1718, and then having suffered in the aftermath of the French Revolution.[4] This extraordinary collection of tales has survived in a most fortuitous way, and has as yet received little attention. The stories it tells must have seemed too trivial to some, and too appalling to others.[5]

Rudolph of Schlettstadt's collection contains 56 tales, some of which possess captions, and others which are distinguished by rubrics. Nineteen of these tales are precisely dated, another eight are partly dated, and some eleven are indirectly datable; they all span a period between 1284 and 1303. The tales are richly localized, they abound with names of actors, place names, diocesan affiliations, and have the ring of *actualia*, of almost journalistic reporting, the rhythms of tabloid sensationalism. Twenty-nine of the tales, an identifiable second half of the text, deal with the vagaries of demonic delusion, distraction and revenge; seven others belong to a genre which we might call *prodigia*—the recounting of unusual and wondrous occurrences which are only loosely moralized, the sort of snippets of information which fill the leaves of the co-terminous Dominican *Annals* of Colmar.[6] A third group, the one on which I shall concentrate here, comprises twenty tales, eighteen of which appear in succession: these are accounts of the desecration of the host in the hands of Jews, which arise from the Franconian events, largely known as the *Rintfleischbewegung*, of 1298.[7] The tales appear in an identifiable sequence and mark an important new stage in the making of instructive material on Jews in the Middle Ages. The move from ancient sources— Greek, Latin and largely monastic—to the contemporary, "documented," recognizable and familiar, to news (*novelle*), marks the sort of generic and intellectual aspirations which some of Boccaccio's work came to demonstrate, albeit in a very different way.[8]

So, manuscript 704 of the Princely Library of the Fürstenbergs in Donaueschingen preserves a collection of exemplary tales, most of which deal with Jewish actions and the violence which these had prompted in recent memory in neighboring Franconia, and more specifically, in the diocese of Würzburg (with a few cases from the diocese of Constance, and tales of events which had occurred in Alsace itself). In these tales, the Jews are presented as having brought the violence upon themselves through acts, personal or collective, of abuse of Christ in his eucharistic form. The acts of revenge which followed in turn were led by the "butcher Rintfleisch" (*carnifex Rintfleisch*), whose very name tells an eloquent tale: he was a man who prompted just revenge against Jews, who, to his mind, for too long had been protected by kings and bishops.

The first story in the sequence, which is untitled, describes a complex set of political and economic interests which formed the backdrop to the events of 1298. It introduces the petty lord, Kraft I of Hohenlohe, who had a domain in Franconia and who owed considerable amounts of money to Jewish money-lenders. When these debts mounted with no relief in sight, the Jews of his domain—less because of financial anxiety and more because of fear for their lives—approached the Bishop of Würzburg with a petition to secure their safety from their local indebted lord, "quod nullum Iudeum

in rebus et corpore molestare vellet."[9] Kraft undertook not to harm them. In the security granted them, the Jews grew audacious, and those of Weikersheim bribed a bell-ringer or sacrist, who allowed them into the church on the night of Maundy Thursday. There the Jews committed collective host desecration. When the parish priest approached Kraft with the details of the events, expecting swift justice, Kraft claimed that his hands were tied. Kraft sought the advice of the Bishop, who directed him to exact the proper punishment, death-for-death; so Kraft then sought out all the Jews he could find and gathered them at a pyre, on which they were all burnt.

This tale introduces a central motif present in Rudolph's tales: the tone of justification, of clarification, in tales which establish beyond doubt the justice of a wave of violence so outrageous that it attracted the Emperor's wrath and revenge in its aftermath,[10] and which in its wake even encountered the resistance of several towns and their rulers.[11] In Rudolph's universe, Christians were divided into two groups: those who saw Jewish abuse for what it was and who desired to take revenge in Christ's name, and those whose loyalty was clouded by financial and other considerations and who offered protection to Jews. The tale also sets up an important political context in a region like Franconia: its towns and villages were ruled by a multitude of petty lords, imperial or royal justice was haphazard and distant, Jews depended on complex webs of protection woven between those who owned them and those who did business with them and lived with them in communities. In the midst of these political realities there developed several attitudes and cultural forms, some of which were particularly poignant and relevant to the judgement of Jews and to the interpretation of their intentions and actions. The 'host desecration accusation' was a type of narrative which developed over the thirteenth century, and which had already been elaborated in the famous case of 1290 in Paris. In Rudolph's collection we observe the working of another branch of the narrative, a tale made in German lands which was both indigenous and endemic.

The Jewish tales of Rudolph of Schlettstadt thus belong to a later, emergent attitude towards Jews in the world of religious lore, which provided the frame for social dramas in German towns. In the early Middle Ages, and well until the twelfth century, instructive material and religious tales which involved Jews usually cast them as erring and misguided agents but also as being ultimately open to conversion when they witnessed the truth of Christianity in some overwhelming fashion. The function of Jew as witness to the truth of Christian belief accorded well with theological understandings and ecclesiastical policies. It also had a comforting and useful result in proclaiming Christian truths: if Jews can see the truth, *a fortiori*, a Christian should hold them dear. Famous among such stories is the tale of the 'Jewish Boy' (*De puero iudeo*), in which the protagonist receives communion with his Christian playmates, and sees a vision of the Virgin and Christ on the altar, who feeds him the host. When he returns home and tells his father, he is punished by being thrown into an oven. Yet the child is saved by the Virgin, and the miracle leads many Jews, including the boy and his mother, to convert.[12] The Jewish child and his mother are witnesses to Christian truth, while the father exemplifies Jewish obstinacy, blindness and cruelty. Such stories abounded in Marian collections as well as in other emergent *exempla* collections, where the Jew

takes a step toward testing or even ridiculing Christian practice and ideas, only to be confronted with a miraculous occurrence which convinces him of the truth and causes him to convert.[13]

Rudolph's tales, however, offer something different; they signal the attitude which became apparent throughout the thirteenth century. According to this attitude, the Jew is more of an abuser than a tester of Christian belief. This means that in many cases the stories have not the "happy end" of conversion, but a sorry end of punishment and annihilation.[14] Besides the traditional witness tales one increasingly finds a new kind of story—dark, nasty and unforgiving.

How were such exemplary stories produced? Most probably they evolved slowly, along multiple parallel routes all over Christian Europe. They advanced step-by-step along a line that led from old-fashioned to new-fangled sensibility. In Rudolph's collection, the authority of recent history, of eye-witnesses, of named individuals, often Dominicans, is enlisted, as opposed to the quaint and non-fussy *fertur* or *dicitur* of early collections.[15] The truth-claim in Rudolph's tales is not based on tradition and authority, but relies on the familiarity of rumors, of place-names and protagonists. By these paths a type of accusation could spread not only within a region but between regions, and through such rapid absorption of events patterns of narrative spread into the common stock of instruction. And there was none so efficient as the Dominican milieu for transmitting and collecting apt examples. Indeed, Rudolph proudly points out not only the agency of Dominicans in the affairs discussed, but also their chains of transmission. On 9 November 1304, the Dominican preacher Giordano da Pisa delivered a sermon in Florence that included reference to Jewish host desecration and the revenge of Rintfleisch's massacres: his story line is similar to Rudolph's, as is the inflated number of Jews he claims to have killed (26,000; Rudolph estimated more than 30,000).[16] It may well be that Giordano participated in such southern German networks of recounting, collection or copying. Additionally, on folio 160v of the Donaueschingen manuscript, quite outside Rudolph's collection but bearing a note which relates to it, there are two additional tales about the Eucharist. One is a case of love-magic effected through the use of the host, but the second reports an accusation of host desecration against a Jew of Paris in 1291, reported by a Dominican, "Theodoricus magister in theologia, vir sciencia [et] multis atque virtutibus pluribus decoratus, hec sequencia scripsit."[17] The relation of this latter tale to Rudolph's collection is not clear, but the account of the accusation of host desecration at Paris, which came to involve university masters, and which thus came to the notice of Dominicans, could again have travelled in the form of *novelle*. A privileged circle for the reception of poignant recent tales was thus in place, and the events of 1298–1299 clearly provided a subject for urgent moralizing as well as a source of familiar tales that vindicated both knowledge about Jews and teachings about the Eucharist.

Rudolph of Schlettstadt thus participated in a project of instruction which transmitted useful knowledge of momentous contemporary events. His *post factum* attempts to explain these events might be seen both as triumphantly justificatory and perversely apologetic. The violence in Franconia had been great, what type of argument could serve as sufficient justification? Rudolph vindicates the actions of exactly the sort of people upon whom Dominican entry into German towns depended. The

tales extol townspeople for their natural vengeful piety, parish priests for their responsible conduct of expiatory reclamation of abused hosts, town magistrates for the smoothness with which they wielded their instruments of violence and handed Jews over to Rintfleisch. Those whom the tales do not court were the "protectors" of Jews, including even the Emperor himself. An interesting tale, titled *De defensione Judeorum*, tells of a special envoy sent to Würzburg by Lord Albert, King of the Romans, the Lord of Rinsberg, who was charged with arranging the defense of the King's Jews. When the emissary reached the town he conferred with his kin on the conduct of his mission. He desired to go up to the attic, and there fell and was mortally wounded. A confessor, a Dominican brother named Albert, was sent for; this Albert was a scholarly and honest man, who comforted the wounded man and heard his confession, which included the aims of his mission, of which by then he had doubts ("Defensio Judeorum, que michi in animo et consciencia mea plurimum contradicit"). He resigned his mission and God's wrath was removed from him; he was immediately absolved and restored to health.[18]

Not only princes and kings but towns might decide to defend their Jews. In the tale *De crucifixio sudante*, Rudolph tells of the town-fathers of Opfingen, who assembled and hid their Jews, closing the town gates as Rintfleisch approached ("maiores civitates cupientes eorum Judeos defendere ad portas velociter cucurrerunt easque clauserunt nec eos intromittere simpliciter noluerunt").[19] One of the town-watchmen threw a stone from the parapet and hit an arm of a crucifix carried by Rintfleisch's throng. The crucifix began to sweat profusely, which horrified all in Rintfleisch's crowd who could see it. So they decided to leave it as a bulwark (*propugnaculum*) and to return home. When they retreated, some of the people of Opfingen approached and found the cross lying in its sweat. As soon as the sweat evaporated it was replenished. The miraculous cross was carried to the church by the poor, who were inspired by the miracle to act against the will of the rich and to fall upon their Jews.

Rudolph thus inveighs against those who, motivated by personal interests, would let Jewish evil go unpunished to the detriment of the general well-being of Christians. Throughout, the well-being of Christians is presented as constantly and deeply threatened by Jews, particularly by those Jews who had continuous contacts with Christians as employers and business partners. The many ways in which a Jew could dominate a dependent, especially a Christian woman, are elaborated with relish in a tale without a title (tale 10), which recounts events in the town of "Reinsperg" (maybe Regensburg, in Bavaria).[20] A young Christian woman approached a Jew to cause him pain and mock him. He was aroused, however, and desired to be intimate with her, and so he told her that his wife was ill and that he needed some household help, for which he would pay her if she would do it. They agreed, and the young woman came to perform her duties on several occasions. The Jew was familiar and friendly with her, and eventually asked her whether she would accept having sex with him in exchange for fine clothes. She agreed, and he promised to be quick about it. Thereafter they had sex frequently. A while later, the Jew asked the young woman to bring him a consecrated host, which "you Christians say is your God," promising in return to give her as much money as she wanted ("oblatam, quam dicitis deum vestrum esse, quod datur vobis Cristianis, apud altare velis michi obtinere et dare. Et ego tibi dabo pecuniam secundum placitum

tuum, dummodo hoc in secreto facias"). At Eastertime she did so and handed over the host to the Jew. At an opportune moment, the Jew placed the host on his table and gravely wounded it.[21]

According to such tales, Jews seemed to be able to acquire hosts in a variety of ways, and then proceeded as a matter of course to abuse them. They did this singly or in groups, and often within the family circle. Tales of Jewish abuse had to be mediated by some credible informants; first and foremost, these were converts. In particular, female converts were privileged as tellers of stories of erstwhile abuse, which sometimes, through their miraculous outcome, had turned into prompts for conversion. One such untitled story in Rudolph's collection (tale 9) tells of a convert who, during the persecutions in Franconia ("Cum in tota Franconia persecucio Judeorum nondum finita [erat]"), spoke about what had happened in her father's house.[22] She had been told to light a big fire, for which her father went to the cellar to prepare a cauldron full of fat, which he melted down. Into the boiling fat he dropped a host, saying:

> If you are Jesus Christ, son of the Virgin Mary, true God and man, as the Christians say, who by Christians are served daily and daily are carried about through the byways and city streets, and if you are the one who will judge the living and the dead on the day of judgment, then show me your power, so that I can believe in you, and preach about your power.[23]

The Jew's desire for a miracle was satisfied. The host soon turned into a little boy. The Jew spoke to the boy, who then turned into a youngster (*juvenis persona*). The Jew then prostrated himself, begged for the right to tempt him a third time, and asked for another sign. At this last request, the figure disappeared, leaving a refulgence of light, from which a figure emerged flanked on either side, from the shoulders down, by a sharp sword. The terrified Jew fell on his face and exclaimed his devotion and his disavowal of Judaism; he converted to Christianity, as did his daughter, who told the tale.

More puzzling still is the account of a Jewess who came to Colmar "when king Adolph reigned" (1291–1298), and who sought lodging in the house of a widow. She was a refugee from Würzburg, fleeing for fear of being killed by the Jews because she had witnessed miraculous happenings.[24] She had heard from some Jews that a certain number of them, descendents of those who had said to Pilate, "may his blood be upon us and upon our children," suffered badly from flux and dysentery and could only be cured by the use of Christian blood. A Christian maid of such Jews had told her of their actions, which included the purchase of a host from a priest or sacrist. This host was later thrown onto a table and pierced with sharp metal, which brought forth a flow of blood. The Jews hastened to soak up the blood with cloths and hide it away. Another host that was attacked with knives and needles turned into a charming child, who began to wail and ran away. Having seen this, the Jewess left her faith and received baptism.

The recurrent abuse of the sacrament was revealed to Christians not only by informants who had crossed the religious lines, but through miraculous occurrences, some of which were produced by the abused host itself. Thus the audacious Jews of Wickersheim, of whom we have already heard, convinced a bell-ringer or sacrist to let them into a church on the night of Maundy Thursday, when they took out the hosts and threw them on the altar, where they pierced and cut them.[25] The hosts began to

bleed and stain the Jews' hands and clothes. Furthermore, they assumed the voice of Christ on the cross crying out "Hely, Hely Lama Sabachtani?" so loudly that the neighbors were terrified; the Jews themselves, on the other hand, were miraculously prevented from hearing the cry. Thus they were caught red-handed by the poor neighbors, who apprehended them and handed them over to custody. They then went on to summon Lord Kraft of Hohenlohe, as already mentioned. The following tale (tale 2) tells of the small town of Möckmühl on the river Jagst, where in the poor section of town, a sort of island in the river, a source of light was seen and terrified all who saw it.[26] The town fathers decided to investigate, for they suspected that the Jews, who lived not far from there, may have committed some crime which God wished to reveal in this manner. On the morrow, a group was delegated to explore and found numerous recently dug up and hastily covered holes in the ground. When the delegates reopened these holes, they found in them hosts which had been hidden away by the Jews. These were carefully removed and taken to the church.

The people of Möckmühl were privileged to have another miraculous discovery in their midst. The third tale in Rudolph's collection tells of a rustic who was lying in bed one night and heard a voice speak to him: "Are you awake?" it asked; "I am," the rustic answered. "Go to the priest and tell him to go to the house of Wivlin the Jew, and look under the threshold where you will find Christ's body,"' the voice retorted. The rustic refused to obey, as he thought that the voice was a phantasm. On the next night the voice asked again whether he was asleep and directed him to go to the priest's house. This the rustic now did, and when the priest heard him he reported to the village judge (*scultetum; Schultheiss*), retelling the rustic's story. The village-judge went to the houses and had his servants look for a while, but he found nothing and so concluded that the rustic had been drunk. The judge left, but when the priest tried to leave his feet stuck to the ground, so he decided to look again and duly found five perforated hosts and a hanging string. These having been found, the judge arrested 76 Jews, put them in a strong keep, and without mercy delivered them to the hands of Rintfleisch, by whom they were then burnt.[27]

These short paraphrases offer some of the flavor of the tales, and especially of the sub-group of Jewish tales. If the latter are seen in juxtaposition to the other large group of tales concerning the devil, a world impregnated by the supernatural emerges, rife with religious doubt and spiritual menace. Doubt is interestingly figured in the mouths of Jewish protagonists: these wonder both about the tenets of their own religion and about the truth-claims of Christianity. They discuss their doubts with each other and sometimes are even led on to practical testing of Christian belief. A tale which is outside the sequence of Rintfleisch stories concerns Jews in Tuowerd who hurled the sacrament of the Lord into a fire (tale 25: "De Judeis in Tuowerd, qui in ignem proiecerunt dominicum sacramentum").[28] In 1293 three Jews—father, son and neighbor—discussed the state of the world and the state of faith in a friendly manner. One of them begged permission to voice some of his doubts. As he lay in bed at night, he said, he thought of the succession of rules, first pagan, then Jewish, but that now is the age of Christ. The second Jew then shared his own doubts about the coming of the Messiah. The third added that since the time of Christ's coming, the Jews have had no prophets, and the Christians' law seems to rule and flourish. What to do then, was their

shared question. So they concluded that they would test Christian faith in some way, and decided to throw the Christian God into a fire, resolving that if it defended itself, they would convert. "Optento autem dominico sacramento"—here the way by which the Jews acquired the host is not described, since pursuing it might have interfered with the narrative flow—they went to a secret place and threw the host into a fire, but it managed to liberate itself from the coals. They then tried again, and it freed itself again. The Jews were terrified and dared not do it for a third time. The host then disappeared, but they still did not want to convert. Two years later, the youngest among the three Jews repented and went to the Christians to receive baptism, giving the story of the events as his reason for conversion. The other Jews were immediately caught by an inquisitor. Their relatives in Alsace begged for their release; a family friend, named Copo, went to the Dominican Prior of Gebweiler (Upper Alsace), who sent Brother Bruno to Tuowerd to attend to the matter. They were caught en route; the Jew was burnt and brother Bruno was liberated at the request of his Dominican brethren (the Colmar *Annals* set the liberation attempt in 1295).

Religious doubt, the omnipresence of signs, and the constant Jewish intent to offend Christianity form the backdrop against which the terrible events of 1298 were recounted by Rudolph. The sequence of 16 tales recovers only a few drops from a sea of pain and violence. Rintfleisch, the popular leader of the massacres, is designated by Rudolph as "the butcher" (*carnifex*). It is not clear whether Rintfleisch was a real name, an occupational tag, or a punning name based on his reputation. It is not highly likely that he was simply an urban butcher. On the other hand, comparable massacres usually involved the cooperation of local lords, men such as Kraft of Hohenlohe. The regional massacre which was to follow in the same area in 1336–38 (the "Armleder massacre"), was led by a renegade knight, Arnold of Uissigheim.[29] Such lower-class knights escaped the policing controls of princes in periods of weak imperial sanction, such as the *interregnum* during which Adolf of Nassau and Albert of Habsburg competed for the imperial crown, a conflict resolved only at the battle of Göllheim of 2 July 1298. Although imperial justice did catch up with several of the perpetrators of Rintfleisch violence and imposed fines and bans upon them, as the town-archives of Nürnburg amply show,[30] Rintfleisch's reputation escaped untarnished. Rudolph's string of tales further embellished and immortalized his name. Rintfleisch was the avenging arm, the ever-vigilant protector of Christ's body, whose enemies he discerned with the help of the intuitions and clues offered by his heroic partners, the poor. The offences committed by Jews were always directed against the Eucharist, the archsacrament, the Body of Christ at the core of late medieval liturgy and pastoral theology, devotion to which was well-ripened within popular religion by the late thirteenth century.

We thus arrive at a specific appreciation of a moment in religious sensibility, which informed the work of a single Dominican prior who witnessed some violent and exhilarating events. He and his brethren were charged with being the guardians of Christ, the chroniclers of his manifestations, the avengers of crimes against the Lord. Rudolph wrote the simplest possible Latin, spiced up with occasional vernacular asides, German rhymes and even musical notes for an arousing popular chant. As a writer he used all the skills which we have come to associate with journalism: reported speech,

catchy headlines, sex and violence, strong story-line, clearly designated groups of good-
ies and baddies, the absence of moral ambiguity, populist flattery of the little people
over the powerful and the proud, the exposure of pretensions and demagogic vindica-
tion of "simple home truths," a banal misogyny. In contrast to those Dominican theo-
logians, inquisitors and mystics, who have been the subject of most scholarly study,
here we have a Dominican prior who chose to elaborate a new type of writing, even
within the well-established genre of *exempla*.

Far from being distant, scholarly and remote, Rudolph of Schlettstadt was at the
cutting edge of popular prejudice and self-justification. In ways only too familiar to us
from our own political cultures, a privileged and educated person may well lend exper-
tise, reasoning and order to a plethora of benighted misconceptions, offering an imag-
ined alternative to existing political order and government through the encouragement
of instinctive action, mob violence and self-congratulatory feelings of superiority and
virtue. To these ends, Rudolph identified material which was direct, localized, contex-
tualized and contemporary to his audience, and turned it into narrative. His *exempla*
are no longer the stylized tales taken from early collections from the pages of Gregory
the Great's *Dialogues*, Gregory of Tours' *The Glory of Martyrs*, or *The Lives of the
Fathers* but rather from the rumor and the recent memory of grievances and victories,
which touch upon those values that mattered most: Christ's body and the unquestion-
able (yet questioned) order of ethnic purity and Christian superiority above all others.
Rudolph's Christ is less lively and all pervasive than his devil; he is a custody whose
miraculous manifestations promoted violence and revenge. The tales about injury to
his eucharistic body produced rallying cries for solidarities forged through enthusiasm
and violence.

Exempla have recently been appreciated for their power embedded in the *perfor-
mative* function of their form.[31] The power of *exempla* is in the narrative, in its sug-
gestive force, its ability to move to action through self-identification. It is *exempla*
such as those collected by Rudolph of Schlettstadt—even if we will never know
whether his were heard or read—which contributed to the dissemination of news and
of emergent cultural forms, such as the 'host desecration accusation.' Such persuasive
narratives also suggested patterns of action and taught individuals and communities
the dramatic possibilities—some purifying, some dangerous—of their lives.

NOTES

1. For a short description of the manuscript, see K. A. Barack, *Handschriften der F.-F. Hofbib-
liothek zu Donaueschingen* (Tübingen, 1865), 486–92. The edition used here is Rudolph von Schlettstadt,
Historiae memorabiles. Zur Dominikanerliteratur und Kulturgeschichte des 13. Jahrhunderts, ed.
Erich Kleinschmidt (Cologne-Vienna, 1974). See the introduction, 1–8. Henceforth, I shall cite this
work as *HM*.

2. For a biography, see G. Froben Christoph Werner von Zimmern, *Zimmerische Chronik*, ed.
K. A. Barack, 4 vols. (Freiburg i.B., 1881).

3. *HM*, 9.

4. *HM*, 7.

5. Since the appearance of Kleinschmidt's edition there has been little treatment of the *HM*; see Friedrich Lötter, "Das Judenbild im volkstümlichen Erzählgut dominikanischer Exempelliteratur: Die 'Historiae memorabiles' des Rudolf von Schlettstadt," in *Herrschaft, Kirche, Kultur. Beiträge zur Geschichte des Mittelalters: Festschrift für Friedrich Prinz zu seinem 65. Geburtstag*, ed. G. Jenal with S. Haarländer (Stuttgart, 1993), 431–45. Aron Gurevich refers to Rudolph briefly in his *Medieval Popular Culture: Problems of Belief and Perception* (Cambridge-Paris, 1988), 12, 23–24, 47, 86, 141, 187, 197, 200–1, mainly as a source for ideas about demons.

6. *Les Annales et la chronique des Dominicains de Colmar. Edition complète*, ed. C. Gérard and J. Liblin (Colmar, 1854).

7. For comprehensive surveys, see F. Lotter, "Die Judenverfolgung des 'König Rintfleisch' in Franken um 1298: Die endgültige Wende in den christlich-jüdischen Beziehungen im Deutschen Reich des Mittealters," *Zeitschrift für historische Forschung* 15 (1988): 385–422, and "Hostienfrevelvorwurf und Blutwunderfälschung bei den Judenverfolgungen von 1298 ('Rintfleisch') und 1336–1338 ('Armleder'),"in vol. 5 of *Fälschungen im Mittelalter*, MGH Schriften 33/5 (1988): 533–83.

8. D. Wallace, *Chaucerian Polity*, forthcoming (Palo Alto, California, 1997), 208, 346.

9. *HM*, tale 1, 41–43 (quotation from 41).

10. A. Müller, *Geschichte der Juden in Nürnburg 1146–1945* (Beiträge zur Geschichte und Kultur der Stadt Nürnburg 12, Nürnburg, 1968), 23.

11. M. Rubin, "Imagining the Jew: the late medieval eucharistic discourse," in *In and out of the Ghetto. Jewish-Gentile Relations in Late-Medieval and Early-Modern Germany*, ed. R. P. Hsia and H. Lehmann (Washington, D.C.-Cambridge, 1994), 177–208, esp. 198.

12. On the tale see T. Pelizaeus, *Beiträge zur Geschichte des Legende vom Judenknaben* (Halle, 1914), and E. Wolter, *Der Judenknabe* (Halle, 1879).

13. On the tale and its development in the later Middle Ages see Rubin, "Imagining the Jew," 180.

14. This view fits in with the broad chronology expounded in J. Cohen, *The Friars and the Jews. The Evolution of Medieval Anti-Judaism* (Ithaca, New York, 1983).

15. On sources of tales and authority in *exempla* see A. Murray, "Confession as a Historical Source in the Thirteenth Century," in *The Writing of History in the Middle Ages. Essays presented to Richard William Southern*, ed. R. H. C. Davis and J. M. Wallace-Hadrill (Oxford, 1981), 275–322, esp. 285–92.

16. *Prediche del beato fra Giordano da Rivalto dell'Ordine dei predicatori recitate in Firenze dal MCCCIII al MCCCVI*, ed. D. Moreni, 2 vols. (Florence, 1831), 2: 227–32; compare with *HM*, tale 13, 60–61, at 60.

17. *HM*, 7.

18. *HM*, tale 14, 61–62.

19. *HM*, tale 12, 59.

20. *HM*, tale 10, 55–57.

21. Ibid., 55–56.

22. *HM*, tale 9, 53–55.

23. *HM*, tale 9, 54: "Si tu es Jhesus Cristus Marie virginis, ut Cristiani dicunt, filius verus deus et homo, qui portaris a Cristianis quotidie per vicos et plateas et quotidie ministraris, et si judicaturus eris in die judicii vivos et mortuos, ostende michi potenciam tuam, ut valeam in te credere et tuam potenciam predicare."

24. *HM*, tale 16, 64–66.

25. *HM*, tale 1, 41–43.

26. Ibid., 43–44.

27. Ibid., 44–45.

28. *HM*, tale 25, 79–82. There are problems in identifying this place.

29. K. Arnold, "Die Armledererhebung in Franken 1336," *Mainfränkisches Jahrbuch für Geschichte und Kunst* 26 (1974): 35–62.

30. See n. 10 above.

31. Larry Scanlon, *Narrative, Authority and Power: the Medieval Exemplum and the Chaucerian Tradition* (Cambridge, 1994).

Imitatio Christi: Female Sanctity and Dominican Piety in the Czech *Life of Saint Catherine*

Alfred Thomas

THE AFFECTIVE SENSIBILITY exhibited in the relationship between Christ and female saints in late medieval vernacular hagiographies looks back to the tradition of twelfth-century spirituality where we first see evidence of a new emphasis on Christ's humanity. The valorization of Christ's flesh inevitably came to encompass and elevate the maternal body which had borne him. This more favorable view of womanhood helps to explain the coexistence of intellectual *and* bodily female ideals in that most cerebral and somatic of saints, St. Catherine of Alexandria. It has become *de rigeur* of late to specify the saint's gender as a way of explaining the corporeal emphasis of late medieval female sanctity. Caroline Walker Bynum, for example, argues that gender is overlooked in traditional discussions of Eucharistic piety and claims that lay and religious women from the thirteenth century on were "inspired, compelled, comforted and troubled by the Eucharist to an extent found in only a few male writers of the period."[1] In this essay I shall argue, with close reference to the Czech *Life of St. Catherine*, that one ought to consider as a syncretic unity the religious order to which an author belongs, the gender of his audience and that of his chosen saint. Just as in late medieval art the male figure of Christ often merges mystically with his mother Mary, so is there frequently a deeply affective bond between a male author, his chosen subject and the female audience for whom he writes his *vita* (fig. 38). Such an affective bond is particularly strong in the case of male religious who served women as confessors.

In this essay, I shall maintain that the most likely author of the Czech *Life of St. Catherine*[2] was a Dominican friar, university professor, courtier and confessor to the Emperor Charles IV and his family. Although there is little extrinsic evidence to support this claim, a great deal of textual authority points to the authorship of one John Moravec. I shall argue that John's membership in the Dominican order is as significant to our understanding of the text as the audience for whom it was intended. I detect an important connection between John's secular and religious concerns as a courtier-priest and the ideals of virginity and maternity propagated in the course of the legend. As we shall see, these ideals tell us a great deal about how the author perceived female sanctity and the religious and social role of his (partly) female audience.

ST. CATHERINE OF ALEXANDRIA

Catherine of Alexandria was one of the most popular saints of the Middle Ages, beloved in the eastern and western churches alike. According to legend, she was martyred in

the year 307 A.D. In the eighth century her body was discovered by Egyptian Christians and translated by them to the monastery on Mount Sinai. This monastery was founded by St. Helen (ca. 250–330 A.D.), the mother of the Emperor Constantine, and was embellished by the Emperor Justinian I and renamed in Catherine's honor in 527 A.D. Here her bones were said to exude the heavenly oil with which her wounds were miraculously healed.[3]

The earliest versions of the legend were written in Greek but from the eleventh century we find Latin adaptations of the Greek sources. All of these stories deal exclusively with the martyrdom and the debate with the pagan scholars. At a later point, two other episodes (Catherine's conversion through the agency of a hermit and her mystical marriage to Christ) were added to the core story of the debate and martyrdom.[4] The cult of St. Catherine was one of the most popular in medieval Europe. Numerous images and literary representations of her life and martyrdom survive, most of them based on the immensely popular *Golden Legend* by James of Varazze.[5] The presence of her relics at the Abbey of the Holy Trinity at Rouen in the first half of the eleventh century probably inspired several of the Latin versions of her life. In fact it was the Abbey of Rouen that was largely responsible for disseminating the cult of St. Catherine in Northern Europe.[6] Her renown as a teacher and protectress increased, the former aided no doubt by the spread of the schools, such as the Sorbonne, of which she became the patron saint. Her cult was also important in England where her legend was one of the most frequently represented subjects in late medieval churches.[7] Several versions of her life are extant in English, ranging from a twelfth-century text in prose for anchoresses to a fifteenth-century verse adaptation by an Austin canon from Suffolk.[8]

St. Catherine owed much of her popularity in fourteenth-century Bohemia and Moravia to the Emperor Charles IV, the founder of the University of Prague (1348), who venerated her as a philosopher and teacher. She had also become his personal protectress since the Battle of San Felice, fought on St. Catherine's Feast Day, November 25, 1332, where the army of the sixteen-year-old Emperor had relieved the fortress besieged by the armies of the Italian League.[9] A passionate collector of relics and a mystic typical of his age, the Emperor built a church in Catherine's honor in the so-called new Town of Prague (1356) and dedicated a special chapel to her in his castle at Karlstein (after 1347).

On a lintel of the chapel, which served as the imperial oratory, we find a double portrait of the Emperor and the Empress Anne of Schweidnitz. The figures face each other in profile and each touches the Holy Cross which cuts the painting into two distinct halves. This portrait recalls the Byzantine iconographic type of "Constantine and Helen raising the Cross," developed in Constantinople before the ninth century and widely known in Orthodox churches in the Balkan peninsula. It was also found in Byzantine cameos and coins, through which it might have reached Charles's court.[10] According to tradition, Constantine's mother, St. Helen, discovered the three crosses of the Crucifixion, along with the nails, when she went on a pilgrimage to Jerusalem. There she founded a monastery which was later named for St. Catherine and became the resting-place of the virgin-martyr's bones. The connection between Sts. Helen and Catherine explains why the double portrait of the Emperor and the Empress was placed in the chapel of St. Catherine. This chapel provided an architectonic mirror-image of

the monastery of St. Catherine on Mount Sinai, thus complementing the Chapel of the Holy Cross as a reflection of the celestial Jerusalem (fig. 39). The layout of the chapels at Karlstein illustrates the Emperor's apocalyptic visionarism but also his political ambition to make his kingdom of Bohemia the center of an Empire that would unite western and eastern Christianity under his personal rule. The Emperor's devotion to St. Catherine was so great that he instructed the Archbishop of Prague, Ernest of Pardubice, to set aside November 25 as her holy day. But the saint was equally popular beyond Prague and the royal court: statues and paintings of her survive as far afield as Třeboň in southern Bohemia and Jihlava in Moravia.

THE AUTHOR AND HIS AUDIENCE

The probable author of the anonymous *St. Catherine* was the Emperor's personal confessor, John Moravec, a Dominican theologian and a professor at the new University of Prague who had studied at Paris and Oxford. John was part of the Emperor's inner circle of courtiers, and was entrusted by the Emperor with a diplomatic mission to the papal court of Avignon.[11] He belonged to a preaching order known for using the vernacular in order to spread the word of God to a wide audience of laymen and women. In Germany and in the Low Lands Dominicans had played significant roles in the Inquisition and in the fostering of female piety.[12] The Dominicans were the spearhead of the Emperor's strategy to impose religious unity and orthodoxy on his divided realm. Their presence in Bohemia dates from 1226 when they founded a monastery in the Prague Old Town. In the course of the thirteenth century nineteen Dominican monasteries were established in Bohemia and Moravia, all of which belonged to the Polish province of the order. Only in 1301 did the Bohemian branch of the Dominicans manage to establish their own independent province. But due to internal discord, in 1307 they were placed under the control of the Saxon provincial master, Meister Eckhart.[13] Through their writings in the vernacular and inquisitorial activities, the Dominicans in Bohemia and Moravia were especially important to the conservative Emperor as enforcers of orthodoxy, communicating the tenets of the faith to lay men and women.

The Dominicans had played an influential role at the court of Prague since the reign of Přemysl Otakar II, who gave special support to the order.[14] His wife, Kunhuta, is known to have lent financial support to the so-called *sorores Rotharinne*, a group of Dominican female religious at Nuremberg.[15] Her daughter, the Abbess Kunhuta, had close links with the Bohemian Dominicans Domaslaus and Kolda of Koldice. The Czech *Prayer of Kunhuta* (ca.1290), with its Thomist devotion to the Eucharist, was most likely written by a Dominican friar.[16]

The Emperor Charles invited the Alsatian Dominican theologian John of Dambach (1288–1372) to become the first professor in theology at the University of Prague. John was a pupil of Meister Eckhart and had taught previously at the universities of Paris and Bologna.[17] Like his Alsatian namesake and fellow Dominican, John Moravec was also active as a professor at the University of Prague. In 1348 he was granted the title "magister of theology" by the Pope. Like Domaslaus and Kolda of Koldice before him, he was active as a writer in the Czech language, and may have had a hand in the first Czech translation of the Vulgate, consistent with the mendicant orders' concern to

make God's word available in the vernacular to laymen and women. The mid-four-teenth-century Czech prose *Life of Christ* has also been attributed to a Dominican.[18] In a manuscript of this work (Praha, NUK, XVII A 9), the author informs the reader that he is a member of the Order of Preachers; and in NUK, XVII H 19, leaf 172, he mentions that the work was composed at the instigation of Emperor Charles himself.[19] According to Vilikovský, the Czech prose *Passional* was also composed by a Domini-can.[20] In fact, Vilikovský claimed that the *Passional* and *The Life of Christ* were written by the same author.[21] The affective tone of both texts is similar to the language of *St. Catherine*. Even more revealing are the high-style rhetorical correspondences between the legend and *The Life of Christ*, in particular the use of anaphora in lines 1564–69, 1756–59, 1846–73, 3298–303. Added to the Dominican preference for affective lan-guage which characterizes all three texts, such rhetorical features point to a single authorship.

It is reasonable to assume that the legend was written for the spiritual edification of men and women within court circles since Catherine provides an example both to knights (on account of her courage and faith) and to women due to her physical *imitatio Christi*. Moreover, the emphasis on virginity and maternity are the two ideals to which late medieval noble women were expected to aspire either as nuns or bearers of healthy male offspring. Although the work was probably commissioned by the Emperor, there is a strong possibility that his third wife, Anne of Schweidnitz, served as the model for Catherine just as Anne of Bohemia was the real-life surrogate for the literary figure of Alceste in Chaucer's *Legend of Good Women*. Significantly, there is a reference to St. Anne (the mother of the Virgin Mary) in the Czech version of the legend, where there is none in the Latin source. Even more significant is the fact that Petrarch wrote a short treatise entitled *De laudibus feminarum* for the Empress Anne (whom he addresses as *gloriosissima Augusta*). In this document Petrarch emphasizes the importance of the Empress's intellect as well as her maternal role as the mother of the future Holy Roman Emperor: "Adde quod nec partu tantum, sed ingenio et virtute multiplici et rebus ges-tis et regni gloria sexus est nobilis."[22] It is precisely this kind of emphasis which, I suggest, characterizes the Czech legend in its celebration of female intellect and fecun-dity. The legend was written at about the same time Petrarch penned his *De laudibus feminarum*. The Empress was newly delivered of a baby girl; and the illustrious Italian humanist, who also corresponded with the Emperor Charles and even visited his court at Prague, was at pains to reassure the Empress that she would soon give birth to a much-needed son and heir to her husband as Emperor and King of Bohemia. This con-cern with the virtues of motherhood would certainly help to explain the inclusion of maternal bodily imagery in the Czech legend (for instance, a lactating angel in the prison scenes) as well as the more conventional focus on Catherine's virginity and superior intellect.

The Text: Sources and Manuscripts

There are seventeen extant Latin manuscripts of the Catherine legend in Prague. These can be divided into three groups: first, those which relate the conversion and passion (five); second, those which confine themselves to the conversion (four); and third, those

which deal with the passion alone (eight). The Czech author seems to have used two sources, one belonging to the first category and known by its opening words as *Tradunt annales historiae* (which tells the whole story but concentrates on Catherine's dispute with the fifty pagan scholars), the other belonging to the second category (the conversion) and known by its opening words as *Fuit in insula Cypri rex quidam, nomine Costus*, which tells only of Catherine's conversion and her mystical marriage to Christ. The Czech author includes all of the episodes found in the two sources (the conversion, the mystical marriage, the debate and the passion) but reduces the debate with the pagan scholars while amplifying the scourging scene.

The verse legend, written in the standard trochaic metre and octosyllabic line of medieval Czech poetry, is 3,519 verses long and contains certain east Moravian dialect features. According to George Cummins, the extant redaction was one of many Moravian versions copied between 1350 and 1400 and based on an original of Bohemian provenance.[23] If our theory of Moravian authorship is correct (John Moravec, as his name indicates, was Moravian), Moravian linguistic features would also have been present in the original Bohemian redaction. The manuscript is preserved in a paper codex (129 leaves) dated to the beginning of the fifteenth century and was first recorded in a catalogue entry by the scribe Wenceslas Březan, dated 1602–8, in the library of the last Rožmberk lord, Peter Vok. Consisting of eleven thousand volumes, Peter's library was the largest in humanist Europe. It was housed in the South Bohemian towns of Krumlov and Bechyně. Until the nineteenth century, the manuscript was a treasure of the Royal Library of Sweden where it was taken in 1647 as booty of the Thirty Years' War. It was returned to the Czech Lands in 1878 along with other manuscripts from the Rožmberk library and is now in the State Archive in Brno, capital of Moravia. The same codex contains four other titles in Czech, all of a devotional nature: an exposition on the *Pater noster*; a version of the Passion; a treatise on the battle against sins, and a Good Friday sermon.

The question remains as to how the unadorned manuscript ended up in the Rožmberk library. The Rožmberks were one of the most important and powerful noble families in Bohemia from the thirteenth to the seventeenth centuries when the line died out with the death of Peter Vok. Peter I and his son and successor, Peter II, both served in the court of Charles IV as Lord High Chamberlain of Bohemia.[24] It is possible, therefore, that the latter had the legend transcribed from a master copy in court circulation for the edification of his family.

<div align="center">THE CONVERSION</div>

The legend tells of how Catherine's father, Costus, King of Cyprus, was banished to Alexandria by the Emperor because of a slander of treachery levelled against him by his rivals at the court. In devoting much more space to this episode than the Latin source (37–71), the author wishes to enliven the rather dry, matter-of-fact tone of his model. Costus is presented in hyperbolic terms as the most trustworthy advisor at the court (37–45) who is maligned like Roland and Duke Ernest, hero of the Czech version (ca. 1350) of the German minstrel epic *Herzog Ernst*. He is forced into exile by evil-doers at the imperial court. The language at this point recalls the prologue of the Czech epic *Alexandreida* (ca. 1290–1300) which distinguishes between the positive and nega-

tive members of its audience and condemns the two-faced men who harbor enmity in their hearts (51–52). The plight of Costus also recalls the early episode in *Duke Ernest* where the eponymous son-in-law of the Emperor Otto is slandered by rivals at the court and is forced to undertake the Other-World Voyage to expiate for sins he never commit-ted (820–47). The most striking parallel to our legend, however, is an aside in the *Older Prose Legend of St. Procopius* by an anonymous Dominican friar in which the author criticizes the envy of inferiors within the order:

> Observe, you kings and princes, how much evil envy works in brotherhoods. The sin of envy does not suffer truth, and whatever it cannot have for itself, it seeks through evil words to obtain from all. If an abbot or a superior wishes to instill veneration and piety into his brotherhood, he must suffer many lying speeches against him from his inferiors.[25]

Common to all these parallels is the expression of feudal distrust toward social and class inferiors, whether at the court or the priory. In the case of *St. Catherine* and the *Older Prose Legend of St. Procopius*, it indicates that the author enjoyed a high social status at court and at the university and thought the reformist elements in Bohemia to be motivated by envy.

Like her father, Catherine is also described in a hyperbolic fashion redolent of chi-valric romance: she is said to receive the best education in the world; and these intel-lectual gifts—added to her striking physical beauty—make her contemptuous of any living suitor. Here too Catherine resembles the proud knight of the secular epic. Just as the young Alexander in the *Alexandreida* refuses to lead a subjugated life, so Cath-erine rejects subordination to any earthly spouse (138–40). The wording in the *Alex-andreida* and *St. Catherine* is strikingly similar in both passages:[26]

> When he ceased to be a child, he well understood that it is wrong to be subject to someone else. (161–63)

> For she well understood that it is wrong to live in subjugation, and did not wish to marry. (138–40)

The phrasing in lines 163 and 139 respectively is so close that we must conclude that the author of *St. Catherine* was familiar with the earlier work. The author deliberately interweaves secular and religious motifs in this way to enliven the genre of the saint's life for the noble audience familiar with the hyperbolic style of epic and romance. We find the same tendency in thirteenth-century France when hagiographic writers incor-porated lively romance features in order to make their rather dry subject-matter more palatable to a public enamored of the romances of Chrétien de Troyes.[27]

When the wicked emperor Maxentius seeks her hand in marriage for his son, Cath-erine refuses. Her disappointed mother solicits the advice of a hermit who meets the girl and tells her that there is an ideal spouse, whose name is Jesus. Catherine desires to see this spouse, and so the hermit gives her a diptych representing Christ and his Mother. Before leaving the hermit's lair, Catherine also receives his absolution (669), a detail absent from the source which illustrates the Dominican concern with penance. Catherine makes her way home, carrying the diptych secretly under her sleeve (650–51). When night falls, and all the residents of the castle are asleep and the lights have

been extinguished, Catherine goes into her chamber, locks the door and places the diptych before her, physical details all absent from the Latin source.

According to Vilikovský, these elements are peculiar to the Czech version of the story.[28] What this critic overlooks, however, is the convergence between such physicality and the Dominicans' special interest in representations of the body, especially in the context of female sanctity and piety. In contemporary scenes of the Crucifixion in fourteenth-century Bohemian art, lamenting women at the cross are often seen to shed tears and blood (fig. 40). The domestication of space occupied by holy women is also significant in this connexion. Similar features of quotidian existence characterize the *Annunciation* of the Mérode Altar by the Master of Flémalle (New York, Metropolitan Museum of Art, Cloisters Collection) and the *Birth of the Virgin* by the Master of the Osservanza Altar (National Gallery, London).[29]

The conversion and mystic marriage to Christ are based on a Latin source which reflects the late medieval focus on Christ's loving humanity. What distinguishes the vernacular version from its source, however, is the special prominence accorded to the maternal figure of the Virgin Mary—comparable to the amplification of Marian motifs also evident in the Dominican *Prayer of Kunhuta*—and the vividness with which the saint's physical experience is depicted. In the first vision Catherine's longing for her celestial spouse is so intense that her face becomes stained with tears and her eyes become blood-shot and murky from weeping:

> Tears rolled down her white little face and her eyes became bloodshot from great longing. (698–70)

This description is more concrete and physical than the Latin equivalent, where before and after the first vision, the author denotes Catherine's emotions with the formulaic expressions *cum lacrimis* and *multis lacrimis*. The amplification illustrates the Czech author's view of female sanctity as somatic, a belief influenced by Aristotelian physiological theories of sexual difference: women in their humors were thought to be colder and wetter then men, and humidity the cause of their desire.[30] Hence Catherine's yearning for her celestial spouse is manifested through the physical evidence of tears and blood. These concrete details are intended to reflect male beliefs about the physical nature of women's spiritual desire and to define the audience's response to the story in similarly affective terms.

After fervent prayer, Catherine falls asleep from exhaustion. She dreams that she is in a *locus amoenus* more beautiful than any clearing or meadow she has ever seen (706–20). The familiar European landscape gleams with fresh summer grass which contrasts with the immutable imagery of the jewelled hall in the second vision. Catherine beholds Christ and Mary seated on a throne. The mother and child are described in considerable detail (721–39). Since she has not yet been baptized, Catherine cannot see Christ's face, only his lovely, lily-white neck and golden curly locks which are compared with rings made from pure imagination, an allusion to the impending mystical marriage with Catherine (736–39). There is also an interesting reference to the Virgin's mother, St. Anne, in the Czech version where there is none in the Latin and only the briefest description of Jesus himself ("Cuius ineffabilem pulchritudinem ex splendore [cervicis et] capillorum aureorum cognoscens nec non ex candore niueo suorum ves-

timentorum").[31] The Czech version contains a much longer description, couched in the affective language of courtly love:

> Mary, the blossoming maiden, whose mother is St. Anne, holds her only one, Christ, her beloved little son, caressing him fervently. Above his dear little shoulders his lovely white neck shines and glistens like a pure-white lily gleaming from the brightest love. (723–31)

The reference to Christ's grandmother here is significant. The late medieval cult of St. Anne coincided with the phenomenon of the Immaculate Conception which considered the Virgin Mary to be born without taint from an earthly mother just as Christ emerged sinless from the womb.[32] Due chiefly to the influence of the *Golden Legend* Anne's prominence as *mater matris dei* stresses Jesus's matrilineal, rather than the patrilineal descent of the Gospels, and Jesus's membership in a human family.[33] St. Anne's prominence in the Holy Kinship and related devotional objects such as the statue of Mary and Jesus seated on Anne's lap (known in German as the *Anna Selbdritt*) also came increasingly in the fourteenth and fifteenth centuries to reflect and sanctify women's domestic and biological experience.[34] As the patron saint of midwives, Anne represented the central importance of the family to the gentry and aristocracy mindful of the need to produce healthy offspring.[35] Associated closely with childbearing, she was revered by noble families.[36] Her domestic role as grandmother provides a maternal, nurturing model with whom medieval women could identify more readily than the lofty and idealized Virgin Mary.[37]

Significantly, two of Charles IV's wives were named Anne—Anne of the Palatinate (1329–53) and Anne of Schweidnitz (1339–62)—as was his daughter, Anne of Bohemia, the future Queen of England. Even beyond the court, St. Anne was immensely popular in Bohemia and Moravia in the fourteenth century, signalling a growing recognition of women's positive role in the religious life of the society. Many Bohemian and Moravian churches and chapels were devoted to St. Anne, one of which was the Dominican convent at Prague with its adjacent church dedicated to Mary's mother.[38] The south Bohemian writer Thomas of Štítné, who studied for a time at the new Prague University, lists "the widow Anne" with other positive classical and biblical women (Judith, Esther and the Sibyls) in the preface to his translation of *The Visions of St. Bridget of Sweden*, intended for his daughter Agnes.[39] St. Anne was also the patron saint of miners on account of the precious jewel (Mary) she carried in her womb.[40] In this capacity she was venerated in the Bohemian mining towns of Kutná Hora (Kuttenberg) and Jáchymov (Joachimsthal) in the Ore Mountains.[41]

There can be no doubt that the vivid description of the first vision, which hovers between material detail and immaterial spirituality, owes a great deal to the realism of contemporary panel painting. A possible model for the author was the diptych of the Virgin and Child with Man of Sorrows by Tommaso da Modena, executed for the Emperor's private oratory of St. Catherine at Karlstein (ca.1355). The author of our legend actually mentions that on the panel presented to Catherine two images were painted (644), which could refer to Mary and Christ or two discrete compositions. In the small diptych by Tommaso, Christ is both a child and adult; and his golden curly hair has a three-dimensional sculptural quality. In the Latin model of the legend Jesus is a baby

in both visions, but in the first vision of the Czech version he combines childlike and adult qualities, consistent with Tommaso's diptych of Christ caressing his mother's chin like a lover. Such ambiguity also comports with the Dominican tendency to provide a physical, devotional figure whom women could love as a son and a lover. Consider, for example, the indeterminate child-adult features of the late medieval doll of the Christchild owned by the thirteenth-century German Dominican Marguerite Ebner.[42]

The simile of the pure white lily (730) signifies Christ's and Mary's purity since the lily is the symbol of the Annunciation (fig. 41).[43] The lily is one of the attributes of St. Dominic, as well as one of the Emperor Charles's personal devices, inherited from his first wife, Blanche of Valois (1316–48) whose device was the Capetian *fleur-de-lys.*[44] Catherine is unable to see or speak to her future spouse. The Virgin Mary mediates by appealing to her son to turn and address the suppliant Catherine. He replies that Catherine is not yet worthy to see his divine features since she has not been baptized. Here Mary is identified in circumlocution as the "radiant rose" (827) where there is no reference to her at all in the Latin source.[45] The image of the rose is amplified in the Czech version of the legend. In addition to underlining the virginal purity of Mary and St. Catherine—to whom it is several times applied—the rose may also denote the author's status as a preaching friar, since, some have claimed, St. Dominic had initiated the use of the rosary.

Mary's role as mediatrix between Christ and Catherine comports with the widespread medieval belief that the perfection of God incarnate could be represented to human eyes only through the female image of his mother, the most perfect creature known to humanity after Jesus. For this doctrinal reason, Catherine's oblique exposure to the feminized features of her lover is mediated through the symbolic attributes of Mary (the lily and the flowers in Christ's hair). It is thanks to the intercession of the Virgin, for example, that Dante is granted the vision of the Trinity in canto 32 of *Paradiso.* According to his guide, St. Bernard of Clairvaux, it is only by regarding the brightness of her face that Dante will be able to look at Christ's.[46]

Following the first vision, Catherine is pale from love-longing. She rises at the crack of dawn, puts on her cloak, hurries to the hermit's lair and knocks on his little window (866–73), concrete details peculiar to the Czech version and typical of its attention to somatic detail. The perceptive hermit asks the maiden why she has come so early and what has caused her pallor (879). The hermit now instructs Catherine in the Christian faith and baptizes her. Catherine returns home and locks herself in her chamber at nightfall to pray once more before her diptych. After more weeping, she falls asleep. In a second vision she sees Mary and Christ seated in glory and holding scepters at the end of a jewelled hall. No longer veiled from view, Christ welcomes Catherine in the sweet words of a wooing lover and sings an epithalamium to her.

The courtly iconography of the first and second visions reveals the contamination between devotional and romance texts, a characteristic of western literature since the twelfth and thirteenth centuries.[47] The theme of Christ the Lover was introduced in the twelfth-century sermons of St. Bernard but can be traced as far back as Origen (185–254 A.D.) whose allegorical commentary on the Song of Songs interprets the heroine or Shulamite bride as the soul and the hero as Christ.[48] St. Bernard built on this

allegorical foundation in his influential sermons on the Song of Songs delivered be-
tween 1135 and 1153.[49] His originality lay in the introduction of themes from the love
poetry of the Troubadours and the secular romances of the twelfth century. St. Ber-
nard's Christ is not only a lover; he is also a knight who saves his beloved lady—the
soul—from damnation. The earliest attestation of the theme of Christ as Lover-Knight
in the Czech Lands is found in the Dominican Kolda's parable *De strenuo milite*, one
of several works composed for the Abbess Kunhuta at the Benedictine Convent of St.
George in Prague.[50] Kolda's Christ is not strictly allegorical, as he would be for a male
audience, but a real lover anxious for the welfare of his lady and courageous on her
behalf. Similarly, in the second vision of the *St.Catherine* legend, Christ has become a
fully human, loving bridegroom who makes himself radiant and beautiful for his bride
(1037–39) and sings an epithalamium to her in a "dear, sweet, precious voice" (1064).[51]
His bridal song is more intimate and affective than the formalized restraint of the Latin
model ("Veni, virgo electa et filia mea delecta")[52] as was deemed appropriate for a fe-
male audience:

> Welcome, my most desirable.
> Welcome, my beautiful spouse.
> Come here to me, my darling chosen cheeks,
> my dear little dove. (1067–70)

The epithet "dear little dove" originates in the erotic diction of the Song of Songs 5:2.
The same sobriquet is also found in Oriental literature and is current in both the folk
and literary styles of the Slavonic languages, having equal currency in secular and
religious verse. In the Czech verse romance *Duke Ernest* it is applied as a term of erotic
endearment by the Emperor Otto to the eponymous hero's beloved mother; and by the
jilted lover to his girlfriend in the parodic context of *The Weaver.*[53]

 In her nuptial response to Christ, Catherine states that she has need of no other
mirror than the one provided by her beloved spouse (1086–87). The specular motif to
designate maidenhood can be traced to the writings of the eastern Early Church Father
St. Gregory of Nyssa (ca.339–394 A.D.), a Platonizing Christian who followed the lead
of Origen.[54] Writing about St. Gregory, Peter Brown states:

> The virgin body was an exquisitely appropriate mirror, in which human beings
> could catch a glimpse of the immense purity of the *image of God.* The woman's
> untouched flesh was both a mirror of the purity of her soul and a physical image
> of the virgin earth of the garden of Eden.[55]

According to St. Gregory's Platonizing view of virginity, the translucent body of the
virgin is like a mirror in which the image of God is reflected. In the Czech legend,
Christ's face has become the mirror where the virgin Catherine sees her own ideal
reflection. Woman is thus no longer a mirror wherein Christ sees His own perfection
but an autonomous image. This inversion illustrates the great prominence accorded to
the sanctity of the female body in the later Middle Ages.

 The setting of the mystic marriage is a beautiful jewelled hall with hard glittering
surfaces (962–1009), its immutable imagery of eternity contrasting with the ephemer-
ality of the earthly setting of the first vision.[56] The transition from a familiar earthly

landscape to an unfamiliar interior glistening with bright colors symbolizes the saint's progress from the familiar world of the senses to the transcendent realm of mystical experience. On the ceiling of the hall the sun, moon and stars shine as they move in their orbits, measuring every moment of time (984–989). It is clear from the wording of the passage that we are dealing here with a painterly representation (986) of these celestial spheres rather than the actual planets, which suggests the influence of contemporary painting and architecture. In 1913 Franz Spina argued that the author had seen the chapels of St. Catherine and the Holy Cross at Karlstein and possibly also the Chapel of St. Wenceslas in the Cathedral of St. Vitus.[57] This hypothesis was later refuted by Jan Vilikovský who argued that the author drew upon the description of the heavenly Jerusalem in Revelations, 21:18–23.[58] Whether or not the author had actually seen the chapels at Karlstein is less important than the symbolic attributes common to both the imaginary and architectonic evocations of the celestial kingdom and the sensory mode of depiction.

Like the jewelled hall, the Chapel of the Holy Cross and the Chapel of Saint Catherine (the imperial oratory) on the third and second floors respectively of Karlstein Castle are embellished with semi-precious stones.[59] In the Chapel of St. Catherine, there is a painting of Mary and the Christchild seated on a throne and receiving the fealty of the Emperor Charles and the Empress Anne. Since only the Emperor and his confessors would have had access to the imperial oratory, it is possible that the author of the legend had actually seen this painting and was influenced by it in his description of the first vision where mother and child, enthroned, are bracketed together with St. Anne. On the right side of the altar in the oratory there is an image of St. Catherine for whom the chapel is named.

If the Chapel of St. Catherine provides an architectonic analogue to the first vision, the Chapel of the Holy Cross surely corresponds to the jewelled hall of the second vision. The Chapel of St. Catherine is on a smaller scale and on a lower level than the Chapel of the Holy Cross. Moreover, the former leads up to the latter just as the first vision is followed by the spiritually more elevated second vision. Like the jewelled hall of the second vision, the Chapel of the Holy Cross was designed and perceived as an evocation of the New Jerusalem where the resurrected bodies of the holy reside in eternity. Thus in the hall of the second vision, the symbol of jewels conflates the celestial city of the New Jerusalem with the pure bodies of the virgins who reside there. The New Jerusalem is also linked with the cosmic Woman who is described as "clothed with the sun, and the moon was under her feet, and upon her head a crown of twelve stars" (Apocalypse 12:1). One of the most popular apocalyptic agents, the *mulier amicta sole* is a dominant image in medieval literature and art, identified both with *Ecclesia* and the Virgin Mary.[60] At Karlstein there seems to be stressed a symbolic identification of the apocalyptic woman with the Empress Anne for whom, I have argued, our legend was primarily intended.[61] Like the woman of St. John's vision, Anne gave birth to a son, Wenceslas; this was an important event for the Luxembourg dynasty, since the Emperor had no surviving male heir until this birth in February 1361. The importance of the event is stressed in the opening words of the Emperor's own autobiography addressed to those who would follow him and sit on the two thrones of Bohemia and the Holy Roman Empire.[62] And the dynasty, whose posterity had been

assured in real life, is traced backwards in art along the walls of the palace portion of Karlstein.

Absent from the Latin source, the twelve precious gems which adorn the walls of the hall correspond to those enumerated in Ezechiel 28:13 and to the description of the New Jerusalem in chapter 21 of the Apocalypse of St. John. This amplification can be explained in connection with the ideal of virginity and the resurrected body in late medieval piety. The gems in the Book of Ezechiel clothe the body in paradise,[63] while the city and the gems which adorn it in the New Jerusalem are closely identified with the virginal Bride of Christ. In the Apocalypse 21:9–10, the Bride of the Lamb is conflated with the holy city, just as in the Middle English poem *Pearl*, the Pearl-Maiden is fused with the heavenly landscape.[64] In medieval literature, the Lamb of the Apocalypse is associated with martyrs and virgins, especially with dead children, probably because Apocalypse 14 is read at the Feast of the Holy Innocents. The marriage imagery associated with the Lamb could be appropriated as well by the mystic visionary (such as St. Catherine), who thus becomes synonymous with the Bride of the Lamb.[65] The typological link between Catherine's mystic marriage and St. John's vision is widely attested in late medieval art, most notably in Hans Memling's beautiful altarpiece *The Mystic Marriage of St. Catherine* in the Sint-Jans Hospital in Bruges.[66]

The religious symbolism of the gems which encrust the walls of the hall was familiar to a medieval audience through the availability of lapidaries in upper-class houses and castles. In the later Middle Ages, precious gems came to denote specifically female virginity: Aldhelm in his *De Virginitate* describes holy maidens as *Christi margaritae, paradisi gemmae*;[67] the Bohemian monk Christian, author of the tenth-century Latin legend of the lives of the martyrs Sts. Wenceslas and Ludmila, *Vita et passio sancti Wenceslai et sancte Ludmile avie eius*, speaks of Ludmila *virtutum gemmis ornans* ("adorned with the jewels of virtue")[68] and in the Middle English *Seinte Margarete* the eponymous saint refers to her own virginity as a *deore gimstan* ("precious jewel").[69] In Dante's *Paradiso* the purity of the Virgin Mary is compared with a blue sapphire, the color of Mary and the azure sky traditionally associated with her: "Il bel zaffiro / del quale il ciel più chiaro s'inzaffira" ("the fair sapphire by which the sky is so brightly ensapphired").[70]

THE PASSION

The wicked Emperor Maxentius has begun a campaign to persecute Christians. The newly baptized Catherine begins to spread the gospel among her subjects and goes to the Emperor. They argue and Catherine is put in prison. To coerce her into relinquishing the new faith and into marrying his son, the Emperor invites fifty pagan scholars to dispute with the virgin. Fortified, however, by the Archangel in her dungeon, Catherine succeeds in converting the pagan scholars to the true faith, whereupon the furious Emperor has them all thrown into a fiery furnace and Catherine scourged. Her snow-white, naked body is beaten with horse-hair whips with three lashes ending in lead knots in which steel hooks are fixed. This scene of torment culminates in a comparison between Christ and Catherine and Tristan and Isolde: the love potion is Catherine's faith strengthened by her suffering on Christ's behalf. Catherine is returned to a deep,

dark dungeon which, when the Empress and her captain of the guard, Porphirius, visit her there, is found to be fragrant and suffused with light, for now Catherine is kept company by an angel who anoints her wounds with heavenly oils and unguents. The Empress and Porphirius are converted and subsequently martyred in grisly fashion, along with two hundred heathen knights. The Emperor orders Catherine to be brought from her cell and is amazed to find that she is even more beautiful than before the scourging. Intent on maiming her lovely body, the Emperor orders a torture machine to be constructed which consists of four-bladed wheels, the blades resembling the hoe used to rake the soil in the field. But an angel shatters the wheels and the splinters which fly from them kill four thousand heathen onlookers. Unable to persuade Catherine to abandon her faith, the Emperor orders her to be decapitated. Just before she dies, Catherine hears Christ speaking to her as his true bride. Her head is severed, and instead of blood milk flows from her neck. She dies at the sixth hour like Christ on the cross and her body is translated by angels to Mount Sinai where her miraculous relics are still preserved.

Catherine's debate with the pagan sages is largely in direct speech, in contrast with the indirect speech that predominates in the Latin model. Altogether fifty-two percent of the Czech text is in direct speech.[71] Importance was attached to demonstrating doctrinal points in dramatic form to make the theological abstractions more palatable to a secular audience untrained in the niceties of ecclesiastical dogma.[72] This mode of adaptation is certainly consistent with the sermon techniques of a Dominican friar concerned to present events in vivid, dramatic terms. Also important in the debate is the amplification of the term *blud* (doctrinal error), which occurs three times (1131, 2190, 3119), and its adjectival form *bludný* which occurs six times qualifying different nouns (1445, 1212, 2616, 3128, 2756 and 1217). As elsewhere in Europe, the Dominicans of Bohemia and Moravia were the spearhead of the papal Inquisition, responsible for rooting out heresy and for converting its perpetrators back to the true faith. One of Catherine's many functions in the Middle Ages was her role as theologian and teacher, a role with which the Dominicans closely identified. It was on account of her status as a theologian that Catherine was venerated as the patron saint of the Sorbonne at Paris. Hence the saint's principal function in the debate is to represent Catholic orthodoxy and to convert the pagans to the true faith. Consider, for example, the wording of the following passage in which Catherine rebukes the Emperor Maxentius for his stubborn refusal to embrace Christianity:

> Catherine boldly went to the place where the Emperor was standing and said to him: "What is the use of your misguided power, evil Emperor? You know I am right, so why do you dare to persist in your error? (1214–20)

It is instructive at this point to compare Catherine's embodiment of the truth with the similar role of the martyrs in the Old Czech *Passional*. In *The Life of St. Eustace*, Christ appears in a vision and congratulates Eustace for having crushed the Devil through the true faith.[73] Occasionally, the author of *The Passional* allows the pagans to claim the true faith as their own, as, for example in *The Life of St. George*, when the evil Emperor tells his wife (who wishes to become a Christian) that she is deviating from the true

faith.[74] The point of this curious appropriation by a pagan is to demonstrate just how insidious and dangerous is the discourse of the heretic and non-believer.

The second theme of Catherine's speech is the Incarnation exemplified by her own passion. The debate is conducted in a civil and courteous fashion; these are no philistine pagans but eager seekers after truth, a further indication of a refined, courtly audience. It is Catherine's role to witness to this truth and to embody the Church (*Ecclesia*), first through the literal word of the Gospels and the teachings of the Church (the debate) and later through the Word made flesh (the Passion). As we have seen, the Czech author enhances the affective bond between Catherine and Christ through vivid, concrete description and courtly language in the scenes of the conversion and the mystic marriage based on the first Latin source. Similarly, in those scenes based on the second source, he pares the debate while expanding the flagellation and passion. This change of emphasis suggests that the author regarded female sanctity as essentially somatic, a male-centered assumption with which medieval women were expected to identify.[75] For the author there was no contradiction between Catherine's intellectual role as a theologian and her physical role as a martyr; on the contrary, he perceived a seamless unity between the verbal truth she represents as a teacher and the higher, mystical truth she embodies as a martyr. Yet the greater emphasis placed on Catherine's physical imitation of Christ, and the corresponding downplaying of her intellectual prowess, tells us a great deal about the author's conservative vision of religious practice and the perceived role of women within it. In an age when heresy among women was greatly feared and severely punished, it is not surprising that a text associated with the conservative Emperor's family and inner court circle should be highly traditional in its theological and social outlook.

The scourging scene provides a direct parallel to the flagellation of Christ before the Crucifixion and incorporates courtly love symbolism to reinforce the theme of the *sponsa Christi*. With its special code of meanings, the color symbolism introduced in the flagellation scene seems to have been devised for a noble audience of initiates. Color symbolism is attested both in secular and in religious writings of the later Middle Ages. One possible source for the color coding in the flagellation scene of our legend is the French *Château d'Amour* by Robert Grosseteste, Bishop of Lincoln, whose works were known in medieval Bohemia. The *Château d'Amour* is a religious allegory written in a courtly manner for a noble English audience. The castle of the title, which corresponds to the pure body of the Virgin Mary, is painted in three colors: green, blue and red. The green foundation of the castle signifies faith, the blue colour hope and the red color love.[76]

In Czech medieval literature color symbolism is attested in the prose romance *Štilfríd*, in certain parodic elements in *The Little Weaver* and in the Czech love lyric known as *De amore mundi cancio de coloribus*. Vilikovský has also found references to color symbolism in a Latin treatise entitled *De confessione* in a manuscript in the library of the chapter-house of the Cathedral at Olomouc.[77] This treatise is concerned with the confessional preparation for the taking of communion and distinguishes between the secular and spiritual connotations of the colours green, black, grey, red, white, azure, brown, violet and yellow. These spiritual connotations correspond

closely to those enumerated in the legend, although they sometimes differ from the verses of the lyric *De amore* cited by the author of the treatise.

Catherine's skin changes color under each cruel blow of the whip: the green covering the face from shame denotes dawning love. As in the treatise, green here has a positive spiritual meaning where it is negative in the lyric: "et signat spiritualiter deum incipere amare, quod fit per timorem." In the secular context of German *Minnesang*, green also denotes incipient love.[78] In the mystical writings of the German Dominican Elsbeth von Oye, whose imitation of Christ was especially physical, the color green is associated with the continual blossoming of the sharpened crucifix with which she mortifies her own flesh.[79] The white of the body signifies hope as in the treatise *De confessione* and in the secular courtly context of *Von den farben* (65–69). The red of the blood denotes the fervor of spiritual love as in the *Château d'Amour* and in the treatise *De confessione* as well as in the secular context of courtly poetry (*Von den farben*, 29–32). The black of the wounds, from which the flesh has been torn away, is the symbol of grief or sadness, in religious terms for Christ in his humiliation and in secular terms, sadness at the lover's neglect (*Di siben varben*, 3–5). The colour blue, traces left by the whip, denotes constancy and perseverance both to God and to the lover (*Von den farben*, 51–53).

The gold of Catherine's loosened hair is the symbol of the fulfilment of all desires and the gratification of love in her mystical union with Christ (2301–2380). Gold or yellow was identified with love and marriage even in classical times. In Ovid's *Metamorphoses*, for example, Hymen, the male god of marriage, is dressed in saffron robes (*croceo amictu*).[80] The color gold is also associated from the time of the Early Church with the malleable perfection attained by bodies in future ages.[81] Thus Catherine's virginal body takes on the hue of heavenly perfection. Indeed, her celestial destination is anticipated from the beginning of the legend by her golden hair which resembles Christ's in the two visions (in the Latin model it is brown). This color correspondence further underscores her distinctly female, literal imitation of Christ.

Where the Catherine legend differs most remarkably from any known source or parallel is the extraordinary tension between corporeal and spiritual description. The key to this polarity is surely the contradictory vision of Woman as fallen woman and virgin, defined through her physical and idealized body. The description of the flagellation—complete with metal hooks attached to the end of the scourge—reflects actual medieval religious practice. In 1349, large groups of flagellants from various cities in Belgium congregated in Tournai; one group from Liège was accompanied by a Dominican friar who preached a sermon in which he extolled the sacrifice of these so-called "Red Knights of Christ."[82] Self-chastisement was also an aspect of Dominican female piety. Elsbeth von Oye frequently whipped herself with a barbed scourge and wore a sharpened crucifix so close to her waist that it cut into her skin. The Czech author was clearly concerned to present such a female imitation of Christ in the moderate terms of the courtly love code appropriate to his noble audience.

At the moment the color red is introduced the bloody wound in the broken skin becomes aestheticized as a rose. On the realistic level, this image connotes the corrupt female body (the wound-associated vagina was a particular source of horror to the male

imagination); on the spiritual level, it symbolizes the Passion and Mary's compassion for her crucified son. The Virgin's affinity with her son's suffering developed from the eleventh century onward, linking the Incarnation and the Passion in a unified vision of the Christian faith.[83] As Miri Rubin puts it, "in vernacular literature a strong bond was created between the eucharistic body and the original body born from a virgin womb, to produce a powerful image linked both to crucifixion and to nativity in the Virgin Mary."[84]

The connection between the flagellation and confession followed by communion is important for an understanding of the legend's religious function. The correspondence discussed earlier between the treatise *De confessione* and our legend suggests that the flagellation scene can be interpreted in liturgical terms as the penitence and confession which precede Holy Communion. Significantly, the elaborate emphasis on confession points to Dominican influence, since one of the main functions of the Order was to assist the bishops with their increased pastoral workload by preaching, the hearing of confessions, and the provision of spiritual advice.[85]

Following the flagellation is the courtly comparison of Christ and Catherine with the lovers Tristan and Isolde (2385–90). The author assumes that his female audience would be familiar with the courtly love code and would understand the connection between the secular conceit and its eucharistic associations. The "precious drink of Isolde" (*drahé Izaldy napitie*) (2385), for instance, is the faith she receives after her mystic marriage to Christ which fortifies her in the midst of pain and suffering. The Czech author introduces the secular *matière* of the Celtic lovers to convey the love-bond between Christ and Catherine; conversely, the German poet Gottfried von Strassburg in the prologue to his romance *Tristan* incorporates the image of the eucharistic bread to describe the salvific effect of his story on his intimate audience of "noble hearts." Both German and Czech poets combine religious and courtly elements and their common source of influence was, without doubt, St. Bernard's popular sermons on the Song of Songs.[86] Dominican authorship would explain the coexistence of courtly language and eucharistic symbolism at this point, since the Dominicans and the women to whom they preached were especially noted for their eucharistic piety.[87]

Catherine's flagellated body is cast into a deep dungeon. But angelic light suffuses the cell and illuminates the darkness. The virgin is comforted by angels who anoint her tortured flesh with heavenly and fragrant ointments. Here the Czech text is quite faithful to the Latin source ("et angelos dei plagas et carnis scissuras aromatico unguine circumfoventes.")[88] But the Czech version reinforces the somatic nature of Catherine's experience and her affective bond with Christ:

> They (the angels) rub the blows and wounds
> with heavenly balms; thus with his angelic
> physicians Christ comforted his bride. (2563–66)

As well as "to comfort" or "to console," the Old Czech word *kojieše* (2566) also means "to breast feed." Thus Christ's body incorporates the traditional female function of lactation. In the Nativity panel of the Vyšší Brod Altarpiece, for example, Mary's right hand is poised below Christ's breast and displays the characteristic pinching gesture of lactation (fig. 42). His eyes turned toward the viewer, the Christ child appears to offer his

own breast to the faithful suppliant. From the twelfth century on, writers frequently saw Jesus as a mother and nurse, as well as a lover, brother and father (and sometimes all of these things at once). St. Bernard associates Christ the bridegroom with nursing;[89] and Guerric of Igny (died ca. 1157) envisages Christ as a feeding mother and a nurse in his loving care, as well as a father in his qualities of strength and authority.[90]

In the Latin model, Christ sends a white dove from heaven to give Catherine spiritual sustenance just as he fed Daniel for seven days in the den of lions.[91] In the Czech version the dove is replaced by an angel who nurtures Catherine back to health. The introduction of an angel is characteristic of the Czech author's concern to give Christ's love for his bride a more physical and loving form. This emphasis on the love between Christ and his spouse is also present in Catherine's defiant speech to the stupified Emperor as she emerges, unscathed, from her dungeon:

> Know that I received bodily food from no-one but only from the angel who sated Daniel when he was imprisoned by the Babylonian king in the den of lions. He generously fed, gave me milk and healed me from his breast and glorified me with his love . . . (2679–87)

The fifteen-verse description of the torture machine devised by the wicked Emperor introduces a comparable simile drawn from the everyday world of experience: the blades of the machine are likened to a harrow, the spikes of which break up the clumps of soil in the rye field (2763–77). Although it may seem odd to find such a homely detail in a high-style context, this (and the other rural similes found in this work) perhaps tells us something about the Dominican author's predilection as a trained writer of sermons for vivid rural images drawn from the world of everyday life.[92]

Following Catherine's fervent prayer, the infernal machine—its blades as sharp and deadly as the swords of the heathen Tartars and Saracens (2777)—is destroyed by the miraculous intervention of an angel, thus guaranteeing the maiden's invulnerability to physical pain and her triumph over death through faith.[93] Almost out of his mind, the Emperor orders Catherine to be decapitated with a sword, hence the two iconographic attributes of the wheel and the sword in visual images of the saint.[94] In her final prayer before execution, Catherine asks God to bless and protect from fire and storm those faithful people whose walls or books are adorned with images of her passion (3365–80) and prays for the physical and material welfare of born and unborn children (3375–80) and the salvation of the dead (3381–87). We find a similar allusion in *The Legend of the 10,000 Knights* where the author mentions that scenes from this legend, besides being hewn in stone, cut in wood and drawn in books, were painted in black and white on the walls of the rooms of private houses.[95]

Vilikovský claims that in this passage the author is promoting artists and their workshops.[96] In fact, such words of protection are formulaic: similar phrasing occurs, for example, in the fifteenth-century English *vitae* of Sts. Dorothy, Margaret and Katherine by the Suffolk Austin canon Osbern Bokenham. St. Dorothy, for example, beseeches God to protect those mothers in childbed who remember her passion and houses from fire where her passion is represented:

> And yf wummen wyth chyld of hyr had mende,
> That he tham hastly wold socour sende;

> And that noon hous where were hyr passyonarye
> Wyth feer ner lyhtnyng shuld neuyr myskarye. (4908–10)[97]

In all of these cults of the Roman virgin-martyrs, one of their principal functions ever since the Early Church has been to protect people and intercede for them with God.[98]

In paintings of Catherine, too, the artists often stress her protective powers. In the miniature book of hours known as the *Heures du Maréchal de Boucicaut* (1410–15) by an unknown Flemish-Franconian artist, the eponymous marshal kneels before the saint, his hands lifted in supplication. The inscription surrounding the smiling virgin articulates her response: *Ce que vous voudres* ("Whatever you want"), a promise of aid and acceptance.[99] The Marshal de Boucicaut belonged to the nobility, that privileged group which expressed its devotion to her more fervently and consistently than any other class of society. What they admired above all was her courage and dignity in the face of suffering, virtues expected of brave knights and warriors. Knights made pilgrimages not only to Jerusalem, but also to Catherine's shrine on Mount Sinai, in the hope of being accepted into the elite ranks of a "Knight of Jerusalem." If accepted, the knight would be allowed to wear the emblem of the saint: the wheel penetrated by a sword.[100]

Moments before death, Catherine casts a bold look at the executioner and pulls back her golden hair to spare it from the blade before lowering her neck (3435–37). These concrete, physical details are peculiar to the Czech version, and combine the corporeality of female sanctity with the general doctrinal importance of bodily integrity as a prerequisite for resurrection.[101] Catherine's slender neck is pure white (3437), recalling Christ's lily-white neck in the first vision and underlining her literal *imitatio Christi*. Her head is severed at one stroke and, instead of blood, milk pours from her neck as a token of virginal purity (3451–55). The adverb used here is "generously" as in the description of the lactating angel in the dungeon (2685). Important here is the maternal, nurturing function of the female body. The posthumous miracles of milk gushing from the saint's severed neck and the curative oil which oozes from her bones (3495–3501) illustrate the Aristotelian equation of the female body with moisture and excessive bodily fluids.

In addition to its symbolic significance as a sign of virginal purity, milk denotes the salvific blood of the Eucharist, the visible proof of the doctrinal truth of the Word made flesh to which Catherine witnesses before the heathen scholars. In late medieval religious practice we find numerous instances of the association of milk with blood. According to the physiological theories of the time, the mother's milk was believed to be produced from her blood.[102] This equation explains the presence of maternal, feeding imagery in *The Prayer of Kunhuta*. The speaker addresses Christ as present in the bread and wine who is requested to feed his children with his body and blood:

> Deign to feed us today, fill us with living food, strengthen us with its strength and pour its delight into our soul.[103]

In a eucharistic prayer in Czech and German by the Moravian preacher John Milíč of Kroměříž, a preacher and former member of the imperial chancellery who preached at

the Dominican church of St. Giles in Prague, the full humanity of Christ's body and blood is conveyed by the maternal metaphor of feeding:

> For our mother fed us with her own or others' breasts to full growth, but you feed us, your children, with your own sacred body and blood . . . [104]

CONCLUSION

How are we to explain the curious intrusion of maternal bodily imagery (the lactating angel, tears of blood) into a vernacular saint's life written in praise of a learned virgin and bride of Christ? The answer, I have proposed, lies within the complex late medieval image of woman as teacher, virgin *and* mother. In his *De laudibus feminarum*, a letter addressed to the Empress Anne, Petrarch stresses the neo-Platonic importance of female intellect as well as the traditional significance attached to her bodily function as a mother. The author of our legend similarly associates Catherine of Alexandria with all three female virtues—intellect, motherhood and virginity. Like the courtier-poet Petrarch, he is responding to the pragmatic needs of dynastic continuity and to his own ideals as a humanist intellectual. The most likely addressee of the legend was the Empress Anne who was yet to give birth to a son and heir to her husband's kingdom. I have also maintained that the most likely author of our legend was the Dominican John Moravec, whose complex profile as courtier and cleric goes some way to explaining the text's secular and doctrinal concerns and its successful fusion of courtly love discourse with the intricacies of theological debate.

NOTES

1. Caroline Walker Bynum, "Women Mystics and Eucharistic Devotion in the Thirteenth Century," in *Fragmentation and Redemption. Essays on Gender and the Human Body in Medieval Religion* (New York, 1992), 122.

2. For the Czech edition of the so-called Latin "Vulgate" (the source of the dispute and the passion), see *Dvě verse starofrancouzské legendy o sv. Kateřině Alexandrijské*, ed. Jan Urban Jarník (Prague, 1895). For the Latin source of the conversion (*Fuit in insula Cypri rex quidam, nomine Costus*) and the unique Czech manuscript (Brno, Moravian Provincial Library, III F 6), the edition used here is *Die altčechische Katharinenlegende der Stockholm-Brünner Handschrift*, ed. Franz Spina (Prague, 1913). For a modern Czech translation of the Czech text, see *Legenda o svaté Kateřině*, trans. Jiří Pelán with an introduction by Jan Lehár (Prague, 1993).

3. See Henri Brémond, *Saint Catherine d'Alexandrie* (Paris, 1923), 10.

4. Franz Spina, ed., *Die altčechische Katherinenlegende*, xii.

5. Jacobus de Voragine, *The Golden Legend*, trans. W. Granger Ryan and Helmut Ripperger (New York, London and Toronto, 1941), 708–16.

6. See Clemence of Barking, *The Life of St. Catherine*, ed. William McBain, ANTS 18 (Oxford, 1984), xiii.

7. See Eamon Duffy, "Holy Maydens, Holy Wyfes: the Cult of Women Saints in Fifteenth- and Sixteenth-century England," in *Women in the Church*, ed. W. J. Sheils and Diana Wood (Studies in Church History, 27, Oxford, 1990), 175–96 at 185.

8. See *Seinte Katerine*, ed. S. R. T. O. d'Ardenne and E. J. Dobson, EETS 7 (Oxford, 1981); for an anthology of the so-called "Katherine-Group," see *Medieval English Prose for Women: The Katherine*

Group and Ancrene Wisse, ed. Bella Millet and Jocelyn Wogan-Browne (Oxford, 1990); also Osbern Bokenham, *Legendys of Hooly Wummen,* ed. Mary S. Serjeantson, EETS Original Series, 206 (London, 1938).

9. See Franz Machílek, "Privatsfrömmigkeit und Staatsfrömmigkeit," in *Kaiser Karl IV: Staatsmann and Mäzen,* ed. Ferdinand Seibt (Munich, 1978), 87–101 at 88.

10. For the Emperor's life and work, see Ferdinand Seibt, *Karl IV. Ein Kaiser in Europa, 1346 bis 1378* (Munich, 1994).

11. See Vladimír J. Koudelka, "Zur Geschichte der böhmischen Domikanerprovinz im Mittelalter: I- Provinzialprioren, Inquisitoren, Apost. Poenitentiare," in AFP 25 (1955): 75–79 at 79.

12. For the association of Dominicans with female piety, see Edith Ennen, *The Medieval Woman,* trans. Edmund Jephcott (Oxford, 1989), 133–36.

13. See Friedrich Prinz, *Böhmen im mittelalterlichen Europa: Frühzeit, Hochmittelalter, Kolonisationsepoche* (Munich, 1984), 169.

14. Ibid.

15. Ennen, *The Medieval Woman,* 135.

16. *Nejstarší česká duchovní lyrika,* ed Antonín Škarka (Prague, 1948), 76–81.

17. See Josef Hemmerle, "Karl IV. und die Orden," in *Kaiser Karl IV,* 301–305 at 304.

18. For the Dominican authorship of the prose *Life of Christ,* see Vladimir J. Koudelka, "Zur Geschichte der böhmischen Dominikanerprovinz im Mittelalter: III- Bischöfe und Schriftsteller," AFP 17 (1957): 39–110 at 57–59. For the Czech translation of the Vulgate, see Kavka, "Die Hofgelehrten," in *Kaiser Karl IV,* 249–53 at 250.

19. See Jan Vilikovský, *Próza z doby Karla IV* (Prague, 1938), 256.

20. Vilikovský, *Písemnictví českého středověku* (Prague, 1948), 154–55.

21. Ibid., 154.

22. Francesco Petrarca, *Le Familiari* 21.8, ed. Vittorio Rossi, 4 (Florence, 1942). For information about Petrarch's correspondence with the Empress Anne, I am indebted to David Wallace who allowed me to read chapter 12 of his forthcoming *Chaucerian Polity. Absolutist Lineages and Associational Forms in England and Italy* (Stanford, 1997).

23. George M. Cummins, *The Language of the Old Czech Legenda o sv. Kateřině* (Munich, 1975), 363.

24. For Peter II's piety and love of books, see Jan Kadlec, "Petr II z Rožmberka," in *Strahovská knihovna* 5–6 (1970–71), 1, 89–98.

25. See *Czech Prose. An Anthology,* ed. and trans. William E. Harkins (Ann Arbor, 1983), 13–14.

26. *Alexandreida,* ed. Václav Vážný (Památky staré literatury české, 28, Prague, 1963), 36.

27. Brigitte Cazelles, *The Lady as Saint. A Collection of French Hagiographic Romances of the Thirteenth Century* (Philadelphia, 1991), 30–38.

28. Jan Vilikovský, *Písemnictví českého středověku,* 181.

29. For the domestication of sacred scenes in the context of female piety, see Diana M. Webb, "Woman and Home: the Domestic Setting of Late Medieval Spirituality," in *Women in the Church,* 159–74.

30. Joan Ferrante, *Woman as Image in Medieval Literature From the Twelfth Century to Dante* (New York, 1975), 6.

31. See F. Spina, ed., *Die altčechische Katherinenlegende,* 26.

32. See Kathleen Ashley and Pamela Sheingorn, "Introduction," *Interpreting Cultural Symbols: Saint Anne in Late Medieval Society,* ed. K. Ashley and P. Sheingorn (Athens and London, 1990), 25.

33. Ibid., 17.

34. Bynum, "The Female Body and Religious Practice in the Later Middle Ages," in *Fragmentation and Redemption,* 198.

35. Ashley and Sheingorn, "Introduction," *Interpreting Cultural Symbols,* 2.

36. See Gail McMurray Gibson, "Saint Anne and the Religion of Childbed: Some East Anglian Texts and Talismans," in *Interpreting Cultural Symbols,* 95–110.

37. See Merry E. Wiesner, *Women and Gender in Early Modern Europe* (New Approaches to European History, 1, Cambridge, 1993), 184. It is interesting to compare the role of St. Anne with the domestic, down-to-earth Virgin Mary in the Czech *Life of Christ* where the Mother of God performs the domestic tasks of sewing and cooking.

38. See *Praha středověká,* ed. Emanuel Poche et al. (Prague, 1983), 202.

39. *Počátky staročeské mystiky,* ed. Jan Menšík (Prague, 1948), 80.

40. Peter Burke, *Popular Culture in Early Modern Europe* (New York, 1978), 35.

41. Ibid.

42. See Ulrika Rublack, "Female Spirituality and the Infant Jesus in Late Medieval Dominican Convents," *Gender and History* 6, 1 (1994): 37–57 at 43.

43. For the lily as a symbol of the Annunciation, see Marina Warner, *Alone of All Her Sex: The Myth and Cult of the Virgin Mary* (New York, 1983), 99.

44. The Czech art historian Pešina regards the coronation of the Emperor and Blanche of Valois in 1347 as the source for the golden *fleur-de-lys* embossed on the cape of the Angel Gabriel in the Annunciation panel of the Vyšší Brod Altar. See Jaroslav Pešina, *Mistr Vyšebrodského cyklu* (Prague, 1982), 18.

45. F. Spina, ed., *Die altčechische Katharinenlegende*, xviii.

46. Dante Alighieri, *The Divine Comedy. 3: Paradiso* 32.85–87, trans. John D. Sinclair (Oxford, 1961), p. 466.

47. See the introduction to Cazelles, *The Lady as Saint.*

48. Warner, *Alone of All Her Sex*, 126.

49. See *The Cistercian World: Monastic Writings of the Twelfth Century*, ed. Pauline Matarasso (Harmondsworth, 1993), 65.

50. For the Abbess Kunhuta and her *Passional*, see Vilikovský, *Písemnictví*, 26–40.

51. Neither of these affective details is present in the Latin source.

52. F. Spina, ed., *Die altčechische Katharinenlegende*, 35.

53. Alfred Thomas, *The Czech Chivalric Romances Vévoda Arnošt and Lavryn in their Literary Context* (Göppinger Arbeiten zur Germanistik, 504, Göppingen, 1989), 136.

54. Peter Brown, *The Body and Society: Men, Women and Sexual Renunciation in Early Christianity* (New York, 1988), 299.

55. Ibid.

56. Derek A. Pearsall and Elizabeth Salter, *Landscapes and Seasons of the Medieval World* (London, 1973), 147.

57. F. Spina, ed., *Die altčechische Katharinenlegende*, xxi.

58. Vilikovský, *Písemnictví*, 186–87.

59. See Vlasta Dvořáková, "Karlštejn a dvorské malířství doby Karla IV," in *Dějiny českého výtvarného umění*, 2 vols (Prague, 1984), 1: 310–27.

60. See Richard K. Emmerson, "The Apocalypse in Medieval Culture," in *The Apocalypse in the Middle Ages*, ed. Richard K. Emmerson and Bernard McGinn (Ithaca and London, 1992), 293–332 at 313.

61. See Michael Levey, *Painting at Court* (London, 1971), 31.

62. *Vita Caroli Quarti (Die Autobiographie Karls IV.)*, ed. and trans. Eugen Hillenbrand (Stuttgart, 1979), 66.

63. See Eduard Petrů, "Symbolika drahokamů a barev v Životě svaté Kateřiny," in *Slavia* 64/4 (1995): 381–86 at 384. Petrů sees a parallel between the colors of the jewels and the colors of Catherine's body in the later flagellation scene, but omits to explore how the metaphor of the virginal, resurrected body gives significance to this parallelism.

64. Emmerson, "The Apocalypse in Medieval Culture," 322.

65. Ibid., 326.

66. Ibid., 328.

67. See *Pearl*, ed. E. V. Gordon (Oxford, 1980), xxvii.

68. *Kristiánova legenda*, ed. Jaroslav Ludvíkovský (Prague, 1978), 30.

69. *Medieval English Prose for Women*, 48.

70. Dante, *Paradiso* 23.101–2 (trans. Sinclair, 334).

71. F. Spina, ed., *Die altčechische Katharinenlegende*, vxiii.

72. Compare a similar mode of adaptation in the early thirteenth-century prose life of St. Catherine written for an audience of anchoresses. See *Anchoritic Spirituality; Ancrene Wisse and Associated Works*, trans. and ed. Anne Savage and Nicholas Watson (New York, 1991), 261.

73. *Výbor z české literatury*, ed. Bohuslav Havránek et al. (Prague, 1957), 1: 525.

74. Ibid., 529.

75. A similar emphasis can be found in the Middle English prose *Ancrene Wisse* and *Seinte Katherine* from the early thirteenth century.

76. See *Le Château d'Amour de Robert Grosseteste, évêque de Lincoln*, ed. J. Murray (Paris, 1918), lines 605–28.

77. See Jan Vilikovský, *Latinská poesie žákovská v Čechách* (Bratislava, 1932), 122–24. For the love lyric "Píseň o barvách," see *Staročeská lyrika*, ed. Jan Vilikovský (Prague, 1940), 63–64.

78. See J. Pelikán, "Příspěvky ke kritice a výkladu štokholmské legendy o sv. Kateřině," *Listy filologické* 18 (1891): 64–73 (especially 66–73). The citations of German *Minnesang* color symbolism are taken from this essay.

79. Quoted from Peter Ochsenbein, "Leidensmystik in dominikanischen Frauenklöstern des 14. Jahrhundert am Beispiel der Elsbeth von Oye," in *Religiöse Frauenbewegung und mystische Frömmigkeit im Mittelalter*, ed. Peter Dinzelbacher and Dieter R. Bauer (Cologne and Vienna, 1988), 353–72 at 362.

80. Ovid, *Metamorphoses* 10.1, trans. Mary M. Innes (Harmondsworth, 1955), 225.

81. Brown, *The Body and Society*, 167–68.

82. R. W. Southern, *Western Society and the Church in the Middle Ages* (Harmondsworth, 1970), 307.

83. Miri Rubin, *Corpus Christi: The Eucharist in Late Medieval Culture* (Cambridge, 1991), 142.

84. Ibid.

85. See William A. Hinnebusch, *The Early English Friars Preachers* (Rome, 1951), 279–96.

86. See the introduction to Gottfried von Strassburg, *Tristan*, trans. A. T. Hatto (Harmondsworth, 1960), 14–15.

87. Bynum, "Women Mystics and Eucharistic Devotion in the Thirteenth Century," in *Fragmentation and Redemption*, 119–50.

88. *Dvě verse starofrancouzské legendy*, ed. Jarník, 49.

89. Bynum, "Jesus as Mother and Abbot as Mother: Some Themes in Twelfth-Century Cistercian Writing," in *Jesus as Mother. Studies in the Spirituality of the High Middle Ages* (Berkeley, Los Angeles and London, 1982), 117.

90. Ibid., 122.

91. *Dvě verse starofrancouzské legendy*, ed. Jarník, 56.

92. Compare also the rural simile in lines 13–14 of the legend.

93. See Bynum, "The Female Body and Religious Practice in the Later Middle Ages," in *Fragmentation and Redemption*, 231–32.

94. Compare the fresco of Catherine with her wheel and sword on the north wall of the Church of St. Vitus in Český Krumlov, south Bohemia (ca.1420) where we see the green of the saint's mantel and her golden hair and crown, the first and last of the six colors enumerated in the description of the flagellation in our legend.

95. *Kremsmünsterská legenda o 10,000 rytířích*, ed. V. Vondrák, *Listy filologické* 16 (1889): 21–45 at 38–39, lines 305–29.

96. Vilikovský, *Písemnictví*, 184–85.

97. Bokenham, *Legendys of Hooly Wummen*, 134.

98. See Duffy, "Holy Maydens," 189. For virgins as powerful protectors in early Christianity, see Brown, *The Body and Society*, 156–59.

99. Anneliese Schröder, *St. Catherine: Text of Story and Legend*, trans. Hans Hermann Rosenwald (The Saints in Legend and Art, 17, Recklinghausen, 1965), 18.

100. Ibid., 21.

101. Bynum, "Material Continuity, Personal Survival and the Resurrection of the Body: A Scholastic Discussion in Its Medieval and Modern Contexts," in *Fragmentation and Redemption*, 269.

102. Bynum, "The Female Body and Religious Practice in the Later Middle Ages," in *Fragmentation and Redemption*, 214.

103. *Nejstarší česká duchovní lyrika*, ed. Škarka, 79.

104. Quoted from Vilikovský, *Písemnictví*, 134–35.

The Dominican Presence
in Middle English Literature

Siegfried Wenzel

As other contributions to this volume demonstrate, Dominicans and their thought formed a lively and important part in the last three centuries of medieval culture, in theology, preaching, pastoral care, the graphic arts, and other areas. Did they do so also in literature, and if so, in what ways? For an answer I will examine the three major poets of the Ricardian age in England—Chaucer, Langland, and Gower—and the early English religious lyric. The term "presence" of my title, admittedly somewhat vaguer than "appearance" or "influence," allows me to consider a number of different ways in which Dominicans might appear in works of imaginative literature.

I begin with literary depiction. The three Ricardian poets present several friars in their works, and they do so in very different ways. In his *Vox clamantis*, John Gower, under the guise of a dream vision, relates allegorically the events of the Rising of 1381 and then turns to ask what caused the terrible upheaval and violence he had witnessed. Like a typical medieval moralist, Gower does not see social injustices, oppression, poor economic conditions, or bad government, but rather the moral deterioration of society and a multitude of sins in its members. To analyze these, he considers at length the three estates. Beginning with the clergy, he lists and describes common failings of prelates and curates, and of monks, canons, and nuns, and in the end turns to the friars.[1] Though he acknowledges that their founders were holy men, and that the existing orders contain many good members, he compiles an amazingly rich list of their failings. Friars have abandoned their original rule and covet wordly goods, political power and influence, architectural splendor, and predominance in the world of learning. They are, thus, false to their professed rule, hypocrites who do not practice what they preach and who gloss and bend sacred authority to their selfish ends. Instead of ministering to God's people as the clergy should, they wander about in whatever shape they please and assume roles that by right belong to other professional groups, including medical doctors and lawyers. And the end of their pursuit is often bluntly immoral personal gratification. The bad friar, Gower declares,

> relies upon deceit, he makes cunning speeches, he increases and heaps up and multiplies his trickeries. He promotes strife, he inflames quarrels into anger. He nourishes ill will and fosters envy. He breaks the bonds of peace, he disrupts the ties of nuptial love and sets faith at variance. He suggests incest, he urges violation of chastity, dissolution of marriage, and defilement of the bridal bed.[2]

The accusations here raised agree fully with what Gower has to say about mendicant friars in a second work, his Anglo-Norman *Mirror of Man*,[3] which again addresses the moral decay of contemporary society and, again, blames the friars for being hypo-

crites, flatterers, intriguers, adulterers, and false prophets. The rhetoric of the *Mirour* is a little different from the *Vox clamantis*, in that here Gower uses personification and speaks of Friar Hypocrisy, Friar Flattery, and so on; but the moral critique is precisely the same in the two works.

In his condemnation Gower lumps all friars together and makes absolutely no differentiation between Dominicans and others. In his *Mirour* he mentions St. Francis and, a few lines later, St. Dominic,[4] but only to say that the sons of both no longer follow their examples. Similarly, a single line (21,760) speaks of Jacobins, Carmelites, and Minorites, but this is no more than a rhetorical variant of the notion "all mendicant friars."

Gower's schematic and panoramic review of society yields in Chaucer's work to a much more vivid and brilliant creation of individual characters. Nonetheless, the moral criticism raised by Gower reappears in Chaucer's depiction of friars with a striking, almost mirror-like similarity. Chaucer creates two mendicant figures: one is his pilgrim Friar Huberd, who is described at some length in the General Prologue and then set into dramatic conflict with the Summoner at the end of the Wife of Bath's prologue and again after her tale;[5] the other friar figure is John, the embarrassed hero of the Summoner's Tale.[6]

The portrait of Friar Huberd is, from the first line on, heavily satiric. We hear that he was "wantowne" and "merye" (line 208), and though the force of the former adjective was probably less sexual and negative than it has become since, this friar's joviality and merriness set the tone of the entire picture Chaucer is drawing, the picture of a man who is affable and on superb social terms with people, especially franklins, wives, barmaids, and the "riche and selleres of vitaille" (248). His major professional occupation is begging, in which he outdoes the other brethren of his house; and he is so good at it, with his lisping, sweet speech, that he will have a farthing even from the poorest widow. He sings and fiddles, presumably in the tavern, and he is a great help on lovedays, when legal disputes were settled out of court. Of more strictly religious activities, Chaucer mentions only his hearing confession. Here is what emerges:

> Full swetely herde he confessioun,
> And plesaunt was his absolucioun:
> He was an esy man to yeve penaunce,
> Ther as he wiste to have a good pitaunce.
> For unto a povre ordre for to yive
> Is signe that a man is wel yshryve;
> For if he yaf, he dorste make avaunt,
> He wiste that a man was repentaunt;
> For many a man so hard is of his herte,
> He may nat wepe, althogh hym soore smerte.
> Therfore in stede of wepynge and preyeres
> Men moote yeve silver to the povre freres.
> (Lines 221–232)

Such a worthy "lymytour"[7] is shown in full action in the Summoner's Tale. Accompanied by a socius and a servant who carries their bag for what gifts a farming population can offer, Friar John preaches in church solliciting alms for his order that

will help the poor souls in purgatory as well as the friars in their building projects. As he then visits the house of farmer Thomas, he characterizes his own preaching as follows:

> I have to day been at youre chirche at messe,
> And seyd a sermon after my symple wit—
> Nat al after the text of hooly writ,
> For it is hard to yow, as I suppose,
> And therfor wol I teche yow al the glose.
> Glosynge is a glorious thyng, certeyn,
> For lettre sleeth, so as we clerkes seyn—
> There have I taught hem to be charitable,
> And spende hir good ther it is resonable.
> (1788–96)

What follows is a superb picture of Friar John making himself at home where he has often had a friendly reception before. He drives the cat off the bench to settle himself (1775); he greets Thomas's wife "full courteously and embraces her closely in his arms, and kisses her sweetly, and chirps like a sparrow with his lips" (1802–5). Thomas, on the other hand, becomes the focus of his zeal as a confessor. "I wole with Thomas speke a litel throwe," he says; "thise curatz been ful necligent and slowe / To grope tendrely a conscience" (1815–17). And so he takes over the pastor's duty with an amazing combination of slimy hypocrisy, self-advertising, insinuation, and plump begging for money, all clothed in a powerful display of fourteenth-century pulpit oratory.

These two depictions of begging friars have a wonderfully rich texture that no short summary can do justice to. But to what order or orders do Huberd and John belong? Chaucer's description and narrative are not explicit on this point, and modern scholars have expressed diverse opinions that range from identifying John as a Carmelite[8] to seeing both him and Huberd as modeled after historical Franciscans,[9] and further to denying their affiliation with any specific order altogether and instead reading them as "stage friars," graphic creations that sum up conventional commonplaces of antifraternal literature.[10] Though I am inclined to think that in depicting Huberd Chaucer had in mind an ideal image of St. Francis whose characteristic features are here severely undercut,[11] the question remains moot. In any case, neither Huberd nor John bears any traces that could be considered specifically Dominican.

The third poet to consider, William Langland, shares Chaucer's and Gower's topical concern with society, its order and members, as well as their highly critical and satirical view of the friars. This emerges at many points in his long allegorical-vision poem, for Langland has the habit, almost an obsession, to launch into cataloguing professional groups of society and their failings whenever he has a chance. Saints Francis and Dominic are mentioned as holy men who followed poverty and love perfectly, but the orders they founded have sadly decayed.[12] Nowadays, friars preach for profit, glossing the gospel for their benefit,[13] and they hear confession for money, which they spend on elegant clothes and sumptuous buildings.[14] Their absolution is easy when a gift is in the offing, and they can be especially recommended to people who have lechery on their consciences.[15] When they receive a donation for the privilege of being buried in

their cemetery, they take the money but later do not honor their promise.[16] They flatter with false speech[17] and have late masses for people who like to sleep in on Sundays.[18] They wish to be called masters and devise fancy questions to please the proud, but leave the common people without solid instruction.[19] Avarice is one of their major besetting sins,[20] envy is another,[21] and wrath is said to have been a gardener in the friars' convent, where he grafted shoots of lying and flattery that have borne the fruit of verbal contentiousness between friars and possessioners.[22]

To these general complaints against friars Langland adds individual friar figures in at least three places where they form a locus to create a significant dramatic stage in the Dreamer's search for Holy Truth and his allegorical vision of history. The first involves two Franciscans, which therefore need not engage our attention here.[23] The second is the banquet scene in passus 13 of the B-text. In his quest for Dowell, the Dreamer has already met such allegorical teaching figures as Thought, Wit, Dame Study, Clergie, Scripture, and even Reason himself, and has received a good deal of instruction, much of which he would rather contentiously dispute than willingly accept. In this progress he has been personally humiliated and learned the need for patience and poverty. Now he meets a doctor of divinity at a banquet. Four days earlier, this doctor had preached before the Dean of St. Paul's, and at this point he learnedly discusses the meaning of Dowell, Dobetter, and Dobest and preaches on the need for penance, all the while making merry at his meal:

> He eet manye sondre metes, mortrews and puddynges,
> Wombe cloutes and wilde brawen and egges yfryed with grece.[24]

No wonder the Dreamer gets angry at "this Goddes gloton . . . with hise grete chekes" who "hath no pite on us povere" (lines 77–78) and ends up accusing him of intellectual arrogance and utter hypocrisy, of not practicing what he preaches. Though this doctor of divinity is not at once introduced as a friar, he soon turns out to be one and is in fact called thus.[25]

The banquet scene therefore incorporates antifraternal satire into the Dreamer's personal quest for knowledge and holiness. In a similar way, the final passus of the poem incorporates the same complaint elements into the Dreamer's vision of society and its evils as it nears the end of time. Antichrist has arrived and is followed by friars whom he clothes in rich copes (20.58). The Dreamer, under attack by Old Age, takes refuge in the Barn of Unity, Langland's image for the Church, which is being ruled by Conscience. The mounting assault by Antichrist and his helpers causes the faithful within the barn to realize their need for penance:

> The while Coveitise and Unkyndenesse Conscience assaillede,
> In Unitee Holy Chirche Conscience held hym,
> And made Pees porter to pynne the yates
> Of alle taletelleris and titeleris in ydel.
> Ypocrisie at the yate harde gan fighte,
> And woundede wel wikkedly many a wise techere
> That with Conscience acordede and Cardynal Vertues.
> Conscience called a leche, that coude wel shryve,
> To go salve tho that sike were and thorugh synne ywounded.

Shrift shopp sharp salve, and made men do penaunce
For hire mysdedes that thei wroght hadde,
And that Piers [pardon] were ypayed, *redde quod debes.*
Some liked noght this leche, and lettres thei sente,
If any surgien were in the sege that softer koude plastre.[26]

Naturally, a more accommodating physician is found soon enough; it is Friar Flatterer. At first, Conscience is opposed to admitting him, saying: "We have no need; there is no better physician I know of than your parson or parish priest" (20.319–20). But the friar procures a letter from the bishop, overcomes the gatekeeper's objections with his affable speech, and thus gets into Unity, where he attends to the spiritually sick and—as was to be expected—"gave them a compress of private payment," promising he will pray for them "in Mass and in matins," making them "brothers of our fraternity for a little silver" (20.364–68). And so we reach the end of the poem in which nothing is resolved: the intellectual and moral muddle in which mankind and the Dreamer find themselves continues as always; and friars are not just evil in themselves but deeply harmful to the spiritual health of Christendom.

Thus, Langland presents friar figures who are beset by the same moral failings we have seen in Chaucer and Gower. Which order do they belong to? Again, Langland parallels the practice of his fellow poets by giving no clear indication about the order of mendicants he may have had in mind.[27] The situation is a touch more complicated in his case, though, because the master in the banquet scene may well have been intended to be a Dominican. Langland not only stresses his academic learning but at one point has the Dreamer call him a "jurdan":

I shal jangle to this jurdan with his juste wombe
To telle me what penaunce is, of which he preched rather!
(13.83–84)

The Middle English word *jurdan* means chamber-pot, whose physical shape and invective connotation fit the context perfectly. But critics have further seen in it an allusion to William Jordan, a well-known English Dominican who in the 1350s and 1360s was involved in several controversies.[28] This is a possibility, though I must add that some readers who are thoroughly familiar with Langland's poetic practices have remained sceptic; Schmidt, for instance, comments that planting such an allusion "does not seem in tune with Langland's methods and views as a satirist."[29] The identification, thus, must remain somewhat speculative.

In the picture that our three poets draw of friars, we therefore find two major traits: they lump all mendicants together, and they represent them as entirely immoral. In light of the large and bitter controversies between friars and the secular clergy that raged from the 1250s on, and of the resulting tradition of antifraternalism, there is nothing surprisingly new in this picture. But such hostility among *lay* writers of the late fourteenth century is a curious and, to some readers, disturbing phenomenon. Were contemporary friars indeed as hypocritical, greedy, slimy, and power-hungry as they are here depicted, or are Langland, Chaucer, and Gower merely following models they found in Jean de Meun's *Roman de la rose* and intervening works? Or are their friars so bad because, in the eyes of our three poets, all society is bad? Or were Chaucer

and Langland touched by the intellectual fermentation begun by Wyclif and popular-
ized by the Lollards, who considered the friars' lifestyle contrary to the Gospel? I
confess that I find none of these possible explanations fully convincing. As Kathryn
Kerby-Fulton has recently written: "Why intelligent, perceptive and *thinking* men like
Chaucer, Gower or Langland chose to perpetuate what was in large part a mythopoeic
structure, and not a very nice one at that, is a fascinating question, the answers to
which could range from personal animosities to the irresistibility of the satirical con-
ventions."[30] She also hints at a deeper socio-psychological cause which our age can
understand so well from experiences that perhaps form an eerie parallel to medieval
antifraternalism, when she speaks of a "sense of threat and paranoia which stems
partly from confronting a force outside of the traditional system."[31] However this may
be, such hostility was certainly deep-seated and enduring; and from its inception it was
directed against all mendicants without distinction. As in this tradition of antifrater-
nalism, so in our three poets, Dominicans are not especially singled out.

 Should we, then, look for a Dominican presence under a different form than liter-
ary depiction? Were our three Ricardian poets perhaps indebted to Dominican writers
as their sources or inspirations? Here a good case can be made especially for Chaucer,
among whose sources is a learned English Dominican of the early fourteenth century,
Nicholas Trevet.[32] Formed at Oxford and Paris in the first two decades of the century,
Trevet eventually became a lector at the London Blackfriars and was, in Beryl Smalley's
words, "a true polymath, being theologian, biblicist, hebraist, historian, and classi-
cist."[33] His works gained a considerable popularity, not only in England but at Avignon
and in Italy. Chaucer[34] used his writings significantly in two major enterprises. There
is good evidence to show that, when he translated *The Consolation of Philosophy*, he
had, together with a Latin text of Boethius and a French translation, Trevet's commen-
tary at his elbow. Some critics even argue that Trevet's reading of the *Consolation*
influenced Chaucer further in certain philosophical passages of his *Troilus and
Criseyde*.[35] In addition, for his Man of Law's Tale Chaucer borrowed the story of Con-
stance from Trevet's Anglo-Norman Chronicle. The same story, incidentally, was also
used by Gower, in his *Confessio amantis*, but it seems that both poets were familiar
with Trevet's account directly. It must be said, though, that Chaucer never mentions
Trevet by name, as he similarly does not acknowledge his debt to other Dominican
authors, such as William Peraldus and Raymond of Peñafort in his Parson's Tale,
Jacobus de Voragine in the legend of Cecilia retold in the Second Nun's Tale, and Vin-
cent of Beauvais in various places throughout the Canterbury Tales.[36]

 Nevertheless, Trevet and other Dominican writers were in fact well known by
name in the cultural context that surrounded Chaucer and his fellow poets. This can
be seen especially in that form of literature that, during the later Middle Ages, served
to disseminate knowledge and authorities to a wider audience, the sermon. A wide
spectrum of sermons written and preached between the 1370s and the 1430s, for in-
stance, frequently name the two Dominicans Robert Holcot and John Bromyard, and
the quotations are often identified with precision. Thus, Holcot's very popular com-
mentary on the Book of Wisdom is quoted in a collection of university sermons given
at Oxford near the end of the fourteenth century[37] as well as in a repertory of sermons
heard at Cambridge between 1417 and 1425.[38] He is cited, again by name, at least twice

in the cycle of Sunday sermons made in 1431 by John Felton, perpetual vicar of St. Mary Magdalen's in Oxford.[39] His name also appears several times in sermons that were written by and for Franciscans and were copied by Nicholas Philip, O.F.M.[40] Elsewhere, Holcot is quoted in sermons made by Benedictine monks or preached to Benedictine students at Oxford.[41] And in yet other environments, material from his commentary appears in sermons that were seemingly intended for a broader audience.[42] The material quoted from the commentary on Wisdom has a similarly broad range. Occasionally a preacher borrows a simple distinction or a simile (Q-17, 18, 52, 63). But just as often he cites or quotes Holcot as an authoritative voice in order to develop a moral or theological point on such matters as the transitoriness of physical beauty (Q-23), the fact that pride is often caused by ignorance (S-13), or the theology of Mary's sinlessness after the Incarnation (W-104).

Exactly the same points can be made about John Bromyard, who took not only theology but canon as well as civil law in his stride and compiled that enormously rich encyclopedia of *materia praedicabilis*, the *Summa called Praedicantium*, in the 1330s and 40s.[43] Two generations later he is frequently quoted by English preachers, often by name, and occasionally with a precise reference to the respective article in the *Summa*.[44] My examples come from Benedictine preachers, though closer examination would probably show his presence elsewhere, too. He is several times quoted by Robert Rypon, a noted preacher active at the turn of the century.[45] I have also found a peculiar story Bromyard tells, with its moralization, copied in a series of notes among a sermon collection from the Benedictine Worcester priory.[46] And the editor of the sermons by Bishop Brunton of Rochester, another Benedictine of the period, noted over thirty passages in his sermons, many of them used more than once, that she traced to the *Summa praedicantium*.[47] While some of these reflect material that is common in fourteenth-century preaching, others point quite specifically to Bromyard, even if in Brunton's work he is never cited by name. We have, thus, two eminent English Dominicans of the early fourteenth century whose writings were clearly known and drawn upon in the intellectual and cultural milieu of England in the 1380s and 90s. Yet, if the names of Dominican scholars were in contemporary preachers' mouths, they did not find their way into the poetry of our three Ricardian poets.

My examination of possible borrowing from the writings of Dominican authors and of the literary depiction of friar figures, thus, does not reveal much of a Dominican presence in the poetry of Gower, Chaucer, and Langland. Perhaps a different approach may bring a greater yield. Both Chaucer and Langland show a lively interest in certain theological and philosophical questions, such as freedom of the will or the salvation of the virtuous heathen. In incorporating these topics, indeed in discussing them, might they perhaps reflect the teachings of Dominican authors? Especially *Piers Plowman* has been subjected to close inspection in this regard, from what was the first book-length critical study of the poem, Father Dunning's interpretation of the A-Text of 1937,[48] who read the poem through the lenses of Thomas Aquinas, to the most recent article on Langland's figure of Ymaginatif.[49] Yet the endeavor to tie Langland to specific scholastic authors remains questionable, both in substance and in methodology. It seems clear that Langland nourished theological concerns but was no formal theologian; and that by the 1370s and 80s, a whole century had passed since Thomas

Aquinas's *Summa theologiae* had been written, whose brilliant and assured synthesis of Christian faith and Aristotelian science had given way to various forms of doubt and skepticism. Analyses of the theological or doctrinal tenor of *Piers Plowman*—and to some extent of Chaucer's poetry as well—tend to speak of skepticism or fideism and of a strong interest in the will and in decision making. But these concerns, in the late fourteenth century, were not characteristically Dominican ones.

There is, however, another possibility of discussing the presence of Dominicans in Middle English literature, namely the appearance of features that are essential to their thought and piety—what one might call 'Dominicanism'—in the religious lyric. In this field, the situation is very different from what I have discussed so far. For one thing, a number of friars are known by name who certainly collected and very probably also authored these poems. In addition, many modern critics who have written about the medieval lyric with a view to its backgrounds and major inspirations have emphasized its vital connection with mendicant spirituality. But alas, the friars involved are all Franciscans. Very early in the fourteenth century, William Herebert wrote 19 English poems, all translated from Latin or Anglo-Norman hymns and biblical or liturgical pieces.[50] Later in the century, John of Grimestone included some 240 English poems in his alphabetical commonplace book for preachers, among which are some of the pearls of the vernacular religious lyric.[51] And over a hundred years later, yet another Franciscan, James Ryman, put together a "book of hymns and songs" he had composed, with some 166 pieces, of which about three fourths are English carols.[52] I should emphasize that I am here speaking of genuine lyrics, not the versified renderings of biblical and patristic and other authoritative quotations that occur ubiquitously in Latin sermons and such preacher's handbooks as *Fasciculus morum*.[53] The personal contribution of Franciscan friars to Middle English lyric poetry is clear, and it is dominant. And beyond the evidence of personal names, it is Franciscan spirituality itself that has been seen to stand behind the later medieval lyric in many different languages. In fact, such an eloquent critic as John Fleming comes very close to crediting Franciscanism with causing the new developments within later medieval vernacular literature in many of its genres.[54] In this view, which is shared by Raby for the Latin Christian poetry of the Middle Ages, and by David Jeffrey for Middle English poetry, Dominicans are nowhere in sight.[55]

But there are some problems with this picture. First of all, while we have the names of Franciscan lyric poets for the fourteenth century, the same does not hold for the years when the Middle English lyrics made its first appearance. A number of the latter have been preserved in thirteenth-century miscellanies or anthologies of lyric and other poetry, or of poetry and prose, and the attempt to determine the early history of these—who made them, what purposes they were made for, and who their earliest owners were—has engaged scholarly acuity and speculation over several generations. Here is not the place to review the labors begun by Carleton Brown and Rossell Hope Robbins[56] and continued in a spate of more recent books and articles, except to say that the issue remains full of uncertainties. What must be noted is that the occasionally rather enthusiastic and sweeping claims raised by spokesmen for Franciscan authorship are severely undercut by more careful investigations that pay attention to manuscript contexts and source relations. Particularly the work by Karl Reichl, with its eye on philological detail, promotes a very sceptical view of "the Franciscan theory."[57]

But—does it really matter, in a field that is characteristically anonymous, whether we know the name of a poet and his religious connection, or the affiliation of a particular manuscript? Is it not much more important to focus on the spirit that informs and pervades and has generated these lyrics? This, in our case, would be the intense devotion which St. Francis himself experienced and then passed on to his followers, a loving devotion "to the person of the incarnate Christ and [his] self-identification with him, especially in his sufferings,"[58] realized in a vivid evocation of the wounded and bleeding Christ on the cross and of his mother in her abandonment and sorrow. There is simply nothing like this in St. Dominic and his followers; indeed, as Father Simon Tugwell has said so soberly, "the early Dominicans were not particularly concerned, either for themselves or for others, with what has come to be called the 'interior life'. Some of them, certainly, were great men of prayer, but their prayer was simple, devotional and largely petitionary."[59] Hence the salient presence one may detect in the early Middle English lyrics, in the sense of its informing spirituality, is not Dominican but Franciscan.

It is, of course, not my intention to dispute the spiritual differences that set Franciscans and Dominicans, as well as their founders, apart. What I am concerned with is the connection between their respective forms of devotion and specific anonymous Middle English lyrics. And here I must point out how tenuous this connection often is and how fraught with intellectual pitfalls some attempts to establish it have been.

For instance, in the introductory paragraphs on "Franciscan Christianity" in his *History of Christian-Latin Poetry from the Beginnings to the Close of the Middle Ages*, Raby wrote of St. Francis: "Religion had once more come to find its expression in a personal experience, in an emotion of the heart, in a direct relation between the human soul and Christ." This personal note "makes itself heard in the whole of the religious poetry inspired by the Franciscan movement, and it is the key to the whole emotional content of Franciscan literature."[60] After discussing Bonaventure and the *Meditationes vitae Christi*, Raby concludes this section as follows:

> This is the emotional atmosphere in which the poetry of Franciscan Christianity had its beginnings. The subjects are ever the same—the passion of Jesus and the sorrows of Mary. The Franciscan singers, from Bonaventure to Jacopone, sang always with their faces set to the scene of this double passion, where "Under the world-redeeming rood / The most afflicted mother stood, / Mingling her tears with her Son's blood." The whole of Franciscan poetry is invested with this pathos, and filled with this compassion. It is charged with tears for that suffering divine and human by which the world is redeemed.[61]

If, with these moving words in mind, we consider one of the earliest Middle-English lyrics that have come down to us:

> Nou goth sonne vnder wod,—
> Me reweth, Marie, þi faire rode.
> Nou goþ sonne vnder tre—
> Me reweþ, Marie, þi sone and þe,

we might indeed feel that this medieval forerunner of the minimalist lyric does precisely what Raby described: it evokes Mary under the Cross of her son and expresses

the speaker's compassion with her. Furthermore, it does so in an idiom that itself shares the humility and poverty espoused by St. Francis. The poem may thus well be deemed an archetypical lyrical formulation of Franciscan devotion. However, these lines occur in the *Speculum ecclesiae* by St. Edmund of Abingdon, where they are said to have been spoken "by some Englishman."[62] They were probably not used by St. Edmund himself but inserted into the Anglo-Norman translation of the treatise made around the middle of the thirteenth century. What matters is their appearance in a chapter that teaches and gives a model of how one should meditate on Christ's Passion: at midday, one should reflect on the Virgin under the cross. St. Edmund's text is here deeply indebted to such earlier laments of the Virgin as the *Dialogue of Blessed Mary and Anselm on the Passion of the Lord* and the *Quis dabit capiti meo*, works that derive from and reflect the spirituality of such pre-thirteenth-century writers as John of Fecamp, Anselm, Bernard of Clairvaux, and Aelred of Rievaulx.[63] This earlier form of spirituality, as has often been pointed out, was not invented but at best appropriated and popularized by the Franciscans' devotion to the suffering Christ. As one examines thirteenth-century English lyrics like "Nou goth sonne," one must therefore remain aware of the presence of pre-Franciscan traditions and, hence, proceed with some caution. I notice incidentally that in her authoritative study of *The English Religious Lyric in the Middle Ages* Rosemary Woolf abstained altogether from connecting her subject with the Franciscans, and no doubt did wisely so.

If personal devotion, compassion, and identification with the suffering Christ and his mother thus may have inspired lyric poems written by members of different orders—maybe even by Dominicans—perhaps one could find a more refined approach to help us distinguish between Franciscan and Dominican influences on the lyric? Such attempts have been made several times, and invariably run into the same difficulties I have indicated. Often a critic's asssociating a specific abstract idea, theme, or mood, or even of a concrete stylistic feature in a given lyric with one order or the other is flatly contradicted by whatever evidence we have of the historical affiliation of the same lyric with a particular known author or his milieu. For example, David Jeffrey focuses on Bonaventure's exemplarism, the notion that all creation is a mirror of the divine, and from this basis generalizes that a poem that is rich in concrete, realistic detail and appeals to all the senses therefore expresses Franciscan spirituality.[64] As an illustration he cites the well-known "Sumer is icumen in," with its singing cuckoo, flowering meadow, bleating lamb, and farting bullock. But this musically very sophisticated *Cuckoo Song* has been uniquely preserved in a Benedictine manuscript of about 1240.[65] Somewhat differently, Gregory Schrand has analyzed Middle English religious lyric poetry on the basis of the difference between a hypothetical Franciscan and Dominican aesthetic.[66] For him, Dominicanism is defined by "unity of substantial form and primacy of the intellect" (p. 10), which he claims produce in the lyric a closed, intellectual structure together with paradox and wordplay—elements that Walter Ong had previously characterized as "wit."[67] On the other hand, Franciscanism for Schrand is distinguished by philosophical pluralism, an appeal to the will, and the use of an emotive rhetoric that elicits fear and compassion. All this makes good sense; but when Schrand applies these contrasting aesthetics to specific poems, his analysis runs into problems. "Nou goth sonne," which Jeffrey had linked to Franciscan spirituality, here

emerges as a Dominican lyric, because of its pun on wood and tree.[68] Conversely, another piece Schrand associates with the Franciscan aesthetic turns out, as we will see in a moment, to have a greater claim to Dominican authorship than any other Middle English lyric. And yet another piece, which he classifies as "Dominican and antithetic to the Franciscan lyric because it is closed and cyclic," is not a lyric at all but a versified sermon division, whose putative stylistic features derive from structural prescripts that any medieval student of the art of preaching—Franciscan, Dominican, Benedictine, secular, or whatever—would have known.[69]

It would appear, then, that such notions as exemplarism, affective piety, and a Franciscan or Dominican aesthetic are not very reliable tools in scanning the corpus of anonymous Middle English poems of the thirteenth and early fourteenth centuries for a Dominican presence, and I believe scholarly inquiry has to return to questions of authorship or at least affiliation. In this way, patient search and careful examination of codicological and literary contexts can lead to more credible results, as I will demonstrate with one example. The following lyric has been preserved in a single manuscript:

> Louerd þu clepedest me
> an ich naȝt ne ansuarede þe
> bute wordes scloe and sclepie.
> þole þet [=yet] þole a litel.
> bute þiet [=yet] and þiet was endeles
> and þole a litel a long wexis.[70]

These lines translate a moving and dramatic passage in Augustine's *Confessions:*

> I had no answer to make when you said, "Awake, you who sleep, and arise from the dead, and Christ shall give you light." You used all means to prove the truth of your words, and now that I was convinced that they were true, the only answer I could give were the drowsy words of an idler—"Soon," "Presently," "Let me wait a little longer." But "soon" was not soon, and "a little longer" grew much longer.[71]

In the manuscript, they are preceded by Augustine's Latin text,[72] but it appears that they are more than the simple translations preachers made by the hundreds to have to hand for their sermons, because here the English reveals an intention to create a verse with metrical and rhythmic features that go beyond the normal four-stress line used for utilitarian verses in preaching. These features have received careful attention from a handful of students of medieval verse and music, ranging from George Kane to Robert Stevick and Thomas Duncan.[73] They have also received high praise. George Kane, for example, wrote of this poem:

> To have seen how those few lines in the great book [i.e., the *Confessions*] were a unity, to have cast them into poetic form, making the abstract expression of the original concrete, and to have done this briefly, intensely and beautifully were the work of a man who had either entered into the experience of the famous penitent in his imagination, or had himself experienced the same spiritual movement in his own right. However that may be, his poem was produced by a sincere poetic impulse and shows signs of an inspired creative imagination.[74]

That this inspired poet, who expressed a deeply felt personal emotion, was in all likelihood a Dominican emerges from the following evidence. The manuscript that contains the lines, New College Ms. 88 at Oxford, is a thick quarto-sized volume of over 490 folios. It once belonged to Thomas Cranley, Archbishop of Dublin (died 1417), who left it to the college where he had been a scholar, fellow, and eventually warden. Its handwriting places it a little before 1300. Besides Bonaventure's *Breviloquium*, it contains a plethora of sermons, sermon outlines, and other material of use to preachers, following no liturgical order. Its unprofessional writing and the sketchiness of many entries suggest that it is a preacher's notebook that gathers material its compiler or compilers found useful for his or their work. Several sermons come with the name of preachers, one or two indicate the locality where they were preached, and there are references to a "bound black book" and a "red book" from which the compiler had copied material.[75] A short rhetorical address to Oxford in one sermon[76] suggests the place and milieu where it was made. Among the sermons are a number for St. Dominic[77] and for St. Peter the Martyr;[78] others are for the transitus and the translation of St. Dominic.[79] At one point the compiler has listed about a dozen sermon themata for the same saint.[80] Several times he refers to him as "pater noster Dominicus,"[81] and at least once he says, with reference to the saint, "in ordine isto."[82] Among the named preachers one may, with all due hesitation, recognize the Dominicans Henton, Leominster, Graynesby, and perhaps Simon of Feuersham.[83] This is obviously a book with very strong Dominican connections, to say the least. It is also a somewhat scruffy affair that reveals several stages of its making. First, a compiler wrote out, in a late thirteenth-century, rather informal Gothic hand, sermons and notes in a random order. Then another hand wrote sermon notes in the spaces around the main text, in a slightly larger and more cursive script. Finally, rubrics were added to both text and marginal material in the upper margins. The result looks just like a notebook made on the fly and over some time. Since many entries, especially those in the lower margins, are highly telegraphic as well as poorly written, it is no wonder that the volume has repelled closer scholarly scrutiny.[84]

In addition to the unique version of "Louerd, thou clepedest me," the notebook also contains a loose English metrical rendering of *Respice in faciem Christi*,[85] which is one of the most influential meditative commonplaces that lie behind so many English lyrics on the Passion.[86] Its rendering in this manuscript also is unique. Both poems appear in the main text of the manuscript, and they have been written after their respective Latin source texts but without any connecting phrase similar to "as someone has said in English." Although there remains a slight possibility that whoever compiled this book had picked up the two lyrics from another preacher, who could have been a Franciscan, the greater likelihood is that both pieces were made by the compiler himself. And this must have been a Dominican.

My primary purpose here is not to enter the claim for a hitherto unrecognized Dominican lyricist into the annals of Middle English literature. Nor is it my aim to deny that the ideals that inspired thirteenth-century Dominicans were very much different from those that animated their Franciscan brethren, just as the characters and aspirations of the founders of the two orders were of course enormously different. What I have intended is to demonstrate that there *is* in fact a concrete Dominican presence

in the early religious lyric in English, and that this can be pinned down more convincingly than by such abstractions as Dominicanism or Franciscanism.

At the beginning of the fourteenth century, another poet, in another country, showed his clear awareness of the spiritual difference between Saints Francis and Dominic and expressed it brilliantly:

> L'un fu tutto serafico in ardore,
> L'altro per sapienza in terra fue
> Di cherubica luce uno splendore.

("The one was all like a seraph in his ardor, the other, through his wisdom on earth, was a splendor of cherubic light.")[87] Dante's illuminating and sharp distinction between the two founders, however, and between their spiritual families, cannot be easily extended to that of a Dominican versus a Franciscan aesthetic that might have informed or produced early religious lyrics in English. Nor do we find anything like it in the poetry and—if such an inference is permitted—in the perception of the three English poets whose works form the first golden age of English literature. As we noticed earlier, Chaucer, Gower, and Langland lump both orders together as "friars" and see both in a totally negative moral light. Whatever may account for our poets' hostility to friars, the distinction between Franciscan and Dominican (to which one might as well add Augustinian and Carmelite) is of no importance for them. One is tempted to speak here of a fraternal syncretism, in which the differences between the mendicant orders have collapsed. One may also add that such fraternal syncretism in the major poetry of the late fourteenth century—though not the antagonism that comes with it—apparently reflects real life, in so far as we can gauge the latter from *The Book of Margery Kempe*. In her highly emotional and fervent devotion, and her wandering through England and as far as Jerusalem, Margery encountered all sorts of clergymen, from the Archbishop of Canterbury down to humble secular parish priests, as well as monks and friars grey, black, and white. Some laughed at her, others feared her as a heretic, and one famous Franciscan preacher would not tolerate her rantings during his sermons. But others were deeply sensitive to her devotional gifts and willing to advise and help. Among these were Franciscans and Carmelites and Austin friars and secular clergy, and also a Dominican anchorite who served as her confessor for many years. Margery's life, and I think Middle English literature, thus present a very motley picture in terms of religious affiliations, and while the men in black and white do not dominate the scene (as in fact no single group does), they are nonetheless present in it, though in a way that does not draw attention to the characteristic ideals and traditions of their Order.

NOTES

1. G. C. Macaulay, ed., *The Complete Works of John Gower*. Vol. 4: *The Latin Works* (Oxford, 1902; reprt. Grosse Pointe, Michigan, 1968). The friars are dealt with at 4.16–24 (185–200). *Vox clamantis* has been translated by Eric W. Stockton, *The Major Latin Works of John Gower* (Seattle, 1962).

2. *Vox* 4.22 (trans. Stockton, 190).

3. *Mirour de l'homme,* ed. Macaulay in vol. 1 of *The Complete Works: The French Works* (Oxford, 1899). The major passage on the friars is lines 21,181–21,780 (238–46).

4. Gower, *Mirour,* lines 21,522 and 21,554 respectively (243).

5. *The Riverside Chaucer,* general editor Larry D. Benson (Boston, 1987). The respective passages are: General Prologue, lines 208–69 (26–27); Wife of Bath's Prologue, lines 829–56 (116); Friar's Prologue, lines 1265–1300 (122).

6. The Summoner's Tale, 129–36.

7. General Prologue, line 209, and Summoner's Tale, line 1710.

8. Arnold Williams, "Chaucer and the Friars," *Speculum* 28 (1953): 510.

9. John Matthews Manly, *Some New Light on Chaucer* (New York, 1926; reprt. Gloucester, Mass., 1959), 104 and 118.

10. John V. Fleming, "The Antifraternalism of the *Summoner's Tale,*" JEGP 65 (1966): 688–700, at 700.

11. Muriel Bowden has assembled the evidence for such a view, in *A Commentary on the General Prologue to the Canterbury Tales* (New York, 1949), 119–45, esp. 139–40.

12. References are to the B text as edited by A. V. C. Schmidt, *The Vision of Piers Plowman* (London, 1978); citations are to passus and lines. The founders are mentioned at 4.121; 15.231; 15.419; and 20.252; the orders' decay, at 15.230–32.

13. Prologue 58–67.

14. Prologue 61–63; 3.48–50; 5.264–67; 14.198–99; 15.78; 15.327–29; 20.58.

15. 3.35–63.

16. 11.54–83; 13.7–10.

17. 2.230; 20.316.

18. 5.411–12.

19. Prologue 62; 10.71–77; 15.70–76.

20. Prologue 61; 5.264–68.

21. 5.80.

22. 5.135–50.

23. In B text 8.8–62 the Dreamer meets two "maistres of the menours" who teach him about Dowel, Dobet, and Dobest.

24. B text 13.61–62: "He munched many sorts of foods, mutton stews and puddings, / Eggs fried in fat, and tripe, and flesh of wild boar"; William Langland, *Will's Vision of Piers Plowman: An Alliterative Verse Translation* by E. Talbot Donaldson, ed. Elizabeth D. Kirk and Judith H. Anderson (New York-London, 1990), 133.

25. 13.69a–73 and 198.

26. 20.297–311; in Donaldson's translation, 238–39:

> While Covetousness and Unkindness came to attack Conscience,
> In Unity, Holy Church, Conscience held himself
> And appointed Peace porter to bar the gates
> To all tale-tellers and tattlers of gossip.
> With their help Hypocrisy made a hard assault:
> Hypocrisy at the gate began a grim fight
> And wounded most maliciously many a wise teacher
> Who'd been in accord with Conscience and cardinal virtues.
> Conscience called a doctor who could give good shrift:
> "Go give salve to those that are sick whom sin has wounded."
> Shrift composed a sharp salve and made men do penance
> For the dubious deed that they had done before,
> And that Piers's pardon might be paid, *redde quod debes.*
> Some did not like this surgeon, and they sent letters
> To see if there were a doctor in the siege that applied
> softer compresses.

27. The exception is the passage noted above in n. 23.

28. The identification was proposed by M. E. Marcett, *Uhtred de Boldon, Friar William Jordan, and Piers Plowman* (New York, 1938), 57–63.

29. Schmidt, ed., *The Vision,* 339.

30. Kathryn Kerby-Fulton, *Reformist Apocalypticism and Piers Plowman* (Cambridge, 1990), 139–40.

31. Ibid., 136.

32. For a good account of his life and work, see Beryl Smalley, *English Friars and Antiquity in the Early Fourteenth Century* (Oxford, 1960).

33. Smalley, *English Friars*, 58.

34. Brief accounts of Chaucer's indebtedness and further references can be found in the Explanatory Notes to the respective works, in *The Riverside Chaucer*.

35. Mark J. Gleason, "Nicholas Trevet, Boethius, Boccaccio: Contexts of Cosmic Love in *Troilus*, Book III," M&H N.S. 15 (1987): 161–88. See also various articles in *The Medieval Boethius. Studies in the Vernacular Translations of "De Consolatione Philosophiae"*, ed. A. J. Minnis (Woodbridge, Suffolk, 1987), and Minnis's review of Chaucer's indebtedness to Trevet in "Chaucer's Commentator: Nicholas Trevet and the 'Boece'," in *Chaucer's "Boece" and the Medieval Tradition of Boethius*, ed. A. J. Minnis (Cambridge, 1993), 83–166.

36. To these may be added material on dreams from Holcot's commentary on the Book of Wisdom, utilized in the Nun's Priest's Tale; see Robert A. Pratt, "Some Latin Sources of the Nonnes Preest on Dream," *Speculum* 52 (1977): 538–70.

37. Oxford, Balliol College, Ms. 149, fols. 53v and 61. These are sermons S-13 and S-15 as indexed in S. Wenzel, *Macaronic Sermons: Bilingualism and Preaching in Late-Medieval England* (Ann Arbor, Michigan, 1994). Further sermon references by sigla in the following footnotes are to this book.

38. Cambridge, Gonville and Caius College, Ms. 356/583, pp. 2–3, 31, 91, 97. These are sermons 2 (two references), 37, 51, 105, and 111 (two references), as indexed in S. Wenzel, "A Sermon Repertory from Cambridge University," forthcoming in *History of Universities* 14.

39. Philadelphia, University of Pennsylvania, Ms. lat. 35, fols. 19 and 31v. These are sermons 6 and 11.

40. Oxford, Bodleian Library, Ms. lat.th.d.1, fols. 51v, 54v, 74v, 144v, and 162. These are sermons Q-17, Q-18, Q-23, Q-52, and Q-63 in Wenzel, *Macaronic Sermons*.

41. Oxford, Bodleian Library, Ms. Bodley 649, fol. 102v (O-18); Ms. Laud misc. 706, fol. 142v (R-29); Worcester, Cathedral Library, Ms. F.10, fols. 198 (W-104) and 290ra (W-154, edited in Wenzel, *Macaronic Sermons*, 318); perhaps also Cambridge, Jesus College, Ms. 13, art. vi, fols. 101, 121v, and 141v.

42. London, British Library, Ms. Harley 331, fol. 8v (H-02); Arras, Bibliothèque Municipale, Ms. 184 (254), fol. 47vb (Z-16).

43. On the date, see Leonard E. Boyle, "The Date of the *Summa Praedicantium*," *Speculum* 48 (1973): 533–37, reprinted in *Pastoral Care, Clerical Education and Canon Law, 1200–1400* (Variorum CS, London, 1981), item X.

44. An earlier example occurs in a sermon preached by John Sheppey, Benedictine bishop of Rochester, on Ash Wednesday 1353/54, with several references, in text and margins, to Bromyard's *Distinctiones* and perhaps his *Summa*: Oxford, New College, Ms. 92, fols. 156v and 158v.

45. London, British Library, Ms. Harley 4894, fols. 83v–84 and 151r–v.

46. Worcester, Cathedral Library, Ms. F.10, fol. 153vb.

47. Sister Mary Aquinas Devlin, O.P., *The Sermons of Thomas Brinton, Bishop of Rochester (1373–1389)*, 2 vols. (Camden Third Series 85–86, London, 1954), passim; see the Index of References, s.v. "Bromyard."

48. T. P. Dunning, *Piers Plowman: An Interpretation of the A-Text* (Dublin, 1937); second edition rev. and ed. T. P. Dolan (Oxford, 1980).

49. Patrick J. Gallacher, "Imaginatif and the *Sensus communis*," YLS 6 (1992): 51–61.

50. Stephen R. Reimer, *The Works of William Herebert, OFM* (Toronto, 1987).

51. Edward Wilson, *A Descriptive Index of the English Lyrics in John of Grimestone's Preaching Book* (Medium Aevum Monographs N.S. 2, Oxford, 1973), and S. Wenzel, *Preacher, Poets, and the Early English Lyric* (Princeton, 1986), 101–73.

52. Julius Zupitza, "Die Gedichte des Franziskaners Jakob Ryman," *Archiv* 89 (1892): 167–338; 93 (1894): 281–338, 369–98.

53. Siegfried Wenzel, *Verses in Sermons: "Fasciculus Morum" and Its Middle English Poems* (The Mediaeval Academy of America Publications 87, Cambridge, Mass., 1978).

54. John V. Fleming, *An Introduction to the Franciscan Literature of the Middle Ages* (Chicago, 1977), esp. chapter 4.

55. F. J. E. Raby, *A History of Christian-Latin Poetry from the Beginnings to the Close of the Middle Ages* (Oxford, 1953), chapter 13; David Jeffrey, *The Early English Lyric and Franciscan Spirituality* (Lincoln, Nebraska, 1975).

56. Most succinctly enshrined in Rossell Hope Robbins, ed., *Secular Lyrics of the XIVth and XVth Centuries* (2nd. ed., Oxford, 1955), xvii–lv.

57. Karl Reichl, *Religiöse Dichtung im englischen Hochmittelalter: Untersuchung und Edition der Handschrift B.14.39 des Trinity College in Cambridge* (Munich, 1973), and " 'No more ne willi wiked be': Religious Poetry in a Franciscan Manuscript (Digby 2)," in *Literature and Religion In the Later Middle Ages: Philological Studies in Honor of Siegfried Wenzel*, ed. Richard G. Newhauser and John A. Alford (Medieval & Renaissance Texts & Studies, Binghamton, New York, 1995), 297–317.

58. John Moorman, *A History of the Franciscan Order from Its Origins to the Year 1517* (Oxford, 1968), 257.

59. Simon Tugwell, O.P., *Early Dominicans: Selected Writings* (Classics of Western Spirituality, New York, 1982), 3.

60. Raby, *History,* 417–18.

61. Ibid., 421.

62. The relation between the different versions is discussed by A.D. Wilshere, ed., *Mirour de seinte Eglyse (St Edmund of Abingdon's Speculum Ecclesiae),* ANTS 40 (1982). The English quatrain appears in chapter 24 (66–68) and is discussed on 103 and xvi.

63. Rosemary Woolf, *The English Religious Lyric in the Middle Ages* (Oxford,1968), has discussed the influence of such meditative texts on the Middle English religious lyric in detail. For the two treatises mentioned, see 247f.

64. Jeffrey, *The Early English Lyric,* 97.

65. London, British Library, Ms. Harley 978, fol. 11v. Text and music are analyzed in E. J. Dobson and F. L. Harrison, *Medieval English Songs* (London-Boston, 1979), 68–70, 143–45.

66. Gregory J. Schrand, "The Franciscan and Dominican Aesthetics in Middle English Religious Lyric Poetry" (Ph.D. dissertation, Rice University, 1982).

67. Walter J. Ong, S. J., "Wit and Mystery: A Revaluation in Mediaeval Latin Hymnody," *Speculum* 22 (1947): 310–42, at 321 and 312.

68. Jeffrey, *The Early English Lyric,* 61; Schrand, "Aesthetics," 136.

69. This is "I sayh hym wi ffless al bi-sprad," discussed in Schrand, 148–50. That these lines are not a lyric poem but a sermon division was shown by S. Wenzel, "Poets, Preachers, and the Plight of Literary Critics," *Speculum* 60 (1985): 343–63.

70. Oxford, New College, Ms. 88, fol. 181v (modern pencil foliation). The poem has been printed in Carleton Brown, ed., *Religious Lyrics of the XIVth Century,* 2nd rev. ed. by G. V. Smithers (Oxford, 1952), 3.

71. Augustine, *Confessions* 8.5; the translation is taken from R. S. Pine-Coffin, *Augustine, Confessions* (Harmondsworth, England, 1961), 165. Augustine is quoting Eph. 5:14.

72. Oxford, New College, Ms. 88, fol. 181v: "Augustinus in libro Confessionum: 'Non erat quid responderem tibi ueritate conuictus dicenti mihi: Surge qui dormis et exurge a mortuis et illuminabit tibi Christus, Ephesiorum 5, nisi uerba lenta et sompnolenta: Modo, ecce modo, sine paululum. Sed modo et modo non habebant modum, et sine paululum in longum ibat.' Similiter est de differentibus penitere."

73. Notably George Kane, *Middle English Literature: A Critical Study of the Romances, the Religious Lyrics, "Piers Plowman"* (London, 1951); Robert D. Stevick, "The Criticism of Middle English Lyrics," MP 64 (1966): 103–17, at 104–11; Thomas G. Duncan, "Two Middle English Penitential Lyrics: Sound and Scansion," in *Late-Medieval Religious Texts and Their Transmission: Essays in Honour of A. I. Doyle,* ed. A. J. Minnis (Cambridge, 1994), 55–65, at 64. Stevick especially offered an important formal and structural analysis of the lines.

74. Kane, *Middle English,* 114.

75. New College, Ms. 88, fols. 225v and 246v.

76. New College, Ms. 88, fol. 167: "Emissiones tue, o uniuersitas Oxon', idest scolares quos emittas a te in patriam suam."

77. Ibid., fols. 32, 151, 325, 326v, 460v (ad populum).

78. Ibid., fols. 35, 429v (note only).

79. Transitus: fol. 202v; translatio: fol. 326.

80. New College, Ms. 88, fol. 325v.

81. Ibid., fols. 32v, 326v (twice).

82. Ibid., fol. 202v.

83. Ibid., at fols. 111, 158, 108, and 110 respectively.

84. On fol. 491v, half-way down the page, after the end of the text and before a table, occurs

an erasue of 4–5 lines ending with "Qui hunc titulum deleuerit anathema sit. Fiat, fiat. Amen." Dr. Malcolm B. Parkes, who has kindly examined the page for me under ultraviolet light, could recover the words "conceditur fratri Roberto [.] ad terminum uite sue" before the quoted line but reports that the surname is not legible. I discuss the entire manuscript further and offer a reconstructed reading of the ownership note in a forthcoming article in AFP.

85. New College, Ms. 88, fol. 181; printed in Brown, *Religious Lyrics*, 3.

86. See Woolf, *Religious Lyric*, 30–32.

87. Dante, *Paradiso* 11.37–39, in *La Divina Commedia di Dante Alighieri*, ed. C. H. Grandgent (rev. ed., Boston, 1933), 754.

The Cosmic Christ:
The Christology of Richard Fishacre, O.P.

R. James Long

IN HIS INAUGURAL sermon to the first commentary on Peter Lombard's *Sentences* written at Oxford (ca. 1241), Master Richard Fishacre, Order of Preachers, discusses the subject matter or material cause of the science of theology, which he is about to explicate. There are three simple natures, he says, and three composite. The highest nature is the divinity, the lowest is body, and the medial nature created spirit; out of these are derived the three composite natures: the human creature (composed of the lowest and the medial natures), the Church (composed of the medial and supreme— that is, the members and head of the mystical body), and finally Christ, who is composed of all three natures—body, spirit, and divinity.[1]

Just as the science of geometry in one sense is said to be about a point, so in a similar way the sacred science is said to be about God, Fishacre says, that is, it treats the minimally composed and indivisible being from whom there flows whatever constitutes the subject matter of this science. In a truer sense, however, geometry is about body, which contains in itself all of the elements of the science, namely, point, line, surface, and three-dimensionality. In a similar manner, the sacred science is about Christ, the maximally composed being, who possesses in himself, as it were, all of the parts that constitute whatsoever touches on the subject matter of this science.[2]

Discovering his own principle for the division of the Lombard's text into four books, Fishacre says that of the three books that deal with *things,* as opposed to signs, the first treats of the Creator, the second the creature, and the third Christ, "who is composed of Creator and creature."[3] In the very first distinction of the third book, moreover, Fishacre, departing from the text of the Lombard, raises the following questions: first, whether it was possible for God to take on flesh? and second, whether it was fitting or necessary that the Creator be united with a creature?[4]

It is in answer to the latter question that the Dominican friar sounds the central theme of his Christology and one might even say the leitmotif of his entire theology: quite apart from the redemptive value of the Christ-event, which was necessary because of the sin of Adam, there is a fittingness and a symmetry in the Incarnation simply as the completion and perfection of God's creation. Since the highest nature is God and the lowest earth, then it seems that the circle of creatures (*circulus creaturarum*) would be complete and perfect only when the highest is united to the lowest. Now the universe is not perfect before the extremes are closed (as in a circle), thus precluding the possibility of further addition. Therefore it was appropriate, Fishacre says, that earth be joined to God and conversely. This happened when the Word was made flesh.[5]

Likewise, the first uncreated being is God, the last created is the human being. The

circle of creation, then, is brought to completion when God is made man. Thus there is truth in one reading of the verse from Isaiah (44:6), "I [speaking in the person of Christ] am the first and I am the last": the first, namely God; the last, namely man.[6] Without the Incarnation not only the universe as a whole but each single part of it would have remained incomplete. Since the human person is a microcosm of all of creation,[7] this completion and perfection was brought about when God united himself to a man.[8]

Of the remaining nine arguments for a predestinated Incarnation, some are arguments from symmetry, others invoke the Platonic principle of the self-diffusiveness of the good. As an example of the latter, one may consider the following: it is characteristic of great goodness to communicate itself to all through its presence in all; it is a greater goodness that communicates itself to the just through grace; it is, however, a mark and vestige of the greatest goodness that it communicates itself to the human creature and consequently to every kind of thing in the unity of a single person. The first sharing, which is through God's presence, is universal but ordinary (*modica*), the second—his communication through grace—is greater but restricted, the last—the hypostatic union—absolutely singular but the greatest.[9]

"Pay heed," concludes Fishacre, "that all these reasons prove not only that it was fitting that God take on humanity, but also that, whether the human creature would have sinned or not, it would have been suitable that God do this."[10] In fact, sin could only have changed the human creature for the worse, and thus it would have been less receptive of such goodness than before sin. Fishacre's argument is that if in fact the Word assumed a nature that was fallen, *a fortiori* the Word would have embraced a nature that was not debased by sin. Lest he be accused of holding God to the confines of human logic, however, Fishacre quickly adds:

> Whether God would have thought this or not, I do not know. God knows, because as the Psalmist says: 'O Lord, how great are your works! Your thoughts are exceeding deep.'[11]

But what of the redemption of humankind as a cause of the Incarnation? Fishacre asks. If the completion of the universe (*completio universi*) and the reparation of fallen human nature (*reparatio lapsi*) both be causes of the Incarnation, why is it that both Scripture and the holy commentators touch only on the redemption as cause? The Gloss on First Timothy (1:15: "Christ Jesus came into the world to save sinners. . . . "), in fact, asserts that "there was no cause for Christ the Lord to come except to save sinners." Remove wounds and disease, and medicine is no longer a cause of healing.[12]

In reply, Fishacre suggests that *perhaps* both completion and redemption were causes of the Incarnation. As to the reason behind the silence of Scripture and the commentators with respect to the theory of completion, Fishacre speculates that it is a commonplace of our fallen nature that we are more grateful for that which is given to a few than for that which is granted to all. Appropriating an example from ecclesiastical politics (which he does not infrequently) he says that some cleric might express more gratitude to a bishop for a living (*praebenda*) that is not given to all than to God for the ministry of the sun, moon, and stars, for his soul, the members of his body, for the grace of baptism, the Eucharist, and the rest of the sacraments, though these latter

be incomparably greater than any benefice. It is owing to the wretchedness of the human condition that we value goods in inverse proportion to their being shared. According to the principle that the good is self-diffusive, however, the opposite is true: the highest goods are those that are most widely shared.[13]

Knowing our miserable state, therefore, the writers of sacred Scripture and the commentators focused on the redemptive cause of the Incarnation in order more to inflame our love for God. Had they discussed both causes, a person might respond: God became incarnate but it was not for my sake alone. Yet God's Incarnation *for either reason* took place *as if* it had been for us alone, that is, for us human beings as opposed to all of creation, because "just as the redemption, so also the completion of the universe is a good specifically for us, since this completion was brought about most especially in our nature."[14]

In fact, the Scriptures do include this second cause of the Incarnation, though, Fishacre admits, rather vaguely (*obscurius*). Fishacre interprets Paul's words to the Galatians (4:4), "When the fullness of time had come," as referring to the completion of the universe, and the following verse (4:5), "that he might redeem them who were under the law," as referring to the first cause, namely the redemption. But the key text for Fishacre is Paul's letter to the Ephesians (1:9–11):

> That he might make known unto us the mystery of his will, according to his good pleasure, which he has purposed in him, in the dispensation of the fullness of times, to reestablish all things in Christ, that are in heaven and on earth, in him, in whom we also are called by lot.[15]

To those who are still unconvinced by his "subtle pedagogy"[16] that humankind received a singular benefit in the Incarnation of the Word, Fishacre argues that even

> if the Incarnation was not brought to pass for you [singular] alone, the Passion of the Incarnate One was accomplished for you alone, for the perfection of the universe did not require his Passion as it required his Incarnation.[17]

Certainly it is immeasurably greater to die ignominiously after the afflictions of thirty-three years of human existence than simply to take on human flesh. In the Incarnation God was indeed humbled but to the level of the worthiest of creatures; in the Passion, however, he was reduced to the basest of creatures, for suffering is not nature but its defect. Even if the Incarnation, considered in isolation, benefited not only the human race but also the entire universe, the God-made-flesh still suffered and died for each human person—alone in all the universe of beings.[18]

Which of these causes of the Incarnation, then, should be given precedence? Not untypically, Fishacre refuses to decide between them. It could be the case that God, foreknowing before creation that the first human creature would fall, and foreknowing also how he would repair it, endowed human nature—and by extension the universe—with the capacity to be perfected by the Word, which he would not have done if Adam had not sinned. Were this the case, however, the future sin of Adam would not have been the *cause* of the Incarnation but only its *occasion*. The cause remains the goodness of God, which makes use of evil to work the greatest good. In the hypothetical case that Adam would have stood firm in his test, and if God would have endowed man with the capacity for perfection by union with the Son, his intention to become incar-

nate would have been the completion of the universe and of every creature in the universe. If the first case be true, then the principle cause of the Incarnation is mankind's redemption and the secondary cause the completion of the universe; if the second be true, then the priority of causes is reversed.[19]

For the source of this extraordinary Christological theory one need not look far. The dominant force at the early Oxford studium, Robert Grosseteste, had speculated on the predestination of Christ when he was lector to the Franciscans.[20] In a work intended primarily to show that the Old Law was superseded by the New Law, titled *De cessatione legalium*, Grosseteste articulates (by one count) some nineteen arguments[21] to establish his view that the Incarnation of the Word was a part of the divine plan, whether or not Adam would have sinned.[22]

Grosseteste's arguments, which are somewhat haphazardly ordered, can be grouped under five different "persuasions."[23] First, invoking the principle originally articulated in Plato's *Timaeus*, Grosseteste argues that God would not withhold from the universe any good that it was capable of receiving; thus the true cause of the Incarnation is ultimately the goodness of God.[24] Secondly, since sin is a defect and privation of nature, the Incarnation is more fittingly grounded in a human nature without the liability of sin. Thirdly, a God-made-man is necessary not only for the redemption of humankind from the original sin but also for its justification, since it is only through becoming brothers and sisters of Christ that we are made sons and daughters of the Father; moreover, complete happiness is only possible if all our powers are absorbed in contemplation—our minds bent on the divinity of Christ, our bodily senses on his humanity. Fourthly, the Church and its sacraments, especially marriage and the Eucharist, are consequent on the Incarnation; it would be unseemly to suppose that the union between Christ and the members of his mystical body were not a part of God's original plan or that sin should be the cause of the sacraments. Lastly, the unity of all creation, the closing of the circle of the universe, can only be brought about through the union of the Godhead and human nature.[25]

Of these five considerations, Fishacre reproduces only three, the first, second, and last.[26] However, as closely as he agrees with Grosseteste in substance, there is no evidence of a literary dependence. As is true concerning the question of free choice,[27] it is clear that Fishacre is not merely reworking Grosseteste's arguments, but constructing his own.

Ironically, it is Richard Rufus, Franciscan master of theology, who reproduces Grosseteste's arguments almost *verbotenus* but with the purpose of disagreeing with him. Rufus's disagreement, moreover, is not with specific arguments, with which he in fact never deals ("ecce, de omnibus his non curo," he says with characteristic disparagement[28]), but rather with the fundamental issue of the transcendence and mystery of God. Where Grosseteste and Fishacre see the unity and symmetry of the universe and the Incarnation as "the final act of the cosmic drama,"[29] Rufus is offended by their view and attempts to safeguard the divine freedom. Where Grosseteste and Fishacre see the fittingness of the Incarnation and even in a sense its necessity, Rufus sees only its absolute contingency. The Incarnation is incomprehensible, argues Rufus; no reasons could possibly be found for it. He is here sounding the first notes of the theme later to be orchestrated by John Duns Scotus and his followers.[30]

Fishacre's own student, Robert Kilwardby, also remained unconvinced by the the-

ory of completion. In the second question of his *Questions on the Third Book of the Sentences*, he asks about the cause of the Incarnation. He suggests three possible causes: the completion of the universe, the manifestation of divine glory, and the reparation of the human race. The first of these arguments he presents as follows: Creator and creature are distinct and separate, and there would be no completion of the universe unless the two were united in a third nature, composed of both.[31] Kilwardby responds to this argument by insisting that the Creator is not a part of the universe, of the universe that is intended by the text of Genesis (1:31) which reads, "And God saw *all the things* that he had made." Just as the army is beneath its leader and the body beneath its head, so too the universe is beneath the Creator.[32]

Alhough he concedes that the theory of completion is "reasonable and, as it were, philosophical," Kilwardby is moved more by the argument from authority: the saints nearly always (*fere ubique*) speak of the Incarnation "as though there were no other cause than the reparation of mankind." This cause is more enkindling (*provocativus*) of love and more consonant with faith, Kilwardby says, although he concedes that the other cause, as proposed by his teacher, is not contrary to faith.[33]

Given Fishacre's exhaustive development of the theme of what I will call the 'cosmic Christ',[34] that is, Christ as the completion and perfection of creation, in book three of his commentary on the *Sentences*, one would have expected that the same theme would be an integral part of his account of the six days of creation in book two. That is not the case, however.[35] Whenever, in fact, Fishacre is presented with an opportunity to discuss the Incarnation, it is always in terms of Anselm's 'satisfaction theory'. For example, Fishacre asks:

> Why should God be censured, if in the first man he left some imperfection, since from that imperfection he knew how great a good he would confer on that same human nature? For from that imperfection it happened that man sinned and consequently that the Son of God was made incarnate, which perhaps (*forte*) would not have happened, if man had from the first been made altogether immortal.[36]

This is nothing short of the *felix culpa* notion of the Easter vigil liturgy.

In another distinction, commenting on the kinship among all human souls, he ventures the following:

> Because <human> souls have a favorable disposition (*affectio*) toward a body, there is a special kinship <among them> by reason of their bodiness, and because all of us were in the loins of Adam, and all of our sins were originally contracted from that source, from that person is satisfaction made for that root sin (*radicali peccato*) through the suffering of the body of Christ, itself from the body of Adam, from whom in identical manner is satisfaction made for all the sins proceeding from that same root.[37]

Why is Fishacre here in his account of creation virtually mute about the idea of the cosmic Christ, which brackets the sin of Adam? Even if we suppose that Fishacre when composing book two had not yet turned his attention formally to the matter of the Incarnation and thus had not yet studied Grosseteste's *De cessatione legalium*, composed shortly after 1230,[38] the dominant influence on his hexaemeral questions was

Grosseteste's *Hexaemeron*,[39] composed between the years 1232 and 1235 and hence after the *De cessatione*. Although the *Hexaemeron* does not exploit the idea of the cosmic Christ as fully as his earlier work, it is certainly clear that for Grosseteste the Incarnation is the *raison d'être* of creation.[40]

In one passage, which is paraphrased by Fishacre,[41] Grosseteste speaks of the Word abbreviating and abbreviated (*abbrevians et abbreviatum*): abbreviating, because in that one Word God says (and thus creates) all things; abbreviated, because this is the same Word that took flesh and dwelt among us (Jn 1:14). "For in Him were all things created in heaven and on earth, visible and invisible," as Paul says (Col 1:16) and Grosseteste here repeats.[42]

Further on, and even more explicitly, when commenting on the text from Genesis, "Complevitque Deus die septimo opus suum" (or *sexto die* in the Septuagint version), Grosseteste says that allegorically this text can be understood as meaning that "in the sixth age Christ assumed flesh and thus completed and consummated all things. For he reduced all natures as if into the unity of a circle."[43] For God according to his divinity did not have a common and univocal nature with any creature, but when God was made man, the God-man did share a nature with the rational creature in a univocal sense, and the circle was made complete, terminating where it began, in God. "Therefore," he concludes, "in Christ all things were made perfect and consummated by a certain natural perfection and consummation."[44]

Finally, Grosseteste, continuing his allegorizing, says that God consummated all his works on the sixth day (in the Septuagint version), because it was on the sixth day of the week (Friday) that Christ brought all things to completion on the cross. As he gave up his spirit, Christ said "Consummatum est," and by his death he reconciled the human race to God the Father, thus restoring all things to their ancient dignity.[45]

What then accounts for the virtual silence of Fishacre concerning the 'completion theory' in his account of the creation? The simplest explanation is that such a vision was not suggested by the work on which he was commenting. Whatever the merits of Peter Lombard's books of *Sentences*, Christocentrism was not among them.[46] The questions of the possibility and the fittingness of the Incarnation, for example, questions that open out into Fishacre's most interesting theologizing, are departures from the Lombard's text.

On the other hand, the Lombard does include in book two, distinction fifteen, chapter seven,[47] the same text (Genesis 2:2) that evoked the above-mentioned response from Grosseteste, but that elicited no such reaction from Fishacre. His silence here remains inexplicable.

What we do find in Fishacre's account of the six days of creation, however, is a kind of Christ-consciousness, which goes far beyond what is prompted by the Lombard text. God foresaw from eternity that Christ would come.[48] Of all the bodies in the universe there is none better than the human body, and of human bodies the best is the body of Christ.[49] Furthermore, if the human person is the total aggregate of the vestiges of the divine goodness, this is especially the case with the supreme representative among human beings, Christ.[50] Indeed, as Paul tries to show, Christ's mortality notwithstanding, he is superior in dignity to the highest angels, even the Seraph.[51]

The natural place of Christ's body is heaven. If it were not—and this is unthink-

able—he would be in the wretched state of being separated eternally from his natural place. Christ's place is also the warrant and pledge of the natural place of our bodies—which is not here on earth, but in heaven.[52] Playing on the Augustinian distinction between image (*imago*) and likeness (*similitudo*), Fishacre anticipates Dante's final vision in the *Paradiso*.[53] He argues that just as the human soul is the image of God in this life but the likeness of God only when it sees God face to face, so too the human body—out of all the bodies in the visible universe, including the heavenly bodies—is the image of God in this life but becomes God's likeness only when it gazes on the body of Christ in the next world.[54]

Did Christ enjoy the beatific vision while in this life? If the answer is positive—and Fishacre asserts that the soul of Christ saw the whole Trinity with more clarity than any of the Seraphim—the objection is that he could not therefore have suffered a most dreadful death. Fishacre replies that the inferior part of the reason in Christ was sensitive to suffering, even while the superior part of the reason enjoyed the vision of God.[55]

Lastly, in one of the moral lessons (*moralitates*)[56] with which his commentary is replete, Fishacre says that the body of Christ in the Eucharist is the bond of love shared by all of his followers. Those who live together are accustomed to love one another as do those who share a common table. We faithful, says Fishacre, are children of the same Father, cohabit the same home, which is the Church, and are refreshed by the same food, the body of Christ. Where there exists such an intimate union, our love ought to be proportionate.[57]

What can we conclude about the Christology of Richard Fishacre? However unoriginal and derivative his notion of a predestined Incarnation and however undeveloped his notion of the centrality of Christ in creation, the man must be measured by his own time, not by the sensibilities of Bonaventure's and Thomas Aquinas's generation. By that measure, the most modest conclusion one can reach is that Christ is at least as central to Richard Fishacre's theology and at least as present to his consciousness as was the case with the mendicant and secular masters who were his contemporaries at Oxford and Paris.

That Fishacre should have followed the bold Christological lead of Grosseteste, now in the context of a systematic theology, is more suggestive, moreover, of a distinctively Oxford school of thought rather than a specifically Dominican school. In fact, the hypothetical question of the inevitability of the Incarnation was ultimately not embraced by Richard Fishacre's Dominican brothers.[58] Thomas Aquinas's rejection of the doctrine was probably what proved decisive.

NOTES

1. Richard Fishacre, *In I Sent.* prol.: "De quo autem sit haec tamquam de subiecto vel materia divisione investigandum. Tria quidem sunt simplicia: scilicet natura suprema, quae est Deus; et natura infima, quae est corpus; et natura media, scilicet rationalis creatura. Tria sunt insuper ex his composita: scilicet compositum ex infima et media natura, homo scilicet; et compositum ex media et su-

prema, ex quibus fit illud unum de quo Apostolus *Cor.* 6 <17>: 'Qui adhaeret Deo, unus spiritus est'—et hoc est unum quod est Ecclesia, scilicet caput et membra; et tertium est quod ex omnibus his componitur naturis, scilicet Christus. Sex igitur sunt in universo." The text is from my edition, "The Science of Theology according to Richard Fishacre: Edition of the Prologue to his *Commentary on the Sentences,*" *Mediaeval Studies* 34 (1972): 91–92.

2. Fishacre, *In I Sent.* prol. (ed. Long, 92): "Mihi autem videtur quod de quolibet horum trium potest dici hanc scientiam esse sed tamen de unico eorum ut de subiecto. In aliis quidem scientiis videmus quidem aliquid esse minimum et aliquid subiectum et tertium summe compositum in illo genere. Sic dicitur geometria esse de puncto ut de minimo suo; de magnitudine immobili ut de subiecto; de corpore ut de summe composito in illo genere. Dicitur ergo esse de puncto, quia a natura puncti fluit tota natura sui subiecto. Dicitur esse de corpore, quia prae sui compositione continet in se omnia quaecumque sunt sui subiecti, ut punctum, lineam, superficiem, et dimensionem trinam. Similiter aestimo hanc scientiam esse de Deo tamquam de minimo et indivisibili, a quo fluit quicquid est in subiecto huius scientiae. De Christo vero est ut de maxime composito, habens in se quasi partes componentes quaecumque sunt in subiecto huius scientiae."

3. Fishacre, *In I Sent.* prol. (ed. Long, 98).

4. Fishacre, *In III Sent.* d.1. q.1 (Oxford, Oriel College, Ms. 43 [B 4.3] 3:9b): "Secundo quaeritur an decuit vel oportuit Creatorem creaturae uniri." One of the peculiarities of the Oriel manuscript (siglum O) is that the pages of each book are individually numbered; hence '3:9b' would be book three, page nine, second column. I am grateful to my collaborator, Dr. Gerhard Leibold, for supplying me with the transcription from the Oriel manuscript for book three. I will correct O with readings from Vatican, Cod. Ottob. lat. 294 (siglum V), if and when necessary.

5. Fishacre, *In III Sent.* d.1 q.1 (MS O, 3:9b): "Cum natura suprema sit Deus, infima terra, tunc primo videtur circulus creaturarum completus et perfectus, cum unitum fuerit supremo infimo. Nec est aliter completum universum, quia antequam extrema claudantur, semper est possibilis additio, et perfectum est cui non est possibilis additio. Ergo decuit ad completionem universi terram Deo et econverso uniri. Quod factum est cum Dei Filius carni est unitus secundum illud *Ioan.* 1 <14>: 'Verbum caro factum est'."

6. Fishacre, *In III Sent.* d.1 q.1 (MS O, 3:9b): "Item, primum increatum est Deus, ultimum creatum est homo. Tunc igitur circulus creaturae est perfectus, cum Deus homo factus est, et nisi hoc fieret, perfectio universi non fuisset. Et tunc est verum uno modo quod dicitur *Is.* 44 <6>: 'Ego primus (quia Deus) et novissimus' (quia homo)."

7. Fishacre, *In III Sent.* prol. (MS O, 3:5a): "Homo est quaedam omnium creaturarum universitas; unde dicitur microcosmus. . . . Cum igitur Deus sit unitus homini totaliter, sicut anima unita est corpori et cuilibet parti et ita deitas animae et corpori et cuilibet eorum parti, erunt singulae partes universi in illo uno homine a deitate assumptae summe perfectae." Cf. *In III Sent.* d.1 q.1 (MS O, 3:9b et passim). For a study of Grosseteste's microcosmology, which is unquestionably the source of Fishacre's inspiration, see Richard Dales, "A Medieval View of Human Dignity," *Journal of the History of Ideas* 38 (1977): 569–72, and James McEvoy, *The Philosophy of Robert Grosseteste* (New York, 1982), 378–404.

8. Fishacre, *In III Sent.* d.1 q.1 (MS O, 3:9b): "Item, non tantum universum mansisset incompletum, sed et singula pars universi. Quippe non nihil nobilitatis et proinde perfectionis sortitur terra ex hoc quod nobiliori elemento utpote aquae vel aeri vel igni unitur in mixto. Magis autem cum unitur caelo, magis cum spiritu vegetabili, quia ignobilissimus spiritus nobilissimo corpore est nobilior, magis cum sensibili, magis cum rationali. Igitur si possibile fuit et terrae insita potentia ut Deo uniretur, scilicet summo spiritui quod res iam facta probavit, patet quod terra non in summo suae nobilitatis fuisset nisi hoc contigisset, similiter de aqua et sic de singulis quae omnia tunc primo videntur perfecta, cum Deus homini est unitus cum in homine sit omnis creatura. Unde et dicitur microcosmus."

9. Fishacre, *In III Sent.* d.1 q.1 (MS O, 3:10a): "Item, magnae bonitatis est se communicare omnibus per sui in omnibus praesentiam, sed maioris bonitatis communicatio qua se communicat bonis per gratiam, maxime autem bonitatis indicium et vestigium qua communicat se homini et per consequens generibus singulorum in personae unitatem. Prima communicatio est universalis sed modica, secunda particularis sed maior, tertia singularis sed maxima."

10. Fishacre, *In III Sent.* d.1 q.1 (MS O, 3:10b): "Attende quod hae rationes omnes non tantum probant Deum decere humanitatem assumere, sed etiam quod sive homo peccasset sive numquam peccasset quod hoc eum facere decuisset."

11. Fishacre, *In III Sent.* d.1 q.1 (MS O, 3:10b): "Quippe peccatum potius mutavit creaturam omnem et hominem in peius quam in melius. Igitur non capacior fuit natura humana et cetera omnia bonitatis post peccatum quam prius. Igitur si tanta capacitas infuit post peccatum ut posset capere

Deum, multo fortius et ante. Igitur qui dat omnibus affluenter, licet homo non peccasset, illam capaci-
tatem implesset, *Ps.* <103:28>: 'Aperiente te manum tuam omnia implebuntur bonitate.' Quod utrum
cogitaret Deus vel non, nescio. Deus scit, quia, ut dicit *Ps.* <91:6>: 'Nimis profundae factae sunt cogi-
tationes tuae'."

12. Fishacre, *In III Sent.* d.1 q.1 (MS O, 3:10b): "Sed tunc quaeres quomodo ergo reparatio lapsi,
fuit una perfecta causa vel duae causae incarnationis, quid est quod Scripturae et sancti expositores
earum cum tangunt causam incarnationis tantum alteram tangunt, scilicet reparationem lapsi; super
(*om.* O) I *Tim.* 1 <15>: 'Item Christus Iesus venit in hunc mundum peccatores salvos facere quorum
primus ego sum,' *Glossa:* 'Nulla causa veniendi fuit Christo Domino nisi peccatores salvos facere,'
[*Glossa ord.* in h.l., PL 114: 626]. Tolle vulnera, tolle morbos et nulla est causa medicinae."

13. Fishacre, *In III Sent.* d.1 q.1 (MS O, 3:10b–11a): "Ad primum dici potest quod forte utrumque
fuit causa. Ad secundum sciverunt et scriptores et expositores hoc esse universale apud miseriam
hominum quod minus acceptum habent beneficium quanto pluribus exhibetur et magis gratum acci-
pientibus quod exhibetur paucioribus. Hinc est quod maiores gratias agit aliquis episcopo pro prae-
benda quae non datur omnibus quam Deo pro ministerio solis et lunae et stellarum, pro anima, pro
membris, pro gratia baptismali, pro eucharistia et ceteris sacramentis, cum tamen haec illis, scilicet
omnibus praebendis, incomparabiliter praevaleant. Sed haec omnibus communiter dantur, praebendae
paucis. Hinc est quod plus amatur et magis amicus aestimatur qui te aliquantulum amat et nullum
alium quam aliquis qui tantumdem te amat et omnes alios. Insuper est hic amor proprietatis et odium
communitatis quod reprehendit Apostolus, *Phil.* 2 <21>: 'Omnes quae sua sunt quaerunt, non quae Iesu
Christi.' *I Cor.* 10 <24>: 'Nemo quod suum est quaerat, sed quod alterius,' *I Cor.* 13 <5>: 'Caritas non
quaerit quae sua sunt,' sed potius cupiditas. Unde praedixit <*I Cor.* 13:5> in medietate: 'Caritas non est
ambitiosa.' Haec est humana miseria tamquam res minus valeat quanto magis est communicata. Cum
tamen eo ipso plus valeat, quia bonum est sui communicativum, et etiam est ei melior quanto aliis
communior, Seneca: 'Nulla sine consortio iucunda est possessio' <*Ad Lucilium* 1.6.4>."

14. Fishacre, *In III Sent.* d.1 q.1 (MS O, 3:11a): "Hanc nostram scientes miseriam hoc tetigerunt
quod nos accendere posset magis ad Dei amorem. Si enim utrumque tetigissent, diceret homo: 'Incar-
natus est, sed non tantum pro me.' Cum tantumdem Deus fecerit pro nobis, immo amplius, quia hac
et alia de causa incarnatus est sicut si tantum pro nobis. Sicut enim reparatio sic et completio universi
bonum est nobis, quia maxime haec completio in nostra facta est natura."

15. Fishacre, *In III Sent.* d.1 q.1 (MS O, 3:11a): "Verumtamen utramque causam aliquando teti-
gerunt, ut videtur, sed alteram obscurius. *Gal.* 4 <4>: Quando 'venit plenitudo temporis,' ecce universi
completio. Et subdit: 'ut eos qui sub Lege erant redimeret.' *Is.* 10 <22>: 'Consummatio abbreviata'
quantum ad primum, 'inundabit iustitiam' quantum ad secundum. *Eph.* 1 <9–11>: 'Proposuit in pleni-
tudine dispensationis temporum instaurare omnia in Christo quae in caelis et quae in terris sunt in
quo etiam sorte vocati sumus.'"

16. The characterization is that of Peter Raedts, *Richard Rufus of Cornwall and the Tradition of
Oxford Theology* (New York, 1987), 233.

17. Fishacre, *In III Sent.* d.1 q.1 (MS O, 3:11a): "Quod si parum vel minus ideo tibi factum re-
putes, quia non propter te solum factum est, licet tibi totum factum sit, attende quod si incarnatio non
est facta pro te solo, incarnati tamen passio pro te solo facta est; non enim passione eius indiguit
universi perfectio sicut incarnatione."

18. Fishacre, *In III Sent.* d.1 q.1 (MS O, 3:11a): "Et certe supra modum maius fuit mori turpissime
post afflictiones multas triginta tres annorum quam incarnari. In incarnatione humiliatus est Deus sed
usque ad dignissimam creaturarum. In passione autem ad illud quod inferius est vilissima creatura-
rum; poena enim non est natura, sed eius defectus. Esto igitur quod pro te sit et pro universo incar-
natus, pro te tamen solo passus; I *Petri* 2:21: 'Passus Christus est pro nobis.'"

19. Fishacre, *In III Sent.* d.1 q.1 (MS O, 3:11b): "Quid etiam si Deus praesciens lapsum hominis
ante omnis creaturae creationem et sciens quomodo repararet, talem capacitatem indidit naturae hu-
manae et proinde universo quam non indidisset si homo peccaturus non fuisset? Nec propter hoc pec-
catum futurum fuit causa huius boni collati homini et universo, sed tantum occasio. Et bonitas Dei
causa qua novit malo bene, immo optime, uti. Aut si indidisset talem capacitatem creaturae, et si homo
non fuisset peccaturus, tunc intentio fuit Dei incarnari propter singulorum et universi completionem.
. . . Si primo modo fuit, finis incarnationis principaliter fuit homo et secundarius universi completio.
Si secundo modo, tunc principalis finis incarnationis fuit universi completio, secundaria hominis repa-
ratio. Tamen quare de carne Adam acceperit et quare mortuus fuerit, principalis causa fuit reparatio
hominis."

20. For a magisterial exposition of the teaching of the *De cessatione legalium,* see James McEvoy,

"The Absolute Predestination of Christ in the Theology of Robert Grosseteste," in *Sapientiae Doctrina: Mélanges de théologie et de littérature médiévales offerts à Dom Hildebrand Bascour O.S.B.* (RTAM numéro spécial 1, Louvain, 1980), 212–30; reprinted in James McEvoy, *Robert Grosseteste: Exegete and Philosopher* (Variorum CS, Brookfield, Vermont, 1994), item IV: 212–30. See also R. W. Southern, *Robert Grosseteste: The Growth of an English Mind in Medieval Europe*, 2nd ed. (New York, 1992), 219–25. Southern considers the necessity of the Incarnation to be Grosseteste's "most original theological idea" (222).

21. McEvoy, "The Absolute Predestination," 212.

22. The work received an earlier and uncritical edition by D. J. Unger, in "Robert Grosseteste Bishop of Lincoln (1235–1253) on the Reasons for the Incarnation," *Franciscan Studies* 16 (1956): 3–18, and a more recent critical edition by R. C. Dales and Edward B. King: *De cessatione legalium*, Auctores Britannici Medii Aevi 7 (London, 1986). Although Grosseteste claims that he does not recall the question being determined by any of the authorities he had seen ("Nichil enim . . . a nostris auctoribus super hoc determinatum me vidisse recolo"; *De cess. leg.* 3.2.1, ed. Dales and King, 133), in fact there were antecedents, namely, the twelfth-century theologians Rupert of Deutz and Honorius of Autun; see McEvoy, "The Absolute Predestination," 220–22.

23. Robert Grosseteste, *De cess. leg.* 3.1.3 (ed. Dales and King, 120): "Quod videtur sic posse persuaderi." The grouping of arguments is McEvoy's in "The Absolute Predestination," 212–16.

24. Raedts, *Richard Rufus*, 238, identifies this argument as "mild determinism."

25. Robert Grosseteste, *De cess. leg.* 1.3.3–30 (ed. Dales and King, 120–33).

26. An attempt to set the arguments side-by-side turned out to be vain. The arguments are simply too different.

27. See R. James Long, "Richard Fishacre's Treatise *De libero arbitrio*," in vol. 2 of *Moral and Political Philosophers in the Middle Ages*, ed. Carlos Bazàn et al. (Ottawa, 1995), 879–91.

28. Quoted by Raedts, *Richard Rufus*, 234 (from Oxford, Balliol College, Ms. 62, fol. 197). Just above, Rufus has said: "Nescio de omnibus his nec definio. Sed forte mihi videntur omnes praedictae rationes non cogere, sed longum esset ad singular respondere" (quoted by Raedts, 235).

29. Raedts, *Richard Rufus*, 237.

30. Raedts, *Richard Rufus*, 238–39. See Allan Wolter, "Duns Scotus and the Predestination of Christ," *The Cord: A Franciscan Spiritual Review* 5 (1955): 366–72.

31. Robert Kilwardby, question 2 of *Quaestiones in librum tertium Sententiarum (Teil I: Christologie)*, ed. Elisabeth Gössmann (Munich, 1982), 6: "Consequenter quaeritur: Si potuit Deus incarnari, quae causa vel congruitas quare oportuit? Et ponuntur diversae huius rationes. Una, universitatis perfectio. Quia cum sit creatura spiritualis seorsum et corporalis seorsum, non esset universum completum nisi fuisset tertia natura ex utraque, quare a simili, cum si Creator seorsum et creatura seorsum, non erit completio nisi unum fiat ex his."

32. Kilwardby, *In III Sent.* q.2 (ed. Gössmann, 9): "Ad primum potest dici quod non est simile, quia Creator non est pars universi, sicut est quaelibet creatura. Immo universum in illa summa completur de qua *Gen.* 1: 'Vidit Deus cuncta quae fecit,' et est universum sub Creatore sicut exercitus sub duce et corpus sub capite."

33. Kilwardby, *In III Sent.* q.2 (ed. Gössmann, 13): "Verumtamen licet iste modus rationabilis videatur et quasi philosophicus, tamen multum movere debet quod sancti loquuntur de incarnatione fere ubique quasi non sit alia eius causa nisi hominis reparatio. Hoc enim aperte dicunt multoties, et iste modus est magis amoris provocativus et fidei consonus, quamvis et reliquus non sit contra fidem."

34. I use the expression in its metaphysical sense as first expressed by the Greek Fathers, as in Jaroslav Pelikan, *Jesus Through the Centuries* (New Haven, 1985), rather than in its mystical sense, as in Matthew Fox's *The Coming of the Cosmic Christ* (San Francisco, 1988).

35. By way of contrast, see Bonaventure's *Collationes in Hexaemeron* 1.1 (Quaracchi Edition 5: 329): "From where to begin, that is, from the center (*medium*), which is Christ: for if this Medium is overlooked, no result is obtained."

36. All the texts I quote from Fishacre's commentary on the second book of the *Sentences* are from my forthcoming edition, based on six manuscripts, to be published by the Bavarian Academy of Sciences. Here, *In II Sent.* d.19 q.1: "Quare increparetur Deus, si in homine primo reliquit aliquid imperfectum, cum ex illo imperfectionis sciverit quantum bonum eidem naturae conferret? Ex illa enim imperfectione accidit hominem peccasse et consequenter Filium Dei incarnatum fuisse, quod forte non fuisset, si primo omnino homo immortalis factus fuisset." Note should be taken of Fishacre's statement that "perhaps" (*forte*) the Word would not have become incarnate were it not for Adam's sin.

37. Fishacre, *In II Sent.* d.21 q.6: "Verumtamen quia animae habent affectionem ad corpus, est

cognatio ratione corporum maxime, et quia omnes fuimus in lumbis Adae, et omnia nostra peccata originaliter inde contracta sunt, ex quo satisfactum est pro illo radicali peccato per poenam corporis Christi de corpore Adae, eodem satisfactum est pro omnibus peccatis ab illa radice prodeuntibus. Quod quia in angelis non est, nec reparatio."

38. This is the date assigned by R. C. Dales and S. Gieben in their edition of Grosseteste's *Hexaemeron*, Auctores Britannici Medii Aevi 6 (New York, 1982): xii. They base their conclusion on the phrase "plusquam per mille et ducentos et trigenta annos" in *De cess. leg.* 3.6.16 (ed Dales and King, 154). Beryl Smalley, "The Biblical Scholar," in *Robert Grosseteste, Scholar and Bishop: Essays in Commemoration of the Seventh Centenary of His Death*, ed. D. A. Callus (Oxford, 1955), 251, and Richard Southern, *Robert Grosseteste*, 30 n. 5, give the dates 1230–1235; McEvoy, "The Absolute Predestination," 212, prefers the later dates, 1234–1238. Whatever the precise dates, Grosseteste was lector to the Franciscans during this period, not to the Dominicans, and it was only gradually that Fishacre became acquainted with the daunting corpus of Grosseteste's writings.

39. This has been amply documented by Richard C. Dales, "The Influence of Grosseteste's 'Hexaemeron' on the 'Sentences' Commentaries of Richard Fishacre, O.P. and Richard Rufus of Cornwall, O.F.M.," *Viator* 2 (1971): 271–300, and confirmed by my own research.

40. That this was an important and abiding issue with Grosseteste is indicated by the fact that he returned to the subject at least twice more: once in a Christmas homily, *Exiit edictum a Cesare Augusto* (edited in part by Unger, "Robert Grosseteste," 18–23), and again in the form of a *quaestio*, written probably after his installation as bishop. Unnoticed by any earlier bibliographer, the question concerning the completion of the universe was edited and studied by Joseph Goering and F. A. C. Mantello in "Two *Opuscula* of Robert Grosseteste: *De vniversi complecione* and *Exposicio canonis Misse*," *Mediaeval Studies* 53 (1991): 89–124. This "brief and unprepossessing" little work repeats a number of the earlier considerations but has a distinctively Marian focus that may have heralded a new interest on Grosseteste's part (100–5). There is no evidence, however, that Fishacre knew either of these works.

41. See Fishacre, *In II Sent.* d. 14 q.1: "Deus semel Verbum genuit, in quo simul et semel omnia dicit, quia se perfecte dicit illo unico Verbo." Cf. Bonaventure, *Collationes in Hexaemeron* 1.13 (Quaracchi Edition 5: 331).

42. Robert Grosseteste, *Hexaemeron* 1.13.1 (ed. Dales and Gieben, 69–71).

43. Ibid. 9.8.1 (275–76).

44. Ibid. 9.8.2–3 (276).

45. Ibid. 9.8.4 (276–77).

46. One cannot know if he took heed of this silence, but if he had, Grosseteste would have had yet another argument against the use of the *Sentences* as *the* textbook in the theology faculty: namely, it constituted an added and unnecessary buffer between the theologian and the text of Scripture. It was the latter and the latter only that was the source of theological truth. For the definitive treatment of Lombard's Christology see vol. 1 of Marcia Colish, *Peter Lombard* (New York, 1994), 398–470.

47. Peter Lombard, *II Sent.* d.15 c.7 (Quaracchi Edition 1/2: 403–4.)

48. Fishacre, *In II Sent.* d.2 q.5: "UNDE ILLUD, *Eccli.* 1,4: PRIMO OMNIUM CREATA EST SAPIENTIA. Legitur hoc de Christo, qui secundum humanitatem creatus est. Et *primo*, quia ab aeterno praevidit Deus eum futurum."

49. Fishacre, *In II Sent.* d.8 q.1: "Nec meliora habere possunt quam sunt corpora humana, quia non sunt meliora. Probatio. 'Si optimum in hoc est melius optimo in illo, tunc hoc illo simpliciter est melius,' ut dicit Aristoteles in *Topicis.* Sed optimum in corporibus humanis est melius optimo in quovis alio genere corporum, scilicet corpus Christi. Ergo simpliciter corpus humanum quovis alio genere corporum est melius." Cf. Fishacre, *In II Sent.* d.14. q.9.

50. Fishacre, *In II Sent.* d.9 q.8: "Et ex hoc patet, si hoc dico verum est, quod homo est universitas vestigiorum divinae bonitatis, et maxime Supremus hominum. Et ideo merito dicitur homo 'factus ad Dei imaginem' plusquam aliqua alia creatura.'"

51. Fishacre, *In II Sent.* d.10 q.1: "Apostolus *ad Heb.* 1 <4–7> nititur ostendere Christum digniorem angelis, licet in hoc sit parum minor quod mortalis. Et non intendebat ostendere eum maiorem aliquibus angelis, sed generaliter omnibus." Cf. *In II Sent.* d.15 q.4.

52. Fishacre, *In II Sent.* d.14 q.9: "Locus naturalis corporis Christi est caelum. Alioquin cum locus naturalis animae eius sit caelum, concupiscet etiam caro eius contra spiritum, quia caro naturaliter appeteret locum suum naturalem, et tunc Christus miser esset. Sed idem est locus naturalis eius corporis et nostri, quia de nobis carnem accepit, sicut idem locus naturalis est totius terrae et unius glebae. Igitur corporis nostri locus naturalis est caelum."

53. Dante, *Paradiso* 33.127–32: "Quella circulazion che sì concetta / pareva in te come lume re-

flesso, / dalli occhi miei alquanto circunspetta, / dentro da sè, del suo colore stesso, / mi parve pinta della nostra effige; / per che 'l mio viso in lei tutto era messo."

54. Fishacre, *In II Sent.* d.16 q.4: "Sicut igitur nobilitas corporis solaris indicat aut nullum spiritum esse ei unitum aut nobilissimum, Deo scilicet simillimum, sic et nobilitas corporis humani indicat spiritum sibi unitum esse Deo simillimum. Et sicut universaliter inter omnia anima dicitur imago Dei nunc in via, similitudo vero in patria cum Deum videbit, sic et corpus, si potest dici humanum, inter omnia corpora et prae omnibus corporibus est Dei imago. Sed et similitudo erit in patria per intuitionem corporis Christi, sicut anima per intuitionem deitatis."

55. *In II Sent.* d.18 q.3: "Deum intelligere est ultimum potentiae in creatura rationali.... Igitur anima tota in Deum pergens non potest simul et corpori intendere. Tamen hoc potuit anima Christi ceteris potentior, sicut angelus simul habet cognitionem matutinam et vespertinam.... Obicietur sic: Christus comprehensor fuit in via, ita ut in via anima Christi limpidius videret totam Trinitatem quam aliquis de ordine Seraphin et abundantius ea frueretur. Igitur si tanta eius fruitio non abstulit ei sensum acerbissimum gravissimae passionis, multo magis nec raptus Pauli nec exstasis Adae, id est fruitio utriusque modica quidem respectu frutionis animae Christi, sensum doloris eis non auferent. Solutio. Si dicatur, sicut dicunt aliqui, quod inferior pars rationis in Christo sensit passionem, superior vero fruebatur, eadem ratione dici posset de Adam et de Paulo."

56. See R. James Long, "The Moral and Spiritual Theology of Richard Fishacre: Edition of Trinity Coll. MS O.1.30," AFP 60 (1990): 5–8.

57. Fishacre, *In II Sent.* d.18 q.1: "Consueverunt cohabitantes se diligere, similiter commensales, ita ut quodlibet istorum per se sit sufficiens amoris causa. Nunc autem omnes homines fideles de uno processimus; in eadem domo ecclesiae cohabitamus; eodem cibo etiam numero reficimur, scilicet corpore Christi. Quanta ergo debetur dilectio, ubi tanta est unio?"

58. Thomas Aquinas rejected the doctrine of the cosmic Christ in favor of the historical reality of the fall and redemption in ST 3 q.1 a.3, notwithstanding Albert the Great's acceptance of the doctrine and his own earlier acceptance of it in his *Scriptum super Sententias.*

Christ, Christianity, and Non-Christian Religions: Their Interrelation in the Theology of Robert Kilwardby

Richard Schenk, O.P.

I. GREAT EXPECTATIONS?
THE SYSTEMATIC INTEREST IN AN HISTORICAL DISCUSSION

IF MARTIN HEIDEGGER was right that historical investigations are guided by prior expectations of what might be found in historical material and how the results of historical research might help us to grasp and develop a problem,[1] we must begin by asking what we are searching for and why.

Today's theological situation is often described as a paradigm shift from inner-Christian, ecumenical dialogue to inter-religious discussion.[2] As incontestable as this description might be, it passes too quickly over the fact that changes in the Christian understanding of non-Christian religions at the same time have an impact on the self-understanding of Christianity, including the inner-Christian ecumenical dialogue on questions such as the idea of cultic sacrifice, world religions vis-à-vis the four *solus-formulae,* and the tenability of a strictly Christocentric foundation for justification and grace, sacraments, or a community of cult and belief. Changes in the Christian theology of non-Christian religions force movement in both Christology and the self-perception of Christianity. The present essay will explore some of these interrelations as they unfolded in Robert Kilwardby's Christology, his understanding of Christianity, and his theology of non-Christian religions.

But, before turning to Kilwardby himself it will be helpful to offer the following observations on the present state of the systematic question of religions.

In the first place, the once solid opposition between two main positions in the Christian theology of religions, the "inclusivist," and, the "pluralist," seems to be dissolving. Alternative theories within each of these two general groups of theories, but especially within the pluralist *genus,* have come to the fore, making evident once-hidden quandaries of the general position,[3] what Langdon Gilkey calls the paradoxes of pluralism.[4] New uncertainties have been defined by internal debates among pluralist theories about the future possibility of religious identity and thus of interreligious dialogue itself. There is a more candid admission of the cultural singularity, the new claims to superiority, and the moments of exclusivist logic intrinsic to many pluralistic standpoints. New *aporiai* of the practical and theoretical limits of plurality in questions such as environment, justice, and public discourse have emerged. A sign of maturation, this process of internal differentiation and heightened problematization is not unique to pluralistic theories. With the decline of the specific theory of anonymous

Christianity dominant in Roman-Catholic circles prior to today's post-Rahnerian era, alternative and rival models of an inclusivist type have as well become more prominent. In pointing out certain limits of the inclusivist and the pluralist positions, the debates within each *genus* have also shown them to be less antithetical than had previously been thought.

Moreover, not only the ambivalence between one theory and another within each group, but the ambivalence of most individual theories in themselves has become more evident as well.[5] Pluralist critiques of inclusivist thought can point to the exclusivist dimensions within inclusivism, while also acknowledging that inclusivist positions prepared by their own pluralist potential the later pluralist positions. Despite claims to the contrary, the categorization of each theory into an exclusivist, inclusivist, or pluralist model is not "comprehensive, unavoidable and adequate," since any given theory is made up of individual arguments, some of which may belong to another genus: e.g., exclusivist and pluralistic elements within a mainly inclusivist theory, or, exclusivist and superioristic dimensions in a basically pluralist position. Specific theories can be classified according to the dominant line of argument, but minor motifs from other theories can be present in greater or lesser proportions: one pluralist theory can be less relativistic than another. One inclusivist theory might be nearer to exclusivism, another, to pluralism. Motifs such as the traditional *figura-veritas* model of the older and the newer covenants have an inclusivist and an exclusivist potential: religions are said to have a share in the truth from the beginning, while falling short of the one true religion in the end. The constitution of any given theory from lines of argument drawn from different general types makes for ambivalence. It is not just an ambivalence between a self-seeking hermeneutic and an argumentative confrontation with the other, as, say, in D. Tracy's sense of ambivalent discussion, however legitimate that might be, but an ambivalence of argumentative analysis itself. If truth is (also) an *adaequatio intellectus ad rem,* then perhaps such ambivalence stemming from the co-existence of exclusivist, inclusivist, and pluralist threads of argument is necessary to weave the truth of a reality as multi-faceted as religion, with so much to be criticized, compared, or simply respected. The increased transparency of the ambivalence of the general types and specific theories due to the heterogeneity of their constituent parts is a further sign of the maturation of the discussion.

Another such sign of development is increased clarity on the relation of the question of Christianity and religions to the question of Christ. In *The Metaphor of God Incarnate,* John Hick defends his brand of Anglo-American religious pluralism against its continued critique by European theologians allergic to the appearance of relativism. Hick claims simply to be extending the European de-absolutization of Christ to the de-absolutization of Christianity.[6] As recent German examinations of pluralist theologies of religion show, the desire to avoid the relativism suggested by much interreligious discussion forces a new examination of whether behind the many contextual relativities in the history of Christology a common text can be identified, which would demand today that Christ still be considered the decisive mediator of eschatological fulfillment.[7]

Finally, the debates on inclusivism and pluralism display but a rudimentary knowledge of theologies of religions much prior to Vatican II. Where there is detailed

knowledge, it is usually limited to supposed fore-runners, such as Lessing or Troeltsch. All too often, earlier theologies are dismissed *en bloc*, as simply "exclusivist." Enough is generally known about religious persecution and extremely exclusivist *axiomata* that these are cited *pars pro toto* as a fairly adequate description of the earlier theology of religions. Theories and practices which stood in widespread opposition to such phenomena are unfamiliar, and a fear of finding additional negative expressions discourages comprehensive investigation. There is little detailed knowledge of older Christian theologies of religions, about which debates set what theory against the others, or about the heterogeneous lines of argument which stood in tension to one another within the individual theories. It is the ambivalence of medieval religious theory which needs closer study. Whereas there is a broader knowledge of the controversial history of Christological questions on the Incarnation, the ways in which medieval views of Christ varied and vacillated with parallel changes and ambiguities in the theology of non-Christian religions have received comparatively little attention. An historical investigation has the task of searching not for the perfectly even, self-consistent or still convincing theory, but for fissures, ridges and other signs of seismic movement beneath the topography of medieval theology in order to show where pressure had developed and what changed as a result. The discovery today of the co-existence of exclusivist, inclusivist, and pluralist lines of argument within medieval theories of religion, the alternative combination of these argumentative strains from theology to theology or within the shifting thought of individual theologians, and finally the impact of this on Christology might help us, contrary to the common wisdom, to understand better the structures and dynamics of our own unstable theological geology as well.

II. The Development of Robert Kilwardby's Interest in Non-Christian Religions Prior to his Questions on the Fourth Book of the Sentences

In the course of preparing the critical edition of Robert's *Questions* on the text of Peter Lombard, it was established that the Dominican wrote his work only in the latter half of the 1250s and/or in the first two years of the 1260s. He seems to have treated the individual books in their proper order; internal references attest to Robert's book I preceding his book II and then book III, where the work on Christology preceded the work on moral theology. Robert's questions on the fourth book[8] refer back to book II, and the development of thought on our question makes it seem probable that it followed book III as well.

The late date makes it possible that Robert consulted the commentaries by Thomas Aquinas or Peter of Tarantaise, especially for the latter books, but the use of two other Parisian commentaries, those of Bonaventure and Richard Rufus, is far more evident and central. In many questions especially of the final two books, Robert follows these two Franciscans, and even in his disagreements he often appropriates their state of the question.[9] In his final book a positive use of William de Militona is also central, whether the immediate source be William's own *Questions* or some work preparatory for the first parts of the final book of the *Summa Halensis*.[10] Only after these three Franciscans is the presence of a Dominican source felt: Richard Fishacre.[11] While Kilwardby was clearly not Fishacre's immediate successor at Oxford, it remains unknown whether the older claim that Kilwardby had Fishacre as a teacher is true. *De ortu scien-*

tiarum lets us place Kilwardby around 1250 as a Dominican at Oxford, where Fishacre had died two years before.

Robert's unedited Christological *quaestio disputata*, the *Triplex quaestio de incarnatione Dei*, has yet to receive the detailed study which would define conclusively its relationship to his longer work on the *Sentences*.[12] But the shorter *Triplex quaestio* seems to represent a stage of thought prior to the lengthier study. The *Triplex quaestio* follows Anselm closely, and the views which will prove most original in Kilwardby's longer treatment of Christology seem less developed in the shorter *quaestio disputata*. Were this priority to be confirmed, and presuming that only a master would publish a *quaestio disputata*, it would be a further argument for the likelihood that, like Richard Fishacre's commentary and questions a good ten years before, Robert's *Quaestiones in libros Sententiarum* were the fruit of a master's lectures rather than the work required for attaining the *magisterium*.

This suspected relationship can be illustrated by looking at the use of an example invoked by Robert in different variations in the *quaestio disputata* and at least five times in the *Questions on the Sentences*. In the latter work, but also in the redactional table of contents which now prefaces the longer version of the *Triplex quaestio* (Merton, Coxe 131), the example is designated as a "parable."

In the shorter work the only thing remarkable about this "parable" is its length:

Take the following example: Assume that there is a king, whose people has transgressed the law, and that for reparation or satisfaction in accord with the decree of a just law everyone is held to pay the king a talent. By decree of an equally just law, as often as anyone violates the law, they owe another talent as reparation. Whoever does not pay is to be incarcerated forever and forfeit all goods. Assume now that at the same time there is only one single talent, and it is in the treasury of the king. It is thus the case that no one of such a people is able to make amends, unless it be by the mercy of the king, who holds the talent. Let it be that the king is such a zealot of justice that he is unwilling to let any violation be reconciled in any other way than in accord with the form of the law described. There are only two possibilities: either this transgressing people will be damned with prison and the loss of its goods or the king will take pity on the people by sharing his talent. Assume that the king, devoted to and moved for his people by their beseeching mercy, does donate his talent as the offering for the people to the king. Thus it would be a perpetual gift through all generations for everyone of his people who would convert to him from the heart and would love him, so that anyone who violated the law of the king in the manner described could offer the king the royal talent in satisfaction and avoid prison and the loss of goods. Then it is so that there were no transgressors among that people who couldn't have the gift meant to please the king, if they so wished; if, however, they scorned the gift of the king, instituted for each and everyone for the purpose of satisfying, then by right they will be damned both for not giving and making satisfaction and for their contempt of such mercy. It is like that in the matter under discussion; the adaptation is self-explanatory.

(Note therefore how mercifully that sacrament was instituted, *in which the people of God have this gift of satisfaction which always should be offered and always has been offered for the satisfaction of its sins, namely Christ. From this it is clear how in the one Christ we have a sufficiency of redemption and liberation*

and satisfaction as regard both the infinitude of humans and the infinitude of sins.)[13]

In this first version no attention is paid to the problem of non-Christian religions; the generations spoken of are those between Christ and the end of time. Even for them, there is no indication that there is any further need to wait for salvation, once the talent—Christ—has been offered. While the possibility of rejection is mentioned, there is no word of faith as necessary for acceptance, though the necessity of love is included, if a bit forced on the story. At the end, the talent, Christ, is identified with the sacrament of Christ in the Eucharist. It appears at first almost an afterthought of the author or a redactor, although such a repeated presentation of the talent, as frequent as transgression itself, was implied in the text by the second decree. The example also touches upon the importance of Christian prayer. The tie is made, then, between Christology and Christian cult, but not yet to non-Christian cult or religions.

In the introduction to her edition of Robert's *Questions* on the Christological half of the third book of *Sentences*, Elisabeth Gössmann draws attention to three features unusual for their content and length: the treatment of the concept of person, in particular of the relative personhood of the *anima separata*; the questions on the cult of Christ, the cross, the saints, and images as well as the reverence for superiors (*latria et dulia*); and finally the critique of the need for or even the possibility of any mediator's bearing an infinite punishment. It is in the context of this third issue that Robert brings more nuanced versions of what he now calls his parable. He argues that no one who ever does penance for sin owes eternal punishment; rather, it seems to be the faith and preaching of the Church that true penance transforms the debt of eternal punishment into a debt of limited duration. Robert rejects the claim that this is only the case since the coming of Christ. He accepts that there are forms of penance which, while seeming to come from a love of justice and not just from a dislike of punishment, still remain hollow (*fictus*), insufficient, or erroneous, because they are without love. And yet he insists that wherever there were faith, hope, and love of future redemption, there was not only a spirit of penance but *ipso facto* already an effective penitential sacrament of the church and the remission of sins.[14] Already in his questions on the second book, Robert had recalled that the first parents and their progeny retained the possibility of repentance with the promise of justification and even mediation contained implicitly within it.[15] Without exploring the consequences of this possibility, Kilwardby sees in human repentence a sign of God's future mercy and divine-human mediation. Now in his Christological tract, Kilwardby stresses how, in fact, the primal acceptance of the promise implicit in penance had become a sacrament of grace alongside matrimony; both sacraments are as old as humankind. Even if the direct vision of God would come only with the passion and resurrection of Christ, all those from Adam on who developed a penance of this kind had their sins forgiven in their own lifetime and suffered no punishment of pain in the afterlife; with Christ they attained the immediate vision of God. Robert reworks his "parable" to express this, now focusing not on the time after but on the time before Christ:

> These things can be seen somewhat in a parable like this: Let us say that a certain servant breaks the law and causes losses to his lord beyond what he himself or

any of his own could restore. Admittedly, the lord could justly cut him off from his inheritance forever or even execute him, but he declines to do so out of mercy; rather, moved by the prayers of the servant, the lord will not prosecute the offense as long as the servant restores what he took. The lord says: 'I remit the offense against me, but you must satisfy for the loss you caused. Until you or someone in your stead has satisfied for the loss caused, you shall not enter your inheritance, but you shall wait in the meantime in prison.' Then the servant responds: 'Lord, you know that then I will be forever cut off from my inheritance and will forever be in prison, because satisfaction is possible neither for me nor those I can call my own. I ask you to have mercy on me, and if you should still want a just satisfaction to be made for me, provide someone who can do this, and I will be provided with satisfaction by what he does.' And thus the lord speaks in mercy: 'Without a doubt I will provide for you as far as I shall see that you love me faithfully in other things and that you believe that I wish to do this, and can do it, too, and that you wait patiently until it should please me to free you and to send someone to satisfy for you. If you have done this, I will send at the proper time your liberator, someone to satisfy for you, and, when he has satisfied, you will go forth from prison and enter your inheritance.' Adapt similarly the various details to the preceding discussion.[16]

The major innovation over and against the first version is the shift in focus to the problem of pre-Christian peoples. In the context of Question 84,[17] where the revision occurs, attention has been shifted to this problem in order to show why the mediator need not bear an infinite punishment: because the penitential spirit of pre-Christian peoples would already have won from God the temporal limitation of their punishment. The re-worked parable thus elaborates on the penitential spirit, the prayers, and the love of these peoples, including now the spirit of waiting for deliverance. The inclusion of necessary faith and confidence to be found among them is also new. Christology has led Kilwardby to the theology of religions.

As regards penance, Robert sees that self-inflicted suffering and even regret are not redemptive of themselves;[18] rather, it is grace at work in faith, hope, and love which makes penance possible as the usually necessary condition of liberation from the sentence of eternal punishment. The theological virtues thus become something of a pledge and security deposit of the promised liberation; caused by God, they are God's down-payment on human justification. This is the thrust of a further reworking of the parable within this same question:

As an example: Someone has put a servant in jail for some crime, and he could legally keep him there forever; yet, taking pity on the servant, he swears he will someday be liberated and gives him some pledge or sign of the future release. Once this has happened, he can no longer legally demand from him to remain in jail forever, but rather it will be a crime if he would, as that servant would not owe such a life-long incarceration.

Neither can you say that the pledge or security deposit provided by God in faith, hope, and love is not certain or definite. Since the gifts of God are never in vain, whatever is given by him to be believed and hoped comes about without a doubt. For if what would never happen were to be believed and hoped for, this would be an error and a deception, which cannot occur in God's gifts.

Thus it follows that whoever does penance will someday be liberated. Because there is a remission of the perpetuality of punishment based on the promise of God which was made in the security deposit or with the pledge given, the one to whom that promise was made is not held to such punishment, as long as he maintains that security or the pledge he received.[19]

It is here that cracks begin to appear in the Christological ramifications of Kilwardby's position. Robert pushes the idea of true penance until it verges on being not only the necessary but even the sufficient condition for the remission of sins and the freedom from eternal punishment. Before penance, one is held generally to some punishment, but whether to transitory or eternal punishment will depend upon whether that penance finally takes place. "Thus, absolutely considered, no *viator* has the debt of eternal punishment before his end, except conditionally,"[20] i.e., if he does not finally repent. Kilwardby poses the objection that, if this penance based on loving faith and hope in a future mediator would release from eternal punishment, and yet the mediator would not in fact come, there would be a remission of sin and punishment without Christ. Robert first replies, not too convincingly, that such a supposition contradicts the very tenet on which penance was based, namely that the mediator would come.[21] This lack of clarification of the relationship between Christ and pre-Christian grace will come back to haunt Kilwardby in the further course of his reflections. Here he underpins his first argument with a more manageable point that this would seem to imply an impossible kind of injustice on God's part:

> Supposing that the Mediator never would have come, it follows that Adam would in fact have remained in his sins forever, but it does not follow by the force of the objection that he would have owed this eternal punishment, I mean of course presupposing that penance has already taken place; for the following argument is invalid: 'This person remains under a punishment he merited; but he remains under a perpetual punishment; therefore, a perpetual punishment is due him.' Likewise invalid here is the following: 'Given that someone would merit prison for a time; but that he would be kept by a tyrant perpetually in prison; it is true that he is rightfully held in prison.' But it does not follow that he merits that it be perpetual, although it might be in perpetuity, since it is by a figure of speech in transferring 'what' into 'when' and 'how much'. In both these cases an appropriate qualifier could be assigned, since some prison due such a criminal is one thing, while perpetual prison is another, and thus the middle term in each syllogism is not identical.
> It is in a similar way that the second objection should be answered. It is to be conceded that the passion of Christ liberates only those doing penance and, indeed, from due punishment. But, for the reason given, it does not follow from the fact that he frees them from eternal punishment that those doing penance are held to eternal punishment; rather, he frees them from eternal punishment, i.e. from punishment which would have been eternal, were he not to free them. But if he were not to free them following the gift of penance, this would be a crime against them.[22]

The initial point of this revision of the prison-image, the third within Question 84, namely that humans before Christ did not all have the debt of eternal punishment,

corresponds to another central aim of Kilwardby: to show that Christ did not need to bear infinite punishment. Robert's contemporaries, including Thomas and Bonaventure, likewise denied that Jesus suffered every pain on the cross; salvation comes from love, not suffering, and there are modes of suffering which preclude love.[23] But Kilwardby goes further in this direction to deny that any human could ever suffer absolutely[24] and to warn against maintaining too apodictically that Christ felt the physical pain of his torture more acutely than others as a consequence of a heightened sensibility of touch. "This ought not to be asserted with temerity, but rather with a 'maybe' ";[25] there might, after all, be similar sensitivities in others lacking those spiritual qualities of Christ which would mitigate the pain.[26] Robert openly departs from his principal sources in denying the suffering of higher reason in Christ, his spiritual sadness or his unwillingness to die. In his minimization of the sufferings of Christ, Kilwardby sees himself in the tradition of twelfth-century theology: "Although few today would sustain this position, it is convincingly stated, and one should be content to answer here with the Master of the *Sentences.*"[27] At this point Kilwardby's unusually long discussion in the third book, defending the relative personhood of the separate soul, comes into its full Christological context: the less ruinous death appears in itself, the less unwillingness there will be in Christ to accept it; and following the hermeneutical circle back again, the less tragically Christ experienced his death, the less tragic Christians need to consider their own.

The theology of the *triduum mortis,* whose philosophical roots were set in the questions on substantial form in book II (to which Kilwardby refers in book III[28]) the ramifications of which would become clear in Robert's prohibition of Thomistic theses at Oxford almost twenty years later, shows its Christological weight here in a programmatic relativization of the necessity, the possibility, the profundity and the facticity of Christ's sufferings. This relativization of the suffering Christ is the reverse side of a positive treatment of pre-Christian religiosity and its theocentric hopes.

Robert absorbs much of Bonaventure's commentary on *latria* and *dulia* in distinction IX, but he goes well beyond his sources: Kilwardby's interest in cult, veneration, and reverence is manifest here as well. Two questions are of particular importance in our present context. The first involves the compatibility of the prohibition of cultic images in the first covenant with their encouraged use in the second. Robert accepts much of John Damascene's defense of icons. Kilwardby plays down the contrast between the two covenants in several ways: he refers to images commanded by God in the older covenant, such as the bronze serpent or the two cherubs, while conversely admitting a possible misuse of images in the younger covenant due to ignorance or ill-will. The merely indirect reference of the newer images to the Godhead itself *via* the humanity of Christ or the veneration of non-divine realities, such as the true cross, its images, or images of saints, does not, he argues, directly violate the older prohibition against images of God. In addition, the older law had reflected temporal motives which were now *passé:* the need to segregate one people from all others and to become aware that God had not yet been made man. In both dispensations, the rules aimed at furthering the devotion of the faithful.[29]

The questions on the reverence and service of subjects deal only briefly with Christ's own (free) subjugation to his parents and the law. Robert omits the usual ques-

tions on Christ's difference from Levi in the loins of Abraham and whether Christ, too, had thereby paid tithes to a greater priesthood than his own.[30] While the question, motivated by a somewhat wobbly argument in the *Letter to the Hebrews*, is strictly Christological in Peter Lombard, distinguishing Christ's conception from all others, thirteenth-century commentators had increasingly taken the opportunity of this question to reflect on the general insignificance of the older cult, even beyond the practice of tithing. Fishacre, typically, uses the opportunity to snipe at cult in general, although tithing seemed to him the least offensive part of pre-Judeo-Christian practice.[31] In his questions on *dulia*, Robert makes altogether too clear that his positive evaluation of pre-Christian religions is not accompanied by an interest in revising the negative attitude and practice towards non-Christians of his own day. He presents without critique the civil and canon laws making the ownership of Christian slaves exceedingly difficult for Jews, apostates and other non-Christians.[32] By contrast, he is relatively mild in the question of continued duty to a merely excommunicated ruler, a point corrected later by a discontented scribe in the lower margins of the Merton manuscript.[33] Kilwardby's later advancement to cardinal had not a little to do with papal displeasure at Robert's vigorous sense of duty to the English crown. By contrast, Kilwardby shows no such softening when noting " . . . that Jews ought not to be permitted to hold secular dignities or public offices among Christians."[34] He groups all present-day non-Christians in the category of "evil persons."[35]

The unusual upgrading of pre-Christian religions which will become evident in Kilwardby's fourth book is therefore not motivated by a concern for living non-Christians. It does not seem to be catechetical or proselytizing, and it betrays no knowledge of Jewish customs not transmitted by well-known literature. On the other hand, it was not designed to show that the continued practice of Judaism was heretical, as was Robert Grosseteste's *De cessatione legalium*, a book, whose practical goals are perhaps underestimated by its editors.[36] Kilwardby's later dealings with Jews as provincial and bishop, described in detail by Sommer-Seckendorff, all remain in the realm of the ordinary.[37] We have no sign of how he was affected by the sufferings of the Blackfriars priory in London, which at precisely this time was suffering adversity due to its protection of a Jew from mock justice.[38] Regarding the Jews, Kilwardby shows neither Robert Grosseteste's animosity nor the new esteem attributed at this time to, for example, Joachimite circles.[39] It is possible that Kilwardby's higher estimation of pre-Christian religions had solely to do with those theoretical questions about non-Christians which were significant for the self-understanding of Christianity. The discussion of non-Christian religions was meant as a debate about the proper form of Christianity itself: whether and in what sense it was to be a cultic religion. Only here does the discussion seem to aim at practical consequences.

Robert deals briefly with pre-Christian religions in his questions on the second half of Lombard's third book. The moral law expressed in the decalogue can be contrasted to faith as nature is contrasted to grace. The latter presupposes the former, which all peoples have held. At the same time, the moral law is carried by a kind of implicit faith. Arguing against Augustine and Peter Lombard and with Hugh of Saint-Victor, Robert insists on the indirectness of implicit faith, which demands merely some explicit belief in God and the redemption of humankind by the "poenitentium

redemptor."[40] Without stating it again here, Robert thinks Anselm has shown how even faith in a mediator can be merely an unnoticed implication of an explicit faith in redemption, as this excludes merely extrinsic salvation; the greater mercy allows those forgiven the privilege and dignity of partial atonement, which in turn is first made possible by a mediator who is divine and human. In a further stress on the indirectness or mere implicitness of pre-Abrahamic faith, Robert goes beyond Hugh in denying that, before the prophets, even the "maiores in Ecclesia" could possibly have had explicit belief in Christ.[41] The tendency and problematic of this insistence on the non-Christian foreground of a merely implicitly Christian faith before Christ will be developed in the *Questions on the fourth book of Sentences.*

III. Christ and the Movement of Religions in Robert Kilwardby's *Quaestiones in librum quartum Sententiarum*

Kilwardby's investigations on the final book of the *Sentences* are probably his last academic work, and they deal exclusively with the question of religions. The focus is on the cult of the older covenant, in particular on its sacrament of initiation and the light shed by this sacrament on the other ceremonial practices of the first testament. The cult of the younger covenant and the cultic practices of non-Judeo-Christian religions are examined only in their relationship to the first covenant. The Christian sacraments are not examined individually, and no other topic is discussed in the book.[42]

For the theologians who became masters in the 1250s, the debate on religions was defined by an older and by a more recent controversy:

The older controversy was the option between Peter Lombard's critique of pre-Christian religion and Hugh of Saint-Victor's higher estimation of it.[43] The former stance could find little intrinsic meaning in the details of the older cult, say the fact, timing, or tools of circumcision. This lack of immanent sense in the details of the cult corresponded to a marked lack of grace proper to such ceremonies considered in themselves; the attitudes towards symbolism and efficacy are interrelated. According to Peter, if pre-Christian cults were of any value at all, it was because they shared Christian faith, perhaps implicitly and by way of figures, but it was *eadem fides,* that very same faith in Christ. Only insofar as the details of cultic practice could prefigure and thus awaken this faith did the older cult make any sense or prove to be a source of grace. There is little difference to be found between the cult of natural religions and that of the first covenant; whatever meaning or value they might have had, this was in each case only by way of an anticipation of Christian faith. By contrast, Hugh of Saint Victor's sense of the qualitative difference of the three ages of salvific history prevented him from such a leveling process. Both the religions prior to or outside the Judeo-Christian tradition and the cult of the first testament made sense and were gracious in themselves, while at the same time also foreshadowing the coming of Christ, the Christian faith and cult. Given this option, Robert Kilwardby represents a programmatic, and perhaps the most consequential, development of Hugh's position.[44]

The masters of the 1250s were confronted by a more recent and more heated debate as well: the one between covenantal and symbolic causality. Having read Moses Maimonides' *Dux perplexorum,* William of Auvergne and Richard Fishacre inter-

preted the sacraments of both covenants as being occasions of grace based upon a *pactum*, or contract. Whenever God saw that the agreed-upon cult was in fact practiced, he gave grace directly and without the sacral instrumentality of the cult; any other deed, if agreed upon, would have done as well and as little. In reaction to this development, theologians such as Hugh of Saint-Cher had begun to restate more forcefully the older position of sacramental instrumentality, ascribing to the symbolic enactment itself a more intimate role in mediating grace.[45]

In adopting this position identified especially with Fishacre, Bonaventure seems to have stirred up internal dissension within the Franciscan order. He refers to this bitter strife in his concluding remarks on the *Sentences*, defending himself by reminding the brethren that, after all, even their beloved William of Auvergne had defended this view in the presence of the more traditional Alexander of Hales.[46] This dispute may well have been the reason why the Franciscans could not agree, without papal intervention, on who should head the team to finish their theological encyclopedia, the *Summa Halensis*. An opponent of Bonaventure's position on the issue, William de Militona, was chosen instead.

Following the newer trend, Robert Kilwardby takes up an image used by William of Auvergne and Bonaventure. In doing so, he touches on a brief revision of his "parable":

> They give an example like this: Formal letters from the king free from prison not by any power immanent within them, which would come forth to free and lead hence those who were to be released. Rather, it is simply by a power of signifying which is relational and instituted just for this.[47]

In this version, the royal pledge or letters given are no longer internal faith or remorse, but rather the agreed-upon cultic action. (In passing it might be noted that the example presupposes a secularization of the symbolic power of royal and imperial documents still unknown in the tenth or eleventh centuries.) Other examples illustrating the covenantal theory were known to Kilwardby as well, such as ecclesiastical bulls and documents authenticated by special seals, lead coins used as a form of food stamps, coins of a high agreed value but lesser metal worth, gloves as pledges or as signs of office, along with the many other signs of ecclesiastical investiture, such as the staffs of bishops and abbots. In all these cases the "pignus" was no longer interior faith, but an exterior, cultic sign.[48]

Given the two controversies, there were four basic options in the 1250s regarding pre-Christian cult, matching a negative or positive view of pre-Christian cult with a covenantal or intrinsically causal view of the sacraments.[49]

First, there could be a positive reading of their symbolic-causal vitality. This position, typified in large measure by William of Militona, was shared by Thomas Aquinas only in regards to circumcision,[50] to which Thomas in all but his latest writings ascribed the same kind of causality and much the same effect as baptism. It deleted original sin and provided sanctifying grace, albeit in less plentiful form than did baptism. In regards to the rest of the older cult, Thomas took up the second option from the start.

Another possibility was the negative reading of the causal efficacy of pre-Christian cult, which ascribed nothing like the assumed gracious agency of Christian sacraments to any pre-Christian cult. Whatever grace was to be had in pre-Christian times came by a participation of Christian faith, *eadem fides*. The differences from the Christian context thematized by the immediate references of pre-Christian ceremonies and symbols were not a source of grace. Around 1272, after returning to a study of the *Corpus Paulinum* and finding there the insistence on salvation in Christ alone, Thomas includes circumcision in the category of non-effective rites, mentioning twice in the *Tertia pars* his change of mind. It must always have seemed unfitting to have the sacrament of initiation be of a different order than the sacraments into whose practice one was thereby initiated. Thomas also saw the weakness of his initial idea of a somewhat less sanctifying grace.

If we ask whether Thomas changed his Christology because of his theology of religions or whether he changed his view of non-Christian religions to fit a shift in his Christology, then the answer must be that in his case, perhaps otherwise than with Robert Kilwardby, it was both. Given Thomas's increasing tendency to see the merit of pre-Christian religiosity and existence in that very same faith and very same grace as Christianity, there could no longer be any essential superiority of the principal Christian sacrament over the principal Jewish sacrament, unless at least the modes of their causality were different. The conviction of some such superiority is common and basic to all Christian authors of the time, as is especially clear when they alter other positions (e.g., on circumcision) to save this more basic one. The shift on lower-level truth-claims now shows the constant to be higher in the hierarchy of truth-claims, a point which can be of special importance in dealing with the idea of a *cessatio legalium*. Thomas now claims that all effective sacramental causality depends upon the temporal completion of Christ's Passion and death. This allows him to ascribe an equality of salvation to those who before Christ had come implicitly to such crypto-Christian faith, while claiming an inequality of the cultic systems. The discussion of religions leads to assigning Christ a new importance, the discretion between effective and ineffective cults.

On the other hand, it was Thomas's renewed attention to Pauline Christology which made him emphasize the implicitly Christian faith of pre-Christian existence in the first place. Only belief in Christ could have offered them that same sanctifying grace he is convinced many pre-Christians had; the rest, what is specifically non-Christian in the thematic horizon of pre-Christian existence, is now of little matter. Thomas does not on the whole describe the older cult in the dramatically negative terms sometimes employed by Fishacre and others, but he does see it as useless. The "truth" of pre-Christian cult and belief is located exclusively in their formal identity with belief in Christ. There is no longer an admission of any principal superiority of the first covenant cult *vis-à-vis* natural religions. The indirectness implied on other issues in the doctrine of analogy, with its distinct formalities of a truth, and the sense of the positive role of non-Christian *propria* in merely implicit faith recede here in preference for the *eadem fides in Christo*. The earlier advantage of the whole concept of a causation by symbolizing is put at risk: the most mechanical-sounding descriptions of sac-

ramental causality to be found in Thomas's work, favoring images of thing-like causality rather than intentionality as the medium of sacramental instrumentality, occur in the context of this late difficulty in distinguishing the two covenants.

Two further options, now of the covenantal alternative, were also available to the new masters of the 1250s. As in Richard Fischacre, there could be a negative view of the quality and extent of older covenant arrangements. Borrowing from the cult critique in Rabbi Moses's exoteric work, Richard sees the older cult, especially its sacrifices, as tolerated or permitted by God, but not as initiated or simply willed by him. Displeasing to him, animal sacrifices and other bloody features of the older cult were "quasi extorta," "viliora et inefficaciora . . . ornamenta."[51] At the same time, Fishacre can stress commonalities between the two covenants: the same moral demands and the same capacity to fulfill them, or the same lack of instrumental causality in its sacraments. Richard claims that cultic practices, because they are less "consonant with reason" than moral practices, become more and more burdensome by virtue of their increasing number and frequency. This anti-liturgical statement might well have offered not only a descriptive lesson on pre-Christian cult but also a prescriptive point for Fishacre's student *confratres.* The potential advantage of the newer cultic dispensation should not be forfeited by excessive liturgical energy, a point made by Thomas as well.

The final option, the one Kilwardby will follow, was that prepared for by William of Auvergne. It sees widespread and positive covenantal agreements in the cult of both testaments and thus must find other ways of showing the necessity and superiority of a new covenant. Kilwardby develops the positive evaluation of the pre-Christian cult with a programmatic consequence rarely equaled in medieval theology. While denying that non-Abrahamic religions were offered an explicit *pactum* by God, Robert sees in their cult an approximation to covenantal arrangements.[52] In waiting for God in faith, hope, and love, and regretting his continued distance by penance, something of this experience of the first "age" retains its validity even later, or better, it had anticipated something valid of the later dispensations from the start. God did not directly reveal the sacrifices, oblations, and tithing of the pre-Judeo-Christian cult, but he did inspire and instigate these peoples by intensifying their inner virtues to develop such cultic practices, which in this indirect sense he thus "conferred."[53] Although no single practice could be prescribed as necessary without a divine pact, some such practice or "discipline" was felt to be necessary beyond the moral obligations of natural law. Like a father forced to dismiss his son from the house but seeing to it covertly and round about that the son not fall too far, God pretends the anger of silence and hides his still constant care: the *divina simulatio irae et dissimulatio pietatis.* The locus of such hidden care is the conscience. Here Kilwardby takes up the theme of the third book again: "The eternal truth of human consciences dictates this: that the justice of God does not punish anyone eternally to whom his mercy has given the gift of penance from sins committed."[54]

While Robert is now willing to admit the possibility of an explicit faith in a mediator,[55] his stress remains on the indirect nature of this cultic faith. The pre-Judeo-Christian cult was first of all directed toward a justification before God in its own day, and by God's instigation and covert institution it also achieved its goal. Only secondarily and on the basis of this first context did the pre-Abrahamic cult foreshadow Christ

and the Christian sacraments. Justification was a more important part of the preparation for the future faith than any education provided by prefigurative symbols.

The same analysis is repeated in regards to the first covenant, but it is intensified on the basis of the explicit promise, *pactum,* and institution of sacramental rites of the covenant. Kilwardby rejects the common restriction of sanctification to the one sacrament of circumcision, claiming that the first purpose for the institution of the whole cult into which circumcision initiated was to give sanctifying and actual grace, an intent he sees fulfilled by all the sacraments and feasts of the older testament.[56] That God would institute useless rites appears unfitting. As was also the case with the rites of religions *de lege naturali,* Robert insists that the transcontextual significations of the "res significata tantum et non effecta," namely the prefigured Christ, his sacraments, and eschatological fulness,[57] were secondary and based upon the more immediate references: "the reality then present, contained and effected by them: justification from original sin; the distinction of people from people by a perceivable character; the interior unity of faith and the exterior concordance of rite in the observance of the law."[58] An analysis of the ritual signs shows that most details had a sense proper to that time, whether simply pragmatic (the eighth day after birth was to ensure that circumcision would not be postponed indefinitely) or whether symbolic of the faith of that age, as belonging to a people set apart. Far fewer associations are made with what the cultic details might foreshadow. These could be direct, such as finally being cut free from natural corruption in the final resurrection in Christ, or indirect, e.g., the restriction of the prescribed initiation rite to one sex rather than the later practice of a common rite for both was interpreted as a sign of the general advance of the all-inclusive grace which the younger covenant would bring. All such prefiguration was subordinate to the primary signification in the context of the previous age itself.

Robert criticizes not only his contemporaries and Peter Lombard for denigrating the graciousness of these pre-Christian realities, he exercises what R. Bultmann called "Sachkritik" in regards to St. Paul's more critical remarks on the older cult. Kilwardby calls them an "imperfecta oratio et ideo ambigua."[59] Kilwardby goes beyond Augustine's defense of the continued practice of the older cult for a time after the resurrection of Christ. While agreeing with Augustine that such tolerance was meant to distinguish the older cultic law from idolatry and that it was not of itself harmful ("mortifera"), as Jerome had insisted, Kilwardby claimed that neither was it useless ("mortua"), as Augustine had maintained, but rather that it continued to give life long after Christ on the basis of its own immediate "res contenta et effecta."

The obvious difficulty of indicating some advantage of the newer covenant over the older one was not made easier by Robert's detailed criticism of instrumental sacramental causality; all sacraments are gracious merely on a contractual basis, *solo Deo.* Just as with the older sacraments, a lack of faith in the exercise of the newer sacraments would invalidate their *pactum.* Near the end of the book, however, Kilwardby's argument abruptly swerves to try and "save" that "imperfecta oratio et ambigua" he had criticized beforehand. Robert accepts in the end that the traditional Christian contrasts of the two covenants must somehow be valid: spiritual / carnal; love / fear; cause of salvation / occasion of death; liberation / servitude; alleviation / burden; fulfillment / promise.[60] Although a *cessatio legalium* was hinted at earlier in his book by the pre-

figurative functions of the pre-Christian cult, it was a subordinate aspect which seemed not to be the main conduit for the flow of grace. Now the pre-Christian religions seem to demand their absorption into Christianity.[61] Kilwardby's first attempt to hide this rupture in the structure of his presentation is unconvincing: he claims that such contrasts apply only to the "common" average experience of each dispensation.[62] The transition from natural to covenant religions had seemed more plausible. The reader, in learning that the danger of idolatry had grown so severe just prior to Abraham, might wonder how God's pedagogy and inspiration, contained in the pre-Abrahamic rites, could have failed its purpose so thoroughly; and yet the more open pact is of obvious advantage over a hidden one.[63] The transition from the older to the newer covenant seems more difficult to justify, since the kind of covenant and grace remains identical; the derogatory characterization of the average members of the first covenant as *superbissimi, invidissimi, avarissimi*, and *infidelissimi* stands opposed to the presence of sanctifying graces which Robert describes.[64] Robert himself goes on to admit that, on the one hand, such negative descriptions are foreign to the true meaning and purpose of the older law, while allowing, on the other hand, that, on the average, Christians, too, fall short of their evangelical ideals.

This crisis in Robert's theory of religions forces him to take a second look at his Christology, where he finds another reason for the *cessatio legalium*. In an attempt to show the exclusivity of Christianity after its effective promulgation, Robert brings a final revision to the parable:

> On the second point consider an example like the following: If someone were ruler of the world and you were to offend against the law of his kingdom and you were thrown into prison by his minister who would prefer to execute you, and if then you would cry out to the king's mercy, and he himself would take note of your misery and outcry and would take action from a remote corner of the world, wanting to free you altogether but only in a legal way, which requires his own presence, then he would send you a document of his certain promise, so that you could hold out in patience until he would come. After he had come and freed you, you wouldn't care any longer about the document. So it is in the matter before us: the monarch of the world is God acting already from afar before the incarnation; the sinner against the law of his kingdom is of course humankind; the jailer so hateful of humankind is the devil; God's document sent to humankind is the written law (of the first covenant); and liberation is the incarnation of Christ.[65]

To explicate convincingly this close an association of liberation and the Incarnation, Robert would have had to return to that point of his Christology which he had left unclear: what the necessary relation was between Christ and every form of internal liberation. The late and sudden verge toward a negative evaluation of even the pre-Christian phase of other religions was motivated by largely unnamed factors, involving the superiority of the newer covenant, more important in the hierarchy of truth-claims than what had changed. They now demanded a thematic discussion, not unlike the return today to Christology from the theology of religions. For Robert Kilwardby, this was not to be. At the end of what might have been less than five years as a professor of theology, a promising career was abruptly cut short. In September of 1261, the first

definite date in his biography, Robert Kilwardby was elected Provincial of the English province.

<div style="text-align:center">NOTES</div>

1. Cf. M. Heidegger, *Sein und Zeit* (Tübingen, 1972[12]) § 32, 148–53.
2. Referring to Thomas S. Kuhn, *The Structure of Scientific Revolutions* (Chicago, 1970[2]); cf. *Das neue Paradigma von Theologie. Strukturen und Dimensionen*, ed. Hans Küng and David Tracy (Oekumenische Theologie 13, Gütersloh, 1986).
3. Cf. R. Schenk, "Keine *unica vera religio?* Die Wahrheitsproblematik der pluralistischen Religionstheologien," in *Wahrheit. Recherchen zwischen Hochscholastik und Postmoderne*, ed. Thomas Eggensberger and Ulrich Engel (Walberberger Studien, Philosophische Reihe 9, Mainz, 1995), 167–85.
4. Langdon Gilkey, "Plurality and Its Theological Implications," in *The Myth of Christian Uniqueness. Toward a Pluralistic Theology of Religions*, ed. John Hick and Paul F. Knitter (New York, 1994[4]), 37–50.
5. Cf. R. Schenk, "Die Suche nach einer widerspruchsfähigen Ambivalenz. Wahrheitsparadigmen als ein Unterscheidungsmerkmal von Religionstheologien christlicher Provenienz," in *Die spekulative Philosophie der Weltreligionen. Ein Beitrag zum Gespräch der Weltreligionen im Vorfeld der EXPO 2000 Hannover*, ed. P. Koslowski (Vienna, 1997), 59–90.
6. John Hick, *The Metaphor of God Incarnate. Christology in a Pluralistic Age* (Louisville, 1994), 1–14.
7. Cf. *Der einzige Weg zum Heil?*, ed. M. von Brück and J. Werbick (Quaestiones disputatae 143, Freiburg, 1993); and Ulrich Ruh, "Selbstrelativierung kein Ausweg. Ansatz und Probleme einer pluralistischen Religionstheologie," *Herder Korrespondenz* (48) 1994: 576–80.
8. Robert Kilwardby, *Quaestiones in quattuor libros Sententiarum*, Bayerische Akademie der Wissenschaften: Veröffentlichungen der Kommission für die Herausgabe ungedruckter Texte aus der mittelalterlichen Geisteswelt, 10, 12, 13, 16, 17, 19 (Munich, 1982–95): *Quaestiones in librum primum Sententiarum*, ed. Johannes Schneider (Bd. 13, 1986); *Quaestiones in librum secundum Sententiarum*, ed. by Gerhard Leibold (Bd. 16, 1992; this edition is hereafter cited as "II"); *Quaestiones in librum tertium Sententiarum*, Teil 1: Christologie, ed. by Elisabeth Gössmann (Bd. 10, 1982; hereafter cited as "III/1"); *Quaestiones in librum tertium Sententiarum*, Teil 2: Tugendlehre, ed. by Gerhard Leibold (Bd. 12, 1985; hereafter cited as "III/2"); *Quaestiones in librum quartum Sententiarum*, ed. by Richard Schenk (Bd. 17, 1993; hereafter cited as "IV"). On the chronological order of Kilwardby's questions, see Schenk, "Einleitung," IV: 46*.
9. See the introductions to these volumes.
10. See Schenk, "Einleitung," IV: 63*.
11. Ibid., 64*.
12. Cf. A. Dondaine, "*De necessitate incarnationis* de Robert Kilwardby," RTAM 8 (1936): 97–100; and Schenk, "Einleitung," IV: 53*.
13. Oxford, Merton College, Codex L. 1. 3 (Coxe 131) fol. 220[rb] (= M); Chartres 389, fol. 198[rb] (= C): "Ad hoc sume (C: est; M: *add.* tale) exemplum: pone regem, cuius populus praeva-[M 220[va]] -ricatus fuerit, et pro satisfactione iuxta iustae legis decretum quilibet teneatur regi talentum dare, et quod quotienscumque aliquis deliquerit talentum (M: *add.* pro satisfactione) debeat, quod quicumque non solverit incarceretur perpetuo et omnia bona amittat, et hoc ex decreto iustae legis ut prius. Pone simul (C: etiam) quod non sit talentum nisi unicum et illud (C: *add.* sit) in thesauris regis. Constat (C: Patet) iam quod nullus de tali populo satisfacere potest (M: potest satisfacere) nisi de regis misericordia qui talentum habet. Esto igitur (M: ergo) quod rex tantus fuerit [C: *add.* iustitiae] zelator quod noluerit (M: voluerit) aliquem praevaricantem reconciliari aliter quam secundum formam legis praedictae. Restat ergo quod aut populus praevaricans carcere et bonorum amissione damnetur aut quod rex talentum suum (C: suum talentum) communicando populi misereatur. Pone igitur (M: ergo) quod rex pius populi misertus omnibus eius imploribus misericordiam suum donet talentum pro se (M: *add.* ipsi) eidem regi offerendum; ita videlicet ut sit donum perpetuum omnium populi sui (M: sui populi) ex corde ad ipsum conversorum et ipsum amantium et hoc per singulas generationes, ut quicumque in legem regis prae-

dicto modo deliquerit pro carcere et bonorum amissione vitandis regi regium offerat talentum in satis-factionem. Constat tunc quod nullus sit in tali populo praevaricator qui non habeat donum quo regem placet si voluerit, qui autem donum regis ad hoc constitutum ut pro omnibus et singulis satisfiat contemnit, merito et pro satisfactione non reddita vel non facta [M: *om.* non reddita vel non facta] et pro contemptu tantae misericordiae damnabitur (C: condemnabitur). Sic est in proposito (C: hic) et patet (M: *add.* per se) adaptatio. Vide ergo quam misericorditer (M: add. et quam utiliter) sacramentum illud institutum [C: *del.* institutum; *add.* altaris scilicet institutum] est in quo populus Dei hoc donum satisfactorium scilicet Christum semper habet offe(re)ndum et semper offertum in satisfactionem suorum peccatorum. Ex his patet quomodo in uno Christo sufficientiam habemus redemptionis et liberationis et satisfactionis et quoad infinitos etiam homines et infinita peccata (C: *om.* est . . . pec-cata)".

14. Robert Kilwardby, *In III Sent.* q.48 corp. (III/1: 231, lin. 86–88).

15. See Robert Kilwardby, *In II Sent.* q.106 (II: 115 f., and especially 281f. [nota post ad 1 sed contra] lin. 39–51) where the assurance given implicitly along with the spirit and age of penance is shown to imply the promise both of future justification and of the mediator necessary for this. The "tempus merendi per poenitentiam," described as a gift of God, refers to the pre-Christian period. The tension between this confidence immanent in the penitential spirit and merit of the pre-Christian age and that need for a mediator which is rooted in the insufficiency of the merits of human penance anticipates the problematic which will become more evident as Kilwardby's *Quaestiones* progress: "Ex hoc nota quod sequitur, scilicet ex quo Deus dedit homini tempus merendi per poenitentiam, debuit ex sua iustitia aliquando eum liberare a poena. Culpae enim temporali debetur poena temporalis. Non enim esset iustum ut quem a culpa per poenitentiam liberaret, aeternaliter pro illa affligeret. Poeniten-tiam autem dedit ei Deus ad culpae satisfactionem. Praeterea si poenitentia illa fuit homini meritoria, alioquin non magis concessisset Deus homini tempus poenitendi quam angelo, statum autem meriti debet sequi status praemii, sequitur quod a statu isto aliquando transferri debuit ad praemium. Sed hoc non posset nisi prius culpa dimissa fuisset. Aut ergo debuit Deus culpam omnino dimittere aut aliquis debuit pro eo satisfacere. Sed omnino dimittere fuit contra iustitiam. Ergo necesse fuit aliquem pro culpa satisfacere. Sed homo non habuit unde satisfaceret, ut probat Anselmus in libro *Cur Deus homo.* Ergo necesse fuit per Deum fieri satisfactionem, et sic Deum incarnari."

16. Robert Kilwardby, *In III Sent.* q.48 corp. (III/1: 236f., lin. 239–56): "Haec in parabola aliqua-tenus videri possunt tali: Esto quod aliquis servus gravissime delinquat et dominum suum damnificet ultra quam restituere possit ipse vel aliquis suorum, dominus autem licet iuste posset eum perpetuo exhaeredare et interficere, nolit tamen ex misericordia, immo ad preces eius motus ignoscat ei offen-sam suam, dum tamen restituat quod abstulit, dicens: 'Offensam meam remitto, ita tamen quod satis-facias de damno quod fecisti. Sed antequam tu satisfeceris pro damno facto vel aliquis pro te, numquam intrabis haereditatem tuam, sed expectabis interim in carcere.' Esto quod respondeat servus: 'Domine, nosti quod tunc semper exhaeredabor et incarcerabor, quia mihi et meis est impossibilis satisfactio. Rogo te miserere mei, et si omnino vis pro me fieri iustam satisfactionem, provide quis eam faciat, et mihi ratum erit factum eius.' Esto quod dominus misericors dicat: 'Ego absque dubio providebo, dum-modo te videam fideliter de cetero me diligere et credere quod hoc velim et possim, et expectare pa-tienter, donec placuerit mihi liberare te et mittere qui satisfaciat pro te. Si enim haec feceris, mittam tempore opportuno tui liberatorem et pro te satisfactorem, et cum ipse satisfecerit, egredieris de car-cere et haereditatem tuam intrabis.' Adapta tu ad omnia praecedentia circumquaque simile."

17. This corresponds to Question 48 of the edition, Kilwardby, *In III Sent.* (III/1: 228f.).

18. Robert Kilwardby, *In III Sent.* q.47 corp. (III/1: 225, lin. 218): "Poena absolute nullum sublevat a culpa in gratiam."

19. *In III Sent.* q.48 corp. (III/1: 231f., lin. 96–109): "Exemplum. Si quis incarceraverit servum pro delicto suo et posset eum de iure semper in carcere tenere, sed tamen misertus eius spondet ei libera-tionem aliquando et pignus sive signum futurae liberationis ei donat, profecto non potest postea de iure ab eo exigere perpetuitatem carceris, sed iniuria erit si fecerit, quare nec ille servus debet eam.

Nec potes dicere quod pignus sive arra Dei in fide, spe et caritate non sit certa et firma, quia cum dona Dei non sint inania, quod ab illo credi et sperari datum est, eveniet absque dubio. Alioquin enim si crederetur vel speraretur quod numquam eveniret, error esset et deceptio, quod in donis Dei contin-gere est impossibile. Sequitur igitur quod poenitens aliquando liberabitur, et quia ex Dei sponsione in arra vel pignore dato facta est remissio perpetuitatis poenae, non tenetur ille cui facta est sponsio, ad eandem dummodo arram vel pignus susceptum servaverit."

20. Ibid. (III/1: 235, lin. 206 f.).

21. *In III Sent.* q.48 ad 1 (III/1: 233, lin. 139–45).

22. *In III Sent.* q.48 ad 1 and ad 2 (III/1: 233, lin. 146–60): "Dato quod non venisset Mediator, sequitur quod Adam semper mansisset in poenis, sed non sequitur vi suae rationis quod deberet aeternam poenam, supposita, dico, sua poenitentia praecedente, quia illud argumentum non valet: 'Iste permanet in poena sibi debita, sed permanet in poena perpetua, ergo ei debetur perpetua'; sicut nec hic: 'Esto quod aliquis mereatur carcerem ad tempus, sed a tyranno detineatur in perpetuo carcere, verum est quod iste tenetur in carcere merito'. Sed non sequitur quod meruit perpetuum, quamvis sit in perpetuo. Est enim figura dictionis ex commutatione quid in quando vel quantum. Potest etiam ibidem congrue assignari accidens, quia aliter est carcer tali delinquenti debitus et aliter perpetuus, et ideo variatur medium. Similis est responsio ad secundum. Concedendum enim est quod passio Christi solos poenitentes liberat et a poena debita. Sed non sequitur propter hoc, cum liberet a poena aeterna, quod poenitentes tenentur ad aeternam, ratione praehabita. Sed liberat ab aeterna, hoc est ab illa quae foret aeterna nisi liberaret. Sed si non liberaret, cum praecesserit donum poenitentiae, iniuriaretur illis."

23. Cf. Kilwardby's point that "poena absolute nullum sublevat a culpa in gratiam" (q.47 corp.; III/1: 225, l. 218) with Thomas Aquinas, ST 3 q.14 a.1 ad 1 (" . . . non enim esset satisfactio efficax nisi ex caritate procederet"); and Bonaventura, *In III Sent.* d.15 a.1 qq.1–3 (Quaracchi Edition 3: 330–35).

24. Robert Kilwardby, *In III Sent.* q.47, from ad 2 onwards (III/1: 223–27).

25. *In III Sent.* q.49 corp. (III/1: 240, lin. 66f.)

26. Ibid.

27. *In III Sent.* q.46 corp.(III/1: 199, lin. 152f.)

28. *In III Sent.* q.8a corp. (III/1: 39, lin. 97f.)

29. *In III Sent.* q.31 ad 4 (III/1: 135–37).

30. Cf. Peter Lombard, *Sententiae* 3 d.3 c.3 (Quaracchi Edition 2: 34f.).

31. Richard Fishacre, *In IV Sent.* (Cambridge, Gonville and Caius, Ms. 329, fol. 360ra). Fishacre refers to a text by Hugh of St. Victor, which seems to support his preference for tithing: *De sacramentis*, Bk.1, pars 6, c.3 (PL 176: 448 D): "Sub lege naturali primum data sunt sacramenta decimationes, sacrificia et oblationes, ut in decimatione peccatorum remissio, in sacrificiis carnis mortificatio, in oblatione boni operis exhibitio significaretur." Kilwardby simply leaves the question open. Kilwardby argues that none of the sacraments of natural religion was instituted by God, despite his hidden inspiration and consolation in them, so that the meanings of different practices fluctuated, as did their interpretation by Christian theologians, even within Hugh's work (cf. *In IV Sent.* q.12 ad 1; IV: 50, lin. 10–24). And yet it is clear from his statements here and at *In IV Sent* q.8 corp. (IV: 40f., lin. 23–32) that Kilwardby sees tithing as the least likely sacrament of initiation and justification.

32. *In III Sent.* q.35 passim (III/1: 144–59).

33. Cf. *In III Sent.* q.35c corp. (III/1: 149, ad lin. 151).

34. Ibid. (III/1: 150, lin. 171f.)

35. Ibid. (III/1: 148, lin. 122–26).

36. Robert Grosseteste, *De cessatione legalium*, ed. Richard C. Dales and Edward B. King, Auctores Britannici Medii Aevi 7 (London, 1986). Grosseteste's insistence on the heretical nature of the Jewish religion posed the threat of eminently practical consequences.

37. E. M. Sommer-Seckendorff, *Studies in the Life of Robert Kilwardby* (Institutum Historicum Fratrum Praedicatorum, Dissertationes Historicae 8, Rome 1937).

38. W. A. Hinnebusch, *The Early English Friars Preachers* (Dissertationes Historicae 16, Rome 1951), 29.

39. CUP 1: 272–76: "Errores 31 a quibusdam magistris theologiae Parisiensibus ex Introductorio in Evangelium aeternum a. D. 1254 excerptos", for example: " . . . quod novum Testamentum est evacuandum, sicut vetus est evacuatum; quod evangelio Christi aliud evangelium succedet; quod sicut veniente Johanne Baptista ea que precesserant reputata sunt vetera propter nova supervenientia, ita adveniente tempore Spiritus Sancti sive tertio statu mundi ea que precesserant reputabuntur vetera propter nova que supervenient. Et ex hoc datur intelligi quod novum Testamentum reputabitur vetus et proicietur; quod sacramenta nove legis evacuabuntur in tertio statu mundi, et per evacuationem sacramenti altaris infert evacuationem aliorum sacramentorum; quod sacramenta nove legis non durabunt amodo, nisi per sex annos proximo futuros, id est usque ad annum Incarnationis MCCLX"; cf. H. Denifle, "Das Evangelium aeternum und die Commission zu Anagni", *Archiv für Literatur- und Kirchengeschichte des Mittelalters* 1 (1885): 49–98; Denifle, "Protokoll der Commission zu Anagni," ibid., 99–164.

40. Robert Kilwardby, *In III Sent.* q.8 sed c. (III/2: 34, lin. 18).

41. *In III Sent.* q.8 corp. (III/2: 35).

42. Cf. Schenk, "Einleitung," IV: 33*–71*.

43. For the pre-history of the ambivalence of the *figura-veritas*-model, which could serve the purposes of both sides of the debate, see the magisterial study of Yves Congar, "Ecclesia ab Abel," in *Abhandlungen über Theologie und Kirche. Festschrift für Karl Adam*, ed. M. Reding, (Düsseldorf, 1952), 79–108, reprinted in Yves Congar, *Etudes d'ecclésiologie médiévale* (Variorum CS 168, London, 1983), item II.

44. R. Schenk, "*Divina simulatio irae et dissimulatio pietatis*. Divine Providence and Natural Religion in Robert Kilwardby's Quaestiones in librum IV Sententiarum," in *Mensch und Natur im Mittelalter*, ed. A. Zimmermann (Miscellanea Mediaevalia 21,1, Berlin/New York, 1991), 431–55.

45. R. Schenk, "Covenant Initiation. Robert Kilwardby and Thomas Aquinas on the Sacrament of Circumcision," in *Ordo sapientiae et amoris: Image et message de saint Thomas à travers les récentes études historiques, herméneutiques et doctrinales. Hommage au Professeur J.-P. Torrell*, ed. C.-J. Pinto de Oliveira (Studia Friburgensia N.S. 78, Fribourg, 1993), 555–94; idem, "Die Suche nach dem Bruder Abel. Zum Streit um das analoge Sakramentsverständnis," *Jahrbuch für Philosophie des Forschungsinstituts für Philosophie Hannover* Band 5, 1994, ed. P. Koslowski, R. Löw, R. Schenk (Vienna, 1993), 69–87.

46. Bonaventura, *In III Sent.* d.40, dubium 3 (Quaracchi Edition 3: 893–96).

47. Kilwardby, *In IV Sent.* q.39 corp. (IV: 202, lin. 151–153): "Et ponunt exemplum tale: Litterae regis liberant de carcere non per aliquam virtutem illis insitam quae procedat ad liberandos solvendos et extrahendos, sed per significativam potentiam quae est relativa et instituta ad hoc."

48. Cf. *In IV Sent.* qq.39–40 (IV: 191–219).

49. For the following, see Schenk, "Covenant Initiation," "Die Suche nach dem Bruder Abel," and "Opfer und Opferkritik aus der Sicht römisch-katholischer Theologie," in *Zur Theorie des Opfers*, ed. R. Schenk et al (Stuttgart-Bad Cannstatt, 1995), 193–250.

50. Thomas Aquinas, *In IV Sent.* d.1 q.1 a.5 q.1 corp. (*Scriptum* 4: 41): "excepta circumcisione."

51. Cf. Schenk, "Opfer," 203.

52. See Schenk, "*Divina simulatio irae et dissimulatio pietatis.*"

53. Cf. Kilwardby, *In IV Sent.* q.4b ad 2 (IV: 25). At the request of the editors, the letters from our edition have been added here to the numbers provided in the manuscripts to help to identify the set of subquestions cited. On the structure of Robert's questions cf. E. Gössmann's introduction to III/1, 17*–36*.

54. *In IV Sent.* q.4b corp. (IV: 19, lin. 136–38): "Hoc enim dictat aeterna veritas humanae conscientiae, quod iustitia Dei non punit aeternaliter, cui sua misericordia praestitit paenitentiam de peccatis commissis."

55. Cf. Schenk, "*Divina simulatio*," 450f.

56. Cf. Schenk, "Einleitung," IV: 67f.

57. Cf. Schenk, "Covenant Initiation," 578.

58. Kilwardby, *In IV Sent.* q.27 ob.1 (IV: 100, lin. 7–10): " . . . res tunc praesens eis contenta et effecta: iustificatio ab originali peccato; distinctio populi a populo per sensibilem characterem; unitas interior fidei et concors exterior ritus in observantia legali."

59. *In IV Sent.* q.28 ad 3 (IV: 104, lin. 79).

60. *In IV Sent.* qq.43–51 passim (IV: 231–51).

61. *In IV Sent.* q.37 ad 7 (IV: 160, lin. 187–97): "Ex his satis patet, quod, sicut duo parietes uniuntur in uno angulo, sic duo populi gentium et Iudaeorum in Christo per conformitatem sacramentorum et morum. Et hoc congruum est, quod tempus gratiae sit tempus unitatis in cultu Dei et tempus praecedens multitudinis, quia ad unam civitatem per multas vias tenditur, sic ad civitatem Christianae religionis quae est finis et complementum omnis religionis in via. Item. Primo sunt partes domus segregatae abinvicem et diversas formas habent, donec in unam formam unius domus copulentur; sic in proposito: quia religio Christiana est domus inhabitationis Dei, ad quam sumuntur gentes ex omni ritu quae prius erant in modo venerandi Deum segregatae, sed sub fide catholica in uno modo catholico uniuntur."

62. For the repeated references to the common majority cf. the note to *In IV Sent.* q.43 corp. (IV: 232, lin. 32f.)

63. Cf. "*Divina simulatio.*" On the self-corrective intent of the charge of idolatry raised against others, cf. R. Schenk, "Götzendienst oder Gottesdienst? Gegenwart und Abwesenheit Gottes in den Religionen im Lichte des ersten Gebots," in *Jahrbuch für Philosophie des Forschungsinstituts für Philosophie Hannover*, Band 6, 1995, ed. R. Schenk, P. Koslowski and R. Löw (Vienna, 1994), 169–181.

64. Kilwardby, *In IV Sent.* q.4g, nota post corp. (IV: 24, lin. 281–86).

65. Kilwardby, *In IV Sent.* q.37a corp. (IV: 155, lin. 55–66): "De secundo exemplum tale: Si unus

aliquis esset mundi monarcha, et tu offenderes contra legem regni sui et mittereris in carcerem ab eius ministro qui vellet te interficere, et tu clamares ad regis misericordiam, et ipse attendens tuam miseriam et clamorem ageret in ultimis partibus orbis et volens te liberare omnino, sed solum per viam iustitiae, quod fieri non posset nisi per sui ipsius praesentiam, mitteret tibi chartam suae certissimae promissionis, quod tu sustineres patienter usque ad eius adventum et ipse pro certo te liberaret. Si inquam ita esset, diligenter interim chartam eius custodires donec ille veniret, sed postquam ille venisset et liberasset, de charta non amplius curares. Sic in proposito: monarcha mundi, Deus adhuc longe agens ante incarnationem; peccator in legem regni sui, homo: carcerarius eius hominem odiens, diabolus; charta Dei homini missa, lex scripta; liberatio, Christi incarnatio."

Albert the Great on Christ and Hierarchy

Edward P. Mahoney

A CENTRAL, THOUGH not exclusive, purpose of this essay is to explore the ways in which Albert the Great brought together a conceptual scheme of metaphysical hierarchy that he sets forth in some of his works with his views on the nature and role of Christ in the universe of being. My use of the word "hierarchy" in the title of this essay, however, is deliberately ambiguous, for I shall also refer to Albert's use of the term in regard to the angels and the Church, that is, to the celestial hierarchy and the ecclesiastical hierarchy. Indeed, Albert wrote commentaries on the *De coelesti hierarchia* and *De ecclesiastica hierarchia* by pseudo-Dionysius the Areopagite;[1] he also carefully studied and wrote a commentary on Dionysius's *De divinis nominibus*, which contains elements of a conceptual scheme of metaphysical hierarchy. That scheme was adopted and elaborated upon not only by Albert but also by Thomas Aquinas and such other medieval and Renaissance thinkers as Siger of Brabant, Giles of Rome, Henry of Ghent, Marsilio Ficino, Agostino Nifo, Pietro Pomponazzi and Marcantonio Zimara.[2] Accordingly, my use of the term "hierarchy" in the title of my essay is meant to capture these various senses of the word, as it refers to the angelic and ecclesiastical hierarchies and to the hierarchy of being. Indeed, I would suggest that one cannot at all understand Albert's views on the angelic hierarchies if one does not understand his conception of the hierarchy of being, which is often referred to as the "Great Chain of Being," a phrase made famous by Arthur Lovejoy's book.[3] Some medieval and Renaissance philosophers in fact used the term "golden chain" to refer to the hierarchy of being.[4]

My intention, then, is to see how Albert reconciles his theological views on Christ, the God-Man, with his hierarchical vision of reality. One approach in medieval Christology, which was taken, for example, by Bonaventure and Nicholas of Cusa, makes Christ an element in the ontological structure of reality.[5] Albert clearly does not adopt such an approach—what we might call the concept of "the cosmic Christ"—though he does relate Christ to the hierarchy of being as well as to the angelic and the ecclesiastical hierarchies. What should become clear is that Albert pays a great deal of attention to the Virgin Mary, setting forth in a particular fashion her relation to the angels.[6] Albert's Christology has a striking Marian element that no doubt reflects his strong personal devotion to Mary as well as the prayer life of the religious order to which he belonged. His statement that Mary leads us to Jesus and Jesus leads us to the Father might encourage some to see here an anticipation of the more recent Marian doctrines of a Louis-Marie Grignion de Montfort or a William Joseph Chaminade. In fact, Albert is simply following an idea that presumably he gathered from Bernard of Clairvaux.[7]

The central role played by Christ in Albert's conceptions of the celestial and ecclesiastical hierarchies will be clear in our sketch. With respect to the celestial hierarchy, what must be emphasized is that although Christ is genuinely human—his soul and

body are creaturely—Albert places him above the angels in the hierarchical structure of reality. It is especially noteworthy that he also places the Virgin Mary above the angels. Similarly, although Albert makes much of the hierarchical nature of the Church, in his analysis of the ecclesiastical hierarchy in terms of the seven "orders" it is in fact Christ who is the center of attention. Albert's focus is on the priesthood and its two basic activities, namely, celebrating the Eucharist, which involves the real body of Christ, and exercising the power of binding and loosening sins, which relates to the mystical body of Christ. There is thus a Christocentric orientation to Albert's conception of both the celestial and ecclesiastical hierarchies. It is significant that Albert seems uninterested in the so-called "legal hierarchy," a term used by pseudo-Dionysius to refer to the hierarchy to be discerned in the Jewish Scriptures, or Old Testament. That hierarchy anticipated the ecclesiastical hierarchy founded by Christ, which, as Albert understands it, is alluded to in the New Testament.[8]

THE HIERARCHY OF BEING

Albert the Great was one of the first philosopher-theologians of the thirteenth century to adopt a conceptual scheme of metaphysical hierarchy that had its roots in the writings of Proclus, pseudo-Dionysius and the *Liber de causis,* as well as in some relevant texts in works by Avicenna.[9] The young Thomas Aquinas, one might add, evidently learned about this scheme during the time that he spent at Cologne following Albert's lectures on Dionysius's *De divinis nominibus.*[10]

In *De divinis nominibus,* Dionysius presents God as the measure (*metron*) and number (*arithmos*) of all other things, including those things in the celestial and ecclesiastical hierarchies. The inequality among the Intelligences is the result of their degree of participation in God, which is itself determined by the Divine Ideas and Wishes.[11] According to the degree and rank that it has as a result of its 'falling away' from God, an Intelligence receives more or less purification, illumination and perfection from God. These three divine operations—purifying, illuminating and perfecting—vary in intensity among the members of the celestial hierarchy according to their greater or lesser capacity to receive these operations.[12] The Intelligences also differ in metaphysical ranking according to the variation in their mode of cognition, that is, their intelligible species or intelligible forms, and also in their intelligible objects.[13] By a law of continuity, Dionysius declares, the lowest in a higher rank touches the highest in a lower rank. Key ideas of Dionysius concerning metaphysical hierarchy were anticipated by Proclus in his *Elements of Theology,* which was translated into Latin by William of Moerbeke after Albert wrote his commentary on Dionysius's *De divinis nominibus.*[14] On the other hand, Albert knew well the Latin translation of the *Liber de causis,* which was to some extent dependent on Proclus and which speaks of God as the One and as pure Being. Beings other than God participate in unity. The closeness (*propinquitas*) of a thing to God determines the mode of its existence. Accordingly, Intelligences closer to God are simpler and have greater power. The *Liber* likewise speaks of God as the measure (*mensura*) of all sensible and intelligible things.[15]

Albert probably composed his commentary on Dionysius's *De divinis nominibus* around 1250. In this work, he states that God is called the measure (*mensura*) of being

because he is a simple essence (*simplex essentia*). Each thing participates more or less in being ("unumquodque magis et minus participat de esse") according as it approaches the likeness of God ("secundum quod accedit ad similitudinem eius"). For Albert, the notion of metaphysical hierarchy and the doctrine of participation are wedded together, just as they would be for Thomas Aquinas and many other medieval philosophers. God alone does not have his existence from another, since he does not participate in existence but is existence itself. All other things have existence (*habent esse*) by participation, and that existence is a certain mode of existing (*modus essendi*).[16] The more things participate in God the closer (*propinquiora*) they are to him.[17] Moreover, the closer an Intelligence is to God and the more it recedes from matter the greater is the universality of its cognition.[18]

Not surprisingly, Albert's adoption of this conceptual scheme of metaphysical hierarchy, culled from pseudo-Dionysius and the *Liber de causis*, is also to be found in his paraphrase-commentary of the latter work, titled *De causis et processu universitatis a prima causa*. Here the language of *gradus* and *mensura* is in evidence.[19] Elements of the hierarchical scheme appear in Albert's *Summa theologiae*,[20] and there are also references to it in his earlier commentary on the first book of Peter Lombard's *Sentences*.[21] Indeed, in his commentary on Aristotle's *Metaphysics*, Albert even appears to attribute the scheme to Averroës.[22]

CHRIST AND THE CELESTIAL HIERARCHIES

In his *Summa theologiae*, his commentary on the second book of the *Sentences*, and in his *Summa de creaturis*, Albert discusses various definitions of hierarchy that he gleaned from the writings of pseudo-Dionysius.[23] The first is drawn from the third chapter of *De coelesti hierarchia*, where Dionysius states: "According to me a hierarchy is a sacred order (*ordo divinus*), a state of understanding and an action approximating as much as possible to the divine form and which ascends in a proportionate manner to the likeness (*similitudo*) of God by illuminations divinely given to it."[24] The second definition is taken from the same chapter in *De coelesti hierarchia*: "Whoever says 'hierarchy' means universally a certain sacred arrangement (*dispositio*), an image of divine beauty (*speciositas*) that makes sacred (*sacrificans*) the mysteries of its own illumination in hierarchic orders (*ordines*) and states of knowledge (*scientiae hierarchicae*) and that has been assimilated—as this is allowable (*ut licet*)—to its own source (*principium*)."[25] Albert offers a third definition given by *antiqui magistri*, which states that "hierarchy is the ordered power (*ordinata potestas*) of sacred and rational beings who hold fast rule (*dominatus*) over their subjects (*subditi*)." Albert explains that the first definition sets forth the essential elements of hierarchy and its proper effect on the substances that are within it. Following Dionysius, he singles out order (*ordo*), knowledge (*scientia*) and action (*actio*) as being of the very essence of hierarchy: they account for something becoming like God. It seems noteworthy that in his discussions regarding the three definitions, Albert adopts grade language (*gradus*) and conceives hierarchy as a *totum potestativum*, a conception and a corresponding terminology that he consistently uses when discussing the human soul.[26] One should note that Réné

Roques gives these same two definitions in the introduction to his magisterial work on Dionysius's hierarchical thought.[27]

Examining these definitions more closely, Albert judges that each of them regards hierarchy as it is common to both the angelic and human hierarchies. The last hierarchy is the ecclesiastical hierarchy, which Albert also calls "our hierarchy." In his *Summa de creaturis*, he states that these definitions concern the angelic and human hierarchies but are inapplicable to the divine hierarchy, since they refer to assimilation to, or union with, the divine hierarchy, which cannot itself be assimilated to anything further.[28] However, Albert goes on to suggest that, although Dionysius divides hierarchy only into the angelic and the human, if the term 'hierarchy' be taken as sacred rule (*sacer principatus*) then it can be divided thrice, into the divine, angelic and human hierarchies. These are commonly referred to as the supercelestial hierarchy (*hierarchia supercoelestis*) or divine hierarchy, the celestial hierarchy (*hierarchia coelestis*), and the subcelestial hierarchy (*hierarchia subcoelestis*).[29] In his commentary on the second book of the *Sentences*, Albert states clearly that Dionysius himself did not recognize a supercelestial or divine hierarchy.[30]

Albert relies on the authority of Hugh of Saint-Victor to set down the two things that constitute the essence of hierarchy, namely, participation in the grace of illumination ("participatio gratiae illuminationis") and in turn the pouring forth of that illumination on lower things ("effusio ipsius super inferiora"). The essential elements of hierarchy, namely order (*ordo*), science (*scientia*) and action (*actio*), are connected to the dynamic of being illuminated and in turn illuminating. Three things are required for participation in illumination: (1) conversion (*conversio*) to the principle of illumination, which is 'order'; (2) the reception of light (*receptio luminis*), which is 'knowledge'; (3) perfection in regard to the illumination received, which involves the 'action' of pouring forth infusions of illumination (*infusiones illuminationis*) on lower beings. Albert refers to this as the perfection of the hierarchy or the act of the hierarchy ("perfectio hierarchiac sive actus hierarchiae").[31] Purging, illuminating and perfecting are, of course, the basic hierarchical acts according to Dionysius.[32] Among these, Albert considers illumination to dominate; indeed, this act explains the other two hierarchic acts of purging and perfecting.[33] Albert is careful to point out that the ascension (*ascensus*) brought about in the angels when they are elevated to a greater clarity of illumination does not involve their rising up to a higher level or grade of dignity (*gradus dignitatis*) in a hierarchy; rather, their 'ascension' refers to the mode of participation in the theophany ("modus participationis theophaniae") that is transferred from higher to lower angels.[34]

Albert explains that Dionysius's division of the celestial hierarchies is made according to the diversity of illuminations received by the angels, which varies according to each angel's faculty or capacity for receiving illumination ("facultas recipiendi illuminationem"). The angelic intellect surpasses the human intellect but is less than the divine intellect. Albert interprets Dionysius as distinguishing three hierarchies of angels according to the mode in which they are related to the human and divine intellects. The angel can be taken as the *medium* in itself or as in some way touching on one of the extremes (*contingens extrema*) between which it is situated; thus there is a

superior (*suprema*), middle (*media*) and inferior (*inferior*) hierarchy among the angels. The three hierarchies remain interconnected insofar as all three involve 'order', 'knowledge' and 'action'; they differ in their mode of receiving illuminations.[35]

In his *Summa de creaturis* and in his *Summa theologiae*, Albert examines in great detail the various orders (*ordines*) found in the three angelic hierarchies. The superior or first hierarchy is composed of the three orders of Seraphim, Cherubim and Thrones. The Seraphim is characterized by ardor of charity (*caritas*) while the Cherubim is characterized by the fullness of its knowledge (*scientia*). Among the gifts, love or charity holds the first grade or rank (*primus gradus*) in dignity (*dignitas*) while knowledge holds the second grade or rank (*secundus gradus*) in dignity.[36] Regarding such terminology one might well observe that when Albert later discusses the order of the universe (*ordo in universo*) he again refers to *gradus dignitatis* and cites Augustine from *De civitate dei* (book 12, chapter 2) as stating that God orders natures in grades of essences (*essentiarum gradus*).[37] The three orders of the middle hierarchy are the Dominations (*Dominationes*), Virtues (*Virtutes*) and Powers (*Potestates*), all of which are mentioned in the Epistle to Ephesians (1:21).[38] Albert takes these three orders to involve three grades (*gradus*) of the power of majesty (*potentia majestatis*) that moves and governs the world.[39] The third and lowest of the hierarchies, finally, includes the orders of Principalities (*Principatus*), Archangels (*Archangeli*) and Angels (*Angeli*). This hierarchy involves the accepting and then communicating of illumination.[40] Albert credits Dionysius with having proved through the canon of Scripture (*per canonem Bibliae*)— that is, by scriptural texts—that these three hierarchies exist. Albert remarks further that the first hierarchy is illuminated by God, the second by the first hierarchy and the third by the second hierarchy, and adds that the ecclesiastical hierarchy is illuminated by the third and lowest angelic hierarchy.[41]

What is for Albert the relationship between Christ and the celestial hierarchy? In his commentary on *De coelesti hierarchia*, Albert raises two relevant doubts concerning this question: (1) whether the angels cared for Christ and (2) whether Christ received illumination from them. Albert explains that because Christ was not someone who was weak and in danger from sin there was no need for angels to care for him, although they did care for him *per accidens* inasmuch as they instructed those human beings who were charged with caring for him. Christ himself did not wish to instruct them, since he wanted to exhibit the acts of a child during his boyhood years lest he seem to be an apparition (*phantasma*) and not a true human being (*verus homo*). Concerning the second doubt, Albert points out that the only knowledge that increased in Christ was that based on experience (*scientia experimentalis*), when he turned toward sensible things that he had not previously seen; for this kind of knowledge, Christ did not require illumination from an angel.[42] Nevertheless, Albert says, as a man Christ was subject to angelic orderings since he did not become incarnate in order to destroy the order of things (*ordo rerum*) but in order to repair every order.[43]

In his commentary on *De coelesti hierarchia*, Albert follows Dionysius when he explains that the "first essences" (*primae essentiae*), or highest angels, receive illuminations from Jesus. As they truly approach Jesus, the angels receive directly from God his deifying light; he makes them divine by participation (*participatio*). According to his humanity, Christ receives a divine light over all creatures.[44] And just as it is by

means of his human nature (*natura humana*) that Christ descends (*descendit*) by taking on flesh, so now he ascends (*ascendit*) according to that human nature ("secundum naturam humanitatis"), bearing flesh up with him. According to his divine nature ("secundum divinitatis naturam"), however, he remains ever with his Father. He is the lord (*dominus*) of the angels, the king (*rex*) and giver of glory (*dator gloriae*).[45] Albert also comments on why some have called Jesus an "angel." This is because the term 'angel' signifies those who accept illuminations from God and bear them to us, as did Christ.[46] In his treatise *De resurrectione*, Albert, citing Gregory the Great, explains how Christ, in regard to the office that he exercised when he was sent in the flesh, can be called an archangel (*archangelus*), that is, a prince of angels (*princeps angelorum*).[47]

Albert repeats these ideas in his treatise *De incarnatione*. In this text, he accepts the notion that Christ is the head of the angels, but he sets forth three possible meanings regarding the meaning of the term 'head' (*caput*). According to the first meaning, the term 'head' may be taken broadly as that which has the nature of a principle (*ratio principii*) in regard to those things which are ordered (*ordinantur*) to it. In this sense, Christ is the head of all creatures but so is the Father; the Father, however, is the principle (*principium*) of both Christ and creatures while Christ is the principle only of creatures. According to the second meaning, the term 'head' may be taken more broadly as the principle of some being that exists in conformity with the head. In this sense, Christ according to his divine nature is again said to be the head of the blessed and the angels ("caput beatorum et angelorum"), for they draw from him blessed and divine existence. According to the third meaning, the term 'head' is taken in its strict and proper sense, as the principle of a being which is in conformity with a head that exists with the same nature as its members. In this sense, Christ is said to be a 'head' inasmuch as he is one person in two natures: he is the principle of spiritual life through his divine nature (*divinitas*), and he is in conformity with his members through his human nature (*humanitas*).[48]

In a comprehensive fashion, Albert compares Christ's knowledge to that of God the Father and that of the angels. The uncreated intellectual power of the Father and the created intellectual power belonging to the created soul of Christ differ as regards the medium whereby each knows all things. The Father knows by Ideas that are the divine essence itself, while as man, that is, as a "wayfarer" (*viator*), Christ knows by way of created innate habits (*habitus creati*), which are similar to the Father's Ideas but are not as luminous because they are created. Having made this general distinction, Albert examines the question with greater precision, setting out six ways in which Christ possesses knowledge. First of all, he has the knowledge that belongs to a *viator* as *viator*. This knowledge is the same as that which was enjoyed by Adam, namely a knowledge of all natural things that enabled Adam to give names to all things according to their natures. Secondly, Christ has the knowledge that a *viator* acquires from sense experience. Thirdly, that same knowledge can also belong to Christ as a *comprehensor* by way of innate notions (*formae concreatae*) that are similar to the Ideas in the divine mind; such is the knowledge that the angels possess by nature. Fourthly, Christ can possess that same knowledge by way of a direct knowledge of the *Verbum*; such is the beatifying knowledge that is enjoyed by the blessed in heaven. Fifthly, considered as God alone, Christ possesses a divine knowledge whereby he knows all things by means

of himself. Sixthly, considered as a human being united with God, Christ has knowledge of all things in the *Verbum* with which his human nature is united. Albert is careful to note that Christ knew all things only in the fifth and sixth modes of cognition.[49] In a parallel discussion in his commentary on the third book of the *Sentences*, he points out that Christ's soul knows all things in the *Verbum* whereas the angels enjoy only innate knowledge.[50]

Throughout his writings, Albert states explicitly and authoritatively that Christ is above all the hierarchies of angels. More remarkably, perhaps, in many passages he states that the Virgin Mary also is above all of the angels. It is to some of these passages that we now turn.

The Virgin Mary and the Celestial Hierarchies

Albert's strong devotion to Mary is surely reflected in the range of honorific titles that he applies to her.[51] In the opening chapter of his commentary on the Gospel according to Luke, he explains that the name *Maria* can be taken to mean illuminator (*illuminatrix*), star (*stella*), bitter sea (*amarum mare*) and Lady (*Domina*). He commands his reader to invoke the Mother of God, to look to the illuminator and to call upon Mary whenever he is surrounded by darkness and his pathway is hidden; to look to the Star and call upon Mary whenever the winds of evil suggestions should arise; to raise his eyes to the Lord and invoke Mary if tribulations knock him down. Reflecting Bernard of Clairvaux, whom he mentions, Albert declares that Mary possesses in their fullness the seven grades (*gradus*) of virtue, namely faith, hope and charity as well as the cardinal virtues of practical wisdom (*prudentia*), temperance, fortitude and justice.[52] She is most solid in faith, most certain in hope, most fervent in charity, aided by grace above all others, and most perfect in blessedness.[53] In Mary's encounter with the angel Gabriel, light and mercy descend from God to Gabriel and from Gabriel to Mary and from her to the whole world.[54]

Mary is also said to be the flower of virgins (*flos virginum*), leader (*dux*) in the waves of temptations and thereby star of the sea (*stella maris*), lady (*domina*) and protector (*protectrix*) in tribulations, the sanctity of matrons and the example (*exemplum*) for the ministry of holy widows.[55] When the Gospel of Luke (2:35) states that a sword pierced Mary's heart, it likewise means, Albert explains, that it pierces the soul of the believer, who is Mary according as she is the image of the Church (*imago ecclesiae*).[56] Albert suggests that the Virgin Mary was chosen to be Mother of God because of the virtues that were found in her in an excellent fashion, disposing her *meritorie* to be so chosen.[57] He refers to her dignity as Mother of the Lord of all creatures ("dignitas matris Domini omnium creaturarum").[58] She had a special dignity of grace in being united with God.[59] Albert is careful to emphasize, however, that Mary did not *merit* being the Mother of God.[60] Indeed, she was affected by original sin and stood in need of sanctification by way of three purgations.[61]

The various honorific titles that Albert bestowed upon the Virgin Mary make evident the depth of his Marian devotion. What is central for us, however, is to determine the place that Mary holds in Albert's hierarchical discussions. In *De resurrectione*, he tells us that because of the special connection of the body of the Virgin Mary to the

body of Christ, Mary's resurrection precedes the common resurrection.[62] In *De incarnatione*, Albert relates the Virgin Mary to the angels, stating that in regard to the beatitude that she would eventually enjoy she was superior to every angel, although as regards beatitude during this life and the revelatory illuminations she received from the angels the situation was different.[63]

CHRIST, MARY AND THE THREE HEAVENS

In order to understand how Christ and Mary are above the angels, one should consider Albert's distinctions among different heavens. Like several other medieval writers, Albert speculated that there were at least two heavens beyond the firmament, namely an empyrean heaven and a heaven of the Trinity. When considering whether God is in things locally or by way of circumscription, he also addresses the question whether angels are in place. He cites as authorities both Bede and Walafrid Strabo (to whom he attributes the *Glossa ordinaria*), who explain that what is meant in Genesis 1 by the heaven (*coelum*) that God created is the empyrean heaven (*coelum empyreum*), which was filled with angels as soon as it was created. By reason of its light, Albert comments, this heaven was suitable for contemplation and is thus the place for both angels and the blessed. Jesus' words about the many mansions (*mansiones*) in his Father's house (John 14:2) are taken by Albert to refer to the differences in beatitude enjoyed there. He approvingly cites Augustine, Bede and Strabo (i.e., the *Glossa ordinaria*) as *sancti* who say that the empyrean heaven is full and uniform in light and also free of motion.[64] Thomas Aquinas, in contrast, is more cautious about the *coelum empyreum*, noting that it is postulated only because of authoritative statements (*auctoritates*) by Strabo, Bede and Basil, whose arguments differ and are not very cogent, though they all agree that the empyrean is the place of the blessed (*locus beatorum*).[65]

When he treats the question of the heaven of the Trinity in his *Summa de creaturis*, Albert relates that Scripture and the *sancti* distinguish the firmament (*firmamentum*), the crystalline heaven (*coelum crystallinum*), the empyrean heaven (*coelum empyreum*) and the heaven of the Trinity (*coelum Trinitatis*).[66] The empyrean heaven, the noblest among the simplest bodies, is said to be fiery or glowing because of its bodily light. The angels fill the empyrean heaven not because they are located in a place but because they are distinguished into hierarchies, choirs and the many mansions mentioned in the Gospel of John (14:2). Since the empyrean heaven is not ordered to generation and corruption but to the contemplative state, it is immobile. As a result, the philosophers were unable to recognize it.[67] According to Albert, the last heaven, the heaven of the Trinity, is really the same as God but is distinguished from God by a precision of human reason. It is the excellence of God's power (*virtus*) which contains all created things.[68] The heaven of the Trinity is said to exist outside the empyrean heaven because of its very nature and dignity, that is, the infinity of the divine substance. In no way is the heaven of the Trinity outside the empyrean heaven in terms of any bodily location or distance from the empyrean heaven.[69] Only the three persons of the Trinity, the Father, Son and Holy Spirit, are present in the heaven of the Trinity, since to exist in that heaven is to exist in the very equality of God's power, which contains and preserves all the things contained under that power.[70] Albert later dis-

cusses whether Mary as well as Jesus illuminates the angels, but he does not discuss whether either is in the empyrean heaven or in the heaven of the Trinity.[71]

Albert also treats the different heavens in his commentary on the second book of the *Sentences*. Directing his attention to a text in which Peter Lombard distinguishes the firmament (*coelum firmamentum*) and the empyrean heaven (*empyreum*), Albert states that the empyrean heaven, which is the place of the blessed (*locus beatorum*), is not known to us since it does not move. He explains that God is the heaven of the Trinity (*coelum Trinitatis*) according as God contains himself and all other things and according as he rests and delights in himself in a perfect fashion. Albert rejects the idea that Christ according to his human nature exists in the heaven of the Trinity. He also rejects the argument that since the angels are in the empyrean heaven, and the Virgin Mary is exalted above the choirs of angels, then she must be beyond the empyrean heaven and in the heaven of the Trinity, since that is the only thing beyond the empyrean heaven. Albert admits that the person of Christ (*persona Christi*) is in the heaven of the Trinity, although his human nature is not. The Virgin Mary, in turn, is not exalted in place beyond all the distinctions of the angels but is above them in dignity (*dignitas*) and order (*ordo*). She is clothed with the glory, or brightness, of her son. In turn, all the saints receive light from her and pour back on her that which they receive of dignity and grace under Jesus her son and under God.[72]

In his commentary on the third book of the *Sentences*, Albert sets forth further arguments that are relevant to our discussion. Addressing the question whether Christ ascended by reason of both his divine and human natures or only by reason of one nature, he states that according to his divine *persona*, Christ is always in heaven and yet also everywhere; therefore, in the strict sense of the word 'ascending' is to be attributed to Christ's human nature.[73] To the further question whether Christ's ascension was to a dignity (*dignitas*) or to a place (*locus*), and then only to the place of the crystalline heaven, Albert responds that the bodies of Christ and the Virgin Mary, which have more dignity than any place, are now to be found in the empyrean heaven, since it is the place that has the highest dignity (*locus dignissimus*). Albert therefore maintains that Christ's ascension is both to a dignity and also to a bodily place ("ad locum secundum corpus") that is the most dignified of all places, namely to the highest point of the empyrean heaven ("ad locum dignissimum omnium locorum, in supremum scilicet caeli empyrei"). Insofar as Christ is considered as a divine person, his ascension is to the dignity of equality with the Father ("ad dignitatem aequalitatis Patris"), so that he is seated at the right hand of God (Colossians 3:1–2), that is, in the heaven of the Trinity. It is not that Christ previously lacked that dignity but rather that by reason of the ascension he sits at the right hand in his humanity, as believers affirm by faith and the angels affirm by knowledge. Finally, if Christ is considered as regards both body and soul, that is, simply in his humanity, his ascension is to a dignity that consists in the greater goods that he receives from the Father ("bona potiora Patris"). Albert considers it to be a "stupid fantasy" (*phantasia fatua*) to say that the glorified bodies of Christ and Mary are in the crystalline heaven, which is subject to generation and corruption, or to say that the blessed (*sancti*) are there whereas Christ and Mary alone are in the empyrean heaven. What Albert is stressing here is that the blessed too

must be in the empyrean heaven with Jesus and Mary, since that is the place of beatitude (*locus beatitudinis*).[74]

Albert similarly treats Christ's ascension in his *De resurrectione*, but with some nuances. He relates that Christ ascends both to a place and to a dignity by virtue of his being a divine person. Insofar as he is human, he does not ascend to an equality with God nor to the heaven of the Trinity, which is the same thing. The statement in Ephesians 4:10 that Christ "ascends over all the heavens" can be understood to mean the different modes of contemplation found among the angels. On the other hand, insofar as Christ is the Son of God he never departs from equality with the Father.[75] However, Albert takes account of an argument that is based on a statement in a sermon on the Assumption of Mary attributed to Jerome, which declares that all the souls of the saints are assumed in accord with the choirs of angels with the sole exception of the Blessed Virgin, who was assumed above all the choirs of angels ("super omnes choros angelorum"). This would mean that she is in a place above the angels, just as the ascended Christ would then be beyond the place of the Virgin. Albert states firmly that Christ and his mother do not form a distinct hierarchy but are in the third hierarchy of angels. Nonetheless, they are above all the angels in that hierarchy, the Seraphim, Cherubim and Thrones. Moreover, as regards their place (*locus*) and their mode of participating in blessedness ("modus participandi beatitudinem"), Christ and Mary are beyond all the angels. While the angels and the blessed jointly populate the empyrean heaven, which is the common place (*locus communis*) of all the blessed, there are also proper places (*loca propria*) that can be distinguished in the empyrean heaven according to the individual dignities of the blessed ("propriae dignitates beatorum"). Christ and Mary are thus above all the angels as they are above all other humans, but they are nevertheless within the empyrean heaven.[76]

CHRIST AND THE ECCLESIASTICAL HIERARCHY

In his commentary on Dionysius's *De hierarchia ecclesiastica*, Albert reviews the hierarchies and orders of angels in order to indicate how the angelic hierarchy and the human, ecclesiastical hierarchy are alike and unlike.[77] While there are nine orders in the angelic hierarchies there are only three in the ecclesiastical hierarchy, namely bishops (*Episcopi*), priests (*Presbyteri*) and deacons (*Diaconi*).[78] Albert correctly identifies Dionysius's "hierarch" (*hierarcha*) as the bishop,[79] and refers to the three grades of the ecclesiastical order ("tres gradus ecclesiastici ordinis").[80] Although he affirms that the episcopacy (*episcopatus*) is the first order in "our hierarchy" (*nostra hierarchia*),[81] he nevertheless emphasizes that Jesus is in fact our first priest ("Jesus primus noster sacerdos")[82] and the highest priest (*summus sacerdos*).[83]

According to Dionysius, the respective functions of the grades or orders of the ecclesiastical hierarchy are to purge or purify (the function of deacons), to purge or purify and also illuminate (the function of priests), and to purify, illuminate and also perfect (the function of the bishop).[84] Following the lead of Dionysius, Albert distinguishes three further orders (*ordines*) that are subject to the activities of the three grades or orders of deacons, priests and bishops and receive from them. These further

orders are not called 'orders' because they have any dignity (*dignitas*) of their own, but only because they receive the operations of the three orders above them in an ordered fashion (*ordinate*). The first of these orders comprises those who are to be purged or purified by the deacons, namely those who should be sent out and not permitted to view and partake of the sacred things belonging to the eucharistic liturgy. The first group in this grade is composed of the catechumens, who are to be delivered as by a midwife (*obstetricandi*) to the rebirth (*regeneratio*) of baptism through the teaching activities of the deacons. Penitents are another group in this grade.[85] Although Albert states that the catechumens are not an order in the Church, since they do not have any of the sacraments and need to be taught the elements of the faith, nonetheless he does consider them to have received something of a sacrament, namely, their being catechized (*catechizatio*), which is a disposition toward baptism. Accordingly, in some way they are in the Church and hold an order, albeit the lowest.[86]

The second, middle order of those who are to be perfected is called the order of faithful people (*ordo fidelis populi*). Having already been purifed by the deacon, they are worthy both to contemplate by sight and to communicate (*communicare*) or share (*participare*) in the sacrament. This order is illuminated (*illuminatur*) by the priests.[87] On the other hand, those who belong to the third order are not only purified and illumined but also perfected. This is the order of monks (*ordo monachorum*) who ascend by means of the teachings of the bishops to the highest perfection of spiritual contemplation accompanied by a certain excellence ("altissima perfectio spiritualis contemplationis cum quadam excellentia").[88] Albert stresses that although this order has the "special name" (*specialis nomen*) of *monachi*, and is a higher order, it is not established in a grade of dignity (*dignitatis gradus*) above that of the common people (*populus communis*). Monks are consecrated by a priest, not by a bishop.[89]

In his commentary on the fourth book of the *Sentences*, Albert develops the role of Christ in the ecclesiastical hierarchy. He follows Peter Lombard in distinguishing seven grades or orders of spiritual offices in the Church ("spiritualium officiorum gradus sive ordines").[90] He also follows Peter in holding that all seven of the orders existed in the primitive Church and were founded by Christ; only later were they divided. Inasmuch as there were so few ministers in the early Church and those who received orders were very suitable, because almost all of them possessed great holiness (*excellens sanctitas*), at that time all the lower orders were conferred at once with the diaconate. Subsequently, with the increase of the numbers of ministers (*ministri*) and the decrease in their suitability, the Church established the division of the orders among themselves.[91] The priesthood alone is the perfect order (*ordo perfectus*) because of its principal action of consecrating the body and blood of Christ and its secondary action of loosening or binding sins. To this order pertains spiritual power (*potestas spiritualis*) over the true body of Christ (*corpus Christi verum*) in the Eucharist and also over the mystical body of Christ (*corpus Christi mysticum*).[92] The sacrament of the Eucharist is itself a cause of the mystical body of Christ, that is, the Church, as it is gathered together from many believers (*fideles*).[93] Christ is the spiritual food of the Church (*cibus spiritualis Ecclesiae*).[94] In his commentary on *De ecclesiastica hierarchia*, Albert declares that the Eucharist is preeminent among the sacraments (*dignissimum sacramentorum*) because it contains the whole Christ according to his divinity and human-

ity. In contrast, the other sacraments contain only some particular grace.[95] Albert enumerates the reasons why the Eucharist in particular is called "communion" (*communio*). First of all, the uniting of many into one, which is the very nature of *communio* and is what the Eucharist causes, is signified by the many grains of wheat made into the one bread and the many grapes made into the wine. In no other sacrament are the visible appearances (*species*) composed of a many coming together into a one and thereby signifying *communio*. Secondly, it is the one Christ in his humanity and divinity—the true body of Christ—in whom are united all those who communicate. Thirdly, those communicating in the Eucharist are the mystical body that is signified by the *species* or visible appearances of this sacrament.[96]

The preeminence of the sacrament of the Eucharist serves as the basis of Albert's argument that the episcopacy is not an order distinct from the priesthood. Since no act can be more excellent than that of confecting the body of Christ in the Eucharist, there can be no order beyond that of the priesthood. Nonetheless, there can be various offices of jurisdiction over the mystical body. Albert thus allows that there is a grade of dignity pertaining to jurisdiction ("gradus dignitatis secundum jurisdictionem") that can also be called an 'order' (*ordo*). Examples are primates and archbishops.[97] Albert makes the same points in his *De sacramentis*, where he states that all of the orders are directed toward and serve the ultimate order (*ultimus ordo*) of the priesthood, the principal act of which is to consecrate the body and blood of Christ and distribute it to the Church. Accordingly, the secondary act of the priesthood is to prepare the mystical body to be worthy of receiving the true body of Christ, and involves the power of binding and loosening. When Christ first ordained the apostles he also gave them jurisdiction over the mystical body. To speak of a fourfold order of bishops, composed of patriarchs, archbishops, metropolitans and bishops, is to equivocate, since the term *ordo* in this case stands for a grade of dignity among prelates ("gradus dignitatis in praelatione"), and not for an *ordo* that is a sacrament. The episcopacy (*episcopatus*) itself is not an order beyond priesthood, though it involves further charisms and rule within the Church.[98]

In his commentary on chapter 4 of the Gospel of Luke, Albert openly states that bishops are the successors of the apostles and priests are successors of the disciples. (Albert perceives Luke in this chapter to be constructing the Church in its various grades, ministries and offices.)[99] Elsewhere he carefully distinguishes two ways in which the Church itself can be considered an 'order'. The one order of the Church is similar to the ordering (*ordinatio*) of the members of a natural body in relation to the one spirit that moves and vivifies them. It is in regard to such an ordering that Christ is called the "head of the Church" (*caput ecclesiae*). According to another sense of the term, the Church resembles an 'order' of citizens under one prelate and one law, inasmuch as its members constitute an order of subjects referred to a prelate in the dispensation of faith and good morals.[100] Although Albert allows that all priests have the 'power of the keys' by which they may absolve sins, and that bishops, legates and popes exercise a greater jurisdiction than do priests, it is in fact Christ himself who holds the keys, and who does so in an excellent way, of himself from the Father.[101]

In his *De sacramentis*, Albert presents the core of his ideas on the seven orders in succinct form. Here he states again that there are seven orders because of the sevenfold

grace of the Spirit. All of them are ordered (*ordinati*) to the final order (*ultimus ordo*) of the priesthood, the principal act of which is to consecrate the body and blood of Christ. Because these gifts should be distributed to the mystical body which is the Church, there is another act of the priesthood, to loose and to bind, which prepares the mystical body of Christ to be fit for receiving the true body of Christ. Albert again explains that to be a bishop does not involve an order but is the name of a dignity (*dignitas*) and an office (*officium*).[102] In his treatise *De annunciatione*, he makes clear that he considers Christ and not some prelate to be the head of the whole Church (*caput totius ecclesiae*), and calls Christ a "spiritual king" (*rex spiritualis*).[103] Elsewhere, however, Albert refers to Peter's rule (*principatus*) as being over the whole Church.[104]

Although it may seem that Albert's mind-set is excessively hierarchical and that he is content with a generic order of lay people, on occasion he appears to discern other grades (*gradus*) in the Church. When speaking of Christ's reign (*regnum*) in his commentary on Luke's Gospel, he turns to pseudo-Dionysius for the view that every kingdom or reign (*regnum*) involves a distribution of goods, laws and order. Such distribution, Albert comments, is the goal of a king, and it involves distribution of orders and grades ("distributio ordinum et graduum") according to the status of the different persons (*status personarum*) in the kingdom. Accordingly, Christ reigns in us, distributing graces and goods. Albert lists the following grades of persons in the Church for which different goods are appropriate: the prelate (*praelatus*), the subject (*subditus*), the knight (*miles*), the one whom the knight defends, the religious (*religiosus*), the secular (*saecularis*), the matron (*matrona*), the widow (*vidua*) and the virgin (*virgo*). He gravely warns against changing the order or grade (*ordo vel gradus*) to which one has been called by God, likening such a change to changing the order and grade in the orders of the heavens ("in ordinibus coeli"). Not surprisingly, one of the scriptural texts that Albert cites as an authority is 1 Corinthians 7:20. When he warns against changing one's *gradus*, Albert might well have in mind his own *gradus* as a Dominican. Finally it should be noted that Albert identifies Christ's reign as a universal kingdom (*regnum catholicum*).[105]

Albert indicates that, besides the other roles Christ plays in the ecclesiastical hierarchy, he must be the model to which clerics, most especially prelates, conform their lives.[106] Clerics must overcome ambition and the temptation to delight in power by imitating the humility and meekness of Christ, who by his example taught humility to the disciples. Christ is the prototype of humility (*prototypus humilitatis*), the most humble of all the humble (*omnium humilium humilior*), the first figure of humility (*figura prima humilitatis*).[107] Indeed, no one who is given to "carnal love" (*amor carnalis*), that is, love of self and one's own, can be a disciple of Christ. Humility and meekness are among the virtues required to oppose self-love and to acquire the discipline of Christ (*disciplina Christi*).[108] Only someone who humbles himself for the benefit of his subjects makes good use of the power that he has received within the Church.[109] Moreover, the cleric who humbles himself to be like a child is more suited to establish the Church. Indeed, nothing is easier than to rule subjects if one does so in humility and meekness. In the early Church (*primitiva ecclesia*), there was not great concern for power and all paid heed to examples of humility and love (*caritas*). Only

with the increase of wicked people in the Church has severe rule become necessary and serving as a prelate become intolerable.[110]

There are three ways that one comes to Christ: (1) by conforming to him and becoming like him (*conformatio* and *similitudo*); (2) by humbly following him (*imitatio* and *consecutio*) as our leader (*dux*) and model (*exemplar*); (3) by spiritual perfection (*perfectio* and *consummatio*). The first of these ways involves the taking up (*acceptio*) and the raising up (*exaltatio*) of one's own cross, for it is carrying our cross that configures (*configurat*) us to Christ.[111] Asserting that there should be a certain agreement between the particular cross and the person who bears it, Albert discerns a correspondence between the burden of one's cross and the hierarchical ranking of his ecclesiastical office. According as they hold the place of Christ to a greater or lesser degree, the Vicar of Christ, that is, the Pope, should bear a heavier cross than all the others, patriarchs and bishops a heavier cross than those beneath them, and prelates a heavier cross than their subjects.[112]

According to Albert, Christ instructed the disciples to exercise ecclesiastial power (*potestas ecclesiastica*) in the spirit of mildness (*lenitas*) and meekness (*mansuetudo*).[113] The greater one's humility the greater the graces one receives. Indeed it is humility that renders someone worthy of advancement in the ecclesiastical order.[114] Only one who is humble, who 'puts on Christ' in the humility (*humilitas*) and (*simplicitas*) of a child, ought to hold a great place (*magnus locus*) in the Church among the ministers of Christ (*ministri Christi*). Moreover, Albert adds, Christ thought that whoever did not so 'put him on' by way of humility should be barred from ministry.[115]

Christ goes before us as our leader (*dux noster*), carrying his cross. It is glorious to go past him since one thereby configures (*configurat*) oneself to the leader (*dux*). So Christ bids each of us to take up our cross as he has taken up his. Whoever attempts each day to approach the Crucified One by way of his own cross is the one who truly raises up the cross. Albert explains how one is crucified for Christ by way of specific forms of self-denial. He straightforwardly denounces as hypocrites those who appear externally to carry a cross but who in fact drag the cross along the ground insofar as they really prefer what is to their own comfort or gain.[116] One of the seven deadly sins or major vices of prelates is their simulating of virtues while in fact they have real pride, real envy and real anger accompanied by false humility, false brotherly love and false meekness.[117]

Albert excoriates contemporary prelates for being tyrants and oppressors of the souls entrusted to their care rather than being their physicians. Such prelates act most evilly, since they bring about the evil reign within the Church and cause the name of Christ to be blasphemed.[118] Albert considers some prelates of his day to tolerate and even to favor the wicked, since they are more committed to the self-indulgent Sardanapalus than they are to Jesus Christ.[119] Popes, Cardinals, archbishops and bishops, who should be sources of light (*illuminatores*) for others, are in fact darkened because of their ignorance and evil life (*nigra vita*).[120] Given Albert's harsh judgment of highly placed prelates by reason of their failure to live up to the model of Christ, one may conclude that it is not only his theoretical conception of the ecclesiastical hierarchy that is Christocentric. So too is his conception of the practical life of the hierarchical

Church, in regard both to the celebration of the Eucharist and to what should be expected of its ministers, that is, its priests, prelates, bishops, Cardinals and Popes.

METAPHYSICAL HIERARCHY AND SCRIPTURAL EXEGESIS

In general, Albert seems to keep separate metaphysical and scriptural ways of thinking. On more than one occasion, however, when explicating a scriptural passage related to Christ, he introduces metaphysical considerations, in particular the concept of metaphysical hierarchy. For example, when commenting on Luke 2: 51–52: "Et Jesus proficiebat, etc.," Albert appeals to basic elements of the conceptual scheme of metaphysical hierarchy outlined above. After remarking that there was a due increase in Jesus' body and in his bodily strength, he observes:

> And appropriately so. For since there is a one (*unum*) in every genus that is the measure (*mensura*) of the others <in that genus>, and according to an approach (*accessus*) to it the others <in the genus> participate (*participant*) in its nature, it is befitting that in the genus of human beings this measure (*mensura*) be in the Son of God. And therefore with no impediments of nature (as happens in other <human beings>) he advanced toward what was due (*debitum*) in quantity and strength. . . .

Albert then cites Ephesians 4:13: "we would hasten to the perfect man to the measure (*mensura*) of the age of the fullness of Christ."[121]

Later, when commenting on Luke 6:48, "Similis est homini aedificanti domum," Albert again calls on the doctrine of participation for help in discerning the meaning of the text. He understands the similitude (*similitudo*) to refer to Christ, who is man in a singular fashion (*singulariter*). That is the case because in the nature of every species there is some one thing that is primary (*aliquod unum primum*) which has that nature truly and simply (*vere et simpliciter*) and which is the measure (*mensura*) of all the others in the species. All other individuals participate (*participant*) in that nature and species according to an analogy or proportion (*analogia vel proportio*) to the one that is primary in the species. The same must hold for the human species. The two possible candidates for primary member of the human species are Adam and Christ. Because Adam abandoned the truth of human nature by his sin whereas Christ repaired that nature, human nature existed more simply and truly (*simplicius et verius*) in Christ than it did in Adam. Accordingly, Christ is the man in relation (*proportio*) to whom all others are called men.[122]

Some of these ideas are also evident in Albert's *De resurrectione*. There he states that human nature exists most truly and most simply (*verissime et simplicissime*) in Christ, appealing to Aristotle's statement in *Metaphysics* 10, chapter 1 (1052b31–1053a1) that each thing is measured by the minimal (*minimum*) and the most simple thing (*simplicissimum*) belonging to its genus, for in every species a unit or one (*unum*) is to be accepted. So, Albert states, God has set one angel above the angels, one horse above horses and the man Jesus Christ above human beings. Therefore Christ's power to grow measures the like powers in all other human beings.[123]

In at least two passages in his commentary on the Gospel according to John, Albert

invokes the conceptual scheme of metaphysical hierarchy. In the first, which concerns the prologue of the Fourth Gospel, Christ, the *Verbum*, is identified with the universal agent intellect (*intellectus agens*) that is the cause of the order of things according to their essential grades (*essentiales gradus*) insofar as they are related to that agent intellect in a closer or more distant fashion (*propinquius et remotius*).[124] (Elsewhere Albert interprets the first agent intellect to be God.[125])

In the other passage (John 8:35), which concerns the servitude of sin and the liberation from it wrought by Christ, Albert brings out evaluative aspects of the concept of the "Great Chain of Being." He points out that in general 'servitude' means subjection, but there can be subjection to the best and the most honorable, such as to God and the divine good ("subiectio ad Deum et ad bonum divinum"). By this sort of subjection one approaches (*appropinquatur*) liberty and rule (*libertas et dominatio*). There is also a servitude that occurs through one's affectivity (*affectus*), whereby one is degraded (*vilificatur*) and truly made a slave (*servus*). Albert explains that man is a middle nature (*natura media*), who approaches (*appropinquat*) the highest being (*summum*) through better things (*meliora*) and the lowest being through more unworthy things (*viliora*). Through the higher things (*superiora*) man is liberated and raised up (*liberatur et extollitur*), since he is ordered (*ordinatur*) to these things from his very nature, while he is degraded (*vilificatur*) through the inferior things, since these are a falling away (*casus*) from his own nature. As supporting texts, Albert cites Romans 6:20 and 22, which speak about a good 'servitude' and a good liberty (*libertas*).[126]

In his commentary on the Gospel of Luke, Albert applies the doctrine of metaphysical participation to the holiness (*sanctitas*) of God and the holiness present in humans. God is the cause of holiness for all those who are holy (*omnes sancti*). Albert invokes the principle and rule of the Philosopher, which states that whatever exists in many things through one nature (*ratio*) exists primarily and principally in the being that is the cause of all those other things. Consequently, the holiness existing in God, which is called holiness by essence (*sanctitas per essentiam*), is the cause of the holiness of all other things that are made holy. Something can be informed with holiness and thereby be holy in two ways, Albert explains. According to the first way, a thing that is not holy is made holy through the gift of holiness it receives from that which is essentially holy (*essentialiter sanctum*). Accordingly, we are holy having not been holy only because we are made holy (*sancti efficiamur*) by the activity of God (*operatio Dei*), that is, by way of grace and the sacraments. According to a second way of being informed with holiness, something that never was made holy having not been holy (i.e., which was never in a state of unholiness) can participate (*participat*) in holiness because holiness is conferred upon it along with its existence (*esse*) by the very God who is holy ("sed confertur ei cum esse sanctitas a sancto Deo"). Albert is referring here to the flesh and the soul of Christ ("sola caro Christi et anima"), which alone of created things were never at any time not holy. They possess the pure essence of holiness (*essentia pura sanctitatis*) without any admixture of its opposite, and they can be called the holy of holies (*sanctum sanctorum*), as it were (*quasi*) having holiness in the very defining (*demonstratio*) of the essence of holiness. Accordingly, each of those other things that are holy has just so much of holiness as it approaches (*accedit*) more closely the very defining of the essence of that holiness.[127] The important point for one to

observe is that Albert presents Christ as the efficient, the formal, the exemplar and the final cause of all holiness.[128]

Conclusion: The Centrality of Christ for Albert the Great

Our examination of Albert's views on the celestial and ecclesiastical hierarchies has brought out the key roles that Christ plays in both of them. Although the question of Christ's place in the hierarchy of being is somewhat different, Albert's treatment of Christ's relation to the celestial hierarchy, as we have seen, raises issues concerning the "Chain of Being," especially in terms of the three "heavens." What must be emphasized is the centrality of Christ in the Christian economy of salvation as regards both the celestial and the ecclesiastical hierarchy. What remains to be investigated, if only briefly, is Albert's formal discussion of Christ's role as mediator between God and humans in his commentary on the third book of the *Sentences.* We shall then note his statements in other works concerning what he considers to be signs of Christ's choosing regularly to be in the "middle." Finally, we shall indicate that despite his notion that Christ chose regularly to reveal himself in the "middle" place, Albert, unlike Bonaventure and Nicholas of Cusa, does not make Christ part of the metaphysical structure of reality, that is, the hierarchy of being.

In his commentary on the third book of the *Sentences,* Albert addresses the topic of why and how rational nature alone can be assumed by God. It is striking that in answering this question he almost immediately appeals to the concept of metaphysical hierarchy and the place of human beings within that hierarchy. Albert states that although God is equally distant from all creatures, nonetheless it is not the case that they are all equally distant from him. By reason of the grades of dignity (*gradus dignitatis*) that are distinguished through participation in the goodnesses (*participatio bonitatum*) that are in God, one thing approaches (*accedit*) God more than another. A living thing approaches God more closely than does something that simply exists, and a sentient being approaches him more closely than does one that only lives. In like fashion, a rational being approaches God more closely than does one that is only sentient. Albert concludes that the rational creature is therefore more unitable to God than is any non-rational creature.[129]

To this argument based on participation and metaphysical hierarchy Albert adds two other metaphysical arguments. The first is based on the contrast between the microcosm (*minor mundus*) and the macrocosm (*major mundus*). In some way, every other creature exists in man, whose nature comprehends the elements, the vegetative and sensitive powers of creatures below it in the hierarchy of being, as well as the rational and intellectual knowledge found in the angelic creatures above it. As a result, the human being is called a microcosm (*minor mundus*), since it gathers within itself all the parts of the macrocosm (*major mundus*). Insofar as the macrocosm exists in the microcosm of the human being, it is raised to a higher dignity (*ad altiorem dignitatem*). A second argument is closely related to this one. The human being is the end of every creature; whatever exists toward some end has its dignity only in that end; therefore, every other creature has its dignity only in the human being.[130]

Further, Albert argues that the human soul has something of the "mean" (*me-*

dium) of a being. It is the soul, which is itself one extreme or opposite, that causes the "unitability" (*unibilitas*) in its opposite, the other extreme (*extremum*), namely human flesh. Moreover, the vegetative and sensitive powers are not of themselves unitable (*unibiles*) to the Godhead (*deitas*). It is the rational power that makes them so, and it thus serves as the "mean" of the resultant being.[131] Albert emphasizes, however, that what makes Christ to be one being is the unity of the eternal person. And while there is a greater distance between created nature and uncreated nature than there is between any two created natures, by reason of the infinite power (*infinita virtus*) of the one uniting the created with the uncreated, who is God, they are all the more united.[132] Regarding the union of human and divine natures in Christ, Albert uses the spatial language of *conjunctio distantium*.[133] In passing, while relating the views of "some," he remarks that by reason of his simplicity God is present in all things, disposing all of them sweetly by a stretching forth, as it were, from the point of the first principle to the ultimate point of the very last creature ("quasi protensione a puncto principii primi usque ad ultimum punctum creaturae novissimae").[134]

When he turns to the topic of Christ as mediator (*mediator*), Albert's remarks are limited. These are based on a text of Peter Lombard, who himself quotes 1 Timothy 2:5, which states that there is one mediator of God and men, the man Christ Jesus. In the objections that he presents to Christ being declared such a mediator, Albert again employs the terms and concepts of "mean" (*medium*) and "extremes" (*extrema*). Although his own position seems to be established primarily by lengthy quotations from Augustine's *De civitate dei* (book 9, chapter 15), Albert offers some nuances regarding Christ as a mediator. As man Christ is in agreement with humans by reason of his mortality that will become immortality. But he also is in agreement with God, since it is from his plenitude of grace that we all receive grace (John 1:16). Christ is also a mediator insofar as he possesses the act of a mediator, which unites the lower extreme to the higher.[135] In this text, Albert does not in fact make use of metaphysical concepts to establish Christ's mediatorship, as he did in previous questions in his commentary on the third book of the *Sentences*.

Brief remarks by Albert in his treatise *De sacrificio missae* cast more light on the way in which Christ is a mediator. Albert states that Christ mediates through his two natures: through his divinity (*divinitas*) he touches God, from whom as from a fountain there flow the charisms of graces, just as through his humanity (*humanitas*) he touches us, in whom there flow such great charisms of graces. It is by means of his role as the true high priest (*verus pontifex*) that Christ mediates between human beings and God. Likewise, it is in Christ that the graces which flow from God are reflected, and through him that they are returned to God.[136] As God made human (*Deus humanatus*) and as man deified (*homo deificatus*), Christ the high priest is a true mediator and he truly mediates.[137]

In various other writings Albert indicates that Christ during his lifetime showed his preference for the middle position, presumably revealing thereby that he was indeed at all times the mediator. Albert remarks that as one who stood midway (*medius*) among men, who hung on the cross midway between thieves, and who appeared thereafter in the middle of his disciples when he was resurrected, Christ reveals himself to be the mediator (*mediator*) between God and man.[138] Commenting on the scene in

Luke (2:46) in which the boy Jesus is seated amidst the teachers (*doctores*) in the temple at Jerusalem, Albert takes the occasion to declare that Christ is always in the middle, showing that in all instances he rejected extremes and loved the mean (*medium*). Christ chose to be born in the middle of two animals; he taught amidst the teachers (*doctores*) in the temple; he was baptized in the middle of those who were to be baptized; he was crucified in the middle of thieves; he rose immortal in the middle of his disciples.[139] All of these signs point to Christ's role as the mediator between men and God.

Despite these striking images from Jesus' earthly life, which depict him as being "in the middle" during different events in his life, Albert makes no effort to establish Christ as an ontological link in a metaphysical scheme, as do Bonaventure and Nicholas of Cusa, who make Christ the ontological nexus between the created world and God, and for whom Christology and metaphysics are welded together. Indeed, in this respect Bonaventure and Cusanus appear to reject the conceptual scheme of metaphysical hierarchy, perhaps because they thought that it excluded Christ. In any event, what is striking in contrast is Albert's concern to "locate" Christ atop the "Great Chain of Being," and to establish his priority by placing him above the angels in the empyrean heaven. Equally striking—or even more so—is Albert's insistence that the Virgin Mary is also above the angels in the empyrean heaven, just below her son. We may safely conclude that Albert bent the conceptual scheme of metaphysical hierarchy in order to bring it into line with the Christian economy of salvation, even though he did not propose anything like the Christocentric metaphysics of Bonaventure and Cusanus.[140]

In sum, Albert's treatment of Christological topics reveals the strong influence of the writings of pseudo-Dionysius on this aspect of his thought, as on many other aspects. Another theme prevalent in Albert's Christological considerations is the image of Christ as the one who is meek and humble of heart. This conception affected his view of the ecclesiastical hierarchy and had serious practical consequences. He demanded that clerics in general and prelates in particular share with Christ the virtues of humility and meekness. If they did not, not only would they prove to be ineffective as Christ's ministers but they would also cause scandal and even be unworthy of their calling. On the other hand, if they did possess the virtues of humility and meekness they would find ruling in the Church less burdensome. Moreover, Albert teaches that the lay members of the Church also should imitate Christ's meekness and humility, so that they may become a true community in Christ. For Albert, of course, the sacrament of the Eucharist, the true body of Christ, is the major cause of unity in the Christian community, the mystical body of Christ.

It is noteworthy, I believe, that in his different works Albert often cites Matthew 11: 28–30. In that pericope, Jesus asks those who are weary to take up his yoke and follow him, for they will find his yoke easy and his burden light, and he will refresh them. He calls on all to learn from him, for he is meek and humble of heart.[141] In his commentary on that passage, Albert explains that Christ's yoke is the bond of love (*vinculum caritatis*), the yoke of evangelical love (*evangelica caritas*) that binds together God and man. From Jesus' example readers should learn to be meek and humble of heart, that is, to tolerate evils with equanimity and to act in such a way that their actions are preserved in goodness.[142] Albert the Great's commitments to Jesus as a per-

sonal model and to the central importance of the love command orient in a particular fashion his hierarchical thinking. We might simply call that thought 'Christocentric'.[143]

<div style="text-align: center">NOTES</div>

1. See Albert the Great, *Super Dionysium De caelesti hierarchia,* ed. Paul Simon and Wilhelm Kübel, Cologne Edition 36/1 (1993) and *Super Dionysium De ecclesiastica hierarchia* (Borgnet 14). There is a noticeable emphasis on *exitus* and *reditus* in Albert's commentaries on the *De caelesti hierarchia* and the *De divinis nominibus.* See the analysis in Gilles Emery, *La Trinité créatrice: Trinité et création dans les commentaires aux "Sentences" de Thomas d'Aquin et de ses précurseurs Albert le Grand et Bonaventure* (Bibliothèque Thomiste 47, Paris, 1995), 140–58. For a clear and succinct presentation of Albert's life and works, see Simon Tugwell, Introduction to *Albert and Thomas: Selected Writings* (New York, 1988), 3–39, 96–116. Still helpful is James A. Weisheipl, "The Life and Works of St. Albert the Great," in *Albertus Magnus and the Sciences: Commemorative Essays 1980,* ed. J. A. Weisheipl (Toronto, 1980), 13–51.

2. Albert the Great, *Super Dionysium De divinis nominibus,* ed. Paul Simon, Cologne Edition 37/1 (1973). See my studies, "Metaphysical Foundations of the Hierarchy of Being according to Some Late-Medieval and Renaissance Philosophers," in *Philosophies of Existence: Ancient and Medieval,* ed. Parviz Morewedge (New York, 1982), 165–257, at 167–68; "Neoplatonism, the Greek Commentators, and Renaissance Aristotelianism," in *Neoplatonism and Christian Thought,* ed. Dominic J. O'Meara (Albany, 1982), 169–77, 264–82; "Il concetto di gerarchia nella tradizione padovana e nel primo pensiero moderno," in vol. 2 of *Aristotelismo veneto e scienza moderna: Atti del 25° anno accademico del Centro per la Storia della Tradizione Aristotelica nel Veneto,* ed. Luigi Olivieri (Padua, 1986), 729–41.

3. See Arthur Lovejoy, *The Great Chain of Being: A Study in the History of an Idea* (Cambridge, Mass., 1936; rept. New York, 1960). For a critical evaluation, see my article, "Lovejoy and the Hierarchy of Being," *Journal of the History of Ideas* 48 (1987): 211–30, reprinted in *The History of Ideas: Canon and Variations,* ed. Donald R. Kelley (Library of the History of Ideas Series 1, Rochester, New York, 1990), 178–97.

4. For the early use of the image of the chain for the hierarchy of being, see Bernard McGinn, *The Golden Chain: A Study in the Theological Anthropology of Isaac of Stella* (Washington, D.C., 1972), 51–70, 86–102. Albert the Great, Duns Scotus, Meister Eckhart and Marsilio Ficino used the phrase "golden chain" when speaking about the hierarchy of being. See my study, "Metaphysical Foundations," 236 n. 105, 241 n. 128.

5. For studies on Bonaventure and Nicholas of Cusa relating to the Christocentric element of their metaphysics, see below, n. 140.

6. The many studies on Albert's Mariology include José M. Bover, "La mediaciòn universal de la Santissima Virgen en las obras de B. Alberto Magno," *Gregorianum* 7 (1926): 511–48; J. S. Bittremieux, "Albertus Magnus ecclesiae doctor, praestantissimus Mariologus," *Ephemerides theologicae Lovanienses* 10 (1933): 217–31; Bruno Korosak, *Mariologia S. Alberti Magni eiusque coaequalium* (Biblioteca Mariana Medii Aevi 8, Rome, 1954); A. Fries, *Die unter dem Namen des Albertus Magnus überlieferten Mariologischen Schriften Literarkritische Untersuchung* (BGPTMA 37/4, Münster, 1954), "Zur Mariologie Alberts des Grossen," FZPhTh 4 (1957): 437–46, and *Die Gedanken des heiligen Albertus Magnus über die Gottesmutter* (Thomistische Studien 7, Freiburg Schweiz, 1958); Robert Buschmiller, *The Maternity of Mary in the Mariology of St. Albert the Great* (Carthagena, 1959). An informative survey of Marian devotion within the Dominican Order is provided by André Duval, "La dévotion mariale dans l'Ordre des Frères Prècheurs," in vol. 2 of *Maria: Études sur la saint vierge,* ed. Hubert du Manoir (Paris, 1952), 737–82; for Albert, see 752–57. Unfortunately there are only passing references to Albert in Celestino Piana, *Assumptio beatae virginis Mariae apud scriptores saec. XIII* (Rome, 1942). For a recent popular book on devotion to Mary in the Dominican Order see A. D'Amato, *La devozione a Maria nell'Ordine Domenicano* (Bologna, 1984).

7. Albert the Great, *De natura boni,* ed. Ephrem Filthaut, Cologne Edition 25/1 (1974): 59a–b, lin. 1–6, 48–52: "Sic ergo patet, qualiter et quare stella dicta sit beata virgo. Est autem stella, quae dicitur etiam et est polus mundi. In polo autem mundi axis mundialis machinae vertitur, sicut volvitur

ostium in cardine. Unde beata virgo cardo et cardinalis est caeli, in quo cardine volvitur totum genus humanum. . . . Axis vero misericordiae sustinentis mundum in his cardinibus sive polis volvitur, quia per matrem accessum habemus ad filium et per filium ad patrem, ut sic conducti reconciliationis pati repulsam nullatenus timeamus." See Bernard of Clairvaux, *Sermo secundus in adventu Domini*, in *Sermones* 1, ed. J. Leclercq and H. Rochais, *Opera* 4 (Rome, 1966): 174: "Sed iam advertistis, ni fallor, quoniam Virgo regia ipsa est via, per quam Salvator advenit, procedens ex ipsius utero, tamquam sponsus de thalamo suo. Tenentes ergo viam, quam priore, si meministis, coepimus vestigare sermone, studeamus et nos, dilectissimi, ad ipsum, per eam ascendere, qui per ipsam ad nos descendit, per eam venire in gratiam ipsius, qui per eam in nostram miseriam venit. Per te accessum habeamus ad Filium, o benedicta inventrix gratiae, genetrix vitae, mater salutis, ut per te suscipiat nos qui per te datus nobis. . . . Domina nostra, mediatrix nostra, advocata nostra, tuo Filio nos reconcilia, tuo Filio nos commenda, tuo nos Filio repraesenta." Cf. Anselme Le Bail, "Bernard (Saint), Abbé de Clairvaux," DS 1 (1932): 1454–1502, at 1489. De Montfort makes heavy use of Bernard's authority when arguing that to go to God the Father one must go to Jesus, but to go to Jesus one must first go to Mary. See his *Traité de la vraie devotion a la Sainte Vierge* in *Oeuvres complètes de saint Louis-Marie Grignion de Montfort* (Paris, 1966), 315–17 n^os 83–86. For Chaminade, see Émile Neubert, *La doctrine mariale de M. Chaminade* (Paris, 1937), 102–10.

8. The fundamental work on Albert's Christology is Ferdinand Haberl, *Die Inkarnationslehre des heiligen Albertus Magnus* (Freiburg i.B., 1939). See also Vincent-Marie Pollet, "Le Christ d'après S. Albert le Grand," *La Vie Spirituelle* 34 (1933): 78–108. One should note that in this essay I shall not concentrate on Albert's commentary on the third book of the *Sentences*, but will attempt to survey a wide range of Albert's writings. Unfortunately it was not possible to study his sermons for this paper. Nor will I discuss some other relevant topics, such as Albert's conception of the Virgin Mary as *mediatrix*.

9. For discussion see Mahoney, "Metaphysical Foundations", 166–67. Details regarding the relevant bibliography are also to be found there (218–21). Among the many studies published since 1982 two at least must be mentioned, namely, W. J. Hankey, *God in Himself: Aquinas' Doctrine of God as Expounded in the "Summa Theologiae"* (Oxford, 1987), and Fran O'Rourke, *Pseudo-Dionysius and the Metaphysics of Aquinas* (Studien und Texte zur Geistesgeschichte des Mittelalters 32, Leiden, 1992). The former author does not sufficiently identify the elements of the conceptual scheme Thomas adopted and his debt to Proclus in regard to it.

10. See James A. Weisheipl, *Friar Thomas d'Aquino: His Life, Thought, and Work* (Washington, D.C., 1983), 41–46. On Thomas's presentation of the scheme, see Mahoney, "Metaphysical Foundations," 169–72 (for relevant bibliography see the notes on 222–29). On the availability of the works of ps.-Dionysius, see H.-F. Dondaine, *Le Corpus dionysien de l'Université de Paris au XIIIe siècle* (Rome, 1953). On Dionysius, Albert and Thomas, see the essay in this volume by Robert Wielockx, "Poetry and Theology in the *Adoro te deuote:* Thomas Aquinas on the Eucharist and Christ's Uniqueness."

11. Ps.-Dionysius, *De divinis nominibus* cc.2,4 (PG 3: 648c, 697c, 700a). For discussion see the classic monograph of René Roques, *L'univers dionysien: structure hiérarchique du monde selon le Pseudo-Denys* (Paris, 1983), 59–62 and 86–87. It should be noted that near the end of his book Roques presents a special section entitled: "Le Christ et les hiérarchies" (319–29). A major result of the present paper is to verify the strong influence that Dionysius had on Albert.

12. Ps.-Dionysius, *De div. nom.* c.5 (PG 3: 821A), and *De coelesti hierarchia* c.8 (PG 3: 240BC). See Roques, *L'univers dionysien*, 96–104.

13. See Roques, *L'univers dionysien*, 87.

14. For apparent acceptance of the principle of continuity see Proclus, *The Elements of Theology*, props. 112, 132, 147 and 175, ed. E. R. Dodds, 2nd ed. (Oxford, 1963), 98–101, 116–19, 128–31, 152–55. Moerbeke's translation was edited by C. Vansteenkiste in *Tijdschrift voor Filosofie* 13 (1951): 263–302, 491–531. For discussion, see Martin Grabmann in vol. 2 of *Mittelalterliches Geistesleben* (Munich, 1946), 413–23; Gérard Verbeke, "Guillaume de Moerbeke, traducteur de Proclus," *Revue philosophique de Louvain* 51 (1953): 349–73.

15. There is an edition of the *Liber de causis* by Adriaan Pattin in *Tijdschrift voor Filosofie* 28 (1966): 90–203, which was published separately as a book with its own pagination: *Le Liber de causis*, ed. A Pattin (Louvain, 1966).

16. Albert the Great, *Super Dionysium De div. nom.* cc.1,4–5,7,9–10 (Cologne Edition 37/1: 14a–15b, 32b–33a, 183b–194a, 315b, 321a, 356b, 387b, 448a).

17. Ibid. c.5 (307a–9a).

18. Ibid. cc.4,7 (170a–b, 180b, 339a, 354b).

19. Albert the Great, *De causis et processu universitatis a prima causa* 2 tr.2 cc.6,15,22,24, ed. Winfrid Fauser, Cologne Edition 17/2 (1993): 99b, 108a, 116a, 117b–18a. To the scholarly literature cited in Mahoney, "Metaphysical Foundations," 221–22 n. 23, should be added Alain de Libera, "Albert le Grand et Thomas d'Aquin interprètes du *Liber de causis*," *Revue des sciences philosophiques et théologiques* 74 (1990): 347–78, and Edward Booth, "Conciliazioni ontologiche delle tradizioni platonica e aristotelica in Sant'Alberto e San Tommaso," in *Sant'Alberto magno: l'uomo e il pensatore* (Studia Universitatis S. Thomae in Urbe 15, Milan, 1982), 59–81.

20. See Albert the Great, *Summa theologiae sive de mirabili scientia Dei* 1.1 tr.6 q.26 c.1, ed. D. Siedler, W. Kübel and H. G. Vogels, Cologne Edition 34/1 (1978): 188a–89a, 191a–92b.

21. Albert the Great, *In I Sent.* d.8 aa.7–8 (Borgnet 25: 228–31).

22. See Albert the Great, *Metaphysica* 10 tr.1 c.5, ed. Bernhard Geyer, Cologne Edition 16/2 (1964): 436b–38b. For further details on Albert's presentation of the scheme in that work, see Mahoney, "Metaphysical Foundations", 222 n. 25.

23. See the following notes 24–26.

24. Albert the Great, *Summa theol.* 2 tr.10 q.37 (Borgnet 32: 405): "Est quidem hierarchia secundum me ordo divinus, et scientia, et actio, deiforme quantum possibile est similans, et ad inditas ei divinitus illuminationes proportionaliter in Dei similitudinem ascendens." See ps.-Dionysius, *De coel. hier.* c.3 (PG 3: 164D). For the various Latin versions of this passage, see vol. 2 of *Dionysiaca: Recueil donnant l'ensemble des traductions latines des ouvrages attribués au Denys l'Aréopage*, ed. Ph. Chevallier (Bruges-Paris, 1937), 785.

25. In *Summa theol.* 2 tr.10 q.37 (Borgnet 32: 406a) Albert quotes as follows: "Hierarchiam qui dicit, sacram quamdam universaliter declarat dispositionem, imaginem divinae speciositatis in ordinibus et scientiis hierarchicis propriae illuminationis sacrificantem mysteria, et ad proprium principium ut licet assimilatam." See ps.-Dionysius, *De coel. hier.* c.3 (PG 3: 165b), and *Dionysiaca* 2: 790.

26. Albert the Great, *Summa theol.* 2 tr.10 q.37 (Borgnet 32: 406a): "Hierarchia est sacrarum et rationabilium personarum ordinata potestas, in subditis proprium retinens dominatum." The three definitions are also quoted in *In II Sent.* d.9 a.1 (Borgnet 27: 188a); *Summa de creaturis* tr.4 q.35 a.1 (Borgnet 34: 527a). The one difference is that in these two works Albert refers to *magistri nostri* and *quidam* as the source of the third definition. For Albert's discussion of the first definition, his adoption of grade language and use of the term and concept *totum potestativum*, see *Summa theol.* 2 tr.10 q.37 memb.1–2 (Borgnet 32: 408b–11b, 413b); *Summa de creaturis* tr.4 q.35 a.3 (Borgnet 34: 532b). There is also relevant discussion in Albert the Great, *Super Dionysium De cael. hier.* c.3 (Cologne Edition 36/1: 44a–48a).

27. See Roques, *L'univers dionysien*, 30.

28. Albert the Great, *Summa de creaturis* tr.4 q.35 a.3 (Borgnet 34: 532a).

29. Ibid. tr.4 q.36 a.1 (538b). A similar line of reasoning is found in *Summa theol.* 2 tr.10 q.38 memb.1 (Borgnet 32: 418a).

30. Albert the Great, *In II Sent.* d.9 a.1 (Borgnet 27: 190a).

31. Albert the Great, *Summa de creaturis* tr.4 q.35 a.3 (Borgnet 34: 533a–b); *Summa theol.* 2 tr.10 q.37 memb.1 (Borgnet 32: 409a–b). See Hugh of St.-Victor, *Commentaria in Hierarchiam Coelestem S. Dionysii Areopagitae* 1 c.5 (PL 175: 934).

32. See Roques, *L'univers dionysien*, 94–95.

33. Albert the Great, *Summa theol.* 2 tr.10 q.37 memb.2 (Borgnet: 32: 414b–415a): "Ad aliud dicendum, quod ordo quidem divinus est, ut dicit Dionysius, in tribus actibus hierarchicis, sed tamen specialiter facit mentionem de illuminatione, quia illa specialis est, et per illam perficiuntur alii, ut dicit Dionysius. Per hoc enim quod illuminatur quis, purgatur a dissimiltudinis sive privationis luminis habitu, et ponitur ut speculum in similitudinem et formam luminis theophaniae in descendentis illuminatione in ipsum. Et quia hoc lumen propria virtute convertit et reducit eum qui illuminatus est in primum principium et fontem luminis et sic perficit ipsum, propter hoc etiam perfectio fit per illuminationem, ut dicit Dionysius." Albert's position here is not unlike that of Roques.

34. Albert the Great, *Summa theol.* 2 tr.10 q.37 ad 13–14 (Borgnet 32: 411b).

35. Albert the Great, *Summa de creaturis* tr.4 q.36 a.2 (Borgnet 34: 539a–43); *Summa theol.* 2 tr.10 q.38 memb.1–2 (Borgnet 32: 417–26); *In II Sent.* d.9 a.2 (Borgnet 27: 192–95). Albert regularly cites Gregory and Bernard in these discussions about the angels. On the interconnection of the three hierarchies, see *Super Dionysium De cael. hier.* c.10 (Cologne Edition 36/1: 160a, 164b).

36. See on this point *Summa theol.* 2 tr.10 q.39 a.1 part.2 quaesitum 1 ad 4–5, quaesitum 2 ad 4 (Borgnet 32: 434a–b, 435a, 437b).

37. Albert the Great, *Summa theol.* 2 tr.11 q.63 memb.1 (Borgnet 32: 604a–6b). Among the cita-

tions from Augustine two are especially noteworthy; see Augustine, *De civitate Dei* 19 c.13, ed. B. Dombart and A. Kalb, CCSL 48 (1955): 679, lin. 11–12: "Ordo est parium dispariumque rerum sua cuique loca tribuens dispositio"; Ibid. 12 c.2 (357, lin. 7–11): "Cum enim Deus summa essentia sit, *hoc est summe sit, et ideo inmutabilis sit:* rebus, quas ex nihilo creavit, esse dedit, sed non summe *esse, sicut est ipse;* et aliis dedit esse amplius, aliis minus: atque ita naturas essentiarum gradibus ordinavit." In the second quotation I have italicized words not found in the quotation as given by Albert.

38. In *Summa theol.* 2 tr.10 q.39 a.1 part.2 quaesitum 1 ad 6 (Borgnet 32: 460), Albert points out that Paul did not intend to put in order (*ordinare*) the various orders (*ordines*) in the hierarchies of angels but only to enumerate them.

39. On this point see Albert the Great, *Summa de creaturis* tr.4 q.45 (Borgnet 34: 575b–76a). In *Summa theol.* 2 tr.10 q.39 a.3 (Borgnet 34: 469–70a), Albert speaks of one form of illumination found in the angels as pertaining to the office and grade (*officium et gradus*) of an angelic order (*ordo*).

40. Albert the Great, *Summa de creaturis* tr.4 qq.37–58 (Borgnet 34: 543–621); *Summa theol.* 2 tr.10 q.39-tr.11 q.43 (Borgnet 32: 426a–510).

41. See Albert the Great, *Summa theol.* 2 tr.10 q.39 memb.2 a.3 (Borgnet 32: 469a–70a).

42. See Albert the Great, *Super Dionysium De cael. hier.* c.4 (Cologne Edition 36/1: 76–77); *Super Matthaeum* 8:10 and 11:27, ed. Bernhard Schmidt, Cologne Edition 21/1 (1987): 282a, 361b–62b. On the whole question of Christ's gaining new human knowledge though he already had divine knowledge, see Johannes Theodorus Ernst, *Die Lehre der hochmittelalterlichen Theologen von der vollkommenen Erkenntnis Christi* (Freiburger Theologische Studien 89, Freiburg i.B., 1971), 131–41; Pietro Mascarucci, "Il progresso di Cristo nella scienza in Sant'Alberto Magno: Studio comparativo con i teologi del suo tempo," *Divus Thomas* 51 (Piacenza, 1948): 217–50.

43. Albert the Great, *Super Dionysium De cael. hier.* c.13 (Cologne Edition 36/1: 188a–b).

44. Ibid. c.7 (109b; see also 105b).

45. Ibid. (111a). Albert is following Dionysius's terminology.

46. Ibid. c.5 (78a): "Littera sic construitur: Diximus, quod angeli, eo quod primo accipientes illuminationes a deo in nos deferunt, angeli dicuntur. . . . "

47. Albert the Great, *De resurrectione* tr.1 q.5, ed. Wilhelm Kübel, Cologne Edition 26 (1958): 247b. Albert also refers to Christ as an archangel in *Super Matthaeum* 24:31, ed. Bernhard Schmidt, Cologne Edition 21/2 (1987): 575b. He identifies his source: "Archangelus autem est Christus, princeps angelorum, ut dicit Glossa." See *Biblia latina cum glossa ordinaria* 4 (Turnhout, 1992) for 1 Thessalonians 4:16.

48. Albert the Great, *De incarnatione* tr.5 q.2 a.5, ed. Ignaz Backes, Cologne Edition 26 (1958): 216b–17b. For another discussion regarding how Christ is head, see Albert the Great, *In III Sent.* d.13 aa.2–4 (Borgnet 28: 238a–41a).

49. Albert the Great, *De incarnatione* tr.4 q.1 aa.2–3 (Cologne Edition 26: 206a–b).

50. Albert the Great, *In III Sent.* d.14 a.2 (Borgnet 28: 257b).

51. On Albert's Mariology, see Korosak, *Mariologia* and other studies listed in note 6 above.

52. Albert the Great, *Super Lucam* 1:27–28 (Borgnet 22: 55a–b). Albert's language is very similar to that of Bernard of Clairvaux in his *Homilia* 2 in the series *In laudibus virginis matris*. See Bernard, *Sermones* 1, ed. J. Leclercq and H. Rochais in *S. Bernardi Opera* 4 (Rome, 1966): 35. At one point Bernard writes: " . . . et sic in temetipso experiris quam merito dictum sit: Et Nomen Virginis Maria" (35). Albert follows almost to the word: "Et sic pro certo in teipso experieris, quam juste vocatum est nomen Virginis Maria" (55a). Albert also uses the title of *illuminatrix* for the Virgin Mary in other works. See for example *Super Marcum* 14:33 (Borgnet 21: 707b); *Super Matthaeum* 1:18 (Cologne Edition 21/1: 28a); *Super Johannem* 10:3 and 11:1 (Borgnet 24: 405b, 435b). See also note 55 below.

53. Albert the Great, *Super Lucam* 1:28 (Borgnet 22: 61a). For an informative analysis of Albert's comments on Luke's infancy narrative, see G.-M. Behler, "S. Albertus Magnus in Lucanum evangelium infantiae," *Divus Thomas* 37 (Piacenza, 1934): 209–25, 350–64. On Albert's biblical commentaries, see Gillis Meersseman, *Introductio in opera B. Alberti Magni O.P.* (Bruges, 1931), 82–98; Iacobus-M. Vosté, *S. Albertus Magnus. Sacrae Paginae Magister*, 2 vols. (Rome, 1932–33); A. Vaccari, "S. Alberto Magno e l'esegesi medievale," *Biblica* 13 (1932): 257–72, 369–84; Albert Fries, "Zur Entstehungszeit der Bibelkommentare Alberts des Grossen," in *Albertus Magnus Doctor Universalis 1280/1980*, ed. Gerbert Meyer and Albert Zimmermann (Walberberger Studien: Philosophische Reihe 6, Mainz, 1980), 119–39.

54. Albert the Great, *Super Lucam* 1:50 (Borgnet 22: 135b–36a).

55. Ibid. 2:17 (Borgnet 22: 216b). Joseph is also granted titles in this passage: *patronus virginis, Christi nutritius, itineris dux* and *familiae fidelissimus procurator*. In his *De sacrificio missae* tr.3 c.20 (Borgnet 38: 156a–b), Albert refers to Mary as *illuminatrix, figura Ecclesiae, stella maris, domina* and

also *dux*. He explains that she is the mother (*mater*) of all since through her compassion she conceives sons of the Church in her chaste flesh and blood.

56. Albert the Great, *Super Lucam* 2:35 (Borgnet 22: 241b).

57. Albert the Great, *De incarnatione* tr.1 a.5 (Cologne Edition 26: 176b–77a). Albert is of course careful to note that it is a matter of befittingness (*congruitas*) and not a necessity of justice.

58. Albert the Great, *Super Lucam* 1:46 (Borgnet 22: 122b).

59. Albert the Great, *De incarnatione* tr.2 q.1 a.6 (Cologne Edition 26: 179a).

60. Ibid. tr.2 q.1 a.6 ad 13 (180b): "Ad aliud dicendum, quod respectu tantae excellentiae, scilicet esse matrem dei, non est aliquod sufficiens meritum. Et ideo potius invenit gratiam istam in misericordia dei, quam meruerit eam. Habuit tamen respectu eius meritum congruentiae."

61. Ibid. tr.2 q.2 a.7 (186a–87a). On discussion among Dominicans regarding the question of the Virgin Mary's Immaculate Conception, see Ulrich Horst, *Die Diskussion um die Immaculata Conceptio im Dominikanerorden. Ein Beitrag zur Geschichte der theologischen Methode* (Veröffentlichungen des Grabmann-Institutes zur Erforschung der mittelalterlichen Theologie und Philosophie N.F. 34, Paderborn, 1987).

62. Albert the Great, *De resurrectione* tr.2 q.5 (Cologne Edition 26: 263b).

63. Albert the Great, *De incarnatione* tr.2 q.1 a.2 ad 3 (Cologne Edition 26: 174b).

64. Albert the Great, *Summa theol.* 1 q.73 memb.1, memb.2 a.1 (Borgnet 31: 751b, 755a, 756b–57b). For discussion of Albert's position on the three heavens and the place of Jesus and Mary, see Haberl, *Die Inkarnationslehre,* 201–4, and Korosak, *Mariologia,* 424–31. There is little relating to the three heavens according to Albert in Pierre Duhem, *Le Système du monde* 7 (Paris, 1956): 168–74, 197–202. More helpful is P. Bernard, "Ciel," DTC 2 (1932): 2474–2511 at 2503–8 ("Speculations scolastiques"). For a comprehensive discussion regarding the medieval concept of the empyrean heaven (*empyreum*), see now Edward Grant, *Planets, Stars, and Orbs. The Medieval Cosmos, 1200–1687* (Cambridge, 1994), 371–89. Although Grant does refer to the issue of whether the glorified bodies of Jesus and Mary are in the crystalline heaven or the empyrean heaven, he does not appear to refer to the heaven of the Trinity (*coelum Trinitatis*). There are references to the heaven of the Trinity in Bonaventure, *In II Sent.* d.2 pars 2 dub.2 (Quaracchi Edition 2: 86b). Alexander of Hales also refers to it. See Walter H. Principe, *Alexander of Hales' Theology of the Hypostatic Union* (Toronto, 1967), 166–67.

65. Thomas Aquinas, ST 1 q.66 a.3 corp. For a collection of texts from Aquinas that concern the empyrean heaven, see Thomas Litt, *Les corps célestes dans l'univers de saint Thomas d'Aquin* (Philosophes médiévaux 8, Louvain-Paris, 1963), 255–61. In addition, Litt lists various medieval thinkers who maintained the empyrean heaven, and he provides texts from their writings (255–58 n. 1).

66. Albert the Great, *Summa de creaturis* tr.3, introduction to q.10 and a.1 (Borgnet 34: 416a–17a). Albert here does not discuss further the crystalline heaven.

67. Ibid. tr.3 q.11 aa.1–3 (420a–23b). Its existence was established above all by Genesis 1:3.

68. Ibid. tr.3 q.10 a.2 (417b).

69. Ibid. tr.3 q.10 a.4 (420a–b).

70. Ibid. tr.3 q.10 a.3 (418a–19a).

71. Ibid. tr.4 q.32 a.2 (510a–14b).

72. Albert the Great, *In II Sent.* d.2 aa.3,7–8 (Borgnet 27: 51b–52, 56a–58b). For discussion of Albert's views on *natura, persona* and *suppositum* in Christology along with indications of the influence of William of Auxerre, Hugh of St.-Cher and Roland of Cremona on his thought, see Marie Lamy de la Chapelle, "L'unité ontologique du Christ selon saint Albert le Grand," *Revue thomiste* 70 (1970): 181–226, 534–59.

73. Albert the Great, *In III Sent.* d.22 a.7 (Borgnet 28: 396a–97a).

74. Ibid. d.22 a.8 (397a–98b). The *phantasia fatua* to which Albert refers was one of ten errors condemned in 1241: "Quartus, quod animae glorificatae non sunt in coelo empireo cum angelis, nec corpora glorificata erunt ibi, sed in coelo aqueo vel cristallino, quod supra firmamentum est, quod et de beata Virgine praesumitur"; CUP 1: 171 n° 128.

75. Albert the Great, *De resurrectione* tr.2 q.9 aa.1–3 (Cologne Edition 26: 285b–87a). For similar discussions, see Albert the Great, *De sacrificio missae* tr.2 a.6 (Borgnet 38: 63b); *Super Johannem* 16:16 (Borgnet 24: 590a–b).

76. Albert the Great, *De resurrectione* tr.2 q.9 a.5 (Cologne Edition 26: 288a–b). Albert's clear statement on the issue merits quotation: "Unde dicendum, quod secundum actum hierarchicum, qui est reducere inferiores in deum vel sic vel sic, Christus cum matre est in tertia hierarchia; secundum autem modum participandi beatitudinem et secundum locum sunt ultra omnes angelos. Nec sequitur ex hoc, quod aliquam faciant specialem hierarchiam, quia secundum hoc duae hierarchiae non distin-

388 EDWARD P. MAHONEY

guuntur; alioquin multae erunt hierarchiae etiam in uno choro" (288b, lin. 57–65). The text ascribed to Jerome in question is the following: "Hinc, rogo, omnes pariter festivitatem gloriosae semper virginis Mariae devotissime celebremus, quia haec est dies praeclara, in qua meruit exaltari super choros angelorum, et pervenire ultra quam nostrae humanitatis est natura. Ubi non substantia tollitur, sed gloriae magnitudo monstratur, cum elevatur in dexteram Patris, ubi Christus pro nobis introivit pontifex factus in aeternum ad coeli palatium. . . . Sic itaque ubique confidenter sancta Dei canit Ecclesia, quod de nullo alio sanctorum fas est credere, ut ultra angelorum et archangelorum dignitatem merito transcenderit . . . "; ps.-Jerome, *Epistola IX ad Paulum et Eustochium de assumptione beatae Mariae Virginis* (PL 30: 132c–d). The epistle was actually composed by an earlier medieval author, Paschasius Radbertus. See Albert Ripberger, *Der Pseudo-Hieronymus-Brief IX, "Cogitis me": ein erster Marianischer Traktat des Mittelalters von Paschasius Radbert* (Spicilegium Friburgense 9, Freiburg Schweiz, 1962). See also Hilda Graef, vol. 1 of *Mary: A History of Doctrine and Devotion* (Westminster-London, 1985), 176–80. See also her analysis of Albert's Mariology (1: 266–78).

77. Albert the Great, *Super Dionysium De ecclesiastica hierarchia* c.1 (Borgnet 14: 481 n° 3).

78. Ibid. (483b n° 3). The basic monograph on Albert's ecclesiology is Wilhelm Scherer, *Des seligen Albertus Magnus Lehre von der Kirche* (Freiburger theologische Studien 32, Freiburg i.B., 1928).

79. Albert the Great, *Super Dionysium De eccl. hier.* c.5 (Borgnet 14: 734a n° 28). See I. P. Sheldon-Williams, "*The Ecclesiastical Hierarchy* of Pseudo-Dionysius," *Downside Review* 83 (1965): 20–22, 27.

80. Albert the Great, *Super Dionysium De eccl. hier.* c.5 (Borgnet 14: 703a–4a n° 11).

81. Ibid. (707a n° 12).

82. Ibid. (730a n° 26).

83. Ibid. c.1 (482a–b n° 3).

84. Ibid. c.5 (736a n° 29).

85. Ibid. c.6 (739a–b n° 1). The dismissal of the catechumens, the penitents and others from the Eucharistic liturgy had already been discussed in c. 3 (567b n° 5), where Albert follows Dionysius (PG 3: 425c). There is also a similar discussion in c.3 (593a–b n° 15) again following Dionysius (PG 3: 432c–33a). Albert explains there that the catechumens are likened to infants who lack perfect life, inasmuch as they have never received the sacraments or the teaching possessed by the perfect but have only the rudiments of the faith. Just as the midwife (*obstetrix*) brings forth the infant from its mother's womb, so *praedicatores* by their warnings bring the catechumens to spiritual life in the manner of a midwife. Neither the infant nor the catechumen yet have perfect life. On Dionysius's views regarding the Eucharistic liturgy as participated in by the catchumens, see E. Boularand, "L'Eucharistie d'après le pseudo-Denys l'Aréopagite," *Bulletin de littérature ecclésiastique* 59 (1958): 132–46. On Dionysius's interpretation and explanation of liturgy, see *Dionysius the Pseudo-Areopagite: The Ecclesiastical Hierarchy*, trans. and annotated by Thomas L. Campbell (Lanham, 1981); Paul Rorem, *Biblical and Liturgical Symbols within the Pseudo-Dionysian Synthesis* (Toronto, 1984); Andrew Louth, *Denys the Areopagite* (London, 1989), 17–32, 52–77.

86. Albert the Great, *Super Dionysium De eccles. hier.* c.3 (Borgnet 14: 593a–94a n° 15): " . . . aliquo modo sunt in Ecclesia, et habent aliquem ordinem licet ultimum."

87. Ibid. c.6 (741a–b n° 2).

88. Ibid. (743a n° 3).

89. Ibid. (739b n° 1, 743a–b n° 3).

90. Albert the Great, *In IV Sent.* d.24 a.5 (Borgnet 30: 35a–37a). On Peter Lombard's theology of the sacraments, see A. Michel, "Ordre, Ordination," DTC 11 (1932): 1301–4; Marcia L. Colish, vol. 2 of *Peter Lombard* (Leiden, 1994), 516–700.

91. Albert the Great, *In IV Sent.* d.24 a.36 (Borgnet 30: 76a–b).

92. Ibid. d.24 a.5 (36a).

93. Ibid. d.10 a.4 (251a). Albert adds that the sacrament of the Eucharist is both a sign and also a cause of grace. For further discussion, see Albert Lang, "Zur Eucharistielehre des hl. Albertus Magnus: Das Corpus Christi verum im Dienste des Corpus Christi mysticum," in *Albertus-Magnus-Festschrift, Divus Thomas* 10/2–3 (Freiburg, 1932): 124–42; Antonio Piolanti, *Il corpo mistico e le sue relazioni con l'eucaristia in S. Alberto Magno* (Studi di teologia medievale della Pontificia Università Lateranense 1, Rome, 1969).

94. Albert the Great, *In IV Sent.* d.13 a.10 (Borgnet 29: 349a). See also *Super Dionysium De eccles. hier.* c.3 (Borgnet 14: 582b–583a n° 10), where Albert again calls the body of Christ spiritual food (*cibus spiritualis*).

95. Albert the Great, *Super Dionysium De eccles. hier.* c.3 (Borgnet 14: 558a–b). Albert concedes,

however, that some of the other sacraments can be nobler in a relative manner (*secundum quid*) as regards the higher sort of effect ("effectus maior et dignior") that they bring about in the recipient. Presumably one of the sacraments that Albert has in mind is ordination to the priesthood. He also concedes that all the other sacraments presuppose baptism as their foundation (*fundamentum*). For further discussion regarding Albert's position on the preeminence of the Eucharist, see James W. Kinn, *The Pre-eminence of the Eucharist among the Sacraments according to Alexander of Hales, St. Albert the Great, St. Bonaventure and St. Thomas Aquinas* (Mundelein, Illinois, 1960), 44–68. On the Eucharist, see also R. Garrigou-Lagrange, "De sacrificio missae secundum sanctum Albertum Magnum," *Angelicum* 9 (1932): 213–24; Burkhard Neunheuser, *Eucharistie in Mittelalter und Neuzeit, Handbuch der Dogmengeschichte* 4/4a (Freiburg, 1963): 38–40. For other studies on Albert's doctrine of the sacraments, see Heinrich Weisweiler, "Die Wirkursächlichkeit der Sakramente nach dem Sentenzenkommentar Alberts des Grossen," in *Studia Albertina: Festschrift für Bernhard Geyer zum 70. Geburtstage,* ed. Heinrich Ostlender (BGPTMA Suppl. 4, Münster 1952), 400–19; Campion Murray, "The Composition of the Sacraments according to the 'Summa de sacramentis' and the 'Commentarium in IV Sententiarum' of St. Albert the Great," *Franciscan Studies* 16 (1956): 177–201; Franz-Josef Nocke, *Sakrament und personaler Vollzug bei Albertus Magnus* (BGPTMA 44/4, Münster, 1967); R. F. King, "The Origin and Evolution of a Sacramental Formula: 'Sacramentum tantum, res et sacramentum, res tantum'. De Berengar de Tours à Albert le Grand," *The Thomist* 31 (1967): 21–82; Thomas McGonigle, "The Significance of Albert the Great's View of Sacrament," *The Thomist* 44 (1980): 560–83.

96. Albert the Great, *Super Dionysium De eccles. hier.* c.3 (Borgnet 14: 560a–61a n° 2). For a like treatment of *communio,* see Albert the Great, *De sacrificio missae* tr.3 c.6 (Borgnet 38: 96b–97a).

97. Albert the Great, *In IV Sent.* d.24 aa.39–40 (Borgnet 30: 81a–b). The distinction between sacred *ordines* and *dignitates* which exist in the same grade and differ on the basis of *potestas in ministerio* had been made by Hugh of St.-Victor, *De sacramentis* 2.2 c.5 (PL 176: 418b–19a). For further discussion see Artur M. Landgraf, "Die Lehre von Episkopat als Ordo," in *Dogmengeschichte der Frühscholastik,* Teil 3, Band 2 (Regensburg, 1955), 277–302 at 289–92; Bernard D. Dupuy, "Theologie der kirchlichen Ämter," in *Mysterium Salutis* 4/2, ed. J. Betz et al. (Einsiedeln, 1973), 488–523, at 513–16; Ludwig Hödl, "Das scholastische Verständnis von Kirchenamt und Kirchengewalt unter dem frühen Einfluss der aristotelischen Philosophie ('Per actus cognoscuntur potentiae')," *Scholastik* 36 (1961): 1–22, at 12–14, 20–21; Yves M.-J. Congar, *Sainte Église: Études et approaches écclesiologiques* (Paris, 1963), 277–302.

98. Albert the Great, *De sacramentis* tr.8 q.3, ed. Albert Ohlmeyer, Cologne Edition 26 (1958): 139b–41a.

99. Albert the Great, *Super Lucam* 4:14–22 (Borgnet 22: 319b–20a). See also 6:11 (404b).

100. Albert the Great, *De incarnatione* tr.5 q.2 a.4 (Cologne Edition 26: 216b).

101. See Albert the Great, *In IV Sent.* d.18 aa.5,11; d.19 a.1 (Borgnet 29: 772b, 784b, 803b). It is also Christ who is "primus perfector sanctitatis in corpus mysticum"; see Albert the Great, *De sacrificio missae* tr.3 c.15 (Borgnet 38: 130a). See also tr.3 cc.7,13 (108a, 121b, 126a).

102. Albert the Great, *De sacramentis* tr.8 q.3 (Cologne Edition 26: 139b–41b). See note 97 above for relevant literature. On Peter Lombard, see note 90 above.

103. Albert the Great, *De annuntiatione* tr.2 q.1 (Cologne Edition 26: 180a).

104. Albert the Great, *De resurrectione* tr.2 a.6 ad 3 (Cologne Edition 26: 282b–83a n° 7): "Ad tertium dicendum, quod principatus Petri super universam ecclesiam, quae est in fluctibus passionum, significabatur per hoc quod venit per mare; per hoc autem quod alii discipuli venerunt navigio, significabantur determinatae ecclesiae, quibus praefuerunt."

105. Albert the Great, *Super Lucam* 1:32 (Borgnet 22: 86b–87a). See also 4:44 (350b). The Pope (*Papa*) is the Father of Fathers, the successor of Peter and the Vicar of Christ, from whom there flows to us the *communio* of the unity of the Church. That *communio* of unity descends to us by way of our own individual bishop. Albert states very clearly that the Pope and the bishops are established above other humans and hold the place of one who perfects to sanctity (*perfector sanctitatis*), but he carefully adds that they are men and fragile. They need prayers even more than do others. See Albert the Great, *De sacrificio missae* tr.3 c.6 (Borgnet 38: 105a, 106a). In tr.3 c.8 (113a), Albert goes on to refer to the apostles as comprising a grade (*gradus apostolorum*) and to refer to Peter as the highest apostle and the head of the apostles (*summus et caput Apostolorum*).

106. When commenting on Luke 9:1 (*Super Lucam;* Borgnet 22: 601b), Albert presents the apostles as configured (*configurati*) to Christ in various ways.

107. Albert the Great, *Super Lucam* 9:45–47 (Borgnet 22: 683b, 679a). Albert quotes Matthew 11:29 ("Discite a me quia mitis sum et humilis corde") at 9:46 and 9:47 (679a, 681a). We can give here

only a sample of Albert's remarks regarding Christ as the model of life for prelates and indeed for all clerics.

108. Albert the Great, *Super Lucam* 14:26 (Borgnet 23: 361a–b).

109. Ibid. 9:46 (Borgnet 22: 677a–b).

110. Ibid. 22:26 (Borgnet 23: 682a–b). Albert quotes here both Matthew 18:4 and 11: 29–30.

111. Ibid. 14:27 (Borgnet 23: 362a–b, 365a). Albert returns to *perfectio* and *consummatio* at 18:1 (495a). Elsewhere he makes clear that the Virgin Mary was near Christ's cross, participating in the cross, to which she was configured. See *Super Johannem* 19:27 (Borgnet 24: 660a–b).

112. Albert the Great, *Super Lucam* 14:27 (Borgnet 23: 364b): "Est tertio modo unicuique tollenda crux sua, quando secundum congruitatem personae commensuratur. Magis enim de cruce debet apparere in Vicario Christi quam in aliis: et magis in Patriarchis et Episcopis quam in aliis: et magis in Praelatis quam in subditis, secundum quod Christi locum tenent majorem et minorem."

113. Ibid. 9:55 (Borgnet 22: 692a).

114. Ibid. 9:48 (Borgnet 22: 685b). Elsewhere Albert points out that the Catholic Church is compared to a sheepfold insofar as it is under one pastor, Jesus Christ. But he adds that the Church itself contains smaller flocks of sheep, namely convents of religious (that is, members of religious orders), conventual churches, cathedrals, and parish churches in which are found the simple, meek, subject and humble faithful (*fideles*). These communities have such qualities and thrive because of like qualities of their prelates, namely, meekness, chastity, love (*caritas*), fortitude, learning (*eruditio*) regarding the word of God (*verbum Dei*) and unanimity. See Albert the Great, *Super Johannem* 10:1 (Borgnet 24: 396b–97a). In regard to meekness (*mansuetudo*), Albert quotes Matthew 11:29. By their love (*caritas*) and rule (*gubernatio*), prelates should so care for communities of the faithful (*congregationes fidelium*), whether they be families of lay people, convents of canons and monks, or parishes in villages, that by their example the faithful (*fideles*) will exist in Christ. See *Super Johannem* 15:1 (Borgnet 24: 556a–b). Canons and monks are also listed together in Albert's *Super Matthaeum* 6:26 (Borgnet 20: 323a).

115. Albert the Great, *Super Lucam* 9:49 (Borgnet 22: 686a): "Sed sciendum, quod cum Christus diceret humilem (qui Christum induit in pueri humilitate et simplicitate) solum magnum locum in Ecclesia inter ministros Christi tenere, putabat illum a ministerio esse arcendum, qui sic in pueri humilitate non induit Christum." Just previously Albert had listed some fourteen qualities as proper to a child (*puer*), including simplicity, humility, innocence, chastity, and love of one's fellows (*sociorum caritas*). He then observes that there are fourteen because "childood" (*pueritia*) is extended to the fourteenth year. See also 9:47 (680b–81a).

116. Albert the Great, *Super Lucam* 9:23 (Borgnet 22: 643a, 645b, 646a).

117. Ibid. 11:27 (156a).

118. Ibid. 9:16 (633a). Albert applies to evil prelates Isaiah 3:7. It should be noted that Christ is referred to as a physician (*medicus*) at 1:68 (164b). See also *Super Johannem* 17:3 (Borgnet 24: 607a) for reference to *Jesus Christus medicus*.

119. Albert the Great, *Super Lucam* 22:26 (Borgnet 23: 682b).

120. Ibid. 21:25–27 (644b).

121. Albert the Great, *Super Lucam* 2:52 (Borgnet 22: 257b): "Dicit autem quod '*proficiebat aetate*,' per incrementum debitum corporis, et virtutis corporalis. Et hoc congrue: quia cum in unoquoque genere sit unum, quod est mensura aliorum, et ad cujus accessum alia participant naturam illam, convenit in genere hominum hanc esse mensuram in Dei Filio: et ideo nullo impedimento naturae (sicut in aliis contingit) ad debitam quantitatis et virtutis profecit: ita quod, ad Ephes. IV, 13, dicitur, quod *omnes occurremus in virum perfectum, in mensuram aetatis plenitudinis Christi*. Et ideo dicit, quod *profecit aetate*." It must be admitted that what this means for Albert's metaphysics is not too clear. Nor are its consequences for his Christology all that evident.

122. Albert the Great, *Super Lucam* 6:48 (Borgnet 22: 455b–56a). The first scriptural authority that Albert cites is Ephesians 4:13. There is a similar use of such ideas in Albert's *De sacrificio missae* tr.3 c.6 (Borgnet 38: 103b): "Et ipsa multitudo Angelorum quae est in quolibet est agmine, ad unam personam quae in quolibet ordine praeeminet, adunatur: et ideo *ordo coeli* vocatur, quia omnis ordo est relatio multorum in gradibus differentium ad unum."

123. Albert the Great, *De resurrectione* tr.2 q.6 (Cologne Edition 26: 264b). Albert again cites this passage from Aristotle when he argues that all human justice is measured by that of Christ and the Virgin Mary. See Albert the Great, *Postilla super Isaiam* 11:1, ed. Ferdinand Siepmann, Cologne Edition 19 (1952): 164b.

124. Albert the Great, *Super Iohannem* 1:3 (Borgnet 24: 32b).

125. See Albert the Great, *De causis et processu universitatis* 1 tr.2 c.1 (Cologne Edition 17/2:

26a, lin. 17–19): "Et hoc est intellectus purus universaliter agens, qui ex seipso constituit et producit et facit omne quod est."

126. Albert the Great, *Super Iohannem* 8:35 (Borgnet 24: 356a): "Ad hoc dicendum, quod servitus hinc inde aequivoce sumitur. Servitus enim in communi dicta notat subjectionem. Est autem subjectio ad optimum et honorabilissimum: sicut ad Deum, et ad bonum divinum. Et per hanc servitutem, libertati et dominationi appropinquatur. Et ideo dicit Gregorius, quod servire Deo regnare est. Est etiam servitus per suppositionem ad vilissimum per affectum. Et per hanc servitutem homo vilificatur et vere servus efficitur. Est enim homo natura media: et per meliora appropinquat summo, et per viliora appropinquat infimo. Et ideo per superiora liberatur et extollitur: quia ad illa ordinatur ex natura. Per inferiora autem vilificatur: quia illa sunt casus a natura ipsius. Et hoc modo appropinquando superioribus, loquitur de servitute in auctoritatibus inductis."

127. Albert the Great, *Super Lucam* 1:35 (Borgnet 22: 104a–5a). I will not present here the further refinements that Albert gives regarding the holiness of the Virgin Mary.

128. Ibid. 1:35 (105a).

129. Albert the Great, *In III Sent.* d.2 a.2 (Borgnet 28: 22b–23a).

130. Ibid. d.2 a.1 (23a).

131. Ibid. d.2 a.11 (34b–35).

132. Ibid. d.2 a.12 (37b–38a).

133. Ibid. d.3 a.18 and d.4 a.1 (59a, 76a).

134. Ibid. d.4 a.10 (89b).

135. Ibid. d.19 a.10 (349a–51b). See also Albert's discussion regarding Christ as mediator in *De incarnatione* tr.6 q.2 a.3 (Cologne Edition 26: 231b–32a). Once again he quotes 1 Tim. 2:5 and also quotes at length from *De civitate dei* 9.5. For Augustine's doctrine of Christ as mediator see Gerard Remy, *Le Christ mediateur dans l'oeuvre de Saint Augustin*, 2 vols. (Lille-Paris, 1979). On Albert's view of Christ as mediator, see Haberl, *Die Inkarnationslehre*, 161–62, who also presents similar statements in Hugh of St.-Cher regarding extremes, distance and a *medium* that unites.

136. Albert the Great, *De sacrificio missae* tr.3 c.4 (Borgnet 38: 87b n° 11). Albert again quotes 1 Tim 2:5.

137. Ibid. tr.3 c.6 (99a n° 4). Albert refers to *deus humanatus* and *homo deificatus* in *Super Matthaeum* 1:1 (Cologne Edition 21/1: 13a) and to *deificata humanitas* and *divinitas humanata* over Matthew 16:16 (456b–57b). See John Damascene, *De fide orthodoxa* 3 cc.2,17 (PG 94: 988a, 1069a). But for the precise terminology see John Damascene, *De fide orthodoxa: Versions of Burgundio and Cerbanus* c.46, ed. E. M. Buytaert (Franciscan Institute Publications: Text Series 8, St. Bonaventure, New York, 1955), 172, lin. 36–37: "Ideo non hominem deificatum dicimus, sed Deum humanatum." See also c. 61, 248–49. This terminology was also used by Hugh of St.-Cher. See Wilhelm Breuning, *Die hypostatische Union in der Theologie Wilhelms von Auxerre, Hugos von St. Cher und Rolands von Cremona* (Trierer Theologische Studien 14, Trier, 1962), 365, lin. 140–41.

138. Albert the Great, *Super Lucam* 2:3 (Borgnet 22: 192b): "Ille enim qui mediator est Dei et hominum, qui medius stetit hominum, qui medio jacuit duorum animalium, qui medius stetit latronum in cruce, medius apparuit discipulorum, et semper medium amavit, nec ad superfluum, nec ad diminutum declinans, medium etiam nostri elegit mundi ubi nasceretur." See also 24:36 (764b–65a).

139. Ibid. 2:46 (Borgnet 22: 254a): "Semper enim est in medio, ad quod omnia extrema habent respectum. Natus in medio duorum animalium jacens, nunc in medio Doctorum sedens, baptizandus in medio baptizandorum. Joan. I, 26: *Medius vestrum stetit.* Crucifixus in medio latronum: resurgens immortalis in medio discipulorum. . . . Et in omnibus ostendens, quod extrema immensitate abjicit, et medium secundum temperantiae mensuram diligit." See also Albert's comments over Luke 23:33, 23:38, 24:36 (Borgnet 23: 725a, 730b, 764b–65a). Albert relates a child being established in the middle ("puer in medio statutus") with his ruling his subjects in meekness and humility; see 9:47 (Borgnet 22: 683a).

140. The concept of Christ as the *medium* was central for Bonaventure, most notably in his *Itinerarium mentis ad Deum*. For discussion see W. Dettloff, "Christus tenens medium in omnibus: Sinn und Funktion der Theologie bei Bonaventura," *Wissenschaft und Weisheit* 20 (1957): 28–42, 120–40; Ewart H. Cousins, *Bonaventure and the Coincidence of Opposites* (Chicago, 1978); Zachary Hayes, *The Hidden Center: Spirituality and Speculative Christology in St. Bonaventure* (New York, 1981). For a similar use of the concept of Christ as mediator in a Christocentric metaphysics, see Nicholas of Cusa, *De docta ignorantia*, especially book 3. For discussion see Edmond Vansteenberghe, *Le cardinal Nicolas de Cues (1401–1464), L'action—la pensée* (Paris, 1920; reprt. Frankfurt, 1963), 389–408; Rudolf Haubst, *Die Christologie des Nikolaus von Kues* (Freiburg i.B., 1956), 109–92; Ewart Cousins, "Bonaventure,

the Coincidence of Opposites and Nicholas of Cusa," in *Studies Honoring Ignatius Charles Brady Friar Minor*, ed. Romano Stephen Almagno and Conrad L. Harkins (Franciscan Institute Publications: Theology Series 6, St. Bonaventure, New York, 1976), 177–97. See also the essay in this volume by Maarten Hoenen, "Tradition and Renewal: The Philosophical Setting of Fifteenth-Century Christology. Heymericus de Campo, Nicolaus Cusanus, and the Cologne *Quaestiones vacantiales* (1465)."

141. For a sampling of references to humility and meekness, see Albert the Great, *Super Johannem* 1:29 (Borgnet 24: 65b–66a), 1:49 (190a), 8:6 (331a), 10:1 (396b–97a, 398b), 10:7 (408b–9a), 13:8 (505a), 13:24 (513a), 19:9 (649a); *Super Lucam* 2:12 (Borgnet 22: 208a–10a), 6:13 (407a), 8:9 (535b), 9:47–49 (681a–b, 682b–83b, 684b–86a), 9:55 (692a–b), 9:58 (695b), 10:3 (Borgnet 23: 13a), 10:38 (73ab, 76b, 77b), 11:26 (156a), 12:29 (235a), 12:42 (264a), 14:7 (331b), 14:9–11 (333b–35b), 14:16 (341a), 14:26 (361b–362a), 19:35–37 (586b–87b), 20:9 (603b), 21:19 (639a–b), 22:26 (682a–b). For references to Matthew 11:28–30, see *Super Johannem* 10:1 (Borgnet 24: 397a), 13:8 (505a), 18:36 (641b); *Super Lucam* 2:12 (Borgnet 22: 209b), 5:4 (364b), 6:13 (407a), 6:47 (454b), 8:9 (535b), 9:47 (681a), 10:38 (Borgnet 23: 76b), 15:1 (380a), 16:8 (424a–b), 19:12 (562b), 19:30 (583b), 19: 36 (587b), 20:9 (603b), 22:26 (682a); *De bono* tr.2 q.1 a.6 (Cologne Edition 28: 108a).

142. Albert the Great, *Super Matthaeum* 11:29–30 (Cologne Edition 21/1: 365a–b). See also 5:4 (106b–7a).

143. I am indebted to Stephen Brown, Mark Clark, Kent Emery and Father Michael Tavuzzi, O.P., for answering inquiries related to this paper. Father Simon Tugwell, O.P., and Mark Rascevic enabled me to secure some of the studies that I cite.

Christ in the Writings of
the Rhineland Dominicans

Walter Senner, O.P.

Among teachers in the medieval Dominican province of Teutonia, some modern scholars discern a distinctive tradition of philosophic and theological speculation, which spanned nearly two centuries. Albert the Great is often called the father of this "school of Rhineland Dominicans." In this essay, I shall first identify some of Albert's salient teachings concerning Christ, which may serve to signal his influence upon others. Then I shall investigate texts by later Rhineland Dominicans, all of whom are less known but some of whom are now receiving scholarly attention: Hugh Ripelin of Strassburg, Dietrich of Freiberg, John Picardi of Lichtenberg, John of Sterngassen, and Gisilher of Slatheim. Finally, in light of my survey, I shall pose the question: Was there a "Rhineland Dominican school," at least as far as Christological teachings are concerned?

Albert the Great

Albertus Magnus is the only man to be called "the Great" because of his intellectual achievements. Albert was influenced by the theological traditions of Paris, but more remarkably, in a new and daring way he opened Christian thought to the teachings of Greek, Arabic and Jewish philosophers. His huge encyclopedia introduced the full range of Aristotelian knowledge to the Latin west. Not only by his writings but also by his personal teaching he formed many pupils, some of whom became great thinkers themselves; one need only mention Thomas Aquinas, whose genius Albert recognized, and Ulrich of Strassburg. There is no doubt that in this sense one may speak of a "school of Albert." Moreover, within the last decade he has been seen as the founding father of what has been called the "German Dominican school"[1] or the "Rhineland Dominican school."[2] In this context, then, it is appropriate to see how far his theology, and more precisely his Christology, were received by Rhineland Dominicans. Such an investigation, however, sounds easier than it is, for the available sources are of very divergent types: Scholastic writings, catechetical manuals, mystical sermons, which often survive only in extracts. Much material has been lost; the tradition of the surviving texts is fragmented and unclear; most of the texts are not available in printed editions, and those that are have not always been established on critical principles. Thus, we are fortunate when we can discover thematic parallels, not to mention clear literary dependencies. Nevertheless, an expedition into the writings of these relatively unknown Rhineland Dominicans may be worthwhile.

From the Middle Ages—probably from the next generation after his death—until now, interest in Albert the Great's theology has not been as great as in his philosophi-

cal writings. Concerning his Christology, however, we are relatively well-off: a synthetic study by Ferdinand Haberl covers not only Albert's teaching on the Incarnation but also his understanding of the Passion and his soteriology.[3] Finished in 1939 as a doctoral dissertation directed by Martin Grabmann, Haberl's work is still of value today. Therefore, I do not need to make a general presentation of Albert's Christology, but will focus on some particular doctrines, which, in relation to his predecessors and contemporaries, were controversial.

In the *Summa Halensis* one finds the opinion that Christ is the divine Son of the Father by an eternal begetting, but as far as his human nature is concerned, he is the son of God by creation and by grace. In this respect, he may be called "Son of the Trinity."[4] According to Albert, on the contrary, Christ is not the Son of the Trinity but only of the Father, for his being Son is not founded in his nature but in in his divine personality.[5] As a consequence of this teaching, Albert says that the soul of Christ is not just a logical link (*medium congruitatis*) between his divinity and his humanity,[6] but a real link (*medium rei*), because Christ's soul is the reason for the possibility of this union between the divinity and the humanity.[7] In the *Tractatus de incarnatione*, however, Albert offers another opinion: a *medium secundum rem* is necessary for the union of soul and body, but the union of divinity and humanity in Christ is founded directly on divine power.[8]

Albert clearly affirms that the salvation of mankind by Christ's death on the cross is necessary;[9] concerning the famous question, "Whether the Son of God would have become incarnate if no human being had sinned," however, he is undecided, but is personally inclined to agree that Christ would have.[10]

Concerning Christ's knowledge, Albert argues that in his soul Christ knows what God knows, but does not comprehend (*non claudit comprehendo*) the infinity of God.[11] In his commentary on the *Sentences*, Albert states that Christ's human soul does not possess an undifferentiated, simple, angelic and divine knowledge, but all of his knowledge is founded in his contemplation of the divine Word.[12] In his *Tractatus de incarnatione*, however, he specifies four modes of knowledge in Christ: "Cognitio autem Christi aut est viatoris, inquantum viator est, aut comprehensoris, inquantum comprehensor est, aut ipsius, inquantum est deus, aut hominis, inquantum est unitus divinitati."[13] According to the last two ways, Christ knows everything: as God, he knows all in a simple act; as a human nature united with God, he contemplates all in the divine Word (*in verbo*).[14]

Like William of Auxerre, Albert speaks of a *velleitas* in Christ, that is, of a conditional but not a perfect will.[15] That Christ's human will was conditional may be seen from his prayer on the Mount of Olives: "Si non potest hic calix transire, nisi bibam illum, fiat voluntas tua" (Mt 26:41). Unlike William of Auxerre,[16] Albert explains that Christ really struggled in his soul, subduing his human will to the will of the Father.[17]

Differing from William of Auxerre[18] and Bonaventure,[19] Albert maintains that Christ possessed not only the theological virtue of love (*caritas*), but also the virtues of faith (*fides*), which was identical with his vision, and hope (*spes*), which had the salvation of the body (*gloriam corporis*) as its object.[20]

According to Albert, who on this point follows William of Auxerre[21] and opposes the *Summa Halensis*[22] (and the later position of Thomas Aquinas[23]), Christ is the head

of the angels (*caput angelorum*) only as God and not as man.[24] Ulrich of Strassburg, Albert's closest disciple, does not draw this distinction at all.[25]

The doctrines to which I have referred do not represent an exhaustive list of distinctive features in Albert's Christology, nor may they serve to characterize his Christology as a whole. These briefly noted teachings, however, are important for identifying Albert's particular teaching, and hence are helpful for measuring the reception of his theology in later generations.

Two further remarks may help to characterize Albert's Christological thinking within the general framework of his conception of theology. Hugh of Saint-Victor, as is well-known, distinguished between God's works of creation (*opera conditionis*) and his works of restoration or redemption (*opera restaurationis*).[26] The compilers of the *Summa Halensis* employed this distinction, assigning the subject of the works of redemption to theology, and the subject of the works of creation to the secular sciences.[27] Bonaventure, in turn, understands the whole Christ (*totum integrale*) to be the object of theology.[28] Both of these conceptions of theology are neatly Christocentric. Albert the Great's conception is broader: the object of theology is God. But he qualifies this conception, so that Christian theology will not be mistaken as a part of metaphysics: "deus . . . non autem absolute tantum est subiectum, sed secundum quod ipse est Alpha et Omega, principium et finis."[29]

Romanus Cessario argues that there was a decisive advance in Thomas Aquinas's soteriology from his *Scriptum super Sententias* to the third part of the *Summa theologiae,* from an "Aristotelian understanding of virtue" to a more "personalist" understanding.[30] In this respect, Thomas seems to have gone beyond his teacher. It was Albert, as I have stated, who on a large scale introduced Aristotelian concepts and methods into Christian thought, and the argumentative method and concepts of human science into theology.[31] This was his greatest accomplishment. In comparison with Thomas Aquinas, his theological synthesis appears less perfect, but perhaps this was the price of his great innovation, which required him to be preoccupied with the details of every aspect of learning. That Albert's new style of thinking in theology was not immediately and universally received by his confrères can be seen by considering another German Dominican, Hugh Ripelin of Strassburg.

HUGH RIPELIN OF STRASSBURG

The most popular handbook of theology in the Middle Ages was not Thomas Aquinas's *Summa theologiae,* nor a commentary on the *Sentences* by some other famous master, but the *Compendium theologicae veritatis* by Hugh Ripelin (†1268), an otherwise nearly unknown Dominican from Strassburg.[32] Unlike Scholastic works, this compendium shows no traces of dialectical method; it is a kind of catechetical handbook, aiming at an unsophisticated and complete presentation of Christian doctrine—evidently, the reason for its enormous success.

Although often ascribed to Albert the Great,[33] who is quoted implicitly in the work several times,[34] the *Compendium* for the most part is not based on his theology, but is heavily dependent on Bonaventure's *Breviloquium.*[35] Both texts are divided into seven books and share identical themes.[36] The fourth book in each work, titled *De*

humanitate Christi by Bonaventure and *De incarnatione Verbi* by Hugh, is devoted to Christology. After treatment of God (book 1), the creation (book 2) and its corruption by sin (book 3), the fourth book on Christ is the "turning-point" in the structure of the sevenfold design, preceding the treatments of grace (book 5), the sacraments (book 6), and eschatology (book 7). Following Bonaventure, Hugh stresses the Christocentric perspective in the opening chapter.[37] Whereas the corresponding section in the *Breviloquium* is subdivided into ten chapters, the *Compendium* has twenty-five, covering the whole range of Christ's Incarnation (chapters 1–11, 18), earthly life (chapters 12–17), Passion, Resurrection and heavenly reign (chapters 19–25). Controversial issues are rarely treated; thus, for example, one finds nothing in the *Compendium* addressing the question as to whether Christ would have become man if no human being had sinned. The *Compendium* contains a chapter *De unione et natura assumpta* that is different from the *Breviloquium*.[38] This subject is developed in quite different and more detailed ways in the *Summa Halensis* and by Bonaventure and Albert the Great in their commentaries on the third book of the *Sentences* (distinction 1).[39]

Like Bonaventure,[40] Hugh Ripelin distinguishes five modes of knowledge in Christ; although the content of Hugh's distinction is the same as Bonaventure's, he divides and arranges the modes differently:

> . . . modos et differentiae cognoscendi, qui sunt 5: (1) Primus est cognitio sempi-ternalis ex parte divinitatis: et hoc modo cognoscit omnia simul [*Breviloquium* n° 1: secundum divinam naturam]. . . . (2) Secundus modus est cognitio sensuali-tatis ex parte carnis: et iste modus est cognitio per experientiam [*Breviloquium* n° 5: per experientiam]. . . . (3) Tertius modus est spiritualis ex parte mentis: et iste triplex fuit, scilicet per naturam, per gratiam et per gloriam. Per naturam est igitur tertius modus cognoscendi, quo Christus cognovit omnia, quae spectant ad universi constitutionem, sed longe perfectius quam Adam, etiam existens in natura instituta [*Breviloquium* n° 4: per naturam integram]. . . . (4) Quartus mo-dus est per gratiam: hoc modo Christus cognovit omnia quae spectant ad humani generis redemptionem, sed longe excellentius, quam aliquis prophetarum, vel etiam Angelorum. Non solum enim habuit Christus scientiam per habitum in-natum, ut Adam et Angeli, sed etiam per habitum infusum, velut sancti per gra-tiam illuminati [*Breviloquium* n° 3: per gratiam]. . . . (5) Quintus modus est per gloriam: hoc modo cognovit omnia Christus: finita auidem cognitione actuali, infinita vero non nisi cognitione habituali, vel excessiva. Anima enim Christi per gloriam comprehensionis capiebat quaecumque capere potest natura finita, unita infinito [*Breviloquium* n° 2: per gloriam].[41]

In Bonaventure's *Breviloquium* we do not find a treatment of the will of Christ. Hugh derives his treatment of this topic from Albert's commentary on the *Sentences*.[42] Hugh distinguishes between (1) a created and (2) an uncreated will in Christ. Following William of Auxerre,[43] he subdivides the (1) created will (*voluntas creata*) into (1.1) the rational will (*voluntas rationis*) and (1.2) the sensual will (*voluntas sensualitatis*). He further distinguishes the rational will into (1.1.1) *voluntas rationis, ut ratio est,* and (1.1.2) *voluntas rationis ut natura est.*[44] By means of these distinctions, he confronts the problem of Christ's conditional will on the Mount of Olives:

[1.2] Voluntate sensualitatis voluit aliquid proprium, quod noluit [1.1.1] voluntate rationis ut ratio est, scilicet non mori . . . et sic unaquaeque voluntas quod suum erat tenuit, scilicet [2] voluntas divina justitiam, [1.1.1] voluntas rationis obedientiam, [1.1.2+1.2] voluntas carnis naturam, id est, poenae recusationem.[45]

Hugh does not integrate this treatment with the opinion expressed in the following chapter, which concerns the "defects that Christ assumed" in human nature. Christ assumed what generally (*in communi*) belongs to our human nature, including such bodily defects (*defectus corporales*) as hunger, thirst and weariness as well as those spiritual defects (*defectus spirituales*) that are common to all mankind. Anxiety, pain and sadness, however, are not assigned to Christ's passions, but to a state of mental anticipation, called *propassio*, which does not disturb the perception of the "eye of the mind" (*oculus mentis*).[46] One may hardly speak of a coherent philosophical or even theological anthropology underlying Hugh's various accounts of Christ's passionate and rational nature.

Nonetheless, Alain de Libera rightly defends the *Compendium* against excessive criticism, which would regard it as a mere compilation, unworthy of much consideration.[47] But as Hugh himself states in his preface, he does not intend a work of philosophically qualified theology; indeed, he opposes theology, the queen of sciences, to the inferior and less useful philosophy, its "footmaiden."[48] Only theology—"our philosophy," as he calls it—teaches us to know God, resist the devil and exercise charity.[49] Hugh's *Compendium* can hardly be called "Albertist" in any speculative sense; it is rather governed by immediately catechetical and pastoral aims. These aims were continued by, among others, Gerhard of Sterngassen in his *Medula anime languentis* or *Pratum animarum*,[50] a kind of *summa moralis* on the virtues and vices, which does not address Christological themes.

DIETRICH OF FREIBERG

One of the most original German Dominican thinkers was Dietrich of Freiberg.[51] He was a student in Paris in 1274,[52] later on *lector* in Trier, provincial (1293–96), Master in Paris (1296–97), and Vicar for the Dominican province of Teutonia (1310). He evidently was highly esteemed during his lifetime, but scholars have evaluated his importance for the intellectual and spiritual development of the German Dominicans in widely divergent ways, some ascribing to him almost no influence at all[53] and others seeing in him a decisive pathfinder, who cleared the way for, among others, Meister Eckhart, and even for modern philosophy.[54]

Dietrich has left (or there survive) only two writings that treat Christological issues. These address marginal questions: the first, which was highly disputed in the schools, concerns the identity or difference between Christ's living and dead bodies (*De corpore Christi mortuo*); the second, which is less common, investigates whether in Christ there is some cognitive power that is inferior to the intellect (*Utrum in Deo sit aliqua vis cognitiva, inferior intellectu*).

In *De corpore Christi mortuo*, after long philosophical argumentation about the

distinction between an *oppositio privationis* and *oppositio contradictionis,* and the application of this distinction to living and dead bodies, Dietrich arrives at a summary theological conclusion: the body of the living Christ is identical with the body of the dead Christ, as in the case of every human being.[55]

In *Utrum in Deo sit aliqua vis cognitiva,* on the other hand, Dietrich resolves the question directly and briefly at the beginning, concluding that there was no cognitive power in Christ that was inferior to the intellect.[56] For the rest, he takes the opportunity to develop subtle arguments about an underlying philosophical question concerning the knowledge of separated substances in general. Indeed, in both tractates Dietrich's argumentation is purely philosophical and quite original; as far as I can judge, it was not taken up by other Dominican authors.

JOHN PICARDI OF LICHTENBERG

John Picardi of Lichtenberg was *lector* in the *Studium Coloniense* (1303–1305), afterwards *Sententiarius* at the University of Paris (1305–1310), and then prior provincial of the Dominican province of Teutonia (1308–1310).[57] Of his commentary on the *Sentences* there remains only a copy of the fourth book[58] and fragments of the first book.[59] As *lector* in Cologne John determined 36 disputed questions, one of them preserved in manuscripts at the Vatican Library[60] and at Kraków as well.[61] John addresses Christological issues in two of the disputed questions:

> [Quaestio 2]: Utrum tres persone divine possint assumere eamdem numero humanam naturam (BAV, Cod. Vat. lat. 859, fols. 152rb–152va).

> [Quaestio 3]: Utrum Deus potuit sumere humanam naturam sine supposito (Ibid., fols. 152va–153ra).

In an appendix to this essay, I offer a provisional edition of the longer question 3.[62] Unfortunately, the Vatican manuscript, the only one known to contain this question, is not close to the apograph of the tradition but is a later copy, as is evident from its various accidents. So, based on the testimony of this copy alone, we cannot achieve a really satisfying text.

Both questions contain extended philosophical arguments, which clarify the precise topic of discussion and present differing opinions. At the end of the reasoning John quotes the opinion of Thomas Aquinas as authoritative, but he also hints at divergent positions in different works. The more developed third question evinces thematic parallels with Henry of Ghent's *Quodlibet IV,* question 4 ("Utrum idem re sint natura et suppositum?"),[63] and Godfrey of Fontaines' *Quodlibet VII,* question 5 ("Utrum suppositum addat aliquem rem supra essentiam vel naturam?").[64] John's arguments, however, are different from Henry's and Godfrey's, and far less developed than theirs. John's question also seems to echo the controversy between Dietrich of Freiberg and Nicholas of Strassburg over the separability of accidents.[65] As the works of most of John's contemporaries are not accessible in print, only an in-depth study could turn this glimpse of a highly animated and controversial discussion into a more complete picture of discussions taking place at Cologne in the first decade of the fourteenth century.

Two of at least six series of similar disputed questions by another fourteenth-century Dominican who taught at the Cologne *studium generale,* Hartmann of Augsburg, are preserved in manuscript, but these questions do not involve Christological themes.[66]

JOHN OF STERNGASSEN

John of Sterngassen, born before 1285, was the son of a Cologne baker and the brother of Gerhard (mentioned above) and Hermann; all three brothers were Dominicans. After 1316 John was *lector* at the Dominican *studium* in Strassburg, and in 1333, possibly, at the *studium generale* in Cologne.[67] He is the only German Dominican of his time whose complete commentary on the *Sentences* survives, preserved in thirteen manuscripts.[68] Besides this commentary, there exist two disputed questions[69] and seven complete sermons in Middle-High German as well as fragments from sixteen more.[70]

The German sermons impress one as eloquent popularizations of some of Meister Eckhart's themes, especially the theme of *luterkeit.* In his Latin works, John uses philosophical arguments of an Aristotelian kind; he frequently adduces Averroës, even in theological contexts. From his Latin writings, John of Sterngassen may be characterized as a critical and analytic thinker, but one without synthetic power of his own.[71] In theological questions, he mostly follows Thomas Aquinas, when Thomas's position is not controversial; indeed, John often quotes Thomas verbatim.

Likewise John usually follows Thomas Aquinas in Christological matters. The only article in his commentary on the third book of the *Sentences* that does not closely parallel Thomas's treatment in the *Scriptum super Sententias* or the *Summa theologiae* concerns the predication of certain names in respect of Christ: "Utrum ista nomina: persona, indiuiduum et cetera, predicantur in plurali uel in singulari?" (*In III Sent.* d.6 q.1 a.2).[72] John seemingly does not consider this question to be very important. In the third book of his *Scriptum,* Thomas treats the same terms in the first article of the corresponding question, and divides the article further into four separate questions (*quaestiunculae*); he treats the predication of these terms as involving important issues concerning Christ's subsistent being, and presents arguments on both sides.[73] John, on the other hand, poses the topic only briefly in the second article of the question, lumping together all of the terms; he treats the topic primarily as a linguistic issue and omits arguments *pro* and *contra.*

There are two types of names, John says, that we predicate of Christ. Some names, such as 'particular, individual, singular' (*particulare, individuum, singulare*) can signify participation in any genus whatsoever. These terms may be predicated not only of substances, but also of accidents and parts of other beings. Other names, such as 'thing of nature, supposite, hypostasis, person' (*res naturae, suppositum, hypostasis, persona*), pertain only to the genus of substance; they may be predicated only of something that exists through itself, and cannot be predicated of anything that is a part or an accident of something else.[74]

When speaking of Christ, John states, we must not contradict that teaching which posits "one subsistent concrete being" (*una res subsistens*) in Christ, which is the only

true way of speaking about him. Without contradicting this truth, we may predicate of Christ in the plural all of those terms that signify a particular in any genus. Thus, in the same way that we speak of this hand, which is a part of something else, as an 'individual, particular or singular', so we may speak of the human and divine natures in Christ, which unite as parts of another single being, as two 'individuals, particulars, singulars'. Strictly speaking, however, we should not speak in this way, for human nature cannot be predicated of Christ exclusively any more than it can be of Socrates. Thus, although those terms which signify in any genus, and which can be predicated of beings that exist through themselves and those that exist only through another, can in one sense be applied to Christ in the plural, more precisely we should say that Christ is 'one individual singular particular' (*unum individuum singulare particulare*), and we may not say that Christ is 'many individuals or singulars or particulars' (*plura individua, vel singularia vel particularia*). Finally, according to those terms that signify a particular in the genus of substance, we may never say that there are 'two hypostases or two persons or two things of nature (*res naturae*) or two supposites' in Christ, for these terms may be predicated only in the singular, and in Christ there is only one subsistent reality (*tantum una res subsistens*).[75]

John of Sterngassen is perhaps the only author in the high Middle Ages who follows Thomas Aquinas in the opinion that Christ had a *habitus* of acquired science.[76]

GISILHER OF SLATHEIM

The *Paradisus animae intelligentis*, most likely composed in Erfurt, is a famous collection of early fourteenth-century sermons.[77] Besides Meister Eckhart, the authors of the sermons were a number of Dominicans from the province of Saxony, a certain Hane the Carmelite, and an anonymous Franciscan. Doctrinally, the collection is a "mixed bag," comprising some sermons inspired by Eckhart and others inspired more by Thomas Aquinas. Yet we need not see the teachings of Thomas and Eckhart as mutually exclusive;[78] as I suggested, John of Sterngassen, for one, did not perceive them to be so. In light of the origin of the collection, it is doubtful that the John Franco who wrote five sermons in the collection can be identified with Franco Vlagge from Cologne.[79] Five other sermons in the collection were composed by Gisilher of Slatheim, who was of Thuringian origin and later was *lector* of the Dominican *studium generale* in Cologne.[80] Three of the sermons by Gisilher treat Christological themes.

In a sermon (n° 12) on the scriptural text, "Where is he who is born king of the Jews?" (Mt 2:2), Gisilher introduces the problem of the 'localization' of Christ's resurrected spiritual body, which seems to be a contradiction, because 'place' is a predicament of material entities and not of spiritual beings.[81] Christ's human body was in certain places on earth, Gisilher asserts, "as surely as my body is."[82] Although questions concerning the actions of Christ's resurrrected body were the object of much theological speculation in Gisilher's time, he is not convinced by any of the explanations: the 'location' of Christ's resurrected body is a miracle well within the range of divine power.[83] Gisilher explains Christ's three-day stay in Limbo by referring to Thomas Aquinas's solution in the *Summa theologiae*.[84] Angels, who are purely spiritual beings, occupy locations in the sense that they act on material beings: the place of

the corporeal objects upon which an angel acts is its 'location'.[85] An angel, however, is not bound by the limitations of corporeal motion. If this is possible for the least angel, then it is even more so for Christ, whose actions in all creatures are more intimate to them than they are to themselves, since everything they have comes from him.[86] Christ is especially intimate to good people by his grace, which acts in their intellects and their wills. Christ acts in the intellects of good people in such a way that they know nothing but God, and know everything else through God; he acts in the wills of good people in such a way that they love nothing but God, and love everything else through God.[87]

In another sermon (n° 14) on the text, "The child Jesus advanced in stature, wisdom and grace before God and men" (Lk 2:40), Gisilher focuses on the growth of knowledge in Christ ("dat he [Jesus] zu nam an kunst und an wisheit").[88] He distinguishes four kinds of knowledge or "art and wisdom" (*kunst und wisheit*) in Christ: the art and wisdom of the saints, of the angels, of the human soul, and of God.[89] Christ possessed all four kinds of knowledge.

(1) By his hypostatic union, whereby his human nature was united with the divine nature, Christ had the knowledge that God has of himself and, *uno instanti*, of all creation. But during his life on earth Christ's human soul did not share perfectly in this knowledge, nor did he have knowledge of future contingents, for his human soul was a creature of finite measure, incapable of infinite divine knowledge.[90] On this point, Gisilher disagrees with Thomas Aquinas, who held that Christ could dispose of his divinely infused knowledge (*scientia infusa*), by which he knows everything, at any time, even during his earthly life.[91]

(2) Christ also possessed the knowledge of the saints, that is, the knowledge of the blessed who partake the vision of God in heaven. Gisilher defines the beatific vision as immediate knowledge of God as he is, and in him, of all creation. But this beatific knowledge does not include the whole range of divine potentiality, of everything God by his divine power could do but has not done.[92] Even while he was on earth Christ possessed the art and wisdom of the saints in a perfect way, because his human soul is more closely united with the Godhead than any other soul. Moreover, because his soul was immediately united with God at its creation, Christ's beatific knowledge did not increase or advance, but was perfect from the beginning of his life on earth.[93]

(3) Gisilher describes the art and wisdom of the angels as knowledge of all things in their prototypical ideas; the angels, however, do not know all of these at once, but one after the other.[94] In his soul Christ possessed the created ideas of all things, which he did not need to acquire by experience as we do. He actualized one created species at a time, but he possessed the other species in potency.[95] Thus he did not need to acquire and accumulate them from without.

(4) Gisilher describes "natural knowledge"—the knowledge that human beings have *in statu viatoris*—as an "acting light," which comes to one who "sits and searches for wisdom" and gives him knowledge of what he did not know before.[96] This is the kind of art and wisdom to which the Gospel refers when it says that Christ increased in knowledge from day to day. But even this knowledge Christ did not acquire from others; rather, it came from his own active light. Even when as a boy he sat in the temple, asking the scribes questions, Jesus did not learn from them but rather taught

them, as a wise man often teaches more by his questioning than another one does by his doctrine.[97]

Gisilher treats a Christological topic in one more sermon (n° 25) over the text, "The disciples were confused, and thought that they saw a spirit" (Lk 24:37). This Gospel, which tells of Christ's coming to his diciples through closed doors after his resurrection, provides Gisilher an occasion for presenting different theological explanations of the nature of the resurrected body. He criticizes some masters, who explain too rapidly and "mit halbime sinne" how it is possible that a body composed of the four elements could penetrate through closed doors and be in the same place where another body is already. They simply say that Christ's heavenly or glorified body is composed without coarseness, so that its mobility and subtlety would allow such motion.[98] Referring to "our masters" (unse meistere), Gisilher contradicts this opinion: the four elements (with their properties) remain in the body of Jesus. His conclusion sounds similar to Thomas Aquinas's,[99] but he does not use Thomas's arguments.

Other masters say that the glorified body of Christ could be at the same place as another body because it is transparent and as mobile as the air. These masters do not understand that blood, flesh and bones, which necessarily belong to the true body of our Lord, exclude such incomprehensibility (in the obvious sense of the word) and transparency.[100]

Still other masters explain that Christ could be in the place of another body because his resurrected body is a spirit.[101] But they misunderstand Saint Paul when he speaks of a "spiritual body": "Wir sin cumin in disi werlinz tirliche und sullin uf irstêin geistliche" (cf. 1 Cor 15:45–49). But 'spirit' and 'spiritual' are not the same: the term 'spiritual' signifies here that the body of Christ receives all that it is from the soul.[102] Christ's spiritual body is the perfect body, which realizes everything that it can be. Gisilher recites a last opinion as excluding the possibility that Christ's resurrected body and another body could be in the same place, any more than one body can be in different places at the same time. Gisilher does not accept the two cases as equally contradictory or impossible: whereas even by divine power one cannot be divided and still be one, two (glorified) bodies can be in one place, not naturally, but by God's power.[103] This last distinction comes from the teaching of Thomas Aquinas.[104]

Was there a Rhineland Dominican School?

After this brief investigation of a limited number of texts, we cannot claim to have drawn a 'map' that gives us a precise image of the historical Rhineland landscape. Our sketch shows some trails and rather the obstacles than the crossroads. What we can see is that what has been called the "German" or "Rhineland Dominican school" is a simplification of a far more complex reality than has hitherto been imagined.

I hope that I have shown as regards Christological themes what Ruedi Imbach discovered when he investigated philosophical issues: surrounding the authors whom we have discussed there was a highly controversial atmosphere and a high level of discussion.[105] Even though many of the disputes were philosophical, to a large extent the underlying questions were theological. Thus, concerning the questions that were discussed, I would prefer to speak of a 'philosophically qualified theology'. That followers

of Thomas Aquinas played an important role in these discussions is evident from a closer inspection of the texts. Especially in theological contexts, Albert the Great is less present as a model of thought, and less often quoted directly, even though he can be said to be the founding father of German Dominican intellectual culture. It still remains to be determined more precisely what actual role Dietrich of Freiberg played in the intellectual culture of the Dominican *studia* and convents of the Rhineland.

Such intellectual discussions as those I have presented were not always viewed positively, even among Dominicans. Some doubted their value for the spiritual life;[106] they disgusted Henry Suso, and appeared to him as vanity.[107] Much like Hugh Ripelin of Strassburg, whose interests were more catechetical than intellectual, Henry judged that the *summa ac vera philosophia* does not consist in reasoning about natural causes and effects, but in a spiritual theology, the tradition of which goes back to the desert fathers.[108] This is not Henry Suso's only or last word on the subject, nor should he be considered an anti-dialectical "fundamentalist." Among the Rhineland Dominicans, he and—*a fortiori*—Meister Eckhart deserve complete treatments of their own, which I have not been able to give here, and will leave to others.

NOTES

1. *Albert der Grosse und die deutsche Dominikanerschule: Philosophische Perspektiven*, ed. R. Imbach and C. Flüeler in FZPhTh 32/1–2 (1985). See Imbach's foreword, 3–5.

2. Alain de Libera, *Introduction à la mystique rhénane* (Paris, 1984), and *Albert le Grand et la philosophie* (Paris, 1990). There is not space here to enter into a detailed discussion of de Libera's hypothesis, that Albert's writings imply an exclusiveness of Christian theology (as a special revelation) and theology in general as a part of philosophy (see *Albert le Grand*, 44). On Albert's conception of theology, see Walter Senner, "Zur Wissenschaftstheorie der Theologie im Sentenzenkommentar Alberts des Grossen," in *Albertus Magnus, Doctor universalis 1280–1980*, ed. G. Meyer and A. Zimmermann (Walberberger Studien: Philosophische Reihe 6, Mainz, 1980), 323–43.

3. Ferdinand Haberl, *Die Inkarnationslehre des heiligen Albertus Magnus* (Freiburg i.B., 1939). The value of Haberl's book is augmented by his use of the manuscript tradition (especially of Biblioteca Apostolica Vaticana, Cod. Pal. lat. 1047), which enables him to make many improvements on the defective text of Borgnet's edition (Paris, 1894) of Albert's commentary on the third book of the *Sentences* (see Borgnet, in the table of abbreviations). O. Lottin in BTAM 4 (1941–1943): n° 1433 appraises Haberl's outline of Albert's Christology and its historical background, and is critical only of Haberl's chronology of the relevant works.

4. *Summa Halensis* 3 tr.2 q.1 c.4 sol. (Quaracchi Edition 4: 106a). See Haberl, *Die Inkarnationslehre*, 34f.

5. Albert the Great, *In III Sent.* d.4 a.4 sol. (Borgnet 28: 82a).

6. So in the *Summa Halensis*, 3 tr.1 q.4 c.3 sol. (Quaracchi Edition 4: 53a–b); see Haberl, *Die Inkarnationslehre*, 52f.

7. Albert the Great, *In III Sent.* d.2 a.10 sol. (Borgnet 28: 34b).

8. Albert the Great, *De incarnatione* tr.3 q.2 a.3, ed. Ignaz Backes, Cologne Edition 26 (1958): 198, lin. 19–40. See Haberl, *Die Inkarnationslehre*, 52f.

9. Albert the Great, *In III Sent.* d.20 aa.2–3 (Borgnet 28: 358b–60b).

10. Albert the Great, *In III Sent.* d.20 a.4 (Borgnet 28: 360b–62b); *Quaestio de conceptione Christi* a.4, ed. A. Fries, W. Kübel and H. Anzulewicz, Cologne Edition 25/2 (1993): 263, lin. 11–54. See Haberl, *Die Inkarnationslehre*, 7–10.

11. *In III Sent.* d.14 a.1 sol. (Borgnet 28: 253a–b).

12. *In III Sent.* d.14 a.3 sol. (Borgnet 28: 257b); see Haberl, *Die Inkarnationslehre,* 98f.

13. *De incarnatione* tr.4 q.2 a.3 (Cologne Edition 26: 206, lin. 49–52).

14. Ibid. (206, lin. 70f.).

15. For further remarks on the origin and use of this term, see Haberl, *Die Inkarnationslehre,* 106.

16. William of Auxerre, *Summa aurea* 3 tr.6 c.3 sol., ed. J. Ribaillier (Spicilegium Bonaventurianum 18A, Paris-Grottaferrata, 1986), 83, lin. 39–48.

17. Albert the Great, *In III Sent.* d.17 a.4 sol. et ad 1 (Borgnet 28: 303a–b). See Haberl, *Die Inkarnationslehre,* 106f.

18. William of Auxerre, *Summa aurea* 3 tr.5 sol.[3] (ed. Ribaillier, 76, lin. 143–46): "Est etiam plenitudo excellentie, que est in Christo, qui non habet dona imperfectionis ut fidem et spem. Sed loco fidei habet perfectam cognitionem, loco spei perfectam comprehensionem."

19. Bonaventure, *In III Sent.* d.13 a.1 q.3 ad 1 (Quaracchi Edition 3: 282b). Bonaventure denies *fides* and *spes* in Christ, insofar as the terms imply a lack of knowledge of their object, but in another sense he attributes them to Christ, inasmuch as he possesses the fullness of all virtues.

20. Albert the Great, *In III Sent.* d.13 a.13 sol. (Borgnet 28: 252a–b); see Haberl, *Die Inkarnationslehre,* 111f.

21. William of Auxerre, *Summa aurea* 3 tr.4 c.2 (ed. Ribaillier, 64, lin. 19–22).

22. *Summa Halensis* 3 tr.3 q.1 tit.2 a.1 sol. (Quaracchi Edition 4: 152b).

23. Thomas Aquinas, *In III Sent.* d.13 q.2 a.2 qc.1 (*Scriptum* 3: 410f.); ST 3 q.8 a.4 corp.

24. Albert the Great, *In III Sent.* d.13 a.9 sol. (Borgnet 28: 245a); see Haberl, *Die Inkarnationslehre,* 117f. In *De incarnatione* tr.5 a.7 sol. (Cologne Edition 26: 217, lin. 69–70), it is not exactly the same problem. To understand this text, cf. *De incarnatione* tr.5 a.5 sol. (Cologne Edition 26: 216, lin. 83,–217, lin. 15).

25. Ulrich of Strassburg, *Summa de summo bono* 5 tr.1 c.13, ed. I. Backes in *Thomas de Aquino: Quaesto de gratia capitis accedunt textus inediti S. Alberti Coloniensis et Ulrici de Argentina* (Florilegium Patristicum 40, Bonn, 1935), 30, lin. 22–29.

26. Hugh of St.-Victor, *De sacramentis christianae fidei* prol. c.2 (PL 176: 183f.)

27. *Summa Halensis* 1 tr.introd. q.1 c.3 ad 2 (Quaracchi Edition 1: 6b): "Mundanae sive saeculares scientiae materiam habent opera conditionis, divina Scriptura materiam habet opera restaurationis." See Senner, "Zur Wissenschaftstheorie," 331f.

28. Bonaventure, *In I Sent.* prooem. q.1 (Quaracchi Edition 1: 7).

29. Albert the Great, *In I Sent.* d.1 a.2 sol. (Borgnet 25: 16b). See Senner, "Zur Wissenschaftstheorie," 330.

30. Romanus Cessario, *The Godly Image: Christ and Salvation in Catholic Thought from St. Anselm to Aquinas* (Studies in Historical Theology 6, Petersham, Mass., 1989), 203.

31. Senner, "Zur Wissenschaftstheorie."

32. Kaeppeli, *Scriptores* 2: 276–80, lists 609 manuscripts of the Latin original; Georg Steer, *Hugo Ripelin von Strassburg* (Texte und Textgeschichte 2, Tübingen, 1981), 47–146, identifies more surviving manuscripts and quotes 174 entries from medieval library catalogues (148–72). There are several Middle-High German and Middle-Low German versions, as well as a medieval French translation. The authorship of Hugo Ripelin has been proven by Martin Grabmann, "Studien über Ulrich von Strassburg," *Zeitschrift für katholische Theologie* 29 (1905): 315–30, and "Entscheidung der Autorfrage des 'Compendium theologicae veritatis'," *Zeitschrift für katholische Theologie* 45 (1921): 147–53; see further Steer, *Hugo Ripelin,* 5–7. For the French translation, see Christa Michler, *Le somme abregiet de theologie* (Beiträge zur romanischen Philologie des Mittelalters 11, Munich, 1982).

33. The work is ascribed to Albert in 8 of the 59 printed editions; see Steer, *Hugo Ripelin,* 167–72. To Steer's n° D7 (168), one may add this attribution: Deventer ca. 1480 (= GW n° 601). The *Compendium* is printed among Albert the Great's writings in Borgnet 34: 1–306; my references are to this edition.

34. Albert Hauck, "Hugo Ripelin," *Zeitschrift für Kirchengeschichte* 32 (1911): 378–85, at 383, noted Albert's influence in book 2 of the *Compendium,* along side the preponderant influence of Bonaventure. De Libera, *Introduction,* 74, sees in Hugh a disciple of Albert the Great and in his *Compendium* a "manifeste de l'albertisme." It seems to me that this rather general hypothesis is not sufficiently based on the analysis of the texts.

35. Karl Schmitt, *Die Gotteslehre des "Compendium theologicae veritatis" des Hugo Ripelin von Strassburg* (Münster i.W., 1940). This work is sharply criticized by Steer, *Hugo Ripelin,* 17, for its inattention to textual criticism and transmission (*Traditionsgeschichte*), but it has the merit of showing Hugh's conceptual, doctrinal and often literal dependency on Bonaventure. Steer, 233–37, rightly iden-

tifies the *Summa aurea* of William of Auxerre and especially the *Summa Halensis* as other sources used in the *Compendium.*

36. Schmitt, "Die Gotteslehre," 15f.

37. Hugh Ripelin, *Compendium* 4 c.1 (Borgnet 34: 122a): "Sicut Deus est rerum principium effectivum in creatione, sic est refectivum in redemptione et perfectivum in retributione, quoniam sicut Pater omnia creavit per Verbum increatum, sic omnia recreavit et renovavit per Verbum incarnatum." Cf. Bonaventure, *Breviloquium* 4 c.1 (Quaracchi Edition 5: 241a). See de Libera, *Introduction,* 76f.

38. Hugh Ripelin, *Compendium* 4 c.8 (Borgnet 34: 130f.).

39. *Summa Halensis* 3 q.2 tit.1 (Quaracchi Edition 3: 25–47).

40. Bonaventure, *Breviloquium* 4 c.6 (Quaracchi Edition 5: 246b). On Bonaventure's treatment of *scientia Christi* and its historical setting, see the introduction by Andreas Speer to *Bonaventura: Quaestiones disputatae de scientia Christi* (Philosophische Bibliothek 446, Hamburg, 1992), XI–L.

41. Hugh Ripelin, *Compendium* 4 c.15 (Borgnet 34: 139a–b).

42. Hugh Ripelin, *Compendium* 4 c.17 (Borgnet 34: 141); cf. Albert the Great, *In III Sent.* d.17 a.6 sol. (Borgnet 28: 304a).

43. William of Auxerre, *Summa aurea* 3 tr.6 prol. (ed. Ribaillier, 77, lin. 1–8).

44. Hugh Ripelin, *Compendium* 4 c.17 (Borgnet 34: 141a–b).

45. Ibid.

46. Hugh Ripelin, *Compendium* 4 c.18 (Borgnet 34: 142a): " . . . Christus vere timuit, et vere doluit, et vere tristus fuit, prout ista notant propassionem, non secundum quod significat passionem. Differt autem propassio a passione: quia tunc affectio dicitur propassio, quando anima sic afficitur, quod oculum mentis nequaquam turbat: passio vero dicitur quando ita fortis est, quod oculum mentis turbat, et facit a rectitudine, vel a Deo contemplatione deviare."

47. De Libera, *Introduction,* 74f.

48. Hugh Ripelin, *Compendium* prol. (Borgnet 34: 1f.): "Theologia certe scientiarum est princeps omnium et regina, cui artes caeterae tamquam pedissequae famulantur. . . . Haec est scientia scientiarum, quae super omnem speculationem philosophicam extollitur, et dignitate, ac utilitate omnibus antefertur."

49. Hugh Ripelin, *Compendium* prol. (Borgnet 34: 2): "Nostra vero philosophia, scilicet veritas theologica, haec omnia operatur. Docet enim Deum cognoscere, diabolo resistere, et charitatis exercitiis insudare. Haec est divinorum pigmentorum apotheca, delectabilis super mel et favum." The 'antidialectical' character of this text is more evident in comparison with the opinion of Humbert of Romans, who conceded that philosophical knowledge may be of use as a 'medicine', but not without risks: see Humbert's *Expositio regulae S. Augustini* 4.144, ed. J. J. Berthier in vol. 1 of *Beati Humberti de Romanis quinti Praedicatorum magistri generalis Opera de vita regulari* (Rome, 1888), 436. See Walter Senner, *Johannes von Sterngassen, OP, und sein Sentenzenkommentar. Teil I: Studie* (QF N.F. 4, Berlin, 1995), 109f. (*Teil II: Texte* presents an edition of the text.)

50. The work is preserved only in manuscripts; see Volker Honemann, "Gerhard von Sterngassen," VL2 2 (1980): 1240–43. See also Nikolaus Appel, *Gerhard von Sterngassen und sein Pratum animarum* (Saarlouis, 1934; partial printing of a Ph.D. diss., Bonn, 1934).

51. For his biography and works, see Loris Sturlese, *Dokumente und Forschungen zu Leben und Werk Dietrichs von Freiberg,* CPTMA Beiheft 3 (Hamburg, 1984).

52. Sturlese, *Dokumente,* 8 (Doc. 1.1.2), 9–11. The evidence from doc. 1.1.1 (5f.), however, is not convincing, as this letter was a formula that could be used as *litterae testimoniales* for any student sent to Paris. This does not preclude that it was given to Dietrich as well, but it cannot be used to prove that he was sent to Paris.

53. C. Van Steenkiste, review of volume 1 of *Dietrich von Freiberg: Opera omnia,* in RLT 13 (1980): 342f.

54. See the Introduction of Kurt Flasch to *Dietrich von Freiberg: Opera omnia I: Schriften zur Intellekttheorie,* ed. Burkhard Mojosisch (Hamburg, 1977), IX–XXVI.

55. *Tractatus de corpore Christi mortuo,* ed. Maria Rita Pagnoni-Sturlese in *Dietrich von Freiberg: Opera omnia II: Schriften zur Metaphysik und Theologie* (Hamburg, 1980), 150, lin. 69–72.

56. *Quaestio utrum in Deo sit aliqua vis cognitiva inferior intellectu,* ed. Maria Rita Pagnoni-Sturlese in *Dietrich von Freiberg: Opera omnia III: Schriften zur Naturphilosophie und Metaphysik* (Hamburg, 1983), 295, lin. 65–78.

57. Senner, *Johannes von Sterngassen* 1: 129.

58. Kraków, Biblioteka Jagiellońska, Cod. 1583, fols. 118va–143v. See Zofia K. Siemiatkowska, "Deux decouvertes au sujet de Jacques de Metz et de Jean Picardi," *Mediaevalia Philosophica Polon-*

orum 8 (1961): 29–32. An anonymous commentary on the *Sentences* in Biblioteca Apostolica Vaticana, Cod. Vat. lat. 1114 may not be attributed to John Picardi; see Bruno Decker, *Die Gotteslehre des Jakob von Metz* (BGPTMA 42/1, Münster i.W., 1967), 46–49.

59. Wien, Österreichische Nationalbibliothek, Cod. lat. 2165. See Martin Grabmann, *Mittelalterliches Geistesleben* 1 (Munich, 1926): 412–14.

60. BAV, Cod. Vat. lat. 859, fols. 151r–182v. The manuscript is described in Auguste Pelzer, *Bibliothecae Apostolicae Vaticanae codices manu scripti: Codices Vaticani Latini II/1: Codices 679–1134* (Vatican City, 1931), 232f. See also Artur Landgraf, "Johannes Picardi de Lichtenberg O. Praed. und seine Quaestiones disputatae," *Zeitschrift für katholische Theologie* 46 (1922): 510–45.

61. Kraków, Biblioteka Jagiellońska, Cod. 748. See Wladyslaw Senko, "Joannis Picardi de Lichtenberg quaestio disputata de esse et essentia ex cod. 748 Bibl. Jagellonicae," *Mediaevalia Philosophica Polonorum* 8 (1961): 3–28.

62. I am grateful to Father Frederick John Hinnebusch, O.P., of the Leonine Commission's Washington section for revising my transcription.

63. *Quodlibeta Magistri Henrici Goethals a Gandavo*, ed. J. Badius Ascensius (Paris, 1518; reprt. Louvain, 1961), vol. 1, fols. 90v–91v.

64. *Les Quodlibet cinq, six et sept de Godefroid de Fontaines*, ed. M. De Wulf and J. Hoffmans (Les philosophes Belges 3, Louvain, 1914), 299–336.

65. Ruedi Imbach, "Metaphysik, Ideologie und Politik: Zur Diskussion zwischen Nikolaus von Strassburg und Dietrich von Freiberg über die Abtrennbarkeit der Akzidentien," *Theologie und Philosophie* 61 (1986): 359–95.

66. Kraków, Biblioteka Jagiellońska, Cod. 748, fols. 24r–56v. See Maria Kowalczyk, "Hartmannus de Augusta," *Mediaevalia Philosophica Polonorum* 3 (1959): 25–29. On Hartmann's activity in Cologne, see Senner, *Johannes von Sterngassen* 1: 140f.

67. Senner, *Johannes von Sterngassen* 1: 164–68.

68. The work is partially edited in Senner, *Johannes von Sterngassen* 2.

69. Edited in Senner, *Johannes von Sterngassen* 2: 335–44.

70. Ibid. 2: 347–77.

71. Ibid. 1: 382.

72. Ibid. 2: 302, lin.75,–303, lin. 105.

73. Cf. Thomas Aquinas, *In III Sent.* d.6 q.1 a.1 qc.1–4 (*Scriptum* 3: 222–29). John's résumé consists mainly of the material in Thomas's solution, qc. 4.

74. Ed. Senner, *Johannes von Sterngassen* 2: 312, lin. 75–83.

75. Ibid. 2: 303, lin. 84–105.

76. Thomas Aquinas, ST 2 q.12 a.1 corp.; see J. Ernst, *Die Lehre der hochmittelalterlichen Theologen von der vollkommenen Erkenntnis Christi* (Freiburger theologische Studien 89, Freiburg i.B., 1971), 252–54. Ernst gives extracts from John of Sterngassen, *In III Sent.* d.14 q.2 a.1 sol.

77. Kurt Ruh, "Paradisus anime intelligentis," VL[2] 7 (1989): 298–303, here 298f.

78. Ria van den Brandt, *Godsontvankelijkheid en 'fornuftikeit'* (Nijmegen, 1993), 30. Van den Brandt herself concedes that Thomas Aquinas "was an authority for each Dominican," and so the two teachings need not be seen as mutually exclusive.

79. For the sermons by John Franco, see *Paradisus animae intelligentis*, ed. Philip Strauch, Deutsche Texte des Mittelalters 30 (Berlin, 1919): n[os] 5, 7, 18, 29, 35. For Franco Vlagge of Cologne, see Senner, *Johannes von Sterngassen* 1: 131, 166f.

80. *Paradisus anime intelligentis*, ed. Strauch, n[os] 12, 14, 25, 39, 41. For Gisilher of Slatheim, see Senner, *Johannes von Sterngassen* 1: 130f.

81. *Paradisus* 12 (ed. Strauch, 30, lin. 30–32): "Daz wort 'wo' daz vrêgit noch der stait. Die hedenischin und di krischin meistere wollin daz lipliche dinc alleine habin stait und nicht geistliche."

82. *Paradisus* 12 (ed. Strauch, 30, lin. 37f.): "Daz ist gewis daz sin lip was an einir stait und in siner, alse min lip ist."

83. *Paradisus* 12 (ed. Strauch, 31, lin. 7–10): "Wi daz gesin mochte, da habin di meistere vil rede fon, abir ir keines rede inmochte mime sinne gnugin, wan daz ich ez mit einen wondere begrifen daz ez also were und daz ez Got wol formochte."

84. ST 3 q.51 a.4 corp.

85. *Paradisus* 12 (ed. Strauch, 31, lin. 28–31): "Der engil ist ein lutir geist . . . und he hait craft zu wirkine pobin alle lipliche dinc wan he wil. Nu sprechin di heiligin, da he wirkit an liplichin dingin, da ist sin stait."

86. *Paradisus* 12 (ed. Strauch, 32, lin. 13–17): "Also was di sele Christi in der helle . . . wo ist he

dan an deme ewigin? In allin creaturen innewendigir in mit sime wesine wan si un selbin sin, wan sin wesin ist ein sache fon deme alle wesin vlizin allir creature. Wo ein iclich dinc wirkit, da muiz iz sin."

87. *Paradisus* 12 (ed. Strauch, 32, lin. 25–31): "Abir sunderlichen ist he [Got] in guden luden mit sinir gnade in deme bekentnisse und in der minne . . . und irfullit daz bekentnisse und di minne, also daz daz bekenntnisse nicht me inkennit dan Got, und daz ez bekennit, daz ez daz bekenne durch Got, und daz di minne nicht me inminne dan Got, und waz so minnet, daz si daz minne durch Got."

88. *Paradisus* 14 (ed. Strauch, 35, lin. 10).

89. Ibid. (35, lin. 14–16).

90. Ibid. (35, lin. 31–36): "Wan sin nature forênit was mit gotlicher nature an einode der personen, so muiste daz sin daz he dise kunst [gotlich kunst und wisheit] hette, daz he Got bekente und alle dinc in ume mit ein ander. Abir sin sele indurchkennit nicht Got alse he bekentlich ist, noch ouch di dinc di da sint an siner mugintheit, di he noch geschepphin mochte ob he wolde, wan si ein creature ist und maze hait."

91. ST 3 q.11 a.5 corp.

92. *Paradisus* 14 (ed. Strauch, 36, lin. 5–8): "Wisheit und kunst der seligin lit daran, daz si Got bloizlich bekennen alse he ist, on allis mittil, und alle dinc in ume, die geschaffin sin und noch ge-schaffin sullin werden. Aber si durch kennen un nicht noch ouch di dinc di da sint an siner mogintheit."

93. *Paradisus* 14 (ed. Strauch, 36, lin. 8–11): "Abir wan sin sele nehir was forenit mit der gotheit wan kein sele, so kante su ouch me in disime lichte wan kein sele. An dirre kunst nam he ouch nicht zu, da waz sin sele also vollincumin an du si geschaffin wart, als hude dis tagis."

94. *Paradisus* 14 (ed. Strauch, 36, lin. 12–14): "Englisch kunst und wisheit ist daz der engil alle dinc bekennit in urin bildin, nicht mit einandir, mer ein noch dem anderen. . . . "

95. *Paradisus* 14 (ed. Strauch, 36, lin. 20–23): "In sinir sele warin geschaffin bilde allir dinge, daz he alle dinc bekante in ume, daz sin sele nicht uz inlif di dinc zu bekennene alse unse sele muiz. . . . Di wile he ein dinc hatte an der wirclichkeit, so hatte er daz andere an der mugintheit."

96. *Paradisus* 14 (ed. Strauch, 36, lin. 24–28): " . . . naturlich kunst und wisheit. Daz ist ein wirk-inde licht, daz sine vollincumenheit hait fon innemine ein noch dem anderen des he fore nicht inwiste. Alse ein mensche sizit und trachtit noch wisheit, so cumit sin licht, daz he in sinir sele hait, daz he bekennit daz he fore nicht bekante."

97. *Paradisus* 14 (ed. Strauch, 36, lin. 35–39): "Dise kunst inlernite he [Christus] fon niman, me in ume selber von sime eiginen lichte. Alleine man fon ume spreche daz he saiz under den meistirn und horte si und fragite si, doch inlernte he fon un nicht. Ein wise man lerit dicke me mit sime fragine dan ein ander mit sinir lere" (cf. Lk 2:46).

98. *Paradisus* 25 (ed. Strauch, 59, lin. 34,–60, lin. 6): "Etliche meistere antwortin hi zu mit hal-bime sinne, wan halpsinnige lute antwortin allir snellist . . . daz ez gar muglich si daz unsir herre mit beslozzinir ture queme zu sinen jungerin . . . wan der lichame gemachit ist von den vier elementin. Wan di zusamine gefugit sin mit der helfe des himmlischin libis, so sprechin si, also daz di gropheit der elemente abe gê und di behendikeit und di subtilikeit des himmilischen libes beste an deme geseligten libe unsis herrin."

99. Thomas Aquinas, *In IV. Sent.* d.44 q.2 a.2 qc.1a.

100. *Paradisus* 25 (ed. Strauch, 60, lin. 10–13): " . . . daz ist darumme sprechin si, daz der lichame unsis herrin durchschinic und behende were alse di luft. Di meistere inhabin nicht gemirkit daz bluit, fleisch und bein, daz da werliche was der lip unsis herrin, di durchgrifikeit und durchschinikeit nicht lidin inwil."

101. *Paradisus* 25 (ed. Strauch, 60, lin. 24–26): " . . . aber andire meistere,..daz ist da fon sprechin si, daz der lichame unsis herrin ein geist ist."

102. *Paradisus* 25 (ed. Strauch, 60, lin. 28–32): "Geist und geistlich treit in zvei. Were der lichame unsis herrin ein geist, so inlide wir keine noit an disir rede. Der lichame unsis herrin ist geistlich, wan di gropheit ist ume abegevallin und ist behende wordin, daz he ganz wesin inphahin mac fon der zele und alliz dez di sele giftic ist." *Wesin* must not be translated by 'essence' but rather by 'existence'!

103. *Paradisus* 25 (ed. Strauch, 60, lin. 32,–61, lin. 3): "Andere meistere sprechin daz ez nicht muglich insi daz unse herre beseze di selbin stat di ein andir lichame besaiz. Also wenic alse ein lichame mac gesin an zvein stedin, also wenic mugin zvene lichame gesin an einir stat . . . dise meistere . . . sezin glich daz verre unglich ist. Ez ist nicht muglich eime lichame ze sine an zvein stedin. . . . Daz informac Got nicht daz ein ein si und doch geteili. Ez ist aber muglich daz zvene lichame sin an einir stat; ez enist aber nicht muglich keinir nature, mer wir gebin ez der gotlichin craft."

104. Thomas Aquinas, *In IV. Sent.* d.44 q.2 a.2 qc.2 (= ST Suppl. q.83 a.2 corp.). Lauri Seppänen,

Studien zur Terminologie des "Paradisus anime intelligentis" (Mémoires de la Société Néophilologique de Helsinki 27, Helsinki 1964), 219–25, correctly remarks that this sermon is heavily dependent on Thomas Aquinas, but it is not a mere translation of ST Suppl. q.83, as a comparison of the texts shows.

105. See Imbach's studies, "*Gravis iactura verae doctrinae:* Prolegomena zu einer Interpretation der Schrift *De esse et essentia* Dietrichs von Freiberg O.P.," FZPhTh 24 (1977): 369–425; with U. Lindblad, "*Compilatio rudis ac puerilis:* Hinweise und Materialien zu Nikolaus von Strassburg O.P. und seiner *Summa,*" FZPhTh 32 (1985): 155–233; "Metaphysik, Ideologie und Politik" (see n. 65 above).

106. Senner, *Johannes von Sterngassen* 1: 382.

107. *Horologium sapientiae* 2.1, ed. Pius Künzle (Spicilegium Friburgense 23, Fribourg, 1977), 520–25.

108. Ibid., 526, lin. 11.

APPENDIX

Johannes Picardi de Lichtenberg, *Quaestio III*
(Biblioteca Apostolica Vaticana, Cod. Vat. lat. 859,
fols. 152va, lin. 27,–153ra, lin. 34)

In the following text, I number (in fives) the lines of the columns of the manucript (e.g., *a30*) in the margins opposite the line numbers of the edition. The beginning of the manuscript lines are indicated by line-dividers. For the abbreviations in the apparatus, see the table in the beginning of the volume.

fol. 152va

Utrum Deus potuit sumere humanam naturam sine supposito

Dicenda sunt hic duo. Primo quod differunt, scilicet suppositum et essentia. Secundo quod unum preter alterum sumi potest.
Ad primum sciendum est quod sunt tres opiniones:

5 | Prima quod differant realiter. Et hoc actum dicitur penes triplicem a30
modum. Patet quod differunt in modo predicandi, quia unum non predicatur de altero. Hoc autem non esset nisi in modo includetur differentia realis, quia, que sunt idem re, differunt ratione, uel modo significandi predicantur de se non predicatione formali, sed etiam que sunt per identi-
10 tatem, sicut deus est deitas, non autem homo dicitur humanitas.

| Secundo differunt in modo agendi, quia suppositum agit non autem na- a35
tura. Unde humanitas non causa, sed homo.

Tertio quantum ad modis essendi, quia natura subsistentie in aliquo, non autem simpliciter.

15 Item natura dicitur esse in supposito, non autem e converso proprie.

Item natura dicitur ut habita, suppositum autem ut habens, et multa talia, sicut quod natura humana est assumpta, non autem suppositum. Hoc autem dicunt propter differentiam realem esse. Sed modus ponendi est du- a40
plex: unus quod ita | dicendum differentia nihil est per aliqua nature ad-
20 dita. Sed per quidam modus communicatur nature unius presenti ex communicatione ad rem alterius predicamenti, sicut materia extrinseca differt a se ipsa non extrinseca, nisi per rem additam, sed per modum, in quantum materia est extrinseca affecta accidentaliter.

Alii dicunt quod istud modus sortitur substantia uel nec ab | agente in a45
25 quantum natura habet esse in alio, sicut natura humana assumpta in deo habet esse. Suppositum autem non habet esse in alio, sed per se quod esse sibi tribuitur ab agente.

Sed ista positio non ualet ponens modos.

Primo: sicut impossibile est quod aliqua differant ratione, nisi uel sint
30 diuerse rationes, uel nisi habent, uel includant diuersas res ambo[1] uel al-
terum. Materia ergo extrinsa non | differt realiter a materia non extrinsa, a50
nisi addat aliquem rem extrinsam. Ergo dicitur totum, quia materiam
quantam, et differentie a materia non extrinsa sicut totum a parte.

Item illa, que distinguuntur sola ratione, dicuntur entia rationis.

35 Item illa, que distinguuntur solis relationibus, dicuntur relatiua; illa que
distinguuntur in [rebus][2] sunt entia realia. | Ergo, si aliqua distinguuntur a55
solo modo, sunt modalia. Supposita igitur omnia sola erunt modalia.

Item humana natura in Christo, cum sit assumpta, accidentibus et quan-
titate erit suppositum.

40 Unde est alia opinio, que dicit quod suppositum et natura differunt non
realiter, sed solum in modo significandi. Et sic est in omni absoluto et
[concreto],[3] quia sic se habent suppositum et natura, sicut absolutum et
concretum. Et hoc primo probant: dicitur primo sic: quia illa sunt idem, | b1
que habent eandem diffinitionem. Sed, si diffiniatur homo et humanitas,
45 eadem ponentur in diffinicione utriusque, sicut patet in 7 *Metaphysice*,
PHILOSOPHUS querens, utrum dicat unumquodque et quod quid est eius-
dem, quod in hiis, que sunt per se, non differunt. In hiis autem, que sunt
per acci- | dens, differunt. COMMENTATOR autem li 'per se' exponit de sub- b5
stantia. Unde idem et homo et quod quid est hominis, non autem album
50 et quod quid est albi, quia quod quid est albi est natura albi, que est quali-
tas, quia album puram qualitatem significat, sicut dicitur in *Predicamen-
tis*. Sed habenti album, quod est suppositum eius, est aliud, sicut lignum
uel lapis.

Secundo declarant et dicunt, quod differunt solum in modo significandi,
55 non autem in re significata quia idem signifi- | cat utrumque modus, aut b10
nature est, quod significat rem in abstracto, excludendo accidentia. Sed
suppositum, quod est concretum, significat idem alio modo, quia uel in-
cludendo accidentia, uel saltem non excludendo. Et ideo ex hoc sequitur
quod concretum se habet per modis totius, quia includit uel non excludit
60 accidentia. Natura autem cum precisione[4] accidentium [est][5] sine omnis[6]
extranei. Et ideo per mo- | dum partis significat. b15

Ex hoc etiam sequitur, quod unum de altero non predicatur, licet sint idem
et significent idem, quia ex modo significandi unum includitur, uel sal-
tem non excluditur extraneum, scilicet accidentia. Sed secundo bene

1. ambo] *dub.*
2. rebus] omnibus *scr.*
3. concreto] acreto *scr.*
4. precisione] *dub.*
5. est] *suppl.*
6. sine omnis] *dub.*

65 unum de altero predicatur, quia etiam ex modo significandi nullum acci-
 dens ibi includitur. Item semper est formalis predicatio in propria ab-
 stracti de concreto, sed uera in deo propter ydemptitatem rei | significate b20
 per utrumque.

 Ex hoc etiam patet, quod natura est non humanus, sed quod habetur, uel
70 quod in alio, quia habet se per modum partis cuiuslibet, sunt conditiones,
 et ideo nulli parti conuenit modus concretus, quamdiu pars est, quia ad
 concretum pertinent accidentia que subsistunt.

 Sed ista positio etiam non ualet, quantum ad naturam incertam. Nos enim
 querimus non de homine semper, uel speci- | fice, quia sane intelligendo, b25
75 non est inconueniens concedere quod homo et humanitas habeant se sicut
 concretum et abstractum, et quia non differant re, licet in modo
 significandi. Sed nos hic per suppositum intelligimus indiuiduum in gen-
 ere substantie, ut forma, qui subsistit per naturam autem, quid differet
 suam essentiam. Et quod sic differat re patet ex duobus, que pro alia posi-
80 tione formata sunt. | Ideo sic: quorum est anima differunt realiter, sed in b30
 distinctione suppositi, sed diffinitio notetur ut forma preter illa, que sunt
 nature, uel speciei ponunt indiuidua partem, uel secundum alios indiuidu-
 ata ut hec [corpus],[7] hec anima. Ergo.

 Preterea. In hiis, que sunt per se idem,[8] non autem in hiis, que sunt
85 per accidens. Sed in omni supposito mate- | riali, de quo loquimur, sunt b35
 quedam, que attendunt supposito. Non autem nature, quorum acciden-
 tium quedam sunt determinata alicuius essentialium principiorum, sicut
 declaratur essentia speciei per hanc formam et hanc materiam. Quae de-
 terminatio accidit speciei, sicut rationale animali accidit, et tunc est es-
90 sentiale formali sine supposito, sicut rationale animali accidit, et tunc es-
 sentiale homini.

 Aliqua autem sunt, que non sunt determinata uel designa- | ta[9] alicuius b40
 essentialium principiorum, ut pertinent ad constitutionem indiuidu-
 orum, sed tamen pertinent ad suppositum, et si ad materiam, sicut esse et
95 alia accidentia, utrumque in sprirtualibus corporibus, sed in materialibus,
 que per se indiuiduantur. Est alterum tantum, scilicet accidentia non de-
 terminata, uel constituta, cum igitur in omni ente, preter primum aliquid
 accidat, oportet dicere, quod in | omni re differunt, sed realiter in materi- b45
 alibus. Non quod natura sit una res, et suppositum alia, quia hoc esset
100 secundum illos, qui dicunt naaturam esse formam tantum, que est altera
 pars suppositi. Uel secundum Platonicos, qui ponent quidditates in re
 separatas, sed licet intelligendi, quod unum includit aliud, et aliquid addi-
 tur, scilicet suppositum super materiam. Et per hoc patet ad rationes, quia
 non habet eamdem diffinitionem. Et etiam non sunt per se, non | quod b50

7. corpus] caio *scr.*
8. sunt] *iter.*
9. designata] designantia *scr. sed exp. et corr.*

105 unum sit accidentis unde de 9 supra,[10] quia addit aliquid, quod accidit spe-
 ciei, in qua non est de ratione eius.

 Et ideo sunt alii, qui dicunt differre suppositum et materiam realiter prop-
 ter rationes iam dictas.

 Preterea, si non different realiter, sed solum in modo significandi, cum
110 humana natura fuerit a filio sumpta, eorum | suppositum filius est, sicut b55
 statim patebit.

 Adhuc quidam dicunt, quod Christus est unum suppositum actu, plura
 uero potentia.

 Sed contra: actus et potentia differunt. Cum igitur natura humana sit ac-
115 tus in Christo, potentia et suppositum non erunt idem, sed differunt,
 quod uadit in actum non per additum, sed sola dimissione, si dimiseret,
 sicut una pars aliqua ab alia diferret formaliter a seipsa, et fierent diuersa
 supposita ab agente, nullo autem reali addito.

 fol. 153ra

120 Quidam autem natura in Christo existens, modo non habet rationem sup-
 positi. Hoc est, quia ei non conuenit realis modus significandi in coni-
 uncto, scilicet nec aliqua pars dicitur suppositum quamdiu est pars, sed in
 alio. Sed nec nature cum sit in alio.

 | Sed contra: Si natura humana sibi reliqueret aliquid reale, haberet illud a5
125 nouum suppositum, quod esset aliud a primo, quia creatum. Et illud ad-
 ditum esset esse creatum, nec autem habet aliud esse, quia increatum. Uel
 ideo natura humana, licet sit indiuiduum in genere substantie, tamen quia
 plus ad suppositum exigietur, scilicet quod habeat esse per se, ideo non est
 persona. Est non persona rationalis, nec substantia indiuidua, sed natura,
130 uel pars non est substan- | tia completa, sed pars substantie. a10

 Contra secundum sciendum ex hoc, quod quantumcumque aliqua differ-
 unt, unum potest sumi sine reliquo, cum igitur, ut ostenum est, natura
 humana differt a supposito, potuit unum sine altero sumi. Sed quia sup-
 positum etiam non potuit sumi sic patet. Id enim, quod assumitur, et si
135 non sit prius tempore, tamen potest intellecto a supposito assump- | to, in a15
 illud ergo suppositum, aut realiter aut non. Si non, ergo non esset assump-
 tum, sed magis destructum. Si remaneret, ergo erant duo supposita in
 Christo. Sed ex hoc sequerentur tria inconuenientia. Unum, quod deus
 non esset homo, non[11] e conuerso, quia numquam unum suppositum dis-
140 tinctum ab alio[12] uidetur. Unde etiam in diuinis, ubi est maxima unitas,
 pater non est filius.

10. 9 supra] *dub.*
11. non] ut *scr. sed in* non *corr.*
12. ab alio] de alio *secunda manus*

Secundo, quia non esset unio in una persona, nec etiam in | una natura, a20
cum non possunt esse una natura diuina et humana.

Tertio, quod deus non esset filius unigenitus, sed homo ille, sic patet[13] ita.

145 Ad rationem, si dicit adhuc per aliquid substantiale, adhuc accidentale.
Non substantiale quia, quicquid est substantiale uel essentiale, in natura
continetur. Si accidentale, ergo suppositum est unum per accidens. Dicen-
dum quod addit substantiale indiuiduo, accidentale speciei, sicut sup- | ra a25
dictum est. Posset tamen hic dici secundum alios, quod natura dicit essen-
150 tialia cum precisione[14] accidentium, nec includit, nec excludit formam[15]
uel suppositum, etiam includit indiuiduum.

Notandum tamen, quod THOMAS uidetur <cum>[16] dubio loqui de ista dif-
ferentia, quia in prima parte, q. 39, articulo 5, s. 3a,[17] dicit quod in sim-
plicibus non differant. Et etiam contra [arguit][18] sed in Quolibet,[19] quod
155 differunt | in omni creatura. Sed tamen in fine dicit, quod differunt in a30
modo significandi, et dicit ibidem, quod esse non est de ratione suppositi.
Sed in tertia parte, q. 2, articulo secundo, obiectione ultima, quod realiter
in rebus naturalibus differant, et ibi uidetur dicere, quod esse requiritur
ad suppositum, cum non sufficiant indiuidua, sicut patet de natura hu-
160 mana, que in Christo est una numero.

13. patet] ille *add. corr.*
14. precisione] *dub.*
15. formam] forma *scr.*
16. cum] *suppl.*
17. Thomas Aquinas, ST 3 q.39 a.5: "Utrum nomina essentialia in abstracto significata possint sup-
ponere pro persona" (ad 4).
18. arguit] git *scr.*
19. Thomas Aquinas, *De unione Verbi incarnati* a.1 sol.

Le Christ selon Maître Eckhart

Édouard-Henri Wéber, O.P.

L'Incarnation du Verbe divin est le fait le plus éminent de toute l'histoire du monde, expose Maître Eckhart avec S. Augustin.[1] Dominicain formé en l'école d'Albert le Grand et héritier de Thomas d'Aquin, il enseigne à deux reprises, une fois intégré en 1302 au collège des Maîtres de Paris, en la chaire de Thomas. Citant souvent ce dernier, il déploie sa théologie du Christ dans la foi de l'Église: l'homme Jésus, le Christ, est, considéré comme sujet concret, la Personne même du Fils au sein de la Trinité divine.

Approfondissant l'acquis doctrinal dont il hérite, Eckhart le traduit en formules personnelles à l'intention d'auditoires étrangers à la technique universitaire mais animés d'exigences spirituelles. Il enseigne, comme Thomas, une christologie dite de nos jours «d'en haut» qui lui permet de montrer, de façon plus décisive, à mon avis, que bien des essais récents dits «d'en bas», le dynamisme que la grâce vaut à l'agir humain chez le Christ-homme d'abord et par suite en tout homme.[2]

On ne dispose que peu de textes universitaires siens ni d'aucun traité en forme de christologie, mais toute son œuvre—en grande majorité commentaires de l'Écriture et prédication latine et allemande—est axée sur le Verbe incarné et le salut qu'il offre. Du Christ le Juste par excellence et modèle de tous les justes par grâce, Eckhart écrit: «L'union la plus instauratrice d'unité, après celle qui est propre aux trois Personnes en Dieu, c'est l'union du juste avec Dieu».[3] Il déclare encore:

> *Le Verbe s'est fait chair pour habiter en nous.* . . . Il est par conséquent juste d'affirmer que . . . l'Incarnation elle-même, se trouvant pour ainsi dire médiane entre les processions propres aux Personnes divines et la production des créatures, intègre la nature des unes et des autres. Ainsi l'Incarnation est à l'image des émanations éternelles et est modèle pour toutes les natures inférieures.[4]

Le Nouveau Testament, souligne-t-il, parle du Christ tantôt du point de vue de sa divinité, tantôt à celui de son humanité.[5] Axée sur le titre scripturaire de Médiateur, la christologie que propose notre théologien constitue une synthèse qui coordonne des considérations relatives à la Personne divine du Verbe et d'autres qui concernent l'humanité assumée.[6] D'où deux moments pour notre brève étude: I—la Personne divine du Verbe ou Fils; II—la nature humaine qu'elle a assumée.

I. La Personne divine du Verbe

Je vous ai révélé tout ce que j'ai entendu du Père, a dit le Christ.[7] C'est là, précise Eckhart, la plus sublime des vérités qu'il nous a manifestées. Entendre cette parole, c'est approcher de la conscience de soi qu'a le Christ-homme. Axée sur la Personne du

Fils ou Verbe, la christologie eckhartienne s'autorise du Christ qui justifie sa déclaration à Nicodème stupéfait en déclarant descendre du ciel tout en y demeurant (*Jean 3, 13*). Ce cumul d'une descente et d'une permanence en l'Origine est expliqué comme expression adaptée à la faiblesse de l'interlocuteur en vue de l'amener peu à peu à comprendre.[8] Notre théologien invite à discerner ce que dit, fait et est le Christ à partir du foyer vers lequel l'homme Jésus se focalise: la Personne du Père «Principe et fin».[9]

1. La génération du Fils est de nature intellective

En Dieu il y a Père et Fils. . . . Le Père, en engendrant le Fils, spire en même temps l'amour qui, amour du Père pour le Fils et du Fils pour le Père, est en vérité le lien mutuel des deux, Saint-Esprit spiré par l'un et par l'autre en tant que les deux sont un.[10]

Le Fils ou Verbe procède, en tant que Personne distincte, de celle du Père ou Principe par mode d'engendrement intellectif. A la suite de Thomas d'Aquin et de S. Augustin centrant le thème de l'âme rationnelle image trinitaire sur le ternaire «mémoire-intelligence-volonté», la génération du Fils est déterminée comme conception intellective. En sa nature ou essence, Dieu pur intellect se connaît lui-même en une conception dite Verbe au sens de Logos, Raison, Pensée.[11]

Eckhart insiste sur la nature intellective de Dieu. L'intellection constitue l'essence divine même. En Dieu spécialement, «dans l'intelligence l'être et le vivre sont intelligence et pur penser».[12] Cette nature noétique est soulignée en s'opposant à l'onto-théologisme d'Henri de Gand et de Duns Scot qui, pour contester la noétique averroïsée des maîtres artiens, subordonnent l'intelligence à l'étance ou essence en Dieu.[13] Terme de la conception intellective divine, le Verbe est toujours déjà né et toujours naissant, car la vie divine étant éternelle, la génération du Fils est permanente.[14] L'Écriture l'exprime avec le terme *erat, était*, le passé disant ce qui est accompli et l'imparfait ce qui est toujours en cours.[15] Cette permanence de la procession du Fils est aussi celle de l'action créatrice de Dieu. L'Écriture l'affirme: «tout a été fait par lui» (le Verbe). Le titre de Créateur est donc attribuable en un sens tout à fait propre au Verbe divin.[16]

2. Le Verbe «auprès de Dieu» et «dans le sein du Père»

Avec appui sur *Jean:* «dans le sein du Père» et «auprès du Père», Eckhart rend raison de l'égalité ou consubstantialité du Fils ou Verbe avec son Principe. Cette co-essentialité se révèle par les paroles du Christ: «Le Père et moi, nous sommes Un», «Je suis dans le Père et le Père est en moi» et «Qui me voit, voit le Père».[17] Ici les arguments eckhartiens sont d'une haute technicité. Ils doivent être notés, car ils commandent toute la christologie.

Pour exposer cette égalité de nature dans la distinction des Personnes, des arguments d'origine néoplatonicienne sont invoqués, ce qui porté à prêter à Eckhart allégeance au néoplatonisme. Mais c'est là, à notre avis, grave méprise. L'hénologie néoplatonicienne ne tolère absolument pas que l'Un suprême soit Trinité de Personnes subsistantes et égales.[18]

L'argument principal développe le titre biblique d'Image parfaite de son Principe qui est décerné au Christ-Fils à l'aide de l'épistémologie de Thomas d'Aquin. La forme intelligible est principe de l'intellection du fait de sa double fonction: référer à la chose connue et actuer l'intellect créé en sa réceptivité. L'intellection est par suite dite issue de la réalité connue qui la mesure dans et par la forme intelligible. Ce schéma vaut également pour la conception du Fils, étant précisé que l'intellect divin, acte pur, est affranchi de la réceptivité, ce qui vaut à son intellection d'être rigoureusement égale à l'objet d'intellection, à savoir l'essence divine même, puisque Dieu n'a pas à se rapporter à autre chose que lui-même.[19]

Cette référence à l'essence divine objet d'intellection comporte ainsi ce qui pour nous est réflexivité mais pour Dieu totale présence à soi. L'essence divine est, en la Personne engendrante, forme intelligible, *species*, qui mesure l'opération d'engendrer. D'où l'affirmation que le Verbe est rejeton, *proles*, du Père en égalité d'essence ou nature avec lui.[20] La causalité formelle de mesure qu'exerce l'essence divine implique en la nature intellective du Principe générateur présence réflexive à sa conception qui communique au Fils toute la nature divine.[21] Cette égalité doublée de distinction des Personnes, Eckhart l'exprime à l'aide de la distinction des genres masculin et neutre, *alius*, une autre Personne, mais non pas *aliud*, une essence autre ou différente.[22] Les notions importées du néoplatonisme sont ainsi refondues pour leur infuser une sur-détermination théologique supérieure issue de la Révélation. En Dieu-Trinité, la pluralité des Personnes ne contrarie ni l'unité ni la consubstantialité. Eckhart blâme le sens de nombre ou multiplicité qui, dans la doctrine de la Trinité divine, est trop couramment introduit, même par des clercs qu'il taxe d'ignorance.[23]

> Le Père et le Fils sont «un» en l'essence (divine), laquelle concerne leur être-en-acte *(esse)*. De la sorte la raison et la relation (propres à chacun) sont en l'essence (divine) où elles ont leur être-en-acte sans la différencier, car là, à savoir en l'être-en-acte, elles n'ont plus le caractère différenciant propre à la relation.[24]

II. L'HUMANITÉ ASSUMÉE PAR LE VERBE DIVIN

Le Verbe s'est uni à, non pas une personne, mais à une nature humaine.[25] L'humanité singulière assumée l'est avec des caractères particuliers inhérents à ceux du monde où il vient.

> *Il est venu chez les siens* ... *(Jn 1, 11)*: le sens littéral de ces paroles est que le Verbe a assumé la chair dans la nation juive, son peuple de prédilection, auquel avait été confiées les révélations divines et donnée la Loi où sont préfigurés le Christ, son Incarnation et les autres mystères.[26]

Par chair assumée, Eckhart évoque assurément l'humanité individuelle en l'homme Jésus, mais également et à un titre consécutif, comme les Pères grecs pour qui ce que le Fils n'assume pas n'est pas sauvé, la nature humaine au sens universel, celle que vérifie univoquement chacun des humains et que l'union avec Dieu dans le Christ revêt d'une dignité nouvelle.[27]

Concernant les caractères historiques individuels de l'homme Jésus, Eckhart se borne à noter en bref que, n'étant nullement impassible—le Christ a pleuré, s'est

troublé, a éprouvé la tristesse—sa noblesse d'âme l'a exposé à davantage souffrir.[28] Chez lui, la raison, en tant que simplement humaine, n'avait pas connaissance de l'action que Dieu opère en toute âme (le savoir infus dont il était doté n'est pas ici évoqué).[29] Notre théologien concentre plutôt son attention sur les opérations supérieures du Christ, ce qu'on peut rassembler sous trois thèmes: 1—L'union de la nature assumée et de la nature divine comme grâce suprême; 2—Le don rédempteur de soi que le Christ accomplit; 3—La référence à Dieu-Père qui focalise sa psychologie d'homme.

1. L'union hypostatique, grâce suprême

L'Incarnation du Fils est don suprême de la grâce.[30] Le rapport du Verbe divin et de l'homme est exposé avec la sentence de S. Maxime le Confesseur: «être par grâce ce que le Fils est par nature[31] ». La grâce ainsi évoquée concerne à un titre tout spécial et prioritaire l'humanité de l'homme Jésus, puis à titre consécutif tout juste, selon l'ordre hiérarchique de l'union en substance et de l'union par grâce d'adoption.[32]

Le caractère universel de l'humanité invitée à l'union par grâce s'entend au sens d'une proposition à chaque humain en sa singurarité personnelle et non pas en un sens vaguement général. Le thème biblique d'alliance nuptiale entre Dieu et son peuple est rappelé avec le *Cantique:* «Moi, je suis avec mon Bien-Aimé et Lui est à moi».[33] «Pour se donner tout entier, Dieu a assumé tout ce que je suis».[34] Citant Bède: «Je n'envie pas le Christ fait Dieu, car si je le veux, je puis le devenir sa suite», Eckhart souligne que cette sentence est vraie en dépit du sens que des hérétiques lui ont prêté et qu'il dénonce à la suite de Bède.[35] «Tout ce que Dieu lui (au Christ) a donné . . . il me l'a donné aussi bien qu'à lui, sans rien d'excepté, ni l'union *(eynung),* ni la sainteté propre à la divinité».[36] La raison en est cet amour de Dieu pour nous, qui nous vaut d'être appelés fils et de l'être effectivement.[37]

> Les grands amoureux ont coutume d'échanger leurs vêtements. Dieu a assumé notre revêtement (corporel), pour être vraiment homme dans le Christ, homme au sens propre et en substance, homme et Dieu. La nature humaine assumée (dans le Christ) étant commune à tout homme au sens univoque, il est donné à tout homme de devenir en lui fils de Dieu, fils adoptif par la grâce, le Christ étant Fils en substance.[38]

Avoir l'être du Fils, c'est pouvoir dire avec S. Paul: «Je vis, mais ce n'est plus moi, c'est le Christ qui vit en moi».[39] Ce partage de l'être même du Fils, le Christ l'offre à chaque fidèle avec le don de son Esprit, don lesté de son sang.[40] La totalité du don de soi que Dieu opère dans le Christ se manifeste, enseigne Eckhart, en celle que le Verbe incarné réalise en notre faveur:

> Jésus-Christ, étant source de la vie, est le principe, la raison, le fondement, le nœud et le but final de la rémission du péché, du salut (et) de toute grâce.[41]

Le double témoignage dont en *Jean* se réclame le Christ, celui du Père et celui de ses œuvres de Fils, concerne la révélation du Père par et dans le Verbe incarné. D'où l'explicitation: «C'est comme s'il était affirmé ceci: ce qui est ainsi attesté par ces deux témoins concerne aussi bien les choses divines que les humaines».[42]

2. Le don rédempteur de soi qu'accomplit le Christ

La grâce infinie d'unité selon la Personne de nature divine vaut à l'âme humaine du
Christ d'être, en son intelligence et en son vouloir, promue à un statut sublime de
déiformité. De ce don, traditionnellement dit grâce capitale, dérive la grâce adoptive
pour les humains qui en sont promus, dit Eckhart usant des termes de Denys, à un
statut divin, déiforme.[43] Le Verbe incarné s'est, tel le grain de blé, enfoui en ce champ
qu'est, écrit Eckhart, «sa très louable humanité», champ qui, le plus noble de la terre,
a été préparé par le Père, le Verbe et le Saint-Esprit. Le fruit sublime en est l'âme noble
de Jésus-Christ.[44] Comme le grain de blé meurt pour fructifier, le Christ s'est sacrifié
pour le salut de tous. Lumière divine, le Verbe s'est diffusé en«ceux qui l'ont reçu»,
leur donnant de participer à son être de Fils,[45] les établissant «teints du sang du Christ»
pour être en retour vers le Père, de sorte que le retour corresponde à l'émanation.[46]

Le Christ donne sa vie pour ses ennemis afin de s'en faire des amis.[47] Son œuvre
rédemptrice, loin de se limiter à un sacrifice compensateur du péché offense de Dieu,
s'accomplit au bénéfice des humains, de leur promotion au partage de la félicité du Fils,
en termes bibliques de sa table.[48] Ce sens positif du sacrifice du Christ, Eckhart invite
à le discerner par l'expérience d'un effectif partage par grâce de la vie et donc de l'être
même du Fils qui, comme il a relevé le fils de la veuve de Naïm, répand l'Esprit Saint
avec ses dons pour élever à la vie divine autrement inaccessible.[49] Ici interviennent des
expressions incisives, telles que «avoir l'être même du Fils», ou «présence de l'incréé
en l'âme»—ce dont notre théologien déclare: «J'en parle toujours».[50] S'opposant au vo-
lontarisme en essor à son époque et y discernant les prodromes d'un effondrement de
la théologie de la grâce en une mesquine assistance morale, Eckhart insiste sur l'être
divin effectivement communiqué en participation par la grâce d'adoption:

> Pourquoi Dieu s'est-il fait homme? Pour que je naisse Dieu, le même Dieu. . . .
> *Tout ce que j'ai entendu de mon Père, je vous l'ai révélé.* Du Père qu'entend donc
> le Fils? Le Père ne peut qu'engendrer, le Fils être engendré. Tout ce que le Père
> a, tout ce qu'il est, l'abîme de l'être divin et de la nature divine, il l'engendre
> pleinement en son Fils unique. Voilà ce que le Fils entend du Père, voilà ce qu'il
> nous a révélé, afin que nous soyons le même Fils. Tout ce qu'a le Fils, il l'a de son
> Père, être et nature, pour que nous soyons le même Fils.[51]
> Il serait de peu de prix pour moi que le Verbe se fût fait chair dans le Christ-
> (homme)—en le supposant isolé de moi—s'il ne s'était pas également fait chair en
> moi personnellement pour que moi aussi je sois fils de Dieu.[52]

De telles formules, qu'incriminera la censure, sont précisées en un sens orthodoxe par
le contexte qui rappelle la permanence du statut créé de l'âme lors de l'inhabitation du
Verbe et jusqu'en la gloire promise.[53] Les écarter pour les avoir isolées de leurs explica-
tions mutile la christologie eckhartienne. Scripturaire, la notion d'inhabitation du Fils
en l'âme du juste exprime l'intégration à l'héritage et donc à l'être même de ce même
Fils. Elle récapitule tout l'enseignement d'Eckhart qui, à l'intention des auditoires de
contemplatives dont il a la charge doctrinale, l'exprime avec fréquence en termes de
conception maternelle. Comme Marie mère de Jésus l'a par grâce conçu en son intel-

ligence avant que ce soit en son corps, tout fils adoptif conçoit, sous le souffle du Saint-Esprit, le Verbe en son âme intellective.[54]

Chez ceux que la grâce vivifie comme elle fait suprêmement chez le Christ-homme, une même et unique inhabitation du Verbe s'accomplit, ici en grâce infinie d'unité, là à titre consécutif et sur un mode adoptif qui remodèle sur le Fils Image parfaite du Père.[55] «Si mon âme était aussi disposée que celle de Notre Seigneur Jésus-Christ, le Père agirait en moi aussi absolument qu'en son Fils unique et nullement moins, car il m'aime du même amour dont il s'aime».[56]

La participation par grâce à ce qu'est le Christ le Juste est souvent exposée comme justice (au sens biblique). Le rapport du juste à la Justice réside en participation à une même nature divine selon un certain degré en dépendance de ce cas suprême *per essentiam* qu'est la grâce d'union hypostatique cause et source de la justice participée. «Celui qui saisit la distinction du juste et de la Justice comprend tout ce que je dis».[57] Ce thème de participation est chez notre auteur entendu au sens technique de Thomas d'Aquin.[58]

L'inhabitation du Verbe et de l'Esprit Saint est au cœur de la grâce sanctifiante qui, participation à l'être même de Dieu comme l'enseigne Thomas d'Aquin, possède un mode d'être tout à fait réel conféré en l'essence intellective de l'âme. Cet être réel participé, Eckhart l'entend avec Thomas comme être en acte *(esse)* adjoint à l'essence intellective créée au titre de son actuation. Il est à la fois préteressentiel et supérieur à l'essence créée, d'où le titre d'être surnaturel au sens rigoureux.[59]

Ce surcroît ontologique qu'est le don de la grâce est à l'origine de ce renoncement au Moi dit naturel car égocentré dont le Christ offre l'exemple et qui, chez le fils adoptif, est à exercer en l'ordre noétique avant le moment éthique. Avec *Jean* 16, 7 («c'est votre avantage que je m'en aille»), Eckhart souligne la nécessité non seulement de s'affranchir des ambiguïtés spontanées de l'amour mais d'abord de discerner chez le Christ la transcendance du Verbe sans s'arrêter à sa seule humanité en négligeant sa divinité.[60] Cette ascèse intellective suppose l'apophase en vue de la «percée» qui rejoint, au-delà du sens rationnel de la notion de divinité Cause première, le Père en son essence trinitaire.[61] Tel est le retour ou percée où l'homme entre en concours avec Dieu en sa grâce souveraine, car il s'agit d'une réalisation qui est supérieure à la sortie ou émanation créatrice.[62] Dans le Verbe brille le véritable Moi de chaque élu, le critère de son être accompli: «Être ad-Verbe: c'est ce que je dis en tous mes sermons», avertit notre théologien.[63]

Le retour (selon le schéma «émanation-retour» lisible en *Jean*) réalise la progressive «transformation en l'Image parfaite» qu'est le Fils.[64] «Percée» par delà le créé, il est réponse onéreuse mais facilitée par l'attrait séducteur qui, force anagogique, est diffusé par l'Esprit Saint Amour.[65] A s'y appliquer le fidèle est promu au plein accomplissement de la propriété d'image du Dieu-Trine.[66] En cette tâche se réalise l'accueil de la révélation du Père par et dans le Christ.

3. La référence à Dieu-Père foyer et moteur de la vie humaine du Christ.

Le Fils qui est dans le sein (du Père) manifeste tout ce qui appartient au Père . . . tout ce qui relève de l'unité et de l'indistinction chez le Fils et chez le Père. Et

parce que le Fils n'est pas autre chose que le Père du point de vue non-personnel, il manifeste le Père en sa nature, comme l'Un, et à ce titre il ne le manifeste pas comme personne. . . . Mais parce que le Fils en tant qu'engendré diffère du Père du point de vue de la personne, à ce titre il manifeste le Père comme personne, en tant qu'il en est distinct . . . car le Père et le Fils sont en opposition relative.[67]

L'ampleur du commentaire de la parole «Montre-nous le Père» le confirme, la révélation du Père par le Fils incarné est un des thèmes les plus importants de la christologie eckhartienne.[68] La relation personnelle au Père dans l'égalité de nature est au cœur de l'âme humaine du Christ qui la manifeste par et en son œuvre majeure: le don aux fils adoptifs de sa vie de Fils qui intègre celui de l'Esprit Saint. Tout ce qu'a dit et fait le Christ est, enseigne Eckhart, manifeste cette plénitude qui, propre à sa divinité, comble son humanité et se communique en grâce d'adoption filiale.

Eckhart insiste sur ce sens révélateur de ce qu'en l'homme Jésus une approche trop facile laisse au registre de l'exemple. L'homme Jésus a parfaitement accompli en son intelligence et sa volonté humaines la configuration transformante en l'Image parfaite qu'est le Verbe et donc a traduit au niveau humain le rapport personnel de filiation qui, au niveau divin, est le sien par nature.[69] Verbe divin co-principe, avec le Père, de l'Esprit Saint Amour, le Christ, par son envoi de l'Esprit, est plus que modèle: source de cette charité qu'il montre en lui-même lestée d'abnégation.

Pour avoir montré qu'en Dieu-Trine l'amour au sens essentiel et au sens notionnel ou personnel sont au fond réalité identique du fait de la réflexivité sur l'essence divine qui est inhérente à la conception du Verbe, notre théologien expose la convergence des formules de l'Écriture relatives au Christ-homme et telles que: *conçu du Saint-Esprit, Fils de sa [du Père] dilection*, d'une part, et de l'autre la parole souveraine: *le Paraclet . . . je vous l'enverrai . . . il prendra ce qui est mien pour vous en faire part*, supposée par la doctrine du Verbe co-principe de l'Esprit Saint.[70] D'où l'explicitation: «Le Père engendre son Fils, et il y prend une telle complaisance que tous deux font fleurir-et-s'épanouir le Saint-Esprit».[71]

Cette convergence permet—de pair avec la médiation déjà notée de l'Incarnation entre Trinité et création—d'entrevoir la causalité créatrice de Verbe dans le moment où il envoie l'Esprit. Celui-ci, en mission conjointe avec celle du Verbe, sustente et attire vers le Père l'intellection et le vouloir en priorité chez l'homme Jésus jusqu'en l'unité personnelle du Fils, puis chez tout fils adoptif pour son union au Fils selon sa mesure de grâce. C'est ce que traduit le thème eckhartien de bouillonnement, *bullitio*, de la vie divine de connaissance et d'amour cause, modèle et source de sa diffusion en l'ordre créé, *ebullitio*.[72]

Maître Eckhart rend raison autant qu'il est possible de la réalité sublime de l'union hypostatique propre au Christ. Il évoque, après Thomas d'Aquin, une théorie de noétique philosophique éclairant ce qu'a de transcendant la connaissance intellective. Sans être plus qu'un tremplin pour adhérer à la Révélation, cette comparaison aide à discerner chez l'âme intellective du Christ la référence à son Principe source et modèle de l'anagogie ou tension du retour chez le fils adoptif:

Le Verbe, Dieu, se fait chair et habite en nous de manière visible et sensible chaque fois que nous sommes conformés et configurés aux réalités divines, à

Dieu. . . . Des philosophes ont affirmé que l'Intelligence agente, qu'ils assuraient être une substance séparée, s'unit à nous dans le moment des images au moyen de sa lumière (intellective) qui illumine et pénètre notre pouvoir de construire les images. Après de multiples intellections, cette Intelligence agente nous est finalement unie et se constitue en nous forme, de telle sorte que nous opérons ses œuvres à elle, que nous saisissons les substances séparées comme celles-ci le font. Au gré de ces philosophes, cette Intelligence (séparée) est alors en nous au titre d'intellect acquis.[73]

Par cette comparaison où l'on reconnaît l'identité selon Aristote de l'intellect et de l'objet intelligible, Eckhart ne prétend pas réduire la vérité révélée de l'Incarnation du Verbe divin à un niveau exclusivement rationalisable.[74] Interprétée avec Thomas, cette identité ou unité éclaire autant que possible la référence au Père chez l'homme Jésus, puis, en deçà, chez tout juste.[75]

Dans le retour du Christ au Père «Principe sans principe» et «Fond sans fond»[76] au moyen d'une «percée» radicalisée en kénose pour accéder à la gloire, Eckhart invite à discerner la manifestation en acte de l'union hypostatique. Issue de la référence vive au Père, cette percée s'est accomplie en l'intelligence de l'homme Jésus habitée immédiatement et en plénitude par le Verbe. En conséquence de cette référence, le Christ, par sa parole et de pair avec l'Esprit, diffuse chez les fils adoptifs cette tension qui réfère directement et par delà les images-représentations *(sunder bilde)* au Père et anime tout fidèle en sa foi théologale.[77] «La grâce, c'est (déjà) la gloire, diminuée seulement de notre inaccomplissement».[78] D'où une polarisation qui règne en l'âme chez le Verbe fait chair vers Celui qui est Principe et Fin et dont le fils adoptif est à sa mesure vivifié.[79]

Cet accomplissement du juste qu'opère la grâce en lui donnant de participer à l'être filial du Verbe incarné constitue le sommet de la création par le Verbe. Le don du salut, en termes augustiniens la justification de l'homme déchu, est, rappelle Eckhart, une action divine plus grande que la création du ciel et de la terre.[80] «Ce que suscite la grâce est plus important que l'univers».[81] En l'accomplissant au prix de son sang, le Christ révèle son titre de créateur en tant que Verbe actif jusqu'en son humanité. Retourner à sa suite vers le Principe, loin d'annuler la sortie qu'est la création, en est l'achèvement. Mieux: c'est seulement avec le retour vers le Principe qu'il y a vraiment création. À propos de la promotion du fils adoptif vers son vrai Moi dans le Verbe, Eckhart écrit de tout sujet intelligent créé: «c'est en en ayant soif qu'il reçoit l'être-en-acte qui est sien: *sitiendo accipit esse*».[82] Et encore:

> L'homme, par tout lui-même . . . reçoit tout son être de Dieu seul, de Dieu en tant qu'objet unique d'opération [intellective et volitive]. Et cet être qu'il reçoit, ce n'est pas un être-pour-soi, mais un être-pour-Dieu, pour Dieu, dis-je, en tant que Principe conférant, au titre de fin, l'être, Dieu, dis-je, en vue-de-qui être.[83]

À la différence de l'émanation, le retour à la suite du Christ vers le Père requiert une coopération active parfois nommée «co-engendrement» ou «engendrement de ce qui m'a engendré».[84] Ce n'est pas oubli de la transcendance du Verbe divin, car notre théologien rappelle avec Isaïe que Dieu est actif en toutes nos opérations et qu'à la lumière divine (de grâce) on n'accède pas de soi-même, car c'est elle-même qui y rend présent.[85]

Fondés sur Thomas d'Aquin enseignant la nécessité de la conception intellective qui, en l'intériorité subjective de chacun, est cause et principe de l'activité libre d'aimer: *verbum spirans amorem*, «verbe (conçu) qui spire l'amour», les rappels du pouvoir réel que la grâce communique attestent qu'Eckhart a en vue, lorsqu'il parle d'engendrer à son tour le Fils, la densité ontologique du dynamisme propre à la vie selon la grâce.[86] Le retour ou «percée» dépend—en vertu du *pati divina* dionysien—de cet accueil «passif» qui, à l'instar de Marie mère de Jésus, permet de concevoir le Verbe venant accomplir le fils adoptif jusqu'en son agir selon la grâce condition de la vraie liberté.[87] Enfin est évoqué l'exemple du Christ en acte de louange de Dieu jusque dans le moment de l'épreuve, celle que Dieu en sa Providence ménage en vue d'accroître la capacité de l'âme à partager le bonheur suprême.[88]

Une dernière remarque. La christologie d'Eckhart se développe en mettant en étroite convergence deux discernements de haute théologie soigneusement établis: l'union sublime chez le Christ des natures divine et humaine, d'une part, et de l'autre, l'identité de nature avec le Père que le Christ vérifie en sa Personne dans la distinction personnelle vécue jusqu'au niveau à nous accessible de la nature humaine assumée. Le souci de l'unité, plus encore que de l'union, avec le Christ chez le fils adoptif vaut à cette théologie du Christ d'être la fois de caractère spéculatif et pratique, et l'un parce que l'autre. Elle se distingue ainsi des christologies de l'époque rationaliste qui ont consacré le divorce de la théologie académique et de l'enseignement d'une spiritualité dite mystique parce que privée de considérations spéculatives.[89]

Notes

1. Eckhart, *Sermones et Lectiones super Ecclesiastici* (=*In Eccli.*) 24,27 §41(LW 2: 269–70); *Expositio Sancti Evangelii secundum Iohannem* (=*In Io.*) 2,1 §288 (LW 3: 240–44); *Sermo Latinus* (=*SL*) 42,2 §423 (LW 4: 356); Augustin, *De Trinitate* 13.19.24.

2. *In Io.* 14,12 (*Qui credit in me, opera quae ego facio et ipsa faciet, et maiora horum faciet*) §587–95 (LW 3: 514–18); *Predigt* 29 (DW 2: 78, lin.2): «Dieu ne contraint nullement la volonté (humaine), il lui confère la liberté, de façon à ce qu'elle veuille uniquement ce qu'est Dieu en lui-même: la liberté même». Thomas d'Aquin, ST 3 q.33 a.3 ad 3: «in mysterio incarnationis non consideratur ascensus, quasi alicuius praeexistentis proficientis usque ad unionis dignitatem, sicut posuit Photius haereticus. Sed potius consideratur ibi descensus, secundum quod perfectum Dei Verbum imperfectionem naturae nostrae sibi assumpsit, secundum illud *Ioan.* VI (38; 51): 'descendi de caelo'»; 3 q.34 q.1 a.1.

3. *SL* 52 §523 (LW 4: 437).

4. *In Io.* 1,17 §185 (LW 3: 154). Cf. *Le Commentaire de l'Évangile selon Jean: Le Prologue (chap. 1, 1–18)*, §185, Texte Latin, Avant-Propos, Traduction et Notes par A. de Libera, Édouard Wéber, Émilie Zum Brunn (Paris, 1989); traduction un peu retouchée, 333.

5. *In Io.* 3,13 §350 (LW 3: 297–98); *In Io.* 1,1–2 §35 (3: 29): «in divinis est emanatio et generatio personalis Filii a Patre in quo distinguitur Novum Testamentum a Veteri, in quo non fit aperta mentio de Personarum emanatione. Novum autem ubique loquitur de Filio, sive quantum ad divinitatem, sive quantum ad humanitatem».

6. *In Io.* 1,17 §185 (LW 3: 154): «Dei sapientia sic caro fieri dignata est, ut ipsa incarnatio quasi media inter divinarum personarum processionem et creaturarum productionem utriusque naturam sapit, ita ut incarnatio ipsa sit exemplata quidem ab aeterna emanatione et exemplar totius naturae

inferioris»; *In Io.* 1,1–5 §6 (3: 7–8); *In Io.* 1,3 §56 (3: 46–47); *In Io.* 3,34 §361–64 (3: 306–10); *Liber Parabolarum Genesis (=In Gen. II)* Prologus §3 (LW 1: 453–54); *Expositio Libri Exodi (=In Ex.)* 3,14 §16 (LW 2: 21–22); *In Libri Sapientiae (=In Sap.)* 1,14 §28 (LW 2: 348–49); *In Sap.* 5,16 §64–68 (2: 392–96); *In Sap.* 13,1 §242 (2: 575–76); *Predigt* 16b (DW 1: 267, lin. 1); *Predigt* 69 (DW 3: 168, lin. 8).

7. *Jn* 15,15; *In Io.* 15,15 §640–42 (LW 3: 556–58); *Predigt* 27 (DW 2: 53, lin. 2).

8. *In Io.* 3,13 §349–50 (LW 3: 296–98).

9. *In Io.* 1,1–2 §50 (LW 3: 41): «Finis enim universaliter est id ipsum quod principium»; *In Io.* 3,8 §338 (3: 287): «efficiens et finis sunt in ipso Deo ipsa forma et esse Dei et unum cum illo»; *In Io.* 3,8 §340 (3: 288–89); *In Io.* 5,17 §411 (3: 349): «ipse (Deus) *finis et principium*, si finis, creavit, si principium, creat»; *In Io.* 7,18 §429 (3: 365); *In Io.* 14,10 §582 (3: 509); *SL* 33 §332 (LW 4: 290): «principium et finis coincidunt»; *In Ex.* 15,18 §85 (LW 2: 88–89); *In Gen. II* chs. 1–3 §165 (LW 1: 634–36); *In Eccli.* 24,23 §21 (LW 2: 248–49); *Prologus generalis in opus tripartitum* §19 (LW 1: 163–64).

10. *In Io.* 1,1–14 §162–63 (LW 3: 132–35), §166 (3: 136–37).

11. *In Io.* 1,1–2 §28 (LW 3: 22); *In Io.* 1,1–2 §4 (3: 5), §33 (3: 26), §44 (3: 36); *In Io.* 14,10 §582 (3: 509); *Quaestio Parisienses (=QP)* I §2 (LW 5: 38–39): Thomas d'Aquin *(Summa contra Gentiles; Summa theologiae)*; *In Gen. II* 1,3–4 §62 (LW 1: 528–29); *In Sap.* 1,14 §22 (LW 2: 343); *In Eccli.* 24,23 §9 (2: 237–38); *In Eccli.* 24,27 §38 (2: 265–66). *Memoria-(potentia) intellectiva-voluntas: SL* 2,1 §3 (LW 4: 5); §8 (LW 4: 9): «processus ille est . . . intellectualis»; *SL* 2,2 §12 (LW 4: 13); *SL* 8 §89 (4: 84); *SL* 15,2 §155 (4: 147); *SL* 19 §185 (4: 174); *Predigt* 9 (DW 1: 150, lin. 3); *Predigt* 14 (1: 230, lin. 8); *Predigt* 83 (DW 3: 446, lin. 1).

12. *In Io.* 1,3–4 §61 (LW 3: 51): «esse et vivere in intelligentia intelligentia et simplex intelligere est, esse et intelligere in vita simplex vivere et vita est. Deus autem est vita, *Io* 14,6: *Ego sum via, veritas et vita*»; *In Io.* 1,3 §54 (LW 3: 45); *SL* 8 §88–89 (LW 4: 84); *SL* 22 §214 (4: 199–200); *SL* 54,1 §528 (4: 445); *SL* 55,1 §539 (4: 452); *Predigt* 9 (DW 1: 150); *Predigt* 67 (DW 3: 133, lin. 3); *Predigt* 73 (3: 266, lin. 6), etc.

13. *QP* I §4 (LW 5: 40, lin. 5f.): «non ita videtur . . . ut quia (Deus) sit, ideo intelligat, sed quia intelligit, ideo est, ita quod Deus est intellectus et intelligere et est ipsum intelligere fundamentum ipsius esse». *SL* 29 §300–301 (LW 4: 267–68): «Deus unus est . . . qui est intellectus se toto . . . ipso solo esse est intelligere»; §304 (4: 269–70). En Dieu l'essence intellective subsume et l'être-étant et la vie: *In Io.* 1,1–5 §9 (LW 3: 10); *In Io.* 1,1–2 §28–31 (3:22–25), §34 (3: 27); *In Io.* 16,8 §658 (3: 573); *In Io.* 16,28 §669 (3: 582); *In Io.* 17,3 §678 (3: 592); *Expositio Libri Genesis (=In Gen.)* 1,1 §11 (LW 1: 194–95), *In Gen.* 2,2 §168 (1: 313–14); *In Gen. II* 29,16 §214–15 (LW 1: 690–91); *In Sap.* 12,10 §229 (LW 2: 564). Albert le Grand, *De causis et processu universitatis a Prima Causa* 2 tr.3 c.5, ed. W. Fauser, Cologne Edition 17/2 (1993), 143, lin. 56f.; *De anima* 1 tr.1 c.11, ed. C. Stroick, Cologne Edition 7/1 (1968), 89 lin.9. Thomas d'Aquin, *ST* 1 q.14 a.4 corp.: «est necesse dicere quod intelligere Dei est eius substantia»; 1 q.34 a.2; *SCG* 1 c.45 *(Liber CG* 2: 58); 4 c.11 (3: 265); *Quaestiones Disputatae de Potentia* q.9 a.5 corp., ed. P. Bazzi et al (Turin-Rome, 1949[8]), 2:236: «Cum ergo in Deo sit intelligere et intelligendo seipsum intelligat omnia, oportet quod ponatur in ipso esse conceptio intellectus, quae est absolute de ratione eius quod est intelligere». Voir R. Imbach, *Deus est intelligere. Das Verhältnis von Sein und Denken in seiner Bedeutung für das Gottesverständnis bei Thomas von Aquin und in der Pariser Quaestionen Meister Eckharts* (Freiburg, 1976). Avec «étance», *entitas, Seiendheit*, on évoque la théorie de l'identité réelle de l'étant, *ens, Seiend*, et de l'être, *esse*, au sens d'existence, qui, n'admet entre eux qu'une distinction de raison, en opposition à la doctrine thomasienne de la composition réelle de l'étant créé et de l'être, *esse*, comme acte de l'essence créée.

14. *In Io.* 1,1–5 §8 (LW 3: 8–9); *In Io.* 1,1–2 §31 (LW 3: 25): «Augustinus: si semper fuit Pater, semper habuit Filium»; §33 (3: 26–27), §34 (3: 27–29), §40 (3: 33–36); *In Io.* 1,18 §197 (3: 166–67); *In Io.* 4,13 §373 (3: 317–18); *In Io.* 5,17 §412 (3: 350); *In Io.* 14,10–12 §591–92 (3: 516–17); *In Sap.* 1,15 §45 (LW 2: 367–69); *In Sap.* 5,16 §67 (2: 395); *In Eccli.* 24,23 §21 (2: 248–49), §23 (2:249–51); *SL* 15 §153 (LW 4: 145), §155 (4: 147–48); *SL* 19 §184 (4: 173–74); *SL* 23 §223 (4: 208–9). P. Lombard, *Sententiae in IV Libris Distinctae* 1 d.9 c.4 #4 (Quaracchi Edition 1 pt.2:107), avec Origène, *Hom.* 9 n° 4.

15. *In Io.*1,1–5 §8 (LW 3: 8–9); *In Io.*1,1–2 §31 (3: 24–25); *Predigt* 44 (DW 2: 347); notation probablement inspirée de Thomas d'Aquin, *In Ioannem* 1,1 lect.1 (*Super Ioan.* 10 n° 39).

16. *In Io.* 1,3–4 §52–69 (LW 3: 43–58); *In Io.* 3,34 §360 (3: 304–5); *In Io.* 14,26 §618 (3: 539); Thomas d'Aquin, *In Ioannem* 1,2, lect.2 (*Super Ioan.* 16–17 n° 76); *ST* 3 q.3 a.8.

17. *Io* 1,1–2; 18: «*in sinu Patris; apud Deum*»; 10,30; 14,9 et 11; *In Io.* 1,1–5 §5 (LW 3: 7); *In Io.* 10,30 §511–18 (3: 442–48)).

18. Que la théologie trinitaire eckhartienne ne soit nullement inféodée au néoplatonisme est d'abord attesté par la détermination qui, au Concile de Nicée et par fidélité à la lettre du Nouveau Tes-

tament, a déterminé l'égalité du Fils avec le Père en écartant du mystère trinitaire l'Un du néoplato-nisme qui motivait Arius. Celui-ci, en son néoplatonisme rigoureux, postulait logiquement la subordi-nation et donc l'inégalité du Fils.

19. *QP* I §2 (LW 5: 38–39); *QP* II §2–4 (5: 50–51), §3 (5: 51): «obiectum dabit esse ei cuius est obiectum»; §5. Eckhart le rappelle sans cesse: toute connaissance vraie est, au niveau créé comme en Dieu, «rejeton (de la chose connue)», *ab obiecto,* de par son principe ou cause formelle qu'est la forme intelligible *(species).* L'intellection est effet issu, par mode d'émanation formelle en l'aptitude de l'in-tellect à s'y rapporter, de ce qui est objet d'intellection; *In Io.* 1,1–5 §5 (LW 3: 7), §7 (3: 8), §10 (3: 10), §23–26 (3: 19–21); *In Io.*1,3 §57 (3: 47–48); *In Io.* 1,12–13 §107 (3: 91–93), §109 (3: 93–94); *In Io.* 1,18 §194 (3: 162–63), §196 (3: 165); *In Io.* 1,48 §252 (3: 209–10); *In Io.* 3,34 §367 (3: 311–12); *In Io.* 4,38 §401 (3: 341); *In Io.* 10, 14–15 §505–6 (3: 435–38); *In Io.* 10,30 §511–12 (3: 442–43); *In Io.* 14,8 §562 (3: 489–91), §564 (3: 492); *SL* 49,2 §509–10 (LW 4: 424–25); *SL* 49,3 §511–12 (4: 425–28); *SL* 50 §513–14 (4: 429–30); *In Gen.* II ch. 3 §150 (1: 620–21): «exemplum de speculo . . . repercutiente speciem . . . obiecti visibilis . . . imagine inde genita tamquam prole»; *In Eccli.* 24,23 §25 (LW 2: 252–53); *In Sap.* 7,12 §121 (LW 2: 457–58); *SL* 40,3, §404 (LW 4: 343–44); *SL* 50 §514 (4: 430); «rejeton», *proles:* S. Augustin, *De Trinitate* 9.12.1.

20. *Filius Imago Patris: Col* 1,5; *He* 1,3; *II Co* 4,4; *In Io.* 1,1–5 §23–27 (LW 3: 19–22); *SL* 49,3 §511 (LW 4: 425): «imago proprie est emanatio simplex, formalis transfusiva totius essentiae purae nudae»; *In Io.* 8,34 §469 (LW 3: 401): «in divinis radicale principium generationis et spirationis est essentia divina»; etc. Eckhart bénéficie de la mise au point de Thomas d'Aquin, ST 1 q.39 a.5 ad 5: «Possu-mus tamen dicere quod essentia est res generans vel Deus generans, si res et Deus supponant pro Per-sona . . . quia primo res tenetur pro Persona, secundo pro essentia»; *De potentia* q.9 a.9 ad 9 (ed. Bazzi, 2:78): «Pater autem est exempla generationis ut generans, Filius ut genitus».

21. *In Io.* 3,34 §358 (LW 3: 304): «Pater communicat se totum quod est Filio; se totum Spiritui Sancto». La réflexivité en Dieu: *In Ex.* 3,14 (*Ego sum qui sum*) §16 (LW 2: 21–22): «ipsius esse quandam in se ipsum et super se ipsum reflexivam conversionem et in se ipso mansionem sive fixionem; adhuc autem quandam bullitionem sive parturitionem sui—in se fervens et in se ipso et in se ipsum liques-cens et bulliens, lux in luce, se toto ad se totum penetrans, et se toto super se ipsum conversum et reflexum undique . . . gignit— . . . et in se ipsum reflexit amorem. Propter hoc *Ioann.* dicitur: *in ipso vita erat.* Vita enim quandam dicit exseritionem, qua res in se ipsa intumescens se profundit primo in se toto, quodlibet sui in quodlibet sui, antequam effundat et ebulliat extra».

22. *In Io.* 1,1–5 §5–6 (LW 3: 7–8), §16 (3: 14); *In Io.* 1,1–14 §133 (3: 114–15), §135–36 (3: 115–16), §138 (3: 117), §161–62 (3: 132–34); *In Io.* 1,18 §194–95 (3: 162–65); *In Io.* 3,34 §358 (3: 303): neutrali-ter/masculine-[vel]-feminine; *In Io.*7,16 §422–23 (3: 358–59); *SL* 2,1 §8 (LW 4: 9–10); *SL* 4,1 §24 (4: 25); *SL* 35 §363 (4: 312); *Predigt* 4 (DW 1: 73); *Predigt* 44 (DW 2: 340, lin. 1); etc. *Alius-aliud:* Thomas d'Aquin, ST 3 q.2 a.3 ad 1; 3 q.17 a.1 corp.; *Compendium theologiae* c.229, éd. G. de Grandpré, Édition Léonine 42 (1979): 179 lin.24; *Quaestio Disputata de unione Verbi Incarnati* a.2 ad 1 (ed. Bazzi, 2: 427), avec Grégoire de Naziane, *Epist. CI,* PG 37, 180 A-B ; S. Bernard, *Super Cantica,* 71, §3,7–§4, 9; 80, §3,5. Comme tout théologien de classe, Eckhart est bien conscient que tout exposé rationnel de théologie trinitaire reste en deçà de son objet révélé. Pourtant, rappelle-t-il, l'exposé en exprime vrai-ment quelque chose : *omne quod de Trinitate beata . . . dicitur, nequaquam sic se habet . . . cum Deus sit . . . in sua natura indicibilis . . . Verum quidem est quod est aliquid respondens Trinitati quod dicimus.* En son souci de rigueur, l'exposé théologique est le mode adapté à la raison humaine d'ac-cueillir la vérité révélée. La réflexivité intellective, qui rend raison de l'égalité du Verbe et du Père, confirme le principe «des meilleurs maîtres»: *essentia non generat,* «l'essence (divine) n'engendre pas», car «essence» ne dit pas agent principe d'effet, ni relation subsistante (titre attribué avec Thomas aux Personnes divines): *In Io.* 1,1–2 §43 (LW 3: 36); *In Io.* 10,30 §512–13 (3: 443–45); *SL* 2,1 §6 (LW 4: 8); *In Eccli.* 24,23 §11 (LW 2: 240–41); *In Ex.* 15,3 §28 (2: 32–33); etc. Par suite la notion de «puissance d'engendrer» désigne à titre direct l'essence divine et en un sens second la relation, en l'occurrence celle de «paternité» qui caractérise la Personne du Père: *In Io.* 1,1–2 §43 (LW 3: 36); *In Ex.* 15,13 §28 (LW 2: 32–33); *In Eccli.* 24,23 §11 (2: 240–41); *SL* 2,1 §6 (LW 4: 8) (avec Thomas, ST 1 q.41 a.5).

23. *In Sap.* 1,14 §38 (LW 2: 359–60); *In Sap.* 7,11 §112 (2: 448–49); *Predigt* 10 (DW 1: 173, lin. 1): «Prêchant un jour en latin le jour de la Trinité, j'ai dit: la distinction dans la Trinité vient de l'Unité. Plus grande est la distinction (des Personnes), plus grande est l'unité . . . Y aurait-il mille personnes, il n'y aurait là qu'unité». *SL* 11,2 §118 (LW 4: 111–12): «Deus ab omni numero proprie eximitur. Est enim unus sine unitate, trinus sine trinitate». Eckhart serait à coup sûr également sévère à l'endroit de la thèse prétendant que sa théologie trinitaire relève du néoplatonisme philosophique.

24. *SL* 2,1 §8 (LW 4: 10); la relation en Dieu: *In Ex.* 15,13 §63–64 (LW 2: 67–69). Avec ces préci-

sions d'ordre noétique dont il dote sa théologie trinitaire, Eckhart conteste la théorie fameusement controversée qu'avance son contemporain Jean Duns Scot d'une distinction formelle *ex parte rei* censée sauvegarder l'égalité des Personnes divines.

25. *In Io.* 2,1 §288–89 (LW 3: 240–42); *SL* 6,2 §57 (LW 4: 56–57); *SL* 20 §199 (4: 183–84); *Predigt* 46 (DW 2: 379, lin. 6).

26. *In Io.* 1,11 §104 (LW 3: 89) (avec Thomas, ST 1–2 q.102 a.2).

27. *In Io.* 2,1 §289 (LW 3: 241): «natura est nobis omnibus aequaliter communis cum Christo univoce»; *In Io.* 3,13 §52 (3: 299): «sic arguit Augustinus: 'divina substantia longe distantior potuit suscipere humanam naturam, ut une persona fieret, quanto credibilius alii sancti fiunt cum homine Christo unus Christus, ut omnibus ascendentibus ipse unus ascendat in caelum'»; *In Io.* 3,13 §353–55 (3: 299–301); *SL* 25,2 §263 (LW 4: 239–40); *SL* 52 §523 (4: 437–38); *Predigt* 5b (DW 1: 86, lin. 8).

28. *Predigt* 86 (DW 3: 490, lin. 12).

29. *Predigt* 60 (DW 3: 19, lin. 5).

30. Avec *Jn* 4,9, *In Io.* 2,1 §288 (LW 3: 240–41): «Augustinus . . . : 'in rebus per tempus ortis illa summa gratia est quod homo in unitate personae coniunctus est Deo'»: Augustin, *De Trinitate* 13.14.19.

31. *In Io.* 1,12–13 §106 (LW 3: 90–91): «Fructus Incarnationis Christi, Filii Dei, primus est quod homo sit per gratiam adoptionis quod ipse est per naturam, secundum quod hic dicitur: *dedit eis potestatem filios Dei fieri*»; *In Io.* 1,14 §117–18 (3: 101–3); *In Io.* 1,17 §185 (3: 154–55); *SL* 52 §523 (LW 4: 437–38); *Predigt* 12 (DW1: 193, lin. 8); *Predigt* 66 (DW 3: 109, lin. 9). Due à Maxime le Confesseur, *Ambigua*, PG 91: 1088C, version Scot Erigène, PL 122: 1208 A-B, cette sentence (déjà formulée par S. Irénée de Lyon et souvent prêtée à S. Augustin) est lisible au XIIᵉ s. chez les Victorins et Guillaume de St-Thierry, puis au XIIIᵉ s. chez Thomas d'Aquin: voir *Note complémentaire n⁰ 5*, trad. franç. de Libera-Wéber-Zum Brunn, du *Commentaire de le Prologue de Jean*, 396–432.

32. *In Io.* 1,17 §185 (LW 3: 154–58).

33. *In Io.* 2,1 §292 (LW 3: 244–45); *Cant* 6, 2.

34. *SL* 47,1 §485 (LW 4: 400–1).

35. *In Io.* 2,1 §289 (LW 3: 241); Bède, Homiliae 7 (PL 94: 39).

36. *Predigt* 5a (DW 1: 77, lin. 10; la *Bulle* de Jean XXII (*Enchiridion* de Denziger-Schönmetzer, n⁰ 961), en sa visée des hérétiques rhénans, compte, privée de tout contexte, cette formule au nombre des propositions censurées.

37. *In Io.* 2,1 §288 (LW 3: 240–41).

38. *SL* 52 (*Induimini Dominum Jesum Christum* [Rm 13, 14]) §523 (LW 4: 437).

39. *In Io.* 14,10 §586 (LW 3: 513), avec *Ga* 2, 20.

40. *SL* 6,1, §55 (LW 4: 53–55); *SL* 25,1, §256 (4: 233–34) et §261 (4: 238): «primo se ipsum dat».

41. *SL* 42,2, §423 (LW 4: 356).

42. *In Io.* 8,14–18 §435–36 (LW 3: 372–74).

43. *In Io.* 1,1–5 §11 (LW 3: 11): «homo divinus ut sit et deiformis»; *Sermo Paschalis* §5 (LW 5: 140); *SL* 47,3 §492 (LW 4: 10): «deiformissimus»; etc.

44. *Predigt* 49 (DW 2: 439, lin. 1).

45. *Predigt* 48 (DW 2: 418, lin. 1): «J'ai parfois parlé d'une lumière qui est dans l'âme, qui est incréée et incréable. Toujours j'en parle en mes sermons. Cette lumière discerne Dieu sans intermédiaire . . . en sa nudité, tel qu'il est en lui-même. C'est là le saisir en l'accomplissement de la naissance. Je peux vraiment affirmer que cette lumière a plus d'unité avec Dieu qu'elle n'a d'unité avec quelque faculté humaine, avec laquelle elle est cependant "un" dans l'être». *In Io.* 10,14–15 §505–06 (LW 3: 435–38), qui, avec *II Co* 3,18, évoque la thèse de P. Lombard (*Sententiae* 1 d.17) identifiant charité et Esprit Saint: *idem amor est Spiritus Sanctus quo Pater Filium diligit et filius Patrem, quo Deus nos diligit et nos Deum; In Io.* 15,12 §626–28 (3: 544–46). Eckhart connaît la critique de cette thèse par les maîtres parisiens: il la reprend aménagée par Thomas d'Aquin qui coordonne charité créée propre à l'homme et Saint-Esprit amour incréé: *SL* 6,3 §65 (LW 4: 63–64); *SL* 47 §497 (4: 411–12); *SL* 11,1 §113 (4: 106–7) (corrige l'identité du Lombard par la mention d'un ajout perfectif: *passio illa . . . perficit*); *Predigt* 10 (DW 1: 168, lin. 3); *Predigt* 63 (DW 3: 74, lin. 5); *Predigt* 65 (3: 97, lin.10).

46. *SL* 56 §557 (LW 4: 466–67); *SL* 25,1 §259 (4: 237): «prima gratia in quodam effluxu, egressu a Deo. Secunda consistit in quodam refluxu sive regressu in ipsum Deum».

47. *In Io.* 15,13 §633 (LW 3: 550), qui évoque Thomas, *Catena in Ioannem* 15,13–14 (2: 530b).

48. *Predigt* 45 (DW 2: 373, lin. 1).

49. *Predigt* 43 (*Adolescens, tibi dico: Surge*) (DW 2: 325, 7; 328, lin. 2): «Dâ got sich gebirt in sînen eingeboren sun, daz ist unenpfenclich allen crêatûren».

50. *Predigt* 48 (DW 2: 418, lin. 1).

51. *Predigt* 29 (DW 1: 84, lin. 1f.).

52. *In Io.* 1,14 §117 (LW 3: 101–2) avec Origène, *Hom. XXII in Lucam,* Rauer IX, 144, 2s; *In Io.* 1,12–13 §106 (3: 90–91); *In Io.*2,1 §285 (3: 238–39); *Predigt* 5b (DW 1: 86); *Predigt* 38 (DW 2: 228, lin. 1); *In Io.*1,14 §118 (LW 3: 103), avec *I Jn* 3, 1: *Le Verbe s'est fait chair* dans le Christ. Puisque ce fut hors de nous, nous n'en avons pas été rendus parfaits. Mais après, du fait qu' «il a habité en nous», il nous nomme et nous accomplit en perfection. C'est pour *que nous soyons nommés fils de Dieu, et que nous le soyons.*

53. Le thème eckhartien d'union-unité de l'homme en grâce avec Dieu-Fils est sous le signe du couple «fils adoptif-Fils par nature» exposé à l'aide de *II Co* 3,18 (transformation en l'Image, i.e., le Fils) et de *Rm* 8,29 (conformation au Fils). La distinction *alius/aliud,* autre selon le sujet subsistant / autre selon la nature (*In Io.* 1,18 §194 [LW 3: 162–63]), exprime pour le cas créé la doctrine de la participation à une même nature selon des degrés plus ou moins déficients. Ceux-ci sont dépendants, en étant cor- rélatifs, du cas suprême cause *per essentiam,* lequel est caractérisé comme *principium formale radicale . . . increatum* (*In Io.* 8,34 §468 [3: 401]). L'assimilation au Fils par nature qui s'accomplit par l'in- flux d'abord intellectif issu de Verbe divin suppose la noétique d'Eckhart fondée sur la doctrine thomasienne de la composition d'essence et d'être comme actuation de l'essence chez tout sujet intel- ligent créé, ce qui reste méconnu de ses censeurs colonais. En sa déclaration du 13 février 1327, le maître accusé leur a fait avec raison grief de leur ignorance qui les porte à confondre «quelque chose en l'âme» et «quelque chose de l'âme»: voir H. Denifle, «Acten zum Prozess M. Eckharts», *Archiv für Litteratur- und Kirchengeschichte des Mittelalters* 2 (1886): 632. Eckhart développe sa théologie de la grâce de filiation adoptive en référence à celle de Thomas d'Aquin qui définit la vision beatifique chez les élus «sans intermédiaire», *sine medio,* du fait du don de l'essence divine comme forme intelligible à l'intellect en tout élu (*Quaestiones Disputatae de Veritate* q.8 a.1 corp., ed. A. Dondaine, Édition Léonine 22 (1970–74), 218: *essentia divina et intellectu creato fit unum in intelligendo;* ST 1 q.12 a.2 et 5; *SCG* 3 cc.51–52 (*Liber CG* 3: 69–71); chez le Christ homme: *De Veritate* q.20 a.4 ad 7 (Édition Leonine 22: 584): *anima Christi cognocit infinita . . . per speciem increatam, i.e., per ipsam essentiam divinam*). Il réfère à ce moment ultime la vie théologale chez l'homme viateur qui, suscitée par la grâce sanctifiante, s'exerce d'une manière également immédiate vers Dieu se communiquant en participa- tion de grâce. Aucun sens de panthéisme donc, pas plus qu'en la mention d'un quelque chose d'incréé en l'âme. Il est formellement précisé que cette identification avec le Fils n'implique nullement que l'homme quitte son être créé. *Predigt* 80 (DW 3: 387, lin. 2): «L'âme que Dieu attire à lui est transformée en Dieu, elle devient divine, quoique Dieu ne devienne pas l'âme. Celle-ci . . . ne perd pas son vouloir ni son être.»; *Predigt* 30 (DW 2: 94, lin. 6): «Plus Dieu est à l'intime des créatures, plus il leur demeure extérieur».

54. *Predigt* 22 (DW 1: 375, lin. 10). L'inhabitation de grâce est maintes fois présentée avec la formule attribuée à Augustin (en fait Gennade de Marseille) du privilège divin de pénétrer *(illabi)* en l'essence de l'âme: *In Io.* 1,43 §238 (LW 3: 199); *In Io.* 2,10 §304 (3: 253); *In Io.* 2,14–15 §311 (3: 259); *In Io.* 14,10 §581 (3: 508–9), §585 (3: 512–13); *In Sap.* 5,16 §60 (LW 2: 388); *In Sap.* 8,1 §184 (2: 519–21); *SL* 9 §98 (LW 4: 93–94); *SL* 24,2 §244 (4: 224), §249 (4: 227–28); etc.

55. *Predigt* 46 (DW 2: 380, lin. 5): «Wan als daz wâr ist, daz got mensche worden ist, als wâr ist daz der mensche got worden ist. Und alsô ist diu menschlîche natûre überbildet in dem, daz si worden ist das götlîche bilde, daz dâ bilde ist des vaters».

56. *Predigt* 42 (DW 2: 306, lin. 11–12).

57. *Predigt* 6 (DW 1: 105, lin. 2); *iustus-iustitia: In Io.* 1,1–5 §14–27 (LW 3: 13–22); *In Io.*1,1–2 §50 (3: 41); *In Io.* 1,1–5 §82 (3:70–71); *In Io.* 1, 12–13 §106–7 (3: 90–93); *In Io.* 1,15–16 §169–72 (3: 139–42); *In Io.* 1,18 §188 (3: 157–58), §196 (3: 165); *In Io.* 1,43 §236 (3: 197–98), §245 (3: 204–5); *In Io.* 1,48 §253–54 (3: 210–11); *In Io.* 3,8 §341 (3: 289–90); *In Io.* 4,13 §373 (3: 317–18); *In Io.* 4,38 §393–95 (3: 335–36); *In Io.* 5,19 §416 (3: 352–53); *In Io.* 7,16 §426 (3: 361–62); *In Io.* 8,17 §436 (3: 373–74); *In Io.* 8,28 §453 (3: 387–88); *In Io.* 8,39 §462 (3: 395); *In Io.* 8,34 §471 (3: 403–4); *In Io.* 8,36 §476 (3: 409); *In Io.* 8, 58 §490 (3: 422); *In Io.* 10,14–15 §503 (3: 434); *In Io.* 10,30 §511 (3: 442–43); *In Io.* 10,38 §519 (3: 448); *In Io.* 14,8 §558 (3: 487); *In Io.* 14,13 §601 (3: 523–24); *In Io.* 15,15 §643–44 (3: 558–60); *In Io.* 16,8–11 §659 (3: 574–75); *In Gen.* II ch. 3 §149 (LW 1: 618–19); *In Sap.* 1,15 §42–44 (LW 2: 364–67); *In Sap.* 6,17 §76 (2: 407); etc.; *In Io.* 14,10 §586 (LW 3: 513): «dictum . . . de iustitia et iusto sic se habet . . . de ipso Deo et homine divino inquantum divinus est, de igne et ignito inquantum ignitum est». Le thème de participation entendu de façon technique réserve à Dieu seul l'identité *per essentiam,* ce qui est exposé avec le couple *justus-Justitia* (noté *infra*): *In Io.* 1,14 §117 (LW 3: 101–2); *Predigt* 40 (DW 2: 277, lin. 5): «L'unité de l'homme et de Dieu est à entendre selon la ressemblance propre à

l'image. . . . C'est pourquoi si l'on dit que l'homme est un avec Dieu et qu'ainsi il est Dieu, on comprend qu'il l'est selon cette part d'image qu'il vérifie en étant semblable à Dieu et non pas selon qu'il est créature». Les images du fer (ou de la pierre) porté à l'incandescence sans perdre sa nature de fer, de la goutte d'eau jetée dans un fût de vin ou goutte de vin jetée dans la mer, de partage par l'atmosphère de la lumière solaire illustrent le thème de participation: *In Io.* 1,9 §94 (LW 3: 81–82); *In Io.* 1,14 §128 (3: 110); *In Io.* 1,1–14 §155 (3: 127–28); *In Io.* 1,48 §265 (3: 219–20); *In Io.* 3,2 §322 (3: 270–71); *In Io.* 3,13 §354 (3: 300–301); *In Io.* 3,34 §361 (3: 306–7); *In Io.* 8,34 §466 (3: 398–99); *In Io.* 14,10 §578 (3: 506–7), §586 (3: 513–14); *In Io.* 14,12 §595 (3: 518–19); *SL* 25,2 §264 (LW 4: 240–41); *SL* 52 §521 (4: 436); *SL* 55,1 §538 (4: 452).

58. À la différence des censeurs spécialement ignorants sur ce point qui assure le sens orthodoxe des formules eckhartiennes les plus fortes sur l'union de grâce avec Dieu.

59. *In Io.* 14,12 §593 (LW 3: 517): «cum enim gratia . . . sit supernaturalis»; *SL* 27,2 §273 (LW 4: 248): «esse gratuitum est maximum in bonis»; *In Io.* 1,14 §119 (LW 3: 103–4); *In Io.*10,41 §521 (3: 449–50); *In Io.* 14,8 §549 (3: 479–80), §575 (3: 503–5); *SL* 9 §99 (LW 4: 94); *SL* 25,2 §267–68 (4: 242–44): «gratia non est in potentia animae, sed in substantia, in intimo scilicet vel potius in ipso esse animae. . . . Opus gratiae praestantius est omni opere creationis, ut pote supernaturale. . . . Nulla creatura in opus potest gratiae . . . Est etiam incognitum opus gratiae Dei intellectui stanti in solo lumine naturali». *SL* 14,2 §152 (4: 144): «Deus . . . non invenitur nisi in intellectuali natura, ubi imago Dei capax Dei, cuius totum est esse ad aliud: *enixa super dilectum suum* » *(Cant* 8,5); *In Io.* 20,19 §709 (LW 3: 621): «stat (Jesus) medio (discipulorum) quia per gratiam inhabitat et fecundat ipsam essentiam animae». Thomas d'Aquin, ST 1–2 q.110 a.3 corp.: «lumen gratiae quod est participatio divinae naturae». En leur compétence philosophique, Eckhart, comme Thomas, professe que l'activité de pensée intellective est une réalité tout à fait réelle, c'est-à-dire de l'être réel bien que de statut non substantiel, ainsi que l'atteste leur thèse commune de la causalité d'ordre ontologiquement actuateur de l'objet d'intellection sur l'intellect humain en sa réceptivité. En fait d'ajout à l'essence de l'âme intellective, il n'y a, comme chez Thomas que suit Eckhart, que l'actuation ontologique par l'objet d'intellection et à sa mesure. Tel est le sens de l'insistance eckhartienne à désigner (avec Thomas) le siège de la grâce en l'essence de l'âme intellective et non pas, au sens strict, en la seule faculté intellective couramment distinguée de l'essence de l'âme. Eckhart est le seul auteur à discerner le sens de la leçon de Thomas d'Aquin sur la composition réelle d'*esse* et d'*essentia* au niveau créé.

60. *In Io.* 16,7 §655–56 (LW 3: 569–70): «Amor etiam Christi hominis, inquantum creatura, impedit seu retardat amorem Dei . . . præsentia corporalis retardat sinceritatem amoris deitatis . . . oportet Filium adire Patrem, ut spirat . . . ; est autem spirans Spiritum Sanctum unum cum Patre Principium; oportet ergo Filium quasi abire distinctionem et adire unitatem». Proposée assez sûrement à des auditoires de contemplatives facilement tentées de céder à une dévotion empreinte d'affectivité source de déception décourageante—*Predigt* 5a (DW 1: 82, lin. 11): «waynen oder sunftzen . . . es enist als got niht»—, l'assimilation intellective au Verbe incarné se fonde sur *Jn* 17,3, «La vie éternelle, c'est qu'ils te connaissent» et Augustin: *Rationes Equardi*, §6–8, §13 (DW 5: 59); *In Io.* 12,47 §534 (LW 3: 466): «nihil enim incognitum amatur»; *In Io.* 1,1–2 §43 (3: 36); *In Io.* 8,17 §443 (3: 379–80); *In Io.* 10, 14–15 §509 (3: 440–41); *In Io.* 15,15 §642 (3: 558); *In Io.* 16,14 §664 (3: 578); *In Io.* 16,28 §669 (3: 582); *In Io.* 17,3 §673 (3: 587–88), §677 (3: 591): «Patet ergo quod nudam Dei substantiam . . . quae est nostra beatitudo . . . consistit, invenitur, accipitur, attingitur et hauritur per intellectum»: *In Io.* 20,4 §696 (3: 611), §698 (3: 612–13); *In Gen. II* 2,16 §95 (LW 1: 560–61); *SL* 2,1 §5 (LW 4: 7–8); *SL* 2,2 §12 (4: 13–14); *SL* 50 §513 (4: 429–30), *Predigt* 7 (DW 1: 122, lin. 3); *Predigt* 9 (1: 152, lin. 9); *Predigt* 37 (DW 2: 216, lin. 1); *Predigt* 45 (2: 370, lin. 11; *Predigt* 52 (2: 496, lin. 1); *Predigt* 59 (DW 3: 635, lin. 5); etc.); rectification de l'amour en vue d'aimer comme Dieu aime, non pour soi-même (amour mercenaire, avec S. Bernard): *In Jo.* 2,14–15 §312 (LW 3: 260): «Deus operatur . . . propter nostram, non suam utilitatem»; *In Io.* 3,2 §323 (3:271–72); etc.

61. *In Io.* 2,14–15 §312 (LW 3: 260); *In Io.* 15,12 §626 (3: 545); *In Gen.* 2,2 §169 (LW 1: 314–15); *SL* 6,2 §60 (LW 4: 59); *SL* 31 §322 (4: 282). Dieu Père au-delà de Dieu créateur: *In Io.* 14,8 §571 (3: 498): «Patri debetur amor, Domino timor»; *In Io.* 3,2 §323 (3: 271–72); *In Io.* 13,13 §540 (3: 471–72); *In Gen. II* 2,18 §109 (LW 1: 575) *Daz Buoch der göttlîchen trôstunge*, (DW 5: 37, lin. 1); *Predigt* 52 (DW 2, 502, lin. 6): «Her umbe bitte ich got, daz er mich ledic mache gotes . . . als wir got nemen begin der creatûren»; *Predigt* 26 (DW 2: 31, lin. 6); *Predigt* 42 (2: 309, lin. 3).

62. *Predigt* 52 (DW 2: 504, lin.4).

63. *Predigt* 9 (DW 1: 155, lin. 3): bîwort; *Predigt* 22 (DW 1: 389, lin. 1: «*In principio* . . . là j'ai éternellement reposé dans la connaissance du Père éternel . . . En cette pureté il m'a éternellement engendré comme son Fils unique . . . afin que je sois père et engendre ce dont je suis engendré».

64. *In Io.* 1,14 §129 (LW 3: 110–12); *In Io.* 16,13 §661–62 (3: 576–78); *In Io.* 16,20–21 §667–68 (3: 580–81); *SL* 45 §461–68 (LW 4: 382–87): participer à la Passion du Christ; *In Io.* 10,14–15 §505–6 (LW 3: 435–38) (avec *II Co,* 3,18: *revelata facie gloriam Domini speculantes, in eandem imaginem transformamur a claritate in claritatem*); *In Io.* 14,8 §575 (3: 503–5); *Sermo Paschalis* §16 (LW 5: 147–48), évoque la sentence d'Augustin relative au sacrement de l'Eucharistie qui transforme dans le Christ; de même *Predigt* 20 (DW 1: 331, lin. 3); *Predigt* 16b (1: 272, lin. 11); *Predigt* 40 (DW 2: 278, lin. 6): l'Esprit Saint surmodèle l'homme en la forme-de-l'Un propre à Dieu *(überbildet in der götlîchen einformicheit); Predigt* 72 (DW 3: 244, lin. 1) *(überbildet).*

65. Le Saint-Esprit «nœud, *nexus*», du Père et du Fils-Verbe: *In Io.* 1,1–14 §162–66 (LW 3: 132–37); *SL* 2,1 §5 (LW 4: 7–8); *SL* 3 §24–25 (4: 25–26). *Predigt* 67 (DW 3: 132, lin. 2). Comme la lune attire la marée, le Saint-Esprit attire vers le le Père dans le Verbe: *In Io.* 1,43 §235 (LW 3: 196–97); *In Io.* 3,1–2 §319 (3: 267–68); *In Io.* 5,19 §417 (3: 353), *In Sap.* 7,24 §130 (LW 2: 467–68); *In Sap.* 8,1 §174 (2: 509–10); *Daz buoch der götlîchen tröstunge* (DW 5: 29, lin. 20); *Predigt* 23 (DW 1: 396, lin. 2); etc.

66. *SL* 49,1 (LW 4: 421–23); *SL* 49,2 (4: 24–25) et 49,3 (4: 25–28) *(Mat* 22,15: *Cuius est imago haec et superscriptio?*); *Predigt* 81 (DW 3: 399, lin.2): «La grâce . . . rend l'âme conforme à Dieu». *In Io.* 1,51 §282 (LW 3: 236): «homo per gratiam fit aliquid altius se ipso homine».

67. *In Io.* 1,18 §197 (LW 3: 166).

68. *In Io.* 14,8 *(Ostende nobis Patrem)* §546–65 (LW 3: 477–93): 16 raisons concernant la notion de «Un» désignant le Père par appropriation, puis, §566–576 (3: 494–506), 18 arguments pour la notion théologique de Père au sens personnel. *In Io.* 14,10 §577 (3: 506); *In Io.* 14,8 §569 (3: 496–97), §574 (3: 502): «Pater non ostenditur in quantum Pater nisi in generando».

69. L'image comme image est inséparable de ce dont elle est image: *QP I* §8 (LW 5: 44–45); *QP II* §3 (LW 5: 50), §6 (5: 52); *In Io.* 1,15–16 §176 (LW 3: 144–45), *In Io.* 1,18 §197 (3: 166–67); *In Io.* 14,8 §549 (3: 479–80): «Homini autem, cum sit factus ad imaginem totius unius substantiae Dei et sit in esse productus sub ratione unius totius, non sufficit recursus ad simile, sed recurrit ad unum unde exivit, et sic solum sibi sufficit»; *SL* 14,2 §152 (143–44); *SL* 49,1 §505 (4: 421–22); *SL* 49,2 §510 (4: 425); *Predigt* 16b (DW 1: 268, lin. 7): «Hie ist got âne mittel in dem bilde».

70. *Jn* 16,8 et 14; «l'Esprit du Christ»: *Rm* 1,4; 8,9; *I Co* 15,45; *He* 9,14; *In Io.* 16,14 §663 (LW 3: 578); *In Sap.* 5,16 §65 (LW 2: 393–94), etc.; *Filius-philos: In Io.* 1,11 §115 (LW 3: 100); *In Io.* 1,1–14 §165 (3: 136); *In Io.* 8,44 §479 (3: 411–12); *In Io.* 14,13 §602 (3: 524–25); *In Io.* 15,12 §632 (3: 548–49); *In Io.* 15,15 §640–42 (3: 556–58); avec l'étymologie *filius a philos,* selon Papias, *Vocabulista,* noté par Gundissalinus, *De divisione philosophiae, In Io.* 1,1–14 §166 (3: 136–37). Sans remettre en question la distinction *(salvis aliis expositionibus),* Eckhart apporte une précision à «amour» en théologie trinitaire où l'on série amour au sens essentiel car commun aux trois Personnes divines et amour au sens notionnel ou approprié car appliqué spécialement au Saint-Esprit. *In Io.* 8,17 §438 (3: 376): «Li inquantum autem reduplicatio est; reduplicatio vero . . . dicit nexum et ordinem duorum», la notion de *inquantum,* «en tant que», qui considère le point de vue formel, permet d'établir la convergence de ces deux sens. La réflexivité référée à l'essence divine en tant que présente en l'émanation du Fils entraîne, en la volition aimante en Dieu, la référence concomitante à cette même essence divine Bien suprême. En supposant cette référence volitive, la procession du Saint-Esprit vérifie à la fois l'amour au sens notionnel et au sens essentiel ainsi précisé. Ceci rend compte de la parfaite involution ou circumincession des Personnes divines et confirme la consubstantialité de l'Esprit *(In Io.* 1,1–14 §165 [3: 136]; §163 [3: 134]: *Spiritus Sanctus . . . non enim procedit nisi ut Deus est).* La précision constitue un approfondissement parallèle et complémentaire de celle de Thomas d'Aquin qui établit l'attribution au Verbe divin du titre de Créateur en un sens rigoureusement propre et non de simple appropriation.

71. *Predigt* 4 (DW 1: 72, lin. 12); *In Sap.* 5,16 §65 (LW 2: 393–94): l'union hypostatique des natures divine et humaine chez le Christ est l'œuvre de la Trinité entière (ce qui ne s'oppose pas à l'affirmation: le Verbe assume une nature humaine).

72. Voir *supra* n.21; la suite *bullitio/ ebullitio,* bouillonnement interne/bouillonnement qui s'épanche à l'extérieur, traduit la causalité efficiente, formelle exemplaire et finale des émanations trinitaires sur l'ordre créé et en priorité sur celui de la grâce. Eckhart s'appuie sur Denys, *Noms Divins,* II, §4–5 (PG 3: 640D–641B), avec Thomas d'Aquin, *In I Sent.,* d.2 *Divisio textus (Scriptum* 1: 57–58) et d.14 q.2 a.2 Sol. (1: 325–26).

73. *In Io.* 1,1–14 §155 (LW 3: 128). Thomas d'Aquin, *SCG* 4 c.41 *(Liber CG* 3: 329f.); *ST* 3 q.5 a.3; q.35 a.2 ad 2; *Quaestio Disputata de anima* a.16 (ed. Bazzi, 2: 340–44), l'union hypostatique dont est rapprochée l'union—selon Avicenne et Averroès (dont il a scruté l'épistémologie pour la critiquer en retenant ce qu'elle a d'excellent)—de l'Intellect supérieur à l'homme et de celui-ci: voir É.H. Wéber, *Le Christ selon Saint Thomas d'Aquin* (Paris, 1988), 174f.

74. Il en est de même concernant la Trinité divine révélée. La Révélation incite le théologien à lui offrir un digne accueil au niveau rationnel sans prétendre démonstrer au sens fort.

75. *In Io.* 1,1–2 §46 (LW 3: 38); *In Io.* 16,28 §669 (3: 582); *In Io.* 17,3 §677 (3: 591–92), §681 (3: 595–96); *Predigt* 48 (DW 2: 416, lin. 7); etc.

76. La «percée» (briser la coque pour trouver le noyau: *Predigt* 51, (DW 2: 473, lin. 5) ou «retour» suppose l'apophase dionysienne en ses trois moments en synergie: négation-causalité-éminence: *Predigt* 71 (DW 3: 211–31) *(Surrexit autem Paulus . . .)*. «Fond (sans fond)», traduit l'expression patristique «Principe (sans principe)»: outre *supra* n.9, *In Io.* 1,1–5 §19 (LW 3: 16); *In Io.* 1,1–14 §162 (3: 132–33), §165 (3: 136); *In Io.* 3,34 §359 (3: 304); *In Io.* 14,8 §562 (3: 489–91), §568 (3: 495–96); *In Io.* 16,7 §656 (3: 570–71); *In Eccli.* 24,23 §9 (LW 2: 237–38); *Predigt* 69 (DW 3: 178, lin. 3): «Vernünfticheit diu blicket în und durchbrichet alle die winkel der gotheit und nimet den sun in dem herzen des vater und in dem grunde und setzet in irn grunt. . . . Si . . . nimet ez *in principio, in dem beginne*».

77. *Predigt* 46 (DW 2: 380, lin. 1).

78. *SL* 9 §100 (LW 4: 95).

79. *Predigt* 51 (DW 2: 7): Eckhart se dit lui-même *vertoeret,* fou du désir du bien ultime qu'est l'union avec Dieu en son Unité.

80. *In Io.* 14,12 §592–93 (LW 3: 516–17), avec Thomas d'Aquin; *Predigt* 38 (DW 2: 241, lin. 8); *Die rede der underscheidunge,* XII (DW 5: 232, lin. 6) (avec Augustin, *Tr. in Ioannem* 72,3; Thomas, *In IV Sent.* d.17 q.1 a.5 ob 1 and ad 1 [*Scriptum* 4: 848 and 851]).

81. *Predigt* 43 (DW 2: 325, lin. 5).

82. *In Eccli.* 24,29 §45–46 (LW 2: 274–75); *In Gen. II* 1,1 §25 (LW 1: 494–95).

83. *In Io.* 1,12–13 §107 (LW 3: 92).

84. *Predigt* 10 (DW 1: 171, lin. 8); *Predigt* 22 (1: 383, lin. 8): «hât er [Dieu-Père] mich êwiclîche geborn sînen einbornen sun in daz selbe bilde . . . daz ich vater sî und geber den, ven dem ich geborn bin».

85. *In Io.* 15,16 §647 (LW 3: 562): «*opera nostra operatus es in nobis* »(*Is.* 26,12); *Predigt* 70 (DW 3: 196, lin. 9): «Wenne aber diu gnâde wirt volbrâht ûf daz hœhste, sô enist ez niht gnâde; ez ist ein götlich liehte, dar inne man got sihet. Sant Paulus sprichet: *got wonet und innewonet in einem liehte, dâ niht zuoganges enist.* Dâ enist kein zuoganc, dâ is ein dar komen».

86. *In Io.* 1,1–14 §162–65 (LW 3: 132–36); *In Io.* 14,13 §603 (3: 525–26); *In Io.* 16,15 §665 (3: 579): «*omnia quaecumque habet Pater mea sunt,* ergo et hoc meum est quod sum principium Spiritus Sancti, sicut Pater principium est»; *In Sap.* 1,14 §23 (LW 2: 343–44), §27 (4: 346–48); *In Eccli.* 24,23 §8 (LW 2: 235–37); *SL* 4,1 §25 (LW 4: 26); *Predigt* 4 (DW 1: 72, lin. 14); etc.

87. *Predigt* 75 (DW 3: 301, lin. 1): «Waz hülfe mich, daz der vater sînen sun gebære, ich engebære in denne ouch? Dar umbe gebirt sînen sun in einer volkomenen sêle . . . ûf daz si in vort ûzgebære in allen irn werken»; *Predigt* 6 (DW 1: 114, lin. 4): «got und ich wir sunt ein in disem gewürke: er wirket und ich gewirde»; *Predigt* 52 (DW 2: 503, lin. 1): «der mensche ist got alsus in im lîdende»; *Predigt* 22 cité *supra* n.63. Le thème de co-engendrement du Verbe sera repris par S. Jean de la Croix.

88. *Predigt* 49 (DW 2: 443, lin. 8): «(le Christ) mit sînen obersten kreften . . . umbe allez daz, daz lîchame hâte ze lîdene: sô bleip er nochdanne alle zît die gotheit aneschouwende mit wider îngebornem lobe die verterlîche hêrschaft âne underlâz». *Predigt* 68 (DW 3: 151, lin. 5): «Ez enist niht von gotes gerehticheit noch strengicheit, daz er vil heischet von den menschen; ez ist von sîner grôzen milticheit, daz er wil, daz sich diu sêle wîte, daz si vil enpfâhen müge, daz er vil geben müge.»

89. Avec l'épithète «functional», l'étude intéressante de R. Schneider, «The Functional Christology of Meister Eckhart», RTAM 35 (1968), 291–322, semble admettre ce divorce chez Eckhart qui au contraire les coordonne avec une rigueur sans égale.

Medieval Self-Fashioning:
Authorship, Authority, and
Autobiography in Seuse's *Exemplar*

Jeffrey F. Hamburger

Few titles are as concise, yet as evocative, as that given by Heinrich Seuse (ca. 1295–1366) to the authorized anthology of his German writings, compiled in Ulm shortly before his death. Known simply as *The Exemplar,* the collection opens with an account of the Rhenish Dominican's life, followed by the *Büchlein der Ewigen Weisheit,* the *Büchlein der Wahrheit,* and the *Briefbüchlein,* a selection of pastoral letters written to nuns of the Dominican order to whose care Seuse devoted much of his career.[1] At its most literal, Seuse's title defines his desire to establish the compilation as a textual exemplar free of error, doctrinal as well as scribal, a concern elaborated with unusual self-consciousness in the prologue.[2] The title also denotes Seuse's life and writings as good examples to be imitated faithfully by his followers. Yet more is at stake than righteous behavior or respect for the author's intentions. *The Exemplar* is neither a manual on morals nor a treatise on hermeneutics. Instead, it offers the reader a model of the religious life in the form of an extended meditation on the relation between exemplars and experience construed, in absolute terms, as the relation between the Logos and the self. Seuse hints at his higher purpose in the prologue, which defines the *Life* as describing "by concrete example . . . how a beginner should order his inner and outer self according to God's will," and closes by characterizing the entire work as "a comforting help" that "for well-disposed persons lights the way to divine truth and for thoughtful people points out the right path to supreme happiness."[3]

Although often dubbed an early example of autobiography, Seuse's *Life* does not fit comfortably under this quintessentially modern rubric.[4] Seuse refers to the first book of *The Exemplar* simply as "der Súse," identifying himself with his text. The conflation, however, is not complete. In contrast to modern notions of textuality, which posit that there is nothing, not even Being, beyond the text, Seuse's argument relies on a tradition of medieval exemplarism that posits that Being itself supplies the pattern on which everything else is modelled.[5] Seuse asks his readers to live their lives according to his script, but beyond the text lies his experience and, ultimately, the prime Exemplar, Christ himself.[6] Seuse addresses his readers as if in the words of St. Paul (I Corinthians 4:16 and 11:1): "Be ye imitators of me, as I also am of Christ."[7]

Seuse defines the correlation between text and experience at the beginning of "der Súse," which opens with the plea that "his name may be written in the book of life," "an dem lebenden bůch."[8] According to this eschatological formulation, to live eternally is to be inscribed in the rolls of the blessed, to become one with the living book, the Logos, an idea given concrete embodiment in monastic necrologies and the liturgi-

cal rites of *memoria*.[9] Seuse writes so that he and his readers can achieve bliss in paradise: reading, writing and transcription serve as instruments of initiation through which his disciples can assimilate themselves to Christ.[10]

The whole of *The Exemplar*, but especially Seuse's *Life*, invites interpretation as a discourse on the nature of imitation, understood in terms of the right relationship between models and their copies. Seuse's readers shared the same concerns: witness the copy of Seuse's effigy penned by a reader in the margin of an incunabulum copy of *The Exemplar*, printed in 1482 by Anton Sorg in Augsburg (fig. 43). To read Seuse was to imitate him, a process that Seuse himself defined in terms of images. In keeping with the title of the compilation, the language of exemplification—image and likeness, model and copy—permeates the text.[11] Seuse's use of its terminology has ample precedent, but the extent to which he applies it to his own text and, through it, to his own person, is without precedent.[12] Part of what makes Seuse's *Life* so challenging is the extent to which it brings together the concrete and the general, the particular and the exemplary. We find it hard to believe that anyone could characterize himself in terms usually reserved for a saint. Yet, emulating the forms of hagiography, Seuse identifies himself as a mediator through whom his readers can come to know Christ.[13] In effect, Seuse sets himself up for his flock in the role of holy man. But whereas the Desert Fathers, whom Seuse much admired, acted as "human exemplars," making Christ present in their persons, Seuse insists equally on textual mediation, in part because he, as a friar, was denied direct access to the nuns to whom his writings were addressed.[14]

The manifold ways in which Seuse defines his experience as exemplary are summarized by the word "bilde" ("bild" in Seuse's text), a leitmotif in Seuse's writings. The prologue informs the reader that the *Life* is written "mit bildgebender wise," a phrase virtually impossible to translate and only roughly rendered as "describing by concrete example."[15] Among the many definitions of "bilde" in Middle High German are image, idea, example, likeness, even portrait, of which Seuse's *Life* could be said to provide the literary equivalent. Like the Latin "imago," to which it is closely related, the term "bilde" is rich in theological implications, standing simultaneously for God's example and its reflection in the soul.[16] Seuse draws on all these shades of meaning. One important connotation of "bilde" as Seuse employs it, however, is best conveyed by its later derivative, the equally untranslatable word "Bildung," often equated with "education" but better rendered as "edification" or "formation" in the spirit of Paul's words in I Corinthians 14:3: "But he that prophesieth, speaketh to men unto edification, and exhortation, and comfort" ("loquitur aedificationem et exhortationem et consolationes.")[17] Despite his sophistication as a philosopher and theologian, Seuse's primary concern, as in much of the literature addressed to nuns, remains the spiritual edification and formation of his readers.[18]

The Exemplar translates Seuse's experience into textual form, but it also transforms the author into a living image that his audience can imitate by way of reflection. To reading and writing as instruments of initiation, Seuse adds the no less important medium of sight. Drawing on an extensive tradition of pastoral literature, Seuse represents himself as both a *speculum* and an *imago*: a mirror in which his readers will find Christ's example faithfully reflected and, at the same time, an exemplary image or model that they themselves should reflect.[19] In the context of such language, the *Life's*

numerous references to works of art take on a significance far greater than has pre-
viously been acknowledged.[20] More than descriptive details supplied to heighten the
realism of the narrative, the allusions to images provide set-piece demonstrations of
the formative powers Seuse attributes to works of art. Images formed an indispensable
part of Seuse's devotional practice, and in *The Exemplar*, they play no less important a
role as examples and instruments of imitation.

Complementing *The Exemplar*'s many references to works of art is an extensive
program of illustrations, a set of eleven or twelve images devised, if not actually exe-
cuted, by Seuse himself.[21] The images survive in six manuscripts, of which the earliest
was commissioned or at least acquired by the community of the Johanniter in Stras-
bourg (Grünenworth), founded by Rulwin Merswin in 1371, only five years after
Seuse's death.[22] The remaining illustrated copies all date from the fifteenth century.
In the prologue Seuse states that the images "serve the purpose of allowing a reli-
giously minded person, when he leaves the world of the senses and enters into himself,
always to have something to draw him away from this false world, which pulls him
down, and upward toward our beloved God." At the same time, however, Seuse invests
the images with a higher authority, referring to them as "himelsche bild" ("heavenly
images").[23] From the outset, Seuse associates the illustrations with the visions that
punctuate his text, identifying the drawings not simply as pictorial aids or allegories,
but rather as indispensable vehicles of spiritual understanding and transformation.[24]

In light of *The Exemplar*'s elaborate discourse on images, it is surprising that its
illustrations have largely been ignored. In the manuscripts as Seuse envisaged them,
however, if not in modern printed editions, it is impossible to overlook the images or
the degree to which they structure the reader's perception of the text. In all but one of
the illustrated copies of *The Exemplar*, the reader first encounters an image and only
then the prologue, in which Seuse refers to illustrations that "come before and after,"
"dú hie vor und na stand," a clear indication that the placement of the first drawing
prior to any text formed part of his original plan.[25] In addition to authorizing images
as vehicles of mystical ascent no less legitimate than the texts with which they are
associated, the drawings identify the viewing and reproduction of images as a model
for the process of imitation central to the spiritual life itself.

Even if Seuse's modern critics have overlooked the images in *The Exemplar*, his
medieval readers and redactors did not. The record of *The Exemplar*'s reception reveals
that its early audience repeatedly recognized the importance of the visual in Seuse's
work.[26] One way of tracing medieval responses to Seuse's writings is to chart changes—
philological, codicological and iconographical—in the surviving manuscripts.[27] An-
other approach is offered by the apocryphal writings and images associated with Seuse
during the fifteenth century.[28] In lieu of the issues of authorship and authenticity that
long irritated modern scholarship on Seuse, the apocrypha force us to focus on the
problems his writings posed for their medieval readers. Most of the apocrypha repre-
sent responses to images, either the illustrations of *The Exemplar* or works of art men-
tioned in the text. As a result, they shed light on the ways in which his medieval readers
understood the role of images in his thought. They also provide *prima facie* evidence
of the importance attached to those images throughout the later Middle Ages.

The writings of the Dominican Johannes Meyer (d. 1485) offer a case study in the

history of Seuse's reception. An assiduous reformer, Meyer, like Seuse, devoted much of his career to the care of nuns in the Rhineland.[29] Meyer's entire life as well as his writings could be read as a response to and continuation of Seuse's career.[30] Unlike Seuse, however—but in keeping with his contemporaries among the German Observants—Meyer did not hold images in high regard, in large measure because he distrusted their capacity to inspire among nuns the kind of visions and literal imitation of Christ's sufferings so vividly described in the literature of female spirituality.[31] Nonetheless, in a brief biography of his predecessor appended to his reworking of the chronicle of the convent of Töss, Meyer reduces *The Exemplar* to an exemplum concerning the role of images in devotion.[32]

According to Meyer (who paraphrases Chapter 42 of *The Exemplar* virtually verbatim), Seuse's mother entered the cathedral of Constance during Lent, where she fainted upon seeing a statue of the Deposition:[33]

> It happened that at the beginning of Lent she went into the cathedral. In that same church there stood on an altar a deposition of our Lord ["die ablößung unssers herren"] with carved figures ["beschnittenen bilden"]. From pious contemplation ["von andechtigem betrachten"] of the worthy suffering of Christ, she felt in an acute manner the great pain that the compassionate mother of God experienced under the cross. And from her sensitivity to this affliction she fell ill in her body, so that she sank to the earth in a dead faint. And after she had been helped home, she lay there sick until Good Friday at None, the very same hour at which the Son of God, Jesus Christ, died on the holy cross on account of our sins. Then she died as the Passion was celebrated and came to a very holy end.

In its dependence on the commonplace conception of compassion dramatically embodied in the sculptural forms of Rogier van der Weyden's *Prado Deposition*, Meyer's identification of Seuse's mother with the Virgin Mary exemplifies the emotive Passion piety of the later Middle Ages (fig. 44).[34] Seuse's mother becomes Christ-like in the same manner as Mary in van der Weyden's panel. Rogier's Virgin provides the onlooker with a model of *compassio*.[35] Even as she falls in a dead faint beside the body of her son, elevated above the altar at the center of the shallow, shrine-like space, she conforms herself, body and soul, to the *corpus Christi*.

In singling out this story, Meyer recognized that it provided an excellent, indeed, exemplary instance of Seuse's literary and devotional method.[36] The exemplum not only identifies the *imitatio Christi* as the central theme of Seuse's *Life*, it also acknowledges that images are its essential instruments. Through the mediation of an image, Seuse's mother imitates Mary and, through her, Christ.[37] The anonymity of Seuse's mother only facilitates her assimilation to the Virgin.[38] Just as Mary provides her with a mediating model, so she provides one for her son, who in turn aspires to supply one to his readers in the form of his example, understood both as his life and its representation in word and image.

In sanctifying his mother, however, Seuse does more than simply honor the Virgin.[39] In a striking convergence of literary and familial lineage, Seuse's *Life* grants his mother a role no less prominent than that of Monica in Augustine's *Confessions*.[40] Like Seuse's work, the *Confessions* begins as an "autobiographical" narrative and ends as an

exposition of mystical verities and of how the mind may know them. The parallels are hardly accidental: together with the tradition of introspective *soliloquia* spawned by the *Confessions*, Augustine's authoritative account of the soul's journey to God provided Seuse with one of his principal literary models.[41] The form of imitation advocated by Seuse is not, however, simply a literary construct. In an act of elective affinity, Seuse rejected the family title, von Berg, inherited from his father, and chose in its place his mother's maiden name, Sus or Süs (whence Seuse). Whereas Seuse describes his father as "a child of the world" ("der welt kind"), he characterizes his mother as a saintly person "through whose heart and person God had done marvelous things."[42] In a society organized around the principles of primogeniture and agnatic descent, Seuse's adoption of his mother's name represented an extraordinary declaration of independence, even humiliation, not unlike Francis of Assisi's renunciation of his patrimony.[43] Within Seuse's *Life*, it symbolizes the self-conscious identification with the feminine that was to mark his entire career.

Seuse refers to his mother as a "*göt bild*," a "good example," that served as an inspiration to others, especially the doctors that sought to cure her of a sickness beyond their skill, the languor brought on by her empathy with the suffering Christ.[44] The doctors tend to her body, but she provides medicine for their souls. In repeating Seuse's exemplum, Meyer also employs the language of exemplification, introduced, moreover, by an injunction to see: "Observe the holy lives led in immense piety and holiness by the first brothers and sisters; you too should live according to such a holy example."[45] Like Seuse, Meyer aims to inspire imitation of venerated Dominican exemplars. With this in mind, he introduces his exemplum with an image drawn from Luke 6:44 (cf. Matthew 7:16), whose language reinforces an understanding of imitation as both regeneration and a return to institutional roots: "Una queque arbor de fructu suo cognoscitur," "for every tree is known by its fruit."[46] The scriptural image connects Seuse with his mother and both with their ultimate exemplars, Mary and Christ, the stem ("virga") and fruit of the *Arbor vitae*. Yet it also provides a biological link between Meyer and Seuse, identifying him and his contemporaries as Seuse's direct descendants.

For Meyer and his colleagues, his behest that they envisage Seuse's example would not have been abstract. A print depicting Seuse as a "beatus" opens Meyer's largely autograph copy of the *De viris illustribus*, a collection containing biographies of over two hundred Dominican worthies (fig. 45).[47] The woodcut shows Seuse's writings literally bearing fruit: as his attribute Seuse holds a copy of his works from which sprouts a sprig of roses. The quotation from Luke would also have reminded German Dominicans of images diagramming the history of their Order.[48] An Upper Rhenish example, dated 1473, based on a Tree of Jesse includes Seuse among six Dominican saints gathered around their recumbent patron, St. Dominic (fig. 46).[49] Although never canonized, Seuse was widely regarded as a saintly figure; indeed, his *Life* could (misleadingly) be read as a claim to sainthood.[50] Crowned with a garland and clutching a rose, Seuse stands just to the right of the trunk holding the attributes he assigned himself. In the *Life*, Seuse represents himself as a saint: to one of his followers, Anna, he appears in a vision with a chaplet of roses that reminds her of "the golden halo that one usually paints around the head of saints."[51] The specifically pictorial character of the compari-

son does more than liken Seuse to a holy man. It invests him and the illustrations of *The Exemplar* with the authority of sacred images. Seuse is saintlike in that he appears like a cult image.

Much of the scholarship on Seuse's *Life* has been devoted to the authenticity and accuracy of the "autobiography."[52] To Seuse and his audience, however, this debate would have been largely irrelevant, if not meaningless.[53] In keeping with the conventions of hagiographic legend, Seuse presents his life in the form of an exemplary account that serves his readers as a model for their own experience.[54] For medieval readers, legends were stories to live by. Yet Seuse's legendary account of his own life still stands apart from the hagiographical literature on which it depends, even that of his own order, for example, the *Vitae Fratrum*.[55] It is not simply that Seuse's *Life* contains an extraordinary degree of descriptive, one might even say, pictorial detail.[56] In characterizing himself in terms usually reserved for candidates for canonization, Seuse went far beyond the efforts of the living saints of the thirteenth century. Even if they styled themselves as saints, figures such as Francis of Assisi or Leutgard of Aywières left the codification of their legends to others.[57] In contrast, and in keeping with the title of the collection of which it forms the first part, Seuse presents his own life as a case study in the art of imitation. In Seuse's practice, life and legend converge to the point where his person and the corpus of his writings can no longer be distinguished.

In keeping with hagiographical convention, Seuse claims that the legendary account of his life presented in Part I of *The Exemplar* was compiled, if not completed, by a disciple, in his case, Elsbeth Stagel, the prioress of Töss and Seuse's spiritual daughter.[58] The nature and extent of Stagel's contribution may never be determined.[59] But in attributing co-authorship to his spiritual companion, Seuse did more than seek to temper the apparent subjectivity of the *Life*, although that is one consequence of his use of third person narration.[60] Nor did he construct a fictional female collaborator solely for the sake of edifying his female audience.[61] Regardless of Stagel's contribution, the role he assigns her is perfectly plausible (even if not necessarily or demonstrably accurate).[62] It is, moreover, indispensable. In addition to the ideal spiritual daughter, Stagel represents the exemplary imitator and interpreter of Seuse's text. By characterizing the *Life* as a collaboration, Seuse emulated a fundamental fact of his existence as a friar: his preoccupation with the *cura monialium*, or the pastoral care of nuns.[63] As presented in the *Life*, Seuse's self is continually linked with that of a female figure, at the outset, the personification of Eternal Wisdom, then his correspondent, Stagel, and finally, through her, his readers, the majority of whom, the manuscript tradition confirms, were women as well.[64] The dialogue between Seuse and his female counterpart provides a model for the devotional exchange between Seuse's text and its overwhelmingly female audience.

Christian exegesis established marriage as the principal metaphor for the union of God with the soul.[65] Within this framework, however, and with characteristic daring, Seuse self-consciously adopts various gender roles, playing, for example, both the bride of Christ and the bridegroom of Holy Wisdom. Seuse's role-playing across gender lines extends to the program of illustration, where his self-styled feminization is especially pronounced in the earliest illustrated copy—also the earliest extant copy over all. In its drawings, Seuse appears repeatedly in feminine guise, for example, wearing a chaplet

of red and white roses that signify his purity and patience.[66] In all but the first two illustrations, roses also mark Seuse's hands and shoes (but never, in fact, his feet), a simulation of the stigmata revealed to him by an angel in chapter 22 of the *Life*.[67] In the accompanying illustration, however, it is Seuse's imitation of Mary that first meets the eye (fig. 47). Seuse not only adopts the pudic pose and swaying S-curve stance customarily reserved for figures of female saints, above all the Virgin Mary; he also, like her, sways in response to an angelic salutation, as if in an Annunciation, an analogy that lends his figure an added connotation of humility and deference (fig. 48).[68] Like the Virgin Annunciate, Seuse is puzzled by the message from on high, which, the angel explains, "means suffering and more suffering, and some more suffering and still more suffering that God wishes to give you."[69] In body as in mind, Seuse represents himself as the ideal exemplar for his female audience.[70]

The complex crossing of gender boundaries in *The Exemplar* serves a double purpose. In addition to identifying Seuse with his mother and, through her, with the Virgin Mary, it also allows his female followers to identify with him as their immediate exemplar. The process of exemplification and repetition is inscribed in the drawing itself, which, in addition to Seuse's vision, illustrates Seuse as seen by one of his followers, the noblewoman Anna. Complementing the annunciation to Seuse in the upper register, the annunciation to Anna repeats its forms, but at a lower level, spiritual as well as visual. Unlike Seuse, who stands, Anna kneels. Above, the friars flanking Seuse represent the "heavenly company" ("engelschliche geselschaft") among whom Anna feared she might "not recognize him in the midst of the others."[71]

The illustration of Anna's vision does not simply recapitulate the passage it accompanies. Rather, it represents the mediation of divine authority, from God to Seuse and from Seuse to his followers. Unlike the text of *The Exemplar*, which relates Anna's and Seuse's experiences separately (if *seriatim*), the drawing conflates them: we see Anna witnessing Seuse's vision. The two registers of the illustration imply a corresponding hierarchy of vision, as does the repetition of the cross from one level to the other. Whereas at the upper level, the cross identifies the right hand of God as a symbol of divine presence, in Anna's hands it takes the form of a small devotional object analogous to the illustrated book held by the reader. The image implies that whereas Seuse has immediate access to divine reality, for Anna, as for Seuse's other female followers, it can only be experienced through the mediation of his example, understood as both his person and his text.

If Anna represents the exemplary eye-witness to Seuse's visions, then Elsbeth Stagel represents the ideal recipient of and respondent to his writings. By reception, Seuse understood more than the mere transmission of his oeuvre, although the prologue makes clear that the accurate transmission of his writings was of critical concern to him.[72] Instead, consistent with his aims in the prologue, Seuse tries to anticipate readers's responses and to channel the course they might take. Stagel provides his readers—in the first instance, a female reader very much like Stagel—with a preemptive example of correct response, defined in terms of action as well as understanding. Stagel's absence in Part I (Chapters 1–32), the story of Seuse's noviciate, only reinforces the significance of her presence in Part II (Chapters 33–45), which begins with the words, "Confide, filia" (loosely translated as "Take heart, my daughter") and which

describes Seuse's interaction with his spiritual daughter. Stagel's spiritual progress in effect recapitulates Seuse's own: her mirroring of Seuse's model anticipates its further reflection in the reader.[73] The correspondence between Seuse and Stagel that supposedly provided the raw materials for the *Life* does not simply replicate or create the impression of a colloquy that may or may not have taken place; it prefigures an exchange between Seuse and an exemplary reader, an interaction initiated and enacted in the third, speculative section of the *Life* (Chapters 46–53), which takes the form of a dialogue on mystical experience between Seuse and his spiritual daughter.[74]

Turning back to the opening of *The Exemplar* to consider the drawing that prefaces even the prologue, one discovers in retrospect that Seuse's soulmate was present from the beginning (fig. 49). Like David and Solomon at the top and Job and Aristotle below, Seuse and Holy Wisdom are engaged in a dialogue, which the speech scrolls characterize as a marriage: according to the inscription at the top, "Disú bild bewisent der Ewigen wisheit mit der sele geisthlich gemahelschaft," "These pictures show the spiritual marriage of Eternal Wisdom with the soul."[75] Seuse declares: "Diz han ich geminnet vnd vsgesuochet von minen iungen tagen Vnd han mir sie userkorn ze einer gemahel," "This is the one whom I loved and sought out from the days of my youth, and I have chosen her as a spouse." Seuse's involvement with Elsbeth Stagel and, by extension, the female branch of his order, represents the consummation of his career in the service of Wisdom itself. If the nuns in Seuse's care are *sponsae Christi*, then Seuse serves as the bridegroom of the brides of Christ.

As depicted in the manuscripts, however, Seuse's marriage with Holy Wisdom represents more than the traditional coupling of Christ and the soul. Although in the early copy in Strasbourg the inscriptions ("Hanc amavi," etc.; "die Ewige wisheit") and the swaying, hip-shot pose identify the personification of Wisdom as unmistakably feminine, she nonetheless sports a beard, a subtle blurring of genders that corresponds to Seuse's artful combination of masculine and feminine traits. Seuse's carefully cultivated androgeny disappears in later illustrated copies, all of which invariably emphasize Wisdom's identification with Christ and, hence, masculine characteristics (fig. 50).[76] In using his engagement with female spirituality as a means of exploring the inner life, Seuse is typical of mendicant confessors.[77] Far less typical, however—in fact, virtually unprecedented—is the way in which Seuse turns the genre of the *Vita* inside out, establishing Stagel as a virtual mother confessor to whom he reveals his innermost spiritual secrets through the letters that ostensibly provided the basis for his "autobiography."[78] In representing himself as a lover of Wisdom, Seuse presents himself to his female readers in a guise with which they, as brides of Christ, could readily have identified.

In *The Exemplar*'s introductory illustration, Aristotle declares, "Sapientis est ordinare: Swer diser wisheit wil pflegen Der sol ordnen alles sin leben," "It is the role of the wise man to set in order: whoever wants to practice such Wisdom must set his whole life in order."[79] To "set his whole life in order" defines in a nutshell both what Seuse sets out to accomplish in Book I of *The Exemplar* and what he hopes his reader will do having finished his text. The notion of "order" is taken up in the prologue, where Seuse states that his book teaches how one, "mit rehter ordenhafti zů der blossen warheit eins seligen volkomen lebens sol komen," how, "with right discernment

and understanding one shall attain the pure truth of a blessed and perfect life."[80] By "reht[e] ordenhafti" Seuse means not simply good judgment, but something more closely allied with wisdom of the kind alluded to by Luke at the beginning of his Gospel: "Forasmuch as many have taken in hand to set forth in order a narration (or-dinare narrationem) of the things that have been accomplished among us."[81] The intri-cate literary structure of Seuse's *Life* itself serves as an expression of order and a means of unfolding it before the reader. No less important, however, is the meaning of "ordi-nare" developed in the schools during the thirteenth century: the way in which the physical structure of the book, including its illustrations, establish its order, that is, its sense, in the mind of the reader.[82]

Given the importance of images in Seuse's thought and devotional method, texts alone provide an inadequate record of his reception in the later Middle Ages. To under-stand Seuse as he was imagined in the fifteenth century, one must also consider Seuse and his writings as they were represented in images, not least because the images themselves represent interpretations of Seuse's literary corpus. Of these works, an early sixteenth-century panel, part of an altarpiece known from its provenance as the Buxheim retable, offers one of the most complex (fig. 51).[83] Attributed to a workshop active in Ulm—the same city where ca. 150 years previously Seuse had brought *The Exemplar* to completion—the altarpiece was probably commissioned for the Abbey of Heggbach (Kreis Biberach), a community of Cistercian nuns.[84] The panel depicts Christ kneeling in the Garden at Gethsemane, identified both by the wattle fence in the background and the angel descending with a chalice. Yet, in lieu of the sleeping Apostles or the advancing soldiers led by Judas, the panel from Heggbach shows two saints as witnesses together with a second angel kneeling at their feet. Christ's atten-tion seems less directed towards the scriptural cup of sorrow than towards his onlook-ers, who stand in for the viewers outside the frame and establish devotional dialogue as the panel's principal subject. Christ greets the Virgin as if in an inversion of his farewell to his mother.[85] Joining the Virgin is St. Augustine, his heart pierced by the arrow he holds in his hands.[86] The presence of Mary and Augustine effects a temporal displacement that identifies Christ as the object of vision. It also identifies response to Christ's sufferings, not simply their narrative recitation, as the panel's principal sub-ject. In effect, the person praying in front of the panel is presented with an image of Mary and Augustine—two exemplars of compassion—meditating upon the archetypal image of prayer: Christ praying before his own Passion.[87]

Further distancing the panel from Heggbach from traditional representations of the Agony in the Garden is the tree at the center, which finds no justification in scripture. At first glance, it invites identification as an *Arbor vitae* or else as the *Arbor virginis*, the subject of another panel from the same altarpiece (fig. 52). In the panel of Christ in the Garden, however, the cross, far from providing the vertical axis, rests at a curious perpendicular, festooned in the tree along with the other instruments of the Passion. A cue to the scene's iconographic identity comes from the scroll held by Christ Child. As if in response to the words spoken by the tormentor at the upper left—"crucifixere eum"—the scroll reads, "Ich wil rosen brechen und fil liden uf min frund trechen," "I will pluck roses and bestow many sorrows on my friends."[88] The words paraphrase an inscription in one of *The Exemplar*'s illustrations, a drawing in whose upper register

Seuse stands in visual dialogue with the crucified Christ, while the Christ Child plucks and proffers the roses referred to by the text (fig. 53).

In the manuscript in Strasbourg, the image of Christ in the rose bower illustrates the second of the four books gathered in *The Exemplar*, the *Büchlein der Ewigen Weisheit*. In all the other illustrated copies, however, the image illustrates Chapter 34 of Seuse's *Life*, which describes how his disciple, Anna, saw a rose bower in a vision:[89]

> this same holy daughter . . . had seen a beautiful rose bush covered grandly with red roses, and upon the rosebush the Child Jesus appeared with a garland of red roses. Sitting there under the rosebush she saw the servant [i.e., Seuse]. The Child broke off many of the roses and showered them upon the servant so that he was covered with red roses. When she asked the Child what the roses meant, he said, "This multitude of roses are the many different sufferings God intends to send him. He should accept them cheerfully from God and endure them in patience."

In his noviciate Seuse went out of his way to mortify his flesh. As a mature Dominican, however, he advises his readers not to seek out suffering actively, but rather to endure it patiently and passively.[90] In emphasizing obedience and patience over heroic individual experience, Seuse's message could not be more monastic: the *Rule of St. Benedict* begins with the exhortation, "Receive willingly and carry out effectively your loving father's advice, that by the labor of obedience you may return to him from whom you had departed by the sloth of disobedience," and concludes with a reminder that by "persevering in the monastery according to his teaching until death, we may by patience share in the sufferings of Christ and deserve to have a share also in His kingdom."[91] The section governing female novices in the Dominican Constitutions spells out the same principle in words that echo Christ's prayer in the Garden of Gethsemane: "abandon your own will for the will of the majority, observe voluntary obedience in all things."[92] In conflating Anna's vision as described by Seuse with the Agony in the Garden, the panel from Heggbach returns Seuse to his ultimate, if uncited source: the scriptural account of the Agony, where, according to Mark 14:36 Christ cried out: "Non quod ego volo, sed quod tu," "Not what I will, but what thou wilt."

The verses paraphrased in the panel from Heggbach recur in a poem appended to Seuse's *Briefbüchlein*.[93] According to its short prose preface, the poem represents nothing more than Elsbeth Stagel's translation of the "gûte sprüche," or "wise sayings" that provided the program for the cycle of paintings commissioned by Seuse for his oratory in the convent at Constance of which he later sent copies to Stagel. To this extent, the preface is consistent with what Seuse reports in chapter 20 of the *Life* and with other, circumstantial evidence suggesting that some such murals illustrating sayings of the Desert Fathers actually existed.[94] But to this original cycle of illustrated *apophthegmata*, the poem adds two arborial images, the first, a rose bower of temporal suffering ("der rosbom zitliches lidens") corresponding to the rose bower seen by Anna (fig. 53), the second a tree diagram depicting the difference between worldly and divine love ("der bom des underscheides zitlicher und go(e)tlicher minne").[95] Karl Bihlmeyer, the editor of Seuse's German writings, suggested that the inscriptions in the drawing of the rose bower borrowed from Stagel's translation of Seuse's Latin originals, a suggestion which, if true, would make the illustrations as well as the text of the *Life* a collabora-

tive effort.[96] But Bihlmeyer's hypothesis rests on several shaky assumptions: first, that Stagel's contribution represents more than an edifying fiction, and, second, that the paintings purportedly described by the poem once formed part of the oratory's decorative program.[97] Far more likely is the reverse scenario: the verses expand on cues provided by *The Exemplar*'s illustrations, incorporating inscriptions from the images by way of lending themselves an aura of authenticity.

For Seuse's readers, however, the authenticity of the additions to the *Briefbuchlein*, let alone an archeologically accurate reconstruction of Seuse's oratory, were hardly of paramount importance. Their primary concern—one that Seuse sought to foster—would have been to situate themselves imaginatively in their mentor's place of prayer. The additions—by the later fifteenth century considered an inalienable part of Seuse's writings—serve as aids to this end: each directly or indirectly describes images or devotions to images associated with the master.[98] Among the works of art invoked are the murals in Seuse's oratory and the monogram of Christ. The poem alone incorporates verses lifted from three of the twelve drawings in *The Exemplar*.[99] Were we to take its preface at face value, then we, like its fifteenth-century readers, would be forced to conclude that the illustrations of *The Exemplar* represent copies or adaptations of the murals devised by Seuse to adorn his private place of prayer. Read in this manner, an illustrated copy of *The Exemplar* offers its readers the opportunity to situate themselves in Seuse's oratory and to recapitulate his devotional practice in an entirety incorporating images as well as words.

The panel from Heggbach takes on a different light once the source of its inscriptions has been identified. By transplanting the rose bower said to have decorated Seuse's cell to the Garden of Gethsemane and by replacing Seuse with Christ, the panel effectively defines Christ as an imitator of his latter-day follower. The panel does not merely argue that Christ and Seuse mirror one another, it makes the seemingly impossible claim that Christ's experience at Gethsemane replicated Seuse's vision (and the painting that reproduced it). There was, however, an established Christian tradition for this sort of retrospective reading: typology. Typology provided the master model of reading backwards. In effect, the panel defines Christ's prayer at Gethsemane as the "type" of Seuse's prayer, remodelling Christ's devotions on the basis of what, by the fifteenth century, was believed to have been Seuse's pattern of prayer. The reshaping of prototypes in light of their successors could also be read as a logical consequence of the ideology of imitation pursued to the point of identification. Models came to imitate their copies, in art as well as life. Just as Seuse prayed before an image, so should the onlooker, of whom Augustine, his heart pierced by an arrow, represents the ideal embodiment. Not only is the worshiper remade in Christ's image, the image defines itself as a devotional prototype. For persons as for paintings, model and likeness fuse into one.

Literary and visual representations of St. Francis provide the most immediate models, artistic as well as ascetic, for Seuse's practice and telling examples of a similar pattern of typological echoing. For Franciscan exegetes and hagiographers, their patron's sojourn at Alverna, accompanied by a fast of forty days' duration, conjured up a range of Old Testament prototypes, among them Aaron, Moses on Mt. Horeb, and Elijah's ascent of Mt. Carmel (3 Kings 18:42), followed by his forty-day walk through

the desert (3 Kings 19:8).[100] But Francis' encounter with the angel on a remote mountaintop also paralleled Christ's Agony in the Garden on the Mount of Olives, part of a system of likenesses linking Francis to Christ that extended from his person to the places he had inhabited.[101] Representations of the stigmatization underscore the correspondence by echoing the pose and placement of both Christ and the sleeping Apostles in contemporary representations of the Agony (figs. 54 and 55). The parallel may have been prompted by a passage in Bonaventure's *Legenda maior* that compared Francis to Christ at Gethsemane: "And thereby he, the man filled by God, understood that just as he had imitated Christ in the works of his life, so he should become like him in mortification and the extremes of his martyrdom before he went out of this world."[102] The vision of Francis conflates the apostle of poverty with Christ and both, in turn, with another Old Testament prototype, Isaiah, whose prophetic calling originated in his vision of the seraphim standing on the throne of Jehovah (Isaiah 6:1–7).

The Exemplar implicates Seuse and his readers in a comparable process of replication, visual and verbal as well as corporeal (fig. 56). In the words of its title, chapter 43 describes, "how Christ appeared to him in the form of a seraph and taught him how to suffer." Seuse's vision as well as the drawing that accompanies it clearly depend on representations of the stigmatization. Yet Seuse's imitation extends the chain of exemplars, incorporating his persona into its resonant figuration of typological echoes. The reader, in turn, is compelled to participate through the illustration. Although the *Life* insists that Seuse showed the seal of his love only to those who displayed "grosser andaht," "great piety," virtually every illustration shows him baring his chest to reveal the sacred monogram.[103] The illustrations identify the readers as Seuse's confidants, members of a spiritual inner circle.

In the manuscript in Strasbourg, the drawing of Seuse's seraphic vision immediately follows the account of the apparition. The drawing depicts the Dominican kneeling like Francis at the foot of a cross from whose summit Christ looks down in compassion.[104] The inscriptions correspond word for word with those that, according to *The Exemplar*, Seuse himself saw inscribed on the wings: "On the two bottom wings was written, 'Receive suffering willingly.' On the middle ones, 'Bear suffering patiently.' On the top ones, 'Learn to suffer as Christ did.'"[105] In repeating these injunctions verbatim, the drawing does more than simply illustrate the text: it inverts what we too often regard as the normal priority of word-image relationships. Although in reading the manuscript, the picture comes second, its recapitulation of the text provides more than a redundant supplement. Informed by the full account of Seuse's moment of insight, the reader can experience the image as a simulacrum of his vision; in spite of Seuse's presence in the picture, she can imagine herself in his place, participating in his experience. If in *The Exemplar*, we read and then see, the picture reminds us that Seuse first saw and then read. Without the "illustration," the reader might easily overlook the primacy of vision. But by leaving his reader with an image, Seuse rewrote his own text, identifying it as no more than a "transcript" of spiritual sight. At a distance, we recognize that what he attempts is to remove the mediation of words, in effect, to recreate the immediacy of an encounter face to face. The immediate impact, however, is to "write off" the text as a gloss on the primacy of religious revelation. For the reader, as for Seuse (and, one might add, for Christ, St. Francis, and Isaiah, on whose

encounter with a seraph all these moments of vision are ultimately modelled), insight comes initially through the eye. A single-leaf woodcut based on Seuse's vision creates an even greater effect of immediacy; divorced from the text, it allows the viewer to come face to face with the crucified Christ (fig. 57). The unfurled wings, extended to reveal the corpus, enhance the epiphanic effect.[106] Even here, however, text and image remain inseparable. Like the mnemonic diagrams on which it is based, the image links reading to seeing, and both to a visionary source in scripture, a reciprocity nicely captured by a fourteenth-century illustration of Alan of Lille's treatise on the six wings of the cherubim in which the scribe, "Hermannus custos," portrays himself beneath the angel holding open a book inscribed with words from Psalm 16:8: "Protect me under the shadow of thy wings" (fig. 58).[107]

Chapter 45 of Seuse's *Exemplar* provides a set-piece demonstration of the manner in which model-copy relationships extend from texts and images to the persons who make them.[108] The passage is of exceptional importance in that it marks the transition between the narrative portion of the *Life* and the subsequent section, an account of a philosophical dialogue between Seuse and Stagel on the nature of mystical experience. Entitled "The Beloved Name of Jesus," the chapter takes up the leitmotif of Seuse's ardent devotion to the sacred monogram, first introduced in Chapter 4, which recounts how, as a young man, he carved the letters IHS on his chest. A bleeding monogram inserted into the text of *The Exemplar* does more than simply illustrate this passage; it identifies the corpus of Seuse's writings with the *corpus Christi* in the most immediate and tangible fashion (fig. 59).[109] Painted on parchment, the monogram gives eccentric embodiment to the commonplace comparison of vellum and ink to the body and blood of Christ.[110]

In keeping with the second section of the *Life*, Chapter 45 focuses less on Seuse's actions than on their imitation by his first follower, Elsbeth Stagel. In what Seuse characterizes as "a good devotion" ("ein gu(o)ter andaht"), Stagel, "sewed this same name of Jesus in red silk onto a small piece of cloth in this form, IHC, which she herself intended to wear secretly."[111] Stagel uses images to recapitulate Seuse's prayer practice, much as she did in asking her adviser to send her copies of the images decorating his oratory. The literature of female spirituality includes several reports of women adorning their bodies with small devotional images, among them Joanna Maria of Maillé (1331–1414), the beguine, Beatrice of Nazareth (before 1200–1268) and the Dominican nun, Margareta Ebner (ca. 1291–1351).[112] In *The Exemplar*, however, Stagel's exercise serves a prescriptive as well as a descriptive purpose. The way in which the young, i.e., spiritually immature, Seuse so literally imitates Christ's passion bears an uncanny resemblance to the self-inflicted suffering of numerous nuns.[113] By contrast, in Part II of the *Life*, Seuse deliberately distances himself from the extreme asceticism in which he indulged as a novice. The *imitatio Christi* is recast in ritualized, institutionalized forms, governed by texts and enacted through images.[114] Instead of drawing blood, she embroiders in red silk; rather than mortify her flesh, Stagel emulates her adviser's asceticism by adorning her body in his image. The patches of cloth she applies to her body resemble contact relics, yet they also bring to mind the blotches of red ink or paint marking the body of Christ in contemporary images of the Man of Sorrows.

Seuse's example mediates between Stagel and Christ; she reproduces his practice, without reenacting it.[115]

Stagel's simulation of Seuse does not end with her adorning her body in his image. Like him, she manufactures images for further distribution:[116]

> she made from this same name innumerably many names and brought it about that the servant [i.e., Seuse] put them all over his bare breast. She would send them all over with a religious blessing to his spiritual children. She was informed by God: whoever thus wore his name and recited an Our Father daily for God's honor would be treated kindly by God, and God would give him his grace on his final journey.

As presented by Seuse, Stagel acts as the exemplary reader and recipient of his text. First she emulates his imitation of Christ, then he reciprocates by emulating her effort to imitate him. Stagel, moreover, imitates Seuse by making herself a model for others, thereby initiating an unending sequence of response. As if in a chain, Seuse's exemplum ends with an invitation to the reader that they continue this process of imitation enacted through images.

The drawing accompanying chapter 45 illustrates the complex circulation of images in the *cura monialium*, a give-and-take in which the illustrations of Seuse's *Exemplar* also participated (fig. 60). A comparable collaboration produced *The Exemplar* itself—if we take at face value the account of its origins offered in the prologue. Identified by the inscription as "Elisabet," the crowned female figure to Seuse's left has been identified as Elisabeth of Hungary, a nun at the convent of Töss.[117] There is no reason, however, to believe she is anyone other than Elsbeth Stagel. The throne on which she is seated is either the one to which she, as prioress, was entitled, or, quite simply, her seat in the choir stalls. With her right hand, Elsbeth receives from Seuse a wreath of red and white roses containing the sacred monogram; with her left, she passes it on it to the monk and nun who stand at the edge of the outstretched mantle of Holy Wisdom, who envelopes all the figures much like a Madonna of Mercy (fig. 61).[118] Within this chain, Seuse is not the point of origin; he himself receives his wreath directly from Holy Wisdom, just as Elsbeth is crowned by the angel directly above her. The smaller figures clustered beneath Elsbeth's feet, all of whom grasp at tiny red monograms, represent the dissemination of Seuse's devotion to its ultimate audience, the laity, a term that, as understood in fourteenth-century Germany, could have comprehended anyone who was not a priest, i.e., nuns as well as lay men and women.[119] The drawing encapsulates and, to a remarkable extent, anticipates the very process of dissemination and reception played out in the manuscript tradition of Seuse's vernacular writings.[120] Initially composed for (and in part inspired by) his spiritual daughter, they were revised for a monastic readership and eventually found their way to a lay audience.

In an effort to define and, no less important, delimit devotional response, Seuse artfully crafts representations of himself that include preemptive instances of its reception by others. The story of Stagel imitating Seuse by sewing the sacred monogram on silk offers an excellent example. The chapter ends with Stagel's God-given injunc-

tion to say the *Pater noster*, a command underscored in the manuscript in Strasbourg at the bottom of the preceding page (fig. 62). Beneath the rubric or caption introducing the image on the verso, a fourteenth-century reader has followed Stagel's behest, first by repeating the instruction, "Sprich eyn pater noster vnd Aue maria," then by writing out a short prayer in praise of Christ's name and the Virgin Mary.[121] The annotator took a page out of Seuse's book in more ways than one. To the instruction concerning the *Pater noster* and *Ave Maria*, he attached a third prayer. Although the full text of the prayer unfortunately remains illegible, the paired names, IESUS.MARIA, are clearly visible.[122] Imitating Seuse's handling of the sacred monogram, the annotator wrote the paired *nomina sacra* in large, red display letters.

The reading represented by this marginal annotation hardly represents a casual response, for, if we turn back to chapter 4, which describes Seuse's initial act of carving the letters on his chest, we find that, although scarcely legible, the same or a similar set of prayers occupies the margin there (fig. 59).[123] Turning back still farther, we find them a third time, on folio 1r, where they act in lieu of a frontispiece (fig. 63).[124] The prayers inscribed in the margins provide a physical trace of the devotional dialogue enacted by a reader who recognized the cues provided by Seuse's text. As recounted in the *Life*, the dialogue takes place between Seuse and Stagel. More generally, it represents an idealized exchange between any Dominican adviser and one of his spiritual advisees. At yet another, more spiritual level, however, it represents the intercourse between the bride and bridegroom of the Song of Songs, construed either as Christ and the Virgin or as Wisdom and the loving soul. As the servant of divine Wisdom, Seuse becomes the vehicle by which his readers can join him in marriage to the Word. In the end, however, it is Seuse's own words that they experience most directly. The dialogue enacted in the text represents the process of reading itself, an interaction between text and reader of which the annotations are a primary record.

The anonymous annotator of the manuscript in Strasbourg was not alone in understanding *The Exemplar* as a script for an exemplary devotional dialogue. At least one later copy of *The Exemplar*, donated ca. 1485 to the Dominican nunnery of St. Peter's in Seuse's native Constance, but now at Einsiedeln, defines *The Exemplar* in similar terms by prefacing it with a pair of extensively illustrated poems, *Die kreuztragende Minne* and *Die minnende Seele*, both debates between Christ and the soul written by and for female religious.[125] Prefacing the first poem is a miniature depicting a well-dressed woman who reluctantly follows in Christ's footsteps as she is beset by a demon (fig. 64). The female protagonist of the second poem eventually enters Christ's embrace, a conversion represented by her shedding her worldly finery and donning a nun's habit (fig. 65). To the Seuse apocrypha, the Einsiedeln *Exemplar* adds an extensive set of other, closely related catechetical works, among them meditations on the Pater noster and Ave Maria.[126]

In all of these texts, Seuse's mysticism is reduced to a set of straightforward devotional exercises. Yet the apocrypha represent more than a bowldlerization of Seuse's teaching. Like many of Seuse's authentic writings, they offer the reader a set of model devotions, together with precise "how to" instructions.[127] Moreover, like *The Exemplar*, they describe how those devotions were put into practice by the master himself. The texts remain firmly attached to Seuse's person and derive much of their efficacy

from this affiliation. An apocryphal prose passage often attached to the eleventh and last letter in the *Briefbüchlein* offers a telling example. The supplement purports to describe in greater detail than the *Life* itself the exchange between Seuse and Stagel concerning devotion to the Holy Name.[128] In the original letter (which may have formed part of this exchange, assuming it actually took place) Seuse comments on Song of Songs 8:6 ("Pone me ut signaculum super cor tuum"). Explaining "how one should be devoted to the Divine Name of Jesus," he states that, "a seasoned friend of God should always have some good model or saying in the mouth of his soul to chew on that will inflame his heart for God." Seuse elaborates the monastic metaphor of *ruminatio*, then rapidly reviews the other senses by way of recapitulating the process of spiritual ascent. First comes the eye, which "should look upon God with love," then the ear, which "should open to his bidding," and finally, the trinity of "heart, mind and spirit," which "should lovingly embrace him."[129] To this, the apocryphal supplement adds the Latin "original" of Seuse's own model prayer, together with a German translation.[130] Like the devotions described in *The Exemplar*, the apocryphal text represents a model that can readily be recapitulated by a reader wishing to imitate Seuse's example.

Like his Franciscan counterpart, Bernardino of Siena, but over a century earlier, Seuse actively encouraged devotion to the Holy Name, including its reproduction in images (fig. 59).[131] Its presence, however, is far more palpable in manuscripts than in modern editions of *The Exemplar*, where the letters are submerged into the regularized continuum of printed text. Letter XI of the *Briefbüchlein* represents the culmination of Seuse's teaching on the topic, not simply on account of its content, but also by virtue of its placement: it is the last text in *The Exemplar*. Whereas in his youth Seuse had insisted on inscribing the name of God visibly on his chest, he now adorns the invisible interior of the heart with "the golden clasp, IHS" ("daz guldin fúrspan IHS").[132] As always, Seuse drives home his point with an exemplum, closing the letter by asking that the reader "sehen an zu(o) einem bilder," literally "look upon as an example" St. Ignatius of Antioch, who in the course of his martyrdom continually cried out the name of Jesus. "Asked why he was doing this, he responded by saying that Jesus was engraved on his heart. When they had killed him and out of curiosity had cut open his heart, they found written in it everywhere in gold letters: Jesus, Jesus, Jesus."[133] On the model of Paul, also cited as one who took "the name of God, Jesus, in the deep ground of his heart," Seuse describes a transition from letter to spirit, from a monogram engraved in his flesh to an internalized, spiritual understanding of the Godhead conceived as a unity with the Word. Seuse plays on the scriptural metaphor of the tablets of the heart developed by Paul in II Corinthians 3:3: "You are the epistle of Christ, ministered by us, and written not with ink, but with the Spirit of the living God; not in tables of stone, but in the fleshly tables of the heart."[134] In the concluding example of the last letter in his compilation, Seuse comes full circle: in place of the letters on his heart, he offers his readers a letter that they should take to heart.

Seuse's devotion to the name of Jesus has been taken for granted, as if it were an inevitable attribute of his piety.[135] Once, however, we acknowledge that Seuse's work and devotional practice always involved a combination of word and image, the reasons for his singling out the sacred monogram become readily apparent. The monogram

offers the archetypal example of text and image inextricably combined. As is often the case in illuminated manuscripts, one cannot speak of text and image, only of text as image, and vice versa. In addition to providing the instrument of Seuse's *imitatio Christi*, the monogram serves still more powerfully as an emblem of Seuse's devotional method.

Like Elsbeth Stagel, the scribes who copied Seuse's text reproduced the monogram, carrying still further the chain of replication described and mandated in the text. Within this reproductive progression, there is an inherent reciprocity between text and image: to copy Seuse's text was to copy its images and vice versa—not that all scribes understood or acted on this mandate. Not surprisingly, however, the same scribes who omitted *The Exemplar*'s illustrations also tended to eliminate the pictorial handling of the monogram within the text.[136] In those instances, however, where the program of illustration was retained, to copy the text itself constituted an act of imitation, not only of Seuse, who inscribed the monogram on his body, or even of Stagel, who, in copying it like the scribe, distributed it to her followers. It also represented an imitation of Christ himself. More than a combination of text and image, the monogram carved on Seuse's chest represents the Word made flesh and, at the same time, Seuse's flesh transformed into the Word.

Seuse illustrated this reciprocal transformation with a series of initials—aside from the large-scale drawings, the only illustrations that interrupt the *Life*. For all the ink that has been spilled on the *Life*'s literary structure, no one has ever looked to the manuscript evidence to see how their decoration articulates and shapes Seuse's exposition. In the earliest extant copy and the majority of its descendants, the first initial prefaces the prologue and shows two angels supporting the sacred monogram on a heraldic shield surrounded by a chaplet of roses (fig. 66). In addition to identifying himself as a Christian knight, Seuse suggests from the start that whatever wisdom his book contains comes to the reader through a combination of word and image. The second initial opens the *Life* and pairs a bust of Seuse with the monogram (fig. 67). Significantly, it is the only effigy of Seuse in the *Life* in which the monogram does not appear on his chest; at the outset, he has yet to model his body on the Word. The third initial prefaces the second part of the *Life*, which describes Seuse's relationship with his spiritual daughter, Elsbeth Stagel, and, by extension, with all the women who made up his primary audience (fig. 68). The pelican that feeds its young by piercing its breast serves as a symbol of Christ, yet it also represents Seuse as a Christ-like figure, nourishing his own spiritual offspring with the outpourings of his heart.[137] Finally, prior to Part III of the *Life*—the philosophical dialogue that immediately follows chapter 45—Seuse asks the reader to identify with an eagle that soars toward the sun, situated, in the Strasbourg copy, in the upper margin. The eagle's offspring nestle within the letter "S" that introduces a quotation from Deuteronomy 32:11: "Just like an eagle urging its young to fly" (fig. 69).[138] In appending a speculative section to his *Life*, Seuse again follows the model of Augustine's *Confessions*.[139] But now, in place of the pelican's brood, starving for spiritual knowledge, the reader can identify with a bird of prey capable of feeding its offspring. The change represents the transformation of the beginner (Seuse's "anvahender mensch") into an adept—an initiation that also brings with it newfound spiritual responsibilities. The far-sighted bird serves not only as a symbol

of Christ, but also of Seuse and his aspiring followers, who, in the words of Isaiah 40:31, "hope in the Lord [and] shall take wing as eagles."

The initials that subdivide Seuse's *Life* underscore the reciprocity between Christ and Seuse as models of imitation. They also chart the process of transformation undergone by his reader as she progresses through his book. Along with the other illustrations, they imply that to read with understanding is to conform herself to Christ's image, to take him into herself and, conversely, to submerge herself in him. At the beginning of Chapter 46, the introduction to the third and concluding section of the *Life,* Seuse uses the metaphor of molding to define this process of formation, comparing his pliant pupil Stagel to "a soft piece of wax near the fire that is able to take on the form of the seal."[140] If previously Seuse's "good teaching" ("gûtler")provided the mold, from this point on Christ's exemplary life ("daz spiegelich leben Christi," literally "mirror-like life")[141] supplies the model. Initiated in Seuse's "bildriche heilikeit," "holiness rich in pictures" (but also "amply illustrated"), Stagel can now proceed along the apophatic way, where, in Seuse's famous phrase, she should "drive out images with images" ("bild mit bilden us tribe").[142] In comparison to the first two parts of the *Life,* which include ten of *The Exemplar's* twelve illustrations, the concluding section, a dialogue on mystical knowledge, contains only one (fig. 70). Seuse's teaching complete, Christ can set his seal upon it. The image of the seal captures the complimentarity of image and text; Seuse aims to impress his message upon the reader through both media.

Between Christ and Stagel (and, by implication, all his readers), Seuse interposes his text, which takes the place of his person. In lieu of Seuse's body (and, it might be added, the *corpus Christi*), the reader is forced to confront the corpus of Seuse's writings. Through the faithful imitation of Seuse's example, however, the reader becomes Christ-like, one who, to paraphrase the prologue, can share special intimacy with God. The apocrypha invented by Seuse's disciples demonstrate the efficacy of his invention; his followers did not merely copy his text, in reproducing and filling it out, they relived it, reanimating the devotional dialogue between Seuse and Stagel that ostensibly served as its source.

"Every tree is known by its fruit": so said Johannes Meyer speaking of Seuse and his mother. The same can be said of Seuse and the apocryphal texts associated with him in the fifteenth century. Far from irrelevant to our reading of his authentic works, they provide readings of the first importance that we cannot afford to overlook. They tell us that Seuse's readers did not fail, as have modern scholars, to overlook the images that from the outset formed an integral part of *The Exemplar.* They further force us to come to terms with aspects of Seuse's religious imagination that have consistently been ignored. Traditionally regarded as a spiritual *Minnesänger,* a sweet, spontaneous, even sentimental, lyricist of little substance, Seuse only recently has been rescued from the shadow of his eminent teacher, Eckhart, and reevaluated as a substantive philosopher and theologian in his own right.[143] In reading Seuse, however, we need not choose between form and content. *The Exemplar's* manuscript tradition testifies to the extent to which the form in which the text was transmitted to the reader constituted part of its content, understood as the ordering of spiritual experience. In the end, as far as his medieval readers were concerned, to read Seuse right was less a question of

whether any given text was accurate or authentic than of how best to embody and bring Seuse's example to life.

Read as a record of reception, the apocrypha shed unexpected light on another facet of Seuse's "autobiography," one that reflects, in turn, on the vexed question of its authenticity and authorship, long sources of scholarly embarrassment. Whereas some of Seuse's readers have taken his *Life* at face value, today it is regarded, correctly, as an elaborate literary and mystagogical construct.[144] But that is not enough. To come full circle, it is a construct that with consummate self-consciousness crafts a representation of his self that has the potential to serve as an authoritative model for the experience of everyman—or, in its first instance, of everywoman. Seuse's *Life* may be a legend, but, even in his own day, the legend increasingly served as a model for introspective contemplation.[145] In effect, Seuse's *Life* sets out personal religious experience as a meaningful category for his readers; his exemplary account of his own experience allows them to imagine their lives in its terms. At the same time, it interposes his person (and, by extension, the mediation of the mendicants) between his female readers and the ultimate object to which they aspire, Christ himself.

At stake in the debate over the function of Seuse's *Life* is less the "authenticity" of his "autobiography" than what those very modern terms might have meant for a reader in the mid-fourteenth century. In a recent essay on "The Self and Literary Experience in Late Antiquity and the Middle Ages," Brian Stock acknowledges that the autobiography as such was not a common genre in the Middle Ages, but goes on to argue that, "it is within the problematics of reading, writing and selfhood . . . rather than within the genre of the 'autobiography,' that a phenomenon of *longue durée* is to be sought."[146] Stock writes of a transfer of authority "from the divine to the human sphere, where its context is human discourse," and where "literary experience becomes the official intermediary between inner and outer expressions of selfhood, which is institutionalized as readership."[147] Stock's aperçu can be applied to Seuse's *Life* as I have defined it, a precocious and pivotal work in the development that connects the medieval tradition of introspective devotion with the modern secular autobiography.[148] Seuse's *Life*, however, should not simply be read as a milestone in the history of a renascent individualism nor as a sophisticated example of what might be called "medieval self-fashioning."[149] It serves equally well as an embodiment of a paradigm already present in those twelfth-century texts in which Caroline Bynum identified an overriding concern with "how behavior is conformed to models," although it is ironic that despite the text's concern for conformity and copying, its iconographic program is profoundly original.[150] To paraphrase Bynum, the elaborate typologies established by Seuse's text do not hinder the reader's quest for God, they make it possible in the first place.[151]

It is one of the myths of modernism that the self provides the legitimate, perhaps the only true subject of the work of art. In the first half of the fourteenth century, however, this could hardly yet be taken for granted, let alone called into question.[152] Drawing on a complex array of models, Seuse's legendary account of his own life provides a framework within which it becomes possible for each reader to imagine his or her own life as a progress towards union with their own origin and exemplar, God, a path sketched out in the final illustration of the *Life* (fig. 70). In this image, Seuse reduces his life to a generic pattern, a "true path" that others can copy.[153] In place of

the previous illustrations, which depict the visions of Seuse and his disciples, the mystical diagram represents the means by which his readers can aspire to the blinding illumination of the *visio Dei*, a vision beyond all images.

In holding up an idealized representation of his life's trajectory, Seuse did not intend to glorify his own person, although at first blush *The Exemplar* leaves that impression. Instead, in keeping with its underlying theology, Seuse's *Life* redeems suffering and, with it, the value of experience per se.[154] In keeping with the model of Christ, Seuse transforms his own experience into a universal exemplar—which, within his Christian frame of reference, means transforming himself on the model of the all-embracing example, Christ himself.[155] Seuse's *Life* is itself an image in which the author invites his readers to recognize their Creator, the exemplar of all images. At the same time, he invites his readers to model their experience on his own. In this spirit, Seuse ends his *Life* by substituting the reader for himself. The pilgrim's progress traced in the concluding diagram is not Seuse's; instead, its protagonist is a woman, his ideal reader and recipient, Elsbeth Stagel.[156] Regardless of whether or how she contributed to the composition of the *Life*, Stagel—and with her, Seuse's readers—are, like his consort Holy Wisdom, present from the beginning, in the words of Proverbs 8:23, "set up from eternity."

NOTES

1. For the historical circumstances surrounding the composition of *The Exemplar*, see A. M. Haas, "Die deutsche Mystik im Spannungsbereich von Theologie und Spiritualität," *Literatur und Laienbildung im Spätmittelalter und in der Reformationszeit* (Symposion Wolfenbüttel 1981), ed. L. Grenzmann et al. (Germanistische Symposien: Berichtsbände 5, Stuttgart, 1984), 604–39, and W. Senner, "Heinrich Seuse und der Dominikanerorden," in *Heinrich Seuses Philosophia spiritualis: Quellen, Konzept, Formen und Rezeption* (Tagung Eichstätt 2.–4. Oktober 1991), ed. R. Blumrich and P. Kaiser (Wiesbaden, 1994), 3–31. K. Ruh, *Die Mystik des deutschen Predigerordens und ihre Grundlegung durch die Hochscholastik*, (Geschichte der abendländischen Mystik, 3, Munich, 1996), 414–20, gives the likely date of *The Exemplar*'s composition as 1361–62.

Generous grants from Oberlin College and the Alexander von Humboldt-Stiftung have made it possible for me to examine all of the illustrated and many of the unillustrated manuscripts of Seuse's vernacular writings. For their help with photographs and gaining access to manuscripts, my thanks to Father Odo Lang OSB, James Marrow, Joseph Romano, and John Seyfried. For their constructive comments and criticism, I am indebted to Rachel Fulton, William Hood, and, above all, Caroline W. Bynum and Nigel F. Palmer, who each generously read a rough draft and made very different, but equally valuable, suggestions.

2. *Prolog des Exemplars*, in *Heinrich Seuse: Deutsche Schriften*, ed. K. Bihlmeyer (Stuttgart, 1907; reprint, Frankfurt, 1961), 5, lines 1–5; translation from *Henry Suso: The Exemplar, with Two German Sermons*, ed. and trans. F. Tobin (New York, 1989), 58: "after his death it could happen that some foolish people whose word should not be regarded seriously might judge the book falsely, not wanting to recognize his good intentions in it or not being able to understand something better themselves because of their lack of sophistication." For Seuse's self-consciousness, see W. Haug, "Grundformen religiöser Erfahrung als epochale Positionen: Vom frühmittelalterlichen Analogiemodell zum hoch- und spätmittelalterlichen Differenzmodell," in *Religiöse Erfahrung: Historische Modelle in christlicher Tradition*, ed. W. Haug and D. Mieth (Munich, 1992), 75–108, esp. 104 and 106, who observes that, "Was ihn [Seuse] aber insbesondere von Mechthild und von Tauler unterscheidet, ist ein spezifisches Bewusstsein vom literarischen Charakter des Darstellungsmediums, vom Bildhaften der

Vermittlung, von der Sprache als einer Sphäre eigener Art und von der Problematik, die sich daraus ergibt—ein Bewusstsein das nun als explizite Reflexion des Mediums in die Darstellung eingeht. . . . Es ist entscheidend zu sehen, dass dieser Wechsel zwischen Bild und Begriff bewusst gehandhabt wird; Seuse reflektiert, wie gesagt, die Sprache als Darstellungsmedium und bezieht diese Reflexion in den Erfahrungsprozess mit ein."

3. *Prologus* (ed. Bihlmeyer, 1, lines 2–6 and 6, lines 11–16; translation from Tobin, *The Exemplar,* 57 and 59).

4. W. Blank, "Heinrich Seuses 'Vita': Literarische Gestaltung und pastorale Funktion seines Schrifttums," *Zeitschrift für deutsches Altertum und deutsche Literatur* 122 (1993): 285–311, notes that as applied to Seuse's *Life* the term "autobiography" is both anachronistic and inaccurate. For "autobiography" in the Middle Ages, see L. Spitzer, "Note on the Poetic and the Empirical 'I' in Medieval Authors," *Traditio* 4 (1946): 414–22; G. Misch, *Geschichte der Autobiographie,* 4 vols. (Frankfurt, 1949–1967), esp. 4, part 1, 113–310; P. Zumthor, "Autobiography in the Middle Ages," *Genre* 6 (1973): 29–48; H. Wenzel, "Zu den Anfängen der volkssprachlichen Autobiographie im späten Mittelalter," *Daphnis: Zeitschrift für mittlere deutsche Literatur* 13 (1984): 59–75; idem, *Die Autobiographie des späten Mittelalters und der frühen Neuzeit* (Spätmittelalterliche Texte, 3–4, Munich, 1980); J. A. Burrow, "Autobiographical Poetry in the Middle Ages: The Case of Thomas Hoccleve," *Proceedings of the British Academy* 68 (1982): 389–412; and A. Gurevich, *Das Individuum im europäischen Mittelalter* (Munich, 1994), esp. Chapter 5 ("Die Autobiographie: Beichte oder Rechtfertigung"), 141–95.

5. See R. Javelet, *Image et ressemblance au douzième siècle de saint Anselme à Alain de Lille,* 2 vols. (Paris, 1967).

6. Cf. P. Brown, "The Saint as Exemplar in Late Antiquity," *Representations* 1 (1983): 1–25, esp. 6: "in Christian thought, God Himself was proposed to man as the Exemplar behind all exemplars. . . . The result of this view was to present human history as containing a sequence of exemplars, each of which made real, at varying times and in varying degrees, the awesome potentiality of the first model of humanity—Adam, human nature created 'in the image of God,' before the Fall." Bernard of Clairvaux refers to Christ as an exemplar in whose footsteps one should follow; see *S. Bernardi Opera,* ed. J. Leclercq and H. Rochais, vol. 6, part 1 (Rome 1970), Sermon LX ("De Ascensione Domini"), 292, lines 5–6: "Sic per incarnationis suae mysterium descendit et ascendit Dominus, reliquens nobis exemplum ut sequamur vestigia eius."

7. Cited by J. A. Alford, "The Scriptural Self," in *The Bible in the Middle Ages: Its Influence on Literature and Art,* ed. B. S. Levy (Medieval and Renaissance Texts and Studies 89, Binghamton, New York, 1992), 1–21, esp. 3. For the tradition of exemplarism and the *imitatio Christi,* see G. Constable, *Three Studies in Medieval and Religious Thought* (Cambridge, 1995), 165–69 and 244–47.

8. *Seuses Leben,* in *Heinrich Seuse: Deutsche Schriften,* ed. Bihlmeyer, 7, line 2.

9. See A. von Euw, *Liber viventium Fabariensis: Das karolingische Memorialbuch von Pfäfers in seiner Liturgie- und Kunstgeschichtliche Bedeutung* (Studia Fabariensia: Beiträge zur Pfäferser Klostergeschichte, 1, Bern, 1989), and, for the rituals associated with the commemoration of the dead, *Memoria: Der geschichtliche Zeugniswert des liturgischen Gedenkens im Mittelalter,* ed. K. Schmid and J. Wollasch (Münstersche Mittelalter-Schriften, 48, Munich, 1984).

10. For comparable conceptions of reading, see N. F. Palmer, "Das Buch as Bedeutungsträger bei Mechthild von Magdeburg," in *Bildhafte Rede im Mittelalter: Probleme ihrer Legitimation und ihrer Funktion,* ed. W. Harms and K. Speckenbach (Tübingen, 1992), 217–236, esp. 226.

11. See H. Stirnimann, "Mystik und Metaphorik: Zu Seuses Dialog," in *Das 'Einig Ein': Studien zu Theorie und Sprache der deutschen Mystik,* ed. A. M. Haas and H. Stirnimann (Dokimion, 6, Fribourg, 1980), esp. 235–45.

12. C. W. Bynum, *Docere verbo et exemplo: An Aspect of Twelfth-Century Spirituality* (Missoula, 1979), provides an extensive discussion of the rhetoric of "example" in earlier monastic spirituality. Seuse's practice also finds interesting parallels in the life and writings of Richard Rolle, for which see Alford, "The Scriptural Self."

13. For autobiography and hagiography in the later Middle Ages, see J. A. Munitiz, "Hagiographical Autobiography in the Thirteenth Century," *Byzantinoslavica* 53 (1992): 243–49; K. Bihlmeyer, "Die Selbstbiographie in der deutschen Mystik des Mittelalters," *Theologische Quartalschrift* 114 (1933): 504–44, and C. Pleuser, "Tradition und Ursprünglichkeit in der Vita Seuses," in *Heinrich Seuse: Studien zum 600. Todestag, 1366–1966,* ed. E. M. Filthaut (Cologne, 1966), 135–160, esp. 144–48. R. Kieckhefer, *Unquiet Souls: Fourteenth-Century Saints and their Religious Milieu* (Chicago, 1984), 6 introduces the term "autohagiography" to characterize texts such as Seuse's.

14. I draw on the formulation given by Brown, "The Saint as Exemplar," 10, who, it should be noted, distinguishes between Late Antique and late medieval conceptions of imitation.

15. *Prologus* (ed. Bihlmeyer, 3, line 2; translation from Tobin, *The Exemplar*, 57). More awkward, yet more accurate, might be, "in an image- or model-giving manner."

16. See T. McFarland, "Walter's *bilde:* On the Synthesis of Minnesang and Spruchdichtung in 'Ir reinen wîp, ir werden man (L 66,21ff),'" *Oxford German Studies*, 13 (1982): 183–205. My thanks to Nigel Palmer for this reference. See also W.Wackernagel, *Ymagine denudari: Éthique de l'image et métaphysique de l'abstraction chez Maître Eckhart* (Paris, 1991), 17 and 109.

17. See A. M. Haas, "Meister Eckharts mystische Bildlehre," in *Der Begriff der Representatio im Mittelalter*, eds. A. Zimmermann and G. Vuillemin-Diem (Berlin, 1971), 113–62, and W. Wackernagel, *Ymagine denudari: Ethique de l'image et métaphysique de l'abstraction chez Maître Eckhart* (Paris, 1991), 17 and 109 on *bilde* and *Bildung*, both with additional bibliography. For metaphors of edification, see A. Schoenen, "Aedificatio: Zum Verständnis eines Glaubenswortes in Kult und Schrift," *Enkainia* (Festschrift Abtei Maria Laach, Maira Laach, 1956), 14–29; R. Schulmeister, *Aedificatio und imitatio: Studien zur intentionalen Poetik der Legende und Kunstlegende* (Hamburg, 1971); H. Flasche, "Similitudo templi (Zur Geschichte einer Metapher)," *Deutsche Vierteljahrschrift* 23 (1949): 81–125; R. D. Cornelius, *The Figurative Castle: A Study in the Medieval Allegory of the Edifice with especial Reference to Religious Writings* (Bryn Mawr, 1930); F. Ohly, "Haus als Metapher," *Reallexikon für Antike und Christentum* 13 (1986): 905–1063; and, for the etymology of the word, J. and W. Grimm, *Deutsches Wörterbuch* (Leipzig, 1860), 2: 22–23.

18. For this literature, see A. A. Hentsch, *De la littérature didactique du moyen âge spéciale-ment aux femmes* (Cahors, 1903); G. Hasenohr, "La vie quotidienne de la femme vue par l'Église: l'enseignement des "Journées chrétiennes" de la fin du Moyen Age," *Frau und spätmittelalterlicher Alltag* (Internationaler Kongress Krems an der Donau 2. bis 5. Oktober 1984, Vienna, 1986), 75–76; and B. Newman, "Flaws in the Golden Bowl: Gender and Spiritual Formation in the Twelfth Century," *Traditio* 45 (1989–1990): 111–146, reprinted in *From Virile Woman to WomanChrist: Studies in Medieval Religion and Literature* (Philadelphia, 1995), 19–45 and 313–16.

19. See H. Grabes, *The Mutable Glass*, trans. G. Collier (Cambridge, 1982); R. Bradley, "Backgrounds of the Title *Speculum* in Medieval Literature," *Speculum* 29 (1954): 100–115 and idem, "The Speculum Image in Medieval Mystical Writers," in *The Medieval Mystical Tradition in England*, ed. M. Glasscoe (Cambridge, 1984), 9–27.

20. See K. Bihlmeyer, ed., *Heinrich Seuse: Deutsche Schriften*, 45*–65*, and J. F. Hamburger, "The Use of Images in the Pastoral Care of Nuns: The Case of Heinrich Suso and the Dominicans," *Art Bulletin* 71 (1989): 20–46.

21. See Bihlmeyer, 45*–55*; E. Colledge and J. C. Marler, "Mystical Pictures in the Suso *Exemplar*, Ms Strasbourg 2929," *Archivum Fratrum Praedicatorum* 54 (1984): 293–354; and M. Kersting, "Text und Bild im Werk Heinrich Seuses: Untersuchungen zu den illustrierten Handschriften des Exemplars," Inaugural Dissertation, Johannes Gutenberg Universität (Mainz, 1987), kindly brought to my attention by Nigel Palmer. The number of illustrations varies according to the distribution and grouping of the drawings; see A. M. Diethelm, *Durch sin selbs unerstorben vichlichkeit hin zuo grosser loblichen heilikeit: Körperlichkeit in der Vita Heinrichs Seuses* (Deutsche Literatur von den Anfängen bis 1700, 1, Bern, 1987), 164–230, who provides a useful collation.

22. For the stylistic affiliations of the copy in Strasbourg, which tend to confirm a date ca. 1370, see G. Schmidt, "Bohemian Painting up to 1450," in *Gothic Art in Bohemia: Architecture, Sculpture and Painting* (London, 1977), 47, and R. Recht, "Strasbourg et Prague," *Die Parler und der Schöne Stil 1350–1400: Europäische Kunst unter den Luxemburgern* (Cologne, 1980), 4: 106–17, esp. 110 and figs. 13–14 and 17–25. For what little is known about the library of Grünenworth, see S. Krämer, *Handschriftenerbe des deutschen Mittelalters* (Mittelalterliche Bibliothekskataloge Deutschlands und der Schweiz: Ergängzungsband, 1, Munich, 1989), 748, where Strasbourg, BNU Ms. 2929 is assigned, incorrectly, to the fifteenth century. For the inventory of works of art, see J. Rott, "La commanderie Saint-Jean en l'Ile-verte à Strasbourg et ses trésors artistiques avant 1633," *Cahiers Alsaciens d'Archéologie, d'Art et d'Histoire* 32 (1989): 239–56.

23. *Prologus* (ed. Bihlmeyer, 4, lines 24–28; translation from Tobin, *The Exemplar*, 58).

24. With two exceptions, all of the drawings illustrate visions described in the text, passages that by their nature invite translation into visual terms. The exceptions are the allegorical image of Seuse's suffering (no. 5 in the Bihlmeyer edition) and the diagram of the mystical path (Bihlmeyer's no. 11). The pictorial program is closely linked to many of the legendary passages in the *Life* whose authenticity has been challenged. Assuming that the images themselves are accepted as part of Seuse's original conception, they can be considered as corroboration of the legendary passages' authenticity. W. Blank, "Heinrich Seuses 'Vita,'" 308, note 42, observes simply that, "Die legendarischen Partien der 'Vita' sind bislang nicht systematisch untersucht, ja kaum zusammengestellt worden." Yet, as remarked by A. M.

Haas, "Thema und Funktion der Selbsterkenntnis im Werk Heinrich Seuses," in *Nim din selbes war: Studien zur Lehre von der Selbsterkenttnis bei Meister Eckhart, Johannes Tauler und Heinrich Seuse* (Dokimion, 3, Fribourg, 1971), 195, the visions "sind nichts anderes als entscheidende Momente der göttlichen Mystagogie. Ihre Authentizität ruht daher nicht in unmittelbarer Vergegenwärtigung historisch-realer Wirklichkeit im Sinne eines realistisch das Geschehen nachzeichnenden Berichts, sondern im wahrhaftigen Bezug auf die mystische Übermächtigung des Geschöpfs durch Gott." See also A. M. Haas, "Seuses Visionen—Begriff der Vision," in *Kunst rechter Gelassenheit: Themen und Schwerpunkte von Heinrich Seuses Mystik* (Bern, 1995), 179–222, published after this essay was completed.

25. *Prologus* (ed. Bihlmeyer, 4, lines 24–25). The exception is the manuscript in Paris, Bibliothèque Nationale, Ms. All. 222, where the illustrations are gathered on fols. 118v–124v.

26. The diffuse idea of influence employed by U. Weymann, *Die Seusesche Mystik und ihre Wirkung auf die bildende Kunst*, Inaugural-Dissertation, Friedrich-Wilhelms-Universität (Berlin, 1938), differs fundamentally from the pattern of reception I explore in this essay. Weymann casts her net so wide that the images linked most directly to Seuse, the illustrations of his writings, escape her attention.

27. What S. Huot, *The Romance of the Rose and its Medieval Readers: Interpretation, Reception, Manuscript Transmission* (Cambridge, 1993), 1, describes as "the modern interest in the textual object and in the primacy of the reader."

28. There is no literature on the Seuse apocrypha apart from Bihlmeyer's remarks in his edition of 1907. The apocrypha go unmentioned in A. M. Haas and K. Ruh, "Seuse, Heinrich OP," in VL[2], vol. 8: 1109–29. For an (incomplete) list of representations of Seuse, see J. Leibrand and M. Lechner, "Seuse, Heinrich (Suso, gen. Amandus)," in *Lexikon der christlichen Ikonographie*, 8 vols., ed. E. Kirschbaum et al. (Rome, 1968–1976), 8: 333–35.

29. Meyer's writings await a proper evaluation and, in some critical instances, a proper edition. In the meantime consult W. Fechter, "Meyer, Johannes," in VL[2], vol. 6: 474–89.

30. On Seuse's importance for fifteenth-century reformers, see N. Staubach, "Von der persönlichen Erfahrung zur Gemeinschaftsliteratur: Entstehungs- und Rezeptionsbedingungen geistlicher Reformtexte im Spätmittelalter," *Ons geestlelijk Erf* 68 (1994): 200–27.

31. For Meyer's distrust of images, see my essay, "The Reformation of Vision: Art and the Dominican Observance in Late Medieval Germany," in J. F. Hamburger, *The Visual and the Visionary: Art and Female Spirituality in Late Medieval Germany*, forthcoming (Zone Books, NY, 1998), as well as my review of R. Meyer, *Das "St. Katharinentaler Schwesternbuch": Untersuchung, Edition, Kommentar* (Münchener Texte und Untersuchungen zur deutschen Literatur des Mittelalters, 104, Munich, 1995), *Medium Aevum.* 65 (1996): 170–71. For criticism of female spirituality among the German Dominicans, see O. Langer, *Mystische Erfahrung und spirituelle Theologie: Zu Meister Eckharts Auseinandersetzung mit der Frauenfrömmigkeit seiner Zeit* (Münchener Texte und Untersuchungen zur deutschen Literatur des Mittelalters, 91, Munich, 1987); and the studies by W. Williams-Krapp: "Ordensreform und Literatur im 15. Jahrhundert," *Jahrbuch der Oswald von Wolkenstein Gesellschaft* 4 (1986–1987): 41–51; "'Dise ding sint dennoch nit ware zeichen der heiligkeit': Zur Bewertung mystischer Erfahrungen im 15. Jahrhundert," *Zeitschrift für Literaturwissenschaft und Linguistik* 20 (1990): 61–71; "Frauenmystik und Ordensreform im 15. Jahrhundert," *Literarische Interessenbildung im Mittelalter* (DFG-Symposion 1991), ed. J. Heinzle (Stuttgart, 1993), 301–13; "Observanzbewegungen, monastische Spiritualität und geistliche Literatur im 15. Jahrhundert," *Internationales Archiv für Sozialgeschichte der deutschen Literatur* 20 (1995): 1–15.

32. For the authorship of the chronicle of Töss, see K. Grubmüller, "Die Viten der Schwestern von Töss und Elsbeth Stagel: Überlieferung und literarische Einheit," *Zeitschrift für deutsches Altertum und Literatur* 98 (1969): 171–204. T. Lentes, "Tauler im Fegfeuer oder der Mystiker als Exempel: Formen der Mystik-Rezeption im 15. Jahrhundert, mit einem Anhang zum Sterbeort Taulers und Textabdruck," in *Contemplata aliis tradere: Studien zum Verhältnis von Literatur und Spiritualität*, ed. C. Brinker (Bern, 1995), 111–56, analyzes a comparable transformation of one of Seuse's contemporaries in light of Observant ideals.

33. See *Das Leben der Schwestern zu Töss beschrieben von Elsbet Stagel, samt der Vorrede des Johannes Meyer und dem Leben der Prinzessin Elisabet von Ungarn*, ed. F. Vetter (Deutsche Texte des Mittelalters, 6, Berlin, 1906), 97, lines 22–34. For sculptural images of the Deposition and Lamentation in Germany, see J. B. Desel, "*Vom Leiden Christi ader von dem schmertzlichen Mitleyden Marie*": *Die vielfigurige Beweinung Christi im Kontext thüringischer Schnitzretabel der Spätgotik* (Berlin, 1994).

34. The classic exposition of van der Weyden's *Deposition* remains O. G. von Simson, "*Compassio and Co-redemptio* in Roger van der Weyden's *Descent from the Cross*," *Art Bulletin* 35 (1953): 9–16.

35. For the compassion of the Virgin, see E. von Witzleben, "Compassio," *Lexikon der Marienkunde* (Regensburg, 1967), 1: 1179–86; M. Barth, "Zur Herz-Mariä-Verehrung des deutschen Mittelalters," *Zeitschrift für Aszese und Mystik* 4 (1929): 193–219; E. Wimmer, "Maria im Leid: Die Mater dolorosa insbesondere in der deutschen Literatur und Frömmigkeit des Mittelalters," Teildruck, Ph.D. Dissertation, Julius-Maximilians-Universität (Würzburg, 1968); S. Sticca, *The Planctus Mariae in the Dramatic Tradition of the Middle Ages*, trans. J. R. Berrigan (Athens, Georgia, 1988); and G. Satzinger and H.-J. Ziegeler, "Marienklagen und Pietà," in *Die Passion Christi in Literatur und Kunst des Spätmittelalters*, ed. W. Haug and B. Wachinger (Fortuna Vitrea, 12, Tübingen, 1993), 241–76.

36. A. M. Haas, "Sinn und Tragweite von Heinrich Seuses Passionsmystik," in *Die Passion Christi*, 94–112, analyzes the same passage, without, however, considering Meyer's appropriation of the story.

37. There remains no adequate treatment of the *imitatio Mariae*. K. Schreiner, *Maria: Jungfrau, Mutter, Herrscherin* (Munich, 1994), brings together an extraordinary wealth of material; see also G. Lüers, *Die Marienverehrung mittelalterlicher Nonnen* (Munich, 1923); M. Wehrli-Johns, "Haushälterin Gottes: Zur Mariennachfolge der Beginen," *Maria, Abbild oder Vorbild? Zur Sozialgeschichte mittelalterlicher Marienverehrung* (Tübingen, 1990), 146–167; and R. Hale, "*Imitatio Mariae*: Motherhood Motifs in Devotional Memoirs," *Mystics Quarterly* 16 (1990): 193–203.

38. A trope not entirely without precedent; cf. H. Röckelein, "Zwischen Mutter und Maria: Die Rolle der Frauen in Guibert de Nogents Autobiographie," in *Maria, Abbild oder Vorbild? Zur Sozialgeschichte mittelalterlicher Marienverehrung*, ed. H. Röckelein, C. Opitz, and D. R. Bauer (Tübingen, 1990), 91–109.

39. The place of Seuse's mother in his spirituality remains inadequately explored. Throughout the Middle Ages, mothers played an instrumental role in the religious education of their children; see the essays gathered in *La religion de ma mère: Les femmes et la transmission de la foi*, ed. J. Delumeau (Paris, 1992). For the veneration (as well as vilification) of motherhood in Christian spirituality, see C. W. Atkinson, *The Oldest Vocation: Christian Motherhood in the Middle Ages* (Ithaca, 1991), and *Sanctity and Motherhood: Essays on Holy Mothers in the Middle Ages*, ed. A. B. Mulder-Bakker (New York, 1995).

40. See C. W. Atkinson, "'Your Servant, My Mother': The Figure of Saint Monica in the Ideology of Christian Motherhood," in *Immaculate and Powerful: The Female in Sacred Image and Social Reality*, ed. C. W. Atkinson (Boston, 1985), 139–72. In the *Life*, Seuse alludes once to Augustine's mother, Monica, cited in chapter 51 as an authority on the "Unterscheidung der Geister," for which see W. Williams-Krapp, "Sendbrief vom Betrug teuflischer Erscheinungen," VL^2, vol. 8: 1075–77. According to Seuse (*Life* 3.51), Monica distinguishes between "ordinary dream[s]" that "should be disregarded," and "vision[s] using images . . . to be taken seriously" (ed. Bihlmeyer, 183), a reference significant in so far as visions provide the medium through which Seuse's mother speaks to him and through which he, in turn, communicates with his followers.

41. For the pseudo-Augustinian *Soliloquia*, which circulated widely in the Middle Ages, see J. Leclercq and J.-P. Bonne, *Un maître de la spiritualité au XIe siècle: Jean de Fécamp* (Études de théologie et d'histoire de la spiritualité, 9, Paris, 1946), and E. Dekkers, "Le succès étonnant des écrits pseudo-augustiniennes au Moyen Age," *Fingierte Briefe, Frömmigkeit und Fälschung; Realienfälschungen: Fälschungen im Mittelalter* (Internationaler Kongress der Monumenta Germaniae Historica, München, 16.–19. September, 1986, Monumenta Germaniae Historica: Schriften, 33, Hannover, 1988), 5 vols.; vol. 5: 361–68.

42. *Leben* 1.6 (ed. Bihlmeyer, 23, line 210 and 24, lines 3–4; trans. Tobin, *The Exemplar*, 75).

43. See R. C. Trexler, *Naked before the Father: The Renunciation of Francis of Assisi* (Humana Civilitas, 9, New York, 1989).

44. *Leben* 2.42 (ed. Bihlmeyer, 142, lin. 29–30): "es die arzet kuntlich innen wurden und gŏt bild dar ab namen."

45. *Das Leben der Schwestern . . . samt der Vorrede des Johannes Meyer*, 96, lines 4–5: "nement war das selig leben das die ersten prüder und swestern, gehabt habent in aller andacht und heilikeit, und ir auch also sollichen seligen exempel nach leben seit."

46. Ibid., 95, line 12. For genealogical imagery of this kind, see C. Klapisch-Zuber, "The Genesis of the Family Tree," *I Tatti Studies: Essays in the Renaissance* 4 (1991): 105–30.

47. For the manuscript, Basel, Universitätsbibliothek, Cod. E.III.12, formerly D.IV.9, see Fechter, "Meyer, Johannes," 479. For the print, see H. Koegler, *Einzelne Holz- und Metallschnitte des fünfzehnten Jahrhunderts aus der Universitätsbibliothek in Basel* (Strasbourg, 1909), 7, pl. I, nr. 1.

48. See A. Walz, "Von Dominikanerstammbäumen," *Archivum Fratrum Praedicatorum* 34 (1964): 231–75, and A. Auer, "Bilderstammbäume zur Literaturgeschichte des Dominikanerordens,"

in *Liber Floridus: Mittellateinische Studien Paul Lehmann zum 65. Geburtstag* (St. Ottilien, 1950), 363–71.

49. Described in W. L. Schreiber, *Handbuch der Holz- und Metallschnitte des XV. Jahrhunderts*, 8 vols. (Leipzig, 1927), vol. 3: 222–23, no. 1776.

50. See A. Walz, "Der Kult Heinrich Seuses," in *Heinrich Seuse: Studien zum 600. Todestag*, 437–54.

51. *Leben* 1.22 (ed. Bihlmeyer, 64, lines 11–12; translation from Tobin, *The Exemplar*, 106).

52. For a summary, see Haas and Ruh, "Seuse, Heinrich OP," esp. 1117–21, who remark that, "viele Fragen hinsichtlich der genaueren Autorschaft [sind] noch offen."

53. See Staubach, "Von der persönlichen Erfahrung zur Gemeinschaftsliteratur," 206: "inhaltliche und formale Faktoren der Textgestaltung, die nach den Kategorien moderner Erlebnisästhetik einander zu widersprechen, ja auszuschliessen scheinen, in der geistlichen Literatur des Mittelalters nicht unvereinbar sein müssen."

54. An idea touched on by Blank, "Heinrich Seuses 'Vita'," 308, but developed most fully by Haas, *Nim din selbes war*, 154–208, esp. 196–197. For competing concepts of fictional (i.e., literary) and factual truth in German texts of the later Middle Ages, see D. H. Green, *Medieval Listening and Reading: The Primary Reception of German Literature, 800–1300* (Cambridge, 1994), 237–69, esp. 265.

55. See, most recently, A. Boureau, "*Vitae Fratrum, Vitae Patrum:* L'ordre dominicain et le modèle des pères du désert au XIIIe siècle," *Mélanges de l'école française de Rome: Moyen Ages-Temps modernes* 99 (1987): 79–100, and the literature conveniently gathered in S. Tugwell, *Early Dominicans: Selected Writings* (New York, 1982).

56. Cf. K. Ruh, "Zur Grundlegung einer Geschichte der franziskanischen Mystik," in *Altdeutsche und altniederländische Mystik*, ed. K. Ruh (Wege der Forschung, 23, Darmstadt, 1964), 240–71, esp. 257: "In den Franziskuslegenden wie in Seuses 'Vita' finden wir erstmals in der Geschichte der Hagiographie unverwechselbare, individuell gesehene, farbige und plastische Umwelte an Stelle des Goldgrundes der alten Legende."

57. A process described in A. M. Kleinberg, *Prophets in Their Own Country: Living Saints and the Making of Sainthood in the Later Middle Ages* (Chicago, 1992). See also Ruh, "Zur Grundlegung einer Geschichte der franziskanischen Mystik," 241–52 (on Francis) and 252–58 (on the relationship with Seuse's *Life*). In the illustrated *Exemplar* from Altenhohenau in Bavaria, ca. 1480 (Berlin, Staatsbibliothek zu Berlin-Preussischer Kulturbesitz, Hs. germ. fol. 658), described in H. Degering, *Kurzes Verzeichnis der germanischen Handschriften der preussischen Staatsbibliothek* 1: Die Handschriften in Folioformat (Graz, 1970), 72; and H. Wegener, *Beschreibendes Verzeichnis der Miniaturen und des Initialschmuckes in den deutschen Handschriften bis 1500* (Leipzig, 1928), 121–22, Seuse's writings are joined with a collection of saints' lives (fols. 1r–86v) covering the calendar from August 28 (Augustine) through September 28 (Eupraxia).

58. See *Leben* 2.42 (ed. Bihlmeyer, 142–43).

59. For a summary of the scholarship, see U. Peters, *Religiöse Erfahrung als literarisches Faktum: Zur Vorgeschichte und Genese frauenmystischer Texte des 13. und 14. Jahrhunderts* (Hermea: Germanistische Forschungen, N.F. 56, Tübingen, 1988), 235–42.

60. Pleuser, "Tradition und Ursprünglichkeit," 138. Seuse's use of the third person to speak about himself can be considered in light of the distinctions drawn by E. Vance, "Augustine's *Confessions* and the Grammar of Selfhood," *Genre* 6 (1973): 1–28, esp. 3–4: "The autobiographical act is to be defined neither as the enunciation of a subject who in all sincerity 'sets himself down' on parchment or on paper, nor as the manipulation of a figment originating strictly within the system of language, but rather as a dialectic between the two. The 'I' of the present derives its identity from the circumstances (whether true or false) surrounding its enunciation in discourse. The 'I-as-object' belongs to historical statements that determine each other by virtue of their distribution within a network or system of past tenses where the first and third 'persons' coagulate as one."

61. The interpretation offered by Peters, *Religiöse Erfahrung*, 135–42, developing a proposal made by K. Ruh, "Altdeutsche Mystik: Ein Forschungsbericht," *Wirkendes Wort* 7 (1956–1957), 135–47. D. L. Stoudt, "The Production and Preservation of Letters by Fourteenth-Century Dominican Nuns," *Mediaeval Studies* 53 (1991): 309–26 is considerably less skeptical.

62. Cf. Pleuser, "Tradition und Urspruunglichkeit," 138: "Aber selbst wenn Seuses Angaben eine Fiktion wären, durch die die Entstehung der Vita nach literarischer Gepflogenheit eine Begründung erhielte, die den Verfasser gegen den Vorwurf der Eitelkeit schütze, so hätte Seuse die Fiktion immerhin so gewählt, dass die, historisch gesehen, im Bereich der Möglichkeit läge." Seuse opens *The Exemplar* by speaking of "mengerley unkunnende schriber und schriberin," "many unqualified scribes of both

sexes," who have corrupted his text. Peters seems too skeptical of the historicity of such collaborations. Nevertheless, to search Stagel's putative "writings" for an underlying theology, as does B. Stoll, "Die theologischen Denkfiguren bei Elsbeth Stagel und ihren Mitschwestern," *Denkmodelle von Frauen im Mittelalter*, ed. B. Acklin Zimmermann (Dokimion, 15, Fribourg, 1994), 149–72, remains a problematic enterprise.

63. See O. Decker, *Die Stellung des Predigerordens zu den Dominikanerinnen (1207–1267)* in QF 31 (1935); A. Walz, *Dominikaner und Dominikanerinnen in Süddeutschland (1225–1966)* (Freising, 1967); and G. Meersseman, "Les frères prêcheurs et le mouvement dévot en Flandre au XIIIe siècle," *AFP* 18 (1948): 69–130.

64. See R. Blumrich, "Die Überlieferung der deutschen Schriften Seuses" in *Heinrich Seuses philosophia spiritualis*, 189–201, with bibliography.

65. See R. Grégoire, "Il matrimonio mistico," in *Il matrimonio nella società altomedievale* (Settimane di Studio del Centro Italiano di Studi sull'Alto Medioevo, 24 (1976), 2 vols., Spoleto, 1977), 701–94, with additional bibliography.

66. *Leben* 1.22 (ed. Bihlmeyer, 64, lines 9–11).

67. Ibid., 64–65.

68. For the manuscript reproduced here, see M. Mollwo, *Das Wettinger Graduale: Eine geistliche Bilderfolge vom Meister des Kasseler Willehalmkodex und seinem Nachfolger* (Bern, 1944), and P. Hoegger, "The Fourteenth-Century Gradual of Wettingen," in *1000 Years of Swiss Art*, ed. H. Horat (Hudson Hills, NY, 1992), 30–57.

69. *Leben* 1.22 (ed. Bihlmeyer, 64, lines 31–33; translation from Tobin, *The Exemplar*, 107).

70. For devotional discipline defined in terms of comportment and the conforming of what Seuse calls "den ussern und den innern menschen," see the essays gathered in *Disciplina dell'anima, disciplina del corpo e disciplina della società tra medioevo ed età moderna*, ed. P. Prodi (Annali dell'Istituto storico italo-germanico: Quaderna, 40, Bologna, 1994) as well as the extensive literature on prayer gestures, much of it usefully gathered by J.-C. Schmitt, *La raison des gestes* (Paris, 1992).

71. *Leben* 1.22 (ed. Bihlmeyer, 64, line 23; translation from Tobin, *The Exemplar*, 106).

72. In like fashion, by reception I mean more than the study of the transmission ("Überlieferung") of Seuse's texts, an approach exemplified by a certain strain of German scholarship which does not go beyond an (indispensable) inventorying of manuscripts. See, in addition to Blumrich "Überlieferung," G. Hofmann, "Seuses Werke in deutsprachigen Handschriften des späten Mittelalters," *Fuldaer Geschichtsblätter* 45 (1969): 113–208; H. Beckers, "Neue Funde zur handschriftlichen Verbreitung von Seuses Werken am Niederrhein und in Westfalen," *Leuvense Bijdragen* 60 (1971): 243–62; and the literature cited by Ruh in Haas and Ruh, "Seuse, Heinrich OP," 1113–14. For printed editions, see D. Breuer, "Zur Druckgeschichte und Rezeption der Schriften Heinrich Seuses," in *Frömmigkeit in der frühen Neuzeit: Studien zur religiösen Literatur des 17. Jahrhunderts* (Chloe: Beihefte zum Daphnis, 2, Amsterdam, 1984), 29–49, and B. Boge, "Das frühneuzeitliche Köln als medialer Ort der mystischen Frömmigkeit Heinrich Seuses: Die deutsche Ausgabe der Bücher und Schriften Heinrich Seuses von 1661," in *Heinrich Seuses Philosophia spiritualis*, 255–66. As noted by Haas and Ruh, 1125, "die volle Geschichte seine [Seuses] Rezeption ist noch zu schreiben."

73. Blank, "Heinrich Seuses 'Vita'," provides the most nuanced analysis of the *Life*'s formal complexity, although his insight that the section devoted to Stagel mirrors that devoted to Seuse is anticipated by Pleuser, "Tradition und Ursprünglichkeit," 148: "Der mystische Weg wird uns von Seuse in zwei Variationen bildhaft beschrieben: als Seuses eigener Lebensweg und als Lebensweg der geistlichen Tochter."

74. Although the *Life* is formally divided into two books, the dialogue beginning with Chapter 46 marks a separate section in the overall structure of the work. For dialogue as a governing principle of the *Life*, see H. Stirnimann and A. M. Haas, "Die deutsche Mystik im Spannungsbereich von Theologie und Spiritualität," in *Literatur und Laienbildung im Spätmittelalter und in der Reformationsreit* 604–39, esp. 628.

75. Colledge and Marler, "Mystical Pictures," 304–306, completely overlook the imagery of dialogue and marriage, preferring to dwell on details.

76. The manuscript in Strasbourg differs from all later illustrated copies of Seuse's work in its subtle application of the visual rhetoric of gender, defined and differentiated in terms of fourteenth-century stylistic conventions. Whereas in the fifteenth-century copies, Seuse's appearance remains consistent, in Strasbourg, BNU, Ms. 2929 his bodily comportment differs dramatically from scene to scene, in each instance carrying a different set of meanings. The artists of the later manuscripts had available to them a similarly varied set of conventions, but either they chose not to employ them or—more likely,

given the number of other simplifications their copies introduce—they simply did not understand the subtlety of Seuse's original invention.

77. As noted by J. Coakley, "Friars, Sanctity, and Gender: Mendicant Encounters with Saints, 1250–1325," in *Medieval Masculinities: Regarding Men in the Middle Ages*, ed. C. A. Lees (Medieval Cultures, 7, Minneapolis, 1994), 91–110; see also idem, "Friars as Confidants of Holy Women in Medieval Dominican Hagiography," in *Images of Sainthood in Medieval Europe*, ed. R. Blumenfeld-Kosinski and T. Szell (Ithaca, 1991), 222–46.

78. The impression of extraordinary frankness created by Seuse's *Life* stands in stark contrast with what Coakley, "Friars, Sanctity, and Gender," 103–104, characterizes as typical of male mendicants: "men's own inner life is, if not a completely taboo subject of investigation, at least one approached with a good deal of reticence."

79. As noted by Colledge and Marler, "Mystical Pictures," 306, this passage, a paraphrase of Aristotle, *Metaphysics*, Bk. I, Ch. 2, recurs in Seuse's *Horologium sapientiae*, Bk. I, Ch. 6; see E. Colledge, trans., *Bl. Henry Suso: Wisdom's Watch upon the Hours* (Washington, D.C., 1994), 308.

80. *Prologus* (ed. Bihlmeyer, 3, lines 17–18). My translation is adapted from Tobin, *The Exemplar*, 57, who unfortunately provides no equivalent for the key phrase, "mit rehter ordinhafti."

81. My thanks to Nigel Palmer for bringing this allusion to my attention.

82. See M. B. Parkes, "The Influence of the Concepts of "Ordinatio" and "Compilatio" on the Development of the Book," *Medieval Learning and Literature: Essays Presented to R. W. Hunt*, ed. J. J. G. Alexander and M. T. Gibson (Oxford, 1976), 115–41; N. F. Palmer, "Kapitel und Buch: Zu den Gliederungsprinzipien mittelalterlicher Bucher," *Frühmittelalterliche Studien* 23 (1989): 43–88, esp. 59; and R. H. Rouse and M. A. Rouse, "'Ordinatio' and 'Compilatio' Revisited," in *Ad litteram: Authoritative Texts and their Medieval Readers*, eds. M. D. Jordan and K. Emery, Jr. (Notre Dame Conferences in Medieval Studies, 3, Notre Dame, 1992), 113–34.

83. See *Bildhauerei und Malerei vom 13. Jahrhundert bis 1600* (Kataloge des Ulmer Museums, 1, Ulm, 1981), nr. 128, 190–95, and G. Jasbar, "Ulmer Museum: Das Kunstwerk des Monats" (Ulm, December, 1985).

84. For the abbey of Heggbach, see O. Beck, *Die Reichsabtei Heggbach. Kloster, Konvent, Ordensleben: Ein Beitrag zur Geschichte der Zisterzienserinnen* (Sigmaringen, 1980).

85. See, e.g., the single-leaf woodcuts of the scene reproduced in R. S. Field, *German Single Leaf Woodcuts before 1500: Anonymous Artists (.401–.735)* (The Illustrated Bartsch, Supplement, 162, New York, 1989), 280–81 (Schreiber .701–.704).

86. For images depicting Augustine with his heart pierced by an arrow, see J. F. Hamburger, *The Rothschild Canticles: Art and Mysticism in Flanders and the Rhineland ca. 1300* (New Haven, 1990), 74, fig. 137; *Glanz alter Buchkunst: Mittelalterliche Handschriften der Staatsbibliothek Preussischer Kulturbesitz Berlin* (Wiesbaden, 1988), 202–203; and *Manuscripta pretiosa & incunabulae illuminatae: Auswahl aus den Sammlungen der Lippischen Landesbibliothek Detmold und der Erzbischöflichen Akademischen Bibliothek Paderborn* (Auswahl- und Austellungskataloge der Lippischen Landesbibliothek Detmold, 33), ed. D. Hellfaier (Detmold, 1995), 33–35. A vision in the biography of Mechthild von Stans, part of the chronicle of Töss, attributed by Meyer to Elsbeth Stagel, plays on the same imagery; see Stoll, "Die theologischen Denkfiguren," 157–58.

87. For nuns' devotions using images of the Agony in the Garden, see J. F. Hamburger, *Nuns as Artists: The Visual Culture of a Medieval Convent*, Chapter II, "The Sweet Rose of Sorrow" (Berkeley-Los Angeles, 1997), 63–100.

88. Zusätze zum Briefbüchlein (ed. Bihlmeyer, 398). The last five letters of "trechen" are written in a much smaller script in the lower left corner of the scroll.

89. *Leben* 2.34 (ed. Bihlmeyer, 102; translation from Tobin, *The Exemplar*, 136–37).

90. See A. M. Haas, "'Trage Leiden geduldiglich': Die Einstellung der deutschen Mystik zum Leiden," in *Lerne leiden: Leidensbewältigung in der Mystik*, ed. W. Böhme (Karlsruhe, 1985), 35–55, reprinted in A. M. Haas, *Gottleiden-Gottlieben: Zur volkssprachlichen Mystik im Mittelalter* (Frankfurt, 1989), 127–52; and P. Ulrich, "Zur Bedeutung des Leidens in der Konzeption der *philosophia spiritualis* Heinrich Seuses," in *Heinrich Seuses Philosophia spiritualis*, 124–138.

91. *St. Benedict's Rule for Monasteries*, trans. L. J. Doyle (Collegeville, 1948), 1 and 6.

92. *Analecta sacri ordinis Fratrum Praedicatorum seu vetera ordinis monumenta* (Rome, 1897), vol. 3, 342: "propriam voluntatem deserere pro voluntate maiorum, voluntariam obedienciam in omnibus observare."

93. Zusätze zum Briefbüchlein (ed. Bihlmeyer, 396–401).

94. See Hamburger, "The Use of Images in the Pastoral Care of Nuns." For Seuse's devotion to

and admiration of the desert saints, see W. Williams-Krapp, "*Nucleus totius perfectionis:* Die Altväter-spiritualität in der 'Vita' Heinrich Seuses," in *Festschrift Walter Haug und Burghart Wachinger,* 2 vols. (Tübingen, 1992), vol. 1: 405–21, and U. Williams, "*Vatter ler mich*": Zur Funktion von Verba und Dicta im Schrifttum der deutschen Mystik," in *Heinrich Seuses Philosophia spiritualis,* 173–88.

95. Zusätze zum Briefbüchlein (ed. Bihlmeyer, 397, lines 1–3).

96. Bihlmeyer, *Deutsche Schriften,* 54*, note 2 ("Diese drei Verse hat Seuse wohl aus den Sprüchen der Stagel übernommen," and 396: "Die . . . Sprüche sind von Seuse ursprünglich lateinisch abgefasst und von Elsbeth Stagel in deutsche Reime übertragen worden."

97. Not that such a program should in itself be considered implausible. The cycle of paintings in Longthorpe Tower, Cambridgeshire, ca. 1330, includes numerous didactic images. See E. C. Rouse and A. Baker, "The Wall-Paintings at Longthorpe Tower, near Peterborough, Northants.," *Archaeologia* 96 (1955): 1–57, and *The Age of Chivalry: Art in Plantagenet England 1200–1400,* ed. J. J. G. Alexander and P. Binski (London, 1987), 249–50.

98. Zusätze zum Briefbüchlein (ed. Bihlmeyer, 393–96).

99. The correspondences are noted by Bihlmeyer, 398–401.

100. Explored by J. Fleming, *From Bonaventure to Bellini: An Essay in Franciscan Exegesis* (Princeton, 1982), esp. 32–74. To these might be added, as Nigel Palmer kindly pointed out, the New Testament subject of Christ's wandering in the wilderness.

101. The only commentator I know to have noted this relationship is C. Frugoni, *Francesco e l'invenzione delle stimmate: Una storia per parole e immagini fino a Bonaventura e Giotto* (Turin, 1993), 321–24, color plates 11–12.

102. Bonaventure, *Legenda maior S. Francisci Assiensis* (Florence, 1941), 106–107 (Chapter 13, part 2).

103. Ruh, "Zur Grundlegung einer Geschichte der franziskanischen Mystik," 254, compares the monogram with the seal of the stigmata received by St. Francis. For the passage cited, see *Leben* 2.40 (ed. Bihlmeyer, 132, line 24).

104. A parallel noted by Colledge and Marler, "Mystical Pictures," 327–29.

105. *Leben* 2.43 (ed. Bihlmeyer, 145): "An den zwei nidresten vetchen stünd geschriben: enpfah liden willeklich; an den mitlesten stünd also: trag liden gedulteklich; and den obresten stünd: lern liden cristförmklich." Translation from Tobin, *The Exemplar,* 168–69

106. See R. S. Field, *German Single-Leaf Woodcuts Before 1500 (Anonymous Artists: .736–.966-2)* (The Illustrated Bartsch, 163 (supplement), New York, 1990), 231 (S. 931m). A similar set of prints, discussed by Bihlmeyer, *Deutsche Schriften,* 61*, can be related to the twelfth drawing in Bihlmeyer's numeration described on 54*.

107. For the fourteenth-century German example reproduced here, added to a thirteenth-century manuscript, see W. Cahn and J. Marrow, *Medieval and Renaissance Manuscripts at Yale: A Selection, The Yale University Library Gazette* 52 (1978): 195–96.

108. As I have elaborated elsewhere; see Hamburger, "The Use of Images in the Pastoral Care of Nuns."

109. Although Bihlmeyer transcribes the monogram as "IHS", in the manuscript in Strasbourg it clearly combines the three letters, "IHC," a form discussed by P. R. Biasiotto, *History of the Development of Devotion to the Holy Name, with a Supplement* (St. Bonaventure, NY, 1943), 2–4, with a section on Seuse, 63–66.

110. Cf. D. Richter, "Die Allegorie der Pergamentbearbeitung: Beziehungen zwischen handwerklichen Vorgängen und der geistlichen Bildersprache des Mittelalters," in *Fachliteratur des Mittelalters: Festschrift für Gerhard Eis,* ed. G. Keil, R. Rudolf, W. Schmitt, and H. J. Vermeer (Stuttgart, 1968), 83–92.

111. *Leben* 2.45 (ed. Bihlmeyer, 154, lines 7–8; translation from Tobin, *The Exemplar,* 173–74).

112. For Joanna Maria of Maillé (1331–1414), see AA.SS March, vol. 3, 734–65, esp. 744; for Beatrice, Vita Beatricis: De Autobiografie van de Z. Beatrijs van Tienen O.Cist, *1200–1268,* ed. L. Reypens and J. van Mierlo (Studiën en textuitgaven van Ons Geestelijk Erf, 15, Antwerp, 1964), 56–57 (Bk, 1, Ch. 14); for Margareta Ebner, *Margareta Ebner und Heinrich von Nördlingen: Ein Beitrag zur Geschichte der deutschen Mystik,* ed. P. Strauch (Freiburg, 1882; reprint Amsterdam, 1966) 20, line 26,—21, line 3.

113. See, e.g., P. Ochsenbein, "Die Offenbarungen Elsbeths von Oye als Dokument leidensfixierter Mystik," in *Abendländische Mystik im Mittelalter* (Symposion Kloster Engelberg 1984), ed. K. Ruh (Germanistische Symposien Berichtsbände, 7, Stuttgart, 1986), 423–42; idem, "Leidensmystik in dominikanischen Frauenklöstern des 14. Jahrhunderts am Beispiel der Elsbeth von Oye," in *Religiöse Frauenbewegung und mystische Frömmigkeit im Mittelalter,* ed. P. Dinzelbacher and D. R. Bauer (Bei-

hefte zum Archiv für Kulturgeschichte, 28, Cologne, 1988), 353–72; R. Kieckhefer, *Unquiet Souls: Fourteenth-Century Saints and their Religious Milieu* (Chicago, 1984), 113–21; and J. F. Hamburger, "The *Liber miraculorum* of Unterlinden: An Icon in its Convent Setting," in *The Sacred Image East and West*, ed. R. Ousterhout and L. Brubaker, (Champaign-Urbana, 1995), 147–90, esp. 162–70.

114. Seuse's critique of excessive corporeal asceticism forms part of a long tradition; see G. Constable, *Attitudes Toward Self-Inflicted Suffering in the Middle Ages* (Brookline, 1982); idem, "Moderation and Restraint in Ascetic Practices in the Middle Ages," in *From Athens to Chartres: Neoplatonism and Medieval Thought: Studies in Honour of Edouard Jeauneau*, ed. H. J. Westra (Leiden, 1992), 315–27; and, for the Dominicans, K. Gieraths, "Die kluge pastorale Mitte in den aszketischen Forderungen bei Jordan von Sachsen und Heinrich Seuse," in *Heinrich Seuse: Studien zum 600. Todestag*, 305–18, and W. Blank, "Umsetzung der Mystik in den Frauenklöstern," in *Mystik am Oberrhein und in benachbarten Gebieten* (Freiburg, 1978), 25–36.

115. Cf. A. Hollywood, "Suffering Transformed: Marguerite Porete, Meister Eckhart, and the Problem of Women's Spirituality," in *Meister Eckhart and the Beguine Mystics: Hadewijch of Brabant, Mechthild of Magdeburg, and Marguerite Porete*, ed. B. McGinn (New York, 1994), 87–113, esp. 112–13. For the concept of an illustrated saint's life as a mediating model, see M. E. Carrasco, "Spirituality in Context: The Romanesque Illustrated Life of St. Radegund of Poitiers (Poitiers, Bibl. Mun. MS 250)," *Art Bulletin* 72 (1990): 414–35, who argues (435) that, "if Radegund's function as a model is clearly mitigated by the extremism of her ascetic behavior, this very quality accounts for the intercessory power exhibited in her miracles and transmitted through the objects venerated as part of her cult."

116. *Leben* 2.45 (ed. Bihlmeyer, 154–55; translation, with slight changes, from Tobin, *The Exemplar*, 173–74).

117. Colledge and Marler, "Mystical Pictures," 337.

118. For the example reproduced here, see the description by L. Kurras in *E. and R. Kistner: 200 Seltene Bücher und Karten* (Antiquariatskatalog 76 zur 20. Stuttgarter Antiquariats Messe 1981), color plate I and cat. no. 88; E. Schraut, *Stifterinnen und Künstlerinnen im mittelalterlichen Nürnberg* (Nuremberg, 1987), 14–15 and 74; and *Liturgie im Bistum Regensburg von den Anfängen bis zur Gegenwart* (Munich, 1989), 149 and 225.

119. See G. Steer, "Der Laie als Anreger und Adressat deutscher Prosaliteratur im 14. Jahrhundert," *Zur deutschen Literatur und Sprache des 14. Jahrhunderts*, ed. W. Haug, T. R. Jackson, and J. Janota (Heidelberg, 1983), 354–67; idem, "Die Stellung des 'Laien' im Schrifttum des Strassburger Gottesfreundes Rulman Merswin und der deutschen Dominikanermystiker des 14. Jahrhunderts," in *Literatur und Laienbildung im Spätmittelalter und in der Reformationszeit*, 643–60; and K. Schreiner, "Laienfrömmigkeit: Frömmigkeit der Eliten oder Frömmigkeit des Volkes?," in *Laienfrömmigkeit im späten Mittelalter*, ed. K. Schreiner (Schriften des Historischen Kollegs: Kolloquien, 20, Munich, 1992), 1–78.

120. For the transmission of Seuse's writings, see Blumrich, "Die Überlieferung der deutschen Schriften Seuses," and the literature cited in Haas and Ruh, "Seuse, Heinrich OP," 1113–14.

121. Strasbourg, BNU, MS. 2929, fol. 68r: "Gelobt vnd gebenediet sij der werde name vnsers herrn iesu cristi. Vnd der werden juncfrowen vnd kùnigin Marien sín muter eweclichen an ende Amen." My thanks to Nigel Palmer and Hans-Jochen Schiewer for their help with this and the following transcriptions.

122. Strasbourg, BNU, Ms. 2929, fol. 68r: "IESUS.MARIA Minneclicher herre vnd frunt< . . . > unserm lieben seligen herren< . . . >"

123. Strasbourg, BNU, Ms. 2929, fol. 7r: "IESUS.MARIA Minnenclicher herr vnd frunt< . . . > hertzen. Amen." The paraphrases of the *Pater noster* and *Ave Maria* may have been lost when the manuscript was trimmed.

124. Strasbourg, BNU, Ms. 2929, fol. 1r: "Pater noster et Aue Maria. Gelobt vnd gebenediet sij der werde namen [sic] vnsers herren iesu cristi. vnd der hoh gelobten juncfrowen Marien siner mùter eweclichen an ende. Amen. etc. IESUS.MARIA Zarter minnenclicher herre vnd< . . . > wib vnd vrouwe? < . . . > hertzens Amen." Bihlmeyer, *Deutsche Schriften*, 4*, assigned the second prayer on fol. 1r to a second, fifteenth-century hand. Regardless of their date, however, both prayers are written in one and the same script, which is identical, in turn, to that on fols. 7r and 68r. Bihlmeyer noted only the additions at the front of the manuscript, perhaps because they, along with the other "Gebrauchspuren," offered an indication of provenance. The others he omitted altogether.

125. Described in Bihlmeyer, *Deutschen Schriften*, 5*–6*; R. Banz, *Christus und die minnende Seele: Zwei mittelalterliche mystische Gedichte. Im Anhang ein Prosadisput verwandten Inhaltes. Untersuchungen und Texte* (Germanistische Abhandlungen, 29, Breslau, 1908), 6–14; H. Lehmann-

Haupt, *Schwäbische Federzeichnungen: Studien zur Buchillustration Augsburgs im XV. Jahrhunderts* (Berlin, 1929), 144–46; and H. Rosenfeld, "Christus und die minnende Seele," VL², vol. 1: 1235–38 and V. Mertens, "Kreuztragende Minne," VL², vol. 5: 376–79. S. Krämer, *Handschriftenerbe des deutschen Mittelalters* (Mittelalterliche Bibliothekskataloge Deutschlands und der Schweiz: Ergängzungsband, 1, Munich, 1989), does not list the convent of St. Peter's as a manuscript library, a fact kindly brought to my attention by Nigel Palmer.

126. Many of the catechetical texts recur in at least three other codices, all from southern Germany (Munich, Staatsbibliothek, Cgm. 509, 519 and 831), affiliations noted by E. Weidenhiller, *Untersuchungen zur deutschsprachigen katechetischen Literatur des Spätmittelalters nach Handschriften der Bayerischen Staatsbibliothek* (Münchener Texte und Untersuchungen zur deutschen Literatur des Mittelalters, 10, Munich, 1965), 140–52, and K. Schneider, *Die deutschen Handschriften der Bayerischen Staatsbibliothek München* (Catalogus codicum manu scriptorum Bibliothecae Monacensis, V/4, Wiesbaden, 1978), 522. Some of the same texts also recur in Nuremberg, Stadtbibliothek, Mss. Cent. VI,43e and Cent. VII,42, both described in K. Schneider, *Die deutschen mittelalterlichen Handschriften* (Die Handschriften der Stadtbibliothek Nürnberg, I, Wiesbaden, 1965, 87–96 and 346–51. A number of these same manuscripts also include a partial translation of Seuse's *Horologium sapientiae,* Bk. 2, Ch. 7 (in Nuremberg, Stadtbibliothek, Hs. Cent. VI,85,2 attributed to the Dominican, Eberhard Mardach) which again describes how Seuse inscribed the Holy Name on his chest and enjoins the reader to recite the Pater noster and Ave Maria.

127. Cf., for example, the hundred devotions appended to the *Büchlein der Ewigen Weisheit*—according to Seuse, given to him as "he was standing before a crucifix" (ed. Bihlmeyer, 196 and 314–22).

128. For example, in the illustrated copy of the *Exemplar,* Wolfenbüttel, Herzog August Bibliothek, Cod. Guelf 78.5 Aug. 2°, fols. 252r–257r; also in the incomplete collection of Seuse's German writings, Munich, Staatsbibliothek, Cgm. 819, described by K. Schneider, *Die deutschen Handschriften der Bayerischen Staatsbibliothek München,* V/5 (Wiesbaden, 1984), 457–59. The apocryphal additions to the *Briefbüchlein* also circulated separately together with the letter, "Pone me ut signaculum," e.g., in Munich, Staatsbibliothek, Cgm. 412, a manuscript of only 45 folios from the Dominican nunnery of St. Katharina in Augsburg described by K. Schneider, *Die deutschen Handschriften der Bayerischen Staatsbibliothek München,* V/3 (Wiesbaden, 1973), 200–201. Both Cgm. 412 and the *Exemplar* in Wolfenbüttel include the partial translation of Bk. II, Ch. 7 of the *Horologium sapientia,* for additional manuscripts, see the list in Schneider, *Die deutschen handschriften der Bayerischen Staatsbibliothek München,* V/3, 174–75.

129. *XI. Brief* (ed. Bihlmeyer, 391, line 20,—392, line 1; translation from Tobin, *The Exemplar,* 360).

130. The apocryphal passage identifies this prayer, beginning "Anima mea desideravit," with the oration that, according to the *Life,* Ch. 5 (ed. Bihlmeyer, 18, lines 11–13), Seuse included in the *Briefbüchlein.* In effect, the addition makes good on what would otherwise be its inexplicable absence. Although the passage, which serves as a set of prayer instructions in narrative form, encourages the reader to say a *Pater noster* and *Ave Maria* along with Seuse's special prayer, the "Anima mea" is not identical with the third prayer added by the annotator of Strasbourg, BNU, Ms. 2929. The two sets of prayers are nonetheless analogous.

131. For images of St. Bernardino, see M. A. Pavone, *Iconologia Francescana: Il Quattrocento* (Todi, 1988), with additional bibliography; for his context, see A. Benvenuti Papi, "Penitenza e santità femminile in ambiente cateriniano e bernardiniano," in *Atti del simposio internazionale cateriniano-bernardiniano* (Siena 17–20 aprile 1980), ed. D. Maffei and P. Nardi (Siena, 1982), 865–75. Seuse was not alone in translating his devotion to the name of Jesus into idiosyncratic images; cf. the manuscripts made for Philippe de Mézières discussed by J. B. Williamson, "Paris B.N. MS fr. 1175: A Collaboration between Author and Artist," in *Text and Image,* ed. D. W. Burchmore (Acta, 10, Binghampton, NY, 1986), 76–92.

132. *XI. Brief* (ed. Bihlmeyer, 392, lines 6–7; translation from Tobin, *The Exemplar,* 360). The passage invites comparison with an episode described in the chronicle of Weiler, ed. K. Bihlmeyer, "Mystisches Leben in dem Dominikanerinnenkloster Weiler bei Esslingen im 13. und 14. Jahrhundert," *Württembergische Vierteljahrshefte für Landesgeschichte,* N.F. 25 (1916): 61–93, esp. 74: "Eines tages waz sie vereinet in dem chor, da erschein er [John the Evangelist] ir als gar schöne und minniklich und was angelegt mit himelvarben kleydern und het ein güldein fürspang vorn an sein hertzen. Da ward ir zu versten geben, daz dy plaben klyder bezeichent sein himelisch ler und daz fürspang dy götlich mynn, dy sein herz alz gar enzündethet. Da erzeigten auch dy puchstaben, dy also dar inn ergraben waren, caritas Dei."

133. *XI. Brief* (ed. Bihlmeyer, 392, line 21,—393, line 3; translation from Tobin, *The Exemplar,* 360). As kindly pointed out to me by Caroline Bynum, this story does not stem from the early materials associated with the saint. Seuse's likely source was the *Golden Legend.*

134. For this metaphor in devotional writings of the later Middle Ages, see F. Ohly, "Cor amantis non angustum: Vom Wohnen im Herzen," in *Gedenkschrift für William Foerste,* ed. D. Hofmann (Niederdeutsche Studien, 18, Cologne, 1970), 454–76, esp. 460–61.

135. With the exception of the brief discussion in A.-M. Holenstein-Hasler, "Studien zur Vita Heinrich Seuses," *Zeitschrift für Schweigerische Kirchengeschichte* 62 (1968): 185–332, esp. 239–43.

136. My survey of manuscripts of the *Exemplar* and Seuse's *Life* suggests that unillustrated manuscripts also tend to be those in which the pictorial treatment of the monogram is also omitted. See, e.g., the copies in Stuttgart (Würtembergische Landesbibliothek, Cod. Theol. et philos. fol. 281, fol. 52r) and Munich (Staatsbibliothek, Cgm. 819, fols. 12v–13r), where the IHS monogram is consistently replaced with the word, "Ihesus."

137. See C. Gerhardt, *Die Metamorphosen des Pelikans: Exempel und Auslegung im mittelalterlichen Literatur* (Europäische Hochschulschriften, Reihe I, Frankfurt, 1979), 265, and H. Reinitzer, "Kinder des Pelikans," *Vestigia Bibliae* 6 (1984): 191–260.

138. For the eagle as an image of far-sighted, spiritual aspiration, see L. Wehrhahn-Stauch, "Aquila-resurrectio," *Zeitschrift des Vereins für deutsche Kunstwissenschaft* 21 (1967): 105–27; P. Dinzelbacher, "Die mittelalterliche Adlersymbolik und Hadewijch," *Ons geestelijk Erf* 54 (1980): 5–25 reprinted and revised in *Mittelalterliche Frauenmystik* (Paderborn, 1993), 188–204; and M. Wehrli-Johns, "Das Selbstverständnis des Predigerordens im Graduale von Katharinenthal," in *Contemplata aliis tradere,* 241–71.

139. An analogy noted already by J. Schwietering, "Zur Autorschaft von Seuses Vita," originally published in *Humanismus, Mystik und Kunst in der Welt des Mittelalters,* ed. J. Koch, (Studien und Text zur Geistesgeschichte des Mittelalters, 3, Leiden, 1952), 146–58. On the unity of the narrative and speculative sections in the *Life,* see A. M. Haas, *Nim din selbes war,* 190–91.

140. *Leben* 2.46 (ed. Bihlmeyer, 155, lines 15–20; translation from Tobin, *The Exemplar,* 174). Cf. Hugh of St.-Victor's use of the metaphor of seal and wax in the passage discussed by Bynum, *Docere verbo et exemplo,* 82–83. For other instances, see S. Ringler, *Viten- und Offenbarungsliteratur in Frauenklöstern des Mittelalters: Quellen und Studien* (Münchener Texte und Untersuchungen zur deutschen Literatur des Mittelalters, 72, Zurich 1980), 275–76.

141. *Leben* 2.46 (ed. Bihlmeyer, 155, lines 18–19).

142. Ibid. (ed. Bihlmeyer, 155, line 16) and 2.52 (191, line 9). While not inaccurate, Tobin's translation, "holiness based on examples," does not capture all the nuances of the original. For the critical phrase, "bild mit bilden us tribe," see Stirnimann, "Mystik und Metaphorik"; B. Boesch, "Seuses religiöse Sprache," *Festgabe für Friedrich Mauer zum 70. Geburtstag am 5. Januar 1968,* ed. W. Busch (Düsseldorf, 1968), 223–45, esp. 239; and A. M. Haas, *Sermo mysticus: Studien zu Theologie und Sprache der deutschen Mystik* (Dokimion, 4, Fribourg, 1979), 179–81.

143. In addition to the essays gathered in *Heinrich Seuses philosophia spiritualis,* see L. Sturlese and R. Blumrich, ed., *Heinrich Seuse: Das Buch der Wahrheit. Mittelhochdeutsch-Deutsch* (Philosophische Bibliothek, 458, Hamburg, 1993).

144. This, however, is not to say that the *Life* has no basis in Seuse's experience or historical reality. On this point, see P. Dinzelbacher, "Zur Interpretation erlebnismystischer Texte des Mittelalters," *Zeitschrift für deutsches Altertum und deutsche Literatur* 117 (1988): 1–23, reprinted and revised in *Mittelalterliche Frauenmystik,* 304–31. Staubach, "Von der persönlichen Erfahrung zur Gemeinschaftsliteratur," 203, explores the way in which Seuse himself grappled with this issue, what he, paraphrasing Seuse, calls, "die Kluft von *experientia* und *verba vel scripta.*"

145. See K.-H. Göttert, "*devotio-ândaht:* Frommigkeitsbegriff und Darstellungsprinzip im legendarischen Erzählen des hohen Mittelalters," in *Zeiten und Formen in Sprache und Dichtung: Festschrift für Fritz Tschirch zum 70. Geburtstag,* ed. K.-H. Schirmer and B. Sowinski (Cologne, 1972), 151–69, esp. 163, "die Erweckung der *devotio* geradezu als Ziel des Legendenerzählens verstanden werden [müss]," and 165: "der selbst als *itinerarium mentis in Deum* dargestellte Weg des Heiligen fordert eine Art der Betrachtung heraus, die ebenso wieder als Station auf einem eigenen Weg zu Gott verstanden werden kann. Die . . . gestellte Aufforderung zur *imitatio,* die der Verlebendigung des Lebens des Heiligen als *exemplum* entspringen soll, verwirklicht sich damit in einer Erzählform, die sich durch die Bindung and die *devotio* einer mystischen Grundhaltung zuordnet und auf entsprechende Ausdrückmöglichkeiten verwiesen ist."

146. B. Stock, "The Self and Literary Experience in Late Antiquity and the Middle Ages," *New*

Literary History 25 (1994): 839–52, esp. 848–89. See also M. Stevens, "The Performing Self in Twelfth-Century Culture," *Viator* 9 (1978): 193–212, esp. 199.

147. Ibid., 849. Cf. Stock's observation, 848: "The self is like a potential author whose attitude toward acts of reading and writing helps determine the type of authority that he or she seeks to impose on a putative audience. If a person chooses not to write, authority remains 'charismatic;' examples include St. Anthony or St. Francis, both of whom achieve self-definition without resorting to extensive writing. If literate disciplines are involved, authority is 'routinized,' that is, it is transferred to a text that is routinely communicated to its audience through listeners, readers, or viewers. Within this tradition, the ancient 'spiritual exercise' is transformed into the first-person meditation by the self-conscious reader or writer."

148. Ibid., 847. See also D. Aers, "A Whisper in the Ear of Early Modernists; or, Reflections on Literary Critics Writing the 'History of the Subject'," in *Culture and History 1350–1600: Essays on English Communities, Identities and Writing* (Detroit, 1992), 177–202.

149. See S. Greenblatt, *Renaissance Self-Fashioning from More to Shakespeare* (Chicago, 1980), 9: "Self-fashioning is always, although not exclusively, in language."

150. C. W. Bynum, "Did the Twelfth Century Discover the Individual?" in *Jesus as Mother: Studies in the Spirituality of the High Middle Ages* (Berkeley, 1982), 85 and, further, the section, "The Sense of Model," 95–102.

151. Ibid., esp. 84–86. Bynum responds to some of the ideas developed by J. F. Benton, "Consciousness of Self and Perceptions of Individuality," in *Renaissance and Renewal in the Twelfth Century*, ed. R. L. Benson and G. Constable (Cambridge, Mass., 1982), 263–295, esp. 284–87.

152. See K. Grubmüller, "Ich als Rolle: 'Subjektivität' als höfische Kategorie im Minnesang?" in *Höfische Literatur, Hofgesellschaft, Höfische Lebensformen um 1200* (Kolloquium am Zentrum für Interdisziplinäre Forschung der Universität Bielefeld, 3. bis 5. November 1983), ed. G. Kaiser and J.-D. Müller (Düsseldorf, 1986), 387–407.

153. In defining the monastic sermon exemplum, L. Scanlon, *Narrative, Authority, and Power: The Medieval Exemplum and the Chaucerian Tradition* (Cambridge, 1994), 67, speaks of its "dialogic structure . . . whereby the reader can, by emulating the exempla the exemplarist offers, acheive the exemplarist's position." Cf. Benton's remark, "Consciousness of Self," 285: "Modern readers more concerned with personality than the soul find Dante's *Inferno* far more interesting than his *Paradiso*, but Dante's own pilgrimage was away from both hell and personality."

154. For the centrality of "experience" as a concept in Seuse's writings, see the brief, but trenchant remarks in Haas, "Die Deutsche Mystik," 627. For medieval understandings of the term, see the essays gathered in *Religiöse Erfahrung*, (see note 2 above) and B. Stock, "Experience, Praxis, Work, and Planning in Bernard of Clairvaux: Observations on the *Sermones in Cantica*," in *The Cultural Context of Medieval Learning* (Proceedings of the First International Colloquium on Philosophy, Science, and Theology in the Middle Ages, September, 1973, Boston Studies in the Philosophy of Science, 26, Dordrecht, 1975), 219–68.

155. Cf. Bynum, "Did the Twelfth Century Discover the Individual," 87: "the twelfth-century thinker explored himself *in a direction* and *for a purpose*. The development of the self was toward God;" also 108: "a personal religious vision tends to be an imitation of Christ, an identification with the ultimate example, and therefore that, *in what one is* as imitator of Christ, one is not an isolated or lone individual but an evangelizer, teacher, and frequently even a founder of a new group or revitalizer of an old."

156. As noted by Pleuser, "Tradition und Urspruunglichkeit," 148.

Tradition and Renewal:
The Philosophical Setting of Fifteenth-Century Christology. Heymericus de Campo, Nicolaus Cusanus, and the Cologne *Quaestiones vacantiales* (1465)

Maarten J. F. M. Hoenen

INTRODUCTION

THROUGHOUT ITS HISTORY, philosophy has shown two faces looking in opposite directions. Some thinkers have striven to preserve and develop philosophies from the past that have proved to be powerful and important. Other thinkers have searched for, and been fascinated by, new ways of thinking, which, they judged, would more adequately express the intellectual needs of their time. Perhaps more than in any other discipline, the history of philosophy evinces contrary movements of 'tradition' and 'renewal' co-existing at the same time.

This double tendency comes to the fore especially in times which, we may see in retrospect, were periods of great cultural change, when the intellectual climate was dominated by internal tensions and opposing interests. Such an era was the fifteenth century, which historians commonly characterize as strongly marked by diversity and change. This is particularly true for the disciplines of philosophy and theology.[1] In the universities and the *studia* of the religious orders there emerged rival schools of thought, which, rather remarkably, returned to the teaching of such thirteenth-century philosophers and theologians as Albert the Great, Thomas Aquinas and John Duns Scotus. These schools, which were named *albertistae, thomistae* and *scotistae* after their schoolheads, tried to preserve and consolidate their intellectual heritage.[2] In contrast (and often in opposition), others such as Nicolaus Cusanus and the 'humanists' moved away from prevailing academic traditions to sources and methods of philosophical analysis which surpassed the limits of Scholastic discourse and debate.[3]

Questions about the nature of theology and of theological truths played a central role in fifteenth-century intellectual life and debates. In the years after the Great Schism (1378) the essence of academic theology changed significantly. Generally, theologians were no longer inclined to penetrate the mysteries of faith with metaphysical and logico-semantical tools; rather, their intention was only to make the items of belief somehow comprehensible and to protect them against heretical understandings.[4]

Against this background one must understand the rise of the fifteenth-century schools of thought. In short, followers of the schools did not seek new philosophical doctrines or methods but tried to reestablish and reinforce older traditions.[5]

There were some, however, who were convinced that the truth revealed in the mysteries of faith could be penetrated in depth by human reason; what is more, they judged that these theological truths should constitute the essence of any serious metaphysical system. As a result of such thinking, the mystery of the Incarnation became the keystone of a number of late-medieval philosophies. Those who shared this conviction also looked back, not so much to the more famous teachers of the thirteenth century, but to twelfth-century philosophies and theologies and to the works of Raymundus Lullus (Ramón Llull, †1316), a philosopher who attracted much attention in the fifteenth century.[6]

In this essay I shall focus on this double tendency of tradition and renewal, in order to gain insight into fifteenth-century developments in Christology. First, I shall examine the traditional approach to Christology evident in a collection of *Quaestiones vacantiales* that were held at the University of Cologne in 1465. These questions bear witness to the Christological debates among the schools of thought. Secondly, I shall examine a number of texts from the works of Heymericus de Campo (Heymeric van de Velde, †1460), which contrast sharply with the *Quaestiones vacantiales*. Although Heymericus played an important role in the debates between the schools, in such writings as the *Compendium divinorum* (1420–1422) and his commentary on the *Sentences* he strove to go beyond the traditional Scholastic teachings of antagonistic philosophical schools. Heymericus represents what one might call 'the line of innovative philosophizing'. Finally, I shall discuss the *De docta ignorantia* of Nicolaus Cusanus. This work is one of the most important philosophical treatises by the Cardinal and gives extensive consideration to Christ as the mediator between God and creation; in this text, Cusanus develops in a radical fashion the innovative approach taken by Heymericus. Cusanus explicitly reacts against contemporary Scholastic philosophy. He considers his teaching to be independent from, and not indebted to, any existing tradition. (He himself emphasized that the *Docta ignorantia* was a gift from God.) Cusanus's thought stands in evident opposition to the traditional approaches represented in the *Quaestiones vacantiales*. Taken together, these traditional and innovative sources illustrate the philosophical setting of fifteenth-century Christology.

The *Quaestiones vacantiales*

In a recent publication I discussed the manuscript collection of the late-medieval Dominican, Georg Schwartz (died after 1484). During his education and career as a *lector* he collected a large number of philosophical and theological treatises. These works depict the intellectual climate of Schwartz's time, especially the education of Dominicans in Germany.[7]

In one of the manuscripts of the collection (Eichstätt, Universitätsbibliothek, Cod. st 688), Schwartz reported the *Quaestiones vacantiales* he attended during his stay as a student at the University of Cologne in the years 1465 and 1466.[8] *Quaestiones vacantiales*, which were part of the regular university curriculum, were held on Friday morn-

ings during the holidays. Every *baccalaurius* first participated in these disputed questions as the 'opponent' and then as the 'respondent', who was required to answer the objections put forward against the thesis of the disputation by the opponents.[9] The *Quaestiones vacantiales* were open to the public and anyone attending could raise objections, *baccalaurii* as well as masters and members of other faculties.[10] These questions therefore show us, unlike most other sources, the actual topics of theological and philosophical discussion in the university.

These questions are marked by the controversies between the different schools of thought. Occasionally Schwartz noted in the margins the school to which a defended position belonged.[11] Unfortunately, he does not mention the schools in his transcripts of the questions on Christology.[12] Nevertheless, the Christological discussion was also dominated by the debates among the schools, as we shall see.

The question that I shall discuss for purposes of illustration concerns whether or not Christ was born of a virgin: "Utrum filius dei in temporis plenitudine sit incarnatus de virgine."[13] The three syllogisms or *materiae* that follow answer positively.[14] The first syllogism proves that the Word became incarnate in order to restore the fallen human race and therefore only after man had sinned. The next syllogism establishes that the Son of God assumed a real human nature. The last syllogism demonstrates that Christ was born of a virgin according to the flesh but that he was not conceived in sensual desire.[15]

Objections by the opponents follow the three proposed syllogisms. The objections focus on the following points: (1) Why did only the Son become incarnate, and not one of the other divine persons or all three of them? (2) What is the ontological status of Christ's human nature? (3) Would God have become incarnate if man had not sinned?[16]

(1) Can the Three Divine Persons Assume One Human Nature?

We can only make full use of the *Quaestiones vacantiales* as a source for our understanding of the intellectual climate of the time if we succeed in identifying the anonymous respondent. As I said, Schwartz does not mention any contemporary author in his account. Nor are there any references to authorities, except to Aristotle, who is mentioned by an opponent.[17] We must therefore look to the content of the question for signs of the identities of the respondent and opponents. In the second half of the fifteenth century, the Albertists, Thomists and Scotists were the most important schools in Cologne, as the surviving documents indicate.[18] Important information about their views, in particular concerning Christological doctrines, can be found in another collection of *Quaestiones vacantiales* that took place in the late 1470s and early 1480s and were reported by Sebastian Fanckel, a Thomist who studied and worked in Cologne.[19]

Fanckel cites three questions or subjects that especially divided the Albertist and Thomist schools: (1) Whether the three divine persons can assume a human nature that is one and numerically the same? (2) the cause of individuation of the human nature in Christ; (3) Christ's knowledge.[20] The first of these questions, as we have seen, was raised in the disputations recorded by Georg Schwartz. As is clear from Fanckel's notes, the Albertists argued that one human nature cannot be assumed by all three divine

persons, whereas the Thomists argued that it was neither philosophically nor theologically impossible for the three persons to subsist in one human nature. Not only Albertists and Thomists controverted this question. Following their own master, the Scotists argued that it is impossible that one human nature be assumed by all three divine persons.[21] On this point, the followers of Duns Scotus sided with the Albertists against the Thomists.[22]

The argument that the three divine persons can assume one human nature is, therefore, a typical position of the Thomists that distinguishes them from both the Albertists and Scotists. This is exactly the position of the respondent in the question reported by Schwartz. The opponent objects that it is impossible for one human nature to be assumed by the three divine persons, for then the one nature would have three subjects or *supposita,* and thus Christ would be more than one person. The respondent answers that the three divine persons must be considered according to their common divine nature, which would function as a single subject or *suppositum.* The divine persons are therefore not distinct when assuming human nature, as the opponent thinks, but they are one, because their nature is one and the same.[23]

The respondent's argument fully agrees with that of Thomas Aquinas, who on this issue remarks that the divine persons, having the same divine nature in common, do not exclude each other as far as their nature is concerned. The persons exclude each other only from being the same person. Now, if they have the same divine nature, the divine persons could have the same human nature. Hence it is not impossible that they assume one human nature.[24]

Judging from his position on this question, we may conclude that the respondent belonged to the Thomist school; on this difficult issue, at least, he sided with the teaching of Thomas Aquinas against the Albertists and Scotists.

(2) The Unity of Existence in Christ

On other questions as well the respondent adopts Thomistic arguments. Against the objection of an opponent, which states that the human nature in Christ has its own being distinct from the being of the divine nature, he maintains that although the human nature in Christ has its own 'being of essence' (*esse essentiae*), it does not possess its own existential being (*esse existentiae*) separately from the being of the divine nature in Christ. The existential being of Christ's human nature is not derived from its own essential being, but is conferred immediately by divine power. Thus, Christ's human nature is supported by divine being, which is more perfect than human being.[25]

The opponent's argument—that the human nature in Christ has its own existential being—derives from Duns Scotus, who in the third book of his *Ordinatio* maintains that the human nature assumed by the divine Word is not informed by the Word, but remains completely distinct and preserves its own existential being.[26] Again, the contrary position of the respondent is based on Thomas's argument in the *Summa theologiae.* According to Thomas, the Son of God does not acquire new personal being when the human nature is assumed by the divine Word, but rather the already existing personal being of the divine nature is set into a new relationship, whereby the Son

subsists not only in divine but also in human nature. Therefore, in Christ there are not two acts of existence, by one of which he is God and by the other man, but only one.[27]

(3) The Incarnation and Human Sin

Concerning the relationship between the Incarnation and human sin, that is, whether the Incarnation would have occurred if man had not sinned, the opponent defends a famous opinion of Duns Scotus.[28] Even if man had not sinned, the Word would have become incarnate, because the perfection of the universe, which the Incarnation establishes, is independent from the existence of human sin. God became incarnate by reason of his great charity and love for man, which is not contingent on human sin.[29]

The respondent argues the opposite position. God's love towards man is not a sufficient and necessary reason for the Incarnation, as this love is also shown by many other means. Christ came into the world not just to dignify human nature, but to dignify human nature that is affected by the disease of sin and needs to be cured and saved. The Incarnation is a remedy for sin; therefore, if man had not sinned, there would have been no Incarnation.[30] Again the respondent follows Thomas Aquinas, who advises that on this matter one should let himself be guided by sacred Scripture, which many times declares that sin is the reason for the Incarnation. Therefore one should hold that the Incarnation is ordained by God as a remedy for sin ("incarnationis opus ordinatum esse a Deo in remedium peccati"), although by his divine power God could have become incarnate even if there had been no transgression of divine law.[31]

(4) Conclusions

These questions reported by the Dominican Georg Schwartz give evidence that Christological topics were at the center of disputes among Albertists, Thomists and Scotists, and that Thomistic reasonings were attacked particularly by the Scotists. Moreover, from the *Quaestiones vacantiales* one may draw more general conclusions.

The Christological debates, clearly, were not restricted to written literature, but played a prominent part in the actual, oral discussion of the University.[32] That the questions were discussed orally does not suggest, however, that they were timely or provocative, as one might otherwise suppose. Quite the contrary: all of the arguments derive immediately from the teachings of thirteenth-century authors, and seem to be recitations more than dialectical investigations.[33]

Indeed, when one considers the arguments of the Thomist respondent, one cannot escape the impression that he was trained especially in set answers according to the tradition of his school.[34] The emphasis of such training was not on finding new solutions to theological difficulties, but on conserving and consolidating the thirteenth-century tradition. The opponent, though of a different school, was trained in the same way. Nor, even, do the *Quaestiones vacantiales* reflect an adaptation of traditional teachings to new problems, for the questions themselves are borrowed from the common stock of Peter Lombard's *Sentences*. That the practice of philosophy and theology evident in these school questions was not the only one appears from the writings of Heymericus de Campo, to which we now turn.

Heymericus de Campo

Heymericus de Campo was surely involved in the disputes among the schools. Indeed, he was probably the most important Albertist of his day, and was the very one to introduce the particular teachings of his school at the University of Cologne. So, many of his writings are marked by the late-medieval school discussions, especially his *Problemata inter dominum Albertum et sanctum Thomam*, written at Cologne in 1424 or 1425.[35] In other writings, however, he steers a different course, developing a universal metaphysics which he intended to surpass the traditional philosophies. He is fascinated by the idea of understanding the whole of reality on the basis of one comprehensive principle, the One. His main sources are Proclus, Dionysius the Areopagite, Raymundus Lullus and the works of Albert the Great.[36]

Heymericus did not write a separate treatise on Christology. Yet, already from his first treatise, the *Compendium divinorum*, a handbook of metaphysics written at Diest between 1420 and 1422, the prominent role that Christology plays in his thinking is clearly visible. This treatise is especially important because it exposes the metaphysical and cosmological background against which Heymericus's Christology must be understood.[37] Heymericus also treats Christological issues extensively in his commentary on the *Sentences*, written in Cologne in the years 1424–1425. In this commentary, he completes the cosmological view of the *Compendium* with a soteriological approach.[38]

(1) The Cosmology of the *Compendium*

In the *Compendium*, Heymericus deals at length with the first principle and the structure of reality.[39] Basing himself on Albert the Great's commentary on the *Liber de causis*,[40] he tries to explain how the actual structure of reality emanated from the first principle and how reality eventually will return to it. The first principle is completely perfect and good. Because of the sheer excess of its goodness, which is the highest good possible, it seeks to share its being with others and so its being overflows into finite existence.[41] Creation thus proceeds from the primordial cause into existence. The further created being is removed from the first principle, the more it is differentiated and particularized. Therefore creation is multiform and the unity of the first principle manifests itself in a great variety of finite beings. The process of continuing multiplication is not arbitrary, but follows an hierarchical logic. The first or higher level of created being is divided into a second or lower being, so that what is unified on the first level is multiplied in the second.[42] Consequently, the different levels of being, from the first to the last, are intimately connected. There are no gaps in creation. Every possible degree of being emanates from the first principle. Heymericus adheres to the principle of plenitude.[43]

This idea of ordering does not hold only for genera and species, but also for the individuals of a certain species. In every species there is a first and most perfect individual that unites all the possibile perfections of the lower and less perfect individuals in the species, since every order, Heymericus argues, necessarily has a first that measures the rest of that order, even at the individual level.[44]

At this point, the Christology of Heymericus comes to the fore. The highest individual of the human species is identified with Christ. Heymericus maintains that Christ is the measure of all human beings. Christ exemplifies the species of human being in the best possible way and is the limit of what man as human being can be.[45] In this perspective, Christ is a necessary link in the cosmology of creation. Without Christ, creation could not possibly exist as an ordered whole and the principle of plenitude would be invalidated.[46]

According to Heymericus, man stands at the midpoint of creation. Within his being he recapitulates all created things, spiritual and material, for his essence encompasses both a material body and an intellectual soul.[47] This is especially true of Christ, who, metaphysically speaking, is the first in the order of human beings. The human body is a divine mixture of the four elements harmoniously disposed by the light and movement of the heavenly bodies, so that the intellectual light that emanates from the first principle is not contracted or distorted but can be fully received by the soul that enlivens the body.[48] Consequently, the human mind participates in the light of the Intelligences and of the first cause, and can know reality in a way that is similar to the knowledge of the first principle.[49] Perfected human knowledge is thus divine knowledge. Anything that God creates in real being the human mind can create conceptually in intellectual being.[50] Christ possesses such divine knowledge to its fullest extent.

By reason of the unique condition of the human species, which represents the material and intellectual cosmos and is capable of divine knowledge, human beings play a crucial role in the resolution of all things into God. Material beings cannot by themselves return into God because they lack the possibility of knowing their cause. They can only be restored in their primordial cause by an intellectual being who has knowledge of creation. By knowing material things as emanated from the first principle of being, the human mind resolves them into the primordial cause.[51] But there is more. By thinking about creation as emanated from the primordial cause, the human mind is directed towards the first principle, and so man himself returns to the first principle. He realizes that his intellect is an outflow of divine light and that by reflecting on it he can ascend to the divine.[52] Thus man is the pivotal point in the midst of the universe, through which all creation can return into God. As the most perfect human being, Christ is the perfect embodiment of the microcosm and the best possible point of return.

(2) The Soteriology of Heymericus's Commentary on the *Sentences*

In the *Compendium*, the place of Christ is considered only cosmologically. Even the ultimate resolution of all things into God, which has a soteriological aspect, is seen entirely from the cosmological perspective. In his commentary on the *Sentences*, however, Heymericus enters into the soteriological aspects of Christ's role, although the focus remains cosmological. Here, both cosmology and soteriology are centered on the idea that Christ is the mediator, who reestablishes the order of justice broken by man and returns human beings to God.[53] Christ reunites what man has broken by offending against God. He completes the circle of the universe, which began with a unity between God and man, continued in a state of separation caused by sin, and will end in

a state of unity brought about by Christ's atonement.[54] Christ can act as universal mediator because he is both divine (*Creator*) and human (*creatura*); thus, as Creator he can restore creation and as human creature he can take on human sins. Man needs to attain satisfaction, but only God can atone, since the atonement must be in proportion to the one offended. Therefore, only Christ, who is both God and man, can make satisfaction for human sin.[55]

Heymericus's treatment of Christ in his commentary on the *Sentences* is still dominated by neo-Platonic cosmological terms, but here he stresses Christ's uniqueness far more than he did in the *Compendium*, emphasizing those qualities that man as man cannot share. In the *Compendium*, every human being plays a mediating role in the return of creation into God; Christ is conceived as the limit of the human species, who as the most perfect human being plays the most perfect role. Thus Christ is conceived in the perspective of his human nature. In his commentary on the *Sentences*, however, Heymericus conceives Christ primarily in terms of his divine nature, and thus emphasizes Christ's absolute uniqueness as mediator.

In sum, Heymericus makes Christology an integral part of a philosophical, largely neo-Platonic, worldview. Within the limits of orthodoxy, he considers Christ as the turning point of the going forth and return (*exitus et reditus*) of creation. As stated, Heymericus was the protagonist of Albertism in Cologne.[56] Yet nowhere does he defend particular doctrines of Albert the Great's theological Christology against the teachings of other schools. Rather, in his search for the fundamental structure of reality, in which Christ plays the central role, what Heymericus learned from Albert were certain philosophical notions, notably the theory of emanation and the godliness of the human intellect.[57] This godliness of intellect is perfectly realized in Christ, who is the perfection of the human species; in his commentary on the *Sentences*, Heymericus makes clear that divinity is uniquely exemplified by Christ, who is not merely godlike, but God himself.

NICOLAUS CUSANUS

The tendency to employ a theological truth as a keystone in metaphysics culminates in the thought of Nicolaus Cusanus, whose *De docta ignorantia* presents an extensive discussion about Christ and his place in the universe.[58] As is now well known, Cusanus was influenced strongly by the writings of Heymericus de Campo and the Albertist tradition.[59] This is especially true concerning the matters we have been discussing. Like Heymericus, Cusanus emphasizes the dignity of man as the image and likeness of God; indeed, man is a second God.[60] The human mind creates rational things just as God creates real beings.[61] Man encompasses the domains of the senses and the intellect, and can therefore be called a microcosm, standing at the midst of creation.[62] Christ is the most perfect human being. He is the primordial principle through which everything has been created and eventually will return into God. As the beginning and end of creation, he is the door by which everything emanates from God and through which everything will resolve into him. Only Christ can bridge the infinite distance between creation and Creator.[63] The dynamics of created reality, its *exitus et reditus*, can exist only through Christ, who unites finite human nature and

infinite divine nature and therefore can overcome the disjunction between creation and Creator. The Incarnation is thus the *conditio sine qua non* of neo-Platonic emanation.[64]

(1) *De docta ignorantia*

Cusanus finished *De docta ignorantia* in 1440, almost 20 years after Heymericus wrote his *Compendium.* As he remarks in the postscipt addressed to his friend Cardinal Cesarini, he is dissatisfied with the prevailing methods of theologizing and philosophizing and considers "learned ignorance" as a new and alternative approach for overcoming the limits of Scholastic discourse.[65] The book consists of three parts, which are approximately the same length. In the first book, Cusanus discusses God, who is the absolute and perfect unity that enfolds within itself all forms of being that possibly can exist. The second book is devoted to the created universe, which is the unfolding of the infinite being of the divine unity into all forms of finite being. The third book, finally, is concerned with Christ, who partakes both the absolute unity of God and the unfolded plurality of creation.[66]

The central purpose of *De docta ignorantia* is to investigate what man can know about reality and what the nature of human knowledge reveals about the structure of reality. First, Cusanus shows that man cannot have complete knowledge either of finite, created beings or of God. Knowledge is based on comparison. In the created universe, however, no two things are completely identical. All created realities differ from each other in an endless number of ways. Therefore, the human mind cannot comprehend the complete truth of created beings.[67] Moreover, the infinite is beyond human knowledge, for there is no proportion between the infinite and the finite, between God and creation.[68] Human knowledge therefore is basically ignorance and cannot possibily attain the complete truth of anything.

Rather than being the end of his speculation, however, this ignorance is the starting point of Cusanus's investigation. The proper understanding of the impossibility of reaching truth uncovers an important aspect of the structure of reality. Once this is understood, ignorance becomes learned ignorance (*docta ignorantia*).

Every finite and limited being, Cusanus argues, necessarily has a beginning and an end. No matter which two beings one chooses to compare, one is always larger than the other. This being larger or being smaller cannot actually go on endlessly, since then there actually would exist an infinitely large or an infinitely small being among finite beings, which would imply a contradiction: the finite cannot be infinite. This means that the finite must have a limit, the infinite, which necessarily is beyond the domain of the finite. The finite world of creation, therefore, reveals the infinite world of the absolute.[69] Likewise, the human intellect, which is finite and never grasps truth so precisely that it could not be grasped infinitely more precisely, presupposes in its search for truth the existence of the infinite, which as an a priori makes finite, incomplete and thus 'ignorant knowledge' possible.[70]

The very nature of ignorant knowledge, therefore, makes known that there must exist two different worlds. One world is finite and marked by the diversity of things that are always susceptible of more or less, without ever being the greatest possible or

the smallest possible. This world is the domain of inequalities and creation. The other world is infinite and characterized by the absolute unity of infinity, which comprehends both the greatest possible and the smallest possible and is identical with God. The relationship between the two worlds is that of unity and plurality, or of the measurer and the thing measured. The infinite is the measurer of the finite and therefore the enfolding (*complicatio*) and unity of the plurality of created being. Consequently, the finite created universe is what it is by reason of the infinite unity, which, however, cannot be a part of it.[71] Taken as such, this condition is an 'impossibility', since there is no proportion between the infinite and the finite. There needs to be a mediator, who partakes in both worlds and brings them together.

(2) *Christus mediator*

What kind of being must the mediator be? He must be the most perfect representative of a species that in its nature comprehensively includes all created realities, material as well as spiritual, that is, he must be the ultimate representative of the species of man. This one most perfectly possesses everything that creation has, because he is the perfection of all things, in whom all things rest as in their proper perfection. This means that he cannot *only* be limited and contracted as are all other created beings, since then he would not represent the unity of the created universe in a perfect way. Yet, he also cannot be *completely* identical with the absolute truth and unity that is God, as God is no part of creation. He therefore must be both limited and absolute, both man and God. He is the Christ, who in the unity of his person combines the finite nature of man and the infinite nature of God.[72] Because of the unity of finiteness and infinity, Christ can be the mediator of creation and God. He is the only road that brings creation back to its primordial cause. Only he can resolve the plurality of creation in the unity of God.

Cusanus's investigation of the significance of the Incarnation in the third book of *De docta ignorantia* is the culmination of his treatment of human thought as it progresses from speculation about God (book 1) and discussion of the universe (book 2) to their reconciliation in Christ. For him, the mystery of the Incarnation is the summit of our metaphysical speculation about reality.

CONCLUSIONS

The texts that I have examined disclose two distinct approaches to Christological questions: a traditional, Scholastic manner of reasoning, exemplified by the *Quaestiones vacantiales*, and an attempt to establish a new framework for thinking about the metaphysical structure of reality, exemplified by the writings of Heymericus de Campo and Nicolaus Cusanus.

The *Quaestiones vacantiales* held at the University of Cologne in 1465 reveal how young theologians were trained to defend and pass on traditional doctrines that originated in the thirteenth century. These doctrines were by no means identical. Within the limits of orthodoxy there existed many contending (and conflicting) schools of thought. Albertists, Thomists and Scotists all had their own understanding of how to

deal with the main issues of Christology. In the fifteenth century, 'tradition' was understood as the tradition of a particular school of thought. One should note that in these questions, although dialectical techniques and philosophical concepts are involved, the treatment of the Incarnation is kept in its own theological order.

Heymericus and Cusanus developed a more innovative approach. Both incorporate fully the theological truth of the Incarnation into their philosophical speculations about reality.[73] For them, Christ, who is both God and man, is the mediator between God and creation, the pivotal point of reality through which creation flows forth from its source and returns to its first principle. The theological truth of the Incarnation is not just a corollary to speculative metaphysics, but a necessary aspect of the structure and movement of the universe. Did not the twofold nature united in Christ exist, no return of the universe into its primordial cause would be possible or conceivable, either philosophically or theologically.

The centrality of the idea of *Christus mediator* for Heymericus and Cusanus distinguishes their thought from that reflected in the *Quaestiones vacantiales*, in which Christ's role as mediator is mentioned but not elaborated. Although Heymericus, as I have said, was a leading protagonist of late-medieval Albertism,[74] he and Cusanus, who was indebted to him, developed their thinking independently from the disputes of the schools. Thus it would appear that tradition, in the strict sense, was nourished in the schools, and innovation and renewal took place outside of them. The example of Heymericus de Campo suggests that the Albertist school served as a mediator between the old and the new.[75]

Moreover, there is a great difference in style and format between the *Quaestiones vacantiales* on the one hand and the *Compendium divinorum* of Heymericus and Cusanus' *De docta ignorantia* on the other. The *Quaestiones* are clearly the product of long Scholastic tradition, whereas the other two treatises resemble more the works of the modern period. Their style and argumentation is free and not dominated by the structure of the Scholastic disputation. This difference suggests that there is a parallel between style and content, that is, that the differences between the traditional thought reflected in the *Quaestiones* and the innovative approach of Heymericus and Cusanus is a function of differences in the format and structure of the writings. This, however, is only partially the case. Heymericus's commentary on the *Sentences* illustrates the urge for a new way of thinking, yet the work has exactly the same structure as the *Quaestiones vacantiales*. One may not conclude, therefore, that content necessarily determined format, or vice versa.[76]

Furthermore, in their different agendas, approaches, styles and understandings of tradition, the Christological writings we have studied mirror the diversity of fifteenth-century intellectual life inside and outside the schools. The philosophical background of Christology has proved to be a touchstone for discovering the kaleidoscope of late-medieval intellectual culture.[77]

That questions about the Incarnation continued to be central in the discussions of the schools is not surprising; that the Incarnation played a central role in two of the most innovative philosophies of the time perhaps is. Interestingly, both the *Quaestiones vacantiales*, on the one hand, and the writings of Heymericus de Campo and Nicolaus Cusanus, on the other, were nourished by medieval Dominican teachings about

Christ. The *Quaestiones* reveal the continued—or rather, revived—interest in the doctrine of Thomas Aquinas at the end of the Middle Ages, whereas the writings of Heymericus and Cusanus acknowledge a keen interest in philosophical ideas of Albert the Great, which were were not incompatible with the uniqueness of Christ but in fact required it. For the cosmos envisioned by Albert, passed on by the Albertists, and developed by Heymericus de Campo and Nicolaus Cusanus, demanded the figure of Christ at the center of created reality, lest there be no bridge between the finite and the infinite, and lest man's desire for perfection be vain. In a real sense, then, the Dominican tradition was the birthplace *par excellence* of what dominated the setting of fifteenth-century Christology: the opposition between tradition and renewal.[78]

NOTES

1. On the fifteenth century, see with extensive bibliographies, E. Meuthen, *Das 15. Jahrhundert*, 2nd ed. (Oldenbourg Grundriss der Geschichte 9, Munich, 1984), and the more recent *Handbook of European History 1400–1600. Late Middle Ages, Renaissance and Reformation*, ed. Th. A. Brady, H. A. Oberman and J. D. Tracy, 2 vols. (Leiden, 1994–1995).

2. The medieval schools of thought are discussed in W. J. Courtenay, *Schools and Scholars in Fourteenth-Century England* (Princeton, 1987); Z. Kaluza, *Les querelles doctrinales à Paris. Nominalistes et realistes aux confins du XIVe et du XVe siècles* (Quodlibet 2, Bergamo, 1988); G.-R. Tewes, *Die Bursen der Kölner Artisten-Fakultät bis zur Mitte des 16. Jahrhunderts* (Studien zur Geschichte der Universität zu Köln 13, Cologne, 1993).

3. See among many other studies, *Nicholas of Cusa In Search of God and Wisdom*, ed. G. Christianson and T. M. Izbicki (Studies in the History of Christian Thought 45, Leiden, 1991); *Rodolphus Agricola Phrisius 1444–1485*, ed. F. Akkerman and A. J. Vanderjagt (Brill's Studies in Intellectual History 6, Leiden, 1988); *Wessel Gansfort (1419–1489) and Northern Humanism*, ed. F. Akkerman, G. C. Huisman and A. J. Vanderjagt (Brill's Studies in Intellectual History 40, Leiden, 1993).

4. Marsilius of Inghen is a case in point. He was one of the most important logicians of the late fourteenth century. Yet, in his theological masterpiece, the commentary on the *Sentences*, delivered in Heidelberg in the years 1392–1394, he no longer uses logic extensively to analyze and solve theological problems, as did Adam Wodeham, Robert Holcot and Gregory of Rimini in their earlier commentaries. In several places, Marsilius criticizes a logical approach in theology, because theology should be a work of piety and edification (*scientia pietatis*) and not of logical superstition (*superstitio logicalis*). See H. A. G. Braakhuis and M. J. F. M. Hoenen, "Marsilius of Inghen: a Dutch Philosopher and Theologian," in *Marsilius of Inghen* (Acts of the International Marsilius of Inghen Symposium, Nijmegen, 18–20 December 1986), ed. H. A. G. Braakhuis and M. J. F. M. Hoenen (Artistarium Supplementa 7, Nijmegen, 1992), 1–11, esp. 10, and the remarks of Z. Kaluza in *Revue des Sciences Philosophiques et Theologiques* 75 (1995): 150f. Marsilius has been considered a nominalist and a proponent of the *via moderna*. Yet, among the main sources of his commentary of the *Sentences* are such realist authors as Bonaventure and Thomas Aquinas. Concerning Marsilius's sources, see my "Der Sentenzenkommentar des Marsilius von Inghen (†1396). Aus dem Handschriftenbestand des Tübinger Wilhelmsstift," *Theologische Quartalschrift* 171 (1991): 114–29, esp. 125–29, and *Marsilius of Inghen. Divine Knowledge in Late Medieval Thought* (Studies in the History of Christian Thought 50, Leiden, 1993).

5. On the fifteenth-century schools of thought, see my "Late Medieval Schools of Thought in the Mirror of University Textbooks. The *Promptuarium Argumentorum* (Cologne 1492)," in *Philosophy and Learning. Universities in the Middle Ages*, ed. M. J. F. M. Hoenen, J. H. J. Schneider and G. Wieland (Education and Society in the Middle Ages and the Renaissance 6, Leiden, 1994), 329–69, and "The *Reparationes totius philosophiae naturalis* (Cologne 1494) as a Source for the Late-Medieval Debates between Albertistae and Thomistae," *Documenti e studi sulla tradizione filosofica medievale* 4 (1993): 307–44.

6. Many authors of the late fourteenth and early fifteenth centuries, such as Heymericus de Campo and Nicolaus Cusanus, returned to the writings of the twelfth century. On twelfth century thought, see *A History of Twelfth-Century Western Philosophy*, ed. P. Dronke (Cambridge, 1988), and *Aufbruch, Wandel, Erneuerung. Beiträge zur 'Renaissance' des 12. Jahrhunderts*, ed. G. Wieland (Stuttgart, 1995). The influence of Ramón Llull is studied in J. N. Hillgarth, *Ramon Lull and Lullism in Fourteenth-Century France* (Oxford, 1971), and E. Colomer, *Nikolaus von Kues und Raimund Llull* (Quellen und Studien zur Geschichte der Philosophie 11, Berlin, 1961).

7. See my *Speculum philosophiae medii aevi. Die Handschriftensammlung des Dominikaners Georg Schwartz († nach 1484)* (Bochumer Studien zur Philosophie 22, Amsterdam, 1994). On Dominican education, see A. Walz, *Compendium historiae Ordinis Praedicatorum* (Rome, 1948), 210–26; W. A. Hinnebusch, *The History of the Dominican Order. II: Intellectual and Cultural Life to 1500* (New York, 1973); D. Berg, *Armut und Wissenschaft. Beiträge zur Geschichte des Studienwesens der Bettelorden im 13. Jahrhundert* (Geschichte und Gesellschaft: Bochumer Historische Studien 15, Düsseldorf, 1977).

8. Eichstätt, Universitätsbibliothek, Cod. st 688, fol. 258r: "Sequentes quaestiones sunt disputatae tempore vacantiarum Coloniae anno 1466. . . . " See also fol. 261r: "Infrascriptae positiones disputatae sunt tempore vacantiarum in scolis theologorum anno domini 1465, quando eram studens Coloniensis, quibus interfui. . . . " A biography of Georg Schwartz is provided in my *Speculum philosophiae medii aevi*, 11–29.

9. On the *Quaestiones vacantiales* in Cologne, see F. Gescher, "Die Statuten der theologischen Fakultät an der alten Universität Köln," in *Festschrift zur Erinnerung an die Gründung der alten Universität Köln im Jahre 1388* (Cologne, 1938), 71f. (earliest statutes): "Item ordinamus, quod in vacationibus magnis fiant disputationes per bacalarios ad modum, quo Parisius fiunt in collegio de Sorbona, scilicet singulis sextis feriis de mane, nisi festum impediat; et tunc fiant alia die eiusdem septimane convenientiori. Et sit presidens magister in artibus secularis et saltem studens in theologia." See also vol. 1 of F. von Bianco, *Die alte Universität und die spätern Gelehrten-Schulen dieser Stad* (Cologne, 1855): Anhang, 36f, and G. M. Löhr, *Die theologischen Disputationen an der Universität Köln im ausgehenden 15. Jahrhundert nach den Angaben des P. Servatius Fanckel OP* (QF 21, Leipzig, 1926), 17–19. As it appears from the statutes, the *Quaestiones vacantiales* took place under the direction of a master of the arts faculty who studied theology. The subjects for discussion were not arbitrarily chosen. They were drawn from the *Sentences* of Peter Lombard, at least in the period with which we are dealing.

10. Löhr, *Die theologischen Disputationen*, 13, 18.

11. See, e.g., Eichstätt, UB, Cod. st 688, fol. 258r: "Haec positio est secundum viam Scotistarum posita."; fol. 262r: "Hanc positionem posuit Scotista et mirabiliter fuit confusa"; fol. 264v: "Hanc positionem posuit quidem Albertista."

12. The following three questions deal with Christology: *Quaestiones vacantiales* 1465, qq. 6–7 (= Eichstätt, UB, Cod. st 688, fols. 263r–264v), and *Quaestiones vacantiales* 1466, q. 8 (= Ibid., fol. 259v).

13. The complete text of the question is given in Appendix 1. The other two questions are titled: "Utrum christus, qui in primo sue conceptionis instanti sibi et nobis meruit nostrosque defectus assumens, sua nos acerbissima liberavit passione" (= 1465, q.7) and "Utrum verbum dei prius aeternum in tempore caro factum sit gratia et veritate plenum" (= 1466, q.8).

14. All of the questions from the *Quaestiones vacantiales* as recorded by Schwartz have a similar structure. First Schwartz gives the question that is at stake together with the answer. The answer is made up of three parts, which are designated as *materia* or *discursus* and designed as a syllogism with *maior, minor* and *conclusio*. The whole answer thus consists of nine propositions. The Latin of the *quaestio* and the responding propositions is more complicated than the Scholastic latin of the foregoing period, undoubtedly bearing witness to the influence of humanism. After the initial question and its threefold syllogistic answer, which are both in a large handwriting, follows an account of the discussion between opponent and respondent. This part of the disputation is in a much smaller writing and sometimes difficult to read, but the Latin is uncomplicated and straightforward. (For the difference in handwriting, see Appendix I and fig. 71.) Most of the objections raised by the opponent concern the syllogistic propositions that are part of the answer. In some cases, however, the target of the objections is unclear. It is not unlikely that these objections attack the underpinnings of the syllogisms, which unfortunately have not been reported by Schwartz. Also, in a number of cases an objection has more than one answer. This does not necessarily mean that the respondent gave several replies. Other *quaestiones vacantiales* that have survived from the period show that time and again the opponents became involved in a discussion, thereby acting like the respondent (see Löhr, *Die theologischen Disputationen*,

18). This means that if there are several answers, only one was given by the actual respondent, the others were given by the opponents. The account of the discussion, especially the part that is in the small handwriting, gives a vivid picture of the disputation. Yet, it is not an immediate account, at least not the version that has survived in the manuscript. This is clear from two additions that are written in the margins (see the notes to Appendix 1). These additions do not present additional arguments, but arguments that belong to the structure of the text and which Schwartz initially must have overlooked when he wrote down the dicussion as we have it in the version of the manuscript. Obviously, Schwartz first made a draft version during the discussion, which is now lost. Afterwards he wrote the final text that we find in the manuscript.

15. Appendix I, 481–82.

16. Appendix I, 482–85.

17. Eichstätt, UB, Cod. st. 688, fol. 263v (q.6): "Probauit [scilicet opponens] per Aristotelem, qui dicit quod actus non terminantur ad relationem."

18. See E. Meuthen, *Die alte Universität* (Kölner Universitätsgeschichte 1, Cologne, 1988), and Tewes, *Die Bursen der Kölner Artisten-Fakultät.*

19. This collection is partially edited in Löhr, *Die theologischen Disputationen,* 33–73. On Sebastian Fanckel, see Löhr, 1–3.

20. Löhr, *Die theologischen Disputstionen,* 69 n° 125: "Nota. Dicunt Albertiste contra Thomistas, quod una natura humana numero non potuit assumi a tribus personis; quod natura humana in Christo non sit individuata propria individuacione, sed individuacione verbi; non ponunt in Christo scienciam acquisitam distinctam ab alia sciencia, scilicet indita."

21. John Duns Scotus, *Quaestiones in Lib. III Sententiarum* d.1 q.2, *Opera omnia* 7/1 (1639): 36–37 n° 5: ". . . non videtur quod una natura possit simul assumi a tribus personis, quia in omni dependentia essentiali unum dependens non dependet praecise nisi ad unum, quod totaliter terminat eius dependentiam."

22. That according to fifteenth-century theologians there was a serious opposition between Thomas and Duns Scotus on this issue is emphasized by Johannes Capreolus, who contraposes both opinions in his *Defensiones theologiae divi Thomae Aquinatis* 3 d.1 q.1, ed. C. Paban and Th. Pègues, vol. 5 (Tours, 1904), 2, 4–5, 8–9.

23. Eichstätt, UB, Cod. st 688, fol. 263v (to facilitate the reading, I will indicate the division of the question by using headings between brackets, here and in the following notes): "[Quaestio] Vtrum autem tres persone potuissent assumere unam naturam. [Ratio opponentis] Videtur quod non. Si assumerent tres persone unam naturam, videretur quod illa terminaretur ad tria supposita et sic efficeretur tria supposita distincta secundum suppositorum distinctionem. [Responsio respondentis] Respondit quod [quod] sic non fuisset distincta secundum rationem suppositalem, sed quantum ad unam rationem communem fuisset terminata et absolutum suppositum unum."

24. Thomas Aquinas, ST 3 q.3 a.6 corp.: "Est autem talis divinarum personarum conditio quod una earum non excludit alium a communione eiusdem naturae, sed solum a communione eiusdem personae." See the same question ad 2: ". . . illa positione facta, humana natura esset assumpta in unitate non unius personae, sed in unitate singularum personarum, ita scilicet quod, sicut divina natura habet naturalem unitatem cum singulis personis, ita natura humana haberet unitatem cum singulis per assumptionem."

25. Eichstätt, UB, Cod. st 688, fol. 263v: "[Quaestio] Vtrum natura humana habet proprium esse in supposito. [Ratio opponentis] <Videtur quod sic.> Natura humana in Christo, ex hoc quod est substantia ex se, et natura sua habuisset suppositationem et esse actualis existentiae, sed fuit praeventa et assumpta in suppositationem divini suppositi. Et si reliqueretur a divina essentia, suppositaretur per se. [Responsio respondentis] Responsum fuit quod habet esse essentiae, sed esse existentiae habet a potentia divina. [Ratio opponentis altera] Sed arguit: Sequeretur quod natura Christi fuisset imperfectior natura nostra, quia aliquid positiuum defuit illi naturae, scilicet existentia propria vel esse et sic caret aliqua entitate quam natura nostra habet. [Responsio respondentis altera] Dixit quod habet quid perfectius, quia esse divinum, quo existit, quod esse divinum suppositat essentiam humanam in Christo."

26. John Duns Scotus, *In III Sent.* d.6 q.1 (*Opera omnia* 7/1: 174 n° 4): ". . . natura humana unita Verbo non informatur a Verbo, sed manet simpliciter distincta. Vel igitur nullum esse habet, vel aliquod esse proprium."

27. Thomas Aquinas, ST 3 q.17 a.2 corp.: ". . . cum humana natura coniungatur Filio Dei hypostatice vel personaliter, ut supra dictum est et non accidentaliter, consequens est quod secundum humanam naturam non adveniat sibi novum esse personale, sed solum nova habitudo esse personalis

praeexistentis ad naturam humanam; ut scilicet persona illa iam dicitur subsistere, non solum secundum divinam naturam, sed etiam humanam." On Thomas's position, see Appendix 2, "Unity of existence in Christ," in vol. 50 of Thomas Aquinas, *Summa theologiae*, ed. Blackfriars (London, s.d.), 221–28. Again, the positions put forward by Thomas and Duns Scotus on the unity of Christ's existence are contrasted by Johannes Capreolus, *Defensiones theologiae* 3 d.6 q.1 (5: 111–13, 115–19), which shows that the opposition between the Thomistic and Scotistic view on the issue was at the center of interest. The appearance of the discussion in the *Defensiones* of Capreolus might explain why the opponent raised the objection against our respondent. As is witnessed by the notes of Sebastian Fanckel, the *Defensiones* of Capreolus were used as a source in the debates at Cologne. See Löhr, *Die theologischen Disputationen*, 82 n° 185: " . . . sed solvit secundum Capreolum, qui tenet. . . . "

28. John Duns Scotus, *In III Sent.* d.7 q.3 (*Opera omnia* 7/1: 202 n° 3), and *Reportata Parisiensia* 3 d.7 q.4, *Opera omnia* 11/1 (1639): 451 n° 4: "Dico tamen quod lapsus non fuit causa praedestinationis Christi, imo si nec fuisset Angelus lapsus, nec homo, adhuc fuisset Christus sic praedestinatus, imo, et si non fuissent creandi alii quam solus Christus."

29. Eichstätt, UB, Cod. st 688, fol. 263v: "[Ratio opponentis] Christus etiam bene fuisset incarnatus si homo non peccasset, quia caritate est incarnatus et dilectione hominis. Sed haec fuisset etiam si homo non peccasset. [Responsio respondentis] Respondit quod caritatem illam non oportuisset ostendisse per incarnationem, sed per alia opera caritatem illam ostendisset. [Ratio opponentis] Contra: Adhuc fuisset conveniens, quia fuisset dignificata sicut et nunc ipsa natura humana. [Responsio respondentis] Dicendum quod si non peccasset, non fuisset opus eam sic dignificari, quia modo sufficienter(?) in dignitate constituta(?) erat et creata. [Ratio opponentis] Item, perfectio universi non debuit oriri ex culpa. Sed per incarnationem universum est perfectum et ita factum est ex peccato. [Responsio respondentis] Responsum fuit quod si Deus non fuisset incarnatus in Christum, universum <non> fuisset perfectum, licet aliquo modo. Et ex peccato non uenit perfectio universi tamquam ex causa propria, sed quasi ex occasione, quia Deus perfecit universum per suam incarnationem: quia homo erat miser, ideo indigebat reparatione et sic occasio fuit incarnationis."

30. See the text [responsio respondentis] quoted in note 29.

31. Thomas Aquinas, ST 3 q.1 a.3 corp.: " . . . Unde, cum in sacra Scriptura ubique incarnationis ratio ex peccato primi hominis assignetur, convenientius dicitur incarnationis opus ordinatum esse a Deo in remedium peccati, ita quod, peccato non existente, incarnatio non fuisset. Quamvis potentia Dei ad hoc non limitetur, potuisset enim, etiam peccato non existente, Deus incarnari."

32. Unlike *Quaestiones disputatae* or *Quaestiones quodlibetales*, *Quaestiones vacantiales* were not published in any revised form, probably because there was no *determinatio magistri*. The anonymous *Promptuarium argumentorum*, Cologne 1492, in the preface of which the author refers to a dispute "tempore vacationis covenientis," is not an account of a regular *Quaestio vacantialis*. See my "Late medieval Schools of Thought," 346f.

33. One should keep in mind that not only *baccalaurii* participated in the discussion, but also masters and other members of the teaching community. It is therefore not because of the educational level of the *baccalaurii* that the problems discussed are largely based on a well-established tradition. What is more, the same discussions and arguments appear in Johannes Capreolus's *Defensiones theologiae* (see notes 22 and 27 above), which certainly is not an elementary work. On the *Defensiones theologiae*, see vol. 3 of M. Grabmann, *Mittelalterliches Geistesleben. Abhandlungen zur Geschichte der Scholastik und Mystik*, ed. L. Ott (Munich, 1956), 370–410.

34. The same goes for an anonymous *Quaestio assignata* on predestination which survives in the manuscript collection of Georg Schwartz as well (Eichstätt, Universitätsbibliothek, Cod. st 684, fols. 263v–269r). In that question, a large number of arguments are taken verbatim from Thomas Aquinas's *Summa theologiae*, even the *rationes contra*, without mentioning the source. I edited the question in my *Speculum philosophiae medii aevi*, 114–30.

35. The significance of this treatise for our understanding of the debates between the schools is demonstrated by G. Meersseman, *Geschichte des Albertismus II: Die ersten Kölner Kontroversen* (Dissertationes Historicae 5, Rome, 1935). As to the dating, see Meersseman, 24. The most recent discussions of Heymericus's career are J.-D. Cavigioli, "Les écrits d'Heymericus de Campo (1395–1460) sur les ouvres d'Aristote," FZPhTh 28 (1981): 289–371, esp. 296–311; Tewes, *Die Bursen der Kölner Artisten-Fakultät*, 903f. (index), and my "Academics and Intellectual Life in the Low Countries. The University Career of Heymeric de Campo (†1460)," RTAM 61 (1994): 173–209.

36. Heymericus's metaphysics is discussed in Colomer, *Nikolaus von Kues*, 9–39; R. Haubst, *Das Bild des Einen und Dreieinen Gottes in der Welt nach Nikolaus von Kues* (Trierer Theologische Studien 4, Trier, 1952), 344 (index), and my *Heymeric van de Velde. Eenheid in de tegendelen* (Geschiedenis van

de Wijsbegeerte in Nederland 4, Ambo-Baarn, 1990). On the problem of Heymericus's sources, which as a rule are quoted *ad sensum* and not verbatim, see my "Heymeric van de Velde (†1460) und die Geschichte des Albertismus: Auf der Suche nach den Quellen der albertistischen Intellektlehre des *Tractatus Problematicus*," in *Albertus Magnus und der Albertismus. Deutsche philosophische Kultur des Mittelalters,* ed. M. J. F. M. Hoenen and A. de Libera (Texte und Studien zur Geistesgeschichte des Mittelalters 48, Leiden, 1995), 303–31.

37. The *Compendium* is edited by J. B. Korolec, "'Compendium divinorum' Heimeryka de Campo w rkp. BJ 695," *Studia Mediewistyczne* 8 (1967): 19–75; 9 (1968): 3–90. For its dating, see Korolec, "Quelques informations sur le 'Compendium divinorum' de Heimericus de Campo ainsi que sur un commentaire inconnu de ce 'Compendium'," *Mediaevalia Philosophica Polonorum* 10 (1961): 33–39, esp. 38.

38. Heymericus's commentary on the *Sentences* survives in Bernkastel-Kues, St. Nikolaus-Hospital, Cod. Cus. 106, fols. 13r–22r. Its Christology is briefly discussed in R. Haubst, *Die Christologie des Nikolaus von Kues* (Freiburg, 1956), 184. The dating is according to L. Burie, "Proeve tot inventarisatie van de in handschrift of in druk bewaarde werken van de Leuvense theologieprofessoren uit de xve eeuw," *Facultas S. Theologiae Lovaniensis 1432–1797,* ed. E. J. M. van Eijl (Bibliotheca Ephemeridium Theologicarum Lovaniensium 45, Louvain, 1977), 215–72, esp. 226.

39. On the first principle as treated in the *Compendium,* see J. B. Korolec, "Heymeric de Campo et sa vision néoplatonicienne de Dieu," in *Albert der Grosse. Seine Zeit, sein Werk, seine Wirkung,* ed. A. Zimmermann (Miscellanea Medievalia 14, Berlin, 1981), 208–16.

40. A lucid account of Albert's theory of emanation is given in Alain de Libera, *Albert le Grand et la philosophie* (Paris, 1990), 117–77 ("A la recherche de la vérité").

41. Heymericus de Campo, *Compendium divinorum* 3 (ed. Korolec, 3, lin. 39–43), and Mainz, Stadtbibliothek, Hs. I 614, fol. 231rb–va. In the passages that follow here and below, I checked the readings in the Korolec edition, which is based solely on Kraków, Biblioteka Jagiellońska, Cod. 695 (= K), against Mainz, SB, Hs. I 614 (= M). I have noted only the most important variants: "Primum namque ex plenitudine suae fontalitatis essentialis, quae est eius copiosa bonitas per appropriationem, eo quod diffusio et communicatio est proprietas bonitatis, habet fluxum ex se exuberantis, immo omnibus aliis incomparabiliter nobilius, quia virtutem suae fontalitatis non accipit ab alio, sicut fons aquarum et sol."

42. *Compendium divinorum* 4 (ed. Korolec, 64, lin. 1238–50), and Mainz, SB, Hs. I 614, fol. 257va–vb: " . . . hoc esse ingrediens [in *add.* M] universorum constitutionem, inaequalibus gradibus participatur, ut prius patuit, propter analogiam ei accrescentem ex parte secundae negationis unitatis, secundum quam dicitur componi ex finito et infinito, et minimam habens identitatem, immo hoc modo est radix omnis diversitatis formalis. Et secundum hos [hos M, hoc K] gradus analogiae procedens prima causa ex divitiis suis, quibus ad extra magis abundat, substituit diversas possibilitates tamquam susceptibilia ipsius esse sic in diversitate acti. Et ibi fundatur numerus principiorum cum diversitate et commensuratione eorundem. . . . " That what is unified on the higher level of being, is multiplied on the second, is demonstrated by Heymericus in the first book of the *Compendium* (ed. Korolec, 65, lin. 309–13), and Mainz, SB, Hs. I 614, fol. 222rb: " . . . nobilitas essendi, quae praeexistit in causa causaliter et universaliter et simpliciter, est in effectu participative et particulariter et compositive secundis, secundum diversos modos existendi causae et effectus. . . . "

43. The plenitude of the universe manifests itself in three fundamental levels of created being. See *Compendium divinorum* 3 (ed. Korolec, 30, lin. 720–29), and Mainz, Hs. I 614, fol. 239va–vb: " . . . universitas substantiarum est ab uno primo simplici per suam essentialem virtutem ipsas substantiante [substantiante K, substantificante M] et ordinante; ergo est in eis triplex portio talis ordinis, quarum prima continet substantias primo similiores, ultima dissimiliores, et media medio modo se habentes. Itaque, cum prima causa sit substantia intellectualis aeterna et divina, in qua est pura actualitas, erunt substantiae primi ordinis pure intellectuales et divinae et aeternae et actualitatis [et actualitatis K, intellectualitatis M] participativae; de ultimo ordine materiales corruptibiles [corruptibiles K, corporeae M], in quibus esse divinum minime lucet, quinimmo vinciuntur [vinciuntur K, vincantur M] a potentiae ignobilitate; de medio vero ordine sunt substantiae medio modo se habentes." According to the same principle, these three main levels of created being are each divided into three sublevels, and so forth, thus constituting the whole of the created universe. The threefold structure of reality in the thought of Heymericus is dealt with in my "Trinität und Struktur des Seins. Der Traktat 'De signis nocionalibus trinitatis et unitatis superne' und seine Bedeutung für unser Verständnis vom trinitarischen Weltbild des Heymericus de Campo," forthcoming in the Zenon Kaluza Festschrift.

44. Heymericus uses as an example the individuals of the species 'man'. See *Compendium divi-*

norum 4 (ed. Korolec, 51, lin. 699–704), and Mainz, SB, Hs. I 614, fol. 250vb: " . . . in singulis individuis speciei humanae est ordo gradualis, cuius gradus designantur [designantur M, designatur K] per potentias naturales et accidentia naturalia in uno quam in alio validiora. Ex quo patet, quod secundum praehabita in omni ordine est primum, quod est aliorum metrum. Quod similiter in ordine individuorum est unum primum individuum illius speciei."

45. The above text continues as follows (ed. Korolec, 51, lin. 704–6), and Mainz, SB, Hs. I 614, fol. 250vb: "Et hoc est [individuum *add.* M], in quo forma perfectissime vincit materiam in illo ordine, ut in specie humana est tale primum 'Christus homo', quamvis non fuerit primus homo secundum viam generationis."

46. A similar point is put forward by Richard Fishacre, as is shown by R. James Long in this volume, 332–43.

47. *Compendium divinorum* 4 (ed. Korolec, 80, lin. 1893f.)

48. *Compendium divinorum* 4 (ed. Korolec, 80, lin. 1876–80), and Mainz, SB, Hs. I 614, fol. 265va–vb: "Cum quidem lumen et motus ita disposuerunt materiam, ut sit contrarietas maxime confracta [confracta K, refracta M] ad instar qualitatis [qualitatis K, aequalitatis M] complexionis caelestis, quae in genere complexionum est divina, quia stans per seipsam, tunc resultat imago Dei in imagine divini corporis, et divinae complexionis, ut, sicut divinum divino, ita imago divini imagini divini adaptetur." The theory of the disposition of matter by the movements of the heavens goes back to Avicenna, *Liber de philosophia prima sive scientia divina* tr.9 c.5, ed. S. van Riet, vol. 2 (Leiden, 1980), 488–94. It is also maintained by Albert the Great, as is shown by B. Nardi, "La dottrina d'Alberto Magno sull'inchoatio formae," in (Nardi) *Studi di filosofia medievale* (Rome, 1960), 69–101, and L. Sturlese, *Die deutsche Philosophie im Mittelalter. Von Bonifatius bis zu Albert dem Grossen 748–1280* (Munich, 1993), 358f.

49. *Compendium divinorum* 4 (ed. Korolec, 81, lin. 1937–40), and Mainz, SB, Hs. I 614, fol. 266va: "Et per hanc intellectus perfectionem [namely, the highest degree of human knowledge] ordinatur homo ad illuminationem intelligentiarum et primae causae participative per sui luminis sic formati lumini intelligentiae et primae causae applicationem." For the background of this theory of knowledge, which was developed by Albert the Great on the basis of his reading of Averroes, see B. Mojsisch, "La psychologie philosophique d'Albert le Grand et la théorie de l'intellect de Dietrich de Freiberg. Essai de comparaison," *Archives de Philosophie* 43 (1980): 675–93; De Libera, *Albert le Grand*, 215–66; Hoenen, "Heymeric van de Velde (†1460) und die Geschichte des Albertismus," 313–20.

50. *Compendium divinorum* 4 (ed. Korolec, 80, lin. 1887–92), and Mainz, SB, Hs. I 614, fol. 265vb: " . . . anima rationalis dicitur imago Dei, eo quod, sicut Deus est intellectus universaliter agens res in esse [in esse *om.* K] reali, ita intellectus animae rationalis in esse intelligentis, quo modo dicit Philosophus in tertio De anima, quod anima rationalis habet intellectum agentem, quo est omnia [omnia M, animam K] facere, habet et intellectum possibilem, tamquam regionem universalem, in quo omnia formantur [omnia formantur M, anima formatur K] in esse intelligibili."

51. *Compendium divinorum* 4 (ed. Korolec, 80, lin. 1898–96), and Mainz, SB, Hs. I 614, fol. 266ra: "Item: anima rationalis exserit vitam, qua universitas entium, homini [homini M, hominum K] subiectorum, appetit frui et sic in suo genere felicitari; cum enim unumquodque bonum appetit, inquantum est species primi boni, non [boni non *om.* K] quietatur appetitus singulorum perfecte, nisi in primi boni fruitionem radicatur; hoc autem est impossibile in entibus corporalibus homini subiectis quoad eorum entitatem et operationem realem, ut manifestum est; possibile tamen est quoad esse intellectuale in homine, in quo est intellectus divinus habens sub se vires corporeas, species corporeas intellectui adaptando; ergo in homine quaerit felicitari, et sic patet, quod anima est imago primae causae inquantum est felicitatis obiectum."

52. *Compendium divinorum* 4 (ed. Korolec, 81, lin. 1916–48), and Heymericus de Campo, *Problemata* probl. 13 (Cologne, 1496; Hain n° 4302), fols. 40r–44v.

53. I provide an edition of the Christological questions from Heymericus's commentary on the *Sentences* in Appendix II.

54. Heymericus de Campo, *Quadripartitus quaestionum supra quattuor libros Sententiarum* q.9 (Bernkastel-Kues, St. Nikolaus-Hospital, Cod. Cus. 106, fol. 15v): "Divinae praedestinationis impleto tempore ut homo Deus fieret, nectuntur gratuite, peccatum quos seiunxerat. Hic universi circulus dumtaxat finiri debuit in arte conditoris. Quem perfecit Deus trinus opere appropriato sancti Spiritus."

55. Heymericus, *Quadripartitus* q.10 (fol. 16r): "Peccatum instinctu naturae creaturae potentissime contra Deum voluntarie per peccatum totamque speciem ad beatitudinem praedestinatam trahens in reatum est iuste et misericorditer expiabile per satisfactionem [! = satisfactorem?] eiusdem generis virtuositatis contrarie. Huiusmodi fuit peccatum hominis originale, per poenam et virtutum

merita satisfactoris irrei, tam iure belli quam pretii, expurgandum congruissime. Quomodo satisfacere, quia solus homo debuit et solus Deus potuit, Dei et hominis mediator Christus a diabolico peccato [peccata *scr.*] et pena meruit hominem liberare et eidem suoque corpori gloriam resurrectionis impetrare atque ianuam celi reserare."

56. See Meersseman, *Geschichte*, 10–22.

57. On the notion of the godliness of man as it was developed by Albert the Great and authors of the Albertist tradition, who on this point are largely dependent on Proclus and the *Corpus hermeticum*, see L. Sturlese, *Die deutsche Philosophie*, 378–88, and "Homo divinus. Der Prokloskommentar Bertholds von Moosburg und die Probleme der nacheckhartschen Zeit," in *Abendländische Mystik im Mittelalter. Symposion Kloster Engelberg 1984*, ed. K. Ruh (Germanistische Symposien: Berichtsbände 7, Stuttgart, 1986), 145–61.

58. Nicolaus Cusanus, *De docta ignorantia*, book 3. On the metaphysics of *De docta ignorantia*, see among others Haubst, *Das Bild des Einen und Dreieinen Gottes*, and K. Jacobi, *Die Methode der Cusanischen Philosophie* (Freiburg, 1969).

59. The relationship between Albertism and Cusanus has been studied by R. Haubst, "Albert, wie Cusanus ihn sah," in *Albertus Magnus. Doctor Universalis 1280/1980*, ed. G. Meyer and A. Zimmermann (Mainz, 1980), 167–94, and "Zum Fortleben Alberts des Grossen bei Heymerich von Kamp und Nikolaus von Kues," in *Studia Albertina*, ed. H. Ostlender (BGPTMA Supplementband 4, Münster, 1952), 420–47.

60. See Haubst, *Die Christologie*, 43.

61. P. Moffitt Watts, *Nicolaus Cusanus. A Fifteenth-Century Vision of Man* (Studies in the History of Thought 30, Leiden, 1982), 92.

62. Nicolaus Cusanus, *De docta ignorantia: De belehrte Unwissenheit* 3 c.3, ed. R. Klibansky and H. G. Senger (Philosophische Bibliothek 264c, Hamburg, 1977), 20 n° 198, and *De coniecturis: Mutmassungen*, ed. J. Koch and W. Happ (Philosophische Bibliothek 268, Hamburg, 1988), 168–70 nos 142–43.

63. Haubst, *Die Christologie*, 171.

64. On neo-Platonism in Cusanus, see W. J. Hoye, "The Meaning of Neoplatonism in the Thought of Nicholas of Cusa," *The Downside Review* 104 (1986): 10–18.

65. Nicolaus Cusanus, *De docta ignorantia* 3, Epistola auctoris (ed. Klibansky and Senger, 100 n° 264). As to Cardinal Julian Cesarini, see E. Meuthen, *Nikolaus von Kues 1401–1464. Skizze einer Biographie*, vierte Auflage (Münster, 1979), 13f.

66. Cusanus summarizes the three books of *De docta ignorantia* at the outset of the treatise, in book 1, chapter 2, ed. P. Wilpert and H. G. Senger (Philosophische Bibliothek 264a, Hamburg, 1979), 10–12 nos 5–7.

67. *De docta ignorantia* 1 c.3 (ed. Wilpert and Senger, 14 n° 10): "Non potest igitur finitus intellectus rerum veritatem per similitudinem praecise attingere. Veritas enim non est nec plus nec minus in quodam indivisibili consistens, quam omne non ipsum verum exsistens praecise mensurare non potest. . . . Intellectus igitur qui non est veritas numquam veritatem adeo praecise comprehendit, quin per infinitum praecisius comprehendi possit. . . . " The epistemology of the early Cusanus is studied by H. G. Senger, *Die Philosophie des Nikolaus von Kues vor dem Jahre 1440. Untersuchungen zur Entwicklung einer Philosophie in der Frühzeit des Nikolaus (1430–1440)* (BGPTMA N.F. 3, Münster, 1971).

68. *De docta ignorantia* 1 c.3 (ed. Wilpert and Senger, 12 n° 9): "Quoniam ex se manifestum est infiniti ad finitum proportionem non esse, est ex hoc clarissimum quod, ubi est reperire excedens et excessum, non deveniri ad maximum simpliciter, cum excedentia et excessa finita sint."

69. *De docta ignorantia* 1 c.6 (ed. Wilpert and Senger, 24 n° 15): "Ostensum est in praecedentibus omnia praeter unum maximum simpliciter eius respectu finita et terminata esse. Finitum vero et terminatum habet, a quo incipit et ad quod terminatur. Et quia non potest dici quod illud sit maius dato finito et finitum ita semper in infinitum progrediendo, quoniam in excedentibus et excessis progressio in infinitum actu fieri non potest, alias maximum esset de natura finitorum, igitur necessario est maximum actu omnium finitorum principium et finis. . . . Erit igitur maximum simpliciter, sine quo nihil esse potest."

70. Cf. *De docta ignorantia* 1 c.4 (ed. Wilpert and Senger, 16 n° 11).

71. *De docta ignorantia* 3 c.2 (ed. Klibansky and Senger, 12 n° 190): "Bene satis apertum est universum non nisi contracte esse plura, quae actu ita sunt quod nullum pertingit ad simpliciter maximum."

72. As Christ combines both the *maximum absolutum* (God) and the contracted world of crea-

tion, Cusanus considers him as the *maximum contractum*. See *De docta ignorantia* 3 c.2 (ed. Kliban-sky and Senger, 14 n° 192): "Et ex hoc manifestum est ipsum maximum contractum non posse ut pure contractum subsistere, secundum ea quae paulo ante ostendimus, cum nullum tale plenitudinem per-fectionis in genere contractionis attingere possit. Neque etiam ipsum tale ut contractum deus, qui est absolutissimus, esset; sed necessario foret maximum contractum, hoc est deus et creatura, absolutum et contractum. . . . " On Cusanus's Christology, see Haubst, *Die Christologie*; A. F. Forbes Liddell, "The Significance of the Doctrine of Incarnation in the Philosophy of Nicholas of Cusa," in *Actes du XIe Congrès International de Philosophie* (Amsterdam, 1953), 126–31; H. L. Bond, "Nicholas of Cusa and the Reconstruction of Theology. The Centrality of Christology in the Coincidence of Opposites," *Contemporary Reflections on the Medieval Christian Tradition. Essays in Honor of R. C. Petry*, ed. George H. Shriver (Durham, North Carolina, 1974), 81–94, and more recently U. Offermann, *Christus. Wahrheit des Denkens. Eine Untersuchung zur Schrift De docta ignorantia des Nikolaus von Kues* (BGPTMA N. F. 33, Münster, 1991), which contains a discussion of the literature on the subject, and *Nicholas of Cusa on Christ and the Church: Essays in Memory of Chandler McCuskey Brooks*, ed. G. Christianson and T. M. Izbicki (Studies in the History of Christian Thought 71, Leiden, 1996).

73. A third example will be discussed in Appendix 3. Although this approach bears on neo-Platonic Christology and therefore in a certain sense might be considered as 'traditional', compared to main-stream fifteenth-century thinking as preserved in the treatises on metaphysics and the many commen-taries on the *Sentences* it introduces a different and new method of dealing with Christological issues.

74. This reputation lasted well into the modern period. See, e.g., Peter Impens (†1523), *Chronicon Bethlemiticum* 5 a.12 §8: "Magister Heymericus de Campo, sacrae theologiae professor. Hic fuit opi-natissimus et celeberrimus sacrae theologiae professor et a Coloniensi universitate accersitus primus qui Lovanii magistralem sacrae theologiae cathedram summus albertista tenuit et in ea legit." See also J. Hartzheim, *Bibliotheca Coloniensis* (Cologne, 1747), 110b: "Doctrinam Alberti Magni, quae suo in Gymnasio florebat, strenuè voce & calamo propugnavit <Heymericus> contra Thomistas Bursae Mon-tanae."

75. The possible objection that the traditional manner of thought was nourished in the schools because of the preliminary level of education does not hold, as the same traditional style can be found in numerous other works of the period that are definitly mature, among which are the *Sentences* com-mentaries of Thomas Claxton, Henry of Gorkum, Johannes Capreolus, Gabriel Biel and Petrus Tartaretus.

76. See Appendix III below for a comparison between the *Sentences* commentary of Heymericus and the *Quaestiones vacantiales*. From the 1370s there was a shift from the Scholastic format to a more free style of writing. The exact reasons behind this change are difficult to pin down, as it is a complex development, which certainly has to do with changes in intellectual culture, the centers of which were no longer the universities and the *studia* of the religious orders, but the courts and the cities. For some interesting observations on the issue, see Courtenay, *Schools and Scholars*, 356–80, and Tewes, *Die Bursen de Kölner Artisten-Fakultät*, 665–805.

77. Some additional sources of fifteenth-century Christology are mentioned by S. Swieżawski, *Histoire de la philosophie européenne au XVe siècle*, adapt. M. Prokopwicz (Paris, 1990), 194–204.

78. Research for this paper has been funded by the Netherlands Organization for Scientific Re-search (NWO).

APPENDIX I

The Cologne *Quaestiones vacantiales*

Below, I give the complete text of the sixth question of the *Quaestiones vacantiales* that were held at the University of Cologne in the year 1465. The questions were recorded by the Dominican, Georg Schwartz, and are preserved in Eichstätt, Universitätsbibliothek, Cod. st 688, fols. 261r–266v; question 6 is written in fols. 263r–264r.

In the manuscript, a graphic distinction is made between the original question and its answer, and the account of the oral disputation. The question and its answer are written in a large hand, whereas the oral account is in a smaller writing (see fig. 71). This is not a peculiarity of Georg Schwartz. The same phenomenon can also be observed in other manuscripts in which *Questiones vacantiales* have been preserved, e.g., in the collection of Sebastian Fanckel (see G. M. Löhr, *Die theologischen Disputationen*, 4). I have preserved this distinction in the edition.

In the edition, the text of the opponent (*textus opponentis*) is printed in italic script; the text of the respondent (*textus respondentis*) is printed in roman script. I have retained the medieval orthography. Rejected readings are noted in the apparatus. Punctuation and capitalization are according to modern usage. Besides the abbreviations indicated in the table at the beginning of this volume, I have used the following signs:

< . . . > = words supplied by the editor
[. . .] = words that should be deleted
‖ . . . ‖ = indicates words written in the margin
~~example~~ = crossed out in the manuscript
<u>lemma</u> = denotes a lemma

* * *

Questionum vacantialium coloniensium
anno domini 1465

Questio VI

Vtrum filius dei in temporis plenitudine
sit incarnatus de uirgine

Prima materia

5 <Maior> Misit deus in carne uerbum suum ad sanandum genus humanum.
<Minor> Non est opus ualentibus medicus sed male habentibus, qui solum potuit et debuit esse christus, mediator dei et hominum.
<Conclusio> Quare solum post lapsum, dum infinitas hec homini innotuit nec alius medicus apparuit, christus ad sanandum hominem uenit.

10 #### Secunda materia
<Maior> Filium dei humanam naturam assumere conueniebat ex hominis necessitate et dignitate.
<Minor> Natura humana est ex carne et anima rationali composita.
<Conclusio> Igitur filius dei vere est incarnatus.

15 Tertia materia
<Maior> Ante partum, in partu et post partum beata uirgo immaculata fuit, que
uotum uirginitatis perpetue obtulit(?).
<Minor> Cui tamen congruebat uiro desponsari, qui sue uirginitatis esset testis
fidelis et nati filii nutritius.
20 <Conclusio> Igitur christus est de uirgine secundum carnis materiam non libid-
ine genitus.

 Arguitur primo contra primam primi discursus
Incarnare ordinatur erga remissionem peccatorum. Sed hec fuit per spiritum
sanctum. Ergo non filius debuit incarnari, sed spiritus sanctus.
25 Dicebat quod non solum per spiritum sanctum fit remissio peccatorum, sed
etiam per filium, quia opera trinitatis sunt indiuisa.
Et dixit quod filius terminat incarnationem, licet omnes tres persone concurrant
ad incarnationem effective, licet non terminative. Sed quod filius solus terminat
incarnationem sit ex uoluntate diuina. Et ratio potest esse, quia prius homo pec-
30 cat appetiendo sapientiam dei et offendit ratione sapientie, ideo uerbum patri ~~qui~~
~~est~~, cui attribuitur sapientia, debuit incarnari.
Sed dicebat: in diuinis uel est essentia uel relatio. Sed relatio non terminat in-
carnationem, ergo essentia. Et illa est communis tribus. Ergo omnes tres persone
sunt incarnate.
35 Negauit quod relatio non terminaret illam generationem.
Probauit per ARISTOTELEM, *qui dicit quod actus non terminantur ad relationem.*
Sed dictum fuit quod aliud est de relatione diuina et relatione creata, quia diuina
relatio dicit quid subsistens in diuinis.

Quesiuit utrum una persona posset assumere duas naturas singulares humanas.
40 Respondit quod sic et fuissent supposita. Sed non fuissent duo supposita, sed
unum suppositum fuisset, licet fuissent due nature.
Sed contra: si habuisset duas humanitates, fuisset duo homines, quia pluralitas
hominum habet attendi iuxta pluralitatem naturarum.
Dictum fuit quod fuissent duo homines secundum pluralitatem nature, sed non
45 secundum subsistentiam et suppositationem.

Vtrum autem tres persone potuissent assumere unam naturam. Videtur quod
non. Si assumerent tres persone unam naturam, uideretur quod illa terminare-
tur ad tria supposita et sic efficeretur tria supposita distincta secundum suppo-
sitorum distinctionem.
50 Respondit quod [quod] sic non fuisset distincta secundum rationem suppositalem,
sed quantum ad unam rationem communem fuisset terminata et absolutum sup-
positum unum.

Vtrum natura humana habet proprium esse in supposito. <Videtur quod sic.> ||[1]
Natura humana in christo, ex hoc quod est substantia ex se, et natura sua
55 *habuisset suppositationem et esse actualis existentie, sed fuit preuenta et as-*
sumpta in suppositationem diuini suppositi. Et si reliqueretur a diuina essentia,
suppositaretur per se.||[1]

[1]*Natura . . . per se*] *in marg.*

Responsum fuit quod habet esse essentie, sed esse existentie habet a potentia diuina.

60 *Sed arguit: Sequeretur quod natura christi fuisset imperfectior natura nostra, quia aliquid positiuum defuit illi nature, scilicet existentia propria uel esse, et sic caret aliqua entitate quam natura nostra habet.*

Dixit quod habet quid perfectius, quia esse diuinum, quo existit, quod esse diuinum suppositat essentiam humanam in christo.

65 <u>*Ad sanandum genus humanum etc.*</u>, *vel hoc esset ad sanandum peccatum originale, sed hoc non, quia hoc non reddit hominem infirmum, quia dicit solum carentiam originalis iustitie. Sed illa non reddit infirmam naturam humanam.*

Dictum fuit quod effecta est infirma ad consecutionem finis ultimi ad quem facta fuit et derelicta fuit secundum se et deordinata in uiribus suis et ideo sanata est
70 quod possit attingere finem.

<u>*Non est opus ualentibus medicus etc.*</u> *Christus etiam bene fuisset incarnatus si homo non peccasset, quia caritate est incarnatus et dilectione hominis. Sed hec fuisset etiam si homo non peccasset.*

Respondit quod caritatem illam non oportuisset ostendisse per incarnationem,
75 sed per alia opera caritatem illam ostendisset.

Contra: Adhuc fuisset conueniens, quia fuisset dignificata sicut et nunc ||² *ipsa natura humana.*

Dicendum quod si non peccasset, non fuisset opus eam sic dignificari, quia modo sufficienter(?) in dignitate constituta(?) erat et creata.||²

80 *Item, perfectio uniuersi non debuit oriri ex culpa. Sed per incarnationem universum est perfectum et ita factum est ex peccato.*

Responsum fuit quod si deus non fuisset incarnatus in christum, uniuersum <non> fuisset perfectum, licet aliquo modo. Et ex peccato non uenit perfectio uniuersi tamquam ex causa propria, sed quasi ex occasione, quia deus perfecit
85 uniuersum per suam incarnationem: quia homo erat miser, ideo indigebat reparatione et sic occasio fuit incarnationis.

Tunc arguit: Si non fuisset incarnatus, tunc humana natura quantum ad obiectum non fuisset beatificata, quia non habuisset obiectum proprium sicut nunc habet humanam naturam christi.

90 Respondit quod suffecisset diuina essentia que beatificasset totum hominem, primo animam et ex redemptione anime etiam corpus.

Item, christus fuit predestinatus ab eterno. Ergo si homo non peccasset, uidetur quod adhuc fuisset incarnatus, quia quod est predestinatum eueniet.

Dixit quod sicut christus fuit predestinatus, sic fuit prescitum quod homo pec-
95 caret et quod propter redemptionem humani generis hoc fieri debuit.

'Homo est deus' est in materia contingenti. Sed hec 'deus est homo' est in materia naturali. Arguitur quod esset hec in materia contingenti, quia predicatum potest abesse subiecto, quia deus potest humanitatem deponere.

Respondit secundum potentiam absolutam, sed non ordinatam.

100 *Deus unitur omni creature per essentiam, presentiam et potentiam. Ergo assumit omnem creaturam dupliciter.*

²*ipsa . . .* creata] *in marg.*

<Respondit> quod ultra istos modos unitus est ypostatice nature humane secundum quem modum aliis non est unitus.

Hec ex argumentis priori<bu>s

105 *Misit deus uerbum suum etc. Si filius dei est unitus nature humane, uel ergo*
facta est hec unio per medium duorum actuum ad inuicem esse, uel duarum
potentiarum, uel per modum actus et potentie.
Respondit secundum tertium modum.
Sed contra. Sequeretur quod deus esset componibilis et etiam sequeretur quod
110 *esset compositio actus et actus, quia natura humana est actus et etiam diuina*
natura.
Dictum fuit quod non uniuit sibi naturam tamquam forma sibi unit materiam
uel materia formam, sed dixit: humana natura haberet quidem modum accidentis.

Iterum. (264r) Finis incarnationis est diuine essentie uisio et trinitatis. Ergo
115 *uidetur quod debuisset tota trinitas incarnari ut medium corresponderet fini.*
Dictum fuit quod sicut in uno homine tota humana natura indignificata fuisset,
ergo etiam per naturam in una persona diuina homo potuit dignificari. Et quia homo
per inobedientiam ruit et peccat, debuit ergo per obedientiam reparari. Sed tota
trinitas non dicitur obedire ut sic, sed filius patri. Ergo suffecit filium incarnari.

120 Contra primam secundi discursus
Item, si unio facta esset diuine nature ad humanam, vel hoc esset per modum
forme vel mouentis. Sed non primo modo, quia sic haberet rationem partis. Nec
secundo modo, quia sic unificatur omni creature et omnem creaturam assump-
sisset.
125 Dixit quod per modum assumentis.
Sequeretur per modum accidentis et subiecti. Tunc fuisset facta mutatio ex parte
dei.
Respondit quod nulla mutatio facta fuit ex parte dei, sed ex parte creature humane ex hoc quod natura humana fuit suppositata.

130 *Si deus esset incarnatus, sequeretur quod deus esset homo. Sed consequens est*
falsum et impossibile, ergo et antecedens. Probatur consequentia, quia uel pro-
positio 'deus est homo' esset propositio per se, uel per accidens. Sed non per se,
quia in omni propositione per se predicatum de omni contento sub subiecto sicut
de subiecto. Sed pater et spiritus sanctus continentur sub deo et sic dicentur
135 *'pater est homo' et 'spiritus sanctus est homo'.*
Dictum est quod secundum formam uerborum, non per se. Sed reducitur ad
unam per se ex hoc quod hec: 'deus est homo', ibi 'deus' accipitur pro supposito
christi et non pro natura communiter accepta.
Sed replicat. Videtur <quod> debet supponere pro patre, quia est famosius significa-
140 *tum huius termini 'deus'. Sed terminus communis debet stare pro famosiori.*
Respondit quod non famosius significatur una persona per hunc terminum 'deus',
sed accipitur ibi 'deus' pro persona subiecta predicato. Et licet ibi sit ratio origi-
nis, tamen propter illam non dicitur una persona magis deus quam alia. Et licet
ibi una persona prima, alia secunda et tertia, tamen una non est prior alia.

145 *Natura diuina et natura humana plus distant quam duo contraria. Sed duo con-*

traria non possunt esse in uno subiecto. Ergo nec diuina natura et humana possunt uniri in uno supposito.

Dicendum quod non est repugnantia contrarietatis inter naturam diuinam et humanam sicut est repugnantia inter duo[3] contraria et sic non est idem modus dis-
150 tantie. Licet enim in infinitum distant natura diuina et humana, tamen per infinitam uirtutem possunt uniri in unione suppositi sicut factum est, ut fides tenet. Natura diuina assumpsit humanam naturam in instanti cum omnibus suis passionibus naturalibus et potentiis. Licet tamen intellectus noster intelligat ordinem quendam ibi, quod prius habuerit esse humana natura uidelicet, tamen non
155 prioritate temporis, sed nature.

Prebere fulcimentum subsistendi competit toti trinitati, ergo uidetur quod tota trinitas sit incarnata.

Dicebat quod tota trinitas contulit fulcimentum subsistendi, non quidem terminatiue, licet effectiue, sed solus filius, ut dictum est, terminatiue et natura diuina
160 in persona filii.

In assumptione humane nature et diuine sunt due uniones intelligende, scilicet qua diuina essentia[4] unitur humane et anima corpori, licet simul et semel facte sunt. Secunda autem unio separata fuit in triduo cum anima separata fuit a corpore, sed prima nunquam.

APPENDIX II

The *Sentences* commentary of Heymericus de Campo

The commentary on the *Sentences* of Heymericus de Campo has survived in Bernkastel-Kues, St. Nikolaus-Hospital, Cod. Cus. 106, fols. 13r–22r. The two questions of the commentary that concern Christology, written in fols. 15v–16r, are edited below. In the manuscript every sentence begins on a separate line, in order to make clear the syllogistic structure of the argumentation (see fig. 72). I preserve that structure in the edition. For additional details on the structure of Heymericus's commentary on the *Sentences*, see Appendix 3.

* * *

Heymerici de Campo
Quadripartitus questionum
supra quattuor libros Sententiarum

<Questio IX>

VTRUM IN TEMPORE PLENITUDINIS SPIRITUS SANCTI GRATIFI<CA>TIO
FIEBAT FILII DEI ET HOMINIS INCONFUSA UNIO FACIENS UTRIUSQUE
NATURE YDEOMATA CUM SUIS PROPRIETATIBUS COMMUNIA
5 Diuine predestinationis impleto tempore ut homo deus fieret, nectuntur gratuite, peccatum quos seiunxerat.

[3]duo] dua *scr.*
[4]essentia] essentie *scr.*

Hic uniuersi circulus dumtaxat finiri debuit in arte conditoris.
Quem perfecit deus trinus opere appropriato sancti spiritus.

Compositio et assumptiua seu exthatica unio fuit ex eisdem principiis ordine
10 contrario.
Premissa dei et hominis unio non est formalis, personalis aut habitualis compo-
sitio, sed nature humane in personam diuinam exthatica[1] assumptio.
Dei per incarnationem uerbi humanatio est per assumptionem carnis mediante
spiritu hominis deificatio.

15 Licet suppositum nature gemine prefatum eternaliter[2] a patre et temporaliter a
spiritu sancto fuerit perfecte natum, tamen est patris unigenitus et non spiritus
sancti filius naturalis uel adoptiuus.
Qui, cum sit creator et creatura, naturaliter utriusque predicata propria recipit
communiter.
20 Vnde per prophetam[3] recte dicitur quod est simul in unum diues et pauper, id est,
factus infectus, nouus sempiternus, passibilis inpassibilis, latria et ideolatria sa-
lubriter adorandus.

<Questio X>

VTRUM ORIGINALIS LAPSUS HUMANI GENERIS PER UERBI INCARNATI, GRATIA
25 ET UERITATE PLENI, IUSTAM MORTEM, UNIONIS YPOSTATICE SALUATIONEM,[4]
SIT SATISFACTIONE CONDIGNA DUMTAXAT REPARABILIS

In hominis assumpti anima, candori lucis eterne per spiritum sanctum unita,
plenitudo gratie <et> ueritatis resultabat immensa.
In quo etiam homine fuit integritas et ueritas per ipsum reparabilis creature.
30 Qui idcirco fuit in anima innocens et inpeccabile caput hominis,[5] in carne nata
de uirgine <habuit> sensum disciplinabilem et appetitum perpassibilem, <fuit>
mortalis et immortalis quoad anime cum corpore iunculum atque uoluntatis
concordis secundum se totum.

Peccatum instinctum nature creature potentissime contra deum uoluntarie per
35 peccatum totamque speciem ad beatitudinem predestinatam trahens in reatum
est iuste et misericorditer expiabile per satisfactionem[6] eiusdem generis uirtuosi-
tatis contrarie.
Huiusmodi fuit peccatum hominis originale, per penam et uirtutum merita sa-
tisfactoris irrei, tam iure belli quam pretii, expurgandum congruissime.
40 Quomodo satisfacere, quia solus homo debuit et solus deus potuit, dei et hominis
mediator christus a diabolico peccato[7] et pena meruit hominem liberare et eidem
suoque corpori gloriam resurrectionis impetrare atque ianuam celi reserare.

[1]exthatica] exthasica *scr.*
[2]eternaliter] etiam naturaliter *scr.*
[3]Ps. 48:3
[4]saluationem] saluationem *scr.*
[5]hominis] *iter.*
[6]satisfactionem] *nempe* satisfactorem?
[7]peccato] peccata *scr.*

Quia in Christo unio hypostatica uincit[8] et preuenit naturaliter compositionem ex corpore et anima remanet illa prior et firmior hac posteriore dissoluta.

45 Quod fidei fomite, caritate nos deo reconciliante, testimonio accipi<m>us accidisse in mortis jhesu triduo.

Itaque per illud mortis interstitium fuit christus in sepulchro et in inferno totus personaliter, licet non totaliter, sicut tunc non fuit homo integralis.

APPENDIX III

John of Mechelen and His Use of the Commentary on the *Sentences* by Heymericus de Campo

Heymericus de Campo's style of thought and reasoning was adopted by another important Albertist at the University of Cologne, John of Mechelen (†1475). Like Heymericus, John stresses the godliness of the human mind, and maintains that by thinking about his own thought, man can have a direct and purely intellectual knowledge of the first principle without the use of the senses, since the human intellect is a spark of the divine light.[1] The affinity between Heymericus and John of Mechelen is not a matter of coincidence. John studied theology under Heymericus until 1435 and succeeded him as master at the Albertist *bursa Laurentiana* in Cologne, after Heymericus became a professor in Louvain.[2]

There are close parallels between Heymericus's and John's writings, not only in metaphysics and epistemology but especially in theology. Indeed, in his own commentary on the *Sentences* John adopts and amplifies parts of Heymericus's commentary. John's use of Heymericus's commentary is not only occasional and material but regular and structural. To understand John's procedure, we must first consider the structure of Heymericus's commentary on the *Sentences*.

Heymericus's commentary has an unusual form, which he also used in his commentaries on the works of Aristotle and which is closely related to the format of the *Quaestiones vacantiales*.[3] It is striking that the questions in Heymericus's commentary are very short, that he presents no arguments pro and con, and that every question contains exactly nine sentences, each of which begins with a capital letter on a new line. This structure is maintained throughout the commentary and obviously is not a matter of coincidence. Its meaning becomes clear if we compare Heymericus's text with the much larger commentary by John of Mechelen.

Four observations can be made about the structural relationship between the commentaries of Heymericus and John of Mechelen:

[8]uincit] uincis *scr.*

[1]This is clear from his treatise *Tractatus de homine*, edited by A. Pattin, "Le 'Tractatus de homine' de Jean de Malines. Contribution à l'histoire de l'Albertisme à l'Université de Cologne," *Tijdschrift voor Filosofie* 39 (1977): 435–521, and his commentary on *De anima*, as preserved in Kraków, Biblioteka Jagiellońska, Ms. 2074, fol. 73v.

[2]For the biography of John of Mechelen, see A. Pattin, "Jan van Hulshout (1405–1475). Vlaams wijsgeer en theoloog van de Universiteit te Keulen," *Tijdschrift voor Filosofie* 38 (1976): 104–28, and Tewes, *Die Bursen der Kölner Artisten-Fakultät*, 908 (index).

[3]Heymericus's commentaries on Aristotle are partially edited in J.-D. Cavigioli, "Les écrits d'Heymericus de Campo (1395–1460) sur les ouvres d'Aristote," *FZPhTh* 28 (1981): 289–371.

(1) John of Mechelen divides each question of Heymericus into three separate questions.

(2) John proves each question by a syllogism, borrowing the major and minor premises and the conclusion from Heymericus. The syllogism of the first questions parallels the first three sentences in the commentary of Heymericus, that of the second the next three, and the third the last three.

(3) John supports each of the major and minor premises and each conclusion with extended reasoning. Generally, these supporting arguments are lacking in Heymericus's commentary, although they sometimes appear in a very small handwriting in the margins or between the lines.[4]

(4) Thereafter John presents arguments against what is proposed in the syllogisms together with answers to the objections. These arguments and responses are not present in Heymericus's commentary.

John of Mechelen thus reproduces the entire commentary of Heymericus and elaborates on it. He takes over the titles of the questions and the nine lines that follow each of them, understanding that the questions are composed of three separate syllogisms; this is precisely the structure of the Cologne *Quaestiones vacantiales*, which also consists of three different syllogisms that prove the question posed. The close structural resemblance between the *Quaestiones* and the two commentaries is suggestive: although the thought reflected in the *Quaestiones* is quite different from that of Heymericus and his student, all three partook the same form of discourse.

Not surprisingly, the content of John's commentary is also very close to Heymericus's teaching, as the questions concerning Christology reveal. Since the syllogisms in each work are identical, I shall pass over them and concentrate on the supporting arguments. In proving the first syllogism of the first question on Christology, John of Mechelen elaborates on the notion of the circle of the universe put forward by Heymericus.[5] The Incarnation occurred in the fullness of time (*plenitudo temporis*), John argues, when creation was prepared to return into its creator. The Incarnation was preceded by two periods of time, each of which constituted the *exitus* of creation from its primordial cause, namely the era of natural law, in which man lived solely as a natural being according to his inborn law unaided by supernatural powers, and the era of the given law (*lex data* or *lex figura*), in which men were directed towards superior ends, in particular, towards the angels. The Incarnation marks the beginning of the third and final era, in which creation returns to God, man is reunited with God and their original unity is restored. This era is under the law of grace, which will lead man to its source, God, and thereby will finish and close the circle of the universe. Time then changes into eternity and creation recovers its original perfection. This circle is the most perfect expression of God's plan. Having no beginning nor end the circle is complete in itself, a figure to which nothing can be added. It was precisely in order to complete the circle of the universe that God, who is perfection itself and completeness itself, became incarnate.[6]

Thus, for John as for Heymericus the Incarnation is a necessary link in the scheme of *exitus et reditus*, which they adopted from neo-Platonic sources. Although John

[4]On these marginal notes, see K. Hammer, "Johannes von Mecheln, ein Theologe des 15. Jahrhunderts," RTAM 20 (1953): 322–27, esp. 324f., and Haubst, *Die Christologie*, 11. The authorship of these marginal notes remains uncertain. For an example, see note 9 below.

[5]For the notion of the circle of the universe, see also Haubst, *Die Christologie*, 172.

[6]See the edition below, 489–92.

emphasizes that God freely became incarnate, and that the Incarnation was necessary for the restoration of the human race, it is clear from his arguments that without the Incarnation creation would never have been complete, for without Christ, the return of all things to God would have been impossible. The beginning of the return does not start at the lowest level of being, where the going forth of being comes to rest, but is intimately connected with human history. Man must be reunited with God, but he could not accomplish this by himself, since by offending God he had lost his union with him and consequently his nature became distorted by sin. Only when human nature is again unified with the divine can creation return into its primordial cause. Thus, for John of Mechelen as for his teacher, Heymericus de Campo (and Nicolaus de Cusa), the theological doctrine of the Incarnation is the central element in the metaphysical structure of reality. The godliness of man, exemplified and perfected in Jesus Christ, is the foundation of a metaphysics that has its roots in the writings of Albert the Great.

John of Mechelen's commentary on the *Sentences* is preserved in two manuscripts: Saint-Omer, Bibliothèque de la Ville, Ms. 151/2, and Trier, Stadtbibliothek, Hs. 945/907, fols. 1–248. For the edition below, I have used the latter manuscript; the edited questions (1–6) are found on fols. 131v–141r. The edition is not complete but is intended to show only how John used the commentary by Heymericus.[7] All those passages taken directly from Heymericus are in italics, in order to facilitate a comparison between the texts of John and Heymericus (see Appendix 2).

* * *

Iohannis de Mechlinia
Questionum sententiarum
Liber tertius

<QUESTIO I>

Vtrum in tempore plenitudinis spiritus sancti gratifi<ca>tio
fiebat filii dei et hominis unio

Maior:[8] *Diuine predestinationis impleto tempore ut homo deus fieret, nectuntur*
5 *gratuite, peccatum quos seiunxerat.*

Patet, quia plenitudo[9] temporis prediffiniti a diuina prouidentia omnia secundum concilium et propositum sue uoluntatis operante, quod tempus fuit initium periodi reductionis uniuersi creature ad suum creatorem <et> presupponit[10] periodum processionis in esse, posse et agere, que includit tempus exitus creature
10 ad esse totius uniuersi, et addit tempus perfectus[11] creature secundum uniuersum posse legis innate, et cum hoc <tempus> prouidentialis gubernationis creature inferioris a superiori per legem datam, ita quod post legem nature reducentem hominem ad seipsum et legem figure reducentem ipsum ad angelum restabat

[7]The partial edition in K. Hammer, "Johannes von Mecheln," 326f., is misleading, because he is unfamiliar with the structure of the commentary and therefore always leaves out the maior premisses, thereby making John's argumentation unintelligible.

[8]maior] *in marg.*

[9]plenitudo . . . patet propositum] appears in the margin of Cod. cus. 106, fol. 16r, as was noted by K. Hammer, "Johannes von Mecheln," 326.

[10]presupponit] presuppositis *scr.*

[11]perfectus] *nempe* profectus?

tempus legis gratie reducentis ipsum ad fontem gratiarum, deum gloriosum. Ecce
15 quam recte dicitur tempus plenitudinis quasi circulus[12] reductionis temporis ad
eternitatem et ultime periodi totius uniuersi. Circulus quippe est figura perfecta
in qua quiescit perficientis intentio, cum non posset sibi aliquid addi. Cum ergo
opera dei sunt perfecta, patet propositum. . . . Contra arguitur. . . . Solutio. . . .

Minor:[13] *Hic universi circulus dumtaxat* secundum legem *finiri debuit in arte*
20 *conditoris.*
Patet, quia. . . . Contra arguitur. . . . Solutio. . . .

Conclusio:[14] *Quem deus perfecit trinus opere appropriato spiritus sancti.*
Patet, quia. . . . Contra arguitur. . . . Solutio. . . .

<Questio II>

25 VTRUM CHRISTI INCARNATIO FUIT *DEI ET HOMINIS INCONFUSA UNIO*
Maior:[15] *Compositio et assumptiua seu exthatica unio* fiunt *eisdem principiis
ordine* econtrario.
Patet, quia. . . .

Minor:[16] *Premissa dei et hominis unio non est formalis, personalis aut habitualis*
30 *compositio, sed nature humane in personam diuinam extasis* seu *assumptio.*
Patet, quia. . . . Contra arguitur. . . . Solutio. . . .

Conclusio:[17] *Dei per incarnationem uerbi humanatio est per assumptionem car-
nis mediante spiritu hominis deificatio.*
Patet, quia. . . .

35 <Questio III>

VTRUM HEC VNIO *FACIAT UTRIUSQUE YDEOMATA
CUM SUIS PROPRIETATIBUS COMMUNIA*
Maior:[18] *Licet suppositum nature gemine prefatum eternaliter a patre et tem-
poraliter* de *spiritu sancto fuerit perfecte natum, tamen est patris unigenitus et*
40 *non spiritus sancti filius naturalis uel adoptiuus.*
Suppositum prefatum est. . . .

Minor:[19] *Qui, cum sit creator et creatura, naturaliter utriusque predicata propria*
suscepit *communiter.*
Patet, quia. . . . Sed contra. . . . Solutio. . . .

[12]circulus] circularis *scr.*
[13]minor] *in marg.*
[14]conclusio] *in marg.*
[15]maior] *in marg.*
[16]minor] *in marg.*
[17]conclusio] *in marg.*
[18]maior] *in marg.*
[19]minor] *in marg.*

45 Conclusio:[20] *Vnde per prophetam[21] recte dicitur quod est simul in unum diues et pauper, id est, factus infectus, nouus sempiternus, passibilis inpassibilis, latria et yperdulia (!) salubriter adorandus.*
Hoc enim est dictum. . . .

<Questio IV>

50 VTRUM *UERBUM INCARNATUM* FUIT *GRATIA ET UERITATE* PLENUM
Maior:[22] *In hominis assumpti anima, candori lucis eterne per spiritum sanctum unita, plenitudo gratie et ueritatis resultabat immensa.*
Hoc autem quod dicitur. . . . Contra arguitur. . . . Solutio. . . .

Minor:[23] *In quo etiam homine fuit integritas et ueritas per ipsum reparabilis*
55 *creature.*
Patet, quia. . . . Sed arguitur. . . . Solutio. . . .

Conclusio:[24] *Qui idcirco in anima fuit innocens et impeccabile caput homin*um.
Ex proprietatibus premissis. . . . Contra arguitur. . . . Solutio. . . .

Corrolarium:[25] Habuit Christus, *in carne nata de uirgine, sensum disci-*
60 *plinabilem et appetitum* pro*passibilem.*
Quod christus fuit natus de uirgine patet, quia. . . .

Corrolarium:[26] Fuit etiam *mortalis et immortalis quoad anime cum corpore* uin-
culum.
Mortalis quidem fuit a natura. . . .

65 <Corrolarium:> Fuit *uoluntatis* etiam gemine *concordis secundum se totum.*
Patet, quia. . . .

<Questio V>

VTRUM ORIGINALIS LAPSUS HUMANI GENERIS PER CHRISTI MORTEM
SIT SATISFACTIONE CONDIGNA DUMTAXAT REPARABILIS
70 Maior:[27] *Peccatum hominis originale est instinctu creature potentissime contra deum uoluntarie per peccatum.*
Hec propositio loquitur. . . .

Minor:[28] Hoc *totam speciem ad beatitudinem predestinatam trax*it *in reatum.*
Patet etiam. . . .

[20]conclusio] *in marg.*
[21]Ps 48:3
[22]maior] *in marg.*
[23]minor] *in marg.*
[24]conclusio] *in marg.*
[25]corrolarium] *in marg.*
[26]corrolarium] *in marg.*
[27]maior] *in marg.*
[28]minor] *in marg.*

75 Conclusio:[29] Igitur hoc peccatum originale *est iuste et misericorditer expiabile.*
Patet, quia. . . .

Maior:[30] Hoc *tam iure belli quam pretii* est *expurgandum congruentissime.*
Patet, quia. . . .

Minor:[31] *Per satisfac*torem *eiusdem generis uirtuositatis contrarie.*
80 Ratio est. . . .

Conclusio:[32] Igitur purgatio huius delicti fit per *penam et uirtutum merita satis-
factoris irrei.*
Patet, quia. . . .

Quomodo satisfacere solus homo debuit et solus deus potuit.
85 Primum patet, quia. . . . Contra arguitur. . . . Solutio. . . .

Quare *dei et hominis mediator christus a diabolico peccato et pena meruit ho-
minem liberare et eidem suoque corpori gloriam resurrectionis* uie *impetrare
atque ianuam celi reserare.*
Hic supponitur quod. . . .

90 <Questio VI>

Vtrum in Christo mortuo soluebatur ypostatica unio
Antecedens:[33] *In Christo unio hypostatica uincit et preuenit compositionem ex
corpore et anima.*
Patet, quia. . . .

95 Consequens:[34] Ideo *remanet illa prior et firmior hac*[35] *posteriore dissoluta.*
Patet, quia. . . .

Corrolarium.[36] *Itaque in mortis* triduo *fuit christus in sepulchro et inferno totus
personaliter, licet non totaliter, sicut tunc non fuit homo integrali*ter.
Quod homo quidem. . . .

[29]conclusio] *in marg.*
[30]maior] *in marg.*
[31]minor] *in marg.*
[32]conclusio] *in marg.*
[33]antecedens] *in marg.*
[34]consequens] *in marg.*
[35]hac] hec *scr.*
[36]corrolarium] *in marg.*

Familia Praedicatoria in the University of Notre Dame Library: Manuscripts, Incunables and Sixteenth-Century Books Containing Texts and Images of the Order of Preachers

Kent Emery, Jr., and Louis E. Jordan

WE PREPARED AN earlier version of this catalogue for an exhibition in conjunction with the conference, *Christ among the Medieval Dominicans: Representations of Christ in the Texts and Images of the Order of Preachers*, University of Notre Dame, 6–9 September 1995. We have substantially revised the text and added several items from a new collection of rare books acquired by the University Library too recently to have been included in the exhibition. The Library's holdings in manuscripts, incunables and sixteenth-century printed books containing Dominican materials are surprisingly ample. Many of the volumes catalogued here were given to the Library by Abbot Astrik L. Gabriel, now Professor *emeritus* in the University (see nos 16, 22, 24, 26, 29–30, 34, 36, 39, 43 44, 46, 48, 54, 57). It is most fitting, therefore, that this bio-bibliographical catalogue be in his honor, in recognition of his many contributions to medieval studies at Notre Dame and to our library collections.

We hope that, besides recording holdings in the University Library, this catalogue will give a profile of the intellectual and literary life of the Dominican Order from the thirteenth through sixteenth centuries. As one would expect, the entries document the transitions and changes from medieval intellectual and manuscript culture to early-modern intellectual and print culture. Frankly, we find the evidence of continuity more remarkable: the continued presentation of medieval authors and texts in the sixteenth century; the perdurance of medieval literary genres and topics among early-modern writers; relationships between convents and printers that are analogous to those between convents and stationers in the Middle Ages; on a conceptual level, at least—and sometimes more literally—a continuity of traditions of text presentation and format. In short, the medieval book, to the idea and design of which the Dominican Order contributed so much, continued to have a vibrant life that defies our conventional historiographical categories and notions of the "radical transformation" purportedly wrought by the invention of printing.

* * *

PROFESSOR ASTRIK L. GABRIEL AND THE NOTRE DAME LIBRARIES

The distinguished medievalist, Professor Astrik L. Gabriel, O.Praem., was Director of the Medieval Institute from 1952 until 1975. He continues to serve as the Director of

the Frank M. Folsom Ambrosiana Microfilm and Photographic Collection. During his years as Director of the Medieval Institute, he laid the foundations for, and greatly expanded, the Institute's excellent library, one of the finest medieval research collections in the United States. Professor Gabriel formed a special collection in the Medieval Institute, which is named in his honor and shelved in a separate room in the Institute library: the Astrik L. Gabriel University Collection. This is one of the richest collections anywhere of books and materials concerning the history of universities, and it attracts scholars from around the world. Besides books, monographs, journals, copies of doctoral dissertations, photocopies of articles, etc., the collection includes many photographs of university foundations and *regalia*, wax replicas of seals, and over 4,000 microfilms of medieval manuscripts pertaining to the history of universities. Moreover, Professor Gabriel prepared several scholarly apparatus accompanying the collection.

During the 1960s, Professor Gabriel single-handedly negotiated to establish at Notre Dame a complete photographic record of one of the great manuscript collections in the world, the Ambrosiana Library in Milan. He obtained the funding for this project, supervised its reception, prepared special catalogues of its manuscript holdings, acquired the research instruments necessary for gaining access to the collection, and again prepared scholarly apparatus for penetrating it. The photographic collection at Notre Dame consists of 12,000 negative and 12,000 positive microfilms of all the manuscripts—in Greek, Hebrew and Arabic as well as in Latin and western vernaculars—in the Ambrosiana Library. Complementing the microfilms are some 50,000 black and white photographs of miniatures and illuminated initials found in the manuscripts; negatives and photographs of the 350 paintings on display at the Library in Milan; negatives and photographs of 8,000 drawings in the Ambrosiana; and 15,000 color slides representing illuminated folios in the manuscripts and most of the drawings.

Over the years, Professor Gabriel continued to donate incunables and sixteenth-century printed books to the Department of Special Collections of the University Library. Recently he gave a spectacular collection of sixteenth-century printed books, representing each year of the century with at least one book. The collection comprises 262 titles in 245 volumes. It is not surprising, then, that many of the volumes in this catalogue were donated by Professor Gabriel.

In his numerous books and articles on medieval university life, Professor Gabriel treats many Dominican professors and students. He has also written special studies on Dominican brothers and sisters (in order of publication):

——. *Die Heilige Margharethe von Hungarn.* Budapest: Künstinstitut Posner, 1944.

——. *Sainte Marguerite de Hongrie.* Budapest: Imprimerie Posner, 1944.

——. *The Spirituality of St. Margaret of Hungary.* Princeton: s.n., 1950?

——. *The Educational Ideas of Vincent of Beauvais* (Texts and Studies in the History of Medieval Education 4). Notre Dame: University of Notre Dame, 1956; reprinted 1962.

——. *Vincenz von Beauvais: Ein mittelalterlicher Eizieher.* Frankfurt a. M.: Josef Knecht, 1967.

——. *Description of Sermones Discipuli, written by Johannes Herolt (died 1468),*

printed by [Georgius Husner] Strassburg 1483. Notre Dame: University of Notre Dame, 1992.

By his writings and by his contributions to the Notre Dame libraries, Abbot Astrik Gabriel of the Order of Premontré has shown himself to be a true friend of the *familia praedicatoria.*

* * *

Table of Reference Works

Adams	Adams, Herbert Mayow. *Catalogue of Books Printed on the Continent of Europe, 1501–1600, in Cambridge Libraries.* 2 volumes. Cambridge: Cambridge University Press, 1967. References cite volume, page and entry numbers.
Anselmo	Anselmo, Antonio Joaquim. *Bibliografia das obras impressas em Portugal no século XVI.* Lisbon: Biblioteca Nacional, 1926; reprinted, Lisbon 1977. References cite page and entry numbers.
Ascarelli	Ascarelli, Fernanda, and Marco Menato. *La tipografia del '500 in Italia* (Biblioteca di Bibliografia Italiana 106). Florence: Leo S. Olschki, 1989. References cite page numbers.
Baudrier	Baudrier, Julien. *Bibliographie Lyonnaise: Recherches sur les imprimeurs, libraires, relieurs et fondeurs de lettres de Lyon au XVIe siècle.* An exact reproduction of the original edition (1895–1921) in 13 volumes. Paris: F. de Nobele, 1964. References cite volume and page numbers.
Beltrán de Heredia	Beltrán de Heredia, Vicente, O.P. *Domingo de Soto: Estudio biográfico documentado* (Biblioteca de Teologos Españoles 20). Salamanca: Instituto de Cultura Hispanica, 1960.
Benzing and Muller	Benzing, Josef, and Jean Muller. *Bibliographie Strasbourgeoise: Bibliographie des ouvrages imprimés à Strasbourg (Bas-Rhin) au XVIe siècle* (Répertoire bibliographique des livres imprimés en France au seizième siècle 148). 3 volumes (Bibliotheca Bibliographica Aureliana 80, 90, 105). Baden-Baden: V. Koerner, 1981–86. Benzing is the author of volume 1 and Muller is the author of volumes 2–3. References cite volume, page and entry numbers.
BMCGB	[British Museum]. *Short-Title Catalogue of Books Printed in the German-Speaking Countries and German Books Printed in Other Countries from 1455 to 1600 now in the British Museum.* London: British Museum, 1962. References cite page numbers and the call numbers in the British Library.
BMCIB	[British Museum]. *Short-Title Catalogue of Books Printed in Italy and of Italian Books Printed in Other Countries from 1465 to 1600 now in the British Museum.* London: British Museum, 1958. References cite page numbers and the call numbers in the British Library.

Borsa Borsa, Gedeon. *Clavis typographicum librarorumque Italiae 1465–1600* (Bibliotheca Bibliographica Aureliana 35). 2 volumes. Baden-Baden: V. Koerner, 1980. References cite volume and page numbers.

Chaix Chaix, Gérald. *Réforme et Contre-réforme catholiques: Recherches sur la Chartreuse de Cologne au XVIe siècle* (Analecta Cartusiana 80). 3 volumes. Salzburg, 1981. References cite volume, page and entry numbers.

Corbett Corbett, James A. *Catalogue of the Medieval and Renaissance Manuscripts of the University of Notre Dame.* Notre Dame: University of Notre Dame Press, 1978. References cite page numbers.

Distelbrink Distelbrink, Balduinus. *Bonaventurae scripta: Authentica, dubia vel spuria critice recensita* (Subsidia Scientifica Franciscalia 5). Rome: Istituto Storico Cappuccini, 1975.

Fauser Fauser, Winfried. *Codices manuscripti operum Alberti. Pars I: Opera genuina. (Die Werke des Albertus Magnus in ihrer handschriftenlichen Überlieferung. I: Die echten Werke).* Sancti doctoris ecclesiae Alberti Magni Opera omnia: Tomus subsidiarius I. Münster: Aschendorff, 1982.

Getino Getino, Luis G. Alonso. *El maestro Fr. Francisco de Vitoria: Su vida, su doctrina e influencia.* Madrid: Imprenta Católica, 1930.

Geyer Geyer, Bernhard. *Die Albert dem Grossen zugeschriebene Summa naturalium (Philosophia pauperum): Texte und Untersuchungen* (Beiträge zur Geschichte der Philosophie und Theologie des Mittelalters 35/1). Münster: Aschendorff, 1938.

Goff Goff, Frederick R. *Incunabula in American Libraries: A Third Census of Fifteenth-Century Books Recorded in North American Collections.* Millwood, New York: Kraus Reprint Co., 1973. References cite entry numbers.

GW *Gesamtkatalog der Wiegendrucke.* Edited by the Commission for the Gesamtkatalog. 9 volumes and two parts of volume 10 to date. Stuttgart: A. Hiersemann, 1921–; New York: H. P. Kraus, 1968–. References cite entry numbers.

IA *Index Aureliensis: Catalogus librorum sedecimo impressorum.* 10 volumes of Part 1 and 2 volumes of Part 3 (*Clavis typographorum librariorumque saeculi sedecimi*) to date. Baden-Baden: V. Koerner, 1965–. References cite volume and page numbers.

ICEP Moreau, Brigitte, and others, following the manuscripts of Phillipe Renouard. *Inventaire chronologique des éditions parisiennes du XVIe siècle.* 4 volumes to date. Paris: Imprimerie Municipale, 1972–77; Abbeville: Imprimerie F. Paillart, 1985–. References cite volume and page numbers.

Kaeppeli Kaeppeli, Thomas, O.P. *Scriptores ordinis praedicatorum medii*

	aevi. 4 volumes, with *Addenda et corrigenda* by Emilio Panella, O.P., in vol. 4: 13–282. Rome: Sta. Sabina, 1970–93. References cite entry numbers (Panella is cited by volume and page numbers).
Kisky	Kisky, Hans. "Woensam von Worms, Anton," in *Allgemeines Lexikon der bildenden Künstler der Antike bis zur Gegenwart* 36 (Leipzig, 1947): 165–68.
Künzle	Künzle, Pius, O.P., ed., *Heinrich Seuses Horologium Sapientiae* (Spicilegium Friburgense 23). Freiburg (Switzerland): Universitätsverlag, 1977.
Llaneza	Llaneza, Maximino. *Bibliografía del V.P.M. Fr. Luis de Granada de la Orden de Predicatores.* 4 volumes. Salamanca: Establecimiento Tipográfico de Calatrava, 1926–28. References cite volume, page and entry numbers.
Marimon	Marimon, Josep-Maria Madurell i. *Claudi Bornat* (Premi Francesc Carreras Candi 1972). Barcelona: Fundacio Salvador Vives Casajuana, 1973.
Masin	Masin, Anton C. *Incunabula typographica: Catalog of Fifteenth-Century Books held by the Memorial Library of the University of Notre Dame,* with a preface by Astrik L. Gabriel. Notre Dame: University of Notre Dame Press, 1979. References cite page and entry numbers.
Meuthen	Meuthen, Erich. "Thomas von Aquin auf den Provinzialkonzilien zu Mainz und Köln 1451 und 1452," in *Köln, Stadt und Bistum und Reich des Mittelalters: Festschrift für Odilo Engels zum 65. Geburtstag,* 641–58. Edited by H. Vollrath and S. Weinfurter, Cologne: Böhlau Verlag, 1993.
Mortimer	Mortimer, Ruth. *Harvard College Library Department of Printing and Graphic Arts Catalogue of Books and Manuscripts. Part II: Italian 16th Century Books.* 2 volumes. Cambridge, Massachusetts: The Belknap Press (of Harvard University Press), 1974. References cite volume, page and entry numbers.
Quétif-Échard	Quétif, Jacques, O.P., and Jacques Échard, O.P. *Scriptores ordinis praedicatorum recensiti, notisque historicis et criticis illustrati* . . . 2 volumes, each in 2 parts. Originally published in Paris, 1719–23; reprinted New York: Burt Franklin, 1959–61. References cite volume and column numbers.
RHCEE	*Repertorio de historia de las ciencias eclesiasticas en España* (Corpus Scriptorum Sacrorum Hispaniae: Estudios). 7 volumes. Salamanca: Instituto de Historia de la Teologia Española, 1967–79.
Rhodes	Rhodes, Dennis E. *Annali tipografici di Lazzaro de' Soardi* (Biblioteca di Bibliografia Italiana 82). Florence: Leo S. Olschki, 1978. References cite entry numbers.
Ritter	Ritter, Fr. *Répertoire bibliographique des livres du XVIe siècle qui se trouvant à la Bibliothèque Nationale et Universitaire de*

	Strasbourg. 4 volumes. Strasbourg: Editions P. H. Heitz, 1937–55. References cite volume, page and entry numbers.
Schüling	Schüling, Joachim. *Der Drucker Ludwig von Renchen und seine Offizin: Ein Beitrag zur Gechichte der Kölner Buchdrucks* (Wissenschaftliche Beiträge aus dem Deutschen Bucharchiv München 41). Wiesbaden: Harrasowitz, 1992.
Schutte	Schutte, Anne Jacobson. *Printed Italian Vernacular Religious Books 1465–1550: A Finding List.* Geneva: Librairie Droz, 1983. References cite page numbers.
Thomas	Thomas, Henry. *Short-title Catalogue of Books Printed in Spain and of Spanish Books Printed Elsewhere in Europe before 1601 now in the British Museum.* London: British Museum, 1921. References cite page numbers and the call numbers in the British Library.
VD16	*Verzeichnis der im deutschen Sprachbereich erschienen Drucke des XVI. Jahrhunderts (VD 16). I. Abteilung: Verfasser-Körperschaften-Anonyma.* Edited at the Bayerischen Staatsbibliothek in München in association with the Herzog August Bibliothek in Wolfenbüttel. 22 volumes. Stuttgart: Anton Hiersemann, 1983–95. References cite volume and page numbers, with entry numbers in parentheses.
Vindel	Vindel, Francisco. *Escudos y marcas de impressores y libreros en España durante los siglos XV a XIX (1485–1850).* Barcelona: Editorial Orbis, 1942.
Voet	Voet, Leon, with the collaboration of Jenny Voet-Grisolle. *The Plantin Press (1555–1589). A Bibliography of the Works printed and published by Christopher Plantin at Antwerp and Leiden.* 6 volumes. Amsterdam: Van Hoeve Amsterdam, 1980–83. References cite volume, page and entry numbers.
Zappella, *Il ritratto*	Zappella, Giuseppina. *Il ritratto nel libro italiano del Cinquescento.* 2 volumes, text and plates (*Tavole*). Milan: Editrice Bibliografica, 1988.
Zappella, *Le marche*	Zappella, Giuseppina. *Le marche dei tipografi e degli editori italiani del Cinquecento. Repertorio di figure, simboli e soggetti e dei relativi motti.* 2 volumes, text and plates (*Tavole*). Milan: Editrice Bibliografica, 1986.

* * *

CATALOGUE

1. University of Notre Dame Library, Ms. 15

<Nicolaus de Byardo, O.P.>, *Summa de abstinentia*, fols. 1ra–156rb; <Humbertus de Romanis, O.P.>, *Tractatus de habundancia exemplorum in sermonibus ad omnem materiam*, fols. 164ra–226ra. Late 13th-early 14th c.; probably French; parchment; 17.0 × 12.0 cm; 239 fols. Nicholas of Byard (fl. 1250) composed works

compiling and ordering texts and materials, arranged alphabetically according to keywords and topics (*distinctiones*), to assist preachers. The *Summa de abstinentia* circulated widely in medieval manuscripts. Humbert of Romans (†1277) was Master General of the Dominican Order from 1254 to 1263. His *Tractatus* contained in this manuscript was also designed to assist preachers, providing them with exemplary tales to illustrate moral points in their sermons. At the end of Nicholas's *Summa* is a reference table (fols. 156v–161v), which adapts the materials in his book to the Sundays and feasts in the liturgical year. Marginal signs (*ex^m*) mark *exempla* in Humbert's *Tractatus* (fig. 73: fol. 164r, the beginning of Humbert's text). REFERENCES: Corbett 88–90; Kaeppeli n^os 3046, 2012 (the Notre Dame manuscript is not cited).

2. University of Notre Dame Library, Ms. 12

<GUILLELMUS PERALDUS, O.P.>, *Summa de vitiis,* fols. 1r–400v. Early 14th c.; French; parchment; 18.0 × 13.0 cm; 400 fols. William Peyraut (†1271) was Prior of the Dominican convent in Lyon. His *Summa de vitiis,* treating the seven capital vices and the sins of the tongue, was one of the most influential moral works of the Middle Ages. William wrote a companion *Summa de virtutibus,* which often accompanied his *Summa* on the vices in manuscripts. This manuscript has contemporary foliation in Arabic numerals (fols. 1–100) and in a combination of Roman and Arabic numerals (C.1–CCC.20); running headers in red and blue indicate the topic of the book (e.g., *De Gula*). A table of the sequence of topics (fols. 1r–8r) precedes the text; alphabetically and numerically (Arabic) ordered markers in the table correspond to the same signs in the margins of the body of the text (e.g., the signs *.a..1., .b..2.* in fig. 74: fol. 9r [= contemporary fol. 1r], the beginning of the text). REFERENCES: Corbett 81; Kaeppeli n° 1622 (for the manuscript, see Kaeppeli and Panella 4: 106).

3. University of Notre Dame Library, Ms. 53

<BOETIUS, *De consolatione philosophiae, cum Commento novo de* PHILLIPO IADRENSI, O.P.>, fols. 13r–82v. 14th–15th c.; Italian; parchment; 35.0 × 24.0 cm; 84 fols. The text of Boethius was copied in the fourteenth century in a gothic textual hand; the commentary by Philip of Zara, O.P., written in the bottom margins in a hybrid script with humanist features, was added to the manuscript sometime after 1484. Philip's commentary makes a metrical paraphrase of the prose parts of Boethius's *Consolation*. A marginal drawing on fol. 24r depicts the Wheel of Fortune (fig. 75). REFERENCES: Corbett 219–24; S. A. Ives, "Phillipus Iadrensis, A Hitherto Unknown Poet of the Renaissance: A Contribution to Italian Literary History," *Rare Books: Notes on the History of Old Books and Manuscripts* 2 (1943): 3–16.

4. University of Notre Dame Library, Ms. 2

<PSALTERIUM AD USUM FRATRUM ORDINIS PRAEDICATORUM>. After 1423 but before 1456; German; parchment; 16.0 × 11.0 cm; 223 fols.; 15th or 16th c. tooled leather binding. The manuscript contains a Dominican liturgical calendar (fols.

1r–6v); a Psalter with antiphons and musical notation (fols. 7r–187r); canticles (fols. 187r–206r); litanies including Dominican saints (fols. 202r–207r); prayers (fols. 206r–207r); hymns with musical notation (fols. 207r–219v). The book contains special prayers mentioning Saints Dominic, Peter Martyr and Thomas Aquinas (fol. 206r), as well as Saints Vincent Ferrer and Catherine of Siena (fol. 221r). Figure 76 shows the noted beginning of Psalm 26: *Deus illuminacio mea* (fol. 37v). REFERENCE: Corbett 1–4 (with bibliography).

5. University of Notre Dame Library, Ms. 1

<PSALTERIUM AD USUM FRATRUM ORDINIS PRAEDICATORUM>. After 1456 but before 1481; German; parchment; 17.0 × 12.0 cm; 211 fols.; 15th or 16th c. tooled, red pigskin binding. Like the previous entry, this manuscript contains a Dominican calendar (fols. 1r–6v); a Psalter with antiphons and musical notation (fols. 7r–184v); canticles (fols. 184v–196v); litanies including Dominican saints (fols. 196v–201r); prayers (fols. 201r–202r); hymns with musical notation (fols. 202r–211r). The book is less well executed than its companion and bears several corrections of mistakes in the copying. Figure 77 shows the beginning of Psalm 26: *Deus illuminacio mea* (fol. 34r). REFERENCE: Corbett 1–4 (with bibliography).

6. University of Notre Dame Library, Ms. 3

PEREGRINUS <DE OPOLE, O.P., *Sermones de tempore*>, fols. 13r–112v; *Sermones de sanctis*, fols. 113r–175v. 15th c.; German; paper; 29.0 × 21.0 cm; 282 fols.; 15th or 16th c. tooled leather binding with metal resting bosses. Peregrinus of Opole was Prior of the Polish Dominican province (1305–12, 1322–27). His sermon sequences for the temporal and sanctoral liturgical cycles circulated widely in Germany and eastern Europe. Copied in the midst of the sermons in this manuscript (fols. 50r–51v) are texts concerning the celebration of the Mass, excerpted from the *Summa confessorum* of John of Freiburg, O.P. (†1304). The first gathering of the book is copied in two columns; thereafter the text is copied in long lines. The sermons were copied by several writers in typical German cursive bookhands of the fifteenth century (see fig. 78: fol. 114r, sermon for the feast of St. Andrew beginning the *Sermones de sanctis*). REFERENCES: Corbett 9–31; Kaeppeli n[os] 1982 (John of Freiburg), 3194 (Peregrinus; the Notre Dame manuscript is not cited).

7. University of Notre Dame Library, Ms. 29

<NICOLAUS DE AUSIMO, O.S.F., *Supplementum ad Summam de casibus conscientiae de* BARTHOLOMAEO DE SANCTO CONCORDIO PISANO, O.P.>, fols. 1ra–282rb. Second half of the 15th c.; copied in Italy or southern France; parchment; 23.0 × 16.0 cm; 287 fols. This book once belonged to Pope Leo X (1475–1521). The "little Pisan Summa" (*Summa Pisanella*) of Bartholomew of Pisa, O.P. (†1347), designed for use by confessors and preachers, was one of the most popular casuistic manuals in the later Middle Ages. It survives in hundreds of manuscripts throughout Europe. The Supplement to this work copied in this manuscript was composed by the Franciscan, Nicholas of Osimo (fl. ca. 1435). His work is a tribute to the continuing popularity of Bartholomew's manual. In the far left margin of fol. 267v (fig.

79) is a gloss from a text by Antoninus of Florence, O.P. (1389–1459; see catalogue n° 27). Here we find a marginal gloss from a summary to a supplement to another summary!—a nice example of medieval "text-recycling" and "hypertext." REFERENCES: Corbett 135–36; Kaeppeli n° 436 (Bartholomew of Pisa).

8. **University of Notre Dame Library, Ms. 50**
<ENRICO SUSO, O.P.>, *Libro il quale si chiama Orivola della sapientia,* fols. 1r–169v; *Lucifero della sapientia,* fols. 169v–174r; *Cento meditationi con cento petitioni della Passione di Christi,* fols. 174r–179v. 15th c.; Italian; paper; 29.2 × 19.0 cm; 180 fols. This manuscript contains Italian translations of works by the great Dominican spiritual writer, Henry Suso (1295–1366): *Horologium sapientiae* ("The Clock of Wisdom," translated from the Latin), and the 100 meditations on the Passion from the third book of *Das Büchlein der Ewigen Weisheit* ("The Little Book of Eternal Wisdom," translated from the German). The translator of the *Horologium* may have been a certain Fra Giordano, O.P. REFERENCES: Corbett 213–14; Kaeppeli n°s 1851–52; Künzle 263–67 (the Notre Dame manuscript is not cited; cf. 264 n°s 11–17, 266 n. 1).

9. **University of Notre Dame Library, Ms. 18**
CATERINA DA SIENA, *Lettere,* fols. 1r–35v, 55r–103v. 15th c.; Italian; paper; 21.4 × 14.3 cm; 108 fols. This book contains a collection of letters of Catherine of Siena (1347–80), who was a member of the Sisters of Penitence of St. Dominic, a third order affiliated with the Order of Preachers. The manuscript was copied by several hands in typical Italian cursive book scripts; there is no decoration or rubrication. REFERENCE: Corbett 97–102.

10. **University of Notre Dame Library, Ms. 62**
<GRADUALE AD USUM FRATRUM ORDINIS PRAEDICATORUM>. 17th c.; Spanish; parchment; 51.0 × 33.6 cm; 132 fols. The book has a contemporary tooled leather binding over boards with metal clasps and resting bosses; the inside covers bear pastedowns of an earlier liturgical manuscript with musical notation. This giant folio choir book contains propers for several special Dominican feasts, including St. Raymond of Peñafort (23 January, fols. 29v–30r), The Crown of Our Lord (*In festo coronae Domini,* 24 April, fols. 67r–68v), St. Thomas Aquinas (7 March, fols. 51r–54v), St. Hyacinth (7 August, fols. 117r–121r). REFERENCE: Corbett 242–45.

11. **UND Library: Rare Books B765 .T361sd 1460**
Summa de articulis fidei et ecclesie sacramentis, edita a fratre THOMA DE AQUINO, *ordinis fratrum praedicatorum* (Mainz: Johann Gutenberg, before 1460). This is the earliest printed text of a work by Thomas Aquinas (†1274). Johann Gutenberg (ca. 1398–1468), the inventor of printing, may have been responding to strong market demand. During his Papal Legation through Germany, Cardinal Nicholas of Cusa (1401–1464) especially recommended Thomas's treatise on the articles of the faith for the instruction of parish priests, and his recommendation

was enacted in provincial synods (1451–52). This volume has been rubricated by hand. The colophon of the book follows the typical manuscript form: "Explicit summa de articulis fidei et ecclesie scaramentis. edita a fratre thoma de aquino. ordinis fratrum predicatorum. ¶ Deo. Gracias ¶" (fol. 13r). An ex-libris written on the empty fol. 13v states that the book belonged to the "Conuentus Franford," and is dated 1569. REFERENCES: Goff T-273 (the Notre Dame copy is not cited); Masin 126–27 n° 67; Meuthen.

12. UND Library: Rare Books B765 .T361st 1474

<THOMAS DE AQUINO, O.P., *Summa theologiae IIa–IIae*> (Strassburg? about 1474). Authorities assign the printing of this edition to Michael Reyser at Eichstätt or Heinrich Eggestein at Strassburg. This printing of the second half of the second part of the *Summa theologiae*, Thomas Aquinas's great treatise on the moral life, reflects the special esteem for his pastoral and moral teaching in the late Middle Ages, in Germany and elsewhere (see catalogue n° 11). The text of the *Summa* in this edition is preceded by a table of questions (fols. Ir–VIIv). The book is hand rubricated and decorated, with running headlines to the text, and has a fifteenth-century leather semi-binding over boards. The illuminated initial and border design on the first recto of the text is by an Italian artist (fig. 80). REFERENCES: Goff T-211; Masin 128–29 n° 68.

13. UND Library: Rare Books B765 .T361 A2 1498

Opuscula SANCTI THOME: *quibus alias impressis nuper hec addidimus, videlicet, Summam totius logice, Tractatum celeberrimum de vsuris nusquam alias impressum* (Venice: Boneto Locatelli for Ottaviano Scoto, 1498). The volume is based on the 1490 edition of Thomas Aquinas's *Opuscula* printed by Hermann Liechtenstein in Venice, but, as the title page indicates, this edition adds two other treatises on logic and usury, the latter printed for the first time (see title above). The book also contains a Life of St. Thomas by Antonius Pizamanus, a noted Venetian scholar. The colophon (fol. 341v) states that the book was printed in Venice at the request and expense of Ottaviano Scoto of Modena (active 1479–1499; see catalogue n° 72), "under the care and ingenuity" of Boneto Locatelli of Bergamo (active 1487–1524). Scoto's well-known printer's mark (circle and cross) bears his initials (O, S, M). Scoto and Locatelli joined in the publication of another book in this catalogue (see n° 32). REFERENCES: Ascarelli 340–41; Goff T-257; Masin 124–25 n° 66; Zappella, *Le marche*, fig. 273.

14. UND Library: Rare Books B765 .T361p 1500

Divus THOMAS <DE AQUINO> *in octo Politicorum Aristotelis libros cum textu eiusdem, interprete* LEONARDO ARETINO (Venice: Simon de Luere for Andrea Torresano, 31 October 1500). This book is a meeting place of Scholastic and humanistic culture. The medieval commentary by Thomas Aquinas on the *Politics* of Aristotle is attached to the translation of the work by the famous humanist scholar, Leonardo Bruni (1369–1444). The printer Simon de Luere (active 1489–1519) often worked for his eminent colleague, Andrea Torresano (active 1479–

1527), who acquired his press from Nicholas Jensen. The book is printed in two columns with Bruni's translation of Aristotle in larger type and Thomas's commentary in smaller type. REFERENCES: Ascarelli 333, 341; Goff T-251.

15. UND Library: Rare Books BX2307 .T687

Tractatus de efficacia aque benedicte, per venerandum magistrum JOHANNEM DE TURRECREMATA, *sacre theologie professorem ordinis predicatorum* (Augsburg: Anton Sorg, about 1476). The Spanish Dominican Juan de Torquemada (ca. 1388–1468) was a leading ecclesiastical figure in the fifteenth century. He was named a Cardinal priest of the Roman Church in 1439. Schooled in theology at Paris, he participated in the controversial Councils of the fifteenth century (Constance, Basel, Ferrara, Florence). Torquemada's treatise on the sacramental holy water was written against the Englishman Peter Payne (†1455) and other Hussite heretics in Bohemia. REFERENCES: Goff T-509 (the Notre Dame copy is not cited); Kaeppeli n° 2715; Masin 132 n° 70.

16. UND Library: Astrik L. Gabriel Collection n° 37

Expositio in Psalterium Reuerendissimi D. JOANNIS YSPANI DE TURRECREMATA (Venice: Lazzaro de' Soardi, 1513). Juan de Torquemada's commentary on the Psalter was composed in Rome, 1463. The printer of the volume, Lazzaro de' Soardi, was active in Venice between 1490 and 1517. This volume is the second edition of the work, originally printed by Lazzaro in 1502. The title page displays an image of the Cardinal at his writing desk. REFERENCES: Ascarelli 343; Kaeppeli n° 2734; Rhodes n°° 24, 89.

17. UND Library: Rare Books BJ1535 .S631 C3

Tractato contra il peccato della lingua . . . compilata et facta per frate DOMENICO CHAVALCHA *davico pisano frate predicatore* (Florence: Nicolo di Lorenzo della Magna, between 1476 and 1477). Domenico Cavalca entered the Dominican Order in Pisa and spent most of his religious life there until his death in 1342. He wrote many spiritual treatises in Italian. This work on the sins of the tongue borrows heavily from the eighth part of the *Summa de vitiis* of Peraldus (see catalogue n° 2). This is perhaps the first book printed by Nicolo di Lorenzo della Magna, who was active between 1477 (his first dated book) and 1486. The book displays a "classical" page in the tradition of Nicholas Jensen; this copy is initialed by hand in blue ink. REFERENCES: Goff C-338 (the Notre Dame copy is not cited); GW n° 6409; Kaeppeli n° 842; Masin 54 n° 30.

18. UND Library: Rare Books BX4654 .J159L 1478

Legende sanctorum quas compilavit frater IACOBUS IANUENSIS *natione de ordine fratrum predicatorum* (Ulm: Johann Zainer, 1478). The "Golden Legend" (*Legenda aurea*) of Iacobus de Voragine (Varezze), O.P. (ca. 1228–1298), is the most famous collection of saints' lives in the later Middle Ages. The work became the standard source for the iconography of the saints. The edition of the work contained in this volume was printed by Johann Zainer in Ulm, who printed many other Dominican

works (see catalogue n° 20), especially by Albert the Great. The book has printed initials throughout, which is rather rare in this early period. A rubricator has added paraphs and running headlines indicating the number of the legend as given in the table of contents at the beginning of the book. On the last verso (fol. 418vb) the rubricator signs his name and gives a date in red: *Frater Erasmus 1509 Rector philocalus*. The book contains an alphabetical topical index at the end. REFERENCES: Goff J-91; Kaeppeli n° 2154; Masin 86–87 n° 47.

19. **UND Library: Rare Books BT608 .J25 1503**

Mariale sive sermones de beata Maria virgine fratris IACOBI DE VORAGINE (Paris: Iehan Petit I, 1503). Iacobus de Voragine composed this sermon sequence in honor of the Virgin Mary between 1292 and 1298. The printer of the book, Iehan Petit I (active 1492–1530), is the patriarch of a famous Parisian publishing family, whose press was in the "neighborhood" of Saint-Jacques, and thus in the neighborhood of the ancient Dominican convent in Paris. Indeed, members of this family published and printed books by Dominican authors for nearly a century (see n°s 49, 59, 61). The title page bears Petit's device. The beginning of the sermons (fol. 2r) is faced by an engraving of the Annunciation (fol. 1v). REFERENCES: IA 3/2: 125–26, 3/3: 423; ICEP 1: 106 n° 80; Kaeppeli n° 2158.

20. **UND Library: Rare Books BX1756 .L552q**

LEONARDI DE UTINO *divini ordinis fratrum predicatorum Quadragesimales sermones de legibus* (Ulm: Johann Zainer, 1478). The Lenten sermons in this volume by the famous Dominican preacher, Leonardo di Matteo of Udine (†1469), may be associated with the Lenten sermons he preached at S. Maria Novella in Florence in 1434. This is another book by a Dominican author printed by Johann Zainer (see catalogue n° 18). The elaborately printed book contains several reference tables at the end: an extensive alphabetical topical index, an index of scriptural authorities, and an index applying the materials of the Lenten sermons to the Sundays throughout the liturgical year. This copy has been decorated throughout with alternating red and blue initials that mark subdivisions in the sermons. Some sermons begin with large red and blue divided initials of the type found commonly in late-medieval manuscripts from the Low Countries and Germany; figure 81 shows a nice example beginning a sermon on the Passion for Good Friday ("Feria Sexta in passione domini. Sermo Tricesimusoctavus de consilio," fol. Bb7.). The verso opposite the first recto of the text bears an ex-libris from the Dominican convent near Württemberg dated 1484: "Conuentus Gamundiensis ordinis predicatorum 1484." REFERENCES: Goff L-146; Kaeppeli n° 2873; Masin 88–89 n° 48.

21. **UND Library: Rare Books BT70 .H4**

<IOHANNES HEROLT, O.P.>, *Liber Discipuli de eruditione christifidelium* (Reutlingen: Michael Greyff? between 1479 and 1482). The writings of Johannes Herolt, Dominican friar in the convent at Nürnberg (†1468), who signed his works *Discipulus*, were enormously popular throughout Germany and eastern Europe. His work *De eruditione christifidelium* is a moral manual designed to provide material

for preachers. At the end of the volume is a table ordering materials collected from the sermons for preaching on the Sundays of the liturgical year. This table is followed by another topical index, arranged alphabetically. REFERENCES: Goff H-92 (the Notre Dame copy is not cited); Kaeppeli n° 2386; Masin 83–84 n° 45.

22. **UND Library: Rare Books oversize BX1756 .H48 S47 1483**

IOHANNES HEROLT, *Sermones Discipuli de tempore;* fols. 23ra–249vb; *Sermones Discipuli de sanctis,* fols. 252ra–310rb; *Promptuarium exemplorum Discipuli secundum ordinem alphabeti,* fols. 313ra–384rb; *Promptuarium Discipuli de miraculis beate Marie virginis,* fols. 390ra–404vb (Strassburg: Georg Husner, 1483). This book was a gift to the library from Astrik L. Gabriel in 1992. Herolt's sermon sequences survive in many manuscripts and were printed over forty times in the fifteenth century. The *Promptuaria* are "storehouses" of moral examples and tales, and miracles of the Virgin, which can be used readily by preachers. The book was once owned by the Cistercian monastery in Brombach. Printed at the beginning of the volume (fols. 1r–22v) are extensive tables indexing materials on the ten commandments, the seven deadly sins, the seven sacraments, materials in the *Sermones de sanctis,* for dedications, Lent, a table of *exempla,* and of materials relating to canon law (*Casus papales, Casus episcopales, Inhibitiones a sacra communione*). The tables refer to sermon numbers and letters, printed in the body of the text, that divide the text of the sermons alphabetically. A rubricator of this copy has indicated some of these letters in the margin for easier finding. The first folio of the *Sermones de tempore* (fol. 23r) bears an elaborate hand-drawn colored initial, with the ex-libris in the upper margin (fig. 82). No other copy of this book exists in the United States, nor in the British Library, nor in the Bibliothèque Nationale. REFERENCES: Gabriel, *Description;* Goff H-108; Kaeppeli n°ˢ 2387–89, 2391.

23. **UND Library: Rare Books BT70 .H4 1490**

<IOHANNES HEROLT, O.P.>, *Discipulus de eruditione cristifidelium, cum thematibus sermonum domincalium* (Strassburg: Johann Prüss, 1490). This fifteenth-century edition of Herolt's *De eruditone* provides tables indexing the materials for preaching on the Sundays of the liturgical year. The copy is not rubricated but has some marginal annotations in a contemporary hand. REFERENCES: Goff H-95 (the Notre Dame copy is not cited); Kaeppeli n° 2386; Masin 85 n° 46.

24. **UND Library: Rare Books B765 .V743L 1481**

Libri editi a venerabili patre VINCENTIO BELVACENSI: *Liber gratiae, Liber laudum Virginis gloriosae, Liber de sancto Iohanne evangelista, Liber de eruditione puerorum regalium, Liber consolatorius de morte amici* (Basel: Johann Amerbach, 1481). This book was a gift to the library from Astrik L. Gabriel. Vincent of Beauvais, O.P. (†1264) wrote huge encyclopedic works summarizing all the knowledge of his time. This volume, printed by the renowned humanist scholar and publisher, Johann Amerbach of Basel, contains a number of Vincent's smaller treatises. This is the first book printed by Amerbach in which he mentions his name in the colo-

phon on the last verso: "Perlege diuina vatumque volumina lector:/ Et simul hoc nostrum concelebrabis opus./ Ingenium moresque viri pressoris et artem:/ Regia commendat vrbs Basilea satis./ De Amerbach natus nomen sibi forte Iohannes:/ Finem operi imposuit: dum pia virgo parit./ Idibus decembribus Anno a Christi natali die Octua/ gesimoprimo supra millesimum quaterque centisimum/ Bene Uale Lector." REFERENCES: Goff V-277; Kaeppeli nos 3998, 4002–4; Masin 133–34 n° 71.

25. UND Library: Rare Books RM215 .M548

<CONRADUS DE HALBERSTADT, O.P.?>, *Mensa philosophica* (Louvain: Johann von Paderborn, 1481). The *Mensa philosophica,* possibly composed by Conrad of Halberstadt, O.P. (fl. mid-14th c.), is a dietary manual treating the effects of different foods and drinks on the body and the proper diets of people in each condition of life, from emperors to paupers, concluding with the eating habits of good women, bad women, married women, well-behaved widows and virgins. The manual, which summarizes medieval medical lore, offers a "wellness program" modelled after the preachers' moral sermons *ad status.* In the Scholastic manner, the third book treats disputed questions about health, for example, "Whether air is more necessary to life than food?", invoking such contrary authorities as Avicenna and Constantinus Africanus. Johann von Paderborn printed other texts by Dominican writers (see catalogue n° 28). REFERENCES: Goff M-492; GW n° 7418; Kaeppeli n° 773; Masin 91–92 n° 50.

26. UND Library: Astrik L. Gabriel Collection n° 14

<CONRADUS DE HALBERSTADT, O.P.?>, *Mensa philosophica* (Cologne: Cornelius of Zyrickzee, 1508). This edition of the *Mensa philosophica* strengthens the case for the Dominican origin of the work. As the colophon states (fol. 49r), this edition was printed at the Dominican convent in Cologne: "Printed at the house of the Preachers by me, Cornelius of Zyrickzee of the University of Cologne" (fig. 83). Emblems with the shield of the city of Cologne are printed on the verso of the title page and on the last verso of the book. Cornelius of Zyrickzee printed this work a year earlier in 1507. REFERENCES: Kaeppeli n° 773; VD16 13: 570 (M 4643).

27. UND Library: Rare Books BX2264 .A635

ANTHONINI ARCHIEPISCOPI FLORENTINI *in theologia illuminatissimi . . . De eruditione Confessorum* (Memingen: Albrecht Kunne, 1483). Antoninus of Florence (1389–1459) entered the Dominican Order in 1405 and became Bishop of Florence in 1446. Antoninus was an eminent moral theologian; the work published in this volume is the shorter version of the text otherwise titled *Confessionale «Defecerunt».* This work, which was translated into Italian, Spanish and Croatian, circulated in hundreds of manuscripts and was printed many times, 71 times in the fifteenth century alone. The volume also includes a *Sermo de penitencia* attributed to John Chrysostom, and the *Regule ad cognoscendum differentiam inter peccatum mortale et veniale* by "the most famous Doctor," Henry of Hassia (Heinrich

von Langenstein, 1325–97). REFERENCES: Goff A-811; GW n° 2097; Kaeppeli n° 256; Masin 7–8 n° 4.

28. **UND Library: Rare Books BX1749 .N634 1485**

Preceptorium divine legis venerabilis patris, fratris IOHANNIS NIDER, *sacre theologie professoris ordinis predicatorum* (Cologne: Ludwig von Renchen, 1485); <IOHANNES GOBI, O.P.>, *Scala celi* (Louvain: Johannes de Westfalia [i.e, Johann von Paderborn], 1485). This volume binds two separate printed books, each containing a popular work by a Dominican author. The first volume contains the *Preceptorium* of the German Dominican, Iohannes Nider (ca. 1380–1438), who was Vicar of reformed convents in the German province, Prior of the convents in Nürnberg and Basel, and was an active participant in the Council of Basel. The *Preceptorium* contains ten books or "precepts" on the virtues, the sacraments, penance, the vices, etc. The text in this volume is preceded by an extensive alphabetical table of topics and a table of chapter headings. Apparently, this is the only copy of the edition in the United States. Nor is the edition listed in Joachim Schüling's catalogue of books printed by Ludwig von Renchen in Cologne. In this copy, the first recto of the text of the *Preceptorium* is decorated with flourished initials, some illuminated with gold, and a floriate border design (fig. 84). An ex-libris on the first folio of the alphabetical table states that the book once belonged to the Jesuits of Oudenaarde in Flanders (Belgium).

The second book bound in the volume was printed by Johann von Paderborn (see catalogue n° 25). Much less is known about Iohannes Gobi, who was at one time the Prior of the convent of Aix-en-Provence (1323–24). The *Scala celi* is a spiritual treatise arranged topically, chapter-by-chapter, in alphabetical order, from *Abstinentia* to *Usura*. A list of these topics precedes the text. As the topics fall out, the text does not chart a progressive ascent to heaven, as the title and the hand-drawn diagram opposite the first folio of the text seem to promise. This volume once belonged to Robert Hoe, a famous nineteenth-century American collector (inside front cover). REFERENCES: Goff G-313 (Gobi); GW n° 10947 (Gobi); Kaeppeli n°s 2540 (Nider), 2369 (Gobi).

29. **UND Library: Astrik L. Gabriel Collection n° 52**

Formicarius JOANNIS NYDER *theologi profundissimi, pulcherrimus Dialogus ad vitam christianam exemplo conditionum Formice incitativus* (Strassburg: Johann Schott, 1517). This volume was edited by the famous German humanistic scholar, Jacob Wimpfeling (1450–1528). As Wimpfeling explains in the dedicatory letter, Iohannes Nider drew his inspiration for this work, which surveys the "ant-hill" (*Formicarius*) of Christian society in his time, from the image of the purposeful ant in Proverbs 6:6. Accordingly, Nider treats the different status of Christian life (e.g., princes, prelates, priests, monks, enclosed nuns, etc.), and the contemporary perversions of religion (e.g., necromancy, witchcraft). In other words, Nider's work is another Dominican moral writing *ad status*. Of special interest is his treatment of the Beguines and Beghards, or laywomen and laymen who formed reli-

gious communities but did not live under religious vows. Such communities were widespread in Europe in the fifteenth century. The printer Johann Schott was active in Strassburg in the years 1500–1548. REFERENCES: Benzing and Muller 2: 77 n° 50; BMCGB 653 (850. h. 22); Kaeppeli n° 2537; Ritter 3: 1065 n° 1636.

30. UND Library: Astrik L. Gabriel Collection n° 97

Consolatorium timoratae conscientiae venerabilis fratris IOANNIS NIDER *sacrae theologiae professoris de ordine praedicatorum* (Venice: Giovanni Antonio Nicolini da Sabbio e fratelli, 1532). This volume presents a third treatise by Iohannes Nider, which, by analogy to the medical treatment of the ills of the body, provides spiritual remedies to the sickness of the soul and a "frightened conscience." The Nicolini da Sabbio family—fathers, sons and brothers—were active printers in Venice from 1512 through 1600 (see catalogue n° 45). REFERENCES: Ascarelli 353–56; Kaeppeli n° 2535.

31. UND Library: Rare Books oversize PA2888 .B3

Summa que vocatur Catholicon, edita a fratre IOHANNE DE IANUA *ordinis fratrum predicatorum* (Nürnberg: Anton Koberger, 1486). Iohannes Balbus (†1298) was a Dominican in the convent in Genoa. The *Catholicon* is a huge grammatical encyclopedia and dictionary, which survives in many manuscripts and in 23 printed editions. The first four parts treat the rules and principles of basic Latin grammar, progressing from vowels, diphthongs and consonants through sentences, figures of thought and speech, punctuation, etc. Thereafter follows an extensive dictionary. The running headlines in this edition indicate the first two letters of the words entered on the page (e.g., *De littera P ante R, De littera P ante S*). The binding of this volume is contemporary, brown roll-stamped leather over boards, with brass resting bosses. REFERENCES: Goff B-28 (the Notre Dame copy is not cited); GW n° 3192; Kaeppeli n° 2199; Masin 20–21 n° 11.

32. UND Library: Rare Books B655 .C499 1489

AUGUSTINUS, *De civitate Dei cum commento sacre pagine professorum ordinis predicatorum* THOME VALOIS ET NICOLAI TRIVETH (Venice: Ottaviano Scoto, 1489). Although the colophon mentions only the name of Ottaviano Scoto, this book (like catalogue n° 13) was printed for Scoto by Boneto Locatelli. The edition of Augustine's *City of God* includes the commentary on the work by Thomas Waleys, O.P. (fl. 1314–1350) and its continuation by his Dominican confrère, Nicholas Trevet. The work of Waleys and Trevet is the only commentary on the *City of God* that appeared in print in the fifteenth century; it is one of the few—or perhaps the only—extended commentary on Augustine's work written in the Middle Ages. The commentary is continuous through Book 10 of the *City of God*, with scattered glosses in Books 11–22. Thomas Waleys attended the episcopal school at Lincoln and went on to study at Oxford and the University of Bologna. He preached against the party of Franciscan Spirituals, and, in 1333, at Avignon against the notorious sermons of Pope John XXII on the beatific vision (1331–1332), which most Dominican theologians judged to be heretical. The continuator of the com-

mentary, Nicholas Trevet (ca. 1258, still living in 1334), joined the Preachers at Oxford and later studied at Paris. He also wrote commentaries on Genesis, Boethius's *Consolation of Philosophy,* and on the tragedies of Seneca. In this volume, Augustine's text is blocked in large print in the center of the page, surrounded by the commentary in smaller type, a typical manuscript format. Alphabetical text markers in Augustine's text correspond to their fellows in the commentary. An engraving on fol. 1v shows Augustine writing in the top panel; in the lower panel Abel the peaceful shepherd sits in front of the city of God, and Cain with his ax sits before the city of man. REFERENCES: Goff A-1245 (the Notre Dame copy is not cited); GW n° 2889; Kaeppeli n°s 3137 (Trevet), 3891 (Waleys); Masin 13–14 n° 7.

33. UND Library: Rare Books B655 .C499 1494

AUGUSTINUS, *De civitate Dei cum commento sacre pagine professorum ordinis predicatorum* THOME VALOIS ET NICOLAI TRIVETH (Freiburg im Breisgau: Kilian Fischer, 1494). This volume contains another edition of Augustine's *City of God* with the commentary of Thomas Waleys, O.P., and Nicholas Trevet, O.P. This German printing may be compared with Scoto's Venetian edition (catalogue n° 32). Figures 85–86 (L2v–L3r: Book 4, chapters 26–27 of the *City of God*), display two different layouts: the verso (fig. 85) shows the center block of Augustine's text surrounded by the commentary; the recto (fig. 86) shows two full columns of the text with parallel columns of commentary in the margins. This volume is rubricated by hand throughout with attractive red and blue initials. An inscription on the inside front cover indicates that this book was purchased in the fifteenth century for two gold florins. REFERENCES: Goff A-1346; GW n° 2890; Kaeppeli n°s 3137, 3891; Masin 15–16 n° 8.

34. UND Library: Rare Books BX1756 .G68 1496

Frater GREGORIUS BRITANNICUS *sacri ordinis predicatorum professor . . . Sermones funebres . . . <et> nuptiales* (Milan: Leonardo Pachel, 1496). This volume was a gift of Astrik L. Gabriel to the Library in 1986. It contains a collection of marriage and funeral sermons composed by Gregory of Brescia, O.P. (Gregorius Britannicus Brixiensis) in 1495. This is the second edition of the sermons, printed by Leonardo Pachel (1449–1512). The funeral sermons are divided between those appropriate for common folk (*vulgares*) and for the learned (*litterales*). REFERENCES: Ascarelli 147; Goff B-1207 (the Notre Dame copy is not cited); GW n° 5549; Kaeppeli n° 1334.

35. UND Library: Rare Books BF1445 .S981

BARTHOLOMAEUS SIBYLLA DE MONOPOLI, O.P., *Speculum peregrinarum questionum* (Strassburg: Johann Grüninger, 1499). Bartholomew Sibylla (†1493) studied at Bologna and Ferrara. He became the Prior of the Dominican convent in Monopoli near Bari. The *Speculum peregrinarum* is Bartholomew's major writing. The text is ordered mystically into three parts, or "decades," of ten chapters each. The first decade contains questions concerning the origin and immortality of the human soul, hell, limbo, purgatory, the Elysian fields, paradise, the beatitudes,

etc.; the second decade contains questions concerning the good angels, their *esse et essentia*, knowledge, powers and attributes; the third decade treats likewise the powers, etc., of evil angels. In form and substance, this work by a Calabrian Dominican unites a rather Joachimite rhetorical disposition with popular devotion concerning the last things and Scholastic questions. The volume has a contemporary south German, tooled leather binding. The inside covers bear pastedowns, in two columns of French fourteenth-century writing, of a Scholastic text concerning, among other things, the authority of bishops. The image on the title page depicts the creation and fall of Adam and Eve, the resurrection of the body, and, in the foreground, the author dedicating his book to "the most illustrious Prince, Alfonso of Aragon, Duke of Calabria." REFERENCES: Goff S-492 (the Notre Dame copy is not cited); GW n° 3460; Kaeppeli n° 448; Masin 120–21 n° 64.

36. UND Library: Astrik L. Gabriel Collection n° 34

Expositio commentaria prima . . . in Prima Secunde Angelici doctoris SANCTI THOME AQUINATIS *per reverendum sacre pagine professorem interpretemque profundissimum Magistrum* CONRADUM KOELLIN *Conventus Ulmensis ordinis fratrum predicatorum nunc in Colonia regentem eruditissimum* (Cologne: [Heinrich] Quentel, 1512). Konrad Koellin (†1536) entered the Dominican Order at Ulm and later became the Regent of Studies in Cologne. He attended Cajetan's lectures on Thomas Aquinas at Heidelberg. This commentary on the *Prima secundae* of Thomas Aquinas's *Summa theologiae* was printed by Heinrich Quentel, a member of a famous printing family in Cologne whose firm published many Catholic books. The title page bears an ex-libris from the large library of the Carthusians in Buxheim. Presumably, the book once belonged to the bookseller Rosenthal of Munich, for it was on the stock of the library from Buxheim that he built his business and reputation. Thomas's text, printed in slightly larger letters, is followed by Conrad's extensive commentary; large printed letters in the margins correspond to an alphabetical index of topics at the end of the volume. By reference to question number and marginal guide letter, the reader may easily find the topic he desires. REFERENCES: IA 3/3: 430; Quétif-Échard 2/1: 100; VD16 20: 358 (T 1022).

37. UND Library: Rare Books BX4700 .C286S A8

Libro del Dialogo, el qual tracta de la divina providentia de la seraphica et dilectissima sposa del dolcissimo salvatore nostro Iesu Christo, suore del terzo ordine di sancto Domenico SANCTA CATERINA DA SIENA (Venice: Cesare Arrivabene, 1517). The Notre Dame copy of this volume lacks a title page. The book contains the Italian text of Catherine of Siena's *Dialogue of Divine Providence.* The work is preceded by an epistolary proemium in Italian treating St. Catherine's life, "per el reverendo padre . . . fratre N. de Iordine de sancto Domenico," whom we have not yet identified. This *Vita* is followed by the Latin letter of canonization by Pope Pius II (1460). The printer Cesare Arrivabene was active in Venice in the first quarter of the sixteenth century. REFERENCES: Ascarelli 338–39; BMCIB 159 (1350. a. 14); Schutte 123.

38. UND Library: Rare Books BX4700 .C286s A3L 1562

Lettere devotissime della beata vergine santa CATERINA DA SIENA (Venice: Al segno della Speranza, 1562). This volume of the collected letters of Catherine of Siena (catalogue n° 9) was printed at the famous "sign of Hope" in Venice. The names of the printers at this press are not known; they may have been women. The text of the letters is elegantly set in two columns and is printed in the italic typeface made famous by Aldo Manuzio. The title page bears the printer's mark of the allegorical figure of Hope, which graces many important printed books of the sixteenth century (see catalogue n° 40). REFERENCES: Ascarelli 385; BMCIB 159 (3836. b. 43); Zappella, *Le marche*, fig. 1126.

39. UND Library: Astrik L. Gabriel Collection n° 53

Fratris HIERONYMI SAVONAROLAE FERRARIENSIS *ordinis praedicatorum, Triumphus crucis de fidei veritate* (Venice: Luca Olchiense, 1517). The *De triumpho crucis* is perhaps the most popular spiritual writing of the renowned Dominican preacher and reformer, Girolamo Savonarola (1452–1498). As the colophon states, the printer Luca Olchiense was a professor of arts and law: "Impressumque Venetiis accurata diligentia per Lucam olchiense artium & legum professorem. Anno domini M.CCCCCXVII. Die uero octauo mensis Iunii." The text was reviewed by a "learned theologian" (title page). Luca was active as a printer for only a short time (1517–1518). The book consists of 14 quaterni (A–O, 112 fols.) A woodcut on the title page shows the hooded author writing in his study, sitting before a crucifix. The woodcut is based on, and inverts, a woodcut in an earlier Venetian edition (1504) of Savonarola's work by Lazzaro de' Soardi (see catalogue n° 16). REFERENCES: Borsa 1: 237; IA 3/3: 416 (printer); Zappella, *Il ritratto*, 47 and fig. 309b–c.

40. UND Library: Rare Books BX890 .Sa 95t

Triompho della croce di Christo, della verita della fide Christiana, composto per il Reverendo padre frate HIERONYMO SAVONAROLA DA FERRARA, *dell'ordine de i Frati Predicatori* (Venice: Al segno della Speranza, 1547). This volume, printed at the "sign of Hope" (see catalogue n° 38), presents the widely published Italian translation of Savonarola's *Triumph of the Cross* by Domenico Benivieni. It too is printed in the Aldine italic typeface (see catalogue n° 38). REFERENCES: Ascarelli 385; Schutte 350; Zappella, *Le marche*, fig. 1126. A critical edition of Benivieni's Italian translation accompanies the Latin text in Edizione Nazionale delle Opere di Girolamo Savonarola: *Triumphus Crucis. Testo Latino e volgare*, ed. Mario Ferrara (Rome: Angelo Belandetti Editore, 1961).

41. UND Library: Astrik L. Gabriel Collection n° 64

Sermones moralissimi super evangelia dominicalia totius anni . . . Reverendi in Christo GUILHERMI DE PERALDO *ordinis fratrum Predicatorum sacre pagine doctoris . . . Questio adiuncta ad communem utilitatem predicantium per Fratrem* BERNARDUM DE CROSO, *sacri ordinis predicatorum* (Avignon: Jean de Channey, 1519). The Sunday sermon sequence of William Peraldus (†1261) was no less popular than his Summas on the vices and virtues (see catalogue n° 2). In the Middle

Ages, the sermons circulated in hundreds of manuscripts, and they were printed many times through the seventeenth century. This edition adds a disputed question concerning prayers for the dead, purgatory, the Pope's power of binding and loosing, etc., by Bernardus de Croso, O.P. (†1519). Bernard, who was at one time Poenitentiarius to the Pope, also provided an alphabetical table to Peraldus's sermons. The title page, printed in black and red, bears the papal coat of arms and privilege (fig. 87); a woodcut on the verso depicts the Mass of St. Gregory (fig. 89). The printer's device of Jean de Channey on the last verso imitates the dolphin and anchor mark of the famous Venetian humanistic scholar and publisher, Aldo Manuzio (ca. 1550–1515; see fig. 88). An owner's monogram (the letters NB topped by a cross) is written in the papal coat of arms on the title page and on the last verso of Bernardus de Croso's question. An ex-libris on the verso of the back flyleaf states: "Hic liber est fratris Gregorij ad usum suorum amicorum." REFERENCES: IA 3/3: 330 (printer); Kaeppeli n° 1623 (Peraldus); Quétif-Échard 2/1: 40a (Bernardus).

42. **UND Library: Rare Books B485 .A45**

<PS->ALBERTUS MAGNUS <ALBERTUS DE ORLAMUNDA, O.P.?>, *Philosophiae naturalis Isagoge, sive introductiones in libros Aristotelis Physicorum, de Coelo et mundo, de Generatione et corruptione, Meteorum, de Anima* (Strassburg: Ulrich Morhart the elder, 1520). The Notre Dame copy lacks the title page. Already in the Middle Ages, for obvious reasons, the *Summa naturalis philosophiae* (title, fol. 2r) printed in this volume was commonly attributed to Albert the Great, O.P. (1206–1280). Indeed, the *Summa*, which contains epitomes of five works of Aristotle on natural philosophy, consists largely of extracts from, and abbreviations of, Albert's massive paraphrase commentaries on Aristotle (see catalogue n° 72). Albert's works were often digested by his students and confrères for the instruction of the less learned brethren. In earlier manuscripts this "Philosophy for the simple" (*Philosophia pauperum*), as the work was sometimes called, is ascribed only to a "Brother Albert, O.P." Other manuscripts are more specific, mentioning an "Albert of Orlamünde." Scholars now believe that it was this Albert (fl. late 13th c.), a Dominican teacher in Thüringen, who compiled these digests. The printer of the edition, Ulrich Morhart, was active in Strassburg in the years 1519–1523. REFERENCES: Geyer (esp. 42–47); IA 1: 261, 3/3:411; Kaeppeli n° 112; Benzing and Muller 2: 257 n° 2.

43. **UND Library: Astrik L. Gabriel Collection n° 87**

Vita et Officium ac Missa cum cantu SANCTI ANTONINI *Archiepiscopi Florentini, per reverendum sacre theologie doctorem celeberrimum magistrum* VINCENTIUM DE SANCTO GEMINIANO *predicatorum ordinis procuratorem meritissimum composita* (Paris: Macé Des Bois, Enguilbert de Marnef, Nicholas Prévost, 1526 [i.e., 1527]). The Life, Office and Mass of St. Antoninus of Florence, O.P. (†1459; feast day 10 May; see catalogue n° 27) were composed by Vincent Mainard of S. Geminiano, O.P. (†1527), who was a friar at the convent of S. Marco in Florence. This is a revised edition of one printed in 1525, adding musical notation and notes

by another Dominican friar, Hieronymus Pomerius, who in 1528 received his license at the Sorbonne. The title page bears an image of the Archbishop, and a user's inscription: "Frater Sebastianus de Magnale. Nunc 1535." The press of Des Bois and his associates, like the press of the Petit family (see catalogue n[os] 19, 49, 59, 61), was in "the neighborhood" of the ancient Dominican convent of Saint-Jacques. REFERENCES: ICEP 3: 304 n° 1047; Quétif-Échard 2/1: 75.

44. UND Library: Astrik L. Gabriel Collection n° 100

Divi DIONYSII CARTHUSIANI *Opuscula alquot [sic], quae spirituali vitae et perfectioni tam vehementer conducunt . . . Triginta religionis excellentiae* ALANI DE RUPE *sacrae theologiae doctoris* (Cologne: Melchior Neuss [Novesianus], 1534). Denys the Carthusian (1402–1471) was perhaps the most prolific writer of the Middle Ages. The edition of his works made by Dirk Loër and the Carthusian monks in Cologne is one of the great feats of printing in the sixteenth century. Loër, who claims to have used Denys's autograph manuscripts for the edition, almost single-handedly published 57 volumes, printed in different formats by several presses, between the years 1521 and 1538. The printer of this edition, Melchior Neuss (active in Cologne 1525–1551), also printed several other volumes of Denys's writings. Dirk Loër frequently consulted Dominican theologians in Cologne on points of "theological correctness." This volume, containing a series of treatises for beginners in the religious life, was one of the most widely read in the Cologne edition. The book also contains an enormously popular mystical treatise by Hugh of Balma, O.Cart. (fl. late 13th c.), another by Eusebius, and a little protreptic writing by Alain de la Roche, O.P. (1428–1475), which proclaims the advantages of the religious life. Alain studied in the convent of Saint-Jacques at Paris and then lived in various Dominican convents in the Low Countries. By his writings (*Psalterium gloriosissimae virginis Mariae, qui fuit revelatus Beato Dominico*) and his zealous preaching, more than anyone else Alain established the modern devotion of the rosary and popularized the legend that the Virgin Mary revealed the devotion to St. Dominic (see catalogue n° 56). He was the founder of the Confraternities of the Rosary, which spread throughout Europe. REFERENCES: Chaix 2: 493 n° 35.1/1; IA 3/3: 414; Kaeppeli n° 88.

45. UND Library: Rare Books B430 .J328e

Epitomata in decem libris Ethicorum Aristotelis ordinata per fratrem CHRYSOSTOMUM JAVELLUM CANAPICIUM *ordinis predicatorum philosophie et sacre theologie professorem* (Venice: Stefano Nicolini da Sabbio, 1536); *Epythomata in octo libris Politicorum Aristotelis per fratrem* CHRISOSTOMUM JAVELLUM CANIPICIUM *ordinis predicatorum* (Venice: Stefano Nicolini da Sabio, 1536). The two books bound in this volume contain epitomes (with some comment) of Aristotle's *Ethics* and *Politics* by the Italian Dominican, Chrysostom Javellus of Canavese (in Piedmont; died ca. 1540). Besides these works, Chrysostom wrote epitomes of most of Aristotle's other writings and epitomes of Plato's ethical and political doctrines. He also wrote theological treatises on predestination, the Immaculate Conception, and a commentary on the first part of Thomas Aquinas's *Summa theologiae* (see

catalogue nᵒˢ 63, 67). This is another book (see catalogue nᵒ 30) published by a member of the Nicolini da Sabbio family; Stefano was active in Venice in 1524–41. REFERENCES: Ascarelli 354–55, and fig. 35 (printer's mark); Quétif-Échard 2/1: 104b–5b.

46. UND Library: Astrik L. Gabriel Collection nᵒ 106

Homiliarum sive Sermonum doctissimi viri IOHANNIS ECKIJ *adversum quoscunque nostri temporis haereticos, super Evangelia de tempore . . . Tomus I* (Cologne: <Eucharius Cervicornus for Gottfried Hittorp>, 1537). Johann Eck (1486–1543), the relentless adversary of Martin Luther, was a professor at the University of Ingolstadt for thirty years. He was adept in both Scholastic and humanistic learning. This volume contains his sermons *de tempore* from Advent until Easter, with a sermon-treatise on the Passion of Christ. The sermons were originally composed in German (*Christenliche Ausslegung der Evangelien von der seit*) and are translated here by Johann Metzinger. This Latin edition was printed by Eucharius Cervicornus (active 1516–1547) at the expense of Gottfried Hittorp. Hittorp seems to have been anxious about the Lutheran threat; in 1529 he had published a work by a Dominican author against heretics in general and Luther in particular (catalogue nᵒ 69). This volume is only the first of four containing sermons by Eck translated by Metzinger which Eucharius and Hittorp published in the same year. Volume 2 of the series contains Eck's *Sermones de sanctis*; volume 3 contains additional sermons, including a diatribe against the Turks; volume 4 contains sermons concerning the seven sacraments. In 1534, Eucharius himself had published the *Sermones de tempore* and the *Passio Domini nostri Iesv Christi* in two volumes. The present edition contains 58 woodcuts by the well-commissioned artisan in Cologne, Anton Woensam of Worms (†1541). He also made elaborate woodcuts for the volumes in the Cologne edition of the works of Denys the Carthusian (see catalogue nᵒ 44). A handwritten ex-libris on the inside front cover indicates that the book was once used by a Dominican friar in Cologne, Paul of Lobbrich: "ad usum fratris Pauli a Lobbrich ordinis predicatorum in Colonia." An ex-libris label pasted below the inscription and another handwritten ex-libris on the title page indicate that the book was later owned by the Dominican convent in Augsburg. REFERENCES: IA 3/3: 104 (printers); Kisky (Anton Woensam); VD16 5: 623–24 (E 290, E 292, E 295).

47. UND Library: Rare Books BT600 .So68m

Mariale Reverendi patris et Magistri BALTHASARIS SORIO *ordinis predicatorum* (Tortosa: Arnaldus Guillermus de Montepesato, 1538). Balthasar Sorio, O.P. (†1557) was a friar from the convent of S. Onufrio in Valencia. The *Mariale* consists of sermons on the various mysteries of the Virgin's life, e.g., the Conception, Annunciation, Visitation, Purification, Assumption. Balthasar wrote several sermons for each mystery; the running headlines refer to the sermon number in the sequence. This is the first—and apparently the only—edition of Balthasar's *Mariale*. The title page of this copy bears a handwritten ex-libris that indicates that the book once belonged to the very convent in Valencia where the author had lived.

Underneath the author's printed name is the writing: "Filius huius Conventus Sancti Onufri." REFERENCES: IA 3/3: 246; Quétif-Échard 2/1: 159b–160a; Isaías Rodríguez, "Autores espirituales españoles (1500–1572)," in RHCEE 3: 575 n° 278; Thomas 82 (C. 63. g. 41).

48. UND Library: Astrik L. Gabriel Collection n° 115

Opusculum reverendi patris fratris GUILLIELMI PEPIN, *sacre Theologie professoris Parisiensis clarissimi, ordinis predicatorum, Super Confiteor* (Paris: Ambroise Girault, 1540). Guillaume Pepin, O.P. (†1533), graduate of the Sorbonne, was renowned for his annual Advent and Lenten sermons in Paris. Besides sermon collections, he wrote a commentary on Genesis according to its fourfold sense and devotional works on the rosary. The text printed in this volume is a confessional manual treating sins of the heart, sins of the tongue, sins of commission and omission, and contrition and satisfaction. Each of the over 150 chapters begins with the verse, "Confiteor tibi Domini, Pater celi et terra" (Matt. 11:25). This is the third Parisian edition of the work; for the printer, Ambroise Girault, see catalogue n° 59. REFERENCES: Adams 2: 58 n° 623; IA 3/3: 361; Quétif-Échard 2/1: 87a–88a.

49. UND Library: Rare Books BS2635 .V795

Epistolae Pauli et aliorum Apostolorum ad Graecam veritatem castigate, et per reverendissimum dominum dominum THOMAM DE VIO, CAIETANUM, *Cardinalem sancti Xisti, iuxta sensum literalem enarratae* (Paris: Iehan Petit II, 1540). Tommaso de Vio, O.P. (1469–1534) was the most renowned Dominican theologian and philosopher in the sixteenth century. As Master General of the Order (1508–18), he adjudicated the dispute among the friars concerning the cult of Savonarola. In 1518, he was sent as Papal Legate to Germany to interrogate Martin Luther. An intrepid opponent of the philosophical followers of John Duns Scotus, Cajetan is best known as an interpreter of the work of Thomas Aquinas (see catalogue n°s 63, 67). Modern Thomists either praise Cajetan for having discovered the "pure philosophy" in Thomas's mind, or blame him for disfiguring the "authentic" meaning of Thomas's writings. It may also surprise some that Cajetan commented upon sacred Scripture. This volume, published by Iehan Petit II, contains Cajetan's literal commentary on the Epistles of Paul. The title page displays the glory of the Petit family's printing lineage (fig. 90; see catalogue n°s 19, 49, 59, 61). REFERENCES: Adams 1: 223 n° 151; IA 3/3: 423.

50. UND Library: Rare Books BS2665 .S66 1550

Fratris DOMINICI SOTO SEGOBIENSIS, *Theologi, Ordinis Praedicatorum . . . in Epistolam divi Pauli ad Romanos comentarii; Ad sanctum concilium Tridentinum De natura et gratia libri III, cum Apologia contra reverendum Episcopum Catharinum* (Antwerp: Johannes Steelsius, 1550). The Dominican theologian, Domingo de Soto of Segovia (1494–1560), taught in Salamanca and the Low Countries, travelling back and forth between his native land and its conquered northern provinces. In the bitter disputes of his day concerning nature, grace and free will, he argued against both the Lutherans and the "Pelagians" (i.e., certain Jesuits). His

often printed treatise on this subject is printed in this edition by Johannes Steel-
sius (active 1533–76), along with commentaries on the Epistle of Paul to the Ro-
mans. This is the first edition of each work, and one of only two editions of the
commentaries on the Epistles of Paul. Apparently, de Soto was esteemed more as
a logician and philosopher than as a scriptural commentator (see catalogue n° 70).
REFERENCES: Beltrán de Heredia 531–32; IA 3/3: 453 (printer); Quétif-Échard 2/1:
171a–74a.

51. UND Library: Rare Books BV5080 .T191sl

*Homiliae seu Sermones in Evangelia, tam de tempore quam de sanctis . . . per
Divum* IOANNEM THAULERUM, *clarissimum theologum, a Divo* LAURENTIO SURIO
egregie docto, summa cura recogniti (Lyon: Sebastien Honorat, 1557). This volume
contains the sermons of the Dominican mystical preacher, Johann Tauler (†1361).
Tauler preached these sermons in German throughout the Rhineland, teaching
such mystical doctrines as the birth of the eternal Word in the soul, which he had
learned from Meister Eckhart, O.P. (†1327 or 1328). In light of the condemnation
of Eckhart, Tauler mitigated some of the Master's more daring mystical teachings.
Tauler's German sermons were translated into Latin by Laurentius Surius (1552–
1578) of the Charterhouse of St. Barbara in Cologne. Surius made a specialty of
translating the "Rhineland mystics," including Jan van Ruusbroec, and he was a
primary channel of their teachings in the Counter-Reformation. Some of the ser-
mons translated by Surius and printed in this edition, attributed to Tauler, are in
fact by Meister Eckhart, giving his teaching an afterlife in the Counter-Reforma-
tion, with no small consequences. The edition also includes a Life of Tauler drawn
from materials of Iohannes Trithemius (1462–1516), Benedictine monk of Spon-
heim, encyclopedic cataloguer of medieval theological literature, connoisseur of
manuscripts, magus and master of cryptology. The date when the book was bound,
1567, is branded into the cover of the book, with the initials IGH. Dated bind-
ings are a rarity so early in the history of the book. REFERENCES: Baudrier 4: 172;
Kaeppeli n° 2688.

52. UND Library: Rare Books BX1750 .X56 1567

Enchiridion, o Manual de doctrina Christiana hecho por el R. P. Fray DIEGO XIME-
NEZ, *de la orden de los Pedicadores. Un sermon de la Magdalena, y la exposicion
del Psalmo Miserere, del mismo autor. Tambien, Summa de Doctrina Christiana,
hecha por del R. P. Fray* DOMINGO DE SOTO, *de misma orden* (Salamanca: Pedro
Lasso at the expense of Juan Moreno, 1567). The manual of Christian doctrine, the
sermon in honor of Mary Magdalene, and "the very good exposition of the *Mise-
rere*" printed in this edition were composed by Domingo Ximenez Arias, O.P.
(†1578), who studied in Salamanca. The volume concludes with a companion sum-
mary of Christian doctrine by Domingo de Soto, O.P. (†1560; see catalogue n°s 50,
70). The four treatises have separate title pages, although they were printed and
sold as a single volume. The book was actually printed by Pedro Lasso but bears
the mark of the publisher, Juan Moreno. REFERENCES: Beltrán de Heredia 533–34

(edition not cited); J.-R. Guerrero, "Catecismos de autores españoles de la primera mited del siglo XVI (1500–1559)," in RHCEE 2: 244–45; IA 3/3: 389, 411; Quétif-Échard 2/1: 171a–74a, 247; Rodríguez, "Autores espirituales españoles," in RHCEE 3: 504 n° 161.

53. **UND Library: Rare Books BX890 .C2271**

Locorum theologicorum libri duodecim . . . authore Reverendissimo D.D. Melchiore Cano *Episcopo Canariensi, ordinis Praedicatorum, Primariae Cathedrae in Academia Salmanticensi olim Praefecto* (Cologne: the heirs of Arnold Birckmann I, 1574). The Dominican friar, Melchior Cano (ca. 1505–1560), Bishop of the Canary Islands (1552), First Chair of Studies at Salamanca—indeed, the Prefect—*peritus* at the Council of Trent, Inquisitor, was an illustrious ecclesiastic and defender of the faith. The *Loci theologici*, first published posthumously in 1563, is one of the most significant works in the history of modern theology, often said to be the first major work of Catholic "positive theology." Adopting new theories of dialectical and rhetorical invention, taught by Rudolph Agricola (1444–1485) and other Renaissance humanists, Cano orders the sources of Catholic doctrine and tradition into "places," whence one may easily draw material for teaching and controversy. The "places" are arranged hierarchically, according to the authoritative force of their arguments: the authority of apostolic tradition, of the Church, of Councils and synods, of the pronouncements of the Roman Pontiff, of the teachings of the "saints" or Fathers of the Church, of Scholastic Doctors, natural reason, philosophy and human history. The work concludes with a discourse on the limits of Scholastic disputation. This volume is heavily annotated throughout, showing that its owner used this book as its author intended, as a source for ready reference—and probably, for combat. References: IA 6: 421, 3/3: 313 (printer).

54. **UND Library: Astrik L. Gabriel Collection n° 211**

Methodus confessionis seu verius Doctrinae pietatisque christianae praecipuorum capitum epitome, a Divo Petro de Soto (Dillingen: Sebald Mayer, 1576). Pedro de Soto, O.P. (†1563), was a student at Salamanca, and—according to the ideal promoted by Melchior Cano—was learned in the works of the fathers and the teachings of the Councils as well as in Scholastic theology. He was a counsellor to the Emperor Charles V, who urged him to go to Germany to preach against the Lutheran heretics. Many of his writings are controversial. The *Method of Confession* published in this volume is a pastoral work in the tradition of medieval Dominican writings. It treats the ten commandments, the sacraments, the seven capital vices and their remedial virtues, and the art of dying well. Pedro de Soto's writings enjoyed special popularity in Germany; two of his other catechetical works were first published in Germany, and one of them, the *Compendium doctrinae catholicae,* was also translated into German, and was printed by Sebald Mayer, the printer of this volume. This volume binds together another confessional work by the Jesuit Johann Polan, which was also printed by Mayer in 1576. The book has a contemporary pigskin binding over boards, appropriately blind stamped with an image of

Christ's Harrowing of Hell. REFERENCES: Guerrero, "Catecismos de autores españoles," in RHCEE 2: 240–41; IA 3/3: 405; Quétif-Échard 2/1: 183a–84a; VD16 19: 307 (S 7089).

55. UND Library: Rare Books BV4209 .L968e

Ecclesiasticae rhetoricae, sive de ratione concionandi libri sex ... Authore R.P.F. LUDOVICO GRANATENSI, *sacrae Theologiae professore, monacho Dominicano* (Lisbon: Antonio Ribeiro, at the expense of João de Espanha, 1576). Luis de Granada, O.P. (1504–1588), entered the Order at Santa Cruz, and thereafter lived in the convents of Cordoba, Valladolid and Seville. In 1556 he became Provincial of the Order in Portugal. He was an influential spiritual writer (see catalogue nos 56, 77–81), who based his teaching on the doctrines of his fellow Dominicans, Catherine of Siena, Savonarola, John Tauler and Thomas Aquinas. Through the diligent efforts of Melchior Cano (see catalogue n° 53)—a true "hound of God"— some writings by Luis were put on the Index of Prohibited Books. Among other things, Cano objected to Luis' teaching that all Christians should become Christ-like. Luis was later exonerated by his confrères, and was named a Master of Sacred Theology in the Order in 1562. This is the first edition of the *Ecclesiastical Rhetoric*, a new type of preaching manual, similar in overall conception to Erasmus's *Ecclesiastes* (1534). Like Erasmus, Luis applies the principles of ancient eloquence to Christian preaching; his work is as different from medieval Dominican preaching manuals as Renaissance theories of topical invention are from medieval school dialectic. Yet Luis' ideal of wisdom and eloquence had eminent Christian authority: Augustine's *De doctrina christiana*. Following Augustine, Luis subordinated the beauty of "words" to the truth of "realities" in persuasion. The printer Antonio Ribeiro (active 1574–1590) published many books by friars of the different orders. REFERENCES: Anselmo 267–68 n° 923; Llaneza 4: 1 n° 2842; Quétif-Échard 2/1: 285a–91b.

56. UND Library: Rare Books BX2163 .L968r

Rosario della sacratissima vergine Maria, Madre di Dio, nostra Avocata dall'opere del R.P.F. LUIGI DI GRANATA *del ordine de Predicatori, racolto per il R.P.F.* ANDREA GIANETTI *teologo ...* (Rome: Domenico Basa, 1585). Andrea Gianetti de Salo, O.P. (†1575), a friar in Brescia, compiled the texts in this book from the writings of Luis de Granada, and cast them into the form of the decades of the rosary. Between its first edition in 1572 and 1593, de Salo's compilation was published 13 times, and it continued to be published in the seventeenth century. In this edition of 1585, twenty-two full-page engravings accompany the text. In fact, the printer, Domenico Basa (active 1580–1596), has used again the plates engraved by Adamo Montovani ('Scultori') for the 1572 and 1573 Rome editions, printed by Giuseppe degli Angeli (Llaneza 1: 216 n° 552, 220–21 n° 560). On the frontispiece, Basa replaces the original signature of the engraver with his own printer's label (fig. 91). The engravings depict the Virgin Mary revealing the rosary to St. Dominic (fig. 92); Alain de la Roche (see catalogue n° 44) preaching the rosary to ecclesiastical authorities (p. 24); rosary trees for each set of mysteries (joyful, sorrowful and glo-

rious), and images for each separate mystery. REFERENCES: Ascarelli 123; Llaneza 1: 270–71 nº 694; Mortimer 1: 313–14 nº 218; Quétif-Échard 2/1: 231b.

57. UND Library: Rare Books oversize BS445 .Si84

Bibliotheca sancta a Fratre SIXTO SENENSI, *Ordinis Praedicatorum, ex praecipuis Catholicae Auctoribus collecta, et in octo libros digesta . . . nunc vero a* IOANNE HAYO SCOTO, *Societatis Iesu, plurimis in locis a mendis expurgata, atque scholiis illustrata* (Lyon: Sibille de la Porte, 1593). Sisto of Siena was born of Jewish parents in 1520 and as a boy worshipped in the Synagogue. He converted to the Christian faith as a young man and entered the Friars Minor. In 1551, with the permission of Pope Pius V (O.P.), he transferred to the Order of Preachers. The *Bibliotheca sancta*, first published in Venice in 1566, is an encyclopedia of monumental erudition, comprehending an entire literary pedagogy to assist reading the sacred Scriptures. The eight parts of the work comprise material on the structure and order of the Bible; a dictionary of all the authors and writings mentioned in the Scriptures; a treatise on the principles and techniques of interpreting the Scriptures, comparing the different methods of the Fathers; a bio-bibliography of the Catholic commentators on the Scriptures, treating hundreds of commentators; annotations and summaries on difficult and controverted verses of the Scriptures, from Genesis to the Apocalypse; the correction of false or heretical interpretations of verses in the New and Old Testaments, followed by various indices, including an index of heretics. The fourth Book is especially interesting for medievalists. It contains, as stated, bio-bibliographies of hundreds of Christian commentators, from antiquity to Sisto's own time (pp. 190–309); bio-bibliographies of Jewish commentators (pp. 310–11); a register listing the commentators for each book of the Scriptures (pp. 312–17); another register classifying commentators according to their methods (e.g., Scholastic, homiletic, meditational, paraphrase, disputational, pp. 317–20). Sisto of Siena was the Stegmüller of his day, and doubtless anticipated his successor on many points. On the title page, the book identifies itself as belonging to the convent of the Preaching brothers in Augsburg: "Sum Conventus Augustini FF. Praedicatorum." Unusually, the blind stamp cover is branded with its date: 1595. Astrik L. Gabriel acquired this book for the library from the bookseller Rosenthal in February 1952—for $12.50. REFERENCES: Baudrier 7: 357–58; Quétif-Échard 2/1: 206b–8b.

58. UND Library: Rare Books oversize BX2015 .A3 D6 1596

Missale iuxta ritum Fratrum Ordinis Praedicatorum, sub Reverendissimo Patre Fratre HIPPOLYTO MARIA BECCARIA A MONTEREGALI, *totius praefati Ordinis Generali Magistro, Anno Domini MDXCV reformatum* (Venice: Giovanni Bernardo Sessa and Barezzi Barezzo, 1596). Hippolito-Maria Beccaria of Mondovi, O.P., studied at Bologna, and was then attached to Sta. Sabina in Rome and the convent of Sta. Caterina De Formello in Naples. He became Master General of the Order shortly before he died in 1589. The frontispiece of this altar Missal was engraved and signed by Jacopo Franco. The large engraving at the opening of the Missal shows the Virgin Mary presenting St. Dominic and the stigmatized St. Francis to

the wound-bearing, resurrected Christ, who is well-pleased with his sons. The engraving is initialed "C.P." (fig. 93). The Missal includes special Dominican votive Masses to the Five Stigmata of Christ, The Sufferings of Our Lord Jesus Christ, and the Holy Cross. Like the engraving at the beginning, these votive Masses bespeak the Preachers' devotion to the humanity and Passion of Christ. Appended to the Missal is an Office of Blessed Rose of Lima (feast day 26 August). The inside cover bears a twentieth-century ex-libris of the Dominican Fathers in London. REFERENCES: Ascarelli 328,438; BMCIB 387 (C. 52. h. 12); Quétif-Échard 2/1: 292b–93a.

<p style="text-align:center">⋆ ⋆ ⋆</p>

The next part of the catalogue is given over to Thomas Aquinas and his commentators. It was during the sixteenth century, and notably after the Council of Trent, that Thomas came to be perceived, not only as a 'holy' and 'moral' doctor, as he was called in the Middle Ages, but as the 'Common Doctor' of the universal Church. The magnification of Thomas's authority is indicated by the encyclopedic volumes of his works published in the sixteenth century, in which his texts were accompanied by commentaries and apparatus for their study and use. Several of these commentaries and apparatus came to form a standard canon, which circulated among publishers and printers in the same and different cities. So in the early-modern period the works of Thomas Aquinas came to receive the same treatment as sacred Scripture and ancient authoritative texts (e.g., Aristotle) had received in the Middle Ages.

59. **UND Library: Rare Books B765 .T361di**

Divi THOME AQUINATIS *Enarrationes, quas Cathenam vere Auream dicunt. In quattuor Euangelia, ex vetustissimorum codicum collatione quantum licuit emendate ac in lucem edite opera* NICOLAI HIGMAN (Paris: Jacques Kerver, 1537); *Diui* THOME AQUINATIS, *ordinis praedicatorum . . . in beati Pauli apostoli epistolas, commentaria . . .* (Paris: Ambroise Girault, 1538). This book binds together two separate folio volumes that constitute a library of Thomas Aquinas's commentaries on the New Testament. The first volume (340 + 3 fols.), printed by Jacques Kerver (active 1535–1585) at the sign of the two roosters on the rue Saint-Jacques (fig. 94), contains Nicholas Higman's edition of Thomas's "Golden Chain" of continuous commentary on the four Gospels (see catalogue nº 71). The text is printed in two columns, with the scriptural texts in larger letters followed by Thomas's readings in smaller print. At the end of the running commentaries on Matthew, Mark and Luke are tables indicating the folio numbers where Thomas treats the Gospel pericopes for the temporal cycle of the liturgical year; a global index for all four running commentaries for both the temporal and sanctoral sequences follows Thomas's commentary on the Gospel of John. The verso of the title page, curiously, bears a dedication by the famous Parisian publisher and printer, Iehan Petit I (active 1492–1553). Indeed, according to Adams (see below), another publication of Higman's text of the *Catena aurea* printed at Paris in the same year bears the

device of Petit, and has exactly the same foliation and signatures as Kerver's volume. Apparently this is another example of the Petit family sharing print runs with other printers (see catalogue nos 60–61). Otherwise, Kerver's printing is not cited in any of the standard reference works. An ex-libris and *signum manuale* on the title page indicates that in the sixteenth century this book (presumably both volumes) was owned by a Brother Helias Boxtel of the Seminary in 's-Hertogenbosch (the Netherlands).

The second volume bound in this book contains Thomas's commentaries on the Epistles of Paul (13 + 300 fols.). It too is printed in double columns, with the scriptural texts in larger and Thomas's readings in smaller print. The commentaries are preceded by extensive alphabetical topical tables printed in three columns. The title page is printed in red and black and bears the elaborate device of "the honest man" Ambroise Girault (see catalogue no 48), whose office "under the sign of the Pelican" was also on the rue Saint-Jacques (fig. 95). This printing of Thomas's commentaries on Paul is not cited in any of the standard reference works. REFERENCES: Adams 1: 51 no 1476 (Petit's *Catena*); IA 3/3: 383 (Jacques Kerver).

60–61. UND Library: Rare Books B765 .T53 S94 1552, and **B765 .T361sc 1552**
Divi THOMAE AQUINATIS *ex Praedicatoria familia, Summa contra gentiles, quatuor libris comprehensa, commentariis eruditissimi viri, Fratris* FRANCISCI DE SYLVESTRIS, FERRARIENSIS, *doctoris Theologi, ordinis item Praedicatorij* (Paris: Jean Savetier for Vivant Gaultherot, 1552); *Divi* THOMAE AQUINATIS . . . *Summa contra gentiles . . . commentariis . . . Fratris* FRANCISCI DE SYLVESTRIS, FERRARIENSIS (Paris: Jean Savetier for Oudin Petit, 1552). The commentary on Thomas's *Summa contra gentiles* published in these volumes was written by Francis Sylvester of Ferrara, O.P. (1474–1528), who also commented on works of Aristotle, wrote a treatise against Martin Luther, and a Life of Blessed Osanna of Mantua, O.P., to whom he was personally devoted. Despite the different publishers' marks and signatures on their title pages, these books are identical, page-for-page. Even the typesetting of the title pages is identical, except for the devices (for which a space was left) and the line of the publisher's statement (see figs. 96–97). The books were printed in a single run at the Parisian press of Jean Savetier, whom the Petit family several times sub-contracted to print their books. Apparently, the printer Vivant Gaultherot (active 1534–1553) entered an agreement with Oudin, the latest scion of the Petit printing dynasty (active 1540–1572), to share the expense of producing the volume (see catalogue no 59). Remarkably, Gaulterot and Petit seem not to have been the only partners in this enterprise. Adams (see below) lists another printing of Thomas's *Summa contra gentiles* with Sylvester's commentary, also published in Paris in 1552, which was printed by Jean Savetier for another publisher, Jean Foucher (active in Paris 1535–1577). This book has identical foliation and signatures as those published by Gaultherot and Petit; we presume that Foucher's title page is also identical, except for the device and publisher's statement. By happy accident, Oudin Petit's initials, printed on his device (fig. 97) are the same as the Order of Preachers that his family served for so long at the sign of the Lily on the rue Saint-Jacques (see catalogue nos 19, 49, 59). This coincidence on the title page

of a work by Thomas Aquinas seems appropriate, for by juxtaposition it signifies the close affiliation between the printing Petits and the Preachers, making the former honorary members, as it were, of the *familia praedicatoria*. This exemplar of Gaultherot's printing of the *Summa contra gentiles* once belonged to the Dominican convent of St. Raymond of Peñafort in Barcelona. The University of Notre Dame purchased a part of the convent's library in the 1970s (see catalogue n[os] 64–65). References: Adams 1: 49 n° 1419 (Foucher's edition); IA 3/3: 358, 423, 444; Quétif-Échard 2/1: 59b–60b.

62. UND Library: Rare Books B765 .T361st 1569

Sancti Thomae Aquinatis *Summa totius theologiae*, 5 volumes (Antwerp: Christopher Plantin, 1569). These volumes (bound here in three) bear the mark of the "Golden Compasses" of the famous publisher in Antwerp, Christopher Plantin. This landmark edition of Thomas Aquinas's *Summa theologiae* was revised and reprinted several times, and set a standard that other late sixteenth-century publishers of Thomas's work attempted to surpass (see catalogue n[os] 63, 67). The demand for the *Summa theologiae* is indicated not only by the number of editions, but by their massive and elaborate formats, which required large initial investments by the publishers. This edition was prepared by a group of theologians from Louvain, led by Augustine Huens (see catalogue n° 66) and the Dominican Antonius de Conceptione (†1585), who executed the marginal annotations.

Each part of the *Summa theologiae* has its own title page, and each is preceded by two indices: the first alphabetically arranges the "commonplaces" (*locos communes*) contained in the following part; the second presents the order of topics and questions in schematic form. Some parts have supplemental indices. The final volume contains "five new general indices for a long time until now greatly desired by the studious": (1) an index of scriptural authorities in the *Summa*; (2) a diagrammatic table of *locos communes* in the work; (3) an alphabetical register of teachings and memorable *sententiae* in the *Summa*; (4) an index of places suitable for combatting the heretics "of our day"; (5) an index of places in the *Summa* convenient for preaching the Epistles and Gospels of the liturgical year. So the *Summa theologiae* became a manual of preaching materials that supplanted the medieval Dominican works designed for that specific purpose (although those works too continued to be printed). The indices are followed by a "Catalogue of philosophers, orators, poets, pontiffs, Councils, doctors, decretals, definitions, etc." cited by Thomas. The five new indices and the catalogue were reprinted and augmented in many subsequent editions of the *Summa* (see catalogue n[os] 63, 66–67), providing the foundation for the extensive indexing of Thomas's writings and those of his commentators executed by scholars in the next decades. Reference: Voet 5: 2195–2204 n° 2312 gives a detailed description of these volumes and their contents.

63. UND Library: Rare Books B765 .T361st 1581a

Summa S. Thomae Aquinatis, *Doctoris Angelici, Ordinis Fratrum Pradicatorum, vniversam sacram Theologiam complectans, in tres partes diuisa ad Ro-*

manvm exemplar diligenter recognita; cum Commentariis R.D.D. Thomae de Vio Caietani . . . *Nunc vero eruditissima R.F.* Chrysostomi Iavelli *Commentaria in primum partem in lucem prolata hic adicimus. Accessit autem Supplementum Tertiae pars, et Quodlibeta eiusdem S.* Thomae, *itemque Opuscula omnia* Caietani, *et multi iique locupletissimi Indices,* 3 volumes here bound in 5 (Lyon: Thibault Ancelin for Jeanne Giunta, 1581). The title page of the first volume of this set mentions the contents of all three volumes, although each major part has its own title page. The title pages bear the device of a rampant lion with the motto *De Forti Dvlcedo;* this was the mark of the "heirs of Jacopo Giunta," who had established his family's printing operation in Lyon around 1519 (see catalogue n° 71; for the device, see Baudrier 6: 285bis). From the 1480s throughout the sixteenth century, the Giunta family, originally from Florence, established a widespread printing empire in Florence, Venice (catalogue n^os 66–67), Lyon and Spain (catalogue n° 70); descendants of the Giunta family are still active today in the printing business in Florence. In 1577 Jeanne Giunta, the daughter of Jacopo, became the legal proprietor of the Giunta firm in Lyon, and she used the device of the rampant lion for a short time thereafter. Colophons on the blank last versos of each work indicate that the printer of these volumes was Thibault Ancelin, who collaborated with many other publishers in Lyon. In 1580–1581, Jeanne collaborated with another printer, Nicholas Guerin, in a multi-volume edition of all of these same works; this edition is nearly identical with the one printed by Ancelin (see Baudrier 6: 377–79). The heirs of Jacopo Giunta had previously published editions of Thomas Aquinas's *Summa* with the commentaries of Cajetan and some of the other items included in these volumes (in 1558, 1562 and 1568). This new, even more comprehensive edition was perhaps motivated by competitors, such as the Plantin-Louvain edition of 1569.

The first volume of the Giunta-Ancelin edition contains the first part of the *Summa theologiae* of Thomas Aquinas, accompanied by the commentary of Cajetan (see catalogue n° 67), and followed by the commentary (only on the first part) by Chrysostom Javellus, O.P. (†1540; see catalogue n^os 45, 67), here printed for the first time by the Giuntas. At the end of the first volume (second series pp. 493–99) is printed a small work attributed to Thomas Aquinas, *De praescientia et praedestinatione Tractatvs* (see catalogue n° 67). This work was actually written by the fourteenth-century Dominican, Leonardus de Pistorio (Pistoia), who also wrote mathematical treatises and other devotional and catechetical works.

The second volume (here bound in two) contains the first and second parts of the second book of the *Summa* accompanied by Cajetan's commentary. The third volume contains the third part of the *Summa* with Cajetan's commentary; in all three volumes, printed in double columns, Thomas's text in larger print is surrounded in various dispositions by Cajetan's commentary in smaller print. The third volume also contains "additions" to the *Summa,* that is, the *Supplementum,* or questions drawn from Thomas's commentary of the fourth book of the *Sentences,* compiled after Thomas died to complete the scheme of his unfinished work. This text has no commentary. Then follow Thomas's twelve quodlibetal questions and *Svmmae theologiae D. Thomae Aqvinatis Sex copiosissimi indices*

(see catalogue nos 66–67). The first five indices are those printed in the Louvain edition published by Christopher Plantin (catalogue n° 62); to these is added a sixth, a "concordance of [seeming] contradictions" in Thomas's writings. This concordance of seeming discordances indicates that, by 1581, Thomas Aquinas had come to receive the same reverent treatment as the canons of the Church, the holy Fathers, and the sacred Scriptures. And there is more. Following the indices to the *Summa* proper are a topical index to Cajetan's commentary; a topical index to Thomas's *Quodlibeta*; a topical index to the *Opuscula* of Cajetan; a topical index to Chrysostom Javellus' commentary on the first part of the *Summa*; and a "Catalogue of theologians, philosophers, orators, poets and others" cited in Thomas's writings. This catalogue expands the similar one that had been published in the Louvain edition (catalogue n° 62). Finally, in continuing signatures, the edition presents the *Opuscula omnia* of Cajetan (catalogue n° 66), which were anticipated by their index earlier in the volume. (In the Notre Dame exemplar, the third part of the *Summa*, the *Supplementum* and the quodlibetal questions are bound in a fourth volume, and the indices and Cajetan's treatises are bound in a fifth.) In the same year (1581), another printer in Lyon, Barthélemy Honorat, published the *Sex copiosissimi indices*, the accompanying indices and the *Opuscula* of Cajetan, as printed in the last volume in Ancelin's edition (Baudrier 4: 142). Doubtless he too collaborated with the Giunta publishers.

The assembly of Thomas's texts, commentaries on his *Summa theologiae* and apparatus for reading them printed in this edition constituted a late sixteenth-century library of *thomistica*. All of the items and more were printed in later encyclopedic sets published by Jeanne Giunta's cousins in Venice, Jacopo and Filippo Giunta (catalogue nos 66–67). The business relations between the Giuntas in Venice and Lyon were close, which explains the exchange of texts between them. Indeed, it was Filippo Tinghi, who had married into the family and was a counsellor to the brothers in Venice, who was sent to Lyon after Jacopo's death to protect the family's interests there. REFERENCES: Adams 1: 50 nos 1437, 1439; Baudrier 6: 337–69 (Jeanne Giunta, Tinghi); IA 3/3: 300 (Thibault Ancelin); Kaeppeli n° 2881 (treatise of Leonardus de Pistorio); Quétif-Échard 2/1: 104b–5b (Chrysostom Javellus).

64. UND Library: Rare Books oversize BX1749 .T541 B35 1584

Scholastica commentaria in Primam partem Angelici Doctoris Divi THOMAE *usque ad sexagesimam quartum Quaestionum complectentia. Auctore Fratre* DOMINICO BAÑES MONDRAGONENSI, *Ordinis Praedicatorum in florentissima Salmaticensi Academia Sacrae Theologiae Primario Professore* (Rome: Jacopo Ruffinelli, 1584). Domingo Bañez, O.P. (1528–1604) studied at Salamanca under Melchior Cano (see catalogue nos 53, 55) and began his teaching career as a protégé of Domingo de Soto, O.P. (see catalogue nos 50, 52, 70). He was a close friend and advisor of Teresa of Avila. He held the Chair of Theology at Alcalá before becoming the First Chair of Theology at Salamanca (1577–1580). This successor of the distinguished Thomist teachers at Salamanca is by many considered to be the greatest of them all. He commented on nearly all of the major writings of Thomas Aquinas, and was the most formidable opponent of the Jesuit Molina and his fol-

lowers in the crucial disputes over grace and free will. This beautifully printed edition of Bañez' massive commentary on the first part of the *Summa theologiae*, one of the first books produced by Jacopo Ruffinelli (active 1584–1591), emphasizes a clear page. All the indices refer to scriptural citations and topics in the commentary. The title page bears a handwritten ex-libris from the Dominican convent of St. Raymond of Peñafort in Barcelona (see catalogue nos 61, 65). REFERENCE: Ascarelli 126.

65. UND Library: Rare Books oversize B765 .T53 Q82 1586

Quaestiones disputatae SANCTI THOMAE AQUINATIS *Doctoris Angelici, De potentia Dei, De malo, De spiritualibus creaturis, De anima, De daemonibus, De angelis, De veritate, et pluribus aliis Quaestionibus, ut in tabula continetur* (Lyon: Guillaume Rovillé, 1586). The various disputed questions argued by Thomas Aquinas represent his most mature and involved thought. The publisher of this edition, the scholar Guillaume Rovillé (active 1545–1604) stands at the apex of printing in Lyon. (Unhappily, this Notre Dame example of Rovillés' work is water-damaged and eaten by worms.) Guillaume edited the works he published, and he owned his own typeface, sub-contracting the printing to others. This edition is free of apparatus, offering only a table of the questions and articles at the beginning. A handwritten ex-libris on the title page indicates that the book was once owned by the Dominican convent of St. Raymond of Peñafort in Barcelona (see catalogue nos 61, 64). REFERENCE: Baudrier 9: 399.

66. UND Library: Rare Books BX1750 .V795

Opvscvla omnia THOMAE DE VIO CAIETANI, *Cardinalis titvli sancti Xysti, In tres distincta Tomos; Divi* THOMAE AQVINATIS *Doctoris Angelici Qvaestiones Qvodlibetales Duodecim;* AVG[VSTINI] HVNNAEI *De sacramentis ecclesiae Christi Axiomata; Qvaestiones dvae S.* THOMAE DE AQVINO *nuper repertae, ac in lucem editae. Vna De principio individvationis, altera vero De motoribvs coelestium corporum. Qvae repertae fvervnt Florentiae in Bibliotheca D. Marci; Sex copiosissimi Indices diu multumque hactenus ab omnibus desiderati Svmmae theologiae D.* THOMAE AQVINATIS; *Elvcidationes formales, totivs Svmmae theologicae sancti* THOMAE DE AQVINO, *Almi ordinis Praedicatorum . . . per F.* SERAPHINUM CAPONI A PORRECTA, *eiusdem ordinis* (Venice: Filippo and Jacopo Giunta, 1588). This volume binds together six separate items, each with its own title page, all printed in Venice in 1588 by Filippo and Jacopo Giunta. Although the texts in this volume are interrelated and were sold and bound together as here, each book came from the press in a disposable paper cover, so that buyers could make whatever arrangement they wished of the printers' wares. It is likely, therefore, that bibliographers will find one or some of these items separately in other existing volumes. The title pages to Thomas Aquinas's quodlibetal questions (vol. 2), the six indices to his *Summa* (vol. 5), and Serafino Capponi's comments on the *Summa* (vol. 6) display an engraved bust of Thomas enclosed in a classical architectural frame (see catalogue no 67).

These volumes are clearly related to the edition of Jeanne Giunta and Thibault

Ancelin produced in Lyon (catalogue n° 63). The first volume contains the *Opuscula* of Cajetan with their index, which is the same as that printed in the earlier Lyon edition. Likewise, the second volume contains Thomas Aquinas's twelve quodlibetal questions and their index as printed in Lyon.

The third, slender book offers a new item: schematic diagrams, compiled by Augustine Huens (Hunnaeus) of Louvain (1521–1578), which summarize Thomas Aquinas's teaching on the sacraments in the third part of the *Summa theologiae* and in its Supplement. This section also contains a *Brevissimus Catechismus Catholicus* by Huens, with its own title page. Huens participated in the edition of Thomas's *Summa* produced by Plantin in 1569 (see catalogue n° 62). His *Axiomata*, first published in Antwerp in 1570, appeared in many subsequent editions of the *Summa* (see, e.g., catalogue n° 67). His diagrammatic abridgments, Huens claims, reduce the "prolixity" of the *Summa* itself, making its doctrine easier to remember.

The fourth book contains two philosophic questions on the principle of individuation and on the movement of the heavenly bodies, which are here ascribed to Thomas Aquinas. Thomas Buoninsegni of Siena, O.P. (†1609), "illustrious professor" in the University of Florence, found these questions in fifteenth-century manuscripts in the library of S. Marco, and claimed that they had now "come to light" for the first time. He strove to promote a civic celebration for his discovery; unfortunately, while the questions are *ad mentem Thomae*, they are spurious.

The fifth volume presents the "six most copious indices" to the *Summa theologiae* of Thomas Aquinas and the "Catalogue of theologians, philosophers, etc." as printed in the earlier Lyon editions (catalogue n° 63). As printed by the Venetian Giuntas, these indices as well as the schematic diagrams by Huens could be purchased separately by students of Thomas's teaching and attached to other volumes or used as study-aids.

The sixth volume begins with an "Index of heresies and errors and their authors" that are refuted by "natural reason" in the writings of Thomas Aquinas. This global index did not appear in the Lyon editions. Finally, the volume presents the first edition of the *Elucidationes* of Thomas's *Summae theologiae* by Serafino Capponi della Porreta, O.P. (1536–1614; see catalogue n° 67). Brother Serafino professed in Bologna. Besides these "formal elucidations" of Thomas's *Summa*, he wrote annotations to Scripture, compendia of philosophy, and scholia to the *Compendium theologicae veritatis*, a summary of theology that was extremely popular in the Middle Ages. The work was commonly attributed to Albert the Great (as it was by Serafino), but it was actually written by one of Albert's students (see catalogue n° 42), Hugh Ripelin of Strassburg, O.P. (†1268). REFERENCES: Ascarelli 273–74; Kaeppeli n° 1982 (Hugh Ripelin); Quétif-Échard 2/1: 370a–71a (Buoninsegni), 392b–94a (Serafino); Zappella, *Il ritratto*, 228 and fig. 340 (engraving).

67. UND Library: Rare Books B765 .T361st 1596

Summa totius Theologiae Divi THOMAE DE AQUINO *Doctoris Angelici et Sanctae Ecclesiae, almi Ordinis Praedicatorum, cum Elucidationibus formalibus . . . per*

Fratrem SERAPHINUM CAPPONI A PORRECTA, *eiusdem Ordinis . . . Accessere porrò luculentissima, subtilissimique Commentaria Reverendissimi Divi* THOMAE DE VIO, CAIETANI, *Cardinalis Sancti Sixti . . . Adsunt &* CAIETANI *Opuscula, et illa eruditissima; quae admodum R.P.* CHRYSOSTOMUS IAVELLVS *in primum tractaum primam partem composuit. Colliguntur et his Quodlibeta: De praescientia & praedestinatione tractatus Sancti* THOMAE: *eidemque attributae Quaestiones tum de Motoribus orbium, tum de Principio indiuiduationis:* AUGUSTINI HUN-NAEI *Axiomata de sacramentis Ecclesiae, &* Catechismus, 5 volumes (Venice: Francesco de Franceschi for Jacopo and Filippo Giunta, 1596). As the title page of the first volume of the set reveals, this encyclopedic publication by the Giunta brothers in Venice presents a Dominican extravaganza. It consolidates in one place all of the Thomistic materials printed in the Louvain edition published by Plantin, in the edition by their cousin Jeanne in Lyon, and in their own volumes of Thomistic writings and apparatus (catalogue nos 62–63, 66). The volumes contain everything one needs to study the writings of the Angelic Doctor. Although the title page bears the name of Francesco de Franceschi, the colophons state that the volumes were printed by the Giunta brothers. Moreover, the engraving of Thomas Aquinas that the Giuntas had used in their previous editions of Thomistic works (see catalogue n° 66; Zappelli, fig. 340) is reemployed on the verso of each title page. Colophons printed at the end of each volume along with a *Series Chartarum* (register of signatures) indicate that the *Prima et Secunda secundae* of the *Summa theologiae* and their commentaries were printed first in 1595 (see, e.g., vol. 2, on blank verso between pp. 792–93, with printer's device) and that the other volumes were printed in 1596.

The parts of Thomas Aquinas's *Summa theologiae* accompanied by the commentary of Cajetan and the elucidations of Serafino Capponi are distributed through the five volumes: *Prima pars* (vol. 1), *Prima secundae* (vol. 2), *Secunda secundae* (vol. 3), *Tertia pars de salvatore nostro* (vol 4, ST 3 qq.1–59), *Tertia pars de sacramentis* (vol. 5, ST 3 qq. 60–90, Supplement). An index for each part of Thomas's text (*Index textus*), of Cajetan's commentary (*Index commenti*) and of Serafino's elucidations (*Tabula memorabilium*) is printed at the beginning of each volume. The topical indices of the *Summa* and Cajetan's commentary greatly expand and distribute according to parts the material of the general topical indices of these works printed in the Lyon editions (catalogue n° 63); the index of Serafino's elucidations is here printed for the first time. The first volume, moreover, contains an *Index praedicabilium* for the whole *Summa*, which locates materials for preaching in the temporal and sanctoral cycles of the whole liturgical year. This index is based on, but greatly amplifies, the fifth index of the oft-published "six most copious indices" (catalogue nos 63, 66). Likewise, the first volume contains an index of heresies and errors, keyed not only to the *Summa* but to Serafino's elucidations, which expands the similar index printed by the Giuntas in 1588 (catalogue n° 66). These two indices precede the text and commentaries. The index to Chrysostom Javellus' commentary on the first part of the *Summa*, however, which is printed at the very end of the first volume, is identical with the index printed earlier in the

Lyon edition (catalogue n° 63). Finally, the *Concordantiae dictorum et conclv-sionum* that is the last of the "six most copious indices" is here printed in volume 4 (see below) in an expanded and stylistically revised form.

All of the other items of the sixteenth-century Thomistic library are included in the volumes. The commentary of Chrysostom Javellus is printed in volume 1 after the text of the first part of the *Summa* and the comments of Cajetan and Serafino. It is followed as filler by the *Tractatus de praescientia et de praedestina-tione* by Leonardus de Pistorio but attributed to Thomas (fols. 53v–56v). This trea-tise is reprinted as filler at the end of volume 2 (pp. 783–89). In volume 4, after the preliminaries and indices (32 fols.), and the text of, and commentaries on, the first 59 questions of the third part of the *Summa* (548 pp.) are printed, in continuous signatures, the concordances of contradictions (separately numbered fols. 545–81); the *Opuscula omnia* of Cajetan (306 pp.); Thomas's *Quodlibeta* and the two spu-rious questions discovered by Thomas Buoninsegni (58 fols.; catalogue n° 66); the *Axiomata* and catechism by Augustine Huens (26 fols.), and finally, indices to Cajetan's *Opuscula* and Thomas's quodlibetal questions. (The Notre Dame copy lacks all of the items after the concordances). The placement of the concordances and the extra materials in volume 4 presents a printing anomaly, which has con-fused bibliographers. Logically, these items would be printed at the end of volume 5, after the last questions of the third part of the *Summa* and the *Supplementum*. Seemingly, the publisher decided to publish them in the shorter fourth volume (548 pages of text and commentary) rather than in the much bulkier final volume (954 pages of text and commentary).

The pages of these books are spectacular and rather medieval. The texts of Thomas Aquinas are accompanied not only by their commentaries but also by two sets of annotation. Figure 98 (vol. 1, p. 34) demonstrates well the layout of the contents. The text of the first part of the *Summa theologiae*, in larger print, holds the two center columns of the page. The elucidations of Serafino Capponi (see catalogue n° 66), in smaller print, run parallel in columns outside and underneath Thomas's text. At the top of the left column of his comments are cross-references to corresponding questions or places in the writings of other eminent Scholastic theologians. These cross-references begin every article. They refer to Albert the Great, Bonaventure, Giles of Rome, Richard of Middleton, Durandus of Saint-Pourçain, O.P., Duns Scotus, Francis Sylvester of Ferrara, O.P. (see catalogue n[os] 60–61), Domingo Bañez, O.P. (see catalogue n° 64) and many others. The annota-tions in the far outside columns are cross-references to other works by Thomas Aquinas. The extensive commentary of Cajetan follows every article of the *Summa*; here it begins at the bottom of the page and continues in two full columns on the next (p. 35). The fluctuating texts required the typographer to set a different disposition on each page. Wherever Thomas's article happens to end determines where Cajetan's commentary will be placed (e.g., in the middle of a page, marked off from Thomas's preceding and following text by linear dividers, at the foot of a page, or simply facing it on an opposite side). After 62 folios of preliminary mate-rial and indices and 976 large folio pages of this textual display, there follow in this

volume the *Expositio* of the first part of Thomas's *Summa* by Chrysostom Javellus (fols. 1r–53r), the two treatises on God's foreknowledge and predestination (fols. 53v–56v), and the index to Javellus' commentary (4 fols.). The pages of this edition are an early-modern *Glossa ordinaria* to the writings of Thomas Aquinas. (It is even possible that some of the old commentators anticipated the "insights" of modern students who prefer to read Thomas's texts *sine glossa*). These magnificent volumes testify to the continuity of the tradition of piety and erudition. REFERENCES: Adams 1: 50 n° 1444; Ascarelli 401 (Francesco de Franceschi).

<p style="text-align:center">* * *</p>

<p style="text-align:center">ADDITIONS FROM THE DURAND COLLECTION</p>

In late August 1995, the University of Notre Dame acquired about 3000 books and manuscripts collected by Professor José Durand of Berkeley, California. Durand's collection includes several incunables and 515 books printed in the sixteenth century. Durand attempted to reconstruct the library of Garcilaso Inca de la Vega (1539–1616), the son of a Spanish conquistador and an Inca princess, who was born in Cuzco, Perú, and later travelled to Spain, where he settled in Andalucia. Garcilaso was the first prominent mestizo humanist. He was especially interested in classical and Italian humanist literature and in Stoic and neo-Platonic philosophy. Concerning his library and intellectual interests, see José Durand, "La biblioteca del Inca," *Nueva Revista de Filología Hispánica* 2 (1948): 239–64, and "Garcilaso between the World of the Incas and that of Renaissance Concepts," *Diogenes* 43 (1963): 21–45.

Some of the books by Dominican writers discussed here had been owned by Garcilaso while others were collected by Durand for other research. The Durand collection has not yet been catalogued, and so we have thought it prudent not to identify the books by what are only temporary numbers.

68. UND Library: Durand Collection

Sermones PETRI IHIEREMIE *De fide vna cum theologalibus in cuiuscunque sermonis inicio questionibus nuperrime additis* <Brescia: Jacopo Britannico senior, 1502>. Peter Hieremia of Palermo (1399–1452) studied law at the University of Bologna and entered the Dominican Order there in 1425. He wrote several collections of sermons, which were published in separately foliated booklets by Jacopo Britannico in Brescia in 1502. These books could be bound separately, altogether or in various combinations. Besides the present collection, Jacopo printed Peter's (1) sermons for Advent; (2) sermons for Lent concerning penance; (3) sermons concerning prayer, in the form of an exposition of the Lord's Prayer; (4) sermons concerning the ten commandments and the fourfold law; (5) sermons for the feast days of saints. This volume contains Peter's collection of 26 sermons treating the articles of faith. The name of the printer and the place and date of publication do not appear in this separately bound volume of 68 folios printed in double columns, either on the title page or in the colophon: "Expliciunt sermones de fide seu de .xij.

articulis fidei compilati a fratre petro Jeremia de sicilia ordinis predicatorum: predicatore gloriosisssimo" (fol. 68vb). REFERENCES: Ascarelli 168; Kaeppeli n^os 3242–48 (see 3244); Quétif-Échard 1/2: 810a–11a.

69. UND Library: Durand Collection

Catalogus Haereticorum, omnium pene qui ad haec usque tempore passim litterarum monumentis proditi sunt . . . quem F. BERNARDUS LUTZENBURGUS *artium & sacrarum litterarum professor, ordin. Praedicatorij quinque libris conscripsit . . .* (Cologne: Gottfried Hittorp, 1529). Bernard of Luxembourg (†1535) studied at the universities of Cologne and Louvain. He spent most of his life in Cologne, where he taught and became the inquisitor of the diocese, at the time of the beginning of the Lutheran movement. His *Catalogus haereticorum* is divided into five parts. Book 1 treats heretics in general; books 2–3 offer a dictionary of heretics (A-O, P-V), in which the entries give the "names, errors and times" of the persons and doctrines (book 3 gives a list of condemned teachings of "Johannes VVicleff"); book 4 is a supplement to books 2–3; book 5 addresses the errors of Luther and Lutherans. At the end of book 5 is a poem by another Dominican, who otherwise is seemingly unknown, Matthew of Wismar: "Fratris Matthaei VVismariani, Ordinis Praedicatorum, in Martinum Luterum conspurcatorem Christianae religionis impudentissimum Pentacontostichon" (S3r–v). The volume concludes with Bernard of Luxembourg's *Tractatus de pvrgatorio*. This is the fourth edition of the *Catalogus*, as is stated on the title page: "Editio quarta, nunc ab autore et aucta et recognita." Previous editions were printed in Cologne (1522, 1525) and Paris (1524). The printer of this edition, Gottfried Hittorp (catalogue n° 46), had a long career in Cologne (1512–1573). REFERENCES: IA 3/3: 104; Quétif-Échard 2/1: 93a–94a; VD16 2: 309–10 (B 1989).

70. UND Library: Durand Collection

Summule fratris DOMINICI SOTO SEGOBIENSIS *ordinis predicatorum artium magistri* (Burgos: Juan de Junta, 1529). The printer of this volume, Juan de Junta, is another member of the Giunta family and its printing empire. About the time that his cousin, Jacopo, went to Lyon to establish the family business there (see catalogue n° 71), Juan went to Spain (ca. 1520). He published his first book in Burgos in 1526, and was active there and in Salamanca until 1558. The writings of Domingo de Soto (†1560; catalogue n^os 50, 52) illustrate the continuity of medieval intellectual traditions within the Dominican Order. Besides writing commentaries on medieval theological works (the four books of Peter Lombard's *Sentences* and the three parts of Thomas Aquinas's first two books of the *Summa theologiae*), he wrote commentaries on Aristotle's *Organon, Physics,* and *De anima,* and on Porphyry's *Isagoge* "ad modum parisiense." More exceptionally, Domingo's *Summule* present a complete treatment of the distinctive terminist logic of the thirteenth and fourteenth centuries. Among many other topics, the work includes tracts or *Opuscula de suppositione, de consequentiis, de exponibilibus, de insolubilibus,* and *de obligationibus.* Although he expounds the "three ways" of William of Ockham, John

Duns Scotus and Thomas Aquinas, this Dominican shows a preference for the *via nominalista*. This is the first edition of the work; sixteen more editions were printed during the sixteenth and seventeenth centuries. The edition includes several complex diagrams (fols. 62v, 64v, 120v), including an excellent *Arbor terminorum* (fol. 15v), which comprehends in its branches and off-shoots all of the parts of linguistic philosophy (fig. 99). The book is rather rare; apparently, this is the only copy in the United States. REFERENCES: Beltrán de Heredia 526; IA 3/3: 52; Nicolás López Martínez, "Fuentes impresas de Lógica hispano-portuguesa del siglo XVI," in RHCEE 1: 438–40, 462 n° 231; William Pettas, *A Sixteenth-Century Spanish Bookstore: The Inventory of Juan de Junta* (Philadelphia: Transactions of the American Philosophical Society, 1995). A 1554 edition of the *Summule* has been reprinted (Hildesheim: G. Olms, 1980).

71. UND Library: Durand Collection

Cathena aurea Angelici THOME AQUINATIS *in quatuor euangelia ex receptissimis ecclesie doctoribus miro artificio concinnata* (Lyon: Antoine Blanchard for Jacopo and Francesco Giunta, 1530). Jacopo Giunta of Florence (see catalogue n°s 63, 70) was the nephew of Luc'antonio Giunta, who established the family's business in Venice (active 1489–1538), and Filippo Giunta, who established it in Florence (active 1497–1517). Since the offices in these cities were passed on to his uncles' sons, Jacopo went to Lyon, where he founded the family business in 1519 or 1520 (active until ca. 1548). The *Catena aurea* by Thomas Aquinas was one of the first books he published, with his father Francesco and the printer Guillaume Huyon in 1520 (Baudrier 6: 107–8). This volume, which he again published with his father and with the printer Antoine Blanchard (active 1532–1535), is his second edition of the work. The very thick octavo volume (708 fols.), which may yet be held in one's hand, is printed in two columns of tight gothic script. (Its format may be contrasted with the folio library volume of the *Catena* described in catalogue n° 59.) Each of Thomas's running commentaries on the four Gospels, which weave together comments of the fathers, is separately foliated: Matthew (248 fols.), Mark (80 fols.), Luke (195 fols.), John (166 fols.). Each commentary is preceded by a *Registrum* or *Repertorium alphabeticum sententiarum illustrium* (unnumbered fols.). Moreover, each commentary is signed with the same colophon on its last side and begins with the identical title page (figs. 100–1: Jacopo Giunta's mark and colophon on a verso opposite the next title page). The title pages of this volume display a border and triangular etiquette for the title information that Jacopo used in many of his books. He then filled the upper compartment with an appropriate engraving, in this instance the figure of Thomas Aquinas holding a chalice and host, in another instance, for example, the figure of John Duns Scotus writing at a desk (Baudrier 6: 101). Thus, in the style of presentation if not the content of doctrine Jacopo fabricated a certain "concordance" between the great theologians of the Dominican and Franciscan Orders. REFERENCES: Ascarelli 272–73, 328–29 (the Italian Giuntas); Baudrier 6: 77–97, 98 fig. 2, 132–33; IA 3/3: 314, 378 (Blanchard and Huyon).

72. UND Library: Durand Collection

ALBERTI MAGNI *ad logicam pertinentia. De quinque vniuersalibus Liber vnus. De decem predicamentis Liber vnus. De sex principijs Liber vnus. De interpretatione Libri duo. De syllogismo simpliciter. id est. priorum analeticorum Libri duo. De demnstratione. id est. posteriorum analeticorum Libri duo. Thopicorum Libri octo. De sophisticis elenchis Libri duo* (Venice: the heirs of Ottaviano Scoto, 1532). This folio volume, printed in double columns, presents Albert the Great's paraphrase commentaries on the logical works of Aristotle and two works that accompanied them in the medieval corpus, Porphyry's *Isagoge* (i.e., *De quinque universalibus*) and the *Liber de sex principiis*. A dedication (b₂r: "Excellentissimo Philosopho ac Medico consummatissimo Marino Brocardo Veneto") and colophon (fol. 315vb) indicate that the texts were edited and corrected by Bernardinus Plumatius de Verona in 1506. The "heirs of Ottaviano Scoto" (catalogue nᵒˢ 13, 32), the founder's brother Bernardino and his nephew Amadeo (active 1499–1532), first printed this collection of Albert's logical writings in 1506 (IA 1: 256), when Bernardinus Plumatius corrected the texts, and they reprinted the collection in this edition of 1532. The bibliographical literature mentions an earlier edition by "Ottaviano Scoto" in 1500, but such cannot be verified (GW nᵒ 677). We suspect that the reference to a 1500 edition stems from a mental or typographical error in Quétif-Échard (1/1: 172b). In any event, the Scotos took over an earlier edition of these works by Albert (perhaps the first—see GW 1: 322), printed in Venice in 1494 by Giovanni and Gregorio de' Gregori (GW nᵒ 677). The volume titles of the incunable and 1506 editions are identical, and, save three beginning words (*Ista sunt opera . . .*), the title is again the same in 1532 (see above); the incipit titles before the first commentary are identical in all three editions: "Incipit Diui Alberti Magni Logica diligentissime recognita. videlicet. Liber de predicabilibus. De predicamentis. De sex principijs/ Perihermenias. Liber Priorum Analyticorum. Liber Posteriorum Analyticorum. Liber Thopicorum/ Et liber Elenchorum" (fol. 1ra).

It appears that the Scotos' 1506 edition of Albert's logical works was the first in the sixteenth century, that no other edition was published until their reprinting in 1532 (not cited in the *Index Aureliensis*), and that indeed no other edition of Albert's collected logical works was published again throughout the century. Preceding Albert's commentaries in this edition (B₂va–B₄vb) is an anonymous *Questio De contingenti possibili:* "Questio est vtrum Philosophus per contingens possibile intelligat contingens altum seu contingens generice sumptum indifferens ad contingens necessarium et non necessarium: vt Albertus imaginatus est primo priorum in expositione cap. 4. . . . et hoc modo satisfit dubitationi mote: et satis faciliter meo iudicio. Et hec de questione sufficiant ad presens." We have not been able to identify the author of the question, which reflects the fifteenth-century disputes among the schools, referring to interpretations of Aristotle and Boethius by Albert, Thomas Aquinas and the *moderni*.

The heirs of Ottaviano Scoto retained the circle and cross mark of the founder with the initials O, S, M, but surrounded it with a floriate embellishment (title page, fol. 315vb). A handwritten ex-libris on the second flyleaf recto of this copy states that in 1540 the book was used by a brother Michael'angelo(?) of Padua in

the convent of the "Venetian monks"; a stamp on the title page indicates that the book was later owned by the Benedictine monastery in Montiémercy (France). REFERENCES: Ascarelli 330–31, 339; Fauser 1–24 n[os] 1–3, 5–9; Zappella, *Le marche,* fig. 297.

73. **UND Library: Durand Collection**

Molti Devotissimi Trattati del Reuerendo Padre Frate IERONYMO SAUONAROLA DA FERRARA *del l'ordine de frati Predicatori . . .* (Venice: A l'insegna di San Bernardino, 1538). This octavo volume (144 fols.), printed in two columns, presents a collection of devotional and pastoral writings by Savonarola (catalogue n[os] 39–40, 74). The collection includes, among others, small treatises on humility, prayer, charity and the religious life; a series of treatises concerning the love of Christ and contemplation of his life, Cross, his presence and sacrifice in the Mass and his Ascension, along with a sermon for the vigil of the Nativity (fols. 47vb–78va); and two longer treatises on the life of widows (fols. 90va–107va) and the ten commandments (fols. 107vb–134va). The sign of the printer, Bernardino Stagnino (active in Venice 1483–1538), depicts the image of his patron saint, the famous Franciscan preacher, Bernardino of Siena, holding a sunburst monstrance encircling the sacred monogram, IHS (S. Bernardino especially promoted devotion to the holy name). The "sign of San Bernardino," however, does not appear in this volume; its presence in a book of writings by an equally famous preacher of a rival religious order was probably deemed inappropriate. REFERENCES: Ascarelli 337; Zappella, *Le marche,* figs. 174–80. The treatises included in this volume are edited separately, with lists of the early editions, in Edizione Nazionale delle Opere di Girolamo Savonarola: *Operette spirituali,* ed. Mario Ferrara, 2 vols. (Rome: Angelo Belandetti Editore, 1976).

74. **UND Library: Durand Collection** .

Prediche del Reverendo Padre Fra IERONIMO DA FERRARA *per tutto l'anno nuomente con somma diligentia ricorretto* (Venice: Bandino and Ottaviano Scoto, 1539). This volume contains 29 long sermons that Savonarola (catalogue n[os] 39–40, 73) preached in the year 1496. The introduction to each sermon states the day and month when it was preached, the biblical book expounded, and gives the thematic scriptural text (usually from another book). The volume includes a series of sermons on the Book of Ruth (sermons 4–8) that Savonarola delivered in the week 18–25 May 1496, and another series on the Prophet Micah (sermons 9–16, 20–25) that he delivered between 29 May and 11 September in the same year. The latter series is interspersed with sermons for various late-summer liturgical feasts. In a table on the title page verso, the editors claim that these sermons by Savonarola were originally recorded *viua voce.* Ottaviano Scoto junior, the son of Amadeo Scoto, assumed directorship of the family firm (catalogue n[os] 13, 32, 72) in 1533 and published books until 1555. For a brief time (1539–1541) he produced books with his brother, Bandino. An engraving on the title page shows Savonarola preaching, with a secretary by the pulpit recording every word. On the front of the pulpit, instead of a crucifix, is the heart and cross printer's mark with the initials B, O, S

of the Scoto brothers (fig. 102). REFERENCES: Ascarelli 331; Zappella, *Le marche,* fig. 486. See Edizione Nazionale delle Opere di Girolamo Savonarola: *Prediche sopra Ruth e Michea,* ed. Vincenzo Romano, 2 vols. (Rome: Angelo Belandetti Editore, 1962); for the list of editions, see 2: 487–88.

75–76. UND Library: Durand Collection

Summa Sacramentorum Ecclesiae ex doctrina F. FRANCISCI A VICTORIA, *ord. Praed. apud Salmanticam primarij Cathedratici Congesta per F.* THOMAM DE CHAUES *illius discipulum* (Barcelona: Claudio Bornat, 1565); *Summa Sacramentorum Ecclesiae, ex doctrina Fratris* FRANCISCI À VICTORIA, *ordinis Praedicatorum apud Salmanticam olim Primarij Cathedratici Congesta per F.* THOMAM DE CHAUES *illius discipulum* (Salamanca: Andrés de Portonariis, 1565). Francisco de Vitoria (1483–1546) entered the Dominican Order at the convent of St. Paul in Burgos. He was sent by his superiors to Paris, where he studied and taught for 18 years while living at the convent of Saint-Jacques. In 1526 he became the First Chair of Theology at Salamanca. De Vitoria is the founder of the great school of sixteenth-century Spanish Dominican theologians; among his many students were Melchior Cano (catalogue n° 53) and Domingo and Pedro de Soto (catalogue n[os] 50, 52, 54, 70). At Salamanca he replaced the *Sentences* of Peter Lombard with the *Summa theologiae* of Thomas Aquinas as the textbook for studying theology; this practice was followed by other universities in the sixteenth century. Most of de Vitoria's published works are based on lectures and orations he gave at the University, which were recorded in manuscripts by secretaries and students. He lectured on the first two books of the *Summa theologiae* (1, 1–2, 2–2) in 1531–1537. His published *Relecciones,* which comprise 12 treatises on theological, moral and legal topics, were originally orations for the beginning of the academic year delivered in the years 1527–1540. His prologue to the moral *Summa aurea* by Antoninus of Florence, O.P. (catalogue n[os] 7, 27, 43) was first published in Paris in 1521.

The *Summa sacramentorum* is a compilation from de Vitoria's lectures on the fourth book of the *Sentences* (1529–1531). The compilation was made by his student, Tomás Chavez, O.P. (†1565). The *Summa* is divided into ten parts, treating the sacraments in general, each of the seven sacraments in particular, the power of the keys and excommunication. Each part is further divided into questions, which are numbered consecutively in the first eight parts and separately in the last two parts. The first edition of the work was printed in 1560 at Valladolid; there were 80 more editions between 1560 and 1629. The printer of the 1565 Barcelona edition was Claudio Bornat (active 1548–1581); the printer of the Salamanca edition in the same year was Andrés de Portonariis (active 1549–1568), a relative of the Portonari family from Trino in Italy whose members established publishing and printing businesses in Piedmont, Venice and Lyon. The title page of Bornat's edition displays one of his usual printer's marks; the title page of de Portonariis' edition bears an engraving of St. Dominic holding lilies with a dog at his feet, which may be specific to this work. Although the two editions were published in the same year, their texts are different. Bornat's edition, printed early in the year (14 Kalends March, i.e., 16 February), reprints the first; the title page of de Portonariis' edition

states that it presents Chavez's second edition, to which he added many questions with new illustrative materials from decretals and the holy Councils, especially the Council of Trent. This edition adds three questions concerning the sacraments in general, one concerning baptism, six concerning the Eucharist, seven concerning confession, four concerning the sacrament of orders, two concerning marriage and four concerning excommunication. It adds materials to the original questions as well.

Later, after the promulgation of the teachings of the Council of Trent, de Vitoria's sacramental teaching (as represented by Chavez) was incriminated on a point concerning the sacrament of extreme unction. De Vitoria reportedly opined that consecrated oil is not necessary for the validity of the sacrament. A handwritten note on the title page of the Notre Dame copy of the Salamanca edition indicates that the book has been *Expurgando.* Addressing the question "an esset verum sacramentum si quis vngeret oleo non consecrato," de Vitoria remarks: "Caietanus dubitat, an consecratio olei sit de necessitate sacramenti. Et ideo probabiliter credo, quod non est de necessitate sacramenti, licet sit de necessitate praecepti" (p. 172). In this expurgated copy, the phrase "probabiliter credo, quod non est de necessitate sacramenti" has been crossed out. Remarkably, handwritten notes in the Notre Dame copy of the Barcelona edition are more detailed. A note on the title page states: "Vidit et expurgauit fr. Emanuel de Grenolles ex comissione [sic] Inquisitorum iuxta expurgatorium anni 1632." A note beside the incriminating passage specifies: "sententia de oleo non benedicto damnata iam est auctoritate sedis Apostolicis vt temeraria et errori proxima" (fol. 134v). So eight parenthetical words in the classroom are censured by twice as many words of authority, jotted down by a reader who enjoyed the perspicuity rendered by "subsequent developments." REFERENCES: Getino 335–51 (editions of the *Summa*; engraving of St. Dominic on 336); Ramón Hernández, "Téologos dominicos españoles pretridentinos," in RHCEE 3: 225–33; Marimon 75 and fig. 6 (between 86–87); Quétif-Échard 2/1: 128b–30b, 192a; Vindel 186 n° 246 (mark of Bornat).

The next five items testify to the prolific literary activity of Luis de Granada (1504–1588; catalogue n°[os] 55–56) and to the widespread popularity of his writings. The extraordinary catalogue by Maximino Llaneza, O.P. (4 vols.) demonstrates the rapid dissemination of Luis' writings in manifold editions during his lifetime and throughout the seventeenth century, and how they were translated into many languages, anthologized, excerpted and compiled into other works. Surely no other contemporary Dominican writer achieved such instant 'authority'. These entries also testify to the vibrancy of typical 'medieval' Dominican literary genres—spiritual, moral and catechetical treatises, preaching materials—throughout the sixteenth century.

77. UND Library: Durand Collection

Memorial de la vida Christiana: en el qual se enseña todo lo que vn Christiano deue hazer dende el principio de se conuersion, hasta el fin de la perfection: repartido en siete Tratados: Compuesto por el R.P.F. LUYS DE GRANADA *de la orden de*

sancto Domingo. Primer volumen donde se pone lo que pertenece a la doctrina de bien viuir; Segundo volumen del Memorial de la vida Christiana: en qual se contienen los tres Tratados postreros que pertencen a los exercicios de la deuocion, y del amor de Dios, 2 vols. (Salamanca: Andrés de Portonariis, 1566–1567). Luis de Granada's hugely popular *Memorial de la vida Christiana* was first published in Lisbon in 1561 (Llaneza 2: 133 nº 1569). The various redactions of the work, as well as English, French, German, Italian and Latin translations, were published 124 times before 1600, and many times more in the seventeenth century. There were 18 editions of the work in the years 1566–1567 alone, when this edition by Andrés de Portonariis (catalogue nº 76) was printed in Salamanca. De Portonariis' edition presents the first redaction of the *Memorial,* which is divided into seven parts: (1) an exhortation to living well; (2) on penitence; (3) on the sacrament of Holy Communion, with meditations and vocal prayers (including a prayer by Thomas Aquinas); (4) rules for living the Christian life, or for living well; (5) on vocal prayer; (6) on mental prayer; (7) on the love of God, in which consists the perfection of Christian life. The sixth part, concerning mental prayer, provides materials for meditation; these treat the principle mysteries of the life of Christ, our Savior, from his conception to his return in glory at the final judgment and thence proceed to the other Last Things (fols. 133v–241r). After treating vocal and mental prayer in parts 5–6, Luis treats the prayer of aspiration in part 7 (chapter 4).

This edition by de Portonariis is printed in two octavo volumes; the first four *tratados* are in volume 1 and the last three are in volume 2. The title page of the first volume gives the date 1566, when the printing started, but the colophon on the last verso gives the date 1567, when it was completed. The second volume was printed in 1567. Both title pages bear the customary mark of Andrés de Portonariis: a medallion encircling a cross with wreath and crown against a background landscape (Llaneza 1: 17–18). There are two engravings in the first volume (A8r–v), showing Christ extending a hand to Peter across the water and a figure(?) offering a holocaust to God. REFERENCE: Llaneza 2: 143–44 nº 1587.

78. UND Library: Durand Collection

Memorial de la vida Christiana . . . Compuesto por el R.P.F. LUYS DE GRANADA, *dela orden de Sancto Domingo* (Barcelona: Jaime Cendrat for Francisco Trinxer, 1588); *Gvia de Peccadores, en la qval se trata copiosamente de las grandes riquezas y hermosura dela virtud, y del camino que se ha de lleuar alcançarla. Compuesto por el R.P.F.* LUYS DE GRANADA, *dela orden de Sancto Domingo* (Barcelona: Jaime Cendrat for Francisco Trinxer, 1588); *Libro dela Oracion y Meditacion: en el qval se trata de la consideracion delos principales mysterios de nuestra Fe. Con otros tres breues tratados dela Excellencia delas principales obras penitenciales: que son Lymosna, Ayuno, y Oracion. Compuesto por el R.P.F.* LUYS DE GRANADA, *dela orden de Sancto Domingo* (Barcelona: Jaime Cendrat for Francisco Trinxer, 1588); *Elenchvs rervm omnivm qvae in libris omnibvs R.P.F.* LVDOVICI GRANATENSIS *(Qvi vvlgari sermone circunferuntur) continentur, in quo, quae Euangeliorum considerationibus accomodari possunt . . . Per Fratrem* ALFONSUM DE SANÇOLES *prouinciae S. Iacobi minoritam* (Barcelona: Jaime Cendrat, 1588). This folio book,

bound in parchment with the inscription "Obras de ffray lluis de Gra<nada>" on the spine, contains four separately printed works, all of which were produced in the same year (1588). The title pages of the *Memorial, Guia de peccadores* and the *Libro de la Oracion y Meditacion,* composed by Luis de Granada, display the elaborate device of the printer, Jaime Cendrat (active in Barcelona, 1578–1600), but omit his name, giving instead the name of the publisher, Francisco Trinxer (Trincher; active 1581–1596); the same mark with Cendrat's name appears on the last verso of the *Memorial* and on the recto of the last leaf of the *Libro.* Cendrat seems to have printed the topical index (*Elenchus*) to Luis' works independently.

This edition of the *Memorial* by Trinxer and Cendrat presents the original seven parts of the work in two volumes (122 pp., 188 pp.; see catalogue n° 77). There follow *Adiciones al Memorial de la vida Christiana, qve compvso el R.P. Fray* Lvys de Granada *de la Orden de Sancto Domingo,* which comprise a treatise on the love of God and further meditations on the principal events and mysteries of the life of Christ. These *Adiciones* were first published separately in Salamanca in 1574 by Mathías Gast (Llaneza 2: 158–59 n° 1606); thereafter they accompanied the original redaction of the text in many editions. At the end of the volume (pp. 247–50) is printed the *Philomena de sant* Buenauentura, a poem in which the soul, aspiring to union with Christ, in the manner of a nightingale sings praises of Christ's life and virtues. These verses, actually composed by the thirteenth-century English Franciscan, John Pecham (Distelbrink 168–69 n° 179), accompanied the *Adiciones al Memorial* in another edition printed in 1588 at Gerona by Arnau Garich (Llaneza 1: 281 n° 733).

The *Guia de peccadores,* first printed in Lisbon in 1556 (Llaneza 2: 3–5 n° 1222), was one of Luis' most popular and widely published works. The first book contains three parts: (1) an exhortation to virtue and to keeping the divine commandments; (2) a treatise on the spiritual and temporal goods that promote virtue; (3) responses to the excuses that people give for not following the road to virtue. The second book contains two parts, concerning the doctrine and practice of the virtues. The preliminary letter to the Christian reader and prologue (¶2v–¶3r) to the work begin with historiated woodcuts, which appear elsewhere in the volumes: an initial P with the image of St. Peter and an initial D with the image of "S. Hanricvs. Carmelita." These woodcuts are rather unusual, in that they bear the inscription of the saints' names. We imagine that the image accompanying the initial D is in fact some saint whose name begins with that letter, but that the name "S. Hanricvs" has been supplied because Luis dedicated the work to Prince Henry of Portugal.

The *Libro de la Oracion y Meditacion* was first printed in 1554 in Salamanca by Andrés de Portonariis (catalogue n°s 76–77; Llaneza 1: 1–2 n° 1). The work is divided into three parts treating prayer, "considerations" or meditations on the principal mysteries of the Catholic faith, and three small treatises on prayer, fasting and almsgiving.

The last work bound in the volume is an *Elenchus* or topical index to the Spanish text (despite the Latin title) of all of Luis de Granada's writings, arranged for preaching the Gospels of the liturgical year. This index of Luis' writings was not

prepared by a fellow Dominican, but by a Franciscan, Alfonso de Sançoles (San-
zoles) of the province of Compostella; it was published for the first time in 1584 at
Salamanca (Llaneza 1: 264 n° 673). Alfonso wrote commentaries on the Gospels in
the Roman Missal and perhaps prepared this index of Luis' writings in connection
with his own work. Llaneza cites the Trinxer-Cendrat editions of Luis' *Memorial*,
Guia de peccadores and *Libro*, but he did not see them and therefore does not
describe them. He did, however, see and describe a copy of the *Elenchus*. The first
title page (the *Memorial*) of this book bears an ex-libris: "Ex libris Petri Antonij
Gallard de Con[. . .] anno 1735." REFERENCES: IA 3/3: 38 (Trinxer); Llaneza 1: 60
n° 95, 1: 284 n° 748, 2: 42 n° 1291, 2: 181 n° 1654; Vindel 239 n° 316.

79. UND Library: Durand Collection

*Ad Illvstrissimvm Cardinalem Toletanvm. Annotationes in Evangelia totius anni
de tempore & Sanctis ex omni in vniuersum quae hucusque extat doctrina Ad-
modum R.P. Magistri F.* LUDOUICI GRANATENSIS *Ordinis Praedicatorum, Fratre*
BARNABA À XEA *eiusdem instituti Collectore* (Salamanca: Antonio Renaut for the
Dominicans of St. Stephen, 1585). As the title indicates, this book provides anno-
tations drawn from the writings of Luis de Granada and translated into, or para-
phrased in, Latin for the Gospels of the ferial and sanctoral cycles of the liturgical
year, as well as for the Commons of Apostles, Martyrs, Confessors and Doctors,
and Virgins. The compiler was Barnabe Xea, O.P., of Cuenca in Spain, about whom
little else is known. The annotations are cross-referenced to Luis' works; in his
Preface to the Christian reader, the editor explains his system of reference, which,
in order to avoid the confusion caused by so many printed editions, resorts to an
older, broader style of citation: "Allegationes quae ad Conciones remittunt, per se
satis aperte sunt, sed & ille quae ad Rhetoricae librum deseriunt, cum libros &
capita citent, G. litera, librum designat cui nomen est *Guia de Peccadores*. O. *la
Oracion*. M. *el Memorial dela vida Christiana*. Ad. *Addiciones al Memorial*. In
libris quae ad deuotionem pertinent, vt in O. in M. in G. & in Add. neque folia
neque paginas citamus, eo quod cum variae sint impressiones, variae & foliorum
& paginarum computationes. Sed sic citamus, Considerationes, Meditationes,
Regulas, quod facillimo negotio illa quae desiderat lector inueniat" (*7v). The title
page states that this work was published "Apud S. Stephanum Ordinis Praedica-
torum" in Salamanca; the colophon on the recto of the last leaf states that it was
printed by Antonio Renaut, who was active for only a short time (1584–1585).
Barnabe Xea dedicated his work to the Archbishop of Toledo, Don Gaspar de Qui-
roga. Pasted on the inside front cover of this copy is an ex-libris label with coat-of-
arms and inscription: "BIBLIOTECA DEL DVQVE DE MEDINACELI Y SANTISTEBAN."
REFERENCES: IA 3/3: 226, 433 (Renaut); Llaneza 1: 268–69 n° 685; Quétif-Échard
2/1: 332b (Barnabas a Xea).

80. UND Library: Durand Collection

*Conciones qvae de praecipvis Sanctorum festis in ecclesia habentvr, A festo Sancti
Andreae vsque ad festum Beatae Mariae Magdalenae: Auctore R.P.F.* LVDOVICO
GRANATENSI, *sacra Theologiae Professore, Monacho Dominicano; Conciones de*

praecipvis Sanctorvm festis, A festo Beatissimae Mariae Magdelenae, vsque ad finem anni: Auctore R.P.F. Lvdovico Granatensi, *sacra Theologiae Professore, Monacho Dominicano* (Antwerp: Christopher Plantin, 1588). It would be interesting to discover whether these sermons written in Latin exemplify the principles of sacred eloquence that Luis de Granada teaches in his *Ecclesiastica rhetorica* (catalogue n° 55). It would seem that, like his medieval forebears, Luis intended these sermons to be 'models' for preachers; their widespread and rapid dissemination in many printed editions suggests such a practical demand. The sequence of sermons *de sanctis* contained in the second volume of this edition was first published by Antonio Ribeiro in Lisbon in 1576 (Llaneza 3: 168–69 n° 2554); the complete sequence for the whole liturgical year was first published in two volumes at Salamanca by Mathías Gast (catalogue n° 78) in 1578 (Llaneza 3: 173 n^{os} 2563–64). Christopher Plantin published Luis' *Conciones de tempore* in three- and four-volume editions in 1577–1579, 1581, 1583–1584 and 1586–1588 (Voet 3: 1433–43 n^{os} 1594–97). This is Plantin's fourth edition of the *Conciones de sanctis*, which he had previously published in two-volume editions in 1580, 1581 and 1584 (Voet 3: 1445–49 n^{os} 1602–4). Although the title page of the second volume gives the date 1588, the colophon at the end (p. 543) indicates that the printing was finished in 1589. References: Llaneza 3: 207–8 n° 2620; Voet 3: 1450–51 n° 1605.

81. **UND Library: Durand Collection**

Parte primera de la Introdvction del Symbolo de la Fe, en la qval se trata dela Creacion del Mvndo para venir por las Criaturas al conoscimiento del Criador, y de sus diuinas perfectiones. Compvesta por el mvy Reverendo Padre Maestro Fray Luys de Granada *dela Orden de Sancto Domingo; Parte segvnda . . . en la qval se trata delas excelencias de nvestra sanctissima Fe, y Religion Christiana; Parte tercera . . . qve trata del misterio de nvestra Redempcion..; Parte qvarta . . . (procediendo por lvmbre de Fe) se trata del mysterio de nuestra Redempcion..; Parte qvinta . . . la qval es vn Summario de las qvatro principales partes qve se tratan en la dicha Introdvction. Añadiose vn tratado de la manera de enseñar los mysterios de nuestra Fe . . . Compvesta por el P.M. Fray* Lvys de Granada *de la Orden de Sancto Domingo* (Barcelona: Hubert Gotard, 1589). Luis de Granada's *Introduction del Symbolo de la Fe*, first published in 1583 at Salamanca by the heirs of Mathías Gast (Llaneza 2: 241–42 n° 1862), is a comprehensive catechetical work. Its large structure recalls the *De sacramentis christianae fidei* of Hugh of Saint-Victor: it first treats the 'works of creation' (Part 1) and then the 'works of redemption' (Parts 3–4). The work is divided into four major parts, which are subdivided further into parts and are followed by a summary of the whole. The first part, concerning creation, is an encyclopedia of the medieval kind. It ascends from the four elements, to animals, to the outer and inner features and harmonies of the human body, to the soul, and thence to considerations of divine providence and the *grandezas de Dios*. The second part treats 16 "excellences" of the Catholic faith. Parts three and four treat the mysteries of redemption, including 20 fruits of the Cross, ancient prefigurations of Christ, four dialogues between a Master and Disciple concerning the Incarnation and Passion (Part 3), scriptural prophecies, the

prophecies of the Sibyls, extraordinary deeds of Christ, the "fables of the Talmud," and rise finally to considerations of the divinity of Christ, the Trinity, the Passion (again), the Sacrament, and the cessation of the Old and establishment of the New Law. The fifth part consolidates and summarizes all.

In this edition printed by Hubert Gotard (active in Barcelona, 1585–1589), each part has a separate title page and is separately paginated (Part 1: 8 fols. + 150 pp. + 1 fol.; Part 2: 174 pp. + 1 fol.; Part 3: 126 pp. + 1 fol.; Part 4: 176 pp. + 2 fols.; Part 5: 4 fols. + 240 pp. + 2 fols.). The first title page is printed in red and black inks and all the others in black ink only; instead of a printer's device, each title page bears an image of the head of Christ in a medallion surrounded by a square typographic border design. In 1589, financed by various collaborators, Gotard published the *Introduction,* together(?) or in parts at least five times (Llaneza 2: 257–59 n[os] 1895–99). This complete edition, which seemingly he financed himself, is not recorded by Llaneza nor noted in other standard sources. Moreover, Gotard seems to have had some business agreement with the printer Cornelio Bonardo of Salamanca. At the beginning of the first (¶4v) and fifth (*4v) parts, Gotard prints dedications to the "printer Cornelio Bonardo"; the texts of the title pages, including various scriptural verses, are nearly identical to those in the editions of the first four parts of the *Introduction* and separately printed fifth part published by Bonardo in 1588 (Llaneza 2: 254–56 n[os] 1890–92). Like Bonardo, along with the fifth part in consecutive pages (pp. 192–240) Gotard prints a separate treatise by Luis de Granada, with a separate title page: *Breve Tratado en qve se declara de la manera qve se podra propner la doctrina de nvestra sancta Fe, y Religion Christiana, a los nueuos fieles. Ordenado por el Padre Fray* LUYS DE GRANADA (En Barcelona, En casa de Hubert Gotard, Anno 1589). Besides the same text, the title page to this treatise displays the same image of St. Peter surrounded by the verse "Tv es Petrvs, et svper hanc petram aedificabo ecclesiam meam. Matth. 16." as is found in a separate edition of the *Breve Tratado* printed by Bonardo at Salamanca in 1588 (Llaneza 1: 280 n° 728). Like the writings of Thomas Aquinas, at the end of the sixteenth century the writings of Luis seem to have been in such demand that they were replicated rapidly by several printers and publishers at once.

This copy of Gotard's edition is bound in parchment with an inscription on the spine: "Cathecismo. De ffray luis." The hand and ink of this inscription are the same as those on the spine of catalogue n° 78. REFERENCES: IA 3/3: 38, 226 (printers); see the references to Llaneza in the text.

82. UND Library: Durand Collection

Primera parte de la Summa, en la qual se cifra y Summa todo lo que toca y pertenece a los Sacramentos, con todos los casos y dudas morales resueltas y determinadas . . . Compuesta por el Maestro fray PEDRO DE LEDESMA *de la orden de S. Domingo Cathedratico de S. Thomas en la Vniuersidad de Salamanca* (Salamanca: Juan and Andrés Renaut, 1598); with *Doctrina Christiana. Compuesta y ordenada por el Maestro fray* PEDRO DE LEDESMA. Pedro de Ledesma (†1616) was born in Salamanca and entered the Dominicans there in 1563. He later taught in Dominican schools in Segovia and Avila before returning to Salamanca. This edi-

tion of Pedro's *Summa* printed by Juan and Andrés Renaut (active 1587–1599) is the first (there was also a *Segunda parte* of the *Summa* published in 1598). In its structure and subject matter, the work is similar to the *Summa sacramentorum* of Francisco de Vitoria (catalogue nᵒˢ 75–76). It treats the sacraments in general and the seven sacraments in particular and includes chapters on canonical norms and cases concerning the practice and administration of the sacraments, especially confession. In brief, Pedro's *Summa* is a late-sixteenth-century 'confessors' manual'. The text of the *Summa* is printed in two columns surrounded by a border and divided by a line. Joined to this work at the end, in a completely different single-column format without a title page or colophon, is a little treatise (60 pp.) titled *Doctrina Christiana*. Pedro was urged to write this work by the Bishop of Avila, Fernandez Temiño, as a follow-up to acts of a diocesan synod. This 'layfolks' catechism' suggests that the knowledge of the faith expected from ordinary Christians had not changed much since the thirteenth century. In simple formulae, the *Doctrina Christiana* presents the articles of faith, the ten commandments, the gifts and fruits of the Spirit, the vices and virtues, the four last things, the seven sacraments and explanations of the *Pater noster* and *Ave Maria*. So nearly 400 years after Lateran Council IV the friars were still composing works that enumerate the rudiments of faith. REFERENCES: IA 3/3: 226; Quétif-Échard 2/1: 404–5.

Note. Since the completion of this catalogue, the University Library acquired (1997) another incunable containing a work by a Dominican author: ROPERTUS HOLGOT *super libros sapientie* (Reutlinger: Johannes Otmar, 1489; UND Library, Rare Books BS 1755.3 .H65 1489; see Goff H-292). The commentary on Wisdom by Robert Holcot (†1349) survives in nearly 200 manuscripts and was printed twelve times between 1279 and 1294 (Kaeppeli nᵒ 3497). In November 1996 the Library purchased an important collection containing many documents, records and books pertaining to the Dominicans: The Harley L. McDevitt Collection on the Spanish Inquisition. Among its rare items is a printing of a text that is one of the earliest documents concerning the Inquisition in Spain: NICOLAUS EYMERICI, *Directorium inquisitorum* (Barcelona: Johann Luschner for Diego de Deza, Bishop of Palencia, 1503; McDevitt Collection nᵒ 29). Between the years 1357 and 1392, Nicolaus Eymerici (ca. 1320–1399) three times served as the chief inquisitor in Aragon (Kaeppeli nᵒ 3062). The Notre Dame volume is a copy of the second edition of the *Directorium* (see F. J. Norton, *A Descriptive Catalogue of Printing in Spain and Portugal, 1501–1520*, Cambridge, 1978, 62 nᵒ 149); the first edition was printed in Seville by Stanislaus Polonus in 1500 (GW nᵒ 9545). The Luschner edition of 1503 bears a nice woodcut of Christ on the title page verso: *Saluator mundi salua nos* (fig. 103).

Index of Manuscripts

Index of Names

Table of Figures

We thank the libraries, museums and other sources named in the Table for providing us photographs of the figures and for granting us the permission to publish them. In the entries for figures 73–102, we cite the catalogue numbers of the article by Emery and Jordan published in this volume, pages 493–541 (e.g., cat. 10).

* * *

555

11. Giunta Pisano, Crucifix (316 × 285 cm): Bologna, S. Domenico (Photo: Soprinten-denza B.A.S. Bologna).

12. Crucifix (205 × 168 cm), mid-13th c.: formerly Roma, S. Sisto Vecchio, now Roma, Collegio Angelico (Photo: Garrison Collection, Courtauld Institute of Art).

13. Cimabue (attrib.), Crucifix (336 × 267 cm): Arezzo, S. Domenico (Photo: Soprin-tendenza B.A.S. Firenze).

14. Giotto (attrib.), Crucifix (578 × 406 cm): Firenze, S. Maria Novella (Photo: Soprin-tendenza B.A.S. Firenze).

15. Inner faces of a Triptych (20.1 × 49 cm), Byzantine and/or Venetian, first half 14th c.: Dordrecht, Museum Mr. Simon van Gijn, on loan from a private collection (Photo: Stijns, Dordrecht).

16. Triptych, view from above with triptych partly folded, Byzantine and/or Venetian, first half 14th c.: Dordrecht, Museum Mr. Simon van Gijn, on loan from a private collection (Photo: Stijns, Dordrecht).

17. Triptych, outer face of Virgin panel (20.1 × 15.6 cm), Byzantine and/or Venetian, first half 14th c.: Dordrecht, Museum Mr. Simon van Gijn, on loan from a private collection (Photo: Stijns, Dordrecht).

18. Simone Martini, Polyptych, detail showing central figures of Predella (this section approx. 35 × 87 cm), 1320: formerly Pisa, S. Caterina, now Pisa, Museo Nazionale di S. Matteo (Photo: author).

19. Enamelled Plaque (10.3 × 7.8 cm), central Italian, mid-14th c.: New York, Metro-politan Museum of Art (Gift of George E. Seligmann, in memory of his wife Edna, his father Simon, and his brother René. Photo: Metropolitan Museum).

20. Arca di San Domenico, The Story of Blessed Reginald of Orleans: Bologna, S. Domenico (Photo: Villani).

21. Nicola Pisano and his workshop (attrib.), Arca di San Domenico, St. Dominic's Vision of Sts. Peter and Paul, completed by 1267: Bologna, S. Domenico (Photo: Villani).

22. Arca di San Domenico, Confirmation of the Dominican Order: Bologna, S. Domenico (Photo: Villani).

23. Arca di San Domenico, Raising of Napoleone Orsini: Bologna, S. Domenico (Photo: Villani).

24. Arca di San Domenico, Miracle of the Book: Bologna, S. Domenico (Photo: Villani).

25. Sarcophagus "of Stilicho," front face, late-4th c.: Milano, S. Ambrogio (Photo: Pontificia Commissione di Archeologia Cristiana).

26. Arca di San Domenico, Miraculous Provision of Bread: Bologna, S. Domenico (Photo: Alinari/Villani).

27. Painted refectory table (not less than 39 × 575 cm), central section of front face after restoration (1993), Bolognese, 13th c.: Bologna, SS. Maria e Domenico della Mascarella (Photo: Soprintendenza B.A.S. Bologna).

28. Jacobellus ("Muriolus") of Salerno (scribe and artist), detail from the leaf of a Gradual (46.3 × 32 cm), ca. 1270: Malibu, California, Collection of the J. Paul Getty Museum, Ms. 83MH 84 (Ms. Ludwig VI 1), fol. 48v (Photo: J. Paul Getty Museum).

29. Jacobellus ("Muriolus") of Salerno (scribe and artist), Gradual (46.3 × 32 cm), ca. 1270: Malibu, California, Collection of the J. Paul Getty Museum, Ms. 83MH 84 (Ms. Ludwig VI 1), fol. 38r (Photo: J. Paul Getty Museum).

30. Bolognese artist (attrib.), Gradual (52 × 35 cm), last decade 13th c.: formerly belonged to S. Domenico in Gubbio, now Gubbio, Archivio Comunale, Corale C, fol. 76v (Photo: author).

31. Umbrian artist (attrib.), Gradual (56 × 37.5 cm), last quarter 13th c.: formerly belonged to S. Domenico (Salvatore) in Spoleto, now Perugia, Biblioteca Comunale Augusta, Ms. 2795(A), fol. 46v (Photo: author).

32. North wall of the Capella Maggiore in the church of SS. Domenico e Jacopo in Bevagna, first half 14th c. (Photo: author).

33. Jacobellus ("Muriolus") of Salerno (scribe and artist), detail from a leaf of a Gradual (46.3 × 32 cm), ca. 1270: Malibu, California, Collection of the J. Paul Getty Museum, Ms. 83 MH 84 (Ms. Ludwig VI 1), fol. 38r (Photo: J. Paul Getty Museum).

34. Detail from a leaf of a Gradual (see entry 31 above): Perugia, Biblioteca Comunale Augusta, Ms. 2795(A), fol. 46v (Photo: author).

35. Detail from a leaf of a Gradual (see entry 30 above): Gubbio, Archivio Comunale, Corale C, fol. 76v (Photo: author).

36. Miraculous Provision of Bread, fresco on the north wall of the Capella Maggiore in the church of SS. Domenico e Jacopo in Bevagna, Umbrian, first half 14th c. (Photo: author).

37. Perugian artist, detail from a leaf of an Antiphonary (62 × 43 cm), early 14th c.: formerly belonged to S. Domenico in Perugia, now Perugia, Biblioteca Comunale Augusta, Ms. 2785(H), fol. 44v (Photo: Dillian Gordon).

38. *Passionale* of the Abbess Kunhuta, The Mystic Embrace, 14th c.: Praha, Národní Knihovna Ceské Republiky: Universitní Knihovna, Cod. XIV. A.17, fol. 16v (Photo: Erich Lessing/Art Resource, New York).

39. The Chapel of the Holy Cross, Karlstein Castle (Czech Republic), built by Emperor Charles IV, 1316–78 (Photo: Erich Lessing/Art Resource, New York).

74. Guillelmus Peraldus, *Summa de vitiis:* Notre Dame, University of Notre Dame Library, Ms. 12, fol. 9r (cat. 2).

75. Boetius, *De consolatione philosophiae,* with commentary of Phillipus Iadrensis: Notre Dame, University of Notre Dame Library, Ms. 53, marginal drawing of the Wheel of Fortune, fol. 24r (cat. 3).

76. *Psalterium ad usum Fratrum Ordinis Praedicatorum* (Psalm 26): Notre Dame, University of Notre Dame Library, Ms. 2, fol. 37v (cat. 4).

77. *Psalterium ad usum Fratrum Ordinis Praedicatorum* (Psalm 26): Notre Dame, University of Notre Dame Library, Ms. 1, fol. 34r (cat. 5).

78. Peregrinus de Opole, *Sermones de sanctis:* Notre Dame, University of Notre Dame Library, Ms. 3, fol. 144r (cat. 6).

79. Nicolaus de Ausimo, *Supplementum ad Summum de casibus conscientiae* (de Bartholomaeo de Sancto Concordio): Notre Dame, University of Notre Dame Library, Ms. 29, fol. 267v, with marginal gloss from the *Confessionale* of Antoninus Florentinus (cat. 7).

80. Thomas de Aquino, *Summa theologiae* IIa–IIae (Strassburg? Michael Reyser? Heinrich Eggestein? ca. 1474), fol. 1r (cat. 12).

81. Leonardus de Utino, *Quadragesimales sermones de legibus* (Ulm: Johann Zainer, 1478), fol. Bb7v (cat. 20).

82. Iohannes Herolt, *Sermones Discipuli de tempore* (Strassburg: Georg Husner, 1483), fol. 23r (cat. 22).

83. Conradus de Halberstadt? *Mensa philosophica* (Cologne: Cornelius of Zyrickzee, 1508), colophon, fol. 49r (cat. 26).

84. Iohannes Nider, *Preceptorium divine legis* (Louvain: Johann von Paderborn, 1485), fol. 1r (cat. 28).

85–86. Augustinus, *De civitate Dei,* with commentary by Thomas Waleys and Nicolaus Trevet (Freiburg im Breisgau: Kilian Fischer, 1494), fols. L$_2$v-L$_3$r (cat. 33).

87. Guillelmus Peraldus, *Sermones super evangelia dominicalia* (Avignon: Jean de Channey, 1509), title page (cat. 41).

88. Guillelmus Peraldus, *Sermones super evangelia dominicalia* (Avignon: Jean de Channey, 1509), printer's mark of Jean de Channey, which imitates the mark of Aldo Manuzio, last verso (cat. 41).

89. Guillelmus Peraldus, *Sermones super evangelia dominicalia* (Avignon: Jean de Channey, 1509), woodcut of the Mass of St. Gregory, title page verso (cat. 41).

90. Thomas de Vio (Caietanus), literal commentary *Super Epistolas Pauli* (Paris: Iehan Petit II, 1540), title page (cat. 49).

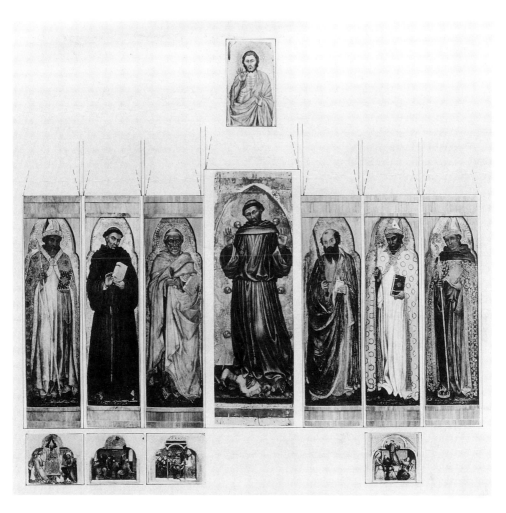

1. Taddeo di Bartolo, high altarpiece (rear face),
Perugia, Galleria Nazionale dell'Umbria

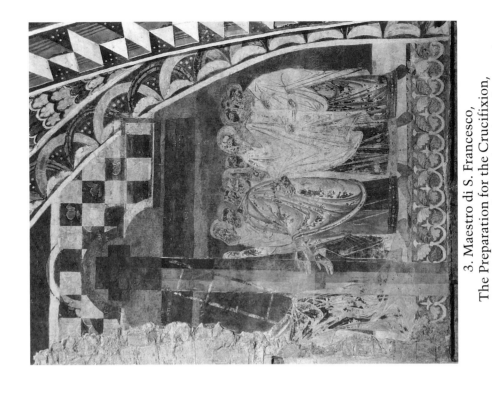

3. Maestro di S. Francesco,
The Preparation for the Crucifixion,
Assisi, S. Francesco (lower church, right nave)

2. Maestro di S. Francesco,
St. Francis Renounces his Possessions,
Assisi, S. Francesco (lower church, left nave)

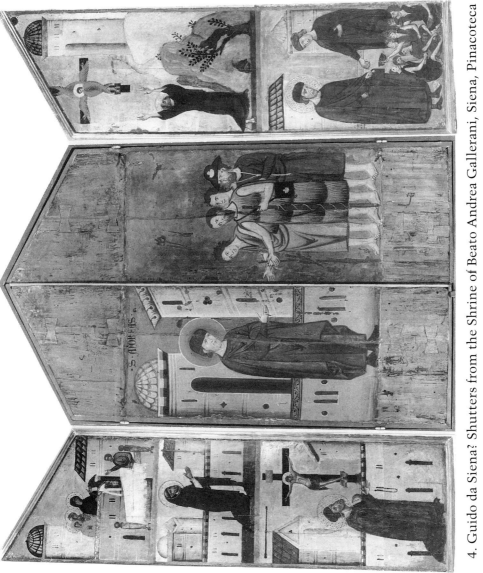

4. Guido da Siena? Shutters from the Shrine of Beato Andrea Gallerani, Siena, Pinacoteca

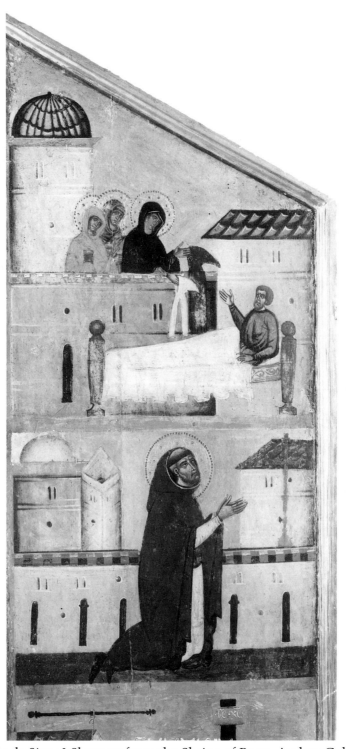

5. Guido da Siena? Shutters from the Shrine of Beato Andrea Gallerani
(inner left face), Siena, Pinacoteca

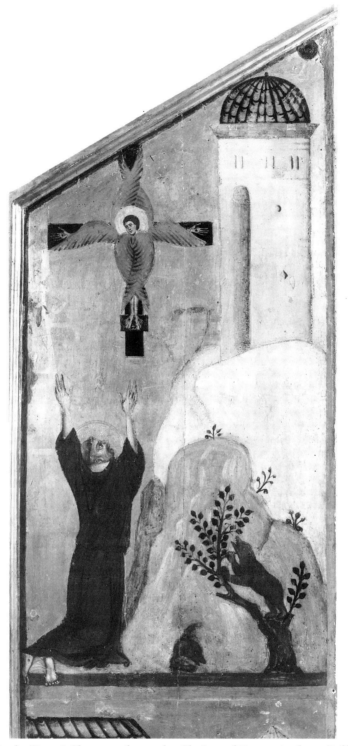

6. Guido da Siena? Shutters from the Shrine of Beato Andrea Gallerani
(inner right face), Siena, Pinacoteca

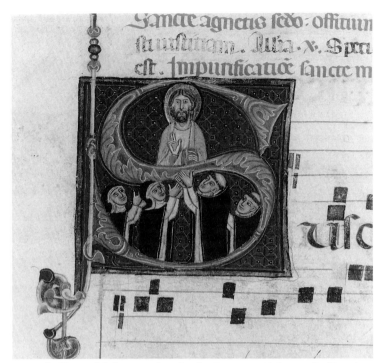

7. Jacobellus of Salerno, Gradual, Geneva, Private Collection

8. Antiphonary (Perugian),
Perugia, Bibl. Com. Aug., Ms. 2797(1), fol. 220v

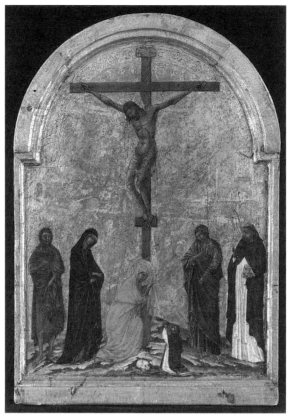

9. Triptych (central panel), Paris, G. Sarti Gallery

10. Crucifix (Dominican Supplicants), Roma, Collegio Angelico

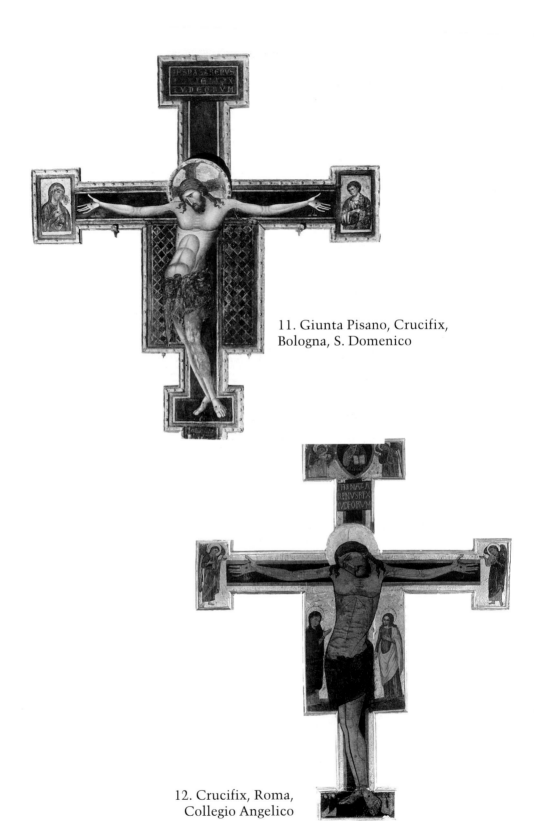

11. Giunta Pisano, Crucifix,
Bologna, S. Domenico

12. Crucifix, Roma,
Collegio Angelico

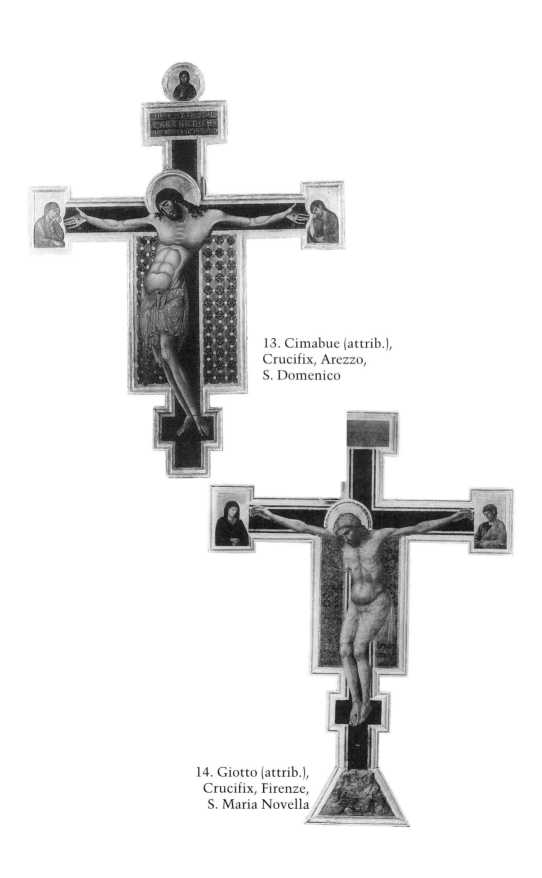

13. Cimabue (attrib.),
Crucifix, Arezzo,
S. Domenico

14. Giotto (attrib.),
Crucifix, Firenze,
S. Maria Novella

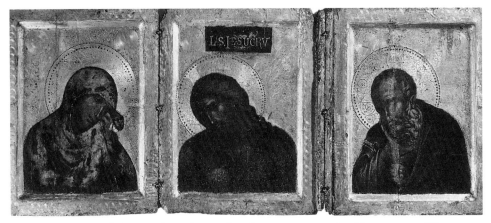

15. Triptych (inner faces), Dordrecht, Museum Mr. Simon van Gijn

16. Triptych (view from above), Dordrecht, Museum Mr. Simon van Gijn

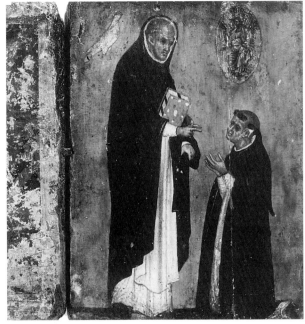

17. Triptych (outer face of Virgin panel), Dordrecht, Museum Mr. Simon van Gijn

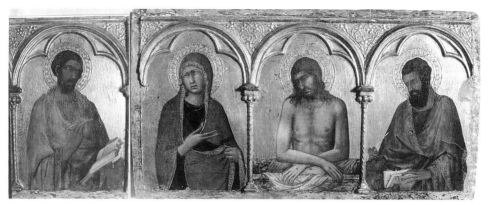

18. Simone Martini, Polyptych (Predella), Pisa, Museo Nazionale di S. Matteo

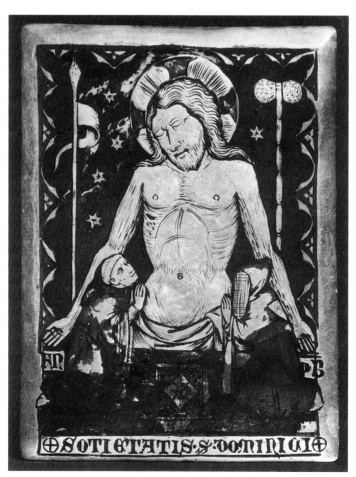

19. Enamelled Plaque (central Italian),
New York, Metropolitan Museum of Art

20. Arca di San Domenico, The Story of Blessed Reginald of Orleans,
Bologna, S. Domenico

21. Arca di San Domenico, St. Dominic's Vision of Sts. Peter and Paul,
Bologna, S. Domenico

22. Arca di San Domenico, Confirmation of the Dominican Order,
Bologna, S. Domenico

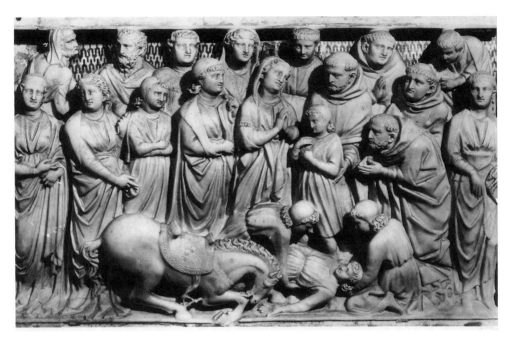

23. Arca di San Domenico, Raising of Napoleone Orsini, Bologna, S. Domenico

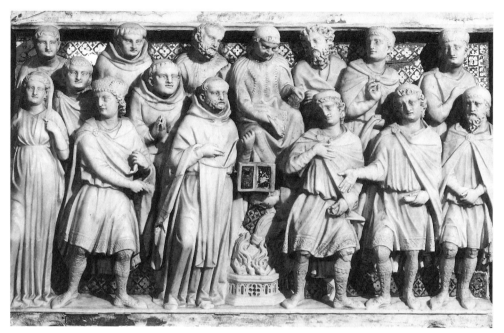

24. Arca di San Domenico, Miracle of the Book, Bologna, S. Domenico

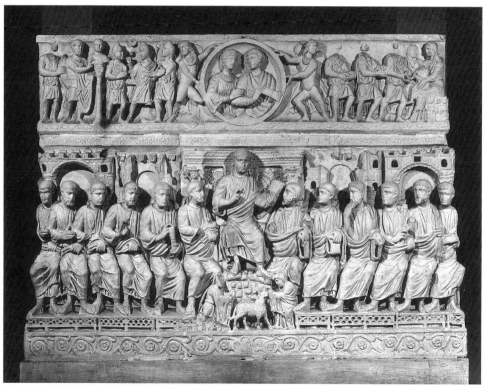

25. Sarcophagus "of Stilicho" (front face), Milano, S. Ambrogio

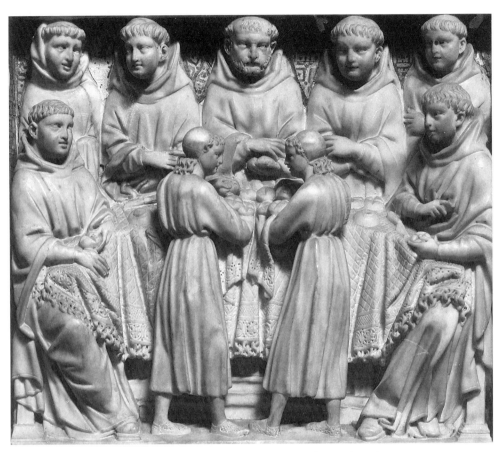

26. Arca di San Domenico, Miraculous Provision of Bread, Bologna, S. Domenico

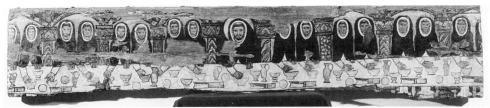

27. Painted refectory table (front face),
Bologna, SS. Maria e Domenico della Mascarella

28. Jacobellus of Salerno, Gradual, Malibu, J. Paul Getty Museum,
Ms. 83MH 84 (Ms. Ludwig VI 1), fol. 48v

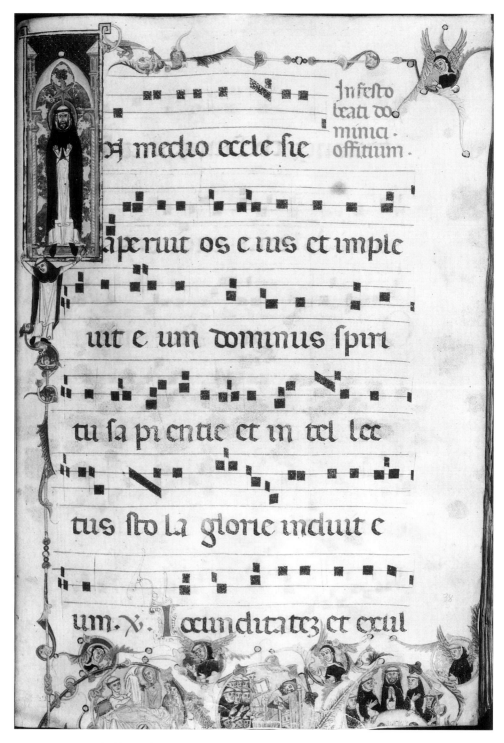

29. Jacobellus of Salerno, Gradual, Malibu, J. Paul Getty Museum,
Ms. 83MH 84 (Ms. Ludwig VI 1), fol. 38r

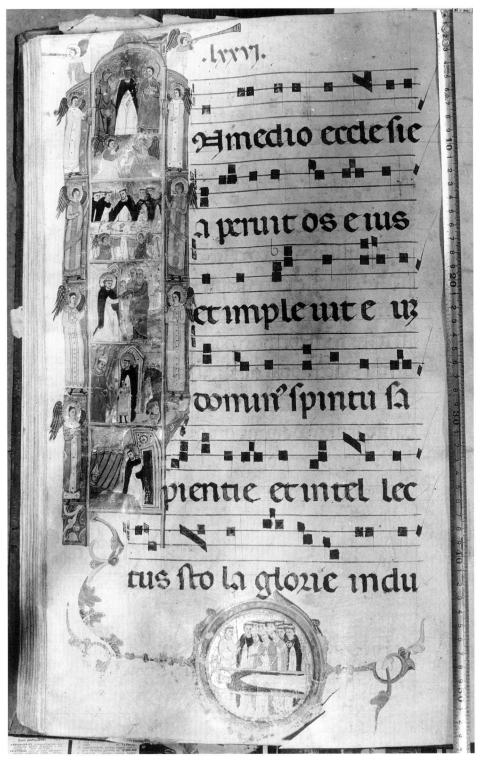

n medio ecclesie

a peruit os eius

et imple uit e u~

domini spintu sa

pientie et intel lec

tus sto la glorie indu

30. Gradual (Bolognese), Gubbio, Arch. Com., Corale C, fol. 76v

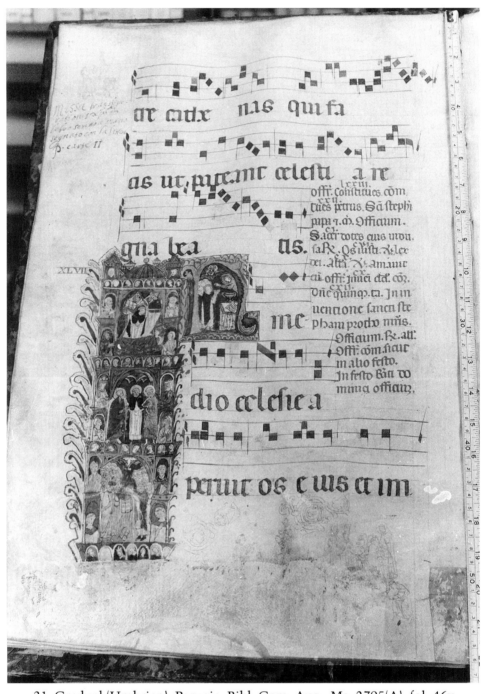

31. Gradual (Umbrian), Perugia, Bibl. Com. Aug., Ms. 2795(A), fol. 46v

32. Capella Maggiore (north wall), Bevagna, SS. Domenico e Jacopo

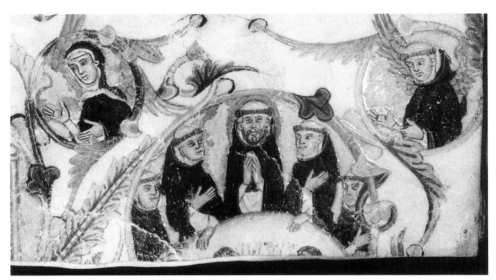

33. Jacobellus of Salerno, Gradual, Malibu, J. Paul Getty Museum,
Ms. 83H 84 (Ms. Ludwig VI 1), fol. 38r

34. Gradual (Umbrian), Perugia, Bibl. Com. Aug.,
Ms. 2795(A), fol. 46v

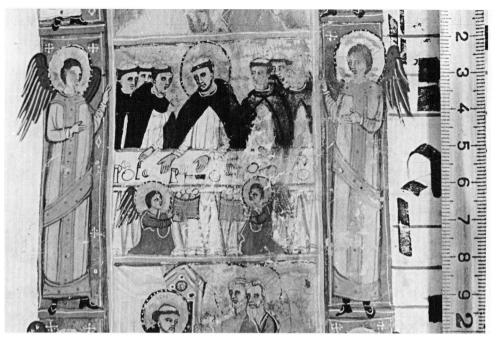

35. Gradual (Bolognese), Gubbio, Arch. Com., Corale C, fol. 76v

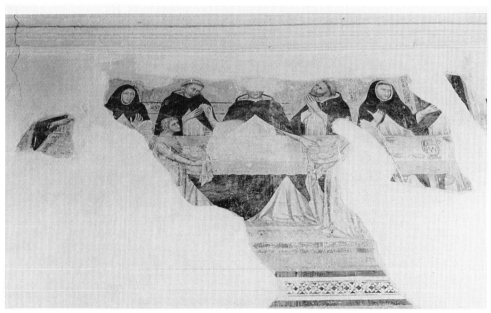

36. Miraculous Provision of Bread, Capella Maggiore (north wall),
Bevagna, SS. Domenico e Jacopo

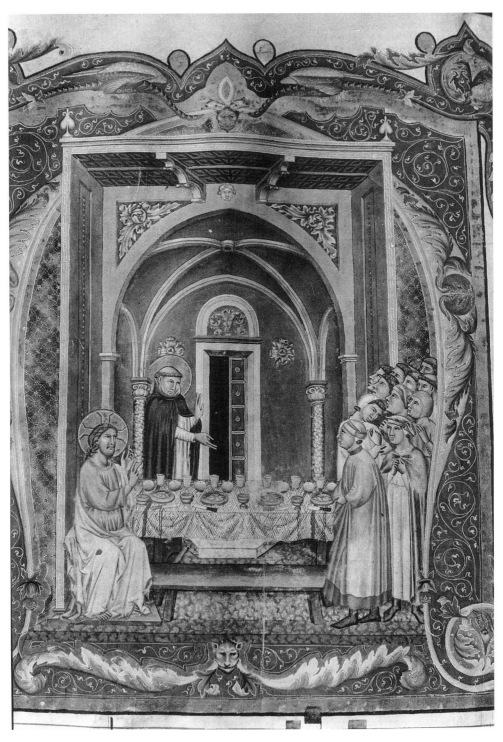

37. Antiphonary (Perugian), Perugia, Bibl. Com. Aug., Ms. 2785(H), fol. 44v

38. *Passionale* of the Abbess Kunhuta, The Mystic Embrace,
Praha, NUK, Cod. XIV.A.17, fol. 16v

39. The Golden Chapel of the Holy Cross, Karlstein Castle (Czech Republic)

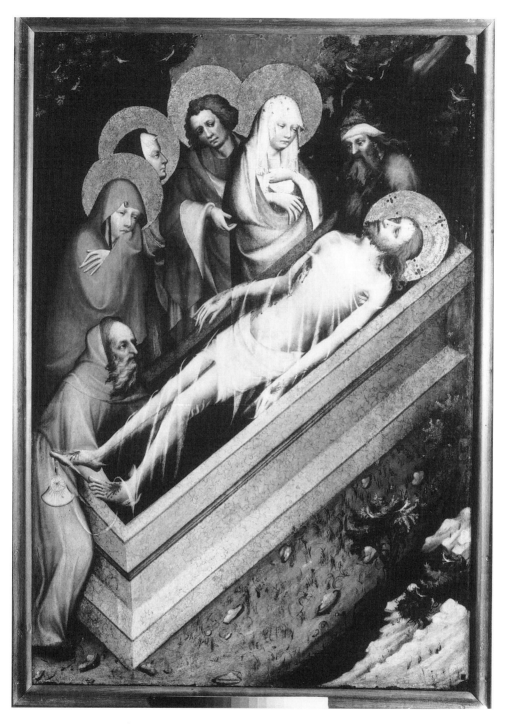

40. Master of Vyšši Brod, The Deposition, Praha, Národní Galerie

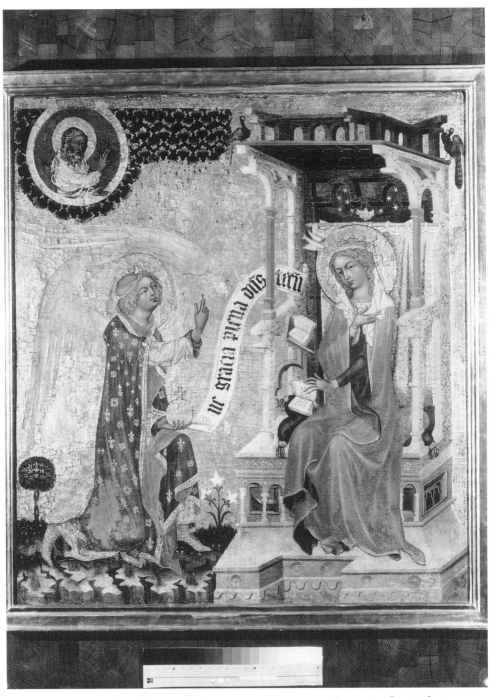

41. Master of Vyšši Brod, The Annunciation, Praha, Národní Galerie

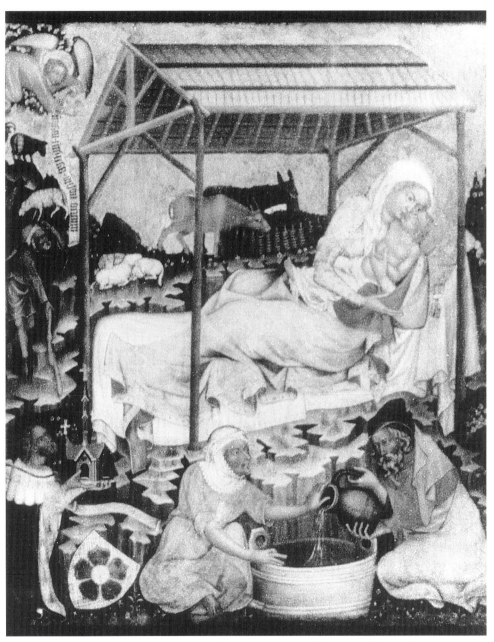

42. Master of Vyšši Brod, The Nativity, Praha, Národní Galerie

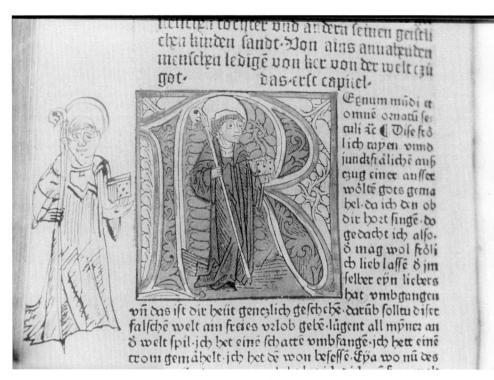

heiligen tochter vnd andern seinen geistli
chen kinden sandt. Von ains annakenden
menschen ledigē von hie von der welt czu
got. das erst capitel.

Egnum mūdi et
omnē ornatū se-
culi ꝛc ꝅ Dise frō-
lich wo̊ten vmb
jundfrälichē auß
czug einer außer-
wo̊ltē gotes gema-
hel. da ich den ob
dir hoꝛt singē. do
gedacht ich also.
d mag wol frṓli-
ch lieb lasse d jm
selber eyn liebers
hat vmbgangen
vñ das ist dir heüt genczlich geschehē. darūb solten diser
falschē welt ain freies vꝛlob gebē. lügent all myner an
d welt spil. jch het einē schatte vmbfangē. jch hett einē
trom gemähelt. jch het ds won besessē. Eya wo nū des

43. Heinrich Seuse, *Exemplar* (Augsburg: A. Sorg, 1482)

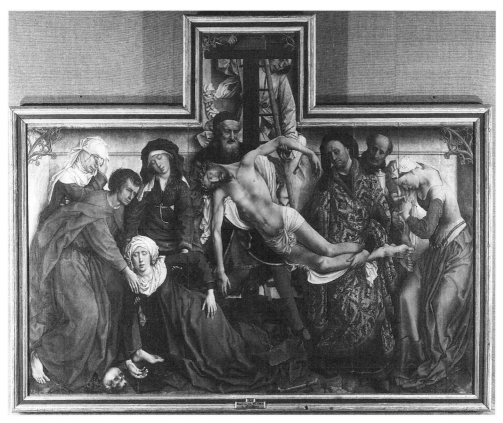

44. Rogier van der Weyden, The Deposition, Madrid, Museo del Prado

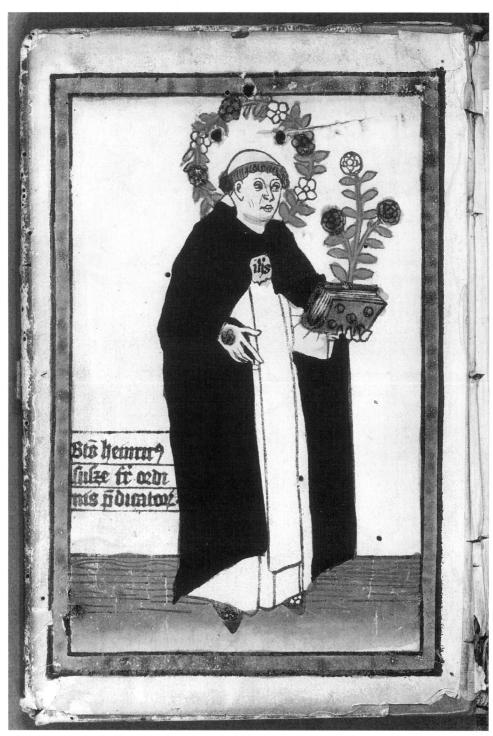

45. Heinrich Seuse as *Beatus*, Basel, UB, Cod. E.III.12, front pastedown

46. Genealogical Tree of the Dominican Order,
London, BM, Dept. of Prints and Drawings, Inv. nr. 1872-6-8 (344)

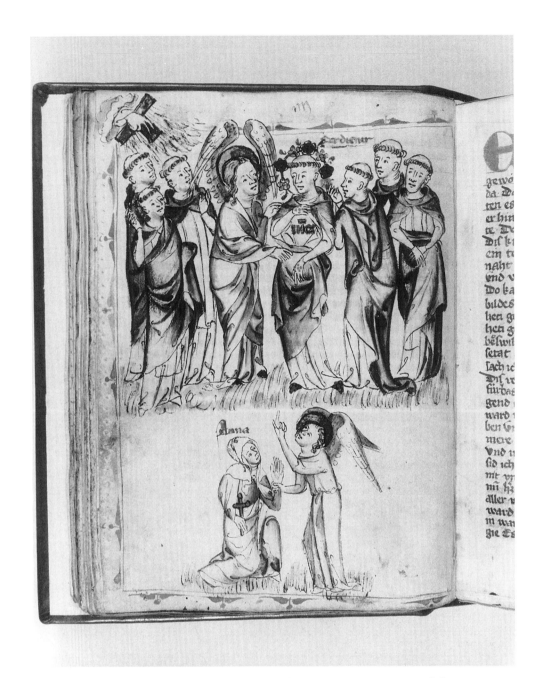

47. Heinrich Seuse, *Exemplar*, Strasbourg, BNU, Ms. 2929, fol. 28v

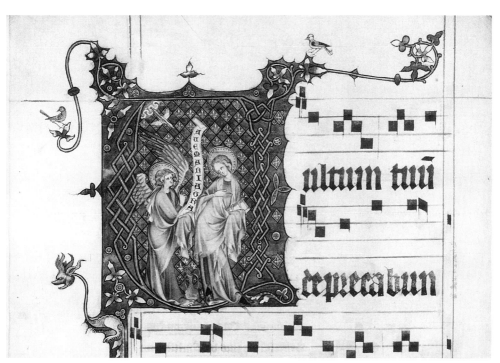

48. *Wettinger Graduale*, The Annunciation,
Aarau, Kantonsbibl., Ms. Bibl. WettFm 3, fol. 23v

49. Heinrich Seuse, *Exemplar*, Strasbourg, BNU, Ms. 2929, fol. 1v

50. Heinrich Seuse, *Exemplar*, Berlin, Staatsbibl.: Stiftung Preuss. Kulturbesitz, Hs. germ. fol. 658, fol. 87v

51. Workshop of Daniel Mauch, Buxheim Retable (lower left outside wing),
Christ in the Garden of Gethsemane with the Virgin Mary and St. Augustine,
Ulmer Museum, Inv.-Nr. 1922.5109

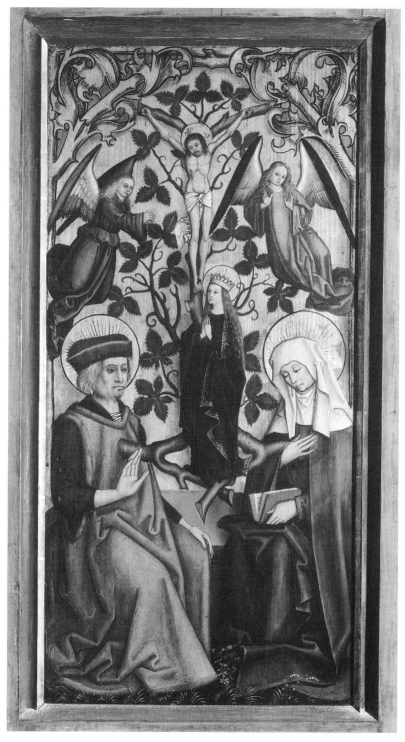

52. Workshop of Daniel Mauch, Buxheim Retable (upper left outside wing), *Arbor virginis*, Ulmer Museum, Inv.-Nr. 1922.5109

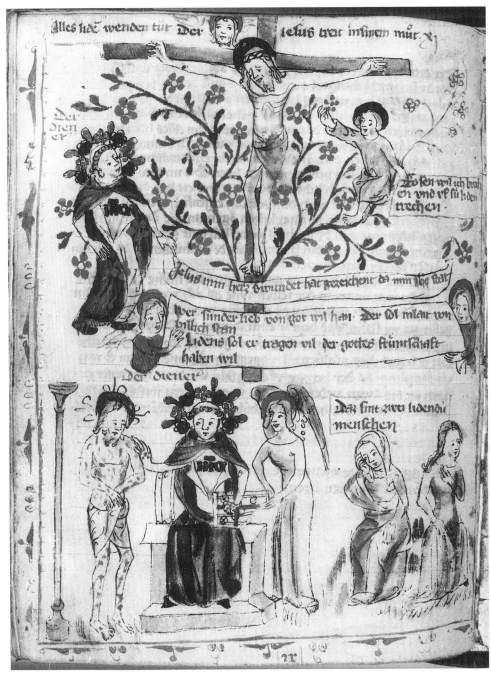

53. Heinrich Seuse, *Exemplar*, Strasbourg, BNU, Ms. 2929, fol. 109v

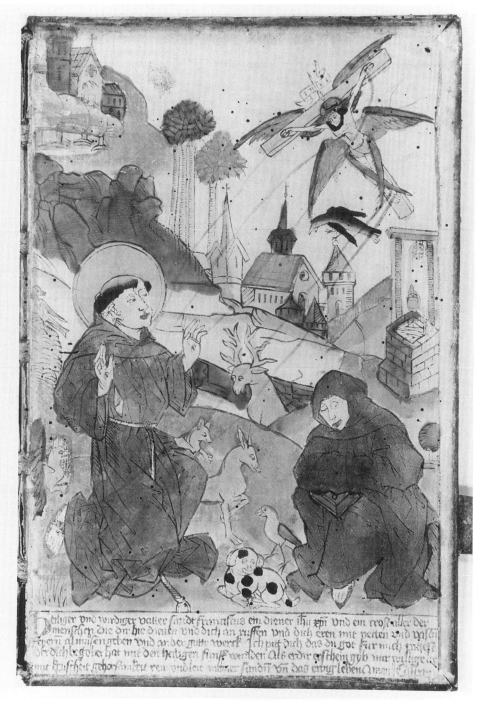

54. The Stigmatization of St. Francis, München, Bayerische Staatsbibl., Rar. 327, inside back cover

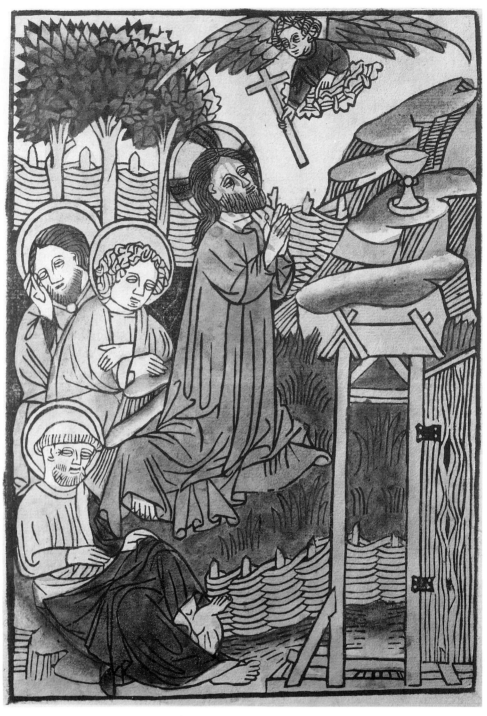

55. Christ on the Mount of Olives, Washington, D.C., National Gallery of Art, Rosenwald Collection (© 1943.3.463 [B-3018]/PR)

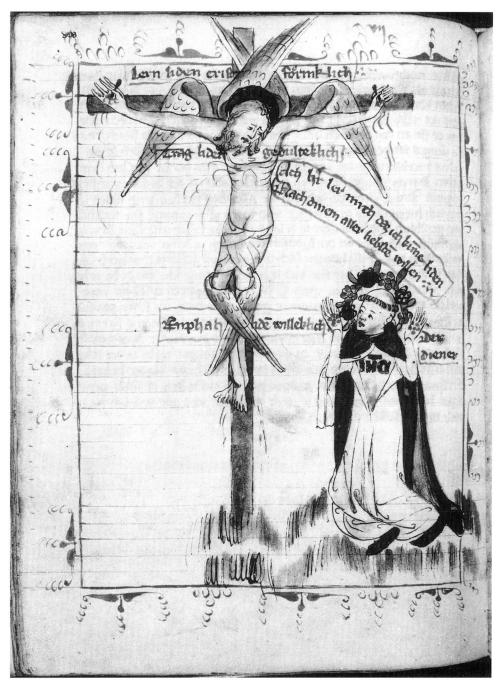

56. Heinrich Seuse, *Exemplar*, Strasbourg, BNU, Ms. 2929, fol. 65v

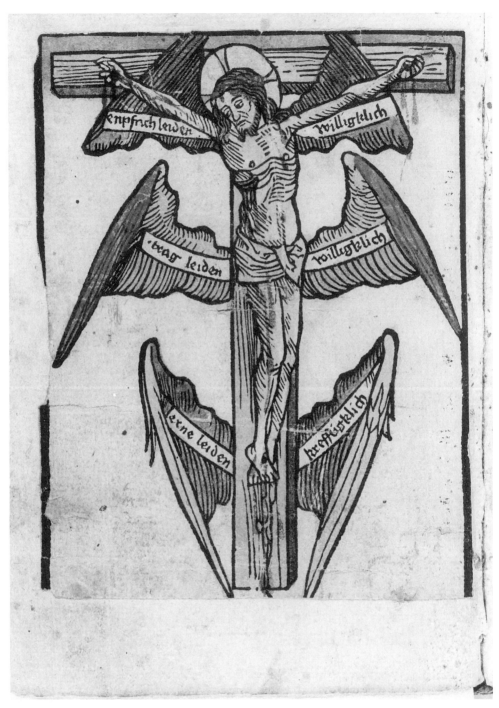

57. Crucifixion (single leaf), Karlsruhe, Badische Landesbibl., (S.931m)

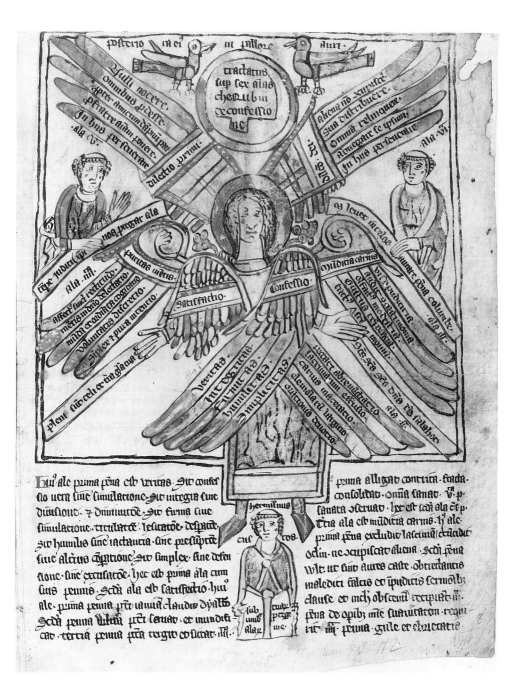

58. Diagram from the *Speculum theologiae,* New Haven, Yale Univ.,
Beinecke Library, Ms. 416, fol. 8r

59. Heinrich Seuse, *Exemplar*, Strasbourg, BNU, Ms. 2929, fol. 7r

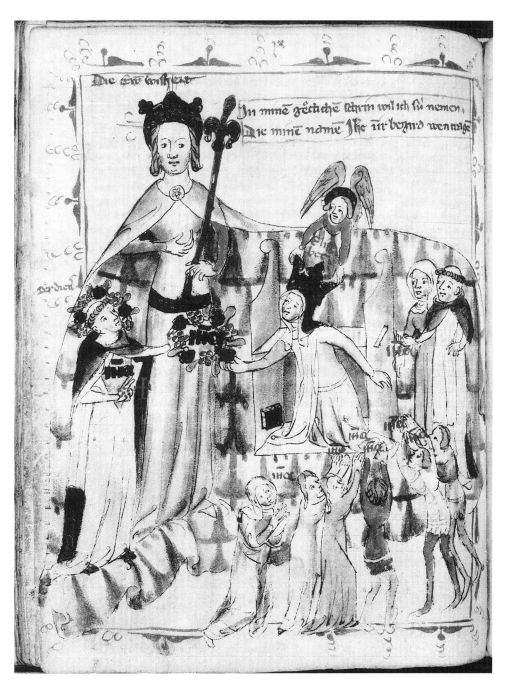

60. Heinrich Seuse, *Exemplar*, Strasbourg, BNU, Ms. 2929, fol. 68v

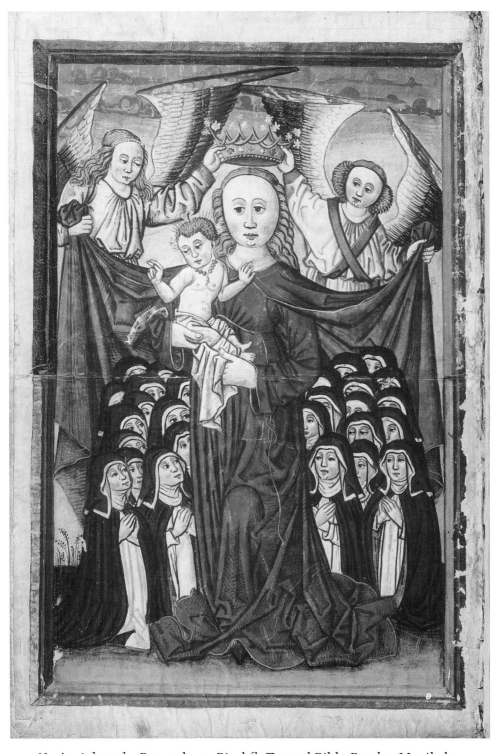

61. *Antiphonale*, Regensburg, Bischfl. Zentral Bibl.: Proske. Musikabt.,
Hs. sine numero

62. Heinrich Seuse, *Exemplar*, Strasbourg, BNU, Ms. 2929, fol. 68r

63. Heinrich Seuse, *Exemplar*, Strasbourg, BNU, Ms. 2929, fol. 1r

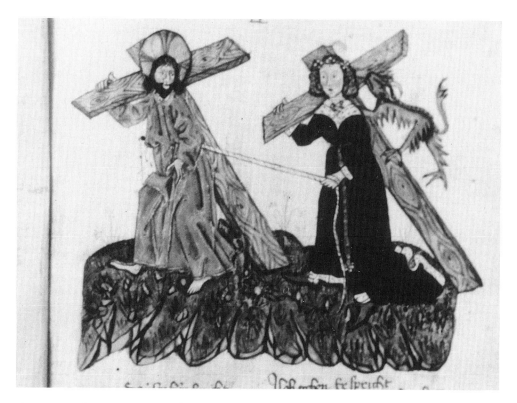

64. Heinrich Seuse, *Exemplar*, Einsiedeln, Stiftsbibl., Cod. 710 (Msc. 322), fol. 1r

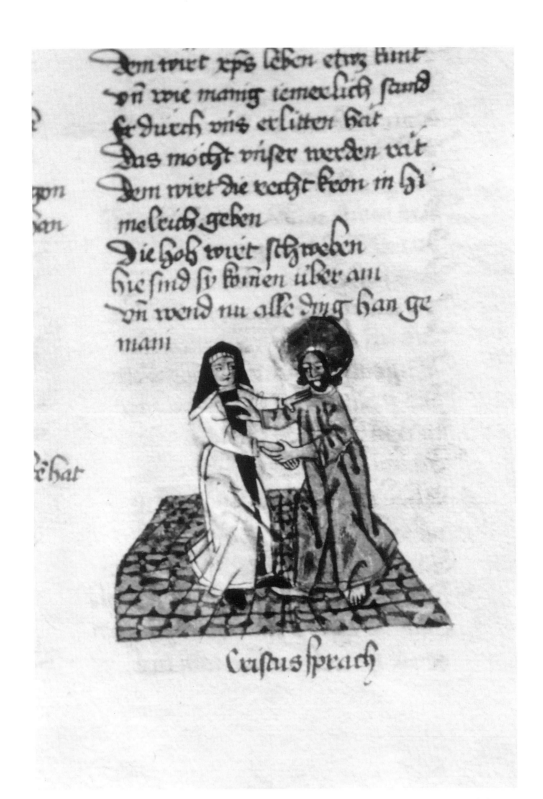

65. Heinrich Seuse, *Exemplar*, Einsiedeln, Stiftsbibl., Cod. 710 (Msc. 322), fol. 20r

66. Heinrich Seuse, *Exemplar*, Strasbourg, BNU, Ms. 2929, fol. 2r

67. Heinrich Seuse, *Exemplar*, Strasbourg, BNU, Ms. 2929, fol. 3r

68. Heinrich Seuse, *Exemplar*, Strasbourg, BNU, Ms. 2929, fol. 42r

69. Heinrich Seuse, *Exemplar*, Strasbourg, BNU, Ms. 2929, fol. 84v

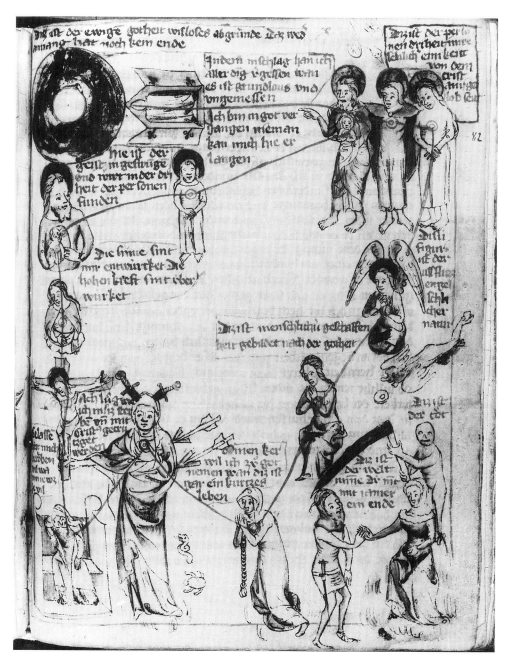

70. Heinrich Seuse, *Exemplar*, Strasbourg, BNU, Ms. 2929, fol. 82r

71. Cologne *Quaestiones vacantiales*, Eichstätt, UB, Cod. st 688, fol. 263r

72. Heymericus de Campo, *Quadripartitus questionum*,
Bernkastel-Kues, St. Nikolaus-Hospital, Cod. Cus. 106, fol. 16r

73. Humbertus de Romanis, *Tractatus de habundancia exemplorum,*
UND Library, Ms. 15, fol. 164r

74. Guillelmus Peraldus, *Summa de vitiis*, UND Library, Ms. 12, fol. 9r

75. Boetius, *De consolatione philosophiae*,
with comm. of Phillipus Iadrensis, UND Library, Ms. 53, fol. 24r

76. Dominican *Psalterium* (Psalm 26), UND Library, Ms. 2, fol. 37v

77. Dominican *Psalterium* (Psalm 26), UND Library, Ms. 1, fol. 34r

78. Peregrinus de Opole, *Sermones de sanctis*, UND Library, Ms. 3, fol. 144r

79. Nicolaus de Ausimo, *Supplementum ad Summum de casibus conscientiae*,
UND Library, Ms. 29, fol. 267v

80. Thomas de Aquino, *Summa theologiae* IIa-IIae (Strassburg? ca. 1474), fol. 1r

tenetur · 7 debet hō non folum de pcō · h etiaʒ
de obliuione dolere que ex negligentia ꝛtigit
Si autem pctm oīo a memoria exciderit tunc
ex impotentia faciendi excufat a debito · 7 fuff
at generalis ꝛtritio de omni eo in quo deum
offendit · Sed qn impotentia tollitur · ficut cū
ad memoriam pctm reuocatur · tunc tenet hō
fpecialitͤ conteri · Sicut etiā ē de paupe qui nō
pōt foluere quod debet · excufat · 7 tn tenetur
cū primo potuerit ꝙ Ad tertiū dic · ꝙ fi igno
rantia oīo tollat voluntatē male agendi excu
fat a non eſt pctm · fed qn non ꝛtotaliter tollit
voluntatē tunc non excufat a toto · Et ideo de
peccato p ignorantiam ꝗmiffo debet hō ꝛteri
 ꝙ Ad quartū dic ꝙ poſt ꝛtritionem de moꝛ
tali pōt remanere veniale · h non poſt ꝛtricōm
de veniali · 7 ideo etiam de venialibꝰ debet eſſe
ꝛtritio · eo modo quo 7 pnia · ꝙ Tūc anima
gͤas agens deo 7 fuis doctoribus · confolata ꝺ
tā nobili declaratione · abibit domū in pace · A̅

ꝙ Feria Serta in paffione domini ·
ꝙ Sermo Tricefimufoctauus de ꝛfilio ·

[initial L] Ilios dei ꝛgregaret in
vnum · Joħ · 11 · c · ꝙ Do
dia aia fimplex · fidelͤ
7 deuota faluti fue in
tenta · accefſit ad eccle
fiam · 7 audiens miffa̅
tam ex lectione ꝓphie
Jere · 18 · c · ꝗ ex euan
gelio · aduertit vnam ꝛcluſionem ꝛꝫ A̅
 ꝙ Qui bonū dat ꝛfilium · pͤ̅ntis vite hͤt fubfi
diū · 7 eterne remunerationis pͤmiū ꝙ Ifta
ꝛcluſio hͤtur · 12 · q · z · c · Bone rei date ſtultū
vt pͤ̅ntis vite habeatur fubfidiū · 7 eterne re
munerationis expectare cernit pͤmiū · h ibi ·
 ꝙ Ratio iftius ꝛcluſionis eſt illa · Rectū cō
filium in hoc ꝛfiftit ꝙ vis cognofcitiua appre
hendat rem alicͤ̅ ſm ꝙ in fe eſt · ꝙ quidͤ̅ pue
nit ex recta difpofitione virtutis apprehenſiue
ficut in fpeculo fi fuerit bene difpofitum impri
munt forme corpoꝛ ſm ꝙ funt · fi vero fuerit
fpeculum male difpofitum · apparent ibi yma
gines diftorte 7 praue fe habentes · Qᷓ aū vir
tus cognofcitiua fit bene difpofita ad recipie̅
dum res ſm ꝙ funt · ꝛtingit quidem radicalitͤ
ex natura · ꝛfumatiue aū ex exercitatio · vͤl ex
munere gͤe · Et hͤc quadruplͤr · Vno modo di
recte ex pͤte ipͤius cognofcitiue virtutis · puta
quia non eſt imbuta prauis ꝛceptionibus · fed
veris 7 rectis · Alio modo indirecte · ex bona di
fpofitione appetitiue virtutis · ex qua fequiͤ̅
ꝙ homo bene indicet de appetibilibꝰ · 7 fic bo
nū virtutis ꝛditiuͤ ꝛfequitur hꝰitus virtutū
moꝛalium circa ea que funt ad finem · 7 circa
ipͤm finem · De rōne aū virtutis hꝰane ē · ꝙ
faciat actū hͤis bonū · Inter ceteros vero ad
hominis ꝓfcͤum eſt ꝛ confiliari · quia importat

quandā rōnis inquifitionem circa agenda · in
quibꝰ ꝛfiftit vita hꝰana · Admuenire autͤ̅ ꝗ
agenda funt p rectam rōnem eſt virtutis bene
ꝛfiliatiue · 7 precipue in his que oꝛdinant in
finem vite eterne · Jdeo tale ꝛfilium meretur
vitam eternam · ꝙ Sciͤ̅d ꝙ ꝛfiliū ē triplex ·
Sicut triplex eſt prudentia · Primū eſt ꝛfilium
falfum · Cum eṁ ꝛfultor prudens fit qui bene
difponit ea que funt agenda ꝗpter aliquͤ̅ bo
nū finem · ille qui ꝗpter malum finē aliqua di
fponit ꝛgruentia illi fini · falfe ꝛfulit · iuxtum
illud quod accipit p fine · non eſt vere bonum
fed ſm fimilitudinem · fic aliquis dicit bonus la
tro · 7 hͤc modo pōt ſm fimilitudinem dici pru
dens latro · qui ꝛuenientes vias adinuenit ad
latrocinand · 7 talis prudentia eſt in folis pctō
ribꝰ · qui funt bene ꝛfiliatiui ad aliquͤ̅ maluʒ
finem · De hac prudentia ꝺ Rom · 8 · c · Prudē
tia carnis moꝛs eſt · fcʒ quia finem vltimū con
ftituit in delectatione carnis · Et hͤc non ē va
prudentia inconfulendo · quia prudentia eſt cō
filiatiua bonoꝛ opeꝝ 7 rectoꝝ · ꝙ non ꝛueit
nifi exiftente rōne 7 appetitu recto · Jdo phꝰ
li · 6 · Ethicoꝝ dicit · Impoſſibile eſt prudentͤʒ
eſſe non antem bonū · Scͤ̅m eſt ꝛfilium bonū
fed impfͤctum · Bonū quidem quia adinuenit
vias accomodas ad finem vere bonū · h eſt im
pfͤctum duplici rōne · Primo quia illud bonū
ꝙ accipit p fine · non eſt ꝛmunis finis totius
hꝰane vite · h alicuius fpecialis negocii · puta
cū aliquis adinuenit vias accomodas ad ne
gociandum vͤl ad nauigand · dicitur prudens
negociatoꝛ · vel nauta · 1° quia deficit in prin
cipali actu prudentie · quia licet bene ꝛfilietur
7 recte indicet de his que ptinent ad totaʒ vi
tam · non tn efficaciter precipit · 7 talis pruden
tia eſt ꝛmunis bonis 7 malis · h ꝗpter defectuʒ
pͤincipalis actus qui eſt precipe non eſt nifi in
malis · Tͤrciū eſt ꝛfiliū bonū 7 pͤfͤctū quo
quis ꝛfiliatur ad bonū finem totius vite · 7 cō
filium ad effectum pducat · Et tale ꝛfilium nō
ē nifi virtuofoꝝ · Dicit eṁ Greg9 li · z · moꝛal
ꝙ cetere virtutes nifi ea ꝙ appetunt · prudentͤ
agant · virtutes nequaꝙ eē pnt · Jdeo qui bo
num ꝛfilium hͤc modo dat · habet gͤam bn 7
meretur vitam eternam · ꝙ Dis intellectis aia
exiuit ab ecclefia · cū ꝓpofito fequendi bonū cō
filium · Et ecce belial intendens eam ab h ꝗpo
fito reuocare ait · O anima fimplex ꝙ facile de
aperis tam leniter credendo · Volo tibi oftͤdere
ꝙ bonū ꝛfilium non dͤducit eum qui dat ad
vitam eternā · ꝙ Primo fic · virtutibꝰ nemo
male vtitur · vt dicit Aug9 li · de libero arbi
trio · Sed ꝛfiliatiua aliqui male vtunt · vel qᷓ
aftuta ꝛfilia excogitant ad malos fines confe
quendos · vel aliqua pͤcta oꝛdinant ad bonum
finͤʒ · puta qui furatur vt elemofinā det · ergo
non omne ꝛfilium dͤducit ad vitam eternam
ꝙ 2° fic · Virtutes funt ꝛneꝛe ad inuicem vt
non poſſit hͤri vna fine altͤra · Sed virtus cō

81. Leonardus de Utino, *Quadragesimales sermones de legibus*
(Ulm: J. Zainer, 1478), fol. Bb7v

Sermones discipuli de tempore per circulu anni incipiut. Dominica prima aduentus domini. Sermo prim de aduentu christi in carnem.

Ecce rex tuus venit tibi mansuetus ⁊c. Zach. ix. Matth. xxi. Mar. xi. Luc. xix. Job. xij. Egregius doctor noster scs Tho. Sa quo dicit q̄ nulla actio sit pfecta siue meritoria nisi fuerit p gratiaz dei illuminata...

Quoniam sicut sol est causa oium generabiliu ⁊ corruptibiliu, sicut dicit Aristo. in.ij.li. physi cor. vbi dicit sic: Homo generat hoiem ⁊ sol. sic ꝗ̄ hō generet a patre ⁊ matre sol coopat̄ Sic verus sol iustitie christus iesus est causa oium gratiaz ⁊ actionu Ideo dicit ysido9 Ø homo in omni ope tuo auxiliu dei posce. quonia sine ipso nulla bona opa possumus p ficere. ipsa veritate attestāte q̄ dicit Joh. xv. Si ne me nihil potestis facere. Pro gratia igit imperanda matrem gratie salutem9 ⁊c. Ecce rex tuus vt supra. Hodie mater ecclesia icipit tps aduent9 christi sicut incarnatus est. ⁊ descē dit de celis ppter nostram salutē. Un Bern. Uenit medicus ad egrotos. redēpto2 ad vendi tos. ad errantes via. ad mortuos vita. venit q̄ sanat omnes infirmitates. Ergo dicat̄: Ecce rex tuus venit. Quia de aduentu dni dies fe stua2 hodierna: Ideo ē scendu. q̄ ē q̄duplex aduent9 dni. ⁋ Prim9 est in mundu p carnis assumptione. Un Job. j. Uerbu caro factum est. Et de illo agit in prima dominica Secūdus est ad iudiciu p merito2ii discus sione. De quo Esa. iij. Dns ad iudiciu veniet cum senioribus populi sui ⁊ principibus eo9. Tunc vt habet Luc. xxi. videbūt filiu hois ve niente cū patre magna ⁊ maiestate. Quonia s̄m ps. xcvij. Judicabit o2bem terraz ⁊ iusticia ⁊ populos in equitate. De quo agit in secūda

dnica. Tertius est in aiaz p gratie infusione. Sap. vij. In aias sanctas se trāsfert Job. xuj. Si quis diligit me. vsq̄. ad eum veniemus ⁊ mansionem apud eum faciem9. De quo agit in tercia dnica. Quartus est aduent9 christi ad mortez hois. Un Luc. vj. Estote parati. q̄ ꝗ̄ hora nō putatis filius hois veniet. De quo agit in quarta dnica. Ad primu dnū aduentū redeo. de ipso non subtilia sed simplicia vt di scipulis conscribendo Unde in prim sermone tria sunt dicenda. ⁋ primo de illo tpe aduent9 ⁊ quare institutum sit ab ecclesia. Scdo quo incarnatō christi facta sit. ⁊ q̄ re natura nostra mūdio2 sit seruanda post incarnatonē. Terto exemplu. B ⁋ Quantu ad primu scdū q̄ presens tps medio mo se tenet ad ipos2 om anni. q̄ partim leticiam continet. ⁊ partim tri sticiā. Deponit enim sancta mater ecclesia cā tica leticie. scz Te deum laudam9 i matutinis Gloria in excelsis in missa. Sed alleluia non deponit. In q̄dragesima oia ista deponit ec clesia. Ite in aduentu ieunat cū lacicinijs. sed in q̄dragesima cū oleo. ⁊ hoc ex precepto. vt ha bet in decretis. In quadragesima est ieunan diu a lacicinijs. dist. iiij. Benig3. Sed q̄re hoc tps aduent9 dni istitutu sit ab ecclesia Rndet ⁋ Primo ad memo2ādū beneficum q̄ dns contulit humano generi in incarnatōe sua. naz in hoc bono2auit nos sup āgelos. Noluit eni christus parentelā o2rabere cū angelica natu ra. sed cū humana. Heb. ij. Nusq3 apprehēdit angelos. sed semen abrae. Ex quo habetur q̄ inter deum ⁊ hoiem est maio2 fraternitas. q̄ inter deum ⁊ angelos. Et fraternitas quide q̄ tantū causat̄ ex altero parentū firma est. Sed q̄ causat̄ ex vtroq3 firmissima est. Angel9 est frater christi tātū ex pte patris eterni. q̄ ena est pater christi p eterna generatione ⁊ angelo2u per creationem. Homo vero est frater christi ex parte patris eterni q̄ est pat christi p eterna generatione ⁊ hois p creatione Ex pte matris q̄ virgo beata est mater christi ⁊ nostra. Un christ9 niūq3 vocat angelos suos fratres sicut hoies. dicens illud ps. Narrabo nomē tuum fratribus meis. Ergo o misericordia saluato2is multi cōfidam9. q̄ caro ⁊ frat noster est Bern. Puto me iam spernere non poterit christus os de ossibus meis ⁊ caro de carne mea. Et er quo christus iesus est frater noster. nunc vult nobiscū pie ⁊ miserico2diter agere ac amicabiliter. ⁊ vt frater cum fratre nobiscū couersari. Qui eni olj erat leo seuer9 mō facet9 est homo mansuetus. Legit enim q̄

et infirmitate inualescente.appropinquat morti. Uocatus sacer
dos vt aiam deo comendaret nō pparuit. Dixit g. eas comēdo
oibus demonibs inferni. Jpo mortuo rogauert sacerdotē ami
ci vt defunctū sepeliret in atrio bndicto. qd sacerdos eis negauit
Habebat aūt dictus sacerdos vnū asinū qui nihil aliud faciebat
ꝗ libros ad eccliam ferre ꝛ referre. ꝛ ideo nullaꝫ aliā viā sciebat
rogauerūt aūt amici sacerdotē vt corpus sup asinuꝫ poneret. ꝛ
ad quēcunꝗ locū illud deferret sepeliret. putantes ꝗ ad ecclesi
am illud delaturus esset vel ad domū sacerdotis qr aliaꝫ viā ne/
sciebat. Placuit pactō sacerdoti. asinus ergo corpus vsurarij su
pra se positum non declinans ad sinistrā vel dexteram tulit ad
patibulum ꝛ se excutiens eiecit sub patibulo ꝛ ibi sepultus est se
pultura patrum suorum.

Presens liber (quē mensaꝫ philosophicā vocant)
vnicuiꝗ perutilis cōpendiose ptractans. in primis
quid in cōuiuijs pro cibis ꝛ potibus sumenduꝫ est.
deinde qui sermones in illis ꝑm exigentiā psonaruꝫ
habendi sunt ꝛ ꝗ questiones discutiende que insup
facecie siue ioci interserendi feliciter explicit. Im-
pressus Colonie apud predicatores. per me Cor
nelius de �zꝛyckꝫee alme vniuersitaꝫ Coloniēn. sup
positū Anno salutis nostre.m.ccccc.viij. Mensis
vero Martij.die.xvij.

84. Iohannes Nider, *Preceptorium divine legis* (Louvain: Johann von Paderborn, 1485), fol. 1r

85-86. Augustinus, *De civitate Dei*, comm. by Thomas Waleys and Nicolaus Trevet (Freiburg im Breisgau: K. Fischer, 1494), fols. L₂v-L₃r

87-88. Guillelmus Peraldus, *Sermones super evangelia dominicalia* (Avignon: Jean de Channey, 1509), title page and last verso

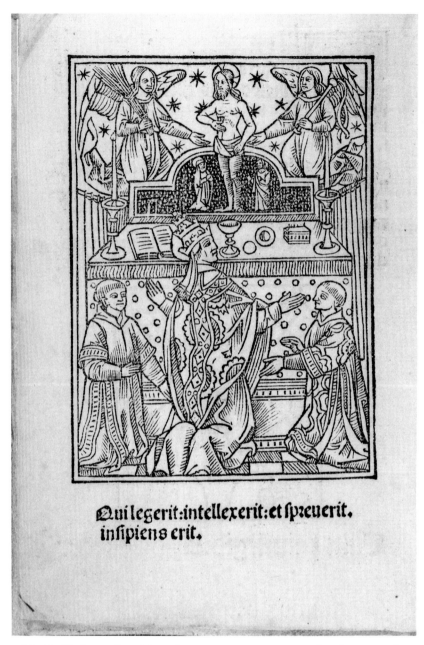

Qui legerit:intellexerit:et spreuerit.
insipiens erit.

89. Guillelmus Peraldus, *Sermones super evangelia dominicalia*
(Avignon: Jean de Channey, 1509), title page verso

90. Thomas de Vio (Caietanus), literal commentary *Super Epistolas Pauli*
(Paris: I. Petit II, 1540), title page

91. Andrea Gianetti, *Rosario della sacratissima vergine Maria*
(Rome: D. Basa, 1585), title page

92. Andrea Gianetti, *Rosario della sacratissima vergine Maria*
(Rome: D. Basa, 1585), engraving by Adamo Montovani,
verso opposite p. 1

93. Dominican *Missale* (Venice: G.B. Sessa and B. Barezzo, 1596),
verso opposite p. 1

Diui Thome Aquinatis

ENARRATIONES, QVAS CATHENAM
vere Auream dicunt. In quattuor Euangelia, ex vetu-
ftiffimorum codicum collatione quátū li-
cuit emēdate ac in lucem edi-
te opera Nicolai
Higman.

¶ Additus eft index rerum fcitu dignarūm.

fratea helias beyfel domimrany bufro antes habet cofum
Oculi mes femper ad dominū quoniá ipfe euellet
De laqueo pedib meos

PARISIIS
APVD IACOBVM KERVERSVB DVOBVS
GALLIS IN VIA IACOBEA.

M. D. XXXVII.

94. Thomas de Aquino, *Cathena aurea* (Paris: J. Kerver, 1537), title page

Diui Thome Aquinatis, ordinis

prædicatorum, viri & vitæ sanctimonia ac sacra-
rum literarum peritia præclari, in beati Pau-
li apostoli epistolas, commentaria, a men-
dis non paucis repurgata ex varia-
rum editionum ac vetustis-
simorum codicum
collatione.

Additus est insuper huic nouissime reco-
gnitioni index copiosissimus rerum sci-
tu dignarum.

PARISIIS.

¶ Ex officina honesti viri Ambrosii Girault sub signo Pellica-
no via ad Diuum Iacobum ante. S. Iuonem.

M. D. XXXVIII.

95. Thomas de Aquino, *In beati Pauli apostoli Epistolas, commentaria*
(Paris: A. Girault, 1538), title page

D. THOMAE AQVINATIS,
EX PRAEDICATORIA
FAMILIA,

SVMMA CONTRA

GENTILES, QVATVOR LIBRIS COMPREHEN-
SA: COMMENTARIIS ERVDITISSIMI VIRI, FRATRIS
Francisci de Syluestris, Ferrariensis, doctoris Theologi, ordinis item Prædicato-
rij, olim post eximium regimen obseruantiç (quæ Lombardiæ vocatur) au-
thoritate ac iussu Clementis VII. Pont. Max. Conuentus & gymnasij
Bononiensis regentis ac moderatoris, & deinde totius dicti
ordinis Magistri generalis illustrata: mendis sanè
quamplurimis passim diligenter &
accurate repurgata.

* *
*

Dominum Christum san
ctificate in cordibus ve-
stris, parati semper ad sa-
tisfactionem omni po
scenti vos rationem
de ea quæ in vo
bis est spe &
fide.

1. Petri 3.

PARISIIS,
Apud Viuantium Gaultherotium, sub insigni D. Martini, in via Iacobea.
1552.

Cum Priuilegio.

96. Thomas de Aquino, *Summa contra gentiles*,
comm. by Franciscus Silvestris Ferrariensis
(Paris: J. Savetier for V. Gaultherot, 1552), title page

D. THOMAE AQVINATIS,

EX PRAEDICATORIA

FAMILIA,

SVMMA CONTRA

GENTILES, QVATVOR LIBRIS COMPREHEN-
SA: COMMENTARIIS ERVDITISSIMI VIRI, FRATRIS
Francisci de Syluestris, Ferrariensis, doctoris Theologi, ordinis item Prædicato-
rij, olim post eximium regimen obseruantiç(quæ Lombardiæ vocatur)au-
thoritate ac iussu Clementis VII.Pont.Max.Conuentus & gymnasij
Bononiensis regentis ac moderatoris,& deinde totius dicti
ordinis Magistri generalis illustrata:mendis sanè
quamplurimis passim diligenter &
accuratè repurgata.

✳ ✳

✳

PARISIIS,

Apud Audoēnum Paruum, sub flore Lilio, in via Iacobea.

1 5 5 2.

Cum Priuilegio.

97. Thomas de Aquino, *Summa contra gentiles,*
comm. by Franciscus Silvestris Ferrariensis
(Paris: J. Savetier for O. Petit, 1552), title page

ergo omnis uniuersalitas est a forma, materia secundum se uniuersalis non est, & cum primum subiectū sit omnium prædicamentorum, ipsa est & infimum subiicibile, partiale tamen, & primū subiectum

est hō includunt, unde, id quod est hō, hēt in se aliquid qđ nō hēt humanitas, & ppter hoc nō est totaliter id idē hō & humanitas; sed humanitas significatur ut pars formalis hominis, quia principia diffinitiõia habent se formaliter, respectu materiæ indiuiduantis. In his igitur, id quæ nō sunt composita ex materia & forma, in quib. indiuiduatio non est per materiā indiuidualem.i. per hanc materiam, sed ipsæ formæ per se indiuiduantur oportet d q̄ ipsæ formæ sint supposita subsistentia, unde in eis non differt suppositum & natura. Et sic, cum Deus non sit compositus ex materia & forma, ut ostensum est, *oportet quod Deº d sit sua deitas, sua uita, & quicquid aliud sic de Deo prædicatur.

ctum informationis, ac per hoc undique indiuiduationis radix. Sed de his commentarijs de ente & essentia, & in q. duabus satis dictum est, & inferius amplius dicetur.

ARTICVLVS III.

Vtrum sit idem Deus quod sua essentia, uel natura.

AD TERTIVM sic proceditur. Videtur q̄ non sit idem Deus quod sua essentia uel natura. Nihil enim est in se ipso, sed essentia uel natura Dei, quæ est deitas, dicitur esse in Deo, ergo vt q̄ Deº nō sit idē qđ sua essentia uel natura.

¶ 2 Præt. effectus assimilatur suæ causæ, quia oē agens agit sibi simile: sed in reb. creatis non est idē suppositum quod sua natura (non.n. idē est hō quod sua humanitas) ergo nec Deus est idē qđ sua deitas.

CONTRA, de Deo dicitur quod est uita, & non solum quod est uiuens, ut patet Io. 14. Ego sum uia, ueritas, & uita. Sicut autem se hēt uita ad uiuēte, ita deitas ad Deum, ergo D eus est ipsa deitas.

RESPON. Dicēdum, quod Deus est idem quod sua essentia uel natura. Ad cuius intellectum sciendum est, quod in reb. cōpositis ex materia & forma necesse est quod differant natura, uel essentia & suppositum, quia essentia uel natura cōprehendit in se illa tm̄, quæ cadunt in diffinitione spēi. sicut humanitas cōprehendit in se ea, q̄ cadunt in diffinitione hōis, his.n. homo est homo, & hoc significat humanitas, hoc. s. quo homo est homo. Sed materia indiuidualis cum accidentib. oib. indiuiduantib. ipsam non cadit in diffinitione spēi. non enim cadunt in diffinitione hōis hæ carnes, & hæc ossa, aut albedo, uel nigredo, uel aliquam hmōi, unde hæ carnes & hæc ossa, & accidentia designantia hanc materiam non concluduntur in humanitate, & tñ in eo quod

AD PRIMVM ergo dicendum, quòd de rebus simplicibus loqui nō possumus, nisi per modum compositorum, a quibus cognitionem accipimus; & ideo de Deo loquentes utimur nominibus concretis, ut significemus eius subsistentiam, quia apud nos non subsistunt nisi composita, & utimur nominibus abstractis, ut significemus eius simplicitatem. Quod ergo dicitur, deitas uel uita, uel aliquid huiusmodi esse in Deo, referendum est ad diuersitatem, quæ est in acceptione intellectus nostri, & non ad aliquam diuersitatem rei.

AD SECVNDVM dicendum, quod effectus Dei imitatur ipsum non perfecte, sed secundum quod possunt, & hoc ad defectum imitationis pertinet, quod id, quod est simplex & unum, non potest repræsentari nisi per multa, & sic accidit in eis compositio, ex qua prouenit, quod in eis non est idem suppositum quod natura.

proprie loquendo, sed interpretatis, Deus est ueritas.i. Verus. Secundo habes quo per rõnē ostendas, errorem hūc cum interpretatione ia li (inquantum. s. negabat proprietate sermonis de ly Deus est ueritas) fuisse merito damnatum in Concilio Reniensi contra illum cōgregato. Nam ibi definit tum fuit contrarium, s. quod illæ propositiones (Deus est ueritas, est Deitas, lux, uita & c.) sunt in proprietate sermonis ueræ. Imo q̄ hæ, Deus est uerus est uiuens, & c. sunt in ar. præ. terpretandæ sic, Deus in sensu magis proprio in ar. præ. terpretandæ sic, Deus est ueritas est uita & c. Huius Concilij acta reperies in Diuo Bernardo sermone 80. super Cantica Canticorum, ubi intendit de finire ueritatem hanc tamquam de fide. Itē a scripturis sanctis sic per Concilium prædictū interpretatis, Ioh. 1. de Deo. Vita erat lux huminum. Erat lux uera & 14. Ego sum uia, ueritas, & uita, & 1. Ioh. 5. Hic est uerus Deus, & uita æterna. Item a Regulis catholicæ fidei, quæ explicatur ab Augustino in lib. de fide ad Petrum, cap. 1. ubi loquendo de filio Dei sic dicitur. Qui utique quoniam uerus Deus est, etiam ueritas est, sicut ipse nos edocet dicens. Ego sum uia ueritas, & uita. De spiritu quoque Sancto Ioānes Apostolus ait. Quia spiritus est ueritas. Et utique nōn potest naturaliter uerus Deus

ARTI- non esse, qui ueritas est. Hæc ibi. Vides ergo Beatum Augustī. hic facere idem in iudicium de dicere Deum esse naturaliter Deū, & dicere Deum esse ueritatem. Sicut ergo Deus est proprie Deus, ita Deus est proprie ueritas, & qui negat Deum esse proprie ueritatem, negat Deum esse proprie Deum. Hæc pro Concilii definitione supradicta, & contra errorem illum, annotata etiam sint, Tertio uides, quomodo ex his uicissim firmetur, declaretur Angelica doctrina.

APPENDIX.

EX articulo habes primo, quomodo per rationē interimas errorem in fide Gilberti natione Galli cognomento Porretani (ut refert Magister Bannes) negātis, q̄ Deus esset ueritas uel Deitas, proprie

Comm. Cardinalis Caietani.

IN titulo statim occurrit ambiguitas, pro quo supponit Deus in hoc quæsito, utrum Deus sit idem quod sua essentia. ex secundo namque argumento, & ex toto processu corporis articuli insinuatur, qđ supponit pro supposito diuino, qm̄ nihil aliud hic tractatur, nisi an suppositū naturæ diuinæ, & ipsa natura sint idē. Ex ratione uero suppositi ostenditur oppositum, qm̄ ad rõnem suppositi requiruntur quinque conditiones. s. quod sit substantia, cōpleta, indiuidua, subsistens, incōicabiliter, substantia, propter accidentia, completa, propter partes, indiuidua, propter speciem subsistēs, propter

propter humanitatē Christi, incōicabiliter propter essentia diuinā, q̄ est cōis trib. suppositis, & sic cū suppositū diuinū idē significet qđ persona diuina, & in hoc articulo nulla fiat mentio de personarū constituitiis, consequens est quod ly Deus, non stat pro supposito diuino, & confirmatur hoc, quia inferius quæretur ex proposito, utrum persona & essentia in Deo sint idem, ergo. &c.

Ad hoc est dđm, q̄ ly Deus p̄t tripliciter sumi. Primo ut significat concretū quasi specificū naturæ diuinæ. i. habens deitatē, sicut hō significat habens humanitatē. Scđo, ut significat cōcretū indiuiduale naturæ diuinæ.i. hūc habentē deitatem seu hunc Deum, sicut hō p̄t supponere, pro hoc noīe. Tertio ut significat suppositū naturæ diuinæ, i. hūc incōicabiliter hāte deitatē.i hāc p̄sonā diuinā, sicut

98. Thomas de Aquino, *Summa theologiae* Ia, with comm., vol. 1 (Venice: F. de Franceschi for J. and F. Giunta, 1596), p. 34

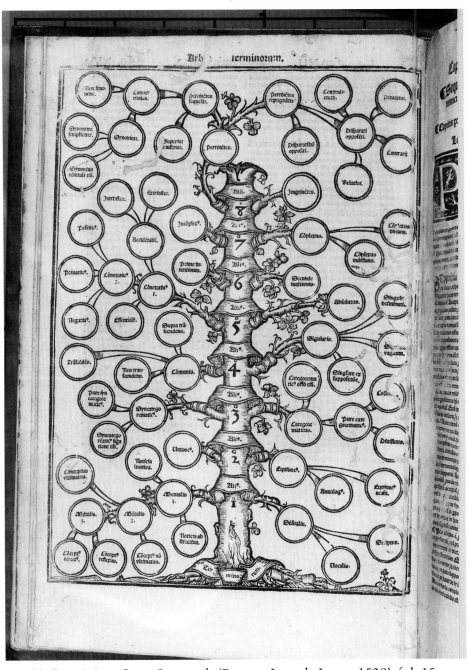

99. Dominicus Soto, *Summule* (Burgos: Juan de Junta, 1529), fol. 15v

BENESCRIPSISTI THOMA·

Cathena aurea Angelici
Thome aquinatis in euangelium Warci:
et receptissimis ecclesie doctoribus mi
ro artificio concinnata iussu summi
pontificis Urbani quarti: opus
plane nostra laude superius
opus iussione dignum apo
stolica z industria prom
ptuz angelica nuper
campestri exanie
politum ac du
plici rege=
sto illu
stra
tu.

100. Thomas de Aquino, *Cathena aurea*
(Lyon: A. Blanchard for J. and F. Giunta, 1530),
comm. on Matthew, title page

101. Thomas de Aquino, *Cathena aurea* (Lyon: A. Blanchard for J. and F. Giunta, 1530), last verso, comm. on Mark, and title page, comm. on Luke

102. Savonarola, *Prediche* (Venice: B. and O. Scoto, 1539), title page

103. Nicolaus Eymerici, *Directorium inquisitorum*
(Barcelona: J. Luschner, 1503), title page verso